# The
# Science Studies
# Reader

# The Science Studies Reader

EDITED BY

# MARIO BIAGIOLI

IN CONSULTATION WITH

PETER GALISON · DONNA J. HARAWAY

EMILY MARTIN · EVERETT MENDELSOHN

SHARON TRAWEEK

Routledge
Taylor & Francis Group

NEW YORK AND LONDON

Published in 1999 by
Routledge
711 Third Avenue, New York, NY 10017

Published in Great Britain by
Routledge
2 Park Square, Milton Park, Abingdon, Oxfordshire OX14 4RN

Library of Congress Cataloging-in-Publication Data

The science studies reader / edited by Mario Biagioli
    p.  cm.
  Includes bibliographical references.
  ISBN 0-415-91867-7 (hbk.). — ISBN 0-415-91868-5 (pbk.)
  1. Science. 2. Science—Philosophy. 3. Science—Authorship.
I. Biagioli, Mario.
Q172.S3  1999
500—dc21                      98-36335
                                 CIP

# Contents

TO THE MEMORY OF

PAUL FEYERABEND

# Introduction

## Science Studies and Its Disciplinary Predicament

### MARIO BIAGIOLI

The definition of science studies would appear to be a simple matter. On the face of it, science studies is about studying science, an enterprise that has succeeded at demarcating its own methodology, epistemological status, institutions, textual genres, and funding agencies. Unlike other academic fields, science studies does not have to define its subject matter in relation to its neighboring disciplines; over the years, the scientists have done much of that work. One might then assume that such a well-delineated object of research would have provided science studies with a unified disciplinary identity. However, quite the opposite has occurred. It is difficult to draw the boundaries of contemporary science studies or to trace its internal subdivisions, cultural genealogies, and sociopolitical valences. And it is no easier to map science studies' institutional ecologies, as its practitioners are dispersed over the widest range of departments and programs.[1]

## I. POWER DIFFERENTIALS

The fact that science is a well-delineated and established enterprise seems to have two opposite effects on science studies: it allows the field to be simultaneously unified (in terms of its object of study) and strongly disunified (in terms of its methodologies, research questions, and institutional locations). The fact that science itself is both very large (both in terms of practitioners and funding) and more influential than science studies makes their relationship not only symbiotic (or perhaps parasitic), but also structured by important power differentials. A few examples may tease out the peculiarity of science studies' predicament vis-à-vis that of other fields in the humanities and social sciences.

Academic fields may define their subject through methodological reflections or manifestos. More often, however, the question of what defines a field emerges in the mundane context of sorting out and demarcating the pool of acceptable research materials. For instance, in literary studies or art history and criticism the question of what literature or art is comes up in the con-

text of considering the inclusion or exclusion of a certain body of texts or artifacts from their subject matter. Does such and such a text qualify as "literature"? If so, is it canonical or not? If not, should one rearrange the canon (and, consequently, one's disciplinary identity) so as to include this kind of text in the canon?

Historians have confronted similar scenarios. When they began to study popular culture, the legitimation of that subfield went hand in hand with discussions about what counted as culture, what boundaries (if any) one should draw between "high" and "low" culture, and how and why popular culture could be accepted as legitimate material for historiography. Similar questions about the definition of culture (or civilization) have reemerged on a grander scale during the debate on "world history" vis-à-vis "Western civilization," or in discussions about the apparently boundless notion of culture put forward by cultural studies.

In all these examples, fields are proactively engaged in demarcating their subject matter. Depending on the disciplinary context in which it is played out, this process resembles either "land reclamation" or the "poaching" of objects and methodologies from other disciplines' "reserves." In either case, fields spend much energy maintaining and/or expanding their boundaries, or claiming that the very notion of disciplinary boundary is sterile.

But as disciplines struggle with each other to carve their fields of inquiry, they are only relatively constrained by their subject matter. Their subject is effectively cast in a passive role, as an object whose definition is a contestable matter to be resolved precisely through such interdisciplinary struggles. In some sense, subject matters are like lands being claimed by competing nations, but there is nothing written on those lands that would make them necessarily belong to one or the other faction. Cultural anthropologists may argue with cultural studies practitioners about what counts as appropriate fieldwork regarding objects that both camps could consider theirs, but the objects themselves cannot bind either camp to a clear-cut definition of what counts as "cultural." Similarly, literary historians may argue against readings by philosophers, political theorists, or linguists of texts they consider "literary." But a Rousseau or a Montaigne (or any other historical author of a text now deemed literary) wouldn't have much to say about these debates not only because they are long gone, but because the disciplines that now claim their texts either did not exist or were radically different then when they were alive.

The problem that concerns me here is not the voicelessness of the interpreted, but the fact that such a voice, even if it were available or heard, would not necessarily seal the debate about what "literature," "culture," or "philosophy" might mean in the context of the contemporary taxonomy of academic disciplines. While contestable subject matters are inherently unstable and their maintenance is labor-intensive, competing disciplines are allowed to treat them as objects they can shape.

The case of science studies is, I think, quite different. Science studies does not define its subject matter because, in some significant way, its subject matter comes prepackaged. It is not that science studies practitioners are obliged to study only what scientists take to be the fundamental aspects of their enterprise (actually the opposite is often true), but simply that science—as the set of scientists' practices, institutions, and so on—remains a socially delineated object no matter how you look at it. As a result, science studies tends not to ask what science is but rather how science works.

The boundary between asking the what and the how is not clear-cut. Some descriptions of the processes of science tend to have a normative ring to them. But the slippages between descriptive and normative registers are not, I believe, only a result of an author's view of how

generalizable his or her interpretation or model of a specific scientific practice may be. They may also indicate the tensions inherent in the "author function" of science studies—a field that is cast as descriptive by its own relationship with an object of research stronger and more influential than itself.

Moreover, science studies practitioners do not necessarily agree about how science works. As shown by the essays in this volume, one can choose many different aspects of science, and represent them as relevant or even exemplary. And it would be very difficult, perhaps impossible, to argue that all these different dimensions and interpretations could be woven into a unified picture of science. In this sense, then, there are probably as many ways to study science as there are to study literature. But the fundamental difference is that, in the case of science studies, methodological disunity does not disunify its subject matter. Its subject matter has become a historical fact and not the product of disciplinary definition.

With this predicament comes an interesting power reversal. Science studies does not colonize its field but, in many ways, is colonized *by* it. This can be illustrated by contrasting science studies with ethnography. One could think of traditional ethnography (the kind that looks at geographically contained cultures) as the field whose relationship with its subject is closest to that of science studies. Ethnographers, like science studies practitioners, deal with research material that appears to be actually circumscribed by the history and practices of that given culture and not by the interpreters' choices. This analogy is not arbitrary; laboratories are routinely pictured as sorts of scientific "tribes." Even if we set aside the important question of how really circumscribed or "authentic" these cultures are, the predicaments of anthropology and science studies are very different because of the different power relationships between the observer and the observed.

Current anthropology has grown reflexive about its own predicament, its colonial past, and the problems of projecting Western notions of culture onto non-Western actors. These political and methodological problems are usually alien to science studies, at least in so far as science studies limits its analyses to Western materials. This is not because science studies is more "politically correct" than anthropology, but because it has never had a chance to develop a "colonial" relationship with its subject. Ethnographers used to have little difficulty "visiting" other cultures and writing whatever they wished about them. Now, contemporary ethnographers of science have to ask permission to enter laboratories, interview scientists, and cite their documents, memos, and E-mails. And as recently shown by the so-called science wars, scientists can be quite forthcoming in voicing their displeasure with some of science studies' views about them.[2]

"Criticism" assumes a peculiar meaning in science studies. The word "criticism" in literature or art has traditionally meant something like "critical appreciation." A critic is someone credited with the skills and sensibility to understand a certain object or text and the process through which it was produced. The outcome of such critical appraisal may not be unconditional praise, but it is not seen as a critique or a debunking of either art or literature in general. Things are different in science studies. Though it does not usually use "criticism" to describe its relationship to science, recently science studies' analyses have been seen by some scientists not as an act of critical appreciation, but as negative attacks on their enterprise as a whole—a general indictment of its epistemological status. These different meanings assumed by "criticism" do not necessarily follow from the content of these interpretations, but are framed by differences in scale, social prestige, and academic clout between the fields.

The effect of these differentials is made clear by a stark comparison. Members of some Native American cultures like the Navajo and the Pueblo have taken exception to the ways West-

ern anthropologists picture them. Consequently, they have tried to control the ethnographers' access to their communities by "screening" them and, in some cases, developing their own ethnographic traditions. But these are responses to perceived denigrations of specific cultures, not to Western anthropologists' misrepresentations of non-Western cultures in general. Like the scientists, these cultures react to perceived misrepresentations but, unlike the scientists, they don't seem to generalize the scope of their claims. Such a difference may be the result of the scale and interconnectedness of science relative to these cultures. For instance, a biologist considers him or herself a biologist *and* a scientist; that is, a member not only of a specific and usually small working group but also of a very large, nationally and internationally connected community. It may be the structure, scale, and social robustness of the scientific community that makes some of its members read local critiques as general ones. Perhaps, if there were a powerful international federation of non-Western communities, the Navajo and Pueblo too might think that the ethnographers who misrepresent them were trying to undermine non-Western culture in general.

Although science studies cannot "control" its subject matter, it can pick its methodologies and research questions very broadly and yet remain a recognizable field. As science studies produces more empirical work, it further "disunifies" itself methodologically while producing increasingly complex and "disunified" pictures of science,[3] *a double trend toward disunity that dissolves neither the field nor its subject matter.*

## 2. INSTRUCTIONS TO THE READER

If we turn from the general predicament of science studies to that of its texts, it becomes evident that no collection of essays can declare the canon of this field—a field simultaneously bound by its object and proliferating in various interpretative directions. This volume can cast itself only as a sampler (though a large and rich one), not a canonical text. This collection presents thirty-six contributions from contemporary history, sociology, gender studies, anthropology, and cultural studies of science that identify various research questions and directions that are likely to remain active in the near future.

Most science studies practitioners have shown a strong concern with methodological issues. Many of these debates are as yet unresolved. Readers of this volume will be able to pick up the main methodological congruences and fault lines dispersed throughout the several essays contained within, and will find references to more in-depth discussions that, for reasons of space, could not be represented here.[4]

The volume has been designed with various audiences and uses in mind. Because of the wide range of materials and approaches it presents, *The Science Studies Reader* can be used as the core text in introductory courses in science studies at the graduate and advanced undergraduate level. Instructors and students will find many of the "classic" essays used in this kind of course, but also more recent contributions and essays. Additionally, the Reader includes a number of methodologically oriented pieces and critiques, making it suitable for more advanced "methods" courses. Many of the articles have been revised and condensed by the authors specially for this Reader, while other pieces have been written specifically for this volume to provide synthetic essay-length treatments of longer arguments. Due to space limitations, the footnote apparatuses

have been often reduced, but the interested reader can easily access that information in the original publications—whose location is always given at the beginning of each essay.

This volume is also aimed at those who have an interest in science studies but are not pursuing it within specialized academic courses and programs. A map of some of the clusterings of essays and topics may help these readers tailor this volume's heterogeneous table of contents to their specific interests.

The epistemological deadlocks associated with the dichotomy between realism and constructivism (or, much more broadly, between "nature" and "culture") are an ongoing concern for much of contemporary science studies. Several contributions to this volume (especially those by Barad, Callon, Fox Keller, Galison, Haraway, Latour, Pickering, Rabinow, Rheinberger, and Rouse) propose alternative frameworks aimed at solving or bypassing these dichotomies while analyzing their genealogies. The essays by Cohen and Lenoir offer critical readings of some of these proposals.

Many of the articles are also informed by the questioning of how different cognitive styles emerge in different disciplines, national cultures, and historical periods, often in connection to the use of specific technologies, instruments, and techniques. The essays by Daston, Davidson, Galison, Hacking, Hughes, Kay, Kohler, Lloyd, Lynch and Law, Martin, Porter, Rabinow, Star and Griesemer, Traweek, Turkle, and Wylie exemplify this literature.

The study of the gender dimensions of science has become an important focus of recent science studies. This broad topic has been often subdivided into a number of interrelated issues: the analysis of the role (and more often the marginalization) of women in science, the critique of science's representation of sexual differences and sexualities, the development of feminist epistemologies, and the study of the pervasively gendered nature of scientific knowledge.[5] The work by Barad, Fox Keller, Haraway, Martin, Traweek, and Wylie focuses primarily on the two last questions, but resonates with the others as well.

As a result of a widespread shift in focus from scientific theory to scientific practices, the study of instruments, experiments, and replication has become one of the most practiced areas of science studies. Many of the essays in this volume gravitate around these questions, but with different emphases. Notions of practice, technique, and skill (not necessarily limited to experimental contexts) are central to the work of Brain and Wise, Collins, Galison, Lynch and Law, MacKenzie, Pickering, Rheinberger, Rotman, Rouse, Schaffer, and Turkle. As practices are inherently tied to bodies and spaces (as distinct from theories, which are more easily associated with minds and mental states), a number of articles (especially those by Callon, Galison, Kohler, Latour, Lynch and Law, Schaffer, Shapin, and Star and Griesemer) focus specifically on the sites of science (laboratories, museums, fields, and fisheries). The different professional cultures, moral economies, forms of initiation, collaboration, and negotiation that develop in these sites (and some of the technologies to make knowledge travel from the place of production) are discussed by Biagioli, Bourdieu, Daston, Galison, Hughes, Kohler, MacKenzie, Pickering, Porter, Schaffer, Shapin, and Traweek. Finally, how instruments migrate across disciplines and mediate the interaction between different socio-professional groups are issues that characterize the essays by Brain and Wise, Galison, and Schaffer. While not limited to the context of instrumental inscriptions, the role of imaging techniques in science is a topic that is closely associated with it. The reader can develop a good sense of the contours of this discussion by looking at the essays by Brain and Wise, Lynch and Law, and Rotman.

The construction of scientific credit, priority, and authorship is a question that is often touched upon within analyses of the establishment of scientific consensus and authority—a

topic that weaves through much of this volume—but is dealt with more specifically in the arti-
cles by Biagioli, Bourdieu, Kohler, Latour ("Give me a Laboratory . . ."), and Shapin. As scien-
tific credit is inherently tied to publications, the reader interested in these issues as well as in the
modalities of signification of scientific texts is referred to the essays by Biagioli, Kay, Rhein-
berger, and Rotman.

Questions about how non-Western cultures have understood and conceptualized nature,
and how these interpretations compare to those of Western science, are part of the long, grand
debate about the relationship between the "West" and the "rest." Anthropologists have addressed
some of these questions (both ethnographically and philosophically), but science studies too has
played a role in the discussion (especially through the history of Islamic and Chinese science and
Indian mathematics). While Hart's and Lloyd's revisions of the debate on the relationship of
Chinese and Western science presented here cover only a specific aspect of this discussion, they
provide a window on some of the conditions of possibility (and structural limitations) of the
general debate on Western and non-Western conceptualizations of nature.

Two bibliographies have been added at the end of the volume to provide references for further
readings. The first catalogs five items for each contributor. These are texts that the contributors
themselves have identified as most representative of their work in science studies. The second,
longer bibliography has been compiled by adding together short bibliographies provided by
each contributor. These lists represent what they take to be the "must read" texts in science stud-
ies today. The bibliography, therefore, does not represent a comprehensive or exhaustive list of
works in science studies, but a collective snapshot of the contributors' orientations.

Having addressed what is included in the Reader, let me discuss what has been left out, as
drastic selection procedures had to be adopted to compress an entire field between two covers.

With a few exceptions, all the essays focus on modern and contemporary science, mostly
physical and biological—a distribution that reflects the field's own chronological focus. Then,
having decided to center the volume around current research questions rather than intellectual
genealogies, I have not included the work of such classic authors as Fleck, Kuhn, Feyerabend,
Merton, Canguilhem, Foucault, Barnes, Bloor, and Bachelard. However, readers are strongly
encouraged to familiarize themselves with this literature as it is very relevant to understanding
the intellectual genealogies of the essays presented here.[7]

Other selections reflect a blend of intellectual and pragmatic considerations. For instance,
philosophical questions are conspicuously present in this volume and some of its contributors
are philosophers, but philosophy of science per se is largely absent from this collection. This does
not reflect on the quality of current philosophy of science, but an acknowledgment that—after a
period in which history and philosophy of science seemed to be the best potential partners in the
analysis of science—the lines of inquiry pursued by philosophy of science have become much
less central to the field that science studies has become.[8]

The almost total exclusion of materials from medicine and technology reflects the fact that
history, sociology, and anthropology of medicine and technology are large and actively practiced
fields whose literature is as sizeable as that of science studies itself.[9] And, ever-changing a field as
cultural studies, could not be adequately represented in this collection.[10]

# ACKNOWLEDGMENTS

I wish to thank Sophie Wadsworth, Rebecca Gelfond, Kristina Stewart, and Jean Titilah for their assistance and to Peter Galison, Donna Haraway, Emily Martin, Everett Mendelshon, and Sharon Traweek for editorial advice. My students in HS200 didn't know they were being enrolled in a pedagogical experiment (without placebos), but I hope they will appreciate the end product. Special thanks to Peter Galison and Sherry Turkle for their ongoing support and to Bill Germano for his stoic patience. This has been an inherently collective project that would have been impossible without the contributors' willingness to adapt their work to this volume. Editing one's work (or to see it edited by someone else) is rarely pleasurable, and I do appreciate the authors' labor and understanding.

This volume is dedicated to the memory of Paul Feyerabend, friend and teacher, who did not believe in disciplinary fields (and a few other things).

NOTES

1. The list is so extreme in its length and range as to be arresting: departments of history, history of science, science studies, philosophy, sociology, anthropology, literature, and art history; programs in cultural studies, gender studies, and history of consciousness; medical and law schools, science departments, art schools, policy institutes, science museums, and even mining schools.

2. The texts that are most frequently referred to in this debate include: Paul R. Gross, Norman Levitt, *Higher Superstition: The Academic Left and Its Quarrels with Science* (Baltimore: Johns Hopkins University Press, 1994); *Social Text*, 46–47 (1996), special issue on "Science Wars"; Paul R. Gross, Norman Levitt, Martin Lewis (eds), *The Flight from Science and Reason* (Baltimore: Johns Hopkins University Press, 1997); Andrew Ross (ed), *Science Wars* (Durham, NC: Duke University Press, 1996); Alan Sokal, "A Physicist Experiments with Cultural Studies," *Lingua Franca*, May/June, 1996, and the responses to it in the July/August issue of *Lingua Franca*.

3. For a discussion of the trend from unity to disunity of science see, Peter Galison, "The Context of Disunity," in *The Disunity of Science: Boundaries, Contexts, and Powe,* (Stanford: Stanford University Press, 1996), pp. 1–33.

4. A fundamental text in these debates is Andrew Pickering (ed), *Science as Practice and Culture* (Chicago: University of Chicago Press, 1992). For more recent developments, see Malcolm Ashmore and Eveleen Richards (eds), "The Politics of SSK," special issue of *Social Studies of Science*, 26 (1996), no. 2.

5. See, for instance, Evelyn Fox Keller and Helen Longino (eds), *Feminism and Science* (Oxford: Oxford University Press, 1996), and Linda Alcoff and Elizabeth Porter (eds), *Feminist Epistemologies* (New York: Routledge, 1993).

6. Other surveys of the field and copious bibliographies can be found in Sheila Jasanoff, Gerald Markle, James Petersen, Trevor Pinch (eds), *Handbook of Science and Technology Studies* (Thousand Oaks, CA: Sage, 1994). R. C. Olby, G. N. Cantor, J. R. R. Christie, M. J. S. Hodge (eds), *Companion to the History of Modern Science* (London: Routledge, 1990); and David Hess, *Science Studies: An Advanced Introduction* (New York: NYU Press, 1997).

7. Ludwik Fleck, *Genesis and Development of a Scientific Fact* (Chicago: University of Chicago Press, 1979); Thomas Kuhn, *The Structure of Scientific Revolutions* (Chicago: University of Chicago Press, 1962), and *The Essential Tension* (Chicago: University of Chicago Press, 1977); Paul K. Feyerabend, *Against Method* (London: NLB, 1975), and *Science in Free Society* (London: NLB, 1978); Robert K. Merton, *The Sociology of Science: Theoretical and Empirical Investigations* (Chicago: University of Chicago Press, 1973); Georges Canguilhem, *The Normal and the Pathological* (New York: Zone Books, 1989); Barry Barnes, *Scientific Knowledge and Sociological Theory* (London: RKP, 1974), and *T. S. Kuhn and Social Science* (New York: Columbia University Press, 1982); David Bloor, *Knowledge and Social Imagery* (London: RKP, 1976), and *Wittgenstein: A Social Theory of Knowledge,* (New York: Columbia University Press, 1983); Gaston Bachelard, *La formation de l'esprit scientifique* (Paris: Vrin, 1986); Michel Foucault, *The Order of Things* (New York: Vintage, 1970), and *Birth of the Clinic* (New York: Pantheon, 1973).

8. A comprehensive survey of recent work in philosophy of science is presented in Richard Boyd, Philip Gasper, J. D. Trout (eds), *The Philosophy of Science* (Cambridge, Mass.: MIT Press, 1991).

9. Readers in the anthropology and history of medicine include: Shirley Lindebaum and Margaret Lock (eds), *Knowledge, Power, and Practice: The Anthropology of Medicine and Everyday Life* (Berkeley: University of California Press, 1993); Carolyn F. Sargent and Thomas M. Johnson, *Medical Anthropology: Contemporary Theory and Method* (Westport, Conn.: Praeger, 1996); Judith Leavitt and Ronald Numbers (eds), *Sickness and Health in America: Readings in the History of Medicine and Public Health* (Madison: University of Wisconsin Press, 1997); Andrew Wear (ed), *Medicine in Society: Historical Essays* (Cambridge: Cambridge University Press, 1992); Peter Wright and Andrew Treacher (eds), *The Problem of Medical Knowledge: Examining the Social Construction of Medicine* (Edinburgh: Edinburgh University Press, 1982).

For the history and sociology of technology, see Donald MacKenzie and Judy Wajcman (eds), *The Social Shaping of Technology* (Milton Keynes: Open University Press, 1985, second edition 1998); Wiebe E. Bijker and John Law (eds),

*Shaping Technology/Building Society: Studies in Sociotechnical Change* (Cambridge, Mass.: MIT Press, 1992); Wiebe E. Bijker, Thomas P. Hughes, Trevor J. Pinch (eds), *The Social Construction of Technological Systems* (Cambridge, Mass.: MIT Press, 1987).

10. As a starting point, see George Marcus (ed), *Technoscientific Imaginaries* (Chicago: University of Chicago Press, 1995), and Mario Biagioli, Roddey Reid, Sharon Traweek (eds), *Located Knowledges: Instersections Between Science, Gender, and Cultural Studies,* a special issue of *Configurations,* 2 (1994).

# I

# Agential Realism

## Feminist Interventions in Understanding Scientific Practices

### KAREN BARAD

The morning after giving an invited lecture on the socially constructed nature of scientific knowledge, I had the privilege of watching as an STM (scanning tunneling microscope) operator zoomed in on a sample of graphite, and as we approached a scale of thousands of nanometers . . . hundreds of nanometers . . . tens of nanometers . . . down to fractions of a nanometer, individual carbon atoms were imaged before our very eyes. The experience was so sublime that it sent chills through my body—and I stood there, a theoretical physicist who, like most of my kind, rarely ventures into the basements of physics buildings experimental colleagues call "home", conscious that this was one of those life moments when the amorphous jumble of history seems to crystallize in a single instant. How many times had I recounted for my students the evidence for the existence of atoms? And there they were—just the right size and grouped in a hexagonal structure with the interatomic spacings as predicted by theory! "If only Einstein, Rutherford, Bohr, and especially Mach, could have seen this!" I found myself exclaiming. And as the undergraduate students operating the instrument (that they had just gotten to work the day before by carefully eliminating sources of vibrational interference—we're talking nanometers here!) disassembled the chamber which held the sample so that I could see for myself the delicate positioning of the probe above the graphite surface, expertly cleaved with a piece of scotch tape, I mused out loud that "seeing" atoms would quickly become routine for students (as previous generations in turn found the examination of cells by visual light microscopes to be and then the structure of molecules by electron microscopes so) and that I was grateful to have been brought up in a scientific era without this particular expectation. (Barad 1996, 161)

This story from a recent essay of mine might be read as the vindication of a realist account of scientific theories: the final scene in a great tale of discovery that, by common tellings, extends from Democritus' imaginings to its very recent imagings under the objective eye of a scanning tunneling microscope.[1] Reminiscent of so many textbook portrayals which provide accounts connecting select historical moments (sometimes separated by centuries, e.g., from Democritus to Dalton), retrospectively identified as "developments" in a linear unfolding of the truth about atoms, it also acknowledges dissension and disagreements as a natural part of science: in this case, Mach was simply wrong. And bringing it all into the very near future is the suggestion that undergraduate and perhaps even high school students will soon perform such experiments as

one of the weekly lab exercises—as something so routine that it becomes simply one more task to check off before the instructor allows one to go for the day.

But there is something a bit queer about this story if one tries to read it purely through the lens of realism. For there is a tension set up between realism and social constructivism that is an acknowledgment of the dichotomous portrayal of these positions—a polarization that itself relies upon the ambiguity of both terms. The dichotomized positions of realism and social constructivism—which presume a subject/object dichotomy—can acknowledge the situated/constructed character of only one of the poles of the dualism at a time. Realists do not deny that subjects are materially situated; constructivists insist upon the socially or discursively constructed character of objects. Neither recognizes their mutually constitutive "intra-action."[2]

The simultaneous recognition of the material *and* the discursive has faltered on this dichotomy. On the one hand, efforts to incorporate material factors in social constructivist accounts have been debilitated by the reductive choice between repositioning the material world outside of discourse or anthropomorphizing nature.[3] On the other hand, the incorporation of discursive factors in realist accounts hinges on a reconsideration of the representational status of language and a foregrounding of the productive dimensions of discourse.[4] Attempts which propose to overcome these difficulties by asserting some unified sense of wholeness or symmetry outside of power relations will not suffice. What is needed is an approach that recognizes the power-laden distinctions drawn between subject and object, nature and culture, human and nonhuman, and examines their consequences.

In an attempt to bypass the problems generated by the dichotomy opposing realism and social constructivism, I propose a framework for analyzing the nature of these distinctions and their consequences. I call such an alternative *agential realism*. Agential realism is an epistemological and ontological framework that provides an understanding of science as "material-discursive" practices.[5,6] These practices are recognized as being productive rather than merely descriptive. However, what is produced is constrained by particular material-discursive factors and not arbitrarily construed. Agential realism theorizes agency in a way that acknowledges that there is a sense in which "the world kicks back" (i.e., nonhuman and cyborgian forms of agency in addition to human ones) without assuming some innocent, symmetrical form of interaction between knower and known.[7]

Contrast the realist reading of the opening story with a rereading as diffracted through the framework of agential realism. According to agential realism, scientific practices are intra-actions of multiple material-discursive apparatuses, including but not limited to the instrumentation employed. There are many different apparatuses that can be identified in that story (and some important ones that will inevitably be left out of any description), aside from the obvious one, the scanning tunneling microscope. These include: the high value accorded to visualization in our epistemic economy; techniques borrowed from a set of scientific practices outside the discipline of physics (such as the geologist's practice of cleaving certain crystals like graphite with scotch tape); the gendered and raced divisions of labor that characterize disciplinary practices and place educational, social, and physical distances between different groups; the local and global economic conditions that make such an experiment possible; the privileging of realist discourses in public and pedagogical accounts of science; the troubleshooting of site-specific problems that had initially prevented the students from obtaining scientifically useful images (such as the vibration problem)—that is, getting the microscope to "work" involves a range of practices including judgments identifying certain aspects of images as artifacts and others as consti-

tuting "data," and under what conditions, and so forth. What emerges out of this specific practice is the production of specific "material-discursive phenomena," elements of "agential reality," including scientists-in-training, atoms (neither Democritus', nor Rutherford's, nor Bohr's, though these histories are embedded in current practices), and consumers of scientific descriptions, among others.[8] That is, there are apparatuses at work constructing both the "subjects" and the "objects."[9]

I turn to the work of physicist Niels Bohr as a place to begin articulating my notion of agential realism. Bohr's search for a coherent interpretation of quantum physics led him to more general epistemological considerations which challenged representationalist assumptions about the nature of scientific inquiry. These considerations focused on: (1) the connections between descriptive concepts and material apparatuses; (2) the inseparability of the "objects of observation" and the "agencies of observation"; (3) the emergence and co-constitution of the "objects of observation" and the "agencies of observation" within particular material and conceptual epistemic practices; (4) the interdependence of material and conceptual exclusions; (5) the material conditions for objective knowledge; and (6) reformulation of the notion of causality. Bohr's epistemological framework, and especially its generalization to agential realism, is a powerful tool for understanding the nature of scientific practices.[10]

Both the feminist reading of Bohr's epistemological framework that I offer and its generalization to agential realism fall under the rubric of feminist science studies.[11] This is in part because they share a normative commitment to a responsible and democratic future for science.[12] As Rouse puts it: "Feminist science studies scholars most evidently differ from the new sociologists in their opposition to relativism, their normative stance toward particular scientific claims, and their willingness to retain and employ suitably revised conceptions of evidence, objectivity, and a distinction between belief and knowledge." It is the effort to work out the implications of these issues in developing a richer understanding of science that has taken feminists from gender issues in science to broader epistemological and ontological issues. Thus, "gender politics are not simply about relations among men and women but are focused precisely on how to understand agency, body, rationality, and the boundaries between nature and culture."[13]

## BOHR'S EPISTEMOLOGICAL FRAMEWORK

Bohr's careful analysis of the process of observation led him to conclude that two implicit assumptions needed to support the Newtonian framework and its notion of the transparency of observations were flawed: (1) the assumption that observation-independent objects have well-defined intrinsic properties that are representable as abstract universal concepts; and (2) the assumption that the measurement interactions between the objects and the agencies of observation are continuous and determinable, ensuring that the values of the properties obtained reflect those of the observation-independent objects, as separate from the agencies of observation. In contrast to these Newtonian assumptions, Bohr argued that *theoretical concepts are defined by the circumstances required for their measurement.* It follows from this fact, and the fact that there is an empirically verifiable discontinuity in measurement interactions, that there is no unambiguous way to differentiate between the "object" and the "agencies of observation." As no inherent cut exists between "object" and "agencies of observation," measured values cannot be attributed to

observation-independent objects. In fact, he concluded that observation-independent objects do not possess well-defined inherent properties.[14]

Bohr constructs his post-Newtonian framework on the basis of quantum wholeness, the lack of an inherent distinction between the "object" and the "agencies of observation." He uses the term "phenomenon," in a very specific sense, to designate particular instances of wholeness: "While, within the scope of classical physics, the interaction between object and apparatus can be neglected or, if necessary, compensated for, in quantum physics *this interaction thus forms an inseparable part of the phenomenon*. Accordingly, the unambiguous account of proper quantum phenomena must, in principle, include a description of all relevant features of the experimental arrangement (Bohr 1963c, 4, my emphasis).

Bohr's insight concerning the intertwining of the conceptual and physical dimensions of measurement processes is central to his epistemological framework. The physical apparatus marks the conceptual subject-object distinction: the physical and conceptual apparatuses form a nondualistic whole. That is, descriptive concepts obtain their meaning by reference to a particular physical apparatus which in turn marks the placement of a constructed cut between the "object" and the "agencies of observation." For example, instruments with fixed parts are required to understand what we might mean by the concept "position." However, any such apparatus necessarily excludes other concepts, such as "momentum," from having meaning during this set of measurements, since these other variables require an instrument with movable parts for their definition. Physical and conceptual constraints and exclusions are co-constitutive.

Since there is no inherent cut delineating the "object" from the "agencies of observation," the following question emerges: What sense, if any, should we attribute to the notion of observation? Bohr suggests that "by an experiment we simply understand an event about which we are able in an unambiguous way to state the conditions necessary for the reproduction of the phenomena."[15] This is possible on the condition that the experimenter introduces a constructed cut between an "object" and the "agencies of observation."[16] That is, in contrast to the Newtonian worldview, Bohr argues that no inherent distinction preexists the measurement process, that every measurement involves a particular choice of apparatus, providing the conditions necessary to give definition to a particular set of classical variables, at the exclusion of other equally essential variables, and thereby embodying a particular constructed cut delineating the "object" from the "agencies of observation." This particular constructed cut resolves the ambiguities only for a given context; it marks off and is part of a particular instance of wholeness.

Especially in his later writings, Bohr insists that quantum mechanical measurements are "objective." Since he also emphasizes the essential wholeness of phenomena, he cannot possibly mean by "objective" that measurements reveal inherent properties of independent objects. But Bohr does not reject objectivity out of hand, he simply reformulates it. For Bohr, "objectivity" is a matter of "permanent marks—such as a spot on a photographic plate, caused by the impact of an electron—left on the bodies which define the experimental conditions" (Bohr 1963c, 3). Objectivity is defined in reference to bodies and, as we have seen, reference must be made to bodies in order for concepts to have meaning. Clearly, Bohr's notion of "objectivity," which is not predicated on an inherent distinction between "objects" and "agencies of observation," stands in stark contrast to a Newtonian sense of "objectivity" denoting observer independence.

The question remains: What is the referent of any particular objective property? Since there is no inherent distinction between object and apparatus, the property in question cannot be attributed meaningfully to either an abstracted object or an abstracted measuring instrument.

That is, the measured quantities in a given experiment are not values of properties which belong to an observation-independent object, nor are they purely artifactual values created by the act of measurement (which would belie any sensible meaning of the word "measurement"). My reading is that the measured properties refer to phenomena, remembering that phenomena are physical-conceptual *intra-actions* whose unambiguous account requires "a description of all relevant features of the experimental arrangement." I use *intra-actions* to signify *the inseparability of objects and agencies of observation* (rather than *interactions,* which reinscribes the contested dichotomy).

While Newtonian physics is well known for its strict determinism, its widely acclaimed ability to predict and retrodict the full set of physical states of a system for all times, based upon the simultaneous specification of two particular variables at any one instant of time, Bohr's general epistemological framework proposes a radical revision of such an understanding of causality.[17] He explains that the inseparability of the object from the apparatus "entails . . . the necessity of a final renunciation of the classical ideal of causality and a radical revision of our attitude towards the problem of physical reality" (Bohr 1963b, 59–60). While claiming that his analysis forces him to issue a final renunciation of the classical ideal of causality, that is, of strict determinism, Bohr does not presume that this entails overarching disorder, lawlessness, or an outright rejection of the cause and effect relationship. Rather, he suggests that our understanding of the terms of that relationship must be reworked: "the feeling of volition and the demand for causality are equally indispensable elements in the relation between subject and object which forms the core of the problem of knowledge" (Bohr 1963a, 117). In short, he rejects both poles of the usual dualist thinking about causality—freedom and determinism—and proposes a third possibility.[18]

Bohr's epistemological framework deviates in an important fashion from classical correspondence or mirroring theories of science. For example, consider the wave-particle duality paradox originating from early-twentieth-century observations conducted by experimenters who reported seemingly contradictory evidence about the nature of light: under certain experimental circumstances light manifests particle-like properties and under an experimentally incompatible set of circumstances light manifests wave-like properties. This situation is paradoxical to the classical realist mindset because the true ontological nature of light is in question: either light is a wave or it is particle; it can't be both. Bohr resolved the wave-particle duality paradox as follows: "wave" and "particle" are classical descriptive concepts that refer to different mutually exclusive phenomena and not to independent physical objects. He emphasized that this saved quantum theory from inconsistencies, since it was impossible to observe particle and wave behaviors simultaneously, since mutually exclusive experimental arrangements are required. To put the point in a more modern context, according to Bohr's general epistemological framework referentiality is reconceptualized: the referent is not an observation-independent reality, but phenomena. This shift in referentiality is a condition for the possibility of objective knowledge. That is, a condition for objective knowledge is that the referent is a phenomenon (and not an observation-independent object).

## AGENTIAL REALISM

Apparatuses, in Bohr's sense, are not passive observing instruments. On the contrary, they are productive of (and part of) phenomena. However, Bohr leaves the meaning of "apparatus"

somewhat ambiguous. He does insist that what constitutes an "apparatus" only emerges in the context of specific observational practices. But while focusing on the lack of an inherent distinction between the apparatus and the object, Bohr doesn't directly address the question of where the apparatus "ends." In a sense this only establishes the "inside" boundary and not the "outside" one. For example, if a computer interface is hooked up to a given instrument, is the computer part of the apparatus? Is the printer attached to the computer part of the apparatus? Is the paper that is fed into the printer? Is the person who feeds in the paper? How about the person who reads the marks on the paper? How about the community of scientists who judge the significance of the experiment and indicate their support or lack of support for future funding? What precisely constitutes the apparatus that gives meaning to certain concepts at the exclusion of others?[19]

A central focus in Bohr's discussion of objectivity is the possibility of "unambiguous communication" which can only take place in reference to "bodies which define the experimental conditions" and which embody particular concepts, to the exclusion of others. This seems to indicate Bohr's recognition of the social nature of scientific practices: making meanings involves the interrelationship of complex discursive and material practices. What is needed is an articulation of the notion of apparatuses that acknowledges this complexity.[20]

Theorizing the social and political aspects of practices is a challenge that was taken up by Michel Foucault. Like Bohr, Foucault is interested as well in the productive dimension of practices embodied in "apparatuses."[21] Reading Foucault's and Bohr's analyses of apparatuses through one another provides a richer overall account of apparatuses: extending the domain of Bohr's analysis from the physical-conceptual to the material-discursive more generally, and providing a further articulation of Foucault's account, extending its domain to include the natural sciences, and offering an explicit analysis of the inseparability of apparatus and subject, and the co-constitution of material and discursive constraints and exclusions. I briefly summarize a few of the main points below.[22]

Significantly, Foucault's apparatuses are productive of specific material and discursive arrangements. According to Foucault, apparatuses of observation are technologies of power: power is exercised, diffused, invested, and transmitted through its productive effects upon individual bodies. These effects are constraining but not determining.

Reading Bohr and Foucault through one another yields the following important points. Apparatuses of observation are not simple instruments but are themselves complex material-discursive phenomena, involved in, formed out of, and formative of particular social processes. Power, knowledge, and being are conjoined in material-discursive practices.

How does this recognition of the material-discursive character of apparatuses matter to the ontological issues that are at stake in debates between realism and social constructivism? Petersen notes an important aspect of Bohr's response to such questions:

Traditional philosophy has accustomed us to regard language as something secondary, and reality as something primary. Bohr considered this attitude toward the relation between language and reality inappropriate. When one said to him that it cannot be language which is fundamental, but that it must be reality which, so to speak, lies beneath language, and of which language is a picture, he would reply "We are suspended in language in such a way that we cannot say what is up and what is down. The word 'reality' is also a word, a word which we must learn to use correctly" (Petersen 1985, 302).

Unfortunately, Bohr is not explicit about how he thinks we should use the word "reality." I have argued elsewhere that a consistent Bohrian ontology takes phenomena to be constitutive of real-

ity (Barad 1996). Reality is not composed of things-in-themselves or things-behind-phenomena, but things-in-phenomena.[23] Because phenomena constitute a nondualistic whole, it makes no sense to talk about independently existing things as somehow behind or as the causes of phenomena.

The ontology I propose does not posit some fixed notion of being that is prior to signification (as the classical realist assumes), but neither is being completely inaccessible to language (as in Kantian transcendentalism), nor completely of language (as in linguistic monism). That reality within which we intra-act—what I term *agential reality*—is made up of material-discursive phenomena. Agential reality is not a fixed ontology that is independent of human practices but is continually reconstituted through our material-discursive intra-actions.

Shifting our understanding of the ontologically real from that which stands outside the sphere of cultural influence and historical change to agential reality allows a new formulation of realism (and truth) that is not premised on the representational nature of knowledge. If our descriptive characterizations do not refer to properties of abstract objects or observation-independent beings but rather describe agential reality, then what is being described by our theories is not nature itself but our participation *within* nature. That is, realism is reformulated in terms of the goal of providing accurate descriptions of agential reality—that reality within which we intra-act and have our being—rather than some imagined and idealized human-independent reality. I use the label *agential realism* for both the new form of realism and the larger epistemological and ontological framework that I propose.[24]

According to agential realism, reality is sedimented out of the process of making the world intelligible through certain practices and not others. Therefore, we are not only responsible for the knowledge that we seek but, in part, for what exists. Scientific practices involve complex intra-actions of multiple material-discursive apparatuses of bodily production.[25] Material-discursive apparatuses are themselves phenomena made up of specific intra-actions of humans and nonhumans, where the differential constitution of "nonhuman" (or "human") itself designates an emergent and evolving phenomenon, and what gets defined as an "object" (or "subject") and what gets defined as an "apparatus" emerges through specific practices. Intra-actions are constraining but not determining.[26] The notion of intra-actions reformulates the traditional notion of causality and opens up a space for material-discursive forms of agency, including human, nonhuman, and cyborgian varieties. According to agential realism, agency is a matter of intra-acting; it is an enactment, not something someone or something has. Agency cannot be designated as an attribute of "subjects" or "objects" (as they do not preexist as such). Agency is about the possibilities and accountability entailed in refiguring material-discursive apparatuses of bodily production, including the boundary articulations and exclusions that are marked by those practices.[27]

## CONCLUSION

Agential realism is a feminist intervention in debates between realists and social constructivists. It provides an understanding of the nature of scientific practices which recognizes that objectivity and agency are bound up with issues of responsibility and accountability. We are responsible for what exists not because it is an arbitrary construction of our choosing, but because agential reality is sedimented out of particular practices that we have a role in shaping. Which material-discursive practices are enacted matters for ontological as well as epistemological

reasons: a different material-discursive apparatus of bodily production materializes a different agential reality, as opposed to simply producing a different description of a fixed observation-independent world. Agential realism is not about representations of an independent reality but about the real consequences, interventions, creative possibilities, and responsibilities of intra-acting within the world.

NOTES

I am grateful to Mario Biagioli, Joe Rouse, Roanne Wilson, and Mikaela Wilson-Barad for their helpful comments and support. I am grateful for the honor of having been selected as the tenth occupant of the Blanche, Edith, and Irving Laurie New Jersey Chair in Women's Studies at Rutgers University and for the opportunities afforded by this position.

1. See Barad (1996). This paper and Barad (1996) offer complementary presentations of agential realism and might usefully be read in conjunction with one another.

2. *Intra-action* is a key concept in the framework of agential realism. It is defined below. I thank Joe Rouse for this inspired way of articulating the realism/social constructivism dichotomy in relation to the challenge agential realism poses for this dichotomy as well as the object/subject one.

3. These issues play a central role in the "epistemological chicken debates" (see Pickering [1992]).

4. See Rouse (1996a) and Barad (1998b) for approaches that acknowledge the performative (productive), as opposed to representational (mimetic), mode of discourses and the consequences that follow for understanding science as particular kinds of performative practices. See Pickering (1995) for a different approach to "understanding science performatively," based on an entirely different understanding of "performativity." For a discussion of the commonalities and differences see Barad (forthcoming).

5. The framework of agential realism challenges the disciplinary divide between epistemology and ontology and suggests a new approach which I label *epistem-onto-logy*, referring to the study of the inseparability of being and knowing (see Barad [1996; 1998a]). Properly speaking, agential realism is an epistem-onto-logical framework.

6. "Material-discursive" refers to the inseparability of the material and the discursive (an analysis of which follows). I understand "discourse" in the Foucauldian sense of discursive practices with its emphasis on the productive dimensions of power (see esp. Foucault [1972]). "Material" can assume a number of its multiple connotations, including physical, biological, technological, economic, and other possible connotations. Although some would argue that Foucault's notion of discourse is material, this is a contentious point which anyway cannot automatically be taken over into science studies because Foucault seemingly accepts a demarcation between the human and natural sciences that manifests itself in his work in his taking for granted the material character of objects.

7. As Casper (1994) demonstrates, using her ethnographic research on experimental fetal surgery, the symmetry with respect to human and nonhuman agency insisted upon by actor-network theorists (see for example Callon [1994]; Latour [1987; 1988]; and Law [1993]) elides the issue of accountability and proves to be problematic politically in thinking through feminist issues such as fetal patienthood. Similarly, Pickering's active-passive dance of agency and his notion of "brute contingency" (as in "it just happened") make it difficult, if not impossible, to deal with issues of accountability (see Pickering [1995]). Both the actor network theorists and Pickering assume some preformed, naturally given, human/nonhuman dichotomy, which leaves the drawing of the boundary between "human" and "nonhuman" outside of the analysis of scientific practices. But the drawing of such boundaries is a politically charged activity from which scientific practices are far from immune (see for example Haraway [1989]). This critique is developed in Barad (forthcoming).

8. *Material-discursive phenomena* and *agential reality* are defined in the following sections. NB: Just because "phenomena" are "produced" (in what sense will be specified below) does not mean that they aren't real. On the contrary, I shall argue that agential reality is as solid as a table (the latter of which is also a material-discursive phenomenon).

9. Of course, this is only an abbreviated rereading of the story as diffracted through the framework of agential realism (see Haraway [1997] and Barad [1997b] on "diffractive readings"). There are many important elements to be brought out including a consideration of the exclusions that are enacted, the role of "human," "nonhuman," and "cyborgian" forms of agency, the intertwining of "material" and "discursive" constraints, and so on. For a detailed example see Barad (1998b). There are also important pedagogical implications (see Barad [1995; 1999]).

10. Before I present my reading of Bohr's general epistemological framework, I want to be clear about the precise focus of the discussion concerning Bohr. As Bohr scholar and philosopher Henry Folse points out:

> While Bohr himself understood from the beginning that he was concerned with philosophical issues extending far beyond his proposed solution to the specific quantum paradoxes that have held the center of attention since 1927, unfortunately, history has not been altogether kind to his philosophical endeavors. Instead of being understood as a general framework within which the new physics was to be justified as an objective description of nature, complementarity came to be identified with the so-called "Copenhagen Interpretation" of quantum theory. (Folse 1985, 6)

It is Bohr's general epistemological framework, and *not* the interpretation of quantum mechanics, that is of interest here.

Although Bohr has been called a positivist, an idealist, an instrumentalist, a (macro)phenomenalist, an operationalist, a pragmatist, a (neo)Kantian, and a realist by various scholars, I would argue that Bohr's philosophy does not fit neatly into any of these categories because it questions many of the dualisms upon which these philosophical schools of thought are founded. For example, while Bohr's understanding of quantum physics leads him to reject the possibility that scientists can gain access to the "things-in-themselves," that is, to the objects of investigation as they exist outside of human conceptual frameworks, he does not subscribe to a Kantian noumena/phenomena distinction. And while his practice of physics shows him to hold a realist attitude toward his subject matter, he is not a realist in any conventional sense, since he believes that the nature of the interaction between the objects of investigation and what he calls "the agencies of observation" is not determinable, and therefore cannot be "subtracted out," leaving us with a representation of the world as its exists independently of human beings.

A separate issue of importance should be noted at this juncture as well. Bohr did not see the epistemological issue with which he was concerned as being circumscribed by Planck's constant. That is, he did not see them as being applicable solely to the microscopic realm. In fact, if Planck's constant had been larger, Bohr insists that the epistemological issues that concern him would have been more evident (and we wouldn't have been as inclined to being fooled into representationalism).

Finally, I want to be clear that I am not interested in mere analogies but rather widely applicable philosophical issues such as the conditions for objectivity, the appropriate referent for empirical attributes, the role of natural as well as cultural factors in scientific knowledge production, and the efficacy of science (especially in the face of increasingly numerous and sophisticated demonstrations of its contingent nature).

11. See for example, Haraway (1991, 1997); Harding (1991); Keller (1992); Longino (1990). For discussions that situate agential realism in conversation with the work of other feminist science studies scholars and feminist epistemologists see for example Barad (1996; 1997a; forthcoming); Haraway (1997); and Heldke (forthcoming).

12. The issues with which Bohr was struggling have interesting resonances with concerns expressed by some contemporary feminist theorists whose focus is not science per se. This is not to claim Bohr as a feminist, rather it is to acknowledge my feminist reading of Bohr. To name but a few of the feminist theories that engage these issues, see for example the feminist postcolonial studies literature (e.g., Fernandes [1997]), the feminist literature theorizing multiple cultures and identity formation (e.g., Anzaldúa [1987]), the literature on materialist feminism (e.g., Hennessy [1993]), and feminist literature on performativity (e.g., Butler [1993]). Barad (forthcoming) explores the mutually informative intersections, reading the work of these theorists and agential realism together. Barad (1998b) reads Butler's notion of performativity and agential realism through one another to provide a richer account of materiality, agency, performativity, and technoscientific practices.

13. Rouse (1996b, 202) and Rouse (1996a, 146) respectively.

14. For more details see Barad (1995). Note: "Agencies of observation" is Bohr's term, which he seems to use interchangeably with "apparatus." Because of the usual association of agency with subjectivity, "agencies of observation" hints at an ambiguity in what precisely constitutes an apparatus for Bohr. For further discussion see the section on "Agential Realism."

15. Bohr quoted in Folse (1983, 124).

16. Bohr called this cut "arbitrary" to distinguish it from an "inherent" cut. But the cut isn't completely arbitrary and so I have used "constructed" as a contrast to "inherent."

17. According to Newtonian physics, the two variables that need to be specified simultaneously are position and momentum. According to Bohr, our understanding of causality as Newtonian determinism must be revised because mutually exclusive apparatuses are required to define "position" and "momentum."

18. For more details see Barad (1998b, forthcoming).

19. For quantum mechanics aficionados this issue may seem to have resonances with the "collapse problem." However, there are significant differences. The concern here is with Bohr's general epistemological framework and not his interpretation of quantum mechanics. (Note: The notion of the collapse of the wave function was a contribution of von Neumann. Bohr never addresses the issue of the collapse. Some scholars have argued that Bohr's interpretation does not require a collapse-type mechanism; others see this as a failure of Bohr's interpretation. At any rate, these issues are not relevant here.)

20. The framework of agential realism provides a further articulation of Bohr's account of apparatuses by acknowledging the complexity of the material and discursive practices which give meaning to certain concepts at the exclusion of others. In this way, agential realism gives Bohr's insights relevance for contemporary studies of science.

21. See especially Foucault (1977), particularly the discussion of "observing apparatuses" such as the panopticon.

22. For more details see Barad (1998b, forthcoming). Rouse (1987, 1996a) also discusses the implications of Foucault's view of power/knowledge for understanding scientific practices.

23. The phrase "things-in-phenomena" hints at an important element of the framework of agential realism: that apparatuses are themselves phenomena.

24. Like Bohr who intended his framework to have epistemological relevance beyond the sphere of science, I do not see any reason to limit the framework of agential realism to the domain of science. Though this is not to presume its universal applicability.

25. "Apparatuses of bodily production" is Haraway's phrase (see her 1988 article "Situated Knowledges" in Haraway [1991], reprinted in this volume). The agential realist rereading of the opening paragraph enumerates some of the apparatuses that are at work in that specific case. See Barad (forthcoming) for details.

26. See Barad (1998b) for details on how to understand the notion of intra-action as a reworking of the traditional notion of causality. (Note: The "intra-action," as opposed to "interaction," of apparatuses refers to the fact that the apparatuses [which are themselves phenomena] are inseparable and mutually constitutive.)

27. Agency and its connection to issues of responsibility and accountability is a central theme of agential realism (see Barad [1996]). For further elaborations see Barad (1998b, forthcoming) and Barad and Heldke (forthcoming). Also see Barad (forthcoming) for detailed examples.

## REFERENCES

Anzaldúa, Gloria. 1987. *Borderlands/La Frontera: The New Mestiza.* San Francisco: Spinsters/Aunt Lute Book Co.

Barad, Karen. 1999. Reconceiving Scientific Literary as Agential Literacy, or Learning How to Intra-act Responsibly within the World. In *Doing Cultural Studies of Science and Medicine,* ed. by Roddey Reid and Sharon Traweek. New York: Routledge.

———. Forthcoming. *Meeting the Universe Halfway.* Book manuscript.

———. 1998b. Getting Real: Performativity, Materiality, and Technoscientific Practices. In *Differences: A Journal of Feminist Cultural Studies* vol. 10, no. 2 (Summer 1998).

———. 1998a. Getting Real. Talk at the Twentieth-Century World Congress of Philosophy, Boston, August 13, 1998.

———. 1997a. Talking Amongst Ourselves: Feminist Conversations on Truth, Reality, Objectivity, and Rationality. Talk given at the enGendering Rationalities Conference, 19 April, Eugene.

———. 1997b. Towards a Diffractive Reading of Diffraction: On Donna Haraway's *Modest_Witness.* Talk given at Social Studies of Science Society meeting, 24 Oct., Tucson.

———. 1996. Meeting the Universe Halfway: Realism and Social Constructivism without Contradiction. In *Feminism, Science, and the Philosophy of Science,* ed. by Lynn Hankinson Nelson and Jack Nelson, 161–94. Dordrecht: Kluwer.

———. 1995. A Feminist Approach to Teaching Quantum Physics. In *Teaching the Majority: Breaking the Gender Barrier in Science, Mathematics, and Engineering,* ed. by Sue V. Rosser, pp. 42–75. New York: Teachers College Press.

Barad, Karen, and Lisa Heldke. Forthcoming. Agential Realism and Objectivity as Responsibility.

Bohr, Niels. 1963a. *The Philosophical Writings of Niels Bohr, Vol. I: Atomic Theory and the Description of Nature.* Woodbridge, Conn.: Ox Bow Press.

———. 1963b. *The Philosophical Writings of Niels Bohr, Vol. II: Essays 1932–1957 on Atomic Physics and Human Knowledge.* Woodbridge, Conn.: Ox Bow Press.

———. 1963c. *The Philosophical Writings of Niels Bohr, Vol. III: Essays 1958–1962 on Atomic Physics and Human Knowledge.* Woodbridge, Conn.: Ox Bow Press.

Butler, Judith. 1993. *Bodies That Matter: On the Discursive Limits of "Sex."* New York: Routledge.

Casper, Monica. 1994. Reframing and Grounding Nonhuman Agency: What Makes a Fetus an Agent? In *American Behavioral Scientist* 37, no. 6 (May).

Callon, Michel. 1994. Four Models for the Dynamics of Science. In *Handbook of Science and Technology Studies,* ed. by S. Jasanoff, G. E. Markle, J. C. Petersen, and T. J. Pinch. Los Angeles: Sage.

Fernandes, Leela. 1997. *Producing Workers: The Politics of Gender, Class, and Culture in the Calcutta Jute Mills.* Philadelphia: U. of Penn. Press.

Folse, Henry. 1985. *The Philosophy of Niels Bohr: The Framework of Complementarity.* New York: North Holland Physics Publishing.

Foucault, Michel. 1977. *Discipline & Punish: The Birth of the Prison.* New York: Vintage Books.

———. 1972. *The Archaeology of Knowledge & The Discourse on Language.* Trans. New York: Pantheon Books.

Haraway, Donna. 1997. *Modest_Witness@Second_Millenium.FemaleMan_Meets_OncoMouse: Feminism and Technoscience.* New York: Routledge.

———. 1991. *Simians, Cyborgs, and Women: The Reinvention of Nature.* New York: Routledge.

———. 1989. *Primate Visions: Gender, Race, and Nature in the World of Modern Science.* New York: Routledge.

Harding, Sandra, ed. 1993. *The "Racial" Economy of Science: Towards a Democratic Future.* Bloomington: Indiana U. Press.

———. 1991. *Whose Science? Whose Knowledge? Thinking from Women's Lives.* Ithaca: Cornell U. Press.

Heldke, Lisa. Forthcoming. Responsible Agents: Connections between Objectivity as Responsibility and Agential Realism. In *enGendering Rationalities,* ed. by Sandi Morgan and Nancy Tuana. Bloomington: Indiana U. Press.

Hennessy, Rosemary. 1993. *Materialist Feminism and the Politics of Discourse.* New York: Routledge.

Keller, Evelyn Fox. 1992. *Secrets of Life/Secrets of Death: Essays on Language, Gender, and Science.* New York: Routledge.

Latour, Bruno. 1988. *The Pasteurization of France.* Cambridge, Mass.: Harvard U. Press.

———. 1987. *Science in Action: How to Follow Scientists and Engineers through Society.* Cambridge, Mass.: Harvard U. Press.

Law, John. 1993. *Modernity, Myth, and Materialism.* Oxford: Blackwell.

Longino, Helen. 1990. *Science as Social Knowledge: Values and Objectivity in Scientific Inquiry.* Princeton: Princeton U. Press.

Petersen, Aage. 1985. The Philosophy of Niels Bohr. In *Niels Bohr: A Centenary Volume,* ed. by A. P. French and P. J. Kennedy. Cambridge, Mass.: Harvard U. Press.

Pickering, Andrew. 1995. *The Mangle of Practice: Time, Agency, and Science.* Chicago: U. of Chicago Press.

———. 1992. *Science as Practice and Culture.* Chicago: U. of Chicago Press.

Rouse, Joseph. 1996a. *Engaging Science: How to Understand its Practices Philosophically.* Ithaca: Cornell U. Press.

———. 1996b. Feminism and the Social Construction of Scientific Knowledge. In *Feminism, Science, and the Philosophy of Science,* ed. by Lynn Hankinson Nelson and Jack Nelson, pp. 195–215. Dordrecht: Kluwer.

———. 1987. *Knowledge and Power: Toward a Political Philosophy of Science.* Ithaca: Cornell U. Press.

# 2

# Aporias of Scientific Authorship

## Credit and Responsibility in Contemporary Biomedicine

### MARIO BIAGIOLI

In the past decade, the definition of authorship has been the topic of many articles and letters to the editor in scientific and especially biomedical journals. The official position of the ICMJE (International Committee of Medical Journal Editors) has been, and continues to be, that authorship must be strictly individual and coupled with full responsibility for the claims published. But the applicability of ICMJE guidelines has come under increasing debate. Indeed, about a year ago, some journal editors called for a paradigm shift in the definition of authorship, while others argued that "it is time to abandon authorship" altogether.[1] But if the problems with traditional definitions of authorship are at this point clearly laid out and a few proposals put forward, a new comprehensive paradigm has yet to emerge.[2]

Coming to this debate as a historian with a background in the early modern period, I am struck by the similarity between the current emphasis on the coupling of scientific authorship and responsibility and older, premarket definitions of the author. Before the emergence of the figure of the intellectual property holder in the late seventeenth and early eighteenth centuries, the author was construed by the state, the prince, or the church as the individual responsible for the content and publication of a given text.[3] The author was not seen as a creative producer whose work deserved protection from piracy, but as the person upon whose door the police would knock if those texts were deemed subversive or heretical.

Although the Office for Scientific Integrity's increasing commitment to democratic due process sets it apart from its inquisitorial ancestors, the current definition of scientific authorship still shares its early modern cousin's relationship to responsibility.[4] Today, if scientists publish dubious claims, they are not accused of *lese majesté* against their absolute ruler or of subverting the church's absolute control on theological doctrines, but they *are* represented as responsible for something that is deemed to be equally absolute: truth.

Although I do not see clear continuities between the sixteenth century and the 1990s, there is something to learn from the genealogy of the figure of the author in science and other fields in

reference to how credit and responsibility have been differently defined, joined, or separated in different disciplines after the demise of early absolutist regimes. In particular, the reward system of science and the liberal economy have developed in parallel as two distinct and yet complementary systems since the seventeenth century, and so the definition of scientific authorship has not been framed by the logic of the reward system of science alone, but by the intersection of these two economies and the way they have carved out different categories of credit and responsibility in relation to each other.

The troubles of scientific authorship have been emphasized by the development of corporate-style contexts of research and professional ethos in the last two decades. The problems, however, were already there. The stress produced by the increased proximity of the complementary economies of science and the market has only highlighted tensions *within* the logic of each system. Authorship is caught between these two tectonic plates, and the pressure is mounting. Although this article cannot prevent earthquakes, I hope it will help locate some of the fault lines and stress points underlying current discussions about the coupling of authorship and responsibility in biomedicine.

## TWO COMPLEMENTARY ECONOMIES OF AUTHORSHIP

In a liberal economy, the objects of intellectual property are artifacts, not nature. One becomes an author by creating something new, something that is not to be found in the public domain. A common view is that copyright is about "original expression," not content or truth.[5] If you paint a landscape, you can claim intellectual property (a form of private property) on the painting (the expression), but not on the landscape itself (the content). Also, copyright does not cover facts or ideas per se. Therefore, though researchers (or journals) can copyright scientific publications and gain some protection from having articles appropriated or reproduced without consent, their rights do not and cannot translate into scientific credit. Saying that they are scientific authors because their papers reflect personal creativity and original expression (the kind of claim one has to make to obtain copyright) would disqualify them as scientists because it would place their work in the domain of artifacts and fiction, not truth. Nor can scientists copyright the content of their claims, because nature is a "fact" and facts (like the landscape represented in a painting) cannot be copyrighted, since they belong to the public domain. In sum, copyright can make scientists authors, but not scientific authors.

Like copyright, patents also reward novelty, since they cover "novel and nonobvious" claims. But, unlike copyrights, such claims need to be useful to be patentable. Scientists, then, can become "authors" as patent holders but cannot patent theories or discoveries per se (either because they are "useless" or because they are about something that belongs to the public domain).[6] It is becoming increasingly common for scientists (mostly geneticists) to patent natural objects, but they do so by making them potentially useful by carving them out of their state of nature.[7] Nature becomes patentable by being turned into something that is less natural and more useful.

As with copyright, the patent system may provide scientists with an authorship venue, but not with scientific authorship. Scientists can patent useful processes stemming from their research, but scientific authorship is defined in terms of the truth of scientific claims, not of their

possible usefulness in the market. In sum, according to definitions of intellectual property, a scientist qua scientist is, literally, a nonauthor. While novel claims are the objects rewarded by both intellectual property law and the reward system of science, the "unit of credit" is dramatically different in these two economies. A new, dramatic discovery that may warrant a Nobel prize cannot be translated, in and of itself, into a patent or a copyright. Likewise, a scientist's copyrights and patents will not earn him or her such an award. It seems, then, that scientific authorship is not "independent" from the logic of the market, but that its definition is complementary to that of market-based authorship as articulated through the copyright or patent systems.

From this complementarity it follows that the primary currency of scientific credit is not money per se, but rewards assigned through peer review (reputation, prizes, tenure, membership in societies, etc.) rather than transacted according to the logic of the market. Intellectual property rights can be exchanged for money because they are a form of private property, and money is the unit of measurement of the value of that form of property. For the same reason, the kind of credit held by a scientific author cannot be exchanged for money because nature (or claims about it) cannot be a form of private property, but belongs in the public domain. Of course, scientists can operate simultaneously in academic and market economies, but, with the help of university lawyers, they need to keep the boundaries between these two systems as distinct as possible. They can also work in industry or government, in which case authorship may be contractually relinquished in accordance with terms of employment. Again, the logic behind the reward of scientific work with "honorific" credit is not independent from, but complementary to, that of monetary economy.

A number of consequences follow. The first is that authorship credit distributed by the reward system of science has to be attached to a scientist's name and cannot be transferred. It is not transferable because scientific authorship cannot be a form of private property, and only private property (like copyrights and patents) can be transferred from one individual to another. The reasons for attaching authorship to a scientist's name, instead, follow from how the notion of truth is construed by the reward system of science.

Truth, unlike private beliefs, is generally defined as something that ought to be public. The accessibility of truth (or simply true information) in the public domain is that which legitimizes liberal democracy as an egalitarian state form.[8] This assumption also justifies the presence of inequality in the private sphere. If you are not as rich as your neighbor, the story goes, you can't blame it on the fact that you lacked access to the same information that was available to the person next door. Empirically, this reasoning may be questionable, but that does not stop it from being widely used as one of the fundamental justifications for the distinction between the public domain and the private sphere (and private property).

The definition of scientific truth as public is usually presented as an epistemological rather than an economic or legal axiom. Truth is defined as public or, more emphatically, as universal, because it is assumed to be transparent and recognizable by anyone who is competent. Truth should be as public and accessible as its object, nature. Putting on hold, for the moment, the question of whether such a definition reflects actual practice, there are other logical reasons for defining truth as public—reasons that stem from the complementarity between the categories of the reward system of science and of liberal economy.

The relationship between truth and private beliefs is parallel to that between the public domain and private property. Both relationships hinge on the distinction between private and public—a distinction that is integral to both science and liberal economy. Private property is

"private" because it is complementary to the public domain, a vaguely defined category that nevertheless provides the conditions of possibility for private property.[9] Likewise, private beliefs are private because they are complementary to public truth, and are made possible by that very category. For instance, when expressed in material forms such as a literary text, a music score, a painting, or a patent, private beliefs (here broadly construed as any personal thought or conception that deviates from the common stock of knowledge and cultural expressions found in the public domain) become the object of intellectual property. Considered as fictions or artifacts, private beliefs may be "bad" from an epistemological point of view, but are simultaneously very "good" in the eyes of liberal economy because they make intellectual property possible.

Whether or not scientific truth is universal, it still has to be defined as such to maintain the logical coherence of both liberal economy and the reward system of science. A notion of universal scientific truth legitimizes private property defined as the result of specific "deviations" from public, "universal" knowledge, and it confirms the epistemological status of science by virtue of being an activity that is outside of monetary economy and private interests. Universal truth is value-free because it is literally defined as valueless, and yet it is the mother of all property values.

How, then, can scientific credit be defined? Intellectual property is often represented as the result of taking as little as possible from the public domain (the shared "pool" of cultural and natural resources) and transforming it into some kind of "original expression."[10] But a scientist is not represented as someone who transforms reality or produces original expression out of thin air, but as a researcher who, with much work, "detects" something specific within nature—the domain of public and "brute" facts. For that finding to be recognized as true, he or she has to put it back in the public domain (here construed as the "public sphere," which includes, but is not limited to, the community of scientific colleagues). Although this is a loop that begins and ends in some version of the public domain, fundamental changes take place along the way. The starting point is *generic* nature, but the result is a *specific* item of true knowledge about nature. Whereas the production of value in a liberal economy involves a movement between two complementary categories (from generic public domain to specific private property), in science the movement is within the same category (the public domain) and goes from unspecified to specified truth. Both cases involve a transformation from something unspecific to something specific. But if in the case of intellectual property such transition can be legally tracked (as it moves across two different categories), scientific credit is much trickier, because the movement from nature and the public domain to a specific true claim about nature does not cross any recognizable legal threshold. As a result, it cannot be legally tracked or monetarily quantified.

Another way to put it is that, in the case of intellectual property, one can rely on the distinction between the form and content of a work (between "original expression" and the "public domain") to determine authorship and property rights. In science, however, a claim cannot be attributed a "form" (in the legal sense of the term), since that would categorize it as an artifact. But, at the same time, a scientific claim cannot be like nature itself, it cannot just be "content." There is a bit of a paradox here. The transition from unspecified to specific truth cannot be attributed to nature, as nature does not investigate itself. Yet that work should not result in a commercially transactable intellectual property because that would destroy its status as truth. Nevertheless, such a transition has to be marked somehow, not only because scientists deserve fair credit for it, but because it has to be marked in order to exist, to be recognized as a specific truth, not just a chunk of undifferentiated, undescribed nature.

Historically, the solution to this paradox has been to attach scientific credit to the scientist's *name* while construing such credit as nonmonetary.[11] That scientific credit is honorific and attached to a scientist's name is a default solution to a problem posed by the inapplicability of the taxonomies of liberal economy to the case of science and, at the same time, by the need to find a solution that does not delegitimize those taxonomies. Such a definition of scientific credit is the result of a metrological necessity. The scientists' "disinterestedness," therefore, is not the cause for scientific credit being honorific, but a professional value practitioners accept or develop by working in an economy that logically requires their credit to be nonmonetary.

But what also needs to be attached to a scientist's name is responsibility, not just credit. If a true claim about nature were like an artifact, a novel expression, or a piece of literary fiction, responsibility could be negotiated legally. In market environments, an author's responsibility is construed as financial liability, that is, as a matter of property and damages. Also, the legally responsible author may not be the actual producer of those claims, but rather the individual or corporation that paid the producer for his or her labor or rights in those claims. But this cannot apply to true claims about nature because they are in the public domain—a category complementary to that of property and monetary liability. Therefore, in the reward system of science, responsibility for scientific claims falls on the scientist who produced them simply because that individual is the only "hook" on which the movement from unspecified to specified truth can be pinned.

Furthermore, responsibility in science is absolute. It is as absolute as truth because, like scientific credit, truth and responsibility *cannot be quantified.* Responsibility becomes absolute by default. That is why, within this logic, scientific authorship has to be defined in strictly individual terms. If truth and responsibility are absolute, they cannot be attached to a corporate author since that would parcel out something that has to remain absolute. But a new paradox emerges from such a solution: Truth (defined as universal, permanent, absolute, etc.) ends up being hinged on something that is extremely local and ultimately transient—the scientist's name. And such a name needs to be a proper name that is unequivocally connected to a person's body, not to a corporation—a *persona ficta.*

This may cast some light on why scientific fraud is seen as a fundamental aberration, not just a serious problem. Commercial fraud—fraud about property—is certainly not a trivial issue, but it can be handled legally; it can be *quantified* (more or less adequately) in terms of financial damages. Scientific fraud, instead, tends to assume a more ominous status, and does so in part because it *cannot* be properly measured in terms of damages. Fraud shares in the absoluteness of truth and the responsibility it is seen to subvert. Of course, legal and administrative actions can be taken against fraudulent scientists. Universities can fire them, and funding agencies can sue them for misuse of research funds. However, this is a bit like getting Al Capone for tax fraud when he could not be charged with murder. Adapting the False Claim Act of 1865 (developed to curb the delivery of substandard equipment to the army) to sentence scientists with punitive damages up to three times the amount they received from funding agencies shows that the reward system of science cannot prosecute scientific fraud per se, but is forced to step outside itself and adopt the logic of commercial fraud.[12] The emotions stirred by scientific fraud and its moral condemnation as a "crime against the truth" may reflect the fact that while fraud rattles the logic of the reward system of science, its punishment cannot be logically commensurate with the "crime."

In the next section I argue that while the complex relationship between authorship, responsi-

bility, and credit has been highlighted by contingent concerns with scientific misconduct, its roots lie in the tensions between (and within) the economies of science and of the market. After being historically and logically constituted in opposition to each other, these economies are now brought into a closer and uneasy proximity by the development of increasingly large-scale, collaborative, and capital-intensive contexts of research. The grassroots emergence of corporate views of scientific authorship that erode individual responsibility is perhaps the most conspicuous hybrid that has resulted from this process.

## BIG SCIENCE AND THE REACTION AGAINST CORPORATE AUTHORSHIP

Historically, the debate on authorship and responsibility in biomedicine has developed in response to two distinct trends: the sharp increase of multiauthorship related to the transformation of biomedicine into a "big science," and the emergence of well-publicized cases of scientific fraud (or alleged fraud). That biomedicine is as much about truth as about healing taxpayers' bodies has added further urgency to the problem of responsibility and has made it an unavoidable focus of the debate.

Quantitatively speaking, the scale of multiauthorship in biomedicine still lags behind that of physics.[13] But if articles with hundreds of authors resulting from large multicenter clinical trials are relatively rare, bylines including six or more authors are not. Journal editors and other commentators began to notice this tendency in the 1970s and usually interpreted it as resulting from the need to pool together different skills and specialized knowledge within increasingly large and collaborative research projects.[14] The multiauthorship trend could have opened the door to the acceptance of a corporate notion of authorship as a way to distribute credit in large cooperative research programs, but it clashed with the requirement of individual responsibility.

What did trigger concerns about responsibility was the growing awareness that a given scientific paper may have required the work of a biostatistician, although that person may have had little or nothing to do with the collection of the data he or she eventually analyzed; or that several contributors who may be considered authors (in the sense that they made important contributions to the project) may not be able to defend the work (or perhaps even understand the tasks) accomplished by some of their other colleagues.[15] This state of affairs would pose no problems in market-based fields where responsibility, credit, and intellectual property rights can be negotiated contractually, but such techniques are not acceptable in science.

While some literary theorists have argued that the emergence of large-scale book markets led to a "death of the author," there has been no parallel movement occasioned by the big science trend in biomedicine.[16] On the contrary, the more collective, corporate, and industrial-style the research contexts become, the more one finds a resistance to accepting the implications this trend is having on the notion of authorship and responsibility. Beyond resistance, there may even be a reaction to the erosion of a notion of individual authorship. For instance, over the years the ICMJE has issued increasingly stricter guidelines about authorship; these guidelines struggle to attach authorship to the "crucial" contributions to a project and to develop taxonomies of credit that would distinguish between authorship (defined as responsibility) and other forms of recognition to be listed not in the authors' byline, but in a separate "acknowledgments" section that, according to some other proposals, could resemble a "film credits" list.[17]

The section on authorship of the ICMJE 1997 *Uniform Requirements for Manuscripts Submitted to Biomedical Journals* reads:

All persons designated as authors should qualify for authorship. The order of authorship should be a joint decision of the coauthors. Each author should have participated sufficiently in the work to take public responsibility for the content.

Authorship credit should be based only on substantial contributions to (1) conception and design, or analysis and interpretation of data; (2) drafting the article or revising it critically for important intellectual content; and (3) on final approval of the version to be published. Conditions 1, 2, and 3 must all be met. Participation solely in the acquisition of funding or the collection of data does not justify authorship. General supervision of the research group is also not sufficient for authorship. Any part of an article critical to its main conclusions must be the responsibility of at least one author. Editors may ask authors to describe what each contributed; this information may be published.

Increasingly, multicenter trials are attributed to a corporate author. All members of the group who are named as authors . . . should fully meet the criteria for authorship as defined in the *Uniform Requirements*. Group members who do not meet these criteria should be listed, with their permission, under acknowledgments, or in an appendix.[18]

Overlapping with analyses of the increasingly corporate structure of research, one also finds frequent expressions of concern about the changing ethos of biomedicine. Big science is often equated with big business, an analogy that points as much to the large role of private sector funding as it does to the increased scale of biomedical research.[19] Accordingly, commentators note that the multiauthorship trend reflects not only the increased complexity of modern research, but a growing entrepreneurial ethos. They see it as a problematic response to an increasingly competitive publication-based regime of credit and professional advancement.[20] Under pressure from this complex, entrepreneurial, and competitive environment, practitioners have been alleged to associate authorship more directly with credit than with responsibility, that is, to treat authorship as "a trading chip in an economic game."[21] Those who are concerned with the trading chip attitude about authorship acknowledge that scientists have serious concerns with professional credit and career advancement. These commentators refer quite explicitly to authorship as the primary "currency" in science but then deplore the "inflation" that excessive multiauthorship might bring to such a currency (not to mention fraud and other unsavory practices that could be elicited by the same pressures toward the accumulation of scientific credit).[22] They criticize the "capitalistic" ethos that seems to be taking over biomedicine but end up casting the threat to science in terms of "inflation." In the end, they use a category that reflects an acceptance of the very market logic they want to resist.

Similarly, the commentators regret, but do not deny, that in practice the quantity rather than quality of publications is often the leading factor in promotion cases, distribution of research funds, etc.[23] While deploring the situation and suggesting improvements (such as quotas on the number of publications submitted for promotion cases), they admit that the big business mentality that has pervaded biomedicine is here to stay. This means that in a large-scale and extremely active professional environment there are material constraints on the time and energy that can be allocated to a review of candidates' or applicants' work on the basis of quality rather than quantity.[24] Practices that have been condemned for their dubious ethics thrive: reliance on "salami science," LPUs (least publishable units), and the rotating distribution of first authorship in a series of related papers published in different disciplinary journals.

# FRAUD AND THE GEOGRAPHY
# OF AUTHORSHIP

Against the background of these changes in the structure of biomedical practice, a series of cases of scientific fraud, or alleged fraud, added urgency to debates about scientific authorship.[25] The Darsee and Slutsky cases, and more recently the so-called (or misnamed) "Baltimore case," have received much attention in the popular press, a publicity that has put further pressure both on the scientific community and policy makers. In some instances, senior scientists whose name was on an article's authors' byline argued that they were not responsible for the mistakes or misconduct of their junior colleagues. Accordingly, the blame was to be placed on Darsee, Slutsky, and people like them, not on the honest (if busy) directors of their labs or the department chairs who had agreed to have their name on the articles according to a practice that has since been labeled "honorific" or "gift" authorship.[26] Similar cases and similar justifications continue to this day.[27]

Even though not all instances of scientific fraud can be reduced to situations in which a senior researcher did not take responsibility for the work of a junior associate, it is interesting that this aspect of the problem has received the most attention and that honorific authorship has become a sort of fighting word in debates about scientific misconduct. The high visibility of some of the senior scientists and their institutions (UCSD, Harvard, MIT) does not fully account for the emphasis that has been placed on this aspect of fraud. Although it is not my business to absolve or condemn those involved in these cases, I believe that the primary focus on honorific authorship signals a difficulty in coming to terms with the fact that the practitioners' perceptions of due credit and responsibility may be informed by their location and role within a collaborative project, and that blame, as appropriate as it may be, is not going to eradicate the sociological roots of the problem.

Scientific authorship has a geography as well as a logic. However, the geographical variability of attitudes about authorship is downplayed by the fact that the term *science* tends to cast an aura of homogeneity on a vast range of diverse disciplines and differently situated individuals and institutions.[28] In science as in society, workers, managers, and lawmakers are not the same people (though they may be citizens of the same state), and such differences are constitutive, not erasable. But scientific culture, because of its emphasis on values such as trust, collegiality, and disinterestedness, has few ways to acknowledge and negotiate these tensions and power differentials. In contrast, liberal economy has abundant categories to explain its litigiousness, and plenty of legal infrastructures to manage it. Therefore, if liberal economy has no problems admitting the sharp economic conflicts at play behind current disputes about intellectual property law, science is inherently ill-equipped to acknowledge that the debate about responsibility, credit, and authorship may reflect struggles among different constituencies.[29]

However, one legacy of the fraud scandals of the early 1980s is precisely the mapping of the different interests and positions of at least three different constituencies: (*1*) Congress and funding agencies; (*2*) universities, research institutions, and academic journals; and (*3*) the practitioners themselves (this group can be further divided into junior and senior researchers).

Some members of Congress, funding agencies, and scientists whose job is to monitor other scientists became concerned about the misuse of research funding and the disrepute that fraud cases bring to biomedical research and to the politicians and institutions that support it.[30] Given

their role and interests, it is not surprising that these constituencies identify authorship with responsibility and see honorific authorship as emblematic of how well-funded scientists have become overconfident in their belief that they do not need to earn the freedom from external regulation that has been granted to them but denied to other professions.[31] According to this constituency, science must cleanse itself from misconduct, establish its own policing infrastructures, or face the possibility of government regulation. To some extent, this possibility materialized in 1989 with the development of the Office of Scientific Integrity (OSI) and the Office of Scientific Integrity Review (OSIR) within the Public Health Services (PHS), with OSI and OSIR being reorganized into the Office for Research Integrity (ORI) in June 1992.[32] The same year, a United States attorney went so far as to suggest that the legal system could take over the adjudication of claims of scientific misconduct—an option that, to the displeasure of universities, has been increasingly exercised.[33]

Universities, research institutions, and journal editors were quick to respond to these moves, but universities and journals have different stakes in these matters. Universities would like to rely on journals and their editorial practices (refereeing system, etc.) to certify good science, detect misconduct, and possibly alert them about potential problems.[34] Journals, on the other hand, claim that although they do their best to ensure the publication of quality articles written by the authors named in the byline, it is not their duty to play judge.[35] After all, their editors are not in the lab and do not have the material resources to push the evaluation process beyond refereeing. In any case, journal editors make decisions based on what scientists themselves (as referees) report to them. When it comes to authorship, most journal editors (in particular those who endorse the ICMJE guidelines) now require all authors to sign a statement such as this:

AUTHORSHIP RESPONSIBILITY: "I certify that I have participated sufficiently in the conception and design of this work and the analysis of the data (when applicable), as well as the writing of the manuscript, to take public responsibility for it. I believe the manuscript represents valid work, I have reviewed the final version of the manuscript and approve it for publication. Neither this manuscript nor one with substantially similar content under my authorship has been published or is being considered for publication elsewhere, except as described in an attachment. Furthermore, I attest that I shall produce the data upon which the manuscript is based for examination by the editors or their assignees if requested."[36]

Such statements cast journals in a curious role. They end up representing themselves as credit-givers while simultaneously minimizing their responsibility for the credit they give. In the end, it is not clear whether journals are casting themselves as publishers or printers. What I find surprising is not that editors are understandably cautious about their practical ability to certify true knowledge, but that their policies put the onus of assessing scientific authorship and the truth value of claims completely on the scientist's shoulders as if the reward system (of which journals are a crucial element) had little to do with certification.

Insistence on the individuality of authorship and its coupling with complete responsibility is so categorical that it amounts to a demand that authors do what the reward system and peer review should but cannot quite do. Ready or not, practitioners are being volunteered for a sort of "mission impossible." I am not suggesting that referees should be formally coresponsible for the articles they review, but that the current definition of scientific authorship casts peer review not as a system of certification, but as little more than a free (and responsibility-free) consulting service for editors.[37] Although journal editors quite laudably do their best to eradicate the problem of honorific authorship, they do not seem to realize that the reputation of their own journals is

constituted through a process that is structurally similar to honorific authorship. If the articles they publish are praised, the journal's credit grows accordingly. But if something goes wrong, the editors can say that they (and the referees) are not responsible for the problem and only the authors are to blame.

This would not be a problem outside of science, where the limits of certification are accepted as a fact of life. For example, the United States Patent Office may grant a patent without checking whether the device or process actually works. Preliminary checks are conducted to detect conspicuous overlaps between a given application and other existing patents, but it is then up to the inventor to find people who would appreciate the value of his or her idea, as it is up to the inventor to defend the patent in court against competing claims. The same can be said about copyrights. In market environments, then, authorship is not absolute, but a resource to be developed (and perhaps defended) through further work, time, and expense.

In contrast, according to the logic of the reward system of science, authorship is as absolute as the truth of the claims on which it rests—a truth that is not to be negotiated in court or through contracts. And authorship credit is construed as something almost instantaneous. You produce a true claim, you take responsibility for it, you publish it, you get credit. Unlike other products, truth does not need to be developed to be recognized. In science, the work for which an author gets credit does not extend past the "filing." The logical function of the peer review system is the certification of truth. It is as though you deposit a check, the bank "reviews" it, and you get the money.

But, in practice, the bank (the peer review system) cannot function so thoroughly and swiftly. A scientist receives full credit for the amount of the "check" she or he deposits, but the funds can be taken back at any later time if it is contested. The check clears immediately and, at the same time, it never really clears. In a liberal economy, the granting of a copyright or a patent is a way of saying that your check looks potentially good, but that it is up to you to develop its actual value in a market. The limits of certification are acknowledged, but there are a range of tools to manage them.

In practice, the reward system of science is faced with the limits of the peer review system, but cannot fully admit them without jeopardizing its own logic—a logic hinged on the absoluteness of truth. Such a contradiction is not solved, but displaced in time in the hope that it will never express itself, that is, that scientific claims will never be assailed as fraudulent.[38]

## SPECIFICITY VERSUS CONDITIONS
## OF POSSIBILITY

If Congress, universities, and journals couple authorship with total responsibility, the practitioners themselves tend to stress the links between credit, labor, and authorship, while attaching them to a notion of limited responsibility. When practitioners write responses to editorials about authorship policies, they point to the power differentials that frame the debates about authorship.[39] Journal editors assemble themselves in committees, issue guidelines that may reflect their needs and wishes (more than the daily realities of the researchers), and can easily air their opinions in the pages of their own journals.[40] Most individual scientists do not have that kind of power. It is almost as though scientists express a wish to "unionize," as they seem to feel they are at the receiving end of authorship policies whose development they do not control.

Expressions of discontent from scientists have become increasingly frequent. In 1988, one could find a letter to the editor stating:

I wish to comment on the preposterous suggestion, being seriously advanced in some quarters, that all of the authors of a given paper are responsible for all of the material that appears in that paper. If that rule were adopted, it would bring multidisciplinary research to a virtual halt.[41]

Recently, letters to *Science* were peppered by remarks like "it is ridiculous to think that each author can or should be able to vouch for each of the others," or:

If marriage partners are not held liable for the actions of their spouses, why should we assume that scientific collaborators are liable? In both cases, liability would be tantamount to an assertion of omniscience, and an omniscient scientist would probably be in no need of collaborators.[42]

A third writer voiced frank skepticism about the idea that responsibility for a multiauthored paper be shared by all its authors by saying that:

This amounts either to banning all papers with more than one author or enshrining a kind of chivalry where scientists agree to destroy their own careers if they happen to work in the same lab as a scientist who commits fraud.[43]

Earlier this year, a report based on a questionnaire circulated through a broad cross section of biomedical practitioners at the University of Newcastle showed that a substantial portion of the scientists could not recall the basic authorship requirements issued by the ICMJE, and when told what they were, found them inapplicable. Many of the respondents (49%) had also experienced situations in which, according to their perception, authorship had been deserved but not awarded.[44]

In sum, researchers seem to favor a notion of authorship that entails limited rather than global responsibility, and view authorship as something that should be extended not just to those who allegedly would be able to defend all results, but to anyone who worked at making a trial possible, such as laboratory workers or the many general practitioners who provided and followed patients but may have contributed little or nothing to data analysis.[45]

A perception of authorship as primarily linked to credit and labor, rather than absolute responsibility, is not limited to the "workers" but also to some senior scientists, and it informs the credit arrangements they may adopt (implicitly or explicitly) with their junior colleagues and assistants. For instance, the occurrence of honorific authorship is important evidence of a perspective according to which a director of a lab who provided space, equipment, or prestige and facilitated access to funding and publication is seen (by him- or herself and perhaps by the associates) as an investor. The role of a "remote" lab director is not unlike that of a general practitioner who provided patients but did not necessarily analyze the data or write up the final papers. Perhaps neither the director nor the general practitioner had much to do with the specific results, but they nevertheless made those results possible. In some ways, honorific authorship resembles a common phenomenon of the early modern period: the dedication of a book to the patron who supported the author or, through his high social status, could help him gain legitimation, visibility, and even some protection from plagiarism for the claims published in that book.[46] If one finds such behavior proper then but not now, this does not mean that early scientists were unethical, but simply that professional ethics is not a matter of ahistorical first principles, but has evolved alongside the reward system of science.

The practitioners who resist a definition of authorship as something that is inherently individual (rather than collective) and tied to absolute (rather than limited) responsibility seem

to think in terms of corporate credit and investments—investments they "pay back" by giving authorship credit. Even though it is easy to see how these behaviors clash with the logic of the reward system of science, they accurately reflect the outlooks practitioners develop when operating in large resource-intensive projects that are extended both in space and time. They are "grass-roots" and quasi-capitalistic. I say quasi-capitalistic because authorship in academic biomedicine remains a matter of name, not money. It is capitalistic only to the extent that authorship is treated like having stock in a particular project, and responsibility is also treated in a corporate manner. Responsibility in this "take" is not an absolute notion (as the reward system of science would require), but is something limited to one's stock in the project.

A way to summarize the differences between the positions of the ICMJE and those of some of the participants in large projects is to say that the ICMJE focuses on the *responsibility for the specific claims* that emerged from a study, whereas the participants attach authorship to those who have provided the *conditions of possibility* of that study. This kind of demarcation is not new. It reproduces (in logic but not in content) the type of distinctions discussed earlier: those between the public domain and private property, and in the case of science, between unspecified nature/truth and specific truth claims.

The ICMJE states that "participation solely in the acquisition of funding or the collection of data does not justify authorship," that is, they attach authorship only to those tasks that made a *difference,* not just provided a *possibility.*[47] In this logic, the general practitioner who provided patients (or in other settings, an instrument maker, a laboratory assistant, a maintenance technician, or a "remote" lab director) are seen as people whose work was not *specific* to that project. They did contribute to its *happening* but not to the fact that the result was X rather than Y. The author, then, is cast as the individual who was *irreplaceable,* someone whose involvement in the study was both necessary and sufficient to its result.

Conceived in those terms, the author would be a sort of bodily counterpart for what has been called the crucial experiment. Accordingly, truth is the outcome of an experiment conceived in a way that only one of its various possible outcomes can be the result of that which is hypothesized as its true cause prior to the conducting of the experiment. The ICMJE's test for authorship seems to translate such a view of natural causality into the domain of human agency. An author is the person, and the only person, who "caused" the outcome of a research project. Of course, more authors can be attached to an article, but the ICMJE guidelines break multi-authorship down to an assembly of separate authors, each fully individual and fully responsible. Coauthorship cannot mean corporate authorship.

But if the ICMJE's position is coherent, it begs at least two further questions. One is whether the view of natural causality entailed by the crucial experiment can be applied to environments where human agency is temporally intermittent and spatially distributed. Unlike gravity acting on all apples all the time, many different people work at different aspects of a research project, often at different times and at different sites. The second is the practical feasibility (rather than conceptual robustness) of a taxonomy of reward that distinguishes true authors from other practitioners eligible only for "acknowledgment" credit.

To begin with the second question, it would appear that, in principle, the widening of categories of scientific credit through the introduction of currencies other than that of authorship could rechannel the pressures that have led to the corporate uses of individual authorship toward the use of other forms of credit giving. But, at present, having one's name in the acknowledgment section or in some other appendix (as requested by the ICMJE) does not do

much good to many practitioners, since these credits are not usually retrievable through computer searches. And in biomedicine today, such searches play a crucial role in the production of the author function. Furthermore, such a reform of authorship would work only if accompanied by a serious reeducation not only of the researchers, but also of those who evaluate them for jobs, promotions, and funding.

## COMPRESSING TIME, SPACE, AND LABOR

Going back to the first, more difficult question, I believe that a two-tier system distinguishing between full authors responsible for the truth of the published claims and all the others who provided "only" the conditions of possibility for those claims would introduce not a graduated credit scale, but an incommensurability between two classes of contributors.

The ICMJE guidelines that try to reduce the entire range of collaborative projects distributed in time and space to the model of individual effort and total responsibility reflect a literal extension of the image of the individual author. In doing so, these guidelines fit in a long tradition that has emphasized the agency of the individual author at the expense of other contributions to the knowledge-making process. In literature, the legal concept of the author was developed in the eighteenth century largely as a way to include immaterial objects such as expression and creativity under the category of private property, a category that until then was about material entities.[48] Both writers and publishers were faced with the financial costs of piracy, the result of an early perception of books as objects one bought, claimed as property, and could use in any way one wished (including reproducing them). The figure of the author as the holder of intellectual property rights was developed as a way to limit the property rights of the book buyer by saying that there was more to a book than its materiality, that there was something that could not be relinquished in the act of selling a book. The author, then, was a market construct, one that made both booksellers and writers very happy.

But one can argue that the focus on the individual author as the holder of such newfangled property rights misrepresented the long chain of human agency that produced a literary work. It involved compression and selection. The historical figure of the individual author as romantic genius is the epitome of such misrepresentation through the compression of human agency. Accordingly, the "work" is seen as emerging from an instantaneous act of creativity, not from the time-extended labor of paper makers, font cutters, editors, typesetters, printers, binders, and booksellers (not to mention the body of previous literary works from which the author drew his or her "inspiration").[49]

A similar, if less drastic, compression and selection of the chain of human agency is found in the depiction of the figure of the scientific author. Since the emergence of experimental philosophy in the seventeenth century, the notion of the individual author was often constituted through the erasure of the contribution of instrument makers and laboratory technicians who, because of their low social status and credibility, were not perceived as true knowledge makers and whose names were omitted from the published reports.[50]

Historically, then, the author has always been more of an efficient accounting device for intellectual property or scientific credit than an accurate descriptive tool of knowledge-making practices. The tensions produced by author-based forms of accounting have been there since the beginning, and have been made only more conspicuous by the increasing complexity and chang-

ing scale of knowledge production (in both the scientific and market economies). The logic behind the two-tier taxonomy of credit one finds in the ICMJE guidelines is homologous to that behind these historical cases. In both cases a line is drawn between the author and those who provided the conditions that made the author's specific results possible. In contemporary biomedicine, the definition of the author does not turn on his or her creativity or original expression, but on his or her responsibility. The parameters that constitute the author are different, but its logic cuts across disciplines and, to a lesser extent, across historical periods.

In fact, the author described in the ICMJE guidelines is not a hyperindividualized romantic genius. Such a figure worked well to legitimize the author's (or his or her bookseller's) claims of intellectual property by representing literary production as an act that borrowed little or nothing from the surrounding culture. However, the journal editors' primary concern is not the maximizing of intellectual property, but the management of responsibility. Therefore, the editors use the figure of the individual author not as a creative genius, but as the person responsible for those aspects of the research process that can be represented as constant and stable throughout the process of knowledge production: the conception of the work, the analysis of the collected data, and the writing of the article. In intellectual property law, the individual genius is the one who creates out of nothing, whereas in science the individual author is the one who gives continuity and consistency to a heterogeneous process. Although one emphasizes instantaneity and the other constancy, both figures work as ways of demarcating the final product from its conditions of possibility.

By drawing a wedge between conception and execution, the ICMJE guidelines carve out research practices in two categories: one that is unified, stable, and allegedly laid out since the beginning of the project, and one made up of diverse activities, ideas, and insights that may have developed along the way at different times and places—items that are much more difficult to subject to a neat accounting. The focus on data analysis rather than data collection as a fundamental aspect of authorship is an attempt to compress temporally and spatially diverse labors to an activity that took place in a specific place at a specific time. Similarly, though no one would question that the writing up of the results is a crucial contribution to any scientific project, a text, being an object that is physically well circumscribed and easily accessible, is also very handy for accounting purposes. It is a stable inscription whose content is frozen in time, available in many locations, and yet always the same as opposed to the complex temporally and spatially dispersed activities it is seen as summarizing.

But as reasonable and convenient as this approach may be, it does not guarantee that the conception of the work can always be located in one or a few distinct individuals or that, together with the division of tasks among the various practitioners, it could have been laid out once and for all at the beginning of the project. Similarly, this does not imply that, in principle, the writing of the final paper should be a task rewarded with a kind of credit (authorship) that is incommensurable with (rather than simply more important than) the credit to be given to those responsible for other tasks.

It is not that the "conception of the work" is a convenient fiction, that the focus on the written outcome of research is simply fetishistic in nature, or that the ICMJE guidelines are wrong. The policies proposed are predetetermined by the logic of the reward system of science. The point is that the choice of the features deemed to be constitutive of authorship reflects an accounting rationale shaped by a symbiosis with liberal economy. It deploys categories that facilitate the accounting process better than the global description of research practices.

No one, I think, would object to the necessity for accountability or responsibility in science. What is happening, however, is that responsibility is treated as something that preexists and is independent from its accounting protocols. But authorship is not just a *result* of the accounting of human agency and responsibility in the knowledge-making process: it is a category that provides the condition of possibility for such an accounting. *Authorship is both accounted and accounting.* What we take to be authorship in science or intellectual property in a liberal economy are coexistent with the accounting systems that rest on those categories as constitutive assumptions, not as empirical categories that exist independent of the system in which they operate.

## CONCLUSIONS

Historically, the law has been continuously modified and articulated to manage the emergence of new forms of production and of new interest groups. Unlike various national legal systems, the reward system of science has remarkably fewer tools to adjust to contingent historical changes. In my opinion this is because its logic has been historically tied to an absolute concept of truth and responsibility. However, I believe that an overhaul of the reward system of science in a market direction would not give authorship its desired flexibility.

For one thing, liberal economy and the reward system of science are not independent, but complementary, and are joined at the hip, so to speak, by the hazy category of the public domain. It is the public domain that, in one case, legitimizes liberal democracy and its notion of private property and, in the other case, grounds the notion of truth as universal, transparent, disinterested, etc.

Science and liberal economy both construe value (be it a true scientific claim or intellectual property) as a process of specification that, depending on the economy, is either from the public domain to private property (via the individual's creative expression) or within the public domain from unspecified nature to specified truth claims (via the individual scientist's responsibility). In short, the fundamental dichotomy in liberal economy between public domain and private property is found, *mutatis mutandis,* in the scientific realm in the distinction between conditions of possibility and specific claims at the roots of credit, authorship, responsibility, and truth.

In both cases the fundamental distinction between specific, individually produced claims and products and the "stuff" that made them possible is both necessary and inherently unstable. Consequently, definitions of authorship in science and in the market—definitions rooted in this distinction—reify such instability. Thus, the conceptual tensions that underlie scientific authorship would not be solved by moving toward more corporate, market-based notions. Although I have a taste for hybrids, in this case a crossbreeding of scientific and market authorship would not join two different and mutually strengthening entities, but two categories that have evolved together (though complementarily) and are both cracking under similar kinds of stress. The crossbreeding would be sterile.

At the same time, authorship policies like those of the ICMJE that reinforce the separation of the economies of science and the market are likely to produce more discontent than sustainable solutions. Erecting stronger boundaries between the two systems is not going to solve the problems, because the problems are *within* each of the two systems. The increased proximity of these different and complementary economies have only enhanced the visibility of previously existing problems.

In sum, I do not think that the conditions for revolutions and new paradigms for scientific authorship are readily available. So much has been hung on it from different sides that, despite its inherent instability, scientific authorship has become virtually unmovable. While there is an implicit awareness that the category of authorship needs to be reconstituted, I think that the proposed solutions find themselves chasing their own tails, often reproducing some of the very tensions they try to solve. And this is not for lack of effort or acumen. Therefore, rather than pursue the chimera of the one conceptually "right" definition, one may take a more pragmatic position by acknowledging that authorship (scientific or not) has always been a matter of compromises and negotiations, and that no new conditions have emerged to change that.

But the logic of compromise begs the question of what are the constituencies that should negotiate it. The current debate and policies, however logically coherent and well intentioned they may be, have a predominantly "top-down" quality to them. This points to the need of appropriate infrastructures to enable a representative number of practitioners with different roles and seniority to participate democratically in the legislation of future authorship protocols. Having been discussed mostly by editors and administrators, authorship has been framed as an administrative problem. It is, instead, an issue whose roots spread so far and wide that its solution may require something of a "constitutional amendment" to the logic of the reward system of science. In the end, the real challenge may be precisely the development of infrastructures to make these broader discussions possible and to provide the conditions of possibility for a workable definition of scientific authorship.

NOTES

Allan Brandt introduced me to this topic and provided crucial suggestions and comments. I hope he will accept my special thanks and relinquish further claims to rights in this essay. I also wish to thank Rebecca Gelfond, my research assistant, for all the competent help she provided throughout the project, and Jean Titilah for her much-needed editorial assistance. Debbore Battaglia, Sande Cohen, Arnold Davidson, Peter Galison, Michael Hart, Barbara Herrnstein-Smith, Michael Gordin, Dan Kevles, and Don MacKenzie have offered important comments and criticism (not all of which, I admit, have found their way into this essay). Finally, I want to thank James Boyle for trying to guide a neophyte through the mazes of the public domain, and Sherry Turkle for having worked through several of the ambiguities of my argument when she had better things to do with her time. This work was supported by a John Simon Guggenheim Fellowship.

1. Richard Smith, "Authorship: Time for a Paradigm Shift? The Authorship System is Broken and May Need a Radical Solution," *Br. Med. J.*, Vol. 314, 5 April 1997, p. 992; Richard Horton, "The Signature of Responsibility," *Lancet*, Vol. 350, July 5, 1997, pp. 5–6. See also Richard Horton, Richard Smith, "Time to Redefine Authorship," *British Medical Journal*, Vol. 312, p. 723; Fiona Godlee, "Definition of 'Authorship' May be Changed," *Br. Med. J.*, Vol. 312, 15 June 1996, pp. 1501–1502; and Evangeline Leash, "Is It Time for a New Approach to Authorship?," *J. Dent. Res.*, Vol. 76, No. 3, 1997, pp. 724–727.

2. The most innovative proposal to date has been put forward by Drummond Rennie, deputy editor (West) of the *Journal of the American Medical Association*. At a conference on scientific authorship held in June 1996 at Nottingham and sponsored by *Lancet*, the *Br. Med. J.*, Locknet (an international peer-review research network), and the University of Nottingham, he proposed to replace "author" with "contributor." Contributors should be listed in the byline and the nature of their contribution described in a footnote. In addition, some contributors who are the most familiar with all aspects of the project should be termed "guarantors," and should be in charge of answering any question that may be elicited by the publication (Evangeline Leash, "Is It Time for a New Approach to Authorship?," p. 726).

3. Michel Foucault, "What is an Author?," Donald F. Bouchard (ed), *Language, Counter-Memory, Practice*, Ithaca: Cornell University Press, 1977, p. 124. See also Carla Hesse, *Publishing and Cultural Politics in Revolutionary Paris*, pp. 1789–1810, Berkeley: University of California Press, 1991.

4. However, some critics have argued that scientists investigated for misconduct may get less than a fair trial from the ORI. Among other problems, the ORI mixes investigatorial and prosecutorial tasks and holds hearings (if the defendant so requires) only after it has found misconduct. (Louis M. Guenin, "The Logical Geography of Concepts and Shared Responsibilities Concerning Research Misconduct," *Academic Medicine*, Vol. 71, No. 6, June 1996, pp. 598–599). Similarly, in his discussion of the "Baltimore case," Daniel Kevles argued that: "Imanishi-Kari was, to all

intents and purposes, prevented from mounting a genuine defense. The OSI [ORI's institutional ancestor] combined the duties of investigator, prosecutor, judge, and jury, and pursued them all in the manner of the Star Chamber." ("The Assault on David Baltimore," *The New Yorker,* May 27, 1996, p. 107).

5. James Boyle, *Shamans, Software, and Spleens: Law and the Construction of Information Society,* Cambridge, Mass.: Harvard University Press, 1996, pp. 51–59.

6. Jeremy Phillips, Alison Firth, *Introduction to Intellectual Property Law, 3d ed.,* London: Butterworths, 1995, pp. 39–42.

7. Eliot Marshall, "Companies Rush to Patent DNA," *Science,* Vol. 275, February 7, 1997, pp. 780–781, provides a review of recent trends. See also "Gene Fragments Patentable, Official Says," *Science,* Vol. 275, February 21, 1997, p. 1055. For an earlier overview on these issues, see Dorothy Nelkin, *Science as Intellectual Property,* New York: MacMillan (for AAAS), 1984.

8. James Boyle, *Shamans, Software, and Spleens,* pp. 25–34.

9. Jessica Litman, "The Public Domain," *39 Emory Law Journal 965, 999* (1990); David Lange, "Recognizing the Public Domain," *44 Law and Contemporary Problems 147* (1981); James Boyle, "A Politics of Intellectual Property" (unpublished manuscript).

10. Views of copyright framed by beliefs in the romantic figure of the author tend to be more extreme as they present the author's work as coming out of thin air, not from the reelaboration of materials found in the public domain. The origin of this view is discussed in Martha Woodmansee's "The Genius and the Copyright: Economic and Legal Conditions of the Emergence of the 'Author,'" *Eighteenth-Century Studies,* Vol. 17 (1984), pp. 425, 443–444.

11. Harriet A. Zuckerman, "Introduction: Intellectual Property and Diverse Rights of Ownership in Science," *Science, Technology, and Human Values,* Vol. 13, Nos. 1 and 2, winter and spring 1988, pp. 7–16; Robert K. Merton, "The Normative Structure of Science," *The Sociology of Science: Theoretical and Empirical Investigations,* Chicago: University of Chicago Press, 1973, pp. 273–275; Robert K. Merton, "Priorities in Scientific Discovery," *The Sociology of Science: Theoretical and Empirical Investigations,* pp. 294–295, 323; Robert Merton and Harriet Zuckermann, "Institutionalized Patterns of Evaluation in Science," *The Sociology of Science: Theoretical and Empirical Investigations,* p. 465. Important views on the relationship between scientific and economic credit have been presented in Pierre Bourdieu, "The Specificity of the Scientific Field and the Social Conditions of the Progress of Reason," *Social Science Information,* Vol. 14 (1975), pp. 19–47 (reprinted in this volume); and in Warren O. Hagstrom, "Gift Giving as an Organizing Principle in Science," Barry Barnes, David Edge (eds), *Science in Context,* Cambridge, Mass.: MIT Press, 1982, pp. 21–34.

12. Paulette V. Walker, "1865 Law Used to Resolve Scientific Misconduct Cases," *The Chronicle of Higher Education,* January 26, 1996, p. A29. Subsequently, some uses of the False Claim Act have been challenged in court (Paulette V. Walker, "Appeals Court Overturns a False-Claim Ruling Against U. Of Alabama at Birmingham," *The Chronicle of Higher Education,* February 7, 1997, p. A37).

13. The protocols of authorship in large particle-physics experiments are discussed in Peter Galison, "The Collective Author," paper presented at the conference on "What is a Scientific Author?", Harvard University, March 7–9, 1997. It is interesting that concerns with responsibility and fraud are not as pressing among physicists as among biomedical scientists.

14. Robert S. Alexander, "Editorial: Trends in Authorship," *Circ. Res.,* July 1953, Vol. 1, No. 4, pp. 281–282; Dardik H, "Multiple Authorship," *Surg. Gynecol. Obstet.,* 1977, Vol. 145, p. 418; R. D. Strub, F. W. Black, "Multiple Authorship," *Lancet,* 1976, Vol. 2, 1090–1091.

15. Arnold Relman wrote in 1979 that "The essential criterion [of authorship] is the quality of the intellectual input. A scientific paper is a creative achievement, a record of original productivity, and coauthorship ought to be unequivocal evidence of meaningful participation in the creative effort that produced the paper. To my way of thinking, therefore, the use of coauthorship as a kind of payment for faithful technical assistance or data collection violates this principle." A. S. Relman, "Publications and Promotions for the Clinical Investigator," *Clin. Pharmacol. Ther.,* 1979; 25, p. 674.

16. Roland Barthes, "The Death of the Author," *Image-Music-Text,* Stephen Heath (ed), New York: Hill and Wang, 1977, pp. 142–148; Walter Benjamin, "The Work of Art in the Age of Mechanical Reproduction," *Illuminations,* New York: Schocken Books, 1969, pp. 217–251.

17. Barbara J. Culliton, "Authorship, Data Ownership Examined," *Science,* Vol. 242, Nov. 4 1988, p. 658; Eugene Garfield, "The Ethics of Scientific Publication: Authorship Attribution and Citation Amnesia," *Essays of an Information Scientist,* Vol. 5, Philadelphia: ISI Press, 1983, p. 622; "Editorial: Author!," *Lancet,* 1982; Vol. 2, p. 1199.

18. ICMJE, "Uniform Requirements for Manuscripts Submitted to Biomedical Journals," *JAMA,* March 19, 1997, Vol. 277, No. 11, p. 928.

19. Daniel M. Laskin, "The Rights of Authorship," *J. Oral Maxillofac. Surg.,* 1987, Vol. 45, p. 1; Addeane S. Caelleigh, "Editorial: Credit and Responsibility in Authorship," *Academic Medicine,* Vol. 66, No. 11, November 1991, pp. 676–677.

20. Marcia Angell, "Publish or Perish: A Proposal," *Annals of Internal Medicine,* 1986, Vol. 104, pp. 261–262; R. L. Engler, J. W. Covell, P. J. Friedman, P. S. Kitcher, R. M. Peters, "Misrepresentation and Responsibility in Medical Research," *New Engl. J. Med.,* 1987, Vol. 317, No. 22, pp. 1383–1389; Drummond Rennie, Annette Flanagin, "Authorship! Authorship!," *JAMA,* 1994 Vol. 271, pp. 469–471; J. Smith, "Gift Authorship: A Poisoned Chalice?," *Br. Med. J.,* 1994, Vol. 309, pp. 1456–1457; D. W. Shapiro, N. S. Wenger, M. F. Shapiro, "The Contributions of Authors to Multiauthored Biomedical Research Papers," *JAMA,* 1994, Vol. 271, pp. 438–442.

21. C.C. Conrad, "Authorship, Acknowledgment, and Other Credits," *Ethics and Policy in Scientific Publication*, CBE Editorial Policy Committee, Bethesda: Council of Biology Editors, 1990, pp. 184–187. According to Herbert Dardik, "Authorship is akin to success and achievement, and cannot and should not deteriorate into a bargaining tool or commodity." (H. Dardik, "Multiple Authorship," *Surg. Gynecol. Obstet.*, 1977, Vol. 145, p. 418). See also Eugene Garfield, "The Ethics of Scientific Publication: Authorship Attribution and Citation Amnesia," pp. 622–626.

22. Daniel M. Laskin, "The Rights of Authorship," *J. Oral Maxillofac. Surg.*, 1987, Vol. 45, p. 1; Addeane S. Caelleigh, "Editorial: Credit and Responsibility in Authorship," *Academic Medicine*, Vol. 66, No. 11, November 1991, pp. 676–677; Drummond Rennie, Annette Flanagin, "Authorship! Authorship!"; William J. Broad, "The Publishing Game: Getting More for Less," *Science*, Vol. 211, 13 March 1981, pp. 1137–1139; Robert N. Berk, "Irresponsible Coauthorship," *AJR*, Vol. 152, pp. 719–720, April 1989.

23. David P. Hamilton, "Publishing by—and for?—the Numbers," *Science*, December 7, 1990, Vol. 250, p. 1332; Drummond Rennie, Annette Flanagin, "Authorship! Authorship!" p. 469; "Are Academic institutions Corrupt?", editorial, *Lancet*, Vol. 342, No. 8867, August 7, 1993, p. 315.

24. Marcia Angell, "Publish or Perish: A Proposal," *Ann. Int. Med.*, 1986, Vol. 104, pp. 261–262; Barbara J. Culliton, "Harvard Tackles the Rush to Publication," *Science*, Vol. 241, 29 July 1988, p. 325; John Maddox, "Why the Pressure to Publish?", *Nature*, Vol.333, June 8, 1988, p. 493; W. Bruce Fye, "Medical Authorship: Traditions, Trends, and Tribulations," *Ann. Int. Med.*, August 15, 1990, Vol. 113, No. 4, pp. 320, 324–325.

25. The transcripts from the May 31, 1988 colloquium at NIH on "Scientific authorship" open with a statement by Alan Schechter linking the origin of the conference to "a particularly tragic outcome of the investigation of a case of alleged scientific fraud here at NIH", A. N. Schechter, J. B. Wyngaarden, J. T. Edsall, J. Maddox, A. S. Relman, M. Angell, W. W. Stewart, "Colloquium on Scientific Authorship: Rights and Responsibilities," *The FASEB Journal*, Vol. 3, Feb. 1989, pp. 209–217. For a summary of the vast literature on the issue of fraud and misconduct, see Marcel C. LaFollette, *Stealing Into Print: Fraud, Plagiarism, and Misconduct in Scientific Publishing*, Berkeley: University of California Press, 1992. A recent analysis of the "Baltimore Case" in Daniel Kevles, "The Assault on David Baltimore," *The New Yorker*, May 27, 1996, pp. 94–109, and his *The Baltimore Case: A Trial of Politics, Science, and Character* (New York: W. W. Norton, 1998).

26. Arnold S. Relman, "Lessons from the Darsee Affair," *N. Engl. J. Med.*, Vol. 308, No. 23, June 9, 1983, p. 1417; Edward J. Huth, "Abuses and Uses of Authorship," *Ann. Int. Med.*, 1986, Vol. 104, No. 2, 266–267; R. L. Engler, J. W. Covell, P. J. Friedman, P. S. Kitcher, R. M. Peters, "Misrepresentation and Responsibility in Medical Research," *N. Engl. J. Med.*, 1987, Vol. 317, No. 22, pp. 1383–1389; Eugene Braunwald, "On Analyzing Scientific Fraud," *Nature*, Vol. 325, January 15, 1987, pp. 215–216.

27. C. Court, L. Dillner, "Obstetrician Suspended After Research Inquiry," *Br. Med. J.*, Vol. 309, 1994, p. 1459; Jane Smith, "Gift Authorship: A Poisoned Chalice?"

28. D. W. Shapiro, N. W. Wenger, M. F. Shapiro, "The Contributions of Authors to Multiauthored Biomedical Research Papers," *JAMA*, 1994, Vol. 271, pp. 438–442; Neville W. Goodman, "Survey of Fulfillment of Criteria for Authorship in Published Medical Research," *Br. Med. J.*, Vol. 309, 3 December 1994, p. 1482; S. Eastwood, P. Derish, E. Leash, S. Ordway, "Ethical Issues in Biomedical Research: Perceptions and Practices of Postdoctoral Research Fellows Responding to a Survey," *Sci. Eng. Ethics*, 1996, Vol. 2, pp. 89–114; Kay L. Fields, Alan R. Price, "Problems in Research Integrity Arising from Misconceptions about the Ownership of Research," *Academic Medicine*, 1993, Vol. 68, No. 9, September Suppl., pp. S60–S64.

29. James Boyle, *Shamans, Software, and Spleens*, pp. 35–60.

30. Walter W. Stewart and Ned Feder's painstaking analysis of the publications of John Darsee is emblematic of this trend. Its conclusion is that "Scientists have to an unusual degree been entrusted with the regulation of their own activities. Self-regulation is a privilege that must be exercised vigorously and wisely, or it may be lost" ("The Integrity of the Scientific Literature," *Nature*, Vol. 325, January 15, 1987, pp. 207–214).

31. According to Congressman John Dingell, "Scientists need to understand that the best way, perhaps the only way, to avoid the threat of 'science police' is for scientists themselves to show that they have the ability and the will to police themselves. It is a matter of morality, but also of self-interest." J. D. Dingell, "Shattuck Lecture—Misconduct in Medical Research," *New Engl. J. Med.*, June 3, 1993, Vol. 328, No. 22, p. 1614.

32. Donald F. Klein, "Should the Government Assure Scientific Integrity?," *Academic Medicine*, Vol. 68, No. 9, September Suppl. 1993, pp. S56–S59.

33. Breckinridge L. Willcox, "Fraud in Scientific Research: The Prosecutor's Approach," *Accounting in Research*, Vol. 2, 1992, pp. 139–151. Rex Dalton, "Heat Rises over UCSD 'Misconduct' Charge," *Science*, Vol. 385, February 13, 1997, p. 566; Paulette V. Walker, "2 Lawsuits May Change Handling of Research-Misconduct Charges," *The Chronicle of Higher Education*, June 6, 1997, pp. A27–A28.

34. According to the editors of *JAMA:* "The parent research institutions rely on publications as the coins academics must use to get through the tollgates on their way to academic promotion. And if the promotion committees function well, they weigh as well as count the coins." Drummond Rennie, Annette Flanagin, "Authorship! Authorship!" See also Marcel C. LaFollette, *Stealing Into Print: Fraud, Plagiarism, and Misconduct in Scientific Publishing*, Berkeley: University of California Press, 1992, pp. 156–194.

35. A reasonable articulation of this position is in Drummond Rennie, "The Editor: Mark, Dupe, Patsy, Accessory, Weasel, and Flatfoot," *Editorial Policy Committee, CBE, Ethics and Policy in Scientific Publication*, Bethesda, Md.:

CBE, 1990, pp. 155–163. See also Don Riesenberg, George D. Lundberg, "The Order of Authorship: Who's On First?," *JAMA*, October 10, 1990, Vol. 264, No. 14, pp. 1857; Helmuth Goepfert, "Responsible Authorship" (editorial), *Head and Neck*, July/August 1989, pp. 293–294; A. N. Schechter, J. B. Wyngaarden, J. T. Edsall, J. Maddox, A. S. Relman, M. Angell, W. W. Stewart, "Colloquium on Scientific Authorship: Rights and Responsibilities," *The FASEB Journal*, Vol. 3, Feb. 1989, pp. 209–217 (especially Maddox's statement on p. 214).

36. *JAMA*, 13 October 1989, Vol. 262, No. 14, p. 2005.

37. P. V. Scott, T. C. Smith, "Definition of Authorship May Be Changed: Peer Reviewers Should Be Identified at the End of Each Published Paper," *Br. Med. J.*, Vol. 313, September 28, 1996, p. 821.

38. The remarkable paucity of analyses of the peer review system before the wave of fraud scandals and the early tendencies to underestimate the frequency of misconduct may reflect a built-in tendency to denial that, far from being arbitrary, is connected to the structural blind spots of the reward system of science. Until recently, the peer review system had been the subject of few sustained analyses (Daryl E. Chubin, Edward J. Hackett, *Peerless Science*, Albany, N.Y.: SUNY Press, 1990, is a notable exception). But several conferences, studies, and publications have emerged since, such as "Guarding the Guardians: Research on Editorial Peer Review," special issue of *JAMA*, March 9, 1990, Vol. 263, No. 10.

39. Michael E. Dewey, "Authors Have Rights Too," *Br. Med. J.*, Vol. 306, January 30, 1993, pp. 318–120. See, also, comments on Dewey's piece in the *Br. Med. J.*, Vol. 306, March 13, 1993, pp. 716–717, which include remarks like "Authors need to organise themselves to redress the current imbalance of power," "The International Committee of Medical Journals Editors should consider the sort of issue discussed by Dewey," and "how a mechanism might be set up to allow authors' grievances to be aired." A radical revision of the relationship between journal and contributors has been recently proposed by *Lancet*'s editor (Richard Horton, "The Signature or Responsibility," *Lancet*, Vol. 350, July 5, 1997, p. 6).

40. Occasionally, some editors seem uneasy about this state of affairs. Commenting on a meeting of the ICMJE, the editor of *Lancet* claimed that "medical editors should be banned from assembling in more than twos or threes, lest they conspire to present a homogeneous front to contributors and readers." ("Editorial Consensus on Authorship and Other Matters," *Lancet*, 1985; Vol. 2, p. 595).

41. Avram Goldstein, "Collaboration and Responsibility," *Science*, December 23, 1988, Vol. 242, p. 1623. See also Arnold Friedhoff's letter on the same page.

42. Letters by Jay M. Pasachoff and Craig Loehle in "Responsibility of Co-Authors," *Science*, Vol. 275, January 3, 1997, p. 14.

43. Letter by Tobias I. Baskin, ibid.

44. Raj Bhopal, Judith Rankin, Elaine McColl, Lois Thomas, Eileen Kaner, Rosie Stacy, Pauline Pearson, Bryan Vernon, Helen Rodgers, "The Vexed Question of Authorship: Views of Researchers in a British Medical Faculty," *Br. Med. J.*, Vol. 314, April 5, 1997, pp. 1009–1012.

45. Domhnall Macauley, "Cite the Workers," *Br. Med. J.*, Vol. 305, July 11, 1992, p. 6845; Ian W. B. Grant, "Multiple Authorship," *Br. Med. J.*, Vol. 298, February 11, 1989, pp. 386–387. See also letters to the editor (*N. Engl. J. Med.*, Vol. 326, No. 16, April 16, 1992, pp. 1084–1985) published in response to J. P. Kassirer, M. Angell, "On authorship and acknowledgments," *N. Engl. J. Med.*, 1991, Vol. 325, pp. 1510–1512. A few editors have taken these complaints seriously. An editorial in *Lancet* a few months ago argued that: "Many researchers think this definition [ICMJE's] is out of touch with their own research practice. It leans toward being a senior authors' charter, falling short of providing explicit credit for those who actually do research. . . . And, in an era of highly technical, multidisciplinary research, how can all authors be expected 'to take public responsibility for the content'? On balance, the definition seems to fail important tests of relevance and reliability." (Richard Horton, "The Signature or Responsibility," *Lancet*, Vol. 350, July 5, 1997, pp. 5–6).

46. Mario Biagioli, *Galileo, Courtier*, Chicago: University of Chicago Press, 1993, pp. 103–157; Mario Biagioli, "Etiquette, Interdependence, and Sociability in Seventeenth-Century Science," *Critical Inquiry*, Vol. 22 (1996), 193–238.

47. ICMJE, "Uniform Requirements."

48. Mark Rose, *Authors and Owners*, Cambridge, Mass.: Harvard University Press, 1993; Peter Jaszi, "Toward a Theory of Copyright: The Metamorphoses of 'Authorship,'" *Duke Law Journal*, 1991, pp. 455–502; Martha Woodmansee, *The Author, Art, and the Market*, New York: Columbia University Press, 1994; Roger Chartier, "Figures of the Author," *The Order Of Books*, Stanford: Stanford University Press, 1994, pp. 25–59.

49. Martha Woodmansee, "The Genius and the Copyright: Economic and Legal Conditions of the Emergence of the 'Author,'" *Eighteenth-Century Studies*, Vol. 17 (1984), pp. 425–448. The problems posed by the romantic view of authorship on contemporary intellectual property law are one of the foci of James Boyle's *Shamans, Software, and Spleens*.

50. Steven Shapin, "The House of Experiment in Seventeenth-Century England," *Isis*, Vol. 79 (1988), pp. 373–374 (reprinted in this volume); and "The Invisible Technician," *American Scientist*, Vol. 77 (November–December 1989), pp. 554–563.

# 3

# The Specificity
# of the Scientific Field
# and the Social Conditions
# of the Progress of Reason[*]

## PIERRE BOURDIEU

*The training of the scientific mind is not only a reform of ordinary knowledge, but also a* conversion *of interests.*

—GASTON BACHELARD, *LE RATIONALISME APPLIQUÉ.*

The sociology of science rests on the postulate that the objective truth of the product—even in the case of that very particular product, scientific truth—lies in a particular type of social condition of production, or, more precisely, in a determinate state of the structure and functioning of the scientific field. The "pure" universe of even the "purest" science is a social field like any other, with its distribution of power and its monopolies, its struggles and strategies, interests and profits, but it is a field in which all these *invariants* take on specific forms.

1. As a system of objective relations between positions already won (in previous struggles), the scientific field is the locus of a competitive struggle, in which the *specific* issue at stake is the monopoly of *scientific authority*, defined inseparably as technical capacity and social power, or, to put it another way, the monopoly of *scientific competence*, in the sense of a particular agent's socially recognised capacity to speak and act legitimately (i.e., in an authorised and authoritative way) in scientific matters.

When we say that the field is the locus of struggles, we are not simply breaking away from the irenic image of the "scientific community," as described by scientific hagiography—and often, subsequently, by the sociology of science—i.e., the notion of a sort of "kingdom of ends" knowing no other laws than that of the perfect competition of ideas, a contest infallibly decided by the intrinsic strength of the true idea. We are also insisting that the operation of the scientific field itself *produces and presupposes* a specific form of interest (scientific practices appearing as "disinterested" only in relation to different interests, produced and demanded by other fields).

References to scientific interest and scientific authority (or competence) are intended to eliminate from the outset certain distinctions which, in the implicit state, pervade discussions of science: thus, to attempt to distinguish those aspects of scientific competence (or authority) which are regarded as pure social representation, symbolic power, marked by an elaborate apparatus of emblems and signs, from what is regarded as pure technical competence, is to fall into the trap which is constitutive of all competence, a *social authority* which legitimates itself by presenting itself as pure technical reason (as can be seen, for example, in the technocratic uses made of the notion of competence).[1] In reality, the august array of insignia adorning persons of "capacity" and "competence"—the red robes and ermine, gowns and mortar-boards of magistrates and scholars in the past, the academic distinctions and scientific qualifications of modern researchers, all this social fiction which is in no way fictitious—modifies social perception of strictly technical capacity. In consequence, judgments on a student's or a researcher's scientific capacities are *always contaminated* at all stages of academic life, by knowledge of the position he occupies in the instituted hierarchies (the hierarchy of the universities, for example, in the United States).

Because all scientific practices are directed towards the acquisition of scientific authority (prestige, recognition, fame, etc.), intrinsically *twofold* stakes, what is generally called "interest" in a particular scientific activity (a discipline, a branch of that discipline, a method) is always two-sided; and so are the strategies tending to bring about the satisfaction of that interest.

An analysis which tried to isolate a purely "political" dimension in struggles for domination of the scientific field would be as radically wrong as the (more frequent) opposite course of only attending to the "pure," purely intellectual, determinations involved in scientific controversies. For example, the present-day struggle between different specialists for research grants and facilities can never be reduced to a simple struggle for strictly "political" power: in the social sciences, those who in the United States have reached the top of the great scientific bureaucracies (such as the Columbia Bureau of Applied Social Research) cannot force others to recognize their victory as the victory of science unless they are also capable of imposing a definition of science implying that genuine science requires the use of a great scientific bureaucracy provided with adequate funds, powerful technical aids, and abundant manpower; and they present the procedures of large-sample surveys, the operations of statistical analysis of data, and formalization of the results, as universal and eternal methodology, thereby setting up as the measure of all scientific practice the standard most favourable to their personal or institutional capacities. Conversely, epistemological conflicts are always, inseparably, political conflicts: so that a survey on power in the scientific field could perfectly well consist of apparently epistemological questions alone.

It follows from a rigorous definition of the scientific field as the objective space defined by the play of opposing forces in a struggle for scientific stakes, that it is pointless to distinguish between strictly scientific determinations and strictly social determinations of practices that are essentially *overdetermined*. In a passage which deserves to be quoted in full, Fred Reif shows, almost despite himself, how artificial and indeed impossible it is to distinguish between intrinsic and extrinsic interest, between what is important for a particular researcher and what is important for other researchers: "A scientist strives to do research which he considers important. But *intrinsic satisfaction and interest are not his only reasons*. This becomes apparent when one observes what happens if the scientist discovers that someone else has just published a conclusion which he was about to reach as a result of his own research. Almost invariably he feels upset by this occurrence, although the *intrinsic interest* of his work has certainly not been affected. The

scientist wants his work *to be not only interesting to himself but also important to others.*"[2] What is regarded as important and interesting is what is likely to be recognized by others as important and interesting, and thus to make the man who produces it appear more important and interesting in the eyes of others. (We shall have to return to this dialectic and the conditions under which it operates to the advantage of scientific cumulativity and not as a simple circle of mutual legitimation.)

If we are not to fall back into the idealist philosophy which credits science with the power to develop in accordance with its immanent logic (as Kuhn still does when he suggests that "scientific revolutions" occur only as a result of exhaustion of the "paradigms") we must posit that investments are organized by reference to—conscious or unconscious—anticipation of the average chances of profit (which are themselves specified in terms of the capital already held). Thus researchers' tendency to concentrate on those problems regarded as the most important ones (e.g., because they have been constituted as such by producers endowed with a high degree of legitimacy) is explained by the fact that a contribution or discovery relating to those questions will tend to yield greater symbolic profit. The intense competition which is then triggered off is likely to bring about a fall in average rates of symbolic profit, and hence the departure of a fraction of the researchers towards other objects which are less prestigious but around which the competition is less intense, so that they offer profits at least as great.[3]

An authentic science of science cannot be constituted unless it radically challenges the abstract opposition (which one also finds elsewhere, in art history for example) between immanent or internal analysis, regarded as the province of the epistemologist, which recreates the logic by which science creates its specific problems, and external analysis, which relates those problems to the social conditions of their appearance. It is the scientific field which, as the locus of a political struggle for scientific domination, assigns each researcher, as a function of his position within it, his indissociably political and scientific problems and his methods—scientific strategies which, being expressly or objectively defined by reference to the system of political and scientific positions constituting the scientific field, are at the same time political strategies. Every scientific "choice"—the choice of the area of research, the choice of methods, the choice of the place of publication, the choice, described by Hagstrom,[4] between rapid publication of partly checked results and later publication of fully checked results—is in one respect—the least avowed, and naturally the least avowable—a political investment strategy, directed, objectively at least, towards maximization of strictly scientific profit, i.e., of potential recognition by the agent's competitor-peers.

2. The struggle for scientific authority, a particular kind of *social capital* which gives power over the constitutive mechanisms of the field and can be reconverted into other forms of capital, owes its specificity to the fact that the producers tend to have no possible clients other than their competitors (and the greater the autonomy of the field, the more this is so). This means that in a highly autonomous scientific field, a particular producer cannot expect recognition of the value of his products ("reputation," "prestige," "authority," "competence," etc.) from anyone except other producers, who, being his competitors too, are those least inclined to grant recognition without discussion and scrutiny. This is true de facto: only scientists involved in the area have the means of symbolically appropriating his work and assessing its merits. And it is also true de jure: the scientist who appeals to an authority outside the field cannot fail to incur discredit.[5] (In this respect, the scientific field functions in exactly the same way as a highly autonomous artistic

field[6]: one of the principles of the specificity of the scientific field lies in the fact that the competitors must do more than simply *distinguish themselves* from their already recognised precursors; if they are not to be left behind and "outclassed," they must integrate their predecessors' and rivals' work into the distinct and distinctive construction which transcends it.

In the struggle in which every agent must engage in order to force recognition of the value of his products and his own authority as a legitimate producer, what is at stake is in fact the power to impose the definition of science (i.e., the delimitation of the field of the problems, methods, and theories that may be regarded as scientific) best suited to his specific interests (i.e., the definition most likely to enable him to occupy the dominant position in full legitimacy) by attributing the highest position in the hierarchy of scientific values to the scientific capacities which he personally or institutionally possesses (e.g., by being highly trained in mathematics, having studied at a particular educational institution, being a member of a particular scientific institution, etc.).[7]

The definition of what is at stake in the scientific struggle is thus one of the issues at stake in the scientific struggle, and the dominant are those who manage to impose the definition of science which says that the most accomplished realization of science consists in having, being, and doing what they have, are, or do. This means, incidentally, that the *communis doctorum opinio,* as the Scholastics put it, is never more than an *official fiction* which is not in the least fictitious because the symbolic efficacy from which it derives its legitimacy enables it to perform a symbolic function similar to that performed for liberal ideology by the notion of "public opinion." Official science is not what the sociology of science generally takes it to be, that is to say, the system of norms and values which the "scientific community," an undifferentiated group, is seen as imposing on and inculcating in all its members, so that revolutionary anomie can only be imputed to the occasional misfiring of scientific socialization.[8] This "Durkheimian" vision of the scientific field may well be no more than the transfiguration of the naively "functionalist" representation of the scientific universe which the upholders of the scientific order have an interest in imposing on others, starting with their competitors.

And it is precisely because the definition of what is at stake in the struggle is itself an issue at stake in the struggle, even in sciences—like mathematics—in which there is apparently a high degree of consensus on the stakes, that the antinomies of legitimacy constantly arise. (This explains why social science researchers have a passionate interest in the natural sciences: what is at stake in their claim to impose the legitimate definition of the most legitimate form of science, i.e., natural science, in the name of epistemology or the sociology of science, is the definition of the principles of evaluation of their own practice.) In the scientific field as in the field of class relations, no arbitrating authority exists to legitimate legitimacy-giving authorities; claims to legitimacy draw their legitimacy from the relative strength of the groups whose interests they express: inasmuch as the definition of the criteria of judgment and the principles of hierarchization is itself at issue in a struggle, there are no good judges, because there is no judge who is not also a party to the dispute.

Scientific authority is thus a particular kind of capital, which can be accumulated, transmitted, and even reconverted into other kinds of capital under certain conditions. The recognition, socially marked and guaranteed (by a whole series of specific signs of consecration[9]), which the competitor-peer group bestows on each of its members, depends on the *distinctive value* of his products and the collectively recognized *originality* (in the information-theory sense) of his contribution to the scientific resources already accumulated. The fact that the authority-capital accruing from a discovery is monopolized by the first person to have made it, or at least, the first

person to have made it known and got it recognized, explains the frequency and importance of *questions of priority.* If several names come to be attached to the first discovery, the prestige of each of them is correspondingly diminished. A scientist who makes the same discovery a few weeks or a few months later has been wasting his time, and his work is reduced to the status of worthless duplication of work already recognized (and this is why some researchers rush into print for fear of being overtaken).[10] The notion of "visibility" which is frequently used by American writers (as is often the case, this is a notion in everyday use among academics) clearly expresses the *distinctive, differential value* of this particular kind of social capital: to accumulate it is "to make a *name* for oneself," one's own name (and for some, their first name), a known, recognized name, a mark which immediately distinguishes its bearer, lifting him as a visible form out of the undifferentiated, unregarded, obscure background in which the common ruck remains (hence, no doubt, the importance of metaphors of perception, the paradigm of which is the opposition *"brilliant"/"obscure,"* in most academic taxonomies).[11]

The logic of distinction operates to the full in the case of multiple authorship, which, as such, reduces the distinctive value accruing to each signatory. It is thus possible to see all the observations made by Harriet A. Zuckerman[12] on "patterns of name ordering" among authors of scientific papers as the product of strategies aimed at *minimizing the loss of distinctive value* entailed by the necessities of the new division of scientific labour. Thus, in order to understand why Nobel prize winners do not take first place more often than others, as one might expect given that authors are normally named in order of the relative value of their contribution, there is no need to invoke an aristocratic ethic of "nobelesse oblige"; if one simply posits that a name's visibility in a series depends first on its *relative visibility,* defined by its rank in the series, and, secondly, on its *intrinsic visibility,* which it owes to the fact that, when already known, it is more easily recognized and remarked (one of the mechanisms which ensure that, here as elsewhere, the rich in capital are the ones who get richer), one can then see why the tendency to abandon first place to others increases as the capital possessed increases, and with it the symbolic profit automatically accruing to its possessor regardless of his place in the order.[13] The market in scientific goods has its laws, and they have nothing to do with ethics. And, if we are to avoid creating a place in the science of science, under various "scientific" names, for what agents sometimes call the "values" or the "traditions" of "the scientific community," we need to be able to recognize as such the strategies which, in universes in which people have an interest in being disinterested, tend to disguise strategies. These second-order strategies, through which agents *regularize their situation* by transfiguring submission to laws (which is the precondition of the satisfaction of their interests) into elective obedience to norms, enable them to compound the satisfactions of enlightened self-interest with the profits more or less universally bestowed on actions which apparently have no other determination than pure, disinterested respect for the rule.

3. The structure of the scientific field at any given moment is defined by the state of the power distribution between the protagonists in the struggle (agents or institutions), i.e., by the structure of the distribution of the specific capital, the result of previous struggles which is objectified in institutions and dispositions and commands the strategies and objective chances of the different agents or institutions in the present struggles. (Here as elsewhere, one only has to observe the dialectical relationship which is set up between the structures and the strategies—through the intermediary of dispositions—in order to dispose of the antinomy of the synchronic and the diachronic, structure and history, in which structuralist objectivism and spontaneist subjectivism

remain trapped.) The structure of the distribution of scientific capital is the source of the transformations of the scientific field through the intermediary of the strategies for conservation or subversion of the structure which the structure itself produces: on the one hand, the position which each individual agent occupies in the structure of the scientific field at any given moment is the resultant, "crystallized" in institutions and dispositions, of the sum of the previous strategies of that agent and his competitors, strategies which themselves depend on the structure of the field through the intermediary of the structural positions from which they originate; and on the other hand, transformations of the structure of the field are the product of strategies for conservation or subversion whose orientation and efficacy are derived from the properties of the positions occupied within the field by those who produce them.

This means that in a given state of the field, researchers' investments depend both in their amount (measurable, for example, in terms of the time devoted to research) and in their nature (and especially in the degree of risk involved) on the amount of actual and potential recognition-capital which they possess, and on their actual and potential positions in the field (by a circular process which may be observed in every area of practice). In accordance with a logic which has often been observed, researchers' aspirations—i.e., what are generally called "scientific ambitions"—rise as their capital of recognition rises: possession of the capital which the educational system bestows at the very outset of a scientific career, in the form of a prestigious qualification, implies and imposes—through complex mediations—the pursuit of lofty aims which are socially demanded and guaranteed by the qualification. Thus, to attempt to measure the statistical relation between a researcher's prestige and the prestige of his initial qualification (his *grande école* or faculty in France, the university where he obtained his Ph.D. in the United States), *once allowance has been made for the effects of his productivity*,[14] is implicitly to accept the hypothesis that productivity and present prestige are mutually independent and also independent of the initial qualification: in reality, insofar as the qualification, as scholastic capital reconvertible into university and scientific capital, contains a probable trajectory, it governs the agent's whole relationship with his scientific career (the choice of more or less "ambitious" projects, greater or lesser productivity, etc.) through the intermediary of the "reasonable aspirations" which it authorizes. The consequence is that the prestige of institutions produces its effects not only in a direct way, by "contaminating" judgments passed on the scientific capacities manifested in the quantity and quality of the work done, and in an indirect way, through the intermediary of contact with the most prestigious teachers thanks to prestigious schooling (usually associated with high social class origin), but also through the intermediary of the "causality of the probable," i.e., by the force of the aspirations which the objective chances authorize or favor (analogous observations could be made as to the effects of social origin when initial qualifications are equal). For example, the opposition between the risk-free investments of intensive, specialized research, and the hazardous investments of extensive research which may lead to wide-ranging (revolutionary or eclectic) theoretical syntheses—those which, in the case of physics which Fred Reif analyzes, involve finding out about scientific developments occurring beyond the strict limits of one's speciality, instead of keeping to the beaten tracks of a tried and tested research direction, and may either lead nowhere or prove a source of fruitful analogies—tends to reproduce the opposition between high-flying and low-flying trajectories in the field of schooling and in the scientific field.[15] In the same way, in order to understand the transformation of scientific practices (one that has frequently been described) which accompanies advance in a scientific career, we must relate the different scientific strategies—e.g., massive, extensive investment in research alone, or

moderate, intensive investment in research combined with investment in scientific administration—not, of course, to age classes, since each field defines its own laws of social aging,[16] but to the amount of scientific capital possessed, which by defining at any given moment the objective chances of profit, defines "reasonable" strategies of investment and disinvestment. One sees how artificial it is to describe the generic properties of the different stages in "the scientific career,"[17] even the "average career" in a particular field[18]—because each career is fundamentally defined by its position in the structure of the system of possible careers.[19] There are as many ways of entering, staying in, and leaving research, as there are classes of trajectories, and any description dealing with such a universe which limits itself to the generic characteristics of a "typical" career loses sight of the essential point, the *differences*. The decline with age in the quantity and quality of scientific output observed in the case of "average careers," which can apparently be explained if it is admitted that an increase in an agent's capital of consecration tends to reduce the urgency of the high productivity that was needed in order to obtain it, is not fully intelligible until we relate average careers to the highest careers, which alone yield right to the end the symbolic profits that are needed to constantly reactivate the propensity to new investment, thereby constantly delaying disinvestment.

4. The form assumed by the inseparably political and scientific struggle for scientific legitimacy depends on the structure of the field, i.e., the structure of the distribution of the specific capital of scientific recognition among those involved in the struggle. This structure can theoretically vary (as in every field) between two theoretical limits, which are in fact never reached—at one extreme, the situation of a monopoly of the specific capital of scientific authority, and at the other, the situation of perfect competition, which would imply equal distribution of this capital among all the competitors. The scientific field is always the locus of a *more or less unequal* struggle between agents unequally endowed with the specific capital, hence unequally equipped to appropriate the product of scientific labor accumulated by previous generations, and the specific profits (and also, in some cases, the external profits such as economic or strictly political benefits) which the aggregate of the competitors produce through their *objective collaboration* by putting to use the aggregate of the available means of scientific production. In every field there is a permanent struggle between forces that are *more or less unequally matched* depending on the structure of the distribution of capital in the field (the degree of homogeneity)—the dominant, who occupy the highest positions in the structure of the distribution of scientific capital, and the dominated, i.e., the newcomers to the field, who possess a scientific capital the amount of which (in absolute terms) increases in proportion with the accumulated scientific resources in the field.

Everything seems to indicate that as the accumulated scientific resources increase, and as, owing to the correlative rise in the cost of entry, the degree of homogeneity rises among the competitors (who, as a result of other factors, tend to become more numerous), so scientific competition tends to become very different in its form and intensity from the competition found in earlier states of the same field or in other fields in which there are smaller accumulated resources and less heterogeneity (cf. below, part 5). These structural and morphological properties of the various fields are what the sociologists of science generally fail to take into account, thereby running the risk of universalizing the particular case. It is because of these properties that the opposition between strategies for conservation and strategies for subversion (which will be analysed below) tends to weaken with the growing homogeneity of the field and the correlative decline in the likelihood of *great periodic revolutions* in favor of *countless small permanent revolutions*.

In the struggle between the dominant and the newcomers, the two sides resort to antagonistic strategies, profoundly opposed in their logic and their principle: the interests (in both senses of the word) which motivate them and the means they employ in order to satisfy them, depend in fact very closely on their position in the field, i.e., on their scientific capital and the power it gives them over the field of scientific production and circulation, and over the profits it produces. The dominant are committed to *conservation strategies* aimed at ensuring the perpetuation of the established scientific order to which their interests are linked. This order cannot be reduced, as is often thought, to *official science,* the aggregate of the scientific resources inherited from the past which exist in *the state of objectification,* in the form of instruments, texts, institutions, etc., and in *the state of incorporation,* in the form of scientific habitus, systems of generative schemes of perception, appreciation, and action, produced by a specific form of educative action, which make possible the choice of objects, the solution of problems, and the evaluation of solutions. It also embraces the aggregate of the institutions responsible for ensuring the production and circulation of scientific goods together with the reproduction of the producers (or reproducers) and consumers of these goods. In the forefront stands the educational system, the only institution capable of securing the permanence and consecration of official science by inculcating it systematically (the scientific habitus) upon all legitimate recipients of educative action, and in particular, upon all new entrants to the actual field of production. In addition to the institutions specifically charged with consecration (academies, prizes, etc.), the established scientific order also includes the instruments of circulation, in particular the scientific journals which, by selecting their articles in terms of the dominant criteria, consecrate productions faithful to the principles of official science, thereby continuously holding out the example of what deserves the name of science, and exercise a de facto censorship of heretical productions, either by rejecting them outright or by simply discouraging the intention of even trying to publish them by means of the definition of the publishable which they set forward.[20]

It is the field that assigns each agent his strategies, and the strategy of overturning the established scientific order is no exception to this. Depending on the position they occupy in the structure of the field (and also, no doubt, on secondary variables such as their social trajectory, which governs their assessment of their chances), the "new entrants" may find themselves oriented either towards the risk-free investments of *succession strategies,* which are guaranteed to bring them, at the end of a predictable career, the profits awaiting those who realize the official ideal of scientific excellence through limited innovations within authorized limits; or towards *subversion strategies,* infinitely more costly and more hazardous investments which will not bring them the profits accruing to the holders of the monopoly of scientific legitimacy unless they can achieve a complete redefinition of the principles legitimating domination: newcomers who refuse the beaten tracks cannot "beat the dominant at their own game" unless they make additional, strictly scientific investments from which they cannot expect high profits, at least in the short run, since the whole logic of the system is against them.

On one side, there is invention according to a previously invented art of inventing which, by solving all the problems likely to be raised within the limits of the established problematic, through the application of proven methods (or by working to save established principles from heretical challenges—one thinks for example of Tycho Brahe) tends to occlude the fact that it only solves the problems it can raise and only raises the problems it can solve; on the other side, there is heretical invention, which, by challenging the very principles of the old scientific order, creates a radical dichotomy, with no chance of compromise, between two mutually exclusive sys-

tems. The founders of a heretical scientific order break the exchange agreement that is accepted, at least tacitly, by candidates for the succession: recognizing no other principle of legitimation than the one they intend to impose, they refuse to enter the cycle of the *exchange of recognition* which ensures an orderly transmission of scientific authority between the holders and the pretenders (i.e., very often between members of different generations, which leads many observers to reduce conflicts over legitimacy to generational conflicts). Rejecting all the sanctions and guarantees offered by the old order, as well as the (progressive) accession to a share in the collectively guaranteed capital which is effected in accordance with the orderly procedures of a contract of delegation, they achieve their initial accumulation by means of a violent wrench, a sharp break with the existing order, diverting for their own benefit the credit which accrued to the former dominant group, without conceding in exchange the tribute of recognition which those willing to take their place in the continuity of a lineage bestow on their elders.[21]

And there is every reason to think that the propensity to conversion strategies or subversion strategies is that much less independent of dispositions towards the established order when the scientific order is itself less independent of the social order in which it is set. This is why there are grounds for supposing that the relation which Lewis Feuer establishes between the young Einsteins' academically and politically subversive leanings and his scientifically revolutionary enterprise is true a fortiori in sciences such as biology or sociology which are far from having achieved the degree of autonomy attained by physics in Einstein's time.[22] And the opposition which Feuer establishes between Einstein's youthful revolutionary dispositions, as a member of a group of Jewish students in revolt against the university order and the social order, and the reformist dispositions evinced by Poincaré, a perfect representative of the "republic of professors," a man of order and orderly reform, both in the political and in the scientific order, cannot fail to remind us of the homologous opposition between Marx and Durkheim.

5. What are the social conditions which must be fulfilled in order for a social play of forces to be set up in which the true idea is endowed with strength because those who have a share in it have an interest in truth, instead of having, as in other games, the truth which suits their interests? It goes without saying that it is not a question of making this exceptional social universe an exception to the fundamental laws of all fields—in particular the law of interest, which is capable of introducing ruthless violence into the most "disinterested" scientific struggles ("disinterestedness," as we have seen, never being anything other than a system of specific—artistic or religious, as well as scientific—interests which implies relative indifference to the ordinary objects of interest—money, honors, etc.). The scientific field always includes a measure of social arbitrariness, inasmuch as it serves the interests of those who are in a position, inside or outside the field, to gather in the profits; but this does not prevent the inherent logic of the field, and in particular, the struggle between the dominant and the new entrants, with the resultant cross-control, from bringing about, under certain conditions, a *systematic diversion of ends* whereby the pursuit of private scientific interests (again in both senses of the word) continuously operates to the advantage of the progress of science.[23]

Partial theories of science and its transformations are predisposed to perform ideological functions in the struggles within the scientific field (or within fields laying claim to scientificity, such as the field of the social sciences) because they universalize the properties attached to *particular states* of the scientific field: this is true of the positivist theory which confers on science the power to solve all the questions it raises, provided they are raised scientifically, and to impose a

consensus on its solutions by applying objective criteria, thus inserting progress into the routine of "normal science" and implying that science passes from one system to another—from Newton to Einstein, for example—through simple accumulation of knowledge, refinement of measurements, and rectification of principles; it is equally true of Kuhn's theory, which, though valid for the beginnings of science (for which the Copernican revolution provides the paradigm—in the true sense of the word), oversimplifies by taking the diametrically opposite position to the positivist model.[24] In reality, the field of astronomy in which the Copernican revolution occurred contrasts with the field of contemporary physics in the same way that, according to Polanyi, the market "embedded in social relationships" of archaic societies contrasts with the "self-regulating market" of capitalist societies. It is no accident that the Copernican revolution implies an express demand for autonomy for a scientific field still "embedded" in the religious field and the field of philosophy, and through them, in the political field; and this demand implies the assertion of scientists' right to decide on scientific questions ("mathematics for the mathematicians") in the name of the specific legitimacy which they derive from their competence.

Until scientific method and the control and/or assistance which it proposes or imposes have been objectified in mechanisms and dispositions, breaks in the continuity of science necessarily take on the aspect of revolutions against the establishment. But once these founding revolutions have excluded all recourse to any weapons or powers, even purely symbolic ones, other than those which are legal tender within the field, it is the operation of the field itself which defines more and more completely not only the ordinary order of "normal science" but also the extraordinary breaks, the "orderly revolutions" as Bachelard calls them, which are written into the logic of the history of science, i.e., the logic of scientific polemics.[25] When scientific method is built into the mechanisms of the field, revolution against instituted science is carried out with the aid of an institution which provides the institutional conditions of the break; the field becomes the scene of a permanent revolution, but a revolution that is increasingly devoid of political effects. That is why this universe of permanent revolution can also, without contradiction, be that of "legitimate dogmatism"[26]: the scientific equipment required to effect a scientific revolution can only be acquired in and by the citadel of the scientific establishment. As accumulated scientific resources increase, so the incorporated scientific capital needed in order to appropriate them and thereby gain access to scientific problems and tools, and thus to the scientific struggle, becomes greater and greater (the cost of entry).[27] The consequence is that scientific revolution is the business not of the poorest but of the richest (in scientific capital) among the new entrants.[28] The antinomy of upheaval and continuity is weakened in a field which makes no distinction between revolutionary phases and "normal science" and which finds the true principle of its continuity in continuous upheaval; and correlatively the opposition between succession strategies and subversion strategies increasingly tends to lose its meaning, since the accumulation of the capital needed to accomplish revolutions, and of the capital accruing from revolutions, increasingly tends to occur in accordance with the regulated procedures of a career.[29]

The transmutation of the anarchic antagonism of particular interests into a scientific dialectic becomes more and more complete as the interest that each producer of symbolic goods has in producing products that, as Fred Reif puts it, are "not only interesting to himself but also important to others," hence likely to win recognition of their importance and of the importance of their author, comes up against competitors more capable of applying the same means in the service of the same intentions—which, with simultaneous discoveries, leads more and more frequently to one or both producers' interests being sacrificed;[30] or, to put it another way, the

transmutation becomes more complete as each individual agent's private interest in fighting and dominating his competitors in order to win their recognition comes to be equipped with a whole set of tools which endow his polemical intention with maximum efficacy by giving it the universal scope of methodical control. And indeed, as accumulated resources increase, together with the amount of capital needed in order to appropriate them, so the market in which the scientific product is put on offer increasingly becomes restricted to competitors who are increasingly well equipped to criticize it rationally and to discredit its author. The antagonism which is the basis of the structure and transformation of any field tends to become more and more radical and more and more fruitful because the *forced agreement* in which reason is generated leaves less and less room for the unthought assumptions of doxa. The collective order of science is built up in and through the competitive anarchy of self-interested actions, each agent finding himself dominated—as is the whole group—by the seemingly incoherent criss-crossing of individual strategies. This means that the opposition between "functional" and "dysfunctional" aspects of the operation of a highly autonomous scientific field has little meaning: the most "dysfunctional" tendencies (e.g., secretiveness and refusal to cooperate) are inherent in the very same functions which generate the most "functional" dispositions. As scientific method takes its place among the social mechanisms regulating the operation of the field, and thereby acquires the higher objectivity of an immanent social law, so it can realize itself objectively in tools capable of controlling and sometimes dominating their users, and in the lastingly constituted dispositions inculcated by schooling. And these dispositions are continuously reinforced by the social mechanisms which, themselves finding support in the rational materialism of objectified, incorporated science, produce both control and censorship, and also innovation and rupture.[31]

6. Science never has any other basis than the collective belief in its bases which is produced and presupposed by the very operation of the scientific field. The objective orchestration of the practical schemes inculcated by explicit instruction and familiarization, which constitutes the basis of the practical consensus on what is at stake in the field, i.e., on the problems, methods, and solutions immediately regarded as scientific, is itself based on the whole set of institutional mechanisms which ensure the social and academic selection of the researchers (through, for example, the established hierarchy of the disciplines), the training of the selected agents, control over access to the instruments of research and publication, etc.[32] The field of argument which orthodoxy and heterodoxy define by their struggles is demarcated against the background of the field of *doxa,* the aggregate of the presuppositions which the antagonists regard as self-evident and outside the area of argument, because they constitute the tacit condition of argument:[33] the censorship exercised by orthodoxy—and denounced by heterodoxy—conceals a more radical censorship which is also harder to detect because it is constitutive of the very functioning of the field, and because it bears on the totality of what is admitted by the mere fact of belonging to the field, and on the totality of what is set beyond discussion by the mere fact that the agents accept the issues at stake in argument, i.e., the consensus on the objects of dissensus, the common interests underlying conflicts of interest, all the undiscussed and unthought areas tacitly kept outside the *limits* of the struggle.[34]

Depending on a particular field's degree of autonomy in relation to external determinations, social arbitrariness figures to a greater or lesser extent in the system of presuppositions which constitutes the particular belief characteristic of the field in question. This means that, in the

abstract space of theory, any scientific field—that of social science or mathematics nowadays, like that of alchemy or mathematical astronomy in the time of Copernicus—may be situated somewhere between the two limits represented at one extreme by the religious field (or the field of literary production), in which official truth is nothing other than the legitimate imposition (i.e., arbitrary imposition misrecognised as such) of cultural arbitrariness expressing the specific interest of the dominant—inside and outside the field—and at the other extreme by a scientific field from which every element of social arbitrariness (or unthought assumption) would be banished and the social mechanisms of which would bring about the necessary imposition of the universal norms of reason.

This raises the question of the degree of social arbitrariness of the *belief* which is produced by the functioning of the field and is the condition of its functioning, or—and this amounts to the same thing—the question of the field's degree of autonomy (in relation, first, to the social demands of the dominant class and the internal and external social conditions of that autonomy). The principle of all the differences between, on one side, scientific fields capable of producing and satisfying a strictly scientific interest and thus maintaining an unending dialectical process, and, on the other side, *learned fields* in which collective labor has no other effect or function than to perpetuate a field identical to itself, by producing, both within the field and outside it, belief in the autonomous value of the objectives and objects which it produces, lies in the relationship of *dependence in the guise of independence* which false science maintains with external demands: the doxosophers, the professors of false science, learned in appearance and learned in appearances, cannot legitimate either the dispossession that they effect by the arbitrary constitution of an esoteric learning inaccessible to the laity, or the delegation that they demand by arrogating to themselves the monopoly of certain practices or of reflection on those practices, unless they can impose the belief that their false science is perfectly independent of the social demand which it could not satisfy so perfectly if it ceased to proclaim so loudly that it refuses to serve them.

From Heidegger speaking of the masses and the élites in the highly euphemised language of the "authentic" and the "inauthentic," to the American political scientists who reproduce the official vision of the social world in the semiabstractions of a descriptive-normative discourse, one always encounters the same strategy of *false separation* which defines learned jargon as opposed to scientific language. Where scientific language, as Bachelard points out, uses inverted commas to indicate that the words of ordinary language or of previous scientific language which it retains are completely redefined, and draw their meaning entirely from the new theoretical system,[35] learned language makes use of inverted commas and neologisms so as to symbolically manifest a fictitious distance and separation from common sense: lacking any real autonomy, it cannot in fact produce its full ideological effect unless it remains sufficiently transparent to continue to evoke the ordinary experience and expression which it *denies*.[36]

Strategies of false separation express the objective truth of fields which have only a false autonomy: whereas the dominant class grants the natural sciences an autonomy corresponding to the interest it finds in the economic applications of scientific techniques, so that they are now (even for the religious consciousness) fully autonomized in relation to the laws of the social world, the dominant class has no reason to expect anything from the social sciences—beyond, at best, a particularly valuable contribution to the legitimation of the established order and a strengthening of the arsenal of symbolic instruments of domination. The belated and precarious development of the social sciences is evidence that the progress towards real autonomy which is

the condition of the establishment of the constitutive mechanisms of a self-regulating, autarkic scientific field necessarily comes up against obstacles not encountered elsewhere; and it cannot be otherwise, because the power which is at stake in the internal struggle for scientific authority within the field of the social sciences, i.e., the power to produce, impose, and inculcate the legitimate representation of the social world, is one of the things at stake in the struggle between the classes in the political field.[37] It follows that positions in the internal struggle can never attain the degree of independence in relation to positions in the external struggle which is to be found in the natural sciences. The idea of a neutral science is a fiction, an interested fiction which enables its authors to present a version of the dominant representation of the social world, neutralized and euphemized into a particularly misrecognizable and symbolically, therefore, particularly effective form, and to call it scientific.[38] By bringing to light the social mechanisms which ensure the maintenance of the established order and owe their strictly symbolic efficacy to misrecognition of their logic or their effects, the basis of a subtly exacted recognition, social science necessarily takes sides in the political struggle. This means that when it succeeds in getting started (which implies the fulfillment of certain conditions correlative with a particular state of the power relations between the classes), the struggle between genuine science and the false science of the doxosophers (who may claim allegiance with the most revolutionary theoretical traditions) necessarily makes a contribution to the struggle between the classes who, at least in this case, do not have an equal interest in scientific truth.[39]

The fundamental question of the sociology of science assumes a particularly paradoxical form in the case of the social sciences: What are the social conditions of development of a science freed from social constraints and demands, given that, in this case, progress in the direction of scientific rationality does not mean progress in the direction of political neutrality? The question can be denied. It is denied, for example, by all those who impute all the particularities of the social sciences to their situation as the most recent arrivals, in the name of a naively evolutionist philosophy which sets official science at the summit of evolution. In reality, the theory of *backwardness* is, paradoxically, only true in the case of official sociology, and more precisely, the official sociology of sociology. One has only to think of Alexander Gerschenkron's famous analyses of "economic backwardness" in order to understand the most characteristic features of the particular forms of learned discourse produced by the *false sciences* (would-be science and science-to-be). Gerschenkron points out that when the process of industrialization starts *late,* it presents systematic differences from the form it assumed in more developed countries, not only in the rate of development but also in the "productive and organizational structures," because it applies new "institutional instruments" and develops in a different ideological climate.[40] The existence of more advanced sciences—major suppliers not only of methods and techniques, which are generally made use of outside the technical and social conditions of their application, but also of examples—is what enables official sociology to furnish itself with all the appearances of scientificity: the outward show of autonomy can here take on an unprecedented form, surpassing the carefully maintained esotericism of the old academic traditions. Official sociology aims not to realize itself as a science but to realize an official image of science (which the sociology of science plays an important part in providing). The official sociology of science, a sort of tribunal which the *community* of official sociologists (the word "community" is perfectly apt here) sets up for itself, has the function not only of providing that community with a justificatory ideology but also, and above all, of imposing on it respect for the norms and models taken from the natural sciences—at the cost of a positivistic reinterpretation.

The first of these functions is most apparent in the social history of social science as practiced by the American sociological establishment.[41] Convincing evidence of its function as a justificatory ideology is obtained as soon as one starts to count the number of works directly or indirectly devoted to *competition,* the key term (though used in a highly restrictive sense) in all American sociology of science and a notion whose obscurity as a native concept raised to the dignity of science concentrates all the unthought assumptions (the *doxa*) of that sociology. The thesis that productivity and competition are directly linked[42] is based on a functionalist theory of competition which is a sociological variant of belief in the virtues of the "free market economy." An approach which reduces all competition to competition between universities, or makes competition between universities the precondition of competition among researchers, ignores the question of the obstacles to scientific competition that are imputable to the inseparably *economic and scientific competition* which reigns in the "academic market place." The competition recognized by this establishment science is competition within the limits of orthodoxy, within the forms and norms of intellectual free enterprise: the extent to which this competition within the limits of social acceptability is an obstacle to true scientific competition, which challenges orthodoxy and, whenever it can, *doxa,* rises with the degree of social arbitrariness in the universe in question.[43] It is not hard to see how exaltation of the unanimity of the paradigm can coincide with competition—or how it is possible, depending on the author, to accuse European sociology both of too much and of too little competition. As an American observer of the British university remarks: "Without intense interpersonal competition with prizes to be won, most scientists simply get on with their research and do not spend a significant part of their time thinking about where they will move next."[44]

No less evident is the second function, that of supplying the instruments and above all the symbolic attributes of scientific respectability, disguises and cosmetics such as technological gadgetry and rhetorical kitsch. In addition to its tools and techniques—computers and standard data-processing programs for example—official sociology takes over a model of scientific practice as it appears to the positivist imagination, and a model of the organization of what it calls "the scientific community" as pictured by its rudimentary science of organizations.[45] But official sociology holds no monopoly of interested readings of the history of science: the particular difficulty which sociology has in conceiving *science scientifically* is related to the fact that sociology is situated at the very bottom of the social hierarchy of the sciences. Whether it rises to conceive other more scientific sciences better than they conceive themselves, or descends to record the triumphant image produced and propagated by scientific hagiography, sociology always encounters the same difficulty in conceiving itself, i.e., conceiving its own position in the social hierarchy of the sciences. The reactions provoked by Thomas Kuhn's book, *The Structure of Scientific Revolutions,* show this very clearly, and would provide high-quality experimental material for an empirical analysis of the ideologies of science and their relationship with their authors' positions in the scientific field. It is true that this book, which never really makes clear whether it is describing or prescribing the logic of scientific change (an example of implicit prescription: the existence of a paradigm is a sign of scientific maturity), invited its readers to seek answers to the question of good and bad science.[46] Among those whom the native language calls "radicals," Kuhn's book was seen as an invitation to "revolution" against the "paradigm,"[47] or a justification of liberal plurality of *world views*[48]—two positions on the book probably corresponding to different positions within the field.[49] Among the upholders of the established scientific order, it was read as an invitation to drag sociology out of its "preparadigmatic" phase by imposing the uni-

fied configuration of beliefs, values, and techniques symbolised by the Capitoline triad of Parsons and Lazarsfeld reconciled in Merton. The exaltation of quantification, formalization, and ethical neutrality, disdain for philosophy, and rejection of system-building aspirations in favor of meticulous empirical verification and the loose ("operational") conceptualization of "middle-range theorizing"—all flow from a wretchedly transparent transmutation of what is into what ought to be, and find their justification in the need to contribute to the strengthening of "community values," without which sociology could not "get off the ground."

As a false science serving to produce and maintain false consciousness, official sociology (the finest flower of which is currently political science) has to flaunt its objectivity and "ethical neutrality" (its neutrality in the struggle between the classes, whose existence it moreover denies) and to present all the appearances of a sharp *separation* from the dominant class and its ideological demands, by multiplying the outward signs of scientificity: thus on the "empirical" side we find the ostentatious *display of technology*, and on the "theoretical" side *"neo" rhetoric* (thriving in the artistic field too), which apes scientific cumulativity by applying the typically academic procedure of "rereading" to a work or set of works, a paradigmatically scholastic operation of simple reproduction which, within the limits of the field and of the belief that the field produces, succeeds in producing all the appearances of "revolution." A systematic analysis is needed of the *rhetoric of scientificity* with which the dominant "community" produces belief in the scientific value of its products and the scientific authority of its members: for example, the whole set of strategies designed to present the *appearances of cumulativity*, such as reference to canonical sources, generally reduced, as the phrase goes, "to their simplest expression" (consider the posthumous fate of Durkheim's *Suicide*), i.e., banal formalities simulating the rigor of scientific discourse, and to articles, the more recent the better (cf. the opposition between the "hard" and the "soft" sciences); or the *foreclosing strategies*, which are intended to mark a decisive separation between the scientific, problematic, and profane public debates (still present, but only as "ghosts in the machine"), generally by means of simple linguistic retranslations; or the *denial strategies* favored by political scientists, who are skillful at realizing the dominant ideal of "objectivity" in an apolitical discourse on politics, in which repressed politics can only appear in the misrecognizable, hence irreproachable guise of its political-scientific denial.[50] But these strategies perform another essential function: like any circle of legitimacy, this circular circulation of objects, ideas, methods, and above all signs of recognition within a community (one should say, a club, open only to native and adopted members of the Ivy League),[51] produces a universe of belief which has its equivalent both in the religious field and also in the fields of literature or *haute couture*.[52]

But here too, one must be careful not to credit official false science with the significance it is accorded in the "radical" critique. Despite their conflict over the *value* which they attribute to the paradigm, seeing it either as a principle of unification needed for the development of science or as an arbitrary instrument of repression—or as both alternately, in Kuhn's case—the conservatives and their "radical" opponents are objective accomplices who agree on the essential point: from the one-sided points of view which they necessarily adopt on the scientific field, by opting, unconsciously at least, for one or the other of the opposing camps, they are unable to see that control or censorship are not effected by any specific institution but by the *objective relationship between opposing accomplices* who, through their very antagonism, demarcate the field of legitimate argument, excluding as absurd, eclectic, or simply unthinkable any attempt to take up an unforeseen position (for example, in this particular case, to use the technical tools created by official science in the service of a different scientific axiomatics).[53]

"Radical" ideology, a thinly euphemized expression of the interests of those dominated in the scientific field, tends to treat every revolution against the established scientific order as a scientific revolution, behaving as if an "innovation" only had to be rejected by official science in order to be regarded as scientifically revolutionary, and thereby neglecting the question of the particular social conditions under which a revolution against the established scientific order is inseparably a scientific revolution and not a mere heresy intended to reverse the established distribution of power in the field without transforming the principles underlying its functioning.[54] As for the dominant, having made all their investments (economically and psychoanalytically speaking) in the established scientific order, and being in a position to appropriate its profits, they are disposed to accept that it is the realization of what ought to be and are logically led to the spontaneous philosophy of science which finds its expression in the positivist tradition, a form of liberal optimism which holds that science progresses through the intrinsic strength of the true idea, and that the most "powerful" are also the most "competent"[55]: one only has to think of earlier states of the field of the natural sciences to see the ideological function of sociodicity that is performed by this philosophy of science, which, by presenting the ideal as realized, eliminates the question of the social conditions of the realization of the ideal.

When it posits that the sociology of science itself functions in accordance with the laws governing the operation of any scientific field, which are established by the scientific sociology of science, the sociology of science in no way condemns itself to relativism. A scientific sociology of science (and the scientific sociology which it helps to make possible) can only be constituted on condition that it is clearly seen that different representations of science correspond to different positions in the scientific field, and that these representations are *ideological strategies* and *epistemological positions* whereby agents occupying a particular position in the field aim to justify their own position and the strategies they use to maintain or improve it, while at the same time discrediting the holders of the opposing position and their strategies. Every sociologist is a good sociologist of his rivals; the sociology of knowledge or of science is no more than the most irreproachable form of the strategies used to disqualify rivals, until it ceases to take as its object the rivals and their strategies and turns its attention to the *complete system of strategies,* i.e., the field of positions within which they are generated.[56] The sociology of science is so difficult only because the sociologist has a stake in the game he undertakes to describe (first, the scientificity of sociology and secondly the scientificity of the form of sociology which he practises) and because he cannot objectify what is at stake, and the corresponding strategies, unless he takes as his object not simply the strategies of his scientific rivals but the game as such, which governs his own strategies too and is always liable to exert an insidious influence on his sociology.

NOTES

* This article is an English translation by Richard Nice of "La spécificité du champ scientifique et les conditions sociales du progrès de la raison."

1. An excellent example of this is the conflict described by Sapolsky, between the advocates of fluoridation, i.e., the holders of official authority, the "health officials" who regard themselves as the sole competent judges in matters of public health, and the opponents of the project, including many scientists who, in official eyes, had stepped outside "the limits of their own area of competence." The social truth of competence can here be clearly perceived as the right to authorized, authoritative discourse which is at stake in the struggle between groups (cf. H. M. Sapolsky, "Science, voters and the fluoridation controversy," *Science* 162 (3852) October 25, 1968, pp. 427–433). The problem of competence emerges in its acutest and clearest form in the relationship with "laymen" (cf. S. B. Barnes, "On the reception of scientific beliefs," in B. Barnes [ed.], *Sociology of science,* London: Penguin, 1972, pp. 269–291; L. Boltanski and P. Maldidier, "Carrière scientifique, morale scientifique et vulgarisation," *Information sur les sciences sociales* 9 [3], 1970, pp. 99–118).

2. F. Reif, "The competitive world of the pure scientist," *Science*, 134 (3494), December 15, 1961, pp. 1957–1962.

3. It is in this light that one can understand why capital should be transferred from a particular field to a lower field, where less intense competition offers the holder of a determinate scientific capital greater chances of profit.

4. W. D. Hagstrom, *The scientific community*, New York: Basic Books, 1965, p. 100.

5. Fred Reif points out that scientists who are so eager to get their work published quickly that they resort to the daily press (like the physicists who announced important discoveries in the *New York Times*) incur the disapproval of their competitor-peers, in the name of the distinction between *publication* and *publicity;* the same distinction lies behind the hostility towards certain forms of popularisation, which are regarded as self-publicisation. We need only quote the comments of the editor of the American physicists' official journal: "As a matter of courtesy to fellow physicists, it is customary for authors to see to it that releases to the public do not occur before the article appears in the scientific journal. Scientific discoveries are not the proper subject for newspaper scoops, and all media of mass communication should have equal opportunity for simultaneous access to the information. In the future we may reject papers whose main content has been published previously in the daily press" (Reif, "Competitive World").

6. On this point, see P. Bourdieu, "Le marché des biens symboliques," *L'année sociologique* 22, 1971, pp. 49–126 (the numerous self-references in this text should be seen as a form of shorthand).

7. At any given moment, there is a social hierarchy of the scientific fields—the disciplines—which strongly orientates practices and especially the "choices" or "vocation"—and within each field, there is a social hierarchy of objects and methods of treatment. (On this point, see P. Bourdieu, "Méthode scientifique et hiérarchie sociale des objets," *Actes de la recherche en sciences sociales* 1, 1975, pp. 4–6.)

8. Like "Durkheimian" social philosophy, which describes conflict in terms of marginality, deviance, or anomie, this philosophy of science tends to reduce the relations of competition between the dominant and the dominated to relations between a "center" and "periphery," reviving the emanatist metaphor dear to Halbwachs of distance from the "hearth" of the central values (cf. for example, J. Ben David, *The scientist's role in society*, Englewood Cliffs, NJ: Prentice-Hall, 1971; and E. Shils, "Center and periphery," in *The logic of personal knowledge: Essays presented to Michael Polanyi on his seventieth birthday*, London, Routledge and Kegan Paul, 1961, pp. 117–130).

9. Glaser lists "eponymy, prizes, awards, fellowships, scholarships, honorary memberships and committee work in scientific organizations, editorships, honorary degrees, professorships, chairs, lectureships, consultantships, mention by historians of science, publication, acknowledgments in others' work, evaluations by colleagues" (B. G. Glaser, *Organizational scientists: Their professional careers*, Indianapolis: Bobbs-Merrill, 1964, p. 2). According to Glaser, "average recognition" is shown in the "supervisor's favorable evaluation of the quality of the scientist's current research, and proper credit, through publication and through acknowledgment in publications of others for his contribution to the cumulative knowledge in his field." The high-prestige honors, "awards, prizes, grants, lectureships, professorships, etc.," are the signs of recognition reserved for "great men" (B. G. Glaser "Comparative failure in science," *Science* 143 (3610), March 6, 1961, pp. 1012–1014).

10. This explains researchers' very different strategies in the diffusion of preprints and reprints. It would be easy to show how all the differences observed according to the discipline and age of the researchers or the institution to which they belong can be understood in terms of the very different functions performed by these two forms of scientific communication. Preprints enable the scientist to avoid the usual delays involved in scientific publication, by the rapid diffusion among a small number of readers who are also his most competent competitors, of products which are not protected against fraudulent appropriation but are likely to be improved by being put into circulation. Reprints permit the wider circulation of "patented" products, socially imputed to a particular name, among all the writer's colleagues or all those interested (cf. W. Hagstrom, "Factors related to the use of different modes of publishing research in four scientific fields," in C. E. Nelson and D. K. Pollock (eds). *Communication among scientists and engineers*, Lexington, Mass.: Heath Lexington Books, 1970).

11. Hence the difficulty that is met with in research on intellectuals, be they scientists or artists, both in the inquiry itself and in publishing the results: if people who spend their lives trying to make a name for themselves are offered *anonymity*, this destroys their principal motivation to take part in an inquiry (cf. the model of the literary survey or the interview); if anonymity is not offered, one cannot ask "indiscreet"—i.e., objectifying, reductive—questions. The publication of the results raises similar problems, if only because anonymity has the effect of rendering the discourse unintelligible or transparent depending on how well informed the readers are (all the more so because certain positions may contain only one element, a name).

12. H. A. Zuckerman, "Patterns of name ordering among authors of scientific papers: a study of social symbolism and its ambiguity," *American Journal of Sociology* 74 (3), November 1968, pp. 276–291.

13. The model set out here explains perfectly—without appealing to any moral determinant—the fact that prize-winning scientists more readily abandon first place after having won their prize, and that their contribution to the prize-winning research is more visibly marked than their share in other collective research.

14. Cf., for example, L. L. Hargens and W. O. Hagstrom, "Sponsored and contest mobility of American academic scientists," *Sociology of Education* 40 (1), winter 1967, pp. 24–38.

15. Cf. P. Bourdieu, L. Boltanski, and P. Maldidier, "La défense du corps," *Information sur les sciences sociales* 10 (4), 1969, pp. 45–86.

16. Statistical analysis shows, for example, that in past generations as a whole, the age of maximum scientific productivity was between twenty-six and thirty for chemists, between thirty and thirty-four for physicists and

mathematicians, and between thirty-five and thirty-nine for bacteriologists, geologists, and physiologists (H. C. Lehman, *Age and achievement*, Princeton, NJ: Princeton University Press, 1953).

17. Cf. F. Reif and A. Strauss, "The impact of rapid discovery upon the scientist's career," *Social problems* 12 (3), 1965, pp. 297–311. Systematic comparison of this article—for which the physicist collaborated with the sociologist—with the article that the physicist wrote a few years earlier would cast a great deal of light on the functioning of American sociological thought. I shall do no more than point out that the price of "conceptualization" (i.e., the translation of naive native concepts into official jargon) is the total disappearance of any reference to the field as a whole, and in particular, to the *system of trajectories* (or careers) from which each career derives its most important properties.

18. B. G. Glaser, "Variations in the importance of recognition in scientist's careers," *Social problems* 10 (3), winter 1963, pp. 268–276.

19. Rather than repeat here the full demonstration, I shall simply refer the reader to P. Bourdieu, "Les catégories de l'entendement professoral," *Actes de la recherche en sciences sociales* (3), 1975, pp. 68–93.

20. On the "filtering" action of social science journal editorial committees, see D. Crane, "The gate-keepers of science: some factors affecting the selection of articles for scientific journals," *American Sociologist* 73 (2), 1967, pp. 195–201. There is every reason to think that, in scientific as in literary production, authors consciously or unconsciously choose places of publication on the basis of what they take to be their "norms." Self-disqualification, which is naturally less perceptible, is probably at least as important a factor as overt elimination (quite apart from the effect of imposing a norm for publishable material).

21. The novel form which the orderly transmission of scientific capital takes on in fields like that of modern physics, in which conservation and subversion are virtually indistinguishable, is discussed below.

22. "Einstein's high interval of original thought was sustained by a strange little circle of young intellectuals, filled with emotions of social and scientific generational rebellion, a counter-community of scientists outside the official scientific establishment, a group of cosmopolitan bohemians, moved in a revolutionary time to see the world in a new way" (L. S. Feuer, "The social roots of Einstein's theory of relativity," *Annals of science* 27 (3), September 1971, pp. 277–298 and 27 [4], December 1971, pp. 313–344). Transcending the naive opposition between individual habitus and the social conditions in which they are realized, Feuer suggests the hypothesis, corroborated by recent work on the science education system in France (cf. M. de Saint Martin, *Les fonctions sociales de l'enseignement scientifique*, Paris-La Haye: Mouton 1971, Coll.: Cahiers du Centre de la sociologie européenne, n°. 8, and P. Bourdieu and M. de Saint Martin, *Le système des grandes écoles et la reproduction de la classe dominante*, forthcoming), that the rapid and easy access to administrative responsibilities which was available in France for pupils of the science *grandes écoles* tended to discourage revolutionary dispositions, whereas they flourish among groups of marginal intellectuals halfway between the educational system and the revolutionary bohemian community: "One might indeed venture the hypothesis that precisely because France was a 'republic' of professors, precisely because the ablest talent of the École Polytechnique was promptly absorbed into the military and engineering cadres, that it was less likely that a very fundamental break with the received principles would take place there. A scientific revolution evidently finds its most fertile soil in a counter-community. Where administrative responsibilities soon beckoned the young scientist, his energies were less available for sublimation in radical research curiosity. As far as revolutionary creativity was concerned, the very openness of the French administration to scientific talent was perhaps more important for explaining its scientific conservatism than other factors that have usually been emphasized."

23. It is a mechanism of this sort which tends to regulate relations with the external universe, the world of "laymen," i.e., "scientific popularization," the scientist's self-publicization (cf. Boltanski and Maldidier, "Carrière Scientifique").

24. There is no doubt that the philosophy of the history of science offered by Kuhn, with its alternation of monopolistic concentration (the paradigm) and revolution, owes a great deal to the particular case of the "Copernician revolution" which he analyzes and considers "typical of any major upheaval in science" (T. S. Kuhn, *The Copernican revolution*, New York: Vintage Books, 1957): when science still has relatively little autonomy in relation to social power and especially the church, scientific revolution (in mathematical astronomy) involves political revolution and implies a revolution in all scientific disciplines, which may have political effects.

25. As well as Bachelard and Reif (already quoted), D. Bloor has seen that transformations in the social organization of science have determined a transformation of the nature of scientific revolutions (cf. D. Bloor, "Essay review: Two paradigms for scientific knowledge?" *Science studies* 1, 1971, pp. 101–115).

26. G. Bachelard, *Le matérialisme rationnel*, Paris: Presses Universitaires de France, 1953, p. 41.

27. The principal control is constituted by this entrance fee, i.e., by the conditions of access to the scientific field and to the educational system which give access to it. A question which deserves attention is that of the properties which the natural sciences (not to mention the social sciences, in which the limitations of the methods give free rein to habitus) owe to their social recruitment, i.e., roughly speaking, to the conditions of access to higher education (cf. Saint Martin, *Le système*).

28. We know that the *inaugural revolutions* which give rise to a new field by making a break which sets up a new domain of objectivity, are themselves almost always the work of the holders of a large specific capital who, as a result of secondary variables (such as belonging to a social class or ethnic group improbable in that universe), find themselves in an unstable position which favours revolutionary inclinations: such is the case, for example, with new entrants who bring into the field capital they have accumulated in a socially superior scientific field (cf. J. Ben David, "Roles and innovation in medicine," *American Journal of Sociology* 65, 1960, pp. 557–568; J. Ben David and R. Collins, "Social factors in the origins of a new science: the case of psychology," *American Sociological Review* 31, 1966, pp. 451–465).

29. We have already seen Fred Reif's description of the most usual form of capital accumulation in such a state of the field.

30. It is generally agreed that disputes over priority become more and more frequent as the scientific struggle becomes more and more intense (despite the effect of a continuous differentiation of the field, which limits the competitors' universe), i.e., more precisely, as accumulated scientific resources grow and the capital needed in order to innovate becomes more widely and more uniformly spread among the competitors, as a result of the rise in the *cost of entry* to the field.

31. All the processes accompanying the autonomization of the scientific field are in dialectical relationship: thus the constant raising of the cost of entry implied in accumulation of the specific resources contributes in return to the autonomisation of the scientific field by setting up a social separation from the profane world of laymen, a separation made all the more radical by the fact that it is not sought for its own sake.

32. The habitus produced by class upbringing in the earliest years of life and the secondary habitus inculcated by schooling play a part (of differing importance in the case of the social sciences and that of the natural sciences) in determining a prereflexive adherence to the tacit presuppositions of the field (on the role of socialization, see Hagstrom, *The Scientific Community,* p. 9, and T. S. Kuhn, "The function of dogma in scientific research," in A. C. Crombie (ed.), *Scientific change,* London: Heineman, 1963, pp. 347–369).

33. One sees what ethnomethodology might become (but would it still be ethnomethodology?) if it realized that what it takes as its object, Schutz's "taken for granted," is prereflexive adherence to the established order.

34. In the case of the field of ideological production (to which the field of the social sciences still belongs) the basis of the consensus in dissensus which defines *doxa* lies, as we shall see, in the censored relationship of the field of production as a whole with the field of power (i.e., the field's hidden function in the class struggle).

35. Bachelard, *Le matérialisme,* pp. 216–217.

36. The rhetoric of false separation is the object of two analyses now being prepared, one on the philosophy of Heidegger and the other on political science.

37. This is why social systems of classification (taxonomies), which are one of the issues at stake in the ideological struggle between classes (cf. P. Bourdieu and L. Boltanski, "Le titre et le poste: rapports entre le système de production et le système de reproduction," *Actes de la recherche en sciences sociales* 2, 1975, pp. 95–107) also constitute—through the positions adopted as to the existence or nonexistence of social classes—one of the major principles of division of the sociological field (cf. P. Bourdieu, "Classes et classements," *Minuit* 5, 1973, pp. 22–24, and A. P. A. Coxon and C. L. Jones, *Occupational categorization and images of society,* Project on occupational cognition, Working Paper n° 4, Edinburgh University Press, 1974).

38. It follows that the sociology of science (and in particular the sociology of the relationship between social science and the dominant class) is not a specialty among others but one of the conditions of a scientific sociology.

39. Cf. P. Bourdieu, "La théorie," *VII 1012,* summer 1970, pp. 13–21.

40. A. Gerschenkron, *Economic backwardness in historical perspective,* Cambridge, Mass.: Harvard University Press, 1962, p. 7.

41. The philosophy of history pervading this social history of social science achieves paradigmatic expression in Terry Clark's book, which Paul Vogt sociologically characterizes in two adjectives: "Terry N. Clark's long-awaited, much circulated in manuscript, *Prophets and patrons*" (cf. T. Clark, *Prophets and patrons, The French university and the emergence of the social sciences,* Cambridge, Mass.: Harvard University Press, 1973, and J. C. Chamboredon, "Sociologie de la sociologie et intérêts sociaux des sociologues," *Actes de la recherche en sciences sociales,* 2, 1975, pp. 2–17).

42. J. Ben David deserves credit for presenting this thesis in its most direct form: for him the high degree of competition which characterizes the American university explains its higher scientific productivity and greater flexibility (J. Ben David, "Scientific productivity and academic organization in nineteenth-century medicine," *American Sociological Review* 25, 1960, pp. 828–843; *Fundamental research and the universities,* Paris, OCDE, 1968; J. Ben David and A. Zloczower, "Universities and academic systems in modern societies," *European Journal of Sociology* 3, 1962, pp. 45–84).

43. And correlatively, this soft theory of competition, shared by all American writers, constitutes the subtlest obstacle to the construction of the scientific field as such, i.e., as the locus of a struggle.

44. J. Gaston, "The reward system in British science," *American Sociological Review* 35 (4), August 1970.

45. On the distortion to which sociological methodology subjects the epistemological reality of scientific practice in the natural sciences, see P. Bourdieu, J. C. Chamboredon, and J. C. Passeron, *Le métier de sociologue,* Paris: Mouton-Bordas, 1968, p. 430.

46. Even more than in this book—whose theses contain little that is radically new, at least for readers of Bachelard, who was the object of similar maneuvers at much the same time, in a different tradition—Kuhn's normative intention comes out in two articles in which he describes the positive functions of "convergent" thought for scientific development, and maintains that dogmatic adherence to a tradition is conducive to research (T. Kuhn, "The function of dogma in scientific research," in Crombie [ed.], pp. 347–369; "The essential tension: tradition and innovation in scientific research," in L. Hudson [ed.], *The ecology of human intelligence,* London: Penguin, 1970, pp. 342–359).

47. Cf., for example, R. W. Friedrichs, *A sociology of sociology,* New York: Free Press, 1970.

48. E. Gellner, "Myth, ideology and revolution," in B. Crick and W. A. Robson (ed.), *Protest and discontent,* London: Penguin, 1970, pp. 204–220.

49. The purely social importance of a journal like *Theory and society* which allows it to remain in existence without any substantive content beyond the sort of vague antipositivist humanism with which "critical sociologists"

(another native concept) identify, lies in the fact that it gives a *strictly negative unity* to all the currents outside the American sociological establishment, for ethnomethodology, the heir of phenomenology, to neo-Marxism, via psychohistory. (A fairly accurate synoptic table of this constellation is to be found in P. Bandyapadhyav, "One sociology or many: some issues in radical sociology," *Sociological review* 19, February 1971, pp. 5–30.)

50. Cf. P. Bourdieu, "Les doxosophes," *Minuit* 1, 1973, pp. 26–45 (especially the analysis of the Lipset effect).

51. The official sociology of science offers a justification for each of these features. For example, avoidance of the fundamental theoretical problems finds its justification in the notion that in the natural sciences, researchers are not concerned with the philosophy of science (cf. Hagstrom, *The Scientific Community*, pp. 277–279). It is not hard to see how much this sociology of science owes to the need to legitimate a de facto situation and transform unavoidable limits into elective exclusions.

52. On the production of belief and fetishism in the field of *haute couture*, see P. Bourdieu and Y. Delsaut, "Le couturier et sa griffe: contribution à une théorie de la magie," *Actes de la recherche en sciences sociales* 1, Jan 1975, pp. 7–36.

53. Such epistemological couples, which are simultaneously sociological couples, may be observed in any field (cf., for example, the *Positivismusstreit* between Habermas and Popper in Germany—a diversionary mechanism which, having proved its effectiveness in Europe, is now beginning to take hold in the United States with the importing of the Frankfurt school).

54. An analysis is needed of all the strategic uses which those dominant in a particular field may make of the ideological transfiguration of their objective position: for example, the *ostentatious display of exclusion* which enables the excluded to continue to make use of the institution (which they recognize sufficiently to reproach it for not having recognized them) while making exclusion a guarantee of scientific status; or the challenge to the "competence" of the dominant which is at the center of every heretical movement (cf. the contesting of the monopoly of the sacraments) which has that much less need of scientific arguments when there is less accumulated scientific authority, etc.

55. A proposition which is true sociologically, but is then reduced to a mere tautology, "competence" denoting nothing other than socially recognized authority, that of the Sorbonne theologian in the Middle Ages or the Nobel prize-winning physicist nowadays.

56. On the need to construct the intellectual field as such, so as to make possible a sociology of the intellectuals which would be something more than an exchange of insults and anathemas between "right-wing intellectuals" and "left-wing intellectuals," see P. Bourdieu, "Les fractions de la classe dominante et les modes d'appropriation de l'œuvre d'art," *Information sur les sciences sociales* 13 (3), 1974, pp. 7–32.

# 4

## Muscles and Engines

### Indicator Diagrams and Helmholtz's Graphical Methods

**ROBERT M. BRAIN**

**M. NORTON WISE**

*What the stethoscope is to the physician, the Indicator is to the skillful*
*Engineer: revealing the secret working of the inner system, and*
*detecting minute derangements of parts remotely situate.*

—THOMAS MAIN AND THOMAS BROWN (1847, P. 5; SEE ALSO
J. HOPKINSON, JUN. 1851, EPIGRAPH OF TITLE PAGE)

*But there is indeed a close connection between both the fundamental*
*questions of engineering and the fundamental questions of physiology*
*with the conservation of force.*

—HELMHOLTZ, 1971, P. 115

*It is a spectacle for Gods, to see the muscle at work like*
*the cylinder of a steam engine.*

—EMIL DU BOIS-REYMOND TO HERMANN HELMHOLTZ IN 1852
(KIRSTEN 1986, P. 123)

The scientific work of Hermann Helmholtz has received more historical attention than any other subject in nineteenth-century German science. Yet, historians of science have given little attention to the significance of the resources and motivations provided by the industrial and military settings in which Helmholtz moved during his early scientific career (Breger 1982 and Lenoir 1997 are notable exceptions). We begin to show here how Helmholtz pursued his work in physiology and physics as a participant in the self-consciously modernizing industrial and military culture of 1840s Berlin. We address the cultural issue in Helmholtz's work through the very specific terms of precision instruments and graphic methods. This focus places

Helmholtz's early work squarely in the context of industrializing Prussia and suggests just how both the technical know-how and the cultural aspirations of Helmholtz and his young colleagues found their place in his science.

But there remains a further, perhaps greater, gain to be made through this approach. Historical scholarship has been unable to make convincing links between his experiments in physiology and his work on energy conservation in physics which engaged him at the very same time. Our focus on Helmholtz's use of precision instruments and graphic methods reveals just how closely related were these two seemingly distinct lines of investigation. We suppose that historians examining Helmholtz's use of these instruments have been thrown off track by accepting at face value Helmholtz's citation of Carl Ludwig's ingenious kymograph, an instrument for recording the pressure waves of arterial pulse and respiration, while ignoring Helmholtz's longer discussion of geneaology of his methods in the family of related instruments known to him and his colleagues in the Berlin Physical Society well before Ludwig's invention (Helmholtz 1850b). Even Ludwig himself ascribed both his and Helmholtz's use of graphic methods to the principles laid out by James Watt in his indicator diagram (fig. 4-1), a device invented to measure work performed in the cylinder of a steam engine: "Helmholtz's curve was obtained by allowing the frog muscle to trace itself in an unmediated manner; this occurred according to the principles of the graphic method of Watt" (Ludwig 1852, p. 333).

Indicator diagrams and a variety of self-registering dynamometric instruments found abundant employ in the sixty-five steam engines of mid-1840s Berlin (Mieck 1965, p. 225–35). Helmholtz, as a regular and "diligent" participant in the Berlin Physical Society, had ample opportunity to ponder them. We will show that he drew heavily upon this framework for indicator diagrams in *On the Conservation of Force* (*Ueber die Erhaltung der Kraft*) and used practical modifications of them in his subsequent muscle physiology experiments.

FIGURE 4-1

*Indicator diagrams with various settings of valves and timing made with*
*Watt's equipment in 1803 (Hills and Pacey 1972, 41; from Portfolio 1381,*
*Boulton and Watt Collection, Birmingham Reference Library).*

# THE YOUNG LIONS OF THE
# BERLIN PHYSICAL SOCIETY

When Helmholtz joined the Berlin Physical Society in 1845, he entered into dialogue with the full range of physical science available in Berlin. The Berlin Physical Society distinguished itself by producing an annual review of the international literature in every branch of pure and applied physics, *Die Fortschritte der Physik* (*Progress in Physics*), with individual members contributing reports in their own areas of research. "In this manner," wrote an impressed visitor, "the apparently insurmountable task of composing a history of contemporary physics finds itself accomplished effortlessly, with the help of the same principle of division of labor which plays such a great role in industrial enterprises" ("Progrés de science," 1846, p. 81).

The membership of the society reveals the broad base of their coalition for progress. Helmholtz belonged to a small contingent of medical men who had received training in the physiology laboratory of Johannes Mueller. At least twelve others of the fifty-four members were engineers; six bore the title "Mechanikus" and another six were lieutenants, probably in the artillery and engineering corps, including Werner Siemens, Helmholtz's longtime friend, telegraph entrepreneur, and founder of the Siemens Corporation. The Berlin Physical Society was a club for the young and fiery but not yet established. A number of professors, most notably the club's patron Gustav Magnus, but also others such as Wilhelm Heinrich Dove, participated in meetings but did not become members (Lenoir 1988).

The talented and ambitious activists who filled out the society's ranks were the offspring of a forceful Prussian industrial policy which for more than twenty-five years had focused its efforts on educational institutions. Members came not only from the university but also from a range of Berlin's more practically oriented scientific, technical, and industrial institutions: the School of Industry (*Gewerbeschule*), the United Artillery and Engineering School (*Vereinigte Artillerie- und Ingenieurschule*), the War College (*Kriegschule*), and Academy of Architecture (*Bauakademie*), which had been established in response to Napoleonic power and were modeled on French institutions (Lundgreen 1975, 32; Schubring 1981, p. 169). The no-nonsense tone of the *Fortschritte* should be ascribed in part to this constituency, which also helps to explain why Helmholtz made the society his venue and why his classic pamphlet *On the Conservation of Force* (Energy) was incubated there (see also Breger 1982, p. 211–26).

# SHOPKEEPER'S BOOKKEEPING—LIEBIG'S
# "*THIERISCHE WÄRME*"

Helmholtz's most direct set of problems and resources for the *Conservation of Force* are set out in his 1845 review, for the first volume of the *Fortschritte der Physik,* of Justus Liebig's newly published "Thierische Wärme" ("Animal Heat"), which developed views already published in his *Animal Chemistry* (*Thierchemie*) of 1842. Following a line of interpretation deriving from Lavoisier, Liebig argued that all heat produced by an animal body necessarily derived from respired oxygen, or more specifically, that the heat was produced by combination of the respired oxygen with the elementary carbon and hydrogen in the portions of food absorbed into the bloodstream. Uncertain of where this *Stoffwechsel* (exchange of materials) occurred and of the

nature of the heat produced, he insisted only that it derived from the interconversion of physical forces (chemical, electrical, mechanical) and rejected any nonphysical source, or vital force, whether located in the activity of the nerves or in the contraction of muscles (Kremer 1990, 202–15; Bevilacqua 1993, pp. 297–304).

At the core of his argument, Liebig placed the prohibition of perpetual motion: "No force, no activity can arise alone out of nothing" (Liebig 1843, p. 28). Elaborating, he insisted that in any chain of conversions of force, the output could never exceed the input, whether in a steam engine, an electric circuit, or a living body. This principle, as principle, served Helmholtz and his physicalist friends as models for their program. Perhaps for that very reason, Helmholtz attacked with vehemence the remaining errors of the famous Giessen professor. Did the entire bodily heat derive in fact from the combination of carbon and hydrogen with respired oxygen? Liebig's decided support for this view rejected the best measurements available (Liebig 1845, pp. 74–75), while his remarks on the conversion process did not deal consistently with mechanical conceptions of either chemical combination or heat. Implying that the inadequacies of Liebig's position were primitive holdovers from a no longer tenable material theory of heat, Helmholtz insisted on heat as motion, "because we see the origin of heat as taken from mechanical forces" (Helmholtz 1847a, p. 350).

The motion view, he claimed, implied that only a definite equivalent of heat could derive from either mechanical, electrical, or chemical forces, but little was known either theoretically or experimentally about this "Principle of the Constancy of Force-Equivalents." On the theoretical side, Helmholtz cited the analysis by the French engineers Sadi Carnot and Emile Clapeyron of the production of work from the fall of heat in steam engines (also based on the prohibition of perpetual motion) and Franz Neumann's theory of electromagnetic induction of currents. On the experimental side, only studies of chemical heats and of heating by electric currents were available to confirm the principle of constancy.

For the moment, Helmholtz limited his critique to Liebig's respiratory theory, relying on the calorimetric measurements of Dulong and Despretz that Liebig challenged and implicitly on his own newly completed experiments on the *Stoffwechsel* in muscles. Animal heat did derive from chemical action, he argued, but not simply from burning elementary carbon and hydrogen in respired oxygen. Any equivalence of inputs and outputs would have to account for complex chemical reactions of the foodstuffs, some of which at least, occurred in the muscles, where work too was produced. The whole accounting procedure (*Berechnungsart*) that Liebig had derived from Lavoisier, Dulong, and Despretz, required reexamination (Helmholtz 1847a, pp. 351–53). Based on an exchange of substances alone, the *Stoffwechsel*, it had constituted in effect a balance sheet of material credits and debits, the sort of thing that Du Bois-Reymond, with characteristic wit and condescension, called "shopkeeper's bookkeeping" (Cranefield 1982, p. 3).

This shopkeeper's bookkeeping was one direct target of Helmholtz's *Conservation of Force*. The problem can be seen in Liebig's formulation of the interconversion principle. He showed great faith in the quantitative interconversion of chemical, electrical, mechanical, and thermal forces, as cause and effect. But he proposed no common analysis of the different forces, only a "substrate," effectively a force substance (Liebig 1843, pp. 30–31). Sometimes this force inhered in ponderable matter and was released by a *Stoffwechsel* as heat, which was not material since it could be converted into motion but was also not mechanical since it could be returned to matter in a *Stoffwechsel*, which Liebig did not treat as mechanical. In Helmholtz's view, this accounting

was literally incoherent. His own solution was to represent both the *Stoffwechsel* and heat as mechanical (matter moving under the action of forces), but empirical evidence was weak. We will argue elsewhere that he sought a principled way out of this dilemma in the much discussed Kantian transcendental introduction to the *Conservation of Force*, where he sought a priori grounds for the duality of matter and force. In any case, the new bookkeeping would require more than mere *Stoffwechsel*, more even than exchanges of a substrate labeled force. It required a complex balance sheet for interconversions, based on a common measure of cause and effect but analyzed in terms of matters, motions, and forces together.

## ENGINEERING MECHANICS
## IN THE *CONSERVATION OF FORCE*

Helmholtz found his new accounting technology in the immediate circles in which he moved in Berlin, namely in the integrated context for chemistry, physics, and technology provided by Magnus and Dove and the Berlin Physical Society. The character of this community appears in the fact that Magnus, who made his initial reputation as a chemist, taught industrial technology at the university, physics at the Artillery and Engineering School, and (briefly) chemical technology at the School of Industry. Already in 1830 he gave his trial lecture as *Privatdozent* on "The Theory of Steams," a theme of later researches on steam as a source of power. As extraordinary professor for technology from 1834 and ordinarius from 1845, Magnus regularly took his class on an excursion to local industrial sites, including in the 1840s the rapidly expanding iron and engine works of August Borsig. And it was to the young group that assembled in Magnus's house that Rudolph Clausius in 1843 reported on the Carnot-Clapeyron theory of steam engines, the source that Helmholtz would choose as his reference (rather than Liebig) in grounding his conservation principle on the prohibition of perpetual motion (Kant 1977; Wolff 1993).

A similar sense of the resources immediately available to Helmholtz derives from Dove's activities as professor of physics at the university and teacher at the War College and the Artillery and Engineering School. Characteristic of his style is the *Repertorium der Physik* (*Repertory of Physics*), which Dove founded in 1836 and edited until 1845. The *Repertorium* emphasized experimental physics: measuring instruments, properties of materials, engineering problems. It contained no speculative theory and little pure mathematical physics. The offerings of Dove's *Repertorium* and of the Magnus circle provide ready material for interpreting the *Conservation of Force* both as a bookkeeping principle and as a grounding for Helmholtz's later graphical method in physiology.

As is well known, Helmholtz deployed the Carnot-Clapeyron formulation of the *perpetuum mobile* principle to prove that the principle of conservation of *vis viva*, familiar in mechanics, must hold for all natural systems (now necessarily systems of matter and force); that is, that the *vis viva* of any system of bodies, in passing through a cycle of changes to return to its initial configuration, necessarily returns to its initial value; or, that the total work done by the forces acting on the bodies during the cycle must vanish. Otherwise the cycle could be used to generate work *ad infinitum*. That condition required, Helmholtz argued, that all forces were necessarily central forces acting between material points and dependent only on distance. The principle of conservation of *vis viva*, now elevated to the "principle of conservation of force," took the form, for a

single material point of mass $m$ moving from $r$ to $R$ under the action of a force of intensity $\phi$ in the direction of the differential displacement $dr$,

$$\frac{1}{2} mV^2 - \frac{1}{2} mv^2 = -\int_r^R \phi dr,$$

where $v$ is the initial velocity and $V$ the final velocity. A system of arbitrarily many material points—meaning any system whatsoever—required a summation over all of them (Helmholtz 1847b, pp. 21–25).

It is for Helmholtz's understanding of this *vis viva* principle that we seek the local resources. His terminology is already unusual, for he named the work integral on the right the sum of the *Spannkräfte* "which strive to move the point $m$, as long as they have still not affected the movement." The term *Spannkräft* had been employed as an equivalent for "force of elasticity," both of steam in the works of Magnus and Dove (Dove 1836; Knochenhauer 1846) and of muscles in those of Eduard Weber (below). Their usages, however, referred not to the amount of work available in the steam or the muscle but to the pressure of the steam and the tension in the muscle. Helmholtz thus subtly changes the meaning of *Spannkraft* from an *intensity* of *Kraft* (force) to a *quantity* of *Kraft,* from the tension immediately present to the work that would be available from it in a differential displacement. That is, *Spannkräft* becomes *potential* work, whether still available (*noch vorhanden*) or already used (*verbrauchten*).

Concerning the principle of *vis viva* itself, its elaboration in terms of "work" derived from engineering mechanics rather than rational mechanics, especially French engineering (Bevilacqua 1993, no. 6). A standard reference was Poisson's *Mécanique,* containing an addition "Relative to the Usage of the Principle of Living Force in the Calculus of Machines in Motion." This usage, wrote Poisson, "forms, so to speak, the point of junction of rational mechanics and industrial mechanics" (Poisson 1833, p. 747). For detailed discussion, Poisson (himself a rational mechanician) referred the reader to the yet unpublished engineering texts of Navier at the École des Ponts-et-Chaussées and to Poncelet, then colonel of engineers at the École de l'Artillerie et du Génie. One of the ways in which their works and his entered the Berlin context was through an 1844 review in Dove's *Repertorium* by Ferdinand Minding, professor of applied mathematics in Dorpat, formerly lecturer in Berlin at the Architecture Academy, the School of Industry, and the University of Berlin (Minding 1844, pp. 71–76). Judging from its details, this review was one of Helmholtz's sources. Like Helmholtz, for example, Minding takes *vis viva* to be $\frac{1}{2}(mv^2)$ rather than the standard $mv^2$. More significantly, Minding extended Gauss's term "potential" for the integral of what was called a *virtual* moment in statics (force times an imagined infinitesimal displacement), to the work integral correlated with *real* motions in the principle of *vis viva,* that is, with the integral of the product $\phi dr$. Helmholtz did the same when he came to electrical and magnetic forces, so that the sum of *Spannkräfte* in a system became its total potential, and Gauss's results for electrostatics and magnetostatics fit right into the sums required for the conservation doctrine (Helmholtz 1847b, pp. 41–43).

For Gauss, the potential apparently had no ontological status in itself. It was a mathematical function from which forces could be expressed as derivatives, greatly simplifying the calculus of static forces. Minding's and Helmholtz's extension into the basic principle of engineering mechanics, which already correlated virtual moment with work, converted Gauss's potential into a real entity, the work content of the system, whether as the work already manifested as *vis viva,* or the work still available (*noch vorhanden*) for use. This transformation of rational

mechanics into industrial mechanics provided the new accounting system that Helmholtz sought, a new balance sheet for quantities of force.

The same engineering sources typically provided as well a graphic representation of the work integral, a representation not available in rational mechanics but familiar to engineers and mechanics since the 1820s as Watt's indicator diagram. Minding followed his description of the *vis viva* principle applied to machines with a description of dynamometers used to measure the work done by moving forces, whether produced by muscles or machines. Citing Arthur Morin, Captain of artillery at the Metz military school, as his primary source, Minding stressed particularly the value of chronometric, self-registering dynamometers, which directly produced a curve of the intensity of force exerted as a function of distance traversed. "By quadrature of the traced curve . . . where the abscissas perpendicular to the ordinates φ are proportional to the distance traveled $r$ . . . one obtains the integral $\int \phi dr$ or the whole work of the moving force during the observation" (Minding 1844, p. 75; using Helmholtz's symbols). Helmholtz's description bears comparison with Minding's: "If we think of the intensities of φ . . . as represented by ordinates raised perpendicularly, then the magnitude in question would designate the area which the curve between the ordinates at $R$ and $r$ encloses with the axis of abscissas" (Helmholtz 1847b, p. 22).

Even more directly relevant to the *Conservation of Force* than Minding's review is Clapeyron's account of Carnot's theory of the motive power of heat, since Helmholtz stated that he wanted to apply Clapeyron's method to every branch of physics, i.e., to apply the perpetual motion principle to establish that the work produced could not exceed the work expended in any cycle of changes whatever. With respect to the graphical method, Clapeyron referred his entire analysis to indicator diagrams, in the idealized form now commonly called Carnot diagrams, displaying the cycle of pressure versus volume in the cylinder of an engine as a closed series of isothermal and adiabatic curves (fig. 4-2). And he described the work integrals associated with the curves in the engineers' graphical language of summing ordinates times differential abscissae under the

FIGURE 4-2
*Clapeyron's original Carnot diagram of 1834*
*(Clapeyron 1843, plate II, no. 13).*

curve. Clapeyron also drew a direct analogy between the conversion of thermal work (as fall of heat) to mechanical work and the conversion of a raised weight (by falling) to *vis viva* (Clapeyron 1843, pp. 450, 457). To carry out his own mechanical program for the conservation principle, therefore, Helmholtz had only to show that Clapeyron's basic scheme would be even more coherent if heat were treated as *vis viva* rather than a substance, that is, if the heat itself, rather than the fall of heat, were converted into mechanical work by a steam engine.

As a practical matter, a close relation thus emerged between Helmholtz's conservation problem and the graphical method, because he required accurate measurements for forces varying over time, particularly those in which the work done was converted into heat. Helmholtz complained about the lack of such experiments especially in his sections *V* and *VI* on electrical and magnetic processes, which make up nearly half of his pamphlet. No one had yet devised means for registering rapidly changing currents and voltages, so that calculations of work expended remained gross approximations for many ordinary circuits. Inconstant batteries and inherently time-dependent phenomena like mutual induction required knowledge of the actual shape of the curve of current, not simply an average of beginning and ending currents, such as Joule had used (Helmholtz 1847b, pp. 52, 55, 65). But experimental physicists had not yet begun to make this kind of measurement. The people who had were civil and military engineers, with their dynamometers and indicator diagrams. Luckily for Helmholtz, he was acquainted with such people and with others who knew their work.

## ACCOUNTING FOR
## MUSCLE CONTRACTION

After completing his treatise on the conservation of force, Helmholtz made strategic changes in his ongoing research into the economy of forces at work in the physiology of muscles. He abandoned investigations into chemical and thermal alterations and in 1848 began work on the temporal recording of muscle contraction. In his new research Helmholtz wielded the conceptual core of the *Conservation of Force*—the principle of *vis viva* combined with the Clapeyron method—as a *theoretical technology*, a set of conceptual and mathematical tools used to perform intellectual work (Warwick 1992). To this he coupled the *practical technology* of Carl Ludwig's newly invented "kymograph" (fig. 4-3), having made the acquaintance of both inventor and instrument while finishing the *Conservation of Force*. Ludwig had self-consciously designed the kymograph according to the principles of Watt's indicator but using a Morin-style chronometric stylus and a Poiseuille hemadynamometer (blood pressure recorder). His sensational instrument realized in practical physiology the theoretical propositions adumbrated in Helmholtz's *Conservation of Force;* and vice versa: Helmholtz's doctrine realized in theoretical physics the principles of Ludwig's kymograph. Thus a theoretical and a practical technology, both the fruits of raids on French engineering, consecrated the alliance of the 1847 group of organic physicists. The following year Du Bois-Reymond, the self-appointed ideologist of the group, promulgated the doctrine that the "proper form of physiological representation should be a curve: The dependence of the effect on each condition presents itself in the form of a curve, whose exact law remains, to be sure, unknown, but whose general character one will be able in most cases to trace" (Du Bois-Reymond 1848–49, xxvi).

The pairing of the *Conservation of Force* and the kymograph bolstered Du Bois-Reymond's

FIGURE 4-3
*Ludwig's Kymograph, in Etienne-Jules Marey,*
Du mouvement dans les fonctions de la vie *(Paris:*
Baillière, 1868), 132. *Cambridge University Library.*

and Helmholtz's confidence in the necessity of direct methods in physiology, a principle they had insisted upon for some time (Lenoir 1992). In 1845, not long after the two had met, Du Bois-Reymond delivered a paper to the Berlin Physical Society which revised Theodor Schwann's famous experiments on the elasticity of muscles by reconstructing his data in the form of curves to show that contracting muscles do not simply compress themselves, rather they respond to particular forces which act upon them. He cited Helmholtz's experiments on the chemical changes in the active muscle as evidence for these forces and lauded the direct methods by which he had brought forth the results. Both Du Bois-Reymond's graphic methods and Helmholtz's chemical analysis served to ascertain the intermediate processes that Schwann's "force" approach and Liebig's "energy" approach left concealed. Du Bois-Reymond concluded his discussion by anticipating Helmholtz's attempts with a thermo-multiplier to achieve a *Sichtbarmachung der Nervenwärme* (visualization of the nervous heat) (Kirsten 1986, p. 84).

The following year Eduard Weber's massive article on *Muskelbewegung* (muscle movement) appeared, which, according to Du Bois-Reymond, both summed up and superseded all previous treatments of muscular force (Du Bois-Reymond 1848, pp. 95–96). As one of his prominent themes, Weber undertook a review of the long tradition of measuring the mechanical *Nutzeffekt* (utility-effect) of human muscular work, to which he himself had made substantial contributions. He fastened particularly on a series of experiments by the physiologist Gabriel Valentin, who had sought to improve upon the precision measurement of "the many types of machine-like outward effect of muscles" with an instrument he called the "myodynamometer" (fig. 4-4)

FIGURE 4-4

*Valentin's Myodynamometer (Valentin 1844). Cambridge University Library.*

(Valentin 1844, p. 120). Modeled on the standard Regnier spring dynamometer used to measure the traction of wagons and other contrivances, Valentin's myodynamometer measured the "load effect," or the "quantity of force" of the isolated frog muscle in contraction, by a spring mechanism. Weber criticized Valentin's method for its inability to measure the initial force necessary to overcome the tension of the dynamometer, a problem that Valentin sought to circumvent by supposing that the weight of the muscle section was proportional to the muscular force. By contrast Weber argued that the muscle is like an elastic band whose elastic forces are balanced off by a *Spannkräfi*; when the muscle passes from the relaxed to the contracted state the elasticity coefficient diminishes. The same weight, in other words, stretches the muscle in its contracted or relaxed state.

Weber contended, moreover, that insofar as Valentin had only measured the force of the muscle in contraction in its normal length and loaded only by its own mass, he had failed to measure utility-effect, which he defined as the load multiplied by its increase in height (work). In response Weber himself devised an experimental apparatus, with which one "can obtain, equivalent to the utility-effect, a *vis viva* which can be transmitted to other bodies by machines and thereby used to produce an intended movement in these bodies" (Weber 1846, p. 91). Using a rotation apparatus to induce muscle contractions of long duration, Weber probed the parameters between the shortening of the muscle, the duration of the contraction, and the weight raised (Weber 1846, pp. 91–100; Olesko and Holmes 1993, pp. 75–76; Kremer 1990, pp. 328–30).

Helmholtz first encountered Weber's *Muskelbewegung* while finishing *On the Conservation of Force,* and his reformulation of Weber's problem reflected the lessons of his theoretical treatise. It hinged upon the problem of time. Despite Weber's brilliant comparative measurements of muscles at rest and in a prolonged state of contraction, he had assumed that the transition between the two states was instantaneous. Extending his argument from the *Conservation of Force* for the necessity of accurate measures of forces varying over time, Helmholtz argued that Weber's

method of continuously stimulating muscles "could not answer one of the principal questions of this field, namely that of the mechanical work that it is capable of producing." The continuously stimulated muscle quickly attained a static condition (*Gleichgewichtslage*) and could not, therefore, produce any work in the sense of mechanics. Helmholtz thus took as his point of departure the principle that: "In order to perform work the muscle must alternate bewteen rest and excitation and the magnitude of its work will depend essentially on the speed of the alteration" (Helmholtz 1850a, p. 764).

Helmholtz came well equipped to the problem of measuring fleeting phenomena. As early as 1845 he had been apprised of a range of new instruments designed to measure high velocities in a paper delivered by Werner Siemens to the Berlin Physical Society, subsequently published in several versions. Siemens's paper served to stake a claim in a raging international priority dispute for work he had conducted with the Prussian Artillery-Testing Commission on techniques used to measure "the velocity of rapidly moving bodies" (cannon balls and bullets) and "the time-spans in which they traverse specific spaces" (Siemens 1847, p. 47). Each of the instruments in question measured time intervals in one of two different ways. One method transformed differences of time into differences of space, in a version of graphic representation. The other method measured the "mechanical effect" (work) which, during the time interval to be determined, brought forth a force of specific intensity, from which one calculated the time. In 1850 Helmholtz reviewed both types of instruments in a lecture intended to provide the background to his research and to show its place within a broader scientific context (Helmholtz 1850b, pp. 862–71).

In fact he used both methods to study the velocity of nerve propagation in muscle contraction. For his first attempt he used the graphic method. He designed an instrument, later called a "myograph" (fig. 4-5), using the self-registering technique of Ludwig's kymograph. Ludwig had

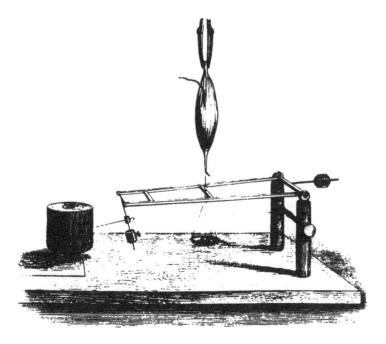

FIGURE 4-5
*Helmholtz's Myograph, in Etienne-Jules Marey,*
Du mouvement dans les fonctions de la vie
*(Paris: Baillière, 1868), 133. Cambridge University Library.*

followed James Watt's technique of placing a flotation device in a cylinder to record variations in pressure by inserting a similar device in a Poiseuille hemodynamometer attached to a rod holding a stylus (Ludwig 1847, pp. 258–67). To the experimental setup used by Weber, in which an isolated frog muscle was suspended from a frame and stretched by a weight at the lower end, Helmholtz attached a metal rod which moved vertically between two plates. This rod, like the rod in Ludwig's instrument, transmitted the signal to the stylus. Helmholtz's myograph did for the myodynamometer what "Ludwig did with the heights of the kymograph: trace the heights to which a weight hanging on the muscle is raised in the succession of points of time during muscle contraction" (Helmholtz 1850a, p. 767).

Helmholtz twitched the muscle with a momentary current induced by the opening and closing of a Neefian induction coil. The resulting *Froschcurven* showed the net values of the "energy" of the muscle (work done) along the ordinate, which unfolded in the "time-spaces" represented along the abscissa. He achieved this temporal measure of the work done by maintaining the force constant with the hanging weight. Despite plaguing problems resulting from friction in the apparatus and the muscle, Helmholtz produced curves that showed a pronounced time lag before the onset of the muscle contraction (fig. 4-6). They showed, he wrote, that "the energy of the muscle does not develop in the moment of the instantaneous stimulus, but rather mostly after this [moment] has ended, then gradually increases, reaches a maximum, and disappears again" (Helmholtz 1850a, p. 770). Helmholtz interpreted the curves as bearing out Weber's findings about the diminishing elasticity coefficient in muscle contraction. The stages of the curve revealed the changing relationship between the contradictory forces which stretched the muscle and those which precipitated its contraction. The convex phases showed the preponderance of the latter, the concavities the preponderance of the former, and the points of inflection the moments of equilibrium between the two forces (Helmholtz 1850a, pp. 769–70; Holmes and Olesko 1995).

After his first set of trials with the myograph, Helmholtz took up the second method of measuring time intervals using the deflection of a ballistic galvanometer, to which the name of the French engineer C. S. M. Pouillet had, as victor in the priority struggle, been attached. This method availed, by other means, a similar measure of the relation between mechanical effect and the velocity of nerve propagation. Helmholtz found that for purposes of precision the second method held certain advantages, the greatest of which was the near limitless reduction of the time intervals that could be measured, which encouraged him to work at determining the value of the propagation velocity of the nerve impulse. But this method also proved amenable, as

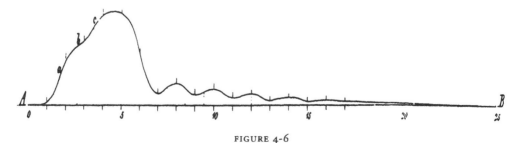

FIGURE 4-6

*Helmholtz's Myograph curve, in Helmholtz 1850a, Tafel 8, Abb. 3. Cambridge University Library (scale enlarged by a hundred percent along the ordinate).*

Olesko and Holmes have admirably shown, to a calculus of probable errors in his measurements, a concern to which he attached great importance (Olesko and Holmes 1993, pp. 95–105).

Helmholtz's first communications of these experiments encountered skepticism from different quarters. Du Bois-Reymond lamented the difficulties he had in explaining, even to a most sympathetic colleague such as Volkmann, who "lacked the ABCs" of physics, what was made visible by the curves. "I spent Easter with Volkmann in Halle," he wrote to Helmholtz, "and I would have had a good time, if I had been able in the course of eight days to make comprehensible to Volkmann that the measure of force is the alteration of the velocity" (Kirsten 1986, p. 113).

Ludwig's comprehension rate, by contrast, was instantaneous. While writing his *Lehrbuch der Physiologie* (*Textbook of Physiology*) he hosted Helmholtz for an eight-day visit, during which time they pondered the frog curves and discussed "all possible physical and physiological topics." In his textbook Ludwig made explicit the sense in which these studies of the isolated frog muscle resolved old problems of the "work of animate and inanimate motors" (Morin 1838) previously solved by mechanical engineers with dynamometers. "As is known and comprehensible, the muscle can communicate to other bodies the motion which its own parts suffer during change of form and thereby perform work in the sense of mechanics. In this connection the consideration of our apparatus belongs together with that of all working machines" (Ludwig 1852, p. 342). The newer techniques of engineering could be translated easily into the physiology laboratory because in the problem of measuring and apportioning work the engineering problems had always been both mechanical and physiological.

Helmholtz's method for making the work of the muscles visible derived from the spectacular strides of the 1840s in electrotechnology made by Siemens and others, so that by 1850 he could compare the nerve fibers to electric telegraph wires (Helmholtz 1850b, p. 873). Both transmitted currents at a distance, and as the French telegraph and instrument maker Louis Breguet pointed out, they transmitted information about work being done. In a paper reviewed by both Siemens and Helmholtz (Siemens 1847, pp. 53–58; Helmholtz 1850b, p. 867), he suggested how his electrification of Morin's dynamometric principle could enable the superintendent to combine shop-floor invigilation and cost accounting in the same technique. The "instrument may, as I imagine," he wrote, "be employed with advantage in manufactories; for, by means of conductors, leading from the office of the superintendent, and communicating either with the fly-wheel or the cylinder of a steam-engine, he may know at every moment in the day, and without disturbing himself, the velocity of either one or the other" (Breguet 1845). Breguet's telegraph and engine system became Helmholtz's physiology of nerves and muscles.

## CONCLUSION: *TITANENARBEIT*

"It is a spectacle for Gods, to see the muscle working like the cylinder of a steam engine" (Kirsten 1986, p. 123). Du Bois-Reymond's choice of metaphors, to convey to Helmholtz in 1852 his excitement about his latest apparatus for measuring electric current during contraction of a frog muscle, symbolizes our thesis. Muscle physiology in the Berlin Physical Society was the work of a new breed of gods who sought to remake natural science as the philosophical face of the engines and engineers who were remaking the Prussian economy. We have concentrated on the technical use of transformed dynamometers and indicator diagrams to produce graphical meth-

ods for analyzing muscles. The diagrams, with their curves of definite shape, carried conceptual content of great significance. They reified organic action as physical work.

But these engine curves cum frog curves carried crucial symbolic value as well. They identified the project for progress of the organic physicists with the much larger project for progress of Prussia, promoted at the highest administrative and social levels by a closely linked group of economic modernizers who included the director of the division of trade and industry P. C. W. Beuth, founder and administrator of the Gewerbeschule; his friend and collaborator Karl Friedrich Schinkel, of architectural fame; and their influential associate and royal advisor Alexander von Humboldt, who rescued Helmholtz from his full obligation as a military doctor. In the early 1840s all of them were members along with Magnus of the *Verein zur Beförderung des Gewerbefleisses* (Society for the Encouragement of Industry), which included entrepreneurs like the engine builder Borsig and three out of four of the royal princes, all four of whom had steam engines installed in their private landscape gardens. Helmholtz and his ambitious colleagues moved within the penumbra of this culture-forming elite and envisaged themselves as the successor class.

An immediate sense of how their interests tied into those of the Verein appears in a series of articles on political economy for its *Verhandlungen* by the Oberbaurat von Prittwitz. "Everything which satisfies a human need, or which can be used or enjoyed . . . comes into being through specific forces, and is therefore called a product in the doctrine of political economy" (Prittwitz 1829, P. 188). Prittwitz sought a general accounting scheme, a means of reckoning the value of all of these productive forces, so as to calculate the national economic capacity, but he limited himself to mechanical forces. Decrying claims to perpetual motion, he reminded his readers that the "mechanical moment" of a moving force was to be measured by the product of resistance overcome and velocity of the motion (rate of working). And he promoted a Prussian effort, analogous to that of French savants, to establish a standard unit of work, the "dynam" or "dynamie," which could serve engineers as a mechanical currency and investors as a guide to cost efficiency. Prittwitz shared some of the same sources and goals as engineers like Poncelet and Morin, whose work figured so prominently in the Berlin Physical Society. To Poncelet, "one of the distinctive characters of mechanical work is that it is the thing that one pays for in the exercise of the force, and that its value, its price in money, increases precisely as its quantity" (Poncelet 1844, vol. 1: p. 44). Again, citing Navier, Poncelet agreed that units like the "dynam" constituted a kind of "monnaie mécanique," essential in comparing the mechanical value and simultaneously the economic value of different motors and machines (Poncelet 1845, vol. 1: pp. 6–8). It was to this context, and to this expression, that Helmholtz returned in both of his lectures for general audiences on conservation of force, in 1854 and 1862, with the remark "work is money" (Helmholtz 1882–95, vol. 1: 53, p. 228).

Not everyone appreciated the cultural imagery of machines and money (Brose 1993). Among physiologists, Rudolph Wagner was one of the detractors of the junior sages of Berlin. Writing to Du Bois-Reymond in 1852, Helmholtz reported Wagner's displeasure with apparent glee. "He rails against the physical-physiological school, [calling us] a young breed of titans [*Titanengeschlecht*] with growing Icarus wings." Wagner had at least one of his metaphors right. The image of Titans, if not of Icarus, came readily to mind to observers of powerful engines. And the most impressive symbol of that power had been constructed in 1843 in Helmholtz's home town of Potsdam, housed in its own temple. It is an eighty-horsepower steam engine, built by Borsig to drive fourteen pumps simultaneously to supply the fountains of the King's gardens at

Sanssouci, the most spectacular of which was a single geyser shooting 126 feet into the air. Promoted by Beuth and housed in a mosque designed by Schinkel's architectural associate, Ludwig Persius, complete with a minaret for a chimney, the magnificent machine and associated fountains were explicitly intended to represent Prussian technological sophistication and growing economic strength to visitors from all over Europe and the wider world.

A visitor's guide captures the intended image. "The noiseless silence and regular movement of imposing masses and forces of these hydraulic steam engines awakens a sense of astonishment over the gigantic power of the human intellect, which knows how to make these elements of service in order to perform true Titan's work [*Titanenarbeit*] without exertion." And closely following: "We rightfully rejoice at these advances [*Fortschritt*] of German national industry as one of the proofs of how Germany is emancipating itself more and more from the British industrial monopoly" (Belani 1843, pp. 67, 68).

Thus the images of *Titanenarbeit* and *Fortschritt* move between Borsig's engine and Helmholtz's frog muscles, showing symbolically how those two objects of cultural production belong together in the same city of Berlin and incorporate many of the same values. Analytically speaking, however, the engines and muscles belong together because they shared a common theoretical foundation and a common instrumental foundation. Those two anchors, the principle of *vis viva* and the kymograph, merged in the indicator diagrams that help to narrate the success of both Helmholtz and Borsig.

REFERENCES

Belani, H. G. R. 1843. *Geschichte und Beschreibung der Fontainenanlagen in Sanssouci.* Potsdam: Janke.

Bevilacqua, Fabio. 1993. Helmholtz's *Ueber die Erhaltung der Kraft:* The Emergence of a Theoretical Physicist. In *Hermann von Helmholtz and the Foundations of Nineteenth-Century Science,* ed. David Cahan. Berkeley and Los Angeles: University of California Press. pp. 291–333.

Breger, Herbert. 1982. *Die Natur als arbeitende Maschine: Zur Entstehung des Energiebegriffs in der Physik 1840–1850.* Frankfurt and New York: Campus Verlag.

Breguet, Louis. 1845. Note sur un appareil destiné à mesurer la vitesse d'un projectile dans différents points de sa trajectoire. *Comptes rendus* 20: p. 157; *Annalen der Physik und Chemie* 59: p. 451; *Dingler's Polytechnisches Journal* 96.

Brose, Eric Dorn. 1993. *The Politics of Technological Change in Prussia. Out of the Shadow of Antiquity, 1809–1848.* Princeton: Princeton University Press.

Cahan, David, ed. 1993. *Hermann von Helmholtz and the Foundations of Nineteenth-Century Science.* Berkeley and Los Angeles: University of California Press.

Clapeyron, Emile. 1834. Ueber die bewegende Kraft der Wärme (1834). *Annalen der Physik und Chemie* 59: pp. 446–51, 566–92.

Cranefield, Paul, ed. 1982. *Two Great Scientists of the Nineteenth-Century. Correspondence of Emil Du Bois-Reymond and Carl Ludwig.* Baltimore: Johns Hopkins University Press.

Crump, W. B., ed. 1972. *The Leeds Woollen Industry, 1780–1820.* Leeds: Thoresby Society. 1931. p. 216. Quoted in R. L. Hills and A. J. Pacey, The Measurement of Power in Early Steam-Driven Textile Mills. *Technology and Culture* 13: pp. 34.

Dove, H. W. 1837. Analogie zwischen Gasen und Dämpfen. *Repertorium der Physik* 1: pp. 58–62.

Du Bois-Reymond, Emil. 1848. Elasticität fester Körper. *Fortschritte der Physik* 2: pp. 95–99.

———. 1848–49. *Untersuchungen über die thierische Elektricität.* 2 vols. Berlin: Reimer.

Helmholtz, Hermann. 1847a. Physiologische Wärmeerscheinungen. *Fortschritte der Physik im Jahre 1845* 1: pp. 346–55.

———. 1847b. Ueber die Erhaltung der Kraft: Eine physikalische Abhandlung. In *Wissenschaftliche Abhandlungen* (WA). Leipzig: Barth. pp. 12–75.

———. 1850a. Messungen über den zeitlichen Verlauf der Zuckung animalischer Muskeln und die Fortpflanzungsgeschwindigkeit der Reizung in den Nerven. In *WA*, pp. 764–843.

———. 1850b. Über die Methoden, kleinste Zeittheile zu messen, und ihre Anwendung für physiologische Zwecke. In *WA*, pp. 862–80.

———. 1882–95. *Wissenschaftliche Abhandlungen.* 3 vols. Leipzig: Barth.

———. 1884. *Vorträge und Reden.* 4 vols. Braunschweig: Vieweg.

———. 1971. The Application of the Law of the Conservation of Force to Organic Nature (1861). In *Selected Writings of Hermann von Helmholtz,* ed. Russell Kahl. Middleton, Conn.: Wesleyan University Press.

Hills, R. L., and A. J. Pacey. 1972. The Measurement of Power in Early Steam-Driven Textile Mills. *Technology and Culture* 13: pp. 25–43.

Holmes, Frederic L., and Kathryn M. Olesko. 1995. Precision's Images: Helmholtz and Graphical Methods in Physiology. In *The Values of Precision*, ed. M. Norton Wise. Princeton: Princeton University Press.

Hopkinson, J. 1851. *The Steam Engine Explained by the Indicator.* London: Simpkin, Marshall, & Co.

Kant, Horst. 1977. Entscheidende Impulse für die Entwicklung der Physik in Berlin. Gustav Magnus zum 175. Geburtstag. *Physik in der Schule* 15: pp. 187–91.

Kirsten, Christa, et al., eds. 1986. *Dokumente einer Freundschaft: Briefwechsel zwischen Hermann von Helmholtz und Emil Du Bois-Reymond 1846–1894.* Berlin: Akademie Verlag.

Knochenhauer, [Friedrich Wilhelm]. 1846. Spannkräfte des Wasserdampfs. *Repertorium der Physik* 7: pp. 221–34.

Kremer, Richard L. 1990. *The Thermodynamics of Life and Experimental Physiology, 1770–1880.* New York and London: Garland.

Lenoir, Timothy. 1988. Social Interests and the Organic Physics of 1847. In *Science in Reflection*, ed. Edna Margalit. Dordrecht, Boston and London: Kluwer. pp. 169–91.

———. 1992. Die Entwicklung quantitativer Begriffe in den Experimentalwissenschaften: Physiologie, 1845–1860. In *Beobachtung und Erfahrung*, ed. Hans Poser. Berlin: Technische Universitäts Verlag. pp. 177–226.

———. 1997. *Instituting Science.* Stanford: Stanford University Press.

Liebig, Justus. 1843. *Die Thierchemie oder die organische Chemie in ihrer Anwendung auf die Physiologie und Pathologie.* Braunschweig: Vieweg.

———. 1845. Ueber die thierische Wärme. *Annalen der Chemie und Pharmacie* 53: pp. 63–77.

Ludwig, Carl. 1847. Beiträge zur Kenntnis des Einflusses der Respirationsbewegungen auf den Blutlauf im Aortensysteme. *Müller's Archiv für Anatomie, Physiologie, und wissenschaftliche Medizin:* pp. 242–301.

———. 1852. *Lehrbuch der Physiologie des Menschens.* 2 vols. Heidelberg: Winter.

Lundgreen, Peter. 1975. *Techniker in Preussen während der frühen Industrialisierung.* Berlin: Colloquium Verlag.

Main, Thomas, and Thomas Brown. 1847. *The Indicator and the Dynamometer.* London: Hebert.

Mieck, Ilya. 1965. *Preussische Gewerbepolitik in Berlin, 1806–1844.* Berlin: de Gruyter.

Minding, Ferdinand. 1844. Ueber die Anwendung des Satzes der lebendigen Kräfte in der Maschinenlehre. *Repertorium der Physik* 5: pp. 71–76.

Morin, Arthur. 1838. *Notice sur divers appareils dynamométriques propres à mesurer l'effort ou le travail dévelopé par les moteurs animés ou inanimés et par les organes de transmission du mouvement dans les machines.* Metz: Lamort.

Olesko, Kathryn M., and Frederic L. Holmes. 1993. Experiment, Quantification, and Discovery: Helmholtz's Early Physiological Researches, 1843–50. In *Hermann von Helmholtz and the Foundations of Nineteenth-Century Science*, ed. David Cahan. Berkeley and Los Angeles: University of California Press. pp. 50–109.

Poisson, Simeon-Denis. 1833. *Traité de mécanique.* 2d ed. 2 vols. Paris: Bachelier.

Prittwitz, [Moritz von]. 1829. Ueber die Anwendung der natürlichen Kräfte für industrielle Zwecke. *Verhandlungen des Vereins zur Beförderung des Gewerbefliesses* 8: pp. 188–218.

Progrés de science physique hor[s] de France. 1846. *Revue scientifique et industrielle* 27: pp. 81–95.

Schubring, Gert. 1981. Mathematics and teacher training: Plans for a polytechnic in Berlin. *Historical Studies in the Physical Sciences* 12: pp. 161–94.

Siemens, Werner. 1847. Ueber Geschwindigkeitsmessungen. *Die Fortschritte der Physik im Jahre 1845* 1: pp. 47–72.

Valentin, Gabriel. 1844. *Lehrbuch der Physiologie des Menschen.* 2 vols. Braunschweig: Vieweg.

Warwick, Andrew. 1992. Cambridge Mathematics and Cavendish Physics: Cunningham, Campbell, and Einstein's Relativity, 1905–1911. *Studies in the History and Philosophy of Science* 23: pp. 625–56.

Weber, Eduard. 1842–53. Muskelbewegung. In *Handwörterbuch der Physiologie mit Rücksicht auf physiologische Pathologie*, ed. Rudolph Wagner. 4 vols. Braunschweig: Vieweg.

Wolff, Stefan. 1993. Gustav Magnus—Sein Weg zum Ordinariat an der Berliner Universität. Dieter Hoffman, ed., *Gustav Magnus und Sein Haus.* Stuttgart, 1955. pp. 33–53.

# 5

# Some Elements of a Sociology of Translation

## Domestication of the Scallops and the Fishermen of St. Brieuc Bay

### MICHEL CALLON

## I. SCALLOPS AND FISHERMEN

Highly appreciated by French consumers, scallops have only been systematically exploited for the last twenty years. In a short period they have become a highly sought-after gourmandise to the extent that during the Christmas season, although prices are spectacularly high, sales increase considerably. They are fished in France at three locations: along the coast of Normandy, in the roadstead of Brest, and in St. Brieuc Bay. There are several different species of scallops. Certain ones, as in Brest, are coralled all year round. However, at St. Brieuc the scallops lose their coral during spring and summer. These characteristics are commercially important because, according to the convictions of the fishermen, the consumers prefer coralled scallops to those which are not.

Throughout the 1970s, the stock at Brest progressively dwindled due to the combined effects of marine predators (starfish), a series of hard winters which lowered the general temperature of the water, and the fishermen who, wanting to satisfy the insatiable consumers, dredged the ocean floor for scallops all year round without allowing time to reproduce. The production of St. Brieuc had also been falling off steadily during the same period, but fortunately the Bay was able to avoid the disaster. There were fewer predators and the consumers' preference for coralled scallops obliged the fishermen to stay on land for half the year. As a result of these factors, the reproduction of the stock decreased less in St. Brieuc Bay than at Brest.[1]

The object of this study is to examine the progressive development of new social relationships through the constitution of a "scientific knowledge" that occurred during the 1970s.[2] The story starts at a conference held at Brest in 1972. Scientists and the representatives of the fishing community assembled to examine the possibility of increasing the production of scallops by controlling their cultivation. The discussions were grouped around the following three elements.

1.  Three researchers who are members of the Centre National d'Exploitation des Oceans (CNEXO)[3] have discovered during a voyage to Japan that scallops are being intensively cultivated there. The technique is the following: the larvae are anchored to collectors immersed in the sea where they are sheltered from predators as they grow. When the shellfish attain a large enough size, they are "sown" along the ocean bed where they can safely develop for two or three years before being harvested. According to the researchers' accounts of their trip, this technique made it possible to increase the level of existing stocks. All the different contributions of the conference were focused around this report.

2.  There is a total lack of information concerning the mechanisms behind the development of scallops. The scientific community has never been very interested in this subject. In addition, because the intensive exploitation of scallops had begun only recently, the fishermen knew nothing about the earlier stages of scallop development. The fishermen had only seen adult scallops in their dredges. At the beginning of the 1970s no direct relationship existed between larvae and fishermen. As we will see, the link was progressively established through the action of the researchers.

3.  Fishing had been carried out at such intensive levels that the consequences of this exploitation were beginning to be visible in St. Brieuc Bay. Brest had practically been crossed off the map. The production at St. Brieuc had been steadily decreasing. The scallop industry of St. Brieuc had been particularly lucrative and the fishermen's representatives were beginning to worry about the dwindling stock. The decline of the scallop population seemed inevitable and many feared that the catastrophe at Brest would also occur at St. Brieuc.

This was the chosen starting point for this paper. Ten years later, a "scientific" knowledge was produced and certified; a social group was formed (the fishermen of St. Brieuc Bay) through the privileges that this group was able to institute and preserve; and a community of specialists was organized in order to study the scallops and promote their cultivation. Basing my analysis on what I propose to call a *sociology of translation,* I will now retrace some part of this evolution and see the simultaneous production of knowledge and construction of a network of relationships in which social and natural entities mutually control who they are and what they want.

## II. THE FOUR MOMENTS OF TRANSLATION

To examine this development, we have chosen to follow an actor through his construction-deconstruction of nature and society. Our starting point here consists of the three researchers who returned from their voyage to the Far East. Where they came from and why they act is of little importance at this point of the investigation. They are the primum movens of the story analyzed here. We will accompany them during their first attempt at domestication. This endeavour consists of four moments which can in reality overlap. These moments constitute the different phases of a general process called translation, during which the identity of actors, the possibility of interaction, and the margins of manoeuvre are negotiated and delimited.

### THE PROBLEMATIZATION, OR HOW TO BECOME INDISPENSABLE

Once they returned home, the researchers wrote a series of reports and articles in which they disclosed the impressions of their trip and the future projects they wished to launch. With their own eyes they had seen the larvae anchor themselves to collectors and grow undisturbed while sheltered from predators. Their question was simple: Is this experience transposable to France and, more particularly, to the Bay of St. Brieuc? No clear answer can be given because the

researchers know that the *briochine* (*Pecten maximus*) is different from the species raised in Japanese waters (*Pecten patinopecten yessoeusis*). Since no one contradicts the researchers' affirmations, we consider their statements are held to be uncontestable. Thus the aquaculture of scallops at St. Brieuc raises a problem. No answer can be given to the following crucial question: Does *Pecten maximus* anchor itself during the first moments of its existence? Other questions which are just as important accompany the first. When does the metamorphosis of the larvae occur? At what rate do the young grow? Can enough larvae be anchored to the collectors in order to justify the project of restocking the bay?

But in their different written documents the three researchers did not limit themselves to the simple formulation of the above questions. They determined a set of actors[4] and defined their identities in such a way as to establish themselves an obligatory passage point in the network of relationships they were building. This double movement, which renders them indispensable in the network, is what I call *problematization*.

THE INTERDEFINITION OF THE ACTORS   The questions formed by the three researchers and the commentaries that they provided bring three other actors directly into the story: the scallops (*Pecten maximus*); the fishermen of St. Brieuc Bay; and the scientific colleagues. The definitions of these actors, as they are presented in the scientists' report, are quite rough. However it is sufficiently precise to explain how these actors are necessarily concerned by the different questions which are formulated. These definitions as given by the three researchers themselves can be synthesized in the following manner.

1.  *The fishermen of St. Brieuc:* they fish scallops to the last shellfish without worrying about the stock; they make large profits; if they do not slow down their zealous efforts, they will ruin themselves. However, these fishermen are considered to be aware of their long-term economic interests and, consequently, seem to be interested in the project of restocking the bay and approve of the studies which have been launched to achieve this plan. No other hypothesis is made about their identity. The three researchers make no comment about a united social group. They define an average fisherman as a base unit of a community which consists of interchangeable elements.

2.  *Scientific colleagues:* participating in conferences or cited in different publications, they know nothing about scallops in general nor about those of St. Brieuc in particular. In addition, they are unable to answer the question about the way in which these shellfish anchor themselves. They are considered to be interested in advancing the knowledge which has been proposed. This strategy consists of studying the scallops in situ rather than in experimental tanks.

3.  *The scallops of St. Brieuc:* a particular species (*Pecten maximus*) which everyone agrees is coralled only six months of the year. They have only been seen as adults, at the moment they are dredged from the sea. The question which is asked by the three researchers supposes that they can anchor themselves and will "accept" a shelter that will enable them to proliferate and survive.[5]

Of course, and without this the problematization would lack any support, the three researchers also reveal what they themselves are and what they want. They present themselves as "basic" researchers who, impressed by the foreign achievement, seek to advance the available knowledge concerning a species which had not been thoroughly studied before. By undertaking this investigation, these researchers hope to render the fishermen's life easier and increase the stock of scallops of St. Brieuc Bay.

This example shows that the problematization, rather than being a reduction of the investigation to a simple formulation, touches on elements, at least partially and locally, which are parts of both the social and the natural worlds. A single question—Does *Pecten maximus*

anchor?—is enough to involve a whole series of actors by establishing their identities and the links between them.[6]

THE DEFINITION OF OBLIGATORY PASSAGE POINTS (OPP)   The three researchers do not limit themselves simply to identifying a few actors. They also show that the interests of these actors lie in admitting the proposed research program. The argument which they develop in their paper is constantly repeated: if the scallops want to survive (no matter what mechanisms explain this impulse), if their scientific colleagues hope to advance knowledge on this subject (whatever their motivations may be), if the fishermen hope to preserve their long-term economic interests (whatever their reasons), then they must: (1) know the answer to the question, How do scallops anchor?, and (2) recognize that their alliance around this question can benefit each of them.

Figure 5-1 shows that the problematization possesses certain dynamic properties: it indicates the movements and detours that must be accepted as well as the alliances that must be forged. The scallops, the fishermen, and the scientific colleagues are fettered: they cannot attain what they want by themselves. Their road is blocked by a series of obstacles-problems. The future of *Pecten maximus* is threatened perpetually by all sorts of predators always ready to exterminate them; the fishermen, greedy for short-term profits, risk their long-term survival; scientific colleagues who want to develop knowledge are obliged to admit the lack of preliminary and indispensable observations of scallops in situ. As for the three researchers, their entire project turns around the question of the anchorage of *Pecten maximus*. For these actors the alternative is clear; either one changes direction or one recognizes the need to study and obtain results about the way in which larvae anchor themselves.[7]

As Figure 5-2 shows, the problematization describes a system of alliances, or associations, between entities, thereby defining the identity and what they "want." In this case, a holy alliance must be formed in order to induce the scallops of St. Brieuc Bay to multiply.

THE DEVICES OF INTERESSEMENT, OR HOW THE ALLIES ARE LOCKED INTO PLACE
We have emphasized the hypothetical aspect of the problematization. On paper, or more exactly, in the reports and articles presented by the three researchers, the identified groups have a real existence. But reality is a process. Like a chemical body, it passes through successive states. At this point in our story, the entities identified and the relationships envisaged have not yet been

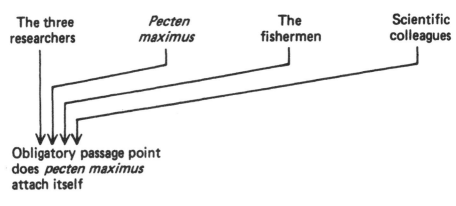

FIGURE 5-1

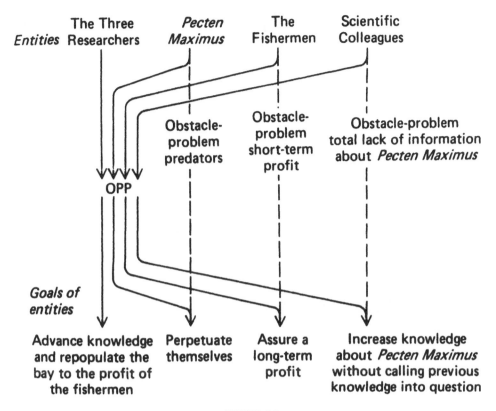

FIGURE 5-2

tested. The scene is set for a series of trials of strength whose outcome will determine the solidity of our researchers' problematization.

THE DEVICES OF *INTERESSEMENT,* OR HOW THE ALLIES ARE LOCKED INTO PLACE
Each entity enlisted by the problematization can submit to being integrated into the initial plan, or inversely, refuse the transaction by defining its identity, its goals, projects, orientations, motivations, or interests in another manner. In fact the situation is never so clear cut. As the phase of problematization has shown, it would be absurd for the observer to describe entities as formulating their identity and goals in a totally independent manner. They are formed and are adjusted only during action.

*Interessement* is the group of actions by which an entity (here the three researchers) attempts to impose and stabilize the other actors it defines through its problematization. Different devices are used to implement these actions. Why talk of *interessement*? The etymology of this word justifies its choice. To be interested is to be in between (*inter-esse*), to be interposed. But between what? Let us return to the three researchers. During their problematization they join forces with the scallops, the fishermen, and their colleagues in order to attain a certain goal. In so doing they carefully define the identity, the goals or the inclinations of their allies. But these allies are tentatively implicated in the problematizations of other actors. Their identities are consequently defined in other competitive ways. It is in this sense that one should understand *interessement.* To interest other actors is to build devices which can be placed between them and all other entities who want to define their

FIGURE 5-3

identities otherwise. A interests B by cutting or weakening all the links between B and the invisible (or at times quite visible) group of other entities C, D, E, and so on, who may want to link themselves to B (see Figure 5-3).

The properties and identity of B (whether it is a matter of scallops, scientific colleagues, or fishermen) are consolidated and/or redefined during the process of *interessement*. B is a "result" of the association which links it to A. This link disassociates B from all the C, D, and E's (if they exist) that attempt to give it another definition. We call this elementary relationship, which begins to shape and consolidate the social link, the triangle of *interessement*.

The range of possible strategies and mechanisms that are adopted to bring about these interruptions is unlimited: anything goes. It may be pure and simple force if the links between B, C, and D are firmly established. It may be seduction or a simple solicitation if B is already close to the problematization of A. Except in extremely rare cases when the shaping of B coincides perfectly with the proposed problematization, the identity and "geometry" of the interested entities are modified all along the process of *interessement*. We can illustrate these points by the story of the domestication of scallops.

The domestication of scallops strikingly illustrates the general *interessement* mechanisms. The three researchers are inspired by a technique that had been invented by the Japanese. Towlines made up of collectors are immersed in the sea. Each collector carries a fine-netted bag containing a support for the anchorage of the larvae. These bags make it possible to assure the free flow of water and larvae while preventing the young scallops from escaping. The device also prevents predators from attacking the larvae. In this way the larvae are protected during the period when they have no defense: that is, when they have no shell.[8] The collectors are mounted in a series on the line. The ends of the two lines are attached to floats that are kept in place by an anchorage system.

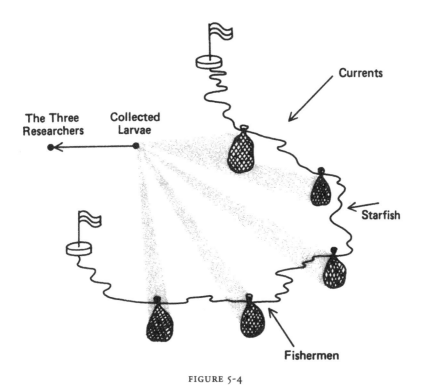

FIGURE 5-4

The towline and its collectors constitute an archetype of the *interessement* device. The larvae are "extracted" from their context. They are protected from predators (starfish) which want to attack and exterminate them, from currents that carry them away where they perish, and from the fisherman's dredge which damages them. They are (physically) disassociated from all the actors who threaten them (see Figure 5-4).

In addition, these *interessement* devices extend and materialize the hypothesis made by the researchers concerning the scallops and the larvae: (1) the defenseless larvae are constantly threatened by predators; (2) the larvae can anchor; (3) the Japanese experience can be transposed to France because St. Brieuc's scallops are not fundamentally different from their Japanese cousins. The collectors would lose all effectiveness if the larvae "refused" to anchor, to grow, to metamorphose, and to proliferate in (relative) captivity. The *interessement*, if successful, confirms (more or less completely) the validity of the problematization and the alliance it implies. In this particular case study, the problematization is eventually refuted.

Although the collectors are necessary for the *interessement* of the scallops and their larvae, this type of "machination" proves to be superfluous for the *interessement* of the fishermen and the scientific colleagues. In addition, the three researchers do not intend to convince the first group as a whole. It is rather the representatives of professional organizations who are the targets of the researchers' solicitation. The three researchers multiply their meetings and debates in order to explain to the fishermen the reasons behind the extinction of the scallops. The researchers draw up and comment upon curves which "indisputably" show the incredible decline of the stock of scallops in St. Brieuc Bay. They also emphatically present the "spectacular" results of the Japanese. The scientific colleagues are solicited during conferences and through publications. The argumentation is always the same: an exhaustive review of the literature shows that nothing is

known about scallops. This lack of knowledge is regrettable because the survival of a species which has increasing economic importance is at stake (in France at least).[9]

For the case of the scallops (like the fishermen and the scientific colleagues) the *interessement* is founded on a certain interpretation of what the yet-to-be-enrolled actors are and want as well as with which entities these actors are associated. The devices of *interessement* create a favorable balance of power: for the first group, these devices are the towlines immersed in St. Brieuc Bay; for the second group, they are texts and conversations which lure the concerned actors to follow the three researchers' project. For all the groups involved, the *interessement* helps corner the entities to be enrolled. In addition, it attempts to interrupt all potential competing associations and to construct a system of alliances. Social structures comprising both social and natural entities are shaped and consolidated.

## HOW TO DEFINE AND COORDINATE THE ROLES: ENROLLMENT

No matter how constraining the trapping device, no matter how convincing the argument, success is never assured. In other words, the device of *interessement* does not necessarily lead to alliances, that is, to actual enrollment. The issue here is to transform a question into a series of statements which are more certain: *Pecten maximus* does anchor; the fishermen want to restock the bay.

Why speak of *enrollment?* In using this term, we are not resorting to a functionalist or culturalist sociology which defines society as an entity made up of roles and holders of roles. Enrollment does not imply, nor does it exclude, preestablished roles. It designates the device by which a set of interrelated roles is defined and attributed to actors who accept them. *Interessement* achieves enrollment if it is successful. To describe enrollment is thus to describe the group of multilateral negotiations, trials of strength, and tricks that accompany the *interessements* and enable them to succeed.

If the scallops are to be enrolled, they must first be willing to anchor themselves to the collectors. But this anchorage is not easy to achieve. In fact the three researchers will have to lead their longest and most difficult negotiations with the scallops. Like in a fairy tale, there are many enemy forces which attempt to thwart the researchers' project and divert the larvae before they are captured. First the currents: of the six towlines, four functioned correctly before different variables intervened. It appears that the larvae anchor themselves better in the innermost parts of the bay where the tidal currents are the weakest.[10]

To negotiate with the scallops is to first negotiate with the currents because the turbulences caused by the tide are an obstacle to the anchorage. But the researchers must deal with other elements besides the currents. All sorts of parasites trouble the experiment and present obstacles to the capture of the larvae.

A large part of the variation is due to the way in which parasites are attracted. We have had many visitors who provoked accidents, displaced lines, entangled collectors. This immediately caused negative results. It seems that the scallops are extremely sensitive to all manipulations (displaced lines, collectors which rub against each other, etc.) and react by detaching themselves from their supports.[11]

The list goes on. A veritable battle is being fought. Currents and visitors are only some of the forces which are opposed to the alliances which the researchers wish to forge with the scallops.[12] In the triangle A–B–C which we spoke of earlier, C, the party to be excluded (whether it is called currents or starfish) does not surrender easily. C (the starfish) has the possibility of interrupting

the relationships between A (the researchers) and B (the larvae). C does this by also interesting B (the larvae) which are coveted by all.

The census done by the researcher also shows that the anchorages are more numerous between 5 meters above the sea floor and the sea floor itself. This is perhaps due to the depth as well as to the specific behavior of the scallops when they anchor: the larvae lets itself sink and anchors itself to the first obstacle that stops its descent.[13]

The towline, an *interessement* device, reveals the levels of anchorage to the observer. The hypotheses and the interpretations of the researchers are nothing but a program of negotiations: Larvae, should we search for you at the bottom of the bay or should we wait for you on your way down in order to trap you as you sink?

This is not all. The researchers are ready to make any kind of concession in order to lure the larvae into their trap. What sort of substances do the larvae prefer to anchor themselves on? Another series of transactions is necessary to answer the question.

It was noted that the development of the scallops was slower with collectors made of straw, broom, or vegetable horsehair. These types of supports are too compressed and prevent water from circulating correctly through the collector.[14]

Thus a modus vivendi is progressively arranged. If all these conditions are united then the larvae will anchor themselves in a significant manner. But what does the adjective "significant" signify? To answer this question, we must introduce, as in the tripartite Vietnam conferences held in Paris, the second actor with whom the three researchers must negotiate: scientific colleagues.

In the beginning a general consensus existed: the idea that scallops anchor was not discussed.[15] However, the first results were not accepted without preliminary negotiations. The proposition: "*Pecten maximus* anchors itself in its larval state" is an affirmation which the experiments performed at St. Brieuc eventually called into question. No anchorages were observed on certain collectors and the number of larvae which anchored on the collectors never attained the Japanese levels. At what number can it be confirmed and accepted that scallops, in general, do anchor themselves? The three researchers are prepared for this objection because in their first communication they confirm that the observed anchorages did not occur accidentally: it is here that we see the importance of the negotiations which were carried out with the scallops in order to increase the *interessement* and of the acts of enticement which were used to retain the larvae (horsehair rather than nylon, and so on). With scientific colleagues, the transactions were simple: the discussion of the results shows that they were prepared to believe in the principle of anchorage and that they judged the experiment to be convincing. The only condition that the colleagues posed is that the existence of previous work be recognized, work that had predicted, albeit imperfectly, the scallops' capacity to anchor.[16] It is at this price that the number of anchorages claimed by the researchers will be judged as sufficient. Our three researchers accept, after ironically noting that all bonafide discoveries miraculously unveil precursors, who had been previously ignored.[17]

Transactions with the fishermen, or rather, with their representatives, are nonexistent. They watch like amused spectators and wait for the final verdict. They are prepared simply to accept the conclusions drawn by the specialists. Their consent is obtained (in advance) without any discussion.

Therefore for the most part, the negotiation is carried between three parties since the fourth partner was enrolled without any resistance. This example illustrates the different possible ways

in which the actors are enrolled: physical violence (against the predators), seduction, transaction, and consent without discussion. This example mainly shows that the definition and distribution of roles (the scallops which anchor themselves, the fishermen who are persuaded that the collectors could help restock the bay, the colleagues who believe in the anchorage) are a result of multilateral negotiations during which the identity of the actors is determined and tested.

THE MOBILIZATION OF ALLIES: ARE THE SPOKESMEN REPRESENTATIVE? Who speaks in the name of whom? Who represents whom? These crucial questions must be answered if the project led by the researchers is to succeed. This is because, as with the description of *interessement* and enrollment, only a few rare individuals are involved, whether these be scallops, fishermen or scientific colleagues.

Does *Pecten maximus* really anchor itself? Yes, according to the colleagues, the anchorages which were observed are not accidental. Yet, though everyone believes that they are not accidental, they acknowledge that they are limited in number. A few larvae are considered to be the official representatives of an anonymous mass of scallops which silently and elusively lurk on the ocean floor. The three researchers negotiate the *interessement* of the scallops through a handful of larvae which represent all the uncountable others that evade captivity.

The masses at no time contradict the scallops which anchor themselves. That which is true for a few is true for the whole of the population. When the CBI negotiates with union delegates they consider the latter to be representatives of all the workers. This small number of individuals speaks in the name of the others. In one case, the epistemologists speak of induction, in another, political scientists use the notion of spokesman. The question however is the same. Will the masses (employers, workers, scallops) follow their representatives?

Representation is also an issue in the researchers' transactions with the colleagues and fishermen. Properly speaking, it is not the scientific community which is convinced but a few colleagues who read the publications and attend the conference. It is not the fishermen but their official representatives who give the green light to the experiments and support the project of restocking the bay. In both cases, a few individuals have been interested in the name of the masses they represent, or claim to represent.

The three researchers have formed a relationship with only a few representatives—whether they be larvae on a collector, professional delegates, or scientific colleagues participating at a colloquium. However it may seem that the situations are not comparable. The delegates and colleagues speak for themselves while the larvae are silent. On the one hand, they are real spokesmen, but on the other, the anchored larvae are simply representatives. However this difference disappears on closer analysis.

Let us return to the scallops. The larvae which anchored themselves on the collector are "equal" to the scallops of St. Brieuc Bay. They themselves express nothing; however, they end up having, like the fishermen, an authentic spokesman. As we have seen, the negotiations between the scallops and the researchers revolve around one question: How many larvae can be trapped? The fact that this number should be retained as a principal subject of discussion is not a result of any absolute necessity. By counting the larvae, the three researchers wish to know what they can count on in their negotiations with their colleagues and the fishermen. Their interlocutors pay particular attention to the number of anchorages: the first to be convinced of the generality of the observation; the latter to be convinced of the efficiency of the device. How many electors

came forward to choose their representatives? How many larvae anchored themselves on the collectors? This is the only question of any importance in either case. The anchorage is equivalent to a vote and the counting of anchored larvae corresponds to the tallying of ballots.[18] When spokesmen for the fishing community are elected the procedure is the same. From the fishing community which is just as silent as the scallops in the bay, a few individuals come forward to slip their votes into the ballot boxes. The votes are counted and then divided between the different candidates: the analysis of these results leads to the designation of the official spokesman. Where are the differences in the case of the larvae? The larvae anchor themselves and are counted; the three researchers register these numbers on sheets of paper, convert these figures into curves and tables which are then used in an article or paper. These results are analyzed and discussed during a conference and, if they judged to be significant, three researchers are authorized to speak legitimately for the scallops of St. Brieuc Bay: *Pecten maximus* does in fact go through an anchorage stage.

The symmetry is perfect. A series of intermediaries and equivalences are put into place which lead to the designation of the spokesman. In the case of the fishermen, the chain is a bit longer. This is because the professional delegates stand between the tallying of the vote and the three researchers. However, the result is the same: both the fishermen and the scallops end up being represented by the three researchers who speak and act in their name. Although no vote is taken, the agreement of the scientific community is also based on the same type of general mechanism: the same cascade of intermediaries who little by little reduce the number of representative interlocutors. The few colleagues who attend the different conferences or seminars speak in the name

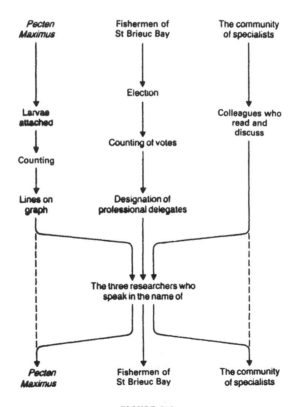

FIGURE 5-5

of all the researchers involved.[19] Once the transaction is successfully accomplished, there are three individuals who, in the name of the specialists, speak in the name of the scallops and fishermen.

The schema below shows how entities as different as *Pecten maximus,* the fishermen of St. Brieuc and the community of specialists are constructed by interposed spokesmen (see Figure 5-5).

Using the notion of spokesman for all the actors involved at different stages of the process of representation does not present any problem. To speak for others is to first silence those in whose name we speak. It is certainly very difficult to silence human beings in a definitive manner but it is more difficult to speak in the name of entities that do not possess an articulate language: this supposes the need for continuous adjustments and devices of *interessement* that are infinitely more sophisticated.[20]

Three men have become influential and are listened to because they have become the "head" of several populations. They have mixed together learned experts, unpolished fishermen, and savoury crustaceans. These chains of intermediaries which result in a sole and ultimate spokesman can be described as the progressive mobilization of actors who render the following propositions credible and indisputable by forming alliances and acting as a unit of force: "*Pecten maximus* anchors" and "the fishermen want to restock the bay." The notion of mobilization is perfectly adapted to the mechanisms that we have described. This is because this term emphasizes all the necessary displacements. To mobilize, as the word indicates, is to render entities mobile which were not so beforehand. At first, the scallops, fishermen, and specialists were actually all dispersed and not easily accessible. At the end, three researchers at Brest said what these entities are and want. Through the designation of the successive spokesmen and the settlement of a series of equivalencies, all these actors are first displaced and then reassembled at a certain place at a particular time. This mobilization or concentration has a definite physical reality which is materialized through a series of displacements.

The scallops are transformed into larvae, the larvae into numbers, the numbers into tables and curves which represent easily transportable, reproducible, and diffusable sheets of paper (Latour 1987). Instead of exhibiting the larvae and the towlines to their colleagues at Brest, the three researchers show graphic representations and present mathematical analyses. The scallops have been displaced. They are transported into the conference room through a series of transformations. The choice of each new intermediary, of each new representative must also meet a double requirement: it renders each new displacement easier and it establishes equivalences which result in the designation of the three researchers as spokesmen. It is the same for the fishermen transformed into voting ballots and then professional delegates whose previously recorded points of view are reported to Brest.

The obtained result is striking. A handful of researchers discuss a few diagrams and a few tables with numbers in a closed room. But these discussions commit uncountable populations of silent actors: scallops, fishermen, and specialists who are all represented at Brest by a few spokesmen. These diverse populations have been mobilized. That is, they have been displaced from their homes to a conference room. They participate, through interposed representatives, in the negotiations over the anchorage of *Pecten maximus* and over the interests of the fishermen. The enrollment is transformed into active support. The scallops and the fishermen are on the side of the three researchers in an amphitheatre at the Oceanographic Center of Brest one day in November 1974.

As this analysis shows, the groups or populations in whose name the spokesmen speak are elusive. The guarantor (or the referent) exists once the long chain of representatives has been put into place. It constitutes a result and not a starting point. Its consistency is strictly measured by

the solidity of the equivalencies that have been put into place and the fidelity of a few rare and dispersed intermediaries who negotiate their representativity and their identity. Of course, if the mobilization is successful, then: *Pecten maximus* exists as a species which anchors itself; the fishermen want the repopulation and are ready to support the experimental project; colleagues agree that the results obtained are valid. The social and natural "reality" is a result of the generalized negotiation about the representativity of the spokesmen. If consensus is achieved, the margins of maneuver of each entity will then be tightly delimited. The initial problematization defined a series of negotiable hypotheses on identity, relationships, and goals of the different actors. Now at the end of the four moments described, a constraining network of relationships, or what I called elsewhere an actor-network (Callon 1986), has been built. But this consensus and the alliances which it implies can be contested at any moment. Translation becomes treason.

## III. DISSIDENCE: BETRAYALS AND CONTROVERSIES

During recent years, sociologists have devoted numerous studies to controversies and have shown the important role they play in the dynamics of science and technology. Why and in what conditions do controversies occur? How are they ended? The proposed schema of analysis makes it possible to examine these two questions in the same way. At the same time, this schema maintains the symmetry between controversies which pertain to nature and those which pertain to society.

Is a spokesman or an intermediary representative? This is a practical and not a theoretical question. It is asked in the same manner for the scallops, the fishermen and the scientific colleagues. Controversy is all the manifestations by which the representativity of the spokesman is questioned, discussed, negotiated, rejected, and so forth.

Let us start with the scallops. The first experiment or, if we use our vocabulary, act of *interessement* mobilizes them in the form of larvae anchored to collectors and in the form of diagrams discussed at Brest before a learned assembly. This group established a fact: *Pecten maximus* anchors itself when in the larval state. About a hundred larvae gathered in nets off the coast of St. Brieuc were enough to convince the scientists that they reflect the behavior of an uncountable number of their invisible and elusive brothers.

But is this movement likely to last? Will the scallops continue to anchor their larvae on the collectors generation after generation? This question is of crucial importance to our three researchers. It concerns the future of the restocking of the bay, the future of the fishermen, and, in consequence, their own future. The years pass and things change. The repeated experiment results in a catastrophe. The researchers place their nets but the collectors remain hopelessly empty. In principle the larvae anchor, in practice they refuse to enter the collectors. The difficult negotiations which were successful the first time fail in the following years. Perhaps the anchorages were accidental! The multiplicity of hostile interventions (this at least is the interpretation of the researchers in their role of spokesman for the scallops), the temperature of the water layers, unexpected currents, all sorts of predators, epizooty, are used to explain why the *interessement* is being inefficient. The larvae detach themselves from the researchers' project and a crowd of other actors carry them away. The scallops become dissidents. The larvae which complied are betrayed by those they were thought to represent. The situation is identical to that of the rank

and file which greets the results of union negotiations with silent indignation: representativity is brought into question.[21]

This controversy over the representativity of the larvae which anchor themselves during the first year's experiments is joined by another: this time it is the fishermen. Their elected representatives had been enrolled in a long-term program aimed at restocking St. Brieuc Bay without a shadow of reservation and without a peep of doubt. In the two years following the first (and only) anchorages, the scallops hatched from the larvae "interested" by the collectors, after being regrouped at the bottom of the bay in an area protected by a concrete belt, are shamelessly fished, one Christmas Eve, by a horde of fishermen who could no longer resist the temptation of a miraculous catch. Brutally, and without a word, they disavowed their spokesmen and their long-term plans.

Faced with these silent mutinies of scallops and fishermen, the strategy of the three researchers begins to wobble. Is anchorage an obligatory passage point? Even scientific colleagues grow skeptical. The three researchers have now to deal with growing doubt on the part of their laboratory director and the organizations which had agreed to finance the experiment.

Not only does the state of beliefs fluctuate with a controversy but also the identity and characteristics of the implicated actors change as well. (What do the fishermen really want? How does *Pecten maximus* behave? . . . ). Nature and society are put into place and transformed in the same movement.

By not changing the grid of analysis, the mechanisms of the closure of a controversy are now more easily understood. Closure occurs when the spokesmen are deemed to be beyond question. This result is generally obtained only after a series of negotiations of all sorts which could take quite some time. The scallops do not follow the first anchored larvae and the fishermen do not respect the commitments of their representatives; this leads the three researchers to transform the device of *interessement* used for the scallops and their larvae and to undertake a vast campaign to educate and inform (i.e., form) the fishermen to choose other intermediaries and other representatives. It is at this point of their story that we leave them in order to examine the lessons that can be drawn from the proposed analysis.

## IV. CONCLUDING REMARKS

Throughout this study we have followed all the variations which affected the alliances forged by the three researchers without locking them into fixed roles. Not only was the identity of the scallops or the fishermen and the representatives of their intermediaries or spokesmen (anchored larvae, professional delegates, and so on) allowed to fluctuate but also the unpredictable relationships between these different entities were also allowed to take their course. This was possible because no a priori category or relationship was used in the account. Who at the beginning of the story could have predicted that the anchorage of the scallops would have an influence on the fishermen? Who would have been able to guess the channels that this influence would pass through? These relationships become visible and plausible only after the event. The story described here, although centered around the three researchers, did not bring in any actor that they themselves did not explicitly invoke nor did it impose any fixed definition on the entities which intervened.

Despite what might be judged a high degree of permissiveness in the analysis, the results were not an indescribable chaos. Certainly the actors studied were confronted with different types of uncertainties. The situation proposed for them here is much less comfortable than that which is generally given by sociology. But their competencies prove to be worthy of the difficulties they encountered. They worked incessantly on society and nature, defining and associating entities, in order to forge alliances that were confirmed to be stable only for a certain location at a particular time. This methodological choice through which society is rendered as uncertain and disputable as nature, reveals an unusual reality which is accounted for quite faithfully by the vocabulary of translation.

First, the notion of translation emphasizes the continuity of the displacements and transformations which occur in this story: displacements of goals and interests and also displacements of devices, human beings, larvae, and inscriptions. Because of a series of unpredictable displacements, all the processes can be described as a translation which leads all the actors concerned to pass, through various metamorphoses and transformations, by the three researchers and their development project.

To translate is to displace: the three untiring researchers attempt to displace their allies to make them pass by Brest and their laboratories. But to translate is also to express in one's own language what others say and want, why they act in the way they do and how they associate with each other: it is to establish oneself as a spokesman. At the end of the process, if it is successful, only voices speaking in unison will be heard. The three researchers talk in the name of the scallops, the fishermen, and the scientific community. At the beginning these three universes were separate and had no means of communication with one another. At the end a discourse of certainty has unified them, or, rather, has brought them into a relationship with one another in an intelligible manner. But this would not have been possible without the different sorts of displacements and transformations presented above, the negotiations, and the adjustments that accompanied them. To designate these two inseparable mechanisms and their result, we use the word *translation*. The three researchers translated the fishermen, the scallops, and the scientific community.

Translation is a process before it is a result. That is why we have spoken of moments which in reality are never as distinct as they are in this paper. Each of them marks a progression in the negotiations which results in the designation of the legitimate spokesmen who, in this case study, say what the scallops want and need and are not disavowed: the problematization, which was only a simple conjecture, was transformed into mobilization. Dissidence plays a different role since it brings into question some of the gains of the previous stages. The displacements and the spokesmen are challenged or refused. The actors implicated do not acknowledge their roles in this story nor the slow drift in which they had participated, in their opinion, wholeheartedly. As the aphorism says, "traduttore-traditore," from translation to treason there is only a short step. It is this step that is taken in the last stage. New displacements take the place of the previous ones but these divert the actors from the obligatory passage points that had been imposed upon them. New spokesmen are heard that deny the representativity of the previous ones. Translation continues but the equilibrium has been modified.

Translation is the mechanism by which the social and natural worlds progressively take form. The result is a situation in which certain entities control others. Understanding what sociologists generally call power relationships means describing the way in which actors are defined, associ-

ated, and simultaneously obliged to remain faithful to their alliances. The repertoire of translation is not only designed to give a symmetrical and tolerant description of a complex process which constantly mixes together a variety of social and natural entities. It also permits an explanation of how a few obtain the right to express and to represent the many silent actors of the social and natural worlds they have mobilized.

NOTES

1. The notion of "stock" is widely used in population demography. In the present case the stock designates the population of scallops living and reproducing in St. Brieuc Bay. A given stock is designated by a series of parameters that vary over time: overall number, cohorts, size, natural mortality rate, rate of reproduction, and so on. Knowledge of the stock thus requires systematic measures which make it possible to forecast changes. In population dynamics mathematical models define the influence of a range of variables (e.g., intensity of fishing and the division of catch between cohorts) upon the development of the stock. Population dynamics is thus one of the essential tools for what specialists in the study of maritime fishing call the rational management of stocks.

2. For this study we had available all the articles, reports, and accounts of meetings that related to the experiments at St. Brieuc and the domestication of scallops. About twenty interviews with leading protagonists were also undertaken.

3. Centre National d'Exploitation des Océans (CNEXO) is a public body that was created in the early 1970s to undertake research designed to increase knowledge and means of exploiting marine resources.

4. The term *actor* is used in the way that semioticians use the notion of the *actant* (Greimas and Courtes 1979). For the implication of external actors in the construction of scientific knowledge or artifacts see the way in which Pinch and Bijker (1984) make use of the notion of a social group. The approach proposed here differs from this in various ways: first, as will be suggested below, the list of actors is not restricted to social entities; but second, and most important, because the definition of groups, their identities and their wishes are all constantly negotiated during the process of translation. Therefore, these are not pregiven data but take the form of an hypothesis (a problematization) that is introduced by certain actors and is subsequently weakened, confirmed, or transformed.

5. The reader should not impute anthropomorphism to these phrases! The reasons for the conduct of scallops—whether these lie in their genes, in divinely ordained schemes, or anything else—matter little! The only thing that counts is the definition of their conduct by the various actors identified. The scallops are deemed to attach themselves just as fishermen are deemed to follow their short-term economic interests. They therefore act.

6. On the negotiable character of interests and identities of the actors see Callon (1980).

7. As can be discerned from its etymology, the word *problem* designates obstacles that are thrown across the path of an actor and which hinder his movement. This term is thus used in a manner which differs entirely from that current in the philosophy of science and epistemology. Problems are not spontaneously generated by the state of knowledge or by the dynamics of progress in research. Rather they result from the definition and interrelation of actors that were not previously linked to one another. To problematize is simultaneously to define a series of actors and the obstacles which prevent them from attaining the goals or objectives that have been imputed to them. Problems, and the postulated equivalences between them, result from the interaction between a given actor and all the social and natural entities which it defines and for which it seems to become indispensable.

8. When the shell is formed it constitutes an effective shield against certain predators such as starfish.

9. Numerous analyses have made it clear that scientific argument may be seen as a device for *interessement*. See, among others, Michel Callon, John Law, and Arie Rip (1986). Since this point is well established, details of the rhetorical mechanisms by which academics and fishermen were interested are not described in the present article.

10. D. Buestel, J-C. Dao, A. Muller-Fuega. 1974. Resultats préliminaires de l'expérience de collecte de naissains de coquilles Saint-Jacques en rade de Brest et en baie de Saint-Brieuc'in Colloque sur l'aquaculture, Brest, October 1973. *Actes de Colloque* I, CNEXO.

11. Ibid.

12. The description adopted here is not deliberately anthropomorphic in character. Just because currents intervene to thwart the experiments of researchers does not mean that we endow them with particular motives. Researchers sometimes use a vocabulary which suggests that starfish, climatic changes, and currents have motives and intentions of their own. But it is precisely here that one sees the distance that separates the observer from the actor and the neutrality of the former with respect to the point of view of the latter. The vocabulary adopted, that of *interessement* and enrollment, makes it possible to follow the researchers in their struggles with those forces that oppose them without taking any view about the nature of the latter.

13. Buestal et al. Resultats préliminaires.

14. Ibid.

15. The discussions were recorded in reports which were made available.

16. One participant in the discussion, commenting on the report of Buestel et al., noted: "At a theoretical level

we must not minimise what we know already about scallops. . . . It is important to remember that the biology of *Pecten* was somewhat better known than you suggested."

17. Buestel et al. Resultats préliminaires.

18. Furthermore, right at the beginning of the experiments, the three researchers gathered the St. Brieuc collectors together and transported them to their laboratory at Brest. Only after their arrival in Brest and in the presence of attentive colleagues were the larvae extracted from the collectors, arrayed on a pallet somewhere near the Spanish Bridge, and counted. There is no difference between this and what happens after the polling stations close and the ballot boxes are sealed. These are only reopened under the vigilant gaze of the scrutineers gathered round the tables upon which they are to be counted.

19. In the course of discussion the researcher whose opinions were constantly sought by the participants made this judgment: "Let me underline the fact that this very remarkable communication marks an important date in our knowledge of the growth of *Pecten maximus.*"

20. This does not imply that all fishermen actively subscribe to the position adopted by their delegates. Rather it simply signifies that they do not interrupt the negotiations that those delegates undertake with the scientists and the larvae. As what subsequently happened reveals, interruption can occur without the fishermen explaining themselves publicly.

21. It is no surprise that the controversy or dispute was not explicitly voiced. Even electors sometimes "vote with their feet."

## REFERENCES

Callon, Michel. 1980. Struggles and negotiations to define what is problematic and what is not: the socio-logic of translation. In *The Social Process of Scientific Investigation. Sociology of the Sciences Yearbook, Vol. 4,* ed. K. D. Knorr and A. Cicourel. Boston: D. Reidel Publishing Company.

Callon, Michel. 1986. The sociology of an actor-network. In *Mapping the Dynamics of Science and Technology,* ed. M. Callon, J. Law, and A. Rip. London: Macmillan.

Callon, Michel, J. Law, and A. Rip, eds. 1986. *Mapping the Dynamics of Science and Technology.* London: Macmillan.

Greimas, A. J., and J. Courtes. 1979. *Sémiotique: dictionnaire raisonné de la théorie du langage.* Paris: Hachette.

Latour, Bruno. 1987. *Science in Action.* Milton Keynes: Open University Press.

Pinch, T. J., and W. Bijker. 1984. The social construction of facts and artefacts: or how the sociology of science and the sociology of technology might benefit each other. *Social Studies of Science* 14: pp. 399–441.

# 6

# Reading Science Studies Writing

## SANDE COHEN

### CLOSELY READING A TEXT
### IN SCIENCE STUDIES

In what follows, I offer a textual or critical-linguistic analysis of Bruno Latour's *We Have Never Been Modern* (hereafter WHNB).[1] How does this text use language to clear its own "intellectual spaces" so as to engage disputes about credible and necessary interpretive schemes? At issue is the analysis of language usage in Latour's version of science studies, since it is not certain which sets of terms, philosophical, sociological, and so forth, are necessary to conceptualize the objects of such studies. Critical-linguistic analysis is interested in how language is stabilized and "normalized" in the workup of science studies as text.[2]

Science studies is not one thing and no doubt shows tendencies which are avant-garde and reactionary, progressive and obstructionist, liberating and repressing. My proposal is to analyze WHNB so as to ascertain how this version of science studies treats rival intellectual claims, notably those of deconstruction, and in this vein, a question will be posed: What if aspects of science studies, treated as text, are themselves repressive of other intellectual models? WHNB raises this topic itself in its scathing denunciation of, for example, Lyotard's famous *The Post-modern Condition*.[3]

Can science studies create concepts and linkages so as to resolve contradictions endemic to cultural analysis? WHNB makes such claims, namely, that intractable problems of modern historicism (periodization) and interpretation (concerning hybrids and social repression) can be settled. Hybrids or unanticipated new beings, whether machinic, biologic, cultural, or political combinations, WHNB insists, have made historicism and interpretation archaic and obsolete because these modes of writing always return new beings to the category of what is already known. Social relations, WHNB insists, whose catch-all phrase is modernism,[4] requires sorting, where only science studies is equipped with the intellectual tools which can forestall the disaster of modern cultural and intellectual *separation*, which drives hybrids into the netherworld. The moderns have created a world, the argument goes, in which the created hybrids are kept in the vacuum of repression by modes of thought that only know how to divide and isolate. Histori-

cism renders images of discontinuity (incommensurable temporalities) and hermeneutics often dissolves into special pleading (e.g., the incomparability of poetry and prose). WHNB insists that science studies, on the basis of a reconceived anthropology—the conjuncture of knowledge, power, and practices (14)—can provide a new monism capable of absorbing the world's proliferation of hybrids or unrecognized phenomena and bypass the quandaries of discursive repression. Outfitting itself in the categories and substance of holistic relations, it comes forward as a collective intellectual promise, entirely analogous to the "once upon a time" of psychoanalytic or Marxist literary studies, whose promises are still part of contemporary intellectual dynamics.

Specifically, three questions are asked of WHNB's claims: (1) How can science studies really use a "few sets of concepts sturdy enough" so as to synthesize incommensurable objectivities, if one definition of a concept is its "unsturdiness," i.e., its value as passage between differences?[5]; (2) Can science studies really transcend semantic/intellectual problematics endemic to critical studies, where a metalanguage is denied to every other discipline, including philosophy and inguistics?; and (3) If Latour's version of science studies is quite repressive toward deconstruction, what does this tell close readers about science studies and the politics of intellectual work?

## EPISTEMIC SUFFERING

WHNB is suffused by a powerful interest in getting out of "history." It calls for an ethnographic-anthropological resolution which reveals the radical autonomy of Western "history" to be a modernist fantasy. The Western overvaluation of "difference" (e.g., economic "take-off," revolutions of rising expectations, rejection of the archaic) is identical to its historiographic illusions. This interest in moving away from the equation "history = difference" is anchored in a generational claim:

Because we are the first who believe neither in the virtues nor in the dangers of science and technology, but share their vices and virtues without seeing either heaven or hell in them, it is perhaps easier for us to look for their causes without appealing to the white man's burden, or the fatality of capitalism, or the destiny of Europe, or the history of Being, or universal rationality. Perhaps it is easier today to give up the belief in our own strangeness. We are not exotic but ordinary. As a result the others are not exotic either. (127)

This "first" (unidentified group) comes now to deflate any and all "exoticisms," everything summarized as "strangeness," and which must be set aside in favor of a de-exoticized anthropology. This negation of historical differences gives science studies the right to enter current intellectual contestation on the side of the "mediators," the "delegates and senders" that are "shuttling forth" between and among the "networks" of every relation; in a world where the key functions belong to those who can *pass between differences,* those who make *connections* between things operational, it is not the "job" of knowledge to produce difference (articulation) as much as it is to acknowledge (reiterate) the already existing hybrids which are unrecognized:

The human is the delegation itself, in the pass, in the sending, in the continuous exchange of forms. . . . Human nature is the set of its delegates and its representatives, its figures and its messengers. . . . We should be talking about morphism. . . . A weaver of morphisms—isn't that enough of a definition? (137–38)

If there is "totality," it belongs to "delegates" and "representatives," "figures" and "messengers," each a mixture of knowledge and power, discourse and practice, and synthesized as a "weaver-weaving" model, whose associations are legion; the "figures and messengers" of any network

"epitomize" any object of study.[6] The unmediated hybrids which the moderns have built, pulled out "by the roots" by epistemologists, by the social scientists who "purify our network of any object" (e.g., make reified abstractions), and deconstructionists who "purge . . . adherence to reality . . . or to power plays," are in a limbo of asymmetry, binarism, methodological individualism, and false relativism, each an instance of a collective intellectual life "out of kilter" (5). These discursive systems have been unable to grasp what is distinctively modern in the modern because they have missed "the delicate shuttle . . . [which has] woven together the heavens, industry, texts, souls and moral law—this remains uncanny, unthinkable, unseemly" (4). The philosophical series, for example, initiated in Boyle's distinction between eyewitness/experimental science as it was connected to Hobbes' defense of collective political authority, "classicized" in Kant's separation of faculties and Hegel's attempt at a dialectical resolution, became that intensified modernism of phenomenology's desperation for a transcendental guarantee (e.g., Habermas's demand for agreeing on incommensurables), and which has crashed in the (putative) nightmare of paralysis. In each series (literature, social demographics, and so on), the same pattern: epistemic deracination, the social sciences emptying the world of agents and agencies (intermediaries, messengers, passes, senders), resulting in a deconstruction/postmodernism which epistemologizes culture and so makes it more separate than ever from other networks. The frame: epistemology makes us suffer; it prevents us from "weaving." That Ariadne's "thread," a figure of mythology, is invoked over and again by WHNB is part of its audacity, of allegorizing the "weaver" as the New Scholar of Return, what Vico, in his boundless skepticism about things linguistic, considered "the conceit of the scholars, who will have it that what they know must have been eminently understood from the beginning of the world" (120).

Science studies comes to *name* and *legitimize* the hybrids because it "knows" the secret of history: the mistakes of the moderns are reversible.

## CLEARING THE SPACE

For twenty years or so, my friends and I have been studying these strange situations that the intellectual culture in which we live does not know how to categorize. (4)

These "strange situations" are the "imbroglios" which have come from three centuries of producing hybrids, which are the uncategorized and unmediated phenomena which surround us. Here is a typical statement of how WHNB poses its resolution: "[to] . . . retie the Gordian Knot by crisscrossing the divide that separates exact knowledge and the exercise of power" (3). This involves breaking from existing knowledge, negating the negations of analysis, while maintaining or conserving the modern narrative structure for future resolution: "we have chosen to follow the imbroglios wherever they take us. To shuttle back and forth, we rely on the notion of translation, or network . . . the Ariadne's thread of these interwoven stories" (3). WHNB conflates translation and network in the rhetoric of exasperation: "Is it our fault if the networks are simultaneously real, like nature, narrated, like discourse, and collective, like society?" This "cry" justifies anthropology's invocation of the principle of symmetry, that the same causes explain opposites, instead of separating into differences (91).

The moderns create hybrids but refuse to acknowledge fully and hence integrate in some network these "monsters." The premoderns, on the other hand, conceive of hybrids and exclude "their proliferation." The moderns produce these hybrids without regard to consequences whereas

the premoderns articulated a kind of antiproduction—things are more mixed there, but they radically control their machines and effects.[7] The three-hundred-year "crisis" of hybrid-repression—an unacknowledged runaway production—requires of science studies that it not flinch in its overarching giving of names: "We are going to have to slow down, reorient and regulate the proliferation of monsters [hybrids] by representing their existence officially. . . . A democracy extended to things?" (12) Science studies, in refusing any epistemic separation or allowing purification only in the name of mediation, will then operate the levers of a legitimation which will illuminate the "positions at the common locus where roles, actions and abilities are distributed." A gigantic enthymeme subtends this version of science studies, something like science studies gets to name what it liberates, repeating the integrative gestures of early psychoanalysis, shifting repressed memory/neurosis into language and signifier, but the move is much stronger than simply opening the "black boxes" of societal production-repression; it involves the use of science studies as a device of *cultural recognition*.

## WHAT MADE THE "MODERNS" MODERN

The damning facet of modernity is its relentless asymmetry, which WHNB locates in the binarism of mediation or translation and purification or separation between humans and nonhumans. The former is disclosed in the conjunction between Boyle's eyewitness-driven, experimental science and Hobbes's protection of collective authority, and which has regularly expanded and produced countless hybrids which the work of purification is unable to acknowledge. To be modern is to insist on the separation between well "constituted" practices and once their non-separation is acknowledged "we immediately stop being wholly modern." Modernism grafted science and politics so that "the representation of nonhumans belongs to science, but science is not allowed to appeal to politics; the representation of citizens belongs to politics, but politics is not allowed to have any relation to the nonhumans produced and mobilized by science and technology . . . the two resources that we continue to use unthinkingly . . . ." (28) Is that true? Or is it rather that Latour so dislikes modernist mediations that he cannot see them as anything but negative separation and purification? The forms of modern economics—from straw companies to monetary instruments to modes of industrial spying—are these not hybrids and are they not themselves mediations? Are hybrids "secret" at all? WHNB asserts that science/politics ("constitution") "renders the work of mediation that assembles hybrids invisible, unthinkable, unpresentable . . . and here the beauty of the mechanism comes to light . . . *the modern constitution allows the expanded proliferation of the hybrids whose existence, whose very possibility, it denies*" (34, Latour's italics). Production is "invisible," in the sense that few of us understand the ins-and-outs of, say, an urban doctor's routine over six months; we do not see the range of information available to that doctor in relation to temporal markers (e.g., a crisis). But is it true that "invisibility" is the effect of the "constitution"? Is Latour saying the processes of production are invisible but not hybridic themselves, while the products are invisible and hybridic, that modern societies make hybrids without any real hybridic interference in underlying systems of production, recording, and consumption? This linguistic quagmire is just ignored, the reader to accept the ubiquity of hybrid-repression.

Nothing better shows this quagmire than WHNB's treatment of power. The logic of modernism is found in the circulation of evasion: modernists "hold all the sources of power . . .

but . . . displace them from case to case with such rapidity that they can never be caught red-handed" (39). Master-evaders, the model is that of "soft violence" such that (this) reader cannot distinguish modernist prescription from obedience, interdiction from powerlessness. This "modernity" is utterly Darwinist: between "holding" power and "never caught" lies the *anticipation* of becoming obsolete, unnetworked, which is to say of avoiding being deprived of the chance to make moves. Competence = capacity to scramble. Could this mean that modernists deprive the social of new games and hybrids instead of repressing what is already here? WHNB does not consider such ideas. Unlike the wise premoderns, the moderns are *adolescents* who "insure themselves by not thinking at all about the consequences of their innovations for the social order" (41). But we need not worry: they are passing away in the face of their unacknowledged hybrids which today befuddle modernist categorization:

the moderns allowed the practice of mediation to recombine all possible monsters without letting them have any effect on the social fabric, or even any contact with it. Bizarre as these monsters may be, they posed no problem because they did not exist publicly and because their monstrous consequences remained untraceable. (42)

Today, Monsters 'R' Us.

## SCIENCE STUDIES AND AESTHETIC UNITY

To absorb all the divisions and ruptures of epistemology, this version of science studies puts forward a principle of symmetry; the generalization of this principle places the new anthropologist "at the median point where he can follow the attribution of both human and nonhuman properties" (96). The only quality which matters is *what* "the networks explicate," in and of themselves, this "central mechanism of all collectives" (104). This concept of the network is the contemporary version of that "perfect fruit fly" Shapin and Schaffer found conjoined in Boyle/Hobbes. Applied to the present, "network" is shorthand for the concept of being at the "median point," so perhaps network means a position like that of "mediator," but WHNB is not coherent on this correlation. The text lets it be understood that to be "networked" involves capitalization of markets, especially making "packages" in which disparate actions are "woven" in the circulation of credits.[8]

  Present collectives, of every kind, are moved into the "middle" and all of them, of no place and every place in particular, are "similar, except for their size." But this is presented in a language more possessive of identifications than the worst sorts of naive writing practices associated with modern criticism. WHNB relies on similes, e.g., networks are "like the successive helixes of a single spiral," "single" a synecdoche for "whole," and refigures "network" and "mediation" as practices subject to significations of aesthetic identity, even purifications (exclusion, division, separation) in their own right. This all-encompassing "spiral" makes new "turns," "translates" current forms of "impetus," and offers knowledge without "mirrors" (that is, absolute epistemic certainty), so long as one believes that there "are no differences in nature—still less in culture" (109).

  This assertion of identity dissolves the difference between aesthetics and epistemology: science studies "knows" the secret, *"no difference,"* whereby identitarian language makes rules of study that are indistinguishable from aestheticization. And "no difference" means we can safely

assume no inadequation between language and meaning, event and result; "no difference" oper-
ates the levers of a thought which aims to be enveloping or, in de Man's phraseology, "particu-
larly seductive."⁹ "No difference" involves accepting that nothing is separate, and this is part of
the new "canon of the savant" where "translation is the very soul of the process of relating" (113).
The cultural epitome of this prefigurative relationism is that it must "serve as an organon for
planetary negotiations over the relative universals that we are groping to construct" (114). Show
me your pass—and you can belong (network = work in the net); no pass = no play. Translation
now is equivalent to passing differences to identity, "planetary negotiations," or difference will
be tolerated so long as it is canceled out in the concentration of identities which matter.

As one might expect from this identitarian, utopic, resolving, and translating nexus, there is
no limit to the language of synthesis; if we should be "fed up" with deconstruction and similar
movements, then networks and collectives let us avoid the "disenchantment of the world,"
where the modern disappears as so many frothy psychological pseudodramas—"mechanized
proletarians," "victims of reductionism," "rationalists" and "materialists," "technological deter-
minism" and the "cold breath of the sciences"—evaporate once we recognize ourselves as not
"radically different" from other collectives and conceive ourselves as a paradox straightened out.
Indeed, our "massive cognitive or psychological explanations" for "equally massive effects" pre-
vents our noticing "small causes for large effects." Small is a substitute for the lack of difference
and is meant to produce an ecstatic rationality: "reason today has more in common with a cable
television network than with Platonic ideas." Why call either "reason"? Against epistemology,
"branchings, subscriptions and decodings" will make it impossible to get "excited about virtues
they [Monsters 'R' Us] are incapable of possessing" (rationalization), and one will then presum-
ably get very excited in studying the mediations: "the extremes, once isolated, are no longer any-
thing at all." The implied terror here is disturbing.

At this level of metadiscourse, WHNB obscures a discussion of violence in favor of remain-
ing with its word-spell of how existing networks scale life:

What, for example, is the size of IBM, or the Red Army, or the French Ministry of Education, or the
world market? To be sure, these are all actors [mediators] of great size, since they mobilize hundreds or even
thousands or even millions of agents. (120)

As these different constructions "mobilize" (the masses, voters, students, homeless), science
studies must as well—the new academic mode of writing should "mobilize a great number of
objects for their description." All that exists is resource for writing, yet another modernist theme,
i.e., a transcoding of Hegel's moral dictum that we must work the negative.

Capitalism, in this context, is a "skein of somewhat longer networks that rather inadequately
embrace a world on the basis of points that become centers of profit and calculation" (121). The
violence of extracting profit from unpaid labor et al. is inconceivable via the focus placed on cap-
ital's "inadequately" formed "skein." The rule is: when violence is mentioned, it is downscaled;
Alfred Chandler's narrative of American business is asserted as "not the Organization described
by Kafka. It is a braid of networks materialized in order slips and flow charts, local procedures
and special arrangements which permit it to spread to an entire continent." We know that Kafka
was not a good "networker." Two hundred years of, say, industrial deaths should not shake us out
of the belief that capital is merely a network, prosaic and nonviolent in its elimination of other,
contentious, semantisemes.

Performatively considered then, as propositions whose force express a mode of existence,[10] this counterknowledge claims to remove the category of violence as such, so one should not be surprised if metaphor and comparison run amuck. We need not fear any longer "domination by machines" because "machines are full of human beings who find their salvation there." Like blood-test workers who are "saved" by tearing open the same sterile packages hundreds of times per week and finding a vein to poke? What if "boredom" is an artifact/hybrid of socially induced impossibilities? WHNB renders it inconceivable to think that "high tech," as manifested in self-poisoning (e.g., steroid consumption) or processed foods, or incessant dumbing-down through television or computer-related illnesses, and so on, might be practices attached to an extensively coded violent social system. No discussion of new types of labor are allowed in this mix, for in the face of the claim that "science studies can demonstrate the permanence of the old anthropological matrix," one must embrace "tinkering, reshuffling, crossbreeding and sorting . . . the fragile heterogeneous networks" (126). That infamous cultural figure, the handyman, is now recast as the future of the new scholar who, in "re-tying" everything, can enjoy its own "saving aphasia" as to choices other than "tinkering."[11]

If the counterknowledge to epistemology is thus to be institutionalized, WHNB performs this by an idealization of a particular contemporary actant, that of the "delegation," those hybrid-subjects who can "pass in the sense of this term as used in ball games." Epistemic separators, intellectual dissidents, must leave the field: in the "ball game" model "the world of meaning and the world of being are one and the same world, that of translation, substitution, delegation, passing" (129). Reminiscent of such older historiographical models as J. H. Hexter's comparison of historical discourse to "following a game," WHNB presents this "delegation" so as to remove the claims of naturalism and socialism. The former reduces the hybrid to a state of nature; the latter denies hybrid production due to ideological sclerosis. Both *overpurify*, making the hybrids invisible. Against both, science studies declares itself done with purification (!) by making this most modern of practices finally subservient to the work of mediation. The objective is

to maintain all the advantages of the moderns' dualism without its disadvantages—the clandestineness of the quasi-objects. To keep all the advantages of the premoderns' monism without tolerating its limits—the restricting of size through the lasting confusion of knowledge and power. (134)

Dualism can remain as it is, good for production so long as it is joined to monism; this mixture should activate knowledge-production and simply leaves the production of objectivities to the existing players. Can you start your own army? But can you. . . . Indeed, WHNB does not merely affirm the nonseparability of mobile objects and subjects, humans and nonhumans, but calls on science studies to prevent interference by concepts, institutions, and practices with

the continuous deployment of collectives and their experimentation with hybrids [an interference which] will be deemed dangerous, harmful and—we may as well say it—immoral. (139)

Which is exactly what every powerful player always wants to say: hands off, we're in charge. Am I reading WHNB as a proposal for cultural analysis or as a political determination which removes criticism from production?

# WHY IS SCIENCE STUDIES HOSTILE
# TO DECONSTRUCTION?

WHNB misses no opportunity to ensure that its own discourse is not contaminated by post-modern language:

As always, however, postmodernism is a symptom, not a solution . . . they are wrong to retain the frame-work and to keep on believing in the requirement of continual novelty that modernism demanded . . . it is a long way from a provocative quotation extracted out of a truly finished past [modernism] to a reprise, repetition or revisiting of a past that has never disappeared. (74)[12]

Why is production severed from "novelty" when it is linked to postmodernism, as it is here? Science studies *wants to name* and officiate over the "repressed," so the critical strategy of a discourse that offers complications to the named is outlawed: giving names is conceived as recognition-propriety, and analysis of names ("novelty") a deprivation of the same.

The mechanisms of displacement, category switching, and repression which WHNB attributes to the "modern constitution" would seem to warrant a cultural studies in which deconstruction had an integral function, since these (modernist) mechanisms are as much linguistic forces as not. But, citing a text by Boltanski and Thevenot, deconstruction is lumped with "critical indignation" and Latour proposes to do to it what the historian Furet did to all the contention around the historicity of the French Revolution: the "particular rabies" of criticism requires intellectuals who will terminate this persistent "accusing one another," which necessitates that deconstructive criticism is to be recast from that of "a resource . . . [and] becomes a topic, one competence among others, the grammar of our indignations."[13] Dropped into a sociomoral category of an underived need for scapegoating, deconstruction is thereby merely a symptom to be studied. Like the "rabies" or certainty of disease with which it is associated by name, deconstruction requires inoculation. And since WHNB wants to establish the category of study as the antithesis of this "critical indignation," a move that will terminate the "staleness" of denunciation, the preferred categories are those of "triage and selection," "arrangement, combination, *combinazione,* combine, but also negotiation or compromise . . . a supple morality more exigent," which arises from the "whirlwind of the mediators" and which eliminates the need for cultural criticism altogether. Deconstruction is unable to provide for science studies' reconstitution of holistic teachings. It is too caught in language. In my asking, above, whether WHNB's appeal is to the operation of *catachresis* ("a name for a still unnamed entity"[14]) or to *prosopon-poiein,* giving names to things which may not exist, I am also asking if "repression" is not also an *inapplicable* concept in Latour's scheme.

Postmodernism, standing in for deconstruction, comes in for special scorn, here a melange of left and right objections: it is "a symptom," it "lives under the constitution" but does not believe in its "guarantees"; it can only "prolong" critique and rejects "all empirical work" in favor of extreme purification; a 1992 text by Baudrillard is alone cited for these judgments. Postmodernism is negatively symmetrical with the modernist rejection of continuism—its suspension of imaginary, alternative, futures confirms the "disconnected instants and groundless denunciations" of the present. Those postmodernists just don't study enough: as soon as we grasp in detail the production of hybrids, we can achieve a "retrospective attitude," a mediation, in which neither a projected new era nor a revolutionary past matters at all, and which operates within the present to "deploy" instead of unveiling, which "adds instead of subtracting, fraternizes instead

of denouncing, sorts out instead of debunking . . . nonmodern (or amodern)" (47). This discursive strain of WHNB, especially "sorting," urges surrender to the ecstasy of networks or disappear![15]

In this culture-scape, deconstruction only signifies an excess spawned by the modern, a proclivity for unnecessary agonistics; in filling in the anthropologic matrix, a better dramatics of study is counseled, one belonging to a new "canon of the savant":

Seen as networks . . . the modern world . . . permits scarcely anything more than small extensions of practices, slight accelerations in the circulation of knowledge, a tiny extension of societies, minuscule increases in the number of actors, small modifications of old beliefs . . . no longer . . . [a] saga . . . of radical rupture, fatal destiny. (48)

Here too the language of enthusiasm turns study into a kind of revivalist salvation, a persistent downgrading of violence in the name of these "tiny networks" with their "minuscule" differences. This involves the very repression WHNB claims to reject. One wonders what the forced diaspora of dozens of millions round the world since WWII could mean to this grammar of a flattened world. This (positive?) downscaling of objectivist epics is matched by the overscaling of the new objectivities of study—"nonmodern worlds . . . as vast as China"—where "vast" is equated with the yet to be described (a rather inept comparison, since "vast = China" is of a piece [woven?] with imperialist fantasies), and enables science studies to present an "accommodation" of hybrids, this to "give them a place, a name, a home, a philosophy, an ontology and I hope, a new constitution" (51).

Deconstruction cannot enter this (neopositivist) descriptive world:

With the postmoderns, the abandonment of the modern project is consummated. I have not found words ugly enough to designate this intellectual movement . . . this intellectual immobility through which humans and nonhumans are left to drift. (61)

A lone, but provocative, citation from Lyotard brings this eliminative judgment, disabling these "hyper-incommensurists," and the charge is identical to the left-right sing-song in which deconstruction is conceived as a simple destruction of representational systems. Representation is that kind of social bond which requires "tension" and any intellectual practice which removes the "tension" in favor of an extreme—as in the construct of a *differend*—has no place in the knowledge-unities of the future. That these judgments against deconstruction *repeat* the *form* of a modernism (which never happened) rejected for its divisive exclusions seems telling, at the very least.

Indeed, when we finally get to see how language is treated in WHNB things become even more bizarre. Language is declared to be a mediation of purification and not the other way round, hence any interest in the specific autonomy of semiotics and language turns discourse away from its service as a "transparent intermediary" producing "contact" between words and things and into another impasse of modernity. Because of the "inimitable" writings of the postmodernists, "language has become a law unto itself, a law governing itself and its own world," assertions which repeat the reactionary projections of conservative academics. WHNB rejects semiology where "everything becomes sign" because it lessens the "connections" between discourse and the "referent" and which inexorably leads to "the point of autodissolution" (64). WHNB is unable to notice that if language cannot be reduced to nature (signifiers always motivated) and cannot be conclusively analyzed (interpreted, rationalized, socialized), then *more reflection* on language is suggested; but here, too much reflection on language's various performa-

tivities dissolves its capacity to serve as an intermediary; it must remain a "median space," an "excellent tool chest" so as to "stitch" nature, collectives and discourse together; "if these domains are kept separate, we remain terrorized by disconnection" (64). But what if disconnection is one of the positive values of *language itself?* Or a strategy of extrapolitical knowledge? WHNB is unable to think such thoughts, no doubt because they evoke a difference which science studies can only acknowledge by negation of difference.

The postmodern "prostration" in which language is rejected as a "delicate shuttle" will be written out of science studies; rejection will allow for the restoration to texts of the "social bond" Latour believes denied them. "Access to the real" must not be blocked and there must be closure to the interminableness of the linguistic question: "Are you not fed up with language games, and with the eternal skepticism of the deconstruction of meaning?" (90). Unaware that the question telegraphs a terroristic preanswer—"of course we are"—science studies provides exactly the proper *prescriptive utterance* which will forestall the plunge into an agonistics of discourse. Delegitimation through agonistics (or argumentative contestation) is something that any anthropologist would negate, WHNB insists, because *the aesthetics of weaving* must be protected. Nothing should prevent us from passing from language to totality (and wasn't the latter a staple of modernism?). Strangely, or perhaps depressingly familiar, this "are you not fed up" recodes a high-modernist defense of a "speculative hierarchy of learning" against the "immanent" foregrounding of doubt concerning discourse.[16]

Finally, WHNB negates any concept of the *marginal,* any extremity of thought and practice. Defense of any margin(al) social act is considered here "somewhat ridiculous": It is fine to want to defend the claims of the suffering body, but since there is no denying the "universality . . . of suffering everywhere," the defense of margins is itself "grotesque" (124). There is no other way to read this than to say it *repeats* the very claim WHNB makes against modernism for excessive division and separation, in a word, purification.

## CONCLUSION

A "freedom . . . redefined as a capacity to sort . . . hybrids" might strike some readers as a colossal begging of the question: Why should most of the members of a society accept the passivity and reactivity of "sorting" instead of determining how and what gets made in the first place? WHNB reads as a traditional piece of enthusiasm for negating separations (of all types), but its enthusiasm is also highly repressive, as the citations concerning deconstruction indicate. It is this confirmation of the corporate determinations of production which makes WHNB a double of the language of producers *cast* in the language of a better "study." Science/cultural studies here may serve "needs" overcoded by deadly modes of production which cannot be discussed.

"The mediators have the whole space to themselves." Instead of this meaning agreement in making the hybrids official, as Latour desires, it more ominously suggests the disappearance of critical writing and its replacement with those who "will talk" (of ozone holes, of chemistry, of voters et al.) and "what does it matter, so long as they are all talking about the same thing?" Writing is to become a "patch" underlining the "shared practices" of the mediators. Isn't this the full force of the network in relation to critical writing: the latter is tolerated only if it promises to not interfere with production? Thus science studies confirms one of the oldest of human terrors: "isolates" (Mary Douglas) watch out.

The aestheticizing scorn of WHNB toward socially constituted violence, a scorn especially directed at the intellectuality of deconstruction on account of the latter's persistent argument that language is saturated in violence, indexes, as it were, de Man's larger argument that aesthetic significations are often the most violent of significations, this because they appeal to "clarity and control," operations which force language to submit to ideology.[17]

In Latour's treatment of science studies, all the "theoretical enigmas" pertaining to language are directly suppressed; science studies is plunged into the discursivity of enthusiasm such that it aggressively precludes any "residue of indetermination" (de Man) which might intrinsically belong to knowledge production or cultural analysis. Despite many of its brilliant insights into modern historicism and other social formations, WHNB finally strikes me as yet another project in the mimesis of *demand,* of order-words, here science studies as laying out a model in the desire for satisfaction (synthesis), a model which suppresses intellectual skepticism. De Man's notion that epistemic suppression requires the violence of language against epistemology, delivered by aesthetic formations of grammar and logic, seems confirmed.

NOTES

1. Bruno Latour, *We Have Never Been Modern* (Cambridge, Mass.: Harvard University Press, 1993). All references to this text will be given in parenthesis within the essay.

2. Paul de Man, *The Resistance to Theory* (Minneapolis: University of Minnesota, 1986), p. 49. De Man's essay, "Hypogram and Inscription," is the main theoretical source of this essay.

3. Jean-François Lyotard, *The Postmodern Condition* (Minneapolis: University of Minnesota Press, 1979).

4. I am using modernism as a synonym for the perpetual recoding of capitalism (which is always neocapitalism), cultural issues of autonomy versus legislation, the relevance of the Kantian-Nietzsche line in art (the sublime is an "outrage" vis-à-vis imagination), technology unbounded by social rules, the excessive pressure of conformity, the calling into question of language as communication.

5. Bruno Latour, *Science in Action* (Cambridge, Mass.: Harvard University Press, 1987), p. 16.

6. I am drawing upon the remarks of Tzvetan Todorov in *The Poetics of Prose* (Ithaca: Cornell University Press, 1977), p. 146. The literariness of "a weaver of morphisms" implies superidealism, that every "network" is original, its lines and connections secondary.

7. One of the most interesting discussions of this topic is found in Deleuze and Guattari's *Anti-Oedipus* (Minneapolis: University of Minnesota Press, 1983).

8. See Mario Biagioli, "Tacit Knowledge, Courtliness, and the Scientist's Body," in *Choreographing History,* ed. Susan Foster (Bloomington: Indiana University Press, 1995).

9. De Man, *Resistance to Theory,* p. 98.

10. G. Deleuze and F. Guattari, *A Thousand Plateaus* (Minneapolis: University of Minnesota, 1987), pp. 82–83.

11. Roland Barthes, *Mythologies* (New York: Hill and Wang, 1972), p. 152.

12. See Sande Cohen, *Historical Culture* (Berkeley: University of California Press, 1986) for a critique of historical thought which arrives at nearly the same conclusions as Latour but does so through semiotic analysis.

13. The plus-value of "resource" is unquestioned by *We Have Never Been.* Nonetheless, the term is not so neatly "filed away" on the side of positive virtues. James Adler, chairman of the Los Angeles County Public Social Services Commission, which is about as fiscally "tight" as a "network" can get, calls for treating "welfare programs themselves" as "resources," i.e., welfare to be replaced by "payment for work performed." *L.A. Times,* Jan. 4, 1994, p. B7.

14. De Man, *Resistance to Theory,* p. 48.

15. "Sorting" can provide superidentity, even in the name of suspending identity. The transsexual critic S. Stone writes that the hybrid or cyborg called "Vampire" can serve as a cultural model for the "metaphorics" of our "simultaneous desire to destroy and to preserve." Do we invoke the Vampire as model to explain the proliferation of hybridic relations or do we invoke the model so as to keep circulating *an ideal,* without which cultural studies would collapse? See S. Stone, "How Like a Goddess," *Artforum,* September 1995, p. 125.

16. Latour's remarks echo the reading of Manfred Frank's *What is Neostructuralism?* (Minneapolis: University of Minnesota Press, 1989).

17. De Man, *Resistance to Theory,* p. 64.

# 7

# The TEA Set
## Tacit Knowledge and Scientific Networks

### H. M. COLLINS

## INTRODUCTION: METHODOLOGICAL AND THEORETICAL ARGUMENT

Thomas Kuhn's concept of "paradigm"[1] has attracted a lot of attention from sociologists and historians of science. In particular, some recent work has involved the search for groups of scientists which are taken to be the social analogue of this idea. I will argue here that the boundaries of those "social circles" of scientists which *have* been found are not likely to correspond with the boundaries of groups sharing a paradigm unless the term be construed in a restricted sense. This is because the research methods used in most cases are unsuitable for the investigation of *cognitive* specificity and discontinuity. But it is precisely because paradigm groups are seen as conceptually homogeneous and bounded that the idea has excited interest in the sociology of science as a branch of the sociology of knowledge.

An impressive number of studies[2] have been published which try to show that workers in scientific specialties are organized in a "social circle."[3] Such groups have been identified with Price's notion of "Invisible College,"[4] and have also been seen as the social location of distinctive sets of "technical and cognitive norms."[5] The claim that a set of actors exists as a social "group" is, of course, partly a matter of definition. A "social circle" is distinguished by the greater density of relations between its members than between members and nonmembers, and this depends on the definition of the relations which are held to be significant. In turn, the discovery of such patterns of relations depends in part on the research methods used to locate them. In the last resort, empirical research can only discover the existence of operationalizations of a relation, not the relation itself. In the case of the recent work by Crane and others, these operationalizations have been based on ideas of the nature of scientific information and influence which are philosophically undeveloped and likely to be sociologically uninteresting. This seems to be the result of a conflation of "information science" and the "sociology of science"[6]—a conflation which is well illustrated by a sentence on the first page of Crane's recent book. She writes:

The growth of scientific knowledge like that of most natural phenomena takes the form of the logistic curve.[7]

But this growth pattern has been shown, at best, only for what Price has called "any reasonable definition of science,"[8] not for "scientific knowledge."[9] The term "Invisible College" itself was used by Price for hypothesized groups of scientists whose interest in meeting together would be to overcome the problems of the "Information Explosion." Within this context, research techniques such as the use of interval scale bibliometric indices and questionnaires are quite appropriate, for "Information Science" treats information as though it can be contained in discrete visible packages of roughly equal value. However, in spite of the operational attractiveness of these techniques, the sociologist has to be concerned, at least at first, with the actor's interpretation of these items, before he can treat them as sociologically relevant. It follows that the "groups" defined by relations based upon the information scientist's research techniques (that is, groups constructed around relations based upon *their own* perceptions of information flow) may not be groups which have any particular interest for the sociologist concerned with the boundaries of networks whose members share a common conceptual map.

Crane and others have missed the point that learning to become part of, or helping in the conceptual development of, a particular paradigm group, is "doing" something, in the same sense that absorbing the conceptual structure that makes, say, logical inference "natural" is learning "to do" something.[10] What is more, there is no reason to suppose that it is possible to formulate the knowledge required to do the activity in question, any more than it is possible to formulate the knowledge required in order to infer logically. Achilles had this problem in his conversation with the tortoise.[11] Because cognitive influences are often intangible it is unlikely that the associations between scientists discovered through the correlation of questionnaire responses or in bibliographic interconnections will reflect them. This has been appreciated in studies of the transfer of technology, where it is more clear that knowledge consists of the ability to do something; thus Burns has written that technological knowledge is the property of people rather than documents.[12] I am suggesting (with Ravetz)[13] that this element is present in all knowledge, however pure, but is perhaps less noticeable elsewhere.

I will repeat the above point, for it is the most important element of the theoretical argument of this chapter.

All types of knowledge, however pure, consist, in part, of tacit rules which may be impossible to formulate in principle. For instance, the ability to solve an algebraic equation includes such normally nonarticulated knowledge as that the symbol "x" usually means the same whether it is written in ball point, chalk, or print, or if spoken, irrespective of the day of the week, or the temperature of the air. But in another sense, x stands for anything at all and may only mean the same—exactly (e.g., 2.75 gms; 27 inches, etc.)—on coincidental and unimportant occasions. Again, sometimes a capital X or an italicized *x* may have a distinctive meaning. x in the equation $x = 5y$ is the *same* as x in the equation $5y = x$, but is not the same as x in $x = 5z$, unless $y = z$: but, on the other hand, "x" is being used in the same way in all the equations. This list of tacit rules as it is extended becomes more confusing, and comes to resemble a list of all the examples of the uses of x which have ever been made. But such a list cannot serve at all as a guide for the use of x in the future.[14] Learning algebra consists of more than the memorization of sets of formal rules; it involves also knowing how to *do* things (e.g., use "x" correctly; use logical inference) which may have been learned long before. This means that while it is quite sensible to say "Mr. Jones taught me to solve equations in the third week of January 1947" (he taught me: "change side change sign"; "get all the x's on one side"; "add all the x's up"; "divide throughout by the number in front of the x"; etc.), it is not sensible to say "Mr. Jones taught me to use symbols" during a particular

week. Now, an important difference between members of different paradigm groups (as I am using the idea) lies in the contents of their tacit understandings of the things that they may legitimately do with a symbol or a word or a piece of apparatus. Because the process of learning, or building up tacit understandings, is not like learning items of information, but is more like learning a language, or a skill, it must be investigated differently. To ask respondents directly for the sources of their tacit knowledge, or to assume that sociograms based on responses to questions about articulated knowledge necessarily picture the diffusion or development of tacit knowledge, is to confuse concept formation with information exchange.

There is a second type of criticism to be made of sociometric studies of scientific groups: this concerns the appropriateness of questionnaire research, even where articulated knowledge is concerned. Crane, reporting her survey of agricultural innovation diffusion researches, writes that some respondents seemed to have difficulty or were unwilling to distinguish the influences upon them of other scientists. Gaston quotes a theoretical physicist:

There are many people who are not very much aware of who they get their ideas from, and six months after they hear the idea they forget who suggested it.

These reservations are serious, but might be less so were it the case that only the most immediately obvious sources of influence and information were significant. Crane writes:

The use of a questionnaire to elicit some of this information probably has the advantage of obtaining the most important influences, rather than a complete list of major and minor influences.

But there is serious doubt that the most important contributors to the ideas of a scientist are necessarily the most obvious contributors. In fact, a recent article seems to imply that the opposite might be the case.

Mark S. Granovetter[15] argues that weak sociometric links are likely to be more important than strong ones for the transmission of influences over long (sociometric) distances and between groups which are not densely connected. If this is true, those sociometric ties which are furthest from the forefront of a respondent's mind could, for some innovatory networks, be the most important. Granovetter argues, from a premise drawn from the theory of structural balance, that where two groups are connected by only one link, or where there is one link between the two which is part of a much shorter sociometric path than any alternative, that link will be weak. It follows (and he has some empirical evidence to back this up) that the tracing out of sequences of weak links from a node in a social network will define a far larger area of the network than will the tracing out of strong links. Sequences of strong links will soon return to the original node and thus define local groups only.[16] Granovetter suggests that this may explain why marginal individuals can be particularly effective diffusers of ideas. It also seems to follow that where a postulated mechanism of innovation is the transfer of ideas from one scientific field (social group) to another, weak sociometric links may form an essential part of the diffusion path. (In commonsensical terms, if ideas brought into one field from another are genuinely new, there can have been little contact, and therefore no strong links, between the fields previously.) It seems probable that Granovetter's ideas will be important in future sociometric studies of the diffusion of innovations. In particular, they throw further serious doubt on the validity of the questionnaire response as a direct indicator of the flow of real scientific innovatory influence.

In order not to be unfairly critical of the authors in question, it must be pointed out that they do show some sensitivity to these issues. Crane concerns herself with student-teacher relationships,

as well as with sociometric choice and published collaboration relations, and of course the former relation may be the seat of the transmission and development of much tacit understanding. She writes:

From each of these types of ties among scientists is obtained a somewhat different picture of the extent to which members of a research area are linked to one another. Nevertheless, if one uses the various indicators of linkage separately and then in combination, one is provided with a fairly complete picture of the amount of relatedness that exists.

Unfortunately, we are never shown the networks which are defined by these different relations, nor are expected differences systematically discussed. Without a clear understanding of the social relations defining the network, it is difficult to see what is meant by the phrase "a fairly complete picture of the amount of relatedness that exists." Relatedness cannot exist unqualified, any more than can equality. Earlier, Crane writes:

The use of citation linkages between scientific papers is an approximate rather than an exact measure of intellectual debts. . . . Sociometric choices can also be criticized as unreliable indicators of relationships between scientists since it is obvious that the scientists may not recall all such contacts and may be biased toward reporting contacts with more prestigious individuals and ignoring those with less prestigious individuals. In the absence of other equally good measures, however, I will proceed on the assumption that such approximate measures can be used to provide some indication of the actual nature of relationships among scientists in a research area.[17]

However, even "these approximate measures" cannot be taken as indicators of anything other than the flow of articulated and therefore visible information.[18]

I will now attempt to illustrate some of the theoretical points made above about the diffusion of tacit knowledge by reporting on a study of a set of experimental physicists. I make no statement about the paradigm of which their practices are a part, and I have not attempted to delineate it. I have picked on experimental physicists because the aspect of their knowledge pertaining to their doing things is more evident than would be the case for theoretical physicists. But, for the reasons touched on above, I want to treat the study as an illustration which is also relevant for theoretical sciences. Perhaps more refined observational techniques could allow direct study of the processes pertaining to the development of theoretical concepts, but I do not know how to do this at present. Nevertheless, it is important that theoretical concepts (such as "paradigm") do not become eroded by the assumption that what cannot be operationalized cannot be discussed.

It has of course been stated many times before (for instance in the work of Menzel)[19] that scientists tend to claim (on questionnaires) that they use informal means (and even unplanned sources) for the transmission of "technical" information. Sociologists have treated communication as though it could be exhaustively divided into the two categories, "formal" and "informal." Informal communication has then been treated like a more flexibly packaged version of formal communication. I want to go beyond this and stress not only the informality of some information exchange, but also its necessary capriciousness—a symptom of the lack of organization of inarticulated knowledge into visible, discrete, and measurable units.

The study I report here is of a set of scientists in different laboratories engaged for one reason or another on the same problem—namely, the building of an operating TEA laser. There is no claim that this set represents a "group" of scientists in any sense other than a definitional one. It is true that a few members of the set saw themselves as members of a "club," and were linked

biographically and occasionally bibliographically, but the choice of a set of scientists working on the same narrowly defined problem is not supposed to imply that they communicated more with each other than with others, or were bounded in any way other than by this particular research interest. Such a set, however, has particular methodological advantages for careful research into communication among scientists. These advantages depend upon the small size of the set involved, the contemporaneity of the scientific research, and the visibility of many of the physical parameters of the technique. Thus members of every laboratory involved could be interviewed in depth about interactions which were comparatively recent. Visible technical variations in the laser itself could be used as a lever for investigating, at a deeper level than is usually possible, the content and quality, as well as the quantity of communications among the members. In addition, a criterion of successful transfer of the technique was readily identifiable—namely, the operation of the laser.

## THE TEA LASER; THE DESIGN OF THE STUDY; THE PARAMETERS OF THE LABORATORIES INVOLVED[20]

In the late nineteen-sixties, many laboratories throughout the world were attempting to increase the power output of gas lasers by increasing their operating pressure. Early in 1970, when no one else had achieved successful operation at pressures above about half an atmosphere, a Canadian defense research laboratory (which I will call "Origin") announced the "Transversely Excited Atmospheric Pressure $CO_2$ laser," which soon became known as the "TEA laser." In fact, the device had first been operated early in 1968, and a more sophisticated version had been built by the autumn of that year; but both generations of laser were classified for two years. Since 1970, a variety of models differing in design detail have been produced by many laboratories, and two or three firms are now marketing versions of the device.

The difficulty involved in constructing high pressure gas lasers is that of producing a uniform "pumping" discharge in the gas, rather than the arc breakdowns that usually occur in electrical discharges in gases above a few torr.[21] The solutions employed in the TEA laser involve pulsed operation, with pulse times too short to allow an arc to build up, and a discharge transverse to the lasing axis which can then be of manageable voltage. The early design solution is known as the "Pin-Bar" laser from its electrode structure, and second generation devices are known as "Double Discharge" lasers because the main pulse is triggered by a preionization discharge. The laser is, when used for most purposes, small enough so that several can be set up in the same laboratory room. The cost of the equipment might be between £500 and £2,000, mostly for mirrors and ancillary equipment such as oscilloscopes and detectors which would be found in any laser laboratory. A Pin-Bar laser could be built in a few days by anybody who had built one before, but a double discharge laser might take several weeks because of the complex machining operations which can be involved. Building a TEA laser is not "Big Science."

In the summer of 1971, I located seven British laboratories who had built, or were building, TEA lasers. This was eighteen months after the first news of the device from Origin, and some months before any device became available commercially. The laboratories were found by a snowball technique: I asked at each location for the names of others making TEA lasers. Three

other methods were used to test the efficacy of this process and to search for isolates: a question-naire sent to every physics department in the country; a check on research applications to the Science Research Council; and a search of literature citing the original papers in the field. No isolates were found, and the three methods located only three, four, and one laboratory respectively; all of these had been picked up by the snowball sample. Members of these laboratories were then interviewed in some depth. Interviews generally involved considerable semitechnical discussion and a tour of the laboratory. Subsequently, it has been possible to interview at the five North American laboratories which were involved in the transfer of the technique into Britain.[22] Interviews with the British laboratories continue, from time to time, and occasionally I have found myself playing an active role in the communication network.

The seven British laboratories involved consist of one government defense research labora-tory (referred to as "Grimbledon"), one other government-run laboratory ("Whitehall"), and five university departments of physics or applied physics ("Seawich," important as a gatekeeper; "Baird," the only Scottish university; and "A," "B" and "C"). The research of four of the labora-tories involves, though not exclusively, development and improvement of the laser, while in the case of the other three concern is overridingly with the provision of a beam of radiation such as the TEA laser produces, for use in other experiments.[23] The North American laboratories (in Canada and the United States) consist of two government-run establishments ("Origin" and "X"), one university department ("Y"), and one industrial firm's research laboratories ("Z," treated as one unit on the diagram below because they interact in a complex manner with regard to their overall external information flows).

Patent rights to some variants of the laser have been sold to two Canadian firms by Origin and X. These firms are now manufacturing the laser, and one at least is having some success in selling the device as a scientific instrument. To date, however, only one has been sold to a British laboratory, in response to a failure in a programme of construction. In spite of their commercial interest, members of both Origin and X have published papers giving details of their lasers, read papers at conferences, and received visitors from all over the world, including Britain. For their licensees they have also provided engineers' drawings and continuing consultancy. There is no evidence (and because the Canadians are far ahead, no rationale) for industrially or militarily motivated secrecy regarding TEA laser design in Britain—though this may not be the case with regard to some of the applications for which the laser is being used. Devices which may be classed as "spin-offs" from laser research have in one or two cases been commercially exploited. All the laboratories involved in this study are concerned to publish articles in the scientific journals, and at the time of writing at least two of them have publications citing the original papers in the field. Others of the group have published results using the laser, but citing papers in other fields.

Though the prime concern of this paper is not to elucidate the social structure of a group of scientists, but rather to discuss the modes of transfer of real, usable knowledge among a set of scientists, it may be worthwhile to discuss the set briefly in terms of other criteria. Firstly, where they are linked bibliographically, it is into more than one subset. A bibliographical analysis would discover separate networks centered on, for instance, gas lasers, plasma physics, and spec-troscopy. These networks would themselves be likely to be much larger than the TEA laser set, and would contain members with no interest in TEA lasers. I have no information about the fre-quency of contact between members of the TEA set compared to that between members of these other networks. Secondly, in a discussion of types of scientific specialty, Law[24] distinguishes

between "technique- or methods-based" specialties, "theory-based" specialties, and "subject matter" specialties. It is not appropriate to assign the TEA set into one of these classes: for one thing, it is not large enough to be termed a specialty; and the TEA set seems to contain some members whose prime concern is laser-building technique, and others who are part of subject matter specialties. For instance, the plasma diagnosticians are concerned with the subject of nuclear fusion. The TEA set is a set of scientists with one problem in common, and other problems not in common.

## THE INVENTION AND CONSTRUCTION OF THE TEA LASER; THE DIFFUSION OF KNOWLEDGE

The process of development and construction of TEA lasers does not consist of the logical accumulation of packages of knowledge. The construction of the first device involved trial-and-error pragmatism in the face of written and verbal assurances that the principle could not possibly work. Because of this its construction seems to have taken most people by surprise. In retrospect, however, the idea of the Pin-Bar laser is very simple.

Serendipity was involved in the development of the double discharge laser, which grew in a quite unforeseen way out of attempts to improve the Pin-Bar system. This development was described as follows:

First of all we had rows of fins instead of pins, but this didn't work too well. We thought this might be because the field uniformity was too great so we put a row of trigger wires near the fins to disturb the field uniformity. Then we started finding out things. It did improve the discharge but there were delays involved. It definitely worked differently to the rationale we had when we first made it. . . .

Even today there is no clear idea about how to get this thing working properly. We are even now discovering things about how to control the performance of these devices, which are unknown. . . .

I have four theories (for how they work) which contradict each other. . . .

The crucial part (in getting a device to operate) is in the mechanical arrangements, and how you get the things all integrated together.

In the electrical characteristics of the mechanical structures. . . .

This is all the black art that goes into building radar transmitters.

Further pointers to the nonsystematic element in TEA laser development can be seen in the different details of design of electrode structures in different laboratories, and in the rival claims to the efficiency and power of these. Two of the laboratories which are part of the industrial firm "Z" are copying quite different types of double discharge laser, each with a rationale for the superiority of its own model. Sometimes there are total failures in construction. One British group (not included in my sample because they have only recently entered the field) report that they built what was, so far as they could see, an exact copy of a laser successfully operated elsewhere, which failed to work. They were at a loss to explain this, and had simply given up. Another respondent reports being particularly impressed by one design of laser because he had actually seen it working. Normally, he reports, laboratories don't demonstrate their big lasers, "because they don't work." They will work perhaps one day in five, unpredictably.

## THE ROLE OF THE LITERATURE IN THE TEA LASER GROUP

The first article submitted to a journal from Origin in late 1969 surprisingly was rejected, because it was, according to the referee's report, not particularly interesting. Subsequently, a news conference was held at Origin, and reports that the device had been built appeared in the scientific "news" press, in such journals as *Canadian Electronics, Laser Focus,* and *New Scientist.* Most British scientists first heard that the laser had been successfully operated from a small "note" in *New Scientist*[25] referring to a "Plywood Laser." (One version had been constructed using a plywood box as the lasing cavity.) The first article in the formal journals appeared six months later in *Applied Physics Letters* of 15 June 1970. This article provided more detail, but as events proved, insufficient to enable anyone to build a TEA laser. In fact, to date, no one to whom I have spoken has succeeded in building a TEA laser using written sources (including preprints and internal reports) as the sole source of information, though several unsuccessful attempts have been made, and there is now a considerable literature on the subject.[26] Here again, it is important to distinguish between the existence of publications and their contents,[27] for there is no doubt that at least the early articles in this field were intended as priority claims and little else.[28] Some respondents stated that the early articles would have been more misleading than helpful; another commented upon the growing trend of producing "pseudo publications," which appear to be full scientific articles, but in reality will keep back a certain amount. A member of Origin commented:

What you publish in an article is always enough to show that you've done it, but never enough to enable anyone else to do it. If they can do it then they know as much as you do.

It cannot be stated categorically that no laboratory could ever build a TEA laser using published sources only, for it is at least possible for the device to be reinvented without even reference to the literature.[29] It was the case, however, that in the diffusion network, as far as I have explored it, written means of communication served at best to keep scientists informed of what had been done and by whom. In most cases, this information would already be known from the conference grapevine, but in the one instance where journals were really important (first informing British workers that the Canadians had succeeded in producing the TEA laser) it was a rapid publication in the "news" press, rather than in the formal journals, which was the source. The major point is that the transmission of skills is not done through the medium of the written word.

## THE ACTUAL PROCESS OF KNOWLEDGE DIFFUSION

The laboratories studied here (other than Origin) actually learned to build working models of TEA lasers by contact with a source laboratory either by personal visits and telephone calls or by transfer of personnel.[30] The number of visits required depended to some extent upon the degree to which appropriate expertise already existed within the learning laboratory, but many capricious elements were also involved. Attempts at building which followed visits to successful laboratories often met with failure, and were backed up with more visits and phone calls. These failures were inevitable simply because the parameters of the device were not understood by the source laboratories themselves,[31] so that even when there was a close examination of the laser in a nonsecretive atmosphere, many crucial elements might be missed. For instance, a spokesman at Origin reports that it was only previous experience that enabled him to see that the success of a laser built by another laboratory depended on the inductance of their transformer, at that time

thought to be a quite insignificant element. A more remarkable example concerns the machining of the electrodes of one model of double discharge laser. Here the source laboratory provided information in the form of a set of equations for the so-called "Rogowski profiles," along with the impression that machining tolerances must be small. The difficulties involved in making the electrodes were found by one laboratory to be insuperable. In the meantime, another British laboratory had produced the shapes roughly from templates and a filing operation, and an American laboratory had simply used lengths of aluminium banister rail, both with complete success.

## NETWORK SHAPE

Figure 7-1 shows the main transfers of information which laboratories used in building their early TEA lasers. Visits between one laboratory and another are not included where they were unproductive. The dominant feature of the diffusion network is the lack of cooperation between British laboratories, other than Grimbledon. Initially a partial explanation of this might be thought to be that the six other labs did not know of each other's interest in the TEA laser. Figure 7-2, however, shows which British laboratories had heard of each other in connection with TEA laser building at the time of my initial survey in the summer of 1971.[32] Eight of the possible twenty-one links in Figure 7-2 are missing; that is, eight of the possible fifteen links between the six laboratories remaining if Grimbledon is removed. In many cases, then, universities were ignorant that others were struggling with, or had solved, the same problems as they themselves. But even when they learned the names of the others as a result of my interview, no new contacts were arranged.[33] It is also apparent that, in their contacts with Grimbledon, the question of the names of other laboratories doing this work was not a high priority; for Grimbledon could have supplied the complete list to any of them. Hence the factor of ignorance does not seem to have much value as an explanation of the lack of cooperation discovered.

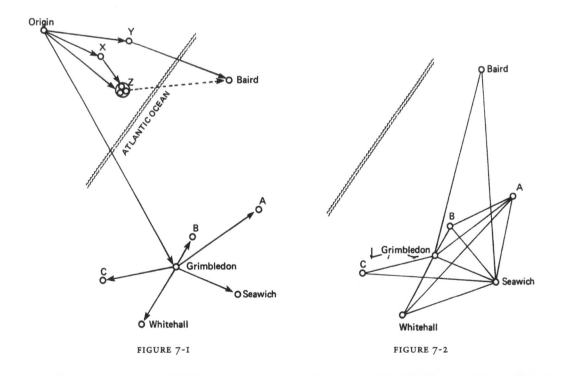

FIGURE 7-1                    FIGURE 7-2

Another factor might be simply that when a laboratory has developed a useful link with another, technically senior to itself (and Grimbledon was well in advance of all the others) there may be nothing to be gained from a collaborative link with a research peer. That this was by no means the whole explanation can be shown in three ways. Firstly, there was the case of the machining of the Rogowski profile electrodes mentioned above. A loss of perhaps six months and £2,000 could have been avoided by collaboration here. There is no reason to suppose that this situation is untypical, and members of most laboratories stated in the interview that they would in general be able to learn from research peers. Secondly, there is some evidence that Grimbledon became less accessible as time went on because the number of enquiries was proving to be a burden.[34] Thirdly, in some cases, universities which were late into the field did approach laboratories less advanced than Grimbledon, but were not received in a completely open manner. Hence there is evidence that cooperation between laboratories other than Grimbledon would have been useful, that Grimbledon would have welcomed relief from the pressure of enquiries upon itself, and that the universities were aware of these factors, both in the cases of the seekers of help and the potential sources.

Nobody reported that they were ever subject to an outright refusal of permission to visit another laboratory, and nearly everybody reported at the outset of my interview that they were "open for anybody to look around whenever they wanted." Tactics for maintaining secrecy—where there is no military or contractual obligation—are less forthright. Sometimes only parts of the set-up will be demonstrated. Thus one scientist reports of a visit to another laboratory:

They showed me roughly what it looked like but they wouldn't show me anything as to how they managed to damage mirrors. I had not a rebuff, but they were very cautious.[35]

A more subtle tactic is that of answering questions, but not actually volunteering information. This maintains the appearance of openness while many important items of information can be withheld because their importance will not occur to the questioner.[36] One scientist put it:

If someone comes here to look at the laser the normal approach is to answer their questions, but . . . although it's in our interests to answer their questions in an information exchange, we don't give our liberty.

Another remarked succinctly:

Let's say I've always told the truth, nothing but the truth, but not the whole truth.[37]

The major explanation for the lack of productive cooperation between the universities is to be found in their sense of competition with one another. Although this was sometimes direct competition (as in one case where an application for a research grant was turned down because of the similarity in the proposed project to that in another university), usually the feeling was more diffuse and extended to scientists working with different research goals. Several laboratories seemed to fear that all possible directions of research using the laser might be monopolized by the larger organizations. A typical comment was:

A small laboratory like this has to be fairly careful what we say to other people who have got larger laboratories and more facilities, because they might pick up our ideas and be able to go ahead faster and we do find this kind of barrier operating. There's nothing I would like more than to be able to tell everyone everything.

The explanation of Grimbledon's unique willingness to act as the "national gatekeeper," as it were, appears to be that it was sufficiently advanced and with sufficient resources, to be

quite secure from attacks upon its prestige from British universities. Thus they were not only the laboratory best equipped to supply laser-building skills but also the one with least to fear from doing so. This seems to account best for the persistence of the predominant star shape of the diffusion graph.

## EXTRASCIENTIFIC FACTORS INVOLVED IN INFORMATION LINKS

As stated, I have no evidence for or against any closure or boundedness of the set or sets of communicators of which these laboratories might be construed as being part, and as the notion of social group depends on some such element,[38] the assignation is not appropriate here. Nevertheless, it is the case that all but one of the links shown on Figure 7-1 involved more than simply the provision of laser-building information. Of the twelve links shown, six were preceded by a history of information exchanges—about, for instance, other types of laser, electronics, or laser output detection devices. Nearly every laboratory expressed a preference for giving information only to those who had something to return. Of these six links, three also involved elements of formal organization (between government laboratories) and one (between Grimbledon and Seawich) an earlier period of colleagueship and coauthorship (at another government laboratory). Of the five remaining links all included an element of direct or indirect acquaintanceship. Seawich played an important role here as a gateway to Grimbledon.[39] One of the relations within North America was set up as a result of a member of the seeking laboratory having been best man at the wedding of a member of a different department of the source laboratory. The one relationship set up simply by the expedient of writing a letter to the source laboratory threatened to be very brittle at first, but has since been reinforced by student placements at the source.

Four of the twelve transfers of information have involved a personnel transfer—on visiting fellowships, student placements, or just periods of work at the source laboratory. Of course, the investigation of such transfers is quite outside the scope of research which depends upon frequency of contact to define relations, such as some of the work criticized earlier in the paper.

The importance of friendship relations explains in part the isolation of Baird, the Scottish laboratory, from the other British laboratories, for while they had no special friendship links across the border one of their members remarked of the American scientists from whom they obtained their information, that:

these people of course had got a Ph.D. working in the same group under the same supervisor, albeit eight or ten years ago. But they're still one of our family.

In this group, then, extrascientific factors played an important part in the setting up of scientific communication relations, and to this extent some of the findings of the researches on social groups of scientists are corroborated.

## DISCUSSION AND CONCLUSION

My argument is that the nature of much scientific knowledge is such as to make it difficult to organize and hence difficult to investigate accurately with conventional sociological techniques. This argument is meant to apply to all scientific fields, but for methodological reasons one particular set (rather than a random sample) of scientists was chosen to illustrate the argument. Ipso facto this set is untypical of scientists in general and their area of science is untypical of science as

a whole. What is more, this area is probably untypically suitable for illustrating my thesis. This is because the field is new and little of the corresponding tacit knowledge will have been learned during the scientists' apprenticeships; and because experimental work is involved, so that much tacit knowledge is embodied in visible rather than abstract objects. It may then have been difficult to produce the appropriate demonstrations using an established field, or a theoretical field, as an exemplar. Indeed, many studies, using conventional techniques,[40] have suggested that theoreticians are not conscious of gaining much information from other than formal channels. Nevertheless, unless there is a serious mistake in the philosophical underpinnings of the argument, the caveat regarding the use of investigative techniques which treat all knowledge as homogeneously measurable must apply to theoretical science as well as experimental science,[41] for, as has been argued, a lack of consciousness of a source of knowledge is not the same as a lack of importance. The point is, as summed up by Ravetz:

in every one of its aspects, scientific inquiry is a craft activity depending on a body of knowledge which is informal and partly tacit.[42]

I have attempted to show the complexities and uncertainties involved in the transmission of one scientific craft. These include the overt concealment of information by scientists who feel that they are in competition with others, and the effect on information transmission of personal and biographical factors which have no relation with the scientific subject matter in question, as well as the less tangible barriers which are the main concern of this paper. In the process described, publications have appeared frequently in the journals, but seemed to have had no significant information content. Even in the case of informal communication, scientists have often made use of techniques which allow an appearance of openness alongside an underlying secrecy. In cases where there has been no deliberate secrecy, a systematic transfer of knowledge has sometimes been impossible, for the source scientist has not been aware of all the relevant parameters. Thus one or both scientists involved in an interaction can be unaware of whether or not usable knowledge is being transferred. Significantly, all the laboratories which acted as sources of knowledge had completed the task of building an operating TEA laser; no one could act as a middle man unless he was himself practised in the skill. This suggests that a participant in the flow of knowledge here was not simply a carrier of packages of information but a part of a small scientific culture.[43] In short, scientific knowledge is heterogeneous and its transmission is often capricious. This suggests that there might be a disjunction between the real sociological significance of interactions among scientists, and any data which can be gathered on this topic by the methods which have been conventionally used by sociologists and information scientists.[44]

I have not attempted to demonstrate that scientific specialties are not organized in social circles—though I have methodological reservations—but to suggest that the research methods used by others to demonstrate this have not yielded any structure with a significance for a sociological theory of scientific knowledge. A prerequisite of any such study must be an acknowledgment of the importance of all the elements and uses of scientific knowledge, not only the formal and informal elements, but the political, persuasive, and emotive, and even the intangible and unspeakable. It is possible to speak *about* that which cannot be spoken.

NOTES
An earlier draft of this paper was read at the British Sociological Association, Sociology of Science Study Group. Among others I wish to thank Colin Bell, Richard Whitley, and Stephen Cotgrove for help and encouragement, and David Edge and an anonymous referee for comments which have improved the paper considerably.

1. T. S. Kuhn, *The Structure of Scientific Revolutions* (Chicago: University of Chicago Press, 1962). The concept of "paradigm" is notoriously difficult to define, but perhaps this accounts for its fruitfulness. Kuhn himself writes:

> Given a set of necessary and sufficient conditions for identifying a theoretical entity, that entity can be eliminated from the ontology of a theory by substitution. In the absence of such rules, however, these entities are not eliminable; the theory then demands their existence. (197, footnote)

A complete definition of a concept is surely not a necessary prerequisite to its heuristic value.

2. Diana Crane, "Social Structure of a Group of Scientists: A Test of the Invisible College Hypothesis," *American Sociological Review*, 34 (1969), pp. 335–52; and *Invisible Colleges* (Chicago: University of Chicago Press, 1972); S. Crawford, "Internal Communication Among Scientists in Sleep Research," *Journal of American Society of Information Science*, 22 (1971), pp. 301–10; J. Gaston, "Big Science in Britain: A Sociological Study of the High Energy Physics Community" (Doctoral dissertation, Yale University, 1969), and "Communication and the Reward System of Science: A Study of a National Invisible College," *Sociological Review Monographs*, 18 (September 1972), pp. 25–41.

3. A "social circle" is a "fuzzy edged" group whose members associate more with each other than with outsiders in respect of one or more social relation. See C. Kadushin, "On Social Circles in Urban Life," *American Sociological Review*, 31 (1966), 786–802, and "Power, Influence and Social Circles," *American Sociological Review*, 33 (1968), pp. 685–99.

4. D. J. de Solla Price, *Little Science, Big Science* (New York: Columbia University Press, 1963).

5. The term is due to Mulkay. See M. Mulkay, *The Social Process of Innovation* (London: Macmillan, 1972). It is cited by Crane, *Invisible Colleges*, p. 26.

6. I use the term "sociology of science" as distinct from "sociology of scientists." Whitley's recent article is important here. See R. Whitley, "Black Boxism and the Sociology of Science: A Discussion of the Major Developments in the Field," *Sociological Review Monographs*, 18 (September 1972), pp. 61–92.

7. Crane, *Invisible Colleges*, pp. 1–2.

8. Price, *Little*, I, pp. 4, 5.

9. May's article showing the relative uselessness of much of the mathematical literature in one field is instructive, and many scientists will make similar comments about the literature in their own fields. See K. O. May, "Growth and Quality of the Mathematical Literature," *Isis*, 59 (1968), pp. 363–71.

10. The phrase is taken from Peter Winch, *The Idea of a Social Science* (London: Routledge & Kegan Paul, 1958). Both the notion of "tacit knowledge" (Polanyi) and the work of Kuhn are immanent in the philosophy of Wittgenstein, particularly *Philosophical Investigations* and *Remarks on the Foundations of Mathematics*. This is nicely brought out in the writings of Winch, a follower of Wittgenstein. For instance, he writes:

> Imagine a biochemist making certain observations and experiments as a result of which he discovers a new germ . . . assuming that the germ theory of disease is already well established in the scientific language he speaks. Now compare with this discovery the impact made by the first . . . introduction of a concept of germ into the language of medicine. This was a much more radically new departure, involving not merely a new factual discovery within an existing way of looking at things, but a completely new way of looking at the whole problem of the causation of diseases, the adoption of new diagnostic techniques, the asking of new kinds of questions about illnesses, and so on. In short, it involved the adoption of new ways of doing things by people involved, in one way or another, in medical practice. An account of the way in which social relations in the medical profession had been influenced by this new concept would include an account of what that concept was. Conversely, the concept itself is unintelligible apart from its relation to medical practice. (*The Idea of a Social Science*, p. 57)

and

> "Time" in relativity theory does not mean what it did in classical mechanics . . . (and) . . . we shall obscure the nature of this development if we think in terms of the building of new and better theories to explain one and the same set of facts; not because the facts themselves change independently, but because the scientists' criteria of relevance change. And this does not mean that earlier scientists had a wrong idea of what the facts were, they had the idea appropriate to the investigation they were conducting. ("Nature & Convention," *Proceedings of the Aristotelian Society*, 60 [May 1960], pp. 231–52.)

After writing this passage I received a preprint of an article from David Bloor entitled "Wittgenstein and Mannheim on the Sociology of Mathematics," since published in *Studies in the History and Philosophy of Science*, 4 (1973), pp. 173–91. Here Bloor discusses the implications for sociology of Wittgenstein's *Remarks on the Foundations of Mathematics* in a far more clear and complete way than I could hope to. Bloor also cites Winch, and is careful to disown the overall Winchian position that sociology is misbegotten philosophy; rather, he suggests that Winch unwittingly shows that the social sciences are required to illuminate philosophical problems. Ernest Gellner makes the same point in "The New Idealism—Cause and Meaning in the Social Sciences," in Lakatos and Musgrove (eds.), *Philosophy of Science* (Amsterdam: North Holland, 1968).

Gellner writes:

> If what matters is cultures, and these are the objects of the studies of social scientists, it follows that philoso-

phy and social sciences have the same subject matter, and the correct method in the one field is also the correct method in the other. From this he [Winch] tries—quite mistakenly in my view—to inform social scientists of the correct method in their field, by deduction from what he considers the correct method in philosophy; while the proper procedure is, it seems to me, to argue the other way, and conclude to the mistaken nature of the method in philosophy, from its inapplicability to the concrete objects of the social sciences. (400)

11. Winch, *Idea,* pp. 55–7.

12. T. Burns, "Models, Images and Myths," in E. G. Marquis and W. H. Gruber (eds.), *Factors in the Transfer of Technology* (Cambridge, Mass.: M.I.T. Press, 1969).

13. J. Ravetz, *Scientific Knowledge and Its Social Problems* (Oxford: Oxford University Press, 1971).

14. Bloor and Winch have clear and extended discussions of this type of point, drawn from Wittgenstein's *Remarks on the Foundations of Mathematics.* See note 10, above.

15. "The Strength of Weak Ties," *American Journal of Sociology,* 78 (1973), pp. 1360–80.

16. The argument is not that strong links and weak links define a larger network than strong links only—that is common sense. The argument is that weak links only define a larger network than strong links only, which is a considerable advance on common sense. In retrospect it is precisely this property of social relations which allows Kadushin's original use of the idea of "social circle." See Kadushin, *On Social Circles,* and its subsequent adoption by Crane. It is concentration on strong links which allows Crane to keep her social circles of scientists within manageable dimensions.

17. Crane, *Invisible Colleges,* p. 20.

18. It being the case that some sociometric measures are sensitive to even slight inaccuracies in data collection, there are grounds for suspicion of the results of studies like Crawford's on sleep researchers. Crawford's network is defined by the question, "Who have you contacted at least three times during the last year?" Part of her analysis is in terms of cliques and isolates, though cliques may be joined or split by the addition or subtraction of only one link. Further, the choice of the number of three contacts seems entirely arbitrary. It would be interesting to know the extent to which the network topology would be changed by the substitution of, say, two or four contacts per year. The same comments apply to her analysis of the network "core" defined by scientists who have at least three contacts per year with at least six others. See, for instance, J. C. Mitchell, "The Concept and Use of Social Networks," in J. C. Mitchell, *Social Networks in Urban Situations* (Manchester: Manchester University Press, 1969); and P. Abell and P. Doriean, *On the Concept of Structure in Sociology* (University of Essex, 1970, unpublished mimeograph).

19. e.g., Herbert Menzel, "Planned & Unplanned Scientific Communication," in B. Barber and W. Hirsch (eds.), *The Sociology of Science* (Glencoe: The Free Press, 1962), pp. 417–47.

20. Many non-sociological details are given so that the reader may judge how typical an area of science is dealt with here.

21. 1 torr = 1 mm. of mercury.

22. These interviews took place in the United States and Canada, and included an interview at Origin.

23. Projects involve the use of laser radiation for damaging surfaces, producing and examining plasmas, construction of a tunable source of laser radiation, and possibly weapons and radar research.

24. J. Law, "The Development of Specialties in Science: The Case of X-ray Protein Crystallography," *Science Studies,* 3 (1973), pp. 275–303.

25. January 22, 1970.

26. Papers citing the original article have appeared at a steady rate of about thirteen per quarter.

27. See M. J. Mulkay, "Conformity and Innovation in Science," *Sociological Review Monographs,* 18 (September 1972), 5–24, and F. Rief, "The Competitive World of the Pure Scientist," in N. Kaplan (ed.), *Science and Society* (New York: Rand McNally & Co., 1965), pp. 133–45.

28. This seems not to be true of more recent articles. A recent article in the *Review of Scientific Instruments* is most unusually detailed. It gives instructions for the construction of a double discharge laser which includes cross-sectional scale drawings, mechanical and electrical layouts, geometric coordinates, photographs and instructions for making a tool to perform the complex machining processes, and even lists of manufacturers' part numbers for the electronics, as well as for the laser body itself. One American university laboratory is attempting to build a laser following this article, but even in this case their first act was to phone the authors to make certain that the tolerances given were really correct, and as a result of this call have decided to machine the electrodes from graphite rather than aluminium, and to contract this work out. The outcome of this attempt should be interesting.

29. Grimbledon and a French laboratory were no more than six months behind Origin in the construction of a double discharge laser, but it seems that the simpler idea of the pin-bar device had not occurred to them.

30. Of the twelve links on Figure 7-1, four involved long-term movement of persons.

31. Some versions seem to work because the trigger pulse preionises the gas with a stream of electrons, and some with ultraviolet radiation.

32. Current developments have included a substantial flow of information back across the Atlantic, particularly from Grimbledon, who have perfected their own distinctive and quite successful design. In addition, the French laboratory involved in this work has had a considerable influence on Grimbledon, one other British laboratory (A) and

several transatlantic laboratories. Figure 7-1 shows the initial flows of information only, but in any case the situation holding between British laboratories has not changed substantially.

33. Later I deliberately fed information about usable progress in one laboratory to another. But they did not respond by trying to set up any information link.

34. One of the inventors of the device reports that this development program was halted for a full year as a result of demands for his appearance at conferences and lectures, etc. He calculates that in the year following the announcement of the device he traveled 86,000 miles.

35. I was allowed to see the apparatus in question at this laboratory. Presumably this was because of my technical noncompetitiveness.

36. Only detailed technical probing elicited the admission that this strategy was used.

37. There is probably an etiquette which governs the type of detail a visitor may ask for, and the type of record he may make of it. Memory is allowed, but photographs, for instance, are not.

38. Some of the confusion over this idea is discussed in Gaston, "Communication and the Reward System," p. 26.

39. Seawich also introduced me to this security-conscious laboratory.

40. e.g., Gaston, "Big Science in Britain."

41. I find the often-made distinction between science and technology too untidy to be useful. For an interesting discussion of this point see L. Sklair, *Organised Knowledge* (London: Hart-Davis MacGibbon, 1973), ch. 2.

42. Ravetz, *Scientific Knowledge*, p. 103.

43. Respondents twice described failed attempts to learn to build the laser from someone who "had all the particulars," but had not themselves built one. The point is that the unit of knowledge cannot be abstracted from the "carrier." The scientist, his culture, and skill are an integral part of what is known.

44. I am sure this disjunction explains conclusions such as Gaston's that in a relatively slow-moving scientific field, formal channels of communication would be sufficient if there were immediate publication when communications were received. Gaston, "Big Science in Britain." See also Garvey and Griffith, who seem to misunderstand the significance of interpersonal contact when they write: "Too often the only informal channel available is the inefficient and expensive one of persons seeking out a source, discovering its originator, and arranging to meet him face to face." W. D. Garvey and B. C. Griffith, "Scientific Communication as a Social System," *Science,* 157 (1967), pp. 1011–6.

# 8

# Objectivity and the Escape from Perspective

## LORRAINE DASTON

## DOES OBJECTIVITY HAVE A HISTORY?

Our usage of the word "objectivity" (French *objectivité;* German *Objektivität*) is hopelessly but revealingly confused. It refers at once to metaphysics, to methods, and to morals. We slide effortlessly from statements about the "objective truth" of a scientific claim, to those about the "objective procedures" that guarantee a finding, to those about the "objective manner" that qualifies a researcher. Current usage allows us to apply the word as an approximate synonym for the empirical (or, more narrowly, the factual); for the scientific, in the sense of public, empirically reliable knowledge; for impartiality-unto-self-effacement and the cold-blooded restraint of the emotions; for the rational, in the sense of compelling assent from all rational minds, be they lodged in human, Martian, or angelic bodies; and for the "really real," that is to say, objects in themselves independent of all minds except, perhaps, that of God. In its thick layering of oddly matched meanings—it is not self-evident, for example, what the repression of the emotions has to do with the ontological bedrock—our concept of objectivity betrays signs of a complicated and contingent history, much as the layering of potsherds, marble ruins, and rusted cars would bespeak the same in an archeological site.

This paper is meant as a modest contribution to that still nascent history. Insofar as objectivity has been a theme in recent science studies, it is questions of existence and legitimacy that have exercised discussants, rather than those of history. Neither the question of whether objectivity exists or not (and if it exists, which disciplines have it), nor that of whether it is a good or bad thing (the theme of some recent feminist literature),[1] will concern me here. All sides of these several debates have largely assumed that objectivity is and has been a monolithic and immutable concept, at least since the seventeenth century. So pervasive and apparently persuasive is this assumption that it is rarely even uttered. Those few works which mention objectivity and history in the same breath examine how various sciences—mechanics, optics, chemistry, biology—successively cross the threshold of objectivity at specific historical junctures, but the implication is that objectivity itself has no history.[2] Among philosophers, those who have written analytically about objectivity recognize (or exemplify) the conceptual fault lines that sunder its various mean-

ings, but all nevertheless treat it as a transhistorical given.[3] Few of these recent studies, even those most directly concerned with objectivity in the sciences or with the historical context in which objectivity allegedly emerged once and for all, seriously entertain the hypothesis that objectivity might have an ongoing history intimately linked to the history of scientific practices and ideals. Insofar as objectivity has a history for these writers, be they old-fashioned progressivists or new-fangled feminists, it has a birthday (usually a Cartesian one, either 1637 or 1644), when it allegedly arrives on the scene full grown and in full armour, like Athena from the head of Zeus.

In the face of such widespread conviction to the contrary, it would be natural to ask what grounds we have to believe that objectivity in the sciences *does* have a history. The conceptual layers I mentioned are a clue to that history, but concrete examples are needed to make the claim interesting as well as plausible. In what follows I shall sketch one episode in the history of objectivity—namely, the ascendance of the ideal of what I will call "aperspectival objectivity" in nineteenth-century science.

Aperspectival objectivity has been praised as "a method of understanding. . . . A view or form of thought is more objective than another if it relies less on the specifics of the individual's makeup and position in the world, or on the character of the particular type of creature he is";[4] it has also been blamed for

rul[ing] out . . . perception which can fool us; the body, which has its frailties; society, which has its pressures and special interests; memories, which can fade; mental images, which can differ from person to person; and imagination—especially metaphor and metonymy—which cannot fit the objectively given external world.[5]

Although aperspectival objectivity is only one component of our layered concept of objectivity, and a relatively recent one at that, it dominates current usage. Indeed, it is difficult for us to talk about objectivity without enlisting the metaphor of perspective or variants such as "point of view," "centerless," "stepping back," "climb[ing] outside of our own minds," or Thomas Nagel's brilliant oxymoron "view from nowhere." Aperspectival objectivity is both conceptually and, as I hope to show, historically distinct from the ontological aspect of objectivity that pursues the ultimate structure of reality, and from the mechanical aspect of objectivity that forbids judgment and interpretation in reporting and picturing scientific results.[6] Whereas ontological objectivity is about the world, and mechanical objectivity is about suppressing the universal human propensity to judge and to aestheticize, aperspectival objectivity is about eliminating individual (or occasionally group, as in the case of national styles or anthropomorphism) idiosyncrasies. Although all these idiosyncrasies came to be tarred with the same brush of subjectivity in the nineteenth century, they are by no means always handicaps: the ability to detect a faintly luminescent substance with the naked eye is as much an idiosyncrasy as a sluggish reaction time. Like all aspects of the current notion of objectivity, aperspectival objectivity is nowadays first and foremost associated with the natural sciences: both its possibility and desirability have been controversial in the social sciences since the turn of this century; and, in much of the recent philosophical literature, its very absence has been thought to be the hallmark of ethics.[7]

This was not always the case. I shall argue that aperspectival objectivity first made its appearance, not in the natural sciences, but rather in the moral and aesthetic philosophy of the latter half of the eighteenth century. Not only did it not figure prominently in the creed of natural scientists of this period; its enforcement would have been incompatible with the regimen of skill and hierarchy that then dictated scientific practice. Only in the middle decades of the nineteenth century was aperspectival objectivity imported and naturalized into the ethos of the

natural sciences, as a result of a reorganization of scientific life that multiplied professional contacts at every level, from the international commission to the well-staffed laboratory. Aperspectival objectivity became a scientific value when science came to consist in large part of communications that crossed boundaries of nationality, training, and skill. Indeed, the essence of aperspectival objectivity is communicability, narrowing the range of genuine knowledge to coincide with that of public knowledge. In the extreme case, aperspectival objectivity may even sacrifice deeper or more accurate knowledge to the demands of communicability.

My argument in support of these claims has four parts. I first give a very brief overview of the meanings of objectivity in the late eighteenth and early nineteenth centuries, in order to establish that what I have called aperspectival objectivity was not among them. I then examine the moral and aesthetic writings of Shaftesbury, Hume, and Adam Smith, where, inter alia, the concept is most fully developed. From there, I address the situation in the natural sciences, contrasting the nineteenth-century attempts to eliminate all traces of the personal with earlier practices. Finally, I conclude with some thoughts about how and why aperspectival objectivity took on moral overtones.

## WHAT OBJECTIVITY MEANT

The terms "objective" and "subjective" were native to scholastic philosophy, where they signified something quite different from what they do now: "objective" pertained chiefly to objects of thought, rather than to those of the external world. These terms were of ontological, not epistemological import in late medieval discussions of universals, and were flavoured with a strong Augustinian aftertaste: truly real objects were ideas in the divine mind.[8] Traces of the scholastic meaning of objectivity can be found in Descartes, who wrote of degrees of "objective reality" contained by various ideas,[9] and indeed in many eighteenth-century philosophical sources, at least in English and German. In French, *objectif* long vied with *positif* for approximately the same semantic territory; in the eighteenth century, the primary definition of *objectif* was that part of a microscope bearing the cognate name in English, with a secondary, ontological definition roughly denoting "degrees of intrinsic (as opposed to 'formal' or actual) reality."[10]

All of these medieval and early modern usages pertain to the word "objectivity," its variants and cognates, and these do not necessarily coincide with practices and ideals that we would now recognize as part of (or at least akin to) our conception of objectivity. For example, the codes of impartiality and disinterestedness developed by jurists in this period clearly capture some of the connotations of objectivity in our sense,[11] although these were not yet coupled with the word "objectivity." Moreover, as Peter Dear shows, some of these legal notions, along with legal procedures for the evaluation of testimony, were imported into early modern natural philosophy.[12] Yet it is still of importance to know when and how word and thing intersected, for the choice of which word to attach to which thing is never arbitrary. When, sometime around the turn of the nineteenth century, the word "objectivity" absorbed the juristic meanings of impartiality along with the philosophical associations of external physical objects, it did not lose its more ancient ontological penumbra. It is this slow process of accretion and absorption that accounts for the layered structure of the notion of objectivity, and it is the historian's problem to explain when and how it became possible to lodge such originally disparate meanings and associations under the same linguistic roof. This is why the history of objectivity must shuttle back and forth

between word and thing, attending to both. A history of the word without the thing risks degenerating into etymology; a history of the thing without the word risks anachronism.

A few eighteenth- and early-nineteenth-century philosophical texts (the word, if not the thing, being the near exclusive possession of philosophers and theologians during this period) will serve to illustrate the ontological import of the term. In 1744, Bishop Berkeley could still invoke the scholastic senses of the word without paradox or redundance: "Natural phenomena are only natural appearances. They are, therefore, such as we see and perceive them: Their real and objective natures are, therefore, the same";[13] here, "objective" means what is perceived, and is in principle distinguishable from the "real." But C. A. Crusius, writing in 1747, registers a shift in meaning closer to the modern sense, all the while preserving the older, theological overtones:

One divides the truth into the objective or metaphysical [*objektivische oder metaphysische*], which is nothing other than the reality or possibility of the object itself . . . [a]nd into the subjective or logicalistic [*subjektlivische oder logikalische*], which is the truth in a really existing mind. . . . all objective truth is thus in the divine mind a subjective truth.[14]

Here is a recognizable variant of our outside/inside version of the objective/subjective distinction, at least where mortal minds are concerned.

These are citations taken more or less at random, and they witness rather than fix the meanings of the word "objectivity" during this period. It is Kant who appropriated the old scholastic derivative *objektiv* as a technical term and gave it a new lease on life as a key concept in philosophy, albeit a concept that still differs significantly from our own. Kant's "objective validity" (*objektive Gültigkeit*) pertains not to external objects *in se,* but rather to the relational categories (such as time, space, and causality) which are the preconditions of experience.[15] For our purposes, Kant's own use of the term is less important than its adoption and adaptation by less nice-minded followers, such as Samuel Taylor Coleridge. It was Coleridge who seems to have reintroduced the term into English philosophical usage in 1817, and it was his creative misunderstanding of Kant that crystallized an opposition of objective and subjective which we can at last readily recognize if not wholly embrace:

Now the sum of all that is merely OBJECTIVE we will henceforth call NATURE, confining the term to its passive and material sense, as comprising all the phenomena by which its existence is made known to us. On the other hand the sum of all that is SUBJECTIVE, we may comprehend in the name SELF or INTELLIGENCE. Both conceptions are in necessary antithesis. Intelligence is conceived of as exclusively representative, nature as exclusively represented; the one conscious, the other as without consciousness.[16]

This gallop through the eighteenth- and early-nineteenth-century usage of the word "objectivity" and its variants in English, French, and German (all deriving and then diverging from the Latin terminology of scholasticism) is intended to make three points. First, "objectivity" concerned ontology, and, post-Kant, to some measure epistemology in a transcendental vein. It had little or nothing to do with emotional detachment, restraint from judgment, method and measurement, or empirical reliability. Second, its inseparable opposite, subjectivity in the sense of the mental, had yet to become a matter for regret or reproach. On the contrary: Coleridge branded our instinctive belief in the existence of things independent of us a "prejudice," and thought "[t]he highest perfection of natural philosophy would consist in the perfect spiritualization of the laws of nature into the laws of intuition and intellect."[17] Third, the perspectival metaphor that so permeates our discussions of objectivity is (so to speak) nowhere on view.[18]

# PERSPECTIVAL FLEXIBILITY

This is not to say that perspectivity and its entourage of metaphors were wholly absent from philosophical discussions during this period—only that they were not yet attached to objects, that is, to the scientific and philosophical problems of describing and understanding the natural world. Rather, the divergence, integration, and transcendence of individual perspectives were the province of moral philosophy and aesthetics. (The most notable exception is Leibniz's thoroughly perspectival metaphysics of the *Monadologie* [1714], but this remains an isolated case.) Here the problem of reconciling individual viewpoints on the same issue emerges full-blown, with the full complement of virtues we now attribute to objectivity (but not yet attached to that term): detachment, impartiality, disinterestedness, even self-effacement—all are enlisted to make shared, public knowledge possible. However, the issues that demand these virtues are not measurements of a cometary position or chemical observations, but rather the dramatic merit of a Roman comedy or the probity of accepting undeserved praise. Eighteenth- and nineteenth-century discussions of perspectivity agree in both their means (de-individualization, emotional distance) and ends (universal knowledge of one sort or another), but they treat very different objects: moral and aesthetic claims on the one hand, and scientific claims on the other.

Given the constraints of time and space, a few examples drawn from the eighteenth-century moral and aesthetic literature must suffice to make this contrast vivid. All those who maintained the existence of universal standards of the beautiful, such as Shaftesbury and Hume, had recourse to the language of individual perspective and critical self-effacement. Consider Hume's advice on judging works of art:

In like manner, when any work is addressed to the public, though I should have a friendship or enmity with the author, I must depart from this situation, and, considering myself as a man in general, forget, if possible, my individual being, and my peculiar circumstances. A person influenced by prejudice complies not with this condition, but obstinately maintains his natural position, without placing himself in that point of view which the performance supposes. . . . By this means his sentiments are perverted; nor have the same beauties and blemishes the same influence upon him, as if he had imposed a proper violence on his imagination, and had forgotten himself for a moment. So far his taste evidently departs from the true standard, and of consequence loses all credit and authority.[19]

Here are almost all the familiar elements of aperspectival objectivity: the peculiarities of an individual's "natural position" must be subdued by "forgetting" one's self in order to attain "the true standard." But the true standard here is that of "catholic and universal beauty," not that of material nature.

Hume's aesthetic version of aperspectival objectivity also departs from the later scientific sort in one other important particular: Hume recommends that the critic cultivate perspectival suppleness, the ability to assume myriad other points of view, rather than the total escape from perspective implied by the "view from nowhere." However, the step from such empathic virtuosity to detached objectivity was a short one, and did not require abandoning the human for the natural domain. Adam Smith's *Theory of Moral Sentiments* (1759) proceeds in incremental steps from the psychological tugs and pulls of sympathy, which transplant us at least partly into the minds and hearts of our fellows, to the more exalted demands of an idealized impartiality that transcends all particular viewpoints. The first promptings of a moral sense come from the irresistible and reciprocal sympathy that stirs the spectator to feel some of the anguish of the

sufferer, *and* the sufferer to approximate the cool indifference of the spectator. However, the psychological averaging of sympathy between sufferer and spectator may suffice to produce social concord but not a full-blown morality of duty and justice. Sympathy alone inflames only the desire for praise; a sense of duty and justice impels us further to the higher desire to be praise-worthy. The one works only under conditions of sociability and social surveillance; the other scrutinizes intentions as well as actions, and requires self-policing. Although the attentive reader may find a gap of argumentation between Smith's psychology of the impartial spectator and his deontology of the "man-within-the-breast," Smith himself apparently saw only a continuum. There is a progressive escalation of the adjectives deployed to describe the impartial spectator that gradually lifts him above any concrete identity, ascending from the "indifferent bystander" to the "great judge and arbiter." Using the designations almost interchangeably, Smith trans-formed the flesh-and-blood "impartial spectator," who sympathetically assumes any and all viewpoints, into the disembodied "man-within-the-breast," who rises above all particular view-points. The perspectival language is Smith's own:

In the same manner, to the selfish and original passions of human nature, the loss or gain of a very small interest of our own, appears to be of vastly more importance, excites a much more passionate joy or sor-row, a much more ardent desire or aversion, than the greatest concern of another with whom we have no particular connexion. His interests, as long as they are surveyed from this station, can never be put into the balance of our own. . . . Before we can make any proper comparison of those opposite interests, we must change our position. We must view them, neither from our own place nor from his, neither with our own eyes nor with his, but from the place and with the eyes of a third person, who has no particular con-nexion to either, and who judges with impartiality, between us.[20]

As in Hume's aesthetics, Smith blames deviation from the "true" moral standard on the prejudices of an unsuitable perspective, self-interest being at once the worst and most common of these per-spectival distortions. In this context, scientists were held to be exemplary by the eighteenth-cen-tury perspectival philosophers, but not because science was presumed free of particular perspectives—that is, "objective" in our latter-day sense. Rather, scientists were revered as paragons of the virtue of disinterestedness, both in the immediate sense of forsaking the motives of selfish gain, and in the more remote sense of remaining serene in the face of public apathy or contempt. Shaftesbury took the contemplative joy of the mathematician as the paradigm for all moral and aesthetic impulses that abandoned "private interest" and "self-good";[21] Adam Smith admired the indifference of the mathematician and natural philosopher to adverse public opinion as akin to the indifference of a wise man unjustly condemned for actions he himself knows to have conformed to the "exact rules of perfect propriety." In contrast to the endless bickering and intriguing of poets to prop up their reputations, Smith believed mathematicians and natural philosophers to be "almost always men of the most amiable simplicity of manners who live in good harmony with one another."[22] Smith's sanguine view of the character of savants was based on an overly credulous reading of the academic *éloges* of Fontenelle,[23] and was at times ludicrously inaccurate, as when he surmised that Newton had been so nonchalant about the public reception of the *Principia* that his "tranquillity . . . never suffered, upon that account, the interruption of a single quarter of an hour."[24] However, for our purposes, the accuracy of this image of the disinter-ested scientist is less important than its widespread currency and its putative grounds. Mathe-maticians and, to a lesser extent, natural philosophers were allegedly disinterested because indifferent to public opinion, and they were indifferent because the certainty or near certainty of

their "demonstrations" freed them from evaluations based only on "a certain nicety of taste." Thus, it was not so much the universality or physical materiality of scientific subject matter as the certainty of scientific arguments (even if evident initially only to their authors) that guaranteed scientists a certain enviable detachment in the eyes of the moral philosophers.

However, disinterestedness was hardly full-fledged aperspectival objectivity. As we have seen, the latter concept was not unknown to eighteenth-century thinkers, but its native soil was aesthetics and, especially, moral philosophy, not the natural sciences. It is in this moral realm, rather than in that of ontological objectivity, that the subjective—or the "private," as it was usually and more revealingly called—acquired an unsavoury odor. Kant could use the "subjective" and the "empirical," both belittled by a prefatory "merely," as near-synonyms in his treatment of duty, so remote was his moral conception of objectivity from the natural sciences. Yet there is an emblematic if uncharacteristic passage in Kant's first *Kritik* that heralds this shift in the meaning of objectivity towards public knowledge. Distinguishing between "objective grounds" for and "subjective causes" of belief, Kant linked the truth of an idea ("agreement with object") to the communicability of the idea: "The touchstone of belief [*Fürwahrhalten*], whether it is [objective] conviction or merely [subjective] persuasion, is thus, externally, the possibility of communicating it," for communicability is made possible both by the shared rationality of minds and the shared object to which the idea refers. Kant was careful to point out that communicability by itself was only a "subjective means" to overcome the privacy of one's judgment, and did not suffice to create full, "objective" persuasion.[25] Nevertheless, Kant's combination of the ontological meaning of a shared object, the epistemological meaning of shared reason, and the social meaning of shared information under the rubric of the "objective" invited a blurring of these distinctions, and proved prophetic of things to come. By the latter half of the nineteenth century, aperspectival objectivity had displaced (though not entirely replaced) ontological objectivity in philosophical discourse, and the natural sciences were touted as its fullest realization.

## APERSPECTIVAL OBJECTIVITY AS SCIENTIFIC OBJECTIVITY

The various kinds of objectivity might be classified by the different subjectivities they oppose. By the mid-nineteenth century, ontological objectivity had come to oppose consciousness per se, and mechanical objectivity opposed interpretation.[26] The aperspectival objectivity attributed to late-nineteenth-century science opposed the subjectivity of individual idiosyncracies, which substituted for the individual interests and "situations" analyzed by the eighteenth-century moral perspectivists. Just as the transcendence of individual viewpoints in deliberation and action seemed a precondition for a just and harmonious society to eighteenth-century moralists, so the transcendence of the same in science seemed to some nineteenth-century philosophers a precondition for a coherent scientific community. The existence of such a community, stretching over time and space, in turn seemed a precondition for—or even an eventual guarantee of—reaching scientific truth.

Charles Sanders Peirce conceived of this necessarily communal form of truth seeking as proceeding by a kind of symmetric cancellation of individual errors:

The individual may not live to reach the truth; there is a residuum of error in every individual's opinions.

No matter, it remains that there is a definite opinion to which the mind of man is, on the whole and in the long run, tending. . . . This final opinion, then, is independent, not indeed of thought in general, but of all that is arbitrary or individual in thought; it is quite independent of how you, or I, or any number of men think.

The objectively real is not that which eliminates the mental but that which eliminates individual idiosyncracy through the prolonged "averaging" of viewpoints by communication.[27] Scientific communication also lies near the heart of Gottlob Frege's conception of objectivity, his reputation as a metaphysical Platonist notwithstanding. Frege objected to a psychological treatment of logic because it would make scientific communication impossible: "Thus, I can also acknowledge thoughts as independent of me. Other men can grasp as much as I: I can acknowledge a science in which many can be engaged in research."[28]

Peirce and Frege bear philosophical witness to changes in scientific practices that wrought corresponding changes in scientific ideals during the middle decades of the nineteenth century. The scale and organization of scientific labour grew and became more complex: more people with more diverse training were in more frequent contact than ever before. Science had been collaborative, at least in principle, since the seventeenth century,[29] and cosmopolitanism was the leitmotif of Enlightenment science.[30] But the scientific province of the eighteenth-century Republic of Letters was not yet a scientific community in the modern sense: academies may have exchanged proceedings, and there were international collaborations like that which observed the transit of Venus in 1761, but the real communicative bonds were friendships (or enmities) between individual scientists, nourished by lifelong correspondences. These were highly selective bonds established between peers, and even if the relationship never progressed from pen-pals to face-to-face meetings, the correspondences often waxed from cordial to intimate, with personal revelations strewn among scientific findings.[31] In contrast, the contacts that knit together the nineteenth-century scientific world were at once more numerous, more heterogeneous, and more impersonal, although they never entirely displaced scientific friendships. For all the cosy *Gemeinschaft* associations of the term "scientific community," the actual relationships that welded it together were increasingly narrow and formal.

But welded together it was, not only by invisible girders that stretched across national and linguistic boundaries in the form of international journals, commissions, and congresses but also by the filaments that crisscrossed levels of skill, status, and training within and among laboratories and observing stations. Articles circulated across oceans and continents, measurements were exchanged, observations tallied, instruments calibrated, units and categories standardized. This bustle of scientific communication was in part made possible by better postal systems, railways, telegraphs, and the like, but it was not caused by these technologies. Nor was it simply the inevitable result of nature's uniformity, enabling many scattered observers to compare notes on universal phenomena. There was nothing inevitable about communicative science; it required hard work at every juncture: new instruments and new methods of data analysis were a precondition for amalgamating measurements made by far-flung observers;[32] international commissions met and wrangled over the standards and definitions that would make the result of, say, statistical or electrical research comparable;[33] scientific labor had to be divided and disciplined to equalize differences of skill and training.[34] The very phenomena had to be pruned and filtered, for some were too variable or capricious to travel well. Already in the eighteenth century, scientists had begun to edit their facts in the name of scientific sociability;[35] by the mid-nineteenth century, the contraction of nature to the communicable had become standard practice among scientists. It

would be an exaggeration, but not a distortion, to claim that it was scientific communication that was the precondition for the uniformity of nature rather than the reverse.

This is the context in which aperspectival objectivity became the creed of scientists, the ideal that corresponded to the practice of well-nigh constant, impersonal communication. As Theodore Porter has argued, certain forms of quantification have come to be allied with objectivity not because they necessarily mirror reality more accurately, but because they serve the ideal of communicability, especially across barriers of distance and distrust.[36] Aperspectival objectivity was the ethos of the interchangeable and therefore featureless observer—unmarked by nationality, by sensory dullness or acuity, by training or tradition; by quirky apparatus, by colourful writing style, or by any other idiosyncracy that might interfere with the communication, comparison, and accumulation of results. Scientists paid homage to this ideal by contrasting the individualism of the artist with the self-effacing cooperation of scientists, who no longer came in the singular—"l'art, c'est moi, la science, c'est nous," in Claude Bernard's epigram. Ernest Renan favoured the "more objective word *savoir*," in which "one is transported to the viewpoint of humanity," over *philosopher*, which conjured up "the subjective fact of the solitary thinker";[37] it became good form among scientists to write studiedly impersonal autobiographies, as in the cases of Darwin and Huxley.[38] Subjectivity became synonymous with the individual and solitude; objectivity, with the collective and conviviality.[39] The ethos of aperspectival objectivity had arrived.

In order to appreciate the novelty of this ethos in science, we must contrast it with the ideals and practices that preceded it. Differences of perspective, literal and figurative, were often remarked upon by natural philosophers of an earlier period. Leeuwenhoek, for example, wrote to the Royal Society of London that he and his artist had disagreed about the size of some "Flesh-fibres of a Whale" observed under the microscope, and provided drawings illustrating both his and the artist's view, "whence appears the difference of one Man's sight from another."[40] Disagreements between scientists and artists about what was seen and how to draw it were commonplace in the sciences of the eye,[41] and were a special case of the even more widespread distinction between competent and incompetent observers. Far from embracing the ideal of the interchangeable observer, seventeenth- and eighteenth-century scientists carefully weighted observation reports by the skill and integrity of the observer. Edmund Halley complained that many astronomical "meteors" "escape the Eyes of those that are best qualified to give a good Account of them," and was scrupulous in evaluating the quality of his own and others' observations of a solar eclipse.[42] Reports of scientific findings, particularly in the empirical sciences but sometimes even in mathematics, were emphatically cast in the first-person singular, for the skill and character (and occasionally social status) of the reporter were often as crucial to judging its worth as its contents.[43] Scientific correspondents may have not known one another personally in all cases, but they probed each other's abilities and trustworthiness with the same thoroughness and care they would have applied to the credentials of a banker about to be entrusted with a large sum of money. Even the testimony of nature could not always trump the testimony of a trusted colleague: when the Paris Académie des Sciences failed to replicate Johann Bernoulli's glowing barometers, even after repeated trials that followed Bernoulli's instructions to the letter, Perpetual Secretary Fontenelle preferred to appeal to the *bisarrerie* of nature than to doubt so eminent a witness's word.[44] Conversely, stacks of corroborative reports failed to move the Académie when the witnesses had low credibility in its eyes—for example, illiterate peasants observing meteorite falls.[45]

Seen against this background, we can better appreciate why aperspectival objectivity did not

figure prominently in eighteenth-century science. Impersonal communication and a refined division of scientific labour were the exception rather than the rule, and the ideal of the interchangeable observer would have exercised little attraction for observers proud of their own hardwon qualifications and alert to minute differences in the qualifications of others. We can also appreciate the high cost of the ideal of aperspectival objectivity, and of the practices that eventually established it in the natural sciences. Nineteenth-century scientists still sometimes complained about the anonymity of international journals in terms their eighteenth-century predecessors would have well understood; for example, in 1881 *The Lancet* reminded editors of their responsibility to "a certain number of readers, and especially those in foreign countries, [who] have no clue to the character of the author beyond the fact that they find his works in good company" in screening articles by contributors locally known to be "constitutionally incapable of telling the simple, literal truth as to their observations and experiments."[46] The distances and sheer numbers of writers and readers spanned by the new networks of scientific communication had undermined the old rules of trust and trustworthiness.

However, the principal casualty of the ideal and practices of aperspectival objectivity was not trust but skill. Skill did not fit comfortably into the enlarged, collective science of the latter half of the nineteenth century, for at least two reasons: first, it was rare and expensive and therefore could not be expected of all scientific workers; and second, it could be communicated at best with difficulty, if at all. As science expanded in the middle decades, so did its need for labor, preferably cheap labor. However, cheap labor was usually badly educated labor (with the notable exception of scientists' wives and sisters),[47] and Charles Babbage suggested that scientists follow the example of manufacturers in dividing tasks into their smallest, simplest parts to minimize the necessary scientific qualifications. Recounting how the French mathematician Prony had farmed out the computation of his logarithm tables to reckoners who could only add and subtract, Babbage pointed out that since this labor "may almost be termed mechanical, requiring the least knowledge and by far the greatest exertions," it "can always be purchased at an easy rate."[48] Babbage touted the accuracy of Prony's human computers, and Claude Bernard thought "an uneducated man" would be a less biased recorder of experimental results,[49] but there can be little doubt that the division of scientific labor altered the nature and distribution of scientific skill. The interchangeable observer was all too often the lowest common denominator observer. As Babbage himself remarked with characteristic crispness,

genius marks its tract, not by the observation of quantities inappreciable to any but the acutest senses, but by placing nature in such circumstances, that she is forced to record her minutest variations on so magnified a scale, that an observer, possessing ordinary faculties, shall find them legibly written.[50]

In short, skill was too aristocratic a trait for a democracy of scientific observers, where democracy carries the Tocquevillean associations of mediocrity.

Skill was also notoriously ineffable, as Zeno Swijtink has pointed out,[51] and therefore increasingly suspect among scientists who equated objectivity with communicability. Georges Cuvier expressed some of this discomfort in his *éloges* of physicians celebrated for their clinical tact, for the causes of their cures were inscrutable to all who were unable to "penetrate to [the physician's] most intimate thoughts . . . or be present at his sudden inspirations."[52] This discomfort had become acute by the time the physiologist Etienne Jules-Marey launched his campaign to replace the human senses with recording instruments. The advantage of, for example, the sphygmometer over the human pulse reader was not only that it leveled individual differences in

sensory sharpness and clinical tact—a relative greenhorn (or a low-paid technician or nurse) could fill in for the experienced physiologist or doctor. It was also that the sphygmometer and other self-inscribing instruments could convey results which language could not. What good was the exquisite skill of the practised pulse reader to science, queried Marey, if he could not communicate it: "How can he hope, by definitions or metaphors, to make the nature of a tactile sensation comprehensible [to others]?"[53] The problems of communicating skill and judgment acquired through long experience were not peculiar to medicine; astronomers and other observers also increasingly turned to statistical methods, the more mechanical the better, to standardize their results in a form immediately accessible to others.[54] The net result was often a loss of valuable information that had previously been an integral part of the observation report— whether the observer was suffering from a head cold, whether the telescope was wobbly, whether the air was choppy—but information too particular to person and place to conform to the strictures of aperspectival objectivity.

## CONCLUSION: THE MORAL HISTORY
## OF OBJECTIVITY

I hope I have by now made at least four points clear concerning the history of aperspectival objectivity: first, that it does not constitute the whole of objectivity, and that its relationships with other aspects of objectivity (for example, the ontological) are conceptually and historically problematic; second, that its first conceptual home was in aesthetics and moral philosophy, not the natural sciences, despite our current associations; third, that when it did emigrate to science in the mid-nineteenth century, it did so because of vast changes in the organization of science, both at a global and local level; and fourth, that the adoption of aperspectival objectivity as a scientific ideal was not without its costs. I have left many questions unanswered, chief among them how aperspectival objectivity came to be fused with the other meanings of objectivity into a single, if conglomerate concept. Why, for example, should public knowledge—observations most easily communicated to and replicated by as many people as possible—lay metaphysical claim to being the closest approximation of the real? These are knotty problems that would require a paper at least twice as long as this one; the best I can do here is to flag them *as* problems.

I would like to conclude with a reflection about the moral import of aperspectival objectivity. No one familiar with its past and present literature can overlook its admonishing, admiring tone. For these authors, there is a certain nobility in the abandonment of the personal, a sacrifice of the self for the collective—if not for the collective good, at least for the collective comprehension. It should be noted that these are entirely different grounds for moral applause than those of Adam Smith and the eighteenth-century moral philosophers, although the same terms "detachment" and "impartiality" are often invoked. Smith, it will be remembered, credited scientists and mathematicians with a certain admirable indifference to public opinion: secure in the knowledge that their work would ultimately be estimated at its true worth, they were immune to the vagaries of contemporary criticism. The detachment required of scientists by aperspectival objectivity was considerably more strenuous: scientists must not only wait to be recognized; they must now give up recognition altogether. Ernest Renan captured the self-denying import of aperspectival objectivity:

[The scientist's] goal is not to be read, but to insert one stone in the great edifice . . . the life of the scientist

can be summarized in two or three results, whose expression will occupy but a few lines or disappear completely in more advanced formulations.[55]

Claude Bernard exhorted scientists to bury their pride and vanity in order "to unite our efforts, instead of dividing them or nullifying them by personal disputes,"[56] for all scientists are ultimately equal in their anonymity:

In this fusion [of particular truths into general truths], the names of promoters of science disappear little by little, and the further science advances, the more it takes an impersonal form and detaches itself from the past.[57]

There is no doubt that these and kindred statements bespeak a high-minded ideal rather than a sociological reality: scientists may have given up writing in the first-person singular, but not signing their articles. There is also some justice in the accusation that in so burying their individual identities in the impersonal collectivity, scientists actually aggrandize rather than surrender their social and intellectual authority. But this is not the whole meaning of the self-denying demands of aperspectival objectivity. Even values honoured only in the breach are nevertheless genuine values, reflecting choices and revealing attitudes. Moreover, the values of aperspectival objectivity left visible traces in the conduct of scientists, in their ever stronger preference for mechanized observation and methods, in their ever more refined division of scientific labour, and in their ever more exclusive focus on the communicable. It would be difficult to explain the force of these values by appeal to either rationality or self-interest alone, and equally difficult to deny that aperspectival objectivity never shook off all traces of its origins in moral philosophy. In the self-denying counsels of aperspectival objectivity there still reverberates the stern voice of moral duty, and it is from its moral character, not from its metaphysical validity, that much of its force derives. The values of aperspectival objectivity are undeniably curious ones, and may well be of dubious merit. But moral values they undeniably are, and we must take this into account when we try to explain how our current confused usage of objectivity came to be. The history of objectivity is an intellectual and a social history, but it is a moral history as well.

## NOTES

This work was supported by U.S. National Science Foundation Grant No. DIR-8911169. I would like to thank Peter Dear and Theodore Porter for comments on an earlier version of this paper.

    1. See, for example, Susan Bordo, *The Flight to Objectivity: Essays on Cartesianism and Culture* (Albany, NY: State University of New York Press, 1987); and Evelyn Fox Keller, *Reflections on Gender and Science* (New Haven, CT: Yale University Press, 1985).

    2. Here I am thinking especially of Charles C. Gillespie's classic *The Edge of Objectivity: An Essay in the History of Scientific Ideas* (Princeton, NJ: Princeton University Press, 1960), which is a history of when and how various sciences attained objectivity, rather than of objectivity itself.

    3. See Karl Popper, *Objective Knowledge: An Evolutionary Approach* (Oxford: Oxford University Press, 1973); Richard Rorty, *Philosophy and the Mirror of Nature* (Princeton, NJ: Princeton University Press, 1979); Thomas Nagel, *The View from Nowhere* (Oxford: Oxford University Press, 1986); R. W. Newell, *Objectivity, Empiricism and Truth* (London: Routledge & Kegan Paul, 1986); and Helen E. Longino, *Science as Social Knowledge: Values and Objectivity in Scientific Inquiry* (Princeton, NJ: Princeton University Press, 1990).

    4. Nagel, *View*, pp. 4–5.

    5. George Lakoff, *Women, Fire, and Dangerous Things: What Categories Reveal about the Mind* (Chicago and London: The University of Chicago Press, 1987), p. 183.

    6. On ontological objectivity in its modern form, see Newell, *Objectivity*, pp. 16–38; on mechanical objectivity, see Lorraine Daston and Peter Galison, "The Image of Objectivity," *Representations* 40 (Fall 1992): pp. 81–128.

    7. Concerning the social sciences, see Max Weber, "Die 'Objectivität' sozialwissenschaftlicher und sozialpolitischer Erkenntnis" (1904), in Johannes Winckelman (ed.), *Gesammelte Aufsätze zur Wissenschaftslehre* (Tübingen: J.C.B. Mohr, 3d ed., 1968), pp. 146–214, and Robert Proctor, *Value-Free Science?* (Cambridge, MA: Harvard University Press, 1992); concerning ethics, see Bernard Williams, "The Scientific and the Ethical," in S.C. Brown (ed.), *Objectivity and*

*Cultural Divergence* (Cambridge: Cambridge University Press, 1984), pp. 209–28. For a discussion of the resurgence of "objective" ethics, see Samuel Scheffler, "Objectivity," *London Review of Books,* Vol. 12, No. 7 (September 13, 1990), pp. 9–10.

8. For examples of the scholastic meanings, see the article "Objective" in the *Oxford English Dictionary;* on Augustine's influence, see John F. Bowler, "Intuitive and Abstract Cognition," in Norman Kretzmann, Anthony Kenny, and Jan Pinborg (eds), *The Cambridge History of Later Medieval Philosophy* (Cambridge: Cambridge University Press, 1982), pp. 460–78.

9. See, especially, Meditation III, in René Descartes, *Meditationes de prima philosophia* (1641); also Calvin Normore, "Meaning and Objective Meaning: Descartes and His Sources," in Amelia Oksenberg Rorty (ed.), *Essays on Descartes' Meditations* (Berkeley, CA: University of California Press, 1986), pp. 223–42; and Peter Dear's "From Truth to Disinterestedness in the Seventeenth Century," *Social Studies of Science,* Vol. 22 (1992), pp. 619–31.

10. See, for example, the article "Objectif," *Dictionnaire de Trévoux* (Paris, 1762).

11. On the professional ethos of disinterestedness among lawyers, see Lucien Karpik, "Le Désinteréssement," *Annales: Economies, Sociétés, Civilisations,* Vol. 44 (May-June 1989), pp. 733–51.

12. See Dear, "From Truth"; also Steven Shapin and Simon Schaffer, *Leviathan and the Air-Pump: Hobbes, Boyle, and the Experimental Life* (Princeton, NJ: Princeton University Press, 1985).

13. George Berkeley, *Siris* (1744), Section 292, quoted in the *OED* article "Objective."

14. C. A. Crusius, *Weg zur Zuverlässigkeit and Gewißheit der menschlichen Erkenntnis* (1747), in G. Tonelli (ed.), *Die philosophischen Hauptwerke* (Hildesheim: Georg Olms, 1965), Vol. 3, p. 95.

15. Immanuel Kant, *Kritik der reinen Vernunft* (1781, 1787), A201-02/B246-47 et passim: Kant uses the word *Gegenstand* to denote the reality of external objects (as opposed to the objectivity of conceptions of objects). See Henry E. Allison's *Kant's Transcendental Idealism,* (New Haven and London: Yale University Press, 1983), pp. 134–55, for a lucid discussion of the distinction.

16. Samuel Taylor Coleridge, *Biographia Literaria* (1817), ed. J. Shawcross, 2 Vols. (Oxford: Oxford University Press, 1973), Vol. 1, p. 174.

17. Ibid., 178, p. 175.

18. I realize that there exists a distinguished philosophical literature which attributes a form of aperspectival objectivity to Descartes: see, for example, Bernard Williams, *Descartes: The Project of Pure Enquiry* (Hassocks, Sussex: Harvester Press, 1978), pp. 69–70; or Karsten Harries, "Descartes, Perspective, and the Angelic Eye," *Yale French Studies,* No. 49 (1973), pp. 28–42. I cannot here address these claims in the detail they deserve. However, I believe that they are the result of mistakenly collapsing the entire history of objectivity into a single moment, thus projecting current meanings and metaphors on to past usage. Here suffice it to remark that Descartes's epistemological worries concern the entire human species, not individuals, and that (in contrast to, say, Montaigne's discussions of morals and manners) the perspectival metaphor is rarely invoked.

19. David Hume, "Of Standards of Taste," in *Philosophical Works,* 4 Vols. (Edinburgh, 1826), Vol. 3, p. 271.

20. Adam Smith, *The Theory of Moral Sentiments* (1759), eds D. D. Raphael and A. L. Macfie (Oxford: Oxford University Press, 1976), p. 135.

21. Anthony, Earl of Shaftesbury, *Characteristics of Men, Manners, Opinions, Times, etc.* (1711), ed. John M. Robertson, 2 Vols. (London, 1900), Vol. 1, p. 296.

22. Smith, *Moral Sentiments,* p. 125.

23. On the motif of disinterestedness in the academic *éloges,* see Charles B. Paul, *Science and Immortality: The Eloges of the Paris Academy of Sciences (1699–1791)* (Berkeley, CA: University of California Press, 1980), and Dorinda Outram, "The Language of Natural Power: The 'Eloges' of George Cuvier and the Public Language of Nineteenth-Century Science," *History of Science,* Vol. 16 (1978), pp. 153–78. Concerning the importance of impartiality among enlightenment intellectuals, see Lorraine Daston, "The Ideal and Reality of the Republic of Letters in the Enlightenment," *Science in Context,* Vol. 4 (1991), pp. 367–86.

24. Smith, *Moral Sentiments,* p. 124.

25. Kant, *Kritik,* A820-22/B848-50.

26. See Daston and Galison, "The Image." The difference between perspectival and mechanical objectivity is brought into sharp focus by their contrasting responses to photography. The photograph is the emblem of mechanical objectivity because it appears to be a direct transcription of nature, free of meddlesome human interference. But perspectival objectivity rejects the photograph, because it preserves "[t]he unfamiliar angle of vision, the seemingly random cropping, which . . . can be understood as ways of stressing the necessary presence of the distinctive perceiving subject, the peculiarly individual point of view." Charles Rosen and Henri Zerner, *Romanticism and Realism: The Mythology of Nineteenth-Century Art* (New York: Viking, 1984), p. 110.

27. Charles Sanders Peirce, "A Critical Review of Berkeley's Idealism" (1871), in Philip Wiener (ed.), *Values in a Universe of Chance: Selected Writings of C. S. Peirce (1839–1914)* (New York: Dover, 1958), pp. 81–83.

28. G. Frege, "Thoughts," in Peter Geach (ed.), *Logical Investigations* (New Haven, CT: Yale University Press, 1977), 8–9; quoted in Thomas G. Ricketts, "Objectivity and Objecthood: Frege's Metaphysics of Judgment," in L. Haaparanta and J. Hintikka (eds), *Frege Synthesized* (Dordrecht: Reidel, 1986), pp. 65–95.

29. See, for example, the rather typical views of Marin Mersenne on the necessity of scientific cooperation: *Questions inouyes ou Recréations des Sçavans* (Paris, 1634), Qu. 30.

30. On the rise and fall of Enlightenment scientific cosmopolitanism, see Daston, "Ideal and Reality" and Lorraine Daston, "Scientific Neutrality and Nationalism under Napoleon," in T. Frängsmyr (ed.), *Solomon's House Revisited* (Canton, MA: Science History Publications, 1990), pp. 95–119.

31. For example, the correspondence between the electricians Charles Dufay and Stephen Gray, or that between the naturalists A. Jussieu and Joseph Banks. On the absence of a scientific community in the eighteenth century, see Wolf Lepenies, *Between Science and Literature: The Rise of Sociology,* trans. R. J. Hollingdale (Cambridge: Cambridge University Press, 1988), p. 2.

32. Zeno J. Swijtink, "The Objectification of Observation," in Lorenz Krüger et al. (eds), *The Probabilistic Revolution,* 2 Vols. (Cambridge, MA: MIT Press, 1987), Vol. 1, pp. 261–85.

33. On the standardization of statistical categories, see Alain Desrosières and Laurent Thevenot, *Les Catégories socioprofessionelles* (Paris: La Découverte, 1988); on electrical units, see Simon Schaffer, "Late Victorian Metrology and Its Instrumentation," this volume.

34. Simon Schaffer, "Astronomers Mark Time," *Science in Context,* Vol. 2 (1988), pp. 115–46.

35. Lorraine Daston, "The Cold Light of Facts and the Facts of Cold Light: Luminescence and the Transformation of Scientific Fact, 1600–1750," in David Rubin (ed), *Signs of Early Modern France II: 17th Century and Beyond* (Charlottesville, VA: Rockwood Press, 1997): pp. 17–44.

36. See Theodore M. Porter's "Quantification and the Accounting Ideal in Science," *Social Studies of Science,* Vol. 22 (1992), 633–52; also Porter, "Objectivity as Standardization: The Rhetoric of Impersonality in Measurement, Statistics, and Cost-Benefit Analysis," *Annals of Scholarship* 9 (1992): pp. 19–59.

37. Ernest Renan, *L'Avenir de la Science* (Paris, 1890), p. 91.

38. Regenia Gagnier, *Subjectivities: A History of Self-Representation in Britain 1832–1920* (Oxford: Oxford University Press, 1990), ch. 6.

39. On the tension between the ideals of solitude and conviviality, see Steven Shapin, "The Mind in Its Own Place: Science and Solitude in Seventeenth-Century England," *Science in Context,* Vol. 4 (1991), 191–218.

40. A. van Leeuwenhoek [Letter of 12 October 1713], *Philosophical Transactions of the Royal Society of London* (reprinted New York: Johnson Reprint, 1963), Vol. 29 (1714–16), pp. 55–56.

41. For other examples of attempts by scientists to police their artists, see Daston and Galison, "Image."

42. Edmund Halley, "Observations of the Late *Total Eclipse of the Sun . . . ,*" *Philosophical Transactions,* Vol. 29 (1714–16), pp. 245–62.

43. On the relationship between social status and trust in early modern English natural philosophy, see Steven Shapin, "'A Scholar and a Gentleman': The Problematic Identity of the Scientific Practitioner in Early Modern England," *History of Science,* Vol. 29 (1991), pp. 279–327.

44. [Bernard de Fontenelle], "Sur le phosphore du baromètre," *Histoire de l'Académie Royale des Sciences: Année 1701* (Paris, 1743), 1–8. See Steven Shapin, "O Henry," *Isis,* Vol. 78 (1987), pp. 417–24, concerning the de facto impossibility of doubting a colleague's word.

45. Ron Westrum, "Science and Social Intelligence about Anomalies: The Case of Meteorites," *Social Studies of Science,* Vol. 8 (1978), pp. 461–93.

46. John S. Billing, "Our Medical Literature'," *The Lancet* (1881), Vol. 2, pp. 265–70, at 270.

47. See Pnina Abir-Am and Dorinda Outram (eds), *Uneasy Careers and Intimate Lives: Women in Science, 1789–1979* (New Brunswick, NJ: Rutgers University Press, 1987), on this widespread and important form of scientific labor.

48. Charles Babbage, *On the Economy of Machinery and Manufactures* (London, 4th ed., 1835), 195. The mechanization of scientific work and the reproduction of scientific images also served the ideal of mechanical objectivity, by purportedly eliminating interpretation: see Daston and Galison, "Image."

49. Claude Bernard, *An Introduction to the Study of Experimental Medicine* (1865), trans. H. C. Greene (New York: Dover, 1957), p. 38.

50. Charles Babbage, *Reflections on the Decline of Science in England and on Some of its Causes* (1830), in Martin Campbell-Kelly (ed.), *The Works of Charles Babbage* (London: William Pickering, 1989), Vol. 7, p. 86.

51. See Swijtink, "Objectification." The best philosophical account of the "tacit" quality of scientific skill is still Michael Polanyi, *Personal Knowledge* (Chicago, IL: The University of Chicago Press, 1958). On the social invisibility of manual skill and technicians in science, see Steven Shapin, "The Invisible Technician," *American Scientist,* Vol. 77 (1989), pp. 554–63.

52. Georges Cuvier, *Recuil des éloges historiques lus dans les séances publiques de l'Institut de France* (Paris, 1861), Vol. 3, 4.

53. E. J. Marey, *Physiologie médicale de la circulation du sang* (1863), quoted in François Dagognet, *Etienne-Jules Marey: La Passion de la trace* (Paris: Hazen, 1987), p. 87.

54. See Swijtink, "Objectification," concerning the statistical treatment of outliers, and Desrosieres and Thevenot, *Catégories,* on the subtleties of statistical coding.

55. Renan, *Avenir,* p. 228.

56. Bernard, *Introduction,* p. 39.

57. Ibid., p. 42.

# 9

# Styles of Reasoning, Conceptual History, and the Emergence of Psychiatry

## ARNOLD I. DAVIDSON

The problem that will concern me in this essay is the following: What are the conditions under which various kinds of statements come to be comprehensible? Not everything is comprehensible at all times, either for individuals or for entire historical periods. I want to examine the conditions under which a corpus of statements, those statements that help to make up the discipline of psychiatry, become comprehensible. To be more precise, I am going to examine one particular form of this problem of comprehensibility, namely under what conditions can one comprehend various kinds of statements as being either true or false? Not every statement claims the status of being either true or false; but those statements that claim a scientific status do claim to be part of the domain of truth-and-falsehood. So my problem is, under what conditions did the statements of psychiatry come to be possible candidates for truth-and-falsehood and so come to claim the comprehensibility of a science?

In order to approach this problem here, I shall be preoccupied with a number of methodological questions, and these methodological questions will lead me to make use of two methodologically central notions, that of a style of reasoning and of a conceptual space and its history. Both notions are, to say the least, methodologically problematic. Styles of reasoning and conceptual spaces are largely metaphorical, and one aim of this essay is to give some philosophical detail to both these ideas. My paramount aim, however, is to show how these notions, despite their metaphorical appearance, really do help us to understand the emergence of psychiatry as an autonomous medical discipline. The emergence of psychiatry involved radical epistemological transformations, and we are likely to overlook them because psychiatry is today so much a part of our framework for understanding other human beings. But the historical conditions that made psychiatry and its diseases possible were quite specific, and, as I hope to show, if we forget these conditions, we are going to find ourselves in great philosophical difficulty. [ . . . ]

In beginning to characterize styles of reasoning, I want to start, so to speak, inside out. Rather than commencing with recent Anglo-American history and philosophy of science, I

want to start with its somewhat more philosophically alien French analogue. Specifically, I want to consider some suggestions of Michel Foucault, who stands in a line of distinguished French epistemologists of science beginning with Gaston Bachelard and running through Georges Canguilhem before it reaches Foucault. At the end of an interview, "Truth and Power," given in the late 1970s, Foucault makes two suggestions:[1]

"Truth" is to be understood as a system of ordered procedures for the production, regulation, distribution, circulation and operation of statements.

"Truth" is linked in a circular relation with systems of power which produce and sustain it, and to effects of power which it induces and which extend it. A "regime" of truth.

Since Foucault is usually his own best interpreter, I like to think of this first suggestion as his own succinct retrospective interpretation of his archaeological method, while the second suggestion is his equally succinct interpretation of his genealogical method. In attempting to understand both the notions of styles of reasoning and of conceptual spaces and their history, I shall take some clues from Foucault, concentrating on the first suggestion, which he calls the method of "archaeology."

If truth is understood as a system of ordered procedures for the production, regulation, distribution, circulation, and operation of statements, and if what is part of the domain of truth is itself variable throughout history, then it should not be surprising that Foucault has undertaken to write a history of truth. Of course, one might respond that it is one thing to write a history of truth and quite another to claim that, as Foucault's colleague at the Collège de France Paul Veyne has put it, there is no other truth than that of successive historical productions.[2] Foucault does not believe that there can be a useful epistemological theory of truth divorced from the variable historical conditions under which statements become candidates for the status of truth. Combining, in his own inimitable way, some lessons from Foucault with some from A.C. Crombie, Ian Hacking (to whom I shall return) has given us the most philosophically promising characterization of styles of reasoning to date. At the end of his paper "Language, Truth and Reason," Hacking makes some assertions and draws some inferences from them that he admits are all in need of clarification. But I shall quote all five of his claims here, since they provide the background for what I want to say about styles of reasoning:[3]

1. There are different styles of reasoning. Many of these are discernible in our own history. They emerge at definite points and have distinct trajectories of maturation. Some die out, others are still going strong.
2. Propositions of the sort that necessarily require reasoning to be substantiated have a positivity, a being true or false, only in consequence of the styles of reasoning in which they occur.
3. Hence many categories of possibility, of what may be true or false, are contingent upon historical events, namely the development of certain styles of reasoning.
4. It may be inferred that there are other categories of possibility than have emerged in our tradition.
5. We cannot reason as to whether alternative systems of reasoning are better or worse than ours, because the propositions to which we reason get their sense only from the method of reasoning employed. The propositions have no existence independent of the ways of reasoning towards them.

For my purposes here, the most important claims that Hacking makes are that there are different styles of reasoning and that these styles determine what statements are possible candidates for truth-or-falsehood (with the exception of those statements that require no style of reasoning at all). As new styles of reasoning develop, they bring with them new categories of possible true or

false statements. To take an example from Hacking, consider the following statement that you might find in a Renaissance medical textbook: "Mercury salve is good for syphilis because mercury is signed by the planet Mercury which signs the marketplace, where syphilis is contracted."[4] Hacking argues, correctly I think, that our best description of this statement is not as false or as incommensurable with current medical reasoning, but rather as not even a possible candidate for truth-or-falsehood, given our currently accepted styles of reasoning. But a style of reasoning central to the Renaissance, based on the concepts of resemblance and similitude, brings with it the candidacy of such a statement for the status of true or false. Categories of statements get their status as true or false vis-à-vis historically specifiable styles of reasoning.

If we take Hacking as having given us a preliminary characterization of styles of reasoning, where are we to look for further clarification? The most difficult problem, no doubt, is precisely that of more fully cashing out the notion of style, and the most obvious place to look for help is to characterizations of style in art history. [ . . . ] Indeed, it is Henrich Wölfflin's *Principles of Art History: The Problem of the Development of Style in Later Art* that will provide my guide in characterizing the notion of style in styles of reasoning. Although I am not unaware of the problems in Wölfflin's account, I am less concerned with the adequacy of its details than with its methodological procedure. Despite the objections one might bring to bear on this account as a whole, his procedure is highly instructive in helping us to understand the idea of a style of reasoning.[5] Wölfflin argues that the difference between the classic and baroque styles is best characterized in terms of five pairs of polar categories or concepts. Moreover, he argues that "there can be discovered in the history of a style a substratum of concepts referring to representation as such, and one could envisage a history of the development of occidental seeing, for which the variations in individual and national characteristics would cease to have any importance."[6] That is, Wölfflin wants to write a history of the visual possibilities to which artists are bound. Thus he will argue, to take a typical example, that the impression of reserve and dignity found in Raphael's paintings is "not entirely to be attributed to an intention born of a state of mind: it is rather a question of a representational form of his epoch which he only perfected in a certain way and used for his own ends."[7] Wölfflin's procedure in writing his history of style is, as is well known, to set forth the determining concepts of classic and baroque art in terms of five pairs of opposed concepts. His five major chapters discuss the linear and the painterly, plane and recession, closed and open form, multiplicity and unity, and clearness and unclearness. The first of each of these pairs of concepts makes up the classic style, and the second of each of the pairs makes up the baroque style. Since I cannot even begin to do justice to the richness of Wölfflin's account in this paper, I will let a quotation from the conclusion to his book serve as a summary:[8]

In its breadth, the whole process of the transformation of the imagination has been reduced to five pairs of concepts. We can call them categories of beholding without danger of confusion with Kant's categories. . . . It is possible that still other categories could be set up—I could not discover them—and those given here are not so closely related that they could not be imagined in a partly different combination. For all that, to a certain extent they involve each other and, provided we do not take the expression literally, we could call them five different views of one and the same thing. The linear-plastic is connected with the compact space-strata of the plane-style, just as the tectonically self-contained has a natural affinity with the independence of the component parts and perfected clarity. On the other hand, incomplete clarity of form and the unity of effect with depreciated component parts will of itself combine with the a-tectonic flux and find its place best in the impressionist-painterly conception. And if it looks as though the reces-

sional style did not necessarily belong to the same family, we can reply that its recessional tensions are exclusively based on visual effects which appeal to the eye only and not to plastic feeling.

We can make the tests. Among the reproductions illustrated there is hardly one which could not be utilised from any of the other points of view.

This summary gives some indication of Wölfflin's procedure in the book. He discusses in detail each of the five pairs of polar concepts, showing how they are exemplified in a wide variety of painting, drawing, sculpture, and architecture. He also shows how the concepts are linked together to constitute what we might think of as two opposed visual spaces, those of the classic and the baroque. In this way we get a determinate conception of classic and baroque style, framed in terms of their contrasted modes of representation. A similar methodological procedure in characterizing style is applied to architecture in an early book written by Wölfflin's former student Paul Frankl. Frankl argues that the differences between the Renaissance (classic) and baroque styles of architecture can be understood in terms of four polar concepts, spatial addition and spatial division, center of force and channel of force, one image and many images, and freedom and constraint.[9] Although his four pairs of polarities differ considerably from Wölfflin's, it is his methodological agreement with Wölfflin in characterizing distinct styles that interests me.

Given his understanding of the opposition between classic and baroque style, Wölfflin can formulate his famous thesis that "Even the most original talent cannot proceed beyond certain limits which are fixed for it by the date of its birth. Not everything is possible at all times, and certain thoughts can only be thought at certain stages of the development."[10] This claim might also have been found in a book by Foucault, since he too is concerned to show the possibilities to which our distinct historical periods bind us. And we should not be surprised to discover something akin to those discontinuities for which Foucault is famous appearing in Wölfflin when he writes:[11]

False judgments enter art history if we judge from the impression which pictures of different epochs, placed side by side, make on us. We must not interpret their various types of expression merely in terms of *Stimmung.* They speak a different language. Thus it is false to attempt an immediate comparison of a Bramante with a Bernini in architecture from the point of view of *Stimmung.* Bramante does not only incorporate a different ideal: his *mode of thought* is from the outset *differently organized* from Bernini's.

It is this conceptualization of style, with its polar categories, realms of limited possibilities, and breaks and discontinuities, that I believe needs to be adopted in trying to understand historically the change in styles of reasoning that gave rise to the emergence of psychiatry. [ . . . ]

In attempting to transfer Wölfflin's characterization of style to styles of reasoning, two differences are immediately evident. First, Wölfflin's five pairs of polar concepts are abstracted from painting, sculpture, and architecture. Since he is dealing with visual media, the concepts of linear/painterly, plane/recession, and so on, are obviously not used in the paintings and sculpture he discusses, but are rather Wölfflin's way of best describing the visual features of these arts. He used conceptual categories to capture the visual differences between two styles. In dealing with styles of reasoning in the sciences, however, we often find that the very concepts or categories that constitute a style are used in the sciences themselves. It is then a question of showing which concepts are fundamental to a scientific style and how they fit together to form the statements of the science, as well as demonstrating the historical specificity of the concepts. This is

most fruitfully done by following Wölfflin's procedure of using polar concepts to characterize opposed styles that are both historically specific and distinct. A second, related point is that Wölfflin was concerned with modes of visual representation, whereas in discussing styles of reasoning we are concerned with what might be called modes of conceptual representation. To be more specific, I will discuss two distinct stylistic modes of representing diseases, the anatomical and the psychiatric. In the latter, diseases are represented with a set of concepts that have no equivalent in the former. In characterizing the differences between anatomical and psychiatric styles of reasoning about disease, I will first emphasize some of the central concepts necessary to understand the emergence of psychiatry. So rather than first delimiting the polar concepts of two styles, I will concentrate on the conceptual peculiarities of psychiatry. Finally, I will conclude by offering some examples in which one can more clearly see some of the polarities that do distinguish anatomical and psychiatric reasoning.

In addition to attempting to understand the conditions of emergence of a psychiatric style of reasoning, I have two other aims in what follows. First, I hope to show what use can be made of the methodological notion of a conceptual space and its history; second, and just as important, I want to begin to try to demonstrate the advantages of this methodology, which I sometimes call conceptual history, over the kind of conceptual analysis most English-speaking philosophers have been taught to think of as occupying the center of philosophy. Unless we carefully examine the historical conditions under which our concepts emerge, we are liable to find ourselves surrounded by philosophical perplexity. [ . . . ]

One purpose of conceptual history lies in showing us that our concepts and their organization are marked by their historical origins, that we will not really understand the problems that many of our concepts give rise to, unless we trace out the conditions of their emergence, however remote from us those conditions may appear to be. In attempting to understand psychiatry's emergence, in the nineteenth century, as an autonomous medical discipline, and specifically its conceptual autonomy from neurology and cerebral pathology, I have been led, in other writings, to focus on the emergence of new disease categories. I have especially emphasized the decline of pathological anatomy as either an explanatory theory for so-called mental diseases and disorders, or the foundation for the classification and description of these diseases. The birth of psychiatry as a distinct medical discipline is simultaneous with the emergence of a new class of functional diseases, of which sexual perversion and hysteria were perhaps the two most prominent examples. Ultimately, these functional diseases were fully describable simply as functional deviations of some kind, diseases that did not have an anatomically localizable pathology. Elsewhere, I have tried to show some of the changes in styles of reasoning that were necessary in order for true or false statements about such functional diseases to become possible, and I have tried to write a history of the modern medical concept of perversion, which required showing the conditions under which perversion emerged as an object of medical knowledge.[12] Although I have claimed that there were no perverts before the later part of the nineteenth century, I do not want to repeat the arguments for that claim now. Rather, I would just like to summarize some of the results of my conceptual history of perversion, first, to show, as it were, the methodology in action, and, second, to indicate some of its advantages over the kind of conceptual analysis philosophers are accustomed to.

The best way to understand the nineteenth-century obsession with perversion is to examine the concept of the sexual instinct, for the actual conception of perversion underlying clinical thought was that of a functional disease of this instinct. That is to say, the class of diseases that

affected the sexual instinct was precisely the sexual perversions. A functional understanding of the instinct allowed one to isolate a set of disorders or diseases that were disturbances of the special functions of the instinct. Moreau (du Tours), in a book that influenced the first edition of Krafft-Ebing's *Psychopathia Sexualis*, argued that the clinical facts forced one to accept, as absolutely demonstrated, the psychic existence of a sixth sense, which he called the genital sense.[13] Although the notion of a genital sense may appear ludicrous, Moreau's characterization was adopted by subsequent French clinicians, and his phrase "sens génital" was preserved, by Charcot among others, as a translation of our "sexual instinct." The genital sense is just the sexual instinct, masquerading in different words. Its characterization as a sixth sense was a useful analogy. Just as one could become blind, or have acute vision, or be able to discriminate only a part of the color spectrum, and just as one might go deaf, or have abnormally sensitive hearing, or be able to hear only certain pitches, so too this sixth sense might be diminished, augmented, or perverted. What Moreau hoped to demonstrate was that this genital sense had special functions, distinct from the functions served by other organs, and that just as with the other senses, this sixth sense could be psychically disturbed without the proper working of other mental functions, either affective or intellectual, being harmed.[14] A demonstration such as Moreau's was essential in isolating diseases of sexuality as distinct morbid entities.

The *Oxford English Dictionary* reports that the first modern medical use in English of the concept of perversion occurred in 1842 in Dunglison's *Medical Lexicon*: "*Perversion,* one of the four modifications of function in disease: the three others being augmentation, diminution, and abolition."[15] The notions of perversion and function are inextricably intertwined. Once one offers a functional characterization of the sexual instinct, perversions become a natural class of diseases; and without this characterization there is really no conceptual room for this kind of disease. Whatever words of pathological anatomy he and others offered, it is clear that Krafft-Ebing understood the sexual instinct in a functional way. In his *Textbook on Insanity* Krafft-Ebing is unequivocal in his claim that life presents two instincts, those of self-preservation and sexuality; he insists that abnormal life presents no new instincts, although the instincts of self-preservation and sexuality "may be lessened, increased or manifested with perversion."[16] The sexual instinct was often compared with the instinct of self-preservation, which manifested itself in appetite. In his section "Disturbances of the Instincts," Krafft-Ebing first discusses the anomalies of the appetites, which he divides into three different kinds. There are increases of the appetite (hyperorexia), lessening of the appetite (anorexia), and perversions of the appetite, such as a "true impulse to eat spiders, toads, worms, human blood, etc."[17] Such a classification is exactly what one should expect on a functional understanding of the instinct. Anomalies of the sexual instinct are similarly classified as lessened or entirely wanting (anaesthesia), abnormally increased (hyperaesthesia), and perverse expression (paraesthesia); in addition there is a fourth class of anomalies of the sexual instinct, which consists in its manifestation outside the period of anatomical and physiological processes in the reproductive organs (paradoxia).[18] In both his *Textbook on Insanity* and *Psychopathia Sexualis,* Krafft-Ebing further divides the perversions into sadism, masochism, fetishism, and contrary sexual instinct.[19]

In order to be able to determine precisely what phenomena are functional disturbances or diseases of the sexual instinct, one must also, of course, specify what the normal or natural function of this instinct consists in. Without knowing what the normal function of the instinct is, everything and nothing could count as a functional disturbance. There would be no principled criterion to include or exclude any behavior from the disease category of perversion. So one

must first believe that there is a natural function of the sexual instinct and then believe that this function is quite determinate. One might have thought that questions as momentous as these would have received extensive discussion during the nineteenth-century heyday of perversion. But, remarkably enough, no such discussion appears. There is virtually *unargued unaminity* both on the fact that this instinct does have a natural function and on what that function is. Krafft-Ebing's view is representative here:[20]

During the time of the maturation of physiological processes in the reproductive glands, desires arise in the consciousness of the individual, which have for their purpose the perpetuation of the species (sexual instinct). . . . With opportunity for the natural satisfaction of the sexual instinct, every expression of it that does not correspond with the purpose of nature—i.e., propagation—must be regarded as perverse.

Nineteenth-century psychiatry silently adopted this conception of the function of the sexual instinct, and it was often taken as so natural as not to need explicit statement. It is not at all obvious why sadism, masochism, fetishism, and homosexuality should be treated as species of the same disease, for they appear to have no essential features in common. Yet if one takes the natural function of the sexual instinct to be propagation, it becomes possible to see why they were all classified together as perversions. They all manifest the same kind of perverse expression, the same basic kind of functional deviation. Thus this understanding of the instinct permits a *unified* treatment of perversion, allows one to place an apparently heterogeneous group of phenomena under the same natural disease-kind. Had anyone denied either that the sexual instinct has a natural function or that this function is procreation, diseases of perversion, as we understand them, would not have entered psychiatric nosology.

Although this truncates a long, convoluted story, it is enough for my purposes here. What I want to do now is contrast this kind of archaeology of the concept of perversion, buttressed as it is by its arcane methodology, with a justly famous, methodologically standard conceptual analysis. Thomas Nagel's "Sexual Perversion," published in 1969 and interestingly revised ten years later for inclusion in his collection *Mortal Questions,* is one of our most famous conceptual analyses, having spawned by itself almost an entire literature. Nagel's paper seems to me, even after all these years, still to be the best of its kind, and I would like to use it as an example of the methodological limitations of its kind of approach. Nagel's analysis proceeds, through an extraordinary coupling of Jean-Paul Sartre and Paul Grice, by way of an analysis of sexual desire, which "in the paradigm case of mutual desire . . . is a complex system of superimposed mutual perceptions."[21] Roughly put, and without any of Nagel's imaginative examples, he argues that in mutual sexual desire, $X$ desires that $Y$ desires that $X$ desires $Y$, and $Y$ desires that $X$ desires that $Y$ desires $X$—"It involves a desire that one's partner be aroused by the recognition of one's desire that he or she be aroused."[22] Nagel continues, "I believe that some version of this overlapping system of distinct sexual perceptions and interactions is the basic framework of any full-fledged sexual relation and that relations involving only part of the complex are significantly incomplete";[23] and finally "various familiar deviations constitute truncated or incomplete versions of the complete configuration, and may be regarded as perversions of the central impulse."[24] Reading this article, one is struck by the fact that, despite its interest, it seems to have very little to do with the concept of perversion. One's perplexity is increased by the first sentence of the article—"There is something to be learned about sex from the fact that we possess a concept of perversion"—and by Nagel's insistence that "if there are any sexual perversions, they will have to be sexual desires or practices that are in some sense unnatural, though the explanation of this

natural/unnatural distinction is of course the main problem."[25] This latter claim showed that Nagel inhabited the same conceptual space as late-nineteenth-century psychiatry, which was able to solve the main problem by offering a conceptually determinate and unambiguous distinction between the natural and unnatural; the theory of the sexual instinct played precisely this role. But when Nagel comes to give his account of perversion as a truncated or incomplete version of the system of superimposed mutual perceptions, the main problem of characterizing the natural/unnatural distinction seems to disappear. Indeed, in the original version of this paper, this distinction plays almost no role at all, even though Nagel also says there that it is the main problem. In the later version of the paper, an extremely interesting extra paragraph and a half is added. Nagel repeats his claim that familiar deviations constitute truncated or incomplete versions of the complete configuration of mutual perceptions, and then immediately adds: "The concept of perversion implies that a *normal* sexual development has been turned aside by distorting influences. I have little to say about this causal condition. But if perversions are in some sense *unnatural,* they must result from interference with the development of a capacity that is there potentially."[26] The next paragraph is concerned with how difficult it is to determine what causal influences are distorting, and Nagel eventually concludes, "We appear to need an independent [noncircular] criterion for a distorting influence, and we do not have one."[27] But if we cannot say what a distorting influence of normal sexual development is, then we cannot say what is natural or unnatural. And if we cannot distinguish the natural from the unnatural, then, by Nagel's own admission, we cannot make sense of the concept of perversion. Again, the theory of the sexual instinct, which was part of nineteenth-century psychiatry, was meant to serve precisely this role.

Consider finally what Nagel says about homosexuality. In the 1969 version of his paper he says, "It is not clear whether homosexuality is a perversion if that is measured by the standard of the described configuration, but it seems unlikely";[28] after a brief further discussion he concludes, "Certainly if homosexuality is a perversion, it is so in a very different sense from that in which shoe-fetishism is a perversion, for some version of the full range of interpersonal perceptions seems perfectly possible between two persons of the same sex."[29] Here is what he says in 1979: "Homosexuality cannot similarly be classed as a perversion on phenomenological grounds. Nothing rules out the full range of interpersonal perceptions between persons of the same sex. The issue then depends on whether homosexuality is produced by distorting influences that block or displace a natural tendency to heterosexual development. . . . The question is whether heterosexuality is the natural expression of male and female sexual dispositions that have not been distorted. It is an unclear question, and I do not know how to approach it."[30] I think it is clear what is going on here. Nagel wants to analyze the concept of perversion, and he is determined by the conceptual space of which that concept is part. In order to do what he claims he wants to do he must say something about the concepts of the natural and unnatural, normal sexual development, and distorting influences. These are concepts without which there is no space for the concept of sexual perversion. But what Nagel in fact does is to present a phenomenological account of ideal sexuality that has nothing to do with the concept of perversion, that makes no real use of the concepts of the natural and unnatural (and related concepts). According to the phenomenological account, certain kinds of sexual behavior need not fall short of the ideal. But it is an entirely different question as to whether they are perversions. Hence Nagel's difficulties in dealing with homosexuality. If we examine the historical conditions under which the concept of perversion emerged, we see that Nagel's claims are determined by those conditions

of emergence. On the other hand, his positive account ignores those conditions of emergence and offers us a description of sexuality that actually seems to have no room for the concept of perversion. This is no matter of mere words. Nagel's account is almost internally incoherent, purporting to analyze the concept of perversion but employing unrelated concepts; this creates deep theoretical problems for his account, as indicated by the differences in the two versions of his paper. If we undertake a conceptual history of perversion, we can explain why he has the theoretical difficulties that he does have. Both determined by the conditions of emergence of the concept and attempting to ignore them, he produces an account that cannot do what he wants it to do. Nagel is "shaped by pre-history, and only archeology can display its shape."[31]

I hope that this contrast between two methods for analyzing the concept of perversion begins to show what the significance and philosophical advantages of conceptual history are. Of course, in my own account here, I have only just begun to detail the conceptual space of psychiatry, and so to show which concepts make up the psychiatric style of reasoning. In previous work, I have discussed some of the differences between the anatomical and psychiatric styles of representing sexual diseases, and I have tried to supplement my conceptual history with a discussion of the distinctive habits of inference and analogy, and the different forms of explanation that characterize the two styles.[32] But since I want to follow Wölfflin's lead in understanding style, let me just assert that if we look at the history of neurology and psychiatry in the nineteenth century, we can begin to reconstruct some of the polar concepts that make up the two opposed styles. For example, we are presented with the polarities between organ and instinct, structure and function, and anatomical defect and perversion. The first of each of these pairs of concepts partially makes up the anatomical style of reasoning about disease, while the second of each of these pairs helps constitute the psychiatric style of reasoning. Just as Wölfflin's polarities differentiate two visual modes of representation, so these polarities distinguish two conceptual modes of representation. By figuring out exactly how the concepts combine with one another in determinate ways to form possible true-or-false statements, and by understanding the kinds of inference, analogy, evidence, and explanation that are linked to these conceptual combinations, we can reconstitute a full-fledged style of reasoning. It is only by engaging in this historical task that we will understand the nature of many of the philosophical problems we face. Crombie has described his enterprise as "a kind of comparative intellectual anthropology,"[33] and I have suggested that we understand it, in the first instance, as a comparative anthropology of concepts, sometimes labeled by its French practitioners not as anthropology but as archaeology. Call it what one will, I think it ought to play a crucial role in philosophical analysis.

Let me proceed to give some examples that I think will show how radically different anatomical and psychiatric styles of reasoning about disease actually were and still are. Like Foucault, I am concerned with how systems of knowledge shape us as subjects, how these systems literally make us subjects. Our categories and conceptualizations of the self determine not only how others view us but also how each person conceives of him- or herself. I am interested in the history of sexuality because I think that, in modern times, categories of sexuality have partially determined how we think of ourselves, have partially determined the shape of ourselves as subjects. Moreover, it is strategically useful to focus on the history of sexuality when discussing the emergence of psychiatric reasoning, since this history allows one clearly to exhibit two distinctive styles of reasoning. If we take the example of sexual identity and its disorders, we can see two systems of knowledge, exhibiting two styles of reasoning, as they are constituted in the nineteenth century. I will consider only one particular case of the anatomical style of reasoning, a case that

Foucault has made famous with his publication of the memoirs of the nineteenth-century French hermaphrodite Herculine Barbin. As Foucault points out in his introduction to the case of Herculine Barbin, in the Middle Ages both canon and civil law designated those people "hermaphrodites" in whom the two sexes were juxtaposed, in variable proportions. In some of these cases the father or godfather determined at the time of baptism which sex was to be retained. However, later, when it was time for these hermaphrodites to marry, they could decide for themselves whether they wished to retain the sex that had been assigned them, or whether they preferred instead the opposite sex. The only constraint was that they could not change their minds again, but had to keep the sex that they had chosen until the end of their lives.[34]

However, gradually in the eighteenth century, and into the nineteenth century, it came to be thought that everybody had one and only one real sex, and it became the task of the medical expert to decipher "the true sex that was hidden beneath ambiguous appearances,"[35] to find the one true sex of the so-called hermaphrodite. It is in this context that the case of Herculine Barbin must be placed. Adelaide Herculine Barbin, also known as Alexina or Abel Barbin, was raised as a girl, but was eventually recognized as really being a man. Given this determination of his true sexual identity, Barbin's civil status was changed, and being unable to adapt to his new identity, he committed suicide. The details of the case are fascinating, but my concern is with how medical science determined Herculine's real sexual identity. Here are some remarks from the doctor who first examined Barbin, and who published a report in 1860 in the *Annales d'hygiène publique et de médecine légale*. After describing Barbin's genital area, Dr. Chesnet asks:[36]

What shall we conclude from the above facts? Is Alexina a woman? She has a vulva, labia majora, and a feminine urethra. . . . She has a vagina. True, it is very short, very narrow; but after all, what is it if not a vagina? These are completely feminine attributes. Yes, but Alexina has never menstruated; the whole outer part of her body is that of a man, and my explorations did not enable me to find a womb. . . . Finally, to sum up the matter, ovoid bodies and spermatic cords are found by touch in a divided scrotum. *These are the real proofs of sex.* We can now conclude and say: Alexina is a man, hermaphroditic, no doubt, but with an obvious predominance of masculine sexual characteristics.

Notice that the real proofs of sex are to be found in the anatomical structure of Barbin's sexual organs.

Writing nine years later in the *Journal de l'anatomie et de la physiologie de l'homme*, Dr. E. Goujon definitively confirms Chesnet's conclusions by using that great technique of pathological anatomy, the autopsy. After discussing Barbin's external genital organs, Goujon offers a detailed account of his internal genital organs:[37]

Upon opening the body, one saw that the epididymis of the left testicle had passed through the ring; it was smaller than the right one; the vasa deferentia drew near each other behind and slightly below the bladder, and had normal connections with the seminal vesicles. Two ejaculatory canals, one on each side of the vagina, protruded from beneath the mucous membrane of the vagina and traveled from the vesicles to the vulvar orifice. The seminal vesicles, the right one being a little larger than the left, were distended by sperm that had a normal consistency.

All of medical science, with its style of pathological anatomy, agreed with August Tardieu when he claimed in his revealingly titled book *Question médico-légale de l'identité dans ses rapports avec les vices de conformation des organes sexuels* that, "to be sure, the appearances that are typical of the feminine sex were carried very far in his case, but both science and the law were nevertheless obliged to recognize the error and to recognize the true sex of this young man."[38]

Let me now bypass a number of decades. The year is 1913, and the great psychologist of sex Havelock Ellis has written a paper called "Sexo-Aesthetic Inversion" that appears in *Alienist and Neurologist*.[39] It begins as follows:[40]

By "sexual inversion," we mean exclusively such a change in a person's sexual impulses, the result of inborn constitution, that the impulse is turned towards individuals of the same sex, while all the other impulses and tastes may remain those of the sex to which the person by anatomical configuration belongs. There is, however, a wider kind of inversion, which not only covers much more than the direction of the sexual impulses, but may not, and indeed frequently does not, include the sexual impulse at all. This inversion is that by which a person's tastes and impulses are so altered that, if a man, he emphasizes and even exaggerates the feminine characteristics in his own person, delights in manifesting feminine aptitudes and very especially, finds peculiar satisfaction in dressing himself as a woman and adopting a woman's ways. Yet the subject of this perversion experiences the normal sexual attraction, though in some cases the general inversion of tastes may extend, it may be gradually, to the sexual impulses.

After describing some cases, Ellis writes further:[41]

The precise nature of aesthetic inversion can only be ascertained by presenting illustrative examples. There are at least two types of such cases; one, the most common kind, in which the inversion is mainly confined to the sphere of clothing, and another, less common but more complete, in which cross-dressing is regarded with comparative indifference but the subject so identifies himself with those of his physical and psychic traits which recall the opposite sex that he feels really to belong to that sex, although he has no delusion regarding his anatomical conformation.

It is significant that one name Ellis considers for this disorder, although he rejects it in favor of "sexo-aesthetic inversion," is "psychical hermaphroditism," but he believes that this latter designation is not quite accurate, because people who suffer from this anomaly "are not usually conscious of possessing the psychic dispositions of both sexes but only of one, the opposite sex."[42]

Ellis's discussion descends from the psychiatric style of reasoning that began, roughly speaking, in the second half of the nineteenth century. Sexual identity is no longer exclusively linked to the anatomical structure of one's internal and external genital organs. It is now a matter of impulses, tastes, aptitudes, satisfactions, and psychic traits. There is a whole new set of concepts that makes it possible to detach questions of sexual identity from facts about anatomy, a possibility that came about only with the emergence of a new style of reasoning. And with this new style of reasoning came entirely new kinds of sexual diseases and disorders. Psychiatric theories of sexual identity disorders were not false, but were rather not even candidates for truth-or-falsehood as little as a hundred and fifty years ago. Only with the birth of a psychiatric style of reasoning were there categories of evidence, verification, explanation, and so on, that allowed such theories to be either true or false. Rules for the production of true discourses about sexuality radically changed in the mid- to late nineteenth century. And lest you think that Ellis's discussion is anachronistic, I should point out that the third edition of the *Diagnostic and Statistical Manual of Mental Disorders* of the American Psychiatric Association discussed disorders of sexual identity in terms that are almost conceptually identical to those of Ellis. It calls these disorders, "characterized by the individual's feelings of discomfort and inappropriateness about his or her anatomic sex and by persistent behaviors generally associated with the other sex," Gender Identity Disorders.[43] We live with the legacy of this relatively recent psychiatric style of reasoning, so foreign to earlier medical theories of sex. So-called sex-change operations were not only technologically impossible in earlier centuries; they were conceptually unintelligible as well.

Here is one final piece of evidence about stylistic changes in representing diseases, this time some visual evidence. It was not uncommon for eighteenth- and nineteenth-century medical textbooks to include drawings depicting hermaphrodites. These poor creatures were shown exhibiting their defective anatomy, the pathological structure of their organs revealing, for all to see, the condition of their diseased sexual identity. Their ambiguous status was an ambiguous anatomical status. But not too many decades later, a new iconography of sexual diseases was to appear. It is exemplified in the frontispiece to D. M. Rozier's tract on female masturbation.[44] When one opens this book, one is confronted by a drawing of a young woman. She is pale and looks as if she is in a state of mental and physical exhaustion. Her head is stiffly tilted toward her left, and her eyes are rolled back, unfocused, the pupils barely visible. She is a habitual masturbator; her body looks normal, but you can see her psyche, her personality, disintegrating before your very eyes. She stands as an emblem of psychiatric disorders, so distinct from her anatomically represented predecessors. Stanley Cavell has accurately captured the depth of the changes that have taken place between these two styles of representation when, concerning the natural and conventional, he writes, "Perhaps the idea of a new historical period is an idea of a generation whose natural reactions—not merely whose ideas or mores—diverge from the old; it is an idea of new (human) nature."[45] [ . . . ] Our experience of sexuality and its disorders is itself a part of just such a new human nature.

NOTES

1. Michel Foucault, "Truth and Power," in *Power/Knowledge* (New York: Pantheon, 1980), 133.

2. Veyne's remark occurs in a discussion of Foucault by some of France's leading historians: *Magazine Littéraire,* April 1977, 21.

3. Ian Hacking, "Language, Truth and Reason," in Martin Hollis and Steven Lukes, eds., *Rationality and Relativism* (Cambridge, Mass.: MIT Press, 1982), 64–65.

4. Ibid., 60.

5. Some of the problems with Wölfflin's account are discussed in section 5 of Meyer Schapiro, "Style," in Morris Philipson and Paul J. Gudel, eds., *Aesthetics Today,* rev. ed. (New York: New American Library, 1980).

6. Heinrich Wölfflin, *Principles of Art History: The Problem of the Development of Style in Later Art,* 7th ed. (New York: Dover, 1950).

7. Ibid.

8. Ibid., 227.

9. Paul Frankl, *Principles of Architectural History: The Four Phases of Architectural Style, 1420–1900* (Cambridge, Mass.: MIT Press, 1968).

10. Wölfflin, *Principles,* ix. The thesis is repeated on p. 11.

11. Ibid., 228.

12. Arnold I. Davidson, "Closing Up the Corpses," in G. Boulos, ed., *Meaning and Method* (Cambridge: Cambridge University Press, 1990). More detailed historical documentation for my claims can be found in that chapter.

13. Paul Moreau (du Tours), *Des aberrations du sense génésique* (Paris: Asselin, 1880), 2.

14. Ibid., 3.

15. *Oxford English Dictionary* (Oxford: Clarendon Press, 1933), s.v., 7:739.

16. Richard von Krafft-Ebing, *Textbook on Insanity* (Philadelphia: Davis, 1904), 79. Krafft-Ebing considers abolition to be the extreme case of diminution.

17. Ibid., 77–81.

18. Ibid., 81. This same classification is given in Richard von Krafft-Ebing, *Psychopathia Sexualis* (New York: Stein and Day, 1965), 34.

19. Krafft-Ebing, *Textbook,* 83–86; *Psychopathia,* 34–36.

20. Krafft-Ebing, *Psychopathia,* 16, 62–63; see also *Textbook,* 81. For other representative statements, see Albert Moll, *Perversions of the Sex Instinct* (Newark, NJ: Julian Press, 1931), 172, 182 (originally published in German in 1891); and Dr. Laupts (pseudonym of G. Saint-Paul), *L'homosexualité et les types homosexuels: Nouvelle édition de perversion et perversités sexuelles* (Paris: Vigot, 1910).

21. Thomas Nagel, "Sexual Perversion," in *Mortal Questions* (Cambridge: Cambridge University Press, 1979), 44.

22. Ibid., 47.

23. Ibid., 46.

24. Ibid., 48.

25. Ibid., 39.

26. Ibid., 48 (my emphasis).

27. Ibid., 50.

28. Thomas Nagel, "Sexual Perversion," *Journal of Philosophy* (16 January 1969): 15.

29. Ibid., 16.

30. Nagel, *Mortal Questions,* 50–51.

31. Ian Hacking, "Proof and Eternal Truths: Descartes and Leibniz," in S. Geukroger, ed., *Descartes: Philosophy, Mathematics and Physics,* (New York: Barnes and Noble, 1980), 169.

32. See n. 12.

33. A. C. Crombie, "Philosophical Presuppositions and Shifting Interpretations of Galileo," in J. Hinfikka, D. Gruedner, and E. Agazzi, eds., *Theory Change* (Dorohecht: Reidel, 1981), 283.

34. Michel Foucault, *Herculine Barbin, Being the Recently Discovered Memoirs of a Nineteenth-Century French Hermaphrodite* (New York: Pantheon, 1980), vii–viii.

35. Ibid., viii.

36. Ibid., 127–28 (my emphasis).

37. Ibid., 135–36.

38. Ibid., 123. Tardieu's book was published in 1874. Parts of it had previously appeared in the *Annales d'hygiène publique* in 1872. A fuller discussion of questions of sexual identity would have to consider this document in detail.

39. Havelock Ellis, "Sexo-Aesthetic Inversion," *Alienist and Neurologist* 34 (1913): 156–67.

40. Ibid., 156.

41. Ibid., 159.

42. Ibid., 158, n. 7.

43. American Psychiatric Association, *Diagnostic and Statistical Manual of Mental Disorders,* 3d ed. (Washington, D.C.: American Psychiatric Association, 1980), 261.

44. D. M. Rozier, *Des habitudes secrètes ou des maladies produites par l'onanisme chez les femmes* (Paris: Audin, 1830). For a discussion of the changing iconography of the insane, see Sander L. Gilman, *Seeing the Insane* (New York: John Wiley, 1982).

45. Stanley Cavell, *The Claim of Reason: Wittgenstein, Skepticism, Morality, and Tragedy* (Oxford: Clarendon Press, 1979), 121.

# 10

# Trading Zone

## Coordinating Action and Belief

### PETER GALISON

PART I: INTERCALATION

#### INTRODUCTION: THE MANY CULTURES OF PHYSICS

I will argue this: science is disunified, and—against our first intuitions—it is precisely the *dis*unification of science that underpins its strength and stability. This argument stands in opposition to the tenets of two well-established philosophical movements: the logical positivists of the 1920s and 1930s who argued that unification underlies the coherence and stability of the sciences, and the antipositivists of the 1950s and 1960s who contended that disunification implies instability. In *Image and Logic,* I have tried to bring out just how partial a theory-centered, single culture view of physics must be. Forms of work, modes of demonstration, ontological commitment—all differ among the many traditions that compose physics at any given time in the twentieth century. In this chapter, drawing on related work in the history and philosophy of science, I will argue that even specialties within physics cannot be considered as homogeneous communities. Returning to the idea of intuition I have sketched elsewhere, I want to reflect at greater length on a description of physics that would neither be unified nor splintered into isolated fragments. I will call this multicultural history of the development of physics *intercalated,* because the many traditions coordinate with one another without homogenization. Different finite traditions of theorizing, experimenting, instrument making, and engineering meet—even transform one another—but for all that they do not lose their separate identities and practices.

To oversimplify one might say the following: the logical positivists took the unification project to involve the identification of a "basis" language of observation that would be foundational across all theory. Antipositivists conclusively (in my view) demolished the possibility of such a hard and fast line between experiment and theory, and concluded (rightly) that no such "protocol language" could exist. But their argument went further, to a vision of science in which not only were theory and experiment inextricable from one another but also they lost their separate dynamics to the point where it did not make sense to think about breaks in one sphere of activity without concomitant shifts in the other. There is another (logical/historiographical/philosophical) alternative: invert the quantifiers. Agree that there is no observation language

valid across every theory change, but at least leave open the possibility that for each change of theory (or experiment or instrumentation) there is a sphere of practice that continues unbroken. The burden of this chapter is to explore both historiographically and philosophically what it would mean to have such an intercalated history.

My original hope (which I sketch in part I of this chapter) was that such a laminated description of the larger community (composed of several subcultures) would do two things at once: it would underline the heterogeneity of practice within the wider physics community, while allowing continuities on one level to bolster discontinuities on another. Physicists' own experience of physics as maintaining a certain continuity even across conceptual breaks might, on this account, be ascribed to the local existence of continuity in the not purely conceptual arenas of practice.

But the more I pressed the laminated picture of intercalated practices (part II of this chapter), the more it seemed to delaminate. The criteria that divided the practitioners of theory, experiment, and instrumentation—different meetings, different preprint exchange, different journals—were the classic sociological dividers Kuhn (and many others since) productively invoked to identify distinct communities. Moreover, the experimenters and theorists often disagreed as to what entities there were, how they were classified, and how one demonstrated their existence—just the criteria Kuhn used to identify incommensurable systems of belief. With distinct communities and incommensurable beliefs, the layers seem to fall apart like decaying plywood; if they are significantly disconnected—if there are distinct communities using terms like *mass* and *energy* in significantly different ways—then the continuity of one level would hardly bolster discontinuity at another.

These considerations so exacerbated the problem that it seemed as if any two cultures (groups with very different systems of symbols, and procedures for their manipulation) would seem utterly condemned to passing one another without any possibility of significant interaction. But here we can learn from the anthropologists who regularly study unlike cultures that do interact, most notably by trade. Two groups can agree on rules of exchange even if they ascribe utterly different significance to the objects being exchanged; they may even disagree on the meaning of the exchange process itself. Nonetheless, the trading partners can hammer out a *local* coordination despite vast *global* differences. In an even more sophisticated way, cultures in interaction frequently establish contact languages, systems of discourse that can vary from the most function-specific jargons through semispecific pidgins, to full-fledged creoles rich enough to support activities as complex as poetry and metalinguistic reflection. The anthropological picture is relevant here. For in focusing on local coordination, not global meaning, I think one can understand the way engineers, experimenters, and theorists interact. At last I come to the connection between place, exchange, and knowledge production. But instead of looking at laboratories simply as the place where experimental information and strategies are generated, my concern is with the site—partly symbolic and partly spatial—where the local coordination between beliefs and action takes place. It is a domain I will call the trading zone.

## LOGICAL POSITIVISM: REDUCTION TO EXPERIENCE

Early in this century, the logical positivists sought to ground knowledge on the solid bedrock of experience. Rudolf Carnap's masterwork, *Der logische Aufbau der Welt* is usually translated as *The Logical Structure of the World,* but might better be construed as *The Logical Construction of the World.* For it is a construction, a building-up from the elementary bits of individual experi-

ence to physics, then to individual psychology, and eventually to the totality of all social and natural sciences. To secure the foundations of this construction, both Carnap and Otto Neurath argued at length that some form of "protocol statements" and their manipulation through logic would form a language that would guarantee the validity of complex inferences constructed with them. "We assumed," Carnap recalled later,

that there was a certain rock bottom of knowledge, the knowledge of the immediately given, which was indubitable. Every other kind of knowledge was supposed to be firmly supported by this basis and therefore likewise decidable with certainty. This was the picture which I had given in the *Logischer Aufbau*.[1]

Carnap had a picture of knowledge being built up like a building, from a firm foundation of observation through the upper stories of physical theory, and up from there to the autopsychological, the heteropsychological and the cultural.

Figure 10-1 might be helpful, encapsulating what I will call the positivists' "central metaphor"

| theory$_1$ | theory$_2$ | theory$_3$ | theory$_4$ |
|------------|------------|------------|------------|
| observation | | | |

FIGURE 10-1
*Positivist Periodization*

Historians begin any investigation, implicitly or explicitly, with a periodization—a methodological commitment that prescribes the breaks and continuities appropriate to the domain under study. By fastening on reports of experience as the basis and the unifier of all science, the positivists committed themselves to an unbroken, cumulative language of observation. For Carnap, theories carried no such guarantee—as long as they could account in a shorthand way for the results of experience, they would stay. But theories come and go, protocol statements would remain.

Historians of science participated in the positivist movement of the philosophers and scientists. It is no accident that the justly famous Harvard Case Histories in Experimental Science[2] chronicled *experimental* triumphs: Robert Boyle's uncovering of the gas law, Pasteur's inquiry into fermentation, and Lavoisier's overthrow of the idea of phlogiston. As the laboratory workers marched onward, it came as no surprise to the positivists, or to their historian-counterparts, that theory fractured. If the equation $PV = nRT$ better accommodated observation, let it stand; if oxygen organized the facts in the laboratory better than phlogiston, then leave phlogiston by the way. The unification of science occurred at the level of observation/experiment (no sharp distinction being made between them); and the stability of the scientific enterprise rested upon the belief that this continuous, unified "physicalist" language provided a continuous, progressive narrative through the history of science.

## ANTIPOSITIVISM: REDUCTION TO THEORY

The 1950s and 1960s saw a sharp reaction in both history and philosophy of science against the positivist picture. Quine denied the unrevisability of the Carnap/Neurath protocol statements, stressing that everything—even the general features of mathematics and logic—were up for revision; but if anything were to be privileged it would be high theory. Others went further. Most importantly the antipositivists insisted that no Carnapian protocol language could exist even in principle, a result sometimes referred to as *theory contamination* or *theory ladenness*.

Following the philosophers' lead—more than they might care to admit—historians of biology, chemistry, and physics adduced example after example in which theory changed first—and experiments then conformed to fit the mold.

Some of the leading antipositivists—including Thomas Kuhn and Russell Hanson—continued the positivists' fascination with early-twentieth-century Gestalt psychology and put it to new use. They now argued that theoretical changes shifted with the abruptness and totality of a Gestalt switch.[3] Just as the duck became a rabbit, experiments showing the absence of phlogiston now became experiments displaying the presence of oxygen. Theory changes *forced* changes all the way through experience, leaving no bit unaffected. Paul Feyerabend spelled out his antipathy for the positivists' central metaphor in no uncertain terms:

[My] thesis can be read as a philosophical thesis about the influence of theories on our observations. It then asserts that observations . . . are not merely theory-*laden* . . . but fully *theoretical* (observation statements have no "observational core"). But the thesis can also be read as a historical thesis concerning the use of theoretical terms by scientists. In this case it asserts that scientists often use theories to restructure abstract matters *as well as* phenomena, and that no part of the phenomena is exempt from the possibility of being restructured in this way.[4]

For Feyerabend, the distinction between theoretical and observational terms was "purely psychological," (as opposed to the privileged role that observation held for the Vienna Circle). Through his own historical examples from the time of Galileo and classical antiquity, and allusions to the wider historical and sociological literature, he contended, "We may even say that what is regarded as 'nature' at a particular time is our own product in the sense that all the features ascribed to it have first been invented by us and then used for bringing order into our surroundings." In a doctrine he linked to Kant, Feyerabend insisted on the "all-pervasive character of basic theory."[5] And while Feyerabend allows that in certain particular cases, there may be facts held in common for different competing theories, in general that is not so: "Experimental evidence does not consist of facts pure and simple, but of facts analysed, modelled, and manufactured according to some theory."[6] Sometimes theories shape the scientific community's treatment of error, sometimes theory fashions the criteria of data selection, and even more pervasively theory is used to express the data. As an epigraph for his views Feyerabend chose a morsel of Goethe: "Das Hoechste zu begreifen waere, dass alles Faktische schon Theorie ist."[7]

Kuhn's view similarly was grounded in a thoroughgoing attack on the possibility of a sense-data language:

The point-by-point comparison of two successive theories demands a language into which at least the empirical consequences of both can be translated without loss or change. . . . Ideally the primitive vocabulary of such a language would consist of pure sense-datum terms plus syntactic connectives. Philosophers have now abandoned hope of achieving any such ideal, but many of them continue to assume that theories can be compared by recourse to a basic vocabulary consisting entirely of words which are attached to nature in ways that are unproblematic and, to the extent necessary, independent of theory.[8]

This was the enemy: a neutral, unproblematic Archimedean point outside of a theoretical structure.

The positivist central metaphor was upended: now theory had primacy over experiment/observation, phenomena were no longer exempt from breaks. When theory changed, the rupture tore through the whole fabric of physics—including experiment/observation. Over such fissures in the tectonic plates of science nothing could cross. A new central metaphor replaced the old

FIGURE 10-2
*Antipositivist Periodization*

The antipositivists' central metaphor has been extraordinarily fruitful. It has precipitated new philosophical debates on meaning and reference, and novel historical insight into the practice of science. No longer could science be described in the fantasy world in which observation was simply cumulative, and in which theory was isolated from philosophical commitments, reduced to a mere shorthand for logical strings of protocol statements.

Both the positivist and antipositivist periodization have a grandeur to them—they both sought and found a single narrative line that would sustain the whole of science, in observation for the positivists and in theory for the antipositivists. Both agreed that language was the linchpin of science—though the positivists looked for a language of experience, and the antipositivists located the key terms in theory. The positivists concluded that the common foundation of all specialties in basic observations guaranteed the unity of science. By denying the possibility of this foundation, antipositivists, preeminently Kuhn, split even the single discipline of physics into a myriad of noncommunicating parts separated by "microrevolutions." All was tied to the language and reference of theory, and theory was multiply torn.

To enforce the Gestalt-switch character of the shift, it was necessary to insist that the moment of theory change was also the moment of empirical shift. I have tried to capture this image in Figure 10-2, now with the breaks of periodization occurring simultaneously at the theoretical and experimental levels. Furthermore, the *direction* of epistemic primacy has shifted from the empirical to the theoretical. The statement that it is impossible to communicate across empirical gaps appears in this image as the totality of the rupture through all layers of scientific practice. Or, said another way (Kuhn's way), it is the absence of a continuous substratum of common practice across the break that underlies the image of "different worlds," in which there is no overarching notion of progress. This is the thesis that has generated so much controversy in the community of historians and philosophers of science.

The central metaphor of the antipositivists has much to recommend it. By their critique of the positivist vision of a simply progressive empirical domain, the antipositivists drew attention to the dynamic role that theory plays in experimental practice. This created historiographical room to link theoretical concerns with the larger context of scientific work including philosophical commitments, ideological assumptions, or national styles of science. A myriad of interesting historical studies have revealed how theoretical notions significantly altered the construction, interpretation, and valuation of experimentally produced data. Moreover, there is no doubt—as the antipositivists persuasively argued—that there are breaks in the arena of observation. The systematic study of the attraction and repulsion of rubbed objects does not continuously meld into the later experimental investigations into electrostatics and then electrodynamics.[9]

Kuhnian antipositivism and logical positivism share the search for a universal procedure of scientific advancement and a view that language and reference form the chief difficulty in the analysis of the experiment/theory relation. But the ties between positivist and antipositivist go

much further. Both models have a well-established hierarchy that lends unity to the process of scientific work. True, they are flip-side versions of one another, but in their mirror reflections there is a good deal of similarity. The central metaphor of Figure 10-2 is an inverted version of Figure 10-1, with the special assumption—in Kuhn's case—that the important experimental and theoretical breaks occur contemporaneously. The unity of each account is, to a certain extent, enforced by the provision of a privileged vantage point, what the literary critics would call a "master narrative": in the case of the positivists it is from the "observational foundation"; in the case of the antipositivists it is from the theoretical "paradigm," "conceptual scheme," or "hard core" looking down and out.[10] This shared intuition that there are blocks of unified knowledge that, like tectonic plates, float past each other without linking has been expressed in many places and many ways.

As compelling as this antipositivist picture is, recent historical and philosophical work on experimentation suggests it needs revision. In the remainder of this paper, I would like to present an alternative sketch of the relation of experiment, theory and instruments reflecting this new work.

## INTERCALATION AND ANTIREDUCTIONISM

Like Gaul, the practice of twentieth-century physics is divided into three parts. Indeed, precisely those criteria that Kuhn laid out some years ago as being the key to identifying separate scientific communities[11] apply to the groupings of experiment, theory, and instrumentation. There are separate journals, such as *Nuclear Instruments and Methods* and *Reviews of Scientific Instruments* for and by those physicists and physicist/engineers concerned with the design and implementation of particle detectors, accelerator technology, and computer data analysis systems. So too are there specifically theoretical publications, including *Theoretical and Mathematical Physics* or the *Journal of Theoretical Physics*. And there are specifically experimental serials, such as the eminent series *Methods of Experimental Physics*. There are separate conferences on theoretical, experimental, and instrumental subjects. Furthermore, the invisible colleges defined by pre- and reprint exchange frequently fall within (not between) these stratifications. Strikingly, in recent decades, graduate students at many institutions are accepted qua experimenter or qua theorist, and increasingly Ph.D.'s are awarded for contributions to instrumentation, considered as a distinct arena of research from experimentation.[12] There are prominent workshops, conferences, and summer schools that segregate these different subcultures. Think of the Johns Hopkins Workshop on Current Problems in Particle Theory, which in a given year might focus on lattice gauge theory, supersymmetry, grand unification, or other topics; the World Conference of the International Nuclear Target Development Society (its members make beryllium plates, not ICBMs); the Winter School of Theoretical Physics in Karpacz. Quite obviously there are national and international laboratories dedicated to experimental physics, some with significant and others with tiny theoretical groups. Less evident are laboratories in industry or in universities (and sometimes sections *within* larger laboratories), devoted solely to the development of instrumentation. Theoreticians have fewer places to themselves, but they are not insignificant: the Institute for Theoretical Physics in Santa Barbara, the Institute for Theoretical Physics in Leningrad, and the International Center for Theoretical Physics in Trieste, to name but a few. Nor are such assemblies restricted to high energy or nuclear physics. Condensed matter theorists often convene without their experimental colleagues in order to discuss the theory of metals or many-body problems. Astronomers sometimes find it appropriate to meet about instrumental

techniques in the radio or optical domains, and when the quantum gravity theorists convene there are few experimentalists or instrumentalists. More recently, computation has arisen as a distinct arena from all of the above, and regular convocations of computer specialists assemble for workshops such as "Computing for High Luminosity and High Intensity Facilities."[13]

While defections from one arena to another are possible, they are rare and discouraged. (Particle physicists like to point to the brilliant exception, Enrico Fermi, who, in his youth, contributed both to theory and experiment; he is a physicist's hero precisely because he traversed a barrier that only a handful have crossed in the last fifty years.) For all these reasons, it has become increasingly awkward to treat physics and physicists as constituting a single, monolithic structure. As historians, we have become used to treating cultures as composed of subcultures with different dynamics. It is now a commonplace that the political dislocations of the French Revolution did not alter economics, social structure, politics, and cultural life in the same measure. Indeed, as Lynn Hunt has shown, even the political impact of the revolution was felt differently by workers concentrated in towns and textile workers dispersed over the countryside.[14] It is high time that we recognize that the physics community is no less complex. Experimentalists—and one could make a similar statement about theorists and instrumentalists—do not march in lockstep with theory. For example, the practice of experimental physics in the quantum mechanical revolution of 1926–27 was not violently dislocated *despite* the startling realignment of theory: spectroscopy continued unabated, as did measurements of specific heat and black-body radiation. And practitioners of these experimental arts continued, undaunted, to conduct a continuing dialogue with theorists across the great theoretical divide. Each subculture has its own rhythms of change, each has its own standards of demonstration, and each is embedded differently in the wider culture of institutions, practices, inventions, and ideas.[15]

Thus for historical reasons, instead of searching for a positivist central metaphor grounded in observation, or an antipositivist central metaphor grounded in theory, I suggest that we admit a wider class of periodization schemes, in which the three levels are *intercalated* (see Figure 10-3).

| | instrument$_1$ | | instrument$_2$ | | instrument$_3$ |
|---|---|---|---|---|---|
| theory$_1$ | | theory$_2$ | | theory$_3$ | |
| | experiment$_1$ | | experiment$_2$ | | experiment$_3$ |

time ⟶

FIGURE 10-3
*Intercalated Periodization*

Different quasi-autonomous traditions carry their own periodizations. There are four facets of this open-ended model that merit attention. First, it is tripartite, granting (or at least offering the possibility of granting) a partial autonomy to instrumentation, experimentation, and theory. It is contingent, not preordained, that each subculture be represented separately as one can easily identify moments in the history of physics where the instrument makers and the experimentalists (to give one example) were not truly distinct. Nor is it *always* the case that break points occur separately. And there are many times when there were competing experimental subcultures each working in the same domain (bubble chamber users and spark chamber users, for example). Second, this *class* of central metaphors incorporates one of the key insights of the antipositivists: *there is no absolutely continuous basis in observation.* Both the level of experimentation and the level of instrumentation have their break points, just as theory does. Third, the local continuities

are *intercalated*—we do not expect to see the abrupt changes of theory, experimentation, and instrumentation to occur simultaneously; in any case it is a matter of historical investigation to determine if they (contingently) do line up. Indeed, there are good reasons to expect that at the moment one stratum splits, workers in the others will do what they can to deploy accepted procedures that allow them to study the split before and after—when a radically new theory is introduced, we would expect experimenters to deploy their best-established instruments, not their unproven ones. Fourth, we expect a rough *parity* among the strata—no one level is privileged, no one subculture has the special position of narrating the right development of the field or serving as the reduction basis (the intercalated strands should really be drawn in three dimensions so no one is on top and each borders on the other two). Just as a bricklayer would not stack set the bricks for fear his whole building would collapse, each individual (or research group) does what it can to set breaks in one practice cluster against continuities in others. As a result of such local actions (not by global planning), the community as a whole does not stack periodize its subcultures.

Examples of the subsistence of experimental practices across theoretical breaks are now abundant in the new literature on experiment. For the first time there is a real interest in the dynamics of experiment outside the provision of data to induce, confirm, or refute specific theories. And among the philosophers, no one has done more than Hacking to separate the knowledge that emerges from the merely confirmatory role experiment usually plays in abstract accounts of scientific research.[16] Surely, then, Hacking would grant experimentation and the creation of phenomena just the sort of partial autonomy I have in mind with this class of periodization models. He would also agree that the experimental/phenomenal domain has its breaks.

Where I differ, perhaps, is in regard to parity among the subcultures. For while I am all for granting experimentation a life of its own, I do not think its life should come at the cost of poor theory's demise. More specifically, I read Hacking's work on the production of experimental entities this way: the possibility of intervening—making, moving, changing—is a way of imposing constraints on what can be the case. When it is possible to manipulate the objects, these restrictions are so severe that there is nothing for it, but to acknowledge the existence of electrons, positrons, or neutral currents.

Theory (or at least high theory), for Hacking, lacks the compulsive force of interventionist experimentation. For this reason he has defended an antirealism about theories and condemned those entities that theory alone demands—such as gravitational lenses or black holes.[17] But for many of the reasons Hacking originally defended the robustness of experiment, I want to defend the robustness of theory and of instrumentation: there are quasi-autonomous constraints on each level. When Duhem talks about the many theories that can each account for the data, he often has in mind positional astronomy as his example;[18] but most theoretical physics—such as particle physics or condensed matter theory—is as far from models of positional astronomy as the determination of Snell's law is from an experiment at SLAC. The theorist is *not* free to admit any particle or effect in order to come into harmony with the experimenter.

Experimenters come to believe in an effect for various reasons; one is the *stability* of the phenomenon—you change samples, you shift the temperature—and still the effect remains. Another road to the closure of an experiment involves the increasing *directness* of our probing of the phenomenon. By increasing the power of a microscope, the energy of a particle beam, the disposition of the apparatus, or the amplification of a signal, one probes further into the causal processes linking phenomena together.[19]

The theorist's experience is not so different. You try adding a minus sign to a term—but can't do it because the theory then violates parity; you try adding a term with more particles in it—forbidden because the theory now is nonrenormalizable and so demands an infinite number of parameters; you try leaving a particle out of the theory—now the law has uninterpretable probabilities; you subtract a different term and all your particles vanish into the vacuum; you split a term in two—now charge isn't conserved; and you still have to satisfy conservation laws of angular momentum, linear momentum, energy, lepton number, baryon number. Such constraints do not all issue axiomatically from a single, governing theory. Rather, they are the sum total of a myriad of interpenetrating commitments of theoretical, instrumental, and experimental practice: some, like the conservation of energy, centuries old. Others, like the demand for naturalness—that all free parameters arise in ratios on the order of unity—have their origin in recent memory. But taken together, the superposition of such constraints make some phenomena virtually impossible to posit, and others (such as the black hole) almost impossible to avoid.

Indeed, the astonishing thing about black holes is that they form (theoretically) in the face of enormous variations in the basic structure of our theory of matter. They don't depend on the details of this or that theory of the strong, the weak, or the electromagnetic force; and to remain consistent with other observations there is practically nothing one can do with the theory of gravity that would get in the way of the formation of black holes. The situation is similar with antiparticles. If one accepts special relativity and locality (the notion that cause and effect should be by near action, not action-at-a-distance) then changes in the charges of particles, the number of particles, the nature of forces, the existence or nonexistence of unification schemes all leave the basic symmetry intact: for every particle there is an antiparticle. This stubbornness against variation is the theoretical analogue of stability, and it is the experience of this stability that eventually brings theorists to accept such objects come what may (almost) from their experimentalist colleagues.

My sense of the heavily constrained nature of theoretical, experimental, and instrumental practice is what underlies my discontent with the heavy emphasis on the "plasticity" of physics. Constraints at the different levels allow theorists to come to beliefs about particles, interactions, electronic effects, stellar phenomena, black holes, and so on even when their experimental colleagues disagree or remain silent. The strength of the enterprise as a whole, on this view, emerges not because the domains of action are so plastic, but because they are so robust—and yet, despite that, fit together. The process by which this fitting occurs is emphatically not that either of a reduction to a protocol language or of a mutual translation of the two finite traditions. This is the intuition that motivates the historical material in *Image and Logic*, and the metahistorical reflections on it; the focus is on finite traditions with their own dynamics that are linked not by homogenization, but by *local coordination*.

## PART II. THE TRADING ZONE

### THE LOCALITY OF EXCHANGE

In an effort to capture both the differences between the subcultures and the felt possibility of communication, consider again the picture of intercalated periodizations discussed earlier but now focus on the boundaries between the strata. To characterize the interaction between the subcultures of instrumentation, experiment, and theory, I want to pursue the idea that these

really are subcultures of the larger culture of physics. Like two cultures, distinct but living near enough to trade, they can share some activities while diverging on many others. In particular, the two cultures may bring to what I will call the *trading zone* objects that carry radically different significance for the donor and recipient. What is crucial is that in the highly local context of the trading zone, *despite* the differences in classification, significance, and standards of demonstration, the two groups can collaborate. They can come to a consensus about the procedure of exchange, about the mechanisms to determine when the goods are "equal" to one another. They can even both understand that the continuation of exchange is a prerequisite to the survival of the larger culture of which they are part.

I intend the term trading zone to be taken seriously, as a social and intellectual mortar binding together the disunified traditions of experimenting, theorizing, and instrument building. Anthropologists are familiar with different cultures encountering one another through trade, even when the significance of the objects traded—and of the trade itself—may be utterly different for the two sides. For example, in the southern Cauco Valley, in Colombia, the mostly black peasants, descended from slaves, maintain a rich culture permeated with magical cycles, sorcery, and curing. They are also in constant contact with the powerful forces of the landowning classes: some of the peasants run shops, others work on the vast sugarcane farms. Daily life includes many levels of exchange between the two sides, in the purchase of goods, the payment of rent, and the disbursement of wages. And within this trading zone both sides are perfectly capable of working within established behavioral patterns. But the *understanding* each side has of the exchange of money is utterly different. For the white landowners, money is "neutral" and has a variety of natural properties; for example, it can accumulate into capital—money begets money. For the black peasants, funds obtained in certain ways have animistic, moral properties, though perhaps none more striking than the practice of the secret baptism of money. In this ritual, a godparent-to-be hides a peso note in his or her hand, while the Catholic priest baptizes the infant. According to local belief, the peso bill—rather than the child—is consequently baptized, the bill acquires the child's name, and the godparent-to-be becomes the godparent of the bill. While putting the bill into circulation, the owner quietly calls it by its name three times and the faithful pesos will return to the owner, accompanied by their kin, usually from the pocket of the recipient. So, when we narrow our gaze to the peasant buying eggs in a landowner's shop we may see two people, perfectly harmoniously exchanging items. In fact, they depend on the exchange for survival. Out of our narrow view, however, are two vastly different symbolic and cultural systems, embedding two perfectly incompatible valuations and understandings of the objects exchanged.[20]

In our case, theorists trade experimental predictions for experimentalists' results. Two things are noteworthy about the exchange. First, the two subcultures may altogether disagree about the implications of the information exchanged or its epistemic status. For example, as we have seen, theorists may predict the existence of an entity with profound conviction because it is inextricably tied to central tenets of their practice—for example, group symmetry, naturalness, renormalizability, covariance, or unitarity. The experimentalist may receive the prediction as something quite different, perhaps as no more than another curious hypothesis to try out on the next run of the data-analysis program. But despite these sharp differences, it is striking that there is a context *within* which there is a great deal of consensus. In this trading zone, phenomena are discussed by both sides. It is here that we find the classic encounters of experiment with theory: particle decays, fission, fusion, pulsars, magnetostriction, the creep effect, second sound, lasing, magnetic

deflection, and so on. It is the existence of such trading zones, and the highly constrained negotiations that proceed within them, that bind the otherwise disparate subcultures together.

## TRADING BETWEEN THEORY AND EXPERIMENT

The example of relativistic mass is an appropriate place to start because over the last thirty years it has become the *locus classicus* for discussions of meaning incommensurability. For Kuhn, the advent of Einsteinian dynamics was a prototype of revolutionary change and, he argued, only at low velocities could the two concepts of mass be measured in the same way.[21] On this view, one would expect there to be no experimental mode of comparison of Einstein's concept of mass and the concepts of mass his theory displaced—those of H. A. Lorentz, Max Abraham, and Henri Poincaré, none of whom shared Einstein's view of an operationally-defined space and time. Feyerabend simply says there is no single experiment: where it appears there is one measurement of mass there actually are several—one experiment for the classical mechanic and one for the relativist. Any scientist who thinks differently, according to Feyerabend, is an instrumentalist not interested in interpretation at all, or is "mistaken," or is simply such a remarkable translator that they "change back and forth between these theories with such speed that they seem to remain within a single domain of discourse."[22] None of these alternatives seem to capture what goes on between theorists and experimentalists.

There is no doubt that the term *mass* was used differently by the different participants in what was referred to as the physics of the electron. Max Abraham and Lorentz both believed that electrons' mass originated purely as the result of their interaction with their own electromagnetic fields. Since they also took electrons to be the basic building block of matter, the *electromagnetic mass* of the electron was the basis of a world view in which mechanical mass was a derivative concept, and electricity the primary substance of nature. But while Abraham took the electron to be a rigid sphere with a uniform surface charge, Lorentz postulated, in addition, that electrons were flattened as they moved through the ether, and he used this hypothesis to explain the Michelson-Morley experiment. Soon afterwards, Poincaré introduced a modified version of Lorentz's theory, adding a nonelectromagnetic force to keep the deformable electron from blowing apart under the stresses of its deformation.[23]

These theories differ significantly from one another about the meaning of mass. And as radical as these theories might have seemed at the time, Einstein's was surely as shocking. Einstein abandoned the attempt to embed his notion of mass in the grand scheme of the electromagnetic world picture, and founded his theory on a positivist critique of the metaphysical categories of space and time, replacing them with clocks and rulers.

Kuhn's claim is that prerelativistic and relativistic uses of the term *mass* make comparison impossible: "Only at low relative velocities may the [Newtonian and Einsteinian masses] be measured in the same way and even then they must not be conceived to be the same."[24] In fact, there was a rich experimental subculture preoccupied precisely with comparing these different theories—and not at low velocities. With Max Kaufmann and Alfred Bucherer leading the way, these experimenters produced experiment after experiment using magnetic and electric fields to measure the mass of the high-velocity electron perpendicularly to its velocity. Moreover, their efforts were clearly understood by all four of the relevant theorists (Poincaré, Lorentz, Abraham, and Einstein) to arbitrate among theories. Lorentz recognized the relevance of one such set to his work and immediately conceded defeat: "Unfortunately my hypothesis [explaining mass by] the flattening of electrons is in contradiction with Kaufmann's results, and I must abandon it. I am,

therefore, at the end of my Latin." These are not the words of someone for whom the experiment was irrelevant or incomprehensible. Only slightly less despairingly, Poincaré conceded that at "this moment the entire theory may well be threatened" by Kaufmann's data.[25] Einstein himself was more confident of his theory, and doubted the execution of Kaufmann's work; he did not challenge the relevance *in principle* of the results. Quite the contrary: Einstein went to considerable pains to produce predictions for the transverse mass of the electron so that Kaufmann and Bucherer could use their experimental methods to study the theory; he constructed a detailed analysis of Kaufmann's data; and he even designed his own modification of the electron-deflection experiments which he hoped someone would execute.[26] For the participants in the fast-electron experiments, there does not seem to be a problem in talking about the experiment or its proximate significance.

Feyerabend suggests that should scientists not acknowledge the existence of two (or presumably more) experiments lurking behind the apparent existence of just one, there were three possibilities. They could be instrumentalists. At least in the present case that would seem to be a hard position to defend. Einstein is famous for his insistence that his goal was to discover how much choice God had in his design of the universe. And while acknowledging that the axiomatic basis of theoretical physics could not be inferred from experience, he maintained throughout his life a deep-seated optimism about theoretical representations. "Can we hope to be guided safely by experience at all when there exist theories (such as classical mechanics) which to a large extent do justice to experience, without getting to the root of the matter? I answer without hesitation that there is, in my opinion, a right way, and that we are capable of finding it." He goes on to say that experience may suggest theoretical ideas in the formal structure of a theory, and experience surely must ultimately be the standard against which physical theories are certified. "But the creative principle resides in mathematics. In a certain sense, therefore, I hold it true that pure thought can grasp reality, as the ancients dreamed."[27] These are not the words of an instrumentalist.

Could it be that Einstein, Lorentz, Poincaré, and Abraham were superfast translators and so could remain in "a single domain of discourse"? Presumably one would look for instances where Einstein switched into the language and calculational practices of the adherents of the electromagnetic world view. Such evidence might be reflections on the details of the charge distribution within or on the surface of the electron, or dynamical explorations of the means by which the electron might resist electrostatic self-destruction, or methodological statements advocating electromagnetism as the starting point of physical theory. As far as I know there are no such examples of this kind of work in the published or unpublished record. On the side of Lorentz (or Poincaré or Abraham) one would look for the opposite: indications, perhaps in private, that these theorists alternated their calculations with ones beginning with Einstein's heuristic starting point. Even if direct methodological statements were not forthcoming, we would expect at least some calculations that began with simple mechanical reflections and set aside the structure of matter. Again, even among the unpublished papers, I know of no such indications. The third and last alternative that Feyerabend put forward was that a scientist who denied the "two experiments in one" interpretation was just plain "mistaken." Lorentz might simply not recognize that Einstein had a different programmatic commitment. But Lorentz once remarked that Einstein "simply postulates what we have deduced." Conversely Einstein explicitly argued that he did not believe that mechanics could be reduced to electromagnetism. Each side recognized the

gap that existed between their orientations, and that this gap was central to the present and future development of physical theory.

The lesson I want to draw from this example is this: despite the "global" differences in the way "mass" classifies phenomena in the Lorentzian, Abrahamian, and Einsteinian theories, there remains a localized zone of activity in which a restricted set of actions and beliefs are deployed. In Kaufmann's and Bucherer's laboratories, in the arena of photographic plates, copper tubes, electric fields, and in the capacity of hot wires to emit electrons, experimentalists and theorists worked out an effective but limited coordination between beliefs and actions. What they worked out is, emphatically, *not* a protocol language—there is far too much theory woven into the joint experimental/theoretical action for that. Second, there is nothing *universal* in the establishment of jointly accepted procedures and arguments. And third, the laboratory coordination does not fully *define* the term mass, since beyond this localized context the theories diverge in a myriad of ways. Theorists and experimentalists are not miraculous instantaneous translators and they are not "mere" instrumentalists uninterested in interpretation. They are traders, coordinating parts of interpreted systems against parts of others. The holism that Quine advocated in the years after World War II is enormously compelling. It is hard to imagine ever trying to resurrect a demarcation criterion that would sever the observable from the theoretical. Yet perhaps we could say this: in the trading zone, where two Quinean webs meet, there are knots, local and dense sets of connections that can be identified with partially autonomous clusters of actions and beliefs.

## THE PLACE OF THE TRADING ZONE

Trading between theorists and experimentalists in the heyday of electron theories was done by mail; given the separation of theoretical and experimental institutes on the Continent this is hardly surprising. In the United States and Britain, this geographical isolation was not as marked. When American universities began to acquire theorists in the 1930s they were housed under the same roof as their experimental colleagues. But it would be a distortion to talk about these communities as if they were coequal: only in the Oppenheimer group at Berkeley was there a strong prewar contingent of theorists. Elsewhere a Wendell Furry, a John Van Vleck, or a John Slater was a distinctly minority presence.

For many reasons World War II changed this relation. Quite obviously, Robert Oppenheimer's performance as director of Los Alamos put theory into prominence. But more importantly, theorists, experimentalists, and engineers were forced to work with one another in the large wartime projects. They emerged with nearly five years' experience of each other's way of approaching problems and an enduring faith that postwar science had to exploit the collaborative efforts that they credited for the atomic bomb and radar. In large part the collaboration consisted of establishing a place where ideas, data, and equipment could be passed back and forth between groups.

The Rad Lab, as it came to be known, was established in late 1940, around the British invention of a device that could produce microwaves of the right frequency for an effective radar. Lee DuBridge agreed to head the project on October 16; by late October a core group had established themselves in room 4-133 at MIT. At first, the divisional structure of the laboratory was designed to replicate the five-part electronic structure of radar, as if the laboratory were a small business: the modulator delivered pulses of power to the magnetron, the magnetron delivered microwave signals, the antenna emitted and collected these signals, the receiver sorted signals

from noise, and the indicator displayed an image via a cathode ray tube. Each function had a room: the physical architecture closely matched the electronic architecture.

These three architectures—physical, electronic, and administrative—did not respect distinctions between engineers and physicists. William Tuller, for example, was an electrical engineer with a desk adjacent to that of Henry Neher, a physicist trained in experimental cosmic-ray investigations. William Hall, who had been an electrical engineer working for Metro-Goldwyn-Mayer doing sound recording, now shared the indicator corner of 4-133 with A. J. Allen, a physicist/electrical engineer, and Ernest C. Pollard, a physicist who had taken his B.A. and Ph.D. at Cambridge and in 1940 was an assistant professor at Yale. At first, theoretical physicists had no physical location in the laboratory—they were consultants, appearing from time to time very much the way they would visit a prewar cosmic ray, spectrographic, or magnetic laboratory. Face-to-face contact—literally so, as is evident from surviving seating plans—counted for much. As one experimental physicist put it at the time: "It is not enough that the discoveries and experiences of one group be occasionally presented in seminars or regular written reports. The former seldom go into sufficient detail to mean much, while the latter are either too detailed or simply unread." Instead, he suggested, the physicists needed to work physically in the same group. It was "[a] far swifter and more painless method of spreading new circuits and general Radar philosophy."[28]

At first glance, the war would seem to have made no contribution whatsoever to such an abstruse and abstract subject as quantum electrodynamics. The usual story about QED runs roughly as follows: during the 1920s and 1930s physicists interested in the subject, including Victor Weisskopf, H. A. Kramers, J. Robert Oppenheimer, Niels Bohr, Julian Schwinger, and others made halting progress in understanding how the quantum theory of the electron could be combined with special relativity. They made only intermittent progress, limited essentially to first-order calculations. For reasons of war work, all those living in the United States supposedly broke off their efforts during World War II to do their required (but "irrelevant" to pure physics) work on engineering, and then returned, triumphantly, to QED in the second half of the 1940s. The story is false on at least two levels. First, as Silvan Schweber has pointed out, the developments in QED were catalyzed in part by the results of wartime microwave technology that made possible the precision measurements of Willis Lamb, R. C. Retherford, Henry Foley, J. M. B. Kellogg, P. Kusch et al. in Rabi's laboratory and the work of Dicke at Princeton.[29] These were extraordinary experiments, but the impact of the war went even deeper. Radar work reconfigured the strategy by which Schwinger approached physical problems. Schwinger himself has alluded briefly to his judgment that his radar work had a strong impact on his postwar thinking; in what follows I will expand on his later remarks, making use of his actual work in radar to complete the picture.

Let us attend to practice—not results. During the war, Schwinger worked in the theoretical section of the MIT Rad Lab; his group had the task of developing a usable, general account of microwave networks. Ordinary network theory—the theory of radio waves in resistors and capacitors—utterly failed because microwaves have a wavelength of the same size as ordinary electrical components. In ordinary components such as resistors, copper wires, or cylindrical capacitors, the microwave energy would radiate away. This meant that the full set of calculational tools available for electronic circuits became useless. With the help of his coworkers, Schwinger began with Maxwell's equations and derived a set of rules by which engineers and physicists could make practical network calculations.[30]

As the war progressed and Schwinger assimilated more of the engineering culture of the Rad Lab, he began to abandon the physicists' abstract scattering theory of electromagnetism, and to search for the microwave analogue of the electrical engineers' more practical representations: simple "equivalent circuits" that imitated just the relevant aspects of the components. It was an old technique among electrical engineers, who were used to treating certain systems, such as loudspeakers, not by their real electrical, mechanical, or electromechanical properties, but as if the loudspeaker were a circuit of purely electrical components. In other words they (symbolically) put the complicated physics of the loudspeaker's electromechanically generated noise into a "black box," and replaced it in their calculations with "equivalent" electrical components. Similarly the conducting hollow pipes and cavities of microwave circuits could be replaced (symbolically) by ordinary electrical components, and so make the cavities amenable to algebraic manipulation—without entering each time into the details of complex boundary-value problems for Maxwell's equations. As the postwar Rad Lab "Waveguide Handbook" put it, the adoption of equivalent circuits "serves the purpose of casting the results of field calculations in a conventional engineering mold from which information can be derived [sic] by standard engineering calculations."[31] It is just this process of appropriation—this "casting" into an "engineering mold" that intrigues me. In this detachment of field calculations from their original context, the full meaning of the terms is cut short. Nor is the meaning suddenly and of a piece brought into engineering lore: microwave frequencies did not allow any simpleminded identification of electrical properties with the well-known categories of voltages, currents, and resistances. The product of this labor was a kind of simplified jargon binding elements of field theory talk with elements of engineering equivalent-circuit talk.

In short, the war forced theoretical physicists—such as Schwinger—to spend day after day calculating things about devices and, through these material objects, linking their own prior language of field theory to the language and algebra of electrical engineering. Modifying the theory, creating equivalent circuits for microwave radiation, solving new kinds of problems was not—and this is the crucial point—a form of translation. Even Schwinger's "glossary" identified newly calculated theoretical elements with recently fabricated fragments of microwave circuitry; neither was part of the prior practice of either the theorists or the radio engineers. Boundaries are substantial, translation is absent, and Gestalt shifts are nowhere in sight.

Schwinger himself has alluded to the link between the two seemingly unrelated domains of waveguides and renormalization. "[T]hose years of distraction" during the war were more than that: "[t]he waveguide investigations showed the utility of organizing a theory to isolate those inner structural aspects that are not probed under the given experimental circumstances. . . . And it is this viewpoint that [led me] to the quantum electrodynamics concept of self-consistent subtraction or renormalization."[32] With an understanding of Schwinger's work in waveguide physics, we are now in a position to unpack this connection between the calculations of radar and renormalization.

In the microwave case, it was impossible to calculate fully the field and currents in the region of the discontinuity; in the quantum electrodynamics case, it was hopeless to try to pursue the details of arbitrarily high-energy processes. To attack the microwave problem, Schwinger (wearing his engineering hat) isolated those features of the discontinuity region's physics that were important for "the given experimental circumstances"—for example, the voltages and currents emerging far from the discontinuity. In order to isolate the interesting features, he dumped the unneeded details of the electrodynamics of the discontinuity region into the parameters of an

equivalent circuit. Faced with the fundamental problem of quantum electrodynamics, Schwinger concluded in 1947 that he should proceed by analogy: one had to isolate those features of the physics of quantum electrodynamics that were important for the given experimental circumstances—for example, magnetic moments or scattering amplitudes. To separate these quantities from the dross, he dumped the unneeded details of high-energy interactions into the renormalization parameters.

One lesson that theoretical physicists learned from their engineer colleagues during the war was, therefore, simple yet deep: concentrate on what you actually measure, and design your theory so that it does not say more than you must to account for these observable quantities. The adoption of this positivist attitude toward theorizing was such a sufficiently sharp break with earlier traditions of theory, that some of Schwinger's contemporaries never accepted it. Even Dirac, one of the greatest of twentieth-century theorists, resisted the idea of renormalization until his death in the 1980s. But the idea rapidly took hold, altering for at least several decades the theorists' attitude toward the limits of their description of nature.

## CONCLUSION: THE COORDINATION OF ACTION AND BELIEF

In this trading back and forth between traditions at the Rad Lab, one can see an interesting analogue to Foucault's gloss of Jeremy Bentham's "Panopticon." The Panopticon was a central tower in an "ideal" prison that could control all its occupant could survey. The heterogeneous, self-consciously democratic structure of laboratories like room 4-133 at the Rad Lab offers both an analogue and *dis*analogue to Foucault's analysis of power and surveillance.[33] For at MIT each of the different subcultures was forced to set aside its longer-term and more general symbolic systems, in order to construct the hybrid of practices that all recognized as "Radar philosophy." Under the gun, the various subcultures coordinated their actions and representations in ways that had seemed impossible in peacetime; thrown together they began to get on with the job of building radar.

As the architecture emerged in parallel with the expanding Radiation Laboratory, one can see the visible manifestations of the new modes of exchange. Rooms are established with movable walls, the interchange with industry began to shape the physicists' self-conceptions. The laboratory not only resembled a factory, its integration was thoroughgoing: by the end of the war almost $3 billion had been spent on radar, the Rad Lab had 3,900 persons in its employment, and the laboratory with its "model shop" had delivered $25 million worth of equipment to the armed forces.[34] These developments had a profound effect on the physics community's plan for a huge centralized laboratory on the East Coast, one modeled explicitly on the Rad Lab: "The laboratory," one leading physicist wrote near the end of the war, "should be essentially of factory-type construction, capable of expansion and alteration. Partitions should be nonstructural." And to emphasize the ideological democracy of this new institution, he added: "[p]anelled offices for the director or any one else should be avoided."[35] But tearing down the paneling should not be confused with the homogenization of the community; there is no question of eliminating the categories of theorist, experimentalist, and engineer.

In planning the establishment of the National Accelerator Laboratory (later Fermilab) the founders recognized the enduring gap between the subcultures. Theorists, while necessary for the laboratory, would need contact with colleagues at neighboring universities and the creation of a weekly NAL "theory day"[36] and more ambitiously a "Theoretical Physics Center" at the laboratory. Even for a group of theorists working in the very midst of experimental activity, it

was recognized from the start that the subject domains of theory and experiment were not perfectly coincident. While the laboratory attended to particle physics, its instrumentation and experiments, the theorists would work not only in strong interaction dynamics field theory, symmetries and groups, axiomatics, and phenomenological studies—they would also work in gravitation, general relativity, nuclear structure, astrophysics, quantum liquids, and statistical mechanics. "[I]t is understood, of course, that any individual theorist may move from one field to another within particle physics and from particle physics to one of the 'peripheral' fields with complete freedom of choice."[37] Precisely because of this recognized difference in the conceptual organization of experiment as distinct from theory, one would see breaks and continuities in theory that would be distinct from that of experiment.

"Sophistication in mathematical reasoning and technology that has accompanied progress in particle physics no longer allows an ordinary mortal to pursue the science both in an experimental laboratory and in the quiet of a study, as in the good old days of Faraday, Cavendish and Rayleigh, or even in the more recent time of Enrico Fermi."[38] I take it to be no accident that the separation of culture is signaled by a separation of place: the "experimental laboratory" is no longer coincident with the "quiet of a study." The contrast between the *vita activa* and the *vita contemplativa* has now been recreated inside the subdiscipline itself, and in the minds of the Fermilab directorate the division demanded a spatial solution: "All members of the group engage in exchange of ideas and knowledge with users [experimentalists from outside NAL who used the facilities] and experimentalists on the staff at Fermilab. These meetings of minds take place more formally in "[the] joint Experimental-Theoretical Seminar which takes place every Friday [and] is an innovative approach to communication among theorists and experimentalists at Fermilab." More frequent are informal meetings "in offices on the third floor of the Central Laboratory and at the Cafeteria, Lounge and airports";[39] these sites become trading zones. Throughout such exchanges there is no attempt to make experimentalists into theorists or vice versa. On the contrary, the concept of collaboration embraced by the physicists during the war involved a reinforcement of these subcultures and an emphasis on exchange.

These various examples of trading between subcultures suggest a model of scientific practice as much at odds with the picture of pure plasticity invoked by some interest theorists as with the rigidly segregated observation language of the early logical positivists. Or perhaps I should say it has links to both. *Within* traditions, I want to emphasize the relatively constrained nature of scientific practice—hardly anything goes. But when radical changes do occur—and no subculture is immune to such alterations—it does not necessarily follow that the other subcultures break as well. Moreover, the relative rigidity and foreignness of one subculture from another does not make crosstalk between the strata impossible; rather, it insures that as the trading domains become established, the structure of the enterprise as a whole has a strength that the antipositivists denied.

Moving away from the stack periodization schemes typical of the Gestalt psychological and sociological paradigm shifts comes at a price: we lose the vivid metaphorical imagery of totalistic transformations. In its place we need some guidance in thinking about the local configurations that are produced when two complex sociological and symbolic systems confront one another. Anthropologists are familiar with such exchanges, and one of the most interesting domains of such investigations has been in the field of anthropological linguistics surrounding the problems of *pidginization* and *creolization*. Both refer to languages at the boundary between groups. A pidgin usually designates a contact language constructed with the elements of at least

two active languages; pidginization is the process of simplification and restriction by which a pidgin is produced. By convention, a pidgin is not used to describe a language that is used even by a small group of people as their native tongue. A creole, by contrast, is by definition a pidgin extended and complexified to the point where it can serve as a reasonably stable native language.[40]

Typically, pidgins arise as contact languages when two or more groups need to establish trade or exchange. One way that such languages arise is when a dominant but smaller group withholds its full language either to guard it to preserve their cultural identity, or because they believe that their social inferiors could not learn such a complex structure. To communicate, the dominant group then produces a "foreigner talk" which is then elaborated as it is used in day-to-day trading. This seems to have been the case, for example, in the production of "Police Motu." Originally the Motu (of what is now Papua New Guinea) created a simplified version of their language (a foreigner talk) to ply their extensive trading network, for example trading pots and sea products in exchange for game and bush products. William Foley, an anthropological linguist, speculates that at this stage the simplified Motu was not a distinct language from Motu itself. Beginning in the 1870s Europeans and later Chinese, Pacific Islanders, and Malay Indonesians arrived; they too acquired the foreigner talk version of Motu. When the British established colonial rule, they enforced their dominance with police, often not native speakers of Motu; the police slipped rather easily into the only lingua franca available, the simplified Motu, but now elaborated the language to make it serve its more complex function of colonial rule. As a more intricate and (forcibly) widespread language, the "Police Motu" gained in significance. Since, in addition, the "criminals" arrested by the police were often men of high social status in their villages (e.g., headhunters), when the incarcerated returned home they carried with them the "Police Motu," according it yet greater status.[41]

The simplification of a native language to a pidgin occurs on many axes.[42] Simplification in linguistic structure can occur *lexically*, through restriction in vocabulary or through monomorphemic words; it can occur *syntactically*, through the elimination of subordinate clauses, hardening of word order; *morphologically*, through the reduction in inflection or allomorphy; or *phonologically*, through the elimination of consonant clusters and polysyllabic words. At first such pidgins may be unstable, varying according to the prior linguistic practices of each learner. But gradually the pidgin in some cases will stabilize; sometimes this will occur when learners of different linguistic backgrounds need to communicate among themselves. As the pidgin expands to cover a wider variety of events and objects, it comes to play a larger linguistic role than merely facilitating trade. Eventually, as children begin to grow up "in" the expanded pidgin, the language is no longer acquired to solve specific functions but now must serve the full set of human demands. Linguists dub such a newly created "natural" language a creole and the process leading up to it, creolization.

I bring up the dynamics of contact languages and their stabilization, structure, and expansion because they offer at least a set of questions relevant to the confrontation of theorists with experimentalists. For example, the process by which experimentalists, theorists and instrumentalists simplify their practices for presentation to the other subcultures needs examination. Can we articulate the process along lines similar to the axes of lexical, morphological, grammatical, and syntactical axes presented by Ferguson? Consider the following example. In the early 1960s, Sidney Drell and James Bjorken set out to write a book on quantum field theory. They soon came to see that they in fact had written two distinct volumes: a first tome, directed at an audience outside the subculture of theorists, that began with the calculational rules of the

theory and a second containing theoretical justifications and proofs of the Feynman techniques. The first book covered Feynman diagrams and the classical applications they made simple— Bremsstrahlung (the emission of a photon by a charged particle), Compton scattering (the deflection of a photon by an electron), and pair annihilation (in which an electron and anti-electron fuse and emerge as a pair of photons). In order to study higher order corrections to processes including these, the authors introduced the renormalization procedure without a systematic exposition. It is a book of *techniques* that begin with rules (such as "For each internal meson line of spin zero with momentum $q$ a factor: $i/(q^2 - \mu^2 + i\epsilon)$," where ($\mu$) is the meson mass and ($\epsilon$) is a small positive number.[43]

Such a development [of the theory], more direct and less formal—if less compelling—than a deductive field theoretic approach, should bring quantitative calculation, analysis, and understanding of Feynman graphs into the bag of tricks of a much larger community of physicists than the specialized narrow one of second quantized theorists. In particular, we have in mind our experimental colleagues and students interested in particle physics.[44]

Left out of the experimentalists' volume is the framework in which the rules find their justificatory place. Also removed are the more general proofs, such as the demonstration that a calculation within quantum electrodynamics, to any order of accuracy, will remain finite.[45] As in Police Motu, the creation of a "foreigner" version of the symbolic system occurs on many fronts. There is an emphasis on plausible, heuristic argumentation rather than a more systematic demonstration, there is an increased focus on the calculation of measurable quantities over formal properties of the theory at some remove from experiment (such as symmetries and invariances). Perhaps more subtly, the theorists' version often links phenomena that are left merely associated for the experimentalists. For example, in the "experimentalists'" volume it is simply postulated that particles with half-integer spins (such as electrons) obey the Pauli exclusion principle, whereas in the "theorists'" volume, this contention is demonstrated for any local quantum field theory obeying Lorentz covariance and having a unique ground state.[46] These and other results are linked ultimately to a different structure in which the basic entities are embedded. In particular, in the experimentalists' volume the basic object—the field $\Psi$—stands for a wave function of a single particle. The experimentalists learn to manipulate this function in various ways following the rule of what is called "first" quantization: the position $x$ and momentum $p$ of classical physics are replaced by operators $x$ and the spatial derivative $d/dx$. The differential equations that result are solved and the dynamics of the particle's wave function therefore determined. For the theorists, $\Psi$ stands in not for the wave function of a single particle; rather $\Psi$ itself is considered to be an operator at each point in space and time. Instead of standing in for a single particle, it represents a field of operators capable of creating and annihilating particles at each space-time point.

Despite this radical difference in the ontology—the set of what there is—a meeting ground exists around the description of the phenomenology of particle physics: How do photons recoil from electrons? How do electrons scatter from positrons? How do photons create pairs of electrons and positrons in the near presence of a proton? For these and similar questions, the experimentalists and theorists come to agreement about rules of representation, calculation, and local interpretation. In a strong sense, Bjorken and Drell Volume I is an example of an attempt to create a stable pidgin language, designed to mediate between experimentalist and theorist. Reduction of mathematical structure, suppression of exceptional cases, minimization of internal

linkages between theoretical structures, removal from a more elaborate explanatory structure—these are all ways that the theorists prepare their subject for the exchange with their experimental colleagues. I take these moves toward regularization to be the formal-language analogues of phonetic, morphological, syntactical, and lexical reduction of natural languages.

By invoking pidgins and creoles, I do not mean to "reduce" the handling of machines to discourse. Quite the contrary. My intention is to *expand* the notion of contact languages to include structured symbolic systems that would *not* normally be included within the domain of "natural" language. On one side, this expansive attitude can be grounded by criticizing attempts to isolate natural languages; after all, even languages like English have been conditioned in part by very intentional intervention. Constructed language games such as backslang and rhyming slang have left grammatical traces within the "purely natural" languages. Even rules such as the use of "he" as a nongender specific pronoun have historical origins.[47] On the other side, "unnatural" languages such as signing, FORTRAN, and even electronic circuits can be used in such broadly expressive modes that any demarcation criterion seems bound to fail.

And indeed there is, not surprisingly, a corresponding "foreigner talk" that experimentalists develop on their side. Just as theorists reduce the complexity by suppressing the "endogenous" structure linking theory to theory, so experimentalists, when addressing theorists, skip the connecting details by which experimental procedures bind to one another.

These "separable" bits of procedure can come as isolable fragments of craft or engineering knowledge, as when the Alvarez group introduced indium as the binding material by which to bind bubble chamber glass to the steel chassis. Between such localized wisdom and material lay computer programs such as the PANG or KICK. Their exchange not only regularized practices in the "image" tradition, the track analysis programs carried over as well into the "logic" tradition, serving in the long run to facilitate the coalescence of the two previously competing cultures. Finally, in many cases, such as the postwar distribution of Ilford emulsions, radar oscillators, or multichannel analyzers, the medium of exchange can be physical. This suggests that the process of "black boxing" can be seen as the precise material analogue of the more linguistic forms of pidginization; just as terms like *electron* can acquire a decontextualized meaning, so *items* like a local oscillator can function as a binding element between subcultures when stripped from its original context and coordinated with a new one. After all, it was the military censors' abiding confidence that (in isolation) these instruments would *not* reveal their function in nuclear weapons or radar development that led them to declassify virtually all electronic instrumentation.

Beginning in Rad Lab seminars during the war itself, the techniques of circuit assembly, component coordination, testing, and general lore were codified into courses, and in the electronic boom after the war into a universe of practices sufficiently self-contained for students to grow up "in" microwave electronics, attached neither to field theory nor to traditional radio engineering. The pidgin has become a creole. Similarly, the development of *particle phenomenology* as a subfield of theoretical physics is an expansion outward of a trading zone: pidgin particle physics is pressed outward embracing an ever-widening domain of practices, some borrowed from the experimentalists and some from the quantum field theorists. As befits their boundary identity such physicists sometimes find themselves both in theoretical and in experimental groups.

What stabilizes a pidgin? What takes an aleatory alliance of linguistic practices assembled for a specific purpose and allows it to endure and expand? One interesting conjecture is that the alignment of three or more languages (*tertiary hybridization*) serves to prevent any single group from reabsorbing the pidgin back into one of the source languages.[48] Perhaps, and this is frankly

speculative, one of the effective features of the huge war laboratories was precisely the imposed orchestration of the practices of theorists, experimentalists, instrument makers, along with electronic and mechanical engineers. It was the felt *difference* of this coordinated activity from the physicists' prior experience that led White, among others, to speak of a *Radar Philosophy*.

Tracing the handing of charts and copper tubes back and forth across the cultural divide, we could say, with the antipositivists, that the worlds of theory, experiment, and engineering cross without meeting. It would, however, be a description that does violence to the expressed experience of the participants. They are not without resources to communicate, but the communication takes place piecemeal, not in a global translation of cultures, and not through the establishment of a universal protocol language. Here is a summary slogan: laboratories are about the coordination between action and belief, not about translation.

This view of science as an intercalated set of subcultures bound together through a complex of pidgins and creole fits poorly in the debate over relativism and realism. In one sense, the view might be labeled "anti-anti-realist" since it directly opposes attempts to disintegrate science into blocks of knowledge isolated both from each other. But it is not for being anti-anti-realist, a defense of metaphysical realism as traditionally conceived. Nothing in the local coordination of the finite subcultures of physics guarantees anything like an asymptotic approach to truth.

Let me conclude with a metaphor. For years physicists and engineers harbored a profound mistrust of disorder. They searched for reliability in crystals rather than disordered materials, and strength in pure substances rather than laminated ones. Suddenly, in the last few years, in a quiet upheaval, they discovered that the classical vision had it backward: the electronic properties of crystals were fine until—*because* of their order—they failed catastrophically. It was amorphous semiconductors, with their *disordered* atoms, that gave the consistent responses needed for the modern era of electronics. Structural engineers were slow to learn the same lesson. The strongest materials were not pure—they were laminated; when they failed microscopically, they held in bulk. To a different end, in 1868 Charles Sanders Peirce invoked the image of a cable. I find his use evocative in just the right way: "Philosophy ought to imitate the successful sciences in its methods. . . . [T]o trust . . . rather to the multitude and variety of its arguments than to the conclusiveness of any one. Its reasoning should not form a chain which is no stronger than its weakest link, but a cable whose fibres may be ever so slender, provided they are sufficiently numerous and intimately connected."[49] With its intertwined strands, the cable gains its strength not by having a single, golden thread that winds its way through the whole. No one strand defines the whole. Rather, the great steel cables gripping the massive bridges of Peirce's time were made strong by the interleaving of many limited strands, no one of which held all the weight. Decades later, Wittgenstein used the same metaphor now cast in the image of thread, as he reflected on what it meant to have a concept. "We extend our concept of number as in spinning a thread we twist fibre on fibre. And the strength of the thread does not reside in the fact that some one fibre runs through its whole length, but in the overlapping of many fibres."[50] Concepts, practices, and arguments will not halt at the door of a conceptual scheme or its historical instantiation: they continue, piecewise.

These analogies cut deep. It is the *disorder* of the scientific community—the laminated, finite, partially independent strata supporting one another; it is the *dis*unification of science—the intercalation of *different* patterns of argument—that is responsible for its strength and coherence. It is an intercalation that extends even further down—even within the stratum of instruments we have seen mimetic and analytic traditions as separate and then combining,

image and logic competing then merging. So too could we see divisions within theory—confrontational views about symmetries, field theory, $S$-matrix theory, for example—as one incompletely overlapped the other.

But ultimately the cable metaphor too takes itself apart, for Peirce insists that the strands not only be "sufficiently numerous" but also "intimately connected." In the cable, that connection is mere physical adjacency, a relation unhelpful in explicating the ties that bind concepts, arguments, instruments, and scientific subcultures. No mechanical analogy will ever be sufficient to do that because it is by coordinating different symbolic and material actions that people create the binding culture of science. All metaphors come to an end.

NOTES

Excerpted from chapter 9 in P. Galison, *Image and Logic: A Material Culture of Microphysics* (Chicago: University of Chicago Press, 1997).

1. Rudolf Carnap, "Intellectual Autobiography," in *The Philosophy of Carnap*, ed. P. A. Schilpp, Library of Living Philosophers, vol. 11 (La Salle, Ill.: Open Court, 1963), 57.

2. James B. Conant and Leonard K. Nash, eds., *Harvard Case Histories in Experimental Science*, 8 vols. (Cambridge, Mass.: Harvard University Press, 1950–54).

3. T. S. Kuhn, *The Structure of Scientific Revolutions*, 2d ed., International Encyclopedia of Unified Science (Chicago: University of Chicago Press, 1970), ch. 10; and Norwood Russell Hanson, *Patterns of Discovery: An Inquiry into the Conceptual Foundations of Science* (Cambridge: Cambridge University Press, 1958), ch. 1–4.

4. Paul K. Feyerabend, *Realism, Rationalism and Scientific Method: Philosophical Papers*, vol. 1 (Cambridge: Cambridge University Press, 1981), x.

5. Ibid., 45, 118. The link to Kant occurs on p. 45, "As is well known, it was Kant who most forcefully stated and investigated this all-pervasive character of theoretical assumptions."

6. Ibid., 61.

7. Ibid., x.

8. T. S. Kuhn, "Reflections on my Critics," in *Criticism and the Growth of Knowledge*, ed. I. Lakatos and S. Musgrave. Proceedings of the International Colloquium in the Philosophy of Science, vol. 4 (Cambridge: Cambridge University Press, 1970), 266.

9. J. L. Heilbron, *Elements of Early Modern Physics* (Berkeley and Los Angeles: University of California Press, 1982).

10. On the notion of the master narrative, see, e.g., Jean-Francois Lyotard, *The Postmodern Condition: A Report on Knowledge*. Theory and History of Literature, vol. 10, trans. Geoff Bennington and Brian Massumi (Minneapolis: University of Minnesota Press, 1984), 27–41.

11. T. S. Kuhn, "Second Thoughts on Paradigms," in *The Structure of Scientific Theories*, ed. F. Suppe (Urbana, Ill.: University of Illinois Press, 1974), 462.

12. The problem of the awarding of Ph.D.'s in physics for *purely* instrumental research has been the subject of much contention within the physics community. See, e.g., U.S. Department of Energy, Office of Energy Research, "Report of the HEPAP Subpanel on Future Modes of Experimental Research in High Energy Physics," DOE/ER-0380 (Washington, D.C.: U.S. Government Printing Office, 1988), 33, 53.

13. A tiny sample of such meetings are represented in the following volumes: G. Domokos and S. Kovesi-Domokos, eds., *Proceedings of the Johns Hopkins Workshop on Current Problems in Particle Theory, 7, Bonn, 1983* (Singapore: World Scientific, 1983); and Jozef Jaklovsky, ed., *Preparation of Nuclear Targets for Particle Accelerators* (New York: Plenum, 1981).

14. Lynn Avery Hunt, *Revolution and Urban Politics in Provincial France: Troyes and Reims, 1786–1790* (Stanford: Stanford University Press, 1978).

15. As we search to locate scientific activities in their context, it is extremely important to recognize that for many activities there is no single context. By viewing the collaboration among people in a laboratory not as a melding of identities but as a coordination among subcultures we can see the actors as separately embedded in their respective, wider worlds. E.g., in the huge bubble chamber laboratory at Berkeley one has to see the assembled workers as coming together from the AEC's secret world of nuclear weapons and from an arcane theoretical culture of university physics. The culture they partially construct at the junction is what I have in mind by the "trading zone."

16. Allan D. Franklin, *The Neglect of Experiment* (Cambridge: Cambridge University Press, 1986); Peter Galison, *How Experiments End* (Chicago: University of Chicago Press, 1987); David Gooding, Trevor Pinch, and Simon Schaffer, eds., *The Uses of Experiment: Studies in the Natural Sciences* (Cambridge: Cambridge University Press, 1989); Peter Achinstein and Owen Hannaway, eds., *Observation, Experiment and Hypothesis in Modern Physical Science* (Cambridge, Mass.: MIT Press, 1985); Jeffrey Sturchio, ed., Special Issue on Artifact and Experiment, *Isis* 79 (1988): 369–476; S. Shapin and S. Schaffer, *Leviathan and the Air-Pump: Hobbes, Boyle, and the Experimental Life* (Princeton:

Princeton University Press, 1985); and Ian Hacking, *Representing and Intervening: Introductory Topics in the Philosophy of Natural Science* (Cambridge: Cambridge University Press, 1983).

17. Hacking, *Representing,* 274–75; and Hacking, "Extragalactic Reality: The Case of Gravitational Lensing," *Philosophy of Science* 56 (1989): 555–81.

18. P. Duhem, *The Aim and Structure of Physical Theory,* trans. Philip Wiener (Princeton: Princeton University Press, 1954), 168–73, and 190–95.

19. See Galison, *How Experiments End* (1987), ch. 5.6, "Directness." On the role of causal explanations and realism about phenomena see Nancy Cartwright, *How the Laws of Physics Lie* (Oxford: Clarendon, 1983).

20. The example of the secret baptism of money is from M. Taussig, *The Devil and Commodity Fetishism in South America* (Chapel Hill: University of North Carolina Press, 1980), ch. 7.

21. "This need to change the meaning of established and familiar concepts is central to the revolutionary impact of Einstein's theory. . . . We may even come to see it as a prototype for revolutionary reorientations in the sciences." Kuhn, *Structure,* 102.

22. Paul K. Feyerabend, *Problems of Empiricism: Philosophical Papers,* vol. 2 (Cambridge: Cambridge University Press, 1981), 159: "It is no good insisting that scientists act as if the situation were much less complicated. If they act that way, then they are either instrumentalists . . . or mistaken: many scientists are nowadays interested in *formulae* while we are discussing *interpretations.*"

23. In all the massive literature on Einstein's special theory of relativity, the best historical book is Arthur I. Miller, *Albert Einstein's Special Theory of Relativity: Emergence (1905) and Early Interpretations (1905–1911)* (Reading, Mass.: Addison-Wesley, 1981). I have drawn liberally on this source for the preceding discussion of early experimental evidence on transverse electron mass experiments.

24. Kuhn, *Structure,* 102.

25. See Miller, *Special Theory,* 334–35.

26. Ibid., 341–45.

27. Albert Einstein, *Ideas and Opinions,* trans. S. Bargmann (New York: Crown, 1954), 274.

28. White, "A Proposal for Laboratory Organization," file "Reorganization," box 59, Radiation Laboratory papers (MIT), Office of Scientific and Research Development, National Archives, New England Region, Waltham, Massachusetts.

29. S. S. Schweber, "Some Chapters for a History of Quantum Field Theory: 1938–1952," in *Relativity, Groups, and Topology II,* Les Houches, Session 40, ed. B. DeWitt and R. Stora (New York: North-Holland, 1984), 163.

30. Schwinger and others at the MIT Radiation Laboratory struggled with the problem of determining the input and output characteristics of radiation to and from waveguide junctions. Working in parallel (or perhaps antiparallel) the theorist Sin-itiro Tomonaga was at work on radar for the Japanese. During the first part of the war, each of the two physicists approached the difficulty using classical "physicists' techniques"—exploiting relations among the amplitudes of waves arriving at and leaving the junction. When put into a scattering "$S$"-matrix these quantities obeyed certain symmetries and, when the process was lossless, unitarity. Because of these symmetries, the $S$-matrix formalism facilitated the solution of problems (such as the split of one waveguide into two) by side-stepping the vast amount of information contained in the full electromagnetic field description and representing only the relation of the *measurable* quantities coming in and out of the junction. Perhaps surprisingly, then, two of the founders of postwar particle physics built their theoretical scattering theory on their wartime radar work. Julian Schwinger, *Tomonaga Sin-itiro: A Memorial. Two Shakers of Physics* ([Japan]: Nishina Memorial Foundation, 1980), 14–16.

31. Nathan Marcuvitz, *Waveguide Handbook,* IEE Electromagnetic Waves Series (London: Peregrinus, 1986).

32. Schwinger, *Shakers,* 16.

33. Michel Foucault, *Discipline and Punish: The Birth of the Prison,* trans. A. Sheridan (New York: Vintage, 1979), 195–228.

34. Henry E. Guerlac, *Radar in World War II,* Tomash Series in the History of Modern Physics 1800–1950, vol. 8 (Los Angeles: Tomash, 1987), 4. On the military and factory models for postwar laboratories, see Peter Galison, "Physics Between War and Peace," in *Science, Technology and the Military,* ed. E. Mendelsohn, M. R. Smith, and P. Weingart, Sociology of the Sciences, vol. 1 (Dordrecht: Kluwer, 1988), 47–86.

35. Smyth, "Proposal," 25 July 1944, revised 7 February 1945, 8, Princeton University Archives, published with permission of Princeton University Libraries, Princeton, New Jersey.

36. Goldwasser, circular letter, 14 January 1969, uncatalogued files, Fermilab Archives, Fermilab, Batavia, Illinois.

37. "Proposal for Theoretical Physics Center of the National Accelerator Laboratory," August 19, 1969, 2, uncatalogued files, Fermilab Archives.

38. B. W. Lee, "Theoretical Physics at Fermilab," *NALREP: Monthly Report of the Fermi National Accelerator Laboratory* (March 1978): 1.

39. Ibid., 7–8.

40. Much of the following is based closely on the excellent review of the literature on pidginization and creolization given by William A. Foley, "Language Birth: The Processes of Pidginization and Creolization," in *Language: The Sociocultural Context,* ed. F. J. Newmeyer. Linguistics: The Cambridge Survey, vol. 4 (Cambridge: Cambridge University Press, 1988), 162–83.

41. Ibid., 173–74.

42. See Charles Ferguson, "Simplified Registers and Linguistic Theory," in *Exceptional Language and Linguistics,* ed. L. K. Obler and L. Menn (New York: Academic Press, 1982), 60.

43. J. Bjorken and S. Drell, *Relativistic Quantum Mechanics* (New York: McGraw-Hill, 1964), 286.

44. Ibid., viii.

45. J. Bjorken and S. Drell, *Relativistic Quantum Fields* (New York: McGraw-Hill, 1965), 330–44.

46. Ibid., 170–72.

47. See, e.g., Peter Mühlhäusler, *Pidgin and Creole Linguistics,* Language in Society, vol. 11 (Oxford: Blackwell, 1986), 60.

48. Ibid.

49. Charles Sanders Peirce, "Some Consequences of Four Incapacities," in *Writings of Charles Sanders Peirce, A Chronological Edition, Vol. 2, 1867–1871* (Bloomington: Indiana University Press, 1984), 213.

50. Ludwig Wittgenstein, *Philosophical Investigations,* 2d ed., trans. G. E. M. Anscombe (Oxford: Blackwell, 1958), par. 67.

# II

# Making Up People

## IAN HACKING

Were there any perverts before the latter part of the nineteenth century? According to Arnold Davidson, "The answer is NO. . . . Perversion was not a disease that lurked about in nature, waiting for a psychiatrist with especially acute powers of observation to discover it hiding everywhere. It was a disease created by a new (functional) understanding of disease."[1] Davidson is not denying that there have been odd people at all times. He is asserting that perversion, as a disease, and the pervert, as a diseased person, were created in the late nineteenth century. Davidson's claim, one of many now in circulation, illustrates what I call making up people.

I have three aims: I want a better understanding of claims as curious as Davidson's; I would like to know if there could be a general theory of making up people, or whether each example is so peculiar that it demands its own nongeneralizable story; and I want to know how this idea "making up people" affects our very idea of what it is to be an individual. I should warn that my concern is philosophical and abstract; I look more at what people might be than at what we are. I imagine a philosophical notion I call dynamic nominalism, and reflect too little on the ordinary dynamics of human interaction.

First we need more examples. I study the dullest of subjects, the official statistics of the nineteenth century. They range, of course, over agriculture, education, trade, births, and military might, but there is one especially striking feature of the avalanche of numbers that begins around 1820. It is obsessed with *analyse morale,* namely, the statistics of deviance. It is the numerical analysis of suicide, prostitution, drunkenness, vagrancy, madness, crime, *les misérables.* Counting generated its own subdivisions and rearrangements. We find classifications of over 4,000 different crisscrossing motives for murder and requests that the police classify each individual suicide in twenty-one different ways. I do not believe that motives of these sorts or suicides of these kinds existed until the practice of counting them came into being.[2]

New slots were created in which to fit and enumerate people. Even national and provincial censuses amazingly show that the categories into which people fall change every ten years. Social change creates new categories of people, but the counting is no mere report of developments. It elaborately, often philanthropically, creates new ways for people to be.

People spontaneously come to fit their categories. When factory inspectors in England and Wales went to the mills, they found various kinds of people there, loosely sorted according to tasks and wages. But when they had finished their reports, mill hands had precise ways in which

to work, and the owner had a clear set of concepts about how to employ workers according to the ways in which he was obliged to classify them.

I am more familiar with the creation of kinds among the masses than with interventions that act upon individuals, though I did look into one rare kind of insanity. I claim that multiple personality as an idea and as a clinical phenomenon was invented around 1875: only one or two possible cases per generation had been recorded before that time, but a whole flock of them came after. I also found that the clinical history of split personality parodies itself—the one clear case of classic symptoms was long recorded as two, quite distinct, human beings, each of which was multiple. There was "the lady of MacNish," so-called after a report in *The Philosophy of Sleep*, written by the Edinburgh physician Robert MacNish in 1832, and there was one Mary R. The two would be reported in successive paragraphs as two different cases, although in fact Mary Reynolds was the very split-personality lady reported by MacNish.[3]

Mary Reynolds died long before 1875, but she was not taken up as a case of multiple personality until then. Not she but one Félida X got the split-personality industry under way. As the great French psychiatrist Pierre Janet remarked at Harvard in 1906, Félida's history "was the great argument of which the positivist psychologists made use at the time of the heroic struggles against the dogmatism of Cousin's school. But for Félida, it is not certain that there would be a professorship of psychology at the Collège de France."[4] Janet held precisely that chair. The "heroic struggles" were important for our passing conceptions of the self, and for individuality, because the split Félida was held to refute the dogmatic transcendental unity of apperception that made the self prior to all knowledge.

After Félida came a rush of multiples. The syndrome bloomed in France and later flourished in America, which is still its home. Do I mean that there were no multiples before Félida? Yes. Except for a very few earlier examples, which after 1875 were reinterpreted as classic multiples, there was no such syndrome for a disturbed person to display or to adopt.

I do not deny that there are other behaviors in other cultures that resemble multiple personality. Possession is our most familiar example—a common form of Renaissance behavior that died long ago, though it was curiously hardy in isolated German villages even late in the nineteenth century. Possession was not split personality, but if you balk at my implication that a few people (in committee with their medical or moral advisers) almost choose to become splits, recall that tormented souls in the past have often been said to have in some way chosen to be possessed, to have been seeking attention, exorcism, and tranquility.

I should give one all-too-tidy example of how a new person can be made up. Once again I quote from Janet, whom I find the most open and honorable of the psychiatrists. He is speaking to Lucie, who had the once-fashionable but now-forgotten habit of automatic writing. Lucie replies to Janet in writing without her normal self's awareness:

*Janet.* Do you understand me?
*Lucie* (*writes*). No.
*J.* But to reply you must understand me!
*L.* Oh yes, absolutely.
*J.* Then what are you doing?
*L.* Don't know.
*J.* It is certain that someone is understanding me.
*L.* Yes.
*J.* Who is that?

*L.* Somebody besides Lucie.

*J.* Aha! Another person. Would you like to give her a name?

*L.* No.

*J.* Yes. It would be far easier that way.

*L.* Oh well. If you want: Adrienne.

*J.* Then, Adrienne, do you understand me?

*L.* Yes.[5]

If you think this is what people used to do in the bad old days, consider poor Charles, who was given a whole page of *Time* magazine on October 25, 1982 (p. 70). He was picked up wandering aimlessly and was placed in the care of Dr. Malcolm Graham of Daytona Beach, who in turn consulted with Dr. William Rothstein, a notable student of multiple personality at the University Hospital in Columbia, South Carolina. Here is what is said to have happened:

After listening to a tape recording made in June of the character Mark, Graham became convinced he was dealing with a multiple personality. Graham began consulting with Rothstein, who recommended hypnosis. Under the spell, Eric began calling his characters. Most of the personalities have been purged, although there are three or four being treated, officials say. It was the real personality that signed a consent form that allowed Graham to comment on the case.[6]

Hypnosis elicited Charles, Eric, Mark, and some twenty-four other personalities. When I read of such present-day manipulations of character, I pine a little for Mollie Fancher, who gloried in the personalities of Sunbeam, Idol, Rosebud, Pearl, and Ruby. She became somewhat split after being dragged a mile by a horse car. She was not regarded as especially deranged, nor in much need of "cure." She was much loved by her friends, who memorialized her in 1894 in a book with the title *Mollie Fancher, The Brooklyn Enigma: An Authentic Statement of Facts in the Life of Mollie J. Fancher, The Psychological Marvel of the Nineteenth Century.*[7] The idea of making up people has, I said, become quite widespread. *The Making of the Modern Homosexual* is a good example; "Making" in this title is close to my "making up."[8] The contributors by and large accept that the homosexual and the heterosexual as kinds of persons (as ways to be persons, or as conditions of personhood) came into being only toward the end of the nineteenth century. There has been plenty of same-sex activity in all ages, but not, *Making* argues, same-sex people and different-sex people. I do not wish to enter the complexities of that idea, but will quote a typical passage from this anthology to show what is intended: "One difficulty in transcending the theme of gender inversion as the basis of the specialized homosexual identity was the rather late historical development of more precise conceptions of components of sexual identity. [fn:] It is not suggested that these components are 'real' entities, which awaited scientific 'discovery.' However once the distinctions were made, new realities effectively came into being."[9]

Note how the language here resembles my opening quotation: "not a disease . . . in nature, waiting for . . . observation to discover it" versus "not . . . 'real' entities, which awaited scientific 'discovery.'" Moreover, this author too suggests that "once the distinctions were made, new realities effectively came into being."

This theme, the homosexual as a kind of person, is often traced to a paper by Mary MacIntosh, "The Homosexual Role," which she published in 1968 in *Social Problems.*[10] That journal was much devoted to "labeling theory," which asserts that social reality is conditioned, stabilized, or even created by the labels we apply to people, actions, and communities. Already in 1963, "A Note on the Uses of Official Statistics" in the same journal anticipated my own inferences

about counting.[11] But there is a currently more fashionable source of the idea of making up people, namely, Michel Foucault, to whom both Davidson and I are indebted. A quotation from Foucault provides the epigraph—following one from Nietzsche—for *The Making of the Modern Homosexual;* and although its authors cite some 450 sources, they refer to Foucault more than anyone else. Since I shall be primarily concerned with labeling, let me state at once that for all his famous fascination with discourse, naming is only one element in what Foucault calls the "constitution of subjects" (in context a pun, but in one sense the making up of the subject): "We should try to discover how it is that subjects are gradually, progressively, really and materially constituted through a multiplicity of organisms, forces, energies, materials, desires, thoughts, etc."[12]

Since so many of us have been influenced by Foucault, our choice of topic and time may be biased. My examples dwell in the nineteenth century and are obsessed with deviation and control. Thus, among the questions on a complete agenda, we should include these two: Is making up people intimately linked to control? Is making up people itself of recent origin? The answer to both questions might conceivably be yes. We may be observing a particular medico-forensic-political language of individual and social control. Likewise, the sheer proliferation of labels in that domain during the nineteenth century may have engendered vastly more kinds of people than the world had ever known before.

Partly in order to distance myself for a moment from issues of repression, and partly for intrinsic interest, I would like to abstract from my examples. If there were some truth in the descriptions I and others have furnished, then making up people would bear on one of the great traditional questions of philosophy, namely, the debate between nominalists and realists.[13] The author I quoted who rejects the idea that the components of the homosexual identity are real entities, has taken a time-worn nominalist suggestion and made it interesting by the thought that "once the distinctions were made, new realities effectively came into being."

You will recall that a traditional nominalist says that stars (or algae, or justice) have nothing in common except our names ("stars," "algae," "justice"). The traditional realist in contrast finds it amazing that the world could so kindly sort itself into our categories. He protests that there are definite sorts of objects in it, at least stars and algae, which we have painstakingly come to recognize and classify correctly. The robust realist does not have to argue very hard that people also come sorted. Some are thick, some thin, some dead, some alive. It may be a fact about human beings that we notice who is fat and who is dead, but the fact itself that some of our fellows are fat and others are dead has nothing to do with our schemes of classification.

The realist continues: consumption was not only a sickness but also a moral failing, caused by defects of character. That is an important nineteenth-century social fact about TB. We discovered in due course, however, that the disease is transmitted by bacilli that divide very slowly and that we can kill. It is a fact about us that we were first moralistic and later made this discovery, but it is a brute fact about tuberculosis that it is a specific disease transmitted by microbes. The nominalist is left rather weakly contending that even though a particular kind of person, the consumptive, may have been an artifact of the nineteenth century, the disease itself is an entity in its own right, independently of how we classify.

It would be foolhardy, in this context, to have an opinion about one of the more stable human dichotomies, male and female. But very roughly, the robust realist will agree that there may be what really are physiological borderline cases, once called "hermaphrodites." The existence of vague boundaries is normal: most of us are neither tall nor short, fat nor thin. Sexual physiology is unusually abrupt in its divisions. The realist will take the occasional compulsive

fascination with transvestitism, or horror about hermaphrodites (so well described by Stephen Greenblatt elsewhere), as human (nominalist) resistance to nature's putative aberrations. Likewise the realist will assert that even though our attitudes to gender are almost entirely nonobjective and culturally ordained, gender itself is a real distinction.

I do not know if there were thoroughgoing, consistent, hardline nominalists who held that every classification is of our own making. I might pick that great British nominalist, Hobbes, out of context: "How can any man imagine that the names of things were imposed by their natures?"[14] Or I might pick Nelson Goodman.[15]

Let me take even the vibrant Hobbes, Goodman, and their scholastic predecessors as pale reflections of a perhaps nonexistent static nominalist, who thinks that all categories, classes, and taxonomies are given by human beings rather than by nature and that these categories are essentially fixed throughout the several eras of humankind. I believe that static nominalism is doubly wrong: I think that many categories come from nature, not from the human mind, and I think our categories are not static. A different kind of nominalism—I call it dynamic nominalism—attracts my realist self, spurred on by theories about the making of the homosexual and the heterosexual as kinds of persons or by my observations about official statistics. The claim of dynamic nominalism is not that there was a kind of person who came increasingly to be recognized by bureaucrats or by students of human nature but rather that a kind of person came into being at the same time as the kind itself was being invented. In some cases, that is, our classifications and our classes conspire to emerge hand in hand, each egging the other on.

Take four categories: horse, planet, glove, and multiple personality. It would be preposterous to suggest that the only thing horses have in common is that we call them horses. We may draw the boundaries to admit or to exclude Shetland ponies, but the similarities and differences are real enough. The planets furnish one of T. S. Kuhn's examples of conceptual change.[16] Arguably the heavens looked different after we grouped Earth with the other planets and excluded the Moon and Sun, but I am sure that acute thinkers had discovered a real difference. I hold (most of the time) that strict nominalism is unintelligible for horses and the planets. How could horses and planets be so obedient to our minds? Gloves are something else: we manufacture them. I know not which came first, the thought or the mitten, but they have evolved hand in hand. That the concept "glove" fits gloves so well is no surprise; we made them that way. My claim about making up people is that in a few interesting respects multiple personalities (and much else) are more like gloves than like horses. The category and the people in it emerged hand in hand.

How might a dynamic nominalism affect the concept of the individual person? One answer has to do with possibility. Who we are is not only what we did, do, and will do but also what we might have done and may do. Making up people changes the space of possibilities for personhood. Even the dead are more than their deeds, for we make sense of a finished life only within its sphere of former possibilities. But our possibilities, although inexhaustible, are also bounded. If the nominalist thesis about sexuality was correct, it simply wasn't possible to be a heterosexual kind of person before the nineteenth century, for that kind of person was not there to choose. What could that mean? What could it mean in general to say that possible ways to be a person can from time to time come into being or disappear? Such queries force us to be careful about the idea of possibility itself.

We have a folk picture of the gradations of possibility. Some things, for example, are easy to do, some hard, and some plain impossible. What is impossible for one person is possible for another. At the limit we have the statement: "With men it is impossible, but not with God: for

with God, all things are possible" (Mark 10: 27). (Christ had been saying that it is easier for a camel to pass through the eye of a needle than for a rich man to enter the kingdom of heaven.) Degrees of possibility are degrees in the ability of some agent to do or make something. The more ability, the more possibility, and omnipotence makes anything possible. At that point, logicians have stumbled, worrying about what were once called "the eternal truths" and are now called "logical necessities." Even God cannot make a five-sided square, or so mathematicians say, except for a few such eminent dissenters as Descartes. Often this limitation on omnipotence is explained linguistically, being said to reflect our unwillingness to call anything a five-sided square.

There is something more interesting that God can't do. Suppose that Arnold Davidson, in my opening quotation about perversion, is literally correct. Then it was not possible for God to make George Washington a pervert. God could have delayed Washington's birth by over a century, but would that have been the same man? God could have moved the medical discourse back one hundred odd years. But God could not have simply made him a pervert the way He could have made him freckled or had him captured and hung for treachery. This may seem all the more surprising since Washington was but eight years older than the Marquis de Sade—and Krafft-Ebing has sadomasochism among the four chief categories of perversion. But it follows from Davidson's doctrine that de Sade was not afflicted by the disease of perversion, nor even the disease of sadomasochism either.

Such strange claims are more trivial than they seem; they result from a contrast between people and things. Except when we interfere, what things are doing, and indeed what camels are doing, does not depend on how we describe them. But some of the things that we ourselves do are intimately connected to our descriptions. Many philosophers follow Elizabeth Anscombe and say that intentional human actions must be "actions under a description."[17] This is not mere lingualism, for descriptions are embedded in our practices and lives. But if a description is not there, then intentional actions under that description cannot be there either: that, apparently, is a fact of logic.

Elaborating on this difference between people and things: what camels, mountains, and microbes are doing does not depend on our words. What happens to tuberculosis bacilli depends on whether or not we poison them with BCG vaccine, but it does not depend upon how we describe them. Of course we poison them with a certain vaccine in part because we describe them in certain ways, but it is the vaccine that kills, not our words. Human action is more closely linked to human description than bacterial action is. A century ago I would have said that consumption is caused by bad air and sent the patient to the Alps. Today, I may say that TB is caused by microbes and prescribe a two-year course of injections. But what is happening to the microbes and the patient is entirely independent of my correct or incorrect description, even though it is not independent of the medication prescribed. The microbes' possibilities are delimited by nature, not by words. What is curious about human action is that by and large what I am deliberately doing depends on the possibilities of description. To repeat, this is a tautological inference from what is now a philosopher's commonplace, that all intentional acts are acts under a description. Hence if new modes of description come into being, new possibilities for action come into being in consequence.

Let us now add an example to our repertoire; let it have nothing to do with deviancy, let it be rich in connotations of human practices, and let it help furnish the end of a spectrum of making up people opposite from the multiple personality. I take it from Jean-Paul Sartre, partly for the

well-deserved fame of his description, partly for its excellence as description, partly because Sartre is our premium philosopher of choice, and partly because recalling Sartre will recall an example that returns me to my origin. Let us first look at Sartre's magnificent humdrum example. Many among us might have chosen to be a waiter or waitress and several have been one for a time. A few men might have chosen to be something more specific, a Parisian *garçon de café*, about whom Sartre writes in his immortal discussion of bad faith: "His movement is quick and forward, a little too precise, a little too rapid. He comes toward the patrons with a step a little too quick. He bends forward a little too eagerly, his eyes express an interest too solicitous for the order of the customer."[18] Psychiatrists and medical people in general try to be extremely specific in describing, but no description of the several classical kinds of split personality is as precise (or as recognizable) as this. Imagine for a moment that we are reading not the words of a philosopher who writes his books in cafés but those of a doctor who writes them in a clinic. Has the *garçon de café* a chance of escaping treatment by experts? Was Sartre knowing or merely anticipating when he concluded this very paragraph with the words: "There are indeed many precautions to imprison a man in what he is, as if we lived in perpetual fear that he might escape from it, that he might break away and suddenly elude his condition." That is a good reminder of Sartre's teaching: possibility, project, and prison are one of a piece.

Sartre's antihero chose to be a waiter. Evidently that was not a possible choice in other places, other times. There are servile people in most societies, and servants in many, but a waiter is something specific, and a *garçon de café* more specific. Sartre remarks that the waiter is doing something different when he pretends to play at being a sailor or a diplomat than when he plays at being a waiter in order to be a waiter. I think that in most parts of, let us say, Saskatchewan (or in a McDonald's anywhere), a waiter playing at being a *garçon de café* would miss the mark as surely as if he were playing at being a diplomat while passing over the french fries. As with almost every way in which it is possible to be a person, it is possible to be a *garçon de café* only at a certain time, in a certain place, in a certain social setting. The feudal serf putting food on my lady's table can no more choose to be a *garçon de café* than he can choose to be lord of the manor. But the impossibility is evidently different in kind.

It is not a technical impossibility. Serfs may once have dreamed of travel to the moon; certainly their lettered betters wrote or read adventures of moon travel. But moon travel was impossible for them, whereas it is not quite impossible for today's young waiter. One young waiter will, in a few years, be serving steaks in a satellite. Sartre is at pains to say that even technical limitations do not mean that you have fewer possibilities. For every person, in every era, the world is a plenitude of possibilities. "Of course," Sartre writes, "a contemporary of Duns Scotus is ignorant of the use of the automobile or the aeroplane. . . . For the one who has no relation of any kind to these objects and the techniques that refer to them, there is a kind of absolute, unthinkable and undecipherable nothingness. Such a nothing can in no way limit the For-itself that is choosing itself; it cannot be apprehended as a lack, no matter how we consider it." Passing to a different example, he continues, "The feudal world offered to the vassal lord of Raymond VI infinite possibilities of choice; we do not possess more."[19]

"Absolute, unthinkable and undecipherable nothingness" is a great phrase. That is exactly what being a multiple personality, or being a *garçon de café*, was to Raymond's vassal. Many of you could, in truth, be neither a Parisian waiter nor a split, but both are thinkable, decipherable somethingnesses. It would be possible for God to have made you one or the other or both, leaving the rest of the world more or less intact. That means, to me, that the outer reaches of your

space as an individual are essentially different from what they would have been had these possibilities not come into being.

Thus the idea of making up people is enriched; it applies not to the unfortunate elect but to all of us. It is not just the making up of people of a kind that did not exist before: not only are the split and the waiter made up, but each of us is made up. We are not only what we are, but what we might have been, and the possibilities for what we might have been are transformed.

Hence anyone who thinks about the individual, the person, must reflect on this strange idea, of making up people. Do my stories tell a uniform tale? Manifestly not. The multiple personality, the homosexual or heterosexual person, and the waiter form one spectrum among many that may color our perception here.

Suppose there is some truth in the labeling theory of the modern homosexual. It cannot be the whole truth, and this for several reasons, including one that is future-directed and one that is past-directed. The future-directed fact is that after the institutionalization of the homosexual person in law and official morality, the people involved had a life of their own, individually and collectively. As gay liberation has amply proved, that life was no simple product of the labeling.

The past-directed fact is that the labeling did not occur in a social vacuum, in which those identified as homosexual people passively accepted the format. There was a complex social life that is only now revealing itself in the annals of academic social history. It is quite clear that the internal life of innumerable clubs and associations interacted with the medico-forensic-journalistic labeling. At the risk of giving offense, I suggest that the quickest way to see the contrast between making up homosexuals and making up multiple personalities is to try to imagine split-personality bars. Splits, insofar as they are declared, are under care, and the syndrome, the form of behavior, is orchestrated by a team of experts. Whatever the medico-forensic experts tried to do with their categories, the homosexual person became autonomous of the labeling, but the split is not.

The *garçon de café* is at the opposite extreme. There is of course a social history of waiters in Paris. Some of this will be as anecdotal as the fact that croissants originated in the cafés of Vienna after the Turkish siege was lifted in 1683: the pastries in the shape of a crescent were a mockery of Islam. Other parts of the story will be structurally connected with numerous French institutions. But the class of waiters is autonomous of any act of labeling. At most the name *garçon de café* can continue to ensure both the inferior position of the waiter and the fact that he is male. Sartre's precise description does not fit the *fille de salle;* that is a different role.

I do not believe there is a general story to be told about making up people. Each category has its own history. If we wish to present a partial framework in which to describe such events, we might think of two vectors. One is the vector of labeling from above, from a community of experts who create a "reality" that some people make their own. Different from this is the vector of the autonomous behavior of the person so labeled, which presses from below, creating a reality every expert must face. The second vector is negligible for the split but powerful for the homosexual person. People who write about the history of homosexuality seem to disagree about the relative importance of the two vectors. My scheme at best highlights what the dispute is about. It provides no answers.

The scheme is also too narrow. I began by mentioning my own dusty studies in official statistics and asserted that these also, in a less melodramatic way, contribute to making up people. There is a story to tell here, even about Parisian waiters, who surface in the official statistics of

Paris surprisingly late, in 1881. However, I shall conclude with yet another way of making up people and human acts, one of notorious interest to the existentialist culture of a couple of generations past. I mean suicide, the option that Sartre always left open to the For-itself. Suicide sounds like a timeless option. It is not. Indeed it might be better described as a French obsession.

There have been cultures, including some in recent European history, that knew no suicide. It is said that there were no suicides in Venice when it was the noblest city of Europe. But can I seriously propose that suicide is a concept that has been made up? Oddly, that is exactly what is said by the deeply influential Esquirol in his 1823 medical-encyclopedia article on suicide.[20] He mistakenly asserts that the very word was devised by his predecessor Sauvages. What is true is this: suicide was made the property of medics only at the beginning of the nineteenth century, and a major fight it was too.[21] It was generally allowed that there was the noble suicide, the suicide of honor or of state, but all the rest had to be regarded as part of the new medicine of insanity. By mid-century it would be contended that there was no case of suicide that was not preceded by symptoms of insanity.[22]

This literature concerns the doctors and their patients. It exactly parallels a statistical story. Foucault suggests we think in terms of "two poles of development linked together by a whole cluster of intermediary relations."[23] One pole centers on the individual as a speaking, working, procreating entity he calls an "anatomo-politics of the human body." The second pole, "focused on the species body," serves as the "basis of the biological processes: propagation, births, and mortality, the level of health, life expectancy and longevity." He calls this polarity a "biopolitics of the population." Suicide aptly illustrates patterns of connection between both poles. The medical men comment on the bodies and their past, which led to self-destruction; the statisticians count and classify the bodies. Every fact about the suicide becomes fascinating. The statisticians compose forms to be completed by doctors and police, recording everything from the time of death to the objects found in the pockets of the corpse. The various ways of killing oneself are abruptly characterized and become symbols of national character. The French favor carbon monoxide and drowning; the English hang or shoot themselves.

By the end of the nineteenth century there was so much information about French suicides that Durkheim could use suicide to measure social pathology. Earlier, a rapid increase in the rate of suicide in all European countries had caused great concern. More recently authors have suggested that the growth may have been largely apparent, a consequence of improved systems of reporting.[24] It was thought that there were more suicides because more care was taken to report them. But such a remark is unwittingly ambiguous: reporting brought about more suicides. I do not refer to suicide epidemics that follow a sensational case, like that of von Kleist, who shot his lover and then himself on the Wannsee in 1811—an event vigorously reported in every European capital. I mean instead that the systems of reporting positively created an entire ethos of suicide, right down to the suicide note, an art form that previously was virtually unknown apart from the rare noble suicide of state. Suicide has of course attracted attention in all times and has invited such distinguished essayists as Cicero and Hume. But the distinctively European and American pattern of suicide is a historical artifact. Even the unmaking of people has been made up.

Naturally my kinds of making up people are far from exhaustive. Individuals serve as role models and sometimes thereby create new roles. We have only to think of James Clifford's "On Ethnographic Self-Fashioning: Conrad and Malinowski." Malinowski's book largely created the participant-observer cultural-relativist ethnographer, even if Malinowski himself did not truly

conform to that role in the field. He did something more important—he made up a kind of scholar. The advertising industry relies on our susceptibilities to role models and is largely engaged in trying to make up people. But here nominalism, even of a dynamic kind, is not the key. Often we have no name for the very role a model entices us to adopt.

Dynamic nominalism remains an intriguing doctrine, arguing that numerous kinds of human beings and human acts come into being hand in hand with our invention of the categories labeling them. It is for me the only intelligible species of nominalism, the only one that can even gesture at an account of how common names and the named could so tidily fit together. It is of more human interest than the arid and scholastic forms of nominalism because it contends that our spheres of possibility, and hence our selves, are to some extent made up by our naming and what that entails. But let us not be overly optimistic about the future of dynamic nominalism. It has the merit of bypassing abstract handwaving and inviting us to do serious philosophy, namely, to examine the intricate origin of our ideas of multiple personality or of suicide. It is, we might say, putting some flesh on that wizened figure, John Locke, who wrote about the origin of ideas while introspecting at his desk. But just because it invites us to examine the intricacies of real life, it has little chance of being a general philosophical theory. Although we may find it useful to arrange influences according to Foucault's poles and my vectors, such metaphors are mere suggestions of what to look for next. I see no reason to suppose that we shall ever tell two identical stories of two different instances of making up people.

NOTES

1. Arnold Davidson, "Closing Up the Corpses," in G. Boulos, ed., *Meaning and Method* (Cambridge, 1990).

2. Ian Hacking, "Biopower and the Avalanche of Printed Numbers," *Humanities in Society*, 5 (1982), 279–95; "The Autonomy of Statistical Law," in N. Rescher, ed., *Scientific Explanation and Understanding* (Pittsburgh, 1983), pp. 3–20; "How Should We Do the History of Statistics?" *I&C*, 8 (1981), 15–26.

3. Ian Hacking, "The Invention of Split Personalities," in *Human Knowledge and Social Knowledge*, A. Donellou et al., eds (Dorohecht, 1986), pp. 63–85.

4. Pierre Janet, *The Major Symptoms of Hysteria* (London, 1906), p. 78.

5. Pierre Janet, "Les Actes inconscients et le dédoublement de la personnalité pendant le somnambulisme provoqué," *Revue Philosophique*, 22 (1886), 581.

6. *The State*, Columbia, S.C., October 4, 1982, p. 3A. I apologize for using a newspaper report, but the doctors involved created this story for the papers and did not reply to my letters requesting more information.

7. Abram H. Dailey, *Mollie Fancher, the Brooklyn Enigma* (Brooklyn, 1894).

8. K. Plummer, ed., *The Making of the Modern Homosexual* (London, 1981).

9. John Marshall, "Pansies, Perverts and Macho Men: Changing Conceptions of the Modern Homosexual," in Plummer, ed., pp. 150, 249, n. 6.

10. Reprinted in Plummer, ed., pp. 30–43, with postscript; originally published in *Social Problems*, 16 (1968), 182–92.

11. John I. Kituse and Aaron V. Cewrel, "A Note on the Uses of Official Statistics," *Social Problems*, 11 (1963), 131–39

12. Michel Foucault, *Power/Knowledge*, ed. C. Gordon (London and New York, 1980), p. 97. The translation of this passage is by Alessandro Fontana and Pasquale Pasquino.

13. After the 1983 conference at which this paper was delivered, Bert Hansen (who has helped me a number of times with this paper) remarked that the relation of the nominalist/realist dispute to homosexuality is used by John Boswell, "Towards the Long View: Revolutions, Universal and Sexual Categories," *Salmagundi*, 58–59 (1982–83), 89–114.

14. Thomas Hobbes, *Elements of Philosophy*, II, 4.

15. Trendy, self-styled modern nominalists might refer to his *Ways of Worldmaking* (Indianapolis, Ind., 1978), but the real hard line is in his *Fact, Fiction, and Forecast* (Cambridge, Mass., 1955)—a line so hard that few philosophers who write about the "new riddle of induction" of that book appear even to see the point. Goodman is saying that the only reason to project the hypothesis that all emeralds are green rather than blue—the latter implying that those emeralds, which are in the future examined for the first time, will prove to be blue—is that the word "green" is entrenched, i.e., it is a word and a classification that we have been using. Where the inductive skeptic Hume allowed that there is a real quality, greenness, that we project out of habit, for Goodman there is only our practice of using the word "green" (*Fact,* chap. 4).

16. T. S. Kuhn, *The Structure of Scientific Revolutions* (Chicago, 1962), p. 115.

17. G. E. M. Anscombe, *Intention* (Oxford, 1957).

18. Jean-Paul Sartre, *Being and Nothingness,* trans. Hazel E. Barnes (London, 1957), p. 59.

19. Ibid., p. 522.

20. E. Esquirol, "Suicide," *Dictionnaire des sciences medicales* (Paris, 1823), LIII, 213.

21. Ian Hacking, "Suicide au XIXᵉ siècle," in A. Fagot, ed., *Médicine et probabilités* (Paris, 1982), pp. 165–86.

22. C. E. Bourdin, *Du suicide considéré comme maladie* (Batignolles, 1845), p. 19. The first sentence of this book asserts in bold letters: *Le suicide est une monomanie.*

23. Michel Foucault, *The History of Sexuality,* trans. Robert Hurley (New York, 1978), p. 139.

24. A classic statement of this idea is in Jack D. Douglas, *The Social Meanings of Suicide* (Princeton, N.J., 1967), chap. 3.

# 12

## Situated Knowledges

### The Science Question in Feminism and the Privilege of Partial Perspective[1]

#### DONNA J. HARAWAY

Academic and activist feminist enquiry has repeatedly tried to come to terms with the question of what *we* might mean by the curious and inescapable term "objectivity." We have used a lot of toxic ink and trees processed into paper decrying what *they* have meant and how it hurts *us*. The imagined "they" constitute a kind of invisible conspiracy of masculinist scientists and philosophers replete with grants and laboratories; and the imagined "we" are the embodied others, who are not allowed *not* to have a body, a finite point of view, and so an inevitably disqualifying and polluting bias in any discussion of consequence outside our own little circles, where a "mass"-subscription journal might reach a few thousand readers composed mostly of science-haters. At least, I confess to these paranoid fantasies and academic resentments lurking underneath some convoluted reflections in print under my name in the feminist literature in the history and philosophy of science. We, the feminists in the debates about science and technology, are the Reagan era's "special interest groups" in the rarefied realm of epistemology, where traditionally what can count as knowledge is policed by philosophers codifying cognitive canon law. Of course, a special interest group is, by Reaganoid definition, any collective historical subject which dares to resist the stripped-down atomism of Star Wars, hypermarket, postmodern, media-simulated citizenship. Max Headroom doesn't have a body; therefore, he alone *sees* everything in the great communicator's empire of the Global Network. No wonder Max gets to have a naïve sense of humour and a kind of happily regressive, pre-Oedipal sexuality, a sexuality which we ambivalently—and dangerously incorrectly—had imagined was reserved for life-long inmates of female and colonized bodies, and maybe also white male computer hackers in solitary electronic confinement.

It has seemed to me that feminists have both selectively and flexibly used and been trapped by two poles of a tempting dichotomy on the question of objectivity. Certainly I speak for myself here, and I offer the speculation that there is a collective discourse on these matters. On the one hand, recent social studies of science and technology have made available a very strong social constructionist argument for *all* forms of knowledge claims, most certainly and especially scientific ones.[2] In these tempting views, no insider's perspective is privileged, because

all drawings of inside–outside boundaries in knowledge are theorized as power moves, not moves towards truth. So, from the strong social constructionist perspective, why should we be cowed by scientists' descriptions of their activity and accomplishments; they and their patrons have stakes in throwing sand in our eyes. They tell parables about objectivity and scientific method to students in the first years of their initiation, but no practitioner of the high-scientific arts would be caught dead *acting on* the textbook versions. Social constructionists make clear that official ideologies about objectivity and scientific method are particularly bad guides to how scientific knowledge is actually *made*. Just as for the rest of us, what scientists believe or say they do and what they really do have a very loose fit.

The only people who end up actually *believing* and, goddess forbid, acting on the ideological doctrines of disembodied scientific objectivity enshrined in elementary textbooks and techno-science booster literature are nonscientists, including a few very trusting philosophers. Of course, my designation of this last group is probably just a reflection of residual disciplinary chauvinism from identifying with historians of science and too much time spent with a microscope in early adulthood in a kind of disciplinary pre-Oedipal and modernist poetic moment when cells seemed to be cells and organisms, organisms. *Pace*, Gertrude Stein. But then came the law of the father and its resolution of the problem of objectivity, solved by always already absent referents, deferred signifieds, split subjects, and the endless play of signifiers. Who wouldn't grow up warped? Gender, race, the world itself—all seem just effects of warp speeds in the play of signifiers in a cosmic force field. All truths become warp speed effects in a hyperreal space of simulations. But we cannot afford these particular plays on words—the projects of crafting reliable knowledge about the "natural" world cannot be given over to the genre of paranoid or cynical science fiction. For political people, social constructionism cannot be allowed to decay into the radiant emanations of cynicism.

In any case, social constructionists could maintain that the ideological doctrine of scientific method and all the philosophical verbiage about epistemology were cooked up to distract our attention from getting to know the world *effectively* by practicing the sciences. From this point of view, science—the real game in town, the one we must play—is rhetoric, the persuasion of the relevant social actors that one's manufactured knowledge is a route to a desired form of very objective power. Such persuasions must take account of the structure of facts and artifacts, as well as of language-mediated actors in the knowledge game. Here, artifacts and facts are parts of the powerful art of rhetoric. Practice is persuasion, and the focus is very much on practice. All knowledge is a condensed node in an agonistic power field. The strong programme in the sociology of knowledge joins with the lovely and nasty tools of semiology and deconstruction to insist on the rhetorical nature of truth, including scientific truth. History is a story Western culture buffs tell each other; science is a contestable text and a power field; the content is the form.[3] Period. The form in science is the artifactual-social rhetoric of crafting the world into effective objects. This is a practice of world-changing persuasions that take the shape of amazing new objects—like microbes, quarks, and genes.

But whether or not they have the structure and properties of rhetorical objects, late-twentieth-century scientific entities—infective vectors (microbes), elementary particles (quarks), and bio-molecular codes (genes)—are not romantic or modernist objects with internal laws of coherence.[4] They are momentary traces focused by force fields, or they are information vectors in a barely embodied and highly mutable semiosis ordered by acts of recognition and misrecognition. Human nature, encoded in its genome and its other writing practices, is a vast library worthy of

Umberto Eco's imagined secret labyrinth in *The Name of the Rose* (1980). The stabilization and storage of this text of human nature promise to cost more than its writing. This is a terrifying view of the relationship of body and language for those of us who would still like to talk about *reality* with more confidence than we allow the Christian right's discussion of the Second Coming and their being raptured out of the final destruction of the world. We would like to think our appeals to real worlds are more than a desperate lurch away from cynicism and an act of faith like any other cult's, no matter how much space we generously give to all the rich and always historically specific mediations through which we and everybody else must know the world.

So, the further I get with the description of the radical social constructionist programme and a particular version of postmodernism, coupled to the acid tools of critical discourse in the human sciences, the more nervous I get. Like all neuroses, mine is rooted in the problem of metaphor, that is, the problem of the relation of bodies and language. For example, the force field imagery of moves in the fully textualized and coded world is the matrix for many arguments about socially negotiated reality for the postmodern subject. This world-as-code is, just for starters, a high-tech military field, a kind of automated academic battlefield, where blips of light called players disintegrate (what a metaphor!) each other in order to stay in the knowledge and power game. Technoscience and science fiction collapse into the sun of their radiant (ir)reality—war.[5] It shouldn't take decades of feminist theory to sense the enemy here. Nancy Hartsock (1983b) got all this crystal clear in her concept of abstract masculinity.

I, and others, started out wanting a strong tool for deconstructing the truth claims of hostile science by showing the radical historical specificity, and so contestability, of *every* layer of the onion of scientific and technological constructions, and we end up with a kind of epistemological electroshock therapy, which far from ushering us into the high-stakes tables of the game of contesting public truths, lays us out on the table with self-induced multiple personality disorder. We wanted a way to go beyond showing bias in science (that proved too easy anyhow), and beyond separating the good scientific sheep from the bad goats of bias and misuse. It seemed promising to do this by the strongest possible constructionist argument that left no cracks for reducing the issues to bias versus objectivity, use versus misuse, science versus pseudoscience. We unmasked the doctrines of objectivity because they threatened our budding sense of collective historical subjectivity and agency and our "embodied" accounts of the truth, and we ended up with one more excuse for not learning any post-Newtonian physics and one more reason to drop the old feminist self-help practices of repairing our own cars. They're just texts anyway, so let the boys have them back. Besides, these textualized postmodern worlds are scary, and we prefer our science fiction to be a bit more utopic, maybe like *Woman on the Edge of Time* or even *Wanderground*.

Some of us tried to stay sane in these disassembled and dissembling times by holding out for a feminist version of objectivity. Here, motivated by many of the same political desires, is the other seductive end of the duplicitous objectivity problem. Humanistic Marxism was polluted at the source by its structuring ontological theory of the domination of nature in the self-construction of man and by its closely related impotence to historicize anything women did that didn't qualify for a wage. But Marxism was still a promising resource in the form of epistemological feminist mental hygiene that sought our own doctrines of objective vision. Marxist starting points offered tools to get to our versions of standpoint theories, insistent embodiment, a rich tradition of critiques of hegemony without disempowering positivisms and relativisms, and nuanced theories of mediation. Some versions of psychoanalysis aided this approach immensely,

especially anglophone object relations theory, which maybe did more for United States socialist-feminism for a time than anything from the pen of Marx or Engels, much less Althusser or any of the late pretenders to sonship treating the subject of ideology and science.[6]

Another approach, "feminist empiricism," also converges with feminist uses of Marxian resources to get a theory of science which continues to insist on legitimate meanings of objectivity and which remains leery of a radical constructivism conjugated with semiology and narratology (Harding, 1986, pp. 24–26, 161–62). Feminists have to insist on a better account of the world; it is not enough to show radical historical contingency and modes of construction for everything. Here, we, as feminists, find ourselves perversely conjoined with the discourse of many practicing scientists, who, when all is said and done, mostly believe they are describing and discovering things *by means of* all their constructing and arguing. Evelyn Keller has been particularly insistent on this fundamental matter, and Harding calls the goal of these approaches a "successor science." Feminists have stakes in a successor science project that offers a more adequate, richer, better account of a world, in order to live in it well and in critical, reflexive relation to our own as well as others' practices of domination and the unequal parts of privilege and oppression that make up all positions. In traditional philosophical categories, the issue is ethics and politics perhaps more than epistemology.

So, I think my problem and "our" problem is how to have *simultaneously* an account of radical historical contingency for all knowledge claims and knowing subjects, a critical practice for recognizing our own "semiotic technologies" for making meanings, *and* a no-nonsense commitment to faithful accounts of a "real" world, one that can be partially shared and friendly to earthwide projects of finite freedom, adequate material abundance, modest meaning in suffering, and limited happiness. Harding calls this necessary multiple desire a need for a successor science project and a postmodern insistence on irreducible difference and radical multiplicity of local knowledges. *All* components of the desire are paradoxical and dangerous, and their combination is both contradictory and necessary. Feminists don't need a doctrine of objectivity that promises transcendence, a story that loses track of its mediations just where someone might be held responsible for something, and unlimited instrumental power. We don't want a theory of innocent powers to represent the world, where language and bodies both fall into the bliss of organic symbiosis. We also don't want to theorize the world, much less act within it, in terms of Global Systems, but we do need an earthwide network of connections, including the ability partially to translate knowledges among very different—and power-differentiated—communities. We need the power of modern critical theories of how meanings and bodies get made, not in order to deny meaning and bodies, but in order to live in meanings and bodies that have a chance for a future.

Natural, social, and human sciences have always been implicated in hopes like these. Science has been about a search for translation, convertibility, mobility of meanings, and universality—which I call reductionism—when one language (guess whose) must be enforced as the standard for all the translations and conversions. What money does in the exchange orders of capitalism, reductionism does in the powerful mental orders of global sciences: there is finally only one equation. That is the deadly fantasy that feminists and others have identified in some versions of objectivity doctrines in the service of hierarchical and positivist orderings of what can count as knowledge. That is one of the reasons the debates about objectivity matter, metaphorically and otherwise. Immortality and omnipotence are not our goals. But we could use some enforceable,

reliable accounts of things not reducible to power moves and agonistic, high-status games of rhetoric or to scientistic, positivist arrogance. This point applies whether we are talking about genes, social classes, elementary particles, genders, races, or texts; the point applies to the exact, natural, social, and human sciences, despite the slippery ambiguities of the words *objectivity* and *science* as we slide around the discursive terrain. In our efforts to climb the greased pole leading to a usable doctrine of objectivity, I and most other feminists in the objectivity debates have alternatively, or even simultaneously, held on to both ends of the dichotomy, which Harding describes in terms of successor science projects versus postmodernist accounts of difference and I have sketched in this chapter as radical constructivism versus feminist critical empiricism. It is, of course, hard to climb when you are holding on to both ends of a pole, simultaneously or alternately. It is, therefore, time to switch metaphors.

## THE PERSISTENCE OF VISION[7]

I would like to proceed by placing metaphorical reliance on a much maligned sensory system in feminist discourse: vision. Vision can be good for avoiding binary oppositions. I would like to insist on the embodied nature of all vision, and so reclaim the sensory system that has been used to signify a leap out of the marked body and into a conquering gaze from nowhere. This is the gaze that mythically inscribes all the marked bodies, that makes the unmarked category claim the power to see and not be seen, to represent while escaping representation. This gaze signifies the unmarked positions of Man and White, one of the many nasty tones of the word *objectivity* to feminist ears in scientific and technological, late-industrial, militarized, racist, and male-dominant societies, that is, here, in the belly of the monster, in the United States in the late 1980s. I would like a doctrine of embodied objectivity that accommodates paradoxical and critical feminist science projects: feminist objectivity means quite simply *situated knowledges.*

The eyes have been used to signify a perverse capacity—honed to perfection in the history of science tied to militarism, capitalism, colonialism, and male supremacy—to distance the knowing subject from everybody and everything in the interests of unfettered power. The instruments of visualization in multinationalist, postmodernist culture have compounded these meanings of disembodiment. The visualizing technologies are without apparent limit; the eye of any ordinary primate like us can be endlessly enhanced by sonography systems, magnetic resonance imaging, artificial intelligence-linked graphic manipulation systems, scanning electron microscopes, computer-aided tomography scanners, color enhancement techniques, satellite surveillance systems, home and office VDTs, cameras for every purpose from filming the mucous membrane lining the gut cavity of a marine worm living in the vent gases on a fault between continental plates to mapping a planetary hemisphere elsewhere in the solar system. Vision in this technological feast becomes unregulated gluttony; all perspective gives way to infinitely mobile vision, which no longer seems just mythically about the god-trick of seeing everything from nowhere, but to have put the myth into ordinary practice. And like the god-trick, this eye fucks the world to make technomonsters. Zoe Sofoulis (1988) calls this the cannibal-eye of masculinist extraterrestrial projects for excremental second birthing.

A tribute to this ideology of direct, devouring, generative, and unrestricted vision, whose technological mediations are simultaneously celebrated and presented as utterly transparent, the volume celebrating the 100th anniversary of the National Geographic Society closes its survey of

the magazine's quest literature, effected through its amazing photography, with two juxtaposed chapters. The first is on "Space," introduced by the epigraph, "The choice is the universe—or nothing" (Bryan, 1987, p. 352). Indeed. This chapter recounts the exploits of the space race and displays the colour-enhanced "snapshots" of the outer planets reassembled from digitalized signals transmitted across vast space to let the viewer "experience" the moment of discovery in immediate vision of the "object."[8] These fabulous objects come to us simultaneously as indubitable recordings of what is simply there and as heroic feats of technoscientific production. The next chapter is the twin of outer space: "Inner Space," introduced by the epigraph, "The stuff of stars has come alive" (Bryan, 1987, p. 454). Here, the reader is brought into the realm of the infinitesimal, objectified by means of radiation outside the wavelengths that "normally" are perceived by hominid primates, i.e., the beams of lasers and scanning electron microscopes, whose signals are processed into the wonderful full-colour snapshots of defending T cells and invading viruses.

But of course that view of infinite vision is an illusion, a god-trick. I would like to suggest how our insisting metaphorically on the particularity and embodiment of all vision (though not necessarily organic embodiment and including technological mediation), and not giving in to the tempting myths of vision as a route to disembodiment and second birthing, allows us to construct a usable, but not an innocent, doctrine of objectivity. I want a feminist writing of the body that metaphorically emphasizes vision again, because we need to reclaim that sense to find our way through all the visualizing tricks and powers of modern sciences and technologies that have transformed the objectivity debates. We need to learn in our bodies, endowed with primate color and stereoscopic vision, how to attach the objective to our theoretical and political scanners in order to name where we are and are not, in dimensions of mental and physical space we hardly know how to name. So, not so perversely, objectivity turns out to be about particular and specific embodiment, and definitely not about the false vision promising transcendence of all limits and responsibility. The moral is simple: only partial perspective promises objective vision. This is an objective vision that initiates, rather than closes off, the problem of responsibility for the generativity of all visual practices. Partial perspective can be held accountable for both its promising and its destructive monsters. All Western cultural narratives about objectivity are allegories of the ideologies of the relations of what we call mind and body, of distance and responsibility, embedded in the science question in feminism. Feminist objectivity is about limited location and situated knowledge, not about transcendence and splitting of subject and object. In this way we might become answerable for what we learn how to see.

These are lessons which I learned in part walking with my dogs and wondering how the world looks without a fovea and very few retinal cells for colour vision, but with a huge neural processing and sensory area for smells. It is a lesson available from photographs of how the world looks to the compound eyes of an insect, or even from the camera eye of a spy satellite or the digitally transmitted signals of space probe-perceived differences "near" Jupiter that have been transformed into coffee-table color photographs. The "eyes" made available in modern technological sciences shatter any idea of passive vision; these prosthetic devices show us that all eyes, including our own organic ones, are active perceptual systems, building in translations and specific *ways* of seeing, that is, ways of life. There is no unmediated photograph or passive camera obscura in scientific accounts of bodies and machines; there are only highly specific visual possibilities, each with a wonderfully detailed, active, partial way of organizing worlds. All these pictures of the world should not be allegories of infinite mobility and interchangeability, but of

elaborate specificity and difference and the loving care people might take to learn how to see faithfully from another's point of view, even when the other is our own machine. That's not alienating distance; that's a *possible* allegory for feminist versions of objectivity. Understanding how these visual systems work, technically, socially, and psychically ought to be a way of embodying feminist objectivity.

Many currents in feminism attempt to theorize grounds for trusting especially the vantage points of the subjugated; there is good reason to believe vision is better from below the brilliant space platforms of the powerful (Hartsock, 1983a; Sandoval, n.d.; Harding, 1986; Anzaldúa, 1987). Linked to this suspicion, this chapter is an argument for situated and embodied knowledges and against various forms of unlocatable, and so irresponsible, knowledge claims. Irresponsible means unable to be called into account. There is a premium on establishing the capacity to see from the peripheries and the depths. But here lies a serious danger of romanticizing and/or appropriating the vision of the less powerful while claiming to see from their positions. To see from below is neither easily learned nor unproblematic, even if "we" "naturally" inhabit the great underground terrain of subjugated knowledges. The positionings of the subjugated are not exempt from critical reexamination, decoding, deconstruction, and interpretation; that is, from both semiological and hermeneutic modes of critical enquiry. The standpoints of the subjugated are not "innocent" positions. On the contrary, they are preferred because in principle they are least likely to allow denial of the critical and interpretative core of all knowledge. They are savvy to modes of denial through repression, forgetting, and disappearing acts—ways of being nowhere while claiming to see comprehensively. The subjugated have a decent chance to be onto the god-trick and all its dazzling—and, therefore, blinding—illuminations. "Subjugated" standpoints are preferred because they seem to promise more adequate, sustained, objective, transforming accounts of the world. But *how* to see from below is a problem requiring at least as much skill with bodies and language, with the mediations of vision, as the "highest" technoscientific visualizations.

Such preferred positioning is as hostile to various forms of relativism as to the most explicitly totalizing versions of claims to scientific authority. But the alternative to relativism is not totalization and single vision, which is always finally the unmarked category whose power depends on systematic narrowing and obscuring. The alternative to relativism is partial, locatable, critical knowledges sustaining the possibility of webs of connections called solidarity in politics and shared conversations in epistemology. Relativism is a way of being nowhere while claiming to be everywhere equally. The "equality" of positioning is a denial of responsibility and critical enquiry. Relativism is the perfect mirror twin of totalization in the ideologies of objectivity; both deny the stakes in location, embodiment, and partial perspective; both make it impossible to see well. Relativism and totalization are both "god-tricks" promising vision from everywhere and nowhere equally and fully, common myths in rhetorics surrounding Science. But it is precisely in the politics and epistemology of partial perspectives that the possibility of sustained, rational, objective enquiry rests.

So, with many other feminists, I want to argue for a doctrine and practice of objectivity that privileges contestation, deconstruction, passionate construction, webbed connections, and hope for transformation of systems of knowledge and ways of seeing. But not just any partial perspective will do; we must be hostile to easy relativisms and holisms built out of summing and subsuming parts. "Passionate detachment" (Kuhn, 1982) requires more than acknowledged and self-critical partiality. We are also bound to seek perspective from those points of view which can

never be known in advance, which promise something quite extraordinary, that is, knowledge potent for constructing worlds less organized by axes of domination. In such a viewpoint, the unmarked category would *really* disappear—quite a difference from simply repeating a disappearing act. The imaginary and the rational—the visionary and objective vision—hover close together. I think Harding's plea for a successor science and for postmodern sensibilities must be read to argue that this close touch of the fantastic element of hope for transformative knowledge and the severe check and stimulus of sustained critical enquiry are jointly the ground of any believable claim to objectivity or rationality not riddled with breathtaking denials and repressions. It is even possible to read the record of scientific revolutions in terms of this feminist doctrine of rationality and objectivity. Science has been utopian and visionary from the start; that is one reason "we" need it.

A commitment to mobile positioning and to passionate detachment is dependent on the impossibility of innocent "identity" politics and epistemologies as strategies for seeing from the standpoints of the subjugated in order to see well. One cannot "be" either a cell or molecule—or a woman, colonized person, laborer, and so on—if one intends to see and see from these positions critically. "Being" is much more problematic and contingent. Also, one cannot relocate in any possible vantage point without being accountable for that movement. Vision is *always* a question of the power to see—and perhaps of the violence implicit in our visualizing practices. With whose blood were my eyes crafted? These points also apply to testimony from the position of "oneself." We are not immediately present to ourselves. Self-knowledge requires a semiotic-material technology linking meanings and bodies. Self-identity is a bad visual system. Fusion is a bad strategy of positioning. The boys in the human sciences have called this doubt about self-presence the "death of the subject," that single ordering point of will and consciousness. That judgment seems bizarre to me. I prefer to call this generative doubt the opening of nonisomorphic subjects, agents, and territories of stories unimaginable from the vantage point of the cyclopian, self-satiated eye of the master subject. The Western eye has fundamentally been a wandering eye, a traveling lens. These peregrinations have often been violent and insistent on mirrors for a conquering self—but not always. Western feminists also *inherit* some skill in learning to participate in revisualizing worlds turned upside down in earth-transforming challenges to the views of the masters. All is not to be done from scratch.

The split and contradictory self is the one who can interrogate positionings and be accountable, the one who can construct and join rational conversations and fantastic imaginings that change history.[9] Splitting, not being, is the privileged image for feminist epistemologies of scientific knowledge. "Splitting" in this context should be about heterogeneous multiplicities that are simultaneously necessary and incapable of being squashed into isomorphic slots or cumulative lists. This geometry pertains within and among subjects. The topography of subjectivity is multidimensional; so, therefore, is vision. The knowing self is partial in all its guises, never finished, whole, simply there and original; it is always constructed and stitched together imperfectly, and *therefore* able to join with another, to see together without claiming to be another. Here is the promise of objectivity: a scientific knower seeks the subject position not of identity, but of objectivity; that is, partial connection. There is no way to "be" simultaneously in all, or wholly in any, of the privileged (subjugated) positions structured by gender, race, nation, and class. And that is a short list of critical positions. The search for such a "full" and total position is the search for the fetishized perfect subject of oppositional history, sometimes appearing in feminist theory as the essentialized Third World Woman (Mohanty, 1984). Subjugation is not grounds for an ontology;

it might be a visual clue. Vision requires instruments of vision; an optics is a politics of positioning. Instruments of vision mediate standpoints; there is no immediate vision from the standpoints of the subjugated. Identity, including self-identity, does not produce science; critical positioning does, that is, objectivity. Only those occupying the positions of the dominators are self-identical, unmarked, disembodied, unmediated, transcendent, born again. It is unfortunately possible for the subjugated to lust for and even scramble into that subject position—and then disappear from view. Knowledge from the point of view of the unmarked is truly fantastic, distorted, and so irrational. The only position from which objectivity could not possibly be practiced and honored is the standpoint of the master, the Man, the One God, whose Eye produces, appropriates, and orders all difference. No one ever accused the God of monotheism of objectivity, only of indifference. The god-trick is self-identical, and we have mistaken that for creativity and knowledge, omniscience even.

Positioning is, therefore, the key practice grounding knowledge organized around the imagery of vision, as so much Western scientific and philosophic discourse is organized. Positioning implies responsibility for our enabling practices. It follows that politics and ethics ground struggles for the contests over what may count as rational knowledge. That is, admitted or not, politics and ethics ground struggles over knowledge projects in the exact, natural, social, and human sciences. Otherwise, rationality is simply impossible, an optical illusion projected from nowhere comprehensively. Histories of science may be powerfully told as histories of the technologies. These technologies are ways of life, social orders, practices of visualization. Technologies are skilled practices. How to see? Where to see from? What limits to vision? What to see for? Whom to see with? Who gets to have more than one point of view? Who gets blinkered? Who wears blinkers? Who interprets the visual field? What other sensory powers do we wish to cultivate besides vision? Moral and political discourse should be the paradigm of rational discourse in the imagery and technologies of vision. Sandra Harding's claim, or observation, that movements of social revolution have most contributed to improvements in science might be read as a claim about the knowledge consequences of new technologies of positioning. But I wish Harding had spent more time remembering that social and scientific revolutions have not always been liberatory, even if they have always been visionary. Perhaps this point could be captured in another phrase: the science question in the military. Struggles over what will count as rational accounts of the world are struggles over *how* to see. The terms of vision: the science question in colonialism; the science question in exterminism (Sofoulis, 1988); the science question in feminism.

The issue in politically engaged attacks on various empiricisms, reductionisms, or other versions of scientific authority should not be relativism, but location. A dichotomous chart expressing this point might look like this:

| | |
|---|---|
| universal rationality | ethnophilosophies |
| common language | heteroglossia |
| new organon | deconstruction |
| unified field theory | oppositional positioning |
| world system | local knowledges |
| master theory | webbed accounts |

But a dichotomous chart misrepresents in a critical way the positions of embodied objectivity which I am trying to sketch. The primary distortion is the illusion of symmetry in the chart's

dichotomy, making any position appear, first, simply alternative and, second, mutually exclusive. A map of tensions and resonances between the fixed ends of a charged dichotomy better represents the potent politics and epistemologies of embodied, therefore accountable, objectivity. For example, local knowledges have also to be in tension with the productive structurings that force unequal translations and exchanges—material and semiotic—within the webs of knowledge and power. Webs *can* have the property of systematicity, even of centrally structured global systems with deep filaments and tenacious tendrils into time, space, and consciousness, the dimensions of world history. Feminist accountability requires a knowledge tuned to resonance, not to dichotomy. Gender is a field of structured and structuring difference, where the tones of extreme localization, of the intimately personal and individualized body, vibrate in the same field with global high tension emissions. Feminist embodiment, then, is not about fixed location in a reified body, female or otherwise, but about nodes in fields, inflections in orientations, and responsibility for difference in material-semiotic fields of meaning. Embodiment is significant prosthesis; objectivity cannot be about fixed vision when what counts as an object is precisely what world history turns out to be about.

How should one be positioned in order to see in this situation of tensions, resonances, transformations, resistances, and complicities? Here, primate vision is not immediately a very powerful metaphor or technology for feminist political-epistemological clarification, since it seems to present to consciousness already processed and objectified fields; things seem already fixed and distanced. But the visual metaphor allows one to go beyond fixed appearances, which are only the end products. The metaphor invites us to investigate the varied apparatuses of visual production, including the prosthetic technologies interfaced with our biological eyes and brains. And here we find highly particular machineries for processing regions of the electromagnetic spectrum into our pictures of the world. It is in the intricacies of these visualization technologies in which we are embedded that we will find metaphors and means for understanding and intervening in the patterns of objectification in the world, that is, the patterns of reality for which we must be accountable. In these metaphors, we find means for appreciating simultaneously *both* the concrete, "real" aspect and the aspect of semiosis and production in what we call scientific knowledge.

I am arguing for politics and epistemologies of location, positioning, and situating, where partiality and not universality is the condition of being heard to make rational knowledge claims. These are claims on people's lives; the view from a body, always a complex, contradictory, structuring and structured body, versus the view from above, from nowhere, from simplicity. Only the god-trick is forbidden. Here is a criterion for deciding the science question in militarism, that dream science/technology of perfect language, perfect communication, final order.

Feminism loves another science: the sciences and politics of interpretation, translation, stuttering, and the partly understood. Feminism is about the sciences of the multiple subject with (at least) double vision. Feminism is about a critical vision consequent upon a critical positioning in in-homogeneous gendered social space.[10] Translation is always interpretative, critical, and partial. Here is a ground for conversation, rationality, and objectivity—which is power-sensitive, not pluralist, "conversation." It is not even the mythic cartoons of physics and mathematics—incorrectly caricatured in antiscience ideology as exact, hyper-simple knowledges—that have come to represent the hostile other to feminist paradigmatic models of scientific knowledge, but the dreams of the perfectly known in high-technology, permanently militarized scientific productions and positionings, the god-trick of a Star Wars paradigm of rational knowledge. So

location is about vulnerability; location resists the politics of closure, finality, or, to borrow from Althusser, feminist objectivity resists "simplification in the last instance." That is because feminist embodiment resists fixation and is insatiably curious about the webs of differential positioning. There is no single feminist standpoint because our maps require too many dimensions for that metaphor to ground our visions. But the feminist standpoint theorists' goal of an epistemology and politics of engaged, accountable positioning remains eminently potent. The goal is better accounts of the world, that is, "science."

Above all, rational knowledge does not pretend to disengagement: to be from everywhere and so nowhere, to be free from interpretation, from being represented, to be fully self-contained or fully formalizable. Rational knowledge is a process of ongoing critical interpretation among "fields" of interpreters and decoders. Rational knowledge is power-sensitive conversation (King, 1987a):

> knowledge : community :: knowledge : power
> hermeneutics : semiology :: critical interpretation : codes.

Decoding and transcoding plus translation and criticism; all are necessary. So science becomes the paradigmatic model not of closure, but of that which is contestable and contested. Science becomes the myth not of what escapes human agency and responsibility in a realm above the fray, but rather of accountability and responsibility for translations and solidarities linking the cacophonous visions and visionary voices that characterize the knowledges of the subjugated. A splitting of senses, a confusion of voice and sight, rather than clear and distinct ideas, becomes the metaphor for the ground of the rational. We seek not the knowledges ruled by phallogocentrism (nostalgia for the presence of the one true Word) and disembodied vision, but those ruled by partial sight and limited voice. We do not seek partiality for its own sake, but for the sake of the connections and unexpected openings situated knowledges make possible. The only way to find a larger vision is to be somewhere in particular. The science question in feminism is about objectivity as positioned rationality. Its images are not the products of escape and transcendence of limits, i.e., the view from above, but the joining of partial views and halting voices into a collective subject position that promises a vision of the means of ongoing finite embodiment, of living within limits and contradictions, i.e., of views from somewhere.

## OBJECTS AS ACTORS: THE APPARATUS
## OF BODILY PRODUCTION

Throughout this reflection on "objectivity," I have refused to resolve the ambiguities built into referring to science without differentiating its extraordinary range of contexts. Through the insistent ambiguity, I have foregrounded a field of commonalities binding exact, physical, natural, social, political, biological, and human sciences; and I have tied this whole heterogeneous field of academically (and industrially, for example, in publishing, the weapons trade, and pharmaceuticals) institutionalized knowledge production to a meaning of science that insists on its potency in ideological struggles. But, partly in order to give play to both the specificities and the highly permeable boundaries of meanings in discourse on science, I would like to suggest a resolution to one ambiguity. Throughout the field of meanings constituting science, one of the commonalities concerns the status of any object of knowledge and of related claims about the

faithfulness of our accounts to a "real world," no matter how mediated for us and no matter how complex and contradictory these worlds may be. Feminists, and others who have been most active as critics of the sciences and their claims or associated ideologies, have shied away from doctrines of scientific objectivity in part because of the suspicion that an "object" of knowledge is a passive and inert thing. Accounts of such objects can seem to be either appropriations of a fixed and determined world reduced to resource for the instrumentalist projects of destructive Western societies, or they can be seen as masks for interests, usually dominating interests.

For example, "sex" as an object of biological knowledge appears regularly in the guise of biological determinism, threatening the fragile space for social constructionism and critical theory, with their attendant possibilities for active and transformative intervention, called into being by feminist concepts of gender as socially, historically, and semiotically positioned difference. And yet, to lose authoritative biological accounts of sex, which set up productive tensions with its binary pair, gender, seems to be to lose too much; it seems to be to lose not just analytic power within a particular Western tradition, but the body itself as anything but a blank page for social inscriptions, including those of biological discourse. The same problem of loss attends a radical "reduction" of the objects of physics or of any other sciences to the ephemera of discursive production and social construction.[11]

But the difficulty and loss are not necessary. They derive partly from the analytical tradition, deeply indebted to Aristotle and to the transformative history of "White Capitalist Patriarchy" (how may we name this scandalous Thing?) that turns everything into a resource for appropriation, in which an object of knowledge is finally itself only matter for the seminal power, the act, of the knower. Here, the object both guarantees and refreshes the power of the knower, but any status as *agent* in the productions of knowledge must be denied the object. It—the world—must, in short, be objectified as thing, not as an agent; it must be matter for the self-formation of the only social being in the productions of knowledge, the human knower. Zoe Sofoulis (1988) identified the structure of this mode of knowing in technoscience as "resourcing"—the second birthing of Man through the homogenizing of all the world's body into resource for his perverse projects. Nature is only the raw material of culture, appropriated, preserved, enslaved, exalted, or otherwise made flexible for disposal by culture in the logic of capitalist colonialism. Similarly, sex is only the matter to the act of gender; the productionist logic seems inescapable in traditions of Western binarisms. This analytical and historical narrative logic accounts for my nervousness about the sex/gender distinction in the recent history of feminist theory. Sex is "resourced" for its re-presentation as gender, which "we" can control. It has seemed all but impossible to avoid the trap of an appropriationist logic of domination built into the nature/culture binarism and its generative lineage, including the sex/gender distinction.

It seems clear that feminist accounts of objectivity and embodiment—that is, of a world—of the kind sketched in this chapter require a deceptively simple manouvre within inherited Western analytical traditions, a maneuvre begun in dialectics, but stopping short of the needed revisions. Situated knowledges require that the object of knowledge be pictured as an actor and agent, not a screen or a ground or a resource, never finally as slave to the master that closes off the dialectic in his unique agency and authorship of "objective" knowledge. The point is paradigmatically clear in critical approaches to the social and human sciences, where the agency of people studied itself transforms the entire project of producing social theory. Indeed, coming to terms with the agency of the "objects" studied is the only way to avoid gross error and false knowledge of many kinds in these sciences. But the same point must apply to the other

knowledge projects called sciences. A corollary of the insistence that ethics and politics covertly or overtly provide the bases for objectivity in the sciences as a heterogeneous whole, and not just in the social sciences, is granting the status of agent/actor to the "objects" of the world. Actors come in many and wonderful forms. Accounts of a "real" world do not, then, depend on a logic of "discovery," but on a power-charged social relation of "conversation." The world neither speaks itself nor disappears in favour of a master decoder. The codes of the world are not still, waiting only to be read. The world is not raw material for humanization; the thorough attacks on humanism, another branch of "death of the subject" discourse, have made this point quite clear. In some critical sense that is crudely hinted at by the clumsy category of the social or of agency, the world encountered in knowledge projects is an active entity. In so far as a scientific account has been able to engage this dimension of the world as object of knowledge, faithful knowledge can be imagined and can make claims on us. But no particular doctrine of representation or decoding or discovery guarantees anything. The approach I am recommending is not a version of "realism" which has proved a rather poor way of engaging with the world's active agency.

My simple, perhaps simpleminded, maneuvre is obviously not new in Western philosophy, but it has a special feminist edge to it in relation to the science question in feminism and to the linked questions of gender as situated difference and of female embodiment. Ecofeminists have perhaps been most insistent on some version of the world as active subject, not as resource to be mapped and appropriated in bourgeois, Marxist, or masculinist projects. Acknowledging the agency of the world in knowledge makes room for some unsettling possibilities, including a sense of the world's independent sense of humor. Such a sense of humor is not comfortable for humanists and others committed to the world as resource. Richly evocative figures exist for feminist visualizations of the world as witty agent. We need not lapse into an appeal to a primal mother resisting becoming resource. The Coyote or Trickster, embodied in American Southwest Indian accounts, suggests our situation when we give up mastery but keep searching for fidelity, knowing all the while we will be hoodwinked. I think these are useful myths for scientists who might be our allies. Feminist objectivity makes room for surprises and ironies at the heart of all knowledge production; we are not in charge of the world. We just live here and try to strike up noninnocent conversations by means of our prosthetic devices, including our visualization technologies. No wonder science fiction has been such a rich writing practice in recent feminist theory. I like to see feminist theory as a reinvented coyote discourse obligated to its enabling sources in many kinds of heterogeneous accounts of the world.

Another rich feminist practice in science in the last couple of decades illustrates particularly well the "activation" of the previously passive categories of objects of knowledge. The activation permanently problematizes binary distinctions like sex and gender, without however eliminating their strategic utility. I refer to the reconstructions in primatology, especially but not only women's practice as primatologists, evolutionary biologists, and behavioural ecologists, of what may count as sex, especially as female sex, in scientific accounts (Haraway, 1989b). The *body*, the object of biological discourse, itself becomes a most engaging being. Claims of biological determinism can never be the same again. When female "sex" has been so thoroughly retheorized and revisualized that it emerges as practically indistinguishable from "mind," something basic has happened to the categories of biology. The biological female peopling current biological behavioural accounts has almost no passive properties left. She is structuring and active in every respect; the "body" is an agent, not a resource. Difference is theorized *biologically* as situational,

not intrinsic, at every level from gene to foraging pattern, thereby fundamentally changing the biological politics of the body. The relations between sex and gender have to be categorically reworked within these frames of knowledge. I would like to suggest this trend in explanatory strategies in biology as an allegory for interventions faithful to projects of feminist objectivity. The point is not that these new pictures of the biological female are simply true or not open to contestation and conversation. Quite the opposite. But these pictures foreground knowledge as situated conversation at every level of its articulation. The boundary between animal and human is one of the stakes in this allegory, as well as that between machine and organism.

So I will close with a final category useful to a feminist theory of situated knowledges: the apparatus of bodily production. In her analysis of the production of the poem as an object of literary value, Katie King offers tools that clarify matters in the objectivity debates among feminists. King suggests the term "apparatus of literary production" to highlight the emergence of what is embodied as literature at the intersection of art, business, and technology. The apparatus of literary production is a matrix from which "literature" is born. Focusing on the potent object of value called the "poem," King applies her analytic frame to the relation of women and writing technologies (King, 1987b). I would like to adapt her work to understanding the generation— the actual production and reproduction—of bodies and other objects of value in scientific knowledge projects. At first glance, there is a limitation to using King's scheme inherent in the "facticity" of biological discourse that is absent from literary discourse and its knowledge claims. Are biological bodies "produced" or "generated" in the same strong sense as poems? From the early stirrings of romanticism in the late eighteenth century, many poets and biologists have believed that poetry and organisms are siblings. *Frankenstein* may be read as a meditation on this proposition. I continue to believe in this potent proposition, but in a postmodern and not a romantic manner of belief. I wish to translate the ideological dimensions of "facticity" and "the organic" into a cumbersome entity called a "material-semiotic actor." This unwieldy term is intended to highlight the object of knowledge as an active, meaning-generating axis of the apparatus of bodily production, without *ever* implying immediate presence of such objects or, what is the same thing, their final or unique determination of what can count as objective knowledge at a particular historical juncture. Like King's objects called "poems," which are sites of literary production where language also is an actor independent of intentions and authors, bodies as objects of knowledge are material-semiotic generative nodes. Their *boundaries* materialize in social interaction. Boundaries are drawn by mapping practices; "objects" do not preexist as such. Objects are boundary projects. But boundaries shift from within; boundaries are very tricky. What boundaries provisionally contain remains generative, productive of meanings and bodies. Siting (sighting) boundaries is a risky practice.

Objectivity is not about disengagement, but about mutual *and* usually unequal structuring, about taking risks in a world where "we" are permanently mortal, that is, not in "final" control. We have, finally, no clear and distinct ideas. The various contending biological bodies emerge at the intersection of biological research and writing, medical and other business practices, and technology, such as the visualization technologies enlisted as metaphors in this chapter. But also invited into that node of intersection is the analogue to the lively languages that actively intertwine in the production of literary value: the coyote and protean embodiments of a world as witty agent and actor. Perhaps the world resists being reduced to mere resource because it is— not mother/matter/mutter—but coyote, a figure for the always problematic, always potent tie of meaning and bodies. Feminist embodiment, feminist hopes for partiality, objectivity, and

situated knowledges, turn on conversations and codes at this potent node in fields of possible bodies and meanings. Here is where science, science fantasy, and science fiction converge in the objectivity question in feminism. Perhaps our hopes for accountability, for politics, for ecofeminism, turn on revisioning the world as coding trickster with whom we must learn to converse.

NOTES

1. This chapter originated as a commentary on Harding (1986), at the Western Division meetings of the American Philosophical Association, San Francisco, March 1987. Support during the writing of this paper was generously provided by the Alpha Fund of the Institute for Advanced Study, Princeton, New Jersey. Thanks especially to Joan Scott, Rayna Rapp, Judy Newton, Judy Butler, Lila Abu-Lughod, and Dorinne Kondo.

2. For example, see Knorr-Cetina and Mulkay (1983); Bijker *et al.* (1987); and especially, Latour (1984, 1988). Borrowing from Michel Tournier's *Vendredi* (1967), Latour's brilliant and maddening aphoristic polemic against all forms of reductionism makes the essential point for feminists: "Méfiez-vous de la pureté; c'est le vitriol de l'âme" (Latour, 1984, p. 171). Latour is not otherwise a notable feminist theorist, but he might be made into one by readings as perverse as those he makes of the laboratory, that great machine for making significant mistakes faster than anyone else can, and so gaining world-changing power. The laboratory for Latour is the railroad industry of epistemology, where facts can only be made to run on the tracks laid down from the laboratory out. Those who control the railroads control the surrounding territory. How could we have forgotten? But now it's not so much the bankrupt railroads we need as the satellite network. Facts run on lightbeams these days.

3. For an elegant and very helpful elucidation of a non-cartoon version of this argument, see White (1987). I still want more; and unfulfilled desire can be a powerful seed for changing the stories.

4. In her analysis exploring the fault line between modernism and postmodernism in ethnography and anthropology—in which the high stakes are the authorization or prohibition to craft *comparative* knowledge across "cultures," from some epistemologically grounded vantage point *either* inside, outside, or in dialogical relation with any unit of analysis—Marilyn Strathern (1987a) made the crucial observation that it is not the written ethnography that is parallel to the work of art as object-of-knowledge, but the *culture*. The romantic and modernist natural-technical objects of knowledge, in science and in other cultural practice, stand on one side of this divide. The postmodernist formation stands on the other side, with its "anti-aesthetic" of permanently split, problematized, always receding and deferred "objects" of knowledge and practice, including signs, organisms, systems, selves, and cultures. "Objectivity" in a postmodern frame cannot be about unproblematic objects; it must be about specific prosthesis and translation. Objectivity, which at root has been about crafting *comparative* knowledge (how to name things to be stable and to be like each other), becomes a question of the politics of redrawing of boundaries in order to have non-innocent conversations and connections. What is at stake in the debates about modernism and postmodernism is the pattern of relationships between and within bodies and language.

5. Zoe Sofoulis (1988) has produced a dazzlingly (she will forgive me the metaphor) theoretical treatment of technoscience, the psychoanalysis of science fiction culture, and the metaphorics of extra-terrestrialism, including a wonderful focus on the ideologies and philosophies of light, illumination, and discovery in Western mythics of science and technology. My essay was revised in dialogue with Sofoulis's arguments and metaphors in her Ph.D. dissertation.

6. Crucial to this discussion are Harding (1986), Keller (1985), Hartsock (1983a, 1983b), Flax (1983, 1987), Keller and Grontkowski (1983), H. Rose (1986), Haraway (1985), and Petchesky (1987).

7. John Varley's science fiction short story called "The Persistence of Vision" is part of the inspiration for this section. In the story, Varley constructs a utopian community designed and built by the deaf-blind. He then explores these people's technologies and other mediations of communication and their relations to sighted children and visitors (Varley, 1978). In "Blue Champagne," Varley (1986) transmutes the theme to interrogate the politics of intimacy and technology for a paraplegic young woman whose prosthetic device, the golden gypsy, allows her full mobility. But since the infinitely costly device is owned by an intergalactic communications and entertainment empire for which she works as a media star making "feelies," she may keep her technological, intimate, enabling, other self only in exchange for her complicity in the commodification of all experience. What are her limits to the reinvention of experience for sale? Is the personal political under the sign of simulation? One way to read Varley's repeated investigations of finally always limited embodiments, differently abled beings, prosthetic technologies, and cyborgian encounters with their finitude despite their extraordinary transcendence of "organic" orders is to find an allegory for the personal and political in the historical mythic time of the late twentieth century, the era of techno-biopolitics. Prosthesis becomes a fundamental category for understanding our most intimate selves. Prosthesis is semiosis, the making of meanings and bodies, not for transcendence but for power-charged communication.

8. I owe my understanding of the experience of these photographs to Jim Clifford, University of California at Santa Cruz, who identified their "land ho!" effect on the reader.

9. Joan Scott reminded me that Teresa de Lauretis (1986a, pp. 14–15) put it like this:

Differences among women may be better understood as differences within women. . . . But once understood in their constitutive power—once it is understood, that is, that these differences not only constitute each

woman's consciousness and subjective limits but all together define the *female subject of feminism* in its very specificity, its inherent and at least for now irreconcilable contradiction—these differences, then, cannot be again collapsed into a fixed identity, a sameness of all women as Woman, or a representation of Feminism as a coherent and available image.

10. Harding (1986, p. 18) suggested that gender has three dimensions, each historically specific: gender symbolism, the social-sexual division of labor, and processes of constructing individual gendered identity, I would enlarge her point to note that there is no reason to expect the three dimensions to covary or codetermine each other, at least not directly. That is, extremely steep gradients between contrasting terms in gender symbolism may very well not correlate with sharp social-sexual divisions of labor or social power, but may be closely related to sharp racial stratification or something else. Similarly, the processes of gendered subject formation may not be directly illuminated by knowledge of the sexual division of labor or the gender symbolism in the particular historical situation under examination. On the other hand, we should expect mediated relations among the dimensions. The mediations might move through quite different social axes of organization of both symbols, practice, and identity, such as race. And vice versa. I would suggest also that science, as well as gender or race, might usefully be broken up into such a multipart scheme of symbolism, social practice, and subject position. More than three dimensions suggest themselves when the parallels are drawn. The different dimensions of, for example, gender, race, and science might mediate relations among dimensions on a parallel chart. That is, racial divisions of labor might mediate the patterns of connection between symbolic connections and formation of individual subject positions on the science or gender chart. Or formations of gendered or racial subjectivity might mediate the relations between scientific social division of labor and scientific symbolic patterns.

The chart below begins an analysis by parallel dissections. In the chart (and in reality?), both gender and science are analytically asymmetrical; i.e., each term contains and obscures a structuring hierarchicalized binarism, sex/gender and nature/science. Each binarism orders the silent term by a logic of appropriation, as resource to product, nature to culture, potential to actual. Both poles of the binarism are constructed and structure each other dialectically. Within each voiced or explicit term, further asymmetrical splittings can be excavated, as from gender, masculine to feminine, and from science, hard sciences to soft sciences. This is a point about remembering how a particular analytical tool works, willy-nilly, intended or not. The chart reflects common ideological aspects of discourse on science and gender and may help as an analytical tool to crack open mystified units like Science or Woman.

| Gender | Science |
|---|---|
| symbolic system | symbolic system |
| social division of labor (by sex, by race, etc.) | social division of labor (by craft, industrial, or post-industrial logics) |
| individual identity/subject position (desiring/desired; autonomous/relational) | individual identity/subject position (knower/known; scientist/other) |
| material culture (gender paraphernalia and daily gender technologies: the narrow tracks on which sexual difference runs) | material culture (laboratories: the narrow tracks on which facts run) |
| dialectic of construction and discovery | dialectic of construction and discovery |

11. Evelyn Fox Keller (1987) insists on the important possibilities opened up by the construction of the intersection of the distinction between sex and gender, on the one hand, and nature and science, on the other. She also insists on the need to hold to some non-discursive grounding in "sex" and "nature," perhaps what I am calling the "body" and "world."

REFERENCES

Bijker, Wiebe E., Hughes, Thomas, P., and Pinch, Trevor, eds (1987) *The Social Construction of Technological Systems.* Cambridge, MA: MIT Press.

Bryan, C.D.B. (1987) *The National Geographic Society: 100 Years of Adventure and Discovery.* New York: Abrams.

de Lauretis, Teresa (1986a) 'Feminist studies/critical studies: issues, terms, and contexts', in de Lauretis (1986b), pp. 1–19.

Eco, Umberto (1980) *Il nome della rosa.* Milano: Bompiani.

——— (1983) *The Name of the Rose,* William Weaver, trans. New York: Harcourt Brace Jovanovich.

Flax, Jane (1983) 'Political philosophy and the patriarchal unconscious: a psychoanalytic perspective on epistemology and metaphysics', in Harding and Hintikka (1983), pp. 245–82.

——— (1987) 'Postmodernism and gender relations in feminist theory', *Signs* 12(4): 621–43.

Haraway, Donna J. (1985) 'Manifesto for cyborgs: science, technology, and socialist feminism in the 1980s', *Socialist Review* 80: 65–108.

——— (1989b) *Primate Visions: Gender, Race, and Nature in the World of Modern Science.* New York: Routledge.

Harding, Sandra (1986) *The Science Question in Feminism.* Ithaca: Cornell University Press.

Hartsock, Nancy (1983a) 'The feminist standpoint: developing the ground for a specifically feminist historical materialism', in Harding and Hintikka (1983), pp. 283–310.

——— (1983b) *Money, Sex, and Power.* New York: Longman; Boston: Northeastern University Press, 1984.

Keller, Evelyn Fox (1985) *Reflections on Gender and Science.* New Haven: Yale University Press.

——— (1987) 'The gender/science system: or, is sex to gender as nature is to science?', *Hypatia* 2(3): 37–49.

——— and Grontkowski, Christine (1983) 'The mind's eye', in Harding and Hintikka (1983), pp. 207–24.

King, Katie (1987a) 'Canons without innocence', University of California at Santa Cruz, PhD thesis.

——— (1987b) *The Passing Dreams of Choice . . . Once Before and After: Audre Lorde and the Apparatus of Literary Production,* book prospectus, University of Maryland at College Park.

Knorr-Cetina, Karin and Mulkay, Michael, eds (1983) *Science Observed: Perspectives on the Social Study of Science.* Beverly Hills: Sage.

Kuhn, Annette (1982) *Women's Pictures: Feminism and Cinema.* London: Routledge & Kegan Paul.

Latour, Bruno (1984) *Les Microbes, guerre et paix, suivi des irréductions.* Paris: Métailié.

——— (1988) *The Pasteurization of France, followed by Irreductions: A Politico-Scientific Essay.* Cambridge, MA: Harvard University Press.

Mohanty, Chandra Talpade (1984) 'Under western eyes: feminist scholarship and colonial discourse', *Boundary* 2, 3 (12/13): 333–58.

Petchesky, Rosalind Pollack (1987) 'Fetal images: the power of visual culture in the politics of reproduction', *Feminist Studies* 13(2): 263–92.

Sofoulis, Zoe (1988) 'Through the lumen: Frankenstein and the optics of re-origination', University of California at Santa Cruz, PhD thesis.

Strathern, Marilyn (1987a) 'Out of context: the persuasive fictions of anthropology', *Current Anthropology* 28(3): 251–81.

Tournier, Michel (1967) *Vendredi.* Paris: Gallimard.

Varley, John (1978) 'The persistence of vision', in *The Persistence of Vision.* New York: Dell, pp. 263–316.

——— (1986) 'Blue champagne', in *Blue Champagne.* New York: Berkeley, pp. 17–79.

White, Hayden (1987) *The Content of the Form: Narrative Discourse and Historical Representation.* Baltimore: Johns Hopkins University Press.

# 13

# On the Problem
# of Chinese Science

## ROGER HART

T he contention that science is uniquely Western has never been presented as a thesis to be demonstrated historically—that is, stated explicitly, formulated rigorously, and documented comprehensively. Instead, variants on this theme most commonly appear in panegyrics for Western civilization ("Science . . . is the glory of Western culture"),[1] in the forgings of exalted origins for the West in Greek antiquity ("science originated only once in history, in Greece"),[2] and in accounts that confidently offer purported explanations for the absence of science in other civilizations—accounts thus unencumbered by any requirement to examine sciences already known to be absent.[3] As presented, these are hardly simple assertions of differential developments of specific sciences in particular geographic areas during particular historical periods. Instead they assert a Great Divide between the imagined community "the West" and its Other.[4] One particularly dramatic formulation is Ernest Gellner's "Big Ditch" symbolizing the enormous differences separating "traditional" societies from the scientific "Single World or Unique Truth" produced by "one *kind* of man."[5] Such assertions—although apparently about the West—depend for their validity on investigations of other cultures. However, the historical evidence accompanying such claims relates only to the uncontroversial half of the assertion—the existence of sciences in the West. The substantive half—the assertion of the absence of science in every other culture—has rested on little more than the ignorance of the sciences of other cultures, mistaken for the ignorance of other cultures of science. The most important historical counterexample has been China—research beginning in the 1940s has increasingly provided considerable evidence that there were in China many forms of knowledges and practices similar to those that have been called "science" in the West.[6] This, then, is the reason that "Chinese science" became a problem.

Despite this evidence, claims that science is uniquely Western have continued to appear even in the most respected scholarly literature in the history of science;[7] on the other hand, major research projects on Chinese science have often—up to the present—been framed within these disputes. But rather than returning to take sides within these debates, this article will take the framework that has preconditioned these controversies as itself the object of historical analysis. That is, this article will analyze what these accounts share: the assumption that the imagined

communities "China" and "the West" are to be fundamental starting points in analyses of the history of science; that to "the West" and "China" we can then rigorously assign antithetical pairs of attributes (e.g., scientific versus intuitive, theoretical versus practical, causal versus correlative thinking, adversarial versus irenic, or geometric versus algebraic) that remain valid across historical periods, geographic locales, social strata, gender identifications, economic and technological differentials, and fields of scientific research along with their subfields and competing factions; and that ultimately, studies of science can contribute to the further assignment of normative attributes in praise-and-blame historiographies of civilizations (e.g., the uniqueness of the West in producing universal science, the xenophobia of China, or the equality of all civilizations). This article will present a historical analysis of this literature which takes as its themes "science," "China," and "the West."

## THE SCIENTIFIC WEST
## AND THE INTUITIVE EAST

Accounts written in the early twentieth century often portrayed China and an undifferentiated "East" as lacking science entirely.[8] Bertrand Russell, after lecturing in China, wrote in 1922 in a chapter entitled "Chinese and Western Civilization Contrasted," that "comparing the civilization of China with that of Europe, one finds in China most of what was to be found in Greece, but nothing of the other two elements of our civilization, namely Judaism and science. . . . Except quite recently, through European influence, there has been no science and no industrialism."[9] In the 1940s, Filmer Northrop, a professor of philosophy at Yale University, posited suprahistorical differences between "Eastern intuitive" and "Western scientific" philosophical systems representative of entire civilizations, arguing that "a culture which admits only concepts by intuition is automatically prevented from developing science of the Western type."[10] Similarly, Wilmon Sheldon, also a professor of philosophy at Yale, contrasted Eastern and Western philosophy, asserting bluntly that "the West generated the natural sciences, as the East did not."[11] Albert Einstein, in a casual letter which was frequently quoted by later historians, stated in 1953 that the "development of Western science is based on two great achievements: the invention of the formal logical system (in Euclidean geometry) by the Greek philosophers, and the discovery of the possibility to find out causal relationship by systematic experiment (Renaissance). In my opinion one has not to be astonished that the Chinese sages have not made these steps. The astonishing thing is that these discoveries were made at all."[12] These accounts then offer no analysis of Oriental sciences, presumably because there were not supposed to be any to analyze.

It was to disprove such claims that Needham began his *Science and Civilisation in China,* which soon developed into a multivolume series documenting the developments in China in chemistry, mathematics, astronomy, physics, and other sciences.[13] Needham too shared the assumption that civilizations were to be a fundamental starting point in studies of the history of science: in place of science versus non-science, he offered his own set of four major contrasts between China and the West (organic versus mechanical philosophies, algebra versus Euclidean geometry, wave versus particle theories, and practical versus theoretical orientations);[14] his "grand titration" was to redistribute credit for scientific discoveries among civilizations;[15] he proposed to restore for China its pride, correcting its slighting by making it an equal contributor

among the tributaries that flowed into the river of modern science; ultimately, he sought to discover the social and economic reasons that Chinese civilization was more advanced than the West before the sixteenth century and later fell behind.[16] Needham's project was from its inception formulated not as one component of, but rather in opposition to, mainstream history of science which asserted that science was unique to Western civilization. Yet Needham's project adopted many of the features of these histories of [Western] science of the period: against catalogues of scientific achievements claimed for the glory of the West, he offered achievements now claimed for the Chinese; against exaggerated claims of Western contributions to other civilizations, Needham asserted Chinese influence where the evidence was incomplete.

Historians of [Western] science, for their part, also often perceived Needham's research not as one part of a larger project of the study of the history of science, but in opposition to their own work. In the late fifties and early sixties they continued to insist that science was exclusively Western: in response to studies of the sciences of other civilizations (and Needham's in particular), the criteria defining *science* changed; however, the defining boundaries of science as exclusively Western did not. For example, in A. C. Crombie's account, the Orient became differentiated into distinct civilizations, but the "achievements" of these distinct civilizations were undifferentiatedly dismissed as technologies. Western science was no longer defined solely in stark opposition to Oriental intuition. In its place, *Western science* was defined by an incongruous amalgam of "essential elements" culled from the tradition claimed for the West, including noncontradiction, empirical testing, Euclid, and logic:

Impressive as are the technological achievements of ancient Babylonia, Assyria, and Egypt, of ancient China and India, as scholars have presented them to us they lack the essential elements of science, the generalized conceptions of scientific explanation and of mathematical proof. It seems to me that it was the Greeks who invented natural science as we know it, by their assumption of a permanent, uniform, abstract order and laws by means of which the regular changes observed in the world could be explained by deduction, and by their brilliant idea of the generalized use of scientific theory tailored according to the principles of noncontradiction and the empirical test. It is this essential Greek idea of scientific explanation, "Euclidean" in logical form, that has introduced the main problems of scientific method and philosophy of science with which the Western scientific tradition has been concerned.[17]

In another account—even though the defining features of the "mainstream" of science were different—the defining boundaries of science as Western remained stubbornly constant. For de Solla Price, this "mainstream" was the emblem of scientific modernity—mathematical astronomy; instead of attributing the development of science to a scientific method, he appealed to "inspiration" as historically causal. Thus mathematical astronomy differentiated "our own high civilization" from its Other:

What is the origin of the peculiarly scientific basis of our own high civilization? . . . Of all limited areas, by far the most highly developed, most recognizably modern, yet most continuous province of scientific learning, was mathematical astronomy. This is the mainstream that leads through the work of Galileo and Kepler, through the gravitation theory of Newton, directly to the labours of Einstein and all mathematical physicists past and present. In comparison, all other parts of modern science appear derivative or subsequent; either they drew their inspiration directly from the successful sufficiency of mathematical and logical explanation for astronomy, or they developed later, probably as a result of such inspiration in adjacent subjects.[18]

# PRIMITIVE VERSUS MODERN SCIENCE

The two views presented above—Crombie and de Solla Price—were in response to the discoveries of the sciences of other civilizations, and Needham's work in particular; these views themselves elicited a response from Needham.[19] Needham noted that the increasing discoveries of the sciences of other cultures resulted not in the rejection of claims of European uniqueness but rather in the deprecation of the sciences of other cultures: "As the contributions of the Asian civilizations are progressively uncovered by research, an opposing tendency seeks to preserve European uniqueness by exalting unduly the role of the Greeks and claiming that not only modern science, but science as such, was characteristic of Europe, and of Europe only, from the very beginning. . . . The counterpart of this is a determined effort to show that all scientific developments in non-European civilizations were really nothing but technology" (41).

However, as attention to Needham's phrase "not only modern science, but science as such" suggests, this criticism was not Needham's central thesis. Needham presented two problems that became the central "Needham questions" defining the field of the history of Chinese science:

Why did modern science, the mathematization of hypotheses about Nature, with all its implications for advanced technology, take its meteoric rise *only* in the West at the time of Galileo? This is the most obvious question which many have asked but few have answered. Yet there is another which is of quite equal importance. Why was it that between the second century B.C. and the sixteenth century A.D. East Asian culture was much *more* efficient than the European West in applying human knowledge of nature to useful purposes? (16, emphasis in original)[20]

Critics who saw in Needham an exaggerated attempt to rehabilitate Chinese science ignored his ultimate reaffirmation of modern science as uniquely Western—Needham did not dispute the radical break between the scientific and nonscientific, but only the manner in which the boundary was drawn. For Needham, this break derived directly from accounts which asserted a radical divide in the West between the ancient and modern by appending to "science" the even more amorphous term "modern" (14–16): "When we say that modern science developed only in Western Europe at the time of Galileo in the late Renaissance, we mean surely that there and then alone there developed the fundamental bases of the structure of the natural sciences as we have them today, namely the application of mathematical hypotheses to Nature, the full understanding and use of the experimental method, the distinction between primary and secondary qualities, the geometrisation of space, and the acceptance of the mechanical model of reality" (14–15). And indeed Needham's central concern is this supplemental term "modern": "Hypotheses of primitive or medieval type distinguish themselves quite clearly from those of modern type. Their intrinsic and essential vagueness always made them incapable of proof or disproof, and they were prone to combine in fanciful systems of gnostic correlation. In so far as numerical figures entered into them, numbers were manipulated in forms of 'numerology' or number-mysticism constructed *a priori,* not employed as the stuff of quantitative measurements compared *a posteriori*" (15).[21] Thus against schemes that posited a radical difference between civilizations East and West, Needham insisted on preserving the uniqueness of modern Western science by claiming the premodern world—including China and Greece—"must be thought of as a whole" (16); the radical break for Needham was the boundary between the modern and the primitive.[22]

Despite Needham's brief list of the characteristics of modern science—experimentalism, mathematization, geometrization, and mechanism—these were hardly the central features that

animated his discussion of modern science. Instead, for Needham the central distinction between primitive and modern science was its universality: "Until it had been universalized by its fusion with mathematics, natural science could not be the common property of all mankind. The sciences of the medieval world were tied closely to the ethnic environments in which they had arisen, and it was very difficult, if not impossible, for the people of those different cultures to find any common basis of discourse" (15). Needham then incorporated science into this universal teleology: "the river of Chinese science flowed, like all other such rivers, into this sea of modern science" (16). And by the concluding paragraph, Needham's "science" has become nothing more than impoverished signifier in a teleology purely utopian: "Let us take pride enough in the undeniable historical fact that *modern* science was born in Europe and only in Europe, but let us not claim thereby a perpetual patent thereon. For what was born in the time of Galileo was a universal palladium, the salutary enlightenment of all men without distinction of race, colour, faith or homeland, wherein all can qualify and all participate. Modern universal science, yes; Western science, no!" (54, emphasis in original).

## SCIENTIFIC REVOLUTIONS
## AND *THE* SCIENTIFIC REVOLUTION

The most important response to the two Needham questions—why China was more proficient at technology before the sixteenth century and why modern science arose only in the West—was a series of criticisms presented by Nathan Sivin.[23] Against the former, Sivin argued that in the period from the first century B.C. to the fifteenth century A.D., science and technology were separate and thus Chinese superiority in technology was not indicative of more advanced science;[24] he also criticized attempts to compare the science and technology of civilizations in their entirety.[25] In response to the latter—Needham's "Scientific Revolution problem"—Sivin critiqued several assumptions underlying the question of why China lacked a scientific revolution and pointed out fallacies of historical reasoning that discovered conditions that were asserted to have inhibited the growth of Chinese science.[26] Sivin's ultimate response, however, was to assert that "by conventional intellectual criteria, China had its own scientific revolution in the seventeenth century."[27] This revolution was not, Sivin argued, as sweeping as the Scientific Revolution in Europe.[28]

Sivin's claim was part of his criticism of the received accounts of the rejection by a xenophobic, conservative, traditional China of modern Western science introduced by the Jesuits.[29] Against portrayals of the Jesuits as having introduced modern science, Sivin argued that the Jesuits withheld the Copernican system, instead presenting the Tychonic system as the most recent and misrepresenting the history of Western astronomy to disguise this.[30] Against claims that the lack of Chinese acceptance of early modern science was due to intellectual, linguistic, or philosophical impediments, Sivin argued that it was contradictions in the Jesuit presentation of Western astronomy—including these misleading characterizations of Copernican astronomy which the Jesuits were by decree forbidden to teach—that made it incomprehensible.[31] And against caricatures of the Chinese as xenophobic and conservative, Sivin argued that the Chinese did accept Western astronomical techniques, resulting in a "conceptual revolution in astronomy."[32]

Sivin's response, however, incorporated many of the assumptions within which the claims he critiqued had been framed.[33] Seventeenth-century European astronomy remained "modern

science" posed against "traditional" Chinese science,[34] for example in Sivin's assertion that Wang and his contemporaries did not succeed "in a mature synthesis of traditional and modern science."[35] The West remained the source of modern science for the Chinese: "The character of early modern science was concealed from Chinese scientists, who depended on the Jesuit writings. Many were brilliant by any standard. As is easily seen from their responses to the European science they knew, they would have been quite capable of comprehending modern science if their introduction to it had not been both contradictory and trivial."[36] The limited extent of the transformation of the scientific revolution in China remained the result of distorting nonscientific influences, blamed now not on the Chinese but on the Jesuits: "In short, the scientific revolution in seventeenth-century China was in the main a response to outmoded knowledge [transmitted by the Jesuits] that gave little attention to, and consistently misrepresented, the significance of developments in the direction of modern science."[37] And ultimately, in Sivin's critiques this episode remained framed as an "encounter in China between its cognitive traditions and those of Europe."[38]

The key to Sivin's argument was thus his redistribution of "scientific revolutions" among civilizations: by asserting that there was not one but two scientific revolutions—one Chinese and one European—Sivin implied that differences between China and Europe were of degree rather than kind.[39] However, by the criteria he used for scientific revolutions—shifts in a disciplinary matrix—there certainly have been many others.[40] Sivin's account adopted from the histories of Western science the conflation of scientific revolutions in this technical sense with the mythologies of *the* Scientific Revolution—a difference that Sivin implicitly notes in his use of a capitalized "Scientific Revolution" for Europe.[41] This conflation was itself rooted in attempts by these histories to offer scientific revolutions as the historical cause of the radical break between the ancient and modern that *the* Scientific Revolution emblematized.[42] This radical break had then been translated to a radical difference between the modern scientific West (unique among civilizations in having had the Scientific Revolution) and traditional China. Sivin documented a scientific revolution in China—a change in the disciplinary matrix in Chinese astronomy which was itself a limited copy of the Scientific Revolution of Europe. But he denied to this scientific revolution the miraculous transformative powers claimed in the mythologies of the Scientific Revolution of the West.

## PRAISE-AND-BLAME HISTORIES
## OF CIVILIZATIONS

Much of the scholarly literature on the question of Chinese science written during the period when Sivin and Needham were publishing their work offered no study of any aspect of it. Instead, these works (sometimes presented against Needham by borrowing from earlier claims that science was uniquely Western, and sometimes following Needham's call to find the social causes that made modern science unique to the West) purported to offer explanations for the absence of science in China—philosophical, social, linguistic, logical, and political.[43] For example, Mark Elvin offered the metaphysical thought developed from Wang Yangming as "the reason why China failed to create a modern science of her own accord."[44] Joseph Levenson explained the purported absence of a Chinese scientific tradition as the result of an "amateur ideal."[45] Alfred Bloom asserted that the Chinese language had inhibited the ability of the Chinese to

think theoretically.[46] Robert Hartwell argued that the major impediment was the absence of the formal logical system embodied in Euclidean geometry.[47] And Wenyuan Qian provided a "politico-ideological" explanation.[48]

Yet this literature was not about science. Levenson failed to cite a single primary source on Chinese science in his bibliography; instead he drew his conclusions on the nondevelopment of science and modernity by universalizing the ethics of Ming painting as exemplary of all of Ming culture, and comparing this with stereotypes of Western science and modern values.[49] Bloom made no pretense of citing historical materials, much less scientific materials from China or the West, in justifying his leap from measuring the testing skills of students in present-day China—presented in the language of the Sapir-Whorf hypotheses—to the development of Chinese science in the past. Elvin cited one scientist.[50] Hartwell's explanation of the nondevelopment of Chinese science was appended to a study of trends in Chinese historiography.[51] And Qian's dialogic narrative contained its own admissions of the historical falsity of central theses of the book.[52] These accounts—because the absence of [modern] science in China was known—could ignore the technical details specific to the sciences themselves and instead derive lessons on topics deemed more vital—whether political despotism, philosophical orthodoxy, linguistic inadequacies, or cultural stagnation.

## REITERATING THE DIFFERENCES

The focus on comparisons of science in China and the West has resulted in enough research that several recent works have been written that attempt to synthesize or reevaluate the theses presented in this literature.[53] The most important recent comparative study is G. E. R. Lloyd's *Adversaries and Authorities*.[54] Lloyd seeks to relate differences in the philosophy and science of China and Greece to fundamental differences in their respective cultures. He begins his analysis by reexamining differences in their social and political context, following one variant of the conventional view: "my starting point is . . . a common view of a fundamental contrast"—the view of Burckhardt and others—that "the Greeks exhibited highly developed agonistic traits in every part of their culture . . . philosophy and science included"; in contrast, "it has often been claimed that the Chinese were irenic rather than polemical and rejected aggressive adversariality of any kind" (20). His approach is to present evidence for this conventional view, subject it to a "severe critique,"[55] refine it, and finally seek explanations for the differences (21). Lloyd then analyzes the differences in the science of early Greece and China by reexamining several contrasts: techniques of demonstration (especially Greek axiomatization and deduction); "cause-oriented Greek culture and a correlation-oriented Chinese one" (93); the use of dichotomies in Greek and Chinese thought; Chinese and Greek views of the infinite; the Greeks' emphasis on geometrical models and strict proof in astronomy contrasted with the Chinese political demand for accuracy in the prediction of portents (184); and views of the body and the state. These too are for the most part conventional theses, and in each case Lloyd essentially follows an approach similar to that outlined above—offering an outline of the thesis, a critique, a refinement, and finally relating the contrasts to differences in cultural context. Although Lloyd emphasizes "in the strongest possible terms, the difficulties and dangers of generalization," his ultimate conclusion on whether there is a fundamental difference between the science of early Greece and China is "clearly yes" (209); and his ultimate explanation for these differences—encapsulated in the title of the book—is the fundamental difference between the

adversarial Greeks and the authority-bound Chinese which resulted from differing social and political institutions.[56]

The most important of the contrasts between Chinese and Greek science that Lloyd analyzes is the "three interrelated concepts of axiomatization, certainty and foundations" exemplified by the Euclidean tradition of mathematics with "its insistence not just on deduction, but on axiomatic-deductive demonstration" (211–12): of the conventional views, this is both the most commonplace and the most plausibly significant;[57] it is also this contrast that Lloyd emphasizes in his concluding chapter (211–12, 214–15). Even here Lloyd's argument remains filled with numerous qualifications and caveats: he notes that axiomatics in Greek mathematics is a style that is a "recurrent, but not a universal, one" (212); often, what in Greek geometry was claimed to be incontrovertible "turns out to be a proposition that is anything but" (63); and on the other hand, Chinese mathematics also offered proofs (212). Yet there is much more wrong with the conventional view than Lloyd's critique suggests. Rigorously defined, axiomatization was not possible outside of geometry;[58] it makes little sense to identify axiomatization with the science of an entire civilization—whether the West or ancient Greece. Lloyd's remaining contrasts fare no better. He notes that the Greeks "were no strangers to correlative thinking" (94), and "Chinese interest in the explanation of events is certainly highly developed in such contexts as history and medicine" (109). What all of Lloyd's careful analysis, caveats, and reservations suggest is reevaluating the assumption that Lloyd does not question—that "Greece" and "China" are appropriate categories from which to generalize about science. For as long as it is assumed that it is "the divergent early histories of philosophy and science in those two ancient civilisations that are our chief *explanandum*" (223), the solutions can only lie in debates over which of the antithetical attributes asserted to characterize entire civilizations are the most significant.

## THE POSTMODERNS' WEST

In recent works, the cross-disciplinary credulity toward "the West"—equated with reason, science, logic, and rationality—has provided poststructuralist critiques with their inflated urgency. For example, without this intensified essentialization of "the West," Derridean deconstruction of Western logocentrism becomes little more than a critique of the application of structuralist readings to literary and philosophical texts.[59] In a deflationary view, Foucault's archaeology of madness silenced by the language of Western reason becomes no more than a genealogy of psychiatric practices traced to eighteenth-century moral therapies.[60]

If two central lacunae of poststructuralist analyses (as exemplified by the works of Derrida, Foucault, and Bourdieu) were science and "non-Western" cultures, more recent work in the cultural, gender, and social studies of science has turned toward the critique of science contextualized in culture. However, one result of these studies of the relationship of science to culture and of culture to science has been the further identification of science with Western culture—studies of non-Western cultures have often focused not on non-Western science but rather on Western science in colonial settings. Perhaps the most important critique of the assumptions about cultures made in contemporary science studies is Bruno Latour's provocative *We Have Never Been Modern*. Yet although Latour criticizes assertions of the Great Divide between the West and its Other,[61] he ultimately accepts the divide itself and questions only what constitutes it;[62] he asserts that the differences are only of size (of networks), yet to explain these differences Latour returns

to claims of a fundamental difference in worldviews.[63] Thus Latour's work, still framed within the assumption of a fundamental division between the West and its Other, can offer no alternative other than to posit yet another antithesis as an explanation.[64]

## CONCLUSIONS

The history of science is ostensibly a discipline united by the investigation of the single subject of "science" irrespective of geopolitical boundaries that construct cultures and civilizations. Yet much of the research literature on Chinese science has taken as its starting point a credulity toward the imagined communities "China" and "the West," and the Great Divide that constitutes them. The debates on Chinese science are only one genre from the literature in history, philosophy, anthropology, and sociology on the Great Divide between the West and its Other. In this broader literature, science is but one possible solution among many that have been offered to explain the purported differences—linguistic (alphabetic versus "ideographic" scripts, the existence versus nonexistence of the copula, poetic versus scientific, theoretical versus practical, abstract versus concrete), economic (capitalism), philosophic (conceptions of natural law, correlative versus causal thinking, the ordering of time and space, demonstrative logic versus consensus), or political (democracy versus Oriental despotism), to name a few. No satisfactory answer has ever been posed.

This article has analyzed debates about Chinese science which were framed within this broader context. In the first half of the twentieth century, authors asserted an absolute divide between the scientific West and an exoticized, intuitive East. In opposition, Needham proposed to redistribute credit for scientific discoveries among civilizations by a "grand titration"; against the assertions of a radical civilizational divide between China and the West, he revived claims of a radical temporal break between primitive science (which included that of China and equally ancient Greece) and modern science, which for Needham remained culturally universal yet uniquely Western in origin. Sivin criticized many of the excesses in Needham's rehabilitation, and further questioned the uniqueness of the West by proposing that China had had its own, albeit limited, scientific revolution. Yet the scientific revolution Sivin discovered for China was the conversion to "modern science" from the West, incomplete because of Jesuit distortions; the Scientific Revolution Sivin compared it to in the West was itself only an emblem of the purported radical break between the ancient and modern. Other studies of this period, framed within the legacy of assertions of the Great Divide between "China" and "the West," offered explanations—social, political, philosophical, or linguistic—for the assumed absence of science in a "China" which then became the anthropomorphized subject of a praise-and-blame historiography of civilizations. Most recently, the cultural turn in the history of science has further identified the culture of "the West" with "science"; the cross-disciplinary credulity toward the concept of "the West"—equated with science, reason, and rationality but now critiqued as hegemonic—which provided many poststructuralist and postcolonial critiques with their inflated urgency only further reinforced this identification of "science" and "the West." This article has proposed that rather than taking "the West" and "China" as a starting point for historical studies of the development of science, the project of comparison must itself be subjected to historical critique—it is through the narration of stories about radical differences that the antithetical communities "China" and "the West" are imagined.

NOTES
Mario Biagioli, Benjamin Elman, David Keightley, Haun Saussy, and Ted Porter offered detailed criticisms. Versions of this paper have been presented at the Fairbank Center for East Asian Research at Harvard University, the Society for the Social Studies of Science, and the Chinese Historiography Studies Group at the Association for Asian Studies. Students in a seminar on Chinese science at Stanford University offered perceptive comments. I would like to thank all those who offered suggestions.

1. Henry E. Kyburg, Jr., *Science & Reason* (New York: Oxford University Press, 1990), 3.

2. Lewis Wolpert, *The Unnatural Nature of Science* (Cambridge, Mass.: Harvard University Press, 1992), 35.

3. Several examples will be discussed below.

4. For examples of debates over this kind of a "Great Divide," see Robin Horton and Ruth Finnegan, ed., *Modes of Thought: Essays on Thinking in Western and Non-Western Societies* (London: Faber, 1973). For criticisms of assertions of a "Great Divide," see Clifford Geertz, "Anti Anti-Relativism," in *Relativism: Interpretation and Confrontation,* ed. Michael Krausz (Notre Dame, Ind.: University of Notre Dame Press, 1989), 19; and Bruno Latour, *We Have Never Been Modern,* trans. Catherine Porter (Cambridge: Harvard University Press, 1993), 97–109, discussed below.

5. Ernest Gellner, *Spectacles & Predicaments: Essays in Social Theory* (Cambridge: Cambridge University Press, 1979), 145–47; and idem., "Relativism and Universals," in *Rationality and Relativism,* ed. Martin Hollis and Steven Lukes (Cambridge, Mass.: MIT Press, 1982), 188–200.

6. The two most important examples are the work of Joseph Needham and Nathan Sivin. For a comprehensive overview of Chinese science, see Needham's multivolume series *Science and Civilisation in China* (Cambridge: Cambridge University Press, 1954–). For important correctives of Needham's work, see Sivin's *Science in Ancient China: Researches and Reflections,* Variorum Collected Studies Series (Brookfield, Vt.: Ashgate Publishing Company, 1995). For Needham's publications (up to 1973), see "Bibliography of Joseph Needham" in *Changing Perspectives in the History of Science: Essays in Honour of Joseph Needham,* ed. Mikuláš Teich and Robert Young (Boston: D. Reidel, 1973). For Sivin's works, see "The Published Writings of Nathan Sivin: An Annotated Bibliography," *Chinese Science* 13 (1996): 135–42. For a review of current research, see Sivin, "Science and Medicine in Imperial China—The State of the Field," *Journal of Asian Studies* 47, no. 1 (1988): 41–90; and idem., "Selected, Annotated Bibliography of the History of Chinese Science: Sources in Western Languages," in *Science in Ancient China.*

7. For two important recent examples, see Toby E. Huff, *The Rise of Early Modern Science: Islam, China and the West* (New York: Cambridge University Press, 1993); and the work of A. C. Crombie, especially *Styles of Scientific Thinking in the European Tradition: The History of Argument and Explanation Especially in the Mathematical and Biomedical Sciences and Arts,* 3 vols. (London: Duckworth, 1994); and idem., "Designed in the Mind: Western Visions of Science, Nature and Humankind" and "The Origins of Western Science," in *Science, Art and Nature in Medieval and Modern Thought* (London: Hambledon Press, 1996). For example, in his review of Huff's book, Crombie, quoting from the introduction to his own multivolume work, presents the following theses: "the history of science as we have it is the history of 'a vision and an argument initiated in the West by ancient Greek philosophers, mathematicians and physicians'"; "it is 'a specific vision, created within Western culture'"; it was based on the Greeks' "two fundamental conceptions of universal natural causality matched by formal proof"; "'from these two conceptions all the essential character and style of Western philosophy, mathematics, and natural science have followed'" (*Journal of Asian Studies* 53, no. 4 (1994): 1213–14; quoted from idem, *Styles of Scientific Thinking,* 3–5). In comparison, Crombie asserts, "China had no Euclid, and did not adopt his scientific style when that became available" (1215). It should be noted, however, that the number of adherents to such viewpoints is decreasing.

8. These claims were part of a literature of the period asserting Chinese absence of modernity, capitalism, science, and philosophy. For related examples of claims that China lacked mathematics, see John [Jock] Hoe, *Les Systèmes d'Équations Polynômes dans le* Siyuan yujian *(1303)* (Paris: Collège de France, Institut des Hautes Études Chinoises, 1977), 7–8.

9. Bertrand Russell, "Chinese and Western Civilization Contrasted," in *The Basic Writings of Bertrand Russell, 1903–1959,* ed. Robert E. Egner and Lester E. Denonn (New York: Simon and Schuster, 1961), 551; reprinted from *The Problem of China* (London: George Allen & Unwin, 1922).

10. Filmer S. C. Northrop, "The Complementary Emphases of Eastern Intuitive and Western Scientific Philosophy," in *Philosophy—East and West,* ed. Charles A. Moore (Princeton: Princeton University Press, 1944), quoted in Hu Shih, "The Scientific Spirit and Method in Chinese Philosophy," in *The Chinese Mind: Essentials of Chinese Philosophy and Culture,* ed. C. A. Moore (Honolulu: University of Hawaii, 1967), 104. A shorter version of Hu's article appeared in *Philosophy East and West* 9, nos. 1 and 2 (1959): 29–31. See also Northrop, *The Meeting of East and West: An Inquiry Concerning World Understanding* (New York: Macmillan Company, 1946), chaps. 8–10. Northrop asserted a "unity of Oriental culture" (a "single civilization of the East" which included China, Japan, and India) and distinguished an entire Western scientific philosophy from an Eastern intuitive philosophy (312).

11. Wilmon Henry Sheldon, "Main Contrasts between Eastern and Western Philosophy," in *Essays in East-West Philosophy: An Attempt at World Philosophical Synthesis,* ed. Charles A. Moore (Honolulu: University of Hawaii Press, 1951), 291; also quoted in Hu, "Scientific Spirit and Method," 104. The assertions by Northrop and Sheldon are criticized by Hu, who presents the views of two Chinese philosophers, Wang Chong (27–*ca.* 100) and Zhu Xi (1130–1200). However, Hu never cites evidence from Chinese scientific treaties.

12. Quoted in Arthur F. Wright, review of *Science and Civilisation in China,* vol. 2, *History of Scientific Thought,*

by Joseph Needham, *American Historical Review* 62, no. 4 (1957): 918; and Wolpert, *Unnatural Nature of Science*, 48. Cited in C. C. Gillispie, *The Edge of Objectivity: An Essay in the History of Scientific Ideas* (Princeton: Princeton University Press, 1960), 9; and Robert M. Hartwell, "Historical Analogism, Public Policy, and Social Science in Eleventh- and Twelfth-Century China," *American Historical Review* 76, no. 3 (1971): 722–23.

13. *Science and Civilisation in China* presently comprises the following volumes: *vol. 1, Introductory Orientations; vol. 2, History of Scientific Thought*; vol. 3, *Mathematics and the Sciences of the Heavens and the Earth*; vol. 4, *Physics and Physical Technology*—pt. 1, *Physics*, pt. 2, *Mechanical Engineering*, pt. 3. *Civil Engineering and Nautics*; vol. 5, *Chemistry and Chemical Technology*—pt. 1, *Paper and Printing*, pt. 2, *Spagyrical Discovery and Invention: Magisteries of Gold and Immortality*, pt. 3, *Spagyrical Discovery and Invention: Historical Survey, from Cinnabar Elixirs to Synthetic Insulin*, pt. 4, *Spagyrical Discovery and Invention: Apparatus, Theories, and Gifts*, pt. 5, *Spagyrical Discovery and Invention: Physiological Alchemy*, pt. 6, *Military Technology: Missiles and Sieges*, pt. 7, *Military Technology: The Gunpowder Epic*, pt. 9, *Textile Technology, Spinning and Reeling*; vol. 6, *Biology and Biological Technology*, pt. 1, *Botany*, pt. 2, *Agriculture*, pt. 3, *Agro-Industries and Forestry*; vol. 7, pt. 1, *Language and Logic*. More volumes are forthcoming.

14. Joseph Needham, "Poverties and Triumphs of the Chinese Scientific Tradition," in idem., *Grand Titration*, 20–23; first published in *Scientific Change: Historical Studies in the Intellectual, Social and Technical Conditions for Scientific Discovery and Technical Invention, from Antiquity to the Present*, ed. A. C. Crombie (London: Heinemann, 1963). Needham (like G. E. R. Lloyd) affirms these oppositions with some reservations, for example stating that he does "not want to disagree altogether with the idea that the Chinese were a fundamentally practical people" (23). See also the comments and discussion on Needham's article in the *Scientific Change* volume.

15. Needham proposed a retrospective competition between the West and China, fixing dates of discovery through a "grand titration" that compared "the great civilizations against one another, to find out and give credit where credit is due." Joseph Needham, *The Grand Titration: Science and Society in East and West* (London: George Allen & Unwin, 1969), 12.

16. Needham sought to "analyse the various constituents, social or intellectual, of the great civilizations, to see why one combination could far excel in medieval times while another could catch up later on and bring modern science itself into existence." Ibid., 12.

17. A. C. Crombie, "The Significance of Medieval Discussions of Scientific Method for the Scientific Revolution," in *Critical Problems in the History of Science*, ed. Marshall Clagett (Madison: University of Wisconsin Press, 1959), 81; quoted in Needham, "Poverties and Triumphs," 41–42. Needham's response to this view is discussed below. For a detailed presentation of Crombie's views, see *Styles of Scientific Thinking*.

18. Derek de Solla Price, *Science Since Babylon* (New Haven: Yale University Press, 1961, 2–5); quoted in Needham, "Poverties and Triumphs," 42.

19. Needham, "Poverties and Triumphs." Needham also presents similar views from J. D. Bernal and C. C. Gillispie.

20. Needham proposed the following solution: "Only an analysis of the social and economic structures of Eastern and Western cultures, not forgetting the great role of systems of ideas, will in the end suggest an explanation of both these things" (16).

21. Needham's characterization of "primitive" (i.e., premodern) science is not true for either all of the early Greek or early Chinese sciences.

22. Needham states, "Galileo broke through its walls"; "the Galilean break-through occurred only in the West" (15).

23. Sivin's criticisms of the Needham questions begin on the first page of his first book—see *Chinese Alchemy: Preliminary Studies* (Cambridge, Mass.: Harvard University Press, 1968), 1. Some of Sivin's most important critiques appeared in the following articles: "Copernicus in China," *Studia Copernicana* (Warsaw) 6 (1973): 63–122; "Shen Kua" and "Wang Hsi-shan," in *Dictionary of Scientific Biography*, ed. Charles Coulston Gillispie (New York: Scribner, 1970–); and "Why the Scientific Revolution Did Not Take Place in China—Or Didn't It?" *Chinese Science* 5 (1982): 45–66. Revised versions of these essays have been collected in his *Science in Ancient China*; unless otherwise noted, I have used the revised versions. See also idem., "Max Weber, Joseph Needham, Benjamin Nelson: The Question of Chinese Science," in *Civilizations East and West: A Memorial Volume for Benjamin Nelson*, ed. Eugene Victor Walter (Atlantic Highlands, N.J.: Humanities Press, 1985).

24. Sivin, "Scientific Revolution," 46.

25. Sivin argues that although before the fifteenth century Europe was technologically less advanced, Chinese astronomy even in the fourteenth century was less accurate than Ptolemaic astronomy which predated it by a thousand years. Sivin, "Scientific Revolution," 46–47.

26. Ibid., 51–59.

27. Ibid., 62.

28. In his analysis of the introduction of European astronomy into China by the Jesuits, Sivin asserts that Wang Xishan, Mei Wending, and Xue Fengzuo were responsible for what Sivin terms a scientific revolution—a fundamental conceptual change from numerical to geometric methods in astronomy. Sivin states, "They radically and permanently reoriented the sense of how one goes about comprehending the celestial motions. They changed the sense of which concepts, tools, and methods are centrally important, so that geometry and trigonometry largely replaced traditional numerical or algebraic procedures. Such issues as the absolute sense of rotation of a planet and its relative dis-

tance from the earth became important for the first time. Chinese astronomers came to believe for the first time that mathematical models can explain the phenomena as well as predict them. These changes amount to a conceptual revolution in astronomy." Sivin, "Scientific Revolution," 62.

29. For example, George C. Wong argued that Chinese scholar-officials' opposition to Western science was due to their traditional beliefs. Wong, "China's Opposition to Western Science during the Late Ming and Early Ch'ing," *Isis* 54 (1963): 29–49; see also Sivin's critical response, "On 'China's Opposition to Western Science during the Late Ming and Early Ch'ing,'" *Isis* 56 (1965): 201–05.

30. Sivin asserts that the cosmology presented by the Jesuits from 1608–42 was written from an Aristotelian point of view: Schall, Schreck, and Rho did not mention Galileo. Sivin states that Schall's "quasi-historical treatise" *On the Transmission of Astronomy in the West* included Copernicus and Tycho with Ptolemy in the ancient school; the modern school comprised Schall, Rho, and their collaborators; the summary of Copernicus's *De revolutionibus* did not mention the motion of the earth; and Schall's conclusion asserted that astronomy had not progressed beyond Ptolemy. For the Jesuits in China, Sivin notes, "heliocentricism was unmentionable." Sivin, "Copernicus in China," 19–22.

31. European cosmology was discredited, Sivin argues, by its internal contradictions, and only in the mid-nineteenth century were contemporary treatises introduced that resulted in acceptance of the heliocentric system; "European cosmology had been discredited by its incoherence." Ibid., 1, 50.

32. Sivin, "Scientific Revolution," 62.

33. And like Needham, Sivin also incorporated into his criticisms many of the assumptions of teleological histories of Western science. For example, although Sivin in his work emphasizes the importance of studying science in cultural context, his analysis often implicitly assigns to internalist scientific criteria an explanatory causal role. The inevitability of the acceptance of Western astronomy is naturalized by appeal to anachronistic modern scientific criteria such as accuracy and explanatory power: it was the power of Western models not only to predict but also to exhibit inherent patterns, he asserts, that attracted the Chinese. Social context is then incorporated into Sivin's account primarily as a distorting factor to account for error: European cosmology was rendered incomprehensible by the misleading characterizations of Copernican astronomy which the Jesuits were forbidden to teach, and was ultimately discredited by its internal contradictions. This naturalizing of scientific truth and the sociology of error are elements of a conventional teleology of scientific development implicit in his account.

34. See also Sivin's study of the thought of Shen Gua from which he concludes that there was no unified conception of science. Sivin, "Scientific Revolution," 47–51.

35. Sivin, "Wang Hsi-shan," in *Dictionary of Scientific Biography,* 163.

36. Sivin, "Copernicus in China," 1.

37. Sivin, "Wang Hsi-shan," in *Dictionary of Scientific Biography,* 166 n "n." Sivin notes that this thesis is documented in his article "Copernicus in China."

38. Sivin, "Wang Hsi-shan," in *Science in Ancient China,* 1.

39. Sivin, "Scientific Revolution," 65. Sivin also mentions a third scientific revolution "that didn't take place in Archimedes' lifetime."

40. The term *disciplinary matrix* is introduced in Kuhn's postscript to *The Structure of Scientific Revolutions* to mean that which is shared by practitioners and accounts for the unanimity of their judgment; the term replaces his earlier concept of *paradigm.* Kuhn's disciplinary matrix consists of four major components: (1) symbolic generalizations (statements which can be formalized into logical or mathematical symbols, functioning to define terms and express relations); (2) the metaphysical conceptions involved in scientific interpretations and models which provide preferred analogies; (3) values that are shared by a wider community than one group of scientific practitioners; and (4) "exemplars"—concrete solutions to scientific problems. Thomas S. Kuhn, *The Structure of Scientific Revolutions,* International Encyclopedia of Unified Science, 2d ed., enl. (Chicago: University of Chicago Press, 1970), 182–87.

41. Sivin, "Scientific Revolution," passim.

42. Perhaps the most dramatic emblem of the radical shift between the worldviews of the ancients and moderns is the shift from the geocentric to the heliocentric picture of the solar system; see Kuhn, *The Copernican Revolution: Planetary Astronomy in the Development of Western Thought* (Cambridge, Mass.: Harvard University Press, 1957). Alexandre Koyré offers a similarly dramatic symbolization of the radical break between the "closed world" of the ancients and the modern "infinite universe" (Koyré, *From the Closed World to the Infinite Universe* [Baltimore: Johns Hopkins University Press, 1957]). Kuhn's example of the duck/rabbit diagram is yet another example of an emblem of this radical shift (Kuhn, *Structure of Scientific Revolutions,* 114).

43. For an overview of the literature predating this work, see Sivin "Scientific Revolution," 54 n 7. Elsewhere, Sivin also repeatedly criticizes sinologists for ignoring scientific texts (idem., "Copernicus in China," 13).

44. Mark Elvin, *The Pattern of the Chinese Past: A Social and Economic Interpretation* (Stanford: Stanford University Press, 1973), 234.

45. Joseph R. Levenson, *The Problem of Intellectual Continuity,* vol. 2 of *Confucian China and Its Modern Fate: A Trilogy* (Berkeley and Los Angeles: University of California Press, 1968), chaps. 1 and 2.

46. Alfred H. Bloom, *The Linguistic Shaping of Thought: A Study in the Impact of Language on Thinking in China and the West* (Hillsdale, N.J.: Lawrence Erlbaum, 1981).

47. Hartwell, "Historical Analogism," 723.

48. Wenyuan Qian, *The Great Inertia: Scientific Stagnation in Traditional China* (Dover, N.H.: Croom Helm, 1985), 26.

49. Levenson, *Problem of Intellectual Continuity,* 204–09.

50. Elvin's example is Fang Yizhi (1611–71), *Pattern of the Chinese Past,* 227–34.

51. Hartwell's thesis is that historical analogism "was dominant among policy makers during most years of the eleventh, twelfth, and thirteenth centuries" (694); it was displaced by "an orthodoxy of the Zhu Xi classicist-moral-didactic compromise" from the fourteenth to nineteenth centuries (717).

52. Qian, *Great Inertia,* 12–14, 96–97. As Sivin notes, Qian's book is "a shallow 'answer' to the Scientific Revolution Problem uninformed by acquaintance with the primary literature" (Sivin, "Selected, Annotated Bibliography," 7).

53. Two examples are Huff, *Rise of Early Modern Science*; and Derk Bodde, *Chinese Thought, Society, and Science: The Intellectual and Social Background of Science and Technology in Pre-Modern China* (Honolulu: University of Hawaii Press, 1991).

54. G. E. R. Lloyd, *Adversaries and Authorities: Investigations Into Ancient Greek and Chinese Science,* Ideas in Context (Cambridge: Cambridge University Press, 1996). An eminent historian of early Greek science and medicine, Lloyd has devoted recent years to learning classical Chinese and has conducted numerous seminars at Cambridge University in preparation for his comparative work.

55. Lloyd finds the arguments supporting the conventional theses on Greek/China comparisons so misconceived that in the first chapter he generalizes the mistakes he hopes to avoid, basing his approach on what he terms "anti-generalization" (the requirement to respect differences in historical periods, geographical areas, domains of science, and different schools within domains), and "anti-piecemeal" (the requirement not to seek simple equivalents of prominent Greek theories in China and vice versa) (3–9).

56. Lloyd argues against a "simplistic contrast" noting its "shortcomings"—adversariality and respect for authority can be found in both societies, but not equally (44).

57. For several examples already mentioned in this article of conventional views on the importance of Euclid and axiomatic deduction, see the views of Einstein, Crombie, Needham, and Hartwell noted above.

58. Even in mathematics, the axiomatization of arithmetic was not possible until the late nineteenth century.

59. For example, see Jacques Derrida, *Dissemination,* trans. Barbara Johnson (Chicago: University of Chicago Press, 1981).

60. A more precise statement of a central thesis of his book is given by Foucault himself: "What we call psychiatric practice is a certain moral tactic contemporary with the end of the eighteenth century, preserved in the rites of asylum life, and overlaid by the myths of positivism." Michel Foucault, *Madness and Civilization: A History of Insanity in the Age of Reason,* trans. Richard Howard (New York: Vintage Books, 1988), 276; originally published as *Folie et déraison: histoire de la folie à l'âge classique* (Paris: Plon, 1961).

61. Latour states: "'We Westerners are absolutely different from others!'—such is the moderns' victory cry, or protracted lament. The Great Divide between Us—Occidentals—and Them—everyone else, from the China seas to the Yucatan, from the Inuit to the Tasmanian aborigines—has not ceased to obsess us. . . . [Westerners] do not claim merely that they differ from others as the Sioux differ from the Algonquins, or the Baoules from the Lapps, but that they differ radically, absolutely, to the extent that Westerners can be lined up on one side and all the cultures on the other, since the latter all have in common the fact that they are precisely cultures among others. In Westerners' eyes the West, and the West alone, is not a culture, not merely a culture" (97). Science, Latour notes, is central to the representation of the uniqueness of the West—the West claims to mobilize Nature through the science it invented.

62. Latour advocates a triply symmetric anthropology that (1) offers the same explanation for truth and error, (2) studies the human and nonhuman simultaneously, and (3) "refrains from making any *a priori* declarations as to what might distinguish Westerners from Others" (103). The distinction itself, then, does remain, and in the end, the Great Divide remains reaffirmed even in Latour: "We are," he declares at one point, "indeed different from others" (114).

63. Latour provides for his networks an economistic "scale of the mobilization" (105) to measure civilizations: his principle of symmetry aims at not just "establishing equality" but also "registering differences" (107) now conceptualized not as qualitative but as differences "only of size" (108). Yet elsewhere the difference is not just one of size: "Moderns do differ from premoderns by this single trait: they refuse to conceptualize quasi-objects as such" (112). The dual process of purification and translation (which creates hybrids and networks) becomes not just constitutive of the representations of the moderns but the explanation for the difference between Us and Them, as Latour outlines in the three central hypotheses of his book: (1) for the moderns, purification makes hybrids possible; (2) for the premoderns, conceiving of hybrids excluded their proliferation; and (3) the nonmodern present must "slow down, reorient, and regulate the proliferation of monsters by representing their existence officially" (12). For a succinct summary of the purported differences in worldviews, see Latour's diagram 4.3 (102).

64. Latour's divide is conceived not through relativism but instead as differences in dimension (12, 114) which resulted from the separation of Nature and Society and the human and the nonhuman by the "Modern Constitution" instituted by the "Founding Fathers" Hobbes and Boyle (28–29). For the premoderns, "the nonseparability of natures and societies had the disadvantage of making experimentation on a large scale impossible, since every transformation of nature had to be in harmony with a social transformation, term for term, and vice versa" (140). Latour provides no evidence from scientific treatises of "premodern" cultures to justify this common anthropological stereotype.

# 14

# The Evolution of Large
# Technological Systems

## THOMAS P. HUGHES

## DEFINITION OF
## TECHNOLOGICAL SYSTEMS

Technological systems contain messy, complex, problem-solving components. They are both socially constructed and society shaping.[1] Among the components in technological systems are physical artifacts, such as the turbogenerators, transformers, and transmission lines in electric light and power systems.[2] Technological systems also include organizations, such as manufacturing firms, utility companies, and investment banks, and they incorporate components usually labeled scientific, such as books, articles, and university teaching and research programs. Legislative artifacts, such as regulatory laws, can also be part of technological systems. Because they are socially constructed and adapted in order to function in systems, natural resources, such as coal mines, also qualify as system artifacts.[3]

An artifact—either physical or nonphysical—functioning as a component in a system interacts with other artifacts, all of which contribute directly or through other components to the common system goal. If a component is removed from a system or if its characteristics change, the other artifacts in the system will alter characteristics accordingly. In an electric light and power system, for instance, a change in resistance, or load, in the system will bring compensatory changes in transmission, distribution, and generation components. If there is repeated evidence the investment policies of an investment bank are coordinated with the sales activities of an electrical manufacturer, then there is likely to be a systematic interaction between them; the change in policy in one will bring changes in the policy of the other. For instance, investment banks may systematically fund the purchase of the electric power plants of a particular manufacturer with which they share owners and interlocking boards of directors.[4] If courses in an engineering school shift emphasis from the study of direct current (dc) to alternating current (ac) at about the same time as the physical artifacts in power systems are changing from dc to ac, then a systematic relationship also seems likely. The professors teaching the courses may be regular consultants of utilities and electrical manufacturing firms; the alumni of the engineering

schools may have become engineers and managers in the firms; and managers and engineers from the firm may sit on the governing boards of the engineering schools.

Because they are invented and developed by system builders and their associates, the components of technological systems are socially constructed artifacts. Persons who build electric light and power systems invent and develop not only generators and transmission lines but also such organizational forms as electrical manufacturing and utility holding companies. Some broadly experienced and gifted system builders can invent hardware as well as organizations, but usually different persons take these responsibilities as a system evolves. One of the primary characteristics of a system builder is the ability to construct or to force unity from diversity, centralization in the face of pluralism, and coherence from chaos. This construction often involves the destruction of alternative systems. System builders in their constructive activity are like "heterogeneous engineers" (Law).

Because components of a technological system interact, their characteristics derive from the system. For example, the management structure of an electric light and power utility, as suggested by its organizational chart, depends on the character of the functioning hardware, or artifacts, in the system. In turn, management in a technological system often chooses technical components that support the structure, or organizational form, of management.[5] More specifically, the management structure reflects the particular economic mix of power plants in the system, and the layout of the power plant mix is analogous to the management structure. The structure of a firm's technical system also interacts with its business strategy.[6] These analogous structures and strategies make up the technological system and contribute to its style.

Because organizational components, conventionally labeled social, are system-builder creations, or artifacts, in a technological system, the convention of designating social factors as the environment, or context, of a technological system should be avoided. Such implications occur when scholars refer to the social context of technology or to the social background of technological change. A technological system usually has an environment consisting of intractable factors not under the control of the system managers, but these are not all organizational. If a factor in the environment—say, a supply of energy—should come under the control of the system, it is then an interacting part of it. Over time, technological systems manage increasingly to incorporate environment into the system, thereby eliminating sources of uncertainty, such as the once free market. Perhaps the ideal situation for system control is a closed system that does not feel the environment. In a closed system, or in a system without environment, managers could resort to bureaucracy, routinization, and de-skilling to eliminate uncertainty—and freedom. Prediction by extrapolation, a characteristic of system managers, then becomes less fanciful.

Two kinds of environment relate to open technological systems: ones on which they are dependent and ones dependent on them. In neither case is there interaction between the system and the environment; there is simply a one-way influence. Because they are not under system control, environmental factors affecting the system should not be mistaken for components of the system. Because they do not interact with the system, environmental factors dependent on the system should not be seen as part of it either. The supply of fossil fuel is often an environmental factor on which an electric light and power system is dependent. A utility company fully owned by an electrical manufacturer is part of a dependent environment if it has no influence over the policies of the manufacturer but must accept its products. On the other hand, ownership is no sure indicator of dependence, for the manufacturer could design its products in

conjunction with the utility.[7] In this case the owned utility is an interacting component in the system.

Technological systems solve problems or fulfill goals using whatever means are available and appropriate; the problems have to do mostly with reordering the physical world in ways considered useful or desirable, at least by those designing or employing a technological system. A problem to be solved, however, may postdate the emergence of the system as a solution. For instance, electrical utilities through advertising and other marketing tactics stimulated the need for home appliances that would use electricity during hours when demand was low. This partial definition of technology as problem-solving systems does not exclude problem solving in art, architecture, medicine, or even play, but the definition can be focused and clarified by further qualification: It is problem solving usually concerned with the reordering of the material world to make it more productive of goods and services. Martin Heidegger defines technology as an ordering of the world to make it available as a "standing reserve" poised for problem solving and, therefore, as the means to an end. This challenging of man to order the world and in so doing to reveal its essence is called enframing (Heidegger 1977, p. 19).

Technological systems are bounded by the limits of control exercised by artifactual and human operators. In the case of an electric light and power system, a load-dispatching center with its communication and control artifacts and human load dispatchers is the principal control center for power plants and for transmission and distribution lines in the system. The load-dispatching center is, however, part of a hierachical control system involving the management structure of the utility. That structure may itself be subject to the control of a holding company that incorporates other utilities, banks, manufacturers, and even regulatory agencies. An electric utility may be interconnected with other utilities to form a regional, centrally controlled electric light and power system. Regional power systems sometimes integrate physically and organizationally with coal mining enterprises and even with manufacturing enterprises that use the power and light. This was common in the Ruhr region in the years between World War I and World War II. Systems nestle hierarchically like a Russian Easter egg into a pattern of systems and subsystems.

Inventors, industrial scientists, engineers, managers, financiers, and workers are components of, but not artifacts, in the system. Not created by the system builders, individuals and groups in systems have degrees of freedom not possessed by artifacts. Modern system builders, however, have tended to bureaucratize, de-skill, and routinize in order to minimize the voluntary role of workers and administrative personnel in a system. Early in this century, Frederick W. Taylor's scientific-management program organized labor as if it were an inanimate component in production systems. More recently, some system builders have designed systems that provide labor with an opportunity to define the labor component of a system. The voluntary action does not come to labor as it functions in the system but as it designs its functions. A crucial function of people in technological systems, besides their obvious role in inventing, designing, and developing systems, is to complete the feedback loop between system performance and system goal and in so doing to correct errors in system performance. The degree of freedom exercised by people in a system, in contrast to routine performance, depends on the maturity and size, or the autonomy, of a technological system, as will be shown. Old systems like old people tend to become less adaptable, but systems do not simply grow frail and fade away. Large systems with high momentum tend to exert a soft determinism on other systems, groups, and individuals in society.

Inventors, organizers, and managers of technological systems mostly prefer hierarchy, so the systems over time tend toward a hierarchical structure. Thus the definer and describer of a system should delimit the level of analysis, or subsystem, of interest (Constant 1987). For instance, interacting physical artifacts can be designated a system, or physical artifacts plus interacting organizations can be so designated. The turbogenerators in an electric power system can be seen as systems with components such as turbines and generators. These artifacts can, in turn, be analyzed as systems. In a large technological system there are countless opportunities for isolating subsystems and calling them systems for purposes of comprehensibility and analysis. In so doing, however, one rends the fabric of reality and may offer only a partial, or even distorted, analysis of system behavior.

The definer or describer of a hierachical system's choice of the level of analysis from physical artifact to world system can be noticeably political. For instance, an electric light and power system can be so defined that externalities or social costs are excluded from the analysis. Textbooks for engineering students often limit technological systems to technical components, thereby leaving the student with the mistaken impression that problems of system growth and management are neatly circumscribed and preclude factors often pejoratively labeled "politics." On the other hand, neoclassical economists dealing with production systems often treat technical factors as exogenous. Some social scientists raise the level of analysis and abstraction so high that it does not matter what the technical content of a system might be.

A technological system has inputs and outputs. Often these can be subsumed under a general heading. For instance, an electric light and power system has heat or mechanical energy as its primary input and electrical energy as its output. Within the system the subsystems are linked by internal inputs and outputs, or what engineers call interfaces. An electrical-manufacturing concern in the system may take electrical energy from the utility in the system and supply generating equipment to the utility. The manufacturing concern may also take income from the profits of the utility and from sale of equipment to the utility and then reinvest in the utility. Both may exchange information about equipment performance for purposes of design and operation. An investment bank may take profits from its investments in a manufacturing company and a utility and then also invest in these enterprises. Financial and technical information about light and power systems is also interchanged. In the examples given, one assumes interlocking boards of directors and management and control.

## PATTERN OF EVOLUTION

Large, modern technological systems seem to evolve in accordance with a loosely defined pattern. The histories of a number of systems, especially the history of electric light and power between 1870 and 1940, display the pattern described in this chapter. The sample is not large enough, however, to allow essentially quantitative statements, such as "most" or "the majority," to be made. Relevant examples from the history of modern technological systems, many from electric light and power, support or illustrate my arguments. I also use a number of interrelated concepts to describe the pattern of evolution. The concept of reverse salient, for instance, can be appreciated only if it is related to the concept of system used in this chapter. The concept of technological style should be related to the concept of technology transfer. The term "pattern" is

preferable to "model" because a pattern is a metaphor suggesting looseness and a tendency to become unraveled.

The pattern suggested pertains to systems that evolve and expand, as so many systems originating in the late nineteenth century did. With the increased complexity of systems, the number of components and the problems of control increased. Intense problems of control have been called crises of control (Beniger 1984). Large-scale computers became a partial answer. An explanation of the tendency of systems to expand is offered here. The study of systems contracting, as countless have through history, would by comparison and contrast help explain growth. Historians of systems need among their number not only Charles Darwins but also Edward Gibbons.

The history of evolving, or expanding, systems can be presented in the phases in which the activity named predominates: invention, development, innovation, transfer, and growth, competition, and consolidation. As systems mature, they acquire style and momentum. In this chapter style is discussed in conjunction with transfer, and momentum is discussed after the section on growth, competition, and consolidation. The phases in the history of a technological system are not simply sequential; they overlap and backtrack. After invention, development, and innovation, there is more invention. Transfer may not necessarily come immediately after innovation but can occur at other times in the history of a system as well. Once again, it should be stressed that invention, development, innovation, transfer, and growth, competition, and consolidation can and do occur throughout the history of a system but not necessarily in that order. The thesis here is that a pattern is discernible because of one or several of these activities predominating during the sequence of phases suggested.

The phases can be further ordered according to the kind of system builder who is most active as a maker of critical decisions.[8] During invention and development inventor-entrepreneurs solve critical problems; during innovation, competition, and growth manager-entrepreneurs make crucial decisions; and during consolidation and rationalization financier-entrepreneurs and consulting engineers, especially those with political influence, often solve the critical problems associated with growth and momentum. Depending on the degree or adaptation to new circumstances needed, either inventor-entrepreneurs or manager-entrepreneurs may prevail during transfer. Because their tasks demand the attributes of a generalist dedicated to change rather than the attributes of a specialist, the term "entrepreneur" is used to describe system builders. Edison provides a prime example of an inventor-entrepreneur. Besides inventing systematically, he solved managerial and financial problems to bring his invention into use. His heart, however, at least as a young inventor, lay with invention. Elmer Sperry, a more professional and dedicated inventor than Edison but also an entrepreneur, saw management and finance as the necessary but boring means to bring his beloved inventions into use (Hughes 1971, pp. 41, 52–53).

## INVENTION

Holding companies, power plants, and light bulbs—all are inventions. Inventors, managers, and financiers are a few of the inventors of system components. Inventions occur during the inventive phase of a system and during other phases. Inventions can be conservative or radical. Those occurring during the invention phase are radical because they inaugurate a new system; conservative inventions predominate during the phase of competition and system growth, for they improve or expand existing systems. Because radical inventions do not contribute to the growth

of existing technological systems, which are presided over by, systematically linked to, and financially supported by larger entities, organizations rarely nurture a radical invention. It should be stressed that the term "radical" is not used here in a commonplace way to suggest momentous social effects. Radical inventions do not necessarily have more social effects than conservative ones, but as defined here, they are inventions that do not become components in existing systems.

Independent professional inventors conceived of a disproportionate number of the radical inventions during the late nineteenth and early twentieth centuries (Jewkes et al. 1969, pp. 79–103). Many of their inventions inaugurated major technological systems that only later came under the nurturing care of large organizations; the systems then stabilized and acquired momentum. Outstanding examples of independent inventors and their radical inventions that sowed the seeds of large systems that were presided over by new organizations are Alexander Graham Bell and the telephone, Thomas E. Edison and the electric light and power system, Charles Parsons and Karl Gustaf Patrik de Laval and the steam turbine, the Wright brothers and the airplane, Marconi and the wireless, H. Anschütz-Kaempfe and Elmer Sperry and the gyrocompass guidance and control system, Ferdinand von Zeppelin and the dirigible, and Frank Whittle and the jet engine.[9] Even though tradition assigns the inventions listed to these independent inventors, it should be stressed that other inventors, many of them independents, also contributed substantially to the inauguration of the new systems. For instance, the German Friedrich Haselwander, the American C. S. Bradley, and the Swede Jonas Wenström took out patents on polyphase systems at about the same time as Nikola Tesla; and Joseph Swan, the British inventor, should share credit with Edison for the invention of a durable incandescent filament lamp, if not for the incandescent lamp system.

Even though radical inventions inaugurate new systems, they are often improvements over earlier, similar inventions that failed to develop into innovations. Historians have a rich research site among the remains of these failed inventions. Elmer Sperry, who contributed to the establishment of several major technological systems, insisted that all his inventions, including the radical ones, were improvements on the earlier work of others (Sperry 1930, p. 63). The intense patent searches done by independents reinforces his point.

The terms "independent" and "professional" give needed complexity to the concept of inventor. Free from the constraints of organizations, such as industrial or government research laboratories, independent inventors can roam widely to choose problems to which they hope to find solutions in the form of inventions. Independent inventors often have their own research facilities or laboratories, but these are not harnessed to existing systems, as is usually the case with government and industrial research laboratories. Not all independent inventors are "professional"; professional inventors support their inventive activities over an extended period by a series of commercially successful inventions. They are not salaried employees, although they might take consulting fees. Many independents who were not professionals, such as Alexander Graham Bell, gained immense income from several major inventions and then chose to live, or enjoy, life other than as inventors. Elmer Sperry, Elihu Thomson, Edward Weston, Thomas Edison, and Nikola Tesla are outstanding examples of inventors who persisted as professionals for an extended period during the late nineteenth and early twentieth centuries.

The independents who flourished in the late nineteenth and early twentieth centuries tended to concentrate on radical inventions for reasons both obvious and obscure. As noted, they were not constrained in their problem choices by mission-oriented organizations with high inertia.

They prudently avoided choosing problems that would also be chosen by teams of researchers and developers working in company engineering departments or industrial research laboratories. Psychologically they had an outsider's mentality; they also sought the thrill of a major technological transformation. They often achieved dramatic breakthroughs, not incremental improvements. Elmer Sperry, an independent inventor, said: "If I spend a life-time on a dynamo I can probably make my little contribution toward increasing the efficiency of that machine six or seven percent. Now then, there are a whole lot of arts that need electricity, about four or five hundred per cent, let me tackle one of those" (Sperry 1930, p. 63). To achieve these breakthroughs, the independents had the insight to distance themselves from large organizations. They rightly sensed that the large organization vested in existing technology rarely nurtured inventions that by their nature contributed nothing to the momentum of the organization and even challenged the status quo in the technological world of which the organization was a leading member. Radical inventions often de-skill workers, engineers, and managers, wipe out financial investments, and generally stimulate anxiety in large organizations. Large organizations sometimes reject the inventive proposals of the radicals as technically crude and economically risky, but in so doing they are simply acknowledging the character of the new and radical.

Independent inventors have more freedom but consequently more difficulty in identifying problems than inventors and scientists working in large-company engineering departments or industrial research laboratories. On several notable occasions academics stimulated the problem choices of independent inventors who flourished in the late nineteenth and early twentieth centuries. Charles Hall heard his professor of science say that the world awaited the inventor who could find a practical means of smelting aluminum; a professor at the Polytechnic in Graz, Austria, stimulated Nikola Tesla to embark on the search that culminated in his polyphase electrical system (Hughes 1983, p. 113); Professor Carl von Linde of the Munich Polytechnic defined a problem for his student Rudolf Diesel that eventually resulted in Diesel's engine (Diesel 1953, p. 97); and physics professor William A. Anthony of Cornell University outlined several problems for young Elmer Sperry that climaxed in his first major patents.[10] Perhaps the academics' imaginations ranged freely because they, like independent inventors, were not tied to industry but at the same time were broadly acquainted with technical and scientific literature.

Inventors do publish, despite widespread opinion to the contrary. They publish patents, and they often publish descriptions of their patented inventions in technical journals. The technical articles, sometimes authored by the inventors, sometimes by cooperating technical journalists, brought not only recognition but also publicity of commercial value. Whether patent or article, the publication informed the inventive community about the location of inventive activity. This alerted the community about problems that needed attention, for rarely was a patent or invention the ultimate solution to a problem, and experienced inventors realized that a basic problem could be solved in a variety of patentable ways, including their own. So, by keeping abreast of patents and publications, inventors could identify problem areas. This helps explain why patents tend over a period of several years to cluster around problem sites.

Professional inventors have other reasons for their problem choices. In avoiding problems on which engineering departments and industrial research laboratories were working, independents narrowed their problem choice. The challenge of sweet problems that have foiled numerous others often stimulates the independents' problem choices. They believe their special gifts will bring

success where others have failed. Not strongly motivated by a defined need, they exhibit an elementary joy in problem solving as an end in itself. Alexander Graham Bell, a professor of elocution and an authority on deafness, seeing the analogy between acoustic and electrical phenomena, pursued the goal of a speaking telegraph despite the advice of friends and advisers who urged him to continue to concentrate on the problem of multiplexing wire telegraphy, a conservative telegraph-industry-defined problem. Another independent, Elisha Gray, who was also working on multiplexing and who also saw the possibility of a speaking telegraph, made the conservative decision and concentrated on multiplexing (Hounshell 1975).

The independent professionals had not only freedom of problem choice but also the less desirable freedom from the burden of organizational financial support. Their response has been ingenious. At the turn of the century they often traded intellectual property for money. In an era before a patent became essentially a license to litigate and before the large companies amassed the resources to involve an independent in litigation to the point of financial exhaustion, independent professionals transformed their ideas into property in the form of patents. Having done this, they sold their intellectual property to persons with other forms of property, especially money. Sometimes the inventor and the financier would each deposit so many patents and so much cash and divide the stock of a new company founded to exploit the patent. In democratic America the ability of a self-made inventor to match wits with the presumedly ill-gotten gains of financiers was believed wonderfully meritocratic.

As the armaments race, especially the naval one, increased in intensity before World War I, inventors turned to the government for development funds. These came as contracts to supply airplanes, wireless, gunfire control, and other high-technology artifacts of the day. Governments contracted for a few models that were in essence experimental designs. With income from these contracts the inventors invested in further development. In order to contract with the armed services, many of the inventors allied with financiers to form small companies. The possibility existed that the company would flourish, and then the inventor would be harnessed to a burden of his own making; but many of the companies collapsed, leaving the inventor to savor independence again. The independents also raised funds by setting up as consultants or by organizing small research and development companies that would develop their own and others' inventions. Perhaps the ideal of funding and freedom came when the inventor had licensed sufficient patents over the years to bring a steadily mounting income that could be reinvested in invention. The investment was often in workshop, laboratory facilities, and staff, for contrary to myth, independent inventors were not necessarily "lone" inventors.

An aspect of radical invention less understood than problem choice and funding lies at the heart of the matter: the times of inspiration or "Eureka!" moments. There exists a helpful body of literature on the psychology of invention and discovery, but it lacks richly supported and explored case histories of invention.[11] The inventors themselves have rarely verbalized their moments of inspiration. Some promising but unexplored leads to follow exist, however. Frequently, inventors speak of their inventions in terms of metaphor or analogy. All analogy is is an invention that carries its creator from the known to the unknown. Inventors often develop a particular mechanism or process that they then formulate as an abstract concept, probably visual, that subsequently becomes a generalized solution. So prepared, the inventor becomes a solution looking for a problem. These clues, however, only tantalize. Historians and sociologists of technology should join psychologists in exploring the act of creation.[12]

# DEVELOPMENT

Radical inventions, if successfully developed, culminate in technological systems. One inventor may be responsible for most or all of the inventions that become the immediate cause of a technological system; the same inventor may preside over the development of the inventions until they result in an innovation, or a new technological system in use. If one inventor proves responsible for most of the radical inventions and the development of these, then he or she fully deserves the designation inventor-entrepreneur.

Development is the phase in which the social construction of technology becomes clear. During the transformation of the invention into an innovation, inventor-entrepreneurs and their associates embody in their invention economic, political, and social characteristics that it needs for survival in the use world. The invention changes from a relatively simple idea that can function in an environment no more complex than can be constituted in the mind of the inventors to a system that can function in an environment permeated by various factors and forces. In order to do this, the inventor-entrepreneur constructs experimental, or test, environments that become successively more complex and more like the use world that the system will encounter on innovation. Elmer Sperry, for instance, having written, or having had written for him, the equations of his concept of a gyro ship stabilizer gave the concept material form in a model of a rolling ship consisting of a simple pendulum and a laboratory gyroscope. In the next step he redesigned the invention, making it more complex, and experimented with it in an environment incorporating more ship and sea variables than the simple pendulum could provide. In time the model reached a level of complexity that in Sperry's opinion allowed it to accommodate to use-world variables. He tested the ship stabilizer on a destroyer provided by the United States Navy. The testing of inventions as mathematical formulas and as models stripped down to scientific abstractions permits small investments and small failures before the costly venture of full-scale trial and ultimate use is attempted.

There are countless examples of independent inventor-entrepreneurs providing their inventions with the economic, political, and other characteristics needed for survival. Edison's awareness of the price of gaslight deeply influenced his design of a competitive electric light system. In the early 1880s in England, Lucien Gaulard and John Gibbs invented a transformer with physical characteristics that allowed the transformer's output voltage to be varied as required by the Electric Lighting Act of 1882 (Hughes 1983, pp. 34–38, 89–90). The Wright brothers carefully took into account the psychology and physiology of the pilots who would have to maintain the stability of their flyer. According to David Noble, digital machine tool systems have built into them the interests of the managerial class (Noble 1979).

Because new problems arise as the system is endowed with various characteristics, radical inventor-entrepreneurs continue to invent during the development period. Because problems arise out of the systematic relationship of the system components being invented, the choice of problems during the development process becomes easier. If, for instance, during development the inventor varies the characteristics of one component, then the other interrelated components' characteristics usually have to be varied accordingly. This harmonizing of component characteristics during development often results in patentable inventions. An entire family of patents sometimes accompanies the development of a complex system.

A large organization inventing and developing a system may assign subprojects and problems

to different types of professionals. When the Westinghouse Corporation developed Tesla's poly-phase electric power transmission system, it used him as a consultant, but ultimately a talented group of Westinghouse engineers brought the system into use (Passer 1953, pp. 276–282). Physicists, especially academic ones, have sometimes proven more adept at invention than engineers, who often display a preference and a capability for development. Until World War II academic physicists were relatively free of organizational constraints, and during World War II this frame of mind survived, even in such large projects as the Radiation Laboratory in Cambridge, Massachusetts, the Manhattan Project laboratory in Chicago under Arthur Compton, and the Los Alamos laboratory under Robert Oppenheimer. Since the end of the nineteenth century, engineers have been associated with large industrial corporations, or, in the case of academic engineers, they have tended to look to the industrial sector for definition of research problems (Noble 1977, pp. 33–49).

The relationships between engineers and scientists and between technology and science have long held the attention of historians, especially historians of science. From the systems point of view the distinctions tend to fade. There are countless cases of persons formally trained in science and willing to have their methods labeled scientific immersing themselves fully in invention and development of technology.[13] Engineers and inventors formally trained in courses of study called science have not hesitated to use the knowledge and methods acquired. Persons committed emotionally and intellectually to problem solving associated with system creation and development rarely take note of disciplinary boundaries, unless bureaucracy has taken command.

## INNOVATION

Innovation clearly reveals technologically complex systems. The inventor-entrepreneur, along with the associated engineers, industrial scientists, and other inventors who help to bring the product into use, often combines the invented and developed physical components into a complex system consisting of manufacturing, sales, and service facilities. On the other hand, rather than establishing a new company, the inventor-entrepreneur sometimes provides specifications enabling established firms to manufacture the product or provide the service. Many of the independent professionals of the late nineteenth and early twentieth centuries, however, founded their own manufacturing, sales, and service facilities because, in the case of radical inventions, established manufacturers were often reluctant to provide the new machines, processes, and organizations needed for manufacture. Independent inventor-entrepreneurs chose to engage in manufacture because they wanted to introduce a manufacturing process systematically related to the invention. They often invented and developed the coordinated manufacturing process as well as the product. If, on the other hand, the invention was a conservative one, in essence, an improvement in an ongoing system, the manufacturer presiding over this system would often be interested in manufacturing the invention.

Edison also provides a classic example of the inventor-entrepreneur presiding over the introduction of a complex system of production and utilization. Edison had the assistance of other inventors, managers, and financiers who were associated with him, but he more than any other individual presided over the intricate enterprise. The organizational chart of 1882 of Edison-

founded companies outlines the complex technological system. Among the Edison companies were The Edison Electric Light Company, formed to finance Edison's invention, patenting, and development of the electric-lighting system and the licensing of it; The Edison Electric Illuminating Company of New York, the first of the Edison urban lighting utilities; The Edison Machine Works, founded to manufacture the dynamos covered by Edison's patents; The (Edison) Electric Tube Company, established by Edison to manufacture the underground conductors for his system; and the Edison Lamp Works (Jones 1940, p. 41). When Edison embarked on the invention of an incandescent lighting system, he could hardly have anticipated the complexity of the ultimate Edison enterprise.

System builders, such as Edison, strive to increase the size of the system under their control and to reduce the size of the environment that is not. In the case of the Edison system at the time of the innovation, the utilities, the principal users of the equipment patented by The Edison Electric Light Company and manufactured by the mix of Edison companies, were being incorporated into the system. The same group of investors who owned the patent-holding company owned The Edison Electric Illuminating Company of New York, the first of the Edison urban utilities. The owners of the Edison companies accepted stock from other utilities in exchange for equipment, thereby building up an Edison empire of urban utilities variously owned and controlled. Similar policies were followed later by the large manufacturers in Germany. The manufacturers' absorption of supply and demand organizations tended to eliminate the outside/inside dichotomy of systems, a dichotomy avoided by Michael Callon in his analysis of actor networks (Callon 1987).

Once innovation occurs, inventor-entrepreneurs tend to fade from the focal point of activity. Some may remain with a successful company formed on the basis of their patents, but usually they do not become the manager-entrepreneurs of the enterprise.

## TECHNOLOGY TRANSFER

The transfer of technology can occur at any time during the history of a technological system. Transfer immediately after innovation probably most clearly reveals interesting aspects of transfer, for the technological system is not laden with the additional complexities that accrue with age and momentum. Because a system usually has embodied in it characteristics suiting it for survival in a particular time and place, manifold difficulties often arise in transfer at another time or to a different environment. Because a system usually needs adaptation to the characteristics of a different time or place, the concepts of transfer and adaptation are linked. Besides adaptation, historians analyzing transfer have stressed the modes of transfer.[14]

Aspects of adaptation can be shown by episodes drawn from the early history of the transformer. As noted, Lucien Gaillard and John Gibbs introduced the transformer with characteristics that suited it to British electric lighting legislation. They organized several test and permanent installations of their transformer in the early 1880s. In 1884 Otto Titus Blàthy and Charles Zipernowski, two experienced engineers from Ganz and Company, the preeminent Hungarian electrical manufacturer, saw the transformer on exhibit in Turin, Italy. They redesigned it for a Ganz system and for Hungarian conditions, under which electrical legislation did not require the complex characteristics embodied in the Gaulard and Gibbs device. The

resulting transformer has been designated the world's first practical and commercial transformer (Halacsy and Von Fuchs 1961, p. 121). But such a designation is misleading because the transformer was practical for Hungary, not for the world. In the United States the Westinghouse Company acquired the rights to the patent, and had it adapted to American conditions. Westinghouse employed William Stanley, an independent inventor, to develop a transformer system of transmission on the basis of the Gaulard-Gibbs device. Subsequently, the engineering staff at Westinghouse gave the system an American style by presuming a large market and adapting the transformer and the processes for manufacturing it for mass production (Hughes 1983, pp. 98–105).

The case of the Gaulard-Gibbs transformer reveals legislation and market as critical factors in transfer and adaptation, but there are other factors involved, including geographical and social ones (Lindqvist 1984, pp. 291–307). The Gaulard and Gibbs case involves a physical object being transferred and adapted; when a technological system is transferred, organizational components are as well. There are numerous cases of the transfer, successful and unsuccessful, of companies as well as of products. Whether the agent of transfer is an inventor, an engineer, a manager, or some other professional depends on the components being transferred and the phase of development of the technological system.

## TECHNOLOGICAL STYLE

Exploration of the theme of technology transfer leads easily to the question of style, for adaptation is a response to different environments and adaptation to environment culminates in style. Architectural and art historians have long used the concept of style. When Heinrich Wölfflin in 1915 wrote about the problem of the development of style in art, he did not hesitate to attribute style in art and architecture to individual and national character. The concept of style can, on the other hand, be developed without reference to national and racial character, or to *Zeitgeist*. Historians of art and architecture now use the concept of style warily, for "style is like a rainbow. . . . We can see it only briefly while we pause between the sun and the rain, and it vanishes when we go to the place where we thought we saw it" (Kubler 1962, p. 129).

Historians and sociologists of technology can, however, use the notion of style to advantage, for, unlike historians of art, they are not burdened by long-established and rigid concepts of style, such as those of the High Renaissance and the baroque that can obfuscate perceptive differentiation. Historians and sociologists can use style to suggest that system builders, like artists and architects, have creative latitude. Furthermore, the concept of style accords with that of social construction of technology. There is no one best way to paint the Virgin; nor is there one best way to build a dynamo. Inexperienced engineers and laymen err in assuming that there is an ideal dynamo toward which the design community Whiggishly gropes. Technology should be appropriate for time and place; this does not necessarily mean that it be small and beautiful.[15]

Factors shaping style are numerous and diverse. After the traumatic Bolshevik Revolution of 1917 and during the shaky beginnings of the new state, the Soviets needed the largest and the fastest technology, not for economic reasons but in order to gain prestige for the regime (Bailes 1976). After comparing the gyrocompass he invented with German ones, Elmer Sperry decided that his was more practical because the Germans pursued abstract standards of performance, not

functional requirements. His observation was a comment on style. Charles Merz, the British consulting engineer who designed regional power systems throughout the world, said in 1909 that "the problem of power supply in any district is . . . completely governed by local conditions" (Merz 1908, p. 4).

The concept of style applied to technology counters the false notion that technology is simply applied science and economics, a doctrine taught only a decade or so ago in engineering schools. Ohm's and Joule's laws and factor inputs and unit costs are not sufficient explanation for the shape of technology. The concepts of both the social shaping of technology and technological style help the historian and the sociologist, and perhaps the practitioner, to avoid reductionist analyses of technology.

The concept of style also facilitates the writing of comparative history. The historian can search for an explanation for the different characteristics of a particular technology, such as electric power, in different regions. The problem becomes especially interesting in this century when international pools of technology are available to the designers of regional technology because of the international circulation of patents, internationally circulated technical and scientific literature, international trade in technical goods and services, the migration of experts, technology transfer agreements, and other modes of exchange of knowledge and artifacts. Having noted the existence of an international pool of technology and having acknowledged that engineering science allows laws to be stated and equations to be written that describe an ideal, or highly abstract, electrical system made up of electromotive forces, resistances, capacitors, and inductances that are internationally valid and timeless, we come upon the fascinating problem: Why do electric light and power systems differ in characteristics from time to time, from region to region, and even from nation to nation?

There are countless examples in this century of variations in technological style. A 1920 map of electricity supply in London, Paris, Berlin, and Chicago reveals remarkable variation from city to city in the size, number, and location of the power plants (Hughes 1983, p. 16). The striking variation is not the amount of light and power generated (the output in quantitative terms), but the way in which it is generated, transmitted, and distributed. (Focusing on the quantitative, the economic historian often misses variations in style.) Berlin possessed about a half dozen large power plants, whereas London had more than fifty small ones. The London style of numerous small plants and the Berlin style of several large ones persisted for decades. London, it must be stressed, was not technically backward. In the London and Berlin regulatory legislation that expressed fundamental political values rests the principal explanation for the contrasting styles. The Londoners were protecting the traditional power of local government by giving municipal boroughs authority to regulate electric light and power and the Berliners were enhancing centralized authority by delegating regulatory power to the city of Berlin (Hughes 1983, pp. 175–200, 227–261).

Natural geography, another factor, also shapes technological style. Because regions as traditionally defined are essentially geographical and because geography so deeply influences technology, the concept of regional technological style can be more easily identified than national style. When regulatory legislation applies on a national level, however, regional styles tend to merge into national ones. Before 1926 and the National Grid in Great Britain, for example, there were distinctive regional styles of power systems—London in contrast to the northeast coast; but the grid brought a more national style as legislation prevailed over other style-inducing factors.

Regional and national historical experiences also shape technological style. During World War I a copper shortage in Germany caused power plant designers to install larger and fewer generators to save copper. This learning experience, or acquired design style, persisted after the war, even though the critical shortage had passed. After World War I the Treaty of Versailles deprived Germany of hard coal–producing areas and demanded the export of hard coal as reparations, so the electric power system builders turned increasingly to soft coal, a characteristic that also persisted after the techniques were learned. Only history can satisfactorily explain the regional style of Ruhr and Cologne area power plants with their post–World War I dependence on lignite and large generating units (Hughes 1983, pp. 413–414).

## GROWTH, COMPETITION, AND CONSOLIDATION

Historians of technology describe the growth of large systems but rarely explore in depth the causes of growth. Yet in modern industrial nations technological systems tend to expand, as shown by electric, telephone, radio, weapon, automobile production, and other systems. A major explanation for this growth, and one rarely stressed by technological, economic, or business historians, is the drive for high diversity and load factors and a good economic mix. This is especially true in twentieth-century systems in which accountants pay close attention to, and managers are informed about, interest on capital investment. The load factor, a concept now applied to many systems, originated in the electrical utility industry in the late nineteenth century. The load factor is the ratio of average output to the maximum output during a specified period. Best defined by a graph, or curve, the load factor traces the output of a generator, power plant, or utility system over a twenty-four-hour period. The curve usually displays a valley in the early morning, before the waking hour, and a peak in the early evening, when business and industry use power, homeowners turn on lights, and commuters increase their use of electrified conveyance. Showing graphically the maximum capacity of the generator, plant, or utility (which must be greater than the highest peak) and tracing the load curve with its peaks and valleys starkly reveal the utilization of capacity. Because many technological systems now using the concept are capital intensive, the load curve that indicates the load factor, or the utilization of investment and the related unit cost, is a much relied on indicator of return on investment.

The load factor does not necessarily drive growth. A small technological system can have a high load factor, for example, if the load, or market, for output is diversified. The load of an electric power system becomes desirably diverse if the individual consumers make their peak demands at different times, some in the late evening, some in the early morning, and so on. When this is not the case, the managers of a technological system try to expand the system in order to acquire a more desirable load or diversity. The load can also be managed by differential pricing to raise valleys and lower peaks. In general, extension over a larger geographical area with different industrial, residential, and transportation loads provides increased diversity and the opportunity to manage the load to improve the load factor. During the twentieth century expansion for diversity and for a high load factor have been prime causes for growth in the electric utility industry. The load factor is, probably, the major explanation for the growth of capital-intensive technological systems in capitalistic, interest-calculating societies.[16]

The managers of electric power systems also seek an improved economic mix. This results, for instance, in the interconnection of a power plant located in the plains near coal mines with another in distant high mountains. The Rheinisch-Westfälisches Elektrizitätswerk, a utility in the Ruhr Valley of Germany, expanded in the 1920s hundreds of miles until the system reached the Alps in the south. Then, after the spring thaws, it drew low-cost hydroelectric power from the Alps and at other times from the less economical coal-fired plants of the Ruhr. The outputs of the regional plants could also be mixed, the less efficient carrying the peak loads on the system and the more economical carrying a steady base load. The intellectual attraction—the elegant puzzle-solving aspect—that the load factor, economic mix, and load management had for the engineer-managers of rapidly expanding electric power systems becomes understandable. For those more concerned with the traditional drive for power and profit, elegant problem solving was coupled with increased profits, market domination, and organization aggrandizement.

As the systems grew, other kinds of problems developed, some of which can be labeled "reverse salients." Conservative inventions solved these problems, whereas radical ones brought the birth of systems. A salient is a protrusion in a geometric figure, a line of battle, or in expanding weather front. As technological systems expand, reverse salients develop. Reverse salients are components in the system that have fallen behind or are out of phase with the others. Because it suggests uneven and complex change, this metaphor is more appropriate for systems than the rigid visual concept of a bottleneck. Reverse salients are comparable to other concepts used in describing those components in an expanding system in need of attention, such as drag, limits to potential, emergent friction, and systemic efficiency. In an electrical system, engineers may change the characteristics of a generator to improve its efficiency. Then another component in the system, such as a motor, may need to have its characteristics—resistance, voltage, or amperage—altered so that it will function optimally with the generator. Until that is done, the motor remains a reverse salient. In a manufacturing system one productive unit may have had its output increased, resulting in all the other components of the system having to be modified to contribute efficiently to overall system output. Until the lagging components can be altered, often by invention, they are reverse salients. During the British Industrial Revolution, observers noted such imbalances in the textile industry between weaving and spinning, and inventors responded to the reverse salients by inventions that increased output in the laggard components and in the overall system. In a mature, complex technological system the need for organization may often be a reverse salient. In the 1920s manager-entrepreneurs saw the need for an organizational form that could preside over the construction, management, and financing of horizontally and vertically integrated utilities. The invention of an appropriate holding-company form corrected the reverse salient.

Entrepreneurs and organizations presiding over expanding systems monitor the appearance of reverse salients, sometimes identifying them by cost-accounting techniques. Having identified the reverse salients, the organization assigns its engineering staff or research laboratory to attend to the situation, if it is essentially one involving machines, devices, processes, and the theory and organized knowledge describing and explaining them. The staff or laboratory has the communities of technological practitioners possessing the traditions of relevant practice (Constant 1987). Communities of inventors congregate at reverse salient sites, for a number of companies in an industry may experience the reverse salient at about the same time. The inventors, whether engineers or industrial scientists, then define the reverse salient as a set of critical

problems, which when solved will correct it. Reverse salients emerge, often unexpectedly; the defining and solving of critical problems is a voluntary action. If the reverse salient is organizational or financial in nature then the individuals or communities of practitioners who attack the problem may be professional managers or financiers who come forth with their inventive solutions. In each stage in the growth of the system the reverse salients elicit the emergence of a sequence of appropriate types of problem solver—inventors, engineers, managers, financiers, and persons with experience in legislative and legal matters (Hughes 1983, pp. 14–17).

Industrial research laboratories, which proliferated in the first quarter of this century, proved especially effective in conservative invention. The laboratories routinized invention. The chemist Carl Duisberg, a director of Bayer before World War I, aptly characterized the inventions of industrial research laboratories (*Etablissementserfindungen*) as having "Von Gedankenblitz keine Spur" (no trace of a flash of genius) (Van den Belt and Rip 1987). Unfortunately for the understanding of technological change, the public relations departments and self-promoting industrial scientists persuaded the public, managers, and owners that industrial laboratories had taken over invention from independent inventors because the independents were less effective. Considerable evidence shows, to the contrary, that radical inventions in disproportionate number still come from the independents.[17] A mission-oriented laboratory tied to corporation or government agency with vested interest in a growing system nurtures it with conservative improvements or with inventions that are responses to reverse salients.

The early problem choices of the pioneer industrial laboratories suggest this rigid commitment to conservative inventions and relative disinterest in radical ones. After the Bell Telephone System in 1907 consolidated its research activities in the Western Electric Company and in American Telephone & Telegraph, its staff of scientists and engineers concentrated on reverse salients that arose out of the decision to build a transcontinental telephone line. Attenuation, or energy loss, proved a major reverse salient. The invention of the loading coil reduced attenuation. By 1911 the introduction of improved repeaters for transmission lines became a major problem for the research and development staff.[18] Reverse salients in electric light and power systems attacked by engineers and scientists at the General Electric Research Laboratory at about the time of its founding in 1900 included improved filaments and vacuums for incandescent lamps and improvements in mercury vapor lamps. Even Irving Langmuir, a distinguished GE scientist who was given exceptional freedom in his choice of research problems, did not neglect highly practical problems encountered by the General Electric Company as it expanded its product lines. Willis R. Whitney, laboratory director, pursued the policy of "responsiveness to business needs" (Wise 1980, p. 429).

When a reverse salient cannot be corrected within the context of an existing system, the problem becomes a radical one, the solution of which may bring a new and competing system. Edward Constant has provided an example of the emergence of a new system out of an established one in which a "presumptive anomaly" was identified. Constant states that presumptive anomalies occur when assumptions derived from science indicate that "under some future conditions the conventional system will fail (or function badly) or that a radically different system will do a much better job" (Constant 1980, p. 15). A presumptive anomaly resembles a presumed reverse salient, but Constant rightly stresses the role of science in identifying it. A notable presumptive anomaly emerged in the late 1920s when insights from aerodynamics indicated that the conventional piston engine-propeller system would not function at the near-sonic speeds foreseen for airplanes. The inventors Frank Whittle, Hans von Ohain, Herbert Wagner, and

Helmut Schelp responded with the turbojet engine, the first three working as independents when they conceived of the new engine (Constant 1980, pp. 194–207, 242).

Edison and others presiding over the growth of the dc electric lighting system in the early 1880s failed to solve a reverse salient and saw other inventors and engineers respond to it with radical inventions that inaugurated the ac system. A "battle of the systems" then ensued between the two, culminating in the 1890s, not with victor and vanquished, but with the invention of devices making possible the interconnection of the two systems. These motor-generator sets, transformers, and rotary converters interconnected heterogeneous[19] loads, such as incandescent lamps, arc lamps, induction motors for industry, dc motors for streetcars, or trams, into a universal system[20] supplied by a few standardized polyphase generators and linked by high-voltage transmission and low-voltage distribution lines. The design and installation of universal power systems in the 1890s is comparable to the introduction by AT&T a decade or so later of a universal telephone network and is similar to the recent design by computer manufacturers of large interconnections for diverse systems. These physical linkages were accompanied by the organizational linkages of utilities and manufacturers who had nurtured the competing systems. The Thomson-Houston Company, with its ac system, merged in 1893 with the Edison General Electric Company with its dc system.[21] Consolidation of electric light and power systems occurred throughout the industrial world until the interwar period, when two large manufacturers in the United States (General Electric and Westinghouse) and two in Germany (Allgemeine Elektrizitäts-Gesellschaft and Siemens) dominated electrical manufacturing. Similarly, large regional utilities prevailed in electrical supply. At about the same time industry-wide standardization of technical hardware created, for instance, standard voltages, frequencies, and appliance characteristics. Similar mergers and standardization took place in the telephone and automobile-production systems during the early twentieth century.

## MOMENTUM

Technological systems, even after prolonged growth and consolidation, do not become autonomous; they acquire momentum. They have a mass of technical and organizational components; they possess direction, or goals; and they display a rate of growth suggesting velocity. A high level of momentum often causes observers to assume that a technological system has become autonomous.[22] Mature systems have a quality that is analogous, therefore, to inertia of motion. The large mass of a technological system arises especially from the organizations and people committed by various interests to the system. Manufacturing corporations, public and private utilities, industrial and government research laboratories, investment and banking houses, sections of technical and scientific societies, departments in educational institutions, and regulatory bodies add greatly to the momentum of modern electric light and power systems. Inventors, engineers, scientists, managers, owners, investors, financiers, civil servants, and politicians often have vested interests in the growth and durability of a system. Communities of practitioners, especially engineers maintaining a tradition of technological practice, sometimes avoid deskilling by furthering a system in which they have a stake (Constant 1987). Actor networks, as defined by Michel Callon, add to system momentum (Callon 1987). Concepts related to momentum include vested interests, fixed assets, and sunk costs.

The durability of artifacts and of knowledge in a system suggests the notion of trajectory,[23] a

physical metaphor similar to momentum. Modern capital-intensive systems possess a multitude of durable physical artifacts. Laying off workers in labor-intensive systems reduces momentum, but capital-intensive systems cannot lay off capital and interest payments on machinery and processes. Durable physical artifacts project into the future the socially constructed character-istics acquired in the past when they were designed. This is analogous to the persistence of acquired characteristics in a changing environment.[24]

The momentum of capital-intensive, unamortized artifacts partially explains the survival of direct current after the "battle of the systems," despite the victory of the competing alternating current. The survival of high-temperature, high-pressure, catalytic-hydrogenation artifacts at the German chemical firm of Badische Anilin- und Soda-Fabrik (BASF) from about 1910 to 1940 offers another example of momentum and trajectory (Hughes 1969). In the BASF case a core group of engineers and scientists knowledgeable about the hydrogenation process through the design of nitrogen-fixation equipment during World War I subsequently deployed their knowl-edge and the equipment in the production of methanol during the Weimar period and of syn-thetic gasoline during the National Socialist decade.

From 1910 to 1930 system builders contributed greatly to the momentum of electric light and power systems in the industrialized West. Combining complex experiences and competence, especially in engineering, finance, management, and politics, Hugo Stinnes, the Ruhr magnate, Emile and Walther Rathenau, the successive heads of Germany General Electric (AEG), and Oskar von Miller, who helped create the Bayernwerk, the Bavarian regional utility, built large German systems. Walter Rathenau, who was especially fascinated by the aesthetics of system building, said approvingly in 1909 that "three hundred men, all acquainted with each other [of whom he was one], control the economic destiny of the Continent" (Kessler 1969, p. 121). In 1907 his AEG system was "undoubtedly the largest European combination of industrial units under a centralized control and with a centralized organization." In Great Britain consulting engineer Charles Merz presided over the growth of the country's largest electric supply network, the Northeastern Electric Supply Company. In the United States Samuel Insull of Middle West Utilities Company, S. Z. Mitchell of Electric Bond and Share, a utility holding company associ-ated with General Electric, and Charles Stone and Edwin Webster of Stone & Webster ranked among the leading system designers.

Stone and Webster's became an exemplary system. Just graduated from the Massachusetts Institute of Technology in 1880, they founded a small consulting engineering company to advise purchasers of electric generators, motors, and other equipment. Knowing that the two young men were expert in power plant design and utility operation, J. P. Morgan, the investment banker, asked them to advise him about the disposition of a large number of nearly defunct util-ities in which he had financial interest. From the study of them, Stone and Webster identified prime and widespread reverse salients throughout the utility industry and became expert in rec-tifying them. Realizing that money spent prudently on utilities whose ills had been correctly diagnosed often brought dramatic improvement and profits, Stone and Webster in about 1910 were holistically offering to finance, construct, and manage utilities. As a result, a Stone and Webster system of financially, technically, and managerially interrelated utilities, some even physically interconnected by transmission lines, operated in various parts of the United States. In the 1920s Stone and Webster formed a holding company to establish closer financial and managerial ties within the system (Hughes 1983, pp. 386–391). Similar utility holding companies spread throughout the Western world. Some involved the coal-mining companies supplying fuel

for the power plants in the system; others included electrical manufacturers making equipment for the utilities. Others established linkages through long-term contractual relations, interlocking boards of directors, and stock purchases with manufacturing firms and transportation companies that were heavy consumers of electricity. In Germany local government sometimes shared the ownership of the utilities with private investors. Brought into the system, thereby, local government became both regulator and owner.

Appearances of autonomy have proved deceptive. During and immediately after World War I, for instance, the line of development and the characteristics of power systems in England changed appreciably. Before the war the British systems were abnormally small compared to those in the United States and industrial Germany. Utility operators elsewhere called the British system backward. In fact, the British style accorded nicely with prevailing British political values and the regulatory legislation that expressed them. Traditionally, the British placed a high value on the power of local government, especially in London, and electrical utilities were bound within the confines of the small political jurisdictions.[25] World War I in particular and the increasingly apparent loss of industrial preeminence in general brought into question the political and economic values long prevalent in Great Britain. During the war Parliament overrode local government sensibilities and forced interconnection of small electrical systems to achieve higher load factors and to husband scarce resources. With victory the wartime measures could have been abandoned, but influential persons questioned whether the efficiency achieved during the war was not a prerequisite for industrial recovery in peacetime. As a result, in 1926 technological change in electric power systems was given a higher priority than tradition in local government. Parliament enacted legislation that created the first national interconnection, or grid. The political forces that were brought to bear more than matched the internal dynamic of the system.

These instances, in which the momentum of systems was broken, remind historians and sociologists to use such concepts and patterns of envolving systems as heuristic aids and system managers to employ them cautiously as predictive models. Momentum, however, remains a more useful concept than autonomy. Momentum does not contradict the doctrine of social construction of technology, and it does not support the erroneous belief in technological determinism. The metaphor encompasses both structural factors and contingent events.

## CONCLUSION

This chapter has dealt with the patterns of growing or evolving systems. Countless other technological systems in history have arrived at a stage of stasis and then entered a period of decline.[26] In the nineteenth century, for instance, the canal and gas light systems moved into stasis and then decline. Historians and sociologists of technology should also search for patterns and concepts applicable to these aspects of the history of technological systems.

NOTES

The Wissenschaftszentrum (Berlin) and the Wissenschaftskolleg zu Berlin provided support for the preparation of this chapter, which is part of a long-term study of technological change.

1. The concept of technological system used in this essay is less elegant but more useful to the historian who copes with messy complexity than the system concepts used by engineers and many social scientists. Several works on systems, as defined by engineers, scientists, and social scientists, are Ropohl (1979), von Bertalanffy (1968), and Par-

sons (1968). For further references to the extensive literature on systems, the reader should refer to the Ropohl and the Bertalanffy bibliographies. Among historians, Bertrand Gille has used the systems approach explicitly and has applied it to the history of technology. See, for instance, his *Histoire des techniques* (1978).

2. In this chapter "technical" refers to the physical components (artifacts) in a technological system.

3. A coal mine is analogous to the wind in John Law's Portuguese network, for the winds are adapted by sails for use in the system. See Law 1987.

4. Most of the examples of systems in this essay are taken from my *Networks of Power* (1983). For the relation between investment organizations and electrical manufacturers, for instance, see pp. 180–181 and 387–403 of that book.

5. I am grateful to Charles Perrow of Yale University for cautioning me against acceptance of the contingency theory of organization, which holds that an organization simply reflects the pattern of hardware, or artifacts, in a system. Perrow has contributed to the clarification of other points in this essay.

6. In contrast to Alfred D. Chandler, Jr. (1966, pp. 15–19), who locates technological (technical) changes as part of a context, including population and income, within which an organization develops strategy and structure, I have treated technical changes as part of a technological system including organizations. Borrowing from architectural terminology, one can say not only that in a technological system organizational form follows technical function but also that technical function follows organizational form.

7. The manufacturer, Allgemeine Elektrizitäts-Gesellschaft and the utility Berliner Electrizitäts-Werke were linked by ownership and cooperated systematically in design and operation of apparatus (Hughes 1983, pp. 175–200).

8. For an extended set of case histories supporting the phase- and system-builder sequence suggested, see my *Networks of Power* (1983).

9. Existing telephone and telegraph companies played a minor role in the early history of the wireless; existing compass makers did not take up the gyrocompass; and existing aircraft manufacturers provided little support for early turbojet inventive activities.

10. Anthony told Sperry that there was a need for an automatically regulated constant-current generator (Hughes 1971, p. 16).

11. See, for instance, Arieti (1976).

12. Arthur Koestler provides imaginative insights in *The Act of Creation* (1964). Arieti (1976) is also stimulating.

13. See, for example, Hoddeson (1981), Wise (1980), and Hughes (1976b). For an analysis of positions taken in the journal *Technology and Culture*, see Staudenmaier (1985, pp. 83–120).

14. An issue of *Technikgeschichte* (1983, vol. 50, no. 3) with articles by Ulrich Troitzsch, Wolfhard Weber, Rainer Fremdling, Lars U. Scholl, Ulrich Wengenroth, Wolfgang Mock, and Han-Joachim Braun, who has written often on transfer, is given over to *Technologietransfer im 19. und 20. Jahrhundert*.

15. Compare the concept of technological frame proposed by Wiebe E. Bijker, "The Social Construction of Bakelite: Toward a Theory of Invention," pp. 159–187 (in: *The Social Construction of Technological Systems*).

16. For a further discussion of load—and diversity—factors, see Hughes (1983, pp. 216–222). Alfred Chandler labels a similar but less graphic concept applied to manufacturing and chemical industries as "throughput" (1977, p. 241).

17. Jewkes et al. (1969) persuasively argue the case for the independents in the past and present.

18. For more on invention (conservative) and the expanding telephone system, see Hoddeson (1981).

19. See Law on heterogeneous entities and engineers.

20. I am indebted to Robert Belfield for the concept of universal system, which he encountered in the Charles F. Scott papers at Syracuse University.

21. On the "battle of the systems," see Hughes (1983, pp. 106–135). See also Bijker (in *The Social Construction of Technological Systems*).

22. Langdon Winner (1977) has analyzed the question of whether or not technology is autonomous. For a sensible discussion of the questions of autonomy and technological determinism, see the introduction to MacKenzie and Wajcman (1985, pp. 4–15).

23. For a discussion of trajectory, see Van den Belt and Rip.

24. Edward Constant has explored and explained communities of practitioners.

25. For an extended account of the electric utility situation in Great Britain before and after World War I, see Hughes (1983, pp. 227–261, 319–323, 350–362).

26. I am indebted to Richard Hirsh of Virginia Polytechnic Institute and State University for calling my attention to stasis in the post–World War II electrical utilities. Hirsh explores the concept in his unpublished manuscript, "Myths, Managers, and Megawatts: Technological Stasis and Transformation in the Electric Power Industry."

## REFERENCES

Arieti, S. 1976. *Creativity: The Magic Synthesis*. New York: Basic Books.

Bailes, K. 1976. "Technology and legitimacy: Soviet aviation and Stalinism in the 1930's." *Technology and Culture* 17: 55–81.

Beniger, J. R. 1984. *The Control Revolution*. Cambridge, Mass.: Belknap Press.

von Bertalanffy, L. 1968. *General Systems Theory: Foundations, Development, Applications.* New York: Braziller.

Bijker, W. E. 1987. "The Social Construction of Bakelite: Toward a Theory of Invention" pp. 159–187. (in: *The Social Construction of Technological Systems,* W. E. Bijker, T. P. Hughes, T. Pinch, eds., Cambridge, Mass." M.I.T. Press).

Callon, M., 1987. "Society in the making: The study of technology as a tool for sociological analysis" pp. 83–103 (in: *The Social Construction of Technological Systems*).

Carlson, W. B. 1983. "Elihu Thomson: Man of many facets." *IEEE Spectrum,* October, 72–75.

Chandler, A. D., Jr. 1966. *Strategy and Structure.* Garden City, N.Y.: Doubleday.

Chandler, A. D., Jr. 1977. *The Visible Hand: The Managerial Revolution in American Business.* Cambridge, Mass.: Belknap Press.

Constant, E. W., II. 1980. *The Origins of the Turbojet Revolution.* Baltimore: Johns Hopkins University Press.

Constant, E. W., II, 1987. "The social locus of technological practice: Community, system, or organization?" pp. 223–242 (in *The Social Construction of Technological Systems*).

Diesel, E. 1953. *Diesel: Der Mensch, Das Werk, Das Schicksal.* Stuttgart: Reclam.

Enos, J. L. 1962. *Petroleum Progress and Profits.* Cambridge, Mass.: MIT Press.

Halacsy, A. A., and von Fuchs, G. H. 1961. "Transformer invented seventy-five years ago." *Transactions of the American Institute of Electrical Engineers: Power Apparatus and Systems* 80: 121–125.

Heidegger, M. 1977. *The Question Concerning Technology and Other Essays,* W. Lovitt, trans. New York: Harper & Row.

Hellige, H. D. 1984. "Die gesellschaftlichen und historischen Grundlagen der Technikgestaltung als Gegenstand der Ingenieurausbildung." *Technikgeschichte* 51 (4): 281–283.

Hoddeson, L. 1981. "The emergence of basic research in the Bell Telephone Lab." *Technology and Culture* 22: 512–524.

Hounshell, D. A. 1975. "Elisha Gray and the telephone: On the disadvantages of being an expert." *Technology and Culture* 16: 133–161.

Hounshell, D. A. 1984. *From the American System to Mass Production, 1800–1932.* Baltimore: Johns Hopkins University Press.

Hughes, T. P. 1969. "Technological momentum in history: Hydrogenation in Germany 1898–1933." *Past & Present,* August, 44: 106–132.

Hughes, T. P. 1971. *Elmer Sperry.* Baltimore: Johns Hopkins University Press.

Hughes, T. P. 1976b. "The science-technology interaction: The case of high-voltage power transmission systems." *Technology and Culture* 1–7: 646–659.

Hughes, T. P. 1983. *Networks of Power: Electrification in Western Society, 1880–1930.* Baltimore: Johns Hopkins University Press.

Hunter, L. C. 1949. *Steamboats on the Western Rivers: An Economic and Technological History.* Cambridge, Mass.: Harvard University Press.

Jenkins, R. V. 1975. "Technology and the market: George Eastman and the origins of mass amateur photography." *Technology and Culture* 16: 1–19.

Jewkes, J.; Sawers, D.; and Stillerman, R. 1969. *The Sources of Invention.* London: Macmillan.

Jones, P. 1940. *History of the Consolidated Edison System, 1878–1900.* New York: Consolidated Edison Co.

Kaldor, M. 1981. *The Baroque Arsenal.* New York: Hill and Wang.

Kessler, H. 1969. *Walther Rathenau: His Life and Work.* New York: Howard Fertig.

Koestler, A. 1964. *The Act of Creation.* New York: Macmillan.

Kranakis, E. F. 1982. "The French connection: Giffard's injector and the nature of heat." *Technology and Culture,* January, 23: 3–38.

Kubler, G. 1962. *The Shape of Time: Remarks upon the History of Things.* New Haven: Yale University Press.

Law, J., "Technology and heterogeneous engineering: The case of Portuguese expansion," Wiebe E. Bijker, Thomas P. Hughes, Trevor Pinch (eds.), *The Social Construction of Technological Systems* (Cambridge: Mass.: MIT Press, 1987), pp. 111–134.

Layton, E. 1978. "Millwrights and engineers," in *Dynamics of Science and Technology,* W. Krohn, E. Layton, and P. Weingart, eds. Dordrecht: Reidel, 61–87.

Lindqvist, S. 1984. *Technology on Trial: The Introduction of Steam Power Technology into Sweden, 1715–1735.* Uppsala: Almqvist & Wiksell International.

MacKenzie, D., and Wajcman, J., eds. 1985. *The Social Shaping of Technology.* Milton Keynes: Open University Press.

Merz, C. H. 1908. "Power supply and its effects on the industries of the north-east coast." *Journal of Iron and Steel Institute,* September, 4.

Noble, D. F. 1977. *America by Design: Science, Technology and the Rise of Corporate Capitalism.* New York: Knopf.

Noble, D. F. 1979. "Social choice in machine design: The case of automatically controlled machine tools," in *Case Studies on the Labour Process,* A. Zimbalist, ed. New York: Monthly Review Press, 18–50.

Parsons, T. 1968. "Social systems." *Encyclopedia of the Social Sciences* 15: 458–472.

Passer, H. C. 1953. *The Electrical Manufacturers, 1875–1900.* Cambridge, Mass.: Harvard University Press.

Ropohl, G. 1979. *Eine Systemtheorie der Technik: Zur Grundlegung der Allgemeinen Technologie.* München und Vienna: Hanser.

Sperry, E. 1930. "Spirit of invention in an industrial civilization," in *Toward Civilization,* Charles A. Beard, ed. New York: Longmans Green, 47–68.

Staudenmaier, J. M., SJ. 1985. *Technology's Storytellers: Reweaving the Human Fabric.* Cambridge, Mass.: MIT Press.

Uhlmann, L. 1978. *Der Innovationsprozess in westeurpäischen Industrieländern. Band 2: Ablauf industriellen Innovation-sprozesses.* Berlin and München: Duncker and Humblot.

van den Belt, H. and Rip, Arie, 1987. "The Nelson-Winter-Dosi model and synthetic dye chemistry," pp. 135–158 (in: *The Social Construction of Technological Systems*).

Winner, L. 1977. *Autonomous Technology: Technics Out of Control as a Theme in Political Thought.* Cambridge, Mass.: MIT Press.

Wise, G. 1980. "A new role for professional scientists in industry." *Technology and Culture* 21: 408–429.

# 15

# In the Beginning
# Was the Word?

## The Genetic Code and the Book of Life

### LILY E. KAY

*This [the human chromosome] is the book of human life.*
*In this book are instructions, in a curious and wonderful code,*
*for making a human being.*

—ROBERT SINSHEIMER[1]

*A thing is called a book because it has received writing. But a thing is*
*said to be receptive in so far as it contains material potency, which*
*cannot exist in God. Therefore, nothing uncreated is called the book of*
*life. Since book means a kind of collection, it signifies distinction and*
*difference. . . . In every book the writing is something other than the*
*book.*

—ST. THOMAS AQUINAS[2]

*The idea of the book, which always refers to a natural totality,*
*is profoundly alien to the sense of writing. It is the encyclopedic*
*protection of theology and of logocentrism against the disruption*
*of writing, against its aphoristic energy, and . . . against*
*difference in general.*

—JACQUES DERRIDA[3]

The human genome is now generally viewed as an information system, as a book of life written in DNA language, or DNA code, to be read and edited. A 1989 *Nova* PBS television program, "Decoding the Book of Life," promotes the human genome project as a scriptural mission. Sliding one of the volumes of the "Book of Life" from the shelf, a personable white-coated molecular biologist explains how to identify genetic misprints in the sequences of

the DNA text.[4] Harvard molecular biologist and Nobel laureate Walter Gilbert—probably first to argue for copywriting genetic sequences—predicts putting three billion bases on a single CD.

One will be able to pull a CD out of one's pocket and say, "Here is a human being; it's me!" . . . To recognize that we are determined . . . by a finite collection of information that is knowable will change our view of ourselves. It is a closing of an intellectual frontier, with which we will have to come to terms.[5]

These are visions of the "informational man," an image not just in the service of public understanding of science. Addressing a large professional gathering, biotechnology champion, David Jackson argued:

To be fluent in a language, one needs to be able to *read*, to *write*, to *copy*, and to *edit* in that language. The functional equivalents of each of those aspects of fluency have now been embodied in technologies to deal with the language of DNA.[6]

Beyond exegesis the Book of Life awaits revision. That the "language of DNA" is not merely a popularization or rhetoric of persuasion but a representation that also has operational force is evidenced by the emergence in the 1980s of the subspecialty of DNA linguistics. Admittedly not mainstream molecular biology, it illustrates the point: a metaphor literalized.

First championed within linguistic structuralism in the 1960s by the acclaimed linguist Roman Jakobson, DNA linguistics was soon recast within the rigors of the Chomskian paradigm. Theoretical biologists have turned to generative grammar as a framework for understanding genomic organization and expression regulation in prokaryotic and eukaryotic systems in search of biological meaning. This quest has become even more urgent as the sequences cascade from human genome projects and their status—coding, regulatory, normal, abnormal, or so-called junk DNA (95–97 percent of the genome)—needs to be established. These examples spotlight the growing presence of bioinformatics, the pervasive notion of DNA language, and the often naive faith in the unambiguous reading and word processing of the genomic text, as Robert Pollack observes, in spell checking, deleting, adding, and splicing the DNA sequences.[7]

These informational and scriptural representations of heredity are neither new nor unproblematic. The metaphor of the Book of Life and its subsequent variant, the "Book of Nature," reaches back to antiquity; its aporias have been examined by ancient and modern scholars.[8] But this metaphor of transcendent writing acquired new, seemingly scientifically legitimate meanings, through the discourse of information. And as in other contemporary fields of life and social science and in the culture at large—where entities and processes were similarly being recast as information systems—the difficulties (some would say inappropriateness) of these borrowings in molecular biology were criticized by information theorists, cryptologists, linguists, and life scientists even back then. The genome's information content cannot be assessed, for key parameters (e.g., signal, noise, message, channel) cannot be properly quantified (in bits); DNA is not a natural language: it lacks phonemic features, semantics, punctuation marks, and intersymbol restrictions (so unlike any language, "letter" frequency analyses of amino acids yield random statistical distributions); no natural language consists solely of three-letter words (and if it were a formal language it would possess syntax only, but no semantics). The informational representations of the genome do not stand under rigorous scrutiny. From linguistic and cryptanalytic standpoints, the genetic code is not a code, it is just a table of correlations, though not nearly as systematic or predictive as the periodic table, due to contingencies, degeneracies, and

ambiguities in the very structure of the so-called genetic code. But these culturally animated imaginaries have persisted, so it now seems inconceivable that genes did not always transfer information, or that the relation between DNA and protein could be something other than a code. Yet, there were (and probably could be) other ways of knowing. These particular representations were historically specific and culturally contingent; the genetic code is a "period piece," a manifestation of the emergence of the Information Age.

And this is the thesis of my study, *Who Wrote the Book of Life? A History of the Genetic Code:* that molecular biologists used "information" as a metaphor (for biological specificity); in fact, it is a metaphor of a metaphor, thus a signifier without a referent and, as such, it became a rich repository for the scientific imaginaries of the genetic code as an information system and a book of life. The information discourse and the scriptural representations of life were inextricably linked. Metaphors, as we will see, are ubiquitous in science, but not all metaphors are created equal. Some, like the information and code metaphors, are exceptionally potent due to the richness of their symbolisms, their synchronic and diachronic linkages, and their scientific and cultural valences. Though remarkably compelling and productive as analogies, "information," "language," "code," "message," and "text" have been taken as ontologies. And the consequences are far-reaching, for the limits of these analogies also challenge the mastery of the genomic Book of Life, the technological and commercial goals of its "reading" and "editing."[9]

The conceptualization, breaking, and completion of the genetic code, 1953–1967, was one of the most important and dramatic episodes in twentieth-century science, a manifestation of the stupendous reaches of molecular biology. The so-called code—actually a table of correlations—outlined the logic of gene-based protein synthesis, providing the key to what was widely perceived to be the "secret of life." It showed how the four bases of RNA—A, U, C, G—permuted three at a time, yielded sixty-four triplet codons, specifying the assembly of twenty amino acids into myriads of exquisitely specific proteins. Based primarily on studies of bacteria and viruses, this synoptic scheme has nevertheless been regarded as an (almost) universal code, applying to nearly all plant and animal life. From transcription to translation (themselves scriptural operational representations), it tied mechanisms of genetic replication, mutation, and regulation to nucleic acid and protein synthesis, thus bridging molecular genetics and biochemistry; genetic "information"—or what was previously perceived, loosely, as biological and chemical specificity—served as a discursive link between these two, previously distant, fields. Beyond the academy, as captured in the pages of the *New York Times* and *Time* magazine, the genetic code also signaled the potential for genetic engineering, even before the advent of the recombinant-DNA technologies of the 1970s. Genetic information signified an emergent form of biopower: The material control of life would be now supplemented by the promise of controlling its form and logos, its information (the DNA sequence, or the "word").

To understand and assess critically the formation of the genetic Book of Life and its so-called informational and linguistic attributes we will trace their lineages to the 1950s and 1960s, to the formalistic and biochemical phases (respectively) of research on the genetic code.[10] In that postwar world order the material, discursive, and social practices of molecular biology were transformed. Information theory, cybernetics, systems analyses, electronic computers, and simulation technologies fundamentally altered the representations of animate and inanimate phenomena. These new communication sciences began to reorient molecular biology (as they did, to various degrees, in other life and social sciences) even before it underwent a paradigm shift (1953) from

protein-based to DNA-based explanations of heredity. It is within this information discourse that the genetic code was constituted as an object of study and a scriptural technology and the genome textualized as a latter-day Book of Life. The disciplinary and representational space of molecular biology changed, as well, partly through the growing participation of physical scientists. And its institutional structures, worldwide, were reconfigured within cold war organizations, military patronage, and the unprecedented commitment of government resources for scientific research.[11] In short, from the 1950s on, the diachronic resonances of the Book of Life as transcendent writing were amplified by the synchronic articulations of DNA as a programmed text, information became the animator of the primum mobile; the genetic code, the site of life's command and control.

Representations of the genomic Book of Life in the 1960s were inextricably linked to the symbolism of "The Book" as natural, eternal, and universal writing. This metaphor has pervaded Judeo-Christian history, and scholars through the ages have pondered its paradoxical features, but with its perceived linkages to information theory that metaphor has been strained to the point of its deconstruction. When Thomas Aquinas first posed numerous questions and difficulties inherent in the concept of the Book of Life, he was responding not only to its various meanings in the Old and New Testaments but also to interpretations by previous commentators on the subject (notably St. Augustine); Plato's imagery of the human and world-soul as eternal writing animated that metaphoric tradition. Although the Book of Life and the Book of Nature are not quite the same—the first represents the eternity and logos of human souls, the second the eternity and logos of all animate and inanimate things—in both, "book" has always served as a metaphor for the material record of creation. "The invisible things of Him, from the creation of the world, are clearly seen, being understood by things that are made," decreed St. Paul's Epistle to the Romans (Romans, 1:20). And within this tradition, the Book of Nature has functioned as scriptural exegesis, especially after the thirteenth century, with the demarcation of the boundary between knowledge through the light of grace (theology) and that attained through the light of nature (natural philosophy).[12]

But the aporia inherent in this simultaneously material and textual record of creation, as articulated in St. John's Gospel (1:1–14), had challenged believers even back then: "In the beginning was the Word and the Word was with God. . . . In Him was life; and the life was the light of man. . . . and the Word was made flesh and dwelt among us." How can a word, a signifier, precede what is signified, the thought or act? How can language represent the yet unthought? And if God is nonmaterial how can His Word carry material potency and be "made flesh"? As Aquinas pointed out: "Nothing uncreated is called the book of life." Thus both the "Book of Life" and "Book of Nature" pose the same age-old conundrum: What is this nonmaterial writing? Is it creation or revelation? In the beginning was the Wor(l)d? (And in the postwar era the "word" would present additional conundra: If not God, what is the agency of this writing in the secular context of molecular biology? What meaning can this writing convey within the stochastic and syntactical logic of cybernetics and information theory? And how is language possible without human consciousness?)

Thus, from ancient times to recent years nature has always been textualized;[13] its aporias have challenged even religious practitioners of science. And apart from the theological conundra, the synchronic meanings of writing and the Book of Nature also changed with time; they

were reconfigured within the regimes of signification of changing *epistemes* and cultural experiences: ancient, medieval, Renaissance, Scientific Revolution, Enlightenment, romanticism, and twentieth-century modernism. Thus in the punctuated history of the Book of Nature the metaphor has had a remarkable endurance but was always (re)historicized within complex and overlapping layers of old and new meanings.[14]

Pondering the problem of nature's logos and the diversity of life, Lucretius (50 B.C., *De Rerum Natura*) postulated:

The matter and first bodies of each thing
Must be inside the seed; because of this
All things cannot arise from anything.
For each particular seed has, in itself,
Hidden inside, its own distinctive powers.

And given the manifestation of this diversity, he concluded:

Isn't it reasonable to conclude
That many things have tiny elements
In common, just as different words may have
Letters the same?[15]

As Brian Stock has shown, the Book of Nature had a specific meaning in the High Middle Ages. Nature was constituted as a book through interconnections between words, thoughts, and things. The medieval structures of knowledge: logic, grammar, rhetoric, and theology were mobilized to unravel the "secrets of nature." For William of Conches, nature consisted of many books corresponding to the number of controlled interpretations. For Alan of Lille unnatural deviance was a grammatical error. Hugh of St. Victor saw knowledge of nature as inextricable from logic. Ideally signification through things was preferable, but the philosopher, limited to *scientia* knew only the meanings of words. Words, texts, reason, and nature formed the seamless fabric of medieval natural knowledge.[16]

By 1500 the age of scribal culture had ended and the age of print culture had begun, ushering a major transformation. According to Elizabeth Eisenstein, it reconfigured boundaries of knowledge, beaux arts and belles lettres, church, nobility, and learned elites. The physical and social status of "book" had changed. The Book of Nature became a mechanically printed text. In that history of nature and/as text, a decisive moment came in the seventeenth century with the birth of modern science. With the rise of autonomous experimental tradition, representations of nature became intertwined with interventions, or to use Derrida's terms: (reading) the book of nature/life became inseparable from its writing.[17] In a vision reminiscent of the discourse on the genetic code and human genome projects, the Book of Nature in the seventeenth century awaited "decoding" by the experimental investigator equipped with an "ideal language." Bacon tells us that we read God's natural truths with the "alphabet of Nature." Both Descartes and Galileo spoke of the writing and reading of the great Book of Nature; Leibniz searched for the ideal language, "characteristica universalis," which would correspond exactly to nature's written language; Bonnet presumed that "our earth is a book the God has given to intelligences far superior to ours to read."[18]

Giving voice to the German Enlightenment, Immanuel Kant seemed to regard a purely mechanistic command of language as a necessary but not sufficient condition for the acquisition of knowledge:

Nature is a book, an epistle, a fable (in a philosophical sense) or however you want to call her. Suppose we know all its letters as well as possible, we can break all its words into syllables and pronounce them, even know the language in which it is written—is all this already enough to understand a book, moreover, to judge its character from it, or to extract its essence.[19]

And straddling the passage from the Enlightenment to romanticism, Goethe spoke of nature in terms of secret writing. "How readable the Book of Nature will be to me I cannot express to you, my high spelling has helped me," he wrote. Perhaps it is his preoccupation with the ambiguities of nature's writing that inspired Goethe to interrogate them through the figure of Faust, who, in his quest for epistemic mastery and worldly power interprets, "In the beginning was the Word," as "In the beginning was the Act," thus submitting the "word" as signifier to the primacy of the (transcendental) signified. Images of nature as linguistic communication, as hieroglyphs and ciphers, were ubiquitous in the eighteenth century, guiding the studies of practitioners of *Naturphilosophie,* who cultivated poetic and aesthetic impulses as means of reading and narrating nature's hidden poetry (here Novalis stands out). Images of nature's ciphers persisted into the nineteenth century, when modern notions of organic memory (engram or Mneme principle) became linked to biological and molecular knowledge (notably to the combinatorial nature of proteins); telegraphy supplied additional imagery for physiological phenomena such as linguistic communication. Such concepts and imprinting imagery also informed Schrödinger's visions of a hereditary code-script into the 1940s.[20]

But in the 1950s, with the spread of information theory, electronic computers, communication and simulation technologies, the very notion of message, text, and language were transformed, once again, as was the textualization of nature. It now seemed technically legitimate to speak of molecules and organisms as texts, namely as information storage and transfer systems. Heredity became a programmed communication system governed by a code which transferred "linguistic information" through the cell and cycles of life. But aside from the paradoxes associated with a stochastic concept of information devoid of semantics there was also the problem of linguistic signification devoid of agency. Geneticist Philippe L'Héritier pointed out (1967) that, "[B]eing a symbolic language, human language presupposes an interlocutor and a comprehending brain but in genetic language we have nothing but information transfer between molecules (an objection later echoed by others). Claude Lévi-Strauss put his finger on this fundamental philosophical conundrum: "Can there be a prediscursive knowledge of language existing prior to its construction by humans? Could there be something, as biologists claim, which resembles the structure of language but which involves neither consciousness nor subject?" Jean Baudrillard has gone so far as to assert that the genetic code, as an icon of command and control, simulations, electronic programs and texts, can exist only through this crisis of (linguistic) representation:

End of the theater of representation, the space of signs, their conflict, their silence; only the black box of the code, the molecular emitter of signals from which we have been irradiated, crossed by answer/questions like signifying radiations, tested continuously by our own program inscribed in the cells.[21]

Indeed, it was the information catachresis—the double metaphorical construction of information—which seemed to validate the representations of the genetic code as natural, eternal, and universal writing. And it is the space created by these overlaps, slippages, ambiguities, paradoxes, and loss of referentialities that served as a repository for the scientific imaginary of the genomic Book of Life.

Moreover, both the age-old and twentieth-century visions of nature's writings are further problematized if one also interrogates the objectivist perspective on knowledge. That (Platonic, or logocentric) standpoint takes it as a given that genomic writing existed before humans' entry into the world, awaiting decoding (divinely inspired or otherwise). The material and theoretical tools of molecular biology—quantification and experimentation—have enabled, in principle, its unambiguous reading. Guided mostly by mechanistic ideals of language as transparent signification, by faith in the exact correspondence of words and things, of signifier and signified, this objectivist view endowed the initiated with access to positive knowledge of the Book of Life. Yet such absolute concepts of language (like the absolutes of mass, space, and time in the mechanical world picture) had been challenged already in the beginning of the twentieth century by admitting the contextualities within the knowledge system into analyses of meaning, by accepting the contingencies of structuralism. Rather than precise correspondence between signifier and signified and absolute reference, the sign derived its meaning only through differences with other signs, from the context of the whole linguistic system, meanings and words then become polysemic. Thus the very concept of language has been radically altered since the idea of the Book of Life first came into being as universal and absolute writings, and the polysemic aspect of its so-called writing undermines the possibility of its absolute reading.[22] As with molecular biology, structuralist linguistics came briefly under the spell of the Shannon-Wiener theory of communication in the 1950s, before being replaced by Chomskian linguistics. As such it too re-represented its objects of study within the information discourse, soon getting tangled in the hall of mirrors of the language of language, where language is both object and subject.

And beyond difference and structuralism, how does one define "the system" itself—such as a genome—its origins and boundaries? As Derrida (and more generally poststructuralism) has done in problematizing the notion of a linguistic "system," several life scientists have been doing for biological systems in their theory of autopoiesis ("self-production"). For what characterizes all living things is that they are continually self-producing according to their own internal rules and requirements, thus blurring a clear distinction between the "inside" and "outside", between "closed" and "open." Information, according to these revisions, is not a prespecified quantity which exists independently in the world acting as input in the genomic system; rather the "meaning" of that "information" is continuously adjusted, not only by the contextualities *within* the system but also by the interaction between the inside and *outside* of the system. The distance between the genotype and phenotype is therefore considerably increased; and it is a dynamic dialectic of preformation and epigenesis.[23]

Finally, the logocentric view of genomic writing has not probed the construction process of the tools of science, their physical and discursive fashioning; it has not questioned the cognitive assumptions and technological imperatives behind nature's writing. These issues may be illuminated by critiques of technology (e.g., Heidegger), critiques of meaning (e.g., Derrida), which are grounded in the dialectic between *episteme* and *techne,* and between intervention and representation (after Ian Hacking) in the workings of modern science in general and molecular biology in particular. This dialectic challenges the objectivist view that one can have access to an unmediated nature—visible or submicroscopic—or to natural phenomena that are prediscursive and independent of the tools of representation. Even without an immersion in pre-Socratic debates of being and becoming, about essences and ontologies, one can hardly escape the ancient problem of being and knowing. Can being be separated from its manifestation, can an entity or phenomenon be known independently of the means—discursive and material—that form its

representation? When *episteme* and *techne* are seen as intertwined (thus rejecting the Greek logocentric legacy), the time-honored dichotomy between theory and practice, discovery and invention, observer and phenomenon, are blurred. Technology and theory generate each other; epistemic things become technical things and vice versa, as Hans-Jörg Rheinberger has shown.[24]

Writing, from this vantage point, is then on the side of *techne*. It is the process of signification—ordering, naming, isolating, measuring, describing—by which knowledge of entities and phenomena become manifest; writing could be seen as a technology of representation, be it the surface of the earth, cells, or DNA. And from this Derridean vantage point it is the writing itself (qua production of representation) that writes. It comes to possess a kind of agency. For once committed to describing and manipulating biological entities through the information discourse and its scriptural technologies, the scientists had become part of the representational space within which techno-epistemic events of molecular biology take place; the actors' freedom of movement, from experimental design to data interpretation and presentation, is always already mediated through that discursive/material space.[25]

And finally there is the additional conundrum of the authorship of the Book of Life in a godless scientific universe. Perhaps, because of its subject matter of life and reproduction, molecular biology since the 1950s has been suffused with theistic images and religious icons; its practitioners transacting a kind of divine biopower. References to Delbrück's priesthood of the phage church; Caltech and Cold Spring Harbor as molecular biology's Mecca and Medina; disciples' pilgrimages to centers of enlightenment; Monod's college of cardinals issuing an encyclical to abolish the terminology of enzyme "adaptation"; Crick's Central Dogma of biology that information flowed only unidirectionally from DNA to RNA to protein; and classic molecular biology texts analogized to the old and new testaments, are but few (of many, seriously humorous) perceptions of such transcendent authority.[26] There is little doubt that this biopower entailed mastery of the genomic Book of Life, first through secular exegesis and subsequently through secular (re)creation.

Edward Trifonov and Volker Brendel, authors of the book, *Gnomic: A Dictionary of Genetic Codes* (1986) and pioneers of Chomskian DNA linguistics (which they christened "gnomic"), might have unwittingly grasped the powers and limits of genomic writings, with all their theistic, epistemic, and deconstructive force. Situating their linguistic project in the genealogy of primal knowledge, they envisioned molecular biologists as struggling with the age-old difficulties of what they called *"lingua prima* of life."

The nature of the beginning and the foundations of life are central issues in man's spiritual and scientific quest. Goethe had his Faust struggle with this in trying to interpret the first verse of St. John's gospel: "In the beginning was the Word . . ." Was it really to mean "Word" in this context or had it to be translated as "Thought" or "Deed?" Whatever the answer, the literal domain of words—language—is surely associated at least with the beginning of man and with the understanding of man.[27]

Language not as a preexisting entity, but as an outcome of human consciousness. Thus, if the genome stands for the origins of human life, then the Word—the DNA sequence—has brought molecular biologists as close to the act of creation as could be experienced, invoking supernatural and Faustian powers. This scriptural and material mastery was articulated by James Watson in a mandate for the Human Genome Project.

For the genetic dice will continue to inflict cruel fates on all too many individuals and their families who do not deserve this damnation. Decency demands that someone must rescue them from genetic hells. If we don't play God, who will?[28]

NOTES

1. Robert Sinsheimer, *The Book of Life* (Reading, Mass.: Addison-Wesley Publishing, 1967).

2. St. Thomas Aquinas, *Truth,* trans. Robert W. Mulligan, S.J. (Chicago: Henry Regency Company, 1952), vol. I (questions I–IX), p. 287–288.

3. Jacques Derrida, *Of Grammatology,* trans. Gayatri Chakravorty Spivak (Baltimore: Johns Hopkins University Press, 1976), p. 181.

4. "Decoding the Book of Life," PBS, *Nova,* 1989.

5. Walter Gilbert, "A Vision of the Grail," in *The Code of Codes: Scientific and Social Issues in the Human Genome Project,* ed. Daniel J. Kevles and Leroy Hood (Cambridge, Mass.: Harvard University Press, 1990), p. 96.

6. David Jackson, "Template for an Economic Revolution," in *DNA, The Double Helix: Perspective and Prospective at Forty Years,* ed. Donald Chambers (New York: New York Academy of Science, 1995), p. 358.

7. Robert Pollack, *Signs of Life: The Language and Meaning of DNA* (Boston: Houghton Mifflin, 1994).

8. Notably, Aquinas, *Truth*; Derrida, *Of Grammatology.* The most complete study of the "Book of Nature" is by Hans Blumenberg, *Die Lesbarkeit der Welt* (Frankfurt am Mein: Suhrkamp Verlag, 1981), but he accepts rather than interrogates the concept of nature's writing.

9. Lily E. Kay, *Who Wrote the Book of Life? A History of the Genetic Code* (Stanford: Stanford University Press, forthcoming, 1999); see also, idem., "Who Wrote the Book of Life? Information and the Transformation of Molecular Biology, 1945–1955," *Science in Context,* 8 (1995): 609–34; idem., "Cybernetics, Information, Life: The Emergence of Scriptural Representations of Heredity," *Configurations* 5 (1997): 23–91. Donna J. Haraway, "Signs of Dominance: From a Physiology to a Cybernetics of Primate Society, C.R. Carpenter, 1930–1970," *Studies in History of Biology* 6 (1983): 129–219 first called attention to the impact of information theory and cybernetics on the life sciences and the military context of these developments.

10. It is well known that Erwin Schrödinger, in his acclaimed book, *What Is Life?* (Cambridge: Cambridge University Press, 1944), spoke of a notion of a code. And there is a long-standing historiographic debate about Schrödinger's role in the history of molecular biology (see Kay, *Who Wrote the Book of Life?* chapter 2, part 3). There is no doubt that Schrödinger was the first to use the term *code-script* in relation to heredity and this played a role in the history of the genetic code, which Richard M. Doyle has eloquently analyzed in "On Beyond Living: Rhetorics of Vitality and Post-Vitality in Molecular Biology" (Doctoral dissertation, University of California, Berkeley, 1993), chap. 2. But, with others, I argue that the myths of Schrödinger's code were constructed mainly in the 1960s.

11. The impact of the cold war on science has been studied by several scholars, see Kay, *Who Wrote the Book of Life?* ch. 1. The impact on the life science is now receiving attention. John Beatty, "Opportunities for Genetics in the Atomic Age" (paper presented at the Fourth Mellon Workshop, "Institutional and Disciplinary Contexts of the Life Sciences," MIT, April, 1994); idem., "Origins of the U.S. Human Genome Project: The Changing Relationship of Genetics to National Security," in *Controlling Our Destinies: Historical, Philosophical, Social, and Ethical Perspectives on the Human Genome Project,* ed. Phillip Sloan (Notre Dame: University of Notre Dame Press, 1998). Jean-Paul Gaudillière in, "Biologie Moleculaire et Biologistes dans les Années Soixante: La Naissance d'une Discipline. Le cas Francais" (Doctoral dissertation, University of Paris, 1991), has examined in detail the political dynamics of French molecular biology (though not directly in relation to the cold war); and Soraya de Chadarevian is currently completing the book, *The Making of A New Science: Molecular Biology in Britain, 1945–1975* (Cambridge: Cambridge University Press, forthcoming), where she examines explicitly the relation of molecular biology to postwar policies.

12. Aquinas, *Truth.* On the logos of the world-soul, see, Plato, *Timaeus,* trans. Francis M. Cornford (New York: Macmillan Publishing Co., 1959). On the separation of theology and philosophy in the medieval university, see Joseph Ben-David, *The Scientist's Role in Society: A Comparative Study* (Chicago: University of Chicago Press, 1971), ch. 4.

13. Blumenberg, *Die Lesbarkeit der Welt.*

14. Mark Poster, *The Mode of Information: Poststructuralism and Social Context* (Chicago: University of Chicago Press, 1990). See also, Henri-Jean Martin, *The History and Power of Writing,* trans. Lydia G. Cochrane (Chicago: University of Chicago Press, 1994). For a nuanced view of epochal changes of books, see Julian Martin, "Why Manuscripts Matter: Reception and Mutable Mobiles in 17th-Century England" (paper presented at Harvard University, 3 February 1998).

15. Lucretius, *De Rerum Natura* (Baltimore: Johns Hopkins University Press, 1993), verses 170 and 195, pp. 29–30. I am grateful to Matthew Meselson for calling my attention to this source.

16. Brian Stock, *The Implications of Literacy: Written Language and Models of Interpretation in the Eleventh and Twelfth Century* (Princeton: Princeton University Press, 1983), esp. 315–25.

17. Elizabeth L. Eisenstein, "The Advent of Printing and the Problem of the Renaissance," *Past and Present* 45 (1969): 19–89; Derrida, *Of Grammatology,* p. 15. See also Lily E. Kay, "Who Wrote the Book of Life?" pp. 609–634.

18. On the scriptural representations of nature and the "Book of Nature" metaphor in the seventeenth century, see Arbib and Hesse, *The Construction of Reality,* chap. 8 (esp. 149); Francis Bacon, *Natural and Experimental History,* in ed. Richard Foster Jones, *Essays, Advancement of Learning, New Atlantis, and other Pieces* (New York: Odyssey Press, 1937); Bonnet's quote (undocumented) in Derrida, *Of Grammatology,* pp. 15–16. See also, James J. Bono, *The Word of God and the Languages of Man: Interpreting Nature in Early Modern Science and Medicine,* vol. I, (Madison: The University of Wisconsin Press, 1995); and Mario Biagioli, "Stress in the Book of Nature: Galileo's Realism and its Supplements," unpublished manuscript, 1996.

19. Immanuel Kant, *Briefwechsel* (Hamman, 1759), Akademie-Ausgabe X 28; quoted in Blumenberg, *Die Lesbarkeit Der Welt,* 190.

20. Goethe and Charlotte von Stein, June 15, 1786 (Werke XVIII 931); quoted in Blumenberg, p. 216. On Schrödinger's code-script, see, Kay, *Who Wrote the Book of Life?,* chap. 2.

21. Johann Wolfgang von Goethe, *Faust,* trans. Walter Kaufmann (New York: Doubleday, 1961), 1224–37. On romanticism and the Book of Nature, see Blumenberg, *Die Lesbarkeit Der Welt,* ch. 16; Keith Hartley, ed., "The Romantic Spirit in German Art 1790–1990," exhibit text (Scottish National Gallery of Modern Art, Edinburgh), summer 1994; and Joan Steigerwald, "The Cultural Enframing of Nature: Environmental Histories During the German Romantic Period," in *Human and Ecosystems before Global Development,* ed. E. Melville and R. Hoffmann, forthcoming. On the critiques of genomic "language," see MIT Jakobson Paper, MC 72 Box 18.48; transcript of "Un Débat Entre Francois Jacob, Roman Jakobson, Claude Lévi-Strauss et Philippe L'Heritier: Vivre et Parler," September 20, 1967, pp. 17–18, 31. See Kay, *Who Wrote the Book of Life?,* ch. 8. Jean Baudrillard, *Simulations* (New York: Semiotext(e), 1983), p. 104–05.

22. On the rise of structuralist linguistics, see Kay, *Who Wrote the Book of Life?,* ch. 8; see also, Pollack, *Signs of Life,* esp. introduction.

23. On the shift from structuralism to poststructuralism, see Jacques Derrida, *Writing and Difference* (Chicago: University of Chicago Press, 1978), esp. ch. 10. On autopoiesis and the redefinition of system, see Humberto R. Maturana and Francisco J. Varela, *The Tree of Knowledge: The Biological Roots of Human Understanding* (Boston: Shambhala Press, 1992); Francisco Varela, Evan Thompson, and Eleanor Rosch, *The Embodied Mind: Cognitive Science and Human Experience* (Cambridge, Mass.: MIT Press, 1993); Nikolas Luhmann, "The Cognitive Program of Constructivism and a Reality that Remains Unknown," in *Selforganization: Portrait of a Scientific Revolution,* Wolfgang Krohn, Gunther Kuppers, and Helga Nowotny (Dordrecht: Kluwer Publishers, 1991), pp. 30–52; and William Rasch and Cary Wolfe, eds., "Special Issue: The Politics of Systems and Environments, Part I," *Cultural Critique,* 30 (1995).

24. Martin Heidegger, *The Question Concerning Technology and Other Essays* (New York: Harper and Row, 1977); Hacking, *Representing and Intervening* (Cambridge: Cambridge University Press, 1983); Hans-Jörg Rheinberger, "Genetic Engineering and the Practice of Molecular Biology" (paper presented at the Fourth Mellon Workshop, "Genetic Engineering: Transformation in Science, Politics, and Culture," MIT, May 1993). Hans-Jörg Rheinberger, "Experiment, Difference, and Writing: I. Tracing Protein Synthesis, II. The Laboratory Production of Transfer RNA," *Studies in the History and Philosophy of Science,* 23 (1991): 305–331, 389–422; and idem., *Experimental Systems. Toward a History of Epistemic Things. Protein Synthesis in the Test Tube* (Stanford: Stanford University Press, 1997).

25. Derrida, *Of Grammatology,* part I.

26. See for example, Delbrück's festschrift by John Cairns, Gunther S. Stent, and James D. Watson, eds. *Phage and the Origins of Molecular Biology* (Cold Spring Harbor: Cold Spring Harbor Laboratory of Quantitative Biology, 1966); Andre Lwoff and Agnes Ullman, eds. *Origins of Molecular Biology: A Tribute to Jacques Monod* (New York: Academic Press, 1979); and Gunther S. Stent and Richard Calendar, *Molecular Genetics: An Introductory Narrative* (San Francisco: W. H. Freeman and Co., 1978).

27. Edward N. Trifonov and Volker Brendel, *Gnomic: A Dictionary of Genetic Codes* (Rehovot: Balaban Publishers, 1986), preface. I am very grateful to Manfred Eigen for making this text available to me.

28. James Watson, "Values from Chicago Upbringing," in *DNA: The Double Helix: Perspective and Prospective at Forty Years,* ed. Donald A. Chambers (New York: New York Academy of Science, 1995), p. 197.

# 16

# The Gender/Science System

## or, Is Sex to Gender as Nature Is to Science?

### EVELYN FOX KELLER

The most critical problem facing feminist studies today is that of the meaning of gender, its relation to biological sex on the one hand, and its place with respect to other social markers of difference (e.g., race, class, ethnicity, etc.) on the other—i.e., the relation between sex, gender, and difference in general. Similarly, I would argue that the most critical problem facing science studies today is that of the meaning of science, its relation to nature, and its place with respect to other social institutions—i.e., the relation between nature, science, and interests in general. My purpose in this paper is, first, to identify some important parallels, even a structural homology, between these two questions, and second, to suggest that an exploration of this homology (including the factors responsible for its maintenance) can provide us with some useful guidelines in our attempts to address these problems.

Three different kinds of parallels between feminist studies and science studies can be identified immediately: one might be called historical; the second, epistemological; and the third, political. Historically, it is worth noting that modern feminist studies actually emerges with the recognition that women, at least, are made rather than born—i.e., with the distinction between sex and gender. In much the same way, contemporary studies of science come into being with the recognition of a distinction between science and nature—with the realization that science not only is not now, but can never be, a "mirror of nature." With the introduction of these distinctions came the growth of two new (essentially nonoverlapping) fields of study, one devoted to the analysis of the social construction of gender, and the other, of the social construction of science.

In both of these endeavors, however, scholars now find they must contend with what might best be described as a "dynamic instability"[1] in the basic categories of their respective subjects: in the one case, of gender, and the other, of science—an instability in fact unleashed by the very distinctions that had given them birth. If gender is not to be defined by sex, nor science by nature (i.e., by what *is*), how then *are* they to be defined? In the absence of an adequate answer to this question, the difficulties that both feminist and science scholars have encountered in maintaining yet containing their necessary distinctions (between sex and gender on the one hand, and between science and nature on the other) are as familiar as they have been insurmountable.

It is this phenomenon that I am calling the epistemological parallel. Just as discussions of gender tend to lean towards one of two poles—either toward biological determinism, or toward infinite plasticity, a kind of genderic anarchy, so too do discussions of science exhibit the same polarizing pressures—propelled either towards objectivism, or towards relativism. In one direction, both gender and science return to a premodern (and prefeminist) conception in which gender has been collapsed back onto sex, and science, back onto nature. Under the other, we are invited into a postmodernist, postfeminist (and postscientific) utopia in which gender and science run free, no longer grounded either by sex or by nature—indeed, in which both sex and nature have effectively disappeared altogether. Attempts to occupy a "middle ground"—either with respect to gender or to science—must contend not only with the conceptual difficulty of formulating such a position, but also with the peculiarly insistent pressures of a public forum urging each concept toward one pole or the other.

I invoke the label "political" for the third parallel with reference to the politics of knowledge: I believe that, finally, what is at issue in both cases is a question of status—the status, in the one case, of gender, and in the other case, of science, as theoretical categories. Is gender, as an analytical category, different from, perhaps even prior to, categories of race, class, etc.? (Or, to reverse the question, is oppression ultimately the only important variable of gender?) The parallel question is, of course: Is science substantively different from other social structures or "interest groups?"; i.e., are scientific claims to knowledge any better than other (nonscientific) claims to knowledge?

The parallels I am describing between feminist studies and social studies of science have in fact been just that, i.e., parallels; until quite recently, there has been virtually no intersection between the two disciplines, just as there has been virtually no interaction between attempts to reconceptualize gender and science—as if the two categories were independent, each having nothing to do with the other. It is only with the emergence of a modern feminist critique of science that the categories of gender and science have come to be seen as intertwined, and, accordingly, that the two subjects (feminist studies and science studies) have begun to converge. But, as I have argued elsewhere, this most recent development actually required the prior conceptualization both of gender as distinct from sex, and of science as distinct from nature. That is, the modern feminist critique of science is historically dependent on the earlier emergence of each of its parent disciplines. With such a lineage, however, it also (perhaps necessarily) inherits whatever ambiguity/unclarity/uncertainty/instability remains in each of the terms, gender and science. Indeed, it might be said that feminist studies of science has become the field in which these ambiguities are most clearly visible, and accordingly, the field that offers the best opportunity for understanding the factors that may be working against a clear and stable "middle ground" account of both concepts. I suggest also that, for this reason, an examination of the history of feminism and science can provide important insights to help point the way towards resolution of these difficulties.

To illustrate these claims, I will focus on one particular episode in the recent history of feminism and science, namely on contemporary debate over the idea of a "feminist science," and more specifically, over the question of whether or not the recently celebrated cytogeneticist, Barbara McClintock, might be regarded as an exemplar of such a "feminist science." In order to orient this debate, however, I need to preface the discussion with a few very brief remarks about the prior history of the struggles of that group most directly affected by the issues of feminism and science, namely women scientists.

Throughout this century, the principal strategy employed by women seeking entrance to the world of science has been premised on the repudiation of gender as a significant variable for scientific productivity. The reasons for this strategy are clear enough: experience had demonstrated all too fully that any acknowledgment of gender-based difference was almost invariably employed as a justification for exclusion. Either it was used to exclude them from science, or to brand them as "not-women"—in practice, usually both at the same time. For women scientists *as scientists*, the principal point is that measures of scientific performance admitted of only a single scale, according to which, to be different was to be lesser. Under such circumstances, the hope of equity, indeed, the very concept of equity, appeared—as it still appears—to depend on the disavowal of difference. In hindsight, it is easy enough to see the problem with this strategy: If a universal standard invites the translation of difference into inequality, threatening further to collapse into duality, otherness, and exclusion, the same standard invites the translation of equality into sameness, and accordingly, guarantees the exclusion of any experience, perception or value that is other. As a consequence, "others," are eligible for inclusion only to the extent that they can excise those differences, eradicating even the marks of that excision. Unfortunately, such operations are often only partially successful, leaving in their wake residual handicaps that detract from the ability of the survivors to be fully effective "competitors." Yet more importantly, they fail to provide effective protection against whatever de facto discrimination continues to prevail. What such a strategy *can* do however is help obscure the fact of that discrimination.

This dilemma is perhaps nowhere more poignantly illustrated than in the experiences of women scientists in the mid-twentieth century—the nadir of the history of women in American science. Having sought safety in the progressive eradication of any distinguishing characteristics that might mark their gender, by the 1950s, women scientists, qua women, had effectively disappeared from American science. Their numerical representation was no longer recorded; even, by their own choice, their telltale first names were withheld from publications. Unfortunately, however, this strategy failed to protect actual women from the effects of an increasingly exclusionary professional policy—it only helped obscure the effects of that policy.

The principal point here is that these women were caught on the horns of an impossible dilemma—a dilemma that was unresolvable as long as the goal of science was seen as the unequivocal mirroring of nature, and its success as admitting of only a single standard of measurement. It was only with the introduction of an alternative view of science—one admitting of a multiplicity of goals and standards—that the conditions arose for some feminists, in the late 1970s and early 1980s, to begin to argue for the inclusion of difference—in experience, perceptions, and values—as intrinsically valuable to the production of science. Very rapidly, however, the idea of difference in science gave way (in some circles) to the extremely problematic idea of a different science altogether—in particular, to the idea of a feminist science. A feminist science might mean many things to different people, but, in practice, it is almost always used to invoke the idea of a "feminine" science. As it actually happened, though, for the idea of such a feminist/feminine (or "femininist") science to really engage people's fancy, something more than simply the availability of an alternative to the traditional view of science was needed: a source of legitimation was required, and even better, an exemplar. In this need, the Nobel prize committee seemed fortuitously to oblige.

In 1983, that committee selected Barbara McClintock for its award in medicine and physiology for work done almost forty years earlier. With help from an enthusiastic press, they thereby

turned a deviant and reclusive cytogeneticist—a woman who has made respect for difference the cornerstone of her own distinctive philosophy of science—into a new, albeit reluctant, cultural heroine. And with a small but crucial rewriting of the text, advocates of a new "femininist" science found in that moment what they needed: an exemplar who, through her "feeling for the organism," seemed to restore feminine values to science, and who (even more importantly), after years of struggle, had finally been validated, even vindicated, by a reluctant establishment.

Curiously enough, however, at the very same moment, this same establishment was busy welcoming McClintock back into their fold. Now it was their turn to repudiate the differences that in the past had made her such an anomaly. As Stephen Jay Gould informed us (*New York Review*, Mar. 26, 1984), McClintock's "feeling for the organism" is in no way distinctive; all good scientists (himself included) have it and use it. Other reviewers went further. They had always appreciated her work; the claim that she had been misunderstood, unappreciated, was simply wrong. At the very moment that (some) feminists claimed McClintock as one of their own, as a representative of a different science, mainstream scientists closed ranks around her, claiming her as one of their own: there is only one science.

Because I cannot claim to have been an innocent bystander in these developments, I need to say something about my own contribution. In writing my book on McClintock, it seemed important to me to consciously bracket the questions on gender and science that I had been writing about before, and to treat the material on McClintock's life and work, and their relation to the history of modern biology, in their own terms. It seemed unfair to McClintock's own story to burden it with a prior moral of mine, particularly in view of the fact that it was extremely unclear to me just what the relevance of a feminist, or gender, critique to that story might be. McClintock herself is not a feminist; she has throughout her life not only resisted but adamantly repudiated all classification, and her commitment to science as a place where "the matter of gender drops away" is staunch. If gender was to prove an important variable in that story, particularly to an understanding of her scientific deviance, the story itself would have to show both me and the reader how. This stance of course left readers free to draw their own conclusions, which indeed they did—though, perhaps predictably, usually attributing those conclusions to me.

Partly in self-defense, and partly because it needed to be addressed, I turned to the question of a feminist science in my subsequent book (Keller 1985)—focusing in particular on the question of the relevance of gender to the McClintock story. On quite general grounds, I argued that if one means by a feminist science a feminine science, the very notion is deeply problematic: first because it ignores the fundamentally social character of the process by which both science and scientists get named as such, and second because of the extent to which our understanding of "feminine" and "scientific" have been historically constructed in opposition to each other.

Other problems arise in relation to the McClintock story itself: first, there is not only McClintock's own disavowal of all stereotypic notions of femininity, but, in addition, there is the fact that none of the dynamics we think of as key to feminine socialization seem to apply to her. She was never pregnant, never parented, and, although she was a daughter, her relation to her mother was so anomalous as to pose a challenge to conventional assumptions about mother-daughter bonding. Finally, a directly biological account of McClintock's difference won't do because she is in fact not representative of women in general—not even of women scientists; nor are her vision and practice of science absent among male scientists. What then are we to make of the fact that so much of what is distinctive about that vision and practice—its emphasis

on intuition, feeling, connectedness, and relatedness—conform so well to our most familiar stereotypes of women? And are, in fact, so rare among male scientists?

To answer this question, I argued that it was necessary to shift the focus first from sex to gender, and second, from the construction of gender to the construction of science. The question then becomes, not why McClintock relies on intuition, feeling, a sense of connectedness and relatedness in her scientific practice, but how come these resources are repudiated by stereotypic science? Put this way, the question virtually answers itself: the repudiation of these resources, I argued, derives precisely from the conventional naming of science as masculine, coupled with the equally conventional naming of these resources as feminine. The relevance of gender in the McClintock story thus shifts from its role in her personal socialization to its role in the social construction of science. For the project of reclaiming science as a gender-free endeavor—a place where "the matter of gender drops away"—I did however suggest one respect in which McClintock's sex may in fact have provided her with an advantage: "However atypical she is as a woman, what she is *not* is a man"—and hence is under no obligation to prove her "masculinity" (Keller 1985, 174).

In other words, I attempted to articulate the very kind of "middle ground" stance with regard to gender that I have in this paper suggested is so peculiarly difficult (for all of us) to maintain—claiming in particular that the relevance of gender to science is (a) a socially constructed relevance, but (b) *carried* by the sex of its participants (in the sense, that is, that gender specific norms are internalized along with one's "core gender identity"). In short, I argued that gender is a fundamentally relational construct which, although not determined by sex, is never entirely independent of it. In spite of cultural variability and psychological plasticity, it means *something*—though, for many individuals, perhaps not a great deal—to identify oneself as being of one sex and not of another.

Because the responses this argument has generated provide ready evidence of the instability to which our understanding of gender is generally subject, it may be useful to review them here. Many feminists have continued to read the McClintock story as a manifesto of a "feminist science" (in the sense, i.e., of a specifically female science)—in the process, either celebrating me as its proponent, or, if they respond at all to my disclaimers, implying that I lack the courage of my convictions—sometimes even suggesting that I lack the courage of McClintock's convictions. On the other side, a number of readers (both men and women), complained that I ignored McClintock's distinctiveness in attempting to make her "an exemplar of women," or that my argument has to be wrong because of the fact that there *are* men who do think like McClintock, who do have "a feeling for the organism." Hence, they conclude, gender cannot be relevant to this story. Finally, there are those readers for whom the anxiety raised by any reference to gender whatever in the context of science is so great that they simultaneously read both "gender" and "gender-free" as "female" (see, e.g., Koblitz n.d.). For these last readers, especially, the suggestion of even a tenuous link between gender and sex for either women or men is taken as proof of their worst suspicions—i.e., that this argument constitutes a threat to the claim of women scientists to equity.

What is perhaps most notable about these readings is the extent to which they all depend, albeit in different ways, on an unwitting, almost reflexive, equation between questions about gender with questions about sex. That is, they assume that what is really at issue is not the force of gender ideology, but the force of sex. With the space between sex and gender thus eliminated, the original question of McClintock's difference automatically reduces to the exceedingly problematic (and dubious) question of whether or not men and women, by virtue of being male or female, think differently. Not surprisingly, the responses to this last question are both mixed and

extremely fervent. Once read as duality, the question of difference becomes subject to only two responses: yes or no, i.e., either the embrace or the denial of duality—embrace by those who welcome it; denial by those who fear it. The entire spectrum of difference has thus been collapsed onto two poles—duality and universality.

I suggest that the conceptual collapse illustrated here—the difficulty so many of us have in thinking about difference in any other terms than either duality or universality—is rooted not in biology but in politics: not a consequence of any limitations in the way in which our brains are constructed, but rather the consequence of an implicit contest for power. I am suggesting that duality and universality are responses actually structured by, as well as employed in, a contest that is first and foremost political. As I've already implied, the Nobel prize plays a crucial role in creating out of McClintock's science a zone of contention in the first place, inviting both feminists and mainstream scientists to claim her as one of their own. The legitimation and authority provided by the Nobel prize endowed McClintock's scientific practice with a value worth fighting over—a value claimed by one side by the negation of difference, and by the other by its reformulation as duality. It is precisely in the context of such a competition that the question of difference itself becomes a contested zone—our conceptualization of difference molded by our perceptions (as well as the reality) of power. In other words, in this context at least, the very debate between duality and universality both presupposes and augments a prior division between an "us" and a "them," bound in conflict by a common perception of power. It refers not to a world in which we and they could be said to occupy truly separate spheres, with separate, noninteracting sources of power and authority—in such a world, there would be no debate—but, rather, to a world perceived as ordered by a single source (or axis) of power that is at least in principle commonly available; a world in which duality can be invoked (by either side) to create not so much a separation of spheres as an inside and an outside—in other words, as a strategy of exclusion. It is in just such a world that the perennially available possibility of difference becomes a matter to contest—invoked or denied according, first, to the value attached to that difference, and second, to one's position relative to the axis of power. With nothing to lose, but possibly something to gain, a difference of value can safely and perhaps usefully be claimed as a mark of duality. Standing inside the circle, however, it is more strategic to assimilate any difference that is known to be valuable, and to exclude, through the invocation of duality, those differences that promise no value.

In the particular case at hand, the power at stake is, to put it quite simply, the epistemic authority of scientists. And although I have so far been speaking as if there were only one demarcation capable of effecting exclusion, namely that between men and women, it is neither the case that all women are without scientific authority nor that all those without scientific authority are women. Another demarcation is also operative here—indeed, I would even say, primary: namely, the demarcation between science and nonscience, potentially at least as exclusionary as that between men and women. It is the threat of this second demarcation that polarizes our discussions about the nature of scientific knowledge in much the same way as the first polarizes our discussions of gender. The question of whether scientific knowledge is objective or relative is at least in part a question about the claim of scientists to absolute authority. If there is only one truth and scientists are privy to it (i.e., science and nature are one), then the authority of science is unassailable. But if truth is relative, if science is divorced from nature and married instead to culture (or "interests"), then the privileged status of that authority is fatally undermined. With this move, the demarcation between science and nonscience appears to have effectively

dissolved. Because the notion of a feminist/feminine science engages both these demarcations simultaneously—indeed, it could be said that the very proposal of a feminist science depends on the possibility of playing one off against the other—an understanding of this debate requires that we pay attention to both sets of dynamics. Once again, an examination of the responses of women in science is especially instructive, for it is that group of individuals that is most directly positioned by these two demarcations—indeed, positioned by their intersection.

For women who have managed to obtain a foothold within the world of science, the situation is particularly fraught. Because they are "inside," they have everything to lose by a demarcation along the lines of sex that has historically only worked to exclude them. And precisely because they are rarely quite fully inside, more commonly somewhere near the edge, the threat of such exclusion looms particularly ominously. At the same time, as scientists, they have a vested interest in defending a traditional view of science—perhaps, because of the relative insecurity of their status, even more fiercely than their relatively more secure male colleagues. On two counts, then, it is hardly surprising that most women scientists (as well as historians and philosophers of science) vehemently resist the notion of a feminist/feminine science: the suggestion that women, as a class, will do a different kind of science simultaneously invokes the duality of sex, and undermines (or presupposes the undermining of) our confidence in the privileged attachment of science to nature.

What *is* surprising is the extent to which so many women scientists have been able to read into McClintock's Nobel prize the possibility of an alternative to the classical dichotomies. The McClintock story is compelling to many women working in science because it testifies for them the viability of difference within the world of science as we know it. They read the Nobel prize not as an invitation to rebellion, but as evidence of the legitimacy of difference within the established criteria of scientific "truth"—as making room within the prevailing canon for many of the questions, methodologies and interpretations that their more familiar version of that canon did not permit. In this, they seek a larger canon rather than a different one; a richer, perhaps even multifaceted, representation of reality, but not a separate reality. Their resistance to the reduction of difference to duality is firm, and it is, admittedly, a resistance clearly in the service of their own interests as women scientists. But it is also in the service of a larger interest, and that is the preservation of some meaning to the term "science."

Even accepting that the scientific endeavor is not as monolithic as the received view would have it, accepting that science does not and cannot "mirror" nature, the question remains, what do we mean by "science"? Does, indeed, any meaning of the term remain? If it does, that meaning must derive from the shared commitment of scientists to the pursuit of a maximally reliable (even if not faithful) representation of nature, under the equally shared assumption that, however elusive, there is only one nature. We may now realize that science is not capable of apprehending reality "as it is," as people once thought it could, but belief in the existence of separate realities (a notion in fact often associated with arguments for a "feminine science") is fundamentally antithetical to any meaning that the scientific endeavor might have. To ask women scientists to accept the notion of a different science representing a different reality (as distinct from difference in science) would be to ask them to give up their identity as scientists—in much the same way, incidentally, that traditional science has asked them to give up their identity as women. It is, finally, not so much to counterpose an alternative science as to reinforce the traditional opposition between women and science.

The celebration of difference within science seems therefore to constitute a clear advance

over both the monolithic view of science that threatens to exclude diversity, and the dualistic (or relativistic) view that threatens to deny particular meaning to the category, science. At the same time, however, the attempt to avoid the problem of duality by ignoring gender altogether carries within itself a critically undermining flaw: it blocks our perception of the very important ways in which gender has been and remains constitutively operative in science. In particular, it ignores the fact that it is precisely in the name of gender that the very diversity we would now like to see celebrated has historically been (and continues to be) excluded. Above all, it ignores the uses of gender in maintaining a monolithic ordering of power.

Just as the engendering of culture in general has shown itself as a way of ordering the power structures of our social and political worlds, the engendering of knowledge, and of scientific knowledge in particular, has served to order the sphere of epistemic power. Knowledge *is* power—in many senses of the term. With the rise of modern science, knowledge came to be understood as a particular kind of power—namely, as the power to dominate nature. In this history, we can see the construction of gender *as* the construction of exclusion—of women, of what is labeled feminine, and simultaneously, of the alternative meanings of power that knowledge might engender. As I've argued in my book on this subject (Keller 1985), the exclusion of the feminine from science has been historically constitutive of a particular definition of science— as incontrovertibly objective, universal, impersonal . . . and masculine: a definition that serves simultaneously to demarcate masculine from feminine and scientists from nonscientists—even good science from bad. In the past as in the present, the sexual division of emotional and intellectual labor has provided a readily available and much relied upon tool for bolstering the particular claims that science makes to a univocal and hence absolute epistemic authority—not only in the contest between scientists and nonscientists, but equally, in contests internal to science. In turn, of course, the same authority serves to denigrate the entire excluded realm of the feminine—a realm which, as it happens, invariably includes most women.

Given the cultural uses of gender in maintaining a univocal conception of power, any gender-blind advocacy of difference (by men or women, in science or elsewhere) entails some risk. Given its particular uses to exclude those who are the cultural carriers of "femininity" from the apex of epistemic authority, women scientists incur a special risk in ignoring these uses. Once dissociated from gender (and hence from sex), the celebration of difference ironically lends itself to the same ends as the denial of difference—it can serve once again to render women themselves superfluous. The question of values, in this discourse, preempts the question of jobs. Although in many ways philosophically opposed to postmodernism, in one important respect, the response of these scientists converges on a problem that has already become evident in postmodernist literary discourse—a problem to which an increasing number of literary scholars have already begun to call attention. Put simply, the question becomes: when anyone can learn to read like a woman, what need have we for women readers? In other words, difference without gender invites another kind of degeneracy—not quite the denial of difference, but its reduction to indifference, a way of thinking about difference as potentially capable as universality of excluding actual women.

Where advocates of difference within science critically depart from and effectively counter that tendency in postmodernism towards an indefinite proliferation of difference is in their reminder of the constraints imposed by the recalcitrance of nature—their reminder that, despite its ultimate unrepresentability, nature does exist. As feminists, we can offer an equally necessary counter (though necessary for different reasons) to that same proliferation by recalling the

constraints imposed by the recalcitrance of sex. In truth—perhaps the one truth we actually do know—neither nature nor sex *can* be named out of existence. Both persist, beyond theory, as humbling reminders of our mortality. The question, of course, is how we can maintain this mindfulness without in the process succumbing to the forces that lend to the names we give to nature and sex the status of reality—the forces that constrain our perception and conception of both nature and sex, first, by their naming as science and gender, and second, by the particular namings of science and gender that are, at any particular time, currently normative.

. Our success in maintaining awareness of the bipolar and dialectical influences of both nature and culture on the categories of gender and science may well in the end depend on the adequacy of our analysis of the nature of the forces that work against such an awareness. If these forces do in fact derive from an underlying contest for power, as the story narrated here suggests, then the most central issue at hand is the relation between gender, science, and power—above all, the uses of particular constructions of gender and science in structuring our conceptual and political landscape of power. As long as power itself remains defined in the unitary terms that have prevailed, the struggles for power that ensue provide fuel, on the one hand, for the collapse between science and nature, and gender with sex, and on the other, for the repudiation of nature and/or sex. In other words, they guarantee the very instability in the concepts of gender and science that continues to plague both feminist and science studies.

Feminist analyses have suggested that it is precisely in the interpenetration of our language of gender and our language of science that the multidimensional terrains of nature, of culture, and of power have been transformed into one dimensional contests. If so, the effective defusing of these contests would require a different kind of language, reflecting a higher dimensionality in our landscape—neither homogeneous nor divided, spacious enough to enable multiplicity to survive without degenerating into opposition. In short, we need a language that enables us to conceptually and perceptually negotiate our way between sameness and opposition, that permits the recognition of kinship in difference and of difference among kin; a language that encodes respect for difference, particularity, alterity without repudiating the underlying affinity that is the first prerequisite for knowledge. In this effort, I suggest that the mere fact of sexual difference may itself provide us with one useful reminder: it is, after all, that which simultaneously divides and binds us as a species. But surely, nature, in its mercilessly recalcitrant diversity, provides us with another.

NOTES

Portions of this paper are taken from a talk given at the "Little Three" Conference, January 16, 1986, Amherst, Mass.
    1. The term "instability" has also been employed by Sandra Harding (1986), but with a rather different charge. Where Harding finds instability productive, both politically and intellectually, I find it—again, both politically and intellectually—an obstacle to productive exchange.
    2. See, e.g., the critique of Derrida and Foucault in Teresa de Lauretis, *Technologies of Gender* (Bloomington: Indiana University Press, 1987).

REFERENCES

Harding, Sandra. 1986. The instability of the analytic categories of feminist theory. *Signs* 11 (4):645–664.
Keller, Evelyn Fox. 1983. *A feeling for the organism: The life and work of Barbara McClintock.* New York: W. H. Freeman.
———. 1985. *Reflections on gender and science.* New Haven: Yale University Press.
Koblitz, Ann Hibner. n.d. An historian looks at gender and science. Unpublished manuscript.

# 17

## Moral Economy, Material Culture, and Community in *Drosophila* Genetics

### ROBERT E. KOHLER

### INTRODUCTION

How does science work—and why? How do scientists go about their business of creating knowledge of the natural world, and what has made them so good at what they do? Historians and sociologists of science have been asking themselves these questions more and more insistently since the late 1970s, and today interest in scientific work and practice is as central to science studies as the logical analysis of theories was just twenty years ago.

Interest in scientists' practices takes varied forms, but a few key concerns stand out. Material culture is one—instruments and experimental procedures, the tools and methods of knowledge production. Another is the social organization of working communities and their moral economy, that is, the social rules and customs that regulate such crucial aspects of community life as access to workplaces and tools of production, authority over research agendas, and allocation of credit for achievement. That material culture and social customs are closely related is obvious and well documented. Tools and methods only become productive when they are part of a social system for socializing recruits, identifying doable and productive problems, mobilizing resources, and spreading the word of achievements. The question, with any particular community of practitioners, is how exactly instruments, practices, and moral economy operate together to make a line of work that is productive and attracts recruits and granting agencies, or (more commonly) to make one that breaks no new ground and remains small and local.

This case study deals with one of the great success stories of modern biology, the community of *Drosophila* geneticists created around 1910 by Thomas Hunt Morgan and led by him at Columbia University until 1928 and then at Caltech until his death in 1945.[1] In Morgan's group—the "fly group"—we see the several elements of modern practice in striking form. There was a novel mode of practice: the study of how genes segregate in crosses between different

mutant forms; and the construction of chromosomal maps. This mode of genetic practice, which we now take for granted simply as "modern" genetics, was novel and controversial when Morgan and three of his students—Alfred Sturtevant, Calvin Bridges, and Hermann Muller—invented it between 1910 and 1912. Unlike all other contemporaneous modes of experimental heredity, genetic mapping cut heredity loose from development and evolution to focus on the mechanics of chromosomes in genetic transmission, a narrower but more doable and productive mode of practice.

This new mode of genetic practice was made possible by the invention of a novel kind of scientific instrument, the "standard" organism—in this case, the standard fruit fly, *Drosophila melanogaster*. The standard fly and genetic mapping were inseparable: the fly was created in the course of the mapping project that Sturtevant and Bridges began on May 5, 1912, and genetic mapping would have been impossible without a standardized organism tailor-made for that purpose. Since the fly group's work, biologists have created many more such organisms—maize, bacteria, bacteriophage, mice, white rats, and more recently zebra and puffer fish, the nematode *Caenorhabditis elegans*, *Arabidopsis thallina* (to its devotees, a plant *Drosophila*), and so on. Many others were tried but failed, like the brine shrimp *Gammarus* (which Julian Huxley hoped would become a "British drosophila"), *Planaria* (which Morgan's American opponents hoped would put *Drosophila* out of business), grasshoppers, fungus gnats (*Sciara*), and more.

It may seem counterintuitive, even perverse, to regard living creatures as bits of technology and lump them with physical instruments such as galvanometers or reactors, but in fact they are constructed artifacts distinct in crucial ways from their wild ancestors. (Ecologically, for example, they survive only in the artificial environment of a laboratory.) Standard organisms have become such a common laboratory fixture that we tend to take them for granted and forget the peculiar circumstances that caused *Drosophila*, the pioneer and prototype, to be invented as a dissertation project of a couple of college seniors.

The human inhabitants of laboratories form no less distinctive cultures, and no community was more distinctive in its early years than the fly group. It was remarkable, for example, for its custom of sharing tools (mutant stocks) and research problems. Every member of the group got involved in everyone else's projects, and every publication was more or less a group product. It was hard in some cases to know who had done what, yet the fly group was singularly free of fights over credit—a remarkable social feat. The same was true of students: though officially Morgan's, they were in fact as much Sturtevant's or Bridges's—communal products. Competing for acolytes, so common in academic life, was virtually absent. Another distinctive fly-group custom was their readiness to let other drosophilists—as the fly people called themselves—borrow their mutant stocks. The fly group was the center of an elaborate exchange system for sharing stocks and craft knowledge. Although other biologists at the time also shared this custom (most notably natural historians), none developed it so elaborately as the fly group, and though exchange systems have since been generally adopted by biologists working with other standard organisms, drosophilists even today are noted among biologists for their civility and cooperative spirit—almost a century after the founding of the first fly group! The "moral economies" of working communities can be remarkably robust.

What were these tacit rules that guided the communal life of the fly people, and how did they originate? Answering such questions is the task of science studies. I will argue here that the drosophilists' moral economy evolved spontaneously in the early mapping project, to take advantage of the remarkable abundance of mutants and research problems produced by that tiny

marvel, the standard fly, when it was used for genetic mapping. The mapping project was a cornucopia, each completed piece of work producing far more enticing problems than a few people could ever work up. This abundance almost *drove* the first drosophilists to adopt customs of sharing and free exchange. Standard fly and map, moral economy, and exchange network arose together—produced each other, one could say: the material, social, and moral aspects of a remarkable machine for producing genetic knowledge.

How, then, did this machine come to be made?

## GENETIC MAPPING AND THE CONSTRUCTION OF *DROSOPHILA*

There is a standard story of the invention of *Drosophila* genetics, which has been passed down from generation to generation of beginning biology students, like a myth of tribal heroes. The story is that Morgan brought wild *D. melanogaster* into the lab because it was better suited to Mendelian genetics than the more usual lab animals (mice, peas, snapdragons), with its short life cycle (as short as ten days), large numbers of offspring (up to one thousand), and tolerance of life in the lab, with its regular doses of X rays and ether and constant handling by humans. It is a tidy, rational story, pedagogically useful for socializing students; but it is not a true account of the mess of real research. The fly's advantages were real enough, but they were not why Morgan initially took up the fly.

In fact, the advantages of *Drosophila* for genetic work came to light unexpectedly as Morgan was using it in an experiment on evolution. Morgan was testing the idea that a wild creature, subjected to intense selection, would enter what Hugo De Vries called a "mutating period," that is, it would begin to vary beyond the usual range of variation. Why Morgan liked that odd (to our minds) idea is a long story, but in the course of the experiment Morgan observed a number of mutant forms, the most striking of which (though not the first) was the famous white-eyed mutant. It was not the kind of variation that Morgan had hoped to find (he doubted such extreme mutants had any role in evolution), but when the white-eyed mutation proved to be sex-linked (only males show the trait) and to segregate in Mendelian ratios, Morgan was forced to admit that genetic factors, or "genes," were physically located on specific chromosomes. And when a dozen or so more such mutants turned up in the following months, he realized that he had stumbled upon an animal that was far better for Mendelian genetics than any mouse or pea, with their limited number of Mendelizing traits. Soon Morgan had given up work on "mutating periods" and other projects and devoted his lab almost entirely to Mendelian genetics and *Drosophila*. Other experimental organisms were dropped. The fly took over.

The fly's ecological takeover of Morgan's lab was a major change in the insect's fortunes. *Drosophila* had been around laboratories for about a decade by then, but it had never been used for anything very important. Morgan had used it for student projects on chemical mutation and Lamarckian inheritance (all with negative results), and William Castle at Harvard had used it as a control for his experiments with rodents, to fend off possible criticism that inbreeding lowered reproductive vitality (again, negative). Other biologists found *Drosophila* handy for class demonstrations of tropisms and metamorphosis. In fact, there is evidence that *Drosophila* was first brought into laboratories primarily because it was ideally suited to student projects: it was abundant in the fall in gardens and orchards and active through the winter, when live material

was needed, and cheap and easily replaced when inexperienced students killed off cultures. Plants and rodents, in contrast, were seasonal or expensive to maintain, subject to blights and epidemics, and not forgiving of student mistakes. *Drosophila* was useful for student work, but for that very reason its status as an instrument of research was decidedly low. That is, until it was serendipitously taken up in genetic experiments.

This odd story, so different from the founder myth, points to a crucial question about the relation of nature and experimental practice. If a freshet of mutant flies was what caused this dramatic change in the uses of *Drosophila,* then what caused these mutants suddenly to appear when and where they did, in Morgan's lab between January and May 1910? Why not earlier, or later? Or never? Why not somewhere else, say, in Castle's experiments at Harvard? I believe that mutants appeared as a consequence of scaling up the size of experiments. Drosophilas, like all creatures, will produce visible mutations at a definite but low rate of, say, a few per hundred thousand; therefore if experiments involve large numbers of flies, eventually enough will turn up to be noticed, especially if experimenters are on the lookout for them.

So the question is, what particular experiments circa 1910 were big enough for this statistical threshold to be crossed? Not too many, it turns out: certainly not Morgan's experiments on chemical mutation, which involved at most hundreds of flies; and probably not his students' experiments on generations of flies bred and raised in the dark (in the hope that they might, like cave animals, become eyeless). However, Morgan's search for a "mutating period," which went on without success for some two years—he complained bitterly to a colleague about that in January 1910—certainly involved a sufficient number, and sure enough, mutants began to appear in them. And Morgan's early experiments on neo-Mendelian segregation were even bigger, some requiring him to breed and scrutinize over a hundred thousand flies. It was in the course of these huge experiments that the freshet of mutant flies became a flood. Castle's experiments were probably also big enough to turn up mutants. Since he was interested only in the ability of inbred flies to reproduce, however, he counted only pupae (to save time) and did not inspect large numbers of adults, thus missing the chance to discover mutants. Thus it happened that fly genetics was invented at Columbia University, by Morgan and his students, and not in the other laboratories where *Drosophila* was also being used.

But it was not enough for mutants to exist for them to be seen: human experimenters had to be able to perceive them. Once Morgan had found a few especially striking mutants like the white-eyed fly, he was then predisposed to see more. What previously he dismissed as extreme variations, but within the normal range, he came to see as well-marked mutants. "Epidemics" of similar mutants became a familiar experience in the fly group, a combined result of scaling up and changes in experimenters' perceptions and categories. In short, the first mutants appeared when and where they did because of the unusual qualities of Morgan's experiments. In no other modes of experiment then practiced were all the conditions right.

This argument, note, is neither strictly biological nor strictly cultural but a combination of the two. *Drosophila,* because of its short life cycle and large families, produced lots of mutants. But this property presented itself to biologists, becoming visible and meaningful, only when the fly was involved in certain specific kinds of experiment. *Drosophila's* fecundity was a complex characteristic of an organism in a particular experimental culture. This is a crucial point. We are dealing here with neither biological nor cultural determinism: experimental life is an integral and inseparable mixture of nature and culture, and nature and culture must also blend seamlessly in histories and sociologies of experimental life.

*Drosophila's* potential for turning up mutants was most strikingly realized in mapping genetics. Mapping experiments had an autocatalytic character quite unlike that of any other experimental mode. Each mapping experiment produced more mutants, which had to be mapped, requiring more large experiments, which in turn produced more mutants to map, and so on. In this particular mode of experiment *Drosophila* became a kind of biological breeder reactor, producing more material in the course of an experiment than was consumed. This experimental chain reaction made *Drosophila* a cornucopia of research material and problems that was unlike anything that had ever turned up before in a biological laboratory. Comparison with a "breeder reactor" may seem a tasteless joke, but it is apt in capturing the experience of early drosophilists who felt that they were drowning in the flood of new material to be worked up, unable to cope. Morgan was the first to have this experience. "I am beginning to realize that I should have prepared for a large campaign," he wrote a colleague in early 1911, "but who could have foreseen such a deluge. With vicarious help I have passed one acute stage only I fear to pass on to another." But a year later he was again "head over ears in my flies," unable to keep up with the flood of material to be worked up. A decade later Charles Metz had a similar experience: "The way I am turning out mutants . . . beats any experience I ever had before. If things keep on piling up I will be swamped in another month and will have to call for help."[2] *Drosophila* never lost this capacity to nearly drown experimenters in fruitful work.

There were several reasons why mapping genetics had this special autocatalytic property. First, it was quantitative: distances were calculated statistically from the frequency of crossing over between two positions on a chromosome, and the statistics became more precise the more flies were counted. The legitimacy of gene mapping, which was then new and controversial, depended in part on its quantitative precision (biologists, perhaps because they work with inconstant living organisms, tend to be impressed by things quantitative), and that need was a powerful motive for drosophilists to do very large experiments. Hence more mutants. A second reason was the special character of mapping as a way of classifying and ordering mutants. Maps, unlike other systems of classifying data, are indefinitely elastic. They never fill up, and the fuller the better. So when new mutants turned up, drosophilists did not just set them aside as excess baggage but were obliged to put them on the map, and that required more experiments. Hence more mutants, more crosses, more mutants . . . the breeder reactor.

Other kinds of genetic practice did not have this autocatalytic property; for example, the kind of neo-Mendelian genetics that Morgan was practicing before he switched to mapping in 1912. In this earlier mode, mutants were organized not into chromosome groups but into organ groups (eye mutants, bristle, body color, and so on). This system of data management was not quantitative: its end product was not a map but a set of something like chemical formulas for each mutant form, composed of present or absent factors. New mutants did not necessarily lead to larger experiments. They did, however, require that the formulas for every mutant be revised over and over again, and it was this alarming instability of interpretation that finally caused Morgan and his students (the latter, first) to abandon organ groups for chromosome maps, which just got fuller and better. There is no better illustration of the power of material culture and practices radically to reshape experimenters' aims and concepts. We like to think that ideas and theories precede the nitty-gritty of lab practice, but in fact practice more usually precedes theory. In this case, the ideas of genes, maps, and crossing-over arose when drosophilists were forced to change their handling of data by the fecundity of their little fly.

The practice of genetic mapping also drove the transformation of *Drosophila* from a wild,

inconstant creature into a reliable article of laboratory technology, the "standard fly." Few modes of practice would have impelled experimenters to undertake this daunting, decades-long task, but for mapping it was essential. Again, the argument turns on a mix of biology and human culture, and again the element of precision is crucial. Consistency and reproducibility of results are essential requirements of many kinds of experiment, but, as noted above, in none are they more essential than in genetic mapping. Mapping was quite controversial for a decade or so after it was invented. "Genes" resembled all too closely the discredited material factors of nineteenth-century theorists. And many biologists thought that the drosophilists had made a bad bargain when they traded relevance to embryology and evolution for abundant data on the structure and mechanics of chromosomes. Consistent, precise results were thus an indispensable way of giving the new practice legitimacy in the eyes of doubters. But getting consistent results with *Drosophila* was at first easier said than done.

Wild *Drosophilas* are highly variable creatures whose chromosomes are so loaded with modifier genes, hidden lethals, and other genetic junk that the first experiments seldom turned up the results predicted by Mendelian theory. Experiments with flies of the same species but from different geographical locales gave different results. As did experiments performed under slightly different conditions of food, temperature, moisture, and so on. Naturally! In nature variability ensured survival in an unpredictable environment. In the laboratory, however, variability was a threat to *Drosophila*'s survival. Every departure from theory was a reason to doubt its validity. Every discrepancy between results achieved in different labs was reason to suspect that maybe mapping genetics worked only at Columbia—a death warrant in a culture of laboratory practice that values knowledge only to the extent that is was the same everywhere. (The generic placelessness of laboratories is in part what makes experiment more valued than "mere" observation in nature.)

So the first task that Sturtevant, Bridges, and Muller faced was to clean up *Drosophila,* get rid of its variability, and fix it so that every experiment gave the same and the "right" results. They went about this in various ways. At first they hoped to disarm criticism by simply applying correction factors or disclosing the order in which chromosomal segments were mapped, but that makeshift did not work. Standardizing experimental conditions was more effective, eliminating much of the variability by using one kind of food and culture bottle and standardizing the procedures of genetic crosses. But the ultimate solution to *Drosophila*'s hard-core variability was to retro-engineer the fly itself, excising the genetic junk, and assembling from various stocks chromosomes that gave results that fit Mendelian theory. The chromosomes of standard mapping stocks were bricolages of genetic material from many flies, assembled to ensure clean experiments. The aims of Mendelian genetics were thus built into the instrument itself. What better evidence of the constructed, artifactual nature of *Drosophila*!

The construction of the standard fly was accomplished mainly by Calvin Bridges and took about a decade, though Bridges never ceased to tinker with it, concocting new gadgets and synthetic culture media, introducing new and more efficient mapping stocks, and recalculating standard maps from time to time. Thus was the biological diversity and fecundity of *Drosophila* transformed by the cultural need of biologists for precise, repeatable (and therefore trustable) results into that remarkable biological artifact, the standard fly. Was it a wild creature? Yes. Was it laboratory technology? Again, yes. Nature and human culture were brought together in the drosophilists' "breeder reactor." Other modes of experimental heredity would probably not have led to the creation of a standard organism: standardization was driven by the peculiar practical

and epistemological requirements of mapping. Instrument and practice coevolved in Sturtevant and Bridges's mapping project.

## THE MORAL ECONOMY
## OF THE FLY GROUP

Tools and material alone do not make a productive research community. The production of knowledge also requires an effective *social* technology, to use Steven Shapin's useful phrase. Talented recruits must be drawn in, trained in the use of standard instruments and routines, and taught what counts for the group as significant and creditworthy problems. The disputes that inevitably arise among groups of bright and ambitious people must be managed in a way that prevents the group from falling apart into rival factions and dissention. A workplace culture has to be maintained that encourages original, thorough work. Ways must be invented of spreading the word of new practices and persuading nonpractitioners of its worth. A research community, like a standard organism, is a complex bit of technology, a social instrument artfully constructed to turn raw intellect, zeal, and ambition to producing knowledge that everyone will want to learn about or use.

No aspect of communal work is more important than its "moral economy." This phrase, borrowed from the historian Edward P. Thompson, refers to the moral (as distinct from economic and organizational) principles underlying productive activities. Thompson used the idea to explain the apparently disorderly but in fact principled actions of food rioters in eighteenth-century England. The principles, in his case, were not those of political economy (supply, demand, and price) but older moral rules that defined the mutual obligations of owners and consumers in times of shortage. Embedded in the history and daily life of agricultural communities and seldom articulated, these moral principles are nonetheless powerful guides to action, especially in times of stress, and can be discovered by careful attention to group behavior.[3] Thompson meant "moral economy" to apply only to his particular case; however, I believe that it applies generally to any kind of production, of foodstuffs, manufactures, or cultural products like science. Indeed, it seems especially applicable to scientists, who tend to trade in symbolic more than economic values.

In the case of science, three elements of communal life seem especially central to its moral economy: access to the tools of the trade; equity in the assigning of credit for achievements; and authority in setting research agendas and deciding what is intellectually worth doing. *Access, equity, authority*—much of the success or failure of research groups depends on their ability to manage these crucial and contentious elements of communal work.

The moral economy of the fly group was distinctive and unusually self-conscious. First, access: everyone in the fly group enjoyed completely free and unhindered access to the instruments of production, the communal stocks of mutant flies, research paraphernalia, and know-how. Work in the fly group was intensely communal and egalitarian—visitors often commented on that, especially those from more stratified European laboratories. Everyone in the fly group was always involved in everyone else's projects, offering continual advice and criticism, swapping mutants and tips, engaging in kaleidoscopic collaborative projects. A very high percentage of the papers that came out of the fly group were multiauthored (a custom now common, but not in those days). Calvin Bridges, who kept the communal fly stocks, was famously generous in

supplying material and technical know-how to anyone who asked, as was Alfred Sturtevant with his unequaled knowledge of the *Drosophila* literature, of which he was the unofficial keeper. Individual ownership of particular stocks was strongly discouraged, as was also any effort by individuals to corner problems for their exclusive use. It was understood, of course, that individuals would not try to beat out others to a juicy problem, but all tools and all problems could be taken up by anyone with skills and a good idea of what to do with them. There was never any move to divide the field of *Drosophila* genetics into specialized subfields. The custom of equal and open access is apparent even in the physical space of the fly room at Columbia: one common space, the only door being the one to Morgan's tiny office, which was always open. (At Caltech, there were individual rooms, but there, too, no closed doors.)

The principle of equity was no less crucial to the drosophilists' moral economy: credit was given not to a person who had a good idea first but to the one who first made an idea work experimentally. Ideas that were suggested by a colleague or emerged from the flow of communal shoptalk were a communal resource and could be appropriated freely; they did not even need to be acknowledged formally in publications. Given the communal way in which the fly group worked it would have been very difficult and contentious to assign credit in any other way—who could ever say for sure who had an idea first in the fly room's unceasing buzz of shoptalk? A skillfully performed experiment, in contrast, was unambiguous. Giving credit strictly for good work skillfully and thoroughly done was the drosophilists' golden rule.

This principle of equity did not settle every problem in the assigning of credit. To those who had lots of ideas and a habit of steady, productive work, like Bridges or Sturtevant, the rule seemed eminently fair. To others with different work habits it did not. Hermann Muller, for example, was extremely quick to see the ramifications of ideas but worked very deliberately—he had a taste for grand experiments that took years to prepare and complete. He came to feel that many of the group's best ideas had been his and concluded that Morgan had concocted the rule of credit for work accomplished in order to deprive him of his due.

In fact, the rationale behind the moral principles of access and equity was that it was the work that mattered most, more than personal credit. Work skillfully done and written up advanced the whole field of *Drosophila* genetics and benefited everyone in it. Hence the golden rule: whoever could do a job best deserved the credit.

The same idea guided the drosophilists' handling of authority in the workplace. Research agendas and the choice of problems were not imposed by Morgan, or by Sturtevant and Bridges, but emerged out of the group's communal work on the shop floor. Consider, for example, the group's handling of students and visitors. Officially, all students were Morgan's, since he alone had professorial status.[4] However, Morgan disliked the unending task of assigning topics to graduate students and visitors, and Sturtevant and Bridges—"the boys," as they were known (they began the mapping project as college seniors!)—gradually took over the care and nurture of students. In fact, every student and visitor was a student of the whole group. All the experienced workers took responsibility for helping students select dissertation topics, and when visitors arrived, Sturtevant would ascertain their skills and suggest an appropriate apprentice work, and he and Bridges then shepherded them through more demanding projects to full independence. None of the senior drosophilists regarded students or visitors as disciples who would follow their lead and enhance their status, as was the custom in many academic departments. The fly group had many devoted alumni, but it was not a "school."

This conception of dispersed authority also guided the relations between Morgan and his "boys," though not unambiguously. Almost from the very start of the mapping project in 1912, Morgan gave Sturtevant and Bridges (and Muller, for the years he was in the group) virtually complete control over what was done on the shop floor. The boys controlled their work. Morgan, though he kept sole control of how the Carnegie Institution's grant was spent and of academic business (e.g., curricula), never attempted to set agendas or direct the group's work. Indeed, as the work became more technical and arcane, Morgan relied on the boys to help him design his own experiments. And as Morgan's interest turned to other organisms in the 1920s, it was the boys who ran the drosophila show. In the workplace Morgan, known with respectful affection as the "Boss," behaved much like one of the boys. Research agendas emerged from the group's communal work as individuals chose to pursue one or another of the various leads that turned up.

These values were not preached but practiced. Jack Schultz, who got his Ph.D. in 1929 and remained in the fly group until 1942, thought the group's cooperative spirit derived from Morgan but could recall no explicit discussion of its virtues. It was taught by personal example and came, he thought, from the paramount importance that Morgan and the rest gave to getting on with the work.[5] Doing good work was the only thing that mattered in the end, and the principles of the group's moral economy were practical encouragements to put the work first.

None of these ideals of access, equity, and authority was unique to the fly group, but few research groups displayed all of them so fully and self-consciously. What features of the fly group, then, account for its distinctive customs? The most important cause, I believe, was the fly itself, that cornucopia of research material and problems. The fly group's social organization and moral economy coevolved with the mapping project and was designed to exploit the advantages of a superabundance of material. There was nothing to be gained in limiting access to tools or in exclusive ownership of problems. And it would have been self-defeating to pursue preset agendas or divide up the field when the choicest problems turned up unexpectedly as by-products of the mapping project. Abundance did not merely reduce the temptations of self-interest. Rather, it ensured that self-interest was best served by giving free access to tools, freely exchanging ideas (even if someone else might occasionally reap the benefit), and leaving the choice of problems unconstrained. Just as Bridges's chromosome maps represented the blueprint of the standard fly, so the drosophilists' rules of moral economy constituted the design of an intricate social instrument that enabled them to make the most of the opportunities thrown their way by the mapping project and the fly.

A more parsimonious organism and experimental system would doubtless have given rise to a quite different moral economy. So, too, might the fly in a different cultural context of practice. Material culture does not by itself determine behavior. The logic of advantage and value is logical only in particular scientific cultures and contexts of practice. I have quietly assumed, for example, that the drosophilists would of course exploit the advantages of their breeder reactor. But why of course? They did, but what impelled them to do so? One part of the answer is that they were at first a small minority, pursuing an unfamiliar and suspect mode of genetic practice in a world filled with more established and trusted modes—modes made powerful by other groups exploiting the advantages of their organisms and systems. In this larger context it was logical, even necessary for survival, to take pains to exploit any local advantages. That was how experimental science in general worked (and still does work).

Another part of the answer is that Morgan, as an experimental biologist in the United States around 1900, was a member of a larger community of practice that highly valued mutual aid and cooperation (even when they did not practice it). There are historical reasons why this culture of mutual aid was especially strong at that particular time and place, which have to do with the way in which American academics assimilated European ideals of research into a system of higher education that valued mass teaching and was short on resources for doing research and training researchers.[6] Overexpansion, and the American custom that every institution had a right to participate in high culture, created a generation of academic scientists who aspired to do research but lacked the training and opportunity. In this context, mutual aid was an ideologically acceptable and affordable strategy.

Among biologists the culture of mutual aid was especially strong at centers of community life like the Marine Biological Laboratory (MBL) at Woods Hole, a major purpose of which was to enable teachers in small colleges and high schools to engage with colleagues from research universities in vanguard research.[7] Summer work at the MBL also powerfully reinforced the virtues of equal access and mutual aid. Morgan was a leading figure at the MBL, migrating there every summer during the Columbia years with the whole fly group, complete with flies and paraphernalia. He consciously exemplified the MBL's virtues of access and mutual aid.

The moral economy of the fly group, then, may best be understood as an amplified form of values widely held by American experimental biologists at the time. The amplifier was *Drosophila,* the breeder reactor. Its abundance cooled any selfish temptation to retreat from the ideals of mutual aid and helped drosophilists make their values of access to tools, credit for work, and equal authority in the workplace into living values.

We cannot understand how research communities define what is virtuous and pursue "advantage" without some knowledge of the culture of science in general and of the larger societies in which scientists operate. No community is unconstrained in the way it conceives of basic social qualities like virtues and advantage. Scientists operate socially and ethically with what is given and familiar in their society, as do the members of any subculture. It would be an odd group of scientists whose working customs were not variants of those they had been brought up to live by, and it is unlikely that such a group would be long-lived. Close inspection of group behavior takes us a good way toward understanding why they do what they do, but it risks a vulgar functionalism, which explains behavior in terms of its benefits to group members but leaves unexamined how conceptions of "benefit" and its proper pursuit derive from the larger social context.

## THE MORAL ECONOMY OF EXCHANGE

The fly group's values were not restricted to them but were extended to drosophilists throughout the world by a remarkable custom of free exchange of mutant stocks. This was the custom from the very earliest years, even before the mapping project began in 1912. If a qualified researcher asked for stocks, the fly group provided them free of charge and with no strings attached; and not just stocks that had been worked out and published. Even new, actively producing mutants were expected to be shared if someone dreamed up a productive use for them. Though the custom of exchange was imitated by biologists who worked with other organisms, few engaged in exchange as systematically and devotedly as did the fly people. Drosophilists were unabashedly

proud of their tribal custom. For them it was far more than a technical aid to work; it was a mark of professional identity, a badge of citizenship in a special community.

It would be hard to overstate the importance of this custom of exchange. Exchange enabled the fly group to exploit the abundance of *Drosophila* to a degree not possible had they tried to maintain a local monopoly. Most important, the custom of exchange enabled mapping genetics to become, not one among several competing modes of genetic practice, but the premier mode. Exchange is what made mapping genetics the standard genetics and the fly the *standard* fly. It made a restricted, local form of practice into a universal, cosmopolitan one; it spread the fly group's customs and moral economy to drosophilists everywhere. Free exchange of knowledge and the results of work was an essential feature of experimental science for centuries, but exchanging the tools and means of knowledge production was a far more powerful instrument of dispersal. Formal publications spread the *word* of mapping and the standard fly, but exchange of stocks and know-how spread the *work*.

The exchange system, like the fly group, was an intricate piece of social machinery that required careful design and tending. The intricacy lay less in its mechanics—swapping tubes of flies was not much more complicated than using the public mails—than in its moral rules. Just think of the risk that the fly people took when they sent their most productive mutant stocks to potential rivals! How easy to take unfair advantage! Yet cases of abuse were almost unheard of. Drosophilists were and still are a remarkably civil and trusting bunch, owing to the moral rules that guided their system of exchange.

Though seldom articulated, these rules can readily be discerned in the numerous letters that attended tubes of flies from one drosophilist to another. One was *reciprocity*: the privilege of receiving stocks entailed the obligation to reciprocate if asked. To be sure, the fly group and other large centers gave far more than they received—Bridges spent a great deal of his time sending stocks and directions for their use—but the principle of reciprocity displayed the presumption of equality among producers. Cash was generally not an acceptable alternative to swaps, though stocks provided for classroom use, where there was no basis for reciprocity, gradually moved from the moral economy to the cash nexus. This clear demarcation between swapping and cash exchange illustrates the moral character of reciprocity as nothing else does. We have to do not with market values (political economy) but a moral economy.

A second principle of this moral economy was *disclosure*. Recipients of stocks were expected to inform donors fully of the experiments they intended to do with them, especially if they were working on similar problems. Disclosure was vital for securing trust among potential rivals and dispelling suspicions that were entirely natural among people who were constantly exposing each other to the temptation to betray a trust. Disclosure discouraged poaching by making it impossible (or very awkward) for recipients to give ignorance as an excuse for misbehavior, and giving donors the opportunity to nip unwitting competition in the bud. Failures to disclose were taken as reason to suspect borrowers' intentions and to cut them out of the exchange system (though it almost never came to that).

An important by-product of the custom of disclosure was that exchanging stocks could also serve as an informal system of communicating plans and results in advance of publication. Every stock carried with it information about fast-breaking results and future plans. This informal communication system among producers was faster and more useful for actual practice than official publication (being personal and less guarded), and it was certainly a major reason for the remarkable dispersive and productive power of fly genetics.

A third principle of exchange was *limited ownership*. While problems might be owned temporarily by individuals, tools were regarded as the property of the whole community of producers. Within limits: it was customary with special stocks, like Bridges's multiply-marked mapping stocks, or versatile triploids or translocations, to get permission to use them from their inventors. This courtesy showed respect for the skill and hard work that had gone into constructing these special tools. It was taken for granted that permission would not be refused. But not to ask was taken as reason to suspect that the borrower might be a poacher. When the Swedish geneticist, Gert Bonnier, failed to get Bridges's permission before using one of his special stocks, drosophilists wondered if he could be trusted with further gifts. In this case, as in most, it was simply a beginner's ignorance of etiquette. But when Curt Stern asked the fly group to leave to him a problem on which they had both started work, Sturtevant responded sharply that no one had copyright on any problem, and besides, Stern could rest assured that they were doing a state-of-the-art job. There was no arguing with the drosophilists' golden rule, and Stern did not pursue the matter.[8] The sanctions against abuse of the exchange system were insubstantial but remarkably effective. I know of no instance of serious abuse nor any in which the implicit threat of exclusion was carried out.

No trade secrets, no monopolies, no poaching, no ambushes—these were the practical rules for maintaining trust and harmonious relations among the fly people.

The moral rules of the *Drosophila* exchange system were clearly adaptations of the fly group's customs of communal work to a wider community, in which trust could not be maintained in daily, face-to-face interactions. The question again is: How did these customs arise, and why did they work so well? The answer is in part individual preference: as Morgan wrote his patron, Robert S. Woodward, "The method of locking up your stuff until you have published about it, or of keeping secret your ideas and progress have never appealed to me personally." But what made it possible for individuals to act on their preference for openness was the abundance of the fly: "It may be," Morgan went on, "that we can claim no special virtue here, for Drosophila is like the air we breathe—there is enough for all."[9]

Evidence does in fact exist for Morgan's suggestion that it was the abundance of the fly that enabled drosophilists to be generous. The first glimpse we have of the exchange system in action comes from 1911–12, when Morgan was desperately trying to keep his nose above the flood of mutants. In his need he turned to teachers of biology in small colleges, inviting them to perform some part of the *Drosophila* work in return for a Ph.D. degree. Morgan provided the mutant stocks and know-how, and his distant partners did the work on their own limited schedules. The need for this makeshift diminished when Sturtevant and Bridges became permanent members of the mapping team and as resident graduate students took up some of the load. The mapping project only increased the flood of material, however, and Morgan's improvised system of putting out became a regular system of exchange among *Drosophila* workers, many of them fly-group alumni.

The custom of exchange mixed altruism with enlightened self-interest, bringing substantial benefits to the fly group. Spreading the work of mapping made it widely familiar and acceptable. Prospective students and converts could sign on in confidence that they would have continuing access to the tools of their new trade after leaving the fly group. Who would sign on without such assurance? Morgan was well aware that strength would lie in numbers. Practices limited to one place are open to attack as merely local and idiosyncratic; scientists trust knowledge that is widely practiced and cosmopolitan. And what more compelling reason to trust an unproved

mode of practice than to see it work with your own eyes, as a student, or to make it work with your own hands? Finally, exchange kept the fly group au courant about what other drosophilists were doing, enabling them to spot important new leads and avoid dead ends. None of this makes the custom of exchange any less virtuous: the point is that the abundance of the fly and of genetic mapping united virtue with self-interest.

The fly people did not invent the custom of exchange; natural historians, for example, had been swapping specimens for centuries.[10] But the drosophilists adapted this custom to the world of experimental laboratories and standard organisms, refining its practices and giving it the strength of communal virtue. Similar systems of exchange have since been created for just about every standard organism—maize, bacteria, phage, and so on. But the fly people still, even today, identify most strongly with the ideals of mutual aid and civility. These virtues and practices define who they are and what makes them distinctive. In part this reflects the unusually durable authority of the Morgan group, who set the pace and moral tone of work in a world grown vastly larger and competitive. The standard fly and the practices and values that have accreted around it were both a means of production and the vehicle of a community's distinctive way of life.

## CONCLUSION

Can we generalize from this case study? The fly group was a particular—even peculiar—case. First, it was an extramurally funded research institute somewhat awkwardly encysted in an academic department of zoology, with its quite different customs. (Academic biologists normally avoided competition by working on different organisms.) Second, the grant that enabled Morgan and his students to stay together for thirty years froze the psychosocial dynamic of "Boss" and "boys" at the stage of mentor and students, and this neotenous relation perturbed personal relations in the group. Finally, comparably large and talented groups did not arise to challenge the fly group's leadership for almost twenty-five years, and the absence of institutional rivalries certainly encouraged free exchange. (This changed somewhat in the 1930s.) But if the drosophilists were so special, what can we learn from this case study about experimental biology in general, or physiology, or physics?

In fact we learn a good deal, because while scientists handle the issues of practice and moral economy in varied ways, depending on local contingencies of personality, politics, and material conditions, these issues are universal to experimental life. The practical process of producing experimental knowledge requires that problems be defined, tools and methods devised, wherewithal secured, communities and intergroup relations constituted, moral order maintained. A study of variation in the practices of different groups is very likely, then, to provide insights into these fundamental elements of scientific work.

There is much evidence for this observation. That workers with various standard genetic organisms have devised similar exchange systems strongly suggests that the causal link between material culture and moral order is a general one. That the standard animals of biomedical disciplines (mammals, mainly) tend to be sold for cash and not swapped suggests how a connection with a powerful profession alters this linkage.[11] There is evidence, too, that abundance of material generally supports a moral economy of mutual aid. But where the rewards of labor are limited to a single winner, as in searches for new vitamins and hormones, infectious agents (the AIDS virus, e.g.) or genes—there secrecy, competitive races, and a bitch-the-other-guy-if-you-can

morality prevails. Drosophilist George Beadle discovered this to his disgust when he ventured into the field of vitamin assay. The recent decline of open exchange among molecular biologists is clearly related to their involvement in the highly lucrative biotechnology industry. Now, new tools are patented, and university lawyers rule on proposed exchanges.

Concepts of practice and moral economy are well on their way to being central, defining concerns of science studies, but in an oddly contentious way. Like all the human sciences, science studies is struggling through the great postmodern pandemic, factionalized by theories, methodologies, and interests that seem to have more to do with staying visible and getting a leg up than with achieving a shared understanding of how science works. In the study of scientific practice, theoretical approaches have succeeded one another at an ever faster pace—interest, social construction, actor network, social world, discourse, agency, and mangle, just to mention some of the better known. A vanguard strategy has its uses, true: displays of arcane expertise warn off critics, confer academic status, and protect turf. But there are costs, and even people who are sympathetic are getting confused and a little fed up.

The approaches just listed are hardly worthless. I know of few that have not contributed in important ways to our understanding of science, and I have myself borrowed from a number of them though allied myself with none. Readers in the know will easily recognize how compatible my account is with those especially of Steven Shapin (moral economy, trust), Bruno Latour I (credit cycle) and II (actor-networks, immutable mobiles), and the sociologists of work.[12] My complaint, rather, is that we in science studies are too quick to turn ideas into ideologies and methods into methodologies, and to let means of analysis become ends. Perhaps this odd custom is the best we can do to constitute community and authority in a field that is ambiguously multidisciplinary and has no powerful constituencies to provide shelter in political storms and to broker consensus. In a period of general and profound distrust of central institutions and authorities, scholars who seem overly concerned with consensus and community make themselves and their work easy targets in the skirmishing of cultural politics. But the times may be changing, and if the problem of reconstituting community in a pluralist society should become an urgent social issue, we may be sure that the human sciences—and science studies with them—will not be far behind.

We practitioners of science studies should settle down and concentrate on the subject and the questions that are ours alone and that define us as knowledge producers: How does science work, and why? How do scientists go about their business of producing natural knowledge, and what is it about their practices and communal customs that has won them such high standing in modern societies? How do methods coevolve with material culture, and modes of practice with moral economies? How do the customs of particular communities vary? How do they derive and depart from those of the larger society? It is in the hope of answering these important questions that we study the material culture and practices, the moral economies, and the social history of groups like the drosophilists.

NOTES

1. This paper is a brief reprise of the main ideas of my book, *Lords of the Fly: Drosophila Genetics and the Experimental Life* (Chicago: University of Chicago Press, 1994). I have kept references to a minimum, assuming that readers who want the whole story and full documentation will turn to the book.

2. T. H. Morgan to Charles B. Davenport, 14 March 1911; and Charles Metz to Davenport, 13 Apr. 1911, 13 July 1922, Davenport Papers, American Philosophical Society. Morgan to Hans Driesch, 1 January 1912, Morgan Papers, American Philosophical Society.

3. Edward P. Thompson, "The moral economy of the English crowd in the eighteenth century," and "The moral economy revisited," in Thompson, *Customs in Common* (New York: New Press, 1991), 185–258, 259–351.

4. Sturtevant and Bridges were officially employees of the Carnegie Institution of Washington from 1914 and had no academic appointments. Sturtevant was made professor when the group migrated to Caltech in 1928, but Bridges never was.

5. Jack Schultz to George Beadle, July 31, 1970, Schultz Papers, American Philosophical Society.

6. Robert E. Kohler, "The Ph.D. machine: building on the collegiate base," *Isis* 81 (1991): 638–62.

7. Philip J. Pauly, "Summer resort and scientific discipline: Woods Hole and the structure of American biology, 1882–1925," in *The American Development of Biology,* eds., Ronald Rainger, Keith R. Benson, and Jane Maienschein, (Philadelphia: University of Pennsylvania Press, 1988), 121–50.

8. Kohler, *Lords of the Fly,* 145–46, 150.

9. Morgan to Robert S. Woodward, July 25, 1917, Carnegie Institution Archives.

10. Anne L. Larsen, "Not Since Noah: The English Scientific Zoologist and the Craft of Collecting, 1800–1840" (Ph.D. dissertation, Princeton University, 1993).

11. Bonnie T. Clause, "The Wistar rat as a right choice: Establishing mammalian standards and the ideal of a standardized mammal," *Journal of the History of Biology* 26 (1993): 329–50.

12. Steven Shapin and Simon Schaffer, *Leviathan and the Air Pump: Hobbes, Boyle, and the Experimental Life* (Princeton: Princeton University Press, 1985). Steven Shapin, *A Social History of Truth: Civility and Science in Seventeenth-Century England* (Chicago: University of Chicago Press, 1994). Steven Shapin, "Trust, honesty, and the authority of science," in *Society's Choices: Social and Ethical Decision Making in Biomedicine,* eds. Ruth E. Bulger, Elizabeth M. Bobby, and Harvey V. Fineberg (Washington, D.C.: National Academy Press, 1995), 388–408. Bruno Latour and Steven Woolgar, *Laboratory Life: The Construction of Scientific Facts,* 2d ed. (Princeton: Princeton University Press, 1986), ch. 5. Bruno Latour, "Visualization and cognition: thinking with eyes and hands," *Knowledge and Society* 6 (1986): 1–40. Bruno Latour, *Science in Action* (Cambridge, Mass.: Harvard University Press, 1987). Everett C. Hughes, *Men and their Work* (New York: Free Press, 1958). Adele E. Clarke and Elihu M. Gerson, "Symbolic interactionism in social studies of science," in *Symbolic Interactionism and Cultural Studies,* eds. Howard S. Becker and Michael M. McCall (Chicago: University of Chicago Press, 1990), 179–214.

# 18

# Give Me a Laboratory and I Will Raise the World

## BRUNO LATOUR

In this chapter, I would like to propose a simple line of enquiry: that is, to stick with the methodology developed during laboratory field studies, focusing it not on the laboratory itself but on the construction of the laboratory and its position in the societal milieu (Callon, 1982). Indeed, I hope to convince the reader that the very difference between the "inside" and the "outside," and the difference of scale between "micro" and "macro" levels, is precisely what laboratories are built to destabilize or undo. So much so, that without keeping back the discoveries we made while studying laboratory practices we can reassess the so-called "macro" problems much more clearly than before and even throw some light on the very construction of macroactors themselves. I simply beg the readers to put aside for a time their belief in any real difference between micro- and macroactors at least for the reading of this paper (Callon and Latour, 1981).

## I. "GIVE ME A PLACE TO STAND AND I WILL MOVE THE EARTH"

To illustrate my argument I will extract an example from a recent study done in the history of science (Latour, 1988). We are in the year 1881, the French semipopular and scientific press is full of articles about the work being done in a certain laboratory, that of Monsieur Pasteur at the École Normale Supérieure. Day after day, week after week, journalists, fellow scientists, physicians, and hygienists focus their attention on what is happening to a few colonies of microbes in different mediums, under the microscope, inside inoculated animals, in the hands of a few scientists. The mere existence of this enormous interest shows the irrelevance of too sharp a distinction between the "inside" and the "outside" of Pasteur's lab. What is relevant is the short circuit established between many groups usually uninterested by what happens inside laboratory walls, and laboratories usually isolated and insulated from such attention and passion. Somehow, something is happening in these dishes that seems directly essential to the projects of these many groups expressing their concern in the journals.

This interest of outsiders for lab experiments is not a given: it is the result of Pasteur's work in enrolling and enlisting them. This is worth emphasizing since there is a quarrel among sociologists of science about the possibility of imputing interests to people. Some, especially the Edinburgh school, claim that we can impute interests to social groups given a general idea of what the groups are, what society is made of, and even what the nature of man is like. But others (Woolgar, 1981) deny the possibility of such imputation on the grounds that we do not have any independent way of knowing what the groups are, what society is after, and what the nature of man is like. This dispute, like most, misses the fundamental point. Of course there is no way of knowing which are the groups, what they want, and what man is, but this does not stop anyone from convincing others of what their interests are and what they ought to want and to be. He who is able to translate others' interests into his own language carries the day. It is especially important *not* to rely on any science of society or science of man to impute interests because, as I will show, sciences are one of the most convincing tools to persuade others of who they are and what they should want. A sociology of science is crippled from the start if it believes in the results of one science, namely sociology, to explain the others. But it is still possible to follow how sciences are used to transform society and redefine what it is made of and what are its aims. So it is useless to look for the profit that people can reap from being interested in Pasteur's laboratory. Their interests are a consequence and not a cause of Pasteur's efforts to translate what they want or what he makes them want. They have no a priori reason to be interested at all, but Pasteur has found them more than one reason.

## I. MOVE ONE: CAPTURING OTHERS' INTERESTS

How has Pasteur succeeded in capturing the interests of other indifferent groups? By the same method he has always used (Geison, 1974; Salomon-Bayet, 1982). He transfers himself and his laboratory into the midst of a world untouched by laboratory science. Beer, wine, vinegar, diseases of silk worms, antisepsy and later asepsy, had already been treated through these moves. Once more he does the same with a new problem: anthrax. The anthrax disease was said to be terrible for French cattle. This "terrible" character was "proven" by statistics to officials, veterinarians, and farmers, and their concerns were voiced by the many agricultural societies of the time. This disease was studied by statisticians and veterinarians, but laboratory practice had no bearing on it before Pasteur, Koch, and their disciples. At the time, diseases were local events that were to be studied with all possible attention by taking into account all the possible variables— the soil, the winds, the weather, the farming system, and even the individual fields, animals, and farmers. Veterinary doctors knew these idiosyncrasies, but it was a careful, variable, prudent, and uncertain knowledge. The disease was unpredictable, and recurred according to no clear pattern, reinforcing the idea that local idiosyncrasies had to be taken into account. This multifactorial approach made everyone extremely suspicious of any attempt to cut through all these idiosyncrasies and to link one disease with any single cause, such as a microorganism. Diseases like anthrax, with all their variations, were typically what was thought not to be related to laboratory science. A lab in Paris and a farm in Beauce have nothing in common. They are mutually uninteresting.

But interests, like everything else, can be constructed. Using the work of many predecessors who had already started to link laboratories and anthrax disease, Pasteur goes one step further and works in a makeshift laboratory right on the farm site. No two places could be more foreign to one another than a dirty, smelly, noisy, disorganized nineteenth-century animal farm and

the obsessively clean Pasteurian laboratory. In the first, big animals are parasited in seemingly random fashion by invisible diseases; in the second, microorganisms are made visible to the observer's eye. One is made to grow big animals, the other to grow small animals. Pasteur (the "shepherd" in French) is often seen in the enthusiasm of the moment as the inventor of a new animal husbandry and a new agriculture, but at the time these two forms of livestock have little relation to one another. Once out in the field, however, Pasteur and his assistants learn from the field conditions and the veterinarians and start creating these relations. They are interested in pinpointing all the variations in the onset and timing of the outbreaks of anthrax and in seeing how far these could fit with their one living cause, the anthrax bacillus. They learn from the field, translating each item of veterinary science into their own terms so that working on their terms is also working on the field. For instance, the spore of the bacillus (shown by Koch) is the translation through which dormant fields can suddenly become infectious even after many years. The "spore phase" is the laboratory translation of the "infected field" in the farmer's language. The Pasteurians start by learning this language and giving one of their own names for each of the relevant elements of the farmer's life. They are interested in the field but still useless and uninteresting for the farmers and their various spokesmen.

## 2. MOVE TWO: MOVING THE LEVERAGE POINT FROM A WEAK TO A STRONG POSITION

At this point Pasteur, having situated his laboratory on the farm, is going to transfer it back to his main workplace at the École Normale Supérieure, taking with him one element of the field, the cultivated bacillus. He is the master of one technique of farming that no farmer knows, microbe farming. This is enough to do what no farmer could ever have done: grow the bacillus in isolation and in such a large quantity that, although invisible, it becomes visible. Here again we have, because of laboratory practice, a variation of scale: outside, in the "real" world, inside the bodies, anthrax bacilli are mixed with millions of other organisms with which they are in a constant state of competition. This makes them doubly invisible. However, in Pasteur's laboratory something happens to the anthrax bacillus that never happened before (I insist on these two points: something happens *to the bacillus* that *never* happened before). Thanks to Pasteur's methods of culture it is freed from all competitors and so grows exponentially, but, by growing so much, ends up, thanks to Koch's later method, in such large colonies that a clear-cut pattern is made visible to the watchful eye of the scientist. The latter's skills are not miraculous. To achieve such a result you only need to extract one microorganism and to find a suitable milieu. Thanks to these skills, the asymmetry in the scale of several phenomena is modified: a microorganism can kill vastly larger cattle; one small laboratory can learn more about pure anthrax cultures than anyone before; the invisible microorganism is made visible; the until now uninteresting scientist in his lab can talk with more authority about the anthrax bacillus than veterinarians ever have before.

The translation that allows Pasteur to transfer the anthrax disease to his laboratory in Paris is not a literal, word-for-word translation. He takes only one element with him, the microorganism, and not the whole farm, the smell, the cows, the willows along the pond, or the farmer's pretty daughter. With the microbe, however, he also draws along with him the now interested agricultural societies. Why? Because having designated the microorganism as the living and pertinent cause, he can now reformulate farmers' interests in a new way: if you wish to solve *your* anthrax problem you have to pass through *my* laboratory first. Like all translations there is a real

displacement through the various *versions.* To go straight at anthrax, you should make a detour through Pasteur's lab. The anthrax disease *is* now at the École Normale Supérieure.

But this version of the translation is still a weak one. In Pasteur's lab, there is a microbe, but anthrax infection is too disorderly a thing to be explained with a single cause only. So the outside interests could as well say that the laboratory has no real bearing on the spread of anthrax disease, and that it is just plain arrogance for a scientist to claim that he holds the key to a real disease "out there." But Pasteur is able to make a more faithful translation than that. Inside the walls of his laboratory, he can indeed inoculate animals he has chosen with pure, much-diluted culture of anthrax. This time, the outbreak of an epizootic is mimicked on a smaller scale entirely dominated by the charting and recording devices of the Pasteurians. The few points deemed essential are imitated and reformulated so as to be scaled down. The animals die of the microbes, and only of that, and epizootics are started at will. It can now be said that Pasteur has inside his laboratory, on a smaller scale, the "anthrax disease." The big difference is that "outside" it is hard to study because the microorganism is invisible and strikes in the dark, hidden among many other elements, while "inside" the lab clear figures can be drawn about a cause that is there for all to see, due to the translation. The change of scale makes possible a reversal of the actors' strengths; "outside" animals, farmers, and veterinarians were *weaker* than the invisible anthrax bacillus; inside Pasteur's lab, man becomes stronger than the bacillus, and as a corollary, the scientist in his lab gets the edge over the local, devoted, experienced veterinarian. The translation has become more credible and now reads: "If you wish to solve your anthrax problem, come to my laboratory, because that's where the forces are reversed. If you don't (veterinarians or farmers), you will be eliminated."

But even at this point, the strength is so disproportionate between Pasteur's single lab and the multiplicity, complexity, and economic size of the anthrax outbreaks, that no translation could last long enough to keep the aggregation of interest from falling apart. People readily give their attention to someone who claims that he has the solution to their problems but are quick to take it back. Especially puzzling for all practitioners and farmers, is the *variation* of the disease. Sometimes it kills, sometimes not, sometimes it is strong, sometimes weak. No contagionist theory can account for this variety. So Pasteur's work, although interesting, could soon become a curiosity or more precisely, a laboratory curiosity. It would not be the first time that scientists attract attention, only to have nothing come out of it in the end. Microstudies remain "micro," the interests captured for a time soon go to other translations from groups that succeed in enrolling them. This was especially true of medicine which at the time was tired of continuous fashions and fads (Leonard 1977).

But here Pasteur does something on chicken cholera and on anthrax bacillus inside his laboratory that definitively modifies the hierarchy between veterinary science and microbiology. Once a great many microbes are cultivated in pure forms in laboratories and submitted to numerous trials to make them accelerate their growth or die, a now practical know-how is developed. In a few years, experimenters acquire skills in manipulating sets of materials that never existed before. This is new but not miraculous. Training microbes and domesticating them is a craft like printing, electronics, blue-ribbon cooking, or video art. Once these skills have accumulated inside laboratories, many crossovers occur that had no reason to occur anywhere else before. This is not because of any new cognitive attitude, or because suddenly people become conscious of microorganisms they were unaware of before. It is simply that they are manipulating new objects and so acquiring new skills in a new idiosyncratic setting (Knorr, 1981).

The chance encounter that made possible the first attenuated culture of chicken cholera is well known (Geison, 1974), but chance favors only well-prepared laboratories. Living causes of man-made diseases undergo so many various trials that it is not that surprising if some of these trials leave some microbes alive but weak. This modification would have been invisible if the laboratory had not tried to imitate the salient features of epizootics by inoculating many animals. The invisible modification of the invisible microbes is then made visible; chickens previously inoculated with the modified strain don't get cholera, but they resist inoculation of intact microbes. Submitting cultures of chicken cholera to oxygen is enough to make them less virulent when they are inoculated into the animals. What is made visible through the lab statistics is the chain of weakened microbes, then strengthened microbes and eventually, strengthened animals. The result is that laboratories are now able to imitate the *variation of virulence*.

It is important to understand that Pasteur now does more and more things inside his laboratory which are deemed relevant by more and more groups to their own interests. Cultivating the microbes was a curiosity; reproducing epizootics in labs was interesting; but varying at will the virulence of the microbes is fascinating. Even if they believed in contagion, no one could with this one cause explain the randomness of the effects. But Pasteur is not only the man who has proved the relation of one microbe/one disease, he is also the one who has proved that the infectiousness of microbes could vary under conditions that could be controlled, one of them being, for instance, a first encounter of the body with a weakened form of the disease. This variation in the laboratory is what makes the translation hard for others to dispute: the variation was the most puzzling element that previously justified the skepticism towards laboratory science, and made necessary a clear differentiation between an outside and inside, between a practical level and a theoretical level. But it is precisely this variation that Pasteur can imitate most easily. He can attenuate a microbe; he can, by passing it through different species of animals, on the contrary, exalt its strength; he can oppose one weak form to a strong one, or even one microbial species to another. To sum up, he can do inside his laboratory what everyone tries to do outside, but where everyone fails because the scale is too large, Pasteur succeeds because he works on a small scale. Hygienists who comprise the largest relevant social movement of that time are especially fascinated by this imitated variation. They deal with whole cities and countries, trying to pinpoint why winds, soil, climates, diets, crowding, or different degrees of wealth accelerate or stop the evolution of epidemics. They all see—they are all led to see—in the Pasteurian microcosmos what they are vainly trying to do at the macroscopic level. The translation is now the following: "If you wish to understand epizootics and soon thereafter epidemics, you have one place to go, Pasteur's laboratory, and one science to learn that will soon replace yours: microbiology."

As the reader is aware, I am multiplying the words "inside" and "outside," "micro" and "macro," "small scale" and "large scale," so as to make clear the destabilizing role of the laboratory. It is through laboratory practices that the complex relations between microbes and cattle, the farmers and their cattle, the veterinarians and the farmers, the veterinarians and the biological sciences, are going to be transformed. Large interest groups consider that a set of lab studies talk to them, help them, and concern them. The broad concerns of French hygiene and veterinary sciences will be settled, they all say, inside Pasteur's laboratory. This is the dramatic short circuit I started with: everyone is interested in lab experiments which a few years before had not the slightest relation to their fields. This attraction and capture were made by a double movement of Pasteur's laboratory to the field and then from the field to the laboratory where a fresh source of know-how has been gained by manipulating a new material: pure cultures of microbes.

## 3. MOVE THREE: MOVING THE WORLD WITH THE LEVER

But even at this stage, what was in the laboratory could have stayed there. The macrocosmos is linked to the microcosmos of the laboratory, but a laboratory is never bigger than its walls and "Pasteur" is still only one man with a few collaborators. No matter how great the interests of many social groups for what is being done in one laboratory, there is nothing to stop interests from fading and dispersing if nothing more than laboratory studies happens. If Pasteur stays too long inside his laboratory and, for instance, shifts his research programme using the anthrax microbe to learn things in biochemistry, like his disciple Duclaux, people could say: "Well after all, it was just an interesting curiosity!" It is only by hindsight that we say that in this year 1881 Pasteur invented the first artificial vaccination. By doing so we forget that to do so it was necessary to move still further, this time from the laboratory to the field, from the microscale to the macroscale. As for all translations it is possible and necessary to distort the meanings but not to betray them entirely. Groups that accepted to pass through Pasteur's hands in order to solve their problems nevertheless only go through him to their own ends. They cannot stop in his laboratory.

Pasteur, from the start of his career, was an expert at fostering interest groups and persuading their members that their interests were inseparable from his own. He usually achieved this fusion of interests (Callon, 1981) through the common use of some laboratory practices. With anthrax he does just that but on a more grandiose scale, since he is now attracting the attention of groups that are the mouthpiece of larger social movements (veterinary science, hygiene, soon medicine), and about issues that are the order of the day. As soon as he has performed vaccinations in his laboratory he organizes a field trial on a larger scale.

This field experiment was organized under the auspices of the agricultural societies. Their attention had been captured by Pasteur's former moves, but the translation ("solve your problems through Pasteur's lab") implied that *their* problems could be solved and not only Pasteur's. So the translation is also understood in part as a contract, the counterpart of which is now expected from Pasteur. "We are ready to displace all our interests through your methods and practices so that we can use them to reach our own goals." This new translation (or displacement) is as hard to negotiate as the first one. Pasteur has a vaccine for anthrax in his laboratory at Paris. But how can laboratory practice be extended? In spite of all the niceties written by epistemologists on that point, the answer is simple: only by extending the laboratory itself. Pasteur cannot just hand out a few flasks of vaccine to farmers and say: "OK, it works in my lab, get by with that." If he were to do that, it would *not* work. The vaccination can work only on the condition that the farm chosen in the village of Pouilly le Fort for the field trial be in some crucial respects transformed according to the prescriptions of Pasteur's laboratory. A hard negotiation ensues between Pasteurians and agricultural interests on the conditions of the experiment. How many inoculations? Who will be the umpire? And so on. This negotiation is symmetrical to the initial one when Pasteur came to the farm site, trying to extract the few pertinent elements of the disease that he could imitate inside his laboratory. Here, the problem is to find a compromise that extends Pasteur's laboratory far enough—so that the vaccination can be repeated and work—but which is still acceptable to the farming representatives so that it is seen as an extension of lab science outside. If the extension is overreached, the vaccination will fail and Pasteur will be thrown back inside his laboratory by the disappointed farmers. If the extension is too modest, the same thing will happen: Pasteur will be considered to be a lab scientist uninteresting for others' outside use.

The Pouilly le Fort field trial is the most famous of all the dramatic proofs that Pasteur staged in his long career. The major mass media of the time were assembled on three successive occasions to watch the unfolding of what was seen as Pasteur's prediction. "Staging" is the right word because, in practice, it is the public showing of what has been rehearsed many times before in his laboratory. It is strictly speaking a repetition, but this time in front of an assembled public which has previously invested so much interest and is now expecting its rewards. Even the best performer has stage fright, even if everything has been well rehearsed. Indeed this is what happened (Geison, 1974). But for the media it was not seen as a performance, it was seen as a prophecy. The reason behind this belief shows us exactly why the distinction between inside and outside of the laboratory is so misleading. If you isolate Pasteur's laboratory from the Pouilly le Fort farm, so that one is the inside and the other is the outside world, then of course there is a miracle for all to see. In his lab Pasteur says, "all vaccinated animals will be alive by the end of May; all the untreated animals will have died by the end of May; and outside the lab the animals die or survive." Miracle. Prophecy, as good as that of Apollo. But if you watch carefully the prior displacement of the laboratory to capture farmers' interest, then to learn from veterinary sciences, then to transform the farm back into the guise of a laboratory, it is still interesting, extraordinarily clever, and ingenious, but it is *not* a miracle. I will show later that most of the mystified versions of scientific activity come from overlooking such displacements of laboratories.

But there is still one step to make so that we reach our point of departure: the anthrax outbreaks and their impact on French agriculture. Remember that I said it was a "terrible" disease. While saying this I heard my ethnomethodologist friends jumping on their chairs and screaming that no analyst should say that "a disease is terrible" or that "French agriculture" exists, but rather that these are social constructions. Indeed they are. Watch now how the Pasteur group is going to use these constructions to their advantage and to France's. Pouilly le Fort was a staged experiment to convince the investors—in confidence and later in money—that the translation made by Pasteur was a fair contract. "If you want to solve your anthrax problem go through my microbiology." But after Pouilly le Fort, everyone is convinced that the translation is now: "If you want to save your animals from anthrax, order a vaccine flask from Pasteur's laboratory, École Normale Supérieure, rue d'Ulm, Paris." In other words, on the condition that you respect a limited set of laboratory practices—disinfection, cleanliness, conservation, inoculation gesture, timing, and recording—you can extend to every French farm a laboratory product made at Pasteur's lab. What was at first a capture of interests by a lab scientist is now extending through a network much like a commercial circuit—not quite since Pasteur sends his doses free of charge—that spreads laboratory products all over France.

But is "all over France" a social construction? Yes indeed; it is a construction made by statistics-gathering institutions. Statistics is a major science in the nineteenth century, and is what "Pasteur," now the label for a larger crowd of Pasteurians, is going to use to watch the spread of the vaccine, and to bring to the still uncertain public a fresh and more grandiosely staged proof of the efficacy of the vaccine. Throughout France as it is geographically marked out by its centralized bureaucracy, one can register on beautifully done maps and diagrams the decrease of anthrax wherever the vaccine is distributed. Like an experiment in the Pasteur lab, statisticians inside the offices of the agricultural institutions are able to read on the charts the decreasing slopes that mean, so they say, the decrease of anthrax. In a few years, the transfer of the vaccine produced in Pasteur's lab to all farms was recorded in the statistics as the cause of the decline of anthrax. Without

these statistical institutions it would of course have been utterly impossible to say whether the vaccine was of any use, as it would have been utterly impossible to detect the existence of the disease to begin with. We have now reached the point we started from. French society, in some of its important aspects, has been transformed through the displacements of a few laboratories.

## II. TOPOLOGY OF LABORATORY POSITIONING

I have chosen one example but many could be found in Pasteur's career and I am confident that every reader has many more of these in mind. The reason why we do not acknowledge these many examples is to be found in the way we treat science. We use a model of analysis that respects the very boundary between micro- and macroscale, between inside and outside, that sciences are designed to not respect. We all see laboratories but we ignore their construction, much like the Victorians who watched kids crawling all over the place, but repressed the vision of sex as the *cause* of this proliferation. We are all prudish in matters of science, social scientists included. Before drawing some general conclusions about laboratories in the third part, let me propose a few concepts that would make us become less prudish and would help to liberate all the information that we cannot help having.

### I. DISSOLUTION OF THE INSIDE/OUTSIDE DICHOTOMY

Even in the brief outline given above, the example I have chosen is enough to show that, at worst, the categories of inside and outside are totally shaken up and fragmented by lab positioning. But what word can be used that could help us to describe what happened, including this reversion leading to the breaking down of inside/outside dichotomies? I have used several times the words "translation" or "transfer," "displacement" or "metaphor," words that all say the same thing in Latin, Greek, or English (Serres, 1974; Callon, 1975). One thing is sure throughout the story told above: every actor you can think of has been to some extent *displaced* (Armatte, 1981). Pasteur's lab is now in the middle of agricultural interests with which it had no relation before; in the farms an element coming from Paris, vaccine flasks, has been added; veterinary doctors have modified their status by promoting "Pasteur's" science and the vaccine flasks: they now possess one more weapon in their black bags; and sheep and cows are now freed from a terrible death: they can give more milk and more wool to the farmer and be slaughtered with greater profit. In McNeil's terms (McNeil, 1976), the displacement of microparasites allows the macroparasites—here the farmers— to grow fatter by feeding off healthier cattle. By the same token all the macroparasitic chain of tax collectors, veterinarians, administrators, and landlords prosper by feeding off the richer farmers (Serres, 1980). One last element is pushed out—the anthrax bacillus. Wherever the veterinarian comes the small parasite has to go. In this succession of displacements, no one can say *where the laboratory is* and *where the society is*. Indeed the question "Where?" is an irrelevant one when you deal with *displacements* from a lab in Paris to some farms then back to Paris, drawing along with it the microbes and the farmers' interests; then to Pouilly le Fort where an extended repetition is staged, then to the whole agricultural system through statistics and bureaucracy. But it is clear that the situation of the farms after the moves is not the same as before. Through the leverage point of the lab, which is a moment in a dynamic process, the farm system has been displaced. It now

includes a routine annual gesture, part of which used to be a laboratory practice and still is a lab product. Everyone has changed, including the "whole society," to use common terms. This is why I used in the title a parody of Archimedes' famous motto: "give me a laboratory and I'll move the earth." This metaphor of the lever to move something else is much more in keeping with observation than any dichotomy between a science and a society. In other words, it is the same set of forces that drives people inside Pasteurian labs to strengthen microbiology and outside to stage the Pouilly le Fort experiment or to modify French agriculture. What we will have to understand later is why in this *moment* the laboratory gains strength to modify the state of affairs of all the other actors.

Another reason why the inside/outside notion is irrelevant, is that in this example the laboratory positions itself precisely so as to reproduce inside its walls an event that seems to be happening only outside—the first move—and then to extend outside to all farms what seems to be happening only inside laboratories. As in some topological theorem, the inside and the outside world can reverse into one another very easily. Naturally, the three relations outside, inside, outside again, are in no way identical. Only a few elements of the macroscopic epizootics are captured in the lab, only controlled epizootics on experimental animals are done in the lab, only specific inoculation gestures and vaccine inoculants are extracted out of the lab to be spread to farms. That this metaphorical drift, which is made of a succession of displacements and changes of scale (see below), is the source of all innovations is well known (Black, 1961). For our purpose here, it is enough to say that each translation from one position to the next is seen by the captured actors to be a faithful translation and not a betrayal, a deformation, or something absurd. For instance, the disease in a Petri dish, no matter how far away from the farm situation, is seen as a faithful translation, indeed *the* interpretation of anthrax disease. The same thing is true when hygienists see as equivalent the trials microbes undergo in Pasteur's lab, and the variations of epidemics that masses of people undergo in a large city like Paris. It is useless trying to decide if these two settings are really equivalent—they are not, since Paris is not a Petri dish—but they are deemed equivalent by those who insist that if Pasteur solves his microscale problems the secondary macroscale problem will be solved. The negotiation on the equivalence of nonequivalent situations is always what characterizes the spread of a science, and what explains, most of the time, why there are so many laboratories involved every time a difficult negotiation has to be settled.

For the vaccine to be effective, it has to spread outside in the "real world out there," as people say. This is what best shows the absurdity of the dichotomy between inside/outside and the usefulness of microstudies of science in understanding macroissues. Most of the difficulties associated with science and technology come from the idea that there is a time when innovations are in laboratories, and another time when they are tried out in a new set of conditions which invalidate or verify the efficacy of these innovations. This is the "adequatio rei et intellectus" that fascinates epistemologists so much. As this example shows, the reality of it is more mundane and less mystical.

First, the vaccine works at Pouilly le Fort and then in other places only if in all these places the same laboratory conditions are extended there beforehand. Scientific facts are like trains, they do not work off their rails. You can extend the rails and connect them but you cannot drive a locomotive through a field. The best proof of this is that every time the method of extension of the anthrax vaccine was modified, the vaccine did *not* work and Pasteur got bogged down in bitter controversy, for instance with the Italians (Geison, 1974). His answer was always to check, and see if everything was done according to the prescriptions of his lab. That the same thing can

be repeated does not strike me as miraculous, but it does seem to be for all the people who imagine that facts get out of laboratories without the extension of lab practices.

But there is a second reason why the laboratories have no outside. The very existence of the anthrax disease in the first place, and the very efficacy of the vaccine at the end of the story, are not "outside" facts given for all to see. They are, in both cases, the result of the prior existence of statistical institutions having built an instrument (statistics in this case), having extended their network through the whole French administration so as to gather data, and having convinced all the officials that there was a "disease," a "terrible" one, and that there was a "vaccine," an "efficient" one. Most of the time when we talk about the outside world *we are simply taking for granted the prior extension of a former science* built on the same principle as the one we are studying. This is why lab studies in the end hold the key to the understanding of macroproblems, as I will show at the end of this chapter.

## 2. PLAYING HAVOC WITH DIFFERENCES OF SCALE

But if the inside/outside dichotomy does not hold true, what are we going to say about differences of scale which, the reader should be reminded, are at the origin of many discussions in sociology of science, since it is because of this belief in differences of scale that microstudies are accused of missing some essential points? In the example I sketched out above, we are never confronted with a social context on one hand and a science, laboratory, or individual scientist on the other. We do *not* have a context influencing, or not influencing, a laboratory immune from social forces. This view, which is the dominant view among most sociologists, is exactly what is untenable. Of course, many good scholars like Geison could show why the fact that Pasteur is a Catholic, a conservative, a chemist, a Bonapartist, etc., do count (Farley and Geison, 1979). But this sort of analysis, no matter how careful and interesting, would entirely miss the main point: *in his very scientific work, in the depth of his laboratory, Pasteur actively modifies the society of his time and he does so directly*—not indirectly—*by displacing some of its most important actors.*

Here again Pasteur is a paradigmatic example. As a politician he failed so completely that he was unable to get more than a few votes the few times he tried to get elected senator. But he has along with Carnot, and the Republic itself, the greatest number of streets bearing his name in all French villages and towns. This is also a nice symbol of the studies about Pasteur. If you look for examples of his "politicking" politics, you will of course find them but they are poor, disappointing, and never in keeping with the importance of his scientific work. The poverty of your findings will make readers say that "there is something else in Pasteur, in his scientific achievements, that escapes all social or political explanation." People who would utter this cliché would indeed be right. A poor critical explanation always protects science. This is why the more radical scientists write against science, the more science is mystified and protected.

To study Pasteur as a man acting on society, it is not necessary to search for political drives, for some short-term monetary or symbolic profits, or for long-term chauvinistic motives. It is no use looking for unconscious ideologies or devious drives (drives which, by some mystery, are clear only to the analyst's eyes). It is no use muckraking. You just have to look at what he does in his laboratory as a scientist. To summarize a long study in a nutshell (Latour, 1988), Pasteur adds to all the forces that composed French society at the time a new force for which he is the only credible spokesman—the microbe. You cannot build economic relations without this "tertium quid" since the microbe, if unknown, can bitter your beer, spoil your wine, make the mother of your vinegar sterile, bring back cholera with your goods, or kill your factotum sent to India. You

cannot build a hygienist social movement without it, since no matter what you do for the poor masses crowded in shanty towns, they will still die if you do not control this invisible agent. You cannot establish even innocent relations between a mother and her son, or a lover and his mistress, and overlook the agent that makes the baby die of diphtheria and has the client sent to the mad house because of syphilis. You do not need to muckrake or look for distorted ideologies to realize that a group of people, equipped with a laboratory—the only place where the invisible agent is made visible—will easily be situated everywhere in all these relations, wherever the microbe can be seen to intervene. If you reveal microbes as essential actors in all social relations, then you need to make room for them, and for the people who show them and can eliminate them. Indeed the more you want to get rid of the microbes, the more room you should grant Pasteurians. This is not false consciousness, this is not looking for biased world views, this is just what the Pasteurians *did* and the way they were *seen* by all the other actors of the time.

*The congenital weakness of the sociology of science is its propensity to look for obvious stated political motives and interests in one of the only places, the laboratories, where sources of fresh politics as yet unrecognized as such are emerging.* If by politics you mean elections and law, then Pasteur, as I have said, was not driven by political interests, except in a few marginal aspects of his science. Thus his science is protected from enquiry and the myth of the autonomy of science is saved. If by politics you mean to be the spokesman of the forces you mould society with and of which you are the only credible and legitimate authority, then Pasteur is a fully political man. Indeed, he endows himself with one of the most striking fresh sources of power ever. Who can imagine being the representative of a crowd of invisible, dangerous forces able to strike anywhere and to make a shambles of the present state of society, forces of which he is by definition the only credible interpreter and which only he can control? Everywhere Pasteurian laboratories were established as the only agency able to kill the dangerous actors that were until then perverting efforts to make beer, vinegar, to perform surgery, to give birth, to milk a cow, to keep a regiment healthy, and so on. It would be a weak conception of sociology if the reader were only to say that microbiology "has an influence" or "is influenced by the nineteenth-century social context." *Microbiology laboratories are one of the few places where the very composition of the social context has been metamorphosed.* It is not a small endeavour to transform society so as to include microbes and microbe-watchers in its very fabric. If the reader is not convinced, then he can compare the sudden moves made at the same time by socialist politicians, talking on behalf of another crowd of new, dangerous, undisciplined, and disturbing forces for whom room should be made in society: the laboring masses. The two powers are comparable in this essential feature: they are fresh sources of power for modifying society and cannot be explained by the state of the society at the time. Although the two powers were mixed together at the time (Rozenkranz, 1972), it is clear that in political terms the influence of Pasteurian laboratories reached further, deeper, and more irreversibly since they could intervene in the daily details of life—spitting, boiling milk, washing hands—and at the macroscale—rebuilding sewage systems, colonizing countries, rebuilding hospitals—without ever being clearly seen as a stated political power.

This transformation of what is the very composition of society can in no way be defined through distinctions of scales and of levels. Neither the historian nor the sociologist can distinguish the macrolevel of French society and the microlevel of the microbiology laboratory, since the latter is helping to redefine and displace the former. The laboratory positioning, as I insisted on earlier, was in no way inevitable. Pasteur could have failed to link his work on microbes to his many clients' interests. Had he failed, then I agree that the distinction of levels would hold true:

there would indeed be French agricultural, medical, social, political interests on the one hand, and the insulated laboratory of a disinterested scientist at the École Normale Supérieure on the other. Claude Bernard had such a laboratory. But this was in no way Pasteur's strategy, and still less that of the larger Institut Pasteur, which was always situated in such a way that all the interested commercial, colonial, and medical interests had to pass through their laboratories to borrow the techniques, the gestures, the products, the diagnostic kits that were necessary to further their own desires. Laboratories were set up everywhere: on the front line during the First World war in the trenches they largely made possible; before the colonists arrived in the tropics, allowing the very survival of the white colonists and their soldiers; in the surgery ward that was transformed from a teaching amphitheatre into a laboratory (Salomon-Bayet, 1982); in the plants of the food industries in many public health services; inside the small offices of general practitioners; in the midst of farms, and so on. Give us laboratories and we will make possible the Great War without infection, we will open tropical countries to colonization, we will make France's army healthy, we will increase the number and strength of her inhabitants, we will create new industries. Even blind and deaf analysts will see these claims as "social" activity, but on condition that laboratories are considered places where society and politics are renewed and transformed.

## III. HOW THE WEAKEST BECOMES THE STRONGEST

What I have said about the example treated in Part I now leads us to the more general problem of laboratory practice and of the relevance of microstudies for understanding the "large-scale" problems raised by the field known as Science, Technology, and Society (STS). If I were to summarize the argument presented in Part II, I could say that a sociology of science hamstrings itself from the start: if, that is, it takes for granted the difference of levels or of scale between the "social context" on the one hand and the laboratory or the "scientific level" on the other; and if it fails to study *the very content* of what is being done inside the laboratories. I claim that, on the contrary, laboratories are among the few places where the differences of scale are made irrelevant and where the very content of the trials made within the walls of the laboratory can alter the composition of society.

The most difficult problem for understanding this positioning laboratory practice is to define precisely why it is that in the laboratory and only there new sources of strength are generated. Using the metaphor of the lever, why is a laboratory a solid lever and not a soft straw? In asking this question we are back to the problem of understanding what has been achieved through microstudies of science. Many answers were given by epistemologists before lab studies started pouring in. It was said that scientists had special methods, special minds, or in more culturalist forms of racism, some kind of special culture. It was always in something "special," usually of a cognitive quality, that this source of strength was explained. Of course, the moment sociologists walked into laboratories and started checking all these theories about the strength of science, they just disappeared. Nothing special, nothing extraordinary, in fact nothing of any cognitive quality was occurring there. Epistemologists had chosen the wrong objects, they looked for mental aptitudes and ignored the material local setting, that is, laboratories. The same thing happened with most of the so-called Mertonian sociology. No special sociological relations could explain anything about the strength of science. The "norms" faded away like the "invisible

college" and the "precapitalist recognition of debt," and went into the limbo where "falsification," and the "angels' sexes" are put for a well-deserved eternal rest. The first sociologists made the same mistake as the epistemologists. They looked for something special everywhere except in the most obvious and striking place: the settings. Even scientists themselves are more aware of what makes them special than many analysts. Pasteur, for instance, a better sociologist and epistemologist than most, wrote a kind of treatise on sociology of science simply pointing to the laboratory as the cause of the strength gained by scientist over society (Pasteur, 1871).

Laboratory studies have been successful, but so far only in the negative sense of dissipating previous beliefs surrounding science. Nothing special is happening in the cognitive and in the social aspect of laboratory practice. Knorr-Cetina has reviewed this and there is nothing much else to add, nothing except that we now have to explain what happens in laboratories that makes them such an irreplaceable source of political strength, strength which is *not* explained by any cognitive or social peculiarities.

How do a few people gain strength and go inside some places and the life of the multitudes? Pasteur, for instance, and his few collaborators cannot tackle the anthrax problem by moving all over France and gathering an intimate knowledge of all the farms, farmers, animals, and local idiosyncrasies. The only place where they are able and good workers is in their laboratory. Outside they are worse at farming than the farmers and worse at veterinary medicine than the veterinarians. But they are expert inside their own walls at setting up trials and instruments so that the invisible actors—which they call microbes—show their moves and development in pictures so clear that even a child would see them. The invisible becomes visible and the "thing" becomes a written trace they can read at will as if it were a text. This expertise, in their case, is already obtained by a complete modification of the scale. As has been previously explained, the microbe is invisible as long as it is not cultivated in isolation from its other competitors. As soon as it grows uninhibited on an aptly chosen medium, it grows exponentially and makes itself large enough to be counted as small dots on the Petri dish. I don't know what a microbe is, but counting dots with clear-cut edges on a white surface is simple. The problem now is to link this expertise to the health field. I showed the solution earlier by these three-pronged movements that displace the laboratory. The consequence is clear. By these moves an epizootic occurs inside the laboratory walls that is deemed relevant to the macroproblems outside. Again the scale of the problem is reversed, but this time it's the "macro" that is made small enough to be dominated by the Pasteurians. Before this displacement and inversion that allowed Pasteurians to hook an expertise in setting up inscription devices onto the health field, no one had ever been able to master the course of an epidemic. This "mastery" means that each event—the inoculation, the outbreak of an epidemic, the vaccination, the counting of the dead and of the living, the timing, the places—becomes entirely readable by a few men who could agree among themselves because of the simplicity of each perceptive judgment they were able to make about simple diagrams and curves.

The strength gained in the laboratory is not mysterious. A few people much weaker than epidemics can become stronger if they change the scale of the two actors—making the microbes big, and the epizootic small—and others dominate the events through the inscription devices that make each of the steps readable. The change of scale entails an acceleration in the number of inscriptions you can get. Obtaining data on anthrax epidemics on the scale of France was a slow, painstaking, and uncertain process. But in a year Pasteur could multiply anthrax outbreaks. No wonder that he became stronger than veterinarians. For every statistic they had, he could

mobilize ten of them. Before Pasteur, their statements could be interrupted by any number of other statements just as plausible as theirs. But when Pasteur comes out of his lab with these many figures, who is able to mount a serious attack against him? Pasteur has gained strength simply by modifying the scale. So, in discussions about anthrax, Pasteur has two sources of strength: the epizootic and the microbes. His opponents and predecessors had to work "outside" on a "large scale," constantly stabbed in the back haphazardly by the invisible agent that made their statistics look random. But Pasteur, by building his laboratory and inserting it in the farms as we have seen, dominates the microbe—that he made bigger—and the epizootic—that he made smaller— and multiplies the experiments at small cost *without leaving his laboratory.* This concentration of forces makes him so much stronger than his competitors that they cannot even think of a counterargument except in the few cases where, like Koch, they are equipped as well as he is.

To understand the reason why people pay so much for laboratories which are actually ordinary places, one just has to consider these places as nice technological devices to invert the hierarchy of forces. Thanks to a chain of displacements—both of the laboratory and of the objects—the scale of what people want to talk about is modified so as to reach this best of all possible scales: the inscription on a flat surface written in simple forms and letters. Then everything they have to talk about is not only visible but also readable, and can be easily pointed at by a few people who by doing this dominate. This is as simple and as sufficient as Archimedes' point about moving the earth and making the weakest the strongest. It is simple indeed because making simple moves is what this device is about. "Accumulated knowledge" people say with admiration, but this acceleration is made possible by a change of scale, which in turn makes possible the multiplication of trials and errors. Certainty does not increase in a laboratory because people in it are more honest, more rigorous, or more "falsificationist." It is simply that they can make as many mistakes as they wish or simply more mistakes than the others "outside" who cannot master the changes of scale. Each mistake is in turn archived, saved, recorded, and made easily readable again, whatever the specific field or topic may be. If a great many trials are recorded and it is possible to make a sum of their inscriptions, that sum will always be more certain if it decreases the possibility of a competitor raising a statement as plausible as the one you are defending. That is enough. When you sum up a series of mistakes, you are stronger than anyone who has been allowed fewer mistakes than you.

This vision of the laboratory as a technological device to gain strength by multiplying mistakes, is made obvious if one looks at the difference between a politician and a scientist. They are typically contrasted on cognitive or social grounds. The first is said to be greedy, full of self-interest, short-sighted, fuzzy, always ready to compromise, and shaky. The second is said to be disinterested, far-sighted, honest, or at least rigorous, to talk clearly and exactly and to look for certainty. These many differences are all artificial projections of one, simple, material thing. The politician has no laboratory and the scientist has one. So the politician works on a full scale, with only one shot at a time, and is constantly in the limelight. He gets by, and wins or loses "out there." The scientist works on scale models, multiplying the mistakes inside his laboratory, hidden from public scrutiny. He can try as many times as he wishes and comes out only when he has made all the mistakes that have helped him gain "certainty." No wonder that one does not "know" and the other "knows." The difference, however, is not in "knowledge." If you could by chance reverse the positions, the same greedy, short-sighted politician, once in a laboratory, is going to churn out exact scientific facts, and the honest, disinterested, rigorous scientist put at the helm of a political structure that is full scale and with no mistakes allowed will become fuzzy,

uncertain, and weak like everyone else. The specificity of science is not to be found in cognitive, social, or psychological qualities, but in the special construction of laboratories in a manner which reverses the scale of phenomena so as to make things readable, and then accelerates the frequency of trials, allowing many mistakes to be made and registered.

That the laboratory setting is the cause of the strength gained by scientists is made still clearer when people want to establish elsewhere conclusions as certain as those reached in the laboratory. As I have shown above, it can be said that there is no outside to laboratories. The best thing one can do is to extend to other places the "hierarchy of forces" that was once favourable inside the first laboratory. I showed this for anthrax but it is a general case. The mystification of science comes most often from the idea that scientists are able to make "predictions." They work in their labs and, sure enough, something happens outside that verifies these predictions. The problem is that no one has ever been able to verify these predictions without extending first the conditions of verification that existed in the laboratory. The vaccine extends on the condition that farms are transformed into an annex of Pasteur's lab and that the very statistical system that made anthrax visible in the first place is used to verify if the vaccine had any effect. We can watch the extension of laboratory conditions, and the repetition of the final trial that was favourable, but we cannot watch predictions of scientists extending themselves beyond laboratory walls (Latour and Woolgar, 1979: ch. 4).

If this seems counterintuitive to the reader, a little reasoning will convince him that every counterexample he can think of in fact conforms to the position stated here. No one has ever seen a laboratory fact move outside unless the lab is first brought to bear on an "outside" situation and that situation is transformed so that it fits laboratory prescriptions. Every counterexample is a belief that such a thing is possible. But a belief is not a proof. If the proof is given then the two conditions I stated will always be verified. My confidence in this answer is not based on presumption but on a simple scientific belief, shared by all my fellow scientists, that magic is impossible and that action at a distance is always a misrepresentation. Scientists' predictions or previsions are always postdictions or repetitions. The confirmation of this obvious phenomenon is shown in scientific controversies when scientists are forced to leave the solid ground of their laboratories. The moment they really get "outside" they know nothing, they bluff, they fail, they get by, they lose all possibility to say anything that is not immediately counterattacked by swarms of equally plausible statements.

The only way for a scientist to retain the strength gained inside his laboratory by the process I have described is not to go outside where he would lose it at once. It is again very simple. The solution is in *never going out*. Does that mean that they are stuck in the few places where they work? No. It means that they will do everything they can to extend to every setting some of the conditions that make possible the reproduction of favourable laboratory practices. Since scientific facts are made inside laboratories, in order to make them circulate you need to build costly networks inside which they can maintain their fragile efficacy. *If this means transforming society into a vast laboratory, then do it.* The spread of Pasteurian laboratories to all the places that a few decades before had nothing to do with science is good example of this network building. But a look at systems of Standard Weights and Measures, called "métrologie" in French, is still more convincing. Most of the work done in a laboratory would stay there forever if the principal physical constants could not be made constant everywhere else. Time, weight, length, wavelength, etc., are extended to ever more localities and in ever greater degrees of precision. Then and only then, laboratory experiments can be brought to bear on problems occurring in factories, the tool

industry, economics, or hospitals. But if you just try in a thought experiment to extend the simplest law of physics "outside," without first having extended and controlled all the main constants, you just could not verify it, just as it would have been impossible to know the existence of anthrax and to see the efficacy of the vaccine without the health statistics. This transformation of the whole of society according to laboratory experiments is ignored by sociologists of science.

There is no outside of science but there are long, narrow networks that make possible the circulation of scientific facts. Naturally the reason for this ignorance is easy to understand. People think that the universality of science is a given, because they forget to take into account the size of the "métrologie." Ignoring this transformation that makes all displacement possible is like studying an engine without the railway or the freeway networks. The analogy is a good one since the seemingly simple work of maintaining the physical constants constant in a modern society is evaluated to be three times more than the effort of all the science and technology themselves (Hunter, 1980). The cost of making society conform to the inside of laboratories so that the latter's activity can be made relevant to the society is constantly forgotten, because people do not want to see that universality is a social construction as well.

Once all these displacements and transformations are taken into account, the distinction between the macrosocial level and the level of laboratory science appears fuzzy or even nonexistent. Indeed, laboratories are built to destroy this distinction. Once it is dissolved, a few people can, inside their insulated walls, work on things that can change the daily life of the multitudes. No matter if they are economists, physicists, geographers, epidemiologists, accountants, microbiologists, they make all the other objects on such a scale—maps, economic models, figures, tables, diagrams—that they can gain strength, reach incontrovertible conclusions, and then extend on a larger scale the conclusions that seem favourable to them. *It is* a political process. *It is not* a political process. It is since they gain a source of power. It is not since it is a source of fresh power that escapes the routine and easy definition of a stated political power. "Give me a laboratory and I will move society," I said, parodying Archimedes. We now know why a laboratory is such a good lever. But if I now parody Clausewitz's motto, we will have a more complete picture: "science is politics pursued by other means." It is not politics since a power is always blocked by another counterpower. What counts in laboratory sciences are the other means, the fresh, unpredictable sources of displacements that are all the more powerful because they are ambiguous and unpredictable. Pasteur, representing the microbes and displacing everyone else, is making politics, but by other, unpredictable means that force everyone else out, including the traditional political forces. We can now understand why it was and is so important to stick to laboratory microstudies. In our modern societies most of the really fresh power comes from sciences—no matter which—and not from the classical political process. By staking all social explanations of science and technology on the classical view of politics and economics—profit, stated power, predictable evils or goods—analysts of science who claim to study the macrolevels fail to understand precisely what is strong in science and technology. In speaking of scientists who make politics by other means, their boring and repetitive critique is always that they "just make politics," period. Their explanation falls short. The shortness of it is in the period—they stop where they should start. Why though are the means different? To study these other means, one must get inside the contents of the sciences, and inside the laboratories where the future reservoirs of political power are in the making. The challenge of laboratories to sociologists is the same as the challenge of laboratories to society. They can displace society and recompose it by the very content of what is done inside them, which seemed at first irrelevant or too technical. The careful

scrutiny of laboratory scientists cannot be ignored and no one can jump from this "level" to the macropolitical level since the latter gets all its really efficient sources of power from these very laboratories that have just been deemed uninteresting or too technical to be analyzed.

But we can also understand why students of laboratory practices should not be shy and accept a vision of their own method that would limit them to the laboratory, whereas the laboratory is just a moment in a series of displacements that makes a complete shambles out of the inside/outside and the macro/micro dichotomies. No matter how divided they are on sociology of science, the macroanalysts and the microanalysts share one prejudice: *that science stops or begins at the laboratory walls.* The laboratory is a much trickier object than that, it is a much more efficient transformer of forces than that. That is why by remaining faithful to his method, the microanalyst will end up tackling macroissues as well, exactly like the scientist doing lab experiments on microbes who ends up modifying many details of the whole of French society. Indeed, I think an argument could be made to show that the existence of the macrolevel itself, the famous "social context," is a consequence of the development of many scientific disciplines (Callon and Latour, 1981). It is already clear to me that this is the only way that sociology of science can be rebuilt in keeping with the constraints now set by laboratory studies. I also think that it is one of the few ways that sociology of science can teach something to sociology instead of borrowing from it categories and social structures that the simplest laboratory is destroying and recomposing. It would be high time, since the laboratory is more innovative in politics and in sociology than most sociologists (including many sociologists of science). We are only just starting to take up the challenge that laboratory practices present for the study of society.

REFERENCES

Armatte, Michel (1981) *Ça marche: les traductions de l'homme au travail, Mémoire de DEA,* Paris: CNAM-STS.
Bastide, Françoise (1981) "Le Foie Lavé, analyse sémiotique d'un texte scientifique," *Le Bulletin,* 2: 35–82.
Black, Max (1961) *Models and Metaphors,* Ithaca, NY: Cornell University Press.
Callon, Michel (1975) "Les Opérations de Traductions," in P. Roqueplo (ed.), *Incidence des Rapports Sociaux sur le Développment Scientifique,* Paris: CNRS.
Callon, Michel (1981) "Struggles and Negotiations to Define What is Problematic and What is Not: The Sociologic Translation," in K. Knorr, R. Krohn, and R. Whitley (eds), *The Social Process of Scientific Investigation, Sociology of the Sciences Yearbook,* vol. 4, Dordrecht: D. Reidel.
Callon, Michel (1982) "La Mort d'un Laboratoire Saisi par l'Aventure Technologique" (in preparation).
Callon, Michel, and Latour, Bruno (1981) "Unscrewing the Big Leviathan, or How do Actors Macrostructure Reality?," in K. D. Knorr-Cetina and A. Cicourel (eds), *Advances in Social Theory and Methodology Toward an Integration of Micro- and Macro-Sociologies,* London: Routledge and Kegan Paul.
Collins, H. M. (1975) "The Seven Sexes: A Study in the Sociology of a Phenomenon or the Replication of Experiments in Physics," *Sociology,* 9 (2): 205–24.
Collins, H. M. (1982) "Stages in the Empirical Programme of Relativism," *Social Studies of Science,* 11 (1): 3–10.
Dagognet, François (1973) *Ecriture et Iconographie,* Paris: Vrin.
Eisenstein, Elizabeth (1979) *The Printing Press as an Agent of Change,* Cambridge: Cambridge University Press.
Farley, John, and Geison, Gerald (1974) "Science, Politics and Spontaneous Generation in 19th Century France: The Pasteur-Pouchet Debate," *Bulletin of the History of Medicine,* 48 (2): 161–98.
Geison, Gerald (1974) "Pasteur," in C. Gillispie (ed.), *Dictionary of Scientific Biography,* New York: Scribners.
Goody, Jack (1977) *The Domestication of the Savage Mind,* Cambridge: Cambridge University Press.
Havelock, Eric A. (1981) *Aux Origines de la Civilisation Ecrite en Occident,* Paris: Maspéro.
Hunter, J. S. (1980) "The National System of Scientific Measurement," *Science,* 210: 869–75.
Knorr-Cetina, K. D. (1981) *The Manufacture of Knowledge: An Essay on the Constructivist and Contextual Nature of Science,* Oxford: Pergamon Press.
Knorr-Cetina, K. D., and Cicourel, A. (eds) (1981) *Advances in Social Theory: Toward an Integration of Micro- and Macro-Sociologies.* London: Routledge and Kegan Paul.
Knorr-Cetina, Karen D. (1983), "The Ethnographic Study of Scientific Work," Karin D. Knorr-Cetina and Michael Mulkay (eds), *Science Observed,* London: Sage, pp. 115–140.

Latour, Bruno, and Fabbri, Paolo (1977) "Pouvoir et Devoir dans un Article de Sciences Exactes," *Actes de la Recherche,* 13: 82–95.

Latour, Bruno, and Woolgar, Steve (1979) *Laboratory Life: The Social Construction of Scientific Facts,* London and Beverly Hills: Sage.

Latour, Bruno (1988) *The Pasteurization of France,* Cambridge, Mass.: Harvard University Press.

Leonard, Jacques (1977) *La Vie Quotidienne des Médecins de L'Ouest au 19° Siècle,* Paris: Hachette.

Lynch, Michael (1982) *Art and Artefact in Laboratory Science: A Study of Shop Work and Shop Talk in a Research Laboratory,* London: Routledge and Kegan Paul.

McNeill, John (1976) *Plagues and People,* New York: Doubleday.

Nelkin, Dorothy (ed.) (1979) *Controversy, Politics of Technical Decisions,* London and Beverly Hills: Sage.

Pasteur, Louis (1871) *Quelques Réflexions sur la Science en France,* Paris.

Rosenkranz, Barbara (1972) *Public Health in the State of Massachusetts 1842–1936, Changing Views,* Cambridge, Mass.: Harvard University Press.

Salomon-Bayet, Claire (1982) "La Pasteurisation de la Médicine Française" (in preparation).

Serres, Michel (1974) *Hermès III, La Traduction,* Paris: Editions de Minuit.

Serres, Michel (1980) *Le Parasite,* Paris: Grasset.

Woolgar, Steve (1981) "Interests and Explanation in the Social Study of Science," *Social Studies of Science,* 11 (3): 365–94.

# 19

## One More Turn After the Social Turn . . .

### BRUNO LATOUR

Like Antony, I could say to philosophers, uncertain whether to stone or welcome the young domain of social studies of science, "I come to bury those studies, not to praise them." After years of swift progress, social studies of science are at a standstill. Cornered in what appears to be a blind alley, its main scholars are disputing with one another on where to go next.*

Many of them advocate a return to common sense and claim that we should shun extreme radicalism and take on the classic sociology of scientists (not of science), spiced with a speck of constructivism. Through meetings and journals, I sense a reactionary mood: "Let's abandon the crazy schools and turn to serious matters of science policy and the impact of technology on society. The field has suffered enough from extremism; let's go back to the happy medium." The most generous believe that political relevance for our field will be achieved more readily if we stop dabbling with esoteric theories and instead seize traditional concepts off the shelf. A few, who call themselves reflexivists, are delighted at being in a blind alley; for fifteen years they had said that social studies of science could not go anywhere if it did not apply its own tool to itself; now that it goes nowhere and is threatened by sterility, they feel vindicated. A few others, among the most serious, stick to their trade, deny that they are in a blind alley and go on with business as usual, without realizing that the law of diminishing returns is at work here, as elsewhere, and that professional loyalties are no guarantee against obsolescence. But, fortunately, dozens of researchers are looking for ways out of the deadlock: in literary theory, biology, cognitive science, cultural history, ethnology, ethnography of skills, moral economics, interactionism, and networks. That their moves do not appear more principled or straight than those of a disturbed anthill does not mean that they are not going to find the way. Quite the contrary.

Being one of those ants, accused of being not only frantic but also French, I wish to explore in this paper one of the possible ways out of the dead end that would not force us to retrace our steps. Instead of being less extreme, I want to show that by being a little *more* radical we would end up in a productive and commonsensical research program that would allow us to capitalize on the last twenty years' work and resume our swift pace.

# I. THE TRAP WE BUILT FOR OURSELVES

But first we have to survey the path that led the field of social studies of science to its present quandary. Like any summary, it will appear unfair to everyone's work—including my own—but the aim of this paper is the future of our field, not its past.

The name of the domain, "Sociology of Scientific Knowledge," tells it all. So far, it has been the *application* of social sciences—mainly sociology but also anthropology—to the practice of science. The decisive advance occurred when it was realized that, contrary to what traditional sociology of knowledge and Mertonian sociology of science told us, the *content* of science is fully capable of study, and the implementation of this research program is *a single task* for historians, sociologists, philosophers, and economists. I take those two points as being established beyond doubt (Shapin, 1982; Latour, 1987).

Doubts are back, however, as soon as we look at the *explanatory* resources mobilized to account for the practice of science. Our domain is a battlefield littered with interrupted explanations. All the efforts at using macrosociology to account for the microcontent of science are fraught with difficulties; only very broad features like styles, worldviews, and cultures have been explained. The only research programs that have been successful are those which put to use a fine-grained sociology: ethnomethodology, microsociology, symbolic interactionism, cognitive anthropology, cultural history, and history of practices. The problem with those programs is that they, indeed, account nicely for the details of scientific practice but entirely lose track of the main goals of macrosociology—that is, an account of what holds the society together. They have all been accused (and rightly) of cranking out nice case studies without even the beginnings of social theory or political relevance. It seems that either the social science is subtle enough to explain the content of science but the making of a global society is left in the dark, or that macrosociology is back in but the details of science disappear from view. When literary studies are included it is often worse, since we now have fine-grained studies of scientific rhetoric but even the mere idea of a social explanation is given up. When cognitive sciences are brought in, it is worse still, since social scientists have to renounce any interest in noncognitive explanations or be relegated to an appendix. It is as if we cannot have sociology and the content of science under the same gaze at once.

Another way to sum up the diagnosis is to say that most of the so-called social studies of science are largely *internalist* studies. They did not appear so to the English-speaking world because of the very abstract way in which philosophy of science had been carried on in the Anglo-American tradition before we began to work. When, for instance, Harry Collins added to the gravitation waves animals such as replication, negotiation, styles, core sets, and authority, philosophers of science mistook that zoo for the social (and so did Collins [1985]). Viewed, however from a Continental point of view, most of the "sociological" points could have been made—and indeed had been made—by *internalist* philosophers informed by the history of scientific practice, like Duhem, Mach, Bachelard, or Canguilhem. Social studies of science were not adding society to science but were adding some historical flesh to the often barren English-speaking philosophy of science.

It is now clear that it is as difficult to tie the main concerns of sociology and politics to the microsociological studies of science as it was in the past to tie them to rabid internalism. Most of the good case studies, if we look at them dispassionately, are internalist explanations sandwiched

in between macro- or mesosociological explanations without much connection between the two. The reason why this recipe did not appear so clearly at first was that we all had to fight against the dictates of Mertonian sociology, rational reconstruction of science, and history of ideas, each claiming that the study of scientific practice was infeasible *in principle*. The stubbornness of their defenders forced us to a polemical stand. Now that this battle has been more or less won, and we can examine in peace the quality of the explanations given for the social construction of the contents of science, it is fair to say that they are found wanting. Few of them convincingly tie the fabric of macrosociety to the contents of science, and most follow up bits and pieces of networks, the ends of which are left loose. What the best studies achieve is to spread successive levels on top of one another, the first of which is distinctively "macro" while the last one is clearly technical. They fix club sandwiches instead of hamburgers!

This diagnosis is not new. It was, on the contrary, the starting point of the radical brands of "social" (now in quotation marks) studies of science. Reflexivists have argued all along that it was not desirable to provide a social explanation of scientific content since it would mean that sociology was immune to the critical treatment that it applied to chemistry or physics (Woolgar, 1988; Ashmore, 1989). Ethnomethodologists went much further by denying any relevance to sociology and claiming that social explanations should not be provided at all. It is, on the contrary, they claim, the local technical content of the practitioners that should be used to explain their own world. "There is no other metalanguage to use but the language of the sciences themselves" is Garfinkel-Lynch's principle, in which a new brand of internalism and radical sociology have become barely distinguishable (Lynch, 1985).

The same could be said of us, the so-called actor-network theorists. We extend the principle of symmetry to social sciences and we claim that they, too, are part of our problem, not of our solution. Networks of associations replace both the content of science and society. The growth of networks through translations replaces the differences of scale between micro-, meso-, and macrolevels. Exactly as for reflexivists and ethnomethodologists, the question of a social explanation is dissolved (Callon, 1989; Law, 1986; Latour, 1987). But so are also the resources for understanding our own position. Networks may be "seamless webs," but they appear to our colleagues and nevertheless friends to involve a catchall concept, where everything being possible, nothing is clear and distinct anymore. Everything being a network, nothing is (Shapin, 1988; Collins and Yearley, 1990).

Somber diagnosis, indeed! The more conservative schools have failed to provide a continuous tie between the contents of science and the concerns of sociology. And the radical groups who deconstructed the very aim of a social explanation end in sterility, in jargon, or in a maze of entangled networks. The Gordian knot that tied science and society together before Alexander's sword cut them asunder is still there awaiting someone patient enough to tie it again!

Even if I have overdramatized our quandary, it remains true that outsiders to the field see us like that. Whatever we write or say, the field of social studies of science is recast by friends and enemies alike as the "merely social" argument (Star, 1988). Then, it is not difficult for them to argue that to the "merely social" or "sociohistorical" explanation should now be added *another* explanation, a more internalist one. No wonder if many of our critics, feeling vindicated, rejoice and claim that science is indeed thoroughly incapable of analysis in social terms, that they had long ago shown this impossibility from first principles, and that their graduate students should return to the study of scientists (or of science), or delve into the fashionable cognitive sciences or turn to normative philosophy or science policy. Back to common sense! Down with

constructivism! Enough of theory! As for many atheoretical historians, unsettled for a moment, they might believe that since boxes of archives are waiting to be ransacked, they no longer need the help of all those crazy sociologists.

Here is the blind alley. Here is the trap that we built for ourselves, from which we should escape and resume our quick progress without accepting those reactionary research programs that represent themselves as common sense or claim to rest comfortably in the golden mean between internalism and externalism.

## 2. ONE-DIMENSIONAL SCIENCE

"Radical," "progressivist," "conservative," "reactionary," "golden mean." I used these political adjectives on purpose because they all retrace the same line that is the cause of our deadlock and from which I want to escape. A radical is someone who claims that scientific knowledge is entirely constructed "out of" social relations; a progressivist is someone who would say that it is "partially" constructed out of social relations but that nature somehow "leaks in" at the end. At the other side of this tug-of-war, a reactionary is someone who would claim science becomes really scientific only when it finally sheds any trace of social construction; while a conservative would say that although science escapes from society there are still factors from society that "leak in" and influence its development. In the middle, would be the marsh of wishy-washy scholars who add a little bit of nature to a little bit of society and shun the two extremes. This is the yardstick along which we can log most of our debates. If one goes from left to right then one has to be a social constructivist; if, on the contrary, one goes from right to left, then one has to be a closet realist. As indicated by the two arrows in Figure 19-1, explanations in this frame of reference are accepted only if they start from one of the two extremities, Nature or Society, and move toward the other. Either one is a "natural realist" and one explains the evolution of society, the establishment of consensus by the state of Nature, or one is a "social realist" and explains by social factors how it is that humans settle on matters of fact, or one alternates between the two (Collins and Yearley, 1990). All the intermediary cases are seen as a mixture of these two pure forms, Nature and Society.

This tug-of-war is played in one dimension. It is fun to play, but after twenty years of it we might shift to other games, especially since it makes incomprehensible the very linkages between Nature and Society we wish to account for. I claim that the only way to go on with our work is to abandon this frame of reference and to set up another standard, all the more so if other scholars

FIGURE 19-1

go on to make it more subtle, more precise by adding finer divisions and other labels to the same one-dimensional yardstick (Giere, 1988). We do not want finer divisions and new schools of philosophy of science. We want philosophy to do its job and discover the origin of the yardstick in order for us to overcome it.

The yardstick of our debates was set up by Kant for polemical reasons and since then sociologists, as well as philosophers of science, have adopted it without misgiving. Kant rejected at the two poles—Things-in-themselves on the one hand, the Transcendental Ego on the other—the resources that, when put together, would account for knowledge. This was the foundation of the *Critique* that made us modern, more modern.[1] To be sure, empirical scientific knowledge appeared in the middle, but this middle, the phenomenon, was understood only as the *meeting point* of the two purified sets of resources coming from the subject pole or from the object pole.

There are two reasons why this standard did not appear so bad at first. To begin with, philosophers and sociologists fought so violently to occupy the subject pole designated by Kant—the focus of the Sun in his Copernican Revolution—that no one realized that it did not make much difference[2] whether the elected ruler was Kant's Ego, Durkheim's macro-Society, Foucault's *epistemes,* Dewey's praxis, Wittgenstein's language games, collectives of scientists, brains and neurons, minds, or cognitive structures—as long as this one ruler capitalized all the explanatory resources and had the object turning around it. Where they came from— transcendence, evolution, practice, innate structures—did not matter too much either, as long as phenomena were shaped, in the end, by the dominant authority of this "Sun" pole. The internal rivalry among schools hid the identity of the position to be so strenuously occupied. When compared to the weight of the *Critique* framework, the debates that oppose innate categories to collective *epistemes,* individual minds to groups of scientists, neuronal pathways to social structures, appear minor.

The second reason why this framework had such a great weight is that it was strongly asymmetric. The Sun focus was what counted, not the object circling around it, and thus there were no comparable squabbles about how to modify the status of the object. It really seemed that if one could occupy the right-hand side of the yardstick, much of the left-hand side would be explained. From Kant onward, the Things-in-themselves were left indeed to themselves, without initiative, without activity, passively shaped and framed by the various models or categories pressed upon them. Their only task was to guarantee the transcendental nonhuman character of our knowledge in order to avoid the dire consequences of idealism. Paradoxically, the beautiful movement of Copernicus's Revolution was used by the *Critique* to describe an anthropocentric (or sociocentric or logocentric) enterprise.

In our small field, Bloor's book (1976) was the high-tide mark of this asymmetrical philosophy. As an obedient child of the *Critique,* Bloor designated Durkheimian social structures to occupy the Sun's focus and gave the name "symmetry" to the principle that required us to explain successes and failures in the development of science in the same sociological terms. This was, to be sure, a major advance, since until then only good science was explained by appealing to Nature and only bad science by appealing to Society. However, the very success of this principle of symmetry disguised the complete *a*symmetry of Bloor's argument. Society was supposed to explain Nature! We start from one of the poles to account for the other.

If the one-dimensional diagram I have drawn appears simple-minded and sketchy even after Bloor's "strong program," it might very well be that our implicit philosophy is indeed as simple-minded and as sketchy as that. It is certainly as one-dimensional as that, and this is enough to

explain our previous deadlock: if any move away from one of the poles is a move toward the other, it means that every new position—whatever its originality, direction, and trajectory—will be logged, obsessively, along this single line as a particular combination of the object pole and the subject/collective pole. The two attractors at the extremity of the line are so strong that no new position is tenable since it will be seen as giving strength to one of the two teams engaged in this tug-of-war. The Wall of Berlin has fallen, ideologies are said to be gone, but realists and constructivists are still positioning one another as if we were in the worst days of the 1960s when our opinions had to be pigeonholed as Left or Right.

Fortunately, the two factors that rendered the one-dimensional frame of reference inevitable are now gone: from the relative failures of the social studies of science, we learned that the various schools that strive to occupy the subject/society position make no difference to the general structure of the explanation. We also learned the historical origin of this philosophical asymmetry between the two poles, between the representation of things and the representation of humans (Shapin and Schaffer, 1985; Serres, 1987; Latour, 1990b). To this day, Bloor has not realized that his principle cannot be implemented if another much more radical symmetry is not introduced, a symmetry that treats this time the subject/society pole *in the same way* as the object pole (Callon, 1986). This 90° shift is what I call "one more turn after the social turn" (Figure 19-2). But in order to make this turn and thus free our field from its deadlock, we need to set up another yardstick that will give us another dimension.

*Asymmetry before Bloor*

explain truth with Nature

and error with Society

*Symmetry after Bloor*

Explain truth and error with Society

The first symmetry principle is completely asymmetric

90° shift

*The second principle of symmetry*

Explain Nature and Society
in the same terms

**The second principle absorbs, completes, and makes the first possible
but requires a second dimension to be implemented**

FIGURE 19-2
*The second principle absorbs, completes, and makes the first possible
but requires a second dimension to be implemented*

## 3. A COUNTER-COPERNICAN REVOLUTION

At least the problem is now well defined. Is it possible to modify the respective position of the two attractors, the object pole and the subject/collective pole? Is it possible to modify their number: one, three, many? Is it possible to construct another scale that would allow us to evaluate works and arguments in a second dimension not reducible to the single one described above? Is it possible to do all of that without jargon that would add obscurity to obscurity and without leaving the solid ground of empirical case studies of scientific practice, the ground that I said is the only stable certainty of this new field, common to sociologists, philosophers, and historians of science?

A look at the literature of our field shows that these questions are not at the same level of difficulty. Paradoxically, the last two appear more difficult, since no one, to my knowledge, has offered a clear standard for evaluating works and arguments, a standard at least as finely graded as the one we wish to discard, and since the many philosophies which have tried to "overcome the subject/object dichotomy" have been unable to offer us a precise description of scientific practice and are often shrouded in a thick fog.

Let us start at the relatively "easy" part, the ontological one. The first move is a counter-Copernican revolution that forces the two poles, Nature and Society, to shift to the center and to fuse into one another. This fusing, however, is no simple matter, and the properties of the two poles have to be completely redistributed, since it was their separation that defined them. The main property of the object pole was to guarantee that our world of knowledge not be human-made (whatever the definition of "human" we chose: self, mind, brain, collective); while the main property of the subject pole was, on the contrary, to guarantee that our knowledge be human-made (whichever definition of human activity one sticks to: transcendental Ego, society, subject, mind, brain, *epistemes,* language games, praxis, labor). In addition, the very distinction between the two poles—the distinction which Kant made so sharp—warranted that those two contradictory guarantees would *not* be confused, because the two transcendences—that of the object "out there" and that of the subject/society "up there"—are sources of authority *only if they are as far apart as possible* (Shapin and Schaffer, 1985). They should not mingle with one another any more than the executive branch of government with the judiciary branch.[3]

The word "fact" sums up this threefold system of guarantees. A fact is at once what is fabricated and what is not fabricated by anyone. But the two meanings of the word are never simultaneously present, so that we always feel it necessary to alternate between two asymmetric explanations for the solidity of reality—constructivism or realism.

How can we fuse the two poles together and still retain their three main properties?

(1) the nonhuman origin of knowledge;
(2) its human origin;
(3) the complete separation between the two.

If we retain the three at once, it is impossible to move on, since the three together define the *Critique* on which the whole field of science studies is based. If we abandon the first one, we fall into various brands of social constructivism, forced to build our world with social relations. If we abandon the second, we fall into various brands of realism and are led to build Society with Nature. The only one that might be discarded is the third. Is it proven that the first two guarantees are enforced *only* by the *Critique* or the Modern Constitution that imposes their complete

separation and classifies all explanations in two asymmetrical repertoires? As soon as the question is raised, the point of view is shifted along a new dimension, orthogonal to the first one, and a striking mirror symmetry appears: the two asymmetrical repertoires of realism and constructivism are mirror images of one another. Their symmetry is so exact that a completely coherent framework may be provided if we retain the first two guarantees and discard the third. To be sure there is a price to pay and that is to abandon the *Critique,* or in other words to rewrite the Modern Constitution.

To be sure, the two remaining guarantees are strongly affected by the abandonment of the third. As with all tight-knit structures, taking away one component alters the position of the others.

First modification: Instead of the two opposite transcendences of Nature[4] and Society—not to mention that of the bracketed-out God—we have only *one* transcendence left. We live in a Society we did not make, individually or collectively, and in a Nature which is not of our fabrication. But Nature "out there" and Society "up there" are no longer ontologically different. We do not make Society, anymore than we do Nature, and their opposition is no longer necessary.

Second modification: Instead of providing the explanatory resources in order to account for empirical phenomena, this common transcendence becomes what is to be explained. Instead of being the opposite *causes* of our knowledge, the two poles are a single consequence of a common practice that is now the single focus of our analysis. Society (or Subject, or Mind, or Brain . . . ) cannot be used to explain the practice of science and, of course, Nature cannot either, since both are the results of the practice of science- and technology-making (Latour, 1987, rules 3 and 4). Contrary to the expectation of the "social" students of science—and contrary to the fear of their opponents—the two realisms (social and natural) have to be discarded *together* if either one is to go, since they are one and the same. Or else, both have to be kept.

This new generalized principle of symmetry flows directly from the development of science studies and, in my view, is their most important philosophical discovery. As long as the social sciences did not apply their tools to Nature and to Society at once, the identity of the two transcendences and its common constructed character were left in the dark. Even when established science and stable society were studied together, their common production was still not visible. Only when science in action and society in the making were studied simultaneously did this essential phenomenon become observable. This is why the intermediary solution—social realism alternating with natural relativism—advocated for many years by colleagues like David Bloor or Harry Collins is, in the long run, counterproductive for the field as well as for their own program (Callon and Latour, 1990).

Third modification: This is a direct corollary of the two others. Instead of always being explained by a mixture of the two "pure" transcendences, the activity of nature/society making becomes the *source* from which societies and natures originate. In the Modern Constitution, nothing interesting happened at the meeting-point of the two poles—the phenomenon—since it was just that: at best a meeting point, at worst a confusing boundary. In what I call, for want of a better term, the non–Modern Constitution, everything interesting begins at what is no longer a meeting point but the origin of reality. In the Modern Constitution, one could only say that this production was a hybrid of two pure forms; in the non-Modern one, it is an understatement to talk of hybrids or of monsters. Collins's gravity waves, Shapin's and Schaffer's air pump, Callon's scallops, Geison's microbes, to take just a few examples, are not to be defined as being half natural, half social. They are neither objects, nor subjects, nor a mixture of the two. This is why,

after Serres (1987), I call them *quasi objects*. It is out of their production and circulation that something originates that looks somewhat like Nature "out there," as well as somewhat like Society "up there." What metaphor could express this reversal? Pure Nature and pure Society may exist but they would be like two solid tectonic plates cooling from the hot liquid magma emerging at the seams. Our work aims at exploring this seam and at taking into account the temperature and the direction of the flow.

Fourth modification: History, which was locked away, according to the Modern Constitution, is back in the center. Since whatever happened had to be either the discovery of nature "out there" or the construction by society "up there," history had to be a zero-sum game to be explained by two lists of ingredients, one coming from nature, the other from society. Now, on the contrary, it is the experimental scene that produces and shapes new actants[5] that then increase the long list of ingredients that make up our world. Historicity is back, and it flows from the experiments, from the trials of force (Latour, 1990a). We do not have, on the one hand, a history of contingent human events and, on the other, a science of necessary laws, but a common history of societies and of things. Pasteur's microbes are neither timeless entities discovered by Pasteur, nor the effect of political domination imposed on the laboratory by the social structure of the Second Empire, nor are they a careful mixture of "purely" social elements and "strictly" natural forces. They are a new social link that redefines at once what nature is made of and what society is made of.

Fifth and final (?) modification: The ontological activity that is no longer capitalized at the two extremities may be redistributed among all the actants. It was the necessity of the dual system of appeal either to nature or to society that in the Kantian framework caused all the agencies to be assigned to two and only two lists. Now that we are freed from this necessity, we are allowed to have *as many poles as there are actors*. This irreductionist principle is probably the most counterintuitive consequence of science studies but it is a necessary and a coherent one (Latour, 1988, part II). Monsters that the Modern Constitution wished to cleave into two pure forms (entelechies, monads, fields, forces, networks) are back, claiming an ontological status that does not resemble either that of the forlorn and passive things-in-themselves, or that of humans-among-themselves. Too social to look like the former, they remain too nonhuman to resemble the latter. Dignity, activity, and world-making ability are reclaimed by those actants that are, nevertheless, fully nonhuman, and fully real. Mere intermediaries in the Modern Constitution, they become full-blown mediators in the nonmodern, more democratic, one. Yes, the Gordian knot is tied once again and tightly so.[6]

The problem with this counter-Copernican revolution is that it seems absurd if logged onto the realist-constructivist frame of reference, since every reading of the new object-subject production will appear as yet another "golden-mean" solution. Worse, since the new frame does not make reference to the two extremes, Nature and Society, that previously allowed a coherent interpretation to be drawn, it seems as if common sense were abandoned and a completely obscure field of studies of science were to replace a narrow-minded but at least well-defined one. If I begin, for instance, granting activity to the nonhumans once again, sociologists of science (Collins and Yearley, 1990) begin to protest that outmoded realist positions are back, even though the new active nonhumans are utterly different from the boring inactive things-in-themselves of the realists' plot.

Conversely, if I speak of a history of things, realist philosophers immediately start accusing me of denying the nonhuman reality of Nature, as if I were asking actors to play the equally

tedious role of humans-among-themselves so common in the stories of the sociologists. On the other hand, their joint indignation is understandable since they have no other frame of reference than the modern one and thus they cannot locate our position on their instruments. After having written three books to show the impossibility of a social explanation of science and having been praised (and more often castigated) for providing a social explanation, I am now convinced that no further progress will be made if we do not change our touchstone.

## 4. ADDING A SECOND DIMENSION

Now that the ontology of a viable substitute for the Modern Constitution has been sketched, the next goal is to set up a clearcut standard to locate the various positions and to differentiate nuances of argument at least as finely as with the old instrument—and more finely, if possible. If I sketch the new yardstick, I obtain a diagram that is admittedly crude, but let us remember that the philosophy implicit in science studies might be as crude as that. The one-dimensional yardstick allowed one to position any entity along the object-subject line. I showed that although this was useful, it did not do justice to most of the discoveries of science studies: objects and subjects are belated consequences of an experimental and historical activity that does not clearly differentiate if an entity is "out there" in nature or "up there" in society. This means that any entity should also be logged according to its degree of stabilization.

Figure 19-3 is an attempt to define any entity by two sets of coordinates instead of one. One line is the distance to P′, the locus of the phenomenon in Kant's scenario, and goes either to the subject/collective pole or to the object pole. The other is the degree of stabilization going from O to P′, from instability to stability. It is clear from the diagram that the one-dimensional yardstick I criticized above corresponds to only *one* value of the stabilization gradient. When everything is settled, there is indeed a clear-cut difference between A "out there" and B "up there." Pasteur's microbes are clearly discovered or constructed out of natural and material actants that lie outside the control of our human wishes; hygienic ideas about asepsy and antisepsy are sure means of settling the dispute between Health and Wealth during the Second Empire. For this value of OP′, science students are torn between those two alternative transcendences: a nature that is not of our social making; a society that is not of natural origin. They then have to explain

FIGURE 19-3

Pasteur's achievements by what nature is like, or to account for his discoveries by what society is made of, or to choose any intermediate mixture of pure nature and pure society, or to alternate at will between extreme naturalism and (should I say?) extreme socialism.

But suppose that I now wish to write a book on Pasteur's microbes where I change the value of this whole debate along the "stabilization gradient" (Latour, 1988). Let us say that I now explore the line CD instead of the line A'B', or even the line EF. The complete gamut of positions is now squeezed in the middle and a different account of the entities Pasteur is struggling with becomes possible. Is the microbe a living entity, a chemical one, a physical one, a social one? This is still uncertain. Is nature large enough to accommodate invisible powerful microbes? We will learn the answer from Pasteur's experiments. Are the Second Empire and the Third Republic able to absorb new social links that will add the multitude of microbes to the normal social relations? We are learning the response from Pasteur's laboratories. Whereas, for a higher value of the "stabilization gradient," it is important to decide whether or not something is social or natural, it is meaningless for lower values since this is where what natures and societies are is defined.

Naturally, as the diagram nicely indicates, if I now project the state of the nature/society building I am studying onto the one-dimensional yardstick, my analysis will be completely misunderstood. C' will be taken to mean the emergence of a stabilized natural actant—the nonhuman microbe plays a big role in my story—and D' will be taken to mean that I give too much activity to stabilized social groups (or too little, depending on who is reviewing the book). Worse still, if EF is projected on the same line, E' and F' are now seen as wishy-washy solutions to the problem of realism versus constructivism! I am now seen as attempting to escape the internalist/externalist quandary by squeezing my entities around P', the safe and golden mean, the meeting point of nature and society. But I am not interested just in P'; I am interested in all the values taken along the orthogonal dimension. Instead of having endless discussions on social constructivism, is it asking too much to focus our debates on a few other values of the stabilization gradient?

There is another major advantage in unfolding our debates on two dimensions instead of one: points become lines. As soon as we consider two sets of coordinates for every single entity—its degree of naturalness or socialness on the one hand, and its degree of stabilization on the other—we become able to do justice to the variable ontology of the entities we all studied in our case studies. Boyle's air pump, Pasteur's microbes, Millikan's electrons do not have to be defined as points in the one-dimensional diagram, but as *trajectories* in the two-dimensional one. The "same" microbe may be close to E, then to F, then to B', then to A', then to C, depending on its history. The "same" entity may occupy many states, being impurely social, then purely social, then purely natural, then impurely natural. The "same" actant will be immanent and then transcendent, made and nonmade, human-made and discovered, freely decided and imposed upon us as a *Fatum*. To use still other words, essences become existences and then essences again. Quasi objects may alternate and become objects, or subjects, or quasi objects again, or disappear altogether. The main philosophical interest of science studies, I contend, is in habituating us to consider those variable ontologies. Every actant has an original signature in the diagram above, and there will be as many "microbes" as there are points along the trajectory.

Many words have been offered recently to define such a trajectory. Serres (1987) used the word "quasi object" to designate what circulates in the collective and shapes it by its very circulation. Callon (1986) has offered the term "actor-network" to convey the same double function of

nature-building and society-building. In a more restricted way, Shapin and Schaffer (1985) have proposed "forms of life" and Lynch (1985) "experimental practice" to designate this activity that turns on the silent laboratory-made or society-making experiment. I have played with the words "allies," "collective things," "entelechies," "actants," "networks," and "modalities." All these words, since they designate either state, or process, or actions, however, may be misunderstood when they are seen as one pole in the one-dimensional frame or as the mere combination of the two. In order to be adequate, they themselves have to be adjusted to this new two-dimensional yard-stick. As soon as they are meant to designate points, they become meaningless. Their meaning comes only when they are used to stretch the ontological variations of those bizarre monsters we have uncovered.

"Monsters," "imbroglios," and "mixtures" are themselves ambiguous terms. The paradox is that with the one-dimensional yardstick science students are unable to account for their own discoveries. The reason why we all went studying laboratories, active controversies, skills, instrument making, and emerging entities was to encounter unstable states of Nature/Society and to document what happens in those extreme and novel situations. Most philosophies of science and all of the social sciences were, on the contrary, considering either stabilized sets of natures facing stabilized sets of societies, or letting only one of them be unstable at once. The misunderstanding was complete since what is the rule for us was the exception for them. We see only emerging Society/Nature, they consider only purely social or strictly natural entities. What is the rule for them, purity, is the exception for us. Whereas they are obsessed by the debates between "out there" and "up there," we focus on a region hitherto unknown which might be called "down there." Had we possessed the one-dimensional yardstick only, considered the two sides apart, inspected the lines from the two extremities, and tried to explain an agent by using Nature and Society as causes, we could have been unable even to suspect the existence of the basic phenomenon discovered by science studies, that is the coproduction of collective things. All the entities from the bottom half of Figure 19-3 would be squeezed around P′, the place for wishy-washy interpretations. Thus the framework that the whole field employs to calibrate its evaluations of case studies is totally unable to do justice to what the case studies reveal. The only thing it can convey about entities is that they are a tangle of science and society or a little bit of both . . . No wonder that the domain is in a blind alley; it is not even able to define the instrument that would allow us to read its results!

## 5. CONCLUSION

The year 1989 might not be a bad date for its demise since it is the very same year that witnessed, on the one hand, the dissolution of socialism and, on the other, the dissolution of naturalism. The two poles of our one-dimensional yardstick have been under attack the same year! The fall of the Berlin Wall and the first conferences on global warming all point to the same transformation as the one I have outlined here: it is impossible to dominate nature and to dominate society separately. The modern *Critique* was a nice try but it makes less and less sense, and now that we have realized that neither Nature nor Society can be put at the two opposing poles, it is better to recognize that we have never really been modern, that we have never ceased to do in practice what major schools of philosophy forbade us to do, that is to mix objects and subjects, grant intentionality to things, socialize matter, redefine humans. We, the Westerners, have never been

all that different from the Others who were unjustly accused of confusing the representation of nature with Nature as it really is. It is about time to take up again the threads of the many philosophers squeezed out by the *Critique* in order to create a makeshift philosophy specifically adjusted to the need of our empirical science studies.

I hope to have clarified why it is impossible to escape from our blind alley without doing some philosophical work. The idea that science studies may ignore philosophy altogether, or be content with philosophy *of science,* or not build up its own metaphysics and ontology is foreign to me. Now that we have a touchstone to evaluate science studies, not only by their longitude, so to speak—along the realist/relativist axis—but also by their latitude—along the stabilization gradient—and now that we have freed our interpretations from the prejudices of the *Critique,* the whole task appears straightforward. We can go on doing what the best scholars among us have tried to do for years, but now we know why and when such efforts are at their best. We do not have to retrace our steps, to recant constructivism, and to become "reasonable" again, falling back on a "golden mean" wishy-washy position.

Like Antony, "I have neither wit, nor words, nor worth, action, nor utterance, nor the power of speech," but I hope to have convinced the philosophical reader that the whole domain of science studies, once its "social" attire has been set aside, becomes an exciting domain, not only for understanding science/society but also for easing philosophy out of its modern (and post-modern) predicament.

NOTES

1. In the remainder of this essay, I use "modern" in a technical sense: it means the political philosophy that separates entirely the *representation* of things (science) from the *representation* of humans (politics). Although both are representations, their common origin is hidden. I also use the word *"Critique"* not to refer only to Kant's works but to the whole idea of a critical stand starting from one or from the two opposite poles defined by Kant.

2. There are differences, indeed, to which I cannot pay justice in such a short space, but my point is that they will become much more clearly visible when we shift from the one-dimensional yardstick to the other more complex measure to be defined below.

3. This is why I called this partition the "Modern Constitution of truth" (Latour, 1990a), "Modernity" being defined as the complete separation of the representation of things—science and technology—from the representation of humans—politics and justice—not to mention the bracketing out of God. A constitution is the written or unwritten document that settles the organization of power.

4. The use of the word "transcendence" to describe Nature might seem unusual. But once the symmetry is built, the use of the term is inescapable: the content of scientific knowledge radically escapes from the making of social ties; it is transcendent to society, it is "out there." Symmetrically, society is not of our own making, as Durkheim has shown long ago, it is transcendent to our own individual construction, it is "up there." So we live—or rather, we used to live—in between those two transcendences, Nature and Society, none of them of our making, each of them providing its own explanatory resources.

5. "Actant" is a bit of jargon borrowed from semiotics to make clear that we do not have to choose beforehand "mere things" and "human actors." The attribution to actants of volition and action (anthropomorphism) is as important to document as the attribution to them of "thingness" and "passivity" (phusimorphism). Natural forces are no more immediately given than are human agents (Latour, 1988, part II).

6. It is on purpose that I turn the metaphor upside down. I am against Alexander and his swift but deadly sword, and I want to rehabilitate the patient work of weaving back together science and society, the cart and the horse.

REFERENCES

Ashmore, Malcolm. 1989. *The Reflexive Thesis: Wrighting Sociology of Scientific Knowledge,* Chicago: University of Chicago Press.

Bloor, David. 1976. *Knowledge and Social Imagery,* London: Routledge.

Bradie, Michael. 1986. "Assessing evolutionary epistemology," *Biology and Philosophy,* 1, 401–459.

Callon, Michel. 1986. "Some elements of a sociology of translation: Domestication of the scallops and the fishermen of St. Brieuc Bay," in Law (editor), 196–229 (reprinted in this volume).

———. 1989. *La science et ses réseaux. Genèse et circulation des faits scientifiques,* Paris: La Déecouverte.

Callon, Michel and Latour, Bruno. 1990. "Do not throw out the baby with the Bath School: A reply to Collins and Yearley," in Pickering (editor).

Collins, Harry. 1985. *Changing Order: Replication and Induction in Scientific Practice,* London: Sage.

Collins, Harry, and Yearley, Steven. 1990. "Epistemological Chicken," in Andy Pickering (editor), pp. 302–326.

Giere, Ronald N. 1988. *Explaining Science: A Cognitive Approach,* Chicago: University of Chicago Press.

Latour, Bruno. 1987. *Science and Action,* Cambridge, Mass.: Harvard University Press.

———. 1988. *The Pasteurization of France,* with Appendix: *Irreductions: A Politico-scientific Essay,* Cambridge, Mass.: Harvard University Press.

———. 1990a. "The leverage point of experiments," in H. Le Grand (editor), *Experimental Enquiries,* Dordrecht: Reidel, 49–80.

———. 1990b. "Postmodern? No simply Amodern. Steps toward an anthropology of science. An essay review," *Studies in the History and Philosophy of Science,* 21, 145–171.

———. 1991. *Nous n'avons jamais été modernes. Essai d'anthropologie symétrique.* Paris: La Découverte.

Law, John. 1986. "On the methods of long-distance control: Vessels, navigation, and the Portuguese route to India," in Law (editor), 234–263.

Law, John, editor. 1986. *Power, Action and Belief,* Keele: Sociological Review Monograph No. 32.

Lynch, Michael. 1985. *Art and Artefact in Laboratory Science: A Study of Shop Work and Shop Talk in a Research Laboratory,* London: Routledge.

Pickering, Andy, editor. 1992. *Science as Practice and Culture,* Chicago: University of Chicago Press.

Serres, Michel. 1987. *Statues,* Paris: François Bourin.

Shapin, Steve. 1982. "History of science and its sociological reconstruction," *History of Science,* 20, 157–211.

Shapin, Steven. 1988. "Following scientists around" (review of Latour's *Science in Action*), *Social Studies of Science,* 18, 533–550.

Shapin, Steven, and Schaffer, Simon. 1985. *Leviathan and the Air-Pump,* Princeton: Princeton University Press.

Star, Leigh. 1988. "Introduction," Special Issue on Sociology of Science and Technology, *Social Problems,* 35, 197–205.

Woolgar, Steve. 1988. *Science: The Very Idea,* London: Tavistock.

# 20

# Was the Last Turn
# the Right Turn?

## The Semiotic Turn and A. J. Greimas

### TIMOTHY LENOIR

Henceforth, my dear philosophers, let us be on guard against the dangerous old conceptual fiction that posited a "pure, willess, painless, timeless knowing subject" [which] demand[s] that we should think of an eye that is completely unthinkable, an eye turned in no particular direction, in which the active and interpreting forces, through which alone seeing becomes seeing *something,* are supposed to be lacking. . . . There is *only* a perspective seeing, *only* a perspective "knowing"; and the more affects we allow to speak about one thing, the *more* eyes, different eyes, we can use to observe one thing, the more complete will our "concept" of this thing, our "objectivity," be.[1]

Nietzsche's passage highlights several themes central to recent work in science studies. First, it rejects a single, all-empowering gaze, a nonperspectival seeing, in favor of radical, critically positioned seeing—the theme of situated knowledges. Second, the passage enjoins us not to abandon vision and objectivity, but to reclaim embodied vision, perspectival seeing, even technologically mediated vision as a route to the construction of located, and therefore responsible, knowledges.

This, it seems to me, is roughly where the field is headed, or at least ought to head; in what follows I survey and assess some of the latest efforts to conceptualize science studies as cultural studies. Within this general movement I will limit my concern to the interesting, provocative, and sometimes mystifying "semiotic turn" in some of the most recent science studies. Specifically, I have in mind the papers of Bruno Latour and Madeleine Akrich presenting what they call a "semiotics of human and nonhuman assemblies";[2] Donna Haraway's papers on what she calls "material-semiotic actors," notably her "Promises of Monsters," "Situated Knowledges," and "Cyborg Manifesto";[3] and N. Katherine Hayles's proposal for enrolling these hybrids in a semiotically inspired program of "constrained constructivism."[4] By tracing the versions of semiotics presented in these papers to their source, I seek an answer to this question: Was that last turn the right turn?

Considerations about language, whether Kuhn-inspired interest in quantitative linkages between scientific publications or concerns about Wittgensteinian language games and forms of

life, have always been part of science studies in one form or another. These are not the sources of the recent semiotic turn, but they point us in the right direction. To repeat a familiar story: the point was to move away from theory-dominated accounts of knowledge production in science to an account sensitive to actual scientific practice in which theory was simply one of the many important games in town—experimenters and crafters of instruments and techniques being crucial but silenced laborers in the production of knowledge. The rehabilitation of skill and craft knowledge (even in the domain of theory, mathematical, and computational practice), concerns about tacit knowledge and unarticulable skill, experimenter's regress, interpretive flexibility, and negotiated closure of debate all contributed to newer accounts of science as a disunified, heterogeneous congerie of activities.[5] The emphasis on practice and on the local context of investigation initiated by the first generation of laboratory studies prompted a new wave of inquiries into the ways in which these different domains of practice mesh with one another locally and how they translate globally to other sites. Joan Fujimura's exploration of what she has called "articulation work" in linking up different social worlds examines how networks of heterogeneous actors, practices, and different social worlds, including industry and markets, are knit together in usable, effective packages; she provides one salient example of the way in which studies of practice have expanded into studies of context and linkages between contexts.[6]

Other lines of work have led directly from considerations of science as practice to the view of science as culture studies. Some of these studies have verged into the semiotic turn that interests me. Jim Griesemer and Leigh Star's work on boundary objects is a case in point, where they show that objects, like museum dioramas, mediate multiple domains of interest and programs of meaning-making.[7] Another striking example of the semiotic turn is Steven Shapin's notion of virtual witnessing and the efforts by Robert Boyle and others to construct a literary technology that stabilized facts as preexisting the medium through which they were revealed, and simultaneously erased the labor that went into their production.[8] Gillian Beer, in her examination of Darwin's uses of metaphor and narrative strategies, has taught us to view yet another dimension of the literary technology that goes into fashioning arguments, stabilizing agreement, and enrolling other social worlds.[9]

These studies have embraced a semiotic approach, whether explicitly acknowledged or not. By "semiotic" I do not mean to focus solely on the construction of language, or on the development of literary technologies more broadly conceived. Most of us are not interested in treating the scientific construction of nature as a text. The emphasis on practice in recent science studies has included material as well as symbolic culture. We want to call attention to both a materiality of the text and a materiality beyond it. We want, in Brian Rotman's phrase, to put the body "back in."[10] These objectives do not render semiotics useless to us—but what will not work is an abstracting, ahistorical, structuralist semiotics aimed at looking for a logic of culture, proposing a structural explanation in terms of systems rather than a causal historical account. Ferdinand de Saussure defined semiotics as "the life of signs in society."[11] The semioticians most relevant to our concerns, it seems to me, are persons whose work follows Roland Barthes in extending Saussure's structural linguistics to concerns about representation, images, codes, media, and culture in everyday life. Barthes's studies of the mythologies at work naturalizing a historically produced social order by erasing the historical conflicts and conditions of its production, making them instead appear as the reflection of nature, are models of good practice for science studies.

Present in the semioticians I find relevant to recent directions of science studies is the notion missing in the work of earlier structuralist semiotics: language itself is not pure sign, it is also a

thing. Language is tied to voice, to bitmaps on a screen, to materiality. The word is thus partly object, partly sign. There can be a semiotics of the concrete, of the material; the signifier doesn't always engender sense, but sometimes desire, the sentiment of animal spirits, the return to the happiness of childhood.[12] We can read not only what the language is *saying*, its content, cause, or philosophy; as Paula Treichler has shown us brilliantly in her paper "AIDS . . . An Epidemic of Signification," we can also read what the language is *doing*, its material deployment, the social intervention it is accomplishing.[13]

To feminist historians of science all of this must sound like reinventing the wheel. Feminists have been practicing the semiotic turn almost from day one. Studies of gender have led the way in emphasizing the body as a medium of culture, a surface on which the central rules, hierarchies, and metaphysical commitments of a culture are inscribed and reinforced by, as Susan Bordo observes, the trivial routines, rules, [and] practices through which culture is embodied, *made* body.[14] Science studies, at least the tradition of the sociology of scientific knowledge, has not paid sufficient attention to the work of feminist historians. As Donna Haraway has recently pointed out in a note to her paper "The Promises of Monsters," laboratory studies have circumscribed and defined culture by what is generated inside the laboratory. By drawing their own boundaries on what counts as practice, the laboratory ethnographers, Haraway complains, "don't address the issue of how other practices of masculine supremacy, racism, or other forms of structured inequality get built into and out of working machines."[15] I agree with this objection, and it seems to me to point in the direction of a much broader account of science as culture that many of us think science studies is verging toward.

Science studies conceived as cultural studies and feminist studies are converging along a number of axes, and these call out for closer cooperation between scholars working in these different fields. For example, while many cultural historians have drawn inspiration from Michel Foucault's writings on the materiality of discourse, a number of feminist theorists are unhappy with the implications of Foucauldian discursive formations. Foucault's notion of a discursive event allows him to locate knowledge, the object of historical inquiry, in a finite, social space and to determine the connections between statements without locating them in an originating consciousness. Discursive practices for Foucault do not refer back to a unified subject but to "the various statuses, the various sites, the various positions that he [or she] can occupy or be given when making a discourse."[16] Historians of science interested in abandoning heroic genius accounts can applaud this. While many have welcomed Foucauldian conceptions of subjectivity as supportive of a more contextualized historiography enabling nonreductionistic accounts that avoid internal-external dichotomies and replace talk of causal forces with conditions and constraints, there has been a recent move to reassert agency and the body. Similar concerns are evident among some feminist critics of Foucault. Rosemary Hennessy, for example, warns that materialist feminism needs to be on guard against the Foucauldian body as purely discursive construct.[17] For while in numerous places Foucault describes the body as both a discursive object and a prediscursive resistance or extradiscursive excess, he never provides an account of the relation between discursive and nondiscursive practices. In the absence of such an account, it is difficult to understand how discursively constructed subjects could ever effect social change. Any social constructivist position that positions the body as agent of opposition outside the social, runs into difficulty in formulating a program for change. Deep parallels to this situation confront the constructivist program in science studies as well. Actor-network theory, for example, flattens all relations of power and authority.

My real concern with the actor-network theory is with its version of semiotics. The semiotic turn enters in *Science in Action* with the introduction of "actors" and "actants." Latour proposed this new ontology, you all recall, in order to get out of the apparent asymmetry of the symmetry principle in the original Strong Programme for the Sociology of Knowledge. The first symmetry principle proposed to apply the same sorts of explanation to good and bad science. Rather than attributing the cause of closure of debate to nature in the case of truth, and to social factors in the case of error, both debates were to be conducted in light of the same sociological investigation of negotiation, interpretive flexibility, problems of replicability, etc. The problem with this, according to Latour, is that the only actors are human actors. Nature and other nonhuman actors, such as machines, never enter in as coparticipants and allies in the debates. The second symmetry principle, the generalized symmetry principle due to Michel Callon, overcomes this problem by not privileging the social; nature and society are explained in the same terms through some well-known and entertaining Janus-faced acrobatics. Debates are closed through enrolling allies and extending links in networks, and some of the allies are nonhuman actants.

For many people, this move was a great step out of the feared plasticity of nature lurking in social constructivist accounts: here was some of the resistance of bodies, perhaps even the resistances of the extradiscursive excesses mused upon by Foucault. I am less happy with this outcome. Specifically, my problem is with the manner in which Latour defines actants. Actants, we are told, are the things behind the texts:

At the beginning of its definition the "thing" is a score list for a series of trials. Some of these trials are imposed on it either by the scientific objector and tradition or tailored by the authors. The "things" behind the scientific texts are thus similar to heroes of stories; they are all defined by their performances. Some in fairy tales defeat the ugliest sevenheaded dragons or against all odds they save the king's daughter; others inside laboratories resist precipitation or they triumph over bismuth. . . . At first, there is no other way to know the essence of the hero. This does not last long however, because each performance presupposes a competence which retrospectively explains why the hero withstood all the ordeals. The hero is no longer a score list of actions; he, she or it is an essence slowly unveiled through each of his, her or its manifestations. . . . Behind the texts, behind the instruments inside the laboratory, we do not have Nature. . . . What we have is an array allowing new extreme constraints to be imposed on "something." This "something" is progressively shaped by its re-actions to these conditions.[18]

The reference that Latour provides for this passage makes sense of all the talk about fairy-tale dragons and king's daughters: it is to the structuralist semiotician A. J. Greimas, who set out to produce a generative grammar of narrative in which a finite number of functional themes in binary opposition juxtaposed with possible roles (subject-object; sender-receiver; helper-opponent) would generate the structures we call stories—all of them. Greimas's actants, like Latour's, are not actors. Actants are nonhuman for Greimas as well; they are syntactically defined; and, for Greimas as for Latour, the performance of the actor presupposes competence. Subjects are defined not only as subjects, but by the position occupied in a narrative journey, a journey characterized by the acquisition of competences.[19] Actors are constructed as the conjunction of actantial and thematic roles on this two-by-two grid.

All of this is great fun, but I have some serious doubts about whether we are not led in the end, kicking and screaming, back into an old-style realism. Latour offers us the hook in his inviting definition of semiotics as nontextual, nonlinguistic—in fact, as not necessarily even about signs. Thus, in his and Akrich's "Vocabulary for the Semiotics of Human and NonHuman Assemblies," we read:

*Semiotics:* The study of how meaning is built, but the word "meaning" is taken in its original nontextual and nonlinguistic interpretation; how one privileged trajectory is built, out of an indefinite number of possibilities; in that sense, semiotics is the study of order building or path building and may be applied to settings, machines, bodies, and programming languages as well as texts; . . . the key aspect of the semiotics of machines is its ability to move from signs to things and back.[20]

In an effort to go beyond both moderns and postmoderns, who thought the Saussurian notion of semiotics need not be limited to linguistic phenomena, Latour now bursts through the sign barrier. An elision has taken place between actants as nonhuman in the Greimasian sense and actants as extralinguistic entities in the world.

Apart from my inability to find a satisfying discussion of how we get from Greimas's world of texts and narratives to the world of collective entities, quasi objects, and nature-culture discussed in Latour's most recent essays and his latest homily, *We Have Never Been Modern,* my concern is that, in the form of a grid of preexisting competences and roles, we are being provided a map and potentially a set of taxa that specify certain types of actors and narratives, and with this we are back to the old ground of realism and representation. The sting comes when, reading a bit further in Greimas, we find the following advice about remaining scientific in our semiotic attitude: "Either we are content with the indications of the text, and we say: 'Outside the text no salvation!,' or we bring in psychology and psychoanalysis and history and sociology and we no longer have semiotics: there is a great deal of intelligence, genius, but no longer any coherent analysis."[21] Against this injunction to seek a quasi-scientific semiotics to avoid Nietzschean perspectival seeing and the accidents or contingencies of history, I want to urge caution.

Latour's seductive plea, voiced in the definition of semiotics above, to find a grounding for signs in things-in-themselves, has recently become the refrain of a twelve-step program to rehabilitate postmodern junkies hooked on deconstruction. Since in his wild youth he enticed the rest of us to play epistemological chicken, it is perhaps both surprising and fitting that Latour is one of the first to take the sobriety oath, but the recent chorus of scholars joining him in calling for a return to objectivity and realism is truly remarkable. William Cronon's probing essay "A Place for Stories: Nature, History, and Narrative," written from the heartland of America in profound concern about saving nature, expresses the mood to return to common sense currently appealing to many who have observed postmodernism from its margins. Cronon writes that his analysis of narrative is motivated by a struggle to accommodate the lessons of critical theory without giving in to relativism:

If postmodernism is correct in arguing that narrative devices are deeply present even in such a field as environmental history, which takes for its subject the least human and least storied of worlds—nature—must we then accept that the past is infinitely malleable, thereby apparently undermining the entire historical project? Given my biases, the answer to this question has got to be no, and so my story has worked its way toward an ending about the ultimate justification of history in community, past reality, and nature itself. For me, there is something profoundly unsatisfying and ultimately self-deluding about an endless postmodernist deconstruction of texts that fails to ground itself in history, in community, in politics, and finally in the moral problem of living on earth.[22]

For persons concerned about the environment such as Cronon, as well as for feminists such as Hennessy and Sandra Harding, in order for cultural studies to be an effective tool for social and political change it must be grounded; it cannot forsake reference.

In contrast, a number of recent studies have attempted to preserve objectivity while abandoning reference altogether. They do this by replacing old-style realism with what might be characterized as socially constructed artifactual realism. Central to these efforts are the notion of "collective" entities and the tools of Greimasian semiotics. Donna Haraway, for example, is sympathetic to Latour's insistence on getting the nonhumans into the picture in terms of his hybrids of nature/culture. Central to Haraway's work are what she calls "material/semiotic actors," and in her explication of those collectives she, too, takes recourse to Greimas. Similarly, N. Katherine Hayles has talked about superimposing social construction on Greimasian semiotics in what she calls "constrained constructivism":

Constrained constructivism points to the interplay between representation and constraints. Neither cut free from reality nor existing independent of human perception, the world as constrained constructivism sees it is the result of active and complex engagements between reality and human beings. Constrained constructivism invites—indeed cries out for—cultural readings of science, since the representations presented for disconfirmation have everything to do with prevailing cultural and disciplinary assumptions. At the same time, not all representations will be viable. *It is possible to distinguish between them on the basis of what is really there.*[23]

Hayles gets at these "really there" constraints similarly to Latour, who talks about the determination of properties of objects "out there" in the world: namely, in terms of invariability of operation.[24] Laboratory experiments, drawing upon a repertoire of "black-boxed" procedures, arrange situations so that the relevant natural constraints operate. In Hayles's terms, the constraints select among representations consistent with reality. Notable is the slash in Haraway's "material/semiotic actors," the "cusp" between physical and semiotic constraints in Hayles's discussion, and Latour's "longitudinal axis" between his society and nature poles along which his quasi objects reside. These designations defend against those who make nature either the malleable product of social interests—Latour identifies Pierre Bourdieu as chief culprit here—or against the structuralists and poststructuralists—all those such as Foucault and especially Derrida, according to Latour—who make everything the product of language.[25]

Hayles, Haraway, and Latour desire a science studies that, while sensitive to matters of history and social context, does not give up connection to the world as referent. Thus Hayles:

But language is not all there is. Elusive negativity reveals a synergy between physical and semiotic constraints that brings language in touch with the world. Physical constraints, by their consistency, allude to a reality beyond themselves that they cannot speak; semiotic constraints, by generating excess negativity, encode this allusion into language. There is a correspondence between language and our world, but it is not the mysterious harmony Einstein posited when he said that the mystery of the universe is that it is understandable.[26]

I am not convinced that designating a new species of collectives, material/semiotic actors living precariously on the cusp, is in the end successful at "bracketing the referent" as advertised. In Latour's case this takes the form of a hat trick in which the referent disappears at the beginning of the show, only to be smuggled back in the end. Neopragmatism—"if you can spray it, it's real"—plus instruments and experimental procedures as mediators do not add up to bracketing the referent. To be sure, our contact with the world is mediated, and we are not left with "things-in-themselves." But since Kant, no theory of scientific realism has ever claimed to give access to things in themselves. At issue is always the construction of a representation.

What Haraway and others have proposed is the serious and imposing task of giving up representationalism altogether in order to escape from its inevitable politics of domination. While I am sympathetic to these goals,[27] I want to register a more-than-just-nit-picking concern about the use of Greimas's semiotics as a resource for this project. First, I am not convinced that his structuralist approach is at all capable of opening up the nature/culture interaction in the way Haraway, Hayles, and Latour hope. Of interest to Haraway, for example, is Greimas's narrative theory. The hypothesis is that since nature is an artifact that cannot preexist its social construction, the analysis of the processes involved in the construction of fictive worlds provides a useful critical resource as well as a site to contemplate alternative world-making possibilities. This is an intriguing and productive proposal.[28] To carry it through, Haraway, Hayles, and Latour draw upon the theory of actants, narrative structures, and, especially in Haraway's case, the semiotic square developed by Greimas. But such theories come at a high cost: the problematic ontology to which Greimasian semiotics is committed.[29]

Ultimately, for Greimas, the analysis of signification relies on a minimal set of atomic meanings, "nuclear" semes modeled after chemical elements, replete with isotopies and homotopies, some of which—namely those connected with what Greimas describes as diverse orders of perception, interoception, and proprioception—ground the semic order in the structure of the world. These invariant language/nature interfaces depend on the invariant modes of human perception and the invariant operation of nature. Evident in the following, Greimas's approach borders on a reductivism to biological deep structures:

Thus, the mode of existence of the semiological level, it seems to us, can be specified to some degree: it is an ensemble of categories and semic systems situated and apprehensible at the level of perception, comparable on the whole to the schematized visual perceptions of the birds evoked by Raymond Ruyer. . . . Situated within the processes of perception, the semiological categories represent, so to speak, the external facet, the contribution of the exterior world, to the birth of meaning. Considered from this angle, the semiological categories seem isomorphs of the *qualities* of the sensible world, and comparable, for example, to the *morphophonemes* of which gestural language is composed.[30]

Haraway shares Frederic Jameson's dissatisfaction with this sort of grounding. Jameson proposes dropping the ontology and preserving Greimas's analytic device, the semiotic square (discussed below), which, he argues, is suited to analyzing the workings of any system of meaning based on binary oppositions, and is particularly useful for modeling closed ideological systems based on class conflict. Haraway praises Jameson for his subtle use of the semiotic square, and her paper "The Promises of Monsters" emulates his example.[31] While Jameson jettisons the structuralist ontology, he continues to insist on the importance of external reality. He proposes treating cultural texts as resolutions of determinate, real, social contradictions, and he resists treating external reality as context. Rather, he insists that Reality be considered an active being entering into the construction of the text itself. Jameson writes:

The literary or aesthetic act therefore always entertains some active relationship with the Real; yet in order to do so, it cannot simply allow "reality" to persevere inertly in its own being, outside the text and at a distance. It must rather draw the Real into its own texture, and the ultimate paradoxes and false problems of linguistics, and most notably of semantics, are to be traced back to this process, whereby language manages to carry the Real within itself as its own intrinsic or immanent subtext. Insofar, in other words, as symbolic action—what Burke will map as "dream," "prayer," or "chart"—is a way of doing something to the world, to that degree what we are calling "world" must inhere within it, as the content it has to take up into itself in order to submit it to the transformations of form.[32]

Haraway's proposal of what she calls cyborg, reflexive artifactualism is clearly in sympathy with Jameson's characterization of the relation between the "Real" and the text. Her project intends to evade adopting an inappropriate referential realism in order to make room for an unsettling active quality of "the world." While I applaud her dissent from methodological individualism and liberal theories of agency, her talk about actants as "collective entities doing things in a structured and structuring field of action"[33] makes me worry about creeping Greimasian structuralism; my misgivings are not assuaged by her assurances that we are looking for a coyote grammar of the world, where deep structure can be a surprise, a veritable trickster.[34] The problem is that Haraway distances herself from Greimas in the fashion of Jameson while simultaneously deploying numerous elements of Greimas's work, including his discussion of actors, actants, narratives, and the semiotic square, without showing us how to transmute his ontological structuralism into a coyote grammar of the world (whatever that is).

In the remainder of this essay I want to address the issue of what is and what is not relevant to a semiotic turn in this work. I have argued above that some of the same issues are present in Latourism. In contrast to Latour's claim that his collective, nature/culture entities constructed in explicit reliance on Greimas's semiotics can lead us out of the dark wood of referential realism—an assertion I regard as a fairy tale—I hope for more from Haraway's monsters. But it is not her clunky structuralist Greimasian semiotics that I appreciate. Another semiotic tradition informs much of Haraway's work, explicitly the radically historicist project of *Primate Visions* in which she uses antistructuralist tools derived from Barthes to clear the ground for replacing representations with articulations.[35] The power and suggestiveness of this kind of work demonstrates that Greimasian semiotics, including the semiotic square, is a luxury cultural studies can do without.

The semiotic square is a means of articulating the semantic structure of signification in terms of binary oppositions or alternatives. Greimas emphasized that the oppositions giving rise to meaning are a far richer set than contradiction, the either/or of binary logic. Elaborating on three types of relationship—contradiction, contrariety, and complementarity[36]—he established an exhaustive set of oppositions forming a dialectical logic with four positions rather than three, as in Hegelian dialectic. Given a particular concept—Greimas illustrates this with an example from Lévi-Strauss's discussion of "life" versus "death" in "The Structural Study of Myth"—one can use the semiotic square to unpack its semantic content by specifying the fields of difference, opposition, and separation in which it is embedded with respect to other concepts. Greimas describes the square's fourth position—which I regard as its most engaging aspect—as "explosive." Commentators have depicted it as the "negation of the negation" in Hegelian terms; as such, Jameson notes, the fourth position in the square is frequently enigmatic, opening the possibility of a productive leap to the elaboration of a new system of meaning.[37] Ronald Schleifer, in his excellent discussion of Greimas's work, has shown how this process works, using the fourth position as the opening to an ever-widening web of "zones of entanglement."[38] Intuitively, one can see the appeal of the square for practitioners of cultural studies. They hope that the semiotic square will bring to light the webs of signification constituting the meanings of a text; they believe that it may articulate the intertextual linkages between different domains as well as the underlying assumptions organizing particular cultural fields.

Haraway has made heuristic use of the semiotic square in her paper "The Promises of Monsters: A Regenerative Politics for Inappropriate/d Others." She places in the first quadrant of the square, identified as "real space," an account of Jane Goodall's field research with chimpanzees in Tanzania; she then winds her way to "outer space" in the second quadrant of the square with a

discussion of cold war space-race politics and the reconstitution of masculinity embedded in efforts to put a chimpanzee, HAM, into suborbital space flight in 1961; the third quadrant of the square harbors "inner space," where she describes the contexts of militarization, automation, and visualization in which research on the human immune system is embedded. The fourth quadrant proceeds to "elsewhere," "virtual space," in which the oppositions and deep structures of domination and representation revealed in the previous three squares are metamorphosed, or rather imploded, through John Varley's science fiction character Lisa Foo into a promising new semiotics of articulation.

All this is impressive at first glance, but I wonder whether the semiotic square does indeed make an analytical contribution to Haraway's project. As Jameson notes, the square is particularly suited to analyzing oppositions embedded within a synchronic view of culture. It provides a tool for uncovering the assumptions and contradictions built into the present situation; for Jameson, it makes manifest the political unconscious. But the different quadrants in Haraway's paper are not linked through a dynamic set of dialectical oppositions, used as hypertextual "buttons" to explore other dimensions of an already-given synchronic view; rather, they are slots for the elegant presentation of material imported from elsewhere, namely from Haraway's *Primate Visions*. Each of the semiotic square's quadrants described in "The Promises of Monsters" is a thumbnail distillation of a massive body of historical research. As I read it, the main strategy of that research was to trace the construction of meaning through the historical processes—especially the tangled and layered political and economic histories—that produced the signifiers and welded them to signifieds. Meanings for such a project are constructed through the configuration of chains of signifiers linked metonymically and metaphorically and fused together through interest, domination, and history, rather than through the projected immanence of a finite set of nuclear semes organized by timeless oppositions and contradictions. Such a project finds its rationale in Barthes's notion that "In general . . . the link between signifier and signified is contractual in its principle, but . . . this contract is collective, inscribed in a long temporality (Saussure says that 'a language is always a legacy') and that consequently it is, as it were, *naturalized.*"[39] *Primate Visions* is, from this point of view, a history of the forging of the "contract" between signifier and signified and the naturalization of that contract through the silencing of struggles present in its formation.

Exemplary of this historicist project is Haraway's discussion of the Gulf Oil advertisement entitled "Understanding Is Everything," in which a white female human hand is pictured entwined with the hand of a young ape—the image adorning the jacket of *Primate Visions*. Her remarkable unpacking of this image/text is, for my purposes, emblematic of a Barthesian semiotic analysis. In the fashion of Barthes, Haraway shows that in proclaiming communication, trust, responsibility, and understanding, natural science, coded in the ad as white and feminine, speaks for nature, all threatened species, the third world, peoples of color, Africa, the ecologically endangered earth.[40] At a time (the 1970s) when oil companies were under attack from environmentalists, the power of white, capitalist technoscience to represent and save nature is here presented as a natural state while silencing the complex history of racism, colonialist discourse, and the efforts of African peoples to establish hegemony over the lands in which they live.[41] Haraway's examination of the historical processes involved in assembling this image and coding it for an audience—like Adrian Desmond's study of the configuration of Lamarckism, working-class radicalism, materialism, atheism, and cooperative models of work and organization in early Victorian London,[42]—has taught us that such texts acquire their meanings through complex

narratives constructed by contentious constituencies and adapted to particular social struggles. Inscribed into the social imaginary through technologies of writing, photography, film, museum exhibits, teaching materials, and guidebooks, these struggles to define both society and nature are bled and silenced when they are traced with the dialectical logic of oppositions and the axes of contradiction revealed by the structural semanticist's semiotic square.

The semiotic turn, then, does offer a promising route for future science studies—when it takes a particular direction.[43] Semiotics as practiced by scholars with an interest, not in essences and deep structures, nor in grids of actantial roles and thematic functions, but in the accidents and contingencies of history and the way they become naturalized by signs, can, as *Primate Visions* demonstrates, lead to a vastly enriched historiography of science. Such studies stress both the material and the contested nature of signs and avoid arid formalism by insisting upon embodied or situated knowledge, through which alone, as Nietzsche reminds us, "seeing becomes seeing *something*."

NOTES

1. Friedrich Nietzsche, *On the Genealogy of Morals*, trans. Walter Kaufmann and R. J. Hollingdale (New York: Random House, 1967), p. 119.

2. Madeleine Akrich and Bruno Latour, "A Summary of a Convenient Vocabulary for the Semiotics of Human and Nonhuman Assemblies," in *Shaping Technology/Building Society: Studies in Sociotechnical Change*, ed. Wiebe E. Bijker and John Law (Cambridge, Mass.: MIT Press, 1992), pp. 259–264. Also see Madeleine Akrich, "The De-Scription of Technical Objects," in ibid., pp. 205–224.

3. Donna Haraway, "The Promises of Monsters: A Regenerative Politics for Inappropriate/d Others," in *Cultural Studies*, ed. Lawrence Grosberg, Cary Nelson, and Paula Treichler (New York/London: Routledge, 1992), pp. 295–337; "Situated Knowledges: The Science Question in Feminism and the Privilege of Partial Perspective," in Haraway, *Simians, Cyborgs, and Women: The Reinvention of Nature* (New York: Routledge, 1991), pp. 183–201 (reprinted in this volume); "A Cyborg Manifesto: Science, Technology, and Socialist-Feminism in the Late Twentieth Century," in ibid., pp. 149–181.

4. N. Katherine Hayles, "Constrained Constructivism: Locating Scientific Inquiry in the Theater of Representation," in *Realism and Representation: Essays on the Problem of Realism in Relation to Science, Literature, and Culture*, ed. George Levine (Madison: University of Wisconsin Press, 1993), pp. 27–43.

5. For recent discussions on all these themes see the following collections: Peter Galison and David Stump, eds., *The Disunity of Science: Boundaries, Contexts, and Power* (Stanford: Stanford University Press, 1994); Andrew Pickering, ed., *Science as Practice and Culture* (Chicago: University of Chicago Press, 1992); Ernan McMullin, ed., *The Social Dimensions of Science* (Notre Dame: University of Notre Dame Press, 1992).

6. Joan H. Fujimura, "Crafting Science: Standardized Packages, Boundary Objects, and 'Translation,'" in Pickering *Science as Practice*, pp. 168–211.

7. Susan Leigh Star and James R. Griesemer, "Institutional Ecology, 'Translations,' and Boundary Objects: Amateurs and Professionals in Berkeley's Museum of Vertebrate Zoology, 1907–39," *Social Studies of Science* 19 (1989): 387–420 (reprinted in this volume).

8. Steven Shapin and Simon Schaffer, *Leviathan and the Air-Pump: Hobbes, Boyle, and the Experimental Life* (Princeton: Princeton University Press, 1985).

9. Gillian Beer, *Darwin's Plots: Evolutionary Narrative in Darwin, George Eliot and Nineteenth-Century Fiction* (London: Routledge, 1983).

10. Brian Rotman, *Ad Infinitum: The Ghost in Turing's Machine: Taking God Out of Mathematics and Putting the Body Back In* (Stanford: Stanford University Press, 1993).

11. Ferdinand de Saussure, *Course in General Linguistics*, trans. Roy Harris (La Salle, Ill.: Open Court, 1986), p. 15.

12. See Marshall Blonsky, "The Agony of Semiotics: Reassessing the Discipline," in *On Signs*, ed. idem. (Baltimore: Johns Hopkins University Press, 1985), p. xvi.

13. Paula Treichler, "AIDS, Homophobia, and Biomedical Discourse: An Epidemic of Signification," *October* 43 (Winter 1987): 31–70; see also in *AIDS: Cultural Analysis/Cultural Activism*, ed. Douglas Crimp (Cambridge, Mass.: MIT Press, 1988).

14. Susan R. Bordo, "The Body and the Reproduction of Femininity: A Feminist Appropriation of Foucault," in *Gender/Body/Knowledge: Feminist Reconstructions of Being and Knowing*, ed. Alison M. Jaggar and Susan R. Bordo (New Brunswick, N.J.: Rutgers University Press, 1989), pp. 13–33. Bordo is actually quoting Bourdieu; see Pierre Bourdieu, *Outline of a Theory of Practice* (Cambridge: Cambridge University Press, 1977), p. 94.

15. Haraway, "Promises of Monsters," pp. 331–333 n. 14.

16. Michel Foucault, *The Archaeology of Knowledge*, trans. A. M. Sheridan Smith (New York: Harper and Row, 1976), p. 54.

17. Rosemary Hennessy, *Materialist Feminism and the Politics of Discourse* (New York: Routledge, 1993), pp. 37–46.

18. Bruno Latour, *Science in Action: How to Follow Scientists and Engineers through Society* (Cambridge, Mass.: Harvard University Press, 1987), p. 89. Also see Akrich and Latour, "Summary of a Convenient Vocabulary," p. 259.

19. See A. J. Greimas, "The Love-Life of the Hippopotamus: A Seminar with A. J. Greimas," in Blonsky, *On Signs,* pp. 341–362; and Terence Hawkes, *Structuralism and Semiotics* (Berkeley: University of California Press, 1977), pp. 87–95.

20. Akrich and Latour, "Summary of a Convenient Vocabulary," p. 259.

21. A. J. Greimas, "Love-Life of the Hippopotamus," p. 361.

22. William Cronon, "A Place for Stories: Nature, History, and Narrative," *Journal of American History* 78 (March 1992): 1374.

23. Hayles, "Constrained Constructivism," pp. 33–34.

24. Ibid., p. 33; Bruno Latour, "Pasteur on Lactic Acid Yeast: A Partial Semiotic Analysis," *Configurations* 1 (1993): 141–145. In the introduction to his paper, Latour states: "The main advantage of practicing some sort of semiotics on scientific texts lies in the very limitation of the theory. By bracketing out the question of the referent (there exist only internal referents generated by the text itself) and by bracketing out the question of the locutor (authors and readers are built into the texts and may not relate to any authors and readers in the flesh), we let the texts deploy their own categories. Their world-making activity is no longer squeezed in between a referent that it has to grasp and a locutor or a social context from which it emerges. It becomes an event, which has the same activity, the same materiality, the same complexity, the same historicity as any other event" (p. 130). Several pages later this bracketing procedure is revealed to be no bracketing of the referent at all: "What is an experiment? It is an action performed by the scientist so that the nonhuman will be made to appear on its own. It is a very special form of constructivism. . . . Who is acting in this experiment? Pasteur *and* his yeast. More exactly, Pasteur acts *so that* the yeast acts alone. We understand why it is difficult for Pasteur to choose between a constructivist epistemology and a realist one: he creates a scene in which he does not have to create anything. He develops gestures, glassware, protocols, so that the entity, once shifted out, becomes automatic and autonomous" (pp. 141–142).

25. Haraway declares herself in fundamental agreement with this characterization; see "Promises of Monsters," pp. 296–298.

26. Hayles, "Constrained Constructivism," p. 38.

27. See Timothy Lenoir, "Practical Reason and the Construction of Knowledge: The Lifeworld of Haber-Bosch," in McMullin, *Social Dimensions of Science,* pp. 158–197.

28. But by no means an unproblematic proposal. Greimas himself contemplated similar use of his semiotics for constructing an "efficient science of man": "The problem, which cannot be pursued here, is that of the possibility of returning from the known and described axiological models to ideological models: the establishment of rules of trans-mutation authorizing that passage would add to that of coherence a second criterion of truth of noological models. But simultaneously with the possibility of verification, the possibility of a social and individual therapeutics could be con-sidered. Supposing that the main axiological models of our universe were analyzed and described, supposing also that the paradigms of variations and the rules of transformation of the ideological models were sufficiently well known, we could foresee the possibility one day of constructing and setting in place functional models capable of bending individuals and collectivities toward new axiological structures. An efficient science of man could thus be substituted for the present gropings of psychological and sociological therapeutics" (A. J. Greimas, *Structural Semantics: An Attempt at a Method,* trans. Daniele McDowell, Ronald Schleifer, and Alan Velie [Lincoln: University of Nebraska Press, 1983], pp. 159–160).

29. Latour also points out that the semiotics he is using has a certain ontological weakness; he just never specifies what that weakness is—namely, its reliance on a structural ontology of the world homologous to the stories scientists tell. See Latour, "Pasteur on Lactic Acid Yeast," p. 130.

30. A. J. Greimas, *Structural Semantics,* pp. 72–73.

31. See Haraway, "Promises of Monsters," p. 305.

32. Frederic Jameson, *The Political Unconscious: Narrative as Socially Symbolic Act* (New York: Routledge, 1983), p. 81.

33. Haraway, "Promises of Monsters," p. 313.

34. Ibid., p. 331 n. 11.

35. See especially ibid., p. 303 n 22, where Haraway calls attention to Barthes as a model.

36. See A. J. Greimas, "The Interaction of Semiotic Constraints," in *On Meaning: Selected Writings in Semiotic Theory,* trans. and ed. P. J. Perron and Frank Collins (Minneapolis: University of Minnesota Press, 1987), pp. 48–62; Frederic Jameson, *The Prison House of Language: A Critical Account of Structuralism and Russian Formalism* (Princeton: Princeton University Press, 1972), pp. 163–168; Ronald Schleifer, *A. J. Greimas and the Nature of Meaning: Semiotics and Discourse Theory* (London: Croon Helm, 1987), pp. 26–29.

37. Jameson, *Prison House of Language,* p. 166.

38. Schleifer, *A. J. Greimas,* p. 26.

39. Roland Barthes, *Elements of Semiology,* trans. Annette Lavers and Colin Smith (New York: Hill and Wang, 1967), p. 51.

40. Cf. Roland Barthes, *Mythologies*, trans. Annette Lavers (New York: Noonday, 1957), p. 116: In a barbershop, Barthes is handed a copy of *Paris-Match*, featuring a cover photo of a black soldier saluting an unpictured *tricolour*. Barthes explicates this sign, in the context of its association with a popular magazine and its placement in the everyday space of a barbershop (rather than, say, at a political rally), as indicating the greatness of the French empire: all her sons serve faithfully under her flag without any racial discrimination. In the construction of this signifier, wide and complex histories, including the biographies of both the soldier and the empire he serves, have been silenced and turned into natural states. Even more: once this transformation "from history to nature" has been accomplished, the signified becomes a reference that *establishes* French imperialism; the sign of the photograph "naturally" evokes the concept. The signifier thus gives foundation to the signified; it helps to produce and reproduce it through naturalization.

41. See Donna Haraway, *Primate Visions: Gender, Race, and Nature in the World of Modern Science* (New York/London: Routledge, 1989), chap. 7, pp. 133–185; idem., "Promises of Monsters," pp. 306–308.

42. Adrian Desmond, *The Politics of Evolution: Morphology, Medicine, and Reform in Radical London* (Chicago: University of Chicago Press, 1989).

43. Here I am suggesting that we literally follow Barthes, who was introduced to semiotics by Greimas in the early fifties when they were colleagues in Egypt. Barthes, too, abandoned Greimas; see Jonathan Culler, *Roland Barthes* (New York: Oxford University Press, 1983), p. 19.

# 21

# Science in Antiquity

## The Greek and Chinese Cases and Their Relevance to the Problems of Culture and Cognition

### GEOFFREY LLOYD

I am concerned with three interrelated questions that can be expressed, naively, as follows. Did science develop differently in ancient Greece and in ancient China? Secondly, if so, can we say why? Third, what can we learn from such an investigation about more general issues to do with the relationships between culture and cognition? The analysis of the presuppositions implicit in formulating the questions in that way will bring to light some important methodological points, clarify some potential misconceptions, and indicate some of the limitations of what I think we can hope to achieve in this area. First, I should make clear what I mean by *science* in this context. Obviously in antiquity we are not dealing with the highly institutionalized phenomenon that we are used to, today, in universities and research laboratories. On the strictest reading of science, we have to concede that the term is not applicable to anything before the present century. But that is, no doubt, to be unduly restrictive, and I shall use the term conventionally as a placeholder for a variety of specific inquiries we can identify in both China and Greece. I shall concentrate on astronomy, mathematics, and medicine (though that list is not exhaustive, of course: one could include geography, optics, mechanics, and much else besides).

Those three rubrics themselves are, of course, also problematic (and not just because the last two, mathematics and medicine, stretch beyond the bounds of what some would count as science). But following a methodology I have defended elsewhere,[1] I take it that our first task is to analyze what the ancient investigators themselves thought they were trying to do, their conception of their subject matter, their aims and goals. Of course I do not mean to say that we can ever put ourselves in their shoes. All history has, to be sure, to be evaluative. And that in turn means that it is not merely a matter of reporting what the ancients *said* they were doing, as if we have to take their word for it; for we clearly can and must inspect what they actually did and reflect (as the ancients themselves sometimes did) on the matches and mismatches between what some claimed to do and what they did, between theory and practice. But how *they* saw the subjects they were engaged in must be our starting point.

So I take astronomy to encompass what they included in the study of the heavens. That comprised not just calendar studies and the description of the constellations and investigation of the movements of the sun, moon, and planets, but also—in both Greece and China, though in different ways—the study of celestial omens or other attempts to predict events on earth, in other words what we call *astrology*. Again by *medicine* I mean whatever theories and practices of healing we find. And similarly *mathematics* must be held to comprise the study of numbers and figures, however that was pursued, that is with whatever ambitions, including the ambition to master the universe by cracking its numerological codes.

But then a second preliminary methodological warning relates to the problem of generalizing about ancient Greek and Chinese science, so construed, and the unpacking of science into such components as astronomy, mathematics, and medicine, immediately suggests one important point. We should certainly not expect, and in fact we do not find, precisely the same features prominent in and across *all* those different fields in either ancient Greece or ancient China. We must allow that what is true of the methods, aims, and preoccupations of mathematics differs from those of astronomy, which differ in turn from those of medicine, and so on.

The first point here is that we must pay due attention to the *multiplicity* of both Greek and Chinese investigations in different *domains*. The second is that we must also do so, so far as different *periods* go.[2] Greek science before the Christianization of the Greco-Roman world spreads over some 800 years, from the fifth century B.C. to the third century A.D., some of them centuries of very considerable change, and Chinese science before the impact of Buddhism covers an equivalent period where again the point about change also holds.

A third point is that there is yet another type of multiplicity at work *within* each of the domains I have mentioned, again in both ancient cultures. We are dealing with more than just a *single* tradition in mathematics, astronomy, and medicine, in both Greece and China. The point is most easily made with reference to medicine.[3] In both societies we have first a literate tradition, though in neither case is that totally homogeneous. Just as that variety within the Hippocratic Corpus has for some time been accepted by Greek scholars, so, too, the diversity between the *Huangdi neijing* and the medical texts on the silk scrolls excavated at Mawangdui is recognized by Chinese ones and indeed the divergences *between* the various traditions of the *Inner Canon* (the *taisu* and the *suwen* and *lingshu*[4]). But then in both societies, in addition to healers represented among the literate elite there were others marginal to it, in China the *yong yi* and *su yi*, let alone the *wu* (shamans), in Greece the root cutters, drug sellers, midwives, and various practitioners of temple medicine. But the point can also be argued, if with less clearly demarcated groupings, for the various strands that went to make up astronomy and mathematics. It just will not do, we have to remind ourselves, to take Euclid's *Elements* and works like it to stand for the *whole* of Greek mathematics, ignoring the traditions of the study of problems of mensuration (for which we have evidence in Hero of Alexandria) or of protoalgebra (for which we can turn to Diophantus). And similarly for Chinese astronomy, *li fa* refers primarily to calendar studies, but *tian wen* covers cosmography and the study of the movements of the stars and the portents they betoken,[5] and again we should not underestimate the diversities between them, nor of the contributions to them made from within and from without the Astronomical Bureau. More on that later.

The moral of these preliminary caveats is that we must embark on our study with far more modest expectations than are generally entertained by those with comparativist ambitions. Can we make any headway at all? Given both the biases and the lacunae of our sources (Greek and

Chinese) as well as the difficulty in their interpretation, it must be acknowledged that the most we can hope for is some very tentative and provisional suggestions (I shall not call them results), some of which are applicable only to a small part of the total field.

But in that spirit and with those provisos, I shall attempt some brief exploratory forays, first into mathematics; second, into astronomy; third, into medicine and the study of the body, to test whether there are important differences between China and Greece, and if so, why, and what we can learn from this for more general investigations into the relations between culture and cognition.

I tackle mathematics first for the simple reason that this is the broad area where expectations as to the uniformity of early investigations are likely to be at their strongest. Surely no one is going to deny that 2 + 2 is 4 in both China and Greece. Surely the square on the hypotenuse of a right-angled triangle is equal to the sum of the squares on the other two sides, whether we call this Pythagoras' theorem, or *Gou Gu*. Indeed, indeed. Mathematical truths do not vary across cultures. But the status of those truths and what they are truths about, the nature of mathematical objects or its subject matter, *are* questions to which different answers have been given, and not just in modern times.[6]

While Greek and Chinese mathematicians secured what can be called identical results, that does not mean to say that their preoccupations and the questions they chose to focus on were always the same nor that their styles of reasoning were. In the matter of styles of reasoning, in particular, there is one very marked difference observable between parts of Greek and the whole of ancient Chinese mathematics, and this relates to the deployment of proof in the axiomatic–deductive mode. Please note, before I go any further, that I insist on the term *parts,* since it certainly cannot be said that the whole of extant Greek mathematics shares this particular feature. However, considerable sections of our Greek mathematical texts *do* present results in what we may call Euclidean form, where certain indemonstrable starting points, axioms (or common opinions), definitions, and hypotheses or postulates are first set out, and the mathematician proceeds to the strict deductive proof of a sequence of theorems. Euclid's own *Elements* are the best-known example, of course, but Archimedes, too, often proceeds similarly, setting out explicitly the postulates needed for his studies in, for example, *On the Sphere and Cylinder* and *On Conoids and Spheroids.* He does the same in his statics and hydrostatics, in *On the Equilibrium of Planes* and *On Floating Bodies,* and further afield still we find the astronomer Aristarchus proceeding in a similar fashion in his *On the Sizes and Distances of the Sun and Moon.*

The important feature of the method in question is that, to the requirement for strict deductive rigor, it adds the requirement for axioms. While deductive reasoning is widespread in mathematics of all types, not all such reasoning aims to base conclusions on a limited number of explicit indemonstrable starting points (howsoever classified).

One way of confirming that point is by reference to the extant remains of classical Chinese mathematics,[7] notably the two chief early classics (from the first century B.C. and first century A.D.), the cosmographic and mathematical work known as the *Zhoubi suanjing,* and the more purely mathematical *Jiuzhang suanshu* (*Nine Chapters of the Mathematical Art*), together with the early commentary tradition, on the latter especially, starting with Liu Hui in the third century A.D. Now the mathematics that these works contain is, at points, at a high level of sophistication. Liu Hui, for instance, uses a method of circle division to arrive at an approximation of the circle–circumference ratio (i.e., what we call $\pi$) that is comparable in accuracy to that of Archimedes: we have evidence, too, of his sustained attacks on such questions as the volumes of

the sphere and pyramid, and for his study of the volumes of curvilinear solids we find him using a special case of Cavalieri's theorem.[8] Yet at no point in any of these Chinese texts is there any suggestion that reference to axioms or postulates of any kind is necessary or desirable. The notion of an axiom itself is, indeed, totally absent from classical Chinese mathematics, indeed from classical Chinese thought in its entirety.

This does not mean that there were no procedures for establishing and verifying results. On the contrary. The results themselves were often obtained by the application of what we should call algorithms: but as Karine Chemla, for one, has shown, the validation of those algorithms *is* sometimes carried out.[9] To give just one extremely simple example, in his discussion of the addition of fractions in the first chapter of the *Nine Chapters*, Liu Hui shows that the formula we might represent as $a/b + c/d = (ad+bc)/bd$ is truth preserving. This he does by first citing the steps of the original algorithm and naming the procedures it depends on: "every time denominators multiply a numerator which does not correspond to them, we call this homogenize (*qi*). Multiplying with one another the set of denominators, we call this equalize (*tong*)."[10] But it had been shown that $a/b = ad/bd$ (and $c/d = bc/bd$), that is, that the same fraction may or may not be expressed in its lowest terms. So he now remarks that once cross multiplication has occurred, the addition can be effected and "the procedures cannot have lost the original quantities."[11]

What Liu Hui has done is to rewrite the algorithm to *show* that it is truth preserving. That is as good a *proof* of the procedure as anyone could wish, surely, provided, that is, that we do not limit our notion of what will count as a proof to axiomatic–deductive demonstration in the Euclidean style—provided, that is, that we do not stipulate that for a proof to be a proof it has to be cast in that style. For what more should we expect of the proof of a procedure than an explanation of how and why it works, however that explanation itself proceeds?

So we encounter an apparently fundamental difference in this regard between parts of Greek and Chinese mathematics. The problem is not so much why axiomatic–deductive demonstration is absent from the Chinese traditions as why it was a preoccupation of some Greek ones. The problem is not the Chinese lack of axioms, since they evidently got along perfectly well without them. Perfectly well, we should remark, not just for practical purposes, when mathematics is applied to concrete problems, say of calculation or mensuration. Although Chinese mathematics has repeatedly been characterized as *purely practical* in orientation, that is a gross exaggeration, for there are plenty of theoretical concerns as well. One example to which I have already alluded is the studies of $\pi$, the circle–circumference ratio, in the commentaries on the *Nine Chapters*. For practical purposes a value of 3 or 3⅐ is generally adequate enough. Indeed for these purposes Liu Hui himself adopts 157/50, that is, 3.14, as a good approximate value. Yet in their investigations of the procedures that could be brought to bear to yield closer and closer approximations, the commentators pursue the circle division method to the point where they were calculating the areas of an inscribed polygon of 192 and more sides.[12] Indeed in his studies of the volumes of various rectilinear solids, Liu Hui explicitly remarks that some of the shapes are "of no practical use"[13] but worth investigating, nevertheless, for by their means an attack may be launched on other problems.

Moreover it is not just from a Chinese, but also from some of our own modern perspectives that some of the original Euclidean procedures may seem strange. I am not saying that the drive for axiomatization as such seems so (though no doubt Euclid's conceptions of his indemonstrables differ rather from those of modern axiomatizations). Rather it is Euclid's determination to make all his definitions explicit, for use, indeed, in the subsequent proofs, that may seem odd.

From a modern standpoint some of the terms he takes so much trouble defining might more appropriately be deemed to be primitives in the system, not in need of explicit definition, but themselves implicitly defined by the very mathematics derived on their basis.[14]

This example shows one thing pretty clearly. There was nothing preordained in the particular way in which one particular Greek mathematical tradition developed via the development of axiomatic–deductive modes of demonstration. Our problem is the more acute in that, once Euclid's *Elements* had shown the way, the model it represented was imitated in a wide variety of fields, in some at least of which one might have thought it was quite inappropriate. I have mentioned that Archimedes' statics and hydrostatics are cast in an axiomatic–deductive mold, and here there may be nothing very surprising about Archimedes' ambition to geometrize these studies as far as possible. The same is true also of Aristarchus' *On the Sizes and Distances,* where again, while the initial hypotheses are astronomical, the subsequent arguments are purely geometrical in character. But what are we to say of the ambition in the second-century A.D. physician Galen to deploy proofs *more geometrico* in medicine, not just deductive arguments, but arguments based on self-evident primary premises? Although valiant attempts have been made to justify the bid to produce axiomatic–deductive proofs in medicine,[15] it has to be said that the attempt to specify primary premises there that will meet the requirements of being both necessary and self-evident is chimerical. He appears to have thought that the principle that opposites are cures for opposites is one such: the trouble is that what will count as an opposite is opaque, and when it is clarified, the principle risks being merely vacuous or circular.

The problems may seem intractable enough, but an indirect approach may yield at least some tentative conjectures to help resolve them. One obvious feature that axiomatic–deductive demonstration possesses that other modes of reasoning lack is that it produces certainty. Everything depends on the status of the axioms. But where they can be claimed to be self-evident and the subsequent deductive reasoning is valid, then the conclusions reached have a claim to be not just true, but incontrovertible.

Now certainty and incontrovertibility are admirable qualities in the end results of reasoning, and so there may be no special need to look for any particular motivation for the ambition to secure them. Maybe. But that there is more to the historical question than that suggests emerges, I believe, if we consider some of the background to the development of the notion of strict demonstration in fourth-century B.C. Greece. The first clear statement in our extant texts of the need for demonstrations to be based on indemonstrables comes not in mathematics, but in philosophy, in Aristotle, who insists on the point with an argument: all demonstrations proceed from premises, and although intermediate premises may be the conclusions of prior demonstrations, the *primary* premises of all must themselves be indemonstrable to avoid an infinite regress, for what premises could they be demonstrated from?[16] Moreover, again so far as our extant texts go, it was Aristotle who first set out a taxonomy of the different *types* of indemonstrables, namely (in his view) definitions, axioms, and hypotheses. Even before Aristotle, Plato, too, clearly represents strict demonstration as the ideal, even though he does not set out a *theory* of what makes a demonstration a demonstration.

But it is not just the positive views on strict demonstration that Plato and Aristotle offer that are significant for our purposes, but also what it is contrasted with. Both take strict demonstration as the goal for the highest style of philosophizing—not that they have identical views on that. But both contrast that style with other inferior modes of reasoning. Thus Plato is particularly exercised to contrast philosophy with the merely plausible or persuasive, and he leaves us in

no doubt that the type of thing he has in mind includes, especially, what he considers the irresponsible teachings of the likes of Protagoras and Gorgias and the kinds of arguments deployed in the law courts and political assemblies—sophistic and rhetoric, in short.[17] Similarly Aristotle, too, contrasts demonstrative arguments (where the premises must be necessary as well as true) first with dialectical ones (based on generally accepted opinions or on the admissions of interlocutors) and then with a whole sequence of other lower, not to say deviant, modes of reasoning. These include peirastic (examination arguments), eristic (where the aim is just victory in the argument itself), sophistic (which he thinks of as directed at enhancing reputation—showing off), as well as the three main branches of rhetoric: forensic, deliberative, and epideictic.[18]

In the background to this extraordinary proliferation of categories of argument and arguer we can detect the intense rivalry that existed in fourth-century B.C. Greece between competing claimants to intellectual leadership and prestige. Of course the extent to which Greek mathematics in general and Euclid in particular were influenced by the Aristotelian theory of demonstration set out in the *Posterior Analytics* is controversial and never likely to be fully resolved because of the lack of direct evidence for pre-Euclidean mathematics.[19] But if we see that our problem is a *general* one and ask not just why Greek mathematics developed the axiomatic-deductive method, but why Greek philosophy did so, too, then the negative reactions we see in both Plato and Aristotle to the models of reasoning provided by the legal and political domains may offer some clues. For both Plato and Aristotle, demonstration is the key factor in their justification for their claim that their high philosophizing is different from and superior to all other modes of reasoning. *They* are, at best, merely persuasive: but demonstration can and does yield certainty. If so, this may suggest that Greek intellectuals sought and claimed incontrovertibility chiefly in a bid to outdo their rivals and downgrade their merely plausible arguments.

Inevitably, this is all very conjectural. Yet the hypothesis withstands one negative test rather well. If the demand for certainty in Greece owes something to an adverse reaction to the merely persuasive arguments used in the law courts and assemblies, we can test whether or not an equivalent stimulus existed in China by investigating their traditions of legal and political argument. Certainly the hypothesis would be seriously undermined if there were such a stimulus and yet no corresponding preoccupation with securing certainty.

The first fundamental point relates to Chinese attitudes toward the legal experience, whether in civil or criminal cases, and to litigiousness in general.[20] Civil law as such was, in any event, almost unheard of. More generally, so far from positively delighting in litigiousness, as many Greeks seem to have done, so far from developing a taste for adversarial argument in that context and becoming quite expert in its evaluation, the Chinese avoided any brush with the law as far as they possibly could. Any dispute that could not be resolved by arbitration was felt to be a breakdown of due order and as such reflected unfavorably on *both* parties, whoever was in the right.

There was thus no forensic oratory worth speaking of, since the contexts for its use were lacking. Yet there were plenty of other occasions for the development and practice of the techniques of persuasion.[21] In the *Shuo nan* chapter of *Hanfeizi,* we have evidence for self-conscious reflection on those techniques, and the *Zhanguoce* offers numerous examples of their practice. However both the theory and the practice show some contrasts with Greek deliberative oratory. First the primary contexts for its deployment differ. The circumstances that play the role of model in China relate primarily to the persuasion of the prince or ruler. Of course, individuals, including rulers, were sometimes the targets of Greek persuasion, too, but more often the audience was the citizen body in assembly.

Second and more important, it seems significant that in *Hanfeizi* the focus of attention is on the psychological aspects of persuasion rather than on the analysis of the styles of argument as such. Advice is offered on how to avoid offending the prince. Of course, such considerations are addressed also in Greek manuals of rhetoric. Aristotle, for one, discusses the need to take into account the emotions and prejudices of the audience and advises on how to present yourself as a person who can be trusted. But what he also does is to give an analysis of the modes of argument available to the orator, the enthymeme and paradigm, the equivalent in rhetoric of the syllogism and induction. It is that extra step that brings to the fore the contrasts between the merely plausible and the certain—the topic we are chiefly interested in as the background to the development of the notion of axiomatic–deductive demonstration. The Chinese writers, too, certainly react negatively to some features of the techniques of persuasion but not so much to particular modes of argument as to cleverness in speaking in general. What is regularly opposed to the art of speaking in China is the living embodiment of the *Dao*, the person of the sage. The contrast with the Greeks speaks volumes. Although Greeks, too, were often suspicious of clever speakers, what happens in some writers at least is that what is opposed to rhetoric is true philosophy. What is opposed to persuasion is demonstration, but both those are a matter of *logos*, word, speech, account.

My first foray has focused on demonstration in mathematics and philosophy. For my second I turn to the rich materials for the study of the heavens. In China, as in Greece, this comprised a number of different inquiries: the regulation of the calendar, cosmography sometimes combined with the study of the movements of the planets, and then, third and often especially, the investigation and prediction of portents. There are certainly very considerable similarities in the objects studied and in some at least of the reasons for studying them. But a closer look reveals also considerable differences, especially in the latter.

Take, first, a point to do with the perceived relevance of the study of the heavens for the entire welfare of the country. In China the whole subject was of intense importance to the emperor, for he was personally responsible for keeping the natural order and the political order in tune.[22] The regulation of the calendar was not just a matter of practical concerns, for instance for agriculture, but a question with wide-ranging implications for the order of the state. This importance is reflected in the institutionalization of the subject. The Astronomical Bureau was set up already in Han times, and it lasted all the way down to the Qing, the last imperial dynasty. True, some important ideas originate with outsiders, though if the ideas proved acceptable, their originators often found themselves appointed to posts within the bureau; that even happened, eventually, to the Jesuit Schall.[23] But the existence of the bureau testified to the political significance of the subject.

Getting the calendar right was, to be sure, also an interest of Greek astronomers; but the reception of their work was quite haphazard. Meton and Euctemon already gave good approximations for the lengths of the solar year and lunar month in the 430s B.C. But instead of this leading to a general standardizing of the calendar, the various independent Greek city-states generally persisted in using their own conflicting lunisolar calendars, with different officials responsible not just for observation of the new moon to fix the start of a new month, but also for deciding on the timing of intercalary months. It took the Roman Julius Caesar to impose a more orderly calendar across the Greco-Roman world, but that wasn't until the mid-first century B.C.

But then so far as the styles of astronomical theory developed in China and Greece go, the

most striking difference relates to the eventual Greek construction of geometrical models to represent the movements of the sun, moon, and planets, and why they should have pursued that goal is as big a puzzle as the ambition to give strict demonstrations in mathematics, until we see that in part at least it is the same puzzle. After all, for the purposes of predicting those movements, once their main periodicities are determined, numerical procedures may be perfectly adequate, though they will need adjusting as inaccuracies come to light. Moreover the accuracy of geometrical models can never exceed that of the quantitative parameters they incorporate.

However, the characteristic that geometrical models possess that numerical ones lack is their would-be demonstrative nature. The array of concentric spheres or of epicycles and eccentrics enabled their interrelations to be deduced and explained. The position of a planet could be derived from the geometrical structure of the model, though of course this still had to be interpreted with specific values for its various components, such as the speeds and angles of inclination of the spheres in the concentric model.

The conjecture would be that it was the possibility of such *geometrical demonstrations* that proved the principal attraction to the Greeks of the style of astronomical theory we find from Eudoxus to Ptolemy and beyond. Indeed that is not just pure conjecture, for Ptolemy himself confirms in the Proem of the *Syntaxis* that, in his view, that is precisely where the great strength of mathematical astronomy lies. It is superior, he says, both to "physics" (the study of nature) and to theology, but why? Physics deals with the unstable qualities of changing material objects, and theology is concerned with what is utterly obscure. Mathematics (including astronomy), by contrast, holds out the promise of firm and unshakable knowledge, since its proofs proceed by indisputable methods, namely, those of arithmetic and geometry.[24]

This major divergence in the *aims* of astronomical theory in China and in Greece has repercussions also on that other principal branch of heaven studies: the investigation of portents and the prediction of events on earth. The preferred mode of astrological prediction in Greece, from the Hellenistic period on, is genethlialogy, that is, the casting of horoscopes, geometrical and thus far deductive in character, though recognized by Ptolemy as far from demonstrative since the interpretation of the characters of the planets was based on opinions drawn from ancient tradition, even though he would have claimed that that tradition was generally reliable and had stood the test of time. Compared with the study of the movements of the heavenly bodies themselves, the attempt to derive predictions from them for events on earth is, in Ptolemy's view, secondary, uncertain, and conjectural, even though, he also claims, its *potential* usefulness for all sorts of practical questions concerning the lives of individual human beings is far greater.[25]

In China, by contrast (where horoscopes are in any case a relatively late *import*[26]), the chief concern was not the fortunes of ordinary individuals, but overwhelmingly with that of a single individual, the ruler himself, and thus with the welfare of the empire as a whole. Portents, on this view, are expressions of the will of heaven communicated to the ruler to encourage or admonish him.[27]

Chinese astronomers certainly shared with Greek ones ambitions to extend the domain of what can confidently be predicted, to limit the sphere of the truly portentous in the sense of the totally unpredictable. In China this was a major stimulus to the concerted attack on the problems of predicting lunar and then eventually solar eclipses, where as Sivin has shown, one cycle after another was developed over the hundreds of years of the functioning of the Astronomical Bureau.[28] However, the goals and expectations in China and Greece were different in one crucial respect. The chief aim of the Chinese predictions was not to miss an eclipse.[29] But if they

predicted one that did not occur, that could be, and was, put down to the great virtue of the emperor. Such was his virtue, the thought was, that an eclipse that would have occurred, but for it, did not. So the nonoccurrence of a predicted event did not count *against* the astronomer so much as *for* the emperor.

The order of the heavens was a major preoccupation in both China and Greece, and in both ancient civilizations a matter with grave consequences for morality. But that order was subject to exceptions, in China, that Greek geometrical models could not, in principle, admit. Why the Greeks spent so much time, from the fourth century B.C. on, on planetary models was not just because Plato was supposed to have told them to do so,[30] but rather because their *apparent irregularities* threatened the very notion of celestial order itself. They had to be geometrized to be understood, and once so geometrized, could then be cited as evidence not of irregularity in the heavens, but of regularity. The heavens thereby manifest, as Ptolemy puts it, sameness, good order, proportion, and freedom from arrogance, qualities which the study of astronomy inculcates in us.[31] But the Chinese read the sky both with far greater confidence that it is inherently orderly—that is how *tian* is understood—and at the same time with a far more open mind about its possible messages for earth, messages directed, in any event, in the first instance, to the emperor. That helps to explain why so much more attention is paid to comets and to supernovas, the latter of which often seemed to have been invisible to the Greeks. Chinese theories imposed far less rigid patterns on the order they expected, and they would no doubt have been amazed at the Greek ambition to *prove* celestial regularity.

Thus far my forays have been into mathematics and astronomy. Faced with the awesome variety of material concerning the diverse traditions of inquiry and practice in medicine in China and Greece, our task of assessing relevant similarities and differences there is even more daunting, and my comments must be even more selective. At first sight, the similarities, both in the use of certain diagnostic and investigative techniques and in some of the general circumstances surrounding medical practice in China and Greece, are impressive. In both the doctor engaged in the intent examination of the external appearance of the patient, the Hippocratic *facies* (as in *Prognosis,* chapter 2) and the Chinese technique of diagnosis from the five colors, *se*.[32] In both, pulse lore is elaborated as a means of inferring internal states, especially pathological disturbances, in the body. In both, dissection was (eventually, and in China appreciably later than in Greece)[33] used to study anatomical structures. In both civilizations, again, there is rivalry not just between the learned and folk medical traditions, but also within the learned. Thus we have good direct evidence of this in China in the biography of Chunyu Yi in Sima Qian's *Shiji* (dating from the first century B.C.). This is an explicit apologia by a doctor who had been the subject of a denunciation, where Chunyu Yi offers an account of a series of case histories, where he records his diagnosis and treatments (comparable in some ways to the case histories in the Hippocratic *Epidemics* and in Galen).[34] But in the process he criticizes a number of other practitioners, some unnamed, others named, including a patient who was himself a doctor, named Sui, who had invoked the authority of the famous Bianque, but without any proper understanding of his teaching (so Chunyu Yi says).[35]

Yet when all that is said, the differences are also profound. First as to rivalry, Chunyu Yi shares much more with his opponents than is sometimes the case in Greek medicine. True, he claims his diagnoses (chiefly based on the pulse) are all successful, theirs not (understandable in a text that is a self-defense).[36] But he uses more or less the same therapies (moxa, stone therapy,

drugs) as they. On the Greek side, the degree of disagreement, in medicine as elsewhere, *could* be much more radical.[37] Thus while some insisted on basing medicine on an understanding of hidden causes and underlying reality, others argued that that was irrelevant and/or unattainable and that medicine should focus solely on what produces cures. While most Greek doctors used the same battery of treatments, some, the so-called Methodists, rejected them and concentrated just on countering the lax with the restricted and vice versa.[38]

Dissection itself was controversial in Greece. While some thought it essential as the source of the anatomical knowledge the doctor needs, others, the Methodists again and the Empiricists, dismissed it as useless or irrelevant.[39] As for those who justified it, the explicit argument in Aristotle is that it revealed the causes of the structures in the body, especially the formal and final causes. One might suggest a parallelism with Greek astronomy, where planetary irregularities were turned into proofs of nature's regularity, thanks to geometrical models. So, too, in anatomy, while contemplating the insides of the body was (Aristotle concedes) revolting in itself, nevertheless this led to a greater understanding of the beauty and the craftsmanship of nature, a theme taken up and elaborated by Galen, notably in his "hymn" to nature, the teleological account of the purposes that every part of the body serves in his *On the Uses of Parts*.

Then a further factor at work in the Greek use of dissection emerges from other texts in Galen, which show that in some cases dissections were conducted not just for research, nor even for pedagogy (to train the next generation of doctors). Galen refers to competitive public dissections where animals, sometimes exotic ones, were cut up and rival experts attempted to predict the outcome. On one such occasion the animal was an elephant, and the audience placed bets on who would turn out to have described the structure of its heart correctly. It is clear that these performances were mainly for show:[40] this was a way of winning a reputation, if not notoriety, as also, in a less sensational way, were the public debates on such questions as the fundamental constituents of the human body we hear about already in the Hippocratic Corpus, debates often adjudicated by the lay audience, the bystanders themselves.[41] The very idea that there should be public confrontation between experts on basic questions of physics or anatomy is profoundly un-Chinese, as also is the notion that the winner in such a confrontation should be decided by the public itself.

It is not just points to do with form or style that are at stake in these differences, but also substantial issues to do with the contents of concepts and theories, indeed the way the human body itself was viewed. In the broadest terms, the body was the locus of *Qi*, vital breath, for the Chinese: that was what the doctor was interested in and looked *for* when he looked *at* the colors.[42] For the Greeks, or many of them at least, the body was a system of structures: that was what those who dissected were looking for when they opened the body up. Again the idea that the human body should be in tune with the cosmos runs through much Chinese medical thought and indeed cosmology. The five colors correspond to and resonate with the five phases (all manifestations of *Qi*), and this was part of the shared discourse of Chinese thinkers at least from Han times, when this whole system of correspondences was brought into canonical form. True, in Greece too the idea that the macrocosm and microcosm should tally is also sometimes expressed. But that bland general statement by itself conceals or does not reveal the enormous diversity that existed in Greece, (1) on the nature of the macrocosm itself, (2) on that of the microcosm, (3) on the political images used to describe both, and finally (4) on the actual political ideals that those images in turn reflect. For some Greeks the cosmos is a monarchy under the benevolent rule of an intelligent craftsmanlike force, but others represented it rather as an oligarchy or democracy

of balanced powers or even, in the case of Heraclitus, as anarchy, since for him justice is strife and war rules.[43] These divergences in the way the cosmos was conceived reflect the equally radical disagreements on political ideals and are in turn reflected in divergent models of the human body, where balance sometimes depended on unified rule or control, sometimes on the equality of powers between opposing forces. The contrast with the classical Chinese, united behind the ideal of the benevolent rule of the emperor, is dramatic.

The evidence available for a study such as I have sketched out is enormously rich, and my three tentative forays have done no more than scratch the surface of the problem. But let me turn now briefly, in conclusion, as I promised, to the question of what might be learned here for more general issues to do with the problems of culture and cognition.

Those who investigate problems of cognitive development in children or young adults tend to adopt as their working assumption that there are basic uniformities in all humans. An infant aged one year or a child aged three or six will perform very similarly in experimental situations to others of the same age, whatever their background—findings that may no doubt be taken to corroborate that working assumption at least up to a point. Some historians and philosophers of science, whether or not taking their lead from cognitive scientists, argue similarly that basic human conceptions of space, time, causality, number, even natural kinds, are cross-culturally invariant.

Yet such a view is obviously under considerable strain from the apparent diversities in the *explicit* theories and concepts actually developed in cultures worldwide, including ancient cultures. Wherever ancient Greeks and Chinese may have started, as infants, they certainly seem to have ended with quite different sets of beliefs (and not just a single set on either side) about the stars, the human body, health, and disease, indeed I would also add (though I would need a good deal of space to justify the point) about space, time, causality, number, and nature themselves.[44]

To that difficulty two types of retort are possible. The first would argue that whatever views may be expressed by the actors themselves, at a deeper level there are implicit cross-cultural universals that can be elicited by questioning, provided you ask the right questions (cf. Atran). That remains of course a pure conjecture where the members of ancient societies are concerned since we cannot question them. But the more important point is that if we are studying early attempts to *explain* the world, we have no option but to take the *explicit* theories and concepts actually used in all their diversity as the chief, indeed the sole direct, evidence. So there may be a sense in which at points (if not across the board) universalists and comparativists may be arguing past one another, in that the subject matter they are wrestling with is, in the one case, the postulated implicit assumptions, in the other, the explicit theories the actors themselves propose.

But then the second type of retort would have it that the kinds of theories I have been discussing do not count as real science at all. The argument would be that science, to be science, *has to be* universal, and if there are divergences in the theories in question, that just shows their inadequacies as science. But that equally a priori view is also deeply unsatisfactory. Inadequacies, even failures, cannot be taken to show that an inquiry is *not* science, for not even physics in the twentieth century is adequate through and through, is it? Rather it would be more plausible to argue that the history of science is a history of repeated failures, though that is not totally satisfactory either in that there are failures and failures, a difference between straight failures and failures that appear as temporary successes.

What our studies illustrate is that there is nothing inevitable about the way in which astron-

omy, mathematics, and medicine developed, and their international modern character should not mask their very divergent early manifestations (and not just in China and Greece). Of course in one sense the subject matter of both Greek and Chinese inquiries was the same in that both studied numbers and geometrical figures, the stars, the human body, and so on. But as we have seen, the differences in the theories and concepts they developed relate not just to presentation, but also to the questions they chose to focus on and, correspondingly, to the answers they chose to give to them.

However, if there are these differences, can we begin to say why? If we reject the immanentist and universalist stances I mentioned, can we not expect to be accused of cultural relativism and/or determinism? Well, in that I have been so accused, the danger obviously exists. But the hypotheses I wish to propose and the program of research they suggest are (I hope) more modulated, more tentative, and more modest in their pretensions than the use of such grand but vague labels as relativism and determinism allows to emerge.

First as to "determinism." The lines of attack that my forays suggest may be most promising relate the differences in the inquiries pursued to differences in the values of the societies in question, to their social and political institutions, and to the institutions within which the ancient investigators themselves worked.[45] But the question is how far such an approach can take us. I am very far from suggesting myself that the entire intellectual products of ancient Greek and Chinese science are constrained by such factors (general as their influence is). The very variety in those products that I have insisted on tends to defeat any simple single causal explanation. We have, in particular, to allow that in both ancient societies there were highly idiosyncratic individuals who stood outside the main groups and traditions—a Heraclitus or a Wang Chong—though, as we can see, always at the risk of being marginalized, misunderstood, and quickly forgotten.

Then as to "relativism," where disambiguation is always badly needed. Of course, in one sense my claim that astronomy, mathematics, and medicine developed very differently in China and in Greece is a claim that the different forms they took have to be related to the varying circumstances of their development. So far, then, a relativist. Yet not at all so in other more important respects, in that I have been assuming, all along, that comparison is possible, indeed that judgment and evaluation are inevitable, that is that the factors at work in the developments we are studying (and indeed in *our* study of them) do not solely consist of the influences that come from the values of society and the institutions of the investigators, but partly also from the subject matter of the investigations themselves, even if there is no such thing as an *unmediated* access to that subject matter—whether in science or in the history of science.

It is precisely here that the study of science in ancient civilizations may have some general lessons to offer. The stars that were there to be observed have not changed—not substantially at least. We can identify Vega whether as *Zhi nü* (Weaving Girl) or as Lyra (its Greek name) or as alpha Lyrae, even though in both the Chinese and Greek cases, constellations were also named by this star, and they, the constellations, certainly differ. Nor has the human body changed substantially, for all that some of the diseases that affect it may have. It is the conceptual framework within which those observations were conducted that has varied and continues to do so. To be sure, reality is always socially constructed in a sense, but that construction reflects the investigators' claims (varied ones, for sure) that it was indeed reality that they were investigating and that sometimes checks the investigations, even if sometimes a reality claim is just a persuasive device and no one can step completely outside the conceptual framework within which they operate.

What are the limits to which criticism of one's own conceptual framework is possible? If criticism is possible, does it not presuppose a wider framework? Yes, of course. However as to explicit criticisms and modifications of explicit parts of existing belief systems, we can see this happen before our very eyes when we study both Greece and China, even while the modes of expression of those criticisms vary. Similar processes were at work in later developments that led eventually to modern science, with its distinctive values and institutions. But the history of early investigations in ancient civilizations is the history of the acquisition of a potential for cognitive development, not just with respect to what was believed, but also with regard to the ways of getting to believe it. Where Greece and China are concerned, to go no further afield, history shows both that the ways of acquiring that potential differed and indeed that the potential acquired did. Not that, in either case, the new potential corresponded closely to the expectations that might be generated by naive retrospection from the eventual emergence of modern science. There is much more to be learned about the specificities of those potentials and how they are acquired than I have been able to indicate, but I hope to have shown some of the ways in which in both ancient cultures the investigations undertaken were influenced by the particular values of the society in question and the particular institutions within which the investigators worked. On the one hand, there is the way of adversariality and argument, the dominant Greek way. On the other, there is the construction of the more pragmatic ideal of the sage, the living embodiment of wisdom, the more usual Chinese way. *Logos,* then, and the *Dao:* yet both the one and the other offered prospects, as I have suggested, for the transformation of cognitive capabilities.

NOTES

1. See G. Lloyd, *The Revolutions of Wisdom (RW),* Univ. of California Press, Berkeley, 1987, pp. 1 f. and "Methodological issues in the comparison between East and West," in *Is It Possible to Compare East and West?,* H. Numata and S. Kawada (eds.), Pedilavium, Tokyo, 1994, pp. 23–36.

2. We are dealing, very roughly, with material that dates from the fifth century B.C. to the third century A.D., but of course neither the beginnings nor the ends of classical Chinese science and the Greek counterpart are at all well defined. However, we are concerned with the scientific activity that antedates the official Christianization of the Roman Empire in the one case and the impact of Buddhism in the other.

3. Cf. G. Lloyd, "The definition, status, and methods of the medical *techne* in the fifth and fourth centuries," in *Science and Philosophy in Classical Greece,* A. C. Bowen (ed.), Garland, New York, 1991, pp. 249–60, and "The transformations of ancient medicine" (*TAM*), *Bulletin of the History of Medicine* 66, 1992, pp. 114–32.

4. N. Sivin, *Traditional Medicine in Contemporary China,* Centre for Chinese Studies, Univ. of Michigan, Ann Arbor, 1987, offers the best general introduction to traditional Chinese medicine, cf also "Text and Experience in Classical Chinese Medicine," in *Knowledge and the scholarly medical traditions,* D. Bates (ed.) Cambridge Univ. Press, Cambridge 1995, pp. 177–204. On the composition of the *Huangdi neijing,* see especially Yamada Keiji, "The formation of the *Huang-ti nei-ching,*" *Acta Asiatica* 36, 1979, pp. 67–89. There is a selection of texts in translation in the appendix to Paul U. Unschuld, *Medicine in China,* Univ. of California Press, Berkeley, 1985.

5. See most recently C. Cullen, *Astronomy and Mathematics in Ancient China: The Zhou Bi Suan Jing,* Cambridge Univ. Press, Cambridge, forthcoming, who renders *tian wen* "celestial patterns" and *li fa* "calendrical methods."

6. There is, for instance, a radical dispute between Plato and Aristotle on the nature of mathematical objects and on what mathematical truths are truths about. See especially I. Mueller, "Aristotle on geometrical objects," *Archiv für Geschichte der Philosophie* 52, 1970, pp. 156–71 (reprinted in *Articles on Aristotle,* J. Barnes, M. Schofield, and R. Sorabji [eds.], London, 1979, Vol. 3, Duckworth, pp. 96–107); J. Lear, "Aristotle's philosophy of mathematics," *Philosophical Review* 91, 1982, pp. 161–92; and the articles collected in *Mathematics and Metaphysics in Aristotle,* A. Graeser (ed.), Paul Haupt Verlag, Bern, 1987.

7. A brief analysis is given in Li Yan and Du Shiran, *Chinese Mathematics: A Concise History,* Clarendon Press, Oxford, 1987.

8. See D. B. Wagner, "Liu Hui and Tsu Keng-Chih on the volume of a sphere," *Chinese Science* 3, 1978, pp. 59–79, at pp. 61 ff.

9. See, for example, K. Chemla, "Resonances entre démonstration et procédure: Remarques sur le commentaire de Liu Hui (IIIᵉ siècle) aux *Neuf Chapitres sur les Procédures Mathématiques* (Iᵉʳ siècle)," *Extrême-Orient-Extrême-Occident* 14, 1992, pp. 91–129.

10. In the edition of Qian Baocong, *Suanjing shishu,* Zhonghua, Beijing, 1963, this is on p. 96.

11. Ibid.

12. Ibid. p. 105; cf. Li and Du, *Chinese Mathematics,* p. 68. The investigation continues with the study of an inscribed polygon of 3,072 sides, with a final result of 3.1416 (Qian, *Suanjing,* p. 106). However, the question of which sections of the commentary, at this point, are the work of Liu Hui himself and which that of later commentators is disputed: see D. B. Wagner, "Doubts concerning the attribution of Liu Hui's commentary on the *Chiu-Chang Suan-Shu,*" *Acta Orientalia* 39, 1978, pp. 199–212, at p. 206 f.

13. See D. B. Wagner, "An early Chinese derivation of the volume of a pyramid: Liu Hui, third century A.D.," *Historia Mathematica* 6, 1979, pp. 164–88, at p. 182.

14. Cf. I. Mueller, *Philosophy of Mathematics and Deductive Structure in Euclid's Elements,* MIT Press, Cambridge, Mass., 1981.

15. See J. Barnes, "Galen on logic and therapy," in *Galen's Method of Healing,* F. Kudlien and R. J. Durling (eds.), Brill, Leiden, 1991, pp. 50–102; R. J. Hankinson, "Galen on the foundations of science," in *Galeno: Obra, Pensamiento e Influencia,* J. A. Lopez Ferez (ed.), Universidad Naciónal de Educación a Distancia, Madrid, 1991, pp. 15–29. In the contrary sense, see my "Theories and practices of demonstration in Galen," in *Festschrift G. Patzig: Rationality in Greek thought,* M. Frede and G. Striker (eds.), Oxford Univ. Press, Oxford, forthcoming.

16. Aristotle, *Posterior Analytics,* 1.1–3, for example, 72b18 ff.

17. The evidence is set out in G. Lloyd, *Magic, Reason and Experience (MRE),* Cambridge University Press, Cambridge, 1979, pp. 100–2.

18. Ibid., pp. 62 ff.

19. However, a concern with the distinction between demonstrative and merely likely arguments *in the field of mathematics* surfaces in two texts in Plato, *Phaedo* 92d and *Theaetetus* 162e, discussed in *MRE,* p. 116.

20. On Chinese law and legal procedures, see A. F. P. Hulsewé, "Ch'in and Han law," in *The Cambridge History of China,* D. Twitchett and M. A. N. Loewe (eds.), Cambridge Univ. Press, Cambridge, 1986, Vol. 1, ch. 9, pp. 520–45; cf. Hulsewé, *Remnants of Han Law,* Leiden, 1955, Vol. 1, and *Remnants of Ch'in Law,* Brill, Leiden, 1985.

21. See, for example, Jean Levi, "L'art de la persuasion à l'époque des Royaumes Combattants (V<sup>e</sup>–III<sup>e</sup> siècles av. J. C.)," *Extrême-Orient-Extrême-Occident* 14, 1992, pp. 49–89; and cf. Lloyd, "The Agora Perspective," *Extrême-Orient-Extrême-Occident* 14, 1992, pp. 185–98, at pp. 187–90.

22. Cf. N. Sivin, who refers to "The Chinese theory of the natural order and the political order as resonating systems, with the ruler as a sort of vibrating dipole between them," in "Cosmos and computation in early Chinese mathematical astronomy," *T'oung Pao* 55, 1969, pp. 1–73, at p. 7.

23. On the history of the astronomical bureau, see, for example, Ho Peng Yoke, "The astronomical bureau in Ming China," *Journal of Asian History* 3, 1969, pp. 137–57; and Jonathan Porter, "Bureaucracy and science in early modern China: The imperial astronomical bureau in the Ch'ing period," *Journal of Oriental Studies* 18, 1980, pp. 61–76. On Schall's role in the calendar controversies of the seventeenth century, see Huang Yi-Long, "Court divination and Christianity in the K'ang-Hsi era," *Chinese Science* 10, 1991, pp. 1–20.

24. See Ptolemy, *Syntaxis* I.1 Proem, Heiberg I.6. 17–21: μόνον δὲ τὸ μαθηματικόν, εἴ τις ἐξεταστικῶς αὐτῷ προσέρχοιτο, βεβαίαν καὶ ἀμετάπιστον τοῖς μεταχειριζομένοις τὴν εἴδησιν παράσχοι ὡς ἂν τῆς ἀποδείξεως δι' ἀναμφισβητήτων ὁδῶν γιγνομένης, ἀριθμητικῆς τε καὶ γεωμετρίας.

25. Ptolemy devotes *Tetrabiblos* I.3 10.14–17.10 to showing in what ways astrology is useful, for example, both in regard to goods of the mind and those of the body, where, in both cases, foreknowledge is beneficial, as giving calm and as allowing one to discern what suits one's own temperament and idiosyncrasy. Even though astrology can do less, he says, with regard to the acquisition of wealth and fame, in book 4 he discusses what can be learned from it also in those respects.

26. See Shigeru Nakayama, "Characteristics of Chinese Astrology," *Isis* 57, 1966, pp. 442–54, at p. 442.

27. Ibid. and Kiyosi Yabuuti, "Chinese astronomy: Development and limiting factors," in *Chinese Science,* S. Nakayama and N. Sivin (eds.), MIT Press, Cambridge, Mass., 1973, pp. 91–103, at p. 91.

28. See Sivin, *T'oung Pao.*

29. See Sivin, *T'oung Pao,* p. 25.

30. Simplicius, at *In Cael.* 488.11 ff, quotes Sosigenes who may be drawing on the history of astronomy written by Aristotle's pupil Eudemus. But there is no evidence in the extant dialogues of Plato to confirm that he stimulated the development of astronomical models based on the regular circular movements of concentric spheres.

31. Ptolemy, *Syntaxis* I.1, Proem. Heiberg I.7.17–24: πρός γε μὴν τὴν κατὰ τὰς πράξεις καὶ τὸ οθος καλοκαγαθίαν πάντων ἂν αντη μάλιστα διορατικοὺς κατασκευάσειεν ἀπὸ της περὶ τὰ θεῖα θεωρουμένης ὁμοιότητος καὶ εὐταξ ξας καὶ συμμετρίας καὶ ἀτυφίας ἐραστὰς μὲν ποιοῦσα τοὺς παρακολουθοῦντας τοῦ θείου τούτου κάλλους, ἐνεθίζουσα δὲ καiωσπερ φυσιουσα πρὸς τὴν ὁμοίαν τῆς ψυχῆς κατάστασιν.

32. This theme is explored in S. Kuriyama, "Visual knowledge in/classical Chinese medicine," in D. Bates (ed.), *Knowledge and the Scholarly,* pp. 205–34.

33. Kuriyama, "Visual Knowledge," notes 52 and 53, cites *Lingshu,* ch. 12, and the Wang Mang biography in *Han Shu,* ch. 69b, as the two sole surviving references to dissection in the Han. Saburo Miyasita, "A link in the westward transmission of Chinese anatomy in the later middle ages," *Isis* 58, 1967, pp. 486–90, remarks that when the first human dissections were carried out under the Sung, they were done on criminals. Celsus also tells us that this was the

case with the human subjects dissected and vivisected by Herophilus and Erasistratus at Alexandria, Proem to *De Medicina* 1 paras 23 ff. On the early history of dissection in Greece, see ch. 8 of G. Lloyd, *Methods and Problems in Greek Science (MP)*, Cambridge Univ. Press, Cambridge, 1991.

34. The similarities and differences are the subject of a forthcoming study by E. Hsu and myself.

35. Case 22, in ch. 105 of the *Shi Ji*, 2810–11.

36. Thus even in the cases where the patients examined by Chunyu Yi die, he *predicts* this, sometimes to the day.

37. Hippocratic medicine is also remarkable for the explicit and aggressive claims made by the authors of some of the treatises, for the introduction of new medical theories and practices claimed, in some cases, to be of major importance. See, for example, *RW* ch. 2, on such texts as *On Regimen* I–III, *On Regimen in Acute Diseases,* and *On Airs Waters Places.*

38. On the methodological and epistemological disputes in Hellenistic medicine, see especially H. von Staden, *Herophilus: The Art of Medicine in Early Alexandria,* Cambridge Univ. Press, Cambridge, 1989; M. Frede, *Essays in Ancient Philosophy,* Univ. of Minnesota Press, Minneapolis, 1987, ch. 12–15; and on Methodism in particular, cf. G. Lloyd, *Science, Folklore, and Ideology,* Cambridge Univ. Press, Cambridge, 1983, Part III, ch. 6.

39. See *MP,* ch. 8, and *RW,* pp. 158–67.

40. See Paola Manuli and Mario Vegetti, *Cuore, sangue e cervello,* Il Saggiatore Milan, 1977; Mario Vegetti, *Il Coltello e lo Stilo,* Milan, 1979; *Tra Edipo e Euclide,* Il Saggiatore Milan, 1983; *TAM,* p. 122.

41. See *RW,* pp. 94 ff., on *On the Nature of Man,* ch. 1, and other Hippocratic texts.

42. As emphasized by Kuriyama, "Visual Knowledge," p. 216.

43. I have explored the rival political images used in Greek cosmology in G. Lloyd, *Polarity and Analogy,* Cambridge Univ. Press, Cambridge, 1966, Ch. 4.

44. For the notion of causation in ancient China, see the articles by N. Sivin and Francesca Bray, in D. Bates (ed.) *Knowledge and the Scholarly,* and in ancient Greece, see G. Lloyd, "Ancient Greek concepts of causation in comparativist perspective," in D. Sperber, D. Premack, and A. J. Premack (eds.), *Causal Cognition,* Clarendon Press, Oxford, 1995, pp. 536–56, and on the Greek view of nature, see *MP,* ch. 18. Broader comparativist studies of notions of space have been undertaken by the Cognitive Anthropology Research Group of the Max Planck Institute for Psycholinguistics, for example, "Relativity in Spatial Conception and Description," by Stephen C. Levinson, Working Paper No. 1, 1991.

45. This is one of the central themes of the collaborative studies currently being undertaken by myself and Nathan Sivin, provisionally entitled *Tao and Logos.*

# 22

# Pictures, Texts, and Objects

## The Literary Language Game
## of Bird-watching

MICHAEL LYNCH

JOHN LAW

*Wittgenstein had taken a particular interest in the different kinds of*
*birds that are to be seen at Killary. (Northern Divers, Cormorants,*
*Curlews, Oyster Catchers, Puffins and Terns are all fairly common*
*along that part of the west Ireland coast.) At first he used to ask*
*Tommy [the caretaker of his cottage] to identify the birds for him.*
*He would describe a bird he had seen, and Tommy would do his best*
*to name it, although, as he freely admits: "maybe it wasn't always*
*the right name I gave him." Having caught him out a few times,*
*Wittgenstein relied instead on the illustrated handbooks sent to him*
*by [Maurice] Drury [his former student at Cambridge].*

—RAY MONK, *WITTGENSTEIN: THE DUTY OF GENIUS* (1991, 527)

## EPISTEMOLOGICAL DUCK

The Malheur River in eastern Oregon was named after a bad experience. A group of Arcadian explorers, who had stopped to bathe in the river, were left naked and stranded in a remote desert landscape when a group of Native Americans stole off with their clothes and horses. "Malheur!" The explorers managed to survive, but the name stayed in place. Our story begins a century and a half later, as two visitors, whom we shall call Linda and Fred, are spending a weekend at the Malheur. In the late twentieth century the place is still remote and desolate, but the river has been dammed to form an artificial wetland designated as a national wildlife refuge. Our protagonists are pursuing the popular recreational activity of bird-watching (also known as "birding" or, less respectfully, "twitching"). They are having a good time at the Malheur: they have no horses, but they are comfortably clothed and their car is safely parked at a picnic site. But, at the moment, they are experiencing a nakedness of a different kind from that of the unfortunate Arcadians.

They are peering through binoculars, so their eyes are not naked, but they do not have *field guides* at hand (they left them in the car while taking an afternoon stroll around a pond). Fred is a casual bird-watcher who can recognize many of the more common North American species, but he leans upon his field guide like a crutch when venturing into new territory. Linda is an almost complete novice, and at the moment she is relying upon Fred's uncertain tutelage without the aid of pictures and captions.

Fred and Linda are reenacting a scene in an ancient epistemological discourse on the relationship between words and things: Fred locates a specimen, indicates where it is, recites its name—gadwall, night heron, black tern, kestrel—and then briefly describes its features, habits, and local abundance. Linda tries to follow as best she can, and she often takes the lead by asking "What's that?" after finding an unfamiliar bird. Sometimes it is a kind of bird that neither she nor Fred has seen before, but at other times, or so Fred tells her, it is a kind that he has seen before. Sometimes, Fred tells Linda, it is the same species of bird that *she* has seen before, even just an hour ago. In order to keep track of what she has "seen" on this trip, Linda begins to keep a list. She repeatedly asks Fred whether she should "count" a species that she is not sure she has really seen. So, for example, Fred tells her that a pair of ducks they see floating near some reeds about 100 meters away are "gadwalls." Linda locates the pair with her binoculars, but wonders how these rather dull, featureless ducks differ from the other ducks they have seen. Fred instructs her to notice the dark rear end of the drake, and he observes that the differences in plumage between adult male and female gadwalls are less striking than in comparable species like mallards. He thus presumes, and invites Linda to presume, that the two ducks they see are a mature male paired with a mature female. Linda still remains doubtful. Did she *really see* two gadwalls, or was she simply told *that* she had seen them? She is hesitant to write the name "gadwall" on her list, because she is doubtful that she would recognize another "gadwall" on her own. With some hesitancy, at Fred's urging she writes down the name "gadwall" on her list even though she is convinced that she did not know what she had seen.

Linda's doubts about *what* she had just seen and recorded on her list bring into relief a question Wittgenstein (1958, 214) raises about experiencing the meaning of a word: "What would you be missing if you did not *experience* the meaning of a word?" (emphasis in original). This question is critically related to inquiries about words and meanings which have preoccupied philosophers for millennia and have special interest today for sociologists of science.[1] We should note, however, that Linda's difficulty is a situated problem that differs in certain respects from the prototypical examples discussed in the ancient and modern classics. Her situation recalls, but is not exactly like, St. Augustine's example of learning the referent of an unfamiliar word by grasping an experienced user's "intention."[2] Linda presently has no doubt that she saw the ducks that Fred "intended" for her to see: she is sure that she successfully located the same two ducks he referred to, and she has no difficulty associating the word "gadwall" with a singular pair of ducks in the scene they both panned with their binoculars. She did not associate the name "gadwall" with a pair of swans nesting in a clump of reeds, an insect hovering overhead, or a shimmering pattern of sunlight reflecting on the water. The objects in question were real, live, three-dimensional, densely textured, unequivocal *ducks,* unlike Jastrow's famous sketch of the duck-rabbit. And unlike the child in Kuhn's (1977) fanciful illustration of how a novice learns the differences between ducks, geese, and swans, Linda knows a duck when she sees one. As far as she is concerned, the name "gadwall" is securely fastened to two clearly visible ducks swimming in the marsh. Her problem is to get the name to "stick." Linda is sure that the next

time she sees ducks that look like these two she will be unable to tell on her own that they are "gadwalls."

A number of different explanations can be given for Linda's difficulty. Perhaps she anticipates that she will forget the name "gadwall" the next time she encounters a duck like the two she had just seen. More likely, she anticipates the opposite problem: she can remember the name but is unsure how to apply it to future cases. She may be aware that the individual condition of the ducks she now sees, together with the conditions under which she sees them, are likely to vary the next time she encounters the same (or *possibly* the same) kind of duck. What if she sees just one duck, or a whole group of ducks, and not a single "pair"? Or, even if she does see two ducks swimming together, how will she know that they are a *pair* consisting of one adult male and one adult female, rather than, say, two adult females, or a female and an immature? We may be skilled at recognizing the "tie signs" that identify human couples (Goffman 1971), but what are the signs for duck couples? And why should Linda take Fred's word for it? After all, he does not even pretend to be an expert.

As we diagnose the situation, the name "gadwall" is one name among many for "ducks." Although Linda can identify generic ducks, she is unable to see how the features of the gadwall contrast with other ducks of similar size and profile. The dull grey appearance and the male's black posterior are not juxtaposed against the green and ruddy heads, colorful wing and flank patches, distinct beak shapes, darting movements, and seasonal and regional habitats of comparable species. In other words, Linda does not have at her fingertips (let alone "in her head") a compact device for *collecting and contrasting species identities*. Her companion indicates particular details, and furnishes guidance in a piecemeal way, but he does not supply a synthetic *table of possibilities* that would enable Linda to grasp how the pair of ducks she now sees fits into a taxonomic array of comparable objects with distinguishable characteristics.

Where would such a table of possibilities come from? An isolated bird-watcher might create one for herself, but such a private taxonomy would be more likely to inscribe rather than resolve her uncertainties. Perhaps she could ask an experienced bird-watcher for a systematic taxonomy and set of instructions, but a more likely solution would be to purchase a field guide that makes use of an officially recognized ornithological taxonomy. With field guide in hand, she would have an authoritative basis for compiling her own bird list. She would be able play the familiar *literary language game* of birding.[3] This is a game in which the bird-watcher walks or drives through a field (a marsh, forest, preserve, park, and so on) in search of birds, while consulting a field guide and keeping a list of the species seen. Players of this game are strongly inclined to look for species that they had not seen before, in order to add them to their "life lists." Almost always, these are birds that others have seen with variable frequency in the particular place.[4] There are many variations of the literary language game, and it is by no means the only one played among birders, but it is an especially prevalent one, and for simplicity we shall concentrate on it in this article.

The notion of a literary language game brings into relief the way in which "experiencing the meaning of words" in a specific naturalistic domain requires an apprenticeship to a social organization of reading and writing. More generally, an examination of this game enables us to appreciate how "natural order" is discovered and organized through the use of texts. It also enables us to appreciate that "natural kinds" are not simply representations of what the eye (or the mind's eye) sees. In place of a perceptual model of observation, we suggest open-ended investigations of *situated practices of reading and writing*. The reading and writing that interests us is not the kind

we do in the library (although that too is situated): it requires an active consultation of texts as part of the embodied performance of a socially organized activity. As our story of Linda and the gadwalls suggests, bird-watching is not a naked matter of looking and seeing. When playing the literary language game, bird-watchers use optical equipment, field guides, and lists in a reflexive way, as they go back and forth between the textual categories in hand and the proverbial bird-in-the-bush. The outlines of the game differ significantly when it is played alone, by groups of novices, by guided groups of novices, and by groups of experts. "Expert" and "novice" are of course relative identities, but one mark of expertise is to make species identifications without a text at hand.

As readers may have grasped by now, our interest is not in bird-watching as such (although we *do* enjoy it), but in the way this commonplace activity provides public entry into classic epistemological debates on the relationship between words, objects, and activities. These debates continue to have a central role in philosophy, history, and social studies of science. We recommend bird-watching and related naturalistic activities as a way to *investigate* epistemological topics in the field; to grasp epistemic relations, so to speak, "on the fly."[5] Consequently, we hope that readers will follow what we say by conducting their own field studies. The kind of "nature study" we have in mind is not only a practice of seeing and describing natural kinds, appreciating natural phenomena, and so forth; it is also a kind of natural-philosophical investigation that focuses upon recurrent practices of "observing," "describing," and "categorizing" in specific geographical and cultural situations.

Amateur bird-watching is not a science, but it is a widely accessible form of naturalistic observation that has various historical, conceptual, and cultural connections with more fully accredited scientific practices. We are focusing on birding in this paper, because we both have practiced it and it is widely accessible, but the literary language game we describe has a much broader application. A visit to a natural history museum shop should be sufficient to show that field guides, and the literary language games that go along with them, are available for wildflowers, trees, mammals, reptiles and amphibians, fishes, insects, rocks and minerals, astronomical phenomena, and many other subjects. Many field guides cover entire nations and continents, while others cover specific regions, counties, parks, and other localities. Field guides also range from "complete" guides to a whole array of flora and fauna in a nation or region (Arlott et al. 1981) to highly specialized guides that inventory, for example, the peat mosses of boreal North America (McQueen 1990). The boundary between an amateur pastime and the cutting edge of discovery and debate in a scientific field is more easily crossed when the natural kinds in a given domain grow more numerous (like insects) or more obscure (like peat mosses). For example, Hölldobler and Wilson (1990, 4) estimate that 20,000 species of ant, making up as many of 350 genera, remain to be discovered worldwide. We are also told on good authority that with a few days of diligent investigation it is possible to discover a new species of parasitic wasp in New York City's Central Park![6] Unfortunately, this is not the case for birding. During the Spring warbler migration, casual birders can be hard pressed to see even a few of the dozens of species recorded daily on a blackboard in the lobby of a Central Park café. Nevertheless, local credit, personal satisfaction, and natural-philosophical insight remain available for "discoverers" who contribute to the day's list and/or their own life lists.

## LISTS

---

*He binds sight to crafted description and, further, places this activity*
*in the context of the greater Baconian project.*

—SVETLANA ALPERS, *THE ART OF DESCRIBING:*
*DUTCH ART IN THE SEVENTEENTH CENTURY* (1983, 73)

Lists are central to bird-watching, and practitioners commonly keep several: "life lists" which record a cumulation of species identified by a particular person; occasional lists which record species identified by a person or group at a particular place and time; preprinted checklists distributed to visitors of nature preserves; and lists collectively compiled during "Christmas counts" and other organized surveys sponsored by ornithological societies. Superficially, such lists *represent* a collection of observations, but they do much more than that. The compilation of a list is an important *constituent* of individual and collective observations. Perception is list-driven in an important sense: during a field trip, the present state of the list supplies motives for searching the environment, selectively attending to possible experiences, telling others about such experiences, and reacting to such tellings with excitement, doubt, or boredom. There is thus a reflexive relationship between the literary phenomenon of the list and the embodied and interactional performance of observation and representation. Because the concrete configuration of naturalistic observation depends so heavily upon the textual, interactional, and authoritative production of lists, it cannot be reduced to a relationship between individual perception/cognition and the natural world.

Although bird-watchers commonly keep their own personal lists, list making and list reciting are organizationally accountable. Bird-watchers can be competitive about the length of their life lists, and listings of rare species are subject to rivalry and controversy (Kastner 1986, 211ff.). Local chapters of the Audubon Society and other organizations collate sightings of rare and vagrant species in their regions, and specify constraints about what counts as a competent identification. Novices are instructed to build disciplined descriptions, so that others can assess their accuracy:

Notes should be made and kept in logical and systematic sequence, if possible, for ease of later retrieval. Try to build a description each time in the same order. Do this by looking for different parts of the bird in the same order. This is, of course, not always possible and often you must scramble and take what you can get when you get it but *trying* to follow the same sequence is a start at learning a good habit. What is more important is writing up the details. (Bernstein 1984, 1)

In this ideal world the bird-watcher starts with an overall impression—the gestalt "feel" of the bird—and then moves through an order of parts, starting with the dorsal and moving through the ventral and the "soft parts" (the eye, the mouth, the feet), before describing its song, if any. Bernstein (1984, 2) advises novices to write a systematic description before consulting the depiction in a field manual: "Many possibly good and valid records have been tarnished because the observer consulted a book before finishing the notes. As a result, the description is that of the picture in the book, *not* of the actual live bird seen." However, as another writer advises, it is equally hazardous to write a detailed description "of the actual live bird seen" without attending to the notable distinctions recorded in the book:

[D]ocumentation of a rarity must convince reviewing bodies or editors that similar species were considered and reasonably eliminated. Having in mind the species one needs to eliminate, one becomes selective about the aspects of the bird under scrutiny which are emphasized in the description. (Garrett 1986, 3)

Garrett (1986, 3) adds that recording committees must "juggle multiple descriptions" with different or conflicting interpretations.

Such disciplined descriptions, we suggest, impose durability upon local bird sightings by translating them into a canonical and normalized form which enables an organizational network to monitor, select, and compile master lists. A number of competing systems have been used in the history of field ornithology (Farber 1982), so that the success of any system depends upon the extent to which it enlists a network of local descriptions.

## FIELD GUIDES

Popular field guides have been used for at least two centuries, but the "classic" guide currently used in North America is the late Roger Tory Peterson's *A Field Guide to the Birds of the Eastern and Central North America* (1980 [1934]). Peterson's Western Edition (1961 [1941]) is similar in format to the original Eastern Edition, and is the main source for our analysis of Peterson's illustrations and descriptions. Numerous other popular field guides have appeared in recent years. Two of these, which we shall compare with Peterson's, are the Audubon Society guide (Udvardy 1977) which uses photographs rather than drawings of birds, and a guide published by the National Geographic Society (1983), which, according to Kastner (1986, 208), was aimed at more "sophisticated" bird-watchers.[7]

These guides display important differences, but they also show some deep commonalities:

*Realism:* Despite profound stylistic differences, all three manuals employ conventions of artistic realism (Gombrich 1960). Without having to say so, the manuals and their users are committed to the possibility of seeing actual specimens of the birds depicted in the books. (Possibly extinct species like the Ivory-billed woodpecker [*Campephilus principalis*] are still included in the field guides, but fictional birds like the phoenix and long-gone birds like the passenger pigeon are not listed.) Realism remains relevant, even as it is *realized* through a selective use of textual and pictorial devices.

*Perceptual accountability:* Writers and readers presume that it is possible to identify and distinguish the species listed in the book on the basis of characteristics that can be observed from a distance: size, profile, plumage, song, attitude, habit, and so on. As Peterson (1980, 7) states: "This book was designed so that live birds could be readily identified at a distance by their 'field marks' without resorting to the bird-in-hand characters that the early collectors relied on." None of the books finds it necessary to instruct users on how to dissect specimens or perform genetic typing in order to discern true species identities.

*A picture theory of representation:* The field guides are lavishly illustrated with color photographs, paintings, line drawings, visual profiles, and range maps. It is difficult for us to imagine using a nonillustrated field guide,[8] and certainly such a guide would never sell! Bird illustrations can, of course, be aesthetically valued, but the illustrations in a field guide function overtly, and primarily, as visual aids for detecting and identifying individual field specimens. The operative "picture theory" differs from Wittgenstein's (1961) early conception of a linguistic "word-picture" that corresponds to "the facts"; this "theory" presumes the possibility of seeing that, and seeing how, a drawing or photograph corresponds to a singular specimen of an actually existing species.[9]

*A strategic use of words:* Field guides make strategic use of captions and descriptions. A wordless field manual, without names, captions, pointers, phonetic spellings of bird songs, and so on, would be no more useful than a text without pictures. The internal relations among the pictures, captions, names, and descriptions in a field guide are crucial to the activity of bird-watching. The three field guides we

examined in detail employ different indexing systems to aid bird-watchers when they face the often impossible task of training their binoculars on an elusive specimen while leafing through the manual in a search for pictorial and verbal instructions about what to "look for."

## SCHEMATIC, PHOTOGRAPHIC, AND DIORAMIC BIRDS

Despite their similarities, the three manuals deploy systematically different representational devices. Peterson's guides employ schematic paintings, the Audubon guide uses photographs, and the National Geographic guide depicts naturalistic scenes reminiscent of a museum diorama.[10]

### SCHEMATIC DRAWINGS

Peterson's guides use color and black-and-white plates to juxtapose representative drawings of several different species on a single page (see Figure 22-1 for an example of a color plate, reprinted here in black and white). Each species is represented in paradigmatic fashion with drawings of an adult male, female, and/or immature specimen. Peterson's drawings include only the barest hint of background detail, unlike the photographs and paintings in the other two field guides (Figures 22-2 and 22-3). Peterson labels each drawing and employs a pointer to indicate one or more notable "field marks" that identify the specimens he depicts. On a single page in Figure 22-1 he composes a loosely tabular arrangement of perching accipitors, falcons, and harriers, and in another plate (not shown here) he shows a similar arrangement of flying hawks, viewed from below. A bird-watcher would never see or even expect to see such an orderly flock, but as Peterson makes clear, that is not the kind of pictorial realism he has in mind:

The plates and cuts throughout the text are intended as diagrams, arranged so that quick, easy comparison can be made of the species that most resemble one another. As they are not intended to be pictures and portraits, modelling of form and feathering is often subordinated to simple contour and pattern. Some birds are better adapted than others to this simplified handling, hence the variation in treatment. Even color is sometimes unnecessary, if not, indeed, confusing. (Peterson, 1947, xviii)

In the particular edition of Peterson represented in Figure 22-1, the plate of perching hawks is faced by a page including corresponding profiles and names for genera, names and brief descriptions of each species, and page references to longer descriptions. In a later edition, Peterson (1980, 9–10) states that in order to appeal to the "increased sophistication of birders" he has "leaned toward detailed portraiture in the new illustrations while trying not to lose the patternistic effect in the previous editions." He also places more detailed descriptions on the facing page and includes range maps at the end of the book. He nevertheless maintains a minimalist style because, he says, whereas a "photograph is a record of a fleeting instant; a drawing is a composite of the artist's experience." Consistent with his earlier editions, he aims to "show field marks to best advantage, and delete unnecessary clutter."

The deletion of "clutter" in Figure 22-1 creates an impressive field of constancies that accentuates a relatively limited set of differences and similarities. The apparent distance of each pair of specimens from the viewer is held constant, so that their relative sizes stand out. The visual field is relatively flat, as Peterson does not employ conventions of linear perspective (chiaroscuro, vanishing points, and so on) to connote shadow and depth. There are hints of shadowing, but these

**Plate 16**

## HAWKS

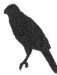

**ACCIPITERS** (True Hawks)
Small head, short wings, long tail.
Adults, barred breasts; immatures streaked.

**COOPER'S HAWK**                                              p. 50
   Crow-sized; rounded tail.

**GOSHAWK**                                                    p. 49
   *Adult:* Pearly breast, light gray back.
   *Immature:* Large; pronounced eye-stripe.

**SHARP-SHINNED HAWK**                                         p. 49
   Small; notched or square tail.

**FALCONS**
Large head, broad shoulders.
Long pointed wings, long tail.

**SPARROW HAWK or AMERICAN KESTREL**                           p. 61
   *Both sexes:* Rufous back, rufous tail.

**PIGEON HAWK or MERLIN**                                      p. 60
   *Male:* Small; slaty back, banded gray tail.
   *Female:* Dusky back, banded tail.

**PEREGRINE FALCON**                                           p. 60
   *Adult:* Slaty back, light breast, black "mustaches."
   *Immature:* Brown, streaked; typical "mustaches."

**HARRIERS**
Small head, long body.
Longish wings, long tail.

**MARSH HAWK (HARRIER)**                                       p. 57
   *Male:* Pale gray back, white rump.
   *Female:* Brown, with white rump.

FIGURE 22-1
*Peterson's schematic hawks*
*Illustrations and captions from the book,* A Field Guide to Western Birds,
*written and illustrated by Roger Tory Peterson,*
*published by Houghton Mifflin Company, Boston.*
*Copyright 1941, 1961 Roger Tory Peterson.*
*Reprinted with permission.*

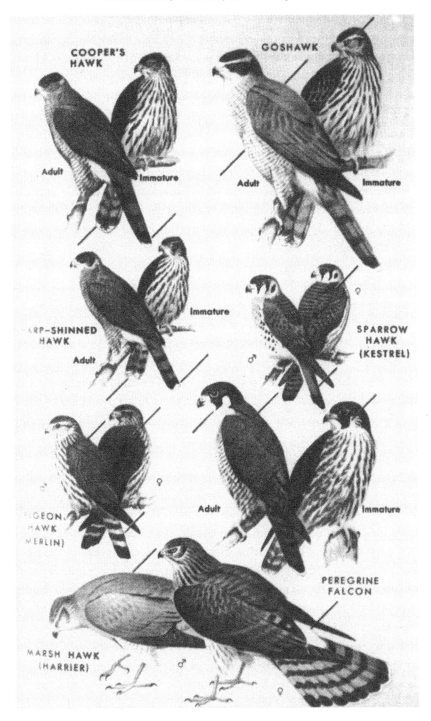

are as though "bleached out" in order to constitute a standard field of colors in which variations are unambiguously tied to the object's surface in constant light. The overlapping arrangement of each pair of birds economizes space on the page while exposing the relevant field marks. In addition to showing different type-specimens, the depiction of each pair systematically exposes different flanks. The array of pairs is placed in rough tabular alignments, with closely related species placed in close proximity. Note that the positioning of the Marsh Hawks disrupts the parallel arrangement in order to fit a larger pair into the available space at the lower margin. The uniformities are especially striking when compared to the arrangement of photographs in the Audubon guide (Figure 22-3), which show birds perched in different poses, in variable lighting conditions, and against different backgrounds. Peterson's depictions exhibit a synchronic, quasi-experimental arrangement, where variables of distance, depth, lighting, pose, and background are held constant. An artfully constructed ceteris paribus clause operates to move the visual in the direction of the categorical.

Peterson's pictorial epistemology is exemplified by his treatment of two of the accipitors in Figure 22-1: the Sharp-Shinned Hawk and the Cooper's Hawk. Adult and juvenile Cooper's hawks are paired in the top left part of the plate, with a similarly posed pair of Sharp-shinned hawks aligned immediately below them. Unlike some of the other pairs depicted on the page, these two pairs are marked for age rather than sex. Presumably, the male and female of the species show the same markings. According to Peterson's minimalist strategy, it would simply clutter the picture to make an issue of "sex" in this case. The tabular alignment accentuates the similar markings and the relative (and in this case highly salient) difference in size between the species pairs. The words "crow sized" under Cooper's Hawk, and "small" under Sharp-shinned Hawk on the facing page, verbally support the depicted size difference while externally indexing the picture to a yardstick species (the familiar crow).

When turning to the section of the book that provides more extensive (yet still very concise) descriptions of the two species, we are given some qualifications: the Cooper's Hawk averages "not quite so large as a Crow" (p. 50); and we also learn that a "[s]mall male Cooper's is often nearly identical in size and pattern with large female Sharp-shin" (p. 50). So, sex does matter after all, and the size difference is not such a trustworthy index. But, having qualified the matter of sex and size, Peterson quickly adds that "generally the Cooper's has a rounded tail" in contrast to the Sharp-shin's "*square-tipped* tail, slightly notched when folded" (p. 50, emphasis in original). This supports the distinction marked by Peterson's pointer in Figure 22-1. But then, he qualifies even this crucial difference by saying that "Sharp-shin's square-tipped tail can look slightly rounded when spread" (p. 50). At this point, the novice birder may begin to feel uneasy. Peterson himself acknowledges in a later edition of his guide to Eastern birds (1980, 152) that "many [Cooper's and Sharp-shinned hawks] cannot be safely identified in the field." He has taken us to the limits of resolution of the game.[11]

Barry Barnes's (1977, 8) observation about an anatomical drawing of an arm also holds for Peterson's drawing of a pair of hawks: "It is designed to facilitate recognition and naming." Such a drawing is not intended as a realistic portrait designed to resemble closely the appearance of a particular specimen; it is schematic. Peterson's drawings nevertheless are realistic in their own way. Together with the supporting verbal and visual devices, each drawing facilitates the identification of particular field specimens. Peterson's textual composition exhibits a coherent conception of seeing and recognizing. This is not a general cognitive theory; instead, it is more like a collection of instructions and tools associated with a particular craft, like pottery or carpentry.

An archaeology of the collection refers us to a typical set of projects and gestures. Peterson's collection is arranged to facilitate the conjoint activity of seeing-and-reading-at-a-glance. The book itself is compact, portable, and durable. Its textual elements are arranged so that a reader can carry it into the field, quickly crack it open after catching a fleeting glimpse of a specimen, and easily derive "essential" information about the names, descriptions, sizes, and distinctive markings of a set of comparable species. The book is designed to be read by distracted eyes; eyes that glance nervously at the page, seeking essential detail before returning to the bird alighting tenuously on its perch or flying overhead. Textual passages that require more extended study, and which instruct the reader about subtleties and ambiguities, are placed in the background. The text sets up a series of cross-references between generic profiles, drawings, names, and brief descriptions. Many of these are internal to the elements included on a single page or between a pair of facing pages: names and descriptions, pictures and captions, members of a pair, an array of pairs, and so forth. There are also page references to other sections of the book. The cross-references include external references as well, such as mentions of "garden variety" birds like the crow, which is used as a yardstick in Figure 22-1. The text presumes that crows (like house sparrows, starlings, robins, and feral pigeons) should be familiar to any North American reader, and in this respect, bird-watching bootstraps itself upon an everyday familiarity with natural kinds (see Law and Lodge 1984, 94). Most importantly, the whole assemblage of textual elements is referenced to the bird that is, or just was, and may be again, "out there" in the field. As much as can be managed under severe practical constraints, the field guide attempts to envelop the "bird out there" in a network of textual devices. Nevertheless, Peterson's formal textual devices do not, and cannot, provide a self-sufficient account of what a bird-watcher sees and does when reading the text in the field. We shall address this issue later.

## PHOTOGRAPHIC REALISM

Unlike Peterson's guides, the Audubon guide uses photographs of representative specimens in its color plates (see Figure 22-2). The author defends this approach by arguing that "photographs add a new dimension in realism and natural beauty. Fine modern photographs are closer to the way the human eye usually sees a bird and, moreover, they are a pleasure to look at" (Udvardy 1977, 10). Figure 22-2 shows an arrangement of two photographs aligned vertically on each page. A single bird is shown in the frame of each photograph. Each photograph includes a brief label giving a consecutive number for the photo, the bird's common name, its size range, and (in some cases) its age and sex. A page reference indexes a description and range map elsewhere in the book. For the Sharp-shinned hawk, two illustrations are used: a perching "immature" and a flying bird (presumably an adult, though this is not explicitly mentioned). Plates are indexed by generic profiles, some of which are color-coded with the dominant hue of the bird (red, yellow, brown, and so on).

Like the Peterson's guides, the photographs in the Audubon edition juxtapose related (or visually similar) species, and the cross-references between textual and pictorial elements accentuate features to look for in the field. There are also some key differences. The Audubon guide's photographic realism is less controlled than Peterson's. The birds appear in different poses, circumstances, and lighting conditions, and they are shown at variable distances. There is no indication of field-marks in the photographs (these are mentioned in the descriptions elsewhere in the text). Peterson fits more birds into the frame, and maintains relative constancy in the way he poses and colors them. His paintings show only what he designs for his readers to see. Where the

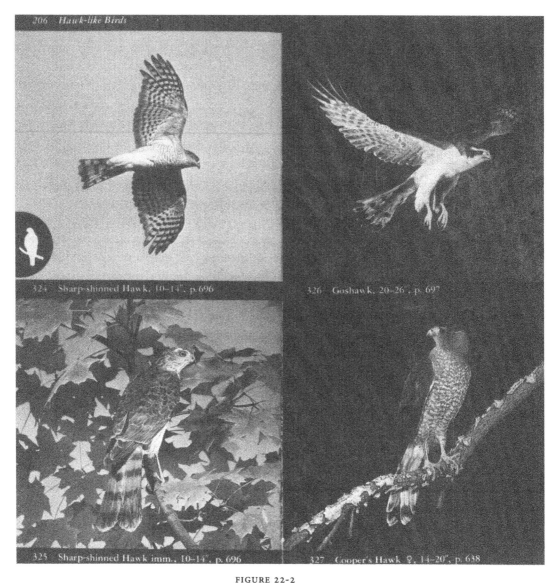

**FIGURE 22-2**
*Photographs of hawks*
*Illustrations from* The Audubon Society Field Guide of North American Birds, Western Region,
*edited by M. D. F. Udvardy, published by Chanticleer Press, Inc., New York.*
*Plate 324 by Harry Darrow, Plate 325 by Karl Maslowski,*
*Plates 326 & 327 by Ron Austing. Reprinted with permission.*

Audubon guide opts for the richness and concrete realism of a snapshot, Peterson's contrived ornithological tables present a set of ideal types. It can be difficult to tell where information turns into clutter in the Audubon guide. For example, a reader might infer from the backgrounds in Figure 22-2 that the Cooper's Hawk prefers conifer trees, while the Sharp-shinned frequents deciduous trees. However, this inference is undermined elsewhere in the text, when the Cooper Hawk is included in a section on birds of the deciduous woods, while the Sharp-shinned is placed among birds of the coniferous forests. Other differences in hue and shading (which are not evident in our black-and-white reproduction of the original color photos), condition of

plumage, posture, and "attitude" all can raise doubts about whether these are incidental to the particular conditions of the photograph and specimen, or typical of the species. The very richness of detail that enhances the photograph's reality effects also invites the reader to project incidental particulars into a species paradigm.[12]

## NATURALISTIC DIORAMA

The National Geographic guide combines characteristics of the other two. The illustrations are hand-drawn by various artists but are more "naturalistic" than Peterson's. The arrangement in Figure 22-3 is typical. Three related species of accipitor are shown in three separate fields. Each species is represented by a pair in the foreground, posed in a conventional but less military fashion than in Peterson's tables. The pairs are posed against backgrounds, with one or more flying birds depicted as though in the distance. They are placed in "natural situations"—having just captured prey, and in one case with an active chase scene shown in the background—much like the stuffed specimens in a museum diorama (Myers 1990, 240).

The naturalism in Figure 22-3 is attenuated by numerous concessions to practicality. This is no diorama to be inspected at leisure. The backgrounds are relatively thin, with attenuated portraits of the types of tree and prey species with which the hawks are associated. The specimens are arranged in a compact space, with minimal overlap. Each adult specimen displays eye, beak, a portion of breast, tail, and feet. And, while each of the three fields is isolated from the others on the page, the specimens are shown in proportionate size. The "controls" in this case are less obvious than in Peterson. The birds look less like cardboard cutouts or stuffed specimens in a museum drawer, and yet they are systematically arrayed. While evoking some of the detail of a photograph, the frame includes a juxtaposition of details that would be extraordinary to find in any single photograph. Poses, lighting conditions, and plumage are idealized for the purpose of displaying type-specimens.

The National Geographic guide makes no use of Peterson's famous lines to point out field marks, although in its description of the Sharp-shinned hawk (Figure 22-3), it does mention, among a number of other distinctive features, a "shortened squared tail, often appearing notched when folded." Generally, the National Geographic guide places less emphasis on single field marks, opting instead for a list of visible and behavioral features (e.g., "sometimes perches on telephone poles, unlike Sharpshins"). The National Geographic Guide provides a denser arrangement of text on the pages facing its plates, so that a user can open the book and find pictures, names, descriptions, and range maps. There is no need to turn elsewhere in the book to find more detailed descriptions or range maps.

## NATURAL DECONSTRUCTION

However well organized the field guide and however admirable the programmatic aims of its author, our experience with all three of the manuals discussed above convinces us that readers will encounter innumerable frustrations, uncertainties, and quandaries when they use the texts in novel situations. Some of these troubles are nicely expressed in a description of a typical encounter between a novice bird-watcher and a little brown bird:

The sparrow sets off the encounter by flying up into a fence wire. Fighting off a sense of panic, the birder tries to focus on the field marks. Does the bird have a streaked or plain breast? Streaked; okay. Is there or is there not a pale central breast spot? And wing bars; do those pale lines qualify as wing bars? At this point the bird drops back into the grass. The observer has noted only one definite field mark: the streaked breast;

### Accipiters

Comparatively long tails and short, rounded wings give these woodland hawks greater agility. The three species in North America are confusingly similar.

### Sharp-shinned Hawk  *Accipiter striatus*

*L 10-14" (25-36 cm) W 20-28" (51-71 cm)*  Distinguished from Cooper's Hawk by shorter, squared tail, often appearing notched when folded, and by proportionately smaller head and neck. Adult lacks Cooper's strong contrast between crown and back. Immature is whitish below with bold, blurry, reddish streaking on breast and belly; narrow white tip on tail; undertail coverts entirely white; head less tawny than in other accipiters. In flight (see also page 207), again note smaller head and proportionately shorter tail and longer wings than in Cooper's Hawk. Fairly common over much of its range; found in mixed woodlands. Preys chiefly on small birds. Migrates singly or in small flocks.

### Cooper's Hawk  *Accipiter cooperii*

*L 14-20" (36-51 cm) W 29-37" (74-94 cm)*  Distinguished from Sharp-shinned Hawk by longer, rounded tail, larger head, and, in adult, stronger contrast between back and crown. Tail is proportionately longer and wings shorter than in Northern Goshawk. Immature has whitish or buffy underparts with fine streaks on breast; streaking is reduced or absent on belly; white tip on tail is broader than on Sharpshin; undertail coverts entirely white. In flight (see also page 207), again note larger head and proportionately longer tail and shorter wings. Uncommon and may be declining. Inhabits broken woodlands or streamside groves, especially deciduous. Preys largely on songbirds, some small mammals. Often perches on telephone poles, unlike Sharpshins. Usually migrates singly or in groups of two or three.

### Northern Goshawk  *Accipiter gentilis*

*L 21-26" (53-66 cm) W 40-46" (102-117 cm)*  Conspicuous eyebrow, flaring behind eye, separates adult's dark crown from blue-gray back. Underparts are white with dense gray barring; appear gray at a distance. Adult has conspicuous fluffy undertail coverts. Immature is brown above, buffy below, with dense, blurry streaking, heaviest on flanks; tail has wavy, dark bands bordered with white and a thin white tip; undertail coverts have dark streaks. In flight (see also page 207), note proportionately shorter tail, longer wings than Cooper's Hawk. Sometimes confused with Gyrfalcon (page 204) and Red-shouldered Hawk (next page). The Goshawk inhabits deep, conifer-dominated mixed woodlands; preys chiefly on birds and ducks; also on mammals as large as hares. Uncommon; winters irregularly south of mapped range in the east. Southward irruptions occur in some winters.

FIGURE 22-3
*Hawks in diorama*
*Illustrations and captions from* Field Guide to the Birds of North America,
*published by the National Geographic Society, Washington D.C.*
*Drawings by Donald L. Malick.*
*Reprinted with permission.*

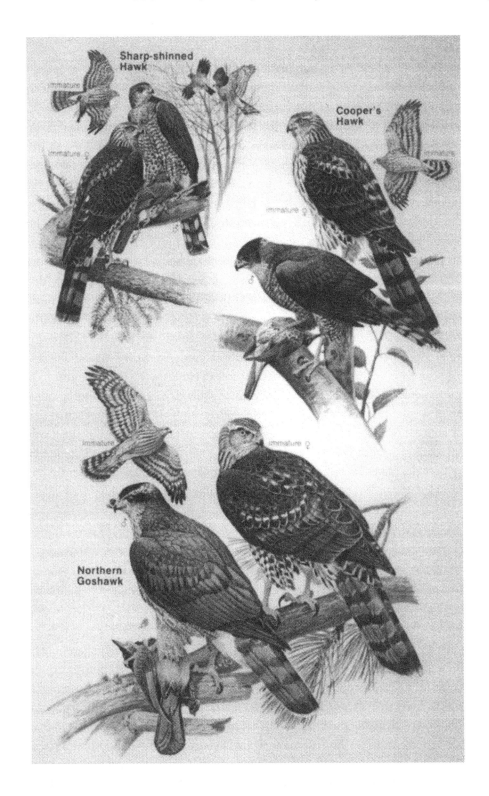

that would rule out some species, except that even most plain-breasted sparrows have streaks in juvenile plumage. (Kaufman 1990)

This story leaves implicit an important aspect of the hapless beginner's struggle: that the observer is likely to be fumbling with a field manual when searching for the relevant marks and distinctions. The text's account of distinctive sparrow field marks sets up the search for streaks, spots, and wing bars. The textual details that inform this search provide the organizational context, detailed contents, and possible remedies for the beginner's troubles. Committed birders typically experience such troubles as temporary problems having to do with personal knowledge and acuity, perspective and lighting, luck, the quality of the equipment at hand, and the elusiveness of the quarry. The troubles generally do not threaten the ontological grounds of the activity.[13] From our point of view, however, such troubles are methodologically significant as disruptions of fluent practice which can reveal contingent properties of "reading" a text in the field. Thus far, we have examined formal features of three books, while alluding to their use in the field, but in the remainder of this article we shall describe a different kind of "deconstruction." This kind of deconstruction does not aim to penetrate a text in an effort to dig out its oppositions and unpack its ideological presuppositions. It is not a matter of scholarly explication. Instead, it occurs as a matter of course when novice bird-watchers carry text into the field in order to play the literary language game of bird-watching. An elusive natural object (the bird-in-the-field) conspires with the book's formal devices to frustrate the reader's effort to bring text and object into correspondence. These frustrations vividly expose in vivo reading practices that are hidden to scholarship performed at the desk. What results is not an intellectual deconstruction of the concept of "nature" but rather a natural deconstruction: a revealing disruption of the concrete practice of "reading the book of nature."[14] In what follows, we shall argue that natural deconstruction elucidates how the field guides we previously discussed differently set up their readers' troubles.

## MISSING THE MARK: TROUBLES WITH
## SCHEMATIC REPRESENTATIONS

This type of trouble arises with guides like Peterson's that employ the conventions of schematic realism, but it also occurs less obviously with guides that employ photographic and naturalistic approaches. All three of the guides we discussed earlier selectively use drawings or photographs to show birds in paradigmatic poses, and their descriptions emphasize key distinguishing marks. "Missing the mark" occurs in an effort to read a schematic account, when (as occurs all too often) the bird flies away or darts into foliage before the observer can get a good look at it with field glasses or spotting scope. It also occurs when a flying bird moves too rapidly or remains too far away to enable a clear view of its markings, and when a stationary bird refuses to pose for the viewer to display the field marks that are so nicely illustrated in the field manual.[15]

A related problem occurs in field manuals like Peterson's earlier editions and the Audubon guide which place pictures, descriptions, and range maps in separate sections of the book. Often, when using such manuals, we have found the pictures and brief captions that accompany them to be insufficient, necessitating an effort to turn to the more extensive descriptions. The extra time this takes increases the chance that the yet-to-be-identified bird flies away or hides itself. The authors of the National Geographic guide, and other more recently published field manuals (e.g., Jonsson 1992; Thiede 1993), attempt to remedy this problem by placing pictures of compa-

rable species together with names, descriptions, and range maps on a pair of facing pages. Note that range maps often provide an invaluable aid for distinguishing similar appearing species like the Eastern and Western meadowlark which inhabit different territories. The exclusive use of range maps is discouraged, however, because it can suppress the discovery of "vagrants" that have wandered far from their habitual range. And, in the world of birding, "vagrants" are highly prized.

## SURPLUS DETAIL: TROUBLES WITH PHOTOGRAPHIC REALISM

Photographic realism can be a source of illusion. The very advantages of photographic realism—the density of detail, singularity, and credibility—are associated with a lack of freedom to manipulate the subject. Bird photographers do endeavor to select "good" subjects (such as healthy adult specimens in breeding plumage, assuming classic postures in good lighting conditions). Nevertheless, an artist has much greater license to show a bird in a pose that reveals its distinctive markings and coloration. Bird artists do not experiment with Cubism, but they take some license with perspective in an effort to highlight an array of field marks in a single plane.[16] A photographer has less leeway to control illumination and distance than an artist like Peterson, and specimens photographed in the field rarely arrange themselves into compact, parallel groupings that clearly exhibit differences between related species. The very freedom from a photograph's perspectival realism enhances the objectivistic "view from nowhere" (or, rather, the view from nowhere in particular) that Peterson's drawings evoke.[17]

Consequently, a birder who uses a photographic field guide like the Audubon guide is faced with the problem of extracting "essential" details from the dense array of a photographic scene, and distinguishing these from "gratuitous details" (Myers 1990, 235) that offer to distract or mislead identification. In theory, the similarity between the view framed by the camera and the view framed by the observer's field glasses should enable the picture in the book to stand proxy for the observer's experience, so that the text's explication of the picture simultaneously explicates what the observer sees. The problem is that countless differences between the two "views" remain noticeable, and not all of the differences are contrived by the artist to facilitate identification. Many differences appear to be accidental. In the Audubon guide we examined, some of the plates show ducks in water without visible feet and hawks with breast feathers obscured or out of focus. Other differences have to do with formal disparity between a camera's snapshot vision (Gibson 1986) and a person's ability to explore a specimen, watch it move, approach it from different angles, and so forth. A paradigmatic drawing can more freely synthesize details that are unlikely to be seen together at any given moment.

The technical quality and usefulness of photographic field manuals has improved over the years, but some of the troubles with using photographic field guides are intractable, because they are associated with the advantages of the genre. So, for example, photographs show more detail than schematic drawings, but in order to show such detail clearly a print in a field guide needs to be fairly large. Like other photographic guides, the Audubon guide places only two or three representative photos on a page (with a maximum of six on consecutive facing pages), whereas Peterson places a much larger number of his schematic birds together. For example, Peterson's (1980, 249) plate of "Confusing Fall Warblers" (warblers migrating along the eastern coast of the United States in autumn which have lost their colorful and distinctive breeding plumage)[18] contains drawings of sixteen warblers marching in columns, and the facing page assists the observer with verbal instructions on how to reduce the confusion. In all of the photographic field guides

we have read, it is necessary to flip through the sections on warblers, and some guides do not include pictures of warblers in nonbreeding plumage (presumably because this would add to the size and expense of the book). Under such circumstances it can be nearly impossible to treat such an array of photographs as instructions, since they do not provide an authoritative, quickly inspectable, synthesis that highlights salient differences.

As anyone who has attempted photography is aware, photography does not simply capture what the eye sees: the chemistry of emulsion film differs from that of the eye; still photography documents a frozen moment, and often the "wrong" moment; light and color come out differently, and often unexpectedly. Depending on the case, these differences can be turned to advantage or disadvantage. Hosking's (1979) justly famous sequence of photographs of a Barn Owl exploits difference to advantage. By using flash photography he shows the owl in the act of bringing a vole to its nest in the dark, a scene that otherwise would be completely lost to view. But, when a photograph is deployed as an observational aid, the moment that is captured in the photograph, and the rich field of detail in its frame, may or may not help the observer *see* the relevant markings, movements, and overall "species-being" of the bird in the field. It is a rare bird that sits still and allows itself to be studied in the way it is possible to study a photograph. Consequently, a frustrated birder can have good reason to question the "realism" of a photograph that might otherwise seem to deliver a more "true-to-life" rendering than a schematic drawing. In recent years, bird-watching videotapes have been developed. Their advantages are obvious: movements and continuous views are visible; and bird songs can be rendered as recordings, rather than written simulacra like *"queedle, queedle"* and *"tsurp-see, tsurp-see"* (Peterson 1980, 224). However, because of at least two main disadvantages—the inconvenient portability and the difficulty of "paging" quickly through a videotape—they do not compete with field guides.

## DISILLUSIONMENT: TROUBLES WITH NATURALISTIC DIORAMA

The National Geographic guide holds some advantages over the other two, but it is by no means trouble free. Many of the troubles that arise with the other two guides also arise with it. Its idyllic naturalism also holds a distinctive hazard. Consider the resemblance between the National Geographic guide's diorama and John J. Audubon's famous paintings in *Birds of America*. Audubon's portraits are more lavish, but the National Geographic guide also depicts birds in idealized "situations." It is not incidental that Audubon, like most nineteenth-century naturalists, used a shotgun to collect his specimens so that he could then pose them more conveniently for his purposes.[19] The naturalistic diorama invites the reader to appreciate a "natural" scene, with little acknowledgment of the artifices of pose, position, and highlighting. Consequently, naive readers may be led to expect to see birds that look "just like" those portrayed in the guide, and then to suffer a kind of disillusionment when finding that birds are not quite so colorful, unruffled, clearly marked, and boldly positioned.

## UBIQUITOUS TROUBLES

In addition to troubles associated with different styles of realism, some troubles appear with obstinate frequency regardless of the field guide used, because they inhere in the very materiality, composition, and organization of any written text. Newly invented information devices may provide technical fixes for some of these troubles, but we expect that they would introduce others while losing some of the advantages of a book. Briefly, we shall mention three such troubles associated with "bulk," place finding, and incompleteness.

BULK  Academic treatments of texts rarely make an issue out of the fact that books are weighty artifacts which require manual labor to hold, open, leaf through, and carry. Despite the current upsurge of interest in bodies and texts, we know of no approach to literary criticism that makes an issue out of the fact that readers must turn pages, and thus exert effort and expend time, in order to find places in a text. No doubt, these properties are well known to print shops and publishing houses, as well as to readers with physical disabilities. Bird-watchers also become acutely and distinctively aware of the materiality of the text. In the literary language game of birding, a text is carried along with field glasses (and sometimes a spotting scope). These items of equipment must be held in hands, hung on a strap, stuck in a pocket, or placed in a backpack. The trick is to carry them securely and conveniently, while having them ready to hand. As a rule, the larger and more complete the manual, the more trouble it presents to its bearer. In addition, sighting a bird with binoculars often requires both hands to focus and steady the instrument. For two-handed persons unaccompanied by porters, and especially for those who wear spectacles, it can be difficult, if not impossible, to keep the field guide in hand while removing spectacles, raising field glasses, searching the field, and adjusting the focus. Bird-watchers often wish they could assume the form of multiarmed Hindu god Shiva, but short of that they often enact an awkward dance while attempting to accommodate text and equipment with hands and eyes.

PLACE FINDING  The novice with book at hand can experience complex difficulties when pursuing an "interesting" but as-yet-unidentified bird. Consider a typical instance. A "hawk-like bird" flies overhead. The birder spots it with naked eye, finds it in the narrow field of binoculars (an interesting task in its own right), and scrutinizes it against a bright sky. The backlighting makes it difficult to detect the markings. The birder then sets the binoculars down and turns to the field guide. This is a rather tense moment, as the bird is unlikely to wait around for long. The birder quickly flips through the guide, finds the section on raptors (hawks, eagles, owls, and so forth), and quickly scans the pictures and descriptions for clues. More than likely, a novice birder will read a description of a subtle, as-yet-unnoticed set of differences to look for in the banding of the tail, shading under the wing, and color of the feet. The birder will also try not to get discouraged by reading about the different color phases of adults and immatures. If by now the "hawk-like bird" has not flown away or landed behind opaque foliage, the reader once again can become a watcher: finding the bird with naked eye, finding it with field glasses, and looking for some telltale marks. The observational-hermeneutic circle between bird and text, and watching and reading, can go on through several more iterations, until the bird goes out of sight, the birder comes up with an identity, or the birder gives up.

The dexterity with which a bird-watcher negotiates the pages of the text has less to do with physiological coordination than with taxonomic coordination. The quickest route to the appropriate picture is to look up the bird's name in the index, but, in a mundane variant of Meno's paradox, in order to take this route the birder must already know or be able to guess the species name. In different field guides, other less precise indices are based on general silhouettes, bird "families," dominant colors, and types of habitat.

INCOMPLETENESS  Novice bird-watchers frequently see specimens that they cannot find in their field guides. Even after obtaining a good look at a stationary bird, and carefully paging through the relevant sections of the book, the birder may find no description or illustration that describes just that bird. The novice is unlikely to conclude that she has discovered an unknown species, and even less likely to be believed if she reports such a discovery to the local ornithological

society. Instead, the novice typically accepts the text's authority and attributes the trouble to inexperience, problems with perspective, or the atypical appearance of the individual bird.

All field guides are, in fact, incomplete. They are circumscribed by region and locality, and they describe "typical" specimens and not all possible variants. Some guides are more complete than others. Generally bird guides are more complete than guides to flowering plants or insects, but some bird guides cover a broader range and give a more complete listing of rare and vagrant species than others. For novices, it is far easier to use a short incomplete guide than a detailed guide that includes many type specimens that are rarely, if ever, seen in the locality. While a novice may see a bird that apparently (and perhaps actually) is not depicted in an abridged guide, when using a more complete guide she is more likely to encounter the reciprocal difficulty: seeing a bird that seems to be covered by descriptions of several closely related species, only one of which is common in the local area.

These three troubles only begin to specify the difficulties encountered while playing the literary language game. However, we would not want to leave the impression that field identifications are hopelessly beset by intractable troubles. Some birds in the field are "seen at a glance": specimen and species identity are appropriated together. How this is accomplished is complex, dependent on circumstances, and worthy of more attention than we shall give it here, but it is no more or less mysterious than seeing the face of a friend or recognizing a familiar tune. We have focused on instances of trouble because they bring into relief the textual labor of making naturalistic identifications.

## CONCLUSION

As noted earlier, we find birding enjoyable in its own right, but when we began this investigation we had something more general in mind than a sociology of bird-watching. To borrow Kuhn's (1970, 188) formulation, we were interested in how members of an epistemic community "attach" authoritative knowledge "to nature." Kuhn addresses that topic by showing how a "law-schema" (in this case Newton's Second Law of Motion $F=ma$) is transformed in different standard situations (free fall, simple pendulum, harmonic oscillators, and so on). Bird-watching has none of the prestige or mathematical difficulty of physics, and it does not count as a science, but we believe there are certain advantages to using it as a case. Kuhn (1977, 390 ff.) himself employs a "bird-watching" example to elucidate his general argument about how communal exemplars organize naturalistic observations. Bird-watching may not be "scientific," whatever that means, but it is in the ballpark. The network of categories, associations, and activities that constitute bird-watching link up with professional ornithology, although the activity itself is designed to be open to virtually anybody. Bird-watching is not so easy to do, and yet it is widely accessible. Thus its attractions for our purposes: we can investigate a socially organized program for observing natural kinds without having to undergo an extensive tutorial. Of course, a study of observation in bird-watching does not give us or our readers access to observation in physics, but it is a genuine case. It is a case that we can describe with some hope that our readers will be able to take what we say "to the field." The general lessons for studies of other, more restricted and specialized forms of observation may be difficult to state with any certainty, but we are confident that we are not just talking about bird-watching.

Bird-watching is one of a huge array of modern activities in which formal (often written) instructions are applied in practice.[20] The problems and uncertainties associated with applying mathematical formulae, replicating experiments from instructions, and building artifacts from plans are well known in science and technology studies (Bloor 1974; Collins 1985), but "how to" manuals and the problems associated with their use also are available for every imaginable activity from fixing a car to raising children. So, what we have said about field guides in bird-watching may exemplify problems and practices that have a place in the natural sciences, but these problems and practices are likely to be endemic to much broader areas of modern life.

Practical texts can be read and studied in isolation, but many of them are designed specifically to be read in the course of the relevant activity. Certainly, such texts are interpreted, but we believe that the classic hermeneutic circle—the reflexive relationship between a reader's background assumptions and the text's meaning—fails to outline the *field* in which the reading operates. The text is read, and reread, in relation to a real-worldly field of practice; a picture is viewed not as an object of art (although it *can* be viewed that way), but as a visible key in a network of cross-references that reaches out into the field. In our account of such reading, we focused on a particular taxonomic activity we called the "literary language game." Lists, field guides, and field glasses were essential items of equipment. The game's playing field extended well beyond a cognitive relationship between a "perceiver" and an "object." It includes purpose-designed texts, items of equipment, places, and embodied routines for looking, searching, and identifying birds in the field.[21]

Bird-watchers' lists are not just columns of names. They are accountable reports of observations. Their accountability is most obvious when they are compiled as part of organized expeditions and field surveys, but even a solitary bird-watcher's lists are responsive to an established cultural context for looking, seeing, and counting. "Counting" in this sense is not a matter of putting numbers on things. As our example of Linda and the gadwalls illustrated, it is a matter of closing the book (both literally and figuratively) on an observation. For a novice, it can be anxious and difficult work. This is because placing a name on a list (even with a question mark after it) is a commitment that is governed by categorical distinctions and canons of proper description that can be difficult, sometimes impossible, to apply in specific cases. A field guide does not solve the problem of "counting" (the bird-watcher must still decide when to close the book), but the text and its troublesome uses can help clarify what that problem involves. In our view, an apprenticeship to the organized activities of bird-watching involves an elaboration of textually organized knowledge in the course of a practical investigation. Accordingly, a study of bird-watching (or any of the array of naturalistic field studies) should contribute to a growing body of historical, literary, and ethnographic investigations of the relationship between textual order and scientific practice.[22]

So, how do we close the book on our observations of bird-watching? To us it seems only sensible that we should close with an opening to "the field" we have described. This article does not offer a final statement about a remote topic; instead, it invites others to explore an accessible form of naturalistic practice. As noted earlier, we recommend "nature study" not in order to experience "nature" (although that is a fine thing to do) but to gain firsthand familiarity with situated practices of observing and describing. In order to see what we have been saying, we suggest a series of natural philosophical exercises for readers to conduct. They require a field guide and field glasses. Some readers may prefer different forms of nature study (wild orchids, astronomy,

Amazon ants), and variations on our suggested steps. We do not envision these exercises as empirical tests, but as experiential bases for appreciating, extending, and exploring more than we can possibly say *here* in this article.

1. Go into the field alone without field guide or binoculars.
2. Go alone with a field guide, but no binoculars.
3. Go alone with a field guide and binoculars.
4. Go with another novice. Record your conversations.
5. Go with an expert.
6. Go with an organized group.
7. Compare experiences 1 through 6, and reflect upon how each variation on the theme of observation reveals a distinctive configuration of authority and practice.

Having accomplished these exercises, we suggest that you reread and criticize this paper. If you learn anything interesting, please tell us.

NOTES

This is a revised version of an earlier paper: John Law and Michael Lynch, "Lists, field guides, and the descriptive organization of seeing: bird-watching as an exemplary observational activity," originally published in *Human Studies* 11(2/3): 271–304, 1988; reprinted in *Representation in Scientific Practice*, ed. M. Lynch & S. Woolgar (Cambridge, Mass.: MIT Press, 1990), pp. 267–99. We are grateful to Bob Anderson, Jeff Bowker, Michel Callon, and Bruno Latour who read and commented on drafts of the original paper.

1. Bird classification is used frequently as an ordinary example to illustrate philosophical discussions of scientific observation. An oft-cited example is Bulmer's (1967) account of why the cassowary (what we would call a flightless bird) is not classified as a bird by members of a New Guinea tribe (Barnes 1983; Law and Lodge 1984; Barnes, Bloor & Henry 1996, 49 ff.).

2. According to Augustine, the intention was shown by bodily movements, "as it were the natural language of all peoples: the expression of the face, the play of the eyes, the movements of other parts of the body, and the tone of voice which expresses our state of mind in seeking, having, rejecting, or avoiding something" (Augustine, *Confessions* I. 8, quoted in Wittgenstein [1958, 2e, note 1]).

3. We borrow Wittgenstein's (1958, §7) term "language game" to speak of a systematic use of words in recurrent practical situations. Wittgenstein introduces the "game" analogy in order to circumscribe the almost exclusive preoccupation with "reference" in the philosophical tradition. Here we are describing a language game that is overtly referential. Moreover, it is a *literary* language game involving written texts as important constituents of a cultural activity.

4. On rare occasions, birders make discoveries of vagrant birds which are seldom recorded in a particular region. In England, the announcement on a bird-watchers' hotline of the sighting of, for example, a red-flanked bluetail—a vagrant from Siberia—touches off a virtual pilgrimage as thousands of birders flock to the field where the bird was seen to pay witness the lonely vagrant. On *very* rare occasions, in places like the Amazon basin, birders (or, more likely, professional ornithologists) discover species that have never been recorded anywhere. See Stap (1990) for a vivid account of the discovery of a new species of parrotlet in the Amazon basin.

5. See Lynch (1993, 299ff.) for a programmatic outline on this approach to "primitive epistopics"—classic epistemological topics respecified by investigations of situated practices. A more general sociological program is outlined in Garfinkel (1991).

6. This example was mentioned during a slide show by Cornell biologist Thomas Eisner, "Why biologists can't stay silent" (paper presented at Knowledge and its Discontents: Science, Expertise, Modernity, a workshop in the Department of Science & Technology Studies, Cornell University, Ithaca, New York, May 4, 1997).

7. We selected these particular editions for comparison when preparing an earlier version of this paper (Law and Lynch 1990). The Audubon guide has since been revised.

8. Botanical illustrations are a mark of amateur field guides. Professional botanists treat illustrations as a distraction, and they prefer diagnostic manuals that present branching series of morphological distinctions to be made when examining field specimens. (Personal communication, Christine Hine, Sept. 1997.)

9. We should stress that the commitment to ontological realism is performative; we use the terms "picture theory" as a crude way of describing pictures-in-use, and not a coherent system of "thought." In philosophical discourse, talk of "actual specimens" is associated with ontological realism, with its assumption of the prior existence of a world "out there," the stable properties of which are knowable in one way or another, but in the case of bird-watching manuals "ontological realism" is a way of speaking of relations which are *effectuated* by arrangements of the subjects, viewpoints, and other textual organizations. For a discussion of the performative character of fine art representation and its ontological implications see Law and Benschop (1997). This is a semiotic treatment, which addresses the formation of subject and object positions in the representational field.

10. Greg Myers (1990) suggests that nature illustrations range along a continuum from the more abstract (like Peterson's pictures in our comparison) to the more realistic (like the Audubon guide's illustrations).

11. Species identifications are not always so difficult. For example, when walking along a river in the south of England, if you happen to see an electric blue flash as a small bird whirs by, you should know that you have just seen a Kingfisher (*Alcedo atthis*).

12. Following the publication of an earlier version of this paper (Law and Lynch 1990), Walther Thiede, an author of several field guides, wrote to us. Thiede criticized us for suggesting that books that employ photographs are less effective in the field. Thiede was kind enough to send us copies of his books, which use excellent quality photographs placed alongside facing pages that include verbal descriptions and in many cases sketches (see, for example, Thiede 1993). Such field guides incorporate many of the advantages we previously attributed to guides that use drawings. With the advent of digital photography and editing, the differences between drawings and photos are likely to collapse even further.

13. Committed birders are "mundane reasoners" (Pollner 1987), who address their difficulties without fundamentally doubting the reality of an intersubjective world. As Law and Benschop (1997) point out, ontologies can be performed in ways other than the realistic ways we discuss here. Also see Bryson (1983, ch. 5).

14. This is a rather more *literal* use of the phrase "reading the book of nature" than Kosso's (1992). We are not implying that "nature" is inherently readable (observable, intelligible, capable of being known). Instead, we suggest that the "book of nature" is composed for a reading and by a reading, and like other books its textual features can be traced to handiwork other than nature's. As Haraway's (1989) semiotic deconstruction of a natural history diorama elucidates, the exhibit does not simply represent a gorilla family group foraging in its natural habitat. Instead, the naturalistic diorama can be construed as a performative articulation of patriarchy, family values, and boy scout virtues. Realist ascriptions to nature's handiwork hide the exhibit's articulation of cultural practices. When we speak of "natural deconstruction" we are also proposing that a text's articulation can be interfered with for the purpose of revealing what naturalistic realism hides, though in this case the disruption occurs not as the function of an oppositional cultural politics, but as a matter of course when the text is used to aid to the very cultural practice it instructs.

15. We suggest the following law: "The more interesting the bird, the sooner it flies away."

16. Like a pre-Renaissance artist, though in a limited way that respects the integrity of a bird's profile, the field manual artist can render "what it felt like to walk about, experiencing structures, almost tactually, from many different sides, rather than from a single, overall vantage" (Edgerton 1975, 9).

17. The conception of objectivism as a "view from nowhere" is developed in Nagel (1986). See Alpers (1983) and Bryson (1983) for discussions of seventeenth-century Dutch cartographic productions of a view from nowhere in particular.

18. Kastner (1986, 7) supplies a cross-cultural example: "Warblers so puzzled the Cherokees that they left many species without names, apparently because they could not tell one from the other—a touch of nature that makes them kin to modern bird-watchers who, looking the birds up in their field guides, find them lumped together in the category 'confusing' warblers."

19. Audubon's painterly technique furnishes for the text what the taxidermist's craft did for the museum diorama. See Haraway (1989) for an historical-feminist critique of the hunter-gatherer-taxidermist approach to natural history.

20. Instructed action—acting in accord with instructions—is an established topic in ethnomethodology (Garfinkel 1967; Livingston 1986; Suchman 1987; Amerine and Bilmes 1988; Bjelic and Lynch 1992; Jordan and Lynch 1992).

21. "Seeing" is not a single kind of act or process. In this article we alluded to an array of different perceptual activities: looking for, looking at, peering, spotting, inspecting, perusing, seeing as, and seeing-at-a-glance. For a discussion of the varieties of perceptual verbs and their implications for theories of perception, see Coulter and Parsons (1991).

22. See Latour and Woolgar (1986[1979]); Bazerman (1981); Gilbert and Mulkay (1984); Latour (1986); Star and Griesemer (1989); and several of the studies in Fyfe and Law (1988), and Lynch and Woolgar (1990).

REFERENCES

Alpers, Svetlana. 1983. *The Art of Describing: Dutch Art in the Seventeenth Century.* Chicago: University of Chicago Press.

Amerine, Ron, and Jack Bilmes. 1988. Following instructions. *Human Studies* 11: 327–39.

Arlott, Norman, Richard Fitter, and Alastair Fitter. 1981. *Collins Complete Guide to British Wildlife.* London: William Collins & Sons.

Barnes, Barry. 1977. *Interests and the Growth of Knowledge.* London: Routledge & Kegan Paul.

———. 1983. On the conventional character of knowledge and cognition. In *Science Observed,* ed. Karin Knorr-Cetina and Michael Mulkay, pp. 19–51. London: Sage.

Barnes, Barry, David Bloor, and John Henry. 1996. *Scientific Knowledge: A Sociological Analysis.* Chicago: University of Chicago Press.

Bazerman, Charles. 1981. What written knowledge does: Three examples of academic discourse. *Philosophy of the Social Sciences* 11: 361–87.

Bernstein, C. 1984. Details on details: Describing a bird. *Western Tanager* 50(6): 1–3.

Bjelic, Dusan, and Michael Lynch. 1992. The work of a (scientific) demonstration: Respecifying Newton's and Goethe's theories of prismatic color. In *Text in Context: Contributions to Ethnomethodology*, ed. Graham Watson and Robert Seiler, pp. 52–78. London: Sage.

Bloor, David. 1973. Wittgenstein and Mannheim on the sociology of mathematics. *Studies in the History and Philosophy of Science* 4: 173–91.

Bryson, Norman. 1983. *Vision and Painting: The Logic of the Gaze.* London: Macmillan.

Bulmer, R. 1967. Why is the cassowary not a bird? *Man* 2: 5–25.

Collins, H. M. 1985. *Changing Order: Replication and Induction in Scientific Practice.* London and Beverly Hills: Sage.

Coulter, Jeff, and E. D. Parsons. 1991. The praxiology of perception: Visual orientations and practical action. *Inquiry* 33: 251–72.

Edgerton, Samuel Y. 1976. *The Renaissance Rediscovery of Linear Perspective.* New York: Harper & Row.

Farber, Paul. 1982. *The Emergence of Ornithology as a Scientific Discipline: 1760–1850.* Dordrecht, Boston, and London: Reidel.

Fyfe, Gordon, and John Law, eds. 1988. *Picturing Power: Visual Depictions and Social Relations.* London and New York: Routledge.

Garfinkel, Harold. 1967. *Studies in Ethnomethodology.* Englewood Cliffs, N.J.: Prentice Hall.

———. 1991. Respecification: Evidence for locally produced, naturally accountable phenomena of order, logic, reason, meaning, method, etc. in and as of the essential haecceity of immortal ordinary society (I)—an announcement of studies. In *Ethnomethodology and the Human Sciences*, ed. Graham Button, pp. 10–19. Cambridge: Cambridge University Press.

Garrett, K. L. 1986. Field tips: The Bishop test. *Western Tanager* 52(10): 1–3.

Gibson, J. J. 1986. *The Ecological Approach to Visual Perception.* New York: Lawrence Erlbaum.

Gilbert, G. Nigel, and Michael Mulkay. 1984. *Opening Pandora's Box: An Analysis of Scientists' Discourse.* Cambridge: Cambridge University Press.

Goffman, Erving. 1971. *Relations in Public: Microstudies of the Public Order.* New York: Harper and Row.

Gombrich, E. H. 1960. *Art and Illusion: A Study in the Psychology of Pictorial Representation.* Princeton: Princeton University Press.

Haraway, Donna. 1989. Teddy bear patriarchy: taxidermy in the Garden of Eden, New York City, 1908–36. In *Primate Visions: Gender, Race, and Nature in the World of Modern Science,* by Donna Haraway. London: Routledge. Originally published in *Social Text* 11 (1984–5): 20–64.

Hölldobler, Bert, and Edward O. Wilson. 1990. *The Ants.* Cambridge, Mass.: Harvard University Press.

Hosking, Eric (with K. MacDonnell). 1979. *Eric Hosking's Birds: Fifty Years of Photographing Wildlife.* London: Pelham Books.

Jonsson, Lars. 1992. *Birds of Europe, with North Africa and the Middle East.* Trans. David Cristie. Princeton: Princeton University Press.

Jordan, Kathleen, and Michael Lynch. 1992. The sociology of a genetic engineering technique: Ritual and rationality in the performance of the plasmid prep. In *The Right Tools For the Job: At Work in Twentieth-Century Life Science,* ed. Adele Clarke and Joan Fujimura, pp. 77–114. Princeton: Princeton University Press.

Kastner, Joseph. 1986. *A World of Watchers.* New York: Knopf.

Kaufman, Ken. 1990. *Advanced Birding.* New York: Houghton Mifflin.

Kosso, Peter. 1992. *Reading the Book of Nature: An Introduction to the Philosophy of Science.* Cambridge: Cambridge University Press.

Kuhn, Thomas. 1977. Second thoughts about paradigms. In *The Structure of Scientific Theories,* ed. F. Suppe. Urbana: University of Illinois Press.

———. 1970. *The Structure of Scientific Revolutions.* Rev. ed. Chicago: University of Chicago Press.

Latour, Bruno. 1986. Visualisation and cognition: Thinking with eyes and hands. *Knowledge and Society: Studies in the Sociology of Culture Past and Present* 6: 1–40.

Latour, Bruno, and Steve Woolgar. 1986. *Laboratory Life: The Construction of Facts.* Princeton: Princeton University Press [London: Sage, 1979].

Law, John, and Ruth Benschop. 1997. Resisting pictures: Representation, distribution and ontological politics. In *Ideas of Difference: Social Spaces and the Labour of Division,* ed. Kevin Hetherington and Rolland Munro. Sociological Review Monograph. Oxford: Blackwell, 1997.

Law, John, and Peter Lodge. 1984. *Science for Social Scientists.* London: Macmillan.

Law, John, and Michael Lynch. 1990. Lists, field guides, and the descriptive organization of seeing: birdwatching as an exemplary observational activity. In Lynch and Woolgar. 267–299; originally published in *Human Studies* 11(2/3) (1988): 271–304.

Livingston, Eric. 1986. *The Ethnomethodological Foundations of Mathematics.* London: Routledge and Kegan Paul.

Lynch, Michael. 1993. *Scientific Practice and Ordinary Action: Ethnomethodology and Social Studies of Science.* New York: Cambridge University Press.

Lynch, Michael, and Steve Woolgar, eds. 1990. *Representation in Scientific Practice.* Cambridge, Mass.: MIT Press.

McQueen, Cyrus B. 1990. *Field Guide to the Peat Mosses of Boreal North America.* Hanover, NH: New England University Press.

Monk, Ray. 1991. *Ludwig Wittgenstein: The Duty of Genius.* London: Vintage.

Myers, Greg. 1990. Every picture tells a story: Illustrations in E. O. Wilson's Sociobiology. In *Representation in Scientific Practice,* ed. Lynch and Woolgar, 235–69.

Nagel, Thomas. 1986. *The View from Nowhere.* New York: Oxford University Press.

National Geographic Society. 1983. *A Field Guide to the Birds of North America.* Washington, D.C.: National Geographic Society.

Peterson, Roger Tory. 1961 [1941]. *A Field Guide to Western Birds.* Boston: Houghton Mifflin.

———. 1980 [1934, 1939, 1947]. *A Field Guide to the Birds of the Eastern and Central North America.* Boston: Houghton Mifflin.

Pollner, Melvin. 1987. *Mundane Reason: Reality in Everyday and Sociological Discourse.* Cambridge: Cambridge University Press.

Stap, Don. 1990. *A Parrot Without a Name: The Search for the Last Unknown Birds on Earth.* New York: Knopf.

Star, Susan Leigh, and James Griesemer. 1989. Institutional ecology, "translations" and boundary objects: Amateurs and professionals in Berkeley's Museum of Vertebrate Zoology, 1907–39. *Social Studies of Science* 19: 387–420 (reprinted in this volume).

Suchman, Lucy. 1987. *Plans and Situated Actions.* Cambridge: Cambridge University Press.

Thiede, Walther. 1993. *Vögel: Die heimischen Arten Erkennen und Bestimmen.* Munich: BLV Naturführer.

Udvardy, Miklos D. F. 1977. *The Audubon Society Field Guide to the North American Birds, Western Region.* New York: Knopf.

Wittgenstein, Ludwig. 1958. *Philosophical Investigations.* Trans. G. E. M. Anscombe. Oxford: Basil Blackwell.

———. 1961. *Tractatus Logico-Philosophicus.* Transl. D. F. Pears and B. F. McGuinness. London: Routledge & Kegan Paul.

# 23

# Nuclear Missile Testing and the Social Construction of Accuracy

## DONALD MACKENZIE

It is time to make explicit an issue that pervades the history of a technology like nuclear missile guidance. How deep does "politics" go? Whether or not to build nuclear missiles is an obviously political decision. How accurate to try to make them is, likewise, a matter of overtly political negotiation, because of the connections between missile accuracy, nuclear strategy, and competition between the armed services. But once a missile is built, are its technical characteristics not beyond politics? If we dig deep enough, even into a politically controversial technology, can we not find a solid foundation of technical fact, matters that cannot rationally be disputed? Is there not, ultimately, a sphere of the technical genuinely insulated from politics and the clash of organizational interests?

I shall look for an answer to these questions in three stages. First, I will examine the most crucial fact of all about nuclear missiles. Do we know that they would work, not in any fancy sense of "work," but in the sense of whether their warheads would explode? Nowadays, there is concern over the more restricted issue of missile reliability, but the most radical form of doubt—that maybe *no* missile would work—seems to have vanished. In the United States of the early 1960s, however, thoroughgoing doubt about whether missiles would work could be found at the heart of the military establishment.

Examining whether we know missiles will work raises this chapter's central theme: the *testing* of technologies. For here, surely, is to be found the solid factual bedrock underlying technological politics. Testing, however, turns out not to be a simple matter. This is particularly the case in the issue that will form the second stage of my discussion: our knowledge of accuracy. The accuracy of a missile appears to be an unproblematic fact: how far from its target it lands. But just how is the accuracy of a missile known? The obvious test is to fire it at a target and see. But this, we shall find, is not taken by insiders as on its own revealing the accuracy of a missile, and, in the early 1980s, public controversy erupted in the United States as to whether nuclear missile accuracies were facts at all.

Nuclear missiles are an unusual technology. There are strong legal and political constraints on how they can be tested, and, thankfully, no record of operational use. Therefore, in the third stage of my discussion I will look "inside the black box" of guidance, to examine the inertial sensors themselves: gyroscopes (which sense rotation) and accelerometers (which measure acceleration). Here, there are no legal or political contraints on testing and no barrier to use. Yet we shall see that even here testing is a complex matter, and the facts it generates are facts only within a wider web of assumptions and procedures.

## WILL NUCLEAR MISSILES WORK?

The single best statement of why it might be wrong to be certain that nuclear ballistic missiles will work came in 1961, from the Armed Services Committee of the United States House of Representatives:

Who knows whether an intercontinental ballistic missile [ICBM] with a nuclear warhead will actually work? Each of the constituent elements has been tested, it is true. Each of them, however, has not been tested under circumstances which would be attendant upon the firing of such a missile in anger. . . . [A]n intercontinental ballistic missile will carry its nuclear warhead to great heights, subjecting it to intense cold. It will then arch down and upon re-entering the earth's atmosphere subject the nuclear warhead to intense heat. Who knows what will happen to the many delicate mechanisms involved in the nuclear warhead as it is subjected to these two extremes of temperature?[1]

By 1961 the United States had conducted many flight tests of ballistic missiles; it had also tested many nuclear warheads. But the missile tests had used missiles either with no warheads or with warheads from which the fissile materials had been removed, while the bombs in ordinary nuclear weapons testing had either been detonated in fixed positions or dropped from towers or aircraft. The challenge mounted by the Armed Services Committee was therefore this: testing the components of a nuclear missile system separately was not adequate to rule out the possibility that some feature of the way they were combined would prevent the missile from working.

The challenge was not treated as absurd. Doubts were strongest at senior levels of the United States armed services. The Joint Chiefs of Staff pressed for missile tests to be conducted with warheads on board, and sought presidential permission to fire an Atlas ICBM with a live warhead from Vandenberg Air Force Base in California. The trajectory would take the missile "near some populated areas," but, though it was argued that "the need to proof-fire the warhead outweighs the risk of the Atlas exploding during launch or in flight and damaging surrounding communities," the Kennedy administration was reluctant to authorize such a test.[2]

A politically more palatable alternative was found, one where the risks were seen as less and were to Pacific islanders or members of the armed services, not American civilians. On May 6, 1962, the United States nuclear submarine *Ethan Allen* fired a live Polaris missile on a 1,200-mile trajectory toward the nuclear testing ground at Christmas Island. Operation Frigate Bird, as it was called, was a success. The shot "hit right in the pickle barrel,"[3] and the warhead exploded with a force estimated at half a megaton.

This looks like as clear-cut a case as one could get: an argument put forward, subjected to a test, and decisively refuted. But there were several ways skeptics could undermine Operation

Frigate Bird. One was to suggest that success in a single test could be a fluke. (Hindsight suggests that this may actually have been the case. The W47 Polaris warhead had been modified following an earlier test that suggested it was prone to inadvertent detonation, and it gradually was realized that the safety mechanism tended to corrode and jam. It was later estimated that between half and three-quarters of W47 warheads would have failed to detonate.) A second way of criticizing the test was to point out that it involved a relatively short-range, submarine-launched missile, not the longer, higher trajectory of an ICBM. A third was to point to the modifications to the missile needed to minimize the risk of Operation Frigate Bird. "There are some unknowns and uncertainties you should know about," Air Force Chief of Staff Curtis LeMay told the Defense Appropriations Subcommittee of the House of Representatives in 1964. "One is that we have only had one test, it was not under fully operational conditions, we fired one Polaris out in the Pacific with a warhead on it. It was not truly operational. It was modified to some extent for the test."[4]

Whether nuclear missiles were known to work became an issue in the 1964 presidential campaign. The Democratic administrations of John F. Kennedy and Lyndon B. Johnson had greatly expanded American nuclear missile forces. But, argued Johnson's 1964 Republican challenger, Barry Goldwater, what was the use of this if we did not know what would happen if a president had to push the nuclear button? Implicitly drawing the distinction between Frigate Bird's Polaris and an ICBM, Goldwater said:

I have raised, and will continue to raise until all the facts are in, fundamental questions about the reliability of our intercontinental ballistic missiles. It is not a question of theoretical accuracy. The fact is that not one of our advanced ICBMs has ever been subjected to a full test (of all component systems, including warheads) under simulated battle conditions.[5]

By 1964 a live ICBM test was impossible. In the face of substantial domestic opposition, the Democratic administration had in 1963 committed the United States to the Partial Test-Ban Treaty, prohibiting nuclear tests in the atmosphere, underwater, or in outer space. Said Goldwater:

This Administration's decision to enter into a test ban treaty precluding all atmospheric nuclear explosions means that we cannot properly test even our present missile systems. . . . [We] are building a Maginot line of missiles.

LeMay and Goldwater had an alternative to propose to reliance on missiles: the manned bomber. By the early 1960s it was far from certain whether there would be any new United States strategic bomber to succeed the 1950s' B-52. What air force leaders such as LeMay saw as the bloodless theoreticians of the Kennedy administration had concluded that ballistic missiles were superior to bombers, and were not inclined to authorize the large expenditure needed to deploy a supersonic bomber to replace the subsonic B-52. Doubt that missiles would work was thus an argument for a new bomber. The statement by the House Armed Services Committee was in justification of voting $337 million to continue manned bomber production the Kennedy administration wished to close down. LeMay was the leader of the fight to protect the future of the manned bomber. Even Goldwater was not simply seeking a way to criticize Democratic defense policy. As well as senator for Arizona, he was an air force reserve major general, who had "long identified himself with the bomber faction."[6]

The constituency of the challenge was clear: it was what we might call the "Bomber Lobby." Since the mid-1960s, however, doubts about missiles working have almost disappeared, at least

in their strong form such as the suggestion that maybe *no* ICBM will work. Senator Goldwater still continued on occasion to point out that "we have never fired a missile with a warhead."[7] By the 1980s, however, the challenge had no force behind it.

I can only speculate why. It can hardly be put down to new evidence. There have been no further American experiments like Operation Frigate Bird (China succesfully conducted two live missile tests in 1966 and 1976; the Soviet Union had also done so, but prior to 1963), so in that sense matters remain as they were in 1964. The challenge's constituency, the Bomber Lobby, did not go away. It did, finally, achieve its goals in the 1980s and 1990s with the deployment of the B-1 and B-2 bombers. Though that success might be seen as having removed the need to dispute the missile's claims, the challenge had declined well before then.

An immediate cause of the issue's decline from public view may have been the way the nuclear issue turned into electoral disaster for Goldwater, branded irresponsibly bomb-happy, in the 1964 campaign. The ban on nuclear testing in the atmosphere proved extremely popular with the public in the United States and elsewhere, ending years of fears about the consequences of fallout from atmospheric tests. It would have been extraordinarily dangerous politically for a United States administration since then to have abrogated the test ban.

One paradoxical reason for the decline of the challenge's plausibility may be precisely this: the impossibility of testing its truth by firing a missile with a live warhead. The plausibility of a scientific hypothesis can be raised simply by the existence of moves to test it. Perhaps the reverse is true too. Perhaps, too, the transformation of the issue, already beginning to be evident in 1964, into the esoteric (and classified) calculus of missile reliability blunted the challenge—it was on this terrain that the Democratic administration, especially Secretary of Defense Robert McNamara, chose to reply to LeMay and Goldwater.

## CONSTRUCTING ACCURACY—
## AND CHALLENGING IT

The issue raised by this first, vanished, challenge was whether the separate testing of missiles and their warheads was sufficient to prove that the latter would work in use when the two would be combined. Whether testing was sufficiently like use to allow inferences to flow was also the central issue in the more recent controversy over whether missile accuracies were facts about missiles or artifacts of the processes of testing them.

The dispute focused on ICBMs. American ICBMs are flight tested from Vandenberg Air Force Base on the coast of California. The target is nearly always a point in the large enclosed lagoon, some ten miles wide and sixty miles long, at Kwajalein Atoll in the Marshall Islands. To test an already-deployed ICBM, a missile is selected at random from the operational force. If it can successfully be brought to "alert" status in its own silo, its reentry vehicles are removed, the live nuclear warheads are taken out and replaced by telemetry equipment. The missile is transported to Vandenberg, the reentry vehicles are replaced, a mechanism for exploding the missile if it goes off course is added, and the guidance system is aligned and calibrated. The missile is brought to alert and fired from a test silo at Vandenberg, with its reentry vehicles targeted at points in the Kwajalein lagoon. Ground-based radars, telescopes, and instruments within the reentry vehicles track the test, and a "splash-net" of hydrophones is used to deduce where the reentry vehicles hit the surface of the lagoon.[8]

Statistical analysis of the offsets between the intended target points and these inferred impact points provides a circular error probable (CEP), officially defined as the radius of the circle round the target within which 50 percent of warheads will fall in repeated firing. Since flight testing will involve trajectories with different geometries and (to some extent) different ranges, in fact a set of circular error probable figures will be produced. Furthermore, since the number of tests is finite, figures for the circular error probable will have a statistical uncertainty—they will have a "confidence interval" associated with them.

What the air force needs to know, of course, is not the accuracy of an ICBM when fired at Kwajalein, but its accuracy when fired at a particular target in a hostile country (traditionally the Soviet Union). Since that cannot be discovered directly, it has to be extrapolated from the results on the test range. This is no straightforward empirical matter, because errors with different causes are understood to extrapolate differently. Some, for example, will vary more or less linearly with range to the target. Others will not. So what is needed is knowledge not just of overall error but of its causes.

The mathematical model embodying such knowledge is known as the missile's *error budget*, so called because in it different proportions of overall error are apportioned to different causes. The precise process of its construction has not been described in open literature, but it is clear that the data used include not only the results of test firings but also of information from laboratory, rocket-sled and ultracentrifuge tests of components (see below), estimates of the errors in mapping and in models of the gravitational field, and so on. A mathematical model of error processes is also used in the actual process of guidance, since with modern missiles (especially American) the onboard computer seeks to correct for predictable errors. In consequence, much more is expected from the test range than just a final total miss distance. Hence the importance of test-range instrumentation. In developing and seeking to verify the theoretical model, it is necessary to have independent data (such as from ground-based sensors) on the position and velocity of the missile at all times. These can then be compared with what the guidance system reports, through radio signals, it "believes" the condition of the missile to be.

Whether the results of this process are facts—reliable measures of missile accuracy—became a matter of public controversy in the 1980s. A variety of critics publicly cast missile accuracy figures into doubt, and their skepticism received widespread press coverage. In particular, they questioned whether the proud accuracy specifications of American ICBMs, especially the new MX missile, had any real validity outside the Vandenberg-Kwajalein test range.

The critics' grounds for skepticism can, somewhat arbitrarily, be divided into two. The first set of grounds are the inverse of a common form of skepticism in science, where a frequent reaction to experiments with heterodox results is the suggestion that the experiments have been incompetently performed. In the dispute about missile accuracy, skeptics argued that the "experiments" involved—the test-range firings—were performed, not incompetently, but *too* competently. In the hundreds of flights of different missiles over a given test range, and even in the dozens of firings of a particular missile, learning is possible which is not possible for "once-off" wartime firings. It was, for example, suggested that a missile about to be tested would receive special attention not received by the bulk of operational missiles. One retired general went as far as to claim that "about the only thing that's the same [between the tested missile and the Minuteman ICBM in the silo] is the tail number; and that's been polished."[9]

The second set of grounds concerns what, again drawing an analogy from studies of science, we might call the *auxiliary assumptions* involved in the extrapolation from test-range to opera-

tional accuracy.[10] A range of physical phenomena were cited as possible sources of unpredicted effects on operational accuracies. Most often raised was an auxiliary assumption concerning gravity: extrapolating from test-range to operational trajectories involves the assumption that our knowledge of Earth's gravitation field over those latter trajectories (e.g., in Arctic regions) is not seriously at fault.

Skeptical arguments of both kinds found common expression in an attempt to redefine missile accuracy. As noted above, the standard measure of accuracy has been the circular error probable, understood as the radius of the circle round the target within which 50 percent of warheads will fall in repeated firing. The critics argued instead that missile accuracy has two components. The circular error probable, according to them, defines a circle round the mean point of impact. But that mean point of impact will also be offset from the target. So systematic "bias" would be present as well as random error, as illustrated in Figure 23-1. Two critics, Andrew and Alexander Cockburn, explained the issue to the readers of *The New York Review of Books* in 1980:

The propositions and conclusions that follow . . . deal with a problem that has led a semi-secret existence for a decade. The shorthand phrase often used to describe this problem is "the bias factor." Bias is a term used to describe the distance between the center of a "scatter" of missiles and the center of the intended target. This distance, the most important component in the computation of missile accuracy, accounts for the fact that the predictions of missile accuracy . . . are impossible to achieve with any certainty, hence the premises behind . . . the MX . . . are expensively and dangerously misleading.

Bias became emblematic because it captured both the "too competent" and the "auxiliary assumptions" critiques. The critics argued that, in repeated test-range firing, bias was artificially set to zero by ad hoc adjustments of guidance systems and software, leaving only random dispersion:

What is probably happening in the case of both countries [US and USSR] is that repeated tests over the same range have internalized a very substantial bias which remains unknown to the owner of the missiles.[11]

For the novel trajectories of wartime, there were no previous firings upon which to base these adjustments. Hence, argued the critics, bias would reappear operationally, and errors in the assumptions on which wartime trajectory calculations were based—"uncorrected gravitational field anomalies, errors in the model of the terminal atmosphere, magnetic drift due to unknown

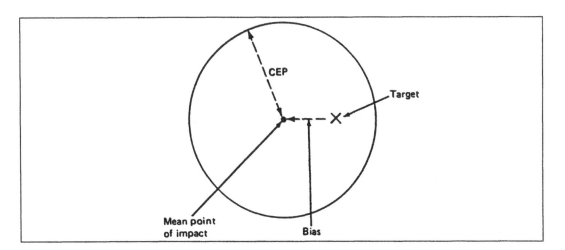

FIGURE 23-1
*"Bias" and the Critics' Definition of Circular Error Probable (CEP)*

electronic charge on the re-entry vehicle—and anything else that has not been thought about"[12]—would also appear in the form of bias.

Defenders of the factual status of missile accuracies denied that what went on was ad hoc test-range tweaking of guidance systems so as to cancel out any systematic tendency to over-shoot, undershoot, or fall to the left of right of the target. They accepted the possibility of bias but claimed that biases were known, understood, small, and—most importantly—included in their definition of the circular error probable. So the latter "really does measure how close its warheads would come to its intended target."[13] Bias-reducing adjustments were never made without the causes of the bias (and thus the form it would take in wartime firings) being understood. In the words of MIT Professor Charles Stark Draper, guru of inertial guidance:

We have at times noted biases in impact patterns for some missiles. In each case we have analyzed the problem to the degree that, where necessary, design or calibration corrections were made commensurate with the performance required. No magic was involved, because the nature of the problem was understood and applicable universally.[14]

The auxiliary assumptions involved in moving from test-range to operational firings were secure, argued the defenders of missile accuracy. The gravity field over the North Pole, at least at the heights of ICBM trajectories, was well known from observation of satellite orbits; the effects of unpredicted winds and other climatic variations was negligible with modern, fast reentry vehicles; the buildup of electrical charge on a reentry vehicle would have to be implausibly large for a significant effect to be exerted by Earth's magnetic field; and other potential effects would be vanishingly small in their consequences.

In sum, wrote General Robert T. Marsh, commander of the Air Force Systems Command:

[T]his pseudo-technical world [of the critics] says one cannot predict ballistic trajectory accuracy a priori, i.e., prior to actually firing some missiles on the expected trajectory. Such reasoning defies all the demonstrated rigor of physical laws from Newton to Einstein. It is akin to saying a gun may not be fired on a new azimuth without a prior shot in that direction. We certainly cannot allow such logic to affect important strategic decisions.[15]

Or as Charles Stark Draper concluded, "There is indeed grave risk in using ballistic missiles, but that risk is not uncertainty of accuracy."

## THE USES OF UNCERTAINTY

One particular issue of the late 1970s and early 1980s lay in the background—and often the fore-ground—of the dispute: the new MX ICBM. A key argument for the latter was that the existing United States Minuteman ICBMs were vulnerable to Soviet missile attack. The critics of accuracy argued that the Soviets were no better placed than the Americans to know how accurate their missiles would be in use. Since wartime accuracies were likely to be much worse than test-range accuracies, there was no real threat to the Minuteman. The complex, expensive, mobile deployment systems being designed for MX were not needed. Furthermore, since MX's vaunted extreme accuracy was a test-range artifact, the missile itself was an unnecessary addition to the United States arsenal.

Most of the public criticism of accuracy was associated with a "dovish" position on defense issues. Perhaps the most prominent critic was J. Edward Anderson, professor of mechanical

engineering at the University of Minnesota, who made clear his overall position in the first pub-
lic attack, in 1970, on the facticity of accuracy:

I agree fully that it is of the utmost urgency that the arms race be stopped and have made my own contri-
bution by leaving the field of missile-guidance engineering for engineering work in non-military fields.[16]

It was the "liberal," anti-MX, interpretation of uncertainty that was most prominent in press re-
portage of the controversy that stretched from *The New York Times* to the Elk River *Star News*.[17]

There were other groups of critics, however, for whom uncertainty of accuracy had quite dif-
ferent implications. It was drawn on in a revival of the Bomber Lobby's campaign against overre-
liance on the ballistic missile led by Arthur Metcalf, a Second World War army air forces
lieutenant colonel, professor of physics at Boston University, and wealthy president of the Elec-
tronics Corporation of America. The implication Metcalf drew, and the audience for whom he
was drawing it, were clear:

To the extent that the Air Force argues in the name of "invulnerability" to commit a large portion of its
budget to MX missiles buried in holes in the ground in a basing mode, the wisdom of which is seriously
questioned, and fails to signal loudly and clearly its requirement for a manned offensive bomber at the
forefront of aeronautical technology, to that measure does it confuse the public understanding of what air-
power is all about and undermine the very rationale for an independent Air Force at all! The great air lead-
ers of the past warned against what could well be a blind jeopardizing of the hard-won achievement of a
separate service for the projection of airpower. And there are with us great air leaders who still warn against
throwing away the experience gained at the cost of much blood and treasure to hazard the national safety
on untried "shell-game" [MX mobile basing] schemes, tied to the ground, which put no enemy military
force at risk.[18]

Metcalf was *not* an opponent of MX, though this kind of language sometimes made it seem as if
he was. Rather, he argued that the new missile should simply be deployed in existing missile
silos, which were at no real risk, and the money thus saved spent on strategic bombers which,
unlike MX, provided real accuracy and counterforce capability.

Metcalf had strong links to leading air force circles, with retired generals being frequent guests
on Metcalf's yacht, *Veritas*. One such link was to General Bruce Holloway, former commander of
the Strategic Air Command. Though involved in the formation of the operational requirement
for MX, Holloway saw force in Metcalf's argument, and arranged for Professor Anderson to brief
the secretary of the air force on the criticism. Senator Goldwater, too, returned to the fray, telling
a 1985 interviewer that he had "never been convinced of the accuracy" of either American or
Soviet ICBMs: "I have seen nothing except computer language that will testify to the accuracy."[19]

Another thread to the challenge to accuracy scarcely surfaced in public but predates consid-
erably the open controversy of the early 1980s. It was centered at the Rand Corporation and
expressed in particular by a Rand analyst, Hyman Shulman. Bias was the issue that most exer-
cised Shulman, who had much experience of analyzing data from Minuteman test firings,
though he was also concerned at the small sample sizes on which many conclusions about accu-
racy were drawn. His solution to bias was radical. It could be reduced greatly by correcting a self-
contained inertial system with radio guidance. "Not part of the inertial guidance mafia,"[20]
Shulman had since the late 1950s advocated continued use of radio guidance for strategic mis-
siles. Jamming he felt to be little real risk, because of the enormous size of jammer needed, and
vulnerability could be removed by building vast redundancy into a network of ground-based
transmitters.

Shulman met with little success in his argument in favor of radio guidance. However, his critique of the accuracy achievable with an all-inertial system found an influential convert in the Rand Corporation's director of strategic studies, James Schlesinger. After Schlesinger became secretary of defense in 1973, he expressed these doubts publicly:

I believe there is some misunderstanding about the degree of reliability and accuracy of missiles. . . . As you know, we have acquired from the western test range [Vandenberg-Kwajalein] a fairly precise accuracy, but in the real world we would have to fly from operational bases to targets in the Soviet Union. The parameters of the flight from the western test range are not really very helpful in determining those accuracies to the Soviet Union. We can never know what degrees of accuracy would be achieved in the real world.[21]

Schlesinger, however, did not embrace Shulman's conclusion that radio guidance was necessary. Instead, he saw uncertainty of accuracy as an argument for bigger nuclear warheads. It meant that the United States's move in the 1960s to less destructive, lower-yield nuclear warheads was mistaken. The formal calculus of counterforce strikes supported this move, because it suggested that accuracy was more crucial to success than yield was. But, reasoned Schlesinger, that very fact implied that operational degradations in accuracy were that much more serious, and he advocated returning to larger-yield warheads to compensate for it.

## THE CONTROVERSY PASSES

For all its heat, this controversy, like the first, passed quickly. The verb is appropriate, since neither side can be said to have won it. At most, the defenders' strategy of seeking to place critics in a position where they "had either to quit or start a new controversy about a still older and more generally accepted fact"[22] caused some of the claims initially made about gravitational uncertainties and especially magnetic effects to be backed away from. It was not that it was impossible in principle to dispute well-entrenched parts of the network of knowledge, like deductions from gravitational and electromagnetic theory. The controversy over the claimed detection of high-flux gravitational radiation, and reports of gravity field anomalies hard to account for by standard theory, show it *could* be done.[23] The critics were however in no position credibly to do so. That did not undermine the entirety of their position, and in interviews with me conducted between 1984 and 1987 both sides were still asserting strongly the correctness of their point of view. But by then not nearly as many people were listening.

Media attention span is doubtless part of the explanation: readers of *The New York Review of Books* could hardly be expected to digest more than one article on gravitational anomalies and the correct statistical definition of missile accuracy. Also important was the Reagan administration's 1983 decision to base MX in Minuteman silos. Suddenly, silo vulnerability switched from being an argument for MX to being an argument against it. The liberal audience for the argument that because of uncertainty of accuracy silos were not really vulnerable (a dominant theme at the peak of the controversy in 1980–81) vanished. From 1983 it was the air force, not the critics of MX, which had to argue that silos were safe. Air force missile proponents did not, however, become in turn an audience for the belief that the missile's accuracy was unknowable. Instead, "auxiliary assumptions" about the geology of the rocks under Warren Air Force Base, where MX was being deployed, were reassessed, and the conclusion reached that silos there were much less vulnerable than had at first been calculated.

# UNCERTAINTY AND THE
# PRODUCTION OF KNOWLEDGE

The controversy passed, but the production of knowledge of accuracy goes on. Most of those who took part in the controversy were at at least one remove from this work. Those I interviewed who were directly involved in the production of accuracy figures seemed to have a point of view subtly different from that of either side of the controversy. They were not critics: none, for example, believed that accuracy was in principle unknowable. Neither, however, were they prepared straightforwardly to defend accuracy figures as facts.

Key to their view was the human vagaries involved in the production of accuracy. An instance is former Air Force Major General John Hepfer, regarded by many as the "father" of MX. Hepfer dismisses the critics' "technical" arguments. Thus any claims about uncertainty in the gravitational or magnetic fields are "weak because technically there's no phenomena in . . . the Earth's gravity or anything else that should have a big effect on it [accuracy firing North as distinct from West] . . . [W]e usually shoot him [J. Edward Anderson] down with his technical arguments." "But," General Hepfer continues, "I wouldn't argue too much that it [operational accuracy] might not be quite as good as the theoretical capability." The reason he gives is "human error." A striking example he quotes concerns the alignment of the Minuteman guidance system, a process crucial to its accuracy: "aligning a Minuteman missile to accomplish its intended mission is like threading a needle 400 feet away." The mirrors used to do this had to be adjusted manually with extreme precision. "They had a tube that went down into the silo, and then they had a mirror, and they would have guys go out in sub-zero weather, minus 30 degrees . . . sighting on the stars and transferring . . . an azimuth alignment . . . You're talking of arc seconds to align to . . . I had some of the young fellows work for me and they would say, 'well, we got kind of cold, and your only desire was to get out of the cold, you didn't really care if was 10 arc seconds or 30 arc seconds,' and that really would negate the accuracy of the system."[24]

Vandenberg, on the California coast, rarely becomes very cold, so climate-induced differences in human behavior could lead to operational performance not being as good as that on the test range. This is a past issue: with Minuteman III, alignment became sufficiently automated that optical alignment crews are no longer needed. But Hepfer was also well acquainted with the possibility for human error in matters such as entering the figures from surveys of both United States silos and Soviet targets:

[T]here is some degradation due to human error in surveying all our sites, all the Soviet sites, and putting all that data into the system. We found numerous times, that no matter how careful we are, somebody will make a mistake. And of course we'd catch it on our range [Vandenberg-Kwajalein] when something goes wrong, but not when you have a thousand missiles out there. . . .

According to Hepfer, human concerns also entered into what was done with the figures for accuracy once they had been produced. As noted above, because of the finite (and, recently, quite small) number of missile test flights, a confidence interval, rather than a single circular error probable, is produced. There is flexibility in how to move from that interval to a single number:

We [the Air Force Ballistic Missile Office] used to tell them [the Strategic Air Command and Air Force Headquarters] that you can use a better number [i.e., lower circular error probable] than you are using and they wouldn't change it. But that trend has changed over in the past ten years. They'll use the best

number you can give them now . . . [T]hey were very conservative and now they're probably going the other way, the reason being political. They want to get the best accuracy they can possibly get to make sure they stay better than submarines. There are many political forces that say, "You know, a submarine's invulnerable under the water." The Air Force response is, "Yes, but it's not very accurate, because it's on a moving base. . . . We have to kill hard targets and the Navy can't do that" . . . so [the Strategic Air Command and Air Force Headquarters] go from the pessimistic to the very optimistic side of the equation now to show they're still more accurate.

Apart from these different forms of "human factor," the other main issue that concerns these insiders is the mathematical models of error processes, the "error budgets." As explained above, an error budget is necessary to construct an operational accuracy. Errors of different types—guidance and control, gravity and geodesy, reentry dispersion and the like, and the suberrors within these, especially the first of them—are extrapolated differently as one moves to different trajectories, ranges, and reentry angles. To separate out different error sources is a difficult procedure, necessitating very good tracking of test firings to be compared with the telemetry from the missile's guidance system. In 1976 John B. Walsh, deputy director of defense research and engineering, described some of the vagaries of the history of the Minuteman ICBM error model:

In 1971 the gravity and geodesy term decreased significantly and the accuracy was reduced. Notice at the same time our understanding of the guidance and control got better, which showed we had a greater guidance and control error—that in 1970 we were just wrong. . . . In 1973 we took out some of the mistakes we had made in 1970 and the guidance and control error went down, and the total error went down.

But now look: as these other large terms go down we began to wonder how to account for the errors we were observing, and concluded the reentry dispersion was probably greater than we previously thought.

In 1973 the reentry error was carried as a larger number. . . . Meanwhile the gravity and geodesy term goes down, which is supported by all the research the whole world is doing in the field of gravity. . . . But right now we carry no improvement in the reentry dispersion because it is unknown. Maybe we will understand it better later.[25]

## THE CERTAINTY TROUGH

There seems, therefore, to be uncertainty of two somewhat different kinds about the facticity of missile accuracies. To stereotype, the first is the uncertainty of the alienated and those committed to an alternative weapon system: the manned bomber. The second, perhaps more surprising, form of uncertainty is that of those closest to the heart of the production of knowledge of accuracy. Rejecting the public critics' arguments, the latter group nevertheless finds, in its intimacy with this process of production, reasons for doubt of a more private and more limited, but nevertheless real, kind. We have here, I would suggest, an analogue for technology of what has been found in the sociology of science:

[C]ertainty about natural phenomena . . . tends to vary *inversely* with proximity to the scientific work . . . [P]roximity to experimental work . . . makes visible the skilful, unexplicable and therefore potentially fallible aspects of experimentation, it lends salience to the web of assumptions that underlie what counts as an experimental outcome . . . [D]istance from the cutting edge of science is the source of what certainty we have.[26]

Between those very close to the knowledge-producing technical heart of programs, and those alienated from them or committed to opposing programs, lie the program loyalists and those

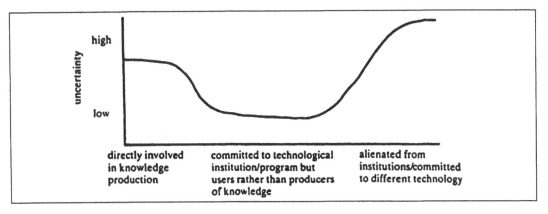

FIGURE 23-2
*The "Certainty Trough"*

who simply "believe what the brochures tell them."[27] These lie in what one might call the "certainty trough" of Figure 23-2.

## ARE THERE FACTS INSIDE
## THE BLACK BOX?

How much of what we have found so far is due to the particularities of the nuclear ballistic missile, the political, legal, and economic constraints on testing, and the absence of a record of use? To approach an answer to this question, let us look inside the black box of guidance and consider the status of knowledge of the technical characteristics of the components to be found there. Here, there are no political or legal restrictions on testing, and though test equipment is (as we shall see) expensive, gyroscopes and accelerometers can be tested many times, or for years on end, without being destroyed, and thousands of each can be tested. They can also be used as well as tested. Participants seemed to treat a missile test flight as equivalent to use from the point of view of guidance *components,* and these components can also be used, if desired, in aircraft rather than missiles. So do all the vagaries of fact-construction we have found for entire missiles disappear for the small components inside their guidance black boxes?

Certainly, testing was regarded by all those concerned with inertial sensor development as an utterly central matter. The development of these sensors had gone hand in hand with the means of determining their characteristics. Without these means, the gyroscopes and accelerometers would themselves have become opaque to those seeking to improve them. Skepticism in the armed services about test results from the manufacturers of inertial sensors had also led to the creation of specialized facilities for inertial component and system testing, to check how sensors and systems got on "away from mother."[28] Most important of these is the Central Inertial Guidance Test Facility, established in 1959 at Holloman Air Force Base, New Mexico.

The existence of these facilities means simple "rigging" of tests by manufacturers would be detected, and this has not been an issue since their establishment. But that does not mean that here we have found factual bedrock. Testing inevitably involves "the construction of a background against which to measure success."[29] For missile accuracy as a whole that background was, at least in the narrowest sense, unproblematic: inferences about impact points from the

splash-net of hydrophones have not been contested (though potentially they could have been: as late as 1963 the limit of accuracy of the splash-net system was reckoned to be 0.15 nautical miles).

For gyroscope and accelerometer testing, however, "construction of a background" was much more difficult. These instruments have to be extraordinarily sensitive. Even a standard inertial gyroscope should "drift" by only a hundredth of a degree per hour, while a 1960s missile accelerometer had to measure accelerations to within a hundred thousandth of Earth's gravity. Constructing a stable background against which to measure these tiny errors was a demanding task. Artificially to provide a rotational input, and then to check the gyroscope's response to it, would require enormously accurate knowledge of that input, so the rotation rate of Earth—a secure piece in the network of knowledge—was generally taken as the input. Similarly, Earth's gravity field was used as a test input to both gyroscopes and accelerometers.

This did not remove the need for high precision in test tables and other equipment. Increased accuracy specifications in sensors necessitated increased accuracy in the test equipment. But this ultrasensitive equipment can be affected by ordinarily imperceptible environmental disturbances, and controlling these becomes of extreme importance. Here we do literally find bedrock, but it is not good enough. Gyro test tables are placed on pillars sunk into solid rock, but even so "microseisms and human cultural activities" interfere.[30] At GEC Marconi's gyro production and test facility in Edinburgh, for example, the systematic movement of human beings that takes place at the end of each working day has a noticeable effect. By 1986 it was reckoned that the limits even of the Central Inertial Guidance Test Facility's New Mexico desert site had been reached, and the search was on countrywide for the new site needed.

As with the missile's error budget, much more is involved in gyroscope and accelerometer testing than simply the production of a single accuracy figure such as a drift rate. Again, a mathematical model of error processes is constructed. In the case of a gyro, for example, this involved even in the 1950s "components insensitive to the earth's gravity field, those proportional to it, and those proportional to the square of it," deduced from test data by the mathematical technique known as Fourier analysis. As accuracy specifications increased, so too did the complexity of the mathematical model. Even the behavior of the supposedly stable background was beginning to be incorporated into the model. By 1973, "the error models for gyroscopes used by various investigators now included in addition to the 10 'classical,' gravity dependent terms, additional terms describing the error contributions of temperature effects, float motion, magnetic effects, power supply variations and of parasitic angular motions of the test stand." Not surprisingly, this caused problems—akin to those in constructing a missile error budget—in separating out the various error sources.[31]

One obvious limitation of using Earth's rotation and its gravity field as input was that testing was only for a particular range of conditions. By altering the orientation of a device being tested it could be subjected to different components of gravitational acceleration ($g$), but it could not be subjected on an ordinary test table to more than one $g$. In ballistic missile use, however, a guidance system can be subject to 20 $g$ or more. The mathematical error model allowed extrapolation from behavior at one $g$ and under to behavior at higher accelerations, but this was not considered on its own entirely adequate.

Two large and expensive types of test equipment have been constructed with which inertial sensors can be subjected to high accelerations under controlled conditions. The first is the precision centrifuge, in which devices could be subject to very high but exactly known accelerations—up to 100 $g$ at the 260-inch radius centrifuge at Holloman Air Force Base. The other is

the high-speed test track. The track at Holloman is a 10-mile "railway" laid out with great precision. Along it hurtle rocket sleds, their velocity measured to a thousandth of a foot per second by a photoelectric cell system.

Each instrument can, however, be argued to have disadvantages. "A centrifuge is very nice, except you always come back to where you started from,"[32] patently not the case in missile flight, while even a ten-mile track allows only a short period for errors to build up and be measured at rocket-sled speeds. Some dispute has indeed taken place as to which provided the better "background against which to measure success." Even moving entirely to "the real thing"—missile flight—has drawbacks. True, telemetry of what the guidance system "believed" to be the missile's position and velocity could be compared with what those "actually were"—but only if what they "actually were" was known with sufficient accuracy. Especially with an entirely over-ocean range, this was originally quite problematic. The development of a system (SATRACK) for tracking missile tests using Global Positioning System navigation satellites has meant that testers now have what is agreed to be a much better background available to them. But again the problem surfaces of knowing exactly what a given deviation between "belief" and "actuality" is caused by: the consequences, say, of initial misalignment of an inertial guidance system can be hard to disentangle from in-flight gyro drift. With enough time to make measurements, the question could be resolved to the satisfaction of all concerned, since the effects of gyro drift will increase with time. But enough time is not necessarily available:

There is inadequate time from launch to burnout for SATRACK or most of the other added instrumentation to really do a good job indentifying an average gyro bias, much less how it changes in flight, so we go on guessing and giving statistics.[33]

## CONCLUSION

What we find, therefore, is that there is no simple continuum whereby the closer we approach "use" the less problematic becomes the knowledge generated. Knowledge is a network, in which different kinds of tests are performed against differently constructed backgrounds, with no one test—not even "use"—and no one background being accepted by all as the ultimate arbiter. It takes a gruesome imagination to think of it, but I could envisage, in the aftermath of a nuclear war, guidance analysts—if any were left alive—deciding that missile performance in it had been "unrepresentative" and "poorly recorded," and that the knowledge of missile accuracies gained in peacetime had been superior.

In the history of missile guidance, there have been several controversies between proponents of different forms of guidance (such as radio versus inertial) or different kinds of component, especially different kinds of gyroscope. Some of the time at least, these controversies concerned not whether accuracy was desirable, but how best to achieve it. When the latter was at issue, it is natural to ask "Why didn't they just try it and see? Wouldn't that have cleared the matter up?" There is of course an analogous question to be asked of science: If scientists believe different theories, will experiment not show which is correct? A whole literature in the history, philosophy, and sociology of science has revealed why this is not always so, and why, in principle, it might *never* be so.

What we have seen shows why it is not so in technology either. A range of tests are available, and the results of one are not necessarily in harmony with those of another. A poor test result

might always be the result of a problem with the "background against which to measure success"—the folklore of inertial guidance testing is full of tales where it was eventually decided that the device being tested was correct and the test equipment, or other assumptions in the test procedure, were wrong. Use, not testing, can be claimed to be the proper ultimate arbiter, and differences between the two cited to deny that inference can flow from testing to use. On the other hand, testing that resembles use, or even use itself, can be said to be too haphazard, too poorly controlled or poorly "instrumented" to be appropriate for the generation of hard fact.

Though it may be possible in the abstract to make any or all of these arguments, it may not always be credible or feasible to do so. The accepted practices of testing are strongly entrenched and largely, if not entirely, consensual, and patterns of belief in the technical community are not infinitely flexible. Nevertheless, testing should not be expected always to close issues of controversy to the satisfaction of all concerned. Furthermore, as error modeling has developed, and as onboard digital computers have become more powerful, the size of "brute" error has become less important than how well the errors of a device can be predicted mathematically. The "inaccuracy" of an inertial sensor has become, in effect, the residual after the guidance system software has corrected for all predictable error processes. What has thus to be evaluated is not merely the device itself but the whole network of knowledge surrounding it.

Nowhere in this complex process of modeling and testing do unchallengeable, elementary, "atomic" facts exist. This does not mean that accuracy is a mere fiction, an "invention" in the pejorative sense, for this absence of "atomic" fact is characteristic of all scientific knowledge. It does mean, however, that the more deeply one looks inside the black boxes of technology, the more one realizes that "the technical" is no clear-cut and simple world of facts insulated from politics.

NOTES

This extract is an edited version of chapter 7 of Donald MacKenzie, *Inventing Accuracy: A Historical Sociology of Nuclear Missile Guidance* (Cambridge, Mass.: MIT Press, 1990). Missile accuracy is central to the "counterforce" approach to nuclear strategy, in which missiles are aimed at the opposing side's nuclear arsenal buried in concrete and steel silos. In contrast, accuracy is much less important to the alternative strategy of "assured destruction" deterrence, because the ultimate targets there are cities, which are large and vulnerable. Earlier chapters of *Inventing Accuracy* describe the history of the dominant inertial (i.e., self-contained) technology of missile guidance, and discuss its relationship to the development of nuclear strategy and to "bureaucratic politics," such as interservice rivalry. Most footnotes have been deleted from this extract, as has a discussion of the nature of American knowledge of the accuracy of Russian missiles.

1. Quoted in K. Johnsen, "Senate Vote Emphasizes Proven Weapons," *Aviation Week and Space Technology*, 22 May 1961, pp. 22–23, at p. 22.

2. "Washington Roundup," *Aviation Week and Space Technology*, May 14, 1962, p. 25.

3. "Live Polaris Launch," *Aviation Week and Space Technology*, May 14, 1962, p. 35.

4. G. C. Wilson, "GOP to Capitalize on LeMay's Charges," *Aviation Week and Space Technology*, April 20, 1964, pp. 26–27, at p. 26.

5. "Goldwater Defense Philosophy," *Aviation Week and Space Technology*, August 31, 1964, p. 11.

6. "Fixes planned for Minuteman Deficiencies." *Aviation Week and Space Technology*, February 2, 1964, pp. 26–27.

7. Senate Armed Services Committee, *Department of Defense Authorization Hearings, Fiscal Year 1979, Part 9, Research and Development* (Washington, D.C.: U.S. Government Printing Office, 1978), p. 6470.

8. The description in this paragraph is drawn from Matthew Bunn and Kosta Tsipis, *Ballistic Missile Guidance and Technical Uncertainties of Countersilo Attacks*, MIT Program in Science and Technology for International Security Report no. 9 (Cambridge, Mass.: MIT Program in Science and Technology for International Security, 1983), Appendix C.

9. Quoted in Arthur T. Hadley, "Our Ever-Ready Strategic Forces: Don't look closely if you want to believe," *Washington Star*, July 1, 1979.

10. See Pierre Duhem, *The Aim and Structure of Physical Theory* (Princeton: Princeton University Press, 1954).

11. K. Tsipis, "Precision and Accuracy," *Arms Control Today*, May 1981, pp. 3–4, at p. 4.

12. J. Edward Anderson, "First Strike: Myth or Reality," *Bulletin of the Atomic Scientists* 37 (November 1981): 6–11, at p. 10.

13. James Fallows, *National Defense* (New York: Random House, 1981), p. 150.

14. Charles Stark Draper, "Imaginary Problems of ICBM," *New York Times,* September 20, 1981, section 4, p. 20.

15. General Robert T. Marsh, USAF, "Strategic Missiles Debated: Missile Accuracy—We do Know!" *Strategic Review* 10 (Spring 1982): 35–37, at p. 37.

16. J. Edward Anderson, Letter to Editor, *Scientific American* 222 (May 1970): 6.

17. Tom Wicker, "Rethinking the MX," *New York Times,* August 25, 1981; Jeanne Hanson, "ICBM Inaccuracy Makes MX System Unnecessary," *Star News* (Elk River), June 25, 1981.

18. Arthur G. B. Metcalf, "Missile Accuracy—The Need to Know," *Strategic Review* 9 (Summer 1981): 5–8, at p. 5.

19. "Interview with Goldwater," *Aviation Week and Space Technology,* February 25, 1985, pp. 110–12, at p. 112.

20. Hyman Shulman, interviewed by the author, Santa Monica, Calif., January 13, 1987.

21. James R. Schlesinger, testimony to the Subcommittee on Arms Control, International Law, and Organization of the Senate Committee on Foreign Relations, *U.S. and Soviet Strategic Doctrine and Military Policies* (Washington, D.C.: U.S. Government Printing Office, 1974), p. 15.

22. Bruno Latour, *Science in Action: How to Follow Scientists and Engineers Through Society* (Milton Keynes: Open University Press, 1987), p. 77.

23. For the former, see Harry M. Collins, "The Seven Sexes: A Study in the Sociology of a Phenomenon, or the Replication of Experiments in Physics," *Sociology* 9 (1975): 205–24, reprinted in Barry Barnes and David Edge, *Science in Context: Readings in the Sociology of Science* (Milton Keynes: Open University Press, 1982), pp. 94–116; also Collins, *Changing Order,* ch. four. For the latter, see Tim Radford, "Physicists Bring Newton's Theory Down to Earth," *The Guardian* [London], 3 August 1988, p. 7.

24. Major General John Hepfer (U.S. Air Force, rtd.), interviewed by the author, Washington, D.C., July 29, 1985; J. M. Wuerth, "The Evolution of Minuteman Guidance and Control," *Navigation: Journal of the Institute of Navigation,* 23, no. 1, (Spring 1976): 64–73, at p. 71.

25. House Armed Services Committee, *Hearings on Military Posture, Fiscal Year 1977: Part Five, Research and Development* (Washington, D.C.: U.S. Government Printing Office, 1976), p. 199.

26. Harry Collins, "The Core-Set and the Public Experiment," typescript.

27. James Schlesinger, interviewed by the author, Washington, D.C., September 22, 1986.

28. William G. Denhard, interviewed by the author, Cambridge, Mass., February 18, 1985.

29. John Law, "Technology and Heterogeneous Engineering: The Case of Portuguese Expansion," in *The Social Construction of Technological Systems: New Directions in the Sociology and History of Technology,* eds. Wiebe E. Bijker, Thomas P. Hughes, and Trevor Pinch (Cambridge, Mass.: MIT Press, 1987), pp. 111–34, at p. 126.

30. Martin G. Jaenke, "Introductory Remarks: Test Technology Trends," in *Testing Philosophy and Methods of Guidance and Control Systems,* AGARD Lecture Series no. 60 (Neuilly sur Seine: NATO Advisory Group on Aerospace Research and Development, October 1973), pp. 1/1–1/3, at p. 1/2.

31. William G. Denhard, *Test and Evaluation of Inertial Components* (Cambridge, Mass.: MIT Instrumentation Laboratory, March 1960, R-200), p. 11; Jaenke, "Test Technology Trends," p. 1.2. The ten "classical" terms are listed in Peter J. Palmer, "Gyro Error Model Development," *Electromechanical Design,* February 1970, pp. 32–39.

32. Norman Ingold, interviewed by the author, Holloman Air Force Base, New Mexico, September 19, 1986.

33. Letter to author from guidance technologist, March 9, 1987.

# 24

# Toward an Anthropology of Immunology

## The Body as Nation State

### EMILY MARTIN

n the new science of immunology, social differences—between men and women, managers and workers, or citizens and foreigners—are written metaphorically into the character of various immune system cells. As Haraway has put it, "the immune system is an elaborate icon for principal systems of symbolic and material 'difference' in late capitalism" (1989:4). In this article I explore some central images that dominate recent popular and scientific discussions of the immune system, spelling out in detail the kind of "social world" the immune system is now imagined to be. I will also suggest what kinds of ideological work this way of picturing the world might be accomplishing and indicate in a preliminary way what kinds of uses people are making of this imagery. Finally I will look comparatively at other ways the immune system might be conceptualized. Cross-cultural and historical comparisons can help us realize the historical specificity of our own body images and suggest the possibility of different ones.

## CENTRAL IMAGES IN POPULAR AND SCIENTIFIC LITERATURE ON IMMUNOLOGY

For the analysis of popular imagery I draw on my examination of major mass media articles on the immune system published in the last five years.[1] These include material from mass-circulation magazines such as *Time* and *Newsweek*, as well as more specialized popular publications like *National Geographic* and *Discover*. I also draw on all the book-length popular publications on the topic I have been able to locate through standard bibliographic search techniques. These total some ten volumes. Although I do not quote from all sources, the images I discuss are pervasive throughout.

The major metaphors used in popular accounts of immunology depict the body as a "regulatory-communications network" (Schindler 1988:1).[2] As Haraway's work has made plain, the body is seen as "an engineered communications system, ordered by a fluid and dispersed command-control-intelligence network" (1989:14). Whereas boundaries within the body are fluid and con-

trol is dispersed, the boundary between the body (self) and the external world (nonself) is rigid and absolute:

At the heart of the immune system is the ability to distinguish between self and nonself. Virtually every body cell carries distinctive molecules that identify it as self. [Schindler 1988:1]

Added to the conception of a clear boundary between self and nonself is a conception of the nonself world as foreign and hostile.

The immune system evolved because we live in a sea of microbes. Like man, these organisms are programmed to perpetuate themselves. The human body provides an ideal habitat for many of them and they try to break in; because the presence of these organisms is often harmful, the body's immune system will attempt to bar their entry or, failing that, to seek out and destroy them. . . . When immune defenders encounter cells or organisms carrying molecules that say "foreign," the immune troops move quickly to eliminate the intruders. [Schindler 1988:1]

As a measure of the extent of this threat, the body is depicted in contemporary popular publications as the scene of total war between ruthless invaders and determined defenders.[3]

If . . . we could become as tiny as cells or bacteria, and visit the sites of these superficially undramatic events, we would experience them as they really are—life and death struggles between attackers and defenders, waged with a ruthlessness found only in total war. [Nilsson 1987:20]

Inside the body, a trillion highly specialized cells, regulated by dozens of remarkable proteins and honed by hundreds of millions of years of evolution, launch an unending battle against the alien organisms. It is high-pitched biological warfare, orchestrated with such skill and precision that illness in the average human being is relatively rare. [Jaroff 1988:56]

Besieged by a vast array of invisible enemies, the human body enlists a remarkably complex corps of internal bodyguards to battle the invaders. [Jaret 1986:702]

A site of injury is "transformed into a battle field on which the body's armed forces, hurling themselves repeatedly at the encroaching microorganisms, crush and annihilate them" (Nilsson 1987:20). The array of forces at the body's command is extensive.

The organization of the human immune system is reminiscent of military defence, with regard to both weapon technology and strategy. Our internal army has at its disposal swift, highly mobile regiments, shock troops, snipers, and tanks. We have soldier cells which, on contact with the enemy, at once start producing homing missiles whose accuracy is overwhelming. Our defence system also boasts ammunition which pierces and bursts bacteria, reconnaissance squads, an intelligence service and a defence staff unit which determines the location and strength of troops to be deployed. [Nilsson 1987:24]

Small white blood cells called granulocytes are "kept permanently at the ready for a blitzkrieg against microorganisms" and constitute the "infantry" of the immune system (Nilsson 1987:24). "Multitudes fall in battle, and together with their vanquished foes, they form the pus which collects in wounds" (Nilsson 1987:24). Larger macrophages are another type of white blood cell that is the "armoured unit" of the defense system. "These roll forth through the tissues . . . devouring everything that has no useful role to play there" (Nilsson 1987:25).

Another part of the immune system, the complement system, can "perforate hostile organisms so that their lives trickle to a halt" (Nilsson 1987:24). These function as "magnetic mines" [which] are sucked toward the bacterium and perforate it, causing it to explode" (Nilsson 1987:72). When complement "comes together in the right sequence, it detonates like a bomb, blasting through the invader's cell membrane" (Jaret 1986:720).

A type of white blood cell, a T-lymphocyte for which the technical scientific name is "killer cell," are the "immune system's special combat units in the war against cancer" (Nilsson 1987:96). Killer cells "strike," "attack," and "assault" (Nilsson 1987:96, 98, 100). "The killer T cells are relentless. Docking with infected cells, they shoot lethal proteins at the cell membrane. Holes form where the protein molecules hit, and the cell, dying, leaks out its insides" (Jaroff 1988:59). The great variety of different "weapons" is a product of evolutionary adaptation to changing defense needs: "Just as modern arsenals are ever changing as the weaponry of a potential enemy becomes more sophisticated, so our immune system has adapted itself many times to counter survival moves made by the microbial world to protect itself" (Dwyer 1988:28).

Although the metaphor of warfare against an external enemy dominates these accounts, another metaphor plays nearly as large a role: the body as police state.[4] Every body cell is equipped with

"proof of identity"—a special arrangement of protein molecules on the exterior . . . these constitute the cell's identity papers, protecting it against the body's own police force, the immune system. . . . The human body's police corps is programmed to distinguish between bona fide residents and illegal aliens—an ability fundamental to the body's powers of self-defence. [Nilsson 1987:21]

What identifies a resident is likened to speaking a national language: "An immune cell bumps into a bacterial cell and says, 'Hey, this guy isn't speaking our language, he's an intruder.' That's defense" (Levy, quoted in Jaret 1986:733).

T cells are able to "remember for decades" the identity of foreign antigens:

the intruders' descriptions are stored in the vast criminal records of the immune system. When a substance matching one of the stored descriptions makes a new appearance, the memory cells see to the swift manufacture of antibodies to combat it. The invasion is defeated before it can make us ill. We are *immune*. [Nilsson 1987:28]

What happens to these illegal aliens when they are detected? They are "executed" in a "death cell" (the digestive cavity inside a feeding cell) (Nilsson 1987:25, 31, 76, 81). "When the walls have closed around the enemy, the execution—phagocytosis—takes place. The prisoner is showered with hydrogen peroxide or other deadly toxins. Digestive enzymes are sent into the death chamber to dissolve the bacterium" (Nilsson 1987:81).

A police state of course requires a highly trained administrative apparatus and field personnel. The body provides for these things in "technical colleges," "training sites" located in lymph nodes, the thymus gland, and elsewhere (Jaret 1986:716; Nilsson 1987:26). "[Lymphocytes] are like blank pages: they know nothing, and must learn from scratch" (Nilsson 1987:26).

These metaphors work easily for those cases where one can see "missiles," "mines," "chemical warfare," or sniper ammunition. They run into trouble when the defensive forces seem inescapably to operate by *consuming* their victims. We are accustomed to blowing up people on battlefields or poisoning them, but we are not accustomed to eating them. Notice in these examples how the metaphors move back and forth between warfare and ingestion. "Once [the white blood cell] has reached its target (for example a bacterium), it uses *phagocytosis*, a process which, quite simply, involves the defender eating the attacker" (Nilsson 1987:25). The antibodies attached to the enemy cells are not seen in this context as identity papers sought by the secret police, but as "appetizers" or an "aperitif" (Nilsson 1987:72, 78).

Feeding cells squeeze through the blood vessel wall and move toward the enemy, with amoeba-like movements. The antibodies stimulate their appetites and, on contact with the bacteria, the feeding cells immediately start to swallow them. The battle is in full swing. [Nilsson 1987:29]

In another example, "Powerful chemicals inside the macrophage will break down and destroy the components of the invading cells. The macrophage literally eats the enemy, digesting and metabolizing its materials" (Jaret 1986:718–719). Finally, when stimulated by T cells to attack viruses, macrophages are "whipped" into a "feeding fury." "They don't necessarily eat faster," notes Dr. Richard Johnston, Jr., of the University of Pennsylvania School of Medicine, "but they kill better" (quoted in Jaroff 1988:59).

In the warfare metaphor, granulocytes are the infantry lost in large numbers; macrophages, the armored tanks. When ingestion enters the picture, we wind up with cannibalism: "During an infection, when millions upon millions of granulocytes are lost in the struggle against the invaders, part of the macrophages' task is to ingest dead microphages—a phenomenon which might be described as a kind of small-scale cannibalism" (Nilsson 1987:25).

What is the relationship between the kind of popular accounts I have quoted so far and the language of more technical scientific publications? Although this is a question that will be investigated more fully in research I have not yet completed, at a general level it is clear that popular accounts often simply take the metaphors that occur in scientific writing a few paces further.[5] For this analysis I am drawing on one year's fieldwork in a university department of immunology, where I regularly attended classes, department seminars, and a journal club. I also attended all planning sessions of one research group within the department. In conjunction with the research of this group, I learned a standard experimental procedure (Western blot) and helped carry out a series of experiments. I have consulted all texts currently required or recommended in graduate classes on immunology in this department and in graduate and undergraduate classes on immunology in another division of the university (i.e., Hood et al. 1984; Kimball 1986; Paul 1989; Roitt, Brostoff, and Male 1985; Sell 1987; and Stites, Stobo, and Wells 1987).

One main image in virtually all scientific literature on the immune system is the distinction between self and nonself, a distinction that is maintained by a defense based on killing the nonself. The editorial from a recent issue of *Science,* "Recognizing Self from Nonself," begins: "Of all the mysteries of modern science, the mechanism of self versus nonself recognition in the immune system ranks at or near the top. The immune system is designed to recognize foreign invaders" (Koshland 1990:1273). A current clinical handbook begins, "The function of the immune system is to distinguish self from non-self and to eliminate the latter" (Kesarwala and Fischer 1988:1). And a textbook concludes its first chapter with a section headed "Self vs. Nonself": "Whatever the time frame, the development of immunocompetence represents a watershed in the life of the animal. At this time the organism learns to discriminate between 'self' and 'nonself'" (Kimball 1986:14).

Images of a police state with associated training of personnel to protect its borders come in too: defense is carried out by "professional phagocytes" (Stites, Stobo, and Wells 1987:170).

The cells and molecules of this defensive network maintain constant surveillance for infecting organisms. They recognize an almost limitless variety of foreign cells and substances, distinguishing them from those native to the body itself. When a pathogen enters the body, they detect it and mobilize to eliminate it. They "remember" each infection, so that a second exposure to the same organism is dealt with more

efficiently. Furthermore, they do all this on a quite small defense budget, demanding only a moderate share of the genome and of the body's resources. [Tonegawa 1985:72]

Language like this is commonplace not only in texts[6] but in explanations in seminars and classes. Once in a journal club discussion of an article on T cell functions, I counted dozens of uses of the words "kill" or "killing."

## THE BODY AND THE NATION

These images of entities within our bodies relate in complex ways to social forms pervasive in our time. Consider, for example, Benedict Anderson's and Ernest Gellner's descriptions of the modern nation state. Both writers stress the important role of communication in the identity of a nation state.

[The] core message is that the language and style of the transmissions is [sic] important, that only he who can understand them, or can acquire such comprehension, is included in a moral and economic community, and that he who does not and cannot, is excluded. [Gellner 1983:127]

Recall the emphasis placed on the immune system as a network of mutual communication and the glossing of an intruding foreign cell as "a guy who doesn't speak our language." Sometimes, as in this example, intruding foreign cells are explicitly compared to people of different national origin:[7]

When you are the ever-vigilant protector of the sacrosanct environment of a body, anything foreign that should dare to invade that environment must be rapidly detected and removed. However, finding certain invaders and recognising them as foreign can be very difficult. . . . It can be as difficult for our immune system to detect foreignness as it would be for a Caucasian to pick out a particular Chinese interloper at a crowded ceremony in Peking's main square. [Dwyer 1988:29]

Consider again the lack of mediating structures in the modern nation state between the individual and the state.

[Nation states] are poorly endowed with rigid internal sub-groupings; their populations are anonymous, fluid and mobile, and they are unmediated; the individual belongs to them directly, in virtue of his cultural style, and not in virtue of membership of nested sub-groups. Homogeneity, literacy, anonymity are the key traits. [Gellner 1983:138]

In the popular picture of the immune system, we see individual cells launched into the body to protect its homogenous interior against attack. These cells are individuals that roam fluidly in blood and lymph within the body: "The immune system consists of an interconnecting network of organs and tissues between which moves a heavy and ceaseless traffic of cells. This cellular traffic is borne along in the flow of blood and lymph" (Kimball 1986:131).

There are structures which produce and "educate" these cells, primarily the thymus and bone marrow. As I pointed out, these "educational institutions" are crucial for maintaining the common language that ties the population of cells together and enables it to distinguish self from nonself.[8] But these structures do not themselves continue to govern the immune response after they have produced and educated the cells. As Jaret describes it, "the human immune system is not controlled by any central organ, such as the brain. Rather it has developed to function as a kind of biologic democracy, wherein the individual members achieve their ends through an information network of awesome scope" (1986:709).

Finally, it seems to be part of the defining character of the nation state that its domain is limited: "the nation is imagined as *limited* because even the largest of them, encompassing perhaps a billion living human beings, has finite, if elastic, boundaries, beyond which lie other nations. No nation imagines itself coterminous with mankind" (Anderson 1983:16). In the maintenance of boundaries, of course, lie many of the conflicts between nation states; and in the protection of its boundaries against invasion from other, equally powerful organisms, lie the bellicose activities of the immune system.

Although Anderson stresses the potentially egalitarian aspect of nations, in which internal hierarchies are flattened out in deference to defining national boundaries, Dumont stresses the way nationalist ideologies often carry within them a kind of suppressed hierarchy (Dumont 1986). For Dumont, nationalism involves the emergence of individualism and egalitarianism which "are a particular transformation on hierarchy . . . whereby hierarchy and its valuation of difference are suppressed. Racism is a property of suppressed hierarchy" (Kapferer 1989:164). Therefore, "Dumont sees nationalism, because it ingrains individualist and egalitarian ideology, to be potentially integral to the generation of a western totalitarianism, fascism and racism" (Kapferer 1989:164). The world of the immune system also contains a kind of suppressed hierarchy within its boundary-oriented, internally mutually interacting system of components. Compare two categories of immune system cells: phagocytes (macrophages are one type), which surround and digest foreign organisms; and T cells which destroy foreign organisms by shooting holes in them or transferring toxin to them. The phagocytes are a lower form of cell evolutionarily and are even found in such primitive organisms as worms (Roitt, Brostoff, and Male 1985:2.1); T cells are more advanced evolutionarily and have higher functions, such as memory (Jaroff 1988:60; Roitt, Brostoff, and Male 1985:2.5). It is only these advanced cells which "attend the technical colleges of the immune system" (Nilsson 1987:26).

There is clearly a hierarchical division of labor here, one that is to some extent overlaid with gender categories. Superficially, there are obvious female associations with the engulfing and surrounding of phagocytes and obvious male associations with the penetrating or injecting of T cells.[9] In addition, many scholars have pointed out the frequent symbolic association of the female with lower functions, and especially with a lack of or a lesser degree of mental functions.

In addition, phagocytes are the cells that are the "housekeepers" (Jaret 1986) of the body, cleaning up the dirt and debris including the "dead bodies" of both self and foreign cells. (One immunologist called them "little drudges."[10])

The first defenders to arrive would be the phagocytes—the scavengers of the system. Phagocytes constantly scour the territories of our bodies, alert to anything that seems out of place. What they find, they engulf and consume. Phagocytes are not choosy. They will eat anything suspicious that they find in the bloodstream, tissues, or lymphatic system. [Jaret 1986:715][11]

Beyond this, when a phagocyte moves to surround a microorganism, the extensions of itself are called "pseudopodia" or false feet. These "feet" surround the particle and lodge it within (Jaret 1986:717; Jaroff 1988:57–58; Leijh, Furth, and Zwet 1986:46.2). To round out the images that may come to mind at the thought of two feet opening wide to engulf something foreign, this process of forming a pouch is explicitly called "invagination" (Vander, Sherman, and Luciano 1980:527). Still more fraught with psychosexual connotations is the fact that the "vaginal" pouch between the phage's feet is also a "death cell," which will execute and then eat its prey.[12]

The feminized, primitive phagocytes kill by engulfing and eating "the enemy." They often

die in the process, but their deaths are seen as routine and unexceptional. One type of phago-cyte, the macrophage, often dies because it engulfs something *too big and pointed*, which punc-tures it (more fertile material for psychosexual analysis). Nilsson comments on an illustration of an asbestos fiber puncturing a macrophage: "It is no use: the asbestos does not break down and the macrophage is defeated" (1987:129).

The masculinized T cells however, kill by penetrating or injecting. They sometimes die, too, but their deaths take place on a battlefield where they shoot out projectiles and poisonous sub-stances. Heroic imagery is brought directly to bear on them, as in one illustration, David (the T cell) takes on Goliath (the tumor cell). "A killer cell—here in monstrous guise—grips a proto-plasm thread of the large tumour cell and starts to penetrate the enemy. Goliath meets David: the giant seldom survives the encounter with the little killer cell" (Nilsson 1987:100).

## WHAT DOES THE IMAGERY DO?

Immunology is a recent science recently institutionalized. Although such entities as macro-phages, lymphocytes, antibodies, and antigens had been identified earlier, it was not until the mid-1960s that the concept of an immune *system* as such existed (Moulin 1989). Only then did macrophages, lymphocytes, and other cells come to be seen as a part of a mutually interacting, self-regulating, whole body system. It was generally not until the 1970s that departments of immunology existed in American or other universities. Popular depictions of immune system functions only began after this time and grew frequent only in the 1980s. Therefore, given that the modern nation state has been in existence for over a hundred years, it is perhaps not even particularly surprising that such imagery should be incorporated by a developing science. It might also seem that there would not be any ideological "work" for such imagery to do, since the forms they reflect are already so well entrenched as to be unquestionable.[13]

As a speculation I suggest that one kind of ideological work such images might do is to make violent destruction seem ordinary and part of the necessity of daily life. Perhaps when the texts slip between warfare and ingestion they in effect domesticate violence. In another scientific lan-guage, used by nuclear defense intellectuals, Carol Cohn (1987) suggests that words and images taken from the home and farmyard serve to blunt the reality of massively destructive forces. For example, getting to see a nuclear missile is called "patting the bomb," and missiles themselves are kept in "silos." In immunology the shifting of imagery from warfare to eating may similarly divert us from seeing that cellular events are constructed as total war. Destruction and death may appear to give way to friendly, sociable eating. Any diversion achieved could only be temporary: the overall picture conveyed by these texts is emphatically one of "the body at war." Some accounts even go so far as to warn us repeatedly against thinking any events inside the body are innocent: "superficially undramatic events" are really total war (Nilsson 1987:20); "tumour cells repos[ing] on a slide" are "no peaceful scene" (Nilsson 1987:102). What may seem innocent is really deadly: killer cells give cancer cells a "poisonous kiss," a "kiss of death," (Nilsson 1987:105) that dispatches them; the feeder cell encloses a bacterium in a "deadly embrace" (Jaret 1986:718; Nilsson 1987:25).

Another kind of ideological work may be accomplished when a structure is posited in the body with hierarchical relations among its parts, a structure that relates to existing hierarchies in society. In the tiny world of these cells we see stereotypically "male" penetrating killer cells and

stereotypically "female" devouring and cleaning cells, male heroes and females in "symbiotic service," to use Jean Elshtain's phrase (1987:198). "Male" activity is valued as heroic and life-giving, and "female" activity is devalued as ordinary and mortal.

Jean Elshtain (1987), Judith Stiehm (1982), and Virginia Woolf (1929) have all argued in different ways that in Western culture warfare depends on females for whose sake male heroes can die. Maintenance of militarism depends on gender in the sense that there cannot be a "hero's" death without "little drudges" keeping things tidy at home. There is not a complete parallel in the cellular world, because the feminized macrophages are on the battlefield killing (by eating) invaders along with the masculinized T cells. However, there is a distinct replication of status difference between them in the many ways I have already discussed.

But it is not clear whether gender is the only overlay on this division of labor. Phagocytes are the cells that actually eat other cells belonging to the category "self," and so engage in a form of "cannibalism." William Arens has done a study of the ideological use of the trait of cannibalism and finds it often if not always associated with the attribution of a lower animal nature to those who engage in it (1979). In immunology phagocytes are seen as feminized in some ways, but as simply "uncivilized" in other ways. These "cannibals" are indiscriminate eaters, barbaric and savage in their willingness to eat any manner of thing at all. The implications of this depiction, with its unmistakable overtones of race and class, will be explored below.

## WHAT DO PEOPLE DO WITH THE IMAGERY?

In my research I have begun to look at the way scientists and others react to immune system imagery when it is pointed out to them, as a way of seeing the role of these constructions in the definition of personal identity and the creation of cultural meaning. The scientists I have worked with have had a variety of reactions, but none has suggested it would be possible (or often, even desirable) to substitute different imagery for the current warfare/internal purity model. The head of the immunology research group in which I have been doing participant observation was attentive when I described my impression of the extent to which the imagery of warfare dominates department discussions, lab talk, and technical literature. He was intrigued enough to report to me later, at the end of a semester course he taught on the immune system, that he had tried to keep track of his own use of such talk. He said that in the first half of the course, on immunochemistry and genetics, he had used no language of warfare or killing. But he did use this kind of language in the second half, when he dealt with "applications." He saw this later language as simply a shorthand, used to give an easy handle to the complexities that students have already understood. "It is hard to avoid reference to the 'killer' cell, for example, or saying the T cell 'kills' the germ, even though the class understands that the T cell only acts when a complex combination of other factors are present," he told me. He referred to the first half of the course as the "conceptual" half, the second as the "applied" half.

When I asked if the two halves were independent, he replied with an emphatic "yes." He also thought that it would not affect the first half of the course at all if he had a different shorthand to use in the second half. If we spoke of the cells, say, as "controlling" rather than "killing," it still would not affect the chemistry and genetics, he claimed.

Another scientist, who is committed to writing biology textbooks so that they are less reflective of patriarchal and hierarchical assumptions in our society, was not fond of the warfare

imagery. However, he commented to me that he was stumped by how else to describe the immune system. The warfare metaphor seemed to him in this case to be the only one that fit the facts.

For people who are suffering from immune system disorders, the warfare language can also appear unobjectionable. My own "buddy,"[14] with whom I had innumerable conversations about the physical and emotional aspects of AIDS, never expressed any hesitation or criticism about the use of this language by medical personnel. However, he himself never used any military or nation state imagery to describe what was happening to him or what the medical treatments were supposed to do. Instead he used only the imagery of a clean house. The treatment involving ablation of his immune system by radiation, which he was hoping to receive, would "clean out the HIV virus"; his brother's immune system cells, injected by bone marrow transplant, would then "set up housekeeping" in his body.

Other HIV patients embrace the warfare imagery wholly and use it creatively to organize their experience of mortal threat.

We have grown up in our bodies, they are our native lands, and although we know their shortcomings by heart, we have a natural affection for them, warts and all. My country has occasionally disappointed me, but like a Resistance fighter, I'll stop at nothing when it comes to throwing off the foreign viral yoke. The main thing is to adopt a guerrilla attitude and reverse our roles. To declare that impostors have taken over my body, that the virus has illegally usurped authority, and that I must set out to recover my morale and all biological ground lost so far. I'm in my own home, this is my body, and it's up to AIDS to get out. [Dreuilhe 1988:8–9]

AIDS activists also create powerful images of collusion between the damage done by the virus to individual bodies and the damage they suspect some political authorities intend. For example, at a public hearing held by the Maryland Governor's AIDS commission, July 10, 1990, an Act Up spokesperson made the following statement: "Schaefer [the Governor] is Hitler, AIDS is the holocaust, Maryland is Auschwitz. This is conscious genocide and can only be seen as the Governor's desire to wipe out this population."

## ALTERNATIVE IMAGES OF THE BODY

However creatively people attempt to forge meaningful uses of these bellicose nation state images, they are still working within what strikes me as a rather narrow range of options. An important role for anthropology is to use its technique of comparative research to make plain the historical specificity of the cultural options that occur to people and therefore their contingency. Other times and places may offer us other resources.

In some times and other cultures, images of biological organisms as engaged in all-out struggle to the death have not held sway. Daniel Todes has shown how in the late nineteenth and early twentieth centuries Russian biologists rejected Darwin's major metaphor, the struggle for existence, especially when it appeared in connection with Malthusian ideas about overpopulation. In developing an alternative theory of mutual aid, Russian naturalists argued four tenets:

the central aspect of the struggle for existence is the organism's struggle with abiotic conditions; organisms join forces to wage this struggle more effectively, and such mutual aid is favored by natural selection; since cooperation, not competition, dominates intraspecific relations, Darwin's Malthusian characterization of

those relations is false; and cooperation so vitiates intraspecific competition that the latter cannot be the chief cause of the divergence of characters and the origin of new species. [Todes 1987:545]

In rejecting Darwin's assumptions, Russians identified the idea of individualized competitive struggle as a product of English culture and society. Darwin's use of this assumption was "the same as if Adam Smith had taken it upon himself to write a course in zoology" (Chernyshevskii, quoted in Todes 1987:541); a Russian expert on fisheries and population dynamics wrote that the English "national type accepts [struggle] with all its consequences, demands it as his right, tolerates no limits upon it" (quoted in Todes 1989:41).

This response to Darwin's theory, common to Russian intellectuals of a variety of philosophical and political viewpoints, derived, as Todes persuasively argues, from several factors:

Russia's political economy lacked a dynamic, pro-laissez faire bourgeoisie and was dominated by landowners and peasants. The leading political tendencies, monarchism and a socialist-oriented populism, shared a cooperative social ethos and a distaste for the competitive individualism widely associated with Malthus and Great Britain. Furthermore, Russia was an expansive, sparsely populated land with a swiftly changing and often severe climate. It is difficult to imagine a setting less consonant with Malthus's notion that organisms were pressed constantly into mutual conflict by population pressures on limited space and resources. [Todes 1989:168]

A second example of an alternative form of imagery comes from the work of Ludwik Fleck. Fleck was a Polish biologist who during the 1930s and 1940s developed important diagnostic and prophylactic measures for typhus fever. He also published a monograph and many papers on the methodology of scientific observation and the principles of scientific knowledge. Although his work was not widely disseminated at the time of its publication, he anticipated many of Thomas Kuhn's arguments (1962) published and acclaimed in the 1960s.[15]

In the 1930s, Fleck had already seen the limitations of the metaphor of warfare in immunology and conceived of another possibility. He described the prevailing idea of

the organism as a closed unit and of the hostile causative agents in facing it. The causative agent produces a bad effect (*attack*). The organism responds with a reaction (*defense*). This results in a conflict, which is taken to be the essence of disease. The whole of immunology is permeated with such primitive images of war. [1979(1935):59]

Out of his experience as a practicing biologist he thundered, "not a single experimental proof exists that could force an unbiased observer to adopt such an idea" (Fleck 1979[1935]:60). Instead of the organism as a self-contained independent unit with fixed boundaries, he proposed a "harmonious life unit," which could range from the cell, to the symbiosis between alga and fungus in a lichen, to an ecological unit such as a forest.[16]

In the light of this concept, man appears as a complex to whose harmonious well-being many bacteria, for instance, are absolutely essential. Intestinal flora are needed for metabolism, and many kinds of bacteria living in mucous membranes are required for the normal functioning of these membranes. [Fleck 1979(1935):61]

Change in such a harmonious life form could be spontaneous (mutation), cyclic (aging), or simply change within the reciprocally acting parts of the unit. In the latter category fall most infectious diseases. But, and this is crucial,

it is very doubtful whether an invasion in the old sense is possible, involving as it does an interference by completely foreign organisms in natural conditions. A completely foreign organism could find no

receptors capable of reaction and thus could not generate a biological process. It is therefore better to speak of a complicated revolution within the complex life unit than of an invasion of it. [Fleck 1979(1935):61]

He meant that any "invading" organism had to have been living in our vicinity, symbiotically, long enough to be able to stick to *our* cells. The ability to generate a biological process could only come about from previous encounters. Thus, a previously minor organism could only rise to prominence within the body's life unit, not invade it as a foreign "other." In the overall scheme of things, this kind of "complicated revolution" would be a decidedly rare event, not one that was constantly on the verge of occurring.

It is interesting to speculate whether Fleck's strongly stated objections to the warfare/internal purity model in immunology was influenced by his experience of the contemporary Nazi application of totalitarian practices to achieve the purity of the social body. By 1935 the removal, incarceration, or killing of German and Austrian Jewish, communist, and socialist physicians was well advanced.[17] After Poland was occupied by the Nazis, Fleck was deported to Auschwitz and forced to produce typhus vaccines for the German armed forces (Trenn and Merton 1979:151). Speculation about the relationship between Fleck's ideas and his Nazi experience is made more compelling by Claude Lefort's observation that totalitarian regimes often produce images of themselves as a body:

At the foundation of totalitarianism lies the representation of the People-as-One . . . the constitution of the People-as-One requires the incessant production of enemies. . . . The enemy of the people is regarded as a parasite or a waste product to be eliminated. . . . What is at stake is always the integrity of the body. It is as if the body had to assure itself of its own identity by expelling its waste matter, or as if it had to close in upon itself by withdrawing from the outside, by averting the threat of an intrusion by alien elements. . . . The campaign against the enemy is feverish; fever is good, it is a signal, within society, that there is some evil to combat. [Lefort 1986:297–298]

As immunology describes it, bodies are imperiled nations continuously at war to quell alien invaders. These nations have sharply defined borders in space, which are constantly besieged and threatened. In their interiors there is great concern over the purity of the population—over who is a bona fide citizen and who may be carrying false papers. False intruders intend only destruction, and they are meted out only swift death. All this is written into "nature" at the level of the cell. It seems possible that Fleck may have wondered whether this imagery might make analogous social practices come to seem ever more natural, fundamentally rooted in reality, and unchangeable.

Within our own contemporary science there are hints of other models that might be used to describe immune responses. For example, Haraway suggests the work of Terry Winograd and Fernando Flores on cognition as providing a way of describing pathology without military imagery. By their account, a "breakdown" would not be "a negative situation to be avoided, but a situation of non-obviousness, in which some aspect of the network of tools that we are engaged in using is brought forth to visibility" (quoted in Haraway 1989:18). Instead of the defended self who destroys the foreign intruder lest it be destroyed, we would have occasions when interaction becomes nonobvious, potentially creative situations that call forth clarification of the terms of the interaction.

One final possibility for an alternative perspective is present as a minor motif in some of the biological texts I have discussed. If the eating aspect of phagocytosis were allowed to dominate in significance over the destructive aspect, the macrophage might be said to catabolize and utilize the "invading foreign organism" in its own metabolic processes. In other words, the microorganism might be seen as food for the macrophage. Some standard sources make plain this aspect of

what a macrophage does, telling us that when a macrophage ingests a microorganism, it "evokes a metabolic burst" which causes increased consumption of oxygen and production of substances which help digestion (Leijh, Furth, and Zwet 1986:46.2; Vander, Sherman, and Luciano 1980:528). But by no means do all texts mention these matters; never are they given very much attention or development in the overall picture. If the view that microorganisms serve as food for macrophages were given prominence, we could see this process as a food chain, linked by mutual dependencies. Instead of a life and death struggle, with terrorism within and war at the borders, we would have symbiosis within a life unit that encompasses the body and its environment, where all organisms are dependent on others for food.

None of these alternative metaphors would be sufficient by itself to encourage us to imagine—let alone bring into existence—different forms of organization in our society than those that now exist. But at the least they can serve to add substance to the question: are there powerful links between the particular metaphors chosen to describe the body scientifically and features of our contemporary society that are related to gender, class, and race?

Full consideration of this question would demand attention to issues I have not taken up here: what is the historical relationship between particular social formations and particular ideas about the body? Is there variation in scientific or popular body images from one kind of nation state to another? From one perspective within a given nation state to another? Although I hope to address these questions in future work, in this article my aim has been more limited: to suggest that as long as there is a possibility that scientific descriptions give an aura of the "natural" to a particular social vision, there is a place for comparative ethnography to set this vision in a context of other ways bodies might be imagined and societies might be organized.

NOTES

This article was presented at a symposium organized by Margaret Lock and Rayna Rapp at the 1989 annual meeting of the American Anthropological Association. My thanks to Margaret Lock and Rayna Rapp, as well as to Alan Harwood and the reviewers of *MAQ*, for helpful suggestions for revision.

Correspondence may be addressed to the author at the Department of Anthropology, Johns Hopkins University, Baltimore, MD 21218.

1. Some portions of an earlier version of this section appeared in Martin (1989).

2. This source is a booklet which is sent out if one calls 1-800-4CANCER and requests information on the immune system. My thanks to Martha Balshem for telling me about it.

3. See Rather and Frerichs (1972) on early uses of military metaphors in Western medicine.

4. At times the "police" become more like antiterrorist squads, as befits the task of finding enemies within who are bent on destruction. Paula Treichler points out that the AIDS virus is a "spy's spy, capable of any deception . . . a terrorist's terrorist, an Abu Nidal of viruses" (1987:282).

5. The study in which I am currently engaged, "Science and Knowledge of the Body," focuses on how ideas and practices related to immunology develop over time in research labs, in urban neighborhoods, and in clinical settings. This research will doubtless modify some of the ideas suggested in this article.

6. See also Roitt, Brostoff, and Male (1985:2.8) on the "kiss of death" and (1985:18.11) on immunosurveillance.

7. The unselfconscious chauvinism and even racism of this remark (as of much else in Dwyer's book) bears noting.

8. See Gellner (1983:138) on the importance of educational institutions in the functioning of nation states.

9. Lauren Berlant suggests to me that in early Renaissance imagery females are linked with others simply via their bodies, while males are always linked via a mediating tool, such as a weapon. That the macrophage engulfs only with its "body" may be part of what makes it seem female in our cultural tradition.

10. Overheard by Paula Treichler, personal communication.

11. Recent work in anthropology has shown the very widespread association of females in funeral rituals with the cleaning up of the dirt and pollution of death (Bloch and Parry 1982). Especially as seen from the vantage point of men, women's bodies produce most of the dirty, defiling stuff in the universe and are thus responsible for carrying away the filth of the corpse at funerals.

12. In some ways these metaphors are presented so that their overall force is not obvious. In part the images occur in separate places, invagination in one account, pseudopodia in another. For materials that discuss the historical roots or psychoanalytic origins of the connection between the female and death, see Abraham and Torok (1986), Auerbach

(1982), and Theweleit (1987). For another arena in which ominous danger is attached to images of the female "other," see Said (1978:57).

13. The phrase "ideological work" has been used by Mary Poovey (1988) to describe the active processes involved in the establishment and contestation of cultural systems of ideas and practices.

14. The term "buddy" refers to a relationship between a trained volunteer and a person with AIDS.

15. In Kuhn's foreword to the recent reissue of Fleck's monograph, he states (1979:viii) that he is "almost totally uncertain" what he took from Fleck.

16. Lewis Thomas evokes powerful images of our symbiotic relationships with bacteria (1974:72–73), but when he describes immunological reactions, he adopts strongly military imagery: "we will bomb, defoliate, blockade, sea off, and destroy all the tissues in the area" (1974:78).

17. "Between 1933 and 1938, 10,000 German physicians were forced from their jobs; many of these were compelled to flee the country, and others were killed in concentration or death camps" (Proctor 1988:282).

## REFERENCES

Abraham, Nicolas, and Maria Torok
    1986 The Wolf Man's Magic Word. In *Theory and History of Literature,* Vol. 37. Nicholas Rand, trans. Minneapolis: University of Minnesota Press.
Anderson, Benedict
    1983 *Imagined Communities: Reflections on the Origin and Spread of Nationalism.* London: Verso.
Arens, William
    1979 *The Man-Eating Myth: Anthropology and Anthropophagy.* Oxford: Oxford University Press.
Auerbach, Nina
    1982 *Woman and the Demon: The Life of a Victorian Myth.* Cambridge, MA: Harvard University Press.
Bloch, Maurice, and Jonathan Parry
    1982 Introduction: Death and the Regeneration of Life. In *Death and the Regeneration of Life.* Maurice Bloch and Jonathan Parry, eds. Pp. 1–44. Cambridge: Cambridge University Press.
Cohn, Carol
    1987 Sex and Death in the Rational World of Defense Intellectuals. *Signs* 12(4):687–718.
Dreuilhe, Emmanuel
    1988 *Mortal Embrace: Living with AIDS.* Linda Coverdale, trans. New York: Hill and Wang.
Dumont, Louis
    1986 *Essays on Individualism: Modern Ideology in Anthropological Perspective.* Chicago: University of Chicago Press.
Dwyer, John M.
    1988 *The Body at War: The Miracle of the Immune System.* New York: New American Library.
Elshtain, Jean
    1987 *Women and War.* New York: Basic Books.
Fleck, Ludwik
    1979[1935] *Genesis and Development of a Scientific Fact.* Thaddeus J. Trenn and Robert K. Merton, eds. Fred Bradley and Thaddeus J. Trenn, trans. Chicago: University of Chicago Press.
Gellner, Ernest
    1983 *Nations and Nationalism.* Oxford: Basil Blackwell.
Haraway, Donna
    1989 The Biopolitics of Postmodern Bodies: Determinations of Self in Immune System Discourse. *Differences* 1(1):3–43.
Hood, I. L., et al.
    1984 *Immunology.* 2d edition. Menlo Park, CA: Benjamin Cummings.
Jaret, Peter
    1986 Our Immune System: The Wars Within. *National Geographic* 169:702–735.
Jaroff, Leon
    1988 Stop That Germ! *Time* 131(21):56–64.
Kapferer, Bruce
    1989 Nationalist Ideology and a Comparative Anthropology. *Ethnos* 54(3–4):161–199.
Kesarwala, Hemant H., and Thomas J. Fischer, eds.
    1988 Introduction to the Immune System. In *Manual of Allergy and Immunology.* 2d edition. Glenn J. Lawlor, Jr. and Thomas J. Fischer, eds. Pp. 1–14. Boston: Little, Brown.
Kimball, John W.
    1986 *Introduction to Immunology.* 2d edition. New York: Macmillan.
Koshland, Daniel E., Jr.
    1990 Recognizing Self from Nonself. *Science* 248(4961):1273.
Kuhn, Thomas S.
    1962 *The Structure of Scientific Revolutions.* Chicago: University of Chicago Press.
    1979 Foreword to *Genesis and Development of a Scientific Fact,* by Ludwik Fleck. Thaddeus Trenn and Robert Merton, eds. Pp. vii–xi. Chicago: University of Chicago Press.

Lefort, Claude
    1986 The Image of the Body and Totalitarianism. In *The Political Forms of Modem Society: Bureaucracy, Democracy, Totalitarianism.* John B. Thompson, ed. Pp. 292–306. Cambridge, MA: MIT Press.
Leijh, P. C. I., R. Van Furth, and T. L. Van Zwet
    1986 In Vitro Determination of Phagocytosis and Intracellular Killing by Polymorphonuclear and Mononuclear Phagocytes. In *Cellular Immunology,* Vol. 2. Handbook of Experimental Immunology in Four Volumes. D. M. Weir, ed. 4th edition. Pp. 46.1–46.5. Oxford: Blackwell Scientific Publications.
Martin, Emily
    1989 The Cultural Construction of Gendered Bodies: Biology and Metaphors of Production and Destruction. *Ethnos* 54(3–4):143–160.
Moulin, Anne Marie
    1989 The Immune System: A Key Concept for the History of Immunology. *History & Philosophy of the Life Sciences* 11:221–236.
Nilsson, Lennart
    1987 *The Body Victorious: The Illustrated Story of Our Immune System and Other Defences of the Human Body.* New York: Delacorte Press.
Paul, W. E., ed.
    1989 *Fundamental Immunology.* 2d edition. New York: Raven Press.
Poovey, Mary
    1988 *Uneven Developments: The Ideological Work of Gender in Mid-Victorian England.* Chicago: University of Chicago Press.
Proctor, Robert N.
    1988 *Racial Hygiene: Medicine Under the Nazis.* Cambridge, MA: Harvard University Press.
Rather, L. J., and J. B. Frerichs
    1972 On the Use of Military Metaphor in Western Medical Literature: The *Bellum Contra Morbum* of Thomas Campanella (1568–1639). *Clio Medica* 7(3):201–208.
Roitt, Ivan, Jonathan Brostoff, and David Male
    1985 *Immunology.* St. Louis, MO: C. V. Mosby.
Said, Edward W.
    1978 *Orientalism.* New York: Vintage Books.
Schindler, Lydia Woods
    1988 *Understanding the Immune System.* Washington, D.C.: U.S. Department of Health and Human Services.
Sell, Stewart
    1987 *Basic Immunology: Immune Mechanisms in Health and Disease.* New York: Elsevier.
Stiehm, Judith
    1982 The Protected, the Protector, the Defender. *Women's Studies International Forum* 5:367–376.
Stites, D. P., F. D. Stobo, and J. V. Wells, eds.
    1987 *Basic and Clinical Immunology.* 6th edition. Norwalk, CT: Appleton and Lange.
Theweleit, Klaus
    1987 *Male Fantasies. Women, Floods, Bodies, History,* Vol. 1. Stephen Conway, trans. Minneapolis: University of Minnesota Press.
Thomas, Lewis
    1974 *The Lives of a Cell: Notes of a Biology Watcher.* New York: Viking.
Todes, Daniel P.
    1987 Darwin's Malthusian Metaphor and Russian Evolutionary Thought, 1859–1917. *Isis* 78:537–551
    1989 *Darwin without Malthus: The Struggle for Existence in Russian Evolutionary Thought.* New York: Oxford University Press.
Tonegawa, Susumu
    1985 The Molecules of the Immune System. In *The Molecules of Life: Readings from* Scientific American. Pp. 71–81. New York: W. H. Freeman and Company.
Treichler, Paula
    1987 AIDS, Homophobia, and Biomedical Discourse: An Epidemic of Signification. *Cultural Studies* 1(3):263–305.
Trenn, Thaddeus, and Robert Merton
    1979 Descriptive Analysis. In *Genesis and Development of a Scientific Fact,* by Ludwik Fleck. Thaddeus Trenn and Robert Merton, eds. Pp. 154–165. Chicago: University of Chicago Press.
Vander, Arthur J., James H. Sherman, and Dorothy S. Luciano
    1980 *Human Physiology: The Mechanisms of Body Function.* 3d edition. New York: McGraw Hill.
Woolf, Virginia
    1929 *A Room of One's Own.* London: Hogarth Press.

# 25

# The Mangle of Practice

## Agency and Emergence in the Sociology of Science[1]

### ANDREW PICKERING

*There is at all times enough past for all the different futures
in sight, and more besides, to find their reasons in it, and
whichever future comes will slide out of that past as easily
as the train slides by the switch.*

—WILLIAM JAMES, *THE MEANING OF TRUTH*

Desire only exists when assembled or machined. *You cannot grasp
or conceive of a desire outside a determinate assemblage, on
a plane which is not pre-existent but which must itself be
constructed.... In retrospect every assemblage expresses and creates a
desire by constructing the plane which makes it
possible and, by making it possible, brings it about....*
[Desire] is constructivist, not at all spontaneist.

—DELEUZE AND PARNET, *DIALOGUES*

The sociology of science has always been somewhat marginal to the discipline as a whole, perhaps because of the peculiar difficulties of its subject matter, but perhaps because its specifically sociological features have not appeared very interesting. While the philosophical import of sociological analyses of scientific knowledge has sometimes seemed scandalous, their sociological import has remained unremarkable.[2] Recently, however, science studies has become sociologically contentious. Ethnographic, ethnomethodological, reflexive, and actor-network critiques of earlier approaches to the sociology of science, and of the traditional sociological frameworks that they implement, have started to proliferate.[3] The representatives of the actor-network approach have been most outspoken. Bruno Latour writes that "the social sciences are part of the problem, not of the solution," and that "we strongly reject the helping hands offered us by the social sciences" (1988*b*, pp. 161, 165). And, at greater length, Michel Callon suggests that "to transform academic sociology into a sociology capable of following

technology throughout its elaboration means recognizing that its proper object of study is neither society itself nor so-called social relationships but the very actor networks that simultaneously give rise to society and to technology. . . . This notion makes it possible to abandon the constricting framework of sociological analysis with its pre-established social categories and its rigid social/natural divide" (1987, pp. 99–100).

Things are happening, then, in the sociology of science that might be of interest to the discipline more generally, and my aim in this essay is a constructive clarification of just what. Two points are, I think, clear, both of which are touched on in the quotation from Callon. First, as I will develop it, the critique of traditional sociologies of science depends on a heightened sense of time.[4] The idea that we should try to understand scientific practice in its temporal unfolding is a central theme of recent science studies, and along with this go doubts about traditional explanatory repertoires that center on enduring causes of action. Studies of scientific practice point instead to the *temporally emergent* structure of scientific research. Second, and more spectacular, the critique reflects an increasingly widespread conviction that the analysis of science calls for a decentering of the human subject. As a discipline, sociology has traditionally focused on human individuals and groups as the locus for understanding and explanation, and what is suggested here is a kind of *posthumanist* displacement of our interpretive frameworks.[5] Beyond this, though, things get murky. How we should conceptualize temporally emergent phenomena, how the posthumanist turn is to be accomplished, and how emergence and the displacement of the human subject are related to one another remain unclear, subject to confusion and debate. In what follows, I try to sort out these issues by delineating a general understanding of the structure of scientific practice which, for reasons explained later, I call *the mangle*.

To begin to explain the mangle by means of some of the salient issues, it is convenient to start with the theme of posthumanism. Traditional sociology of science, like traditional sociology more generally, is humanist in that it identifies human scientists as the central seat of agency. Conversely, traditional sociology of science refuses to ascribe agency to the material world (the introductory paragraphs of Pickering [1984a] actually express this perspective rather well). Here I subscribe to the basic principle of the actor-network approach: I think that the most direct route toward a posthumanist analysis of practice is to acknowledge a role for nonhuman—or material, as I will say—agency in science.[6] Science and technology are contexts in which human agents conspicuously do not call all the shots. But thinking about material agency and its relation to human agency proves tricky, and I will follow the spirit rather than the letter of the actor-network approach, at least as it is presently articulated by Callon and Latour. To see where the difficulties lie, we can turn to a recent critique of actor-network theory by Harry Collins and Steven Yearley.

Collins and Yearley (1992a; 1992b) seek to defend the classically humanist orientation of traditional sociology of scientific knowledge, which accords priority to the human subject through an asymmetric distribution of agency—all to human beings, none to the material world. To do so, they construct a dilemma that, they claim, faces anyone who wants to attribute a role to material agency in science. As analysts, they say, we have just two alternatives. We can see scientists as producing *accounts* of material agency, in which case these accounts fall into the domain of scientific knowledge and should be analyzed sociologically as the products of human agents, or we can try to take material agency seriously—on its own terms as it were—but then we yield up our analytic authority to the scientists themselves: scientists, not sociologists, have the instruments and conceptual apparatus required to tell us how material agency really is. The upshot of

this dilemma, therefore, seems to be that any sociologist with a shred of self-respect had better stick to humanist analysis of scientific accounting for material agency and had better not incorporate material agency per se into her interpretive schemes.[7] Callon and Latour do not see things quite this way, and neither do I, but here our positions diverge.

Callon and Latour (1992) reject the prongs of Collins and Yearley's dilemma. They insist, rightly I think, that there are not just two alternatives in the treatment of nonhuman agency. And their position, if I have understood it correctly, is this.[8] We should not see nonhuman agency in the terms offered us by scientists or by humanist sociologists of scientific knowledge. Instead we should think *semiotically*. Semiotics teaches us how to think symmetrically about human and nonhuman agents. In texts, agents (actors, actants) are continually coming into being, fading away, moving around, changing places with one another, and so on. It is important that their status can easily make the transit between being real entities and social constructs, and back again. Semiotics thus offers us a way of avoiding the horns of Collins and Yearley's dilemma: the agencies we speak about are semiotic ones, not confined to the rigid categories that traditional thought imposes.

This is a clever and ingenious response, but it brings with it two different kinds of problems. One concerns human agency, and I return to it below. The other concerns material agency. One of the most attractive features of the actor-network approach is that its acknowledgment of material agency can help us to escape from the spell of representation. Traditional accounts of science take it for granted that the end of science is to produce representations of how the world really is; in contrast, admitting a role for material agency points to the fact that, in common with technology, science can also be seen as a realm of instruments, devices, machines, and substances that act, perform, and do things in the material world. Or so I am inclined to think: this essay is actually part of an attempt to understand science as a field of performative material devices (and to understand scientific representation in relation to those devices rather than in its usual splendid isolation).[9] From this perspective the appeal to semiotics in the face of Collins and Yearley's dilemma looks like a kind of retreat, a return to the image of science-as-representation that one does not wish to make.[10] Fortunately, as I shall now explain briefly in anticipation of the empirical example to be discussed later, there is another way of steering our way around the humanists.

The trick is to link the posthumanist move to my other theme of temporal emergence. We can take material agency as seriously as traditional sociology has taken human agency, but we can also note that the former is *temporally emergent* in practice. The contours of material agency are never decisively known in advance, scientists continually have to explore them in their work, problems always arise and have to be solved in the development of, say, new machines. And such solutions—if they are found at all—take the form, at a minimum, of a kind of delicate material positioning or *tuning*, where I use "tuning" in the sense of tuning a radio set or car engine, with the caveat that the character of the "signal" is not known in advance in scientific research.[11] Thus, if we agree that we are interested in achieving a *real-time* understanding of scientific practice—and this is a fundamental stipulation of the actor-network approach that the remainder of this essay shares—the scientist is in no better a position than the sociologist when it comes to material agency. No one knows in advance the shape of future machines, but as sociologists we can track the process of establishing that shape without returning to the humanist position that only human agency is involved in it. Of course, after the fact, scientists often offer highly persuasive technical accounts of why the machinic field of science—the field of machines and their powers—has developed in specific ways. But for the purposes of real-time accounting, the sub-

stance of such retrospective accounts is one aspect of what needs to be analyzed; it would make no sense to bow to the scientists and project their retrospection backward in time as part of our explanation. This is my basic thought on how to think about the role of nonhuman agency in scientific practice.

Now for the second difficulty with the actor-network approach's semiotic move, the one that centers on human agency. Semiotics imposes an exact symmetry between the human and material realms. Semiotically, as the actor-network approach insists, there is no difference between human and nonhuman agents: human and nonhuman agency can be continuously transformed into one another. This, I think, is the sticking point for many people as far as the actor-network approach is concerned. Specifically, the sticking point is called *intentionality*. We humans differ from nonhumans precisely in that our actions have intentions behind them, whereas the performances (behaviors) of quarks, microbes, and machine tools do not. I think that this is right. I find that I cannot understand scientific practice without reference to the intentions of scientists, though I do not find it necessary to have insight into the intentions of things.[12] The key remark, for me, is that we humans live in time in a particular way. We construct goals that refer to presently nonexistent future states and then seek to bring them about. I can see no reason to suppose that DNA double helices or televisions organize their existence thus—why should they? So, with a thrill of transgression, in what follows I intend to commit the sin of breaking a symmetry: I will sketch out an analysis of human intentionality that has no material counterpart.[13]

Having said that, though, I need to qualify my faithlessness. A considerable degree of symmetry remains in my account of scientific practice. First, I will argue in the context of my empirical example that human agency is, just like material agency, temporally emergent. We can say more about the intentional structure of the former, but in the end it, too, simply emerges in the real time of practice.[14] Furthermore, I will argue that the trajectories of emergence of human and material agency are constitutively enmeshed in practice by means of a dialectic of resistance and accommodation. Here I return to the fold: like the actor-network approach, my analysis of scientific practice is posthumanist not simply in its twinning of human with material agency but, more profoundly, in its insistence that material and human agencies are mutually and emergently productive of one another.

Now I can talk about the mangle. In a restricted sense, the dialectic of resistance and accommodation just mentioned is what I mean by the mangle of practice. "Mangle" here is a convenient and suggestive shorthand for the dialectic: for me, it conjures up the image of the unpredictable transformations worked upon whatever gets fed into the old-fashioned device of the same name used to squeeze the water out of the washing. "Mangle" can also be used as a verb: I want to say, for example, that the contours of material agency are mangled in practice, meaning emergently transformed and delineated in the dialectic of resistance and accommodation.[15] In a broader sense, though, I take the mangle to refer not just to this dialectic but to an overall image of practice that encompasses it—to the worldview, if you like, that sees science as just described, as an evolving field of human and material agencies reciprocally engaged in the play of resistance and accommodation. An exposition of the mangle in this broader sense is, then, my way of coming to grips with the themes of temporal emergence and posthumanism and their interrelation in the sociology of science.

To go any further, we need an empirical example to hang on to, and for the remainder of the essay I focus on the development of the bubble chamber as an instrument for experimental research in elementary-particle physics.[16] I begin by telling the history of the bubble chamber,

concentrating on the work of Donald Glaser, the chamber's inventor, exemplifying my key concepts of resistance and accommodation—the mangle, in its restricted sense—and emphasizing the goal-oriented nature of Glaser's practice. I then offer a commentary on this episode organized around my themes of agency and emergence. I suggest that we should see the chamber as a locus of nonhuman agency, and I argue that both its material contours and accounts of its character (scientific knowledge) were emergently produced in the real-time dialectic of resistance and accommodation—they were, as I put it, mangled. Turning to human agency, I analyze the intentional structure of Glaser's practice in terms of modeling and argue that Glaser's plans and goals were likewise emergently mangled. I further note that this mangling extended to the social contours of human agency. Not just the vectors of human agency are transformed in practice, then: the unit of analysis changes too. Finally, I compare my account of human agency with traditional humanist accounts of interests and constraints in a way that highlights the posthumanist intertwining of human and material agencies in the mangle.

## BUILDING THE BUBBLE CHAMBER

I turn to the early history of the bubble chamber, an instrument that became the principal tool of experimental elementary-particle physics in the 1960s and 1970s, and I start with some basic technical background. A typical particle-physics experiment has three elements. First, there is a beam of particles—protons, electrons, or whatever. This beam can be derived from natural sources, such as the flux of cosmic rays that rains sporadically on the earth, or it can be artificially produced in a particle accelerator. Second, there is a target—a chunk of matter that the beam impinges on. Beam particles interact with atomic nuclei in the target, scattering—changing energy and direction—and often producing new particles. Third, there is a detector, which registers the passage of the scattered and produced particles in a form suitable for subsequent analysis.

The instruments that we need to think about are cloud chambers and bubble chambers, and since their working principle is similar, a description of the former will suffice for now. A cloud chamber is basically a tank full of vapor held under pressure, which doubles as both target and detector. Particle beams impinge on the vapor and interact and scatter there; when the pressure is released, the vapor begins to condense and small droplets of liquid form first as strings marking the trajectories of any charged particles that have recently passed through it. These "tracks" are photographed as permanent records of any particle interactions or "events" that occurred within the chamber. Now to history, where I follow Peter Galison's account (Galison 1985).

In the early 1950s, a problem was widely recognized in the physics of the so-called strange particles. These particles had been discovered in cosmic-ray experiments using cloud chambers, but it was proving very hard to accumulate data on them. Strange-particle events seemed to be very rare. At this point, Donald Glaser, then beginning his career at the University of Michigan, set himself a new goal. He wanted to construct some new kind of detector, like the cloud chambers that he had worked with as a graduate student but containing some denser working substance. His reasoning was simple: event rates are proportional to the mass of the target for a given beam intensity, so if he could work with a denser medium, he would stand more chance of finding the strange-particle events of interest. He began to investigate a range of techniques using liquids and solids that would, he hoped, register particle tracks like those produced in

cloud chambers, but these failed, one after the other.[17] None of them produced anything like a particle track. These failures constituted, to introduce a key term, a sequence of *resistances* for Glaser, where by resistance I denote the occurrence of a block on the path to some goal. I should emphasize that I want to use "resistance" in just this sense of a practical obstacle, and I do not mean it to refer to whatever account scientists might offer of the source of such obstacles. More on such accounts later; first I want to describe Glaser's responses to such resistances as *accommodations:* in the face of each resistance he devised some other tentative approach toward his goal of a high-density detector that might, he hoped, circumvent the obstacles that he had already encountered. In the early trials, these accommodations took the simple form of moving from the exploration of one working substance and technique to the next. His practice took the form, then, of a dialectic of resistance and accommodation that shifted him through the space of all of the potential new detector arrangements that he could think of. This dialectic is what, in its restricted sense, I call *the mangle of practice.*

Glaser's practice reached a temporary resting place in 1952 when he built the first prototypes of a new detector that worked—the bubble chamber. Its operating principle was like that of the cloud chamber, but instead of being filled with a vapor it was filled with a superheated liquid held under pressure. When the pressure was released, boiling began and small bubbles (instead of droplets) formed along the tracks of particles and could be photographed. The main point to note here is that the liquid filling of the bubble chamber was much denser than the vapor used in cloud chambers, and thus the former held out the promise of the higher event rates that defined Glaser's goal.

Glaser made his work public in early 1953, and I want to concentrate on subsequent developments, since they have an interesting social dimension that earlier ones lack. After Glaser's public announcement of the chamber, several individuals and groups quickly set to work to develop the chamber into a practical instrument, most notably Glaser himself in Michigan, Luis Alvarez at Berkeley, and a group at the University of Chicago. (Glaser and Alvarez were awarded the Nobel prize in physics for this work in 1960 and 1968, respectively.) A point that I want to stress for future reference is that quite different goals were constructed around the bubble chamber at the three locations. In this respect, the work of Alvarez's group was the most impressive, establishing a basis for the big-science approach to particle-physics experiment that came increasingly to dominate the field in the 1960s. I will stay largely with Glaser, however, since his work exemplifies clearly and simply the emergent and posthumanist aspects of practice that I want to emphasize. I will make comparisons with Alvarez's work whenever it is useful.[18]

Prior to his invention of the bubble chamber, Glaser had trained and worked as a cosmic-ray physicist. He was used, that is, to doing particle physics using naturally occurring cosmic rays rather than beams artificially produced in accelerators. And, after the development of the prototypes, his goal became that of inserting his new detector into his existing specialty. Here another resistance was apparent. Since cosmic rays arrive at the surface of the earth erratically, there was little chance of detecting interesting cosmic-ray events by expanding a bubble chamber at random: the odds were high that nothing would be happening at the instant chosen. This problem was already familiar to physicists working with cloud chambers, and the established solution was to use a different kind of detector as a "trigger." A small electronic detector would be rigged up to register the passage of cosmic rays, and its output would be used to initiate the expansion of the chamber. In this way, photographs would be taken only when there was a good chance of finding interesting events.

In the extension of his prototype chambers, therefore, Glaser adopted this triggering strategy—and failed. He found that when he wired his bubble chamber to an electronic trigger it did not produce any tracks. Once more a resistance had appeared on the path to his intended goal, and once more there followed a sequence of attempted accommodations. The material form of the bubble chamber was mangled in this process, as it was attached to a whole series of different triggering arrangements, ending with an attempt to trigger the chamber on the sonic plink that accompanied initial boiling.[19] None of these material transformations worked, and Glaser's next accommodation was more drastic.

Glaser's response to the continuing failure of his attempts to trigger his chamber on cosmic rays was, in fact, twofold. One line of response was to construct a conceptual account of the resistances that he had run into. He reasoned that he had failed because the time required for mechanical expansion of the chamber was greater than the lifetime of tracks within it; triggering, then, had to fail. This accommodation thus took the form of a mangling—an additive one, in this instance—of his *knowledge* about bubble chambers: he had learned something about them in his practice. And this knowledge hung together with his second line of accommodation, which was to revise his goal. He abandoned the attempt to use the bubble chamber in cosmic-ray physics and decided instead to put it to work in the accelerator laboratory. There, bunches of particles arrived at precisely timed intervals, so that one could expand the chamber by the clock and the problem of triggering would not arise.

I will discuss Glaser's work in accelerator physics in a moment, but first I want to emphasize that his departure from cosmic-ray physics served to bring out a social dimension of his practice. Glaser later put it this way: "There was a psychological side to this. I knew that large accelerators were going to be built and they were going to make gobs of strange particles. But I didn't want to join an army of people working at the big machines. . . . I decided that if I were clever enough I could invent something that could extract the information from cosmic rays and you could work in a nice peaceful environment rather than in the factory environment of big machines. . . . I wanted to save cosmic-ray physics" (Galison 1985, pp. 323–24).

The peace versus factory opposition in this quotation points to the tension between two distinct forms of work organization that can be discerned in the physics of the early 1950s, "small science" and "big science." Small science was the traditional work style of experimental physics—an individualistic form of practice, needing only a low level of funding obtainable from local sources, requiring little in the way of collaboration, and promising quick returns on personal initiatives. Big science was the new work style and organizational form that had been born in the United States weapons laboratories of World War II and that made its presence strongly felt in the early 1950s in accelerator laboratories like E. O. Lawrence's at Berkeley, Luis Alvarez's base. Big science was done by teams of physicists and engineers, hierarchically organized; it was characterized by a high level of funding and the bureaucratic processes associated with that, a high degree of interdependence in obtaining access to accelerator beams and in the conduct of experimental research, and a relative lack of flexibility in its response to individual initiatives (for more nuanced historical discussions of big science, see Galison and Hevly [1992]). As the quotation makes clear, Glaser's attachment was to small science, an attachment that, as we shall see, he maintained even as he moved into accelerator-based physics, the home of big science.

With the triggering problem sidestepped, Glaser still faced one difficulty. His prototypes were very small devices, approximately one inch in linear dimensions. They demonstrated the possibility of detecting particle tracks, but in themselves they could not compete in data-

production rates with other kinds of detectors already in use at accelerators. The key variable was again their mass as a target: Glaser's prototypes simply failed to put enough stuff in the path of the beam. The question was, then, how to scale up the bubble chamber. This was partly a question of its linear dimensions but also a question of the working fluid: the denser the fluid, the smaller a chamber of given mass could be. Glaser had initially, for convenience, used ether as his working substance. At Berkeley, Alvarez opted to work with liquid hydrogen since data taken on hydrogen were the most easily interpreted, and the low density of liquid hydrogen implied the construction of a relatively large chamber (eventually 72 inches long). This was the route that led directly into classic big science, the route that Glaser wanted to avoid, which he did by seeking to construct a liquid xenon–filled chamber. Since xenon was much denser than hydrogen, he reasoned that a considerably smaller chamber than Alvarez's could be constructed that would still produce interesting physics. His goal with the xenon chamber was to find "one last 'unique niche that I could [fill] at Michigan without access to all this high technology and large engineering staffs'" (Glaser quoted in Galison 1985, p. 327).

Work proceeded on the xenon chamber, but when completed the chamber yet again failed to produce any tracks whatsoever. Once more a resistance had interposed itself between Glaser and his goal. This time, though, Glaser quickly found a way around it. At the suggestion of colleagues at the Los Alamos laboratory, Glaser and his collaborators tried adding a "quenching" agent, ethylene, to their chamber, and this accommodation was successful. Tracks appeared, and serious experimentation was underway by 1956. The success of adding ethylene additionally invited a reappraisal of the mechanism of bubble formation by charged particles, and the interpretive model that Glaser had worked with all along was abandoned in favor of the "heat spike" theory formalized by Frederick Seitz in 1958. This last sequence of resistance and accommodation in accelerator physics, then, mangled both the material and conceptual aspects of the culture of particle physics: a new material form of the chamber, the quenched-xenon chamber, and new knowledge, a new understanding of the chamber's functioning, emerged together. And further, as I now want to describe, the social dimension of Glaser's practice was mangled in the xenon project too.

Glaser's research before the switch to accelerator physics had been typical small science. From June 1950 to November 1952—the period that saw the invention and early development of the bubble chamber—he worked in collaboration with a single graduate student, David Rahm, and was supported by the University of Michigan with a total of $2,000. At the end of 1952, the university increased its support to $3,000 per year. This is to be contrasted with the funding and manpower of the xenon-chamber project, where "part-time salaries for Glaser, Martin Perl (a new faculty member), a secretary, and four research assistants added to the salaries for a full-time postdoc and a full-time machinist-technician came to about $25,000. Equipment, supplies, and machining ran about the same" (Galison 1985, p. 327). While seeking to propagate the small-science work style, then, Glaser had clearly, in scaling up the chamber and switching to xenon, evolved something of a hybrid, by no means as solitary and independent as the classic form. But Glaser's xenon project should in turn be compared with Alvarez's liquid-hydrogen effort at Berkeley. Although the precise extent of Alvarez's empire has never, to my knowledge, been precisely mapped, Galison's account of the work at Berkeley mentions eleven collaborators—physicists, engineers, and graduate students—and it is probably enough to note that the project was eventually funded by the Atomic Energy Commission at $2.5 million and that Alvarez delegated to Don Gow "a new role that is not common in physics laboratories, but is well known in

military organizations; he became my 'chief of staff.' In this position, he coordinated the efforts of the physicists and engineers; he had full responsibility for the careful spending of our precious 2.5 million dollars, and he undertook to become an expert second to none in all the technical phases of the operation, from low temperature thermodynamics to safety engineering" (Alvarez [1987*b*, p. 259], quoted in part in Galison [1985, p. 334]). In comparison with Alvarez's program, then, which set the standard for bubble-chamber physics in the 1960s, the continued links between Glaser's work on the xenon chamber and small science remain evident.

Before I turn to a general discussion of this passage of practice, two last items of historical information can be included, both of which bear on the social dimensions of particle physics. Galison notes that "in 1960 Glaser moved to Berkeley to join the growing team of hydrogen-bubble-chamber workers. Shortly afterward, in large part because of his disaffection with the large team, he left physics for molecular biology," and, "indeed, by February 1967 Alvarez too had begun to devote almost all his time to other projects, principally his balloon work on cosmic rays" (1985, p. 353). There is a wonderful circularity here, with Alvarez regaining (something like) small science in the field that Glaser had failed to save with the bubble chamber.[20]

## AGENCY, EMERGENCE, AND THE BUBBLE CHAMBER

In telling the story of the bubble chamber, I have introduced the key idea of the dialectic of resistance and accommodation that I call the mangle, and I have outlined the mangling of the material, the conceptual, and the social in Glaser's practice. Now I need to connect this story to my earlier remarks on agency and temporal emergence. I talk first about nonhuman or material agency and then about human agency. In both phases of the discussion the posthumanist intertwining of agency is evident, but in a third stage I seek to highlight the posthumanism of the mangle from a different angle in a comparison of my account of human agency with traditional humanist schemas.

### MATERIAL AGENCY

The most obvious source of agency in my historical narrative is human: I found it necessary to refer several times to Glaser's plans and goals in order to make sense of the story. But my frequent references to the resistances that Glaser encountered en route (he hoped) to those goals should make it clear that he, as a human agent, was not in control of history, and the best way that I can find to think about such resistance is by symmetrizing the picture. As I suggested in the introduction, to understand what is going on in this example, we need to think of Glaser as struggling in his practice with nonhuman agency, somehow centered, in this instance, on the bubble chamber. Just how we should speak of its location is, however, another matter. In general, I can think of two ways to proceed.

On one hand, it seems reasonable to see the bubble chamber itself as an agent. Bubble chambers, when they work, produce tracks and photographs in a way that is not substantively attributable to any human agent. Scientists build and operate chambers, but neither *that* tracks appear in them nor the specific configuration of those tracks is in the hands of the chamber's human companions. On the other hand, one might want to see bubble chambers as not themselves agents but as devices, traps, for capturing (seducing, mobilizing) the agency of elementary

particles. One might think of them as intermediaries that induce the particles to write.[21] I do not think that it matters which form of words one chooses. In the present instance, the latter seems possibly more appropriate, whereas if we were talking about technological artifacts like machine tools or gas turbines, the former might be, but all that my analysis requires is the idea that, in using bubble chambers, physicists are indeed dealing with some form of nonhuman agency.[22] Now I want to connect this idea to my theme of temporal emergence.

The key point that I want to emphasize is that the precise material configuration of nonhuman agency (and its precise character—just what it would do) was temporally emergent in the real time of Glaser's practice. It should be clear from the historical narrative that Glaser had no way of knowing in advance that most of his attempts to go beyond the cloud chamber would fail but that his prototype bubble chambers would succeed, or that most of his attempts to turn the bubble chamber into a practical experimental device would fail but that the quenched xenon chamber would succeed. In fact, *nothing* identifiably present when he embarked on these passages of practice determined the future evolution of the material configuration of the chamber: Glaser had to find out, in the real time of practice, what the contours of material agency might be. This process of finding out is what I have conceptualized in terms of the dialectic of resistance and accommodation, and one can rephrase what has just been said by pointing to the brute emergence of resistance. There is no real-time explanation for the particular pattern of resistances that Glaser encountered in his attempts to go beyond the cloud chamber: in his practice, these resistances appeared as if by *chance*—they *just happened.* It just happened that when Glaser configured his instrument this way (or this, or this) it did not produce tracks, but when he configured it that way, it did. This is the strong sense of temporal emergence implicit in the mangle.[23]

Here it might be useful to return briefly to Collins and Yearley's dilemma concerning material agency. Their argument was that one has either to think about accounts of material agency as the products of human actors or about material agency itself along the lines of the scientists' accounts of it (thus ceding analysis of science to the scientists themselves). As I indicated earlier, the present analysis of material agency as temporally emergent evades both horns of this dilemma. It both recognizes material agency as that with which scientists struggle—that is, as prior to any scientific accounting—and denies that we have to fall in with such scientific accounting. Having said that, of course, attention needs to be paid to the fact that Glaser did produce accounts of the functioning of the bubble chamber—knowledge—as he went along. He explained the failure of triggering in terms of the response time of the bubble chamber, and the initial failure of the xenon chamber in terms of a revised understanding of the mechanism of bubble formation.[24] But, as I noted in the introduction, such accounts pose no problem for real-time analysis of practice—they should themselves be seen as part and parcel of the mangling process, as products of the dialectic of resistance and accommodation, at once retrospective glosses on emergent resistances and prospective elements of strategies of accommodation. Their substance can no more be understood in advance of practice than the material contours of nonhuman agency. Both material agency and articulated scientific accounts thereof are temporally emergent in the mangle.

One last point concerning material agency: I need to emphasize that the present discussion does not imply a technological determinist vision of science. The important remark in this connection is that the trajectory of emergence of material agency does not have its own pure and autonomous dynamics. Material agency does not, as it were, force itself upon scientists; there is,

to put it another way, no such thing as a perfect tuning of machines dictated by material agency as a thing-in-itself; or, to put it yet another way, scientists never grasp the pure essence of material agency. Instead, material agency emerges by means of an inherently *impure* dynamics. The resistances that are central to the mangle are always situated within a space of human purposes, goals, and plans; the resistances that Glaser encountered in his practice only counted as such because he had some particular ends in view. Resistances, in this sense, are *liminal:* they exist on the boundaries, at the point of intersection, of the realms of human and nonhuman agency. They are irrevocably impure human/material hybrids, and this quality immediately entangles the emergence of material agency with human agency (without, in any sense, reducing the former to the latter). This entanglement is, so to speak, the far side of the posthumanism of the mangle: material agency is sucked into the human realm through the dialectic of resistance and accommodation. Now I turn to the converse proposition—that human agency is itself emergently reconfigured in its engagement with material agency.

## HUMAN AGENCY

Donald Glaser was certainly as much an agent in the development of the bubble chamber as the chamber itself: like the chamber, Glaser did things in the world that were constitutive of the historical pattern of events. Beyond this, though, as I indicated in the introduction, it seems that one can say more about Glaser's agency than the chamber's. In particular, human agency in this instance has an interesting temporal structure that material agency lacks. It seems unnecessary, at best, to think that a bubble chamber has any future end or purpose in view when it produces tracks upon expansion. In contrast, one cannot understand Glaser's practice without recognizing its orientation to future goals. Glaser did not assemble bits and pieces of apparatus in the laboratory just for its own sake; he had an end in view—the end of constructing and deploying some novel particle detector. Much of what Glaser did has to be understood as tentative steps toward that end. To get to grips with what is special about human agency, then—to break the perfect human/nonhuman symmetry of actor-network semiotics—one needs to think about the intentions, goals, purposes, or whatever of human action.

A first relevant observation is that goals have to be seen as temporally enduring relative to the details of the passages of practice that are oriented to them. A goal is a relatively fixed image of some future state of affairs at which temporally extended passages of practice aim. And from this observation, it would be a small step to the idea that the intentional structure of human agency has a temporally nonemergent quality. The body of literature in the sociology of scientific knowledge discussed in the following section can easily be read in this way. In general, though, I think that this line of thought is mistaken and that we should see the intentional structure of human agency as itself temporally emergent, albeit on a longer time scale than the details of practice.

To see what is at issue, we can begin by thinking about the formulation of goals. It is clear, I believe, that scientists do not formulate goals at random: the future states of affairs at which practice aims are constructed from present states in a process of *modeling.*[25] Glaser, for example, initially sought to manufacture new detectors modeled upon the cloud chamber—like the cloud chamber in certain respects, but transformed in others. Later, he (and others) sought to construct useful bubble chambers modeled on Glaser's own prototypes. Models are, I think, constitutive of scientific practice, in the sense that it is impossible to imagine Glaser embarking on the path that led to the bubble chamber without the example of the cloud chamber before him. This

centrality of modeling to goal formation situates human agency with respect to the cultural field in which it operates—the field of existing detectors, in the present example. And such cultural situatedness immediately implies a degree of both temporal emergence and posthumanist intertwining in the intentional structure of human agency. Concerning the former, I argued earlier that, for example, the precise material configuration and properties of Glaser's prototype chambers were temporally emergent, and the present discussion connects that emergent form to the goals of Glaser's subsequent practice. The goals of scientific practice must be at least as emergent as the models on which they are based. The posthumanist aspect of those goals follows equally directly. Though Glaser formulated the goals of his practice as a classically human agent, the field of existing detectors in which he formulated those goals was a field of material agency. There is, then, a temporal and posthumanist interplay here between the emergence of material agency and the construction of human goals.

More needs to be said on the nature of modeling in scientific practice, but before that I want to bring the social nature of human agency into the discussion. So far I have talked about modeling as it was constitutive of the technical goals of Glaser's practice, but the analysis is also applicable to the social means that Glaser envisaged en route to those goals. Thus I think that it makes sense to see the small-science pattern of work organization in cosmic-ray physics as functioning as a model in Glaser's practice: he imagined the work of constructing and using new detectors as proceeding along small-science lines. The significance of these remarks should become clearer shortly; for the moment, let me just note that the conception of modeling makes it possible to think about the emergence of both material agency and the social contours of human agency along the same lines.

My next observation is that modeling is an *open-ended* process with no determinate destination: a given model does not prescribe the form of its own extension.[26] Glaser tentatively imagined and sought to construct a whole range of different kinds of detectors—all modeled, in one way or another, on the basic form of the cloud chamber—before eventually succeeding with the bubble chamber. Likewise Glaser, Alvarez, and the Chicago group sought to develop Glaser's prototypes along quite different axes, and Glaser himself, as we have seen, developed the model in many different ways—first the several versions of the triggered chamber for cosmic-ray physics and then the variants of the xenon chamber. Modeling, then, is the link between existing culture and the future states that are the goals of scientific practice, but the link is not a causal or mechanical one: the choice of any particular model opens up an indefinite space of different goals. And the question therefore arises of why particular scientists fix on particular goals within this space. Here I have no principled suggestions. One can speak of scientific creativity, or one can say that the formulation of goals just happens: it just happened, for example, that Glaser set himself the goal of going beyond the cloud chamber, that along the way he hit on the idea that led him to the bubble chamber, and so on. Certainly nothing identifiably present in advance determined the intentional structure of his practice. Again, then, we run into a role for chance and brute temporal emergence in scientific practice, and we need, therefore, to think about the intentional structure of scientific practice as being emergent in at least two senses: practical goals are constructed in a temporally emergent cultural field, and their detailed substance is itself emergently constructed in that field.[27] But more remains to be said. An orientation to future goals serves to distinguish human from material agency, but does not exhaust the former. We need to think about what goal-oriented human practice looks like in its temporal extension.

Most of Glaser's practice did not involve the formulation of goals; it consisted rather in material attempts to achieve such goals. He knew the kind of detectors that he wanted to construct and spent most of his time trying to make them. The latter consideration, of course, returns us to the mangle, to the dialectic of resistance and accommodation in the engagement with material agency. And the point that I now need to stress is that accommodation amounts, to a greater or lesser extent, to revision of plans and goals, to a revision of the intentional structure of human agency. When Glaser gave up the attempt to trigger his chamber, for example, at the same time he gave up the idea of inserting his new detector into cosmic-ray physics and relocated his goal to the accelerator laboratory. Goals, then, while relatively enduring through time, have themselves to be seen as subject to mangling in practice.[28] This observation, in turn, brings us to the third and last sense in which I want to describe intentionality as temporally emergent: the transformation of goals in practice has to be understood in terms of contingently formulated accommodations to temporally emergent resistance. And it points, yet again, to the posthumanism of the mangle. As I remarked when discussing material agency, resistance emerges at the intersection of human and material agency and, as the present argument suggests, serves to transform the former in one and the same process as it delineates the latter. Just as the mangle, then, pulls material agency onto the terrain of human agency, so it materially structures human agency. Just as the evolution of material agency lacks its own pure dynamics, so too does the evolution of human agency.

One last thread remains to be picked up in this stage of the discussion. In the previous section I emphasized the temporal emergence of the material configuration of nonhuman agency, and now I want to symmetrize my analysis by making a similar point about the contours of human agency. I have so far been talking about the intentional structure of Glaser's agency, but now it is time to note that the identity of "Donald Glaser," as he figured in my narrative as the bearer and executor of intentions, varied with time. At the beginning of the narrative, "Glaser" denoted an almost classic microactor—a single human individual (though, even in his early work at Michigan, Glaser was assisted by a graduate student)—whereas in the xenon-chamber project, as we have seen, "Glaser" had become something of a macroactor, denoting a team of no fewer than nine people. Here, again, I want to emphasize the temporal emergence of this transformation of the social contours of human agency. No one could have foreseen in advance that this transformation would come about; no identifiable feature of Glaser's initial situation determined it. Glaser did not intend it at all. Instead, Glaser's small-science model, as I expressed it above, was itself open-endedly mangled in practice.[29] And again I want to emphasize the posthumanist decentering of this mangling. The social evolution of Glaser's work style was itself constitutively the product of maneuvers in the field of material agency. Most strikingly, perhaps, it seems clear that Glaser's practice would have remained much more individualistic if he had succeeded in triggering his chamber on cosmic rays; likewise, the nine-person team would have collapsed if the xenon-chamber project had failed. Here, as before, then, one needs to think of the impure dialectic of resistance and accommodation between human and material agencies to comprehend the mangling of the social contours and embodiment of the former.[30] The social aspects of Glaser's practice did not evolve in accordance with any pure social dynamics; no purely sociological explanation can suffice to explain Glaser's transformation toward the status of a macroactor.

## INTERESTS, CONSTRAINTS, AND THE MANGLE

To complete my presentation of the mangle, it might be useful to thematize its emergent posthumanism from a different angle, so I close with a brief comparison of my account of human agency with traditional humanist accounts. The latter fall into two classes. One class—encompassing, for example, pragmatist and symbolic-interactionist approaches—explicitly recognizes the emergence of human agency and differs from my account only in its human-centeredness.[31] I do not need to discuss it further here. The other class, though, is often cast in nonemergent terms, and this is the class that I need to focus upon. It can itself be subdivided into two rather different understandings of human agency. On one hand, following Marx and Weber, human agency can be characterized positively in terms of, say, the *interests* of individuals and groups. On the other, following Durkheim, it can be characterized negatively, in terms of *constraints* on human action. Both of these lines of thought have been articulated within the sociology of scientific knowledge: the latter by David Bloor (1983), for example, the former in the writings of Barry Barnes (1977; 1982), Steven Shapin (1979; 1982; 1988), and Donald MacKenzie (1981*b*). And it is clear that my account of human agency has resonances with both. Most obviously, my insistence that scientific practice has to be understood as goal-oriented aligns my analysis with the interest model—at least if one is willing to concede that interests are open-ended and subject to emergent redefinition in practice. The question arises, however, of just how interests are transformed in practice. In humanist analyses of science, at least, that question has never been clearly answered, effectively enforcing a nonemergent understanding by default.[32] The answer that I have offered is couched in terms of the dialectic of resistance and accommodation—the mangle—and here my appeal to resistance as an explanatory category clearly puts me somewhere near the terrain of the second accounting scheme, the one that understands human agency in terms of constraint. A clarification of the difference between my conception of resistance and traditional notions of constraint can, though, serve to bring to the foreground what is novel about the mangle.[33]

The point is this. In the humanist schema, constraint has two characteristic aspects. First, it is located *within* the distinctively human realm. It consists, say, in a set of social (or epistemic) norms, derived in some sense from social structure. And second, constraint is *nonemergent*, at least on the time scale of human practice. Constraints are continuously present in culture, even when not actively operative. The language of constraint is the language of the prison: constraints are always there, just like the walls of the prison, even though we only bump into them occasionally (and can learn not to bump into them at all).[34] My usage of resistance has neither of these qualities. As I have emphasized, in the real-time analysis of practice, one has to see resistance as genuinely emergent in time, as a block arising in practice to this or that passage of goal-oriented practice. Thus, though resistance and constraint have an evident conceptual affinity, they are, as it were, perpendicular to one another in time: constraint is *synchronic,* antedating practice and enduring through it, while resistance is *diachronic,* constitutively indexed by time.[35] Furthermore, while constraint resides in a distinctively human realm, resistance, as I have stressed, exists only in the crosscutting of the realms of human and material agency. Resistance (and accommodation) is at the heart of the struggle between human and material realms in which each is interactively restructured with respect to the other—in which, as in our example, material agency, scientific knowledge, and human agency and its social contours are all reconfigured at once. Coupled with the rotation in time just mentioned, this displacement—from constraint as

a characteristic of human agency to resistances on the boundary of human and material agency—serves to define the emergent posthumanist decentering implicit in the mangle.[36]

NOTES

1. I have been lucky enough to receive much stimulating feedback while preparing this essay. Besides four referees of earlier drafts, I thank David Bloor, John Bowers, Geof Bowker, Nancy Cartwright, Soraya de Chadarevian, Norman Denzin, Irving Elichirigoity, Paul Forman, Dilip Gaonkar, Yves Gingras, Laurel Graham, Mary Hesse, Robert Alun Jones, Bruce Lambert, Bruno Latour, John Law, Peter Lipton, Michael Lynch, Ted O'Leary, Peter Miller, Malcolm Nicolson, Michael Power, Diederick Raven, Simon Schaffer, Steven Shapin, Barbara Herrnstein Smith, Leigh Star, Stephen Turner, and Adrian Wilson. Earlier versions have been presented at the Centre for History of Science, Technology and Medicine, Manchester University, the Science Studies Unit, University of Edinburgh, and the Centre de Recherche en Histoire des Sciences et des Techniques, la Villette, Paris, and at a Department of Accounting and Finance workshop, "The Components of Practice," at the London School of Economics. I am very grateful for comments and discussion at each. The present draft was completed while I was at the Department of History and Philosophy of Science of the University of Cambridge, England, and my work on it was partially supported by National Science Foundation grant SBE91–22809.

2. Thus the Mertonian approach to the sociology of science was a self-conscious continuation of the structural-functional approach that then characterized mainstream sociology (see Zuckerman [1988] for an extended review). The sociology of scientific knowledge (SSK, alternatively designated as the strong program, relativism, or constructivism) departed from it in seeking to offer an analysis of scientific knowledge itself and thus created some much-needed philosophical turmoil, but again drew upon stock sociological resources: Bloor (1991; 1983) elaborated a Durkheimian vision of the social constraints upon knowledge production, while Barnes (1977; 1982) and Shapin (1979; 1982) followed more Marxist or Weberian lines in characterizing scientists' agency in terms of interests. Collins's work (1992) was somewhat ambiguous in this respect, combining ethnomethodological sensitivities at the microlevel with an interest model at the macro. For the direct extension of SSK into the analysis of technology, see Pinch and Bijker (1984).

3. For examples, see Traweek's (1992) ethnographic account of particle physics, Lynch's (1992a; 1992b) argument with Bloor (1992) over ethnomethodological versus SSK-type readings of Wittgenstein, and the three-way argument between Collins and Yearley (1992a; 1992b), Woolgar (1992), and Callon and Latour (1992) over the relative merits of, respectively, SSK, reflexivity, and the actor-network approach. (For an earlier phase of the argument between reflexivity and the interest-model version of SSK, see Woolgar [1981a; 1981b], Barnes [1981], and MacKenzie [1981a].)

4. From one angle this can be seen as a product of the ethnographic studies of scientific practice that began in the late 1970s (with Fleck [(1935) 1979] as a notable precursor): see Latour and Woolgar (1986), Knorr-Cetina (1981), and Lynch (1985). From another angle, it appears as a continuation of the concerns of SSK; see Pickering (1984b) and Gooding (1990). Yet another source has been pragmatist studies of science (which take the work of Howard Becker and, esp., Anselm Strauss as their point of departure): see Star (1991, 1992) and Fujimura (1992).

5. By "posthumanist" I want to point to a displacement of the human subject from the center of sociological accounting rather than to an "antihumanist" effacement of the human subject. I finally grasped the significance of this move in conversations with John Law and in reading his recent work (Law 1993, e.g.). Barbara Herrnstein Smith also helped me by pointing out a "residual humanism" in a previous draft of this essay (the residue is still there: see below). That humanism is at the center of contention is made clear by Collins and Yearley (1992a; 1992b). Besides the further works cited below, my development of the posthumanist move owes a lot to Haraway (1991), Deleuze and Guattari (1987), and, more obliquely, to the writings of Michel Foucault. Foucault (1972) provides a general elaboration of the themes of temporal emergence and the displacement of the human subject, though how he connects these themes is not clear to me. I link them below in a discussion of agency, a topic on which Foucault displays a principled reluctance to speak. To make a connection between my analysis of scientific practice and Foucault's analysis of disciplinary mechanisms—see esp. Foucault (1979) and subsequent work in the analysis of the social sciences, management, and accountancy by Anthony Hopwood, Peter Miller, Ted O'Leary, and Nikolas Rose (Hopwood 1987; Miller 1992; Miller and O'Leary, 1994; Rose 1990; Rose and Miller 1992)—one needs only to think of disciplinary apparatuses as machines for capturing, channeling, and framing human agency (see below).

6. For recent important presentations of the actor-network position, see Callon (1991), Callon and Latour (1992), Latour (1987; 1988a), and Law (1993).

7. The denial of material agency serves not just to defend humanist sociology but, oddly enough, to make an alliance with mainstream philosophies of science that are themselves otherwise savaged by SSK. Mainstream philosophy of science, too, seeks to keep material agency at arm's length, preferring to talk only of accounts of agency as items of the theoretical culture of science. There is an alternative tradition in contemporary philosophy, though, that insists that one cannot make sense of science without talking about nonhuman agency (or powers, tendencies, dispositions, or capacities): see Bhaskar (1975), Cartwright (1989), Chalmers (1992), Harré and Madden (1975), and Mellor (1974). I thank Peter Lipton for introducing me to this body of writing; it shades into studies of scientific practice in the work of such authors as Baird (1993), Baird and Nordmann (1994), Hacking (1983; 1992), and Rouse (1987).

8. Let me say in advance that I do not feel too confident of my grasp of Callon and Latour's position (and neither, I suspect, do many of their critics and admirers). The argument that follows, and further arguments elsewhere in the text, might turn out to be hairsplitting. I hope that, even so, this essay can help to clarify matters, if only by marking some new routes across actor-network theory's terrain and by supplying a new example and analysis.

9. See also Pickering (1989) and Pickering and Stephanides (1992). In philosophy of science, Hacking (1983) was perhaps the first widely recognized attempt to escape from the purely representational idiom. I should note that much recent writing on scientific practice actually bears upon the work of constructing representations in science (technology, computer science, etc.): Star (1992) provides access to the literature. I have no quarrel with this line of enquiry, but my focus is elsewhere.

10. Semiotics cannot be the whole story about the actor-network understanding of nonhuman agency, and yet it has been a central theme since Latour and Woolgar's ([1979] 1986) emphasis upon scientific instruments as "inscription devices" and seems invariably to be invoked under pressure. Thus, in response to Collins and Yearley's argument, Callon and Latour (1992, p. 349, fig. 12.3) draw a diagram in which Collins and Yearley's dilemma is represented as a horizontal nature/society axis, to which Callon and Latour add a vertical axis on which they comment: "The vertical axis, however, is centred on the very activity of shifting out agencies—which is, by the way, the semiotic definition of an actant devoid of its logo- and anthropocentric connotations" (1992, p. 350). Likewise, in response to Schaffer's (1991) argument that Latour (1988a) depends on an illegitimate hylozoism—i.e., the imputation of agency to the nonhuman realm—Latour (1992) offers a reading of a single memoir by Pasteur. It seems clear that Latour's route to nonhuman agency in this instance is by means of texts in the most literal sense. (I have only an incomplete draft of Latour [1992], but I attended his seminar presentation of the paper, and conversation later seemed to confirm this judgment.) In a similar vein, Callon writes: "Sociology is simply an extension of the science of inscriptions. Now it should broaden its scope to include not only actors but the intermediaries through which they speak. . . . *The social can be read in the inscriptions that mark the intermediaries*" (1991, p. 140). The position that I take below is much closer to that developed earlier by John Law (in, e.g., Law 1987), where, without any detours through semiotics, he invokes natural forces as part of an actor-network account of the Portuguese maritime expansion.

11. Fleck (1979) discusses the tuning (in my terms) of the Wassermann reaction as a test for syphilis. He notes that "during the initial experiments it produced barely 15–20 percent positive results in cases of confirmed syphilis" (1979, p. 72), but that, after a period of collective development of the detailed performance of the reaction, the success rate rose to 70%–90%. Collins's (1992, chap. 3) account of the work of building a TEA laser can likewise be read as an ethnographic exemplification of the tuning of a material instrument. For more on the tuning of experimental devices in science, see Pickering (1984b, pp. 14, 20, 273–74, 409–10) and the works cited there. Note that it is implicit here that we are considering scientific practice as the work of extending, rather than reproducing, scientific culture—in the sense of building new machines and so on. I argue that material agency is temporally emergent in relation to practice so conceived. Whether material agency per se is temporally emergent is another matter. The relative reliability of certain machines—the fact that some magnets, cars, and TVs perform the same functions day after day, e.g.—indicates that some aspects of material agency evolve, at most, slowly on the time scale of human affairs. I thank Adrian Wilson for prompting me to think about this issue.

12. I am grateful to Simon Schaffer and Steven Shapin for pressing me on the issue of intentionality. They insist that the concepts of agency and intentionality are bound up together and that, therefore, one should not speak of material agency, but I do not think that this is correct. Thus, e.g., Harré and Madden (1975) are happy enough to speak of agency in nature without ever dreaming of imputing intentionality to it. Wise and Smith (1989, p. 419) quote William Whewell, writing in 1841 that "in many cases the work to be done may be performed by various agencies; by men, by horses, by water, by wind, by steam."

13. Ashmore (1993) is a brave and amusing, but not very persuasive, attempt to attribute intentionality to a material agent, namely a "catflap." The other way to preserve a symmetry between nonhuman and human agency is, of course, to deny intentionality to humans. This, I think, is John Law's (1993) strategy in describing human agents as "network effects" "performed" by organizational narratives or "myths" (note the return from agency to textuality via another route). Actually, I think the human/nonhuman symmetry has to be broken somehow, however fastidious one tries to be about it. In any approach that seeks to maintain the symmetry by emphasizing semiotics and textuality (and this includes reflexivity as well as the actor-network approach) it seems necessary to admit that while texts might be written jointly by humans and nonhumans (the latter doing so as or through "inscription devices") they are only read by the former. It might also be noted that Latour often seems to have a pretty clear notion of human intentionality, too. While the early image in Latour and Woolgar (1986) of an "agonistic" war of all against all—a general intention to dominate in battle—can be carried over symmetrically to nonhuman agents or to networks as well (Callon and Latour 1981), I do not think that the same can be said of Latour's (1987, pp. 108–21) later discussion of "translating interests." This latter seems to me only to be applicable to intentional human agents acting on other intentional human agents. For a thoughtful review of sociological understandings of intentionality, see Lynch (1992c); for a survey of recent thinking in the social sciences on human and nonhuman agency, see the contributions to Ashmore, Wooffitt, and Harding (1994).

14. Collins ([1985] 1992) is more or less alone in traditional sociology of science in emphasizing this point (see also my review, Pickering [1987]). Recognition of emergence in human agency aligns my position with symbolic-interactionist, ethnomethodological, and pragmatist sociologies more generally: Denzin (1992) surveys the history of

symbolic interactionism up to the present, stressing its links with pragmatism and ethnomethodology; Lynch (1992*a*) is a good entry point for ethnomethodological studies of science; for access to pragmatist studies of science and technology, see Star (1991; 1992) and Fujimura (1992). Laurel Graham and John Law have long encouraged me to think about the relation between my studies of science and symbolic interactionism; I regret that I did not follow their suggestions earlier.

15. If pressed too hard, the mangle metaphor quickly breaks down. A real mangle leaves the list of clothing unchanged—shirts in, shirts out—which is too conservative an image for the constructive aspect of scientific practice. "Mangling" also carries connotations of mutilation and dismemberment—"my teddy bear was terminally mangled in a traffic accident"—which carry one directly away from this constructive aspect. There is little to be done about this; I can think of no more appropriate word, one has simply to try take to the metaphor seriously enough but not too seriously. (Those of an acronymic turn of mind might substitute "the DRA"—the dialectic of resistance and accommodation—and "DRAed" for "the mangle" and "mangled" wherever they appear.) I thank, among others, Mike Lynch, Ted O'Leary, and Allan Megill for warning me of potential difficulties with mangle-talk and encouraging me to explain it more fully.

16. Several reasons recommend this particular example. The choice to focus on a scientific instrument is indicated by my present concern with material agency, and this is a historically significant instrument, central to two Nobel prizes (see below). As will also become evident, the history of the bubble chamber has an interesting social dimension that many similar histories lack. This social dimension is, however, not so rich or elaborate that it dominates the story, which is as it should be if the structure of the posthumanist displacement of the mangle is to be clearly expressed. Finally, there exists an excellent account of the history of the bubble chamber published by Peter Galison (1985) on which I can draw to establish my central points without myself telling the story in detail.

17. Galison (1985, p. 317) mentions attempts to record polymerization reactions in liquids and to develop track-sensitive Geiger counters as well as "diffusion" cloud chambers (these last improving event rates by being continuously sensitive rather than by having higher density).

18. Galison (1985) gives an extensive account of Alvarez's bubble-chamber work; Pickering (1990) is an analysis of Alvarez's practice along the lines laid out here but lacking the terminology of the mangle.

19. Galison (1985, p. 324) states that after the failure of conventional triggering, "many attempts then followed," including adding carbon dioxide to the chamber to try to slow down the speed of bubble formation.

20. For more on Alvarez's move into small science, see Alvarez (1987*a*).

21. This is the actor-network idea of a scientific instrument as an inscription device that leads immediately into a semiotic analysis. Let me just emphasize that I am interested here in the process of getting the bubble chamber (or particles) to write, not in what chambers have written over the last forty years.

22. Phrases like "induce the particles to write" smack of correspondence realism about scientific knowledge, as if the real existence of elementary particles were being taken for granted, so I should make it clear that such correspondence is no part of my argument. That such particles are responsible for the tracks in cloud and bubble chambers is *the scientists'* way of accounting for events (and is formally on a par with Glaser's accounts of the functioning of his bubble chambers, discussed below). In principle, such accounting should itself be subjected to real-time accounting—but not here. Callon (1991) indicates some appropriate moves in thinking about the precise location of material agency.

23. One can make a connection to early pragmatist philosophy here. Discussing the work of Charles Sanders Peirce, Cohen (1923, p. xix n. 11) explains that "Peirce's tychism is indebted to [Chauncey] Wright's doctrine of accidents and 'cosmic weather,' a doctrine which maintained against LaPlace that a mind knowing nature from moment to moment is bound to encounter genuine novelty in phenomena, which no amount of knowledge would enable us to foresee." The same doctrine is expressed in William James's (1907; 1909 [1978], p. 106) well-known sentiment that "experience, as we know, has ways of *boiling over,* and making us correct our present formulas."

24. As an antidote to correspondence realism, it is worth mentioning that the heat-spike model of bubble formation showed that Glaser's prior understanding, which he had relied on all along, was wrong (Galison 1985, p. 328).

25. I take the idea of modeling from traditional discussions in the history and philosophy of science of the role of metaphor and analogy in theory development. I prefer to speak of modeling since I want to apply the idea to the material culture of science, while metaphor and analogy are usually taken as having textual referents. Modeling, in Kuhnian terms, is developing an exemplar. For access to the relevant literature, see, e.g., Barnes (1982), Bloor (1991), Gooding (1990), Hesse (1966), Knorr-Cetina (1981), Kuhn (1970), and Pickering (1981; 1984*b*). There is now also a growing cognitive-science literature on the role of "mental models" in science and elsewhere (see Gentner and Stevens 1983; Rouse and Morris 1986; and Gorman 1992).

26. Barnes (1982) gives a very clear exposition of this point. On my analysis, the openness of modeling is a necessary counterpoint in the realm of human agency to the emergence of material agency.

27. No doubt more can be said about goal construction in science. Elsewhere (Pickering 1981; 1984*b*), I have argued that expertise is a key variable to consider in the dynamics of scientific practice: one can think of expertise as among the resources that scientists can deploy in pursuit of ends and, hence, as structuring the particular ends that given scientists choose to pursue. But two points about expertise need to be recognized: it is itself open-ended, being deployable in an indefinite range of future projects, and it is itself emergent—expertise comes with practice (and in a posthumanist fashion if that practice engages with material agency). The appeal to expertise does not, therefore, yield

a determinate account of goal formation. In Pickering (1990) I approached the problem from another angle, trying to analyze the goals that Alvarez formulated around the bubble chamber in terms of the intersection of modeling vectors and the piling up of cultural resources. Again, I think that this illuminates the processes of goal formation and elaboration, but it does not efface the elements of contingency and temporal emergence present in it.

28. If one thinks through strategies of accommodation in detail, some ambiguity between means and ends becomes evident in scientific practice. Thus it seems reasonable to see Glaser's move from cosmic-ray to accelerator-based physics as a shift in goal, while his moves through the space of possible triggering arrangements seem better described as the exploration of various possible means to an unvarying end. This ambiguity does not, however, undermine the present argument: both means and ends are bound up in human intentionality. Suchman's (1987) work on "plans and situated actions" is relevant and informative here.

29. Another way to put this point is to note that while Glaser's interest in small science was clear enough, he was not limited in his practice by any closed definition of it. In effect, he had to find out what would count as small science in the course of his project—or, equivalently, to find out what he was willing to tolerate as close enough to his basic conception of small science. Elsewhere (Pickering 1990) I make a similar point concerning Alvarez's finding out just what big science could amount to in bubble-chamber physics. As noted at the end of the historical narrative, both physicists eventually decided that the social organization of bubble-chamber work had become intolerable and left the field, but that this was an emergent upshot of practice is especially clear in the case of Alvarez, who had deliberately set out to construct the big-science form of life that eventually repulsed him (Alvarez 1987a).

30. The emergent "coproduction" of social structure and material agency is a central theme in the actor-network approach: for some exemplifications, see Callon (1987) and Latour (1983; 1987).

31. On pragmatist and symbolic-interactionist understandings of human agency, in science and more generally, see the works cited above in n. 14.

32. To make their point about "social construction," most studies in the sociology of scientific knowledge focus on instances where interests arguably remain constant through practice. In critical theory, Smith (1988, p. 32) spells out an emergent and posthumanist understanding of the intentional structure of human action: "What we speak of as a subject's 'needs,' 'interests,' and 'purposes' are not only always changing, but they are also not altogether independent of or prior to the entities that satisfy or implement them; that is, entities also produce the needs and interests they satisfy and evoke the purposes they implement. Moreover, because our purposes are continuously transformed and redirected by the objects we produce in the very process of implementing them, and because of the very complex interrelations among human needs, technological production, and cultural practices, there is a continuous process of mutual modification between our desires and our universe." Giddens (1979, p. 181) expresses a similar thought in social theory: "To be aware of one's interests, therefore, is more than to be aware of a want or wants: it is to know how one can set about trying to realise them. . . . Interests presume wants, but the concept of interest concerns not the wants as such, but the possible modes of their realisation in given sets of circumstances. . . . Interests imply potential courses of action, in contingent social and material circumstances." In a similar vein, see the quote from Deleuze and Parnet (1987) at the beginning of this essay. For a fascinating discussion of "interest" and related concepts in early German social theory, see Turner (1991).

33. I thank Michael Lynch and others who, in professing to see no difference between resistance and constraint, forced me to think this issue through.

34. Thus Giddens (1984, p. 174) conceptualizes the whole Durkheimian tradition like this: "The structural properties of social systems . . . are like the walls of a room from which an individual cannot escape but inside which he or she is able to move around at whim." In contrast to this picture, Giddens's structuration theory "is based on the proposition that structure is always both enabling and constraining" (1984, p. 169). Hence, the previous quotation continues, "Structuration replaces this view [of complete freedom within a room] with one which holds that structure is implicated in that very 'freedom of action' which is treated as a residual and unexplicated category in the various forms of 'structural sociology.'" The residual, nonemergent and unexplicated walls are still there, though. (Giddens later abandons metaphor for something close to tautology: "What, then, of structural constraint? . . . It is best described as *placing limits upon the range of options open to an actor*" [1984, pp. 176–77].) For a poetic variation on the theme, see Ginzburg (1980, p. xxi): "In the eyes of his fellows, Menocchio was a man somewhat different from others. But this distinctiveness had very definite limits. As with language, culture offers to the individual a horizon of latent possibilities—a flexible and invisible cage in which he can exercise his own conditional liberty"—an invisible rubber prison with very definite limits. As Shapin (1988, n. 14) notes, even Latour is not immune from this style of nonemergent thinking, as, for instance, in his idea that "interests are elastic, but like rubber, there is a point where they break or spring back" (Latour 1987, pp. 112–13). In science studies, Galison (1987; 1988; 1994) offers an analysis of scientific practice based on a posthumanist but still nonemergent notion of constraint; for a critique, see Pickering (1994). I had thought that I was more or less alone in my critical sensitivity to nonemergent prison metaphors in social theory until I came across the following passage (Edwards, Ashmore, and Potter 1992, p. 13): "The problem with the idea of objective limits [or constraints] on textual readings, or on descriptions of physical events, is that it is impossible to say in advance of discussion *what exactly they are*, outside of the circularity of taking the author's word for it, or appealing as Eco does to what other readers will find 'preposterous.' But that is unfortunate too, since what people in general find preposterous is patently a matter of social judgement and consensus, and no more a guarantee of truth or reality than it is when later judgements declare everyone to have got it all wrong."

35. A conversation with Michael Power helped me to see the mangle as a temporally rotated version of traditional accounts of human agency. I hope pointing out that resistance performs in my analysis a role similar to that of constraint in traditional accounts makes it clear that my emphasis on emergence does not amount to the idiotic version of "anything goes" often mistakenly imputed to Paul Feyerabend. Comments from, among others, Irving Elichirigoity, Peter Galison, and Paul Forman have encouraged me to make this explicit. I should also make it explicit that I have no objection to the notion of "constraint" as an actors' category. Certainly, actors often do construe their situations and develop their practice in terms of articulated notions of constraint. I suggest, however, that such accounts need to be analyzed as constructed in practice and themselves subject to mangling—just like any other item of knowledge. They should not be treated, as is often done, as somehow structuring and thus explaining the flow of practice from without. Constraints are as emergent as anything else. Thus, to give one example, in his early work, Glaser found that the interior of a bubble chamber had to be extremely clean if tracks were to be formed. This became an element of bubble-chamber lore and can readily be understood as a constraint on chamber development. Interestingly, though, this lore came under pressure, especially at Berkeley, where it was evident that the big chambers that Alvarez had in mind would necessarily be "dirty" ones (in a technical sense—having metal-to-glass joints). At this point A. J. Schwemin, one of the Berkeley technicians, just ignored the constraint and went ahead, building a relatively large dirty chamber, which proved to work quite satisfactorily. This constraint was discontinuously mangled—it disappeared—in material practice (Alvarez 1987b, pp. 118–19).

36. Note that one can arrive at notions of emergence within traditional humanist accounts of human agency through the introduction of feedback. Interests and constraints might be seen as subject to conscious or unconscious revision in response to practical experience. This line of thought has not been well developed in science studies, but within sociology as a discipline it is familiar in, e.g., the guise of Anthony Giddens's (1984) structuration theory, where the idea is that social structure both constrains (and enables) action and is itself subject to reflexive monitoring and modification in the practice of individual agents. Law (1993) and Law and Bijker (1992) borrow from structuration theory in the sociology of science and technology; the latter construes the entire range of studies collected in Bijker and Law (1992) as emergent. For a valuable history of feedback thought in the social sciences, see Richardson (1991). I thank Bruce Lambert for encouraging me to think about structuration theory in relation to studies of scientific practice. Of course, no amount of feedback can transform the asymmetric attribution of agency that is definitive of traditional humanist approaches.

## REFERENCES

Alvarez, Luis. 1987a. *Alvarez: Adventures of a Physicist.* New York: Basic Books.
————. 1987b. "Recent Developments in Particle Physics." Pp. 110–53 in *Discovering Alvarez: Selected Works of Luis W. Alvarez with Commentary by His Students and Colleagues,* edited by W. Peter Trower. Chicago: University of Chicago Press.
Ashmore, Malcolm. 1993. "Behaviour Modification of a Catflap: A Contribution to the Sociology of Things." In *Kennis en Methode.* 17: 214–29.
————, ed. 1994. *Humans and Other Agents: Studies of Agency and Its Attribution in Contemporary Social Science.* Special Issue of *American Behavioral Scientist* 37(6).
Baird, Davis. 1993. "Analytical Chemistry and the 'Big' Scientific Instrumentation Revolution." *Annals of Science* 50: 267–90.
Baird, Davis, and Alfred Nordmann. In press. "Facts-Well-Put." *British Journal for the Philosophy of Science* 45: 37–77.
Barnes, Barry. 1977. *Interests and the Growth of Knowledge.* London: Routledge & Kegan Paul.
————. 1981. "On the 'Hows' and 'Whys' of Cultural Change (Response to Woolgar)." *Social Studies of Science* 11: 481–98.
————. 1982. *T. S. Kuhn and Social Science.* London: Macmillan.
Bhaskar, Roy. 1975. *A Realist Theory of Science.* Leeds: Leeds Books.
Bijker, Wiebe, and John Law, eds. 1992. *Shaping Technology/Building Society: Studies in Sociotechnical Change.* Cambridge, Mass.: MIT Press.
Bloor, David. 1983. *Wittgenstein: A Social Theory of Knowledge.* London: Macmillan.
————. 1991. *Knowledge and Social Imagery,* 2d ed. Chicago: University of Chicago Press.
————. 1992. "Left and Right Wittgensteinians." Pp. 266–82 in *Science as Practice and Culture,* edited by A. Pickering. Chicago: University of Chicago Press.
Callon, Michel. 1987. "Society In the Making: The Study of Technology as a Tool for Sociological Analysis." Pp. 83–103 in *The Social Construction of Technological Systems: New Directions in the Sociology and History of Technology,* edited by W. Bijker, T. Hughes, and T. Pinch. Cambridge, Mass.: MIT Press.
————. 1991. "Techno-Economic Networks and Irreversibility." Pp. 132–61 in *A Sociology of Monsters? Essays on Power, Technology and Domination: Sociological Review Monograph,* vol. 38. Edited by John Law. London: Routledge.
Callon, Michel, and Bruno Latour. 1981. "Unscrewing the Big Leviathan, or How Do Actors Macrostructure Real-

ity?" Pp. 277–303 in *Advances in Social Theory and Methodology: Toward an Integration of Micro- and Macro-Sociologies,* edited by Karin Knorr-Cetina and Aaron Citourel. Boston: Routledge & Kegan Paul.

———. 1992. "Don't Throw the Baby Out with the Bath School! A Reply to Collins and Yearley." Pp. 343–68 In *Science as Practice and Culture,* edited by A. Pickering. Chicago: University of Chicago Press.

Cartwright, Nancy. 1989. *Nature's Capacities and Their Measurement.* Oxford: Clarendon Press.

Chalmers, Alan. 1992. "Is a Law Reasonable to a Hume?" *Cogito* (winter), 125–29.

Cohen, Morris. 1923. Introduction to *Chance, Love and Logic: Philosophical Essays,* by Charles S. Peirce. Edited by Morris R. Cohen. New York: Harcourt, Brace.

Collins, Henry M. 1992. *Changing Order: Replication and Induction in Scientific Practice,* 2d ed. Chicago: University of Chicago Press.

Collins, Harry M., and Steven Yearley. 1992a. "Epistemological Chicken," Pp. 301–26 in *Science as Practice and Culture,* edited by A. Pickering. Chicago: University of Chicago Press.

———. 1992b. "Journey into Space." Pp. 369–89 in *Science as Practice and Culture,* edited by A. Pickering. Chicago: University of Chicago Press.

Deleuze, Gilles, and Felix Guattarl. 1987. *A Thousand Plateaus: Capitalism and Schizophrenia.* Minneapolis: University of Minneapolis Press.

Deleuze, Gilles, and Christine Parnet. 1987. *Dialogues.* New York: Columbia University Press.

Denzin, Norman. 1992. *Symbolic Interactionism and Cultural Studies: The Politics of Interpretation.* Oxford: Blackwell.

Edwards, Derek, Malcolm Ashmore, and Jonathan Potter. 1992. "Death and Furniture: The Rhetoric, Politics and Theology of Bottom Line Arguments against Relativism." Paper presented at the fifteenth Discourse and Reflexivity Workshop, Sheffield, September.

Fleck, Ludwik. (1935) 1979. *Genesis and Development of a Scientific Fact.* Chicago: University of Chicago Press.

Foucault, Michel. 1972. *The Archaeology of Knowledge.* New York: Pantheon.

———, 1979. *Discipline and Punish: The Birth of the Prison.* New York: Vintage Books.

Fujimura, Joan. 1992. "Crafting Science: Standardized Packages, Boundary Objects, and 'Translation.'" Pp. 168–211 in *Science as Practice and Culture,* edited by A. Pickering. Chicago: University of Chicago Press.

Galison, Peter. 1985. "Bubble Chambers and the Experimental Workplace." Pp. 309–73 in *Observation, Experiment, and Hypothesis in Modern Physical Science,* edited by Peter Achinstein and Owen Hannaway. Cambridge, Mass.: MIT Press.

———. 1987. *How Experiments Ends.* Chicago: University of Chicago Press.

———. 1988. "Multiple Constraints, Simultaneous Solutions." Pp. 157–63 in *PSA 1990: Proceedings for the 1990 Biennial Meeting of the Philosophy of Science Association,* vol. 2. Edited by Arthur Fine and Mickey Forbes. East Lansing, Mich.: Philosophy of Science Association.

———. 1994. "Context and Constraint." In *Theories of Practice/Stories of Practice,* edited by Jed Buchwald. Chicago: University of Chicago Press.

Galison, Peter, and Bruce Hevly, eds. 1992. *Big Science: The Growth of Large-Scale Research.* Stanford, Calif.: Stanford University Press.

Gentner, D., and A. L. Stevens. 1983. *Mental Models.* Hillsdale, N.J.: Erlbaum.

Giddens, Anthony. 1979. *Central Problems in Social Theory.* London: Macmillan.

———. 1984. *The Constitution of Society: Outline of the Theory of Structuration.* Berkeley: University of California Press.

Ginzburg, Carlo. 1980. *The Cheese and the Worms: The Cosmos of a Sixteenth-Century Miller.* New York and London: Penguin.

Gooding, David. 1990. *Experiment and the Making of Meaning.* Dordrecht, Boston, and London: Kluwer Academic.

Gorman, Michael. 1992. *Simulating Science: Heuristics and Mental Models in Technoscientific Thinking.* Bloomington, Indiana University Press.

Hacking, Ian. 1983. *Representing and Intervening.* Cambridge: Cambridge University Press.

———. 1992. "The Self-Vindication of the Laboratory Sciences." Pp. 29–64 in *Science as Practice and Culture,* edited by A. Pickering. Chicago: University of Chicago Press.

Haraway, Donna. 1991. *Simians, Cyborgs, and Women: The Reinvention of Nature.* London: Free Association Books.

Harré, Rom, and E. H. Madden. 1975. *Causal Powers: A Theory of Natural Necessity.* Oxford: Blackwell.

Hesse, Mary. 1966. *Models and Analogies in Science.* Notre Dame, Ind.: University of Notre Dame Press.

Hopwood, Anthony. 1987. "The Archaeology of Accounting Systems." *Accounting, Organizations and Society* 12:207–34.

James, William. (1907, 1909) 1978. *Pragmatism and the Meaning of Truth.* Cambridge, Mass.: Harvard University Press.

Knorr-Cetina, Karin. 1981. *The Manufacture of Knowledge: An Essay on the Constructivist and Contextual Nature of Science.* Oxford and New York: Pergamon.

Kuhn, Thomas. 1970. *The Structure of Scientific Revolutions,* 2d ed. Chicago: University of Chicago Press.

Latour, Bruno. 1983. "Give Me a Laboratory and I Will Raise the World." Pp. 141–70 in *Science Observed: Perspectives on the Social Study of Science,* edited by Karin Knorr-Cetina and Michael Mulkay. Beverly Hills, Calif.: Sage.

———. 1987. *Science in Action: How to Follow Scientists and Engineers through Society.* Cambridge, Mass.: Harvard University Press.

———. 1988*a*. *The Pasteurisation of France.* Cambridge, Mass.: Harvard University Press.

———. 1988*b*. "The Politics of Explanation: An Alternative." Pp. 155–76 in *Knowledge and Reflexivity: New Frontiers in the Sociology of Knowledge,* edited by Steve Woolgar. Beverly Hills, Calif. and London: Sage.

———. 1992. "A 'Matter' of Life and Death—or Should We Avoid Hylozoism?" Paper presented at the Department of History and Philosophy of Science, University of Cambridge, 29 October.

Latour, Bruno, and Steve Woolgar. 1986. *Laboratory Life: The Construction of Scientific Facts,* 2d ed. Princeton, N.J.: Princeton University Press.

Law, John, 1987. "Technology and Heterogeneous Engineering: The Case of Portuguese Expansion." Pp. 111–34 in *The Social Construction of Technological Systems: New Directions in the Sociology and History of Technology,* edited by W. Bijker, T. Hughes, and T. Pinch. Cambridge, Mass.: MIT Press.

———, ed. 1991. *A Sociology of Monsters? Essays on Power, Technology and Domination.* Sociological Review Monograph, vol. 38. London: Routledge.

———. 1993. *Modernity, Myth and Materialism.* Oxford: Blackwell.

Law, John, and Wiebe Bijker. 1992. "Postscript: Technology, Stability, and Social Theory." Pp. 290–308 in *Shaping Technology/Building Society: Studies in Sociotechnical Change,* edited by Wiebe Bijker and John Law. Cambridge, Mass.: MIT Press.

Lynch, Michael. 1985. *Art and Artifact in Laboratory Science: A Study of Shop Work and Shop Talk in a Research Laboratory.* London: Routledge & Kegan Paul.

———. 1992*a*. "Extending Wittgenstein: The Pivotal Move from Epistemology to the Sociology of Science." Pp. 215–65 in *Science as Practice and Culture,* edited by A. Pickering. Chicago: University of Chicago Press.

———. 1992*b*. "From the 'Will to Theory' to the Discursive Collage: Reply to Bloor." Pp. 283–306 in *Science as Practice and Culture,* edited by A. Pickering. Chicago: University of Chicago Press.

———. 1992*c*. "Springs of Action or Vocabularies of Motive." Paper presented at workshop on Vocation, Work and Culture in Early Modern England, sponsored by the Achievement Project: Intellectual and Material Culture in Modern Europe, Oxford, 10–12 December.

MacKenzie, Donald. 1981*a*. "Interests, Positivism and History." *Social Studies of Science* 11:498–504.

———. 1981*b*. *Statistics in Britain, 1865–1930: The Social Construction of Scientific Knowledge.* Edinburgh: Edinburgh University Press.

Mellor, D. Hugh. 1974. "In Defence of Dispositions." *Philosophical Review* 83:157–81.

Miller, Peter. 1992. "Accounting and Objectivity: The Invention of Calculating Selves and Calculable Spaces." *Annals of Scholarship* 9:61–86.

Miller, Peter, and Ted O'Leary. In press. "Accounting, 'Economic Citizenship' and the Spatial Reordering of Manufacture." In *Accounting, Organizations and Society.*

Pickering, Andrew. 1981. "The Role of Interests in High-Energy Physics: The Choice between Charm and Colour." Pp. 107–38 in *The Social Process of Scientific Investigation. Sociology of the Sciences,* vol. 4. Edited by Karin D. Knorr, Roger Krohn, and Richard D. Whitley. Dordrecht: Reidel.

———. 1984*a*. "Against Putting the Phenomena First: The Discovery of the Weak Neutral Current." *Studies in History and Philosophy of Science* 15:85–117.

———. 1984*b*. *Constructing Quarks: A Sociological History of Particle Physics.* Chicago: University of Chicago Press.

———. 1987. "Forms of Life: Science, Contingency and Harry Collins." *British Journal for History of Science* 20:213–21.

———. 1989. "Living in the Material World: On Realism and Experimental Practice." Pp. 275–97 in *The Uses of Experiment: Studies of Experimentation in the Natural Sciences,* edited by David Gooding, Trevor J. Pinch, and Simon Schaffer. Cambridge: Cambridge University Press.

———. 1990. "Openness and Closure: On the Goals of Scientific Practice." Pp. 215–39 in *Experimental Inquiries: Historical, Philosophical and Social Studies of Experimentation in Science,* edited by Homer Le Grand. Dordrecht: Kluwer.

———. 1994. "Beyond Constraint: The Temporality of Practice and the Historicity of Knowledge." In *Theories of Practice/Stories of Practice,* edited by Jed Buchwald. Chicago: University of Chicago Press.

Pickering, Andrew, and Adam Stephanides. 1992. "Constructing Quaternions: On the Analysis of Conceptual Practice." Pp. 139–67 in *Science as Practice and Culture,* edited by A. Pickering. Chicago: University of Chicago Press.

Pinch, Trevor, and Wiebe Bijker. 1984. "The Social Construction of Facts and Artefacts: Or How the Sociology of Science and the Sociology of Technology Might Benefit Each Other." *Social Studies of Science* 14:399–441.

Richardson, G. R. 1991. *Feedback Thought in Social Science and Systems Theory.* Philadelphia: University of Pennsylvania Press.

Rose, Nikolas. 1990. *Governing the Soul: The Shaping of the Private Self.* New York: Routledge.

Rose, Nikolas, and Peter Miller. 1992. "Political Power beyond the State: Problematics of Government." *British Journal of Sociology* 43:173–205.

Rouse, Joseph. 1987. *Knowledge and Power: Toward a Political Philosophy of Science.* Ithaca, N.Y.: Cornell University Press.

Rouse, W. B., and N. M. Morris. 1986. "On Looking into the Black Box: Prospects and Limits in the Search for Mental Models." *Psychological Bulletin* 100:349–63.

Schaffer, Simon. 1991. "The Eighteenth Brumaire of Bruno Latour." *Studies in History and Philosophy of Science* 22:174–92.

Shapin, Steven. 1979. "The Politics of Observation: Cerebral Anatomy and Social Interests in the Edinburgh Phrenology Disputes." Pp. 139–78 in *On the Margins of Science: The Social Construction of Rejected Knowledge.* Sociological Review Monograph, vol. 27. Edited by Roy Wallis. Keele: University of Keele.

———. 1982. "History of Science and Its Sociological Reconstructions." *History of Science* 20:157–211.

———. 1988. "Following Scientists Around." *Social Studies of Science* 18:533–50.

Smith, Barbara H. 1988. *Contingencies of Value: Alternative Perspectives for Critical Theory.* Cambridge, Mass.: Harvard University Press.

Star, Leigh. 1991. "The Sociology of the Invisible: The Primacy of Work in the Writings of Anselm Strauss." Pp. 265–83 in *Social Organization and Social Process: Essays in Honor of Anselm Strauss,* edited by David R. Maines. Hawthorne, N.Y.: Aldine de Gruyter.

———. In press. "The Trojan Door: Organizations, Work, and the 'Open Black Box.'" *Systems/Practice.*

Suchman, Lucy. 1987. *Plans and Situated Actions: The Problem of Human-Machine Communication.* Cambridge: Cambridge University Press.

Traweek, Sharon. 1992. "Border Crossings: Narrative Strategies in Science Studies and among Physicists in Tsukuba Science City, Japan." Pp. 429–65 in *Science as Practice and Culture,* in *Science as Practice and Culture,* edited by A. Pickering. Chicago: University of Chicago Press.

Turner, Stephen. 1991. "Two Theorists of Action: Thering and Weber." *Analyse & Kritik* 13:46–60.

Wise, Norton, and Crosbie Smith. 1989–90. "Work and Waste." *History of Science* 27:263–301, 391–449; 28:221–61.

Woolgar, Steve. 1981a. "Critique and Criticism: Two Readings of Ethnomethodology." *Social Studies of Science* 11:504–14.

———. 1981b. "Interests and Explanation in the Social Study of Science." *Social Studies of Science* 11:365–94.

———. 1992. "Some Remarks about Positionism: A Reply to Collins and Yearley." Pp. 327–42 in *Science as Practice and Culture,* edited by A. Pickering. Chicago: University of Chicago Press.

Zuckerman, Harriet. 1988. "The Sociology of Science." Pp. 511–74 in *Handbook of Sociology,* edited by Neil J. Smelser. Beverly Hills, Calif.: Sage.

# 26

# Quantification and the Accounting Ideal in Science

## THEODORE M. PORTER

*Objectivity, V, may be defined to be:*

$$V = \frac{1}{n} \sum_{i=1}^{n} \left( x_i - \bar{x} \right)^2$$

—YUJI IJIRI and ROBERT JAEDICKE[1]

Historians and sociologists of science are scarcely more likely to look to studies of accounting for inspiration than are natural scientists. A hierarchy of science that almost everyone now views as discredited continues nevertheless to regulate our practice. Among those who write of natural science as a model of intellectual endeavour, this is perhaps not unexpected. But it is powerful testimony indeed to the continued hegemony of physics when sociologists of science pursue a social and political understanding of technology, medical economics, and expert witnessing mainly by applying the lessons learned in the study of harder sciences.[2] I shall defend here the converse proposition, that we can learn a good deal about making natural knowledge from careful study of a less exalted—though by no means less important—disciplined practice: accounting.

Those who feel unease at this departure from the respectful contemplation of the natural scientist at work can draw inspiration from the example of Charles Darwin among the pigeon fanciers.[3] The fanciers cultivated the keenest visual discrimination, and Darwin found them busily engaged in breeding ever more bizarre pouters, puffers, and tumblers. Yet they were oblivious to the magnitude of their own achievements, and scoffed in unison at every suggestion that their varieties derived from common origins. Darwin narrates all this with elegant irony. Naturalists would recognize the myopia of pigeon fanciers, who believed their varieties to be separate acts of divine creation. And yet, by implication, they are scarcely less myopic in insisting on the separate creation of what they call species.

In a similar way, the splendidly Byzantine rules governing tax law and financial reporting are unmistakably the creation of ingenious accountants, in alliance and conflict with lawyers, courts and legislatures. And yet accountants are almost unanimously unwilling to take credit for their own handiwork. Like most natural scientists, they believe that the history of their discipline is

mainly a matter of discovery and clear reasoning. And, as with Darwin's naturalists, those who doubt this may not be able to confine their doubts to the subject matter of accounting.

## THE OBJECTIVITY OF ACCOUNTS

The accountants' view of their field as largely autonomous and technical in nature has, since the late 1970s, been challenged on a wide front. There is now something like a school of accounting sociologists, including a few historians. Their principal journal, *Accounting, Organizations, and Society,* is obligatory reading for academic accountants, and even has acquired a reputation among social scientists, though it seems to be terra incognita for historians of science. Their papers are full of references to Foucault, Latour, and Hacking. They have conferences on topics like deconstruction and accounting.[4] Their standing inside accounting has been compared to that of critical legal studies in law.[5] They are, in some very interesting ways, more extreme in their pursuit of a social interpretation of knowledge than all but a few writers in science studies. Extremism in the deconstruction of accounting, though, is no vice. The profession of grey suits, grey countenances, and grey figures on white paper, exerts an effective tyranny even over people who on principle would refuse to regard an experimental result in physics as anything more than a brilliant rhetorical ploy.[6] But we can learn from them about more than accounting. Their work is especially helpful for understanding the uses of quantification, and for constructing something like a social history of objectivity.[7]

In accounting, objectivity means first of all rules. Accounting realists might think that these rules should be dictated by deep and abiding financial entities.[8] Even the rest of us ought to concede that there is a logic to accounting standards, recognizable sometimes by its presence and sometimes by its absence. There is no question but that these rules must be negotiated. That negotiation brings out the problem of replication and stability in an especially acute way. The challenges that accounting rules must withstand are often more severe than in natural science. They face unremitting efforts to take them apart, to chip away at their boundaries.[9] Science, following an influential pronouncement of Bruno Latour and Steve Woolgar, is now often perceived as an agonistic field,[10] but scientists for the most part share an interest in building stable structures of knowledge and practice. Those who want to defend accounting rules, in contrast, are vulnerable to the hostile intentions of numerous outsiders. They must hold out against legions of endlessly inventive corporate attorneys and managers who are forever trying to carve out tax loopholes, or to avoid disclosing the extent of their exposure to potential loan defaults, or to shift assets out of a foundering savings and loan into the private account of the owner's children, or the local senator's political campaign.

It is instructive to consider what gives strength and stability to the principles of accounting. I propose a twofold answer: rules and entities. Now these are rarely found in isolation, but I want to pull them apart for analytical purposes. By rules I refer to purely arbitrary, unsupported conventions. Their legitimacy depends above all on their evenhandedness and inflexibility. Like the notorious French law that prohibited rich and poor alike from sleeping under bridges, they permit the homeless as well as (American) professors to invest in 403b tax-sheltered retirement accounts. Entities appeal for their authority to something like the nature of things—to rigorously defined financial concepts and to the results of arms-length transactions in the world of finance and banking. Accountants, like physicists, prefer their rules to appear to be grounded in

the nature of things. But it is often necessary to compromise in the interests of standardization and enforceability. Thus the newly established American Securities and Exchange Commission (SEC) decreed during the Depression that corporate book value should be based on original cost of assets, not their replacement value (which seemed closer to being correct), because investors were already nervous enough and direct cost accounting seemed to leave a minimum of room for self-interested manipulation.[11]

This particular compromise was an epochal one for American financial accountants, or at least for accounting researchers. The evident incompatibility between rationality and expediency has continued to grate for more than half a century. It gave rise in the 1960s to a revealing literature on the nature of objectivity, works we can now recognize as unsung classics in science studies. Without exception, accountants recognized objectivity as a defence against the suspicions of meddlesome outsiders. The paramount need to minimize the appearance of subjective discretion—"managerial whim"—in financial reports was stressed in almost every accounting discussion of objectivity.

Typically, as we would expect, realism and constraint were seen as allies. Thus the *Accountants' Handbook* characterized "objective" as implying "the expression of facts without distortion from personal bias." But there was ample reason to worry whether "the facts" were univocal. "Objective facts need not be conclusively objective to be dependable," declared one prominent source.[12] Any departure from established methods, and especially any valuation resting on nothing more than the accountants' own judgment, was likely to cause trouble. The fundamental choice between present value and cost as a basis for financial accounting was conditioned by such considerations. To abandon accounting according to original costs, cautioned Harold Bierman in 1963, would oblige accountants to face "a variety of choices"—whether, for example, to adjust financial quantities only to take account of changing price levels, or to base value on expected future cash flows, or even to use liquidation prices. "The accountant's task would be more complex," he noted. "The above suggestions would lead to manipulation of the reports," and would add to the regulatory burden on the SEC.[13] Still, he thought accountants should accept this inconvenience, in the interests of a better representation of the true state of affairs. Bierman preferred not to dilute rationality with expediency, and he envisioned accounting as a measurement discipline analogous to astronomy and psychology. There is a hint here of the ivory tower, where academic accountants can adhere to high ideals with blissful disregard for the exigencies of practice in a suspicious and bureaucratic world. Working accountants in business and government have learned to maintain their guard against those flights of theoretical fancy arising among the professors.

Bierman's moderate defence of accounting realism proved an impossible compromise, and not only because it seemed unworkable to the "practical men." On the one side, accounting realists challenged severely the view that anything other than truth could be really useful. In accounting, as in other sciences, wrote the Australian R. J. Chambers, we can only claim objectivity when we know what we measure. If our objects are not defined, "it is quite impossible to speak of eliminating known biases and discovering true or estimated measures."[14] True values must be contemporary values; historical cost is meaningless until revised to reflect current conditions. Conventional rules cannot suffice to manufacture objectivity; an objective statement must be one that any other informed person would make about the same subject matter. That informed persons will agree about the proper rationality of accounting, and about the detailed ways in which this could be worked out in practice, was evidently to be deduced from the very

nature of properly scientific inquiry, because Chambers gave no arguments. Such an identity, in the nature of things, between accounting truth and unambiguous rules was asserted in the same year by his ally Edward J. Burke. He invoked the Kantian understanding of explanation as the subsumption of particulars under law to ground accounting rationality, and at the same time to explain how it could be made invulnerable to "emotive considerations."[15]

Unfortunately, as Bierman recognized, it was far from clear that accounting realism provided the most effective grounding for impersonal rules. Quite different implications were drawn out the next year by John Wagner, who wanted to see accounting as a liberal profession, like medicine. This preference for expert judgment over standardized rules was common among élite accounting practitioners, who resisted the inflexible rules backed by academics and government regulators.[16] Wagner issued the following unanswerable syllogism:

The accounting profession's prime asset is an attribute known as *professional judgment*. Judgment, professional or otherwise, is a product of the mind. If judgment must be made synonymous with subjectivity, we cannot have objectivity and a profession at the same time. Clearly we cannot accept such a view of objectivity. Rather, we must show that the exercise of professional judgment and the desire for objectivity are complementary propositions.

A visual metaphor saved the realists' objectivity, which henceforth should mean "a relative absence of perceptual defects in the exercise of professional judgment." Discipline, also, was indispensable. Accountants properly imbued by a strict training with general principles and goals would command a form of judgment "more effective, more controllable, in attaining a desirable state of objectivity."[17]

Discerning judgment is almost always subordinated to the straightforward presentation of numbers in the public rhetoric of accounting. We cannot infer from this the state of mind of accountants, as if they all believe that numbers, collected and processed mechanically, tell all. Not only critics, but many leading spokesmen for accounting, have argued that the exclusive identification of accounting with numbers on a balance sheet is a straitjacket. A recent historical study, largely uninfluenced by the new constructivism in accounting, laments the increasingly mechanical use of management accounting by uninspired executives trained to manage "by the numbers," and attributes this stultifying drive for rigor in large measure to the external imposition of financial reporting conventions.[18] The new hermeneutics of accounting goes only a little way beyond the pronouncements of the old accounting élite when its champions argue that a language of inference and interpretation, resting on the discernment that comes with true expertise, could provide much more helpful guidance to stockholders and creditors than a string of numbers.[19] The point is that this interpretive form of accounting would depend on a great reserve of trust, and it is precisely because trust is in short supply that so much emphasis is placed on the accounts in the first place. Accountants, operating in a highly contentious domain, lack the status and credibility that would permit them to rest their claims mainly on wisdom and insight. It is in large measure for broadly political reasons that a positivistic rhetoric of impersonal facts prevails in accounting. Seemingly rigorous standards are at least as valuable as claims to represent real entities in securing the faith of outsiders in accounts.

The need for impersonality is reflected in the prevailing conception of objectivity among accountants. Yuji Ijiri and Robert Jaedicke, whose pioneering quantitative definition of objectivity is cited in the epigraph to this chapter, complained against the realists that existence

independent of observers has no operational meaning in the context of accounting. The problem faced by accountants is simple: "Accounting is a measurement system which is plagued by the existence of alternative measurement methods." The remedy seemed scarcely less simple:

If the measurement rules in the system are specified in detail, we would expect the results to show little deviation from measurer to measurer. On the other hand, if the measurement rules are vague or poorly stated, then the implementation of the measurement system will require judgment on the part of the observer.

Objectivity, for these accountants, was a mechanism to exclude judgment. It could be "defined to mean simply the *consensus* among a given group of observers or measurers," and hence measured (inversely) as a statistical variance. Its importance was not so overwhelming as to exclude consideration of reliability, meaning ability to make accurate predictions. But it was by no means to be discarded lightly, for without consensus there could be no reliability either.[20] Practising accountants and researchers alike found this reasoning plausible, even compelling. Practitioners were acutely conscious that reaching agreement by following rules provided their most powerful defence against government bureaucrats. Researchers applauded the quantitative form of objectivity for its amenability to empirical, meaning statistical, research, and on this account it became the consensus concept of objectivity in accounting.[21] Nor were research accountants immune to the allure of "perfect operational objectivity," which could be realized "only where the entire accounting process was reduced to programmable sets of procedures."[22]

This insistence on standardizability, even where it violates the best judgment of expert practitioners, will rarely be found except in fields that are highly vulnerable to criticism from outsiders. The conspicuous exercise of personal discretion in the preparation of accounts tends, for obvious reasons, to raise doubts, and for this reason the community of accountants is exposed and in this sense weak. In the United States, the pursuit of standardization has been perhaps the most important activity of the leading professional organization, the American Institute of Accountants. The main reason for this avid pursuit of uniformity, as John Zeff points out, is to forestall "active involvement by government in the establishment of accounting principles."[23]

Still, while uniform standards are highly valued, a gap between methods and reasons is an embarrassment too. And the relationship is not normally one of conflict. More typically, uniformity and standardization are enhanced by the ostensible rationality that comes from explicit theoretical reasoning. Robert Ashton, who subjected a population of accountants to a sample survey in order to measure the objectivity of rival accounting methods, was pleased to find that the theoretically preferred measure, present value, was indeed more objective (that is, showed a lower standard deviation over different measurers) than its rival, accounting by original cost.[24] When, in the late 1940s, the United States Bureau of the Budget wanted to make cost-benefit analysis into an effective brake on the Congressional pork barrel, the application (for the first time) of economic reasoning was immediately recognized as valuable for standardization.[25] It was hard to decide between the diverse practices of various agencies, and to define a coherent, single, authorized practice, except by using the terms of reasoned argument. In practice, rules are most often based on some claim to rationality. Conversely, and despite increasingly persuasive philosophical reservations, it has become very difficult successfully to press claims to scientific rationality for what is not at least potentially reducible to rules.

## A TECHNOLOGY OF DISTANCE

It is important to note that the form of knowledge resulting from this relatively rigid quantitative protocol is decidedly public in character. Such knowledge is especially useful to coordinate the activities of diverse actors, and to lend credibility to forms of belief and action when personal trust is in short supply. Objectivity is a technology of distance: geographical, intellectual, and social. In the (admittedly somewhat mythical) *Gemeinschaft*, face-to-face interactions typically obviated the need for the formal structures of objectivity. We know this from studies of the history of measurement, such as Witold Kula's *Measures and Men,* where we learn that until the eighteenth century, measurements even of land or grain volume were never intended to be purely mechanical, but normally involved an explicit judgment of quality. In a small-scale and unstandardized world, bargaining over measures caused no more inconvenience than bargaining over prices. And even in less intimate situations, where people exercise power by divine right or personal charisma, they will rarely allow their judgment to be supplanted by standardized, objective calculations. Objectivity empowers weak authorities, even as it constrains them.[26]

Accounting, especially, is associated with particular ways of organizing political and economic activity. The accounts of individual entrepreneurs and small partnerships rarely amounted to more than ledgers of income and expenditure, until an increasingly burdensome tax law brought greater rigidity to these things. Alfred Chandler and his followers have shown to what extent the development of cost accounting was associated with the growth of complex, integrated firms, and later with government regulation.[27] The ambit of accounting, in short, is first of all administrative, and not cognitive. Indeed, its contribution to the management of business firms is at least matched in importance by its role in mediating between business and government, or business and the public. The accounting profession got its start in nineteenth-century England, where its members exercised the very public function of presiding over bankruptcies and assuring creditors they would be treated fairly. American and British accountants also began early to audit the accounts of public companies, and thus to provide independent and expert assurance to shareholders and other interested parties that the books were fair and honest.[28] The purposes of accounting and related forms of quantification are to be understood not mainly in terms of a logic of market capitalism, but of political values—usually some mix of justice, openness, and restraint on personal discretion. Their force depends on types of human communities, on forms of power. Objectivity is synonymous with public knowledge in a deeper and more interesting sense than we have yet realized.

Anne Loft's historical study of cost accounting in Britain captures nicely the political resonances of quantitative objectivity. Cost accounting first became important in Britain during World War I. The mobilization of the economy upset private markets, especially for items needed by the military. How were prices to be determined? The government and industry might have simply negotiated a price. But a private agreement resting on no more authority than administrative judgment lacked credibility. An especially untrusting party was the trade unions, whose members, after all, were being asked to hold down wage demands in the national interest. They would have regarded price negotiations between the companies and Whitehall as an opportunity for collusion. They insisted on objective evidence that they were not sacrificing wages for the benefit of profiteers. So cost accounting, rather a new and undeveloped technology, was mobilized during the war to establish quantitatively that manufacturers were taking only a small profit above their actual costs of production.[29] Any economist can give good arguments

why cost plus profit is an inefficient way to run an economy. But in a situation of distrust it may be the most credible way to run a polity.[30]

Modern scholars almost instinctively regard this kind of quantification as a ruse, and the poor workers as dupes. But our habitual suspicions may go too far. If the bureaucrats and industrialists had the power to do whatever they wanted, they would not have been obliged to seek refuge in quantitative rules. We are, after all, talking about public knowledge. Whenever such calculations are exposed to unfriendly eyes, deviations from standard practices can be noted, and the rules become genuinely constraining—though naturally they still leave some room for creative manipulation. The civil servants who are the heroes of this story had to let themselves be standardized by a quantitative protocol in order to minimize conflict and avoid stalemate. The authority of public bureaucrats and private contractors was suspect; the reaction of the trade unions clearly mattered. Since it was difficult, perhaps impossible, to coerce them, they had instead to be persuaded to acquiesce. What went on was not quite reasoned democratic discussion, but neither was it simple coercion or trickery. This is power not in Stalin's sense, but Foucault's. It constrained the administrators almost as much as it constrained the workers. Quantification provided authority, but this is authority as Barry Barnes defines it: not so much power plus legitimacy, but power minus discretion.[31]

It would be a radical mistake to suppose that quantification is inherently liberal. Those whose activities the accounts describe are almost necessarily represented as objects of manipulation, and the numbers support direct administrative intervention.[32] Close surveillance of accounts can provide the basis for strict hierarchical control of those who prepare the accounts, and early modern bureaucracies in France and England developed, almost simultaneously, elaborate mechanisms to limit chicanery. Prominent among them was the requirement that clerks keep detailed diaries, to be filled in on every line and signed by a superior at the bottom of each page, with a strict ban on emendations and erasures.[33] But such detailed mechanisms of control pertain rather to bookkeeping than to accounting, which, like statistics, is less a matter of raw information than of standard ways to summarize and evaluate masses of numbers. As Peter Miller and Nikolas Rose point out, accounting is in important ways typical of the exercise of power in modern liberal societies, especially through the channels of bureaucracy. It is not mainly an agency of direct, dictatorial power, but a set of methods and implicit standards, by which people are judged and by which they judge themselves. Subordinates are left with some autonomy, provided they maintain good numbers. Superiors are not supposed to intervene in the details, nor to impose forcefully their own discretion, but so far as possible to respect the objective measures.[34] This was the strategy developed by Donaldson Brown, a key player with Alfred Sloan in the invention of the modern, multidivisional corporation. He called it "centralized control with decentralized responsibility." His aim was to establish mechanisms by which the central office could maintain effective power without meddling in matters of detail that must inevitably be better understood at lower levels. His solution was to let the divisions manage their own affairs with a minimum of surveillance, so long as they maintained good numbers. "Good numbers" meant something quite specific—an adequate "return on investment," or ROI.[35] Canonization of an accounting category was thus integral to an influential style of management.

# THE ACCOUNTING IDEAL IN SCIENCE

The pressures and incentives by which accounting is shaped help to determine also the forms through which the authority and prestige of the natural sciences are enlisted by political and bureaucratic actors. It is time, though, to turn away from the explicitly political domain, to see what can be learned from the history and sociology of accounting about the uses of quantification within science. The point is not to reduce mathematically expressed laws of physics, biology, or chemistry to accounting conventions, but to notice how quantification serves as a distinctive style of communication and promotes the formation of a certain type of scientific community. My object here is to use the perspective developed in literature on accounting to try to understand the role of quantification in statistical analyses and experimental reports.

The rediscovery of experimentation within studies of science has led to an enormous emphasis on the skills of the laboratory. It is widely argued that experimental skills are tacit and local. Many historians of science, and even more sociologists, are now inclined to characterize science not in terms of public knowledge, but of private craft skills. I think the appreciation of tacit knowledge—Polanyi's insight—is right and valuable, but of course it is not by itself adequate as a basis for understanding science.

Some of the more discerning writers on experiment are already alert to this problem. One answer to it is networks, formed through personal contact and promoting the spread of tacit techniques. This was long unduly neglected and is now exaggerated. To allude to Steven Shapin and Simon Schaffer's study of experiment in seventeenth-century England, the air pump was for some decades a highly problematical and personal technology, but eventually it became something that any interested and moderately prosperous person could buy off the shelf.[36] Once such instruments begin to be mass produced, they promote greatly the pursuit of commensurable lines of research, if not the replication of results.[37] Similar, but of yet more general significance, is the armory of machines and standards that make possible uniform measurement. The standardization of weights and measures has been crucial for reconciling and integrating the work of diverse laboratories. The historical problem of how these were defined and enforced has just recently become an important research topic, and it clearly deserves to be.[38] The activity of public bureaux of standards points to one of the ways in which theories contribute to the practice of experimenters, by providing a common language and often a rationale for choice of units. And very much, if not quite all, of this involves counting, measurement or other forms of quantification. The language of number deserves a prominent place among what Shapin calls "literary technologies."[39] Forms of rhetoric, as everyone recognizes now, are means of communication, and not just sneaky artifices of irrational persuasion. Quantification is a form of rhetoric that is especially effective for diffusing research findings to other laboratories, languages, countries, and continents. The language of distrust is also a superb technology of distance.

Why should this be so? Why do numbers and calculation span continents, leap oceans, link laboratories, factories, and governments? Part of the explanation is that mathematics is a highly structured language. It is a language of rules, the kind of language that even a thing as stupid as a computer can use.[40] Whenever a reasoning process can be made computable, we can be confident that we are dealing with something that has been universalized, with knowledge effectively detached from the individuality of its makers. This does not mean that mathematics is a neutral language, that anything can be translated into mathematics, and thereby simply made more

precise. Quantification is a powerful agency of standardization because it imposes some order on hazy thinking, but this depends on the licence it provides to leave out much of what is difficult or obscure. As nineteenth-century statisticians liked to point out, their science averaged away everything contingent, accidental, inexplicable, or personal, and left only large-scale regularities.[41] Similarly, the literary technologies of the modern scientific paper are inadequate to convey the tacit richness of experimental technique, or, for that matter, the arcane craft of formulating theories. For most purposes, such intimate knowledge is unnecessary. The value of superficiality has been argued by Peter Galison, who observes that the interactions among instrumentalists, experimentalists, and theorists in physics are a bit like a trading zone, involving, say, European merchants and South American Indian craftsmen or farmers. All the meanings—religious, cosmological, ideological—are lost; the traders only need to agree on a price, a number, or ratio. Similarly, it is often mainly predictions and measurements that pass between experimental and theoretical physicists.[42] It may even facilitate easy communication if the rich craft techniques of both communities are simply ignored. This supports the more general point that Peter Dear makes: namely, that objectivity has come to be distinguished first of all by what it leaves out, by the absence of subjectivity.[43]

Nowhere in science is the preference for mechanical and objective reasoning over the communication of complex judgments more evident than in modern uses of statistical methods to analyze experimental and observational data. As in accounting, statistical rules are not simply arbitrary, but there is a strong element of the conventional. For example, the 5% and 1% significance levels have been canonized in various disciplines. This can be taken to rather absurd extremes, as in the case of the editor of a major psychological journal, mentioned by Gerd Gigerenzer, who revealed retrospectively his standards for accepting papers: 5% significance levels may be marginally acceptable for psychology in its current condition, but if psychology is to become really scientific, like physics, it must raise its standards and admit only conclusions vindicated at the 1% level.[44] This identification of quality with levels of statistical significance is silly. It is also impossible to justify the particular conventions of 5% and 1%. They must be understood as monuments to a scientific ethic of self-denial, as limits on what ambitious scientists can claim as positive results. The American Psychological Association, calling upon experimenters to ignore results that approach but do not reach statistical significance, enjoined its readers as follows: "Treat the result like an income tax return. Take what's coming to you, but no more."[45] The conventions also provide standards by which researchers can compare one another's work without a lot of face-to-face discussion, often without real understanding. It is impossible to deny now the importance of tacit experimental skills for science. But, as Zeno Swijtink argues, there is a considerable premium in science on the objective and the mechanical, on replacing personal judgment and private wisdom with public standards and formal knowledge.[46] That is, science enshrines objectivity, meaning (here) not truth to nature, but impersonality, standardization—reducing subjectivity to a minimum.

This in turn has to do with the ethics of the scientific community, and gets us into what Lorraine Daston, most recently, has called the moral economy of science.[47] One of the remarkable, and much envied, achievements of modern science is the ability of scientists to achieve something like consensus. But this did not simply come naturally once scientists began experimenting and calculating. It was an achievement. It resulted partly from the adoption of standard techniques, instruments, and modes of communication. These required an intense social discipline, so that, as E. Walter Maunder wrote in 1900, the ideal observatory became like a White-

hall office, keeping accounts of stars rather than income tax schedules.[48] It came also from agreeing, tacitly, to limit attention to what could be brought under good experimental control. From sometime around 1650 or 1700, science increasingly turned away from remarkable reports, rare events, and mysterious happenings out in the world, focusing its attention ever more strictly on phenomena inside the laboratory, or often simply on paper, that through refinements of art had been made to behave themselves.[49] This of course did not solve the problem of replication entirely, but it made it much more promising that, with the help of a minute description and maybe also some face-to-face discussion, similar phenomena could be transported to other laboratories and revealed to other experimenters. Of course, scientists rarely replicate results for the sake of replication. They try to build on them, to incorporate them into other research programmes. But even this depends on an ability to move techniques and knowledge from one location to another. Every scientific result begins its career as a view from somewhere—say some particular laboratory—and it is really the most fundamental task of every scientist to transform as much as possible into a view from nowhere, at least nowhere in particular.[50]

Some decades ago, Merton identified organized skepticism as one of the basic ethical principles regulating the scientific community, and its relations to the larger political order.[51] We need to reinterpret this a little. It isn't that scientists are fundamentally lacking in trust, nor that they tend strongly to iconoclasm. The relevant point is just that they are professionally engaged in research, and tend often not to be very interested in what they can't put to use in their own work. It is mainly on this account that personal authority by itself does not count for much in workaday science. Like every community, the scientific one depends on being able to get beyond the merely personal. Relatively rigid standards for reporting results, including the quantification of almost everything possible, serve science well in this regard. They were invaluable in creating a unified research community spread over much of the world.

The skepticism of the scientific community is not quite identical to the suspiciousness and subversiveness faced continuously by accountants, but the effect is at least similar. It means that writers are effectively placed at a considerable distance from their readers, and gives them reason to prefer objective—that is mechanical, often quantitative—forms over explicit judgments and an allusive, personal, intimate sort of communication. This goes a long way towards explaining why scientific style is generally more important than scientific content for creating knowledge that is usable in a contentious, macropolitical setting. The premier examples of this are, of course, accounting and statistics, perhaps the most powerful of all forms of knowledge extant, when observed from the standpoint of the political realm. In a sense, science is a prototype of the modern suspicious, pluralist, democratic political order. The organized skepticism of the research community demands formalization and objectivity in a way that is analogous, though of course not identical, to the systems of rules favoured by bureaucracies in modern Western societies. The perspective from accounting studies suggests that the social history of objectivity is a political history too, and opens up new perspectives from which the history of modern science can be related to other aspects of society, politics, and culture.

NOTES

I acknowledge with gratitude support for this research from the John Simon Guggenheim Foundation and the National Science Foundation grant DIR 90–21707. The work was greatly promoted by my one-week tenure as Arthur Andersen Visiting Professor of Accounting at the London School of Economics, and by conversations there with Anthony Hopwood, Peter Miller, and Michael Power.

1. Yuji Ijiri and Robert K. Jaedicke, "Reliability and Objectivity of Accounting Measurements," *Accounting Review*, Vol. 41 (1986), 474–83, at 477. This is the formula for statistical variance, taken over measures of the same entity by different measurers. It is intended as an inverse measure: greater agreement among measurers implies lower variance, and hence (by definition) more objectivity.

2. Wiebe Bijker, Thomas Hughes, and Trevor Pinch (eds.), *The Social Construction of Technological Systems* (Cambridge, MA: MIT Press, 1987); Malcolm Ashmore, Michael Mulkay, and Trevor Pinch, *Health and Efficiency: A Sociology of Health Economics* (Milton Keynes, Bucks.: Open University Press, 1989); Roger Smith and Brian Wynne (eds.), *Expert Evidence: Interpreting Science in the Law* (London: Routledge, 1989).

3. James Secord, "Nature's Fancy: Charles Darwin and the Breeding of Pigeons," *Isis*, Vol. 72 (1981), 163–86.

4. C. Edward Arrington and Jere R. Francis, "Letting the Chat Out of the Bag: Deconstruction, Privilege, and Accounting Research," *Accounting, Organizations, and Society*, Vol. 14 (1989), 1–25.

5. David Chioni Moore, "Accounting on Trial: The Critical Legal Studies Movement and its Lessons for Radical Accounting," *Accounting, Organizations, and Society*, Vol. 16 (1991), 763–91, who, however, argues that the critical accountants have not pressed their case hard enough.

6. This generally reflects no great trust in accountants, but rather a confusion between accounting and mere bookkeeping.

7. On the uses and authority of accounting in general, see Stuart Burchell et al., "The Roles of Accounting in Organizations and Society," *Accounting, Organizations, and Society*, Vol. 5 (1980), 5–27, and various papers in Anthony Hopwood, *Accounting from the Outside: Collected Papers* (New York: Garland, 1988). For a recent introduction to the history of accounting, see Peter Miller, Trevor Hopper, and Richard Laughlin, "The New Accounting History: An Introduction," *Accounting, Organizations, and Society*, Vol. 16 (1991), 395–403.

8. "Ontologically, mainstream accounting research is dominated by a belief in physical realism," writes a recent critic, with some exaggeration, in the leading American accounting journal: Wai Fong Chua, "Radical Developments in Accounting Thought," *Accounting Review*, Vol. 61 (1986), 601–32, at 606.

9. For a fine account of the effort to create and defend standards against the perpetual subversion of creative self-interest, see William Cronon, *Nature's Metropolis: Chicago and the Great West* (New York: W. W. Norton, 1991), chapter 3. He discusses here the standardized grading of grain, which ultimately made it possible for traders in Chicago or London to buy and sell products they had never seen, and never would. Obviously this depended on creating a corps of reliable graders and inspectors. But the great enemy was elevator operators, who learned to dilute grain to the bottom of the grade, and farmers, whose complaints about such dealings endangered the whole system.

10. Bruno Latour and Steve Woolgar, *Laboratory Life: The Construction of Scientific Facts* (Princeton, NJ: Princeton University Press, 1986), 237.

11. Eric Flamholtz, "The Process of Measurement in Managerial Accounting: A Psycho-Technical Systems Perspective," *Accounting, Organizations, and Society*, Vol. 5 (1980), 31–42.

12. Quotes from H. E. Arnett, "What Does 'Objectivity' Mean to Accountants?," *Journal of Accountancy*, Vol. 11 (May 1961), 63–68.

13. Harold Bierman, "Measurement and Accounting," *Accounting Review*, Vol. 38 (1963), 501–07, at 505–06.

14. R. J. Chambers, "Measurement and Objectivity in Accounting," *Accounting Review*, Vol. 39 (1964), 264–74, at 268.

15. Edward J. Burke, "Objectivity and Accounting," *Accounting Review*, Vol. 39 (1964), 837–49, at 842.

16. Paul J. Miranti, Jr., *Accountancy Comes of Age: The Development of an American Profession, 1886–1940* (Chapel Hill, NC: University of North Carolina Press, 1990), 4–5, 128–42.

17. John W. Wagner, "Defining Objectivity in Accounting," *Accounting Review*, Vol. 40 (1965), 599–605, at 600, 605.

18. H. T. Johnson and R. S. Kaplan, *Relevance Lost: The Rise and Fall of Management Accounting* (Boston, MA: Harvard Business School Press, 1987), chapter 6. Some blame remains, to be laid at the door of accounting professors.

19. Don Lavoie, "The Accounting of Interpretations and the Interpretation of Accounts," *Accounting, Organizations, and Society*, Vol. 12 (1987), 579–604, is highly critical of accounting positivism, as are Shahid L. Ansari and John J. McDonough, "Intersubjectivity—The Challenge and Opportunity for Accounting," ibid., Vol. 5 (1980), 129–42. But the need for accountants to interpret their numbers, which can often be misleading, was urged, largely to no avail, by some of the most influential figures in American accounting during what can plausibly be regarded as its formative period, the 1930s and 1940s. See remarks by George O. May (1938) and Walter Wilcox (1941) printed in Stephen A. Zeff (ed.), *Accounting Principles through the Years: The Views of Professional and Academic Leaders* (New York: Garland, 1982), 2, 96, 99, 101.

20. Ijiri & Jaedicke, "Reliability," 476, 474.

21. Robert H. Ashton: "Objectivity of Accounting Measures: A Multirule–Multimeasurer Approach," *Accounting Review*, Vol. 52 (1977), 567–75, at 567; also James E. Parker, "Testing Comparability and Objectivity of Exit Value Accounting," ibid., Vol. 50 (1975), 512–24. Both of these show that the objectivity debates continued to centre around discussion of the advantages of financial accounting according to costs *versus* various measures of present value.

22. Joseph F. Wojdak, "Levels of Objectivity in the Accounting Process," *Accounting Review*, Vol. 45 (1970), 88–97, at 97. On the theme of interchangeable observers and the neutralizing of individuality in science see Lorraine

Daston and Peter Galison, "The Image of Objectivity," *Representations*, Vol. 41 (1992), 81–128; also Daston's "Objectivity and the Escape from Perspective," *Social Studies of Science*, Vol. 22 (1992), 597–618 (reprinted in this volume).

23. John A. Zeff, "Some Junctures in the Evolution of the Process of Establishing Accounting Principles in the USA: 1918–1972," *Accounting Review*, Vol. 59 (1984), 447–68, at 466; Arthur L. Thomas, *The Allocation Problem in Financial Accounting Theory, Studies in Accounting Research*, No. 3 (Evanston, IL: American Accounting Association, 1969), 100; Miranti, *Accountancy.*

24. Ashton, "Objectivity."

25. Federal Inter-Agency River Basin Committee, Subcommittee on Benefits and Costs, *Proposed Practices for Economic Analysis of River Basin Projects* (Washington, D.C.: United States Government Publications Office, 1950).

26. Witold Kula, *Measures and Men*, trans. Richard Szreter (Princeton, NJ: Princeton University Press, 1986); Theodore M. Porter, "Objectivity as Standardization: The Rhetoric of Impersonality in Measurement, Statistics, and Cost-Benefit Analysis," *Annals of Scholarship*, Vol. 9 (1992), 19–59.

27. Alfred Chandler, Jr., *The Visible Hand: The Managerial Revolution in American Business* (Cambridge, MA: Harvard University Press, 1977), 267–69, 273–81; H. Thomas Johnson, "Toward a New Understanding of Nineteenth-Century Cost Accounting," *Accounting Review*, Vol. 56 (1981), 510–18; Johnson & Kaplan, *Relevence Lost.*

28. R. H. Parker, *The Development of the Accountancy Profession in Britain in the Early Twentieth Century* (London: The Academy of Accounting Historians, 1986); Edgar Jones, *Accountancy and the British Economy, 1840–1980* (London: B. T. Batsford, 1981).

29. Anne Loft, "Towards a Critical Understanding of Accounting: The Case of Cost Accounting in the UK, 1914–1925," *Accounting, Organizations, and Society*, Vol. 12 (1987), 235–65. For a similar story, later in the century, see Stuart Burchell, Colin Clubb, and Anthony Hopwood, "Accounting in its Social Context: Towards a History of Value Added in the United Kingdom," ibid., Vol. 10 (1985), 381–413.

30. See Michael Power, "After Calculation? Reflections on Critique of Economic Reason by André Gorz," *Accounting, Organizations, and Society*, Vol. 17 (1992), 477–499.

31. Barry Barnes, "On Authority and its Relation to Power," in John Law (ed.), *Power, Action, and Belief: A New Sociology of Science* (London: Routledge & Kegan Paul, 1986), 180–95.

32. Trevor Hopper and Peter Armstrong, "Cost Accounting, Controlling Labour and the Rise of Conglomerates," *Accounting, Organizations, and Society*, Vol. 16 (1991), 405–38.

33. See John Brewer, *The Sinews of Power: War, Money and the English State* (Cambridge, MA: Harvard University Press, 1988), 109; Peter Miller, "On the Interrelations between Accounting and the State," *Accounting, Organizations, and Society*, Vol. 15 (1990), 315–38.

34. Peter Miller and Nikolas Rose, "Governing Economic Life," *Economy and Society*, Vol. 19 (1990), 1–31; Miller and Ted O'Leary, "Accounting and the Construction of the Governable Person," *Accounting, Organizations, and Society*, Vol. 12 (1987), 235–65; Rose, "Governing by Numbers: Figuring out Democracy," ibid., Vol. 16 (1991), 673–92.

35. Donaldson Brown, *Centralized Control with Decentralized Responsibility* (New York: American Management Association, 1927).

36. Steven Shapin and Simon Schaffer, *Leviathan and the Air Pump* (Princeton, NJ: Princeton University Press, 1985). See also Simon Schaffer's paper, "A Manufactory of Ohms," on the Cavendish Laboratory and the definition of the ohm (reprinted in this volume); and Bruno Latour, *Science in Action* (Cambridge, MA: Harvard University Press, 1987).

37. On the rich variety of ways in which instruments can solidify scientific networks, and connect them with a larger culture, see M. Norton Wise, "Mediating Machines," *Science in Context*, Vol. 2 (1988), 81–117.

38. David Cahan, *An Institute for an Empire* (Cambridge: Cambridge University Press, 1989); Crosbie Smith and M. Norton Wise, *Energy and Empire: A Biographical Study of Lord Kelvin* (Cambridge: Cambridge University Press, 1989).

39. Steven Shapin: "Pump and Circumstance: Robert Boyle's Literary Technologies," *Social Studies of Science*, Vol. 14 (1984), 481–520; Peter Dear, *"Totius in verba:* The Rhetorical Constitution of Authority in the Early Royal Society," *Isis*, Vol. 76 (1985), 145–61.

40. Theodore M. Porter, "Objectivity and Authority: How French Engineers Reduced Public Utility to Numbers," *Poetics Today*, Vol. 12 (1991), 245–65.

41. Theodore M. Porter, *The Rise of Statistical Thinking, 1820–1900* (Princeton, NJ: Princeton University Press, 1986).

42. Peter Galison, "The Trading Zone," (reprinted in this volume).

43. Peter Dear, "From Truth to Disinterestedness in the Seventeenth Century," *Social Studies of Science*, Vol. 22 (1992), 619–31.

44. Gerd Gigerenzer and David J. Murray, *Cognition as Intuitive Statistics* (Hillsdale, NJ: Lawrence Erlbaum Associates, 1987), 23.

45. From the publication manual of the American Psychological Association, second edition, 1958, quoted in Gerd Gigerenzer, "The Superego, the Ego, and the Id in Statistical Reasoning," in G. Keren and C. Lewis (eds.), *A Handbook for Data Analysis in the Behavioral Sciences: Methodological Issues* (Hillsdale, NJ: Erlbaum, 1993).

46. Zeno Swijtink, "The Objectification of Observation: Measurement and Statistical Method in the Nineteenth Century," in Lorenz Krüger, Lorraine Daston, and Michael Heidelberger (eds), *The Probabilistic Revolution, Vol. 1: Ideas in History* (Cambridge, MA: MIT Press, 1987), 261–85.

47. Lorraine Daston, "The Moral Economy of Science," Critical Problems conference, Madison, Wisconsin (October 1991). I learn from Peter Dear that Steven Shapin used this phrase in the title of a talk in 1987.

48. Cited in Simon Schaffer, "Astronomers Mark Time: Discipline and the Personal Equation," *Science in Context,* Vol. 2 (1988), 115–45, at 120; for other accounting analogies, see 129.

49. See Lorraine Daston, "The Cold Light of Facts and the Facts of Cold Light," paper at UCLA Tech-Know Workshop (February 1990).

50. The phrase comes from Thomas Nagel, *The View from Nowhere* (New York: Oxford University Press, 1986).

51. Robert Merton, "Science and Technology in a Democratic Order" (1942), reprinted as "The Normative Structure of Science," in Merton, *The Sociology of Science: Theoretical and Empirical Investigations* (Chicago, IL: The University of Chicago Press, 1973), 267–78.

# 27

# Artificiality
## and Enlightenment

### From Sociobiology to Biosociality

PAUL RABINOW

M ichel Foucault identified a distinctively modern form of power, "bio-technico-power." Biopower, he writes, designates "what brought life and its mechanism into the realm of explicit calculations and made knowledge-power an agent of transformation of human life." Historically, practices and discourses of biopower have clustered around two distinct poles: the "anatomo-politics of the human body," the anchor point and target of disciplinary technologies, on the one hand; and a regulatory pole centered on population with a panoply of strategies concentrating on knowledge, control, and welfare.[1] Today, I believe the two poles of the body and the population are being rearticulated into what could be called a postdisciplinary, if still modern, rationality.

In the annex to his book on Michel Foucault—entitled *On the Death of Man and the Superman*—Gilles Deleuze presents a schema of three *force-forms*, to use his jargon, which are roughly equivalent to Michel Foucault's three *epistemes*. In the classical form, infinity and perfection are the forces shaping beings; beings have a form toward which they strive and the task of science is to represent correctly the table of those forms in an encyclopedic fashion. In the modern form, finitude establishes a field of life, labor, and language within which Man appears as a distinctive being, who is both the subject and object of his own understanding, which is never complete because of its very structure. Finally, today in the present, a field of the *surhomme*, or "afterman," in which finitude, as empiricity, gives way to a play of forces and forms Deleuze labels *fini-illimité*.[2] In this new constellation beings have neither a perfected form nor an essential opacity. The best example of this "unlimited-finite" is DNA: an infinity of beings can and has arisen from the four bases out of which DNA is constituted. François Jacob, the Nobel prize-winning biologist, makes a similar point when he writes: "a limited amount of genetic information in the germ line, produces an enormous number of protein structures in the soma . . . nature operates to create diversity by endlessly combining bits and pieces."[3] Whether Deleuze has seized the significance of Jacob's facts remains an open question. Still, we must be intrigued when something as cryptic as Rimbaud's formula that "the man of the future will be filled (*chargé*) with animals" takes on a

perfectly material meaning, as we shall see when we turn to the concept of model organism in the new genetics.[4]

Deleuze convincingly claims that Foucault lost his wager that it would be language of the anthropological triad—life, labor, language—that would open the way for a new *episteme*, washing the figure of Man away like a wave crashing over a drawing in the sand. Foucault himself acknowledged that his prediction had been wrong when, a decade after the publication of *The Order of Things*, he mocked the "relentless theorization of writing, not as the dawning of the new age but as the death rattle of an old one."[5] Deleuze's claim is not that language is irrelevant but rather that the new epochal practices are emerging in the domains of labor and life. Again, whether Deleuze has correctly grasped the significance of these new practices remains to be seen; regardless, they are clearly important. It seems prudent to approach these terms heuristically, taking them singly and as a series of bonded base pairs—labor and life, life and language, language and labor—to see where they lead.

My research strategy focuses on the practices of life as the most potent present site of new knowledges and powers. One logical place to begin an examination of these changes is the American Human Genome Initiative (sponsored by the National Institutes of Health and the Department of Energy) whose mandate is to produce a map of our DNA. The Initiative is very much a technoscience project in two senses. Like most modern science, it is deeply imbricated with technological advances in the most literal way, in this case the confidence that qualitatively more rapid, accurate, and efficient machinery will be invented if the money is made available. The second sense of technological is the more important and interesting one: the object to be known—the human genome—will be known in such a way that it can be changed. This dimension is thoroughly modern, one could even say that it instantiates the definition of modern rationality. Representing and intervening, knowledge and power, understanding and reform, are built in, from the start, as simultaneous goals and means.

My ethnographic question is: How will our social and ethical practices change as this project advances? I intend to approach this question on a number of levels and in a variety of sites. First, there is the initiative itself. Second, there are adjacent enterprises and institutions in which and through which new understandings, new practices, and new technologies of life and labor will certainly be articulated: prime among them the biotechnology industry. Finally, the emergence of bioethics and environmental ethics lodged in a number of different institutions will bear scrutiny as potential reform loci.

## THE HUMAN GENOME INITIATIVE

What is the Human Genome Initiative? A genome is "the entire complement of genetic material in the set of chromosomes of a particular organism."[6] DNA is composed of four bases, which bond into two kinds of pairs wound in the famous double helix. The current estimate is that we have about three billion base pairs in our DNA; the mouse has about the same number, while corn or salamanders have more than thirty times as many base pairs in their DNA as we do. No one knows why. Most of the DNA has no known function. It is currently held, not without a certain uneasiness, that 90 percent of human DNA is "junk." The renowned Cambridge molecular biologist, Sydney Brenner, makes a helpful distinction between "junk" and "garbage." Garbage is something used up and worthless, which one throws away; junk, though, is some-

thing one stores for some unspecified future use. It seems highly unlikely that 90 percent of our DNA is evolutionarily irrelevant, but what its precise relevance could be remains unknown.

Our genes, therefore, constitute the remaining 10 percent of the DNA. What are genes? They are segments of the DNA that code for proteins. Genes apparently vary in size from about 10,000 base pairs up to two million base pairs. Genes, or at any rate most human genes known today (1 percent of the presumed total), are not simply spatial units in the sense of a continuous sequence of base pairs; rather, they are regions of DNA made up of spans called *exons*, interspersed by regions called *introns*. When a gene is activated (and little is known about this process) the segment of DNA is transcribed to a type of RNA. The introns are spliced out, and the exons are joined together to form messenger RNA. This segment is then translated to code for a protein.

We don't know how many genes we have. It is estimated that *Homo sapiens* has between fifty and one hundred thousand genes—a rather large margin of error. We also don't know where most of these genes are; neither which chromosome they are found on or where they are located on that chromosome. The initiative is designed to change all this: literally to map our genes. This poses two obvious questions: What is a map? And who is the "Our" in "our" genes?

For the first question, then: at present there are three different kinds of maps (linkage, physical, and sequence). Linkage maps are the most familiar to us from the Mendelian genetics we learned in high school. They are based on extensive studies of family genealogies (the Mormon historical archives provide the most complete historical documentation and the French have a similar project) and show how linked traits are inherited. Linkage maps show which genes are reinherited and roughly where they are on the chromosomes. This provides a helpful first step for identifying the probable location of disease genes in gross terms, but it is only a first step. In the hunt for the cystic fibrosis gene, for example, linkage maps narrowed down the area to be explored before other types of mapping completed the task.

There are several types of physical maps: "a physical map is a representation of the location of identifiable landmarks on the DNA." The discovery of restriction enzymes provided a major advance in mapping capabilities. These proteins serve to cut DNA into chunks at specific sites. The chunk of DNA can then be cloned and its makeup chemically analyzed and then reconstructed in its original order in the genome. These maps are physical in the literal sense that one has a chunk of DNA and one identifies the gene's location on it; these have been assembled into "libraries." The problem is to locate these physical chunks on a larger chromosomal map. Cloning techniques involving bacteria were used for a number of years but new techniques, such as *in situ* hybridization techniques, are replacing the more time-consuming cloning techniques.

Polymerase Chain Reaction reduces the need for cloning and physical libraries. It is necessary to clone segments of DNA in order to get enough identical copies to analyze but this multiplication can now be done more rapidly and efficiently by having the DNA do the work itself, as follows. First, one constructs a small piece of DNA, perhaps twenty base pairs long, called a *primer,* or oligonucleotide, which is then commercially made to specification. The raw material from which one takes the base pairs (to be assembled like Lego blocks) is either salmon sperm or the biomass left over from fermentation processes. A particularly rich source are the by-products of soy sauce (hence the Japanese have an edge in this market). This DNA is refined into single bases, or nucleosides, and recombined according to the desired specifications at a cost of about one dollar per coupling in a DNA synthesizer. The nucleosides could all be made synthetically, but it is currently cheaper given the small quantities needed—most primers are about

twenty bases long—to stick to salmon sperm and soy sauce biomass. The current world produc-
tion of DNA for a year is perhaps several grams but as demand grows there will be a growing
market for the oligonucleotides, custom-made strips of DNA. As Gerald Zon, a biochemist at
Applied Biosystems, Inc., put it, the company's dream is to be the world's supplier of synthetic
DNA.[7]

Two primers are targeted to attach themselves to the DNA at specific sites called STSs or
sequence-tagged sites. These primers then simply "instruct" the single strand of DNA to repro-
duce itself without having to be inserted into another organism; this is the polymerase chain
reaction. So, instead of having physically to clone a gene, one can simply tell one's friends in
Osaka or Omaha which primers to build and where to apply them, and they can do the job
themselves (eventually including the DNA preparation, which will be automated). The major
advantage of the PCR-STS technique is that it yields information that can be described as infor-
mation in a data base: no access to the biological materials that led to the definition or mapping
of an STS is required by a scientist wishing to assay a DNA sample for its presence. The com-
puter would tell any laboratory where to look and which primer to construct, and within
twenty-four hours one would have the bit of DNA one is interested in. These segments could
then be sequenced by laboratories anywhere in the world and entered into a data base. Such
developments have opened the door to what promises to be a common language for physical
mapping of the human genome. Sequencing means actually identifying the series of base pairs
on the physical map. There is ongoing controversy about whether it is necessary to have the
complete sequence of the genome (after all, there are vast regions of junk whose role is currently
unknown), the complete set of genes (what most genes do is unknown) or merely the sequence
of "expressed" genes (i.e., those genes whose protein products are known). While there are for-
midable technological problems involved in all this, and formidable technological solutions
appearing with the predicted rapidity, the principles and the goal are clear enough.

Still, even when the whole human genome is mapped and even when it is sequenced, we will
know nothing about how it works. We will have a kind of structure without function. Much
more work remains to be done, and currently is being done, on the hard scientific problems:
protein structure, emergent levels of complexity, and the rest. Remember, the entire genetic
makeup of human being is found in most of our cells, but how a cell becomes and remains a
brain cell instead of a toe cell is not known. What we will have a decade from now is the mater-
ial sequence of the *fini-illimitée,* a sequence map of three billion base pairs and between fifty and
one hundred thousand genes.

As to the second question: Whose genome is it? Obviously not everyone has exactly the same
genes or junk DNA for that matter, if we did we would presumably be identical (and probably
extinct). There was some debate early on in the project as to exactly whose genome was being
mapped; there was a half-serious proposal to have a very rich individual finance the analysis of
his own genome. The problem is now shelved, literally in the clone libraries. The collective stan-
dard consists of different physical pieces mapped at centers around the world. Given the way
genes are currently located on chromosomes, i.e., linkage maps, the easiest genome to map and
sequence would necessarily be composed of the largest number of abnormal genes. In other
words, the pathological would be the path to the norm.

Interestingly, all of the sequenced genes need not come from human beings. Genomes of
other organisms are also being mapped. Several of these organisms, about which a great deal is
already known, have been designated as model systems. Many genes work in the same way,

regardless of in which living being they are found. Thus, in principle, wherever we find a specific protein we can know what DNA sequence produced it. This "genetic code" has not changed during evolution and therefore many genes of simpler organisms are basically the same as human genes. Since for ethical reasons, many simpler organisms are easier to study, much of what we know about human genetics derives from model genetic systems like yeast and mice. Fruit flies have proved to be an extremely useful model system. Comparisons with even simpler organisms are useful in the identification of genes encoding proteins essential to life. The elaboration of protein sequences and their differences has led to new classifications and a new understanding of evolutionary relationships and processes. An Office of Technology Assessment report laconically asserts the utility of comparisons of human and mouse DNA sequences for the "identification of genes unique to higher organisms because mice genes are more homologous to human genes than are the genes of any other well characterized organism."[8] Hence, today, Rimbaud's premonition of future men "filled with animals," can be made to seem perfectly sound.

## FROM STIGMA TO RISK:
## NORMAL HANDICAPS

My educated guess is that the new genetics will prove to be a greater force for reshaping society and life than was the revolution in physics, because it will be embedded throughout the social fabric at the microlevel by a variety of biopolitical practices and discourses. The new genetics will carry with it its own distinctive promises and dangers. Previous eugenics projects have been modern social projects cast in biological metaphors. Sociobiology, as Marshall Sahlins and so many others have shown, is a social project: from liberal philanthropic interventions designated to moralize and discipline the poor and degenerate; to *Rassenhygien* and its social extirpations; to entrepreneurial sociobiology—the construction of society has been at stake.[9]

In the future, the new genetics will cease to be a biological metaphor for modern society and will become instead a circulation network of identity terms and restriction loci, around which and through which a truly new type of auto-production will emerge, which I call *biosociality.* If sociobiology is culture constructed on the basis of a metaphor of nature, then in biosociality, nature will be modeled on culture understood as practice. Nature will be known and remade through technique and will finally become artificial, just as culture becomes natural. Were such a project to be brought to fruition, it would stand as the basis for overcoming the nature/culture split.

A crucial step in overcoming of the nature/culture split will be the dissolution of the category of "the social." By "society" I don't mean some naturalized universal which is found everywhere and studied by sociologists and anthropologists simply because it is an object waiting to be described: rather, I mean something more specific. In *French Modern: Norms and Forms of the Social Environment,* I argue that if our definition is something like Raymond Williams' usage in the first edition of his book of modern commonplaces, *Keywords,* that is, the whole way of life of a people (open to empirical analysis and planned change), then society and the social sciences are the ground plan for modernity.[10]

We can see the beginnings of the dissolution of modernist society happening in recent transformations of the concept of risk. Robert Castel, in his 1981 book, *La Gestion des risques,* presents a grid of analysis whose insights extend far beyond his specific concerns with psychiatry, shedding particular light on current trends in the biosciences. Castel's book is an interrogation of

postdisciplinary society, which he characterizes thus: first, a mutation of social technologies that minimizes direct therapeutic intervention, supplanted by an increasing emphasis on a preventive administrative management of populations at risk; and second, the promotion of working on oneself in a continuous fashion so as to produce an efficient and adaptable subject. These trends lead away from holistic approaches to the subject or social contextualism and move instead toward an instrumentalized approach to both environment and individual as a sum of diverse factors amenable to analysis by specialists. The most salient aspect of this trend for the present discussion is an increasing institutional gap between diagnostics and therapeutics. Although this gap is not a new one, to be sure, the potential for its widening nonetheless poses a new range of social, ethical, and cultural problems, which will become more prominent as biosociality progresses.

Modern prevention is above all the tracking down of risks. Risk is not a result of specific dangers posed by the immediate presence of a person or a group but rather the composition of impersonal "factors" which make a risk probable. Prevention, then, is surveillance not of the individual but of likely occurrences of diseases, anomalies, deviant behavior to be minimized, and healthy behavior to be maximized. We are partially moving away from the older face-to-face surveillance of individuals and groups known to be dangerous or ill (for disciplinary or therapeutic purposes), toward projecting risk factors that deconstruct and reconstruct the individual or group subject. This new mode anticipates possible loci of dangerous irruptions, through the identification of sites statistically locatable in relation to norms and means. Through the use of computers, individuals sharing certain traits or sets of traits can be grouped together in a way that not only decontextualizes them from their social environment but also is nonsubjective in a double sense: it is objectively arrived at and does not apply to a subject in anything like the older sense of the word (that is the suffering, meaningfully situated, integrator of social, historical, and bodily experiences). Castel names this trend "the technocratic administration of differences." The target is not a person but a population at risk. As an AIDS group in France put it: it is not who one is but what one does that puts you at risk. One's practices are not totalizing, although they may be mortal.

Although epidemiological social tracking methods were first implemented comprehensively in the tuberculosis campaign, they came to their contemporary maturity elsewhere. The distinction that Castel underscores as symptomatic of this change is that between disease and handicap.[11] A handicap, according to a French government report authored by the highly respected technocrat François Bloch-Lainé, is "any physical, mental or situational condition which produces a weakness or trouble in relation to what is considered normal; normal is defined as the mean of capacities and chances of most individuals in the same society."[12] The concept of handicap was first used officially in England during World War II as a means of evaluating the available workforce in a way that included as many people as possible. Handicaps were deficits to be compensated for socially, psychologically, and spatially, not illnesses to be treated: orthopedics not therapeutics. "The concept of handicap naturalizes the subject's history as well as assimilating expected performances levels at a particular historical moment to a naturalized normality."[13] True, this particular individual is blind or deaf or mute or short or tall or paralyzed, but can he or she operate the lathe, answer the telephone, guard the door? If not what can we do to him or her, to the work or to the environment, that would make this possible? Performance is a relative term. Practices make the person; or rather, they don't; they just make practitioners.

There is a large historical step indeed from the rich web of social and personal significations Western culture inscribed in tuberculosis to the inclusive grid of the welfare state, which has yet

to inspire much poetry or yield a celebrated *Bildungsroman*. It has, however, increased life expectancy and produced millions of documents, many of them inscribed in silicon. The objectivism of social factors is now giving way to a new genetics and the beginnings of a redefinition and eventual operationalization of nature.

In a chapter entitled "What Is (Going) To Be Done?" in his book *Proceed with Caution: Predicting Genetic Risk in the Recombinant DNA Era,* Neil A. Holtzman documents the ways that genetic screening will be used in the coming years when its scope and sensitivity is increased dramatically by such technological advances as Polymerase Chain Reaction which will reduce cost, time, and resistance. There are already tests for such conditions as sickle-cell anemia, and diagnostics for cystic fibrosis and Alzheimer's are on the horizon. These diseases are among the estimated four thousand single-gene disorders. There is a much larger number of diseases, disorders, and discomforts that are polygenetic. Genetic testing will soon be moving into areas in which presymptomatic testing will be at a premium. Thus, Holtzman suggests that once a test is available for identifying a "susceptibility-conferring genotype" for breast cancer, earlier and more frequent mammograms would be recommended or even required (for insurance purposes). He adds, "monitoring those with genetic predispositions to insulin-dependent diabetes mellitus, colorectal cancer, neurofibromatosis, retinoblastoma, or Wilms tumor for the purpose of detecting early manifestations of the disease might prove beneficial. Discovering those with genetic predispositions could be accomplished either by population-wide screening or, less completely, by testing families in which disease has already occurred."[14] This remark involves a large number of issues, but the only one I will underline here is the likely formation of new group and individual identities and practices arising out of these new truths. There already are, for example, neurofibromatosis groups who meet to share their experiences, lobby for their disease, educate their children, redo their home environment, and so on. That is what I mean by biosociality. I am not discussing some hypothetical gene for aggression or altruism. Rather it is not hard to imagine groups formed around the chromosome 17, locus 16,256, site 654,376 allele variant with a guanine substitution. Such groups will have medical specialists, laboratories, narratives, traditions, and a heavy panoply of pastoral keepers to help them experience, share, intervene, and "understand" their fate.

Fate it will be. It will carry with it no depth. It makes absolutely no sense to seek the meaning of the lack of a guanine base because it has no meaning. One's relation to one's father or mother is not shrouded in the depths of discourse here, the relationship is material even when it is environmental: Did your father smoke? Did your mother take DES? Rest assured they didn't know what they were doing. It follows that other forms of pastoral care will become more prominent in order to overcome the handicap and to prepare for the risks. These therapies for the normal will be diverse ranging from behavior modifications, to stress management, to interactional therapies of all sorts.[15] We might even see a return of tragedy in postmodernist form, although we will likely not simply rail against the gods, but rather be driven to overcome our fates through more technoscience.

## LABOR AND LIFE

The emergence of modern food, that is, food industrially processed to emphasize uniformity and commoditized as part of an internationalization of world agriculture and distribution, can be dated to the 1870–1914 period. Industrial sugar refining and flour milling for the production

of white bread was one of the first examples of a constructed consumer need linked to advertising, transportation expansion, a host of processing and preservation techniques, as well as incidentally the rise of modernism in architecture (for example, Buffalo's silos and Minneapolis' grain elevators, as Reyner Banham has shown in his *Concrete Atlantis*).[16] With these changes agricultural products were on their way to becoming merely an input factor in the production of food, and food was on its way to becoming a "heterogeneous commodity endowed with distinctive properties imparted by processing techniques, product differentiation, and merchandising."[17] These processes accelerated during World War I, which here, as in so many other domains, provided the laboratory conditions for inventing, testing, and improving food products on a truly mass scale. Millions of people became accustomed to transformed natural products like evaporated milk as well as new foods like margarine, in which an industrially transformed product substituted for a processed "rural" product, vegetable fats instead of butter. Using methods developed in the textile industry, it was now possible not only to produce foods at industrial levels not constrained by the "natural rhythms" or inherent biological qualities (even if people had bred for these), but even to get people to buy and eat them.

The cultural reaction against foods classified as "artificial" or "processed" was spearheaded in the years between the wars by a variety of lifestyle reformist groups, satirized by George Orwell. Ecological and environmental campaigns, conducted on a national scale by the Nazis with their characteristic vigor, agitated for a return to natural foods (especially whole grain bread), the outlaw of vivisection, the ban of smoking in public places, and the exploration of the effects of environmental toxins on the human genetic material and so on. Hitler, after all, did not smoke or drink and was a vegetarian.[18] As we have seen in recent decades, not only have the demand for wholesome foods and the obsession with health and environmentalism not meant a return to "traditional" products and processes (although the image of tradition is successfully marketed), few would advocate a return to the real thing with its infected water supplies, low yield, and the like, but it has even accelerated, and will continue to accelerate, the improvement, the enculturization of nature drawing on tradition as a resource to be selectively improved.

Once nature began to be systematically modified to meet industrial and consumer norms—a development perhaps embodied best by the perfect tomato, the right shape, color, size, bred not to break or rot on the way to market, missing only the distinctive taste that dismayed some and pleased others—it could be redescribed and remade to suit other biopolitical specifications, like "nutrition." The value of food is now cast not only in terms of how much it imitates whole natural food in freshness and look but in terms of the health value of its component constituents— vitamins, cholesterol, fiber, salt, and so on. For the first time we have a market in which processed, balanced foods, whose ingredients are chosen in accordance with nutritional or health criteria can be presented as an alternative superior to nature. Cows are being bred for lower cholesterol, canola for an oil with unsaturated fats.

Bernardo Sorj and his coauthors in their *From Farming to Biotechnology*, claim once the basic biological requirements of subsistence are met, the natural content of food paradoxically becomes an obstacle to consumption. Once this cultural redefinition and industrial organization are accepted, then nature, whether as land, space, or biological reproduction, no longer poses a binding constraint to the capitalist transformation of the production process and the social division of labor because the "the rural labor process is now not so much machine-paced as governed by the capacity of industrial capitals to modify the more fundamental rhythms of biological time."[19] This process leads to increased control over all aspects of the food production process

and efforts to make it an industry like any other. New biotechnological techniques working toward the industrial control of plant biology increase the direct manipulation of the nutritional and functional properties of crops accelerating the trends toward rationalization and the vertical integration of production and marketing required for efficiency. Biotechnological advances like nitrogen fixing or the herbicide resistance of newly engineered plant (and eventually animal) species diminish the importance of land quality and the physico-chemical environment as determinants of yields and productivity.

Calgene, a leading California agro-biotech company based in Davis, is proud of its genetically engineered PGI Tomato seeds whose fruit, their 1989 annual report boasted is superior to a nonengineered control group. Calgene's engineering is no ordinary engineering though, even by biotech standards; their tomatoes employ an "antisense" technique considered to be one of the cutting edge achievements in the pharmaceutical and therapeutic fields. Antisense involves disrupting the genetic message of a gene by interfering with either the synthesis of messenger RNA or its expression, that is before its instructions to make a protein are carried out. While the concept is simple, developing techniques refined and specific enough to achieve the desired results is not. Field trials, according to the annual report "verified the ability of Calgene's antisense (AS-1) gene to reduce fruit rotting while increasing total solid content, viscosity and consistency." The gene significantly reduces the expression of an enzyme that causes the breakdown of pectin in fruit cell walls and thereby decreases the shelf life. "This new technology provides a natural alternative to artificial processing, which means that the tomatoes delivered to consumers in the future promise to be closer to homegrown in firmness, color and taste."[20] It looks good, it travels well, and it may soon taste like what those who have still eaten traditional tomatoes think they should taste like.

Traditional tastes pose a challenge, not a threat to technoscience; the more one specifies what is missing from the new product the more the civilizing process proceeds. Tomatoes aren't what they used to be? But you don't like bugs either? Let's see what can be done. A company in Menlo Park is perfecting a bioengineered vanillin, one of the most complex of smells and tastes. Scientists are approaching museums armed with the PCR technique, which enables them to take a small piece of DNA and amplify it millions of times. This recovered DNA could then, at least in principle, be reintroduced into contemporary products. If eighteenth-century tomatoes are your fancy, there is no reason a priori why one day a boutique biotech company aiming at the Berkeley or Cambridge market couldn't produce one that is consistently pesticide resistant, transportable, and delicious for you—and those just like you. In sum, the new knowledges have already begun to modify labor practices and life processes in what Enlightenment botanists called nature's second kingdom.[21]

## A CHALLENGE

François Dagognet, a prolific French philosopher of the sciences, identifies a residual naturalism as the main obstacle to the full exploration and exploitation of life's potentials. He traces the roots of "naturalism" to the Greeks who held that the artisan or artist imitates that which is—nature. Although man works on nature, he doesn't change it ontologically because human productions never contain an internal principle of generation. From the Greeks to the present, a variety of naturalisms have held to the following axioms: (1) the artificial is never as good as the

natural; (2) generation furnishes the proof of life (life is autoproduction); (3) homeostasis (auto-regulation) is the golden rule.[22] Contemporary normative judgments continue to affirm the insecurity of human works, the risks linked to artificiality and the certitude that the initial situation—the Golden Pond or the Sierras—was always incomparably better.

Dagognet argues that nature has not been natural, in the sense of being pure and untouched by human works, for millennia. More provocatively, he asserts that nature's malleability offers an "invitation" to the artificial. Nature is a blind *bricoleur,* an elementary logic of combinations, yielding an infinity of potential differences. These differences are not prefigured by final causes and there is no latent perfection seeking homeostasis. If the word "nature" is to retain a meaning, it must signify an uninhibited polyphenomenality of display. Once understood in this way, the only natural thing for man to do would be to facilitate, encourage, accelerate its unfurling: thematic variation, not rigor mortis. Dagognet challenges us in a consummately modern fashion: "either we go toward a sort of veneration before the immensity of 'that which is' or one accepts the possibility of manipulation." As with nature, so too, it seems, with culture?

NOTES

   1. Michel Foucault, *The History of Sexuality, Vol. I: An Introduction* (New York: Pantheon Books, 1978), p. 139. Special thanks to Vincent Sarich, Jenny Gumperz, Frank Rothchild, Guy Micco, Hubert Dreyfus, Thomas White.

   2. Gilles Deleuze, *Foucault* (Paris: Editions du Minuit, 1986), p. 140.

   3. François Jacob, *The Possible and the Actual* (New York: Pantheon Books: 1982), p. 39.

   4. Deleuze, *Foucault, "L'homme de l'avenir est chargé des animaux,"* p. 141.

   5. Michel Foucault, "Truth and Power," p. 127.

   6. *Mapping Our Genes, Genome Projects: How big, how fast?* (Washington, D.C.: Office of Technology Assessment, 1988), p. 21.

   7. Interview with the author, March 19, 1990.

   8. *Mapping,* p. 68.

   9. Marshall Sahlins, *The Use and Abuse of Biology: An Anthropological Critique of Sociobiology* (Ann Arbor: University of Michigan Press, 1976). Robert N. Proctor, *Racial Hygiene, Medicine Under the Nazis* (Cambridge: Harvard University Press, 1988). Daniel J. Kevles, *In the Name of Eugenics, Genetics and the Uses of Human Heredity* (Berkeley: University of California Press, 1985). Benno Muller-Hill, *Murderous Science, Elimination by Scientific Selection of Jews, Gypsies, and Others, Germany 1933–45* (Oxford: Oxford University Press, 1988).

   10. Paul Rabinow, *French Modern: Norms and Forms of the Social Environment* (Chicago: University of Chicago Press, 1995 [orig. 1989]).

   11. Robert Castel, *La Gestion des risques, de l'anti-psychiatrie à l'après-psychanalyse* (Paris: Les Editions du Minuit, 1981).

   12. François Bloch-Lainé, *Etude du problème général de l'inadaptation des personnes handicapées* (la Documentation française, 1969), p. 111, cited in Castel, *La Gestion,* p. 117.

   13. Ibid., p. 122.

   14. Neil A. Holtzman, *Proceed with Caution: Genetic Testing in the Recombinant DNA Era* (Baltimore and London: Johns Hopkins University Press 1989), pp. 235–36.

   15. Robert Castel, *Advanced Psychiatric Society* (Berkeley: University of California Press, 1986).

   16. Reyner Banham, *A Concrete Atlantis: U.S. Industrial Building and European Modern Architecture 1900–1925* (Cambridge, Mass.: MIT Press, 1986).

   17. David Goodman, Bernardo Sorj, and John Wilkinson, *From Farming to Biotechnology: A Theory of Agro-Industrial Development* (Oxford: Basil Blackwell, 1987), p. 60.

   18. Proctor, *Racial Hygiene,* ch. 8, "The 'Organic Vision' of Nazi Racial Science."

   19. *From Farming to Biotechnology,* p. 47.

   20. *Planning for the Future* (Calgene 1989 Annual Report), p. 14.

   21. François Delaporte, *Nature's Second Kingdom* (Cambridge, Mass.: MIT Press, 1982 [orig. 1979]).

   22. François Dagognet, *La Maitrise du vivant* (Paris, Hachette, 1988), p. 41.

# 28

# Experimental Systems

## Historiality, Narration, and Deconstruction

### HANS-JÖRG RHEINBERGER

## INTRODUCTION

The title avoids the notion of history, or historicity. Instead, it speaks of "historiality." Why this apparent game with words? Moreover, how to speak about an issue that needed a neologism to be approached and that, provisionally and some twenty-five years ago, accompanied a text that since then has become the *locus classicus* of "deconstruction"? In other words, is it possible to think history without "origins" and without "grounds"?[1] The historians of science, like the historians of any cultural texture, are confronted with an unsurmountable obstacle. What is it they are dealing with? Are they looking at a past that is the transformation of another, foregoing past; or are they looking at a past that is the product of a past deferred, if not of a presence?

Early in 1991 a group of historians of biology assembled at the Natural History Museum in what had been East Berlin less than two years before. A paleontologist who had spent his whole professional life ordering and reconstructing fossil material pointed at the famous Solnhofen Archaeopterix of the Berlin collection and summarized the experience of forty years of work with the following words: "At the point of the emergence of the new, the new is not the new. It becomes a novelty only by a transformation that makes it a trace of something to which it has given rise."[2] The new is nothing but an irritation at the point where it first appears: It can be approached only in the mode of a future perfect. Of course, we may try to indicate the conditions of its emergence. But they, and so the new, seem accessible only through and by way of a kind of recurrence[3] that requires the product in order to assess the conditions of its production. This movement, sometimes denounced as whiggish but more often misunderstood as a form of teleological projection, calls for a bending of thought that cannot be linearized. Attempts at such linearization constitute the classical illusion of the task of a historical narrative: to tell—whatever methodological refinements are added to the core of the argument—the story of what, *then*, really happened. This presupposes the existence of an undistorted past "out there" that, from a detached present "in here," can in principle be grasped by means of an analysis whose means are

supposed not to have been altered by what is going to be synthesized.[4] Moreover, it perpetuates the illusion that the task of the historian is to relate "real history" as opposed to just telling stories.[5]

In contrast, what might be called *historial* thinking not only has to accept and even postulate a kind of recurrence inherent in any hindsight—hence interpretation, or hermeneutic action—but also it has to assume that recurrence works in the differential activity of the *system* that is *itself* at stake, and in its time structure. What is called its history is "deferred" in a rather constitutive sense: The recent, so to speak, is the result of something that did not happen. And the past is the trace of something that will not have occurred. Such is the temporal structure of the production of a trace.[6]

In what follows I first offer some comments on the historial character of the production of scientific knowledge. I then discuss a specific episode in the history of virus research in order to provide an empirical background to the more abstract considerations of the first part.

## THE HISTORIAL STRUCTURE
## OF SCIENTIFIC ACTION

Within the tradition of a general history of science, the view of science as a continuous, accumulative process has seriously and lastingly been challenged by the model of a series of more or less radical breaks.[7] However, both the revolutionary and the gradual conception of scientific change assume a global epistemic structure, called "science," that as a whole either continuously grows—toward truth—or is periodically reconstructed according to a new paradigm. Although there is a heavy dose of relativism in the second view, a paradigm, at a given time, is assumed to have enough power to coordinate and make coherent the activity of a whole—and potentially *the* whole—scientific community. But even in the denial of a continuum of rationality there remains an element of "totalization." Science remains a normative process encompassing the ensemble of participants and their practices in a common endeavor. And there remains the general view of an overarching chronological coherence to the process of gaining scientific knowledge.

This view becomes all the more problematic[8] the closer one looks at the microdynamics of scientific activity.[9] At the level of the basic, functional units of scientific activity—we may call them, as practitioners of science do, *experimental systems*[10]—the possibility arises of an assessment of the scientific research process that radically subverts its monolithic, macroscopic appearance. This is not to advocate the introduction of a distinction here that has pervaded modern twentieth-century physics: the distinction between the microscopic indeterminacy and macroscopic determinism of what we take to be natural phenomena. Nevertheless, I do not want to exclude a certain resonance with a conception of uncertainty and indeterminacy that has undermined the scientific self-perception of a whole epoch.

At issue is, in a certain sense, the *fragmentation* of science into systems and their corresponding times. There is a resonance here, too, with recent developments in the field of the thermodynamics of irreversible processes. New possibilities are arising for structuring what on a very abstract level might be called the locality of time. Ilya Prigogine has suggested defining time not simply as a parameter (the $t$ of Newtonian-to-Einsteinian physics) but to introduce an "operational" time into the theory of irreversible processes—that is, to determine time as an operator

(*T*) (Prigogine and Stengers 1988). Viewed formally, an operator is a prescription to manipulate, i.e., to reproduce a function so that the function itself survives the operation but at the same time is changed by some factor or factors. What is of relevance for the present discussion is that, with respect to the movement of material systems, systems of things, or systems of actions, time as an operator is not simply an axis of extension but a structural, local characteristic of any system maintaining itself far from equilibrium.

Thus every system of material entities, and therefore every system of actions concerning such entities, that can be said to possess reproductive traits may also be said to possess its own intrinsic, or *internal time*. It is not simply a dimension of its existence in space and time. It characterizes a sequence of states of the system insofar as they can be considered to undergo a continuing cycle of nonidentical reproduction. Research systems, with which I am concerned here, are characterized by a kind of differential reproduction by which the generation of the unknown becomes the reproductive driving force of the whole machinery. As long as this works, the system so to speak remains "young." "Being young," then, is not here a result of being near zero on the time scale; it is a function (if you will) of the functioning of the system. The age of such a system is measured by its capacity to produce differences that count as unprecedented events and keep the machinery going.[11]

Now we can look at the activities in a particular research field as an assembly, or an ecological network, of experimental systems. Some of them are close enough so that their reproductive cycles are able to become operationally coupled by exchange, and some of them are far enough from one another to perform their operational transformations independently (which in itself is a matter of the actual transformations going on within the different systems). Thus we end up with a *field* of systems that has a very complex time structure, or form of time. The systems, or reproductive series, retain their own internal times as long as they replicate as such, and the epistemic field can no longer be seen as dominated by a general theme, or paradigm.[12] There is no global frame of theory or political power, or social context strong enough to pervade and coordinate this universe of merging or bifurcating systems. And where the systems do get linked, this is not by stable connections but rather by possibilities of contacts generated by the differential reproduction of the systems and the constellation of their ages. There is no common ground, source, or principle of development. The constellation of differently aged systems constitutes a particular field of the possible. In this field, attractors constantly shift; there is no longer a fixed center.

The multiplicity of internal times in an open horizon creates what can be called *historiality:* It escapes the classical notions of linear causation, retroaction, influence, and dominance, as well as that of a purely stochastic process, to both of which the term "historicity" has been connected, by law or by singularity. It is only the trace that will remain which creates, through its action, the origin of its nonorigin. Therefore there can be no global foresight; François Jacob has brilliantly expressed this in the chapter entitled "Time and the Invention of the Future" at the end of his *The Actual and the Possible:* "What we can guess today will not be realized. Change is bound to occur anyway, but the future will be different from what we believe. This is especially true in science. The search for knowledge is an endless process and one can never tell how it is going to turn out. Unpredictability is in the nature of the scientific enterprise. If what is to be found is really new, then it is by definition unknown in advance. There is no way of telling where a particular line of research will lead" (Jacob [1981] 1982, 67).

So we are further than ever from the romantic illusion of history as an all-prevading "totality" dominated by mimetic, metamorphic, or "expressive" relations of the parts within the ensemble.[13]

The figure of differential reproduction of serial lines nestling in a landscape of research however creates another perhaps no less encompassing but much more fragile coherence—one no longer based on the simultaneity of all possible metamorphoses but on the coexistence of replicating systems carrying their own age along with them, thus escaping any unifying time of history. The global structure of this coherence is based not on expression, reflection, or mirroring but on the tension of an "ecological" reticulum, a patchwork of precocious and deferred actions with its extinctions and reinforcements, interferences and intercalations.

If we take Jacob's statement seriously, then we have to cope with the principal impossibility of any algorithm, of any logic of development that is ontologically or methodologically grounded. Then the difficulty for the historian arises that the linearizations of what he calls history are altogether fictions created for the sake of satisfying the desire for a logos-driven process. All that can be said about the "machine for making the future" (Jacob 1988, 9) called modern science is that it is creating the future. The present as the future of the past is not a "result"—whatever that means—of the past; the past is the result of a future—its presence as a surrogate.

Nevertheless, a future-generating device does not produce anything whatsoever. Although unpredictability is in the nature of scientific undertakings, their movement and performance can be characterized in a formal—i.e., structural—way. This may not be obvious after what has been said so far. The following indication has to be taken with every possible precaution. The problem—not its particular form—can be seen as analogous to the epistemological difficulties in dealing with the phenomena of biological evolution. If one follows the scheme that has been established since Darwin, one may say: The difficulty in understanding the process we call evolution lies precisely in its resting on contingencies which produce a scattering field that begins to filter itself because of its own finite possibilities of extension. Now a research process too has to produce something different from the present state of the art in order to remain a research process. And its character as a research endeavor is tied to the production of what only *post festum*, by becoming filtered, acquires the character of a novelty in the sense of a new attractor. Paradoxically, one could state: the goal of the research process is to produce results that by definition cannot be produced in a goal-directed way. The unknown is something that cannot be approached straightforwardly precisely because one does not know what is to be approached.

Given such conditions, a research device has to fulfill two basic requirements. First, it has to be stable enough so that the knowledge which is implemented in its functioning does not simply deteriorate in the course of continuing cycles of realization. This is a necessary but not sufficient condition for its becoming a device that is endowed with internal time and is thus able to act as a historial arrangement.[14] Second, it has to be sufficiently loosely woven so that in principle something unpredictable can happen and over many rounds of performance *must* happen. In everyday life and in most of our social contexts this is a situation that one tries to avoid as an inconvenience. Within the research context it is a situation that has to be actively promoted. In order to balance these two requirements, "experiencedness"[15]—to pick up a somewhat old-fashioned expression of Fleck's ([1935] 1979, 96)—is needed as the principal ability of those involved in the endeavor.

Both prerequisites, sufficient reproductive stability and sufficient sloppiness for the intrusion of the unknown—Max Delbrück characterized this as the "principle of measured sloppiness" (Fischer 1988, 152–53)[16]—make it something fundamentally different from a system closed upon itself. We could rather say—in a way metaphorically, but the character of metaphor depends on the determination we would like to convey to the diacritic boundaries of the signifier—that it follows the

movement of what Derrida has termed the "différance": an "economic concept designating the production of differing/deferring" (Derrida [1967] 1976, 23). In a paper elaborating on this notion Derrida writes: "Everything in the design of the *différance* is strategic and bold. Strategic, because no transcendental truth present outside the field of writing is able to dominate theologically the totality of the field. Bold, because this strategy is not a simple strategy in the sense in which one says that the strategy guides the tactics to a certain end, toward a telos or the motif of a domination, a dominance and a definite reappropriation of the movement of the field. A strategy, finally, without finality; one could call this *blind tactics, empirical roaming around*" (Derrida [1968] 1972, 7, my translation).[17]

I would like to emphasize the expression "blind tactics"—empirical *"tâtonnement"* (as Claude Bernard once called it (Bernard [1878] 1966, 19).[18] It is intimately linked to the nature of the *means* by which a text, and an experimental text as well, gets written. It is the nature of these means—material, graphic entities—that they contain the possibility of an *excess*. They contain more and other possibilities than those to which they are actually held to be bound. The excess embodies the historial movement of the trace: It is something that transgresses the boundaries within which the game appears to be confined. As an excess, it escapes any definition. On the other hand it brings the boundary into existence by cutting a breach into it. It defines what it escapes. The movement of the trace is recurrent. The present is the future of a past that never happened.

In describing an experimental system as pervaded by *différance,* this point is crucial. It stresses that the system undergoes a play of differences and oppositions governed by its own operator-time, *and at the same time* that it decalates or displaces what at any given moment appear to be its borders. This *décalage,* or displacement, implies that other experimental systems are already there against which the displacement can be operated. What goes on, then, could be characterized by the concept of "grafting" as invoked by Derrida[19]—once more, as a model of working on and with textual structure. Interestingly, and probably not by chance, it is derived from a biological background. Grafting keeps alive, as a support, the system on which one grafts. At the same time it induces the supporting system to produce not only its own seeds but also those of the supported graft. On the one hand the relation of graft and support is that of a tight insertion; on the other it is the continuation of a manifest separation. The graft is a special kind of excess: an *intrusion.* It brings the boundary into existence by transgressing it in the reverse direction. But its very functioning as a graft also shows the feasibility of the support to be intruded. Thus there is a fundamental complicity. What is inside and what is outside here ceases to be a question that can be answered in any meaningful way for the process at issue.

So the recombination and reshuffling of and within experimental systems is a prerequisite for producing stories from other stories, something that does not and cannot happen if the "lines" have become too "pure." The historial movement of the *différance* is always impure; it is a hybrid creation, it works by transplantation.

## A CASE FROM VIROLOGY

By way of illustration I present here a very brief and condensed account of a case from the history of virus research.[20] Since the movement of experimentation gains its plausibility from the details of its trajectories, the story that follows inevitably entails some distortion and suppression.[21]

During the period 1910–11 Peyton Rous, who had obtained an appointment in the Pathology

Department of the Rockefeller Institute in 1909, succeeded in transferring a Plymouth Rock chicken tumor from one animal to another, healthy one, by injecting a cell-free extract of the former (Rous 1910, 1911). Because of its physical characteristics (e.g., it passed through a porcelain filter without losing its efficacy) Rous thought of the transferring agent as an ultramicroscopic structure, probably something similar to what since the turn of the century had begun to be thought of as "viral" agents,[22] as distinct from ordinary microbes. Viruses were by then beginning to be phenomenologically, and negatively, characterized as nonbacterial infectious entities. They were not retained by bacterial filters, were not visible in the light microscope, and did not grow on sterile bacterial media. Oncologists received the news from the Rockefeller labs with "downright disbelief" (Rous 1967, 26). It was an unprecedented finding. Rous himself was not able to find similar filterable agents in mammalian tumors during the years that followed, and so, disappointed, he left the field. The chicken sarcoma agent had made its appearance as a *cancer* agent, but it did not become connected to the field of the prevailing cancer research: human oncology. And given the means of pathological analysis then current, other than comparative questions could not be raised within such "viral systems."

However, the controversy over the chicken tumor agent—i.e., Rous's "filterable agent"— slowly intruded, became part of, and so was resumed about a dozen years later within *another* controversy: that over the nature of a virus. The behavior of viruses could be interpreted as stemming from a kind of parasitic ultramicroorganism; but their mode of action could just as well be that of a soluble biochemical substance produced by the living cell under certain conditions. Possibly by assuming that viruses were, so to speak, a minute pocket edition of bacteria, one went in the wrong direction. And maybe the chicken sarcoma agent was the right object of research just *because* one had hesitated in the beginning to accept it as a virus. Anyway, such questions were agitating James B. Murphy, director of the Cancer Laboratory at the Rockefeller Institute, who had earlier been a coworker of Rous, and they finally brought him back to the chicken tumor agent in 1928. The system had been put aside for a time, but it was not difficult to reactivate it at the place it had been in use before.[23] Some biochemical and biophysical characteristics of the agent, especially its behavior in electrodialysis, induced Murphy to believe that it might be an endogenous, "enzyme-like" structure rather than a parasitic organism (Murphy et al. 1928).

At this point in time—1929—Albert Claude came from Belgium to join Murphy's laboratory. He was supposed to set out to demonstrate the so-called nonliving character of the substance causing the tumor. Since the cancer-inducing activity survived rather harsh purification procedures, thus losing some antigenicity but without its activity being diminished, its purely "chemical" constitution appeared to become more and more plausible. Claude and Murphy began to think about the tumor agent as a kind of "transmissible mutagen," chemical in nature and endogenous in origin, that could induce a permanent alteration in the metabolic behavior of the cell (see Murphy 1931). Murphy saw connections to the "transforming agent" of *Pneumococci* (Griffith 1928), on which Oswald Avery's laboratory was then already working, also at the Rockefeller Institute. This was in 1931.

The biochemical characterization and especially the purification procedures available at the beginning of the 1930s did not however allow of any appreciable enrichment and thus of a more detailed analysis of the tumor-inducing component's composition. In 1928 an enzyme-like substance had been favored. Around 1931–32 a nonprotein component seemed to show up. By 1935 proteins and lipoids had taken over (Claude 1935). At that time, however, the experimental system

again began to become sluggish. On the other hand, Wendell Stanley, also of the Rockefeller Institute, had succeeded in crystallizing a virus for the first time—the tobacco mosaic virus (TMV) (Stanley 1935; see also Kay 1986). This reinforced the suspicion that viruses might be nonliving entities.

Also in 1935 two successful attempts at sedimenting the filterable chicken tumor agent by ultracentrifugation were reported (Ledingham and Gye 1935; McIntosh 1935). To keep his research machinery productive, Claude immediately began to implant into his system the method of ultracentrifugation. Within two years he had managed to concentrate the agent by a factor of about 2,800 (Claude 1938a). Upon chemical analysis, nucleoproteins became prominent (Claude 1939). Were they to be regarded as the active material? Anyhow, since the agent could be sedimented, the abandoned option of its being a *particle* came into play again. At the same time, however, matters took a further turn as the result of another astonishing observation. By comparing subcellular fractions of chicken tumor cells and healthy embryonic, actively dividing cells as a control Claude surprisingly found that the composition of the tumor particle could not be distinguished from what appeared to be its normal cellular counterpart (Claude 1938b). Two interpretations were possible. Either the bulk of the tumor fraction simply represented inert elements existing also in normal cells, or the particles of the normal cells might be precursors of the chicken tumor principle "which could assume, under certain conditions, the self-perpetuating properties of the tumor agent" (ibid., 402).

With that, an experimental process was instigated which soon gained its own momentum and quickly led away from the tumor agent that had kept Claude busy for almost ten years. A new option came into play. Ultracentrifugation had been introduced in order to isolate a submicroscopic *cancer* principle. Now it promised to become a tool for fractionating the cytoplasm of *normal* cells. What had been cancer research, now turned into cytomorphology.

For a short time Claude identified his particles with mitochondria or fragments thereof (Claude 1941). Between 1941 and 1943, however, he managed to refine his sedimentation and resuspension conditions and finally came to the conclusion that his "small particles" represented something different from and definitely smaller than mitochondria. Accordingly, he called them "microsomes" (Claude 1943). For quite a time he pursued their purification, starting with normal cells, assuming that he might work on the normal cellular counterparts of what under certain conditions caused uncontrolled malignant growth. Finally he realized that the evidence he could obtain did not support this view and that with microsomes he had something quite different in his hands. The graft had produced, so to speak, its own seeds.

A refined biochemical analysis of microsomes meanwhile had revealed that they contained considerable amounts of ribose nucleic acids in addition to their protein and lipid components. Nucleic acids were just coming into the focus of attention as possible candidates of the genetically active material. Oswald Avery, Colin MacLeod, and Maclyn McCarty were on the point of ascribing to them the transforming activity they had been following up for many years in their *Pneumococcus* experiments (Avery et al. 1944). Claude was inclined to assume that his microsomes might represent some kind of self-reproducing entities within the cell. However, like most researchers at the time he thought of the nucleic acid as a necessary cofactor of reproduction, rather than as of the reproducing entity itself. The latter was generally held to be a protein entity. As a variation on the theme, Jean Brachet (Brachet 1941) and Torbjörn Caspersson (Caspersson 1941) suggested that ribonucleic acid–containing cytoplasmic structures might be involved in the cellular making of protein. Claude, however, remained skeptical to the suggestion that microsomes might be associated with protein synthesis (Claude 1950).

From the early 1940s Claude began to work with still another technique of ultrastructural research: the electron microscope. After some pioneering work on the rather bulky mitochondria (Claude and Fullam 1945; see also Rasmussen 1993), he tried, together with Keith Porter, to visualize the submicroscopic microsomes. Taking advantage of Porter's skill in growing monolayered cell cultures, he succeeded in the electron microscopic representation of what later came to be referred to as the endoplasmatic reticulum (Claude et al. 1947). Much to his disappointment microsomes did not show up as particulate structures of the cytoplasm in these pictures. However, this combined technique of cell-culture preparation and electron microscopy enabled the long-neglected tumor agent to celebrate its ultrastructural comeback. Cells derived from chicken tumors appeared to be crammed with small, electron-dense particles that had no counterpart whatsoever in normal healthy cells. Around 1940 the tumor agent had lost its identity in favor of a regular, constitutive cytoplasmic particle. Now the tumor agent again acquired prominence, this time against a background of invisible microsomes. What remained, with these viral particles, was the motif of self-duplication. Claude, as he reported, even "saw" them duplicate in his ultrastructural pictures (ibid.). But these new particles appeared in malignant cells only, and so the end result of this long and labyrinthian pathway was an exogenous infectious entity—just the opposite of the assumed endogenous biochemical substance that had guided Claude's initial work twenty years earlier.

A summary could read like this: At the beginning, Murphy and Claude had looked for a chemical substance responsible for the induction of chicken sarcoma, which they wanted to establish as an endogenous cellular component, distinct from Rous's initially assumed viral parasitic "ultramicroscopic organism," as the cause of a fowl cancer (Rous 1911, 409). The result of Claude's endeavor however was that he was led by the vagaries of his research trajectory to pioneer the ultrastructural composition of the cytoplasm of normal cells via differential centrifugation. It soon became clear that what he had at first identified as mitochondria, and what he had subsequently begun to detach from them under the "noncommittal" term of microsomes (Claude 1943, 119–20), had little to do with a viral or, more generally, a cancer-inducing agent. Instead he found himself following the trace of something that slowly would become an organelle of protein synthesis rather than a self-replicator. From this organelle electron microscopic structures could finally be distinguished that again came to represent an entity quite different from the original assumption: the cancer-producing agent was not a soluble, single biochemical substance but rather a specific, exogenous pathogen. The microsomes were thus the outcome of research into something that in turn revealed itself as an entity that did not exist in the form in which it had been searched for: namely an endogenous, biochemical cancer-inducing agent.[24] Quite the contrary: the cancer-inducing agent gained identity only as a structure that could be *detached* from an endogenous component of the cell not known before, the microsome, which in turn had gained identity only in the search for a cancer agent. And yet in the labyrinth of all these transformations we are still in the realm of the experimental setup with which Peyton Rous had started in 1910, in which for the riddle of malignant growth he substituted another one, the riddle of the viruses: the chicken sarcoma system.

One thus gets the impression of a highly volatile research process, where at every step what is about to take shape creates unforeseen alternative directions for the next step to be taken. The significance or, better, the significant units of the experimental system concatenate into a constantly changing signifying context. There is no direct progress toward a definite "meaning"—whatever "meaning" might mean here. The so-called "tumor agent" successively signified a virus

(a turn-of-the-century-type virus), an enzyme-like endogenous component of the cell, a "transmissible mutagen," a factor regulating normal cell growth but having escaped control, a microscopic cellular organelle such as the mitochondrion, a submicroscopic "microsome," and finally an extraneous structure probably able to duplicate within the cell. For forty years the experimental system was in a sense oscillating around an "epistemic thing" that constantly escaped fixation; and by transplanting new methods into the setup—ultracentrifugation, electron microscopy— the system itself constantly shifted its borders. There was not, and could not be, any single perspective that could have brought the research movement into line, any definite direction to its "blind tactics," its "empirical roaming around." Claude was looking for something whose likeness he did not and could not know. What was a virus? If *we* want to "know" what a virus represented between 1910 and 1945, the material signifiers of the experimental game will have turned into something that they, at the time, could not (yet) have been. The signified organizing the recurrence draws them in a light corresponding to another conjunction. "Within the truth"[25] of a particular ongoing research there exist always only the minimal conditions for the coherence of a significant chain to be endowed with the dignity of a scientific object. At a given moment and in a given research process, what, say, a microsome or a virus "represents"—in the sense of how it is "produced," how it is "brought forth"—is an articulation of graphemes traced and confined by the procedures of the research process. Thus what André Lwoff of the Pasteur Institute in Paris had to say about viruses in 1957 is not to be read as a tautological joke but precisely points at the argument I am trying to make: "Viruses should be considered as viruses because viruses are viruses" (Lwoff 1957). Here the signified has been crossed out and the reference itself has become a signifier—which is the essence of narration.

## CONCLUSION

What, then, about my introductory remarks concerning recurrence in the history of science? Claude, after his odyssey and, I should add, after having received his Nobel Prize,[26] accounted for his "discovery" (Claude 1975) in the frame of what one might call the "spontaneous history of the scientist."[27] Ilana Löwy summarizes the process quite precisely: "A scientist takes a biological entity, at first poorly defined and thus 'controversial in its nature,' purifies and characterizes it, and, as a consequence, he recognizes its true nature as a '*bona fide* virus'" (Löwy 1990, 100). In the spontaneous recurrence of the scientist the new becomes something already present, albeit hidden, as *the* research goal from the beginning: a vanishing point, a teleological focus. Without the avian sarcoma virus of 1950, Rous's sarcoma agent would have remained something different. But: The virus of 1950 must be seen as the condition of possibility for looking at Rous's agent as that which it had *not* been: the *future virus*. The new is not the new at the beginning of its emergence.

If we would not like to look at it as a mere idealization, or even a malevolent distortion, the retrospective view of the scientist as a spontaneous historian reminds us of the following: An experimental system has *more stories* to tell than the experimenter at a given moment is trying to tell with it. It not only contains submerged narratives, the story of its repressions and displacements; as long as it remains a research system, it also has not played out its excess. Experimental systems contain remnants of older narratives as well as fragments of narratives that have not yet been told. Grasping at the unknown is a process of tinkering; it proceeds not so much by completely doing away with

old elements or introducing new ones but rather by *re-moving* them, by an unprecedented concatenation of the possible(s). It differs/defers. If in the spontaneous history of the scientist the latest story appears always as the one which has already been told, or that at least has been tried to be told, this is not a deliberate dissimulation; it reflects a process of *marginalization* that is born into the ongoing research movement itself. But it reflects the rebuilding, the replacement, the patching, the brushing aside—in short, the *deconstruction* of the research meandering, as a *construction;* and it thus remains within the demiurgic illusion inherent in this notion. In the spontaneous history of the scientist, the present appears as the straightforward result of the past pregnant with what is going to be. Strangely enough, in a kind of double reversion, it inevitably also presents the new as the result of something that never happened. The historical, without realizing it, obeys and discloses the figure and the signature of the historial.

In a recent interview Jacques Derrida stated: "[The term] 'deconstructions,' as I prefer to say in the plural, has certainly never meant a project, a method, or a system. Above all not a philosophical system. Within always very limited contexts, it is a possible way to designate, metonymically in the end, what arrives or doesn't arrive to arrive, i.e., a certain dislocation that repeats itself regularly—and everywhere where there is something and not nothing: in the texts of classical philosophy certainly and exemplarily, but also in every "text," in the general sense I would like to attach to that term—that is, in experience as such, in social, historical, economic, technical, military 'reality'" (Derrida 1991, 26–27, my translation). This applies even more so, it appears, to an experience that is called scientific experimentation and for which the French language has the same and only this expression: *expérience.*

I thank Rainer Nägele for the opportunity to present an earlier version of this paper before the German Department of Johns Hopkins University, Baltimore, on March 14, 1991. Where else could I have referred to Jacques Derrida in speaking about viruses? My thanks go also to Joseph Mali and Gabriel Motzkin, who accepted the paper with minor revisions as part of their workshop on "Narrative Patterns in Scientific Disciplines," and to Gideon Freudenthal for his thoughtful comments.

NOTES
    * A modified German version of this paper has been included in Rheinberger (1992b). For a full account of experimental systems, see Rheinberger, H. J., *Toward a History of Epistemic Things,* (Stanford: Stanford University Press, 1997).
    1. "An unemphatic and difficult thought that, through much unperceived mediation, must carry the entire burden of our question, a question that I shall provisionally call *historial [historiale]*" (Derrida [1967] 1976, 24).
    2. There is a deep irony at work in this coincidental complicity of political history and paleontology—unintended, but inescapable.
    3. This holds for the monuments of natural history as well as for those of the history of science: "The same may be said of all the new varieties of scientific thought, which, after the event, come to project a recurrent light on the obscurities of uncompleted knowledge [qui viennent après coup projeter une lumière *récurrente* sur les obscurités des connaissances incomplètes]" (Bachelard [1934] 1984, 8, my emphasis; I have changed the English translation because Goldhammer's left nothing of the sense of the original sentence). According to Georges Canguilhem it is exactly at this point that the roads of the historian in the traditional sense and the epistemologist in the sense of Bachelard part: "The historian proceeds from the origins toward the present in such a way that the science of today is always to a certain degree founded in the past. The epistemologist proceeds from the actual toward its beginnings in such a way that only part of what yesterday took itself to be science finds itself within the present. So, in founding—never of course forever but over and over again—the science of today also destroys—forever" (Canguilhem [1963] 1975, 178–179, my translation).
    4. Within the framework of art history as a history of formal sequences of things, George Kubler has insistently pointed to what André Malraux called the "Eliot effect": "T. S. Eliot was perhaps the first to note this relationship"—which is here referred to as recurrence—"when he observed that every major work of art forces upon us a reassessment of all previous works" (Kubler 1962, 35). German scholars might add that Goethe addresses this relationship on several occasions with respect to the sciences. He speaks of a "provisional rearrangement" that may become necessary "from time to time" (Goethe [1833] 1982, 424) and of a "rewriting" (Goethe [1810] 1957, 149) of the course of science.

5. For a critical assessment of the constitution of historical narrativity, see White 1980.

6. "The trace is not only the disappearance of origin—within the discourse that we sustain and according to the path that we follow it means that the origin did not even disappear, that it was never constituted except reciprocally by a nonorigin, the trace, which thus becomes the origin of the origin" (Derrida [1967] 1976, 61).

7. No historian and philosopher of science after Karl Popper has, both outside and *within the communities of scientists themselves,* had an influence comparable to that of Thomas S. Kuhn ([1962] 1970; 1979).

8. More recently Thomas Kuhn himself has come to stress not only the diachronic "incommensurability" of paradigms but also the synchronic incommensurability of bits and pieces of the enterprise called science. In characterizing it as a process "driven from behind" (Kuhn 1992, 14), he seems at first glance to contradict the notion of recurrence. Upon closer inspection, however, we note this to be his way of speaking about history without "grounds."

9. For an exploration of such microdynamics in the history of protein synthesis and transfer RNA, see Rheinberger 1992a; 1992b.

10. The notion of "experimental system" as it is used here derives from the everyday language of laboratory science—especially biomedicine, biochemistry, biology, and molecular biology. Cf., for example, François Jacob: "In analyzing a problem, the biologist is constrained to focus on a fragment of reality, on a piece of the universe which he arbitrarily isolates to define certain of its parameters. In biology, any study thus begins with the choice of a 'system.' On this choice depend the experimenter's freedom to maneuver, the nature of the questions he is free to ask, and even, often, the type of answer he can obtain" (Jacob [1987] 1988, 234). With the remarkable exception of Ludwik Fleck (Fleck [1935] 1979, 84–98), historians of science seem only lately to have become aware of its analytical potential in the sense of a "proto-idea" (ibid., 23–25) for shaping the material of their genuine field: the movement of scientific activity. Robert Kohler, in dealing with *Drosophila, Neurospora,* and the rise of biochemical genetics, speaks of "systems of production" (Kohler 1991). David Turnbull and Terry Stokes use the notion of "manipulable systems" in their analysis of *malaria* research at the Walter and Eliza Hall Institute of Medical Research in Melbourne (Turnbull and Stokes 1990).

11. In a quite similar way Kubler describes artistic activity "as a linked progression of experiments composing a formal sequence" whose "characteristic spans and periods" cannot be grasped by "calendaric time" (Kubler 1962, 83, 85).

12. This distinguishes an ensemble of experimental systems from a field of discursive practice in the sense of Foucault, although any experimental system as such can be seen as a discursive unit. See Foucault 1972.

13. The expression is that of Louis Althusser. See the introduction to Althusser and Balibar 1968.

14. In practice, a contemporary research or experimental system consists of a whole bundle of "actants": crafted persons such as experienced technicians, pre- and postdoctoral fellows who are continually coming in and leaving after a couple of years, senior scientists, a variety of measuring and manipulating machines and special equipment, calculation facilities, a system for purchasing sufficiently graded materials, as well as an adequate laboratory architecture. For the notion of "actant" see Latour 1987, 84; he refuses to distinguish between human and nonhuman "actants" in what he calls units of "translation" or of "machination" (ibid., 103–44).

15. Here *Erfahrenheit* is translated as the "state of being experienced." It is the ability to make judgments, an attribute that has to be distinguished from "experience."

16. Fischer is quoting from a letter of Max Delbrück to Salvador Luria dated from autumn 1948.

17. "One never goes farther than when one does not know where one is going" (Goethe [1833] 1982, 547, my translation).

18. Here again we have a remarkable parallel between the work of the experimenter and the work of the artist as described by Kubler: "Each artist works on in the dark, guided only by the tunnels and shafts of earlier work, following the vein and hoping for a bonanza, and fearing that the lode may play out tomorrow" (1962, 125).

19. "One ought to explore systematically not only what appears to be a simple etymological coincidence uniting the graft and the graph (both from the Greek *graphion:* writing instrument, stylus), but also the analogy between the forms of textual grafting and so-called vegetal grafting, or even, more and more commonly today, animal grafting" (Derrida [1972] 1982, 202).

20. For an extended account, see Rheinberger (1995). Cf. Ilana Löwy's instructive paper on variances in meaning in "discoverers'" accounts of their "discoveries" (Löwy 1990).

21. This is basically because the focus is on a single system, and points of encounter are only indicated. Nevertheless, the trace of the argument should still be discernible.

22. Up to the time of Claude Bernard and Louis Pasteur, the term *virus* had been a synonym for an infectious entity in general.

23. The tumor had been preserved in the laboratory by successive transplantations.

24. The post-Claudian irony of cancer research is that with its "oncogenes" it has come back to the concept of cancerous agencies as regular, albeit altered cellular components, mostly growth factors. Cf., for example, Weinberg 1987.

25. Being "within the truth" of a science means something radically different from saying "the truth in the space of a savage out there," as Michel Foucault has formulated by reference to Georges Canguilhem (Foucault 1972).

26. Claude was awarded the Nobel prize in medicine or physiology in 1974. See Porter 1974.

27. Louis Althusser developed the notion of a "spontaneous philosophy of the scientist," on which the above expression is analogously based. See Althusser [1967] 1974.

REFERENCES

Althusser, Louis. [1967] 1974. *Philosophie et philosophie spontanée des savants.* Paris: Editions la Découverte.

Althusser, Louis, and Etienne Balibar. 1968. *Lire le Capital,* vol. 1. Paris: Maspero.

Avery, Oswald T., Colin M. MacLeod, and Maclyn McCarty. 1944. "Induction of Transformation by a Desoxyribonu-cleic Acid Fraction Isolated from Pneumococcus Type III." *Journal of Experimental Medicine* 79: 137–58.

Bachelard, Gaston. [1934] 1984. *The New Scientific Spirit.* Translated by A. Goldhammer. Boston: Beacon Press.

Bernard, Claude [1878] 1966. *Leçons sur les phénomènes de la vie communs aux animaux et aux végétaux.* Reprint of the 2d ed. Paris: Vrin.

Brachet, Jean. 1941. "La détection histochimique et le microdosage des acides pentosenucléiques." *Enzymologia* 10:87–96.

Canguilhem, Georges. [1963] 1975. "L'Histoire des sciences dans l'oeuvre epistémologique de Gaston Bachelard." In his *Etudes d'histoire et de philosophie des sciences,* 173–86. Paris: Vrin.

Caspersson, Torbjörn. 1941. "Studien über den Eiweissumsatz der Zelle." *Naturwissenschaften* 29:33–43.

Claude, Albert. 1935. "Properties of the Causative Agent of a Chicken Tumor. XI: Chemical Composition of Purified Chicken Tumor Extracts Containing the Active Principle." *Journal of Experimental Medicine* 61:41–57.

———. 1938a. "Concentration and Purification of Chicken Tumor I Agent." *Science* 87:467–68.

———. 1938b. "A Fraction from Normal Chick Embryo Similar to the Tumor-Producing Fraction of Chicken Tumor I." *Proceedings of the Society for Experimental Biology and Medicine* 39:398–403.

———. 1939. "Chemical Composition of the Tumor-Producing Fraction of Chicken Tumor I." *Science* 90:213–14.

———. 1941. "Particulate Components of the Cytoplasm." *Cold Spring Harbor Symposium on Quantitative Biology* 9:263–71.

———. 1943. "Distribution of Nucleic Acids in the Cell and the Morphological Constitution of Cytoplasm." *Biological Symposia* 10:111–29.

———. 1950. "Studies on Cells: Morphology, Chemical Constitution, and Distribution of Biochemical Function." *The Harvey Lectures 1947–48* 43:121–64.

———. 1975. "The Coming of Age of the Cell." *Science* 189:433–35.

Claude, Albert, and Ernest Fullam. 1945. "An Electron Microscope Study of Isolated Mitochondria: Method and Preliminary Results." *Journal of Experimental Medicine* 81:51–61.

Claude, Albert, Keith R. Porter, and Edward G. Pickels. 1947. "Electron Microscope Study of Chicken Tumor Cells." *Cancer Research* 7:421–30.

Derrida, Jacques. [1968] 1972. "La différance." In his *Marges de la philosophie,* 1–29. Paris: Editions de minuit.

———. [1967] 1976. *Of Grammatology.* Translated by G. C. Spivak. Baltimore: Johns Hopkins University Press.

———. [1972] 1982. *Dissemination.* Chicago: University of Chicago Press.

———. 1991. "Une 'folie' doit veiller sur la pensée." Interview with François Ewald. *Magazine littéraire* 286 (March):18–30.

Fischer, Ernst Peter. 1988. *Das Atom des Biologen: Max Delbrück und der Ursprung der Molekulargenetik.* Munich: Piper.

Fleck, Ludwik. [1935] 1979. *Genesis and Development of a Scientific Fact.* Translated by F. Bradley and T. J. Tenn. Chicago: University of Chicago Press.

Foucault, Michel. 1972. *L'Ordre du discours.* Paris: Gallimard.

Goethe, Johann Wolfgang. [1810] 1957. "Materialien zur Geschichte der Farbenlehre." In *Die Schriften zur Naturwissenschaft.* Part One, *Texts,* vol. 6, edited by Dorothea Kuhn. Weimar: Hermann Böhlaus Nachfolger.

———. [1833] 1982. "Maximen und Reflexionen." In *Werke* (Hamburg edition), vol. 12, 365–547. Munich: Deutscher Taschenbuchverlag.

Griffith, Fred. 1928. "The Significance of Pneumococcal Types." *Journal of Hygiene* 27:113–59.

Jacob, François. [1981] 1982. *The Possible and the Actual.* Seattle: University of Washington Press.

———. [1987] 1988. *The Statue Within: An Autobiography.* Translated by F. Philip. New York: Basic Books.

Kay, Lily. 1986. "Stanley's Crystallization of the Tobacco Mosaic Virus." *Isis* 77:450–72.

Kohler, Robert. 1991. "Systems of Production: Drosophila, Neurospora, and Biochemical Genetics." *Historical Studies in the Physical and Biological Sciences* 22:87–130.

Kubler, George. 1962. *The Shape of Time: Remarks on the History of Things.* New Haven: Yale University Press.

Kuhn, Thomas S. [1962] 1970. *The Structure of Scientific Revolutions.* Chicago: University of Chicago Press.

———. 1979. *The Essential Tension: Selected Studies in Scientific Tradition and Change.* Chicago: University of Chicago Press.

———. 1992. "The Trouble with the Historical Philosophy of Science." An Occasional Publication of the Department of the History of Science. Cambridge: Mass.

Latour, Bruno. 1987. *Science in Action.* Cambridge: Harvard University Press.

Ledingham, J. C. G., and W. E. Gye. 1935. "On the Nature of the Filterable Tumour-Exciting Agent in Avian Sarcomata." *Lancet* 228 I:376–77.

Löwy, Ilana. 1990. "Variances in Meaning in Discovery Accounts: The Case of Contemporary Biology." *Historical Studies in the Physical and Biological Sciences* 21:87–121.

Lwoff, André. 1957. "The Concept of Virus." *Journal of General Microbiology* 17:239–53.

McIntosh, James. 1935. "The Sedimentation of the Virus of Rous Sarcoma and the Bacteriophage by a High-Speed Centrifuge." *Journal of Pathology and Bacteriology* 41:215:17.

Murphy, James B. 1931. "Discussion of Some Properties of the Causative Agent of a Chicken Tumor." *Transactions of the Association of American Physicians* 46:182–87.

Murphy, James B., Oscar M. Helmer, and Ernest Sturm. 1928. "Association of the Causative Agent of a Chicken Tumor with the Protein Fraction of the Tumor Filtrate." *Science* 68:18–19.

Porter, Keith R. 1974. "The 1974 Nobel Prize for Physiology or Medicine." *Science* 186:516–18.

Prigogne, Ilya, and Isabelle Stengers. 1988. *Entre le temps et l'éternité.* Paris: Fayard.

Rasmussen, Nicolas. 1993. "Mitochondrial Structure and the Practice of Cell Biology in the 1950s." *Journal of the History of Biology* 28:381–429.

Rheinberger, Hans-Jörg. 1992a. "Experiment, Difference, and Writing. I: Tracing Protein Synthesis" and "II: The Laboratory Production of Transfer RNA." *Studies in the History and Philosophy of Science* 23:305–31, 389–422.

———. 1992b. *Experiment, Differenz, Schrift.* Marburg: Basiliskenpresse.

———. 1995. "From Microsomes to Ribosomes: 'Strategies' of 'Representation' 1930–1955." *Journal of the History of Biology* 28:49–89.

Rous, Peyton. 1910. "A Transmissible Avian Neoplasm (Sarcoma of the Common Fowl)." *Journal of Experimental Medicine* 12:696–705.

———. 1911. "A Sarcoma of Fowl Transmissible by an Agent Separable from Tumor Cells." *Journal of Experimental Medicine* 13:397–411.

———. 1967. "The Challenge to Man of the Neoplastic Cell." *Science* 157:24–28.

Stanley, Wendell M. 1935. "Isolation of Crystalline Protein Possessing the Properties of the Tobacco-Mosaic Virus." *Science* 81:644–45.

Turnbull, David, and Terry Stokes. 1990. "Manipulable Systems and Laboratory Strategies in a Biomedical Institute." In *Experimental Inquiries,* edited by H. E. Le Grand, 167–92. Dordrecht: Kluwer.

Weinberg, R. A. 1987. "Cellular Oncogenes." In *Oncogenes and Growth Factors,* edited by R. A. Bradshaw and S. Prentis, 11–16. Amsterdam: Elsevier.

White, Hayden. 1980. "The Value of Narrativity in the Representation of Reality." In *On Narrative,* edited by W. J. T. Mitchell, 1–23. Chicago: University of Chicago Press.

# 29

# Thinking Dia-Grams

## Mathematics and Writing

### BRIAN ROTMAN

In the epilogue to his essay on the development of writing systems, Roy Harris declares:

> It says a great deal about Western culture that the question of the origin of writing could be posed clearly for the first time only after the traditional dogmas about the relationship between speech and writing had been subjected both to the brash counterpropaganda of a McLuhan and to the inquisitorial scepticism of a Derrida. But it says even more that the question could not be posed clearly until writing itself had dwindled to microchip dimensions. Only with this . . . did it become obvious that the origin of writing must be linked to the future of writing in ways which bypass speech altogether.[1]

Harris's intent is programmatic. The passage continues with the injunction not to "replough McLuhan's field, or Derrida's either," but to sow them so as to produce eventually a "history of writing *as writing*."

Preeminent among dogmas that block such a history is alphabeticism: the insistence that we interpret all writing—understood for the moment as any systematized graphic activity that creates sites of interpretation and facilitates communication and sense making—along the lines of alphabetic writing, as if it were the inscription of prior speech ("prior" in an ontogenetic sense as well as the more immediate sense of speech first uttered and then written down and recorded). Harris's own writings in linguistics as well as Derrida's program of deconstruction, McLuhan's efforts to dramatize the cultural imprisonments of typography, and Walter Ong's long-standing theorization of the orality/writing disjunction in relation to consciousness, among others, have all demonstrated the distorting and reductive effects of the subordination of graphics to phonetics and have made it their business to move beyond this dogma. Whether, as Harris intimates, writing will one day find a speechless characterization of itself is impossible to know, but these displacements of the alphabet's hegemony have already resulted in an open-ended and more complex articulation of the writing/speech couple, especially in relation to human consciousness, than was thinkable before the microchip.

A written symbol long recognized as operating nonalphabetically—even by those deeply and quite unconsciously committed to alphabeticism—is that of number, the familiar and simple

other half, as it were, of the alphanumeric keyboard. But, despite this recognition, there has been no sustained attention to mathematical writing even remotely matching the enormous outpouring of analysis, philosophizing, and deconstructive opening up of what those in the humanities have come simply to call "texts."

Why, one might ask, should this be so? Why should the sign system long acknowledged as the paradigm of abstract rational thought and the without-which-nothing of Western technoscience have been so unexamined, let alone analyzed, theorized, or deconstructed, as a mode of writing? One answer might be a second-order or reflexive version of Harris's point about the microchip dwindling of writing, since the very emergence of the microchip is inseparable from the action and character of mathematical writing. Not only would the entire computer revolution have been impossible without mathematics as the enabling conceptual technology (the same could be said in one way or another of all technoscience), but, more crucially, the computer's mathematical lineage and intended application as a calculating/reasoning machine hinges on its autological relation to mathematical practice. Given this autology, mathematics would presumably be the last to reveal itself and declare its origins in writing. (I shall return to this later.)

A quite different and more immediate answer stems from the difficulties put in the way of any proper examination of mathematical writing by the traditional characterizations of mathematics—Platonic realism or various intuitionisms—and by the moves they have legitimated within the mathematical community. Platonism is the contemporary orthodoxy. In its standard version it holds that mathematical objects are mentally apprehensible and yet owe nothing to human culture; they exist, are real, objective, and "out there," yet are without material, empirical, embodied, or sensory dimension. Besides making an enigma out of mathematics' usefulness, this has the consequence of denying or marginalizing to the point of travesty the ways in which mathematical signs are the means by which communication, significance, and semiosis are *brought about*. In other words, the constitutive nature of mathematical writing is invisibilized, mathematical language in general being seen as a neutral and inert medium for describing a given prior reality—such as that of number—to which it is essentially and irremediably posterior.

With intuitionist viewpoints such as those of Brouwer and Husserl, the source of the difficulty is not understood in terms of some *external* metaphysical reality, but rather as the nature of our supposed internal intuition of mathematical objects. In Brouwer's case this is settled at the outset: numbers are nothing other than ideal objects formed within the inner Kantian intuition of time that is the condition for the possibility of our cognition, which leads Brouwer into the quasisolipsistic position that mathematics is an essentially "languageless activity." With Husserl, whose account of intuition, language, and ideality is a great deal more elaborated than Brouwer's, the end result is nonetheless a complete blindness to the creative and generative role played by mathematical writing. Thus, in "The Origin of Geometry," the central puzzle on which Husserl meditates is "How does geometrical ideality . . . proceed from its primary intrapersonal origin, where it is a structure within the conscious space of the first inventor's soul, to its ideal objectivity?"[2] It must be said that Husserl doesn't, in this essay or anywhere else, settle his question. And one suspects that it is incapable of solution. Rather, it is the premise itself that has to be denied: that is, it is the coherence of the idea of primal (semiotically unmediated) intuition lodged originally in any individual consciousness that has to be rejected. On the contrary, does not all mathematical intuition—geometrical or otherwise—come into being in relation to mathematical signs, making it both external/intersubjective and internal/private from the start? But to pursue such a line one has to credit writing with more than a capacity to, as Husserl has it, "document,"

"record," and "awaken" a prior and necessarily prelinguistic mathematical meaning. And this is precisely what his whole understanding of language and his picture of the "objectivity" of the ideal prevents him from doing. One consequence of what we might call the documentist view of mathematical writing, whether Husserl's or the standard Platonic version, is that the intricate interplay of imagining and symbolizing, familiar on an everyday basis to mathematicians within their practice, goes unseen.

Nowhere is the documentist understanding of mathematical language more profoundly embraced than in the foundations of mathematics, specifically, in the Platonist program of rigor instituted by twentieth-century mathematical logic. Here the aim has been to show how all of mathematics can be construed as being about sets and, further, can be translated into axiomatic set theory. The procedure is twofold. First, vernacular mathematical usage is made informally rigorous by having all of its terms translated into the language of sets. Second, these informal translations are completely formalized, that is, further translated into an axiomatic system consisting of a Fregean first-order logic supplemented with the extralogical symbol for set membership.

To illustrate, let the vernacular item be the theorem of Euclidean geometry which asserts that, given any triangle in the plane, one can draw a unique inscribed circle (fig. 29-1). The first translation removes all reference to agency, modality, and physical activity, signaled here in the expression "one can draw." In their place are constructs written in the timeless and agentless language of sets. Thus, first the plane is identified with the set of all ordered pairs $(x, y)$ of real numbers and a line and circle are translated into certain unambiguously determined subsets of these ordered pairs through their standard Cartesian equations; then "triangle" is rendered as a triple of nonparallel lines and "inscribed" is given in terms of a "tangent," which is explicated as a line intersecting that which it "touches" in exactly one point. The second translation converts the asserted relationship between these abstracted but still visualizable sets into the de-physicalized and de-contextualized logicosyntactical form known as the first-order language of set theory. This will employ no linguistic resources whatsoever other than variables ranging over real numbers, the membership relation between sets, the signs for an ordered pair and for equality, the quantifiers "for all $x$" and "there exists $x$," and the sentential connectives "or," "and," "not," and so on.

Once such a double translation of mathematics is effected, metamathematics becomes possible, since one can arrive at results about the whole of vernacular mathematics by proving theorems about the formal (i.e., mathematized) axiomatic system. The outcome has been an influential and rich corpus of metamathematical theorems (associated with Skolem, Gödel, Turing, and Cohen, among many, many others). Philosophically, however, the original purpose of the whole foundational enterprise was to illuminate the nature of mathematics by explaining the emergence of paradox, clarifying the horizons of mathematical reasoning, and revealing the status of mathematical objects. In relation to these aims, the set theoretization of mathematics and

FIGURE 29-1

the technical results of metamathematics are unimpressive: not only have they resulted in what is generally acknowledged to be a barren and uninformative philosophy of mathematics, but (not independently) they have failed to shed any light whatsoever on mathematics as a signifying practice. We need, then, to explain the reason for this impoverishment.

Elsewhere, I've spelled out a semiotic account of mathematics, particularly the interplay of writing and thinking, by developing a model of mathematical activity—what it means to make the signs and think the thoughts of mathematics—intended to be recognizable to its practitioners.[3] The model is based on the semiotics of Charles Sanders Peirce, which grew out of his program of pragmaticism, the general insistence that "the meaning and essence of every conception lies in the application that is to be made of it."[4] He understood signs accordingly in terms of the uses we make of them, a sign being something always involving another—interpreting—sign in a process that leads back eventually to its application in our lives by way of a modification of our habitual responses to the world. We acquire new habits in order to minimize the unexpected and the unforeseen, to defend ourselves "from the angles of hard fact" that reality and brute experience are so adept at providing. Thought, at least in its empirically useful form, thus becomes a kind of mental experimentation, the perpetual imagining and rehearsal of unforeseen circumstances and situations of possible danger. Peirce's notion of habit and his definition of a sign are rich, productive, and capable of much interpretation. They have also been much criticized; his insistence on portraying all instances of reasoning as so many different forms of disaster avoidance is obviously unacceptably limiting. In this connection, Samuel Weber has made the suggestion that Peirce's "attempt to construe thinking and meaning in terms of 'conditional possibility,' and thus to extend controlled laboratory experimentation into a model of thinking in general," should be seen as an articulation of a "phobic mode of behavior," where the fear is that of ambiguity in the form of cognitive oscillation or irresolution, blurring or shifting of boundaries, imprecision, or any departure from the clarity and determinateness of either/or logic.[5]

Now, it is precisely the elimination of these phobia-inducing features that reigns supreme within mathematics. Unashamedly so: mathematicians would deny that their fears were pathologies, but would, on the contrary, see them as producing what is cognitively and aesthetically attractive about mathematical practice as well as being the source of its utility and transcultural stability. This being so, a model of mathematics utilizing the semiotic insights of Peirce—himself a mathematician—might indeed deliver something recognizable to those who practice mathematics. The procedure is not, however, without risks. There is evidently a self-confirmatory loop at work in the idea of using such a theory to illuminate mathematics, in applying a phobically derived apparatus, as it were, to explicate an unrepentant instance of itself. In relation to this, it is worth remarking that Peirce's contemporary, Ernst Mach, argued for the importance of thought-experimental reasoning to science from a viewpoint quite different from Peirce's semiotics, namely, that of the physicist. Indeed, thought experiments have been central to scientific persuasion and explication from Galileo to the present, figuring decisively in this century, for example, in the original presentation of relativity theory as well as in the Einstein-Bohr debate about the nature of quantum physics. They have, however, only recently been given the sort of sustained attention they deserve. Doubtless, part of the explanation for this comparative neglect of experimental reasoning lies in the systematizing approach to the philosophy of science that has foregrounded questions of rigor (certitude, epistemological hygiene, formal foundations, exact knowledge, and so on) at the expense of everything else, and in particular at the expense of any account of the all-important persuasive, rhetorical, and semiotic content of scientific practice.

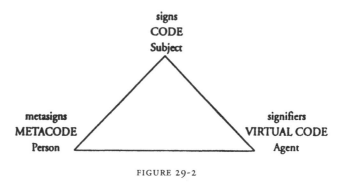

FIGURE 29-2

In any event, the model I propose theorizes mathematical reasoning and persuasion in terms of the performing of thought experiments or waking dreams: one does mathematics by propelling an imago—an idealized version of oneself that Peirce called the "skeleton self"—around an imagined landscape of signs. This model depicts mathematics, by which I mean here the everyday doing of mathematics, as a certain kind of traffic with symbols, *a written discourse* in other words, as follows: All mathematical activity takes place in relation to three interlinked arenas—Code, MetaCode, Virtual Code. These represent three complementary facets of mathematical discourse; each is associated with a semiotically defined abstraction, or linguistic actor—Subject, Person, Agent, respectively—that "speaks," or uses, it. Figure 29-2 summarizes these actors and the arenas in relation to which they operate as an interlinked triad.

The Code embraces the total of all rigorous sign practices—defining, proving, notating, and manipulating symbols—sanctioned by the mathematical community. The Code's user, the one-who-speaks it, is the mathematical *Subject.* The Subject is the agency who reads/writes mathematical texts and has access to all and only those linguistic means allowed by the Code. The MetaCode is the entire matrix of unrigorous mathematical procedures normally thought of as preparatory and epiphenomenal to the real—proper, rigorous—business of doing mathematics. Included in the MetaCode's resources would be the stories, motives, pictures, diagrams, and other so-called heuristics which introduce, explain, naturalize, legitimate, clarify, and furnish the point of the notations and logical moves that control the operations of the Code. The one-who-speaks the MetaCode, the *Person,* is envisaged as being immersed in natural language, with access to its metasigns and constituted thereby as a self-conscious subjectivity in history and culture. Lastly, the Virtual Code is understood as the domain of all legitimately imaginable operations, that is, as signifying possibilities available to an idealization of the Subject. This idealization, the one-who-executes these activities, the *Agent,* is envisaged as a surrogate or proxy of the Subject, imagined into being precisely in order to act on the purely formal, mechanically specifiable correlates—signifiers—of what for the Subject is meaningful via signs. In unison, these three agencies make up what we ordinarily call "the mathematician."

Mathematical reasoning is thus an irreducibly tripartite activity in which the Person (Dreamer awake) observes the Subject (Dreamer) imagining a proxy—the Agent (Imago)—of him/herself, and, on the basis of the likeness between Subject and Agent, comes to be persuaded that what the Agent experiences is what the Subject *would* experience were he or she to carry out the unidealized versions of the activities in question. We might observe in passing that the three-way process at work here is the logico-mathematical correlate of a more general and originating triangularity inherent to the usual divisions invoked to articulate self-consciousness: the self-as-

object instantiated here by the Agent, the self-as-subject by the Subject, and the sociocultural other, through which any such circuit of selves passes, by the Person.

Two features of this way of understanding mathematical activity are relevant here: First, mathematical assertions are to be seen, as Peirce insisted, as foretellings, predictions made by the Person about the Subject's future engagement with signs, with the result that the process of persuasion is impossible to comprehend if the role of the Person as observer of the Subject/Agent relation is omitted. Second, mathematical thinking and writing are folded into each other and are inseparable not only in an obvious practical sense, but also theoretically, in relation to the cognitive possibilities that are mathematically available. This is because the Agent's activities exist and make narrative logical sense (for the Subject) only through the Subject's manipulation of signs in the Code.

The second feature of this model, the thinking/writing nexus, will occupy us below. On the first, however, observe that there is an evident relation between the triad of Code/MetaCode/Virtual Code here and the three levels—rigorous/vernacular/formal—of the Platonistic reduction illustrated above. Indeed, in terms of external attributes, the difference drawn by the mathematical community between unrigorous/vernacular and rigorous/set-theoretical mathematics seems to map onto that between the MetaCode and the Code. This is indeed the case, but the *status* of this difference is here inverted and displaced. On the present account, belief in the validity of reasoning, or acquiescence in proof, takes place only when the Person is persuaded, a process that hinges on a judgment—available only to the Person—that the likeness between the Subject and the Agent justifies replacing the former with the latter. In terms of our example, the proof of the theorem in question lies in the relationship among the Person (who can draw a triangle and see it as a drawn triangle); the Subject (who can replace this triangle with a set-theoretical description); and the Agent (who can act upon an imagined version of this triangle). By removing all reference to agency, the Platonistic account renders this triple relation invisible. Put differently, in the absence of the Person's role, no explication of *conviction*—without which proofs are not proofs—can be given. Instead, all one can say about a supposed proof is that its steps, as performed by the "mathematician," are logically correct, a truncated and wholly unilluminating description of mathematical reasoning found and uncritically repeated in most contemporary mathematical and philosophical accounts. But once the Person is acknowledged as vital to the mathematical activities of making and proving assertions, it becomes impossible to see the MetaCode as a supplement to the Code, as a domain of mere psychological/motivational affect, to be jettisoned as soon as the real, proper, rigorous mathematics of the Code has been formulated.

If we grant this, we are faced with a crucial difference operating within what are normally and uncritically called mathematical "symbols," a difference whose status is not only misperceived within the contemporary Platonistic program of rigor, but, beyond this, is treated within that program to a reductive alphabeticization. The first split in Figure 29-3, the division of writing into the alpha and the numeric, is simply the standard recognition of the nonalphabetic character of numeric, that is, mathematical, writing. The failure to make this distinction, or rather making it but subsuming all writing under the rubric of the alphabet, is merely an instance of what we earlier called the alphabetic dogma. The point of the latter diagram is to indicate the replication of this split, via a transposed version of itself, within the contemporary Platonistic understanding of mathematics. Thus, on one hand, there are ideograms, such as "+," "×," "1," "2," "3," "=," ">," " . . ." "sin z," "log z," and so on, whose introduction and interaction are controlled by rigorously specified rules and syntactic conventions. On the other hand, there are

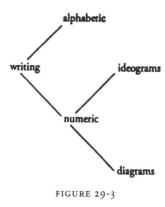

FIGURE 29-3

diagrams, visually presented semiotic devices, such as the familiar lines, axes, points, circles, and triangles, as well as all manner of figures, markers, graphs, charts, commuting circuits, and iconically intended shapes. On the orthodox view, the difference is akin to that between the rigorously literal, clear, and unambiguous ideograms and the metaphorically unrigorous diagrams. The transposition in question is evident once one puts this ranking of the literal over the metaphorical into play: as soon, that is, as one accepts the idea that diagrams, however useful and apparently essential for the actual doing of mathematics, are nonetheless merely figurative and eliminable and that mathematics, in its proper rigorous formulation, has no need of them. Within the Platonist program, this alphabetic prejudice is given a literal manifestation: linear strings of symbols in the form of normalized sequences of variables and logical connectives drawn from a short, preset list determine the resting place for mathematical language in its purest, most rigorously grounded form.

There is a philosophical connection between this transposed alphabeticism and classical ontology. The alphabetic dogma rides on and promotes an essential secondarity. In its original form, this meant the priority of speech to writing, that is, the insistence that writing is the transcription of an always preceding speech (and, taking the dogma further back, that speech is the expression of a prior thought, which in turn is the mirror of a prior realm . . . ). Current Platonistic interpretations of mathematical signs replay this secondarity by insisting that signs are always signs *of* or *about* some preexisting domain of objects. Thus the time-honored distinction between numerals and numbers rests on just such an insistence that numerals are mere notations—names—subsequent and posterior to numbers which exist prior to and independent of them. According to this understanding of signs, it's easy to concede that numerals are historically invented, changeable, contingent, and very much a human product, while maintaining a total and well-defended refusal to allow any of these characteristics to apply to numbers. And what goes for numbers goes for all mathematical objects. In short, contemporary Platonism's interpretation of rigor and its ontology—despite appearances, manner of presentation, and declared motive—go hand in glove: both relying on and indeed constituted by the twin poles of an assumed and never-questioned secondarity.

Similar considerations are at work within Husserl's phenomenological project and its problematic of geometrical origins. Only there, the presemiotic—that which is supposed to precede all mathematical language—is not a domain of external Platonic objects subsequently described by mathematical signs, but a field of intuition. The prior scene is one of "primal intrapersonal intuition" that is somehow—and this is Husserl's insoluble problem—"awakened" and "reacti-

vated" by mathematical writing in order to become available to all men at all times as an objective, unchanging ideality. The problem evaporates as a mere misperception, however, if mathematical writing is seen not as secondary and posterior to a privately engendered intuition, but as constitutive of and folded into the mathematical meaning attached to such a notion. What was private and intrapersonal is revealed as already intersubjective and public.

Nowhere is this more so than in the case of diagrams. The intrinsic difficulty diagrams pose to Platonistic rigor—their essential difference from abstractly conceived sets and the consequent need to replace them with ideogrammatic representations—results in their elimination in the passage from vernacular to formalized mathematics. And indeed, set-theoretical rewritings of mathematics, notably Bourbaki's, but in truth almost all contemporary rigorous presentations of the subject, avoid diagrams like the plague. And Husserl, for all his critique of Platonistic metaphysics, is no different: not only are diagrams absent from his discussion of the nature of geometry, a strange omission in itself, but they don't even figure as an important item to thematize.

Why should this be so? Why, from divergent perspectives and aims, should both Platonism and Husserlian phenomenology avoid all figures, pictures, and visual inscriptions in this way? One answer is that diagrams—whether actual figures drawn on the page or their imagined versions—are the work of the body; they are created and maintained as entities and attain significance only in relation to human visual-kinetic presence, only in relation to our experience of the culturally inflected world. As such, they not only introduce the historical contingency inherent to all cultural activity, but, more to the present point, they call attention to the materiality of all signs and of the corporeality of those who manipulate them in a way that ideograms—which appear to denote purely "mental" entities—do not. And neither Platonism's belief in timeless transcendental truth nor phenomenology's search for ideal objectivity, both irremediably mentalistic, can survive such an incursion of physicality. In other words, diagrams are inseparable from perception: only on the basis of our encounters with actual figures can we have any cognitive or mathematical relation to their idealized forms. The triangle-as-geometrical-object that Husserl would ignore, or Platonists eliminate from mathematics proper, is not only what makes it possible to think that there could be a purely abstract or formal or mental triangle, but is also an always available point of return for geometrical abstraction that ensures its never being abstracted out of the frame of mathematical discourse. For Merleau-Ponty the necessity of this encounter is the essence of a diagram:

I believe that the triangle has always had, and always will have, angles the sum of which equals two right angles . . . because I have had the experience of a real triangle, and because, as a physical thing, it necessarily has within itself everything it has ever been able, or ever will be able, to display. . . . What I call the essence of the triangle is nothing but this presumption of a completed synthesis, in terms of which we have defined the thing.[6]

In fact, the triangle and its generalizations constitute geometry as means as well as object of investigation: geometry is a mode of imagining with and about diagrams.

And indeed, one finds recent commentaries on mathematics indicating a recognition of the diagrammatic as opposed to the purely formal nature of mathematical intuition. Thus Philip Davis urges a reinterpretation of "theorem" which would include visual aspects of mathematical thought occluded by the prevailing set-theoretical rigor, and he cites V. I. Arnold's repudiation of the scorn with which the Bourbaki collective proclaims that, unlike earlier mathematical works, *its* thousands of pages contain not a single diagram.[7]

Let us return to our starting point, the question of writing, or, as Harris puts it, "writing as *writing*." One of the consequences of my model is to open up mathematical writing in a direction familiar to those in the humanities. As soon as it becomes clear that diagrams (and indeed all the semiotic devices and sources of intuition mobilized by the MetaCode) can no longer be thought of as the unrigorous penumbra of proper—Coded—mathematics, as so many ladders to be kicked away once the ascent to pure, perceptionless Platonic form has been realized, then all manner of possibilities can emerge. All we need to do to facilitate them is to accept a revaluation of basic terms. Thus, there is nothing intrinsically wrong with or undesirable about "rigor" in mathematics. Far from it: without rigor, mathematics would vanish; the question is how one interprets its scope and purpose. On the present account, rigor is not an externally enforced program of foundational hygiene, but an intrinsic and inescapable demand proceeding from writing: it lies within the rules, conventions, dictates, protocols, and such that control mathematical imagination and transform mathematical intuition into an intersubjective writing/thinking practice. It is in this sense that, for example, Gregory Bateson's tag line that mathematics is a world of "rigorous fantasy" should be read. Likewise, one can grant that the MetaCode/Code division is akin to the metaphor/literal opposition, but refuse the pejorative sense that set-theoretical rigor has assigned to the term "metaphor." Of course, there is a price to pay. Discussions of tropes in the humanities have revealed that no simple or final solution to the "problem" of metaphor is possible; there is an always uneliminable reflexivity, since it proves impossible, in fact and in principle, to find a trope-free metalanguage in which to discuss tropes and so to explain metaphor in terms of something nonmetaphorical. For mathematics the price—if such it be—is the end of the foundational ambition, the desire to ground mathematics, once and for all, in something fixed, totally certain, timeless, and prelinguistic. Mathematics is not a building—an edifice of knowledge whose truth and certainty is guaranteed by an ultimate and unshakable support—but a process: an ongoing, open-ended, highly controlled, and specific form of written intersubjectivity.

What, then, are we to make of mathematical diagrams, of their status as writing? How are they to be characterized vis-à-vis mathematical ideograms, on the one hand, and the words of nonmathematical texts, on the other? It would be tempting to invoke Peirce's celebrated trichotomy of signs—symbol, icon, and index—at this point. One could ignore indexicals and regard ideograms as symbols (signs resting on an arbitrary relation between signifier and signified) and diagrams as icons (signs resting on a motivated connection between the two). Although there is truth in such a division, it is a misleading simplification: the ideogram/diagram split maps only with great artificiality onto these two terms of Peirce's triad. In addition, there is a terminological difficulty: Peirce restricted the term "diagram" to one of three kinds of icon (the others being "image" and "metaphor"), which makes his usage too narrow for what we here, and mathematicians generally, call diagrams. The artificiality arises from the fact that the ideogrammatic cannot be separated from the iconic nor the diagrammatic from the indexical. Thus, not only are ideograms often enmeshed in iconic sign use at the level of algebraic schemata, but, more crucially, diagrams, though iconic, are also, less obviously, indexical to varying degrees. Indeed, the very fact of their being physically experienced shapes, of their having an operative meaning inseparable from an embodied and therefore situated gesture, will ensure that this is the case.

But this is a very generic source of indexicality, and some diagrams exhibit much stronger instances. Thus, consider Figure 29-4, fundamental to post-Renaissance mathematics, of a coor-

FIGURE 29-4

dinate axis which consists of an extended, directed line and an origin denoted by zero. Let's ignore the important but diffuse indexicality brought into play by the idea of directed extension and focus on that of the origin. Clearly, the function of the ideogram "0" in this diagram is to establish an arbitrarily chosen but fixed and distinguished "here" within the undifferentiated linear continuum. The ideogram marks a "this" with respect to which all positions on the line can be oriented; such is what it means for a sign to function as an origin of coordinates. Indexicality, interpreted in the usual way as a coupling of utterance and physical circumstance, and recognized as present in the use of shifters like "this," "here," "now," and so on, within ordinary language, is thus unambiguously present in our diagram. It does not, however, declare itself as such: its presence is the result of a choice and a determination made in the MetaCode, that is, outside the various uses of the diagram sanctioned within mathematics proper. It is, in other words, the written evidence or trace of an originating act by the Person. Thus, zero, when symbolized by "0," is an ideogrammatic sign for mathematical "nothing" at the same time that it performs a quasi-indexical function within the diagram of a coordinate axis.[8]

It would follow from considerations like these that any investigation of the status of diagrams has to go beyond attempts at classifying them as sign-types and confront the question of their *necessity*. Why does one need them? What essential function—if any—do they serve? Could one do without them? Any answer depends, it seems, on who "one" is: mathematicians and scientists use them as abundantly and with as much abandon as those in the humanities avoid them. In fact, diagrams of any kind are so rare in the texts produced by historians, philosophers, and literary theorists, among others, that any instance sticks out like a sore thumb. An immediate response is to find this avoidance of visual devices totally unsurprising. Would not their embrace be stigmatized as scientism? Indeed, isn't the refusal to use figures, arrows, vectors, and so forth, as modes of explication part of the very basis on which the humanities define themselves as different from the technosciences? Why should texts committed—on whatever grounds—to communicating through words and not primarily interested in the sort of subject matter that lends itself to schematic visual representation make use of it? But this only pushes the question a little further out: What allows this prior commitment to words to be so self-sufficient, and what determines that certain topics or subjects, but not others, should lend themselves so readily to diagrammatic commentary and exegesis? Moreover, this separation by content isn't very convincing: philosophers are no less interested in space, time, and physical process than scientists; literary theorists occupy themselves quite as intensely as mathematicians with questions of pattern, analogy, opposition, and structure. Furthermore, whatever its value, such a response gives us no handle on the exceptions, the rare recourse to diagrams, that do occur in humanities texts.

To take a single example, how should we respond to the fact that in Husserl's entire oeuvre there is but one diagram (in his exegesis of temporality), a diagram that, interestingly enough, few commentators seem to make any satisfactory sense of? Are we to think that Husserl, trained as a mathematician, nodded—momentarily slipping from the philosophical into a more mathematical

idiom? Or, unable to convey what he meant through words alone, did he resort, reluctantly perhaps but inescapably, to a picture? If the latter, then this fact—the possible inexplicability in words of his account of time—would surely be of interest in any overall analysis of Husserl's philosophical ideas. It would, after all, be an admission—highly significant in the present context—that the humanities' restriction to pictureless texts may be a warding off of uncongenial means of expression rather than any natural or intrinsic self-sufficiency in the face of its subject matter. But then would not this denial, or at any rate avoidance, of diagrams results in texts that were never free (at least never demonstrably so) of a willful inadequacy to their chosen exegetical and interpretive tasks; texts whose wordy opacity, hyper-elaboration, and frequent straining of written expression to the edge of sense were the reciprocal cost of this very avoidance?

And what goes for diagrams goes (with one exception) for ideograms: their absence is as graphically obvious as that of diagrams; the same texts in the humanities that avoid one avoid the other. And the result is an adherence to texts written wholly within the typographical medium of the alphabet. The exception is, of course, the writing of numbers: nobody, it seems, is prepared to dump the system that writes 7,654,321 in place of seven million, six hundred fifty-four thousand, three hundred twenty-one; the unwieldy prolixity here is too obvious to ignore. But why stop at numbers? Mathematics has many other ideograms and systems of writing—some of extraordinary richness and subtlety—besides the number notation based on 0. What holds philosophers and textual theorists back? Although it doesn't answer this question, we can observe that the place-notation writing of numbers is in a sense a minimal departure from alphabetic typography: an ideogram like 7,654,321 being akin to a word spelled from the "alphabet" 0, 1, 2, 3, 4, 5, 6, 7, 8, 9 of "letters," where to secure the analogy one would have to map the mathematical letter 0 onto something like a hyphen denoting the principled absence of any of the other given letters.

I alluded earlier to Weber's characterization of Peirce's semiotics as founded on a fear of ambiguity and the like. It's hard to resist seeing a reverse phobia in operation here: a recoil from ideograms (and, of course, diagrams) in the face of their potential to disrupt the familiar authority of the alphabetic text, an authority not captured but certainly anchored in writing's interpretability as the inscription of real or realizable speech. The apprehension and anxiety in the face of mathematical grams, which appear here in the form of writing as such—not as a recording of something prior to itself—are that they will always lead outside the arena of the speakable; one cannot, after all, *say* a triangle. If this is so, then the issue becomes the general relation among the thinkable, the writable, and the sayable, that is, what and how we imagine through different kinds of sign manipulations, and the question of their mutual translatability. In the case of mathematics, writing and thinking are cocreative and, outside the purposes of analysis and the like, impossible to separate.

Transferring the import of this from mathematics to spoken language allows one to see that speech, no less than mathematics, misunderstands its relation to the thinkable if it attempts a separation between the two into prior substance and posterior re-presentation; if, in other words, the form of an always representational alphabetic writing is the medium through which speech articulates how and what it is. By withdrawing from the gram in this way, alphabetic writing achieves the closure of a false completeness, a self-sufficiency in which the fear of mathematical signs that motivates it is rendered as invisibly as the grams themselves. The idea of invisibility here, however, needs qualifying. Derrida's texts, for example, though written within and confined to a pure, diagramless and ideogramless format, nevertheless subvert the resulting

alphabetic format and its automatic interpretation in terms of a vocalizable text through the use of various devices: thus a double text such as "Glas," which cannot be the inscription of any single or indeed dialogized speech, and his use of a neologism such as *différance,* which depends on and performs its meaning by being written and not said. But, all this notwithstanding, any attempt to pursue Harris's notion of a speechless link between the origin and the future of writing could hardly avoid facing the question of the meaning and use of diagrams. Certainly, Harris himself is alive to the importance and dangers of diagrams, as is evident from his witty taking apart of the particular diagram—a circuit of two heads speaking and hearing each other's thoughts—used by Saussure to illustrate his model of speech.[9]

But perhaps such a formulation, though it points in the right direction, is already—in light of contemporary developments—becoming inadequate. Might not the very seeing of mathematics in terms of a writing/thinking couple have become possible because writing is now—postmicrochip—no longer what it was? I suggested above that the reflexivity of the relation between computing and mathematics—whereby the computer, having issued from mathematics, impinges on and ultimately transforms its originating matrix—might be the crux of the explanation for our late recognition of mathematics' status as writing.

NOTES

This article was written during the period when I was supported by a fellowship from the National Endowment for the Humanities.

1. Roy Harris, *The Origin of Writing* (London, 1986), 158.

2. Edmund Husserl, "The Origin of Geometry," trans. David Carr, in *Husserl: Shorter Works,* ed. P. McCormick and F. Ellison (Notre Dame, 1981), 257.

3. Brian Rotman, "Toward a Semiotics of Mathematics," *Semiotica* 72 (1988): 1–35; and *Ad Infinitum . . . The Ghost in Turing's Machine: Taking God Out of Mathematics and Putting the Body Back In* (Stanford, 1993), 63–113.

4. Charles Sanders Peirce, *Collected Writings,* ed. Philip Weiner (New York, 1958), 5:332.

5. Samuel Weber, *Institution and Interpretation* (Minneapolis, 1987), 30.

6. Maurice Merleau-Ponty, *The Phenomenology of Perception,* trans. Colin Smith (London, 1962), 388.

7. Philip Davis, "Visual Theorems," *Educational Studies in Mathematics* 24 (1993): 333–44.

8. See Brian Rotman, *Signifying Nothing: The Semiotics of Zero* (Stanford, 1993).

9. Roy Harris, *The Language Machine* (Ithaca, 1987), 149–52.

# 30

# Understanding Scientific Practices

## Cultural Studies of Science as a Philosophical Program

### JOSEPH ROUSE

My subtitle should induce some uneasiness. Perhaps the most striking point of agreement between the recently emergent interdisciplinary field of cultural studies and the mainstream of contemporary anglophone philosophy is that cultural studies does not constitute a *philosophical* program. Practitioners of cultural studies typically explore the production or emergence of meaning within historically specific and localizable material settings. Cultural studies thus express a resolute historical and social particularism, even when the particular context of meaning-production that they examine is global in scale. Contemporary philosophers, by contrast, still frequently aspire to quite general theories of meaning, thought, knowledge, and action. Cultural studies are usually undertaken from an explicitly politically engaged position; philosophers more frequently aspire to what Thomas Nagel (1986) has called "the view from nowhere." Finally, philosophical theorists have most often cast their projects as allied with or even subsumed by a resolutely naturalistic understanding of the world. As Quine, perhaps the most influential American philosopher of the century, memorably said, "philosophy of science is philosophy enough." No analogous claim could plausibly be made about cultural studies, whose relationship to the natural sciences has been considerably more troubled than that of the "analytic" tradition in philosophy.

Yet I intend that subtitle quite seriously. The theoretical commitments expressed by work in cultural studies, especially cultural studies of science, offer a compelling response to a central question running throughout much of twentieth-century philosophy: How does the richly meaningful, normative field of human activity ever successfully connect to "nature," the seemingly semantically inert inexorability of physical regularities or causal processes? What cultural studies can show is that in posing the question in this way, philosophers have displayed a debilitatingly dualist conception of nature and the intentionality of meaningful thought, language, or action. A "dualism" in this sense is "a distinction whose components are [conceived] in terms that make their characteristic relations to one another ultimately unintelligible" (Brandom 1994, 615).

It may go against the grain, however, to look to the politically engaged practice of cultural studies to reconnect this dualism. The more intimate one's engagement with power relations and social criticism, the more remote one may seem to be from the world disclosed by the sciences, and from the material environment within which people act. A long tradition in philosophy, which often still seizes the imagination, proclaims that one only encounters nature in its brute causal unfolding by turning away from human cultural significance and political stakes. Things must be allowed to manifest themselves as they are, were, and always will be, except to the limited extent that our own similarly brute causal powers can effectively rearrange them. Moreover, such an encounter with independent causal capacities may seem to be the only nonarbitrary constraint upon the inventive and constructive powers of imagination and human cultures.

These intuitions undoubtedly help account for the persistence and even dominance of representationalist construals of intentionality and knowledge. Such accounts begin with the separate constitution of representational content and of the natures or capacities of things represented, and ask how they can ever make appropriate contact. In fact, the most familiar philosophical answers are that they *cannot* effectively bear on one another. Typically, philosophers undertake either an antirealist strategy (representations or practices of inquiry do not respond to things as they really are apart from us but only to their manifestations in experience or social practices), or else a naturalist, realist strategy (representational content is reduced to its causal/functional role already within the natural world). Antirealists then have trouble accounting for how experiences, actions, and social practices or institutions are accountable to the world, except through the brute, unintelligible resistance of empirical anomalies and practical failures. Realists have similar difficulties understanding how the modally robust causal powers and rigidly designated natural kinds that supposedly determine the content of thoughts, utterances, and actions are normatively binding upon human agents, except through the brute, unintelligible success or failure of some of their projects.

Once the normative and the natural or causal dimensions of the world are thus conceived incommensurably as self-enclosed domains, however, they can never effectively be brought back together. We must understand causality as always already normative, and normativity as always already causally efficacious. It is here I turn to cultural studies; their most important contribution is to insist that meaning emerges within *practices,* normatively configured interactions with material surroundings. Cultural studies of science play a pivotal role here because of the importance of *scientific practices* within the contemporary dualism of intentionality and nature. If Descartes's account of mind and body is the paradigmatic dualism, then scientific practices are the pineal gland of contemporary philosophy: the proposed site for the magical reconciliation of what has been conceived irreconcilably. Through the practice of science, supposedly, the brute unintelligibility of nature becomes intelligible. In surpassing such a dualism, cultural studies of science might restore our ability to recognize and understand the accomplishments of the sciences, without having to praise them for squaring the circle.

Practice talk has in fact been rampant within late-twentieth-century philosophy, social theory, and science studies. Amidst its proliferation, however, there has been too little attention to divergent uses of the term. Attending to scientific practices will help us only if we understand *practices* in the right way. My discussion proceeds in four parts. First, I briefly note some pitfalls posed specifically by the extension of the concept of practice to encompass *scientific* practices. Second, I explore a crucial ambiguity in the concept of practices manifest in recent critical discussions of the concept by Stephen Turner (1994) and Steve Fuller (1989; 1992). The third part of

the paper all too briefly takes up some philosophical implications of the conception of practices that I attribute to cultural studies, a conception whose very possibility Turner and Fuller overlook. Specifically, this conception of practices challenges familiar reifications of language, knowledge, and power, and encourages attention to the *temporality* of scientific practices and their meaning, justification, and effects. Finally, I respond to Fuller's explicit worry that cultural studies of scientific practices must inevitably be politically and scientifically conservative.

## I. INITIAL CLARIFICATIONS

A first crucial mistake to avoid is reading the concept of scientific practices in terms of a distinction between *theory* and practice. This mistake is especially tempting because one of the most prominent uses of the term *practices* in science studies has been to emphasize the autonomy of experimental and instrumental practices from theoretical determinations. In contrast to the widespread insistence upon the theory-ladenness of observation and methodology which emerged from the postempiricism of the 1960s and 1970s, it has since frequently been argued that "experiment has a life of its own," and similarly that the development and use of scientific instruments cannot be fully accounted for in terms of their supposed theoretical presuppositions.[1] The target of these criticisms, however, was an overarching conception of theory as *representation*. Thus, an important complement to the rediscovery of experimental practices has been to recognize that theorizing is also misconstrued as the development of static representational structures. Scientific theory is better understood in terms of theoretical *practices:* modeling particular situations or domains; articulating, extending, and reconciling those models and their constituent concepts and techniques; and connecting theoretical models to experimental systems. Such a conception of theorizing diverges both from the classical sense of *theoria* and more recent analyses of theories as axiomatic or model-theoretic systems.[2]

A second mistake would be to understand the turn to practices as an account of the individual or collective doings of scientific researchers, as distinct from the material setting of what they do. Such an interpretation would take *practices* as an alternative account of scientific *subjectivity.* Instead of understanding knowing subjects as disembodied minds representing the world, the idea would be to take them as embodied agents acting upon or within it. This idea is attractive and, up to a point, not mistaken. But it founders when one asks whether the doings of such agents are intelligible and coherent if considered apart from their material setting. When understood as mental representation, subjectivity might have a kind of theoretical autonomy from the world it represents; we can grasp what it would be to (purport to) represent in the absence of any object or situation successfully represented. Similarly, it might seem plausible to speak of socially instituted practical norms as swinging relatively free from their material instantiation.[3] The same cannot be said of practical activity. To open a door or pour a liquid in the absence of the door or the liquid can only be construed as *pretending* to act, performing some *other* action (reaching for a door or tipping an empty bottle, each of which engages a *different* material setting rather than none), or utterly failing to act at all in the requisite way.[4] Elsewhere (Rouse 1996, ch. 5), I have said more about how to begin the analysis of practices, including scientific practices, with the relational complex of materially situated activity rather than with agents' activities or their material setting considered apart from one another. For now, we should think of scientific practices as practical configurations *of the world* rather than as agents' performances abstracted from them.

A final danger to avoid at the outset is the construal of *scientific* practices as clearly bounded and closed off from an extrascientific "context." Undoubtedly, we can identify more or less distinctively scientific practices by their relatively dense interconnections with other scientific practices and by the issues and stakes that arise through those particular interconnections. Nevertheless, the traffic in all directions across whatever boundaries can be thus demarcated will be too heavy to allow for any significant autonomy of a domain of scientific practices.[5] The sciences depend upon their "context" not only for funding and material resources; recruits and auxiliary personnel; institutional location in universities, academies, corporations, bureaucracies, or foundations; social norms, cultural forms, and bodily disciplines; but also for much of what is ultimately at issue or at stake in scientific practices. On this last point, for example, it is instructive to ask how the sciences have come to be so concerned with origins, foundations, secrets, or laws.[6] Moreover, the extension of scientific practices and achievements into new settings cannot always be dismissed as merely the subsequent "application" of antecedently intelligible achievements. The intentionality of scientific practices is often only fulfilled by such extensions beyond the laboratory and outside the field. How, after all, does the manipulation of successive generations of inbred *Drosophila* come to be about *genetics,* or the incorporation of radioactive amino acids in rat liver slices come to be about protein synthesis? The spatiotemporal extension of scientific practices and materials beyond the laboratory is often the vindication of the *semantic* extension of scientific concepts.[7] Scientific practices are often construed to be apart from any surrounding "culture," and even free from culture,[8] but such construals are simply not adequate to the rich and complex phenomena of scientific work.

## II. PRACTICES AS NORMATIVE

With these clarifications in mind, we can now turn to an ambiguity in the concept of practices that emerges from Turner's and Fuller's critical discussions of practice theories. An important philosophical rationale for practice talk comes from Wittgenstein's discussion of rule following and Heidegger's account of understanding and interpretation.[9] The ability to follow a rule or to make an assertion seems to presuppose an unarticulated understanding-in-practice in order to halt regresses of explicit interpretation and justification. If understanding requires recourse to rules, after all, how does one correctly understand a rule? But Turner objects to any attempt to avoid such regresses by situating explicit understanding against a background of practices, arguing that the appeal to practices to account for regularities, continuities, and commonalities in social life is pseudoexplanatory. According to Turner, the inference from common behavior to its supposedly underlying source in *shared* presuppositions or practices cannot be justified, the causal powers of practices are inevitably mysterious, and the transmission or reproduction of practices over time and from one practitioner to another cannot be accounted for. Fuller's criticism echoes Turner's objections to practice talk as pseudoexplanatory, and adds a political dimension: he argues that recourse to the *geisteswissenschaftliche* interpretation of tacit understanding is deeply conservative and antidemocratic, an argument that is buttressed at least ad hominem by reflection upon the political commitments of Heidegger and Wittgenstein, philosophical ancestors of the practice industry.[10]

I take Turner's criticisms very seriously but argue that he has misunderstood their significance. Turner concludes from his arguments that practice talk is altogether bankrupt in

philosophy and social theory. His discussion instead reveals a fundamental ambiguity among uses of the term *practices,* between practices conceived as *regularities* and a *normative* conception of practices. Turner only identifies one side of the ambiguous usage. I think his arguments are indeed telling objections to the conception of practices (as regularities) that he actually addresses, but the upshot of the argument is instead to highlight the importance of conceiving practices normatively. My first task, then, is to consider the differences between conceiving practices as regularities and conceiving them normatively. These differences concern what practices are, how they become evident, the significance of language within practices, and the sense in which practices are "social."

So what are practices? The question arises with some force because of the diversity of things sometimes denoted by the term. Turner notes that "practice" is variously interchangeable with "tradition," "tacit knowledge," "paradigm," "presupposition," and much more. Practices are sometimes regarded as tacit propositional attitudes and sometimes as inarticulable competences or performances. In either case, he claims, the concept of practices is typically invoked to explain continuities or commonalities among the activities of social groups. Turner argues that to do the *explanatory* work thus attributed to them, practices must be objectively identifiable regularities. If they are presupposed propositional commitments, they must have some "psychological reality"; if they are practical competences, they must have some causal efficacy. In either case, moreover, the content or pattern embodied in a practice must be transmissable in ways that would preserve its identity across practitioners. Turner ultimately rejects any explanatory appeal to social practices just because of the allegedly intractable difficulties in justifying the psychological reality, causal efficacy, or transmissable identity of any regularities "underlying" more readily manifest human activities.

Turner, however, fails to recognize the possibility of an alternative conception of a *practice,* in which something belongs to a practice if what it does is appropriately regarded as answerable to norms of correct or incorrect practice. Not all constituents of practices do the same things or presuppose the same beliefs, but some of them are subject to correction for performances that are inappropriate or otherwise incorrect. Of course, not all improprieties are *actually* corrected or sanctioned. So the differential responses that would signify the incorrectness of some performances are themselves normative practices. It is always possible that such chains of proprieties come to an end in some kind of objective regularity. But, as Brandom has noted, "we can envisage a situation in which *every* social practice of [a] community has as its generating response a performance which must be in accord with another social practice" (1979, 189–90). Such a network of practices need not be identifiable as regularities of action or belief, even as a whole. Brandom therefore argues that the difference between regularities and norms should itself be regarded normatively, that is, as a distinction between those patterns *appropriately* explained in causal terms, and those appropriately understood as subject to interpretation and normative response.

Turner's own arguments against the integrity of practices conceived as regularities ironically often point toward such a normative conception of practices. Turner argues, for example, that Marcel Mauss's identification of distinctively French and American ways of walking could not easily be captured in terms of "culture-free causal categories," in part because "one might acquire the 'same' [external] walk by mimicking or by a kind of training which corrected various untutored walks—and corrected them in different respects—to produce a walk which is externally the same" (1994, 22). Moreover, Turner claimed, the *description* of practices typically depends

upon classification schemes that presuppose acquaintance with other practices: such descriptions are only identifiable by contrast to other local, cultural expectations with which they conflict (1994, 24). They are only identifiable *as practices* at all against a background of other practices, and thus can never be reduced to objective regularities. Turner still fails to grasp a normative conception of practices as a genuine alternative, however; what other practice theorists would regard as normative responsiveness, he dismisses as merely an *instrumentalist* appeal to regularities (1994, 37).

Turner objects to such an instrumentalist conception of the appeal to regularities of social practice because it "fails to connect the stuff of thought to the world of cause and substance, . . . [leaving] no basis for using our past understandings or interpretations to warrant future interpretations" (1994, 37). But this objection only makes sense if the domain of practices is conceived too narrowly, in two respects. On the one hand, it presumes that the "world of cause and substance" is somehow distinct from the "world" of meaningful practices, the "social world," such that the two are in *need* of reconnection. It also presumes, more subtly, that practices are distinct from linguistic representation: practices are ontologically suspect, whereas linguistic meaning and reference are not. I turn first to the relation between practice and language.

Practice theorists have often been ambivalent about the significance of language for practices, and vice versa. On the one hand, unarticulated or even inarticulable practices are frequently contrasted to explicit assertions or rules. On the other hand, the domain of practice is often extended to incorporate *conceptual* or linguistic practices, perhaps even as the paradigm case of practices. Shared conceptual schemes or presuppositions are often the focus of practice talk. Once we recognize the difference between conceiving practices as regularities or normatively, however, we can see a fundamental distinction among two conceptions of *linguistic* (or discursive) practices. Those who identify practices with regularities (including shared beliefs or conceptual schemes) typically situate language outside the domain of practices; shared practices may account for particular beliefs or conceptual schemes that are expressible *within* language, but linguistic intentionality itself is then conceived in terms of a representational semantics instead of a pragmatics of discursive practices. By contrast, a normative conception of practices is best understood as a general conception of intentionality. Brandom (1994) has most explicitly worked out such a conception of intentionality as altogether pragmatic, but once we are clear about the distinction, Heidegger and Wittgenstein, and more recently Donald Davidson, are best understood as conceiving of intentionality as pragmatically normative rather than representational.

Such a pragmatic account of language, and of intentionality more generally, understands language dynamically, without reifying meanings, reference, or shared languages. Shared meanings or beliefs are not the preexisting facts that would explain the possibility of communication, but the norms presumptively invoked in the course of interpreting someone or something as communicative.[11] Only by interpreting a speaker as mostly making sense (within a field of linguistic and other practical proprieties that enable me to make sense of myself as making sense) can I acknowledge her activity (or my own) as discursive, and thus as linguistic. Note that this characteristic feature of Davidson's and Brandom's interpretive semantics (namely that truth, meaning, language, and other semantic categories can only be explicated via interpretation in an *unanalyzed* home language[12]) is precisely the feature of practices that most vexed Turner as unacceptably instrumentalist. Turner complains that,

The assumptions [one] attributes to [another] are identifiable as assumptions only because [one] is in a position to make a specific comparison [to one's own understanding of the "same" situation]. Starting from a different comparison . . . would produce different misunderstandings, and different assumptions would need to be attributed. . . . Such "assumptions," then, are *not natural facts,* but hypotheses that solve specific comparative problems. (1994, 33–34; emphasis mine)

But for Davidson, Brandom, Wittgenstein, or Heidegger, linguistic practices are *nonnatural* in precisely this sense.

With this background, we can now turn to Turner's worries about the connection between practices and "the world of cause and substance." Turner clearly takes practice theory to be objectionably antirealist (either instrumentalist or social constructivist) about the causal powers and susceptibilities of practices. But a normative conception of linguistic and other practices challenges the shared commitments of realists and antirealists alike to representationalist semantics.[13] The attitudes and responses that identify a practice (*including* a discursive practice) are only contentful amidst ongoing *intra-actions* with the world.[14] We interpret utterances by making sense of what is said when, i.e., on which occasions, in what worldly *circumstances.* Thus, for Davidson (1984), we interpret utterances via prior acquaintance with their *truth conditions;* for Heidegger, interpretation is an aspect of *being-in-the-world.* To ask how our representations can ever get a foothold in the world is to presume, erroneously, that we can ever make or understand representations without already having a foothold in the world.[15]

Thus, if we take seriously a normative conception of practices, we must recognize that there *is* no such thing as "the social world" (*or* the "natural world") except as reified abstractions from *the* world.[16] The meanings, agency, institutions, or forms of life with which social constructivists would explain how nature becomes manifest to us are themselves senseless apart from those manifestations; they cannot be independent explanans. But supposedly natural kinds and their causal capacities only acquire their constitutive *counterfactual* import from their normative application ceteris paribus within scientific practices of theoretical modeling and experimental manipulation.

## III. PHILOSOPHICAL CONSEQUENCES

So far, we have explored the distinction of a normative conception of practices from mere regularities of social life. I now want to consider, in a similarly programmatic way, some possible consequences of attending to scientific practices understood normatively, instead of as regularities of behavior or belief.[17]

One topic that becomes central when we take scientific practices as normative is their temporality.[18] Postempiricist philosophy of science has recognized the importance of historical changes in the methods, concepts, and standards of the sciences, whether construed as sharp, "revolutionary" breaks or as more gradual, reticulated developments. A central preoccupation of the philosophical responses to Kuhn and Feyerabend has been to understand scientific change in ways that do not render it rationally unintelligible (i.e., unintelligible *as rational*). But such interpretations of scientific change are not yet an adequate conception of the temporality of scientific practices. If one took scientific communities to share specific beliefs, values, conceptual contents, or activities, then it would make sense to ask how those communities and their commitments change over time. But such conceptions presume that there is an already determinate

character to the community itself and to the shared commitments that define its boundaries. Such determinacy cannot be presumed once scientific practices are conceived normatively, for such practices are *constitutively* temporally extended. What the practices are *now* depends in part upon how their normative force is interpreted in ongoing practice, that is, by how practitioners and their surroundings *will* or *would* respond to continuities or variations in what is done. But those future responses are not yet determined. The *present* content of scientific practices is thus subject to reinterpretation and semantic drift. For example, Rheinberger concludes from his historical study of the intertwining of research on oncogenesis, virology, and the functional structure of cells that "the virus of 1950 [depicted by Keith Porter's electron microscopy] must be seen as the condition of possibility for looking at [Peyton] Rous's [1910] agent as that which it had *not* been: the *future virus*" (1994, 77). This point is ontological rather than epistemic: present semantic content is comparable to whether a goal in soccer is the game-winning goal, in being not yet settled by any facts. Understanding practices normatively helps us see why this is so: what a practice is, including what counts as an instance of the practice, is bound up with its *significance,* i.e., with what is at issue and at stake in the practice, to whom or what it *matters,* and hence with how the practice is *appropriately* or *perspicuously* described. The temporality of scientific practices is what François Jacob described as "a machine for making the future" (Rheinberger 1994), and hence their constitutive openness to genuine future *disclosure* cannot be conceived adequately in terms of scientific *change.*

Adequately accounting for the significance of scientific practices and its temporality requires *dynamic* accounts of language, knowledge, and power, or so I argued in *Engaging Science.* We can now see why dynamic or nonreified conceptions of language, knowledge, and power are *mutually* implicated. In criticizing Turner, I already pointed toward a conception of language as discursive practices, that is, as dynamic interactions among speakers and their surroundings. Linguistic practices are mediated not by conventional meanings, languages, or beliefs but by partially shared *situations,* which have a history. One consequence of recognizing their dynamics highlights the importance of tropes, whose contrast class is not "literal" meanings but familiar or uncontested *uses.*[19] Within the sciences, models (including mathematical, verbal, physical, pictorial or schematic, and experimental models) are especially important examples of tropes. We should think of models as simulacra rather than representations. The crucial difference is that "representation" too often denotes a semantic content that intervenes between knowers and the world, whereas simulacra are just more things in the world, with a multiplicity of relations to other things. What makes them models, with an *intentional* relation to what they are models *of,* is their being taken up in practices, ongoing patterns of use that are answerable to norms of correctness.[20]

This constitutive role for proprieties and sanctions in linguistic interaction already shows the indispensability of concepts of *power* and *resistance* for understanding language. Whether an unfamiliar way of speaking about or dealing with a situation is taken as an innovation, a mistake, a curiosity, an irony, or a humdrum variation on the familiar depends crucially upon asymmetries of power among those who encounter it. Yet the recognition of models as simulacra extends the interconnection of meaning and power beyond the immediate relation between speakers and their interpreters. To see why this is so, consider a question sometimes asked rhetorically about meaning: How could merely representing things differently possibly have a causal influence on them? A similar question about simulacra cannot have the same rhetorical effect: simulacra *are* transformations of the world, and more significantly, they transform the

available possibilities for acting, what it is intelligible to do. They do so both by materially enabling some activities and obstructing others, and also by changing the situation such that some possible actions or roles lose their point, while others acquire new significance.[21] Indeed, the most important philosophical role for the concept of power is to express how actions *materially* transform the world in ways that *normatively* reconfigure what can be at stake in subsequent actions.

So far, I have sketched how considerations of power might become relevant to conceptions of language and meaning as emergent from the normativity of discursive practices. If such an account were construed in terms of a *reified* conception of power, the result would be a reduction of meaning to rhetorical force, and language to a technology of persuasion. Such a move is not unknown within science studies. Reducing meaning or significance to rhetorical or material effects is nevertheless a fundamental mistake. The mistake can be avoided if we also conceive of power dynamically, not as a regularity of social life, a thing possessed or exercised by dominant agents, but as a situated and temporally extended relationship among agents and their surroundings.

Wartenburg (1990) developed a partial model for such a dynamic conception of power. He began by noting how power is mediated by what he calls "social alignments": one agent's actions effectively exercise power over another only to the extent that other agents' actions are appropriately aligned with the actions of the dominant agent. For example, judges exercise power over prisoners only if the actions of bailiffs, guards, appeals courts, and others are aligned in the right way with what the judge does. Power relations are dynamic because the *presence* of an alignment and its *effectiveness* depend upon how the alignment is sustained or transformed over time, in response to subordinate agents' efforts to resist or bypass them as well as dominant agents' attempts to utilize, strengthen, or extend them. Power is thus dispersed and deferred across a field of possibilities. Wartenburg's model is only partial, because he mistakenly restricts the mediation of power to *social* alignments of human agents. A more adequate conception would recognize the *materially* circumstantial configuration of power relations, such that tools, processes, and physical surroundings more generally all belong to dynamic alignments of dominance, subordination, and resistance. Thus, just as practices should not be reduced to *social* practices, power should not be reduced to *social* power.

It may be initially more difficult, however, to grasp how to understand knowing without reifying knowledge. Dynamic accounts of language have helpful precedents in Davidson, Derrida, and Brandom; Foucault likewise makes familiar a dynamics of power. Yet Wartenburg's discussion of dynamic power alignments offers a useful analogue to a dynamic conception of knowing.[22] Power is only *effective* in enabling or constraining action through dynamic alignments that bring one action to bear upon another. Knowing is likewise only *informative* through dynamic alignments that enable one thing (a statement, a model, an image, a skillful performance, and so on) to be taken correctly to be *about* another. Philosophers of science nowadays emphasize the importance of "background knowledge" in establishing inferential relations between hypotheses and evidence, but that concept is too homogeneous and static. Knowing is mediated not only by a "background" of beliefs but also by models, skills, instruments, standardized materials and phenomena, and situated interactions among knowers, in short, by *practices*. Moreover, a dynamic account of language as discursive practices obliterates any clear distinction between the representational *content* of knowledge, and its material or social construction or implementation.

The result is a *deflationary* conception of knowledge, modeled on deflationary, prosentialist conceptions of truth.[23] In the latter case, the truth predicate and the capacity to use it are

recognized as indispensable to linguistic and epistemic practices, even though no underlying nature of truth unifies or reifies the instances of its appropriate application.[24] A deflationary account of knowledge likewise denies that "knowledge" or "scientific knowledge" constitutes a theoretically coherent kind. There are many appropriate ascriptions of "knowing" within the multifarious practices of assessing, attributing, relying upon, or contesting understanding and justification, but there is no *nature* of knowledge underlying these ascriptions. This claim has far-reaching consequences: participation in the wholesale legitimation, explanation, or critique of scientific claims to knowledge almost invariably proceeds from a conception of scientific knowledge as a theoretically coherent concept that can be surveyed as a whole. It only makes sense to claim that scientific knowledge as a whole is approximately true, rationally arrived at, socially constructed, or interest-relative if there is such a (kind of) thing.[25] Scientific realists, historical metamethodologists, empiricists, and social constructivists regularly argue for their preferred accounts of the nature or goal of scientific knowledge, but typically and mistakenly take the unity and theoretical integrity of "scientific knowledge" for granted.

## IV. LOCATING CULTURAL STUDIES OF SCIENCE

Conceiving of practices normatively rather than as composed of underlying social (or natural) regularities, and refusing to reify language, power, and knowledge, thus challenge many of the most familiar philosophical and sociological approaches to science studies. An important aspect of this challenge concerns the theoretical and political "location" of science studies themselves, often discussed under the heading of reflexivity. Philosophers and sociologists alike have typically attempted to achieve a standpoint of "epistemic sovereignty" (Rouse 1994), a theoretical position "outside" or "above" scientific practices from which to establish or undermine their legitimacy and authority once and for all. We can now appreciate the conceptual link between aspiring to epistemic sovereignty and conceiving scientific practices as regularities. The various participants in the legitimation project hope to characterize the underlying regularities that most fundamentally govern scientific practices, whether these are socially, psychologically, or rationally predetermined goals, or causally efficacious features of the world. By thus ascertaining what science *really is,* its indispensable nature or goal, they would provide an incontrovertible ground for assessing its successes and failures, and its appropriate place among other human practices and achievements.

If we understand scientific practices normatively, however, no such determining standpoint above or outside of ongoing practice is available. Davidson's and Brandom's semantics offer a useful parallel; they take natural language as its own metalanguage, and ask that we explicate discursive practice from "within." We must likewise recognize *science* to incorporate its own interpretive and critical metapractices, and engage in epistemic and political explication and criticism from within. Science should in this context be construed broadly as the *cultures* of science, the practical, discursive nexus that incorporates everyone and everything in relation to which science is an intelligible and significant category, however contested.

This insistence that science studies are inescapably "internal" to the culture of science may then raise Fuller's principal worry that an interpretive engagement with scientific practices is necessarily conservative.[26] Fuller (1992) claims that interpretive engagement with scientific

practices must abandon any attempt to hold science accountable to norms not of its own choosing. But this criticism only shows Fuller's commitment to a conception of practices as (social) regularities: he limits "science" to the set of practices already conventionally recognized as science, its "norms" to the goals and standards to which its practitioners already subscribe, and he *therefore* concludes that critical perspective can only come from elsewhere. If one recognizes scientific practices as normative, what science or knowledge *is* is not already determined, but is instead *at issue* in scientists' and others' practical responsiveness to their circumstances. Various epistemically significant practices are normatively accountable, but such practices also offer competing *interpretations* of the epistemic and cultural/political norms within which they are situated. The interpretive resources for science studies thus include a multiplicity of sciences and metascientific discourses, *together* with various marginal and oppositional epistemic practices. Science studies do not come in from the "outside" to settle the differences among these coexisting and competing practices but are already situated among them and engaged with them.

The significance of the critical resources for such engagement with the sciences can be seen by comparison to philosophical appeals to the inferential role of "background knowledge" in justification. In my terms, such appeals to background knowledge implicitly invoke a conception of practices as regularities. But there are not, and need not be, any such shared background commitments within science or the larger culture of science. The "background" to justification is not shared belief but partially shared situations (which have a *history* and a futural orientation). We justify actions and interpretations by making sense of a presumptively shared situation. Indeed, on this account, part of what it is to *act* is simply to understand what one does as (defeasibly) making sense within a meaningful situation. There is thus a continuity between action and the explicit interpretation and justification of action: action takes place within the presumptive space of reason giving and sense making, and to *act* in a particular way is also implicitly to construe one's situation in a way that would make sense of one's action within it. Such interpretive construal has an essentially temporal or narrative dimension, because a (partially) shared situation *is* its history, including its *future:* we make sense of what we do by enacting narratives in which what we do has an intelligible place (Rouse 1997, ch. 6). To do science is also to construe its history, while to offer an account of its history (or its supposedly ahistorical nature) is to project particular ways to do science.

The futural dimension of the narrative reconstruction of science is crucial here. Actions and explicit reinterpretations of them do not merely construe the past but also project a future. Such projections leave room for an explicitly utopian dimension of science studies (and scientific practices!) even while insisting upon the grounding of such utopian vision in its implicit past and present. Donna Haraway's work is especially instructive in this respect: it matters enormously that her critical reconstructions and utopian imaginings are responses to a history "we" share, even if that history needs to be reconfigured for us to *recognize* it as ours, and as potentially the past of such an imagined future (or "elsewhere").[27] The critical significance of such narrative reconstructions arises both from their insightful reconfiguration of past and present and from potential alignments with the activities of others that might help effect a future continuous with what they envision.

Such a conception of critical engagement within the culture of science nevertheless may raise a worry frequently associated with Frankfurt School Critical Theory. The worry is that power may be exercised not only to foreclose the *effectiveness* of political criticism but also its rational

legitimacy, if what *is* is permitted to govern the space of reason giving. Fuller thus appropriately cites Marcuse's emphasis upon negative thinking in articulating his objection to the allegedly conservative character of *geisteswissenschaftliche* philosophy and sociology of science.

One indispensable response to this worry is to acknowledge it. There is no guarantee that there will always be adequate resources for the articulation and realization of compelling epistemic and political criticism. Recognition that ongoing political and epistemological work is needed to sustain a space for critical reflection and political transformation is a crucial goad against complacency.[28]

There is also a more substantive response, however. Taking seriously the prospect of an overwhelming ideological hegemony that would foreclose the intelligibility of critical alternatives underestimates the diversity and contestedness of epistemic practices and their political significance. There will always be conflicting interpretations of ascendent scientific disciplines, as well as marginal and alternative ways of knowing, which have at least the potential to support critical perspectives upon dominant practices of justification. What is presently accepted as justification can never be finally secured against alternative interpretations, precisely because there are no self-certifying epistemic foundations immune from criticism. Moreover, the dynamics of linguistic meaning remind us that hegemonic ideologies are open to subversive readings, while social and material alignments of power are not self-maintaining. New forms of power and domination invite counteralignments. If epistemic and political criticism must always be an intelligible response to past and present practice, we must nevertheless remember that what past and present practice *is* includes its possible futures, and those have not yet been fully determined. An appropriate response to worries about irresistable power and seamless ideology is not to seek secure grounds for criticism but to engage the specific forms of domination that trouble us, to articulate imaginative, insightful and effective criticisms of them, and to forge specific alignments and solidarities with others who share (or might come to share) such concerns.

Such a conception of the critical positioning of science studies calls for a thicker conception of reflexivity than has usually been articulated in the science studies literature. Within recent sociology of science, "reflexivity" often marks a concern for a *rhetorical* consistency that would expose the construction of the authoritativeness of one's own texts and truth claims to the same critical scrutiny accorded to scientific texts and practices. In the hands of Steve Woolgar (1988) or Malcolm Ashmore (1989), for example, such scrutiny calls for inventive and playful writing that would undermine naive reading of texts as transparently representational. But such a rhetorical conception of reflexivity too easily overlooks that such textual constructions are also *actions* situated amidst alignments of power and resistance. Reflexivity has moral and political, as well as rhetorical and epistemological, dimensions: What do these writings and sayings *do?* To whom do they speak? What other voices and concerns do they acknowledge, make room for, or foreclose? Which tendencies and alignments do they reinforce and which do they challenge? Above all, to whom are they accountable? These questions arise with considerable force, because science studies as such are not politically or epistemically prepositioned: critical engagement with scientific practices might variously articulate and reinforce dominant epistemic and political alignments, contribute to or extend oppositional discourses and practices, or shift the field to envision new possibilities. A modest and self-critical attentiveness to our own partiality and situatedness, and to our accountability for what we say and do, are the political responsibility incurred by our own contingent positionings within the culture of science.

NOTES

1. Among the most prominent contributors to this experimentalist philosophy and historiography of scientific practices are Hacking 1983; Ackermann 1985; Franklin 1986; Galison 1987; Gooding 1990; and Gooding, Pinch, and Schaffer 1989.

2. Useful introductions to understanding theorizing as practices include Hacking 1983, ch. 12; Cartwright 1983; Rouse 1987, pp. 30–40, 80–95, 111–19; Rouse 1996 127–33, 166–78, 224–33; and Krieger 1992.

3. Thus, Brandom (1994) and Haugeland (1998) take greeting practices as paradigm cases of socially instituted practices whose correctness or incorrectness depends solely upon what the relevant community accepts as a greeting correctly performed. In the end, however, I think that the difference between such "socially instituted" practices and the "constitutive" practices that are normatively accountable to the world (as practically configured) is at most a difference of degree in the *directness* of their normative entanglement with their worldly "surroundings."

4. I speak of "utter" failure, because there are all sorts of ways in which action can fail to be completed successfully (the door might be locked, missing a handle, too heavy, or too symbolically portentous for me to open it), but in the absence of an appropriate material setting, the action cannot even get *started* in a way that would allow for a failure of *completion.* This is true even for speech acts. If my vocalizations or other performances are not appropriately connected (perhaps by complicated inferential networks) to a suitable, publicly accessible material setting, it cannot be *contentful* or referentially indicative.

5. The reverse is also true, that is, that what is left of the social or cultural "world" apart from scientific practices is not autonomously intelligible. It is a truism to note the importance of scientific practices and achievements within the "modern" world, but this truism is often neglected in practice. If as a thought experiment, for example, one were to conceive the image of the social and cultural world constructable by an imaginary overlay of the social science and humanities curricula of most Western universities, one of the more striking divergences between this image and the world it aspires to make intelligible would likely be a seriously truncated view of the natural sciences as sociocultural and material practices.

6. Mario Biagioli's (1993) discussion of Galileo's articulation of a new role as a *courtly* natural philosopher shows this point especially clearly by the constraints that emerged within absolutist court culture upon what *could* be at stake in natural philosophical controversies. Subsequent discussion of the significance of origins, foundations, secrets, and laws can be found in Haraway 1989; Keller 1992; and Cartwright 1994.

7. This general issue of the intentionality of experimental systems is discussed in Rouse 1987, ch. 4, 7; and 1996, part II. The examples of *Drosophila* genetics and in vitro protein synthesis are extensively considered in Kohler 1994 and Rheinberger 1997 respectively, and the latter also extends earlier discussions of the general issue.

8. Traweek (1988) interprets the self-understanding of the physicists she studied as their belonging to "the culture of no culture."

9. Wittgenstein 1953; Heidegger 1962.

10. Turner himself (1989) has argued that the ad hominem consideration of Heidegger's politics must be taken as a quite serious prima facie problem for any conception of practices that draws extensively upon Heidegger's work.

11. "Interpretation" (or as Turner too narrowly construes it, "attributing assumptions") is here understood in a thoroughly pragmatic way, as adopting a practical attitude rather than offering an explicit account: I "interpret" someone as communicative simply by listening and responding in appropriate ways. A useful parallel is Heidegger's (1962) discussion of interpretation (*Auslegung*), in which one interprets something as a hammer by hammering with it; no explicit attribution of properties or meanings is required. An interpreter can, of course, try to make explicit the practical attitudes adopted in making sense of another speaker or agent, but such explications always come to an end in further unexplicated *proprieties:* this is what we do. This Wittgensteinian point is often misunderstood by taking "what we do" as a behavioral regularity, but that cannot be right in the light of Wittgenstein's discussion of rule following. We appeal to "what we do" precisely to halt the regress of explications of a rule (whether the rule is supposed to *govern* the interpreted performances, or is only a regularity the interpreter takes them to exhibit). Such a regress *cannot* end in another regularity, but only in a propriety (to adapt an example from Samuel Wheeler, we should understand "this is what we do" in the sense of "we don't hit other children, do we?"). "What we do" always includes further practices of *correcting* deviant practice.

12. The phrase "relative to an unanalyzed home (or background) language" is the canonical characterization of a point common to Quine, Davidson, Rorty, and Brandom. Strictly speaking, however, such views ought to hold no place for any determinate concept of a *language,* as Davidson (1986) came to recognize, for discursive practice always outruns any previously stable linguistic structure. The background to interpretation must therefore instead be unexplicated discursive *practices,* which Brandom (1994) models as *scorekeeping* practices.

13. Rouse 1987, ch. 5; 1991; 1996, intro. and ch. 7–8.

14. I follow Barad (1996) in adopting the term *intra-action* as a substitute for *interaction,* to avoid the connotation that the things that interact have a determinate identity and character prior to or apart from their interactions.

15. The classic philosophical source for this criticism of representationalism, of course, is the introduction to Hegel's *Phenomenology of Spirit* (1972): the representationalism underlying both realism and antirealism is precisely what Hegel called "the fear of error that reveals itself as fear of the truth" (par. 74).

16. Brandom (1994) still identifies practical proprieties as instituted within *social* practices, but in a sense he describes as an "I-Thou" model of social interaction rather than "I-We." It makes more sense to drop the term *social,*

which inevitably has connotations of supraindividual *entities*. But neither should we think of Brandom's theory as one of *individual* intentionality. Who or what counts as an agent with "original intentionality" is itself a normative question, not a factual one.

17. A more detailed discussion of some of these issues can be found in part II of Rouse 1996.

18. The temporality of scientific practices has also been a central concern in recent work by Andrew Pickering (1995) and Hans-Jörg Rheinberger (1994; 1997).

19. The *loci classici* for such a conception of metaphor are Davidson 1984 and Wheeler 1991.

20. This concept of simulacra is discussed in Rouse 1996, ch. 8. The contrasting sense of "representation" is indifferent to whether representations are conceived as thoughts accessible to individual minds, or as concepts, conceptual frameworks, languages, or forms of life shared by social groups.

21. The sense in which scientific practices transform the available possibilities for human action is more extensively discussed in Rouse 1987, ch. 6–7. That discussion should be connected to my more detailed subsequent account (Rouse 1996, ch. 8) of both theoretical modeling and experimental systems as simulacra rather than representations.

22. The connection is more than just an analogy. Wartenburg's approach to power is deeply influenced by Foucault, whose reflections on the dynamics of power were introduced as an analytics of power/knowledge. Foucault's work of the 1970s suggests a dynamics of knowing, even though it is less extensively articulated than his correlative conception of power.

23. It is crucial to distinguish two oppositely directed *uses* of Tarski's schema for a deflationary (or semantic) conception of truth. For Tarski or Hartry Field, the semantic conception shows how "truth" can be eliminated (at least for formal languages) and thereby rendered innocuous within a thoroughgoing naturalism or physicalism. Reduction, however, is inevitably a two-way street. Along with Davidson, Brandom, and others, I deploy the Tarski schema in the opposite direction, making "truth" the fundamental semantic category, and dispensing with reifications of meaning (or convention), reference, or shared languages.

24. The standard technical objection to deflationary conceptions of truth has been their proponents' inability to articulate what to say about the uses of the truth predicate in conditionally embedded, nominalized, or quantified contexts. Brandom's (1994) development of Grover, Camp, and Belnap's (1975) prosentential theory, and its extension to "refers" as a "proform-forming operator," has resolved the principal technical problems, however, which ought to place a burden of argument upon those who would still call for a more robust and substantive conception of truth.

25. Rouse (1996, intro. and part I) articulates and criticizes the commitments to the "legitimation project" that are necessary to make sense of the disagreements among scientific realists, historical metamethodologists, empiricists, and social constructivists.

26. Strictly speaking, this criticism would allow an alternative to a conservative continuity with current practice, namely an arbitrary imposition upon current practice, but this alternative is *unjustified*, because justification is conceptually linked to continuity with current practices and norms.

27. Among the works that most clearly display the utopian dimension of her project are Haraway 1997; 1992; 1991, ch. 8–10; and 1989, ch. 16.

28. What one might have expected to be a theoretically and politically invigorating freeing of the imagination in the wake of the collapse of the dead weight of "actually existing socialism" in the *annis mirabilis* of 1989 has instead too often led to triumphant reinvocations of an end to ideology or even to history, countered only by halfhearted hopes to mitigate the worst effects of the inevitably dispiriting recurrence of our present political and theoretical circumstances.

REFERENCES

Ackermann, Robert. 1985. *Data, Instruments, and Theory: A Dialectical Approach to Understanding Science*. Princeton: Princeton University Press.

Ashmore, Malcolm, 1989. *The Reflexive Thesis: Wrighting Sociology of Scientific Knowledge*. Chicago: University of Chicago Press.

Barad, Karen. 1996. Meeting the Universe Halfway: Realism and Social Constructivism Without Contradiction. In *Feminism, Science and the Philosophy of Science*, ed. L. H. Nelson and J. Nelson, 161–94. Dordrecht: Kluwer.

Biagioli, Mario. 1993. *Galileo, Courtier*. Chicago: University of Chicago Press.

Brandom, Robert. 1979. Freedom and Constraint By Norms. *American Philosophical Quarterly* 16: 187–96.

———. 1994. *Making It Explicit: Reasoning, Representing, and Discursive Commitment*. Cambridge, Mass.: Harvard University Press.

Cartwright, Nancy. 1983. *How the Laws of Physics Lie*. Oxford: Oxford University Press.

———. 1994. Fundamentalism vs. the Patchwork of Laws. *Proceedings of the Aristotelian Society* 94: 279–92.

Davidson, Donald. 1984. *Inquiries Into Truth and Interpretation*. Oxford: Oxford University Press.

Davidson, Donald. 1986. A Nice Derangement of Epitaphs. In *Truth and Interpretation: Perspectives on the Philosophy of Donald Davidson*, ed. E. LePore, 433–46. Oxford: Basil Blackwell.

Franklin, Allan. 1986. *The Neglect of Experiment*. Cambridge: Cambridge University Press.

Fuller, Steve. 1989. *Philosophy of Science and Its Discontents*. Boulder: Westview Press.

———. 1992. Social Epistemology and the Research Agenda of Science Studies. In *Science as Practice and Culture*, ed. A. Pickering, 390–428. Chicago: University of Chicago Press.

Galison, Peter. 1987. *How Experiments End*. Chicago: University of Chicago Press.

Gooding, David. 1990. *Experiment and the Making of Meaning*. Dordrecht: Kluwer.

Gooding, David, Trevor Pinch, and Simon Schaffer. 1989. *The Uses of Experiment: Studies in the Natural Sciences*. Cambridge: Cambridge University Press.

Grover, Dorothy, Joseph Camp, and Nuel Belnap. 1975. A Prosentential Theory of Truth. *Philosophical Studies* 27: 73–125.

Hacking, Ian. 1983. *Representing and Intervening: Introductory Topics in the Philosophy of Natural Science*. Cambridge: Cambridge University Press.

Haraway, Donna. 1989. *Primate Visions: Gender, Race and Nature in the World of Modern Science*. New York: Routledge.

———. 1991. *Simians, Cyborgs and Women*. New York: Routledge.

———. 1992. The Promises of Monsters. In *Cultural Studies*, ed. L. Grossberg, C. Nelson, and P. Treichler. New York: Routledge.

———. 1997. *Modest_Witness@Second_Millenium.FemaleMan_Meets_Oncomouse*. New York: Routledge.

Haugeland, John. 1998. Truth and Rule-Following. In *Having Thought*. Cambridge: Harvard University Press.

Hegel, Georg W. F. 1972. *Hegel's Phenomenology of Spirit*, trans. A. V. Miller. Oxford, Mass.: Oxford University Press.

Heidegger, Martin. 1962. *Being and Time*. New York: Harper and Row.

Keller, Evelyn Fox. 1992. *Secrets of Life, Secrets of Death: Essays on Language, Gender and Science*. New York: Routledge.

Kohler, Robert. 1994. *Lords of the Fly: Drosophila Genetics and the Experimental Life*. Chicago: University of Chicago Press.

Krieger, Martin. 1992. *Doing Physics: How Physicists Take Hold of the World*. Bloomington: Indiana University Press.

Nagel, Thomas. 1986. *The View From Nowhere*. Oxford: Oxford University Press.

Pickering, Andrew. 1995. *The Mangle of Practice*. Chicago: University of Chicago Press.

Rheinberger, Hans-Jörg. 1994. Experimental Systems: Historiality, Narration, and Deconstruction. *Science in Context* 7: 65–81 (reprinted in this volume).

———. 1997. *Toward a History of Epistemic Things: Synthesizing Proteins in the Test Tube*. Stanford: Stanford University Press.

Rouse, Joseph. 1987. *Knowledge and Power: Toward a Political Philosophy of Science*. Ithaca: Cornell University Press.

———. 1991. Indeterminacy, Empirical Evidence, and Methodological Pluralism. *Synthese* 86: 443–65.

———. 1994. Foucault and the Natural Sciences. In *Foucault and the Critique of Institutions*, ed. J. Caputo and M. Yount, 137–62. State College: Pennsylvania State University Press.

———. 1996. *Engaging Science: How to Understand its Practices Philosophically*. Ithaca: Cornell University Press.

Traweek, Sharon. 1988. *Beamtimes and Lifetimes: The World of High-Energy Physicists*. Cambridge, Mass.: Harvard University Press.

Turner, Stephen. 1989. Depoliticizing Power. *Social Studies of Science* 19: 533–60.

———. 1994. *The Social Theory of Practices*. Chicago: University of Chicago Press.

Wartenburg, Thomas. 1990. *The Forms of Power*. Philadelphia: Temple University Press.

Wheeler, Samuel. 1991. True Figures. In *The Interpretive Turn*, ed. D. Hiley, J. Bohman, and R. Shusterman. Ithaca: Cornell University Press.

Wittgenstein, Ludwig. 1953. *Philosophical Investigations*. Oxford: Basil Blackwell.

Woolgar, Steve. 1988. *Science: The Very Idea*. London: Tavistock.

# 31

# Late Victorian Metrology and Its Instrumentation

## A Manufactory of Ohms

### SIMON SCHAFFER

*The original B.A. standards of resistance are at the Cavendish Laboratory.... When the place is in working order, I hope to be able to verify any standards already constructed and sent to me, but I do not expect or think it desirable that a manufactory of "ohms" should be established in the building.*

—JAMES CLERK MAXWELL, JANUARY 14, 1875

Much scientific work helps make experiments into governable instruments. Experiments with many possible messages are changed into tools with apparently straightforward, unproblematic functions. Recent studies of the laboratory workplace have indicated that institutions' local cultures are crucial for the emergence of robust facts and instruments from fragile experiments. In seventeenth-century English laboratories, gentlemanly codes of honor and trust governed the capacity of natural philosophers to render experience and testimony as reliable reports of natural order, while technologies of machine-minding and reporting were developed to make experimental philosophy fit Baroque social mores. Similarly, in Victorian observatories workers were regulated within factory discipline to guarantee their scrutiny of the stars. New machinery, like galvanic clocks, chart recorders, and telegraphic relays were introduced between the eyepiece and the observer to make an ensemble capable of valid astronomical experience.[1] Such stories indicate the extreme localization of scientific practice: in these examples, experiments and observations are understood in terms of the features of specific workplaces. But if facts depend so much on these local features, how do they work elsewhere? Practices must be distributed beyond the laboratory locale and the contexts of knowledge multiplied. Thus networks are constructed to distribute instruments and values which make the world fit for science. Metrology, the establishment of standard units for natural quantities, is the principal enterprise which allows the domination of this world. Metrology matters because of this relationship between the lab interior, in which values are established and reproduced, and the networks which link labs, in which values are translated and transformed.[2]

Standardization will therefore be an obvious concern for historians of science. The physical values which the laboratory fixes are sustained by the social values which the laboratory inculcates.[3] Metrology has not often been granted much historical significance. But in milieux such as those of Victorian Britain the propagation of standards and values was the means through which physicists reckoned they could link their work with technical and economic projects elsewhere in their society. Instrumental ensembles let these workers embody the values which mattered to their culture in their laboratory routines. Intellectualist condescension distracts our attention from these everyday practices, from their technical staff, and from the work which makes results count outside laboratory walls. In an unprecedented manner, late Victorian scientists joined networks in which standard machines, values, and practices were distributed worldwide: imperialism, mass production, and metrology dominated their universe. They saw an immediate connection between imperial standards and the integrity of their laboratory work. Their great accomplishments, such as electrotechnology, proved their command along the cables upon whose working the Empire's integrity depended. The new British physics laboratories of 1860–80 were part of an imperial communications project, either through their managers' work for the British Association campaign for electromagnetic standards, or through their training of expert telegraphists, instructors, and electrotechnologists.[4]

## CAMBRIDGE METROLOGY
## AND THE TELEGRAPH SYSTEM

In Cambridge, where the Cavendish Laboratory for experimental physics was built between 1871 and 1874, proponents carefully argued for the combination of electrotechnology with liberal pedagogy. The achievements of William Thomson's physics laboratory at Glasgow University indicated how the products of a comparable university laboratory could spread throughout the Empire. In autumn 1870 Kalley Miller, a veteran of the Glasgow system, told Cambridge dons that "the success of the Atlantic cable is in great measure the results of years of patient work in the Glasgow Laboratory." He had to show that the proper enclosure of the laboratory, which would fit it for the genteel Cambridge milieu, would nevertheless allow vital links between the commanding heights of Victorian electromagnetism and thermodynamics, and the practice of metrology. Miller placed equal weight on standardization and on instrument testing: "the determination of the wavelength of light, of the mechanical equivalent of heat, and of the relation between the electrostatic and electromagnetic units are among other vitally important practical points which have been successfully experimented upon. I may add that the excellent electrometers turned out by the Glasgow makers owe much of their value to the fact that each one has been carefully tested and regulated in the University laboratory before it is sent out for service."[5] Within a decade, the Cavendish itself became a center of Victorian electrotechnical metrology, certifying electrometers and resistance boxes for the cable industry and the nascent network of physics laboratories. In March 1874 Clerk Maxwell, the new Cavendish professor, ordered "one or more of the original standard Ohms to verify commercial Ohms withal," and eventually such firms as the instrument company Elliott Brothers asked the Cavendish to verify its resistance boxes. Teaching regimes changed in company with research practice, and this was by no means a straightforward maneuver. By January 1875, in the letter quoted at the head of this chapter, Maxwell stated that when the laboratory "is in working

order, I hope to be able to verify any standard already constructed and sent to me." But he now added a crucial caveat: "I do not expect or think it desirable that a manufactory of 'ohms' should be established in the building."[6] So Maxwell outlined a metrological program for the new Cavendish Laboratory, but he also pointedly distinguished this project from the work of a factory.

Maxwell stressed the point in his inaugural lecture of October 1871: because "modern experiments . . . consist principally of measurements," Maxwell explained, many had come to believe that "in a few years all the great physical constants will have been approximately estimated, and that the only occupation which will then be left to men of science will be to carry on these measurements to another place of decimals." This statement has often been cited as though it were Maxwell's own view. But Maxwell reckoned that this view was doubly wrong: wrong because physics had much more than precision measurement as its task, and wrong because this picture would render the university an inappropriate home for the new laboratory. "Our Laboratory may perhaps become celebrated as a place of conscientious labour and consummate skill, but it will be out of place in the University, and ought rather to be classed with the other great workshops of our country." By 1882, under Lord Rayleigh, the Cavendish was earning a good income from fees charged for verification and testing electromagnetic standards. At the same moment, Rayleigh also insisted on a fruitful "division of labour" between experimentalists and mathematicians.[7] The division of labor mattered to the possibility of making a standards laboratory; and the creation of standards dominated the linkage between the Cavendish and its various constituencies.

The purpose of the story which follows is to explore the cultural setting in which these patterns of labor and skill were established and to use these cultural factors to analyze the relationship between the Cavendish Laboratory and its outside world. There were many Victorian metrological institutions: the Excise Laboratory, Kew Observatory, and the Royal Observatory, for example. In Cambridge a precision measurement standards laboratory was set up within an existing academic institution. We see the resources needed to establish a site of calculation and vigilance and understand the social conflicts which metrology needed to resolve. No Victorian savant could view metrology with condescension. Its public discourse was profoundly moralistic. A culture convinced of the need for accurate data and stern surveillance as the right means of social management would also see precision measures as an ethical good. In late-Victorian culture, it has been observed, "diligence, good time keeping and good behaviour were rewarded. Time measured out by the machine, not that dictated by the Sun or the seasons, had come to impose a different and totally new discipline on the British people."[8] Standardization showed the integrity of the system, its continuity in moral action and physical space and time. Edwin Chadwick concluded his notorious *Report on the Sanitary Condition of the Labouring Classes* (1842) with a paean to "the advantages of uniformity in legislation and in the executive machinery, and of doing the same things in the same way (choosing the best) and calling the same officers, proceedings and things by the same names." A monument to this ethos was Charles Babbage's project for an all-embracing *Table of the Constants of Nature and Art*. Even the phrase "constant of nature" was a neologism which Babbage skillfully used. He urged the production of a collaborative encyclopedia which would contain "all those facts which can be expressed by numbers in various sciences and arts." This project would "call into action a permanent cause of advancement towards truth, continually leading to the more accurate determination of established facts and measurement of new ones."[9]

Babbage helped develop the important notion of "absolute measurement." The career of submarine cables demonstrated this importance. William Thomson showed that telegraph performance depended on a precise knowledge of the resistance per unit length of the cable wire.[10] This knowledge had to be expressed in units which manufacturers and telegraphists could reliably use. The failure of the first Atlantic cable showed how hard it was to achieve this reliability. In summer 1871 Thomson reminded the British Association that the combined material interests of "those who perilled and lost their money in the original Atlantic telegraph," and the British Association's standards committee set up in 1861 to "supply their electricians with methods for absolute measurement" had ensured the profitability of the cable firms, the culture of "accurate measurement in every scientific laboratory in the world," and had started "a train of investigation which now sends up branches into the loftiest region and subtlest ether of natural philosophy."[11] The integrity of the ether, of electromagnetism, of the cables, and of the Empire all hinged on these standards. Many physicists said so in numerous tomes on standard systems.[12] So the link with imperial integrity was secured: the spread of these systems of units and instruments made labs like Glasgow and the Cavendish centers of calculation for world electrotechnology, discrediting rival entrepreneurs.

## THE BRITISH ASSOCIATION
## STANDARDS PROGRAM

The British Association Standards Committee was an important forum for this development. It was established in 1861 following rival reports by the Siemens brothers and by Latimer Clark and Charles Bright on the need for a system of units in the cable industry. The Siemenses were engaged in cable repair and maintenance using "stringent electrical tests which the authors are charged by the British government to apply." They were using the Thomson-Siemens formula for specific induction and a new in-house Siemens resistance unit, based on the resistance of an arbitrary length of mercury. Workers such as Clark and Bright, alert to "the wants of practical telegraphists," also demanded an adequate system.[13] But in the event the committee was made up of a professorial group who commandeered the campaign for reliable units. Many of the new physics labs were managed by committee members, including Maxwell. In the preface to his *Treatise on Electricity and Magnetism,* completed in February 1873, Maxwell noted that this electrotechnology gave "a commercial value to accurate electrical measurements," and *also* allowed tests "on a scale which greatly transcends that of any ordinary laboratory."[14] As a preamble to this campaign, Maxwell told the British Association that "between the student's mere knowledge of the history of discovery and the workman's practical familiarity with particular operations which can only be communicated to others by direct imitation, we are in want of a set of rules, or rather principles, by which the laws remembered in their abstract form can be applied to estimate the forces required to effect any given practical result." He urged that training and standards could only survive in company: "whenever many persons act together, it is necessary that they should have a common understanding of the measures to be employed."[15] Throughout the 1860s Maxwell worked hard to make a reliable resistance standard. His collaborators included the telegraphist Fleeming Jenkin and the instrument maker Charles Hockin, a Cambridge fellow. Links were forged with other members of the British Association committee, and with the manufacturers, notably Elliott Brothers. The salient issue was whether standards made in the

FIGURE 31-1

*The electrotechnology network in the 1880s: John Pender holds the ends of the cables, Charles Bright*
*and Latimer Clark stand behind him. Following a cart carrying the staff of the post office march:*
*William Thomson, Sylvanus Thompson, Cromwell Varley, William Crookes, W. E. Ayrton,*
*John Perry, Grylls Adams; behind them are the Siemens brothers.* Source: The City (*May 5, 1883*).

London labs could be disseminated through cable networks, and, thus, whether the standards of
conduct in the labs could match those in cable-laying ships or telegraph stations (fig. 31-1).

A workable absolute system had to satisfy these constraints. An early effort to make a system
which would coordinate international research was that of Wilhelm Weber, developed at Göt-
tingen as part of the geomagnetic crusade of the 1830s and 1840s, published in 1851. Weber's units
were absolute, and independent of any particular material, but they were therefore abstract and

hard to reproduce. The British agreed that "absolute permanency" was a prerequisite of a resistance unit. Yet they differed from Weber on the relation between work, force, and electromagnetic action. Thomson reckoned that any system of units must display the work performed when unit current flowed across unit resistance at unit potential difference. So they sought to reform Weber's system and to rule out the conventional Siemens system. Werner Siemens fought back. He reckoned that "those cases in which the expression of absolute measure is of advantage occur very seldom and only in purely scientific exercises." Defending his use of standard mercury columns, the great German electrotechnologist argued that "every other definition would not only burden unnecessarily the calculations which occur in modern life, but also confuse our conception of the measure." The British Association committee urged that the cable networks be freed from German industrial control. Their solution was to set up an absolutely permanent standard, weld it into international telegraphy, and then change telegraphic practice to display it as a success for British electromagnetic skill.[16]

Maxwell's team used a spinning coil revolving round its vertical axis in the geomagnetic field to produce a constant deflection on a galvanometer needle at its center. The angle of deflection would depend on the coil's diameter, the rate of spin, and the coil's resistance. The resistance could therefore be established by measuring the other three parameters. This placed major demands on precision engineering and experimental skill.[17] The aim of mobilizing telegraphic and quantitative resources was to make a coil whose resistance was as close as possible to the unit of resistance set up in the electromagnetic system, $10^7$ m/sec (fig. 31-2). Maxwell had to defend this project against Siemens. According to William Thomson, the German's success in producing an accurate length of mercury simply "affects the question of the best material for the con-

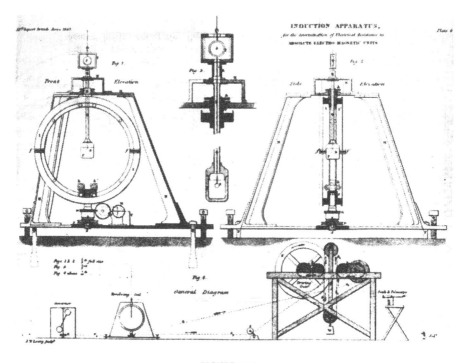

FIGURE 31-2
*Maxwell and Jenkin's apparatus for the determination of a resistance standard,
London 1863.* Source: British Association Reports (1863).

struction and reproduction of the standard," but "leaves the question of its magnitude quite untouched."[18] This spinning coil soon became the emblem and instrument through which standards could be propagated. The tough question was whether this could be achieved without compromising those standards. Maxwell's group dismissed Siemens because his Berlin-based system did not embody work and energy relations which they considered essential to the value of the standards program. Only if standards were reproducible would the network evince the superiority of British physics. The choice between reproducibility and absolute values was a choice between the standards of laboratory physics and of the cable networks. So in 1864 Maxwell, Jenkin, and Hockin repeated their spins at King's College London, changing most of the important elements including wire winding and rotation speed. Uncertified coils had already begun to be produced, by Elliott Brothers and by Siemens, for distribution to the Indian telegraph and elsewhere. "Meanwhile practical standards of resistance are urgently required. . . . Defective systems are daily taking root." By March 1865 Maxwell told the Edinburgh physicist Peter Guthrie Tait, "the true origin of electrical resistance as expressed in BA units" had become "Fleeming Jenkin, Esq., price 2 pounds 10 shillings in a box."[19] But what was boxed was not the absolute unit. Siemens, for one, pointed out that the artifactual character of the associations' boxed units, which erred noticeably among themselves and from any notional absolute, testified to the failure of laboratory standards among Maxwell's London group. They had to work out ways of making their experiments count as instruments.[20]

Jenkin dealt with these puzzles in a series of lectures in spring 1866 at the Society of Arts. He spoke both as Maxwell's London collaborator and as a veteran of seven years' hard work with Thomson's Glasgow group on patents for improvements in telegraphic communication. This was a moment of great risk for the telegraph industry. Confidence in the forthcoming laying of the second Atlantic cable was in question. Jenkin reckoned he could show how the British Association unit could be made to work at sea and on ship. These units were good means of cable fault finding, since if the tester knew the resistance per unit length of the line he could locate any cable break by balancing the potential across a standard resistance against that of the unknown length of cable up to the fault. But this meant knowing that cable materials were made of reliably standardized wire, and thus knowing that laboratory values had been transferred to cable works.[21] Jenkin announced a new regime, developed with Thomson, using the new British Association boxes and Glasgow-made galvanometers and electrometers. Continuity between lab skills and telegraphic skills could be assured through new patterns of training in this electrotechnology. "Undoubtedly this test is not of so simple a nature that it could be executed by an ordinary clerk," Jenkin conceded, "but it is interesting to know that a test does exist by which even a fault which has hitherto baffled electricians can have its position fixed with mathematical certainty." The same message was carried in the report the British Association committee, to which Jenkin was secretary, issued that year. The alleged success of the new, absolute, "coherent" system had moved skill from pure science to real practice. "If resistance only were to have been practically measured, the advantage of adopting the coherent system would have been wholly confined to men of science; but now that measurements of capacity, currents, and electromotive force are becoming common, the practical advantages of the coherent system are very considerable." The report listed agencies and electricians who were now using the new method and standard, including India, Australia, a number of major companies, and the leaders of British electromagnetic research.[22]

Jenkin's gamble paid off, as did the Atlantic Telegraph Company's deals with Jenkin and his colleagues. The company agreed that if they were offered any instruments which seemed better than the galvanometers, keys, electrometers, and test devices designed by the team, then Jenkin's group would be given a year to come up with their own improved instruments. By linking the status of the Association's units with cable integrity, Jenkin and Thomson were playing a powerful hand. On September 8, 1866, just after the British Association meeting, the great transatlantic cable had been secured from Valentia to Newfoundland. British industrialists now rose to international domination of the system.[23] The cable's success was perceptibly linked to electromagnetic wisdom, and the security of laboratory-ship linkage was seen as vital. Just as the projectors of the first, failed cable of 1858 had violated theoretical integrity by ignoring Thomson's principles of electromagnetism, so the warrant of the integrity of the 1866 cable was the integrity of the system of instruments and values which sustained and were vouchsafed by it—resistance boxes developed by Maxwell and Jenkin and made by Elliot Brothers; the conduct of the workshops and labs at London, Birkenhead, and Glasgow; the truth of the electromagnetic connection between resistance, current, and work. Jenkin responded that his instruments' credit rested on "submarine cables, in the examination and manufacture of which, the practical engineer soon found the benefit of a knowledge of electrical laws."[24]

The events of the 1860s resulted in a temporary conciliation between the values of the laboratory and of commerce. Toward the end of the decade, freed from the rigours of his King's College London chair, Maxwell reworked the standards project as part of his electromagnetic physics. Maxwell's experimental resources were compromised because Jenkin and others were recruited to the Atlantic cable team. When Elliott Brothers engineer Hockin was released from cable duty, however, he could help. Maxwell reported he "performed everything, except the actual observation of equilibrium, which I undertook myself." Through Elliott Brothers, Maxwell had access to the British Association condensers and resistances. The firm's engineer, Becker, designed his new electrical balances, and Maxwell could occasionally command J. P. Gassiot's London laboratory with its great batteries.[25] The trials performed there were designed to ascertain the relative values of the electrostatic and electromagnetic units, a task laid down in the mid-1860s for the British Association and adumbrated in his celebrated 1865 "Dynamical Theory" as part of the linkage between light and electromagnetic radiation. It was an example of the way in which "purely scientific" problems could be made commercially crucial. The setup involved balancing the force developed between two oppositely charged discs against the repulsion between two current carrying coils. Maxwell and Hockin reckoned that precision tooling would allow a good estimate of the ratio of the two units and hence the value of Maxwell's electromagnetic program.[26]

Maxwell understood that "the importance of the determination of this ratio in all cases in which electrostatic and electromagnetic actions are combined is obvious. Such cases occur in the ordinary working of all submarine telegraph-cables, in induction coils, and in many other artificial arrangements." This was conventional work for the British Association Committee. But he also insisted that "a knowledge of this ratio is I think of still greater scientific importance when we consider that the velocity of the propagation of electromagnetic disturbance through a dielectric medium depends on this ratio and hence, according to my calculations, is expressed by the very same number."[27] The status of the claim that light was related to electromagnetic radiation was made to hinge on the standards program. But in 1868, Maxwell found very large differences between his calculated velocity, V, and that of light. He told Hockin to find ways of

increasing accuracy.[28] Eventually Maxwell managed to alter the measure of V by suppressing almost one-third of his runs, "on account of the micrometer being touched during the observation of equilibrium," and unremittingly blaming the value of the British Association resistance unit. Recalling his project of the 1860s, Maxwell stressed "the hunting for sources of discrepancies, the hitches in the working of new apparatus, the mathematical difficulties, and not least the physical difficulty of keeping up the spirit of accuracy to the end of a long and disappointing day's work." Needing larger batteries, a better workforce and resistance boxes, his work stalled. It could not be revived until, and may well have prompted, his move to Cambridge in 1871.[29]

## THE CAVENDISH AS A METROLOGICAL INSTITUTION

Maxwell's work with the British Association committee provided him with some resources when he reached Cambridge. But it cannot completely explain the appearance of a standards laboratory inside the university. The experience of the 1860s dramatized the links between cable telegraphy and electrotechnical metrology but did not make an electrotechnical standards program an appropriate enterprise for a liberal educational institution. Two complementary features of the deployment of electrotechnical instrumentation in Cambridge must be stressed. On the one hand, Maxwell and his allies worked hard to make metrology look like a moral enterprise, and so a program fit for the university; on the other hand, the laboratory managers sought to set up work relations within the Cavendish which would make its values reliable and precise measures of useful parameters. In neither of these strategies can we deduce laboratory life solely from the simplified intentions of its professoriate. Life outside the institution, and outside its leadership, mattered at least as much to the metrological program developed there.

During the early 1870s Maxwell tried to match use of the instruments provided by the British Association and the cable engineers with the concerns of other scientific practitioners. Among these were the new astrophysicists, because their spectroscopes showed that light and matter behaved the same way in deep space and on Earth. In a celebrated paper attacking fashionable German models of action at a distance, Maxwell argued for the homogeneity of the luminiferous ether, "this wonderful medium, so full, that no human power can remove it from the smallest portion of space, or produce the slightest flaw in its infinite continuity."[30] The regularity of astronomical spectra in turn connected astrophysics, laboratory physics, and theology. Maxwell peddled this moral argument about metrology throughout the 1870s in public lectures, addresses at the British Association, and in encyclopedias. The fact that molecules behaved identically everywhere proved their vibrations were standard, like soldiers' drill or uniform screws. This linked the values of the barracks and production line with those of God and of each molecule. "From the ineffaceable characters impressed on [molecules] we may learn that those aspirations after accuracy in measurement, truth in statement and justice in action . . . are ours because they are essential constituents of the image of Him who in the beginning not only the heaven and the earth but the materials of which heaven and earth consist."[31] The implication was that a standards program would be fit for varsity science, and that thus electromagnetic physics would connect cables, circuits, spectroscopes, the tutorial room, and the pulpit.

It was necessary to place the Cavendish Laboratory in this network with some circumspection. The example of Glasgow, used by Maxwell, Kalley Miller, and its manager William Thomson

in the early 1870s, was a highly ambiguous resource. A good case of the contrast with Glaswegian values is provided by Maxwell's interrogation of Jenkin and Thomson in summer 1872, a year after his arrival in Cambridge and during the completion of the *Treatise on Electricity and Magnetism*.[32] Maxwell asked Thomson whether he agreed that a "Farad" should be defined as "the capacity of a very large condenser," rather than as "a dose of electricity." Thomson responded brutally that units must be embodied as real instruments with commercial values. "When electrotyping, electric light, etc. become commercial, we may perhaps buy a microfarad or a megafarad of electricity. . . . If there is a name given to it, it had better be given to a real, purchaseable, tangible object, rather than to a quantity of electricity."[33] Before the end of the decade, Thomson would be involved with the distribution of "potted energy," via his association with Joseph Swan and Camille Faure. His blunt and characteristic reply to Maxwell in 1872 revealed one set of values which these instruments were designed to embody: those of the late Victorian marketplace.

These were not, however, values which could be easily absorbed in Cambridge. The establishment of the new experimental physics chair largely resulted from the campaign of mathematicians such as George Stokes, Lord Rayleigh, and their allies for reform of the Mathematics Tripos by introducing experimental topics. Rayleigh indicated he would take the new laboratory job if Maxwell would not.[34] So when considering the post in spring 1871, Maxwell asked both Rayleigh and Thomson for advice. He laid out plans for the lab and told Thomson that "we should get from the BA some of their apparatus for the standards committee. In particular the spinning coil and the great electromagnetometer. If not we must have a large coil made and measured with the utmost precision to be used as a standard." The standards program was central to the new vision, but it was very hard to set up. Hence in March 1871, Maxwell told Rayleigh that "it will need a good deal of effort to make experimental physics bite into our University system which is so continuous and complete without it. To wrench the mind from symbols and even from experiments on paper to concrete apparatus is very trying at first, though it is quite possible to get fascinated with a course of observation as soon as we have forgotten all about the scientific part of it." The worry was that the physicists might "corrupt the minds of youth" until they no longer gained the status of wranglers: "we may bring the whole university and all the parents about our ears."[35] The work on electromagnetic standards meant running the lab like a workshop. It needed new skills and new instrument makers. The localization of these skills and workers makes up the power of laboratory culture.

So managerial problems dominated the institutionalization of Cavendish physics. Initial provision of instruments was hopeless. Maxwell joked to Thomson that the university rowing crew might be used as source of power. These jokes had political implications, because they seemed to subvert the moral order of the university. More seriously, Maxwell had to budget £2500 for restocking and kept lobbying the lab's founder-benefactor, the Duke of Devonshire, for help.[36] This was why the transfer of the British Association instruments agreed during summer 1871 mattered. When the lab was finished in 1874, Maxwell ordered Jenkin to "get laid on the scent" of more standards devices. They reached Cambridge by autumn 1874, but on their own these transfers could not summon a standards laboratory into existence.[37] Maxwell's own laboratory assistant, Pullin, was quite incapable of working on the project, good at ordering railway employees around but no technician. When Rayleigh assumed the chair after Maxwell's death in 1879, Pullin recalled that in his entire career "I soldered two wires together and made some oxygen"; Rayleigh dispensed with him. At the end of Maxwell's regime, Rayleigh judged

that the Cavendish was "very imperfectly provided with apparatus," that they should start laboratory demonstrations, and that major reform would be needed to revive the standards program.[38]

The institutionalization of science is dominated by rites of passage. Cambridge experimental physics was no exception, but training was famously chaotic and hotly disputed. Arthur Schuster, introduced as a Cavendish researcher in 1876 to work on Ohm's law but soon switched to spectroscopy, recalled that "the instruments suffered more than the students by their being so freely allowed to come unchaperoned into mutual contact." Richard Glazebrook, Rayleigh's adjutant, saw disadvantages in such indiscipline. "With a large class of students, all of whom have to be taught certain leading laws and facts in a limited time, organisation . . . is absolutely necessary."[39] The new regime led by Rayleigh and Glazebrook helped manufacture physicists, just as this process was fiercely resisted by the *ci-devant* mathematics coaches. Their spokesman was Isaac Todhunter, chief celebrant of the Mathematics Tripos. Todhunter simply denied that experimenters could be trained. He urged that in an endless repetition of classroom instrumental work "we can never recover any of the interest which belonged to the first trial." He concluded that "it may be said of the experimenter, as of the poet, that he is born and not manufactured." Todhunter and his allies made it all the more difficult to produce trained physicists and a standards lab within the liberal university.[40]

The laboratory managers also had to solve the problems of instrumentation. The gap between laboratory and workshop was crucial. In July 1873 Maxwell reported that "it is impossible to procure many of the instruments as they are not kept in stock, and have to be made to order." Standards instruments needed personal supervision during construction: "their whole value depends on their fulfilling conditions which can as yet only be determined by trial, so that it may be some time before everything is in working order." Technology transfer and design need settings which cultivate tacit skills. These cannot be developed in long-distance, formal, communications between maker and user. So, as Maxwell argued in 1877, the distance between operative and researcher had to be effaced. "The experimenter has only occasional opportunities of seeing the instrument maker, and is perhaps not fully acquainted with the resources of the workshop, so that his instructions are imperfectly understood by the workman. On the other hand the workman had no opportunities of seeing the apparatus at work, so that any improvements in construction which his practical skill might suggest are either lost or misdirected."[41] Changing this situation was hard. At least three resources existed for developing more effective skills: closer links with London and Glasgow engineers; recruitment from the new university engineering department, under Professor James Stuart's controversial leadership; and hiring in-house laboratory technicians. In the mid-1870s the technician Robert Fulcher from Stuart's former factory in Scotland was switched to the Cavendish. Stuart's own shop began to make instruments for the lab, and this helped the new Cambridge Scientific Instruments Company expand from its status as supplier for the university's physiology laboratory into a general scientific instruments concern. The shop began to provide the Cavendish with equipment and jobs for students.[42]

The skills of men like Fulcher were crucial for the electromagnetic standards project. Maxwell began designing new methods for redetermining the resistance unit and for assessing the value of V. They needed high-quality precision skills. He reckoned that a better value of V could be obtained with a commutator linked to an air condenser. The current strength in the circuit could be measured in electromagnetic units using a balancing constant current, while the electrostatic value of the quantity of charge could be found from the commutator's speed and the dimensions of the condenser. This method still needed a good value for the British

Association resistance standard. The aim was to get support staff to eliminate the troubles his team had had in London in the 1860s. Maxwell devised a method with little dependence on battery output variation and no need to calibrate the ballistic galvanometer. To ensure very fast current decay when the commutator was running, he wanted to fit a narrow radial gap filled with an insulator inside the gunmetal former which held the mutual inductance coils. Maxwell's very last lecture at Cambridge was devoted to an investigation of the shape of such a decaying current in a mutual inductance system. Notes on this lecture were posthumously included in the next edition of the *Treatise*.[43]

Good coils and formers were needed. In summer 1877 they could still not be made in Cambridge and were ordered from London. Maxwell's troubles with distant, and thus unverifiable, makers began here. Fulcher would solve them by making the coils on site. In January 1878 Hockin was asked again about other labs' work, including that of Carey Foster in London, where temperature effects on resistance were used. Ambrose Fleming, then a new Cambridge science student, was given the task of getting the London method working in Cambridge.[44] The mathematician George Chrystal was given the surveillance job. During 1878 he told Maxwell of the troubles he faced when winding coils onto the gunmetal formers. He filled a dozen pages of the lab notebook with details of the winding, suggested means for regulating the commutator's resistance, and reported that "the wire we got was not what it should be." The main problem was technical support: "owing to the dearth of assistance I could get no further than a preliminary trial which promised success." By July Chrystal confirmed that "I propose having the coils wound by Fulcher in my immediate presence, so that I can give account of every layer if necessary." Because of this new in-house resource, linking Stuart's technicians and Maxwell's wranglers, the professor was able to tell the university that at last "much of the apparatus to be used in Cambridge which has hitherto been ordered from London may in future be constructed in Cambridge and tested while in the maker's hands by those who are to use it."[45] So the troubles of long-distance calibration which had plagued the isolated laboratory could be solved with a new pattern of workshop skill developed inside the Cavendish.

This solution involved the integration of instrumentation and training. The induction coils, magnetometers, and commutators became emblematic of laboratory initiation. Maxwell's *Treatise* helped explain this status. The text described and rationalized instrumentation. Maxwell's brilliant analysis of ballistic galvanometry was one example. Elsewhere, chapters on instruments outlined a hierarchy of tools, ranging from "null or zero methods" such as the electroscope, through registration devices and scale readings, to "instruments so constructed that they contain within themselves the means of independently determining the true values of quantities." Maxwell here explained the doctrinal and practical significance of absolute measures. His influential program notes on a London scientific instruments exhibition of 1876 served a similar purpose. Instrument design embodied the principles of physics they were designed to illustrate and then to investigate. "There must be a prime mover or driving power, and a train of mechanism to connect the prime mover with the body to be moved." Dynamics was basic in theory and energy transmission basic in design. Electrical instruments were to be classed into sources, channels, restraints, reservoirs, overflows, regulators, indicators, and finally, scales, such as the ohm. By making instruments look like machines, Maxwell helped link workshop with laboratory practices.[46]

This machine vocabulary aided the introduction of the British Association standards into the laboratory. In the 1870s, the custom was to introduce tyros to the Cavendish by getting them to

work on the standard magnetometer, as it "afforded practice not only in reading scales and making adjustments but also in time observations, counting the beats of a watch while observing the vibrating magnet."[47] The status of the British Association machinery was also visible in the laboratory layout. The magnetic room occupied the east end of the ground floor, a site of honor, with solidly based stands and a relatively large space for ancillary equipment. These devices were central to the rites of entrance to the laboratory. But when Glazebrook began work at the Cavendish in 1876 he was ordered to help Chrystal by using a quadrant electrometer to supervise the constant e.m.f. of a set of batteries. Glazebrook soon gave up, revealing the difference in values between the standards program and the varsity *cursus honorum:* "the measurement which I was set to do did not seem likely to afford material for a Fellowship Dissertation."[48]

This was one way in which it was hard to form a cadre of skills. There were others. In the very first year of operations, in spring 1874, Maxwell made his class use the magnetometer to measure the geomagnetic field' strength and direction. Then he checked with Kew Observatory to compare his group's results and to receive instruction on the best way of setting up the great instrument. The same problems developed in his exchanges with Jenkin about the best ways of running the British Association equipment. He asked Jenkin for the recipe for the governor he had designed in the mid-1860s, since "I must have a speedy friction governor essentially on your principle but with some few alterations to secure good balancing." Maxwell did not know where to get one. He also needed lessons on the design of the old equipment, such as the guard-ring condensers which were to play a crucial role in his redetermination of the ohm. Maxwell began to develop a theoretical technology using the *Treatise* to interpret the behavior of his ballistic galvanometer. "We are learning to distinguish between shoves, kicks and jerks in the galvanometer needle." Initially this learning process was ruthlessly empirical. "Rule—set the needle swinging with an amplitude equal to the jerk, then when it is at the extremity of its swing, make or break contact so that the jerk brings it to zero." By the following autumn, however, Maxwell's team was rapidly gaining in competence by linking his work in the *Treatise* on current change with their work on the galvanometer in the mutual inductance circuit.[49] This work is not to be interpreted as the simple-minded application of truths set out in Maxwell's principles. Theoretical and practical resources were produced together. Students and workers were learning to see the laboratory bench electromagnetic skills as instances of more general principles of changing current and field strength. But, as his collaborators often emphasized, there was a very wide gap between visions of a trained workforce and the actual production of routine practical skills. For example, in 1874 W. M. Hicks, inspired by Maxwell's teaching, tried to use a ballistic galvanometer balanced between two coils of different sizes set at different distances to measure the speed of electromagnetic waves: "of course, nothing came of it, but the practice was worth a great deal to me."[50] The problem the Cavendish faced was defining and distributing this fragile notion of practice.

## RESISTANCE UNITS INTERNATIONALIZED

Maxwell's successor, Rayleigh, accepted the Cavendish chair in 1879 at least partly because agricultural depression had reduced his farm income to a level where he could not afford the upkeep of his private laboratory at his country seat at Terling, where he spent much of the 1870s in important work on acoustics, resonators, and experimental optics. As a landed aristocrat,

Rayleigh was well placed to make the interest needed to equip the Cavendish with what he reckoned it needed—between two and three thousand pounds' investment. His Tory political kinsmen, Arthur Balfour and Lord Salisbury, were enrolled and began participating in electromagnetic trials at Cambridge and at home in Terling. The new regime was characterized by careful discipline, centered in the classroom and in the standards project. Schuster reminded Rayleigh that "even a good man is, when he first comes into a Laboratory, a very helpless being." Under Maxwell, "too much time was wasted in consequence of apparatus set up for special experimental work being disturbed because a piece was wanted for an elementary lecture." Under Rayleigh, student numbers rose from about twenty to more than one hundred. New demonstrators were hired, notably the German-trained experimenter Napier Shaw and Glazebrook, and a research agenda imposed—unattractive to most students but key for the managers' plans.[51] Rayleigh's collaborators sought cheap and robust instruments for their classes and searched desperately for new skills. There was a link between these skills and the working machines. Rayleigh told Chrystal, "I wish you were still in Cambridge as we have few workers with experience in experiment. We have been arranging a repetition of the BA experiment with revolving coil, but have not as yet got very far. There is a difficulty in insulating the suspended parts sufficiently from tremors, which has more effect in disturbing the needle than we would expect." Chrystal answered that "Maxwell had considerable faith in the BA method—what you say about the effect of tremor is very curious." The demonstrators learned from Berlin, from Pickering's physics teaching at M.I.T., and from the evening classes in telegraphy conducted by Grylls Adams at King's College London after Maxwell's departure. Cambridge custom was to use the Cavendish magnetometer room to set up standard apparatus for pairs of students, with trials assigned on the basis of a rota displayed on the wall.[52]

Standardized devices became indispensable—the Cambridge Scientific Instrument Company boomed. Manuscript volumes of good procedure, constantly updated, were corrected by the assistant staff and copied by students. These notes resulted in the basic new textbook, *Practical Physics,* issued by Glazebrook and Shaw in spring 1885. The book carried advertisements from the Cambridge Scientific Instrument Company and details of the standard equipment the Cavendish used (fig. 31-3). Glazebrook and Shaw specified that "the description, in order to be precise, must refer to particular forms of instruments, and may therefore be to a certain extent inapplicable to other instruments of the same kind . . . we have thought it best to adhere to the precise descriptions referring to instruments in use in our own Laboratory."[53] Laboratory assistants and company workers were now the force on which this rapid process of standardization and institutionalization depended, while the stipulations about specific instruments were designed to guarantee the spread of this style. Textbooks, workforces, and material standards were all needed to propagate the Cavendish's standards. This was especially important, for example, in the Cambridge engagement with the expansive world of German physics laboratories, where, notably at the physics laboratory at Göttingen, Cambridge values did not yet count. Both Cambridge and Göttingen were visited by the American physicist Henry Rowland in 1875–76. He gave Maxwell some encouragement. He attacked the efforts to produce good electromagnetic standards mounted by the team of Friedrich Kohlrausch at Göttingen. There Rowland saw the original apparatus used by Gauss and Wilhelm Weber to determine the first absolute electric and magnetic units in the early nineteenth century, and also Kohlrausch's new setup for the determination of the absolute value of Siemens's unit. Rowland told Maxwell in March 1876 that despite impressive German achievements, "it seems to me that the *accurate*

# SCIENTIFIC INSTRUMENT COMPANY,

LIMITED,

## CAMBRIDGE.

(ADDRESS ALL COMMUNICATIONS AS ABOVE.)

The Company are prepared to supply all the Apparatus
used in the experiments described in Glazebrook and
Shaw's 'Physics,' and the necessary requisites for a
Physical Laboratory.

**SPECIAL ATTENTION DEVOTED TO EXPERIMENTAL WORK.**

Makers of Callendar and Griffiths' Self-testing Resistance
Boxes and Platinum Pyrometers, Callendar's Patent Electric
Recorder, Boys' Radio-micrometer, Quartz Fibres, &c.

*WRITE FOR CATALOGUES.   SENT POST FREE ON
APPLICATION.*

FIGURE 31-3
*An advertisement for the Cambridge Scientific Instrument Company printed in the endpapers
of Glazebrook and Shaw,* Practical Physics. *Source: Whipple Library, Cambridge.*

measurement of resistance either absolutely or relatively is an English science almost unknown
in Germany."[54]

When Glazebrook and Shaw produced their new textbook in 1885, they used Kohlrausch's
exemplary *Leitfaden der praktischen Physik* (1870; fourth ed. 1880) as their model. Kohlrausch
wrote this work for Göttingen students in the late 1860s. He was encouraged to publish it by his
boss Wilhelm Weber, the veteran of the work with Gauss on absolute units. Kohlrausch had
some useful clues for the Cambridge men. He presented basic training as culminating in electric
and magnetic standards determination. His book also had defects. He did not place dynamics at
the heart of the lab's project, nor could he explicate the relation between the British Association
system and the practical telegraphic units adopted in Britain and Germany. The Cambridge
textbook restated the faith that "the development of physical science on the lines indicated by

the principle of conservation of energy has made more conspicuous the importance of experimental dynamics as the basis of experimental physics." The book relied on Maxwell's *Treatise* and on his 1876 text on instruments. The *Treatise* argued that "the determination of electrical resistance may be considered as the cardinal operation in electricity, in the same way that the determination of weight is the cardinal operation in chemistry." Glazebrook and Shaw agreed: "standards of resistance have the advantage of material standards in general. The resistance is a definite property of a piece of metal, just as its mass is. The coil can be moved about from place to place without altering its resistance and so, from mere convenience, electrical resistance has come to be looked upon as in some way the fundamental quantity in connection with current electricity"[55] The term "convenience" was supposed to refer to Siemens's arbitrary unit and his German admirers. The shift to fundamentals was a characteristic of the Cavendish life style. The student was never to escape the sense that he was an initiate in the worldwide network of electrotechnology, and the local culture of absolute measurement.

Laboratory technicians mediated between the two worlds. George Gordon, a Liverpool shipwright hired by Glazebrook in 1879, linked the standards laboratory and the teaching program, making instruments and designing trials for both.[56] Rayleigh was horrified to learn that such men must be treated as personal hirelings and discouraged from their own research. Gordon was rather his scientific valet and was taken by Rayleigh back to Terling in 1884. He died two decades later in a lunatic asylum after attempting suicide.[57] Within the lab, however, the valet's status was changed into that of technical manager. This had implications for precision standards, where Gordon's workmanship was combined with the skills and labor of Schuster, the manager of the Cambridge Scientific Instrument Company, Horace Darwin, and Rayleigh's family, including his brilliant sister-in-law Eleanor Sidgwick.[58] The whole British Association standards initiative was recast between 1879 and 1882. A comparatively large network of skills and resources was mobilized. Young wranglers were recruited—J. J. Thomson among them. Instrument makers from Darwin's firm were used. Schuster and Rayleigh personally supervised coil winding at Elliott Brothers, who built the new apparatus for Cambridge.[59] Efforts were made to test (and discredit) measures of resistance of mercury columns in the style of Siemens. Kohlrausch was consulted and his work scotched. Rayleigh also studied Maxwell's London and Cambridge setups.[60] The new team found that with access to Maxwell's own apparatus they could improve his accuracy simply by insisting on stricter surveillance in the workshop and among the makers of the coils. For example, Rayleigh judged that the original British Association committees had failed to clarify whether the "breadth" of the coil was its axial or radial dimension. Instead of the old Huygens wheel they used a toothed drive with a Koenig tuning fork to time rotations. A Thirlmere water engine was used as the drive. The team found that the public water supply did not provide a constant head, so they had to build their own water pumps inside the Cavendish. Auxiliary magnetic needles with new Cambridge Scientific Instruments mountings were used. The Cavendish ground floor began to look like that of a factory.[61]

In summer 1881 Rayleigh reported back to the British Association on major improvements in accuracy. He encouraged London labs to replicate their measures. It was soon agreed that a systematic resistance testing regime must be initiated, since the variation of the old British Association standards was intolerably large. "Such a system would be analogous to the system adopted by the Kew Committee for the testing of meteorological instruments at the Kew Observatory. It has not yet been settled by whom this duty should be undertaken." In other words, a standards laboratory was not enough. Major changes in the practices of telegraphy and other electrotech-

FIGURE 31-4

*Schematic diagram of the spinning coil used in the Cavendish resistance experiments in 1881–82.*
Source: Rayleigh, Scientific Papers, vol. 2 (1900).

nological undertakings would also be needed if the Cambridge values were to reach beyond the Cavendish's immediate control.[62] In the second stage of their campaign, Rayleigh's team worked on more robust and portable spins (fig. 31-4). A new Elliott Brothers apparatus "designed more on engineering lines" was commissioned. Rayleigh also ordered Glazebrook to try Rowland's rival method with refinements of Maxwell's proposal for determining a secondary induced current when a primary current in an induction coil was reversed. The method's accuracy depended on the reliability of a ballistic galvanometer, notoriously hard to calibrate. By 1882–83 all the Cavendish's resources were being used to win its rights as the world electromagnetic standards laboratory. Every new resistance method was assessed, including a scheme of Lorenz for spinning a brass disc between two coaxial coils.[63] A test resistance carried the current that passed through the coils, and its value was determined by balancing the induced e.m.f. against that at the resistance terminals. A good example of the surveillance which these trials needed was the variation in the position of the galvanometer needle: "the maximum discrepancy between any two deflections" varied between 1/3000 parts at low speeds and 1/6000 parts at high speeds. Rayleigh concluded that his best estimate of the value of the British Association unit as 0.94865 × 10⁷ m/sec was accurate to within 1/1000 parts. It was claimed that no other lab could compete with this stability.[64] Rayleigh and Mrs. Sidgwick reckoned they should recheck all the factors in the best method, especially the pitch of tuning fork on which their timings relied. They tried to calibrate their fork interruptor against a pendulum. "If it were desired to push the power of the method to its limit, the work should be undertaken at an astronomical observatory, and extended over the whole time to rate the clock by the observations of the stars." In all these cases careful management of complex techniques could be used to make a reliable version of the standard. The whole status of British electromagnetism was at stake.[65]

By the early 1880s the Cavendish had emerged as a plausible candidate for the tribunal of resistance. The head of imperial postal telegraphy, W. H. Preece, announced that he now accepted the Cambridge value of the ohm and was "about to issue a circular to all stations at home and abroad to that effect . . . my instructions will affect some hundreds of observers." Even William Thomson, master of metrology, sent his resistance boxes there to be verified "in true or Rayleigh ohms," as the Glaswegian put it. "From what I have heard . . . about the agreement of the standard ohms which have been sent as accurate from the Cavendish Laboratory, I may be confident that the one I have at Glasgow is near enough to the BA unit for my purpose."[66] The process of displacement of control to Cambridge was both managerial and disciplinary, making the Cavendish look like a plausible judge of others' techniques. But no workshop, and no telegraph office, could hope to ape such a utopia. Furthermore, no rival laboratory, especially German, was likely effortlessly to demur to the Cavendish regime. For all this to happen, robust technologies were needed which could travel without Cambridge. These technologies were *material:* it was intended that Rayleigh's team make and verify new resistance boxes and standard cells. They were *literary:* textbooks like *Practical Physics* were designed to reform laboratory order and change the order of the teaching experiment. Finally, they were ineluctably *social:* hence the significance of changes in the order of the telegraph station, and of the great international conferences where the British physicists were put through their paces in the 1880s.

These technologies made the ohm seem natural, a property of nature rather than of Lord Rayleigh. They also made absolute standards into explicitly moral virtues. Exhibitions, conferences, textbooks, and instruments all helped this happen. Between 1881 and 1893 at least six international rallies of electricians were held, including debates about rival values and standards. Each provided invaluable opportunities for publicity and propaganda on behalf of rival technical systems, including those of Siemens and Thomas Alva Edison. In 1881, for example, the show at Paris, including Thomson, Siemens, Helmholtz, and Clausius, provisionally settled problems of nomenclature; offered a compromise between the Siemens and the Cambridge systems; and firmly agreed the value of a system of units which expressed fundamental dynamical relationships.[67] The meeting the following year, in Rayleigh's absence, agreed that the term "ohm" would refer to the absolute unit itself, not to any approximate embodiment. Long discussions debated averaging over values which differed so much in size and in credibility. Thomson told Rayleigh, "I suppose your ohm must be declared the one and true ohm for our generation." In the event, "it was the particular one or two standards called Siemens units which we had that caused the discrepancy." These were the opening shots in a long war. Carey Foster, returned from Paris in 1882, waspishly told Rayleigh that "apparently the conclusion come to was that more experiments were desired and that anybody should make them who would." Rowland, by contrast, seized on the opportunity, raised funds for a new standards committee, and set out to check the Cambridge values both with his old and with a new, high-precision apparatus. By 1884 it had been agreed that the legal ohm be defined in terms of a length of mercury, roughly 106 cm. This was the closest the delegates could then come to Rayleigh's standard. It amounted to a compromise between the *value,* which belonged to Cambridge, and the *unit,* defined in Siemens's terms.[68]

The power of a standards laboratory was not lost on any delegate. Werner Siemens, who arranged for the dispatch of his mercury standards to Cambridge via his London-based brother William, boldly stated that "there was found no place in Germany for carrying out the difficult work of producing the absolute resistance unit of Weber." Lobbying for the establishment of the

emergent Physikalisch-Technische Reichsanstalt followed.[69] The alliance of laboratory instrumentation and lawlike standards was also registered in Britain in successive Weights and Measures Acts, protocols of which contained recipes for making the ohm and the standard cell. Instructions on the ways of making copper wire of standard properties, which instrument makers supplied materials, and which labs provided checks, were also offered. Nor were these lessons lost on Glazebrook, Rayleigh's unsuccessful nominee to the Cavendish chair in 1884. Defeated by J. J. Thomson, Rayleigh and Glazebrook then worked hard to set up a state-funded National Physical Laboratory. Alliances with the government, via Rayleigh's brother-in-law Balfour, proved successful. Significantly, it was Siemens's Physikalisch-Technische Reichsanstalt which the British lobbyists now used as their ideal.[70] The standards program survived the change in personnel and programs at the Cavendish of the 1890s: reliable instruments needed reliable institutions in which to function.

The same process of institutionalization of training and naturalization of standards was at work in textbook production. A key resolution taken at Paris concerned the publication of an accessible text in which the results of the meeting be displayed and explained. A stream of works followed, each reprinting the Paris resolutions, striving to make the ohm "part of the student's nature," as the London engineering professor William Ayrton put it. These textbooks combined Thomson's absolutism with techniques developed at the Cavendish. Andrew Gray's massively popular *Absolute Measurements in Electricity and Magnetism* (1884) reversed the traditional order of exposition of the science. He began with descriptions of Thomson's and Horace Darwin's instruments; then he compared their values with the absolute system, and ended by spelling out the embodied energy relations. Ayrton adopted the same strategy: "the subject of current is treated first, because in almost all the industries in which electricity is practically made use of, it is the electric current that is employed." Students were told that metrology would "enable results to be expressed in units which are altogether independent of the instruments, the surroundings and the locality of the investigator."[71]

William Thomson turned this thought about the independence of units into a science fantasy in a lecture given to the Civil Engineers in May 1883. After consulting Rayleigh for details on the very latest work at the Cavendish, Thomson sketched the career of "the scientific traveller roaming over the universe," equipped with nothing but the authority of contemporary metrology. "What seems the shortest and surest way to reach the philosophy of measurement . . . is to cut off all connection with the earth, and think what we must then do, to make measurements which shall be definitely comparable with those which we now actually make in our terrestrial workshops and laboratories." Thomson's spaceman gets his unit of length through the wavelength of light determined via a diffraction grating, and thence "goes through all that Lord Rayleigh and Mrs. Sidgwick have done" to get the ohm and the unit of time. Eventually even Maxwell's method for oscillating discharge was proposed as an ideal means of recapturing absolute units of time, hence of all physics.[72] Immense labor had been performed to achieve the vanishing trick through which the local practices needed to make standards had simply disappeared. British physicists told their pupils and customers where to buy the robust instruments, where to learn the right techniques, and what morals would be appropriate for laboratory workers. Then they stated that the absolute system depended on no particular instrument, or technique, or institution. This helps account for metrology's power. Metrology involves work which sets up values and then makes their origin invisible. This paper has attempted to historicize this process, by linking the instruments of metrology with their favored institutions. The integrity of

these instruments and institutions is intimately bound up with their capacity to represent and affect the world beyond their immediate surroundings.

NOTES

1. Steven Shapin, *A Social History of Truth* (Chicago, 1994); Simon Schaffer, "Astronomers Mark Time: Discipline and the Personal Equation," *Science in Context* 2 (1988): 101–31.

2. Bruno Latour, *Science in Action* (Milton Keynes, 1987), p. 251; Thomas P. Hughes, *Networks of Power* (Baltimore, 1983); Joseph O'Connell, "Metrology: the Creation of Universality by the Circulation of Particulars," *Social Studies of Science* 23 (1995): 129–73.

3. For the social and the quantitative notions of value, see T. S. Kuhn, "The Function of Measurement in Modern Physical Science," *Isis* 52 (1961): 161–90; M. Norton Wise, "Mediating Machines," *Science in Context* 2 (1988): 81–117.

4. Daniel Headrick, *The Tentacles of Progress* (Oxford, 1988), p. 97; Crosbie Smith and M. Norton Wise, *Energy and Empire* (Cambridge, 1989), pp. 128–35, 684–98; Graeme Gooday, "Precision Measurement and the Genesis of Physics Teaching Laboratories in Victorian Britain," *British Journal for the History of Science,* 23 (1989), 25–52; Bruce Hunt, "The Ohm Is Where the Art Is: British Telegraph Engineers and the Development of Electrical Standards," *Osiris* 9 (1993): 48–63.

5. R. Kalley Miller, "The Proposed Chair of Natural Philosophy," *Cambridge University Reporter,* November 23, 1870, 118–19.

6. Maxwell to Jenkin, March 17, 1874, Cambridge University Library MSS Add 7655 / II / 240; Elliot Brothers to Maxwell, October 31, 1877, Cambridge University Library MSS Add 7655 / II / 144; Maxwell to Fleming, January 14, 1875, in J. T. Macgregor-Morris, *The Inventor of the Valve: A Biography of Sir Ambrose Fleming* (London, 1954), p. 22.

7. W. D. Niven, ed., *Scientific Papers of James Clerk Maxwell,* 2 vols. (Cambridge, 1890), vol. 2, p. 244; Lord Rayleigh, "Address to the Mathematical and Physical Science Section," *British Association Report* (1882), 437–4, p. 439. See Romualdas Sviedrys, "The Rise of Physical Science at Victorian Cambridge," *Historical Studies in Physical Science* 2 (1970): 127–45, p. 130.

8. James Walvin, *Victorian Values* (London, 1988), p. 139. See E. P. Thompson, "Time, Work-discipline and Industrial Capitalism," *Past and Present* 38 (1967): 56–97.

9. Edwin Chadwick, *Report on the Sanitary Condition of the Labouring Population of Great Britain,* ed. M. W. Flinn (Edinburgh, 1965), p. 425; Charles Babbage, "On Tables of the Constants of Nature and Art," *Smithsonian Institution Annual Report* (1856): 289–302. For "constants" see Ian Hacking, *The Taming of Chance* (Cambridge, 1990), p. 57.

10. William Thomson, "On the Theory of the Electric Telegraph," *Proceedings of the Royal Society* 7 (1855), 82–99. For telegraphy and theory, see Bruce Hunt, "Michael Faraday, Cable Telegraphy and the Rise of Field Theory," *History of Technology* 13 (1991): 1–19.

11. William Thomson, "Presidential Address," *British Association Report* (1871), in Kelvin, *Popular Lectures and Addresses: Volume 2, Geology and General Physics* (London, 1894), p. 162.

12. J. D. Everett, *Illustrations of the C.G.S. System of Units* (London, 1891), p. 18; Smith and Wise, *Energy and Empire,* pp. 684–86.

13. Werner Siemens and William Siemens, "Outline of the Principles and Practice Involved in Dealing with the Electrical Conditions of Submarine Electric Telegraphs," *British Association Report* (1860), 32–34; Latimer Clark and Charles Bright, "On the Formation of Standards of Electrical Quantity and Resistance," *British Association Report* (1861), 37–38. See Werner von Siemens, *Inventor and Entrepreneur: Recollections,* 2d ed. (London, 1966), pp. 166–67.

14. James Clerk Maxwell, *Treatise on Electricity and Magnetism,* 3d ed. (Oxford, 1891), vol. 1, p. vii.

15. James Clerk Maxwell and Fleming Jenkin, "On the Elementary Relations between Electrical Measurements," *British Association Report* (1863), 130–63, pp. 130–1. For King's College see C. Domb, "James Clerk Maxwell in London 1859–1865," *Notes and Records of the Royal Society* 35 (1980): 67–103, pp. 86–90.

16. Fleeming Jenkin, *Report to the Royal Society on Units of Electrical Resistance, and The Cantor Lectures* bound with *Reports of the Committee on Electrical Standards* (London, 1873), pp. 193–94; Siemens protests in his "Suggestions for the Adoption of a Common Unit in Measurement of Electrical Resistance," *British Association Report* (1862): 152–55, p. 154; the need for permanence is asserted in *British Association Report* (1862): p. 126.

17. For the teamwork see Ian Hopley, "Maxwell's Work on Electrical Resistance: The Determination of the Absolute Unit of Resistance," *Annals of Science* 13 (1957): 265–72, pp. 266–68; the governor is discussed in Niven, *Scientific Papers,* vol. 2, p. 112.

18. *British Association Report* (1863), pp. 118–22; compare Silvanus P. Thompson, *Life of William Thomson,* 2 vols. (London, 1910), vol. 1, pp, 418–19.

19. James Clerk Maxwell and Fleeming Jenkin, "Description of a Further Experimental Measurement of Electrical Resistance," *British Association Report* (1864), 350–1. The committee discusses standards on pp. 346–47, of this *Report.* For Jenkin's prices see Maxwell to Tait, March 7, 1865, in P. M. Harman, ed., *The Scientific Letters and Papers of James Clerk Maxwell: Volume 2* (Cambridge, 1995), p. 214.

20. Werner Siemens, "On the Question of the Unit of Electrical Resistance," *Philosophical Magazine* 31 (1866), 328.

21. Robert Louis Stevenson, "Memoir," in S. Colvin and J. A. Ewing, eds. *Papers by Fleeming Jenkin,* 2 vols. (London, 1887) vol. 1, pp. clv–vi; Smith and Wise, *Energy and Empire,* pp. 698–701; C. A. Hempstead, "An Appraisal of Fleeming Jenkin, Electrical Engineer," *History of Technology* 13 (1991): 119–44, pp. 131–2.

22. Jenkin, *Cantor Lectures,* p. 247; *Report of the Electrical Standards Committee* (Nottingham, 1866) (in Cambridge University Library, MSS Add 7655 / V / i / 12).

23. Headrick, *Tentacles of Progress,* pp. 101, 104–09; Smith and Wise, *Energy and Empire,* p. 704.

24. Jenkin, *Cantor Lectures,* p. 192; Hunt, "Faraday, Cable Telegraphy," pp. 8–14.

25. Maxwell on Hockin in *Scientific Papers* (ed. Niven), vol. 2, p. 127; cable duty, in Hockin to Maxwell, July 27, 1868, in Harman, *Maxwell,* 2: 410 n.6.

26. Maxwell describes the method in his *Scientific Papers* (ed. Niven), vol. 2, pp. 130–32, 135 and mentions the time required on p. 127; see I. B. Hopley, "Maxwell's Determination of the Number of Electrostatic Units in One Electromagnetic Unit of Electricity," *Annals of Science* 15 (1959): 91–108, pp. 91–3.

27. Niven, *Scientific Papers,* vol. 2, p. 126. Compare Simon Schaffer, "Accurate Measurement is an English Science," in M. Norton Wise, ed., *The Values of Precision* (Princeton, 1995), 135–172.

28. Hockin to Maxwell, May 15, 1868, in Hopley, "Maxwell's Determination," p. 97.

29. Niven, *Scientific Papers,* vol. 2, pp. 135–36. He remarks on "hitches and difficulties" in Maxwell to Tyndall, 23 July 1868, in Harman, *Maxwell,* 2:409.

30. Niven, *Scientific Papers,* vol. 2, p. 322.

31. Niven, *Scientific Papers,* vol. 2, p. 483 (for "manufactured articles"), and p. 377 (for "the ineffaceable characters"). See Paul Theerman, "James Clerk Maxwell and Religion," *American Journal of Physics* 54 (1986): 312–17.

32. Maxwell, *Treatise,* vol. 2, pp. 268–69, 370.

33. Maxwell to Clark, July 16, 1872; Maxwell to Thomson, August 10, 1872; Thomson to Maxwell August 24, 1872, in Harman, *Maxwell,* 2: 742, 748–49.

34. R. J. Strutt, *Life of Lord Rayleigh,* 2d ed. (Madison, 1968), pp. 49–50, 406–07; *Cambridge University Report,* 16 November 1870, pp. 93–97.

35. Maxwell to Rayleigh, March 15, 1871, in *Life of Rayleigh,* pp. 49–50.

36. Maxwell to Thomson March 21, 1871, in Harman, *Maxwell,* 2: 627; Maxwell to Monro, March 15, 1871, in Lewis Campbell and William Garnett, *Life of James Clerk Maxwell* (London, 1884) and in Harman, *Maxwell* 2: 619. For financing see Cambridge University Library MSS CUR 39.33 53 (3) and MSS p. 381 7655 / II / 138.

37. Maxwell to Jenkin March 17, 1874, and Hockin to Maxwell, May 14, 1874, Cambridge University Library MSS ADD 7655 / II / 240 and 78. For possible examples of Elliott Brothers' produced resistance standards held in the Cavendish in the 1870s, see Kenneth Lyall, *Catalog of Electrical and Magnetic Instruments: Whipple Museum Catalogue 8* (Cambridge, 1991), nos. 278–82 (Wh: 1348, 1541–45).

38. On Pullin and Garnett see *Life of Rayleigh,* pp. 103–04, 412; Pullin to Maxwell, July 5, 1877, Cambridge University Library MSS ADD 7655 / II / 135.

39. William Garnett, "Maxwell's Laboratory," in *James Clerk Maxwell: a Commemoration Volume* (Cambridge, 1934), 109–15, p. 115; Arthur Schuster and Richard Glazebrook comment in *History of the Cavendish Laboratory 1871–1910* (London, 1910), pp. 26, 36, 45. See also Arthur Schuster, *The Progress of Physics during 33 Years* (Cambridge, 1911), pp. 30–31.

40. Todhunter wrote against manufacture of experimenters in *The Conflict of Studies* (London, 1873), pp. 16–19. Compare Henry Sidgwick's attack on the professoriate in "Academic Teachers," *Cambridge University Reporter,* February 22–March 8, 1871, pp. 204–05, 221, 235–36.

41. Maxwell's reports of July 1873 and July 1878, in Cambridge University Library MSS CUR 55.2.

42. *History of the Cavendish Laboratory,* p. 35 on Garnett; T. J. N. Hilken, *Engineering at Cambridge University 1783–1965* (Cambridge, 1967), pp. 63–74 and M. J. Cattermole and A. F. Wolfe, *Horace Darwin's Shop: a History of the Cambridge Scientific Instrument Company* (Bristol, 1987).

43. For instrument design see Hopley, "Maxwell's Determination," pp. 99–101 and "Maxwell's Work on Electrical Resistance—Proposals for the Redetermination of the BA Unit of 1863," *Annals of Science* 13 (1958): 197–210, pp. 201–02. See Maxwell to Chrystal August 7, 1876, Cambridge University Library MSS ADD 8375 f. 4; Maxwell, *Treatise,* vol. 2, p. 396. The ballistic galvanometers are described in Lyall, *Electric and Magnetic Instruments,* nos. 14 and 17 (Wh: 1318, 1334).

44. For Horn see Hopley, "Redetermination of the BA unit," p. 208; see Hockin to Maxwell, January 14, 1878, Cambridge University Library, MSS ADD 7655 / II / 150; Ambrose Fleming, "Some Memories," in *James Clerk Maxwell: A Commemoration Volume* (Cambridge, 1931), 116–24, p. 119.

45. For Chrystal and Fulcher see Hopley, "Redetermination of the BA unit," p. 209; Chrystal to Maxwell July 9, 1878, and Maxwell to Chrystal July 9, 1878, Cambridge University Library MSS ADD 7655 / II / 159 and MSS ADD 8375 f. 16. Maxwell's report, Match 1878, is in MSS CUR 55.2 242a p. 11.

46. Maxwell, *Treatise,* vol. 1, pp. 326–27; program notes in Niven, *Scientific Papers,* vol. 2, pp. 505–27, discussed in Peter Galison, *How Experiments End* (Chicago, 1987), pp. 23–27.

47. *History of the Cavendish Laboratory,* pp. 34–35.

48. R. T. Glazebrook, "Early Days at the Cavendish Laboratory," in *James Clerk Maxwell: A Commemoration Volume,* pp. 135–37.

49. Whipple to Maxwell, May 6, 1874 and Maxwell to Jenkin, July 22 and November 19, 1874, Cambridge University Library MSS ADD 7655 / II / 77, 241–42; Maxwell, *Treatise,* vol. 2, pp. 382–91.

50. *History of the Cavendish Laboratory,* p. 19.

51. Strutt, *Life of Rayleigh,* pp. 75, 412; *History of the Cavendish Laboratory,* pp. 41–42. Rayleigh's petition for an apparatus fund is in Cambridge University Library MSS ADD 7655 / IIIc / 1; Schuster to Rayleigh, January 8, 1880, Imperial College MSS Rayleigh Letters. See Simon Schaffer, "Rayleigh and the Establishment of Electrical Standards, *European Journal of Physics* 15 (1994): 277–85.

52. *History of the Cavendish Laboratory,* pp. 44–46; Edward C. Pickering, *Elements of Physical Manipulation,* 2 vols. (London, 1878), vol. 1, pp. vi–vii; Rayleigh to Chrystal, August 22, 1880, Cambridge University Library MSS ADD 8375 f. 28; Chrystal to Rayleigh September 3, 1880, Imperial College MSS Rayleigh Letters.

53. *History of the Cavendish Laboratory,* p. 254; Richard Glazebrook and W. Napier Shaw, *Practical Physics,* 4th ed. (London, 1893), pp. ix, xii–xiii.

54. Maxwell to Chrystal, July 17, 1878, Cambridge University Library MSS ADD 8375 f. 18 on the dispatch of units to Zurich; see also Hockin to Maxwell, January 14, 1878 and H. Weber to Maxwell, May 19, 1878, Cambridge University Library MSS ADD 7655 / II / 150, 154. See Rowland to Maxwell, March 1876, in Nathan Reingold, *Science in Nineteenth-Century America* (Chicago, 1964), p. 269 for the journey to Göttingen; Rowland to Maxwell, [1877], Cambridge University Library MSS ADD 7655 / II / 105 for the comparison of resistance coils.

55. Glazebrook and Shaw, *Practical Physics,* pp. vii, 527; Maxwell, *Treatise,* vol. 1, p. 465. For Kohlrausch's *Leitfaden* and German physics laboratories see David Cahan, "The Institutional Revolution in German Physics 1865–1914," *Historical Studies in Physical Sciences* 15 (1985): 1–65, pp. 48–50 and Kathryn Olesko, *Physics As a Calling* (Ithaca, 1991), pp. 408–12.

56. For Gordon see Glazebrook and Shaw, *Practical Physics,* p. x; *History of the Cavendish Laboratory,* p. 46; Strutt, *Life of Rayleigh,* p. 104.

57. Strutt, *Life of Rayleigh,* p. 427.

58. Lord Rayleigh, *Scientific Papers,* vol. 2 (Cambridge, 1900), p. 5–12; Rayleigh laboratory notebooks, Imperial College MSS B / Rayleigh / 3 p. 268 (April 21, 1882).

59. Rayleigh, *Scientific Papers,* vol. 2, pp. 38–40, 44; Lyall, *Electrical and Magnetic Instruments,* nos. 278–82.

60. Rayleigh, *Scientific Papers,* vol. 2, pp. 3, 47–50, 78–79; Rayleigh laboratory notebooks, Imperial College MSS B / Rayleigh / 3 pp. 242–5 (March 18, 1881).

61. Rayleigh, *Scientific Papers,* vol. 2, pp. 4–7; Strutt, *Life of Rayleigh,* p. 115.

62. *British Association Report* (1881), pp. 424–25; G. Carey Foster, "Account of Preliminary Experiments on the Determination of Electrical Resistance in Absolute Measure," *British Association Report* (1881), 426–31.

63. Strutt, *Life of Rayleigh,* p. 116; Rayleigh, *Scientific Papers,* vol. 2, pp. 135, 155–56.

64. Strutt, *Life of Rayleigh,* p. 125; Rayleigh, *Scientific Papers,* vol. 2, p. 47.

65. Rayleigh, *Scientific Papers,* vol. 2, p. 181; Rayleigh to Eleanor Sidgwick on tuning forks and scale stability, September 14–23, 1881, Imperial College MSS Rayleigh Letters.

66. Thomson to Rayleigh, May 25, 1883, Rayleigh MSS, Terling.

67. For the 1881 show see "The International Exhibition and Congress of Electricity at Paris," *Nature* 24 (1881): p. 512; "Congrès International des Electriciens," *Revue Scientifique,* 3d series, (1881) vol. 1, part 2, pp. 382–84, 407–15. For publicity at the congress, see Robert Fox, "Edison et la Presse Française à l'Exposition Internationale d'électricité de 1881," in *1880–1980: Un Siècle de l'Electricité dans le Monde,* ed. F. Cardot (Paris, 1987), 223–35.

68. Strutt, *Life of Rayleigh,* pp. 124–25; *History of the Cavendish Laboratory,* pp. 66–64; Rayleigh, *Scientific Papers,* vol. 2, p. 78; *British Association Report* (1889), pp. 42–43; Carey Foster to Rayleigh, November 15, 1882, and Henry Rowland to Rayleigh, June 23, 1883, Imperial College MSS Rayleigh, Letters.

69. William Siemens to Rayleigh, March 3 and May 21, 1882, Imperial College MSS Rayleigh Letters; Siemens, *Inventor and Entrepreneur,* p. 267; David Cahan, "Werner Siemens and the Origins of the Physikalisch-Technische Reichsanstalt," *Historical Studies in the Physical Sciences* 12 (1982): 253–83.

70. *British Association Report* (1891), pp. 154–60; Peter Alter, *The Reluctant Patron: Science and the State in Britain 1850–1920* (Oxford, 1987), pp. 139–40.

71. W. E. Ayrton, *Practical Electricity,* 6th ed. (London, 1894), pp. iv–v; Andrew Gray, *Absolute Measurements in Electricity and Magnetism* (London, 1889), pp. 1–2. See Ayrton to Rayleigh, 10 March 1884, Imperial College MSS Rayleigh Letters; Graeme Gooday, "Teaching Telegraphy and Electrotechnics in the Physics Laboratory: William Ayrton and the Creation of an Academic Space for Electrical Engineering in Britain 1873–1884," *History of Technology* 13 (1991): 73–111.

72. Thomson, *Popular Lectures and Addresses,* vol. 2, pp. 106–7, 114, 120; Thomson to Rayleigh, April 11, 1883, in Silvanus Thompson, *Life of William Thomson* (London, 1910), p. 792.

# 32

# The House of Experiment in Seventeenth-Century England

## STEVEN SHAPIN

*That which is not able to be performed in a private house will much
less be brought to pass in a commonwealth and kingdom.*

—WILLIAM HARRISON, *THE DESCRIPTION OF ENGLAND* (1587)

My subject is the place of experiment. I want to know where experimental science was done. In what physical and social settings? Who was in attendance at the scenes in which experimental knowledge was produced and evaluated? How were they arrayed in physical and solid space? What were the conditions of access to these places, and how were transactions across their thresholds managed?

The historical materials with which I am going to deal are of special interest. Seventeenth-century England witnessed the rise and institutionalization of a program devoted to systematic experimentation, accompanied by a literature explicitly describing and defending practical aspects of that program. Nevertheless, aspects of the historiography manifest in this paper may prove of more general interest. Historians of science and ideas have not, in the main, been much concerned with the siting of knowledge production.[1] This essay offers reasons for systematically studying the venues of knowledge. I want to display the network of connections between the physical and social setting of inquiry and the position of its products on the map of knowledge. I shall try to demonstrate how the siting of knowledge-making practices contributed toward a practical solution of epistemological problems. The physical and the symbolic siting of experimental work was a way of bounding and disciplining the community of practitioners, it was a way of policing experimental discourse, and it was a way of publicly warranting that the knowledge produced in such places was reliable and authentic. That is to say, the place of experiment counted as a partial answer to the fundamental question, Why ought one to give one's assent to experimental knowledge claims?

I start by introducing some connections between empiricist processes of knowledge making and the spatial distribution of participants, pointing to the ineradicable problem of trust that is

generated when some people have direct sensory access to a phenomenon and others do not. I then mobilize some information about where experimental work was in fact performed in mid- to late-seventeenth-century England, focusing upon sites associated with the work of the early Royal Society and two of its leading fellows, Robert Boyle and Robert Hooke. The question of access to these sites is then considered: Who could go in and how was the regulation of entry implicated in the evaluation of experimental knowledge? The public display of the moral basis of experimental practices depended upon the form of social relations obtaining within these sites as much as it did upon who was allowed within. Indeed, these considerations were closely related, and I discuss how the condition of gentlemen and the deportment expected of them in certain places bore upon experimental social relations and, in particular, upon the problems attending the assessment of experimental testimony. The paper concludes by analyzing how the stages of experimental knowledge making mapped onto physical and symbolic patterns of movements within the rooms of a house, particularly the circulation between private and public places.

## ON THE THRESHOLD OF EXPERIMENT

The domestic threshold marks the boundary between private and public space. Few distinctions in social life are more fundamental than that between private and public.[2] The same applies to the social activities we use to make and evaluate knowledge. On either side of the threshold the conditions of our knowledge are different. While we stand outside, we cannot see what goes on within, nor can we have any knowledge of internal affairs but what is related to us by those with rights of access or by testimony still more indirect. What we cannot see, we must take on trust or, trust being withheld, continue to suspect. Social life as a whole and the social procedures used to make knowledge are spatially organized.[3] The threshold is a social marker: it is put in place and maintained by social decision and convention. Yet once in place it acts as a constraint upon social relations. The threshold acts as a constraint upon the distribution of knowledge, its content, quality, conditions of possession, and justification, even as it forms a resource for stipulating that the knowledge in question really is the thing it is said to be.

Within empiricist schemes of knowledge the ultimate warrant for a claim to knowledge is an act of witnessing. The simplest knowledge-producing scene one can imagine in an empiricist scheme would not, strictly speaking, be a social scene at all. It would consist of an individual, perceived as free and competent, confronting natural reality outside the social system. Although such a scene might plausibly be said to be the paradigm case of knowledge production in seventeenth-century empiricist writings, it was not, in fact, recommended by the writers. Three sorts of problems were recognized to attend the privacy of solitary individual observation.[4] First, the transformation of mere belief into proper knowledge was considered to consist of the transit from the perceptions and cognitions of the individual to the culture of the collective. Empiricist writers therefore looked for the means by which such a successful transit might be managed. The second problem was connected with the view that the perceptions of postlapsarian people were corrupt and were subject to biases deriving from interest. Although these factors could not be eliminated, their consequences might be mitigated by ensuring that both witnessing and the consideration of knowledge claims took place in a social setting. Third, there were often contingent practical problems attending the circumstances of observation, which meant that social relations of some kind had to be established for the phenomena in question to be dealt with. Certain observations, par-

ticularly in the natural history sciences but also in experimental science, could, for instance, be made only by geographically privileged persons. In such cases there was no practical way by which a witnessing public could be brought to the phenomena or the phenomena brought to the public. Testimony was therefore crucial: the act of receiving testimony constituted a rudimentary social scene, and the evaluation of testimony might occur in an elaborately constructed social scene.

English empiricists did not think that testimony could be dispensed with, but they worked strenuously to manage and discipline it. Most empiricist writers recognized that the bulk of knowledge would have to be derived from what one was told by those who had witnessed the thing in question, or by those who had been told by those who had been told, and so on. If, however, trust was to be a basis for reliable knowledge, the practical question emerged: Whom was one to trust? John Locke, among others, advised practitioners to factor the creditworthiness of the source by the credibility of the matter claimed by that source.[5] One might accept the report of an implausible phenomenon from a creditworthy source and reject plausible claims from sources lacking that creditworthiness. Credibility as an attribute ascribed to people was not, therefore, independent of theories of what the world was like. One might calibrate persons' credibility by what it was they claimed to have witnessed, just as one might use their accepted credibility to gauge what existed in the world.[6] Nevertheless, credibility had other sources: certain kinds of people were independently known to be more trustworthy sources than others. Roughly speaking, the distribution of credibility followed the contours of English society, and that it did was so evident that scarcely any commentator felt obliged to specify the grounds of this creditworthiness. In such a setting one simply knew what sorts of people were credible, just as one simply knew whose reports were suspect.[7] Indeed, in certain instances Robert Boyle recommended that one ought to credit the testimony of things rather than the testimony of certain types of persons. Discussing one of his hydrostatical experiments of the 1660s, Boyle argued that "the pressure of the water in our . . . experiment having manifest effects upon inanimate bodies, which are not capable of giving us partial informations, will have much more weight with unprejudiced persons, than the suspicious, and sometimes disagreeing accounts of ignorant divers, whom prejudicate opinions may much sway, and whose very sensations, as those of other vulgar men, may be influenced by predispositions, and so many other circumstances, that they may easily give occasion to mistakes."[8] When in 1667 the Royal Society wished to experiment on the transfusion of animal blood into a human being, they hit upon an ingenious solution to the problem of testimony posed by such an experiment. The subject, Arthur Coga, was indigent and possibly mad (so it was expedient to use him), but he was also a Cambridge graduate (so his testimony of how he felt on receipt of sheep's blood might be credited).[9]

## EXPERIMENTAL SITES

One of the considerations that recommended the program of systematic artificial experimentation launched in the middle of the seventeenth century by Boyle and his associates was that experimental phenomena could be arranged and produced at specified times and places. Such phenomena were disciplined, and disciplined witnessing might be mobilized around them. What sorts of places were available for this program? What conditions and opportunities did they provide? Put simply, the task resolves into the search for the actual sites of seventeenth-century English experiment. Where and what was the laboratory?

Two preliminary cautions are necessary. The first is a warning against verbal anachronism. The word *laboratory* (or *elaboratory*) was not in common English usage at the middle of the seventeenth century. For example, despite his extensive description of ideal experimental sites, I cannot find the word used by Francis Bacon, in *The New Atlantis* or elsewhere. As Owen Hannaway has shown, there is some evidence of medieval Latin usage (*laboratorium*), but the word did not acquire anything of its modern sense until the late sixteenth century. It seems that the word was transmitted into English usage in the late sixteenth century, carrying with it alchemical and chemical resonances.[10] Among scores of English usages I have registered through the 1680s, I have not encountered one in which the space pointed to was one without a furnace, used as a nonportable source of heat for chemical or pharmaceutical operations. The word did become increasingly common during the course of the seventeenth century, although even by the early eighteenth century it was not used routinely to refer to just any place dedicated to experimental investigation.[11] On the founding of the Royal Society there were a number of plans for purpose-built experimental sites, none of which materialized, even though the new Oxford Ashmolean Museum (1683) did contain a chemical laboratory in its basement.[12] By the end of the century there still did not exist any purpose-designed and purpose-built structure dedicated to those non-heat-dependent sciences (such as pneumatics and hydrostatics) that were paradigmatic of the experimental program. The new experimental science was carried on in existing spaces, used just as they were or modified for the purpose.

Second, the status of spaces designated as laboratories and of experimental venues generally in seventeenth-century England was intensely contested. Were they private or public, and what status ought they to have? In the rhetoric of English experimental philosophers, what was wrong with existing forms of practice was their privacy. Neither the individual philosopher in his study nor the solitary alchemist in his "dark and smokey" laboratory was a fit actor in a proper setting to produce objective knowledge.[13] In contrast, spaces appropriate to the new experimental program were to be public and easy of access. This was the condition for the production of reliable knowledge within.[14] In stipulating that experiment was to take place in public spaces, experimental philosophers were describing the nature of the physical and social setting in which genuine knowledge might be made.

The performance and the consideration of experimental work in mid- to late-seventeenth-century England took place in a variety of venues. These sites ranged from the apothecary's and instrument maker's shop, to the coffeehouse, the royal palace, the rooms of college fellows, and associated collegiate and university structures. But by far the most significant venues were the private residences of gentlemen or, at any rate, sites where places of scientific work were coextensive with places of residence, whether owned or rented. The overwhelming majority of experimental trials, displays, and discussions that we know about occurred within private residences. Instances could be enumerated ad libitum: the laboratory equipped for Francis Mercury van Helmont at Anne Conway's Ragley House in Warwickshire; the role of Towneley House in Lancashire in the career of English pneumatics; Clodius's laboratory in the kitchen of his father-in-law Samuel Hartlib's house in Charing Cross; Kenelm Digby's house and laboratory in Covent Garden after the Restoration; the Hartlibian laboratory worked by Thomas Henshaw and Thomas Vaughan in their rooms at Kensington; William Petty's lodgings at Buckley Hall in Oxford, where the Experimental Philosophy Club originated in 1649; Thomas Willis's house, Beam Hall, where the club met during the early 1660s.[15]

In the following sections of this paper I will try to display the conditions and opportunities

presented by the siting of experiment in the private house. In particular, I will point to the role of conditions regulating access to such venues and to conventions governing social relations within them. I will argue that these conditions and conventions counted toward practical solutions of the questions of how one produced experimental knowledge, how one evaluated experimental claims, and how one mobilized and made visible the morally adequate grounds for assenting to such claims. To this end I will concentrate on three of the most important sites in the career of experiment in mid- to late-seventeenth-century England: the various residences and laboratories of Robert Boyle, the meeting places of the Royal Society of London, and the quarters occupied by Robert Hooke.

ROBERT BOYLE Boyle had laboratories at each of the three major residences he successively inhabited during his mature life. From about 1645 to about 1655 he was mainly in residence at the manor house of Stalbridge in Dorset, an estate acquired by his father, the first Earl of Cork, in 1636 and inherited by his youngest son on the earl's death in 1643. By early in 1647 Boyle was organizing a chemical laboratory at Stalbridge, perhaps with the advice of the Hartlibian circle whose London laboratories he frequently visited.[16] Late in 1655 or early in 1656 he removed to Oxford, where his sister Katherine, Lady Ranelagh, had searched out rooms for him in the house of the apothecary John Crosse, Deep Hall in the High Street. He was apparently able to use Crosse's chemical facilities, and his own rooms contained a pneumatic laboratory, where, assisted by Hooke, the first version of the air pump was constructed in 1658–1659.[17] During his Oxford period Boyle also had access to a retreat at Stanton St. John, a village several miles to the northeast, where he made meteorological observations but apparently did not have a laboratory of any kind.

Boyle was away from Oxford for extended periods, staying sometimes at a house in Chelsea, sometimes with Katherine in London, and sometimes with another sister, Mary Rich, Countess of Warwick, at Leese (or Leighs) Priory in Essex.[18] In 1666 he had Oldenburg look over possible lodgings in Newington, north of London, but there is no evidence that he ever occupied these. And he periodically stayed at Beaconsfield in Buckinghamshire, possibly at the home of the poet Edmund Waller. But Oxford remained his primary residence and experimental workplace until he moved into quarters with Katherine at her house in Pall Mall in 1668. This was a house (actually two houses knocked into one) assigned to Lady Ranelagh by the Earl of Warwick in 1664. It stood on the south side of Pall Mall, probably on the site now occupied by the Royal Automobile Club. Although luxury building in this area was proceeding apace in the Restoration, at the time Boyle moved in Pall Mall still retained a rather quiet and semirural atmosphere. During the 1670s Boyle's neighbors included Henry Oldenburg, Dr. Thomas Sydenham, and Nell Gwyn.

Boyle's laboratory in Katherine's house was probably either in the basement or attached to the back, and there is some evidence to suggest that one could obtain access to the laboratory from the street without passing through the rest of the house.[19] The unmarried Boyle seems to have dined regularly with his sister, who was a major social and cultural figure in her own right, living "on the publickest scene," and who entertained his guests at the family table.[20] He remained there until his death in 1691, which closely followed Katherine's.

THE ROYAL SOCIETY After its founding in 1660, the weekly meetings of the Royal Society were held in Gresham College in Bishopsgate Street, originally in the rooms of the professor of geometry, afterward in rooms specially set aside for its use. The Great Fire of London in September 1666 made Gresham College unavailable, and temporary hospitality was extended by Henry Howard, later sixth Duke of Norfolk, at Arundel House, his residence in the Strand. The society

met there for seven years, from 1667 to 1674, until Gresham became available again. Gresham continued to be its home until 1710, when the Society for the first time became the owner of its premises, purchasing the former home of a physician, Crane Court, in Fleet Street.[21]

During the 1660s and 1670s the society was continually searching for alternative accommodation and making plans, all of which proved abortive, for purpose-built quarters of its own. In the event, for the first half century of its existence the public business of the Royal Society was transacted largely within places of private residence. Arundel House was unambiguously such a place, and Gresham College, built in the late sixteenth century as the residence of the great merchant banker Sir Thomas Gresham and transformed into a place of public instruction in 1598, had by the 1660s changed its character. When the Royal Society met there, it was a place where some professors lived and taught; where other sinecurist professors lived and did not teach; and where still others, who were not professors, lived in quarters hired out to them. According to its modern historian, Gresham College had by the mid-1670s "declined from a seat of learning into a lodging house." The significance of Arundel House in seventeenth-century English culture and social life cannot be overestimated. Until his death in 1646 it was the residence of Thomas Howard, second Earl of Arundel, who (despite the Catholicism he abandoned in 1616) as Earl Marshal was the head of the English nobility and the "custodian of honour." Arundel was one of the greatest collectors and patron of the arts of his age, and the house that contained his collections was made into a visible symbol of how a cultivated English gentleman ought to live. Indeed, his patronage of the educationalist Henry Peacham resulted in the production of an influential vade mecum for the guidance of English gentlemen. Arundel and his circle set themselves the task of modeling and exemplifying the code of English gentility, drawing liberally upon Italianate patterns. His grandson Henry Howard continued the great Arundel's proclivities, and it was through the encouragement of his friend John Evelyn that the society was offered space in the gallery of Arundel House and, ultimately, became one of the beneficiaries of the celebrated Arundel Collection of books, manuscripts, and objets d'art.[22]

ROBERT HOOKE    On the founding of the Royal Society, Robert Hooke was still serving Boyle as his technical assistant, lodging with Boyle in Oxford, and when in London staying at least occasionally with Lady Ranelagh. When in November 1662 he was appointed by the society to the position of curator of experiments, Boyle was thanked "for dispensing with him for their use." By the next year Hooke was made a fellow (with charges waived) and was being paid by the society to lodge in Gresham College four days a week.[23] In 1664 he was elected professor of geometry at Gresham, with its associated lodgings, and there he remained, even during the society's absence at Arundel House, until his death in 1703. His quarters apparently opened behind the college "reading hall" and contained an extensive pneumatical, mechanical, and optical workshop, supplemented in 1674 by a small astronomical observatory constructed in a turret over his lodgings.[24]

The conditions in which Hooke lived and worked were markedly different from those of his patron Robert Boyle. Margaret 'Espinasse has vividly described his personal life at Gresham, where he "lived like a rather Bohemian scientific fellow of a college." His niece Grace was sharing his quarters from 1672 (when she was eleven years old) and was evidently sharing his bed sometime afterward. Hooke was also having sexual relations with his housekeeper Nell Young and, on her departure, with her successors. To what extent Hooke's domestic circumstances were known to his associates among the fellowship is unclear, though it is possible that there was

some connection between those circumstances and the relative privacy of his rooms. It was Hooke who visited his high-minded patron Boyle; Boyle almost never visited Hooke. Hooke's relations with his various technicians were, in a different way, also very intimate. He took several of them into his lodgings, where they were treated in a manner intermediate between sons and apprentices (three of them becoming fellows of the Royal Society and one succeeding him as curator). Although his rooms were rarely frequented by gentlemen fellows on other than scientific and technical matters, and although his table was not a major venue for their discourses, Hooke lived on a public stage. He circulated through the taverns and the coffeehouses of the City of London and was a fixture at the tables of others. Hooke's place of residence, probably the most important site for experimental trials of Restoration England, was in practice a private place, while he himself lived an intensely public life. It is questionable indeed whether Hooke's quarters constituted a "home" in seventeenth-century gentlemanly usage. It was a place fit for Hooke to live and to work; it was not a place fit for the reception and entertainment of gentlemen.[25]

## ACCESS

The threshold of the experimental laboratory was constructed out of stone and social convention. Conditions of access to the experimental laboratory would flow from decisions about what kind of place it was. In the middle of the century those decisions had not yet been made and institutionalized. Meanwhile there were a variety of stipulations about the functional and social status of spaces given over to experiment, and a variety of sentiments about access to them.

To the young Robert Boyle the threshold of his Stalbridge laboratory constituted the boundary between sacred and secular space. He told his sister Katherine that "*Vulcan* has so transported and bewitched me, that as the delights I taste in it make me fancy my laboratory a kind of *Elysium,* so as if the threshold of it possessed the quality the poets ascribe to *Lethe,* their fictions made men taste of before their entrance into those seats of bliss, I there forget my standish [inkstand] and my books, and almost all things."[26] The experimenter was to consider himself "honor'd with the Priesthood of so noble a Temple" as the "Commonwealth of Nature." And it was therefore fit that laboratory work be performed, like divine service, on Sundays. (In mature life Boyle entered his Pall Mall laboratory directly after his morning devotions, although he had apparently given up the practice of experimenting on the Sabbath.)[27] In the 1640s he told his Hartlibian friends of his purposeful "retreat to this solitude" and of "my confinement to this melancholy solitude" in Dorset. But it was said to be a wished-for and a virtuous solitude, and Boyle complained bitterly of interruptions from visitors and their trivial discourses.[28]

Transactions across the experimental threshold had to be carefully managed. Solitude appeared both as a mundanely practical consideration and as a symbolic condition for the experimentalist to claim authenticity. Models of space in which solitude was legitimate and out of which valued knowledge emerged did exist: these included the monastic cell and the hermit's hut. The hermit's hut expressed and enabled individual confrontation with the divine; the solitude of the laboratory likewise defined the circumstances in which the new "priest of nature" might produce knowledge as certain and as morally valuable as that of the religious isolate. Here was a model of space perceived to be insulated from distraction, temptation, distortion, and convention.[29] Yet experimentalists like Boyle and his Royal Society colleagues in the 1660s were engaged in a vigorous attack on the privacy of existing forms of intellectual practice. The

legitimacy of experimental knowledge, it was argued, depended upon a public presence at some crucial stage or stages of knowledge making. If experimental knowledge did indeed have to occupy private space during part of its career, then its realization as authentic knowledge involved its transit to and through a public space.

This transit was particularly difficult for a man in Boyle's position to accomplish and make visible as legitimate. He presented himself as an intensely private man, one who cared little for the distractions and rewards of ordinary social life. This presentation of self was successful. Bishop Burnet, who preached Boyle's funeral sermon, described him as a paragon: "He neglected his person, despised the world, and lived abstracted from all pleasures, designs, and interests."[30] At the same time, Boyle effectively secured the persona of a man to whom justified access was freely available. He was entitled by birth and by wealth (even as diminished by the Irish wars) to a public life, and, indeed, there were forces that acted to ensure that he did live in the public realm. He advertised the public status of experimental work and, from his first publication, condemned unwarranted secrecy and intellectual unsociability.[31] Yet he chose much solitude, was seen to do so, and was drawn only fitfully into the company of fellow Christian virtuosi, extended exposure to which drove him once more to solitude. In constructing his life and making it morally legitimate, Boyle was endeavoring to define the nature of a space in which experimental work might be practically situated and in which experimental knowledge would be seen as authentic. Such a space did not then clearly exist. The conditions of access to it and the form of social relations within it had to be determined and justified. This space had necessarily to be carved out of and rearranged from existing domains of accepted public and private activity and existing stipulations about the proper uses of spaces.

Many contemporary commentators remarked upon the ease of access to Boyle's laboratory. John Aubrey wrote about Boyle's "noble laboratory" at Lady Ranelagh's house as a major object of intellectual pilgrimage: "When foreigners come to hither, 'tis one of their curiosities to make him a Visit." This was the laboratory that was said to be "constantly open to the Curious, whom he permitted to see most of his Processes." In 1668 Lorenzo Magalotti, emissary of the Florentine experimentalists, traveled especially to Oxford to see Boyle and boasted that he was rewarded with "about ten hours" of his discourse, "spread over two occasions." John Evelyn noted that Boyle "had so universal an esteeme in Foraine parts; that not any Stranger of note or quality; Learn'd or Curious coming into England, but us'd to Visite him." He "was seldome without company" in the afternoons, after his laboratory work was finished.[32]

But the strain of maintaining quarters "constantly open to the curious" told upon him and was seen to do so. As an overwrought young man he besought "deare Philosophy" to "come quickly & releive Your Distresst Client" of the "vaine Company" that forms a "perfect Tryall of my Patience." Experimental philosophy might rescue him "from some strange, hasty, Anchoritish Vow"; it could save him from his natural "Hermit's Aversenesse to Society."[33] When, during the plague, members of the Royal Society descended upon him in Oxford, he bolted for the solitude of his village retreat at Stanton St. John, complaining of "ye great Concourse of strangers," while assuring Oldenburg that "I am not here soe neere a Hermite" but that some visitors were still welcome. Even as John Evelyn praised Boyle's accessibility, he recorded that the crowding "was sometimes so incomodious that he now and then repair'd to a private Lodging in another quarter [of London], and at other times" to Leese or elsewhere in the country "among his noble relations."[34]

Toward the end of his life Boyle took drastic and highly visible steps to restrict access to his drawing room and laboratory. It is reported that when he was at work trying experiments in the

Pall Mall laboratory and did not wish to be interrupted, he caused a sign to be posted on his door: "Mr. Boyle cannot be spoken with to-day." In his last years and in declining health, he issued a special public advertisement "to those of his ffriends & Acquaintance, that are wont to do him the honour & favour of visiting him," to the effect that he desired "to be excus'd from receiving visits" except at stated times, "(unless upon occasions very extraordinary)."[35] Bishop Burnet said that Boyle "felt his easiness of access" made "great wasts on his time," but "thought his obligation to strangers was more than bare civility."[36]

That obligation was a powerful constraint. The forces that acted to keep Boyle's door ajar were social forces. Boyle was a gentleman as well as an experimental philosopher. Indeed, as a young man he had reflected systematically upon the code of the gentleman and his own position in that code. The place where Boyle worked was also the residence of the son of the first Earl of Cork. It was a point of honor that the private residence of a gentleman should be open to the legitimate visits of other gentlemen. Seventeenth-century handbooks on the code of gentility stressed this openness of access: one such text noted that "Hospitalitie" was "one of the apparentest Signalls of *Gentrie.*" Modern historians confirm the equation between easy access and gentlemanly standing: "generous hospitality was the hallmark of a gentleman"; "so long as the habit of open hospitality persisted, privacy was unobtainable, and indeed unheard of." And as the young Boyle himself confided in his *Commonplace Book,* a "Noble Descent" gives "the Gentleman a Free Admittance into many Companys, whence Inferior Persons (tho never so Deserving) are . . . excluded."[37] Other gentlemen knew who was a gentleman, they knew the code regulating access to his residence, and they knew that Boyle was obliged to operate under this code. But they did not know, nor could they, what an experimental scientist was, nor what might be the nature of a different code governing admittance to his laboratory. In the event, as Marie Boas wrote, they might plausibly come to the conclusion that Boyle "was only a virtuoso, amusing himself with science, [that] he could be interrupted at any time. . . . There was always a swarm of idle gentlemen and ladies who wanted to see amusing and curious experiments."[38] When, however, Boyle wished to shut his door to distractions, he was able to draw upon widely understood moral patterns that enabled others to recognize what he was doing and why it might be legitimate. The occasional privacy of laboratory work could be assimilated to the morally warrantable solitude characteristic of the religious isolate.[39]

## RIGHTS OF PASSAGE

What were the formal conditions of entry to experimental spaces? We do have some information concerning the policy of the early Royal Society, particularly regarding access of English philosophers to foreign venues. It was evidently common for the society's council to give "intelligent persons, whether Fellows of the Society or not, what are styled 'Letters Recommendatory.'" These documents, in Latin, requested "that all persons in authority abroad would kindly receive the bearer, who was desirous of cultivating science, and show him any attention in their power."[40] Similarly, in 1663 the society drafted a statute regulating access to its own meetings. As soon as the president took the chair, "those persons that [were] not of the society, [were to] withdraw." There was, however, an exemption for certain classes of persons to remain if they chose, that is, "for any of his majesty's subjects . . . having the title and place of a baron, or any of his majesty's privy council . . . , or for any foreigner of eminent repute, with the allowance of the

president." Other persons might be permitted to stay with the explicit consent of the president and fellows in attendance. Barons and higher-ranking aristocrats could become fellows on application, without the display of philosophical credentials.[41]

Too much should not be made of such fragmentary evidence of formal conditions granting or withholding rights of entry to experimental sites. It is noteworthy how sparse such evidence is, even for a legally incorporated body like the Royal Society. In the main, the management of access to experimental spaces, even those of constituted organizations, was effected more informally. For example, there was the letter of introduction to an experimentalist, a number of which survive. In 1685 one visitor carried with him a letter of introduction, from someone presumably known to Boyle, which identified the bearer as "ambitious to be known to you, whose just character of merit is above his quality . . . being the eldest son of [a diplomat] and brother-in-law to the king of Denmark's envoy."[42] In this instance and in others like it, it was not stated that the proposed entrant to Boyle's society possessed any particular technical competences, nor even that he was "one of the curious," merely that he was a gentleman of quality and merit, as vouched for by the correspondent. In other cases, "curiosity" was explicitly stipulated as a sufficient criterion for entry.

Generally speaking, it appears that access to most experimental venues (and especially those located in private residences) was achieved in a highly informal manner, through the tacit system of recognitions, rights, and expectations that operated in the wider society of gentlemen. If we consider Boyle's laboratories and drawing rooms, it seems that entry was attained if one of three conditions could be met: if the applicant was (1) known to Boyle by sight and of a standing that would ordinarily give rights of access; (2) known to Boyle by legitimate reputation; (3) known to Boyle neither by sight nor by reputation, but arriving with (or with an introduction from) someone who satisfied condition (1) or (2). These criteria can be expressed much more concisely: access to experimental spaces was managed by calling upon the same sorts of conventions that regulated entry to gentlemen's houses, and the relevant rooms within them, in general.[43] These criteria were not codified and written down because they did not need to be. They would be known and worked with by every gentleman. Indeed, they would almost certainly be known and worked with by those who were not gentlemen, shaping their understanding of the grounds for denying entry. Standing gave access. Boyle was perhaps unusual among English gentlemen in reflecting explicitly upon this largely tacit knowledge: "A man of meane Extraction (tho never so advantag'd by Greate meritts) is seldome admitted to the Privacy & the secrets of grate ones promiscuously & scarce dares pretend to it, for feare of being censur'd saucy, or an Intruder."[44]

I have alluded to some formal criteria governing entry to the rooms of the Royal Society. For all the significance of such considerations, informal criteria operated there as well, just as they did in the case of Boyle's laboratories, to manage passage across the society's threshold. These almost certainly encompassed not only the informal criteria mentioned in connection with Boyle, for whom standing gave access, but also other sorts of tacit criteria. When Lorenzo Magalotti visited England in 1668 (after the Royal Society's removal to Arundel House), his arrival at the society's weekly meeting was apparently expected and special experiments had been made ready to be shown. But Magalotti had second thoughts about the advisability of attending and the terms on which he thought entry was offered. "I understood," he wrote to an Italian prelate, "that one is not permitted to go in simply as a curious passer-by, [and] I would not agree to take my place there as a scholar, for one thing because I am not one. . . . Thus, therefore, I got as far as the door and then went away, and if they do not want to permit me to go and be a mere

spectator without being obliged to give opinions like all the others, I shall certainly be without the desire to do so."[45] There are reasons to doubt the absolute reliability of Magalotti's testimony. Nevertheless, he pointed to a crucially important tacit criterion of entry. Magalotti was, of course, the sort of person, carrying the sort of credentials, who would have had unquestioned access to the Royal Society meeting at Arundel House, or, indeed to Arundel House itself. His claims indicate, however, that the experimental activities that went on within its interior imposed further informal criteria regulating entry. These included the uncodified expectation that, once admitted, one would act *as a participant.* The notion of participation followed from a distinction, customary but not absolute, between *spectating* and *witnessing.* The Royal Society expected those in attendance to validate experimental knowledge as participants, by giving witness to matters of fact, rather than to play the role of passive spectators to the doings of others.[46] But there was a further consideration: those granted entry were tacitly enjoined to employ the conventions of deportment and discourse deemed appropriate to the experimental enterprise, rather than those current in, say, hermetic, metaphysical, or rationalist practice. Those unwilling to observe these conventions could exclude themselves. These are the grounds on which one might rightly say that a philosopher like Thomas Hobbes was, in fact, excluded from the precincts of the Royal Society, even though there is no evidence that he sought entry and was turned away. 'Espinasse was therefore quite correct in saying that the society was "open to all classes rather in the same way as the law-courts and the Ritz," and Quentin Skinner was also right to characterize it as "like a gentlemen's club," even if he unnecessarily contrasted that status with the society's ostensible role as "the conscious centre of all genuinely scientific endeavour."[47]

## RELATIONS IN PUBLIC

If we are able to recognize what kind of space we are in, we find we already possess implicit knowledge of how it is customary to behave there. But in the middle of the seventeenth century the experimental laboratory and the places of experimental discourse did not have standard designations, nor did people who found themselves within them have any tacit knowledge of the behavioral norms obtaining there. On the one hand, publicists of the experimental program offered detailed guidance on the social relations deemed appropriate to experimental spaces; on the other, there is virtual silence about some of the most basic features of these places. The situation is about what one would expect if new patterns of behavior in one domain were being put together out of patterns current in others.

In 1663 the Royal Society was visited by two Frenchmen, Samuel Sorbière, physician and informal emissary of the Montmor Academy, and the young Lyonnaise scholar Balthasar de Monconys. Both subsequently published fairly detailed accounts of the society's procedures. Sorbière recorded that the meeting room at Gresham was some sort of "Amphitheatre," possibly the college reading hall or an adaptation of a living room of Gresham's sixteenth-century cloistered house to make it suitable for public lecturing. The president sat at the center of a head table, with the secretary at his side and chairs for distinguished visitors. The ordinary fellows sat themselves on plain wooden benches arranged in tiers, "as they think fit, and without any Ceremony."[48] An account dating from around 1707, toward the end of the society's stay at Gresham, gives a description of three rooms in which it conducted its affairs but omits any detail of the internal arrangements or of social relations within them.[49]

When Magalotti visited the Royal Society at Arundel House in February 1668, he described the assembly room off the gallery, "in the middle of which is a large round table surrounded by two rows of seats, and nearer to it by a circle of plush stools for strangers." On his second visit in April 1669 he recorded that the president sat "on a seat in the middle of the table of the assembly."[50] No visitor, or any other commentator, provides a detailed account of the physical and social arrangements attending the performance of experiments in the Royal Society. Monconys offers a recitation of experiments done, without describing the circumstances in which they were done. Sorbière mentions only that there was brief discussion of "the Experiments proposed by the Secretary." Magalotti records that he saw experiments performed, demonstrated by "a certain Mr Hooke." These were set up on a table in the corner of the meeting room at Arundel House. When working properly, experiments were transferred to a table in the middle of the room and displayed, "each by its inventor." Experimental discussion then ensued.[51] By the 1670s it is evident that experimental "discourse," or formal presentation setting forth and interpreting experiments tried elsewhere, was much more central to the Society's affairs than experiments tried and displayed within its precincts.

Sorbière, Monconys, Magalotti, and other observers all stressed the civility of the Royal Society's proceedings. The president, "qui est toujours une personne de condition," was clearly treated with considerable deference, by virtue of his character, his office, and, most important, his function in guaranteeing good order. Patterns provided by procedure in the House of Commons are evident. Fellows addressed their speech to the president, and not to other fellows, just as members of the House of Commons conventionally addressed the Speaker. Thus, the convenient fiction was maintained that it was always the matter and not the man that was being addressed. Both Sorbière and Magalotti noted that fellows removed their hats when speaking, as a sign of respect to the president (again following Commons practice). Whoever was speaking was never interrupted, "and Differences of Opinion cause no manner of Resentment, nor as much as a disobliging Way of Speech."[52] An English observer said that the society "lay aside all set Speeches and Eloquent Haranques (as fit to be banisht out of all Civil Assemblies, as a thing found by woful experience, especially in *England*, fatal to Peace and good Manners)," just as the reading of prepared speeches was (and is) conventionally deprecated in Commons. "Opposite opinions" could be maintained without "obstinacy," but with good temper and "the language of civility and moderation."[53]

This decorum was the more remarkable in that it was freely entered into and freely sustained. Sorbière said that "it cannot be discerned that any Authority prevails here"; and Magalotti noted that at "their meetings, no precedence or distinction of place is observed, except by the president and the secretary." As in the seventeenth-century House of Commons, the practice of taking any available seat (with the exception of the president and the secretaries, who, like the Commons Speaker, his clerks, and privy councillors, sat at the head of the room) constituted a visible symbol of the equality in principle of all fellows and of the absence of sects, even if the reality, in both houses, might be otherwise.[54] All visitors found it worth recording that the society's mace, laid on the table before the president when the meetings were convened, was an emblem of the source of order. Again, as in Commons, the mace indicated that the ultimate source was royal. The king gave the Society its original mace even as he replaced the Commons mace that had disappeared in the Interregnum. The display of the mace in the Royal Society confirmed that its authority flowed from, and was of the same quality as that of the king. Nevertheless, Thomas Sprat took violent exception to any notion that mace ceremonials constituted rituals of authority: "The *Royal Society*

itself is so careful that such ceremonies should be just no more than what are necessary to avoid Confusion."[55] Sprat took the view that the space occupied and defined by the fellowship was truly novel: it was regulated by no traditional set of rituals, customs, or conventions. An anonymous fellow writing in the 1670s agreed: the Society's job was "not to whiten the walls of an old house, but to build a new one; or at least, to enlarge the old, & really to mend its faults."[56]

Yet no type of building, no type of society is wholly new. And despite the protestations of early publicists, it is evident that the social relations and patterns of discourse obtaining within the rooms of the Royal Society were rearrangements and revaluations of existing models. Aspects of a parliamentary pattern have already been mentioned. The relationship between the proceedings of the early Royal Society and the Interregnum London coffeehouse merits extended discussion, most particularly in connection with the rules of good order in a mixed assembly. Other elements resonate of the monastery, the workshop, the club, the college, and the army.[57] Yet the most potent model for the society's social relations was drawn from the type of space in which they actually occurred. The code which is closest to that prescribed for the experimental discourses of the Royal Society was that which operated within the public rooms of a gentleman's private house.

## THE EXPERIMENTAL PUBLIC

What was the experimental public like? How many people, and what sorts of people, composed that public? In order to answer these questions we have to distinguish rhetoric from reality. When, for example, Sprat referred to the Royal Society's experimental public as being made up of "the concurring Testimonies of threescore or an hundred" and pointed to "many sincere witnesses standing by" experimental performances, he was, it seems, referring to an ideal state. The Royal Society was, of course, the most populated experimental space of Restoration England, but its effective attendance at weekly meetings probably averaged no more than two score, and by the 1670s meetings were being canceled for lack of attendance.[58] More intimate groups assembled as "clubs" of the society, centered particularly upon Hooke and usually meeting at coffeehouses near Gresham College.

In the event, historians have rightly questioned whether the rooms of the Royal Society should properly be regarded as a major experimental site.[59] Most actual experimental research was performed elsewhere, most notably in private residences like Boyle's Oxford and Pall Mall laboratories and in Hooke's quarters. Unsurprisingly, evidence about the population in these places is scarce. Boyle frequently named his experimental witnesses, and in no case does that named number exceed three. We do also have commentators' testimony about the throngs of visitors, but these are probably best regarded as genuine spectators rather than witnesses.[60] I shall mention the circumstances of experimental work in Hooke's lodgings later, but his laboratory was certainly more thinly populated than that of his patron. Apart from Hooke himself, the population of Hooke's laboratory seems mainly to have been composed of his various assistants, technicians, and domestics.

I need in this connection to make a distinction between a real and a relevant experimental public, between the population actually present at experimental scenes and those whose attendance was deemed by authors to be germane to the making of knowledge. We have, for example, conclusive evidence of the presence in Boyle's laboratories of technicians and assistants of various sorts. As we might say, their role was vital, since Boyle himself had little if anything to do with

the physical manipulation of experimental apparatus, and since at least several of these technicians were far more than mere laborers.[61] Yet their presence was scarcely acknowledged in the scenes over which Boyle presided. Two of them, Hooke and Denis Papin, were named and responsible elements in those scenes, although even here Boyle's account probably understates their contribution. Toward the end of his career, Boyle acknowledged Papin's responsibility for the writing of experimental narratives as well as for the physical conduct of air pump trials. "I had," he wrote, "cause enough to trust his skill and diligence." But Boyle still insisted on his own ultimate responsibility for the knowledge produced, and the manner in which he did so is instructive: Boyle asked Papin to "set down in writing all the experiments and the phaenomena arising therefrom, as if they had been made and observed by his own skill. . . . But I, myself, was always present at the making of the chief experiments, and also at some of those of an inferior sort, to observe whether all things were done according to my mind." Certain interpretations of experiments were indeed left to Papin: "Some few of these inferences owe themselves more to my assistant than to me."[62] Still, Boyle, not Papin, was the author of this text.

For the most part, however, Boyle's host of "laborants," "operators," "assistants," and "chemical servants" were invisible actors. They were not a part of the relevant experimental public. They made the machines work, but they could not make knowledge. Indeed, their greatest visibility (albeit still anonymous) derived from the capacity of their *lack* of skill to sabotage experimental operations. Time after time in Boyle's texts, technicians appear as sources of trouble. They are the unnamed ones responsible for pumps exploding, materials being impure, glasses not being ground correctly, machines lacking the required integrity.[63]

Technicians had skill but lacked the qualifications to make knowledge. This is why they were rarely part of the relevant experimental public, and, when they were part of that public, it was because they were only ambiguously functioning in the role of technician. Ultimately, their absence from the relevant experimental public derived from their formal position in scenes presided over by others. Boyle's technicians, including those of mixed status like Hooke and Papin, were paid by him to do jobs of experimental work, just as both were paid to do similar tasks by the gentlemen of the Royal Society. As Boyle noted in connection with his disinclination to become a cleric, those that were paid to do something were open to the charge that this was *why* they did it.[64] A gentleman's word might be relied upon partly because what he said was without consideration of remuneration. Free verbal action, such as giving testimony, was credible by virtue of its freedom. Technicians, as such, lacked that circumstance of credibility. Thus, so far as their capacity to give authentic experimental testimony was concerned, they were truly not present in experimental scenes. Technicians were not *there* in roughly the same way, and for roughly the same reasons, that allowed Victorian families to speak in front of the servants. It did not matter that the servants might hear: if they told what they heard to other servants, it did not signify; and if they told it to gentlemen, it would not be credited.

## THE CONDITION OF GENTLEMEN

The early Royal Society set itself the task of putting together, justifying, and maintaining a relevant public for experiment. Its publicist Thomas Sprat reflected at length on the social composition of this public and its bearing on the integrity of knowledge-making practices. Historians are now thoroughly familiar with the Royal Society's early insistence that its company was

made up of "many eminent men of all Qualities," that it celebrated its social diversity, and that it pointed to the necessary participation in the experimental program of "vulgar hands." Nevertheless, this same society deemed it essential that "the farr greater Number are Gentlemen, free, and unconfin'd." In the view of Sprat and his associates the condition of gentlemen was the condition for the reliability and objectivity of experimental knowledge.[65]

There were two major reasons for this. First, an undue proportion of merchants in the society might translate into a search for present profit at the expense of luciferous experimentation and even into an insistence upon trade secrecy, both of which would distort the search for knowledge. This is what Glanvill meant in praising the society for its freedom from "sordid Interests."[66] More important, the form of the social relations of an assembly composed of unfree men, or, worse, a society divided between free and unfree, would corrupt the processes by which experimental knowledge ought to be made and evaluated, and by which that knowledge might be advertised as reliable. Unfree men were those who lacked discretionary control of their own actions. Technicians, for example, belonged to this class—the class of servants—because their scientific labor was paid for. Merchants might be regarded as compromised in that their actions were geared to achieving the end of present profit. One could not be sure that their word corresponded to their state of belief. Put merchants and servants in an assembly with gentlemen and you would achieve certain definite advantages. But there was also a risk in the shape of the knowledge-making social relations that might be released. Inequalities of rank could, in Sprat's view, corrode the basis of free collective judgment on which the experimental program relied.[67]

As Sprat said, the trouble with existing intellectual communities was the master-servant relationship upon which their knowledge-constituting practices were founded, the scheme by which *"Philosophers* have bin always *Masters,* & *Scholars;* some imposing, & all the other submitting; and not as equal observers without dependence." He judged that "very mischievous . . . consequences" had resulted because "the Seats of Knowledg, have been for the most part heretofore, not *Laboratories,* as they ought to be; but onely *Scholes,* where some have *taught,* and all the rest subscrib'd." Thus the schoolroom was a useful resource in modeling a proper experimental space, precisely because it exemplified those conventional social relations deemed grossly inappropriate to the new practice: "The very inequality of the Titles of *Teachers,* and *Scholars,* does very much suppress, and tame mens Spirits; which though it should be proper for Discipline and Education; yet it is by no means consistent with a free Philosophical Consultation. It is undoubtedly true; that scarce any man's mind, is so capable of *thinking strongly,* in the presence of one, whom he *fears* and *reverences;* as he is, when that restraint is taken off."[68]

The solution to the practical problem thus resolved into the description and construction of a social space that was both free and disciplined. Sprat said that the "cure" for the disease afflicting current systems of knowledge "must be no other, than to form an *Assembly* at one time, whose privileges shall be the same; whose gain shall be in common; whose *Members* were not brought up at the feet of each other." Such disinterested free men, freely mobilizing themselves around experimental phenomena and creating the witnessed matter of fact, could form an intellectual polity "upon whose labours, mankind might . . . freely rely."[69] The social space that Sprat was attempting to describe was a composite of a number of existing and past spaces, real and ideal. Still, one model for such a space was, perhaps, more pertinent than any other, precisely because, as I have shown, it corresponded to the type of space within which experimental discourses typically occurred. This was the gentleman's private residence and, within it, its public rooms. The conventions regulating discourse in the drawing room were readily available for

the construction of the new space and for making morally visible the social relations appropriate to it. It was the acknowledged freedom of the gentleman's action, the honor accorded to his word, the moral discipline he imposed upon himself, and the presumed moral equality of the company of gentlemen that guaranteed the reliability of experimental knowledge. In other words, gentlemen in, genuine knowledge out.

Gentlemen were bound to credit the word of their fellows or, at least, to refrain from publicly discrediting it.[70] These expectations and obligations were grounded in the face-to-face relations obtaining in concrete spaces. The obligation to tell the truth, like the consequences of questioning that one was being told the truth, were intensified when one looked the other "in the face," and particularly when it was done in the public rooms of the other's house. The disastrous effects of violating this code were visible to the Royal Society in the quarrel between Gilles Roberval and Henri-Louis Habert de Montmor in the latter's Parisian town house. As Ismael Boulliau told the story to Christiaan Huygens, Roberval

has done a very stupid thing in the house of M. de Montmor who is, as you know, a man of honor and position; he was so uncivil as to say to him in his own house . . . , that he had more wit than he, and that he was less only in worldly goods. . . . Monsieur de Montmor, who is very circumspect, said to him that he could and should behave more civilly than to quarrel with him and treat him with contempt in his own house.

Roberval never returned to the Montmor Academy, and the group never recovered. The Parisians tried to learn a lesson: as this dispute was over doctrine, they resolved to move "towards the study of nature and inventions," in which civility could be more easily maintained since the price of dissenting publicly from a gentleman's testimony on matters of fact would dissuade others from the contest.[71]

The code relating to face-to-face interactions in the house could be, and was, extended to the social relations of experimental knowledge production generally. It was rare indeed for any gentleman's testimony on a matter of experimental fact to be gainsaid. In the early 1670s Henry More disputed Boyle's report of a hydrostatical matter of fact. The manner of Boyle's response is telling: "Though [More] was too civil to give me, *in terminus,* the lye; yet he did indeed deny the matter of fact to be true. Which I cannot easily think, the experiment having been tried both before our whole society, and very critically, by its royal founder, his majesty himself."[72] Boyle appealed to the honor of a *company* of gentlemen, and, ultimately, to the greatest gentleman of all. In 1667 Oldenburg specifically cautioned fellows not to deny within the Society's rooms experimental testimony deriving from foreign philosophers. Oldenburg took an offending fellow aside afterward and asked him "how he would resent it, if he should communicate upon his own knowledge an unusual experiment to [those foreign experimenters], and they brand it in public with the mark of falsehood: that such expressions in so public a place, and in so mixed an assembly, would certainly prove very destructive to all philosophical commerce."[73]

The same relationship of trust that was enjoined to govern experimental discourse in the drawing room was constitutive of transactions between public and private rooms of the experimental house. I noted at the beginning the central problem posed in empiricist practice by the indispensable role of testimony and trust. The Royal Society was evidently quite aware that the population of direct witnesses to experimental trials in the laboratory was limited by practical considerations if by nothing else. Nevertheless, the trajectory of a successful candidate for the status of matter of fact necessarily transited the public spaces in which it was validated. The practical solution offered by the society was the acceptance of a division of experimental labor and

the protection of a relationship of trust between those within and without the laboratory threshold. Sprat said that there was a natural division of labor among the fellowship: "Those that have the best faculty of *Experimenting*, are commonly most averse from reading Books; and so it is fit, that this *Defect* should be supply'd by others pains." Those that actually performed experimental trials, and those that accompanied them as direct witnesses, were necessarily few in number, but they acted as representatives of all the rest. One could, and ought to, trust them in the way one could trust the evidence of one's own senses: "Those, to whom the conduct of the *Experiment* is committed . . . do (as it were) carry the eyes, and the imaginations of the whole company into the *Laboratory* with them." Their testimony of what had been done and found out in the laboratory, undoubted because of their condition and quality, formed the basis of the assembly's discursive work, "which is to *judg*, and *resolve* upon the matter of Fact," sometimes accompanied by a showing of the experiment tried in the laboratory, sometimes on the basis of narrative alone. Only when there was clear agreement ("the concurring Testimonies") was a matter of fact established. Such procedures were advertised as morally infallible. Glanvill reckoned that "the relations of your Tryals may be received as undoubted Records of certain events, and as securely be depended on, as the Propositions of Euclide." The very transition from private to public space that marked the passage from opinion to knowledge was a remedy for endemic tendencies to "over-hasty" causal conjecturing, to "finishing the *roof*, before the *foundation* has been well laid." Sprat assured his readers that "though the *Experiment* was but the private task of one or two, or some such small number; yet the *conjecturing*, and *debating* on its *consequences*, was still the employment of their full, and solemn Assemblies."[74] An item of experimental knowledge was not finished until it had, literally, come out into society.

## TRYING IT AT HOME

A house contains many types of functionally differentiated rooms, each with its conditions of access and conventions of appropriate conduct within. Social life within the house involves a circulation from one sort of room to another. The career of experimental knowledge is predicated upon the same sort of circulation. Thus far I have spoken of the making of experimental knowledge in a loose way, scarcely differentiating between its production and its evaluation. I must now deal more systematically with the stages of knowledge making and relate these to the physical and social spaces in which they take place.

In mid- to late-seventeenth-century England there was a linguistic distinction the force and sense of which seems to have escaped most historians of science. This was the discrimination between "trying" an experiment, "showing" it, and "discoursing" upon it. In the common usage of the main experimental actors of this setting, the distinction between these terms was both routine and rigorous. The trying of an experiment corresponds to research proper, getting the thing to work, possibly attended with uncertainty about what constitutes a working experiment. Showing is the display to others of a working experiment, what is commonly called demonstration.[75] And experimental discourses are the range of expatiatory and interpretative verbal behaviors that either accompany experimental shows or refer to shows or trials done at some other time or place. I want to say that trying was an activity that in practice occurred within relatively private spaces, whereas showing and discoursing were events in relatively public space. The career of experimental knowledge is the circulation between private and public spaces.[76]

We can get a purchase upon this notion by considering a day in the experimental life of Robert Hooke. I have noted that Hooke lived where he worked, in rooms at Gresham College with an adjacent laboratory, rooms that were little visited by fellow experimentalists, English or foreign. He rose and then dined early, usually at home and frequently with his technicians, some of whom lodged with him. Before issuing forth, Hooke worked at home, trying experiments, as his diary records: "tryd experiment of fire," or "tryd experiment of gunpowder." Some of these, Hooke noted, were preparations for displays at the Royal Society, either next door or, during the Arundel House period, a mile and a half away. It was in the assembly rooms of the society that these experiments were to be shown and discoursed on: "tryd expt of penetration of Liquors . . . shewd it at Arundell house." Experimental discourses could also take place elsewhere. When Hooke left his rooms, he would invariably resort to the local coffeehouses or taverns, where he would expect to meet a small number of serious and competent philosophers for experimental discussion. In the evenings he was a fixture at the tables of distinguished fellows of the Society, notably at Boyle's, Christopher Wren's, and Lord William Brouncker's houses, where further experimental discourse occurred.[77]

Kuhn has written about what he sees as a crucial difference between the role of experiment in mid-seventeenth-century England and preceding practices. In the experimental program of Boyle, Hooke, and their associates, Kuhn says, experiments were seldom performed "to demonstrate what was already known. . . . Rather they wished to see how nature would behave under previously unobserved, often previously nonexistent, circumstances."[78] Broadly speaking, the point is a legitimate one. However, it applies only to one stage of experimentation and to one site at which experimental activity occurs. Hooke and Boyle might, indeed, undertake experimental trials without substantial foreknowledge of their outcome, although they could scarcely have done so without *any* foreknowledge, since they would then have been unable to distinguish between experimental success and failure. An experimental trial could fail; indeed, trials usually did fail, in the sense that an outcome was achieved out of which the desired sense could not be made. Thus, Hooke's diary records, among many other instances: "Made tryall of Speculum. not good"; "Made tryall upon Speculum it succeeded not"; "at home all day trying the fire expt but could not make it succeed." So far as trials are concerned, a failure might legitimately be attributed to one or more of a number of causes: the experimenter was inept or blundered in some way; the equipment was defective or the materials impure; relevant background circumstances, not specifiable or controllable at the time of trial, were unpropitious, and so on.[79] However, a further possibility was open and, indeed, sometimes considered by experimenters, namely that the theory, hypothesis, or perspective that informed one's sense of what counted as a successful outcome was itself incorrect. In a trial it was therefore always possible that an outcome deemed unsuccessful might come to be regarded as the successful realization of another theory of nature. In this way, the definition of what counted as a well-working experimental trial was, in principle, open-ended. In the views of the relevant actors, nature might perhaps speak unexpected words, and the experimenter would be obliged to listen.

The notion of the experimental trial therefore carried with it a sense of indiscipline: the experimenter might not be fully in control of the scene. The thing might fail. It might fail for lack of technical competence on the part of the experimenter, or it might fail for want of theoretical resources required to display the phenomena as docile.[80] Trials were undisciplined experiments, and these, like undisciplined animals, children, and strangers, might be deemed unfit to be displayed in public. This is why experimental trials were, in fact, almost invariably

performed in relatively private spaces (such as Hooke's rooms and Boyle's laboratory) rather than in the public rooms of the Royal Society.

The weekly meetings of the Royal Society required not trials but shows and discourses.[81] It was Hooke's job as curator of experiments to prepare these performances for the society's deliberation, instruction, and entertainment. His notes entitled "Dr. Hook's Method of Making Experiments" stipulate that the curator was to make the trial "with Care and Exactness," then to be "diligent, accurate, and curious" in "shewing to the Assembly of Spectators, such Circumstances and Effects . . . as are material." Even a visitor like Magalotti observed that he who was in charge of the society's experiments "does not come to make them in public before having made them at home."[82] Hooke had specific directions to this effect. For instance, in connection with a set of magnetic experiments, "It was ordered, that Mr. Hooke . . . try by himself a good number of experiments . . . and draw up an account of their success, and to communicate it to the Society, so that they might call for such of them as they should think good to be shewn before them." And in the case of a transfusion trial, Hooke and others were "appointed to be curators of this experiment, first in private by themselves, and then, in case of success, in public before the society."[83] Hooke did labor assiduously "at home," disciplining the trials and, when they had been made docile, bringing them to be shown.

He was a success at his job. His first biographer said that his experiments for the Royal Society were "performed with the least Embarrassment, clearly, and evidently."[84] There was always the risk of "embarrassment" precisely because these were to be not trials but shows, performed not in private but in public. "Embarrassment" was avoided, and the society had a successful meeting, when "the experiments succeeded," that is, when they met the shared expectations attending their outcome (and, presumably, when they offered a certain amount of amusement and entertainment).

But even Hooke did not always succeed. When an experimental show failed, the reasons were more circumscribed than in the case of a trial. With any event labeled as, and intended to be, a show, failure could mean only that the experimenter or the materials under his direction were in some way wanting. Accordingly, the Royal Society was not tolerant of failed shows. Hooke's wrist was smartly slapped when he produced in public the undisciplined phenomena that abounded in private settings: "The operator was ordered to make his compressing engine very staunch; and for that end to try it often by himself, that it might be in good order against the next meeting"; "Mr. Hooke was ordered to try this by himself at home"; "He made an experiment of the force of falling bodies to raise a weight; but was ordered to try it by himself, and then to shew it again in public."[85]

The relations between trials and shows, between activities proper to private and to public spaces, were, however, inherently problematic. The status of what had been produced or witnessed was a matter for judgment. A clear example of this is the case of the so-called anomalous suspension of water. In the early 1660s there was serious dispute in the Royal Society over the factual existence and correct interpretation of this phenomenon. (Water that is well purged of air bubbles will not descend from its initial standing in the Torricellian apparatus when it is placed in an evacuated air pump. Boyle had pointed to descent as crucial confirmation of his hypothesis of the air's spring.) Huygens had produced the alleged phenomenon in Holland, and Boyle disputed its status as an authentic act of nature by suggesting that nondescent was due to the leakage of external air into Huygens's pump. Hooke was directed to prepare the experiment for the Royal Society. During the early phases of the career of anomalous suspension in England, the experimental leaders of the Royal Society were of the opinion that no such phenomenon legitimately existed. Any experiment that showed it was considered to have been incompetently

performed—the apparatus leaked. Since members of the society had considerable experience of Hooke's bringing them experiments in pumps that were not "sufficiently tight," they readily concluded that Hooke's first productions of anomalous suspension were instances of experimental failure.[86] The experimental phenomena had not been made sufficiently docile. Hooke had indeed tried the experiment at home and had deemed it ready to be shown. The leaders of the society concluded otherwise: Hooke had produced only a trial, a failed show. What Hooke claimed to be knowledge, the society rejected as artifact. They disputed his claim by stipulating that the thing was not proper to be shown in a public place.[87]

When the Royal Society was at Arundel House, its curator Robert Hooke was continually ordered to bring the air pump to their meetings from its permanent lodgings in Hooke's rooms a mile and a half away at Gresham. In the course of being trundled back and forth, the brittle seals that ensured the machine against leakage were liable to crack, so that the curator's experimental shows sometimes failed. Hooke made a modest proposal. He suggested that, in this one instance and for this circumscribed practical reason, the honorable fellows who wished to satisfy themselves how matters stood should come to him, instead of Hooke and the machine going to them. Hooke "moved that . . . a committee might be appointed to see some experiments made with [the air pump] at his lodgings."[88]

An ad hoc committee was constituted and the visit to Hooke's rooms was made. In this instance, the normal pattern of movement in seventeenth-century experimental science was reversed: those who wanted to witness experimental knowledge in the making came to where the instruments permanently lived, rather than obliging the instruments to come to where witnesses lived. This inversion of the usual hierarchical ordering of public and private spaces was exceptional in seventeenth-century practice, and, in the event, it was rarely repeated. The showing of experimental phenomena in public spaces to a relevant public of gentlemen witnesses was an obligatory move in that setting for the construction of reliable knowledge. What underwrote assent to knowledge claims was the word of a gentleman, the conventions regulating access to a gentleman's house, and the social relations within it.

The contrast with more modern patterns is evident. The disjunction between places of residence and places where scientific knowledge is made is now almost absolute. The separation between the laboratory and the house means that a new privacy surrounds the making of knowledge whose status as open and public is often insisted upon. The implications of this disjunction are both obvious and enormously consequential. Public assent to scientific claims is no longer based upon public familiarity with the phenomena or upon public acquaintance with those who make the claims. We now believe scientists not because we know them, and not because of our direct experience of their work. Instead, we believe them because of their visible display of the emblems of recognized expertise and because their claims are vouched for by other experts we do not know. Practices used in the wider society to assess the creditworthiness of individuals are no longer adequate to assess the credibility of scientific claims. We can, it is true, make the occasional trip to places where scientific knowledge is made. However, when we do so, we come as visitors, as guests in a house where nobody lives.

NOTES

For criticisms of earlier versions of this paper, I thank Peter Galison, J. V. Golinski, Owen Hannaway, Adi Ophir, Trevor Pinch, Simon Schaffer, and members of seminars at the universities of Bath, Harvard, Illinois, London (University College), Melbourne, Oxford, Pennsylvania, and the Hebrew University of Jerusalem. For permission to quote from the Boyle Papers, I thank the Council of the Royal Society of London.

1. An outstanding exception is Owen Hannaway, "Laboratory Design and the Aim of Science: Andreas Libavius versus Tycho Brahe," *Isis*, 1986, 77:585–610. See also Peter Galison, "Bubble Chambers and the Experimental Workplace," in *Observation, Experiment, and Hypothesis in Modern Physical Science*, ed. Peter Achinstein and Owen Hannaway (Cambridge, Mass.: MIT Press, 1985), pp. 309–373; Larry Owens, "Pure and Sound Government: Laboratories, Playing Fields, and Gymnasia in the Nineteenth-Century Search for Order," *Isis*, 1985, 76:182–194; and, although not concerned with knowledge-making processes, Sophie Forgan, "Context, Image and Function: A Preliminary Enquiry into the Architecture of Scientific Societies," *The British Journal for the History of Science*, 1986, 19:89–113.

2. See, e.g., Erving Goffman, *The Presentation of Self in Everyday Life* (London: Allen Lane, Penguin Press, 1969), ch. 3; Richard Sennett, *The Fall of Public Man* (Cambridge: Cambridge Univ. Press, 1974), esp. ch. 5; Shirley Ardener, "Ground Rules and Social Maps for Women: An Introduction," in *Women and Space: Ground Rules and Social Maps*, ed. Ardener (London: Croom Helm, 1981), ch. 1; Clark E. Cunningham, "Order in the Atoni House," in *Right & Left: Essays on Dual Symbolic Classification*, ed. Rodney Needham (Chicago: Univ. Chicago Press, 1973), pp. 204–238.

3. Anthony Giddens, *The Constitution of Society: Outline of the Theory of Structuration* (Cambridge: Polity Press, 1984), ch. 3 (esp. his discussion of the work of the Swedish geographer Torsten Hägerstrand); Bill Hillier and Julienne Hanson, *The Social Logic of Space* (Cambridge: Cambridge Univ. Press, 1984), esp. pp. ix–xi, 4–5, 8–9, 19. For Foucauldian perspectives see Michel Foucault, "Questions on Geography," in Foucault, *Power/Knowledge: Selected Interviews and Other Writings, 1972–1977*, ed. Colin Gordon (Brighton: Harvester Press, 1980), pp. 63–77; Foucault, *Discipline and Punish: The Birth of the Prison*, trans. Alan Sheridan (New York: Vintage, 1979); and Adi Ophir, "The City and the Space of Discourse: Plato's Republic—Textual Acts and Their Political Significance" (Ph.D. diss., Boston Univ., 1984).

4. For a survey of the evaluation of evidence in this setting, see Barbara J. Shapiro, *Probability and Certainty in Seventeenth-Century England: A Study of the Relationships between Natural Science, Religion, History, Law, and Literature* (Princeton, N.J.: Princeton Univ. Press, 1983), esp. ch. 2; for treatment of experimental practice in these connections, see Steven Shapin and Simon Schaffer, *Leviathan and the Air-Pump: Hobbes, Boyle, and the Experimental Life* (Princeton, N.J.: Princeton Univ. Press, 1985), esp. ch. 2.

5. John Locke, *Essay Concerning Human Understanding*, in Locke, *Works*, 10 vols. (London, 1823), vol. III, on pp. 97–100; and John Dunn, "The Concept of 'Trust' in the Politics of John Locke," in *Philosophy in History: Essays on the Historiography of Philosophy*, ed. Richard Rorty, J. B. Schneewind, and Quentin Skinner (Cambridge: Cambridge Univ. Press, 1984), pp. 279–301.

6. This is an observational version of what Harry Collins has called "the experimenter's regress": H. M. Collins, *Changing Order: Replication and Induction in Scientific Practice* (London: Sage, 1985), ch. 4.

7. Even in legal writings centrally concerned with the evaluation of testimony, the need to spell out the grounds of persons' differential credibility was apparently rarely felt; see, e.g., Shapiro, *Probability and Certainty*, pp. 179–188; Julian Martin, "'Knowledge is Power': Francis Bacon, the State and the Reform of Natural Philosophy" (Ph.D. diss., Cambridge Univ., 1988), esp. ch. 3; cf. Peter Dear, *"Totius in verba:* Rhetoric and Authority in the Early Royal Society," *Isis*, 1985, 76:145–161, on pp. 153–157.

8. Robert Boyle, "An Hydrostatical Discourse, occasioned by the Objections of the Learned Dr. Henry More" (1672), in Boyle, *Works*, ed. Thomas Birch, 6 vols. (London, 1772) (hereafter Boyle, *Works*), Vol. III, pp. 596–628, on p. 626. In other circumstances Boyle elected to credit the testimony of divers: see Boyle, "Of the Temperature of the Submarine Regions," ibid., pp. 342–349, on p. 342; and Shapin and Schaffer, *Leviathan and the Air-Pump*, pp. 217–218.

9. For the Coga episode, see *The Correspondence of Henry Oldenburg*, ed. A. Rupert Hall and Marie Boas Hall, 13 vols. (Madison: Univ. Wisconsin Press; London: Mansell/Taylor & Francis, 1965–1986), vol. III, pp. 611, 616–617; vol. IV, pp. xx–xxi, 6, 59, 77; "An Account of the Experiment of *Transfusion*, practised upon a *Man* in *London*," *Philosophical Transactions*, 9 Dec. 1667, No. 30, pp. 557–559; Henry Stubbe, *Legends No Histories* (London, 1670), p. 179.

10. See Hannaway, "Laboratory Design," pp. 585–586; and (on alchemical usage) Shapin and Schaffer, *Leviathan and the Air-Pump*, p. 57 and note. For reference to the "laboratory" as an intensely private space, see Gabriel Plattes, "Caveat for Alchymists," in Samuel Hartlib, comp., *Chymical, Medicinal, and Chyrurgical Addresses* (London, 1655), p. 87.

11. I shall use the term more loosely, although it should be clear from the context what sort of place is being referred to. Like Hannaway ("Laboratory Design," p. 585), I accept that an intensive investigation of scientific sites would be obliged to take in such places as the anatomical theater, the astronomical observatory, the curiosity cabinet, and the botanic garden.

12. For futile planning by the Royal Society in the late 1660s to construct experimental facilities in the grounds of Arundel House, see Michael Hunter, "A 'College' for the Royal Society: The Abortive Plan of 1667–1668," *Notes and Records of the Royal Society*, 1983–1984, 38:159–186. Wren's plan (p. 173) called for "a fair Elaboratory" in the basement of the proposed house. Before the Society was founded there were several proposals for experimental colleges which included laboratories: see [William Petty], *The Advice of W.P. to Mr. Samuel Hartlib . . .* (London, 1648; rpt. in *The Harleian Miscellany*, Vol. VI [London, 1745]), pp. 1–13 (pp. 5, 7 for the "Chymical Laboratory"); John Evelyn to Robert Boyle, 3 Sept. 1659, in *The Diary and Correspondence of John Evelyn*, ed. W. Bray, 3 vols. (London, 1852), Vol. III, pp. 116–120. A year after the society's foundation a plan emerged for a "Philosophical College," again with "great Laboratories for Chymical Operations": Abraham Cowley, *A Proposition for the Advancement of Experimental Philosophy* (London, 1661), p. 25. For the Ashmolean laboratory, see R. F. Ovenell, *The Ashmolean Museum 1683–1894*

(Oxford: Clarendon Press, 1986), pp. 16–17, 22; and Edward Lhuyd to John Aubrey, 12 Feb. 1686, quoted in S. Mendyk, "Robert Plot: Britain's 'Genial Father of County Natural Histories,'" *Notes Rec. Roy. Soc.*, 1985, 39:159–177, on p. 174 n. 28 (for confusion about what space was designated by "ye Labradory").

13. Robert Boyle, "The Sceptical Chymist," in Boyle, *Works*, Vol. I, pp. 458–586, on p. 461, intended to draw "the chymists' doctrine out of their dark and smokey laboratories" and bring "it into the open light." The contemporary Dutch-Flemish pictorial genre of "the alchemist in his laboratory" generally depicted alchemical workplaces in this way, without the *necessary* implication of criticism: see C. R. Hill, "The Iconography of the Laboratory," *Ambix*, 1975, 22:102–110; Jane P. Davidson, *David Teniers the Younger* (London: Thames & Hudson, 1980), pp. 38–43; and Davidson, "'I Am the Poison Dripping Dragon': Iguanas and Their Significance in the Alchemical and Occult Paintings of David Teniers the Younger," *Ambix*, 1987, 34:62–80 (who diverges from Hill in her acceptance that Teniers's many paintings of the laboratory genre are probably accurate and informed representations of such sites).

14. Thus accusations that the Royal Society's meeting places were *not* public might count as particularly devastating: see, e.g., Thomas Hobbes, "Dialogus physicus de natura aeris" (1661), in Hobbes, *Latin Works*, ed. Sir William Molesworth, 5 vols. (London 1839–1845), Vol. IV, pp. 233–296, on p. 240; Shapin and Schaffer, *Leviathan and the Air-Pump*, pp. 112–115, 350; and Stubbe, *Legends No Histories*, "Preface," sig. *3.

15. Among secondary sources that are relatively rich in material relating to these sites, see Robert G. Frank, Jr., *Harvey and the Oxford Physiologists: A Study of Scientific Ideas* (Berkeley/Los Angeles: Univ. California Press, 1980), ch. 3; Charles Webster, *The Great Instauration: Science, Medicine and Reform 1626–1660* (London: Duckworth, 1975), esp. pp. 47–63, 89–98, 130–157; R. T. Gunther, *Early Science in Oxford*, 15 vols. (Oxford: privately printed, 1923–1967), Vol. I, pp. 7–51; Betty Jo Dobbs, "Studies in the Natural Philosophy of Sir Kenelm Digby," Parts I–III, *Ambix*, 1971, 18:1–20; 1973, 20:144–163; 1974, 21:1–28; Ronald Sterne Wilkinson, "The Hartlib Papers and Seventeenth-Century Chemistry, Part II," *Ambix*, 1970, 17:85–110; Lesley Murdin, *Under Newton's Shadow: Astronomical Practices in the Seventeenth Century* (Bristol: Adam Hilger, 1985); and Michael Hunter, *Science and Society in Restoration England* (Cambridge: Cambridge Univ. Press, 1981).

16. Robert Boyle to Lady Ranelagh, 6 Mar. 1647, in Boyle, *Works*, Vol. I, p. xxxvi, and Vol. VI, pp. 39–40; G. Agricola to Boyle, 6 Apr. 1668, ibid., Vol. VI, pp. 650–651; and James Randall Jacob, "Robert Boyle, Young Theodicean" (Ph.D. diss., Cornell Univ., 1969), pp. 129–138. For the Stalbridge house, see R. E. W. Maddison, "Studies in the Life of Robert Boyle, F. R. S., Part VI: The Stalbridge Period, 1645–1655, and the Invisible College," *Notes Rec. Roy. Soc.*, 1963, 18:104–124; Maddison, *The Life of the Honourable Robert Boyle F. R. S.* (London: Taylor & Francis, 1969), ch. 2; Nicholas Canny, *The Upstart Earl: A Study of the Social and Mental World of Richard Boyle, First Earl of Cork 1566–1643* (Cambridge: Cambridge Univ. Press, 1982), pp. 68, 73, 98–99.

17. Lady Ranelagh to Boyle, 12 Oct. [1655], in Boyle, *Works*, Vol. VI, pp. 523–524; Maddison, *Life of Boyle*, ch. 3.

18. For Chelsea, see *The Diary of John Evelyn*, ed. E. S. de Beer (London: Oxford Univ. Press, 1959), pp. 410, 417; Henry Oldenburg to Robert Boyle, 10 Sept. 1666, in Oldenburg, *Correspondence*, Vol. III, pp. 226, 227n.; and Maddison, *Life of Boyle*, p. 94. For Leese, see Boyle to Oldenburg, 13 June 1666, in Oldenburg, *Correspondence*, Vol. III, p. 160; Mary Rich, *Memoir of Lady Warwick: Also Her Diary, from A.D. 1666 to 1672* (London: Religious Tract Society, 1847?), esp. pp. 51, 161–163, 242–243; and Maddison, *Life of Boyle*, pp. 74, 132, 142.

19. Lady Ranelagh to Boyle, 13 Nov. [1666] (as given, but more likely to be 1667), in Boyle, *Works*, Vol. VI, pp. 530–531 (where Katherine offers her "back-house" to be converted into a laboratory); Thomas Birch, "Life of Boyle," ibid., Vol. I, pp. vi–clxxi, on pp. cxlv, cxxix; John Aubrey, *Brief Lives*, ed. Oliver Lawson Dick (Harmondsworth: Penguin, 1972), p. 198; and Maddison, *Life of Boyle*, pp. 128–129, 133–137, 177–178.

20. Gilbert Burnet, *Select Sermons . . . and a Sermon at the Funeral of the Honourable Robert Boyle* (Glasgow, 1742), pp. 204–205; Maddison, *Life of Boyle*, pp. 134–135; and Webster, *Great Instauration*, pp. 61–63.

21. D. C. Martin, "Former Homes of the Royal Society," *Notes Rec. Roy. Soc.*, 1967, 22:12–19; I. R. Adamson, "The Royal Society and Gresham College 1660–1711," *Notes Rec. Roy. Soc.*, 1978–1979, 33:1–21; and Charles Richard Weld, *A History of the Royal Society*, 2 vols. (London, 1848), Vol. I, pp. 80–85, 192–198. For a satirical account of the Royal Society at Gresham, and esp. of the Repository and "the *Elaboratory-keepers* Apartment," see [Edward Ward], *The London-Spy*, 4th ed. (London, 1709), pp. 59–60.

22. Hunter, "A 'College' for the Royal Society"; and Adamson, "The Royal Society and Gresham College," pp. 5–6. For Arundel House see David Howarth, *Lord Arundel and His Circle* (New Haven, Conn.: Yale Univ. Press, 1985); and Graham Perry, *The Golden Age Restor'd: The Culture of the Stuart Court, 1603–42* (Manchester: Manchester Univ. Press, 1981), ch. 5. For Peacham see Henry Peacham, *The Complete Gentleman . . .*, ed. Virgil B. Heltzel (1622, 1634, 1661; Ithaca, N.Y.: Cornell Univ. Press, 1962), pp. ix–xx.

23. Thomas Birch, *The History of the Royal Society of London*, 4 vols. (London, 1756–1757), Vol. I, pp. 123–124, 250; and Oldenburg to Boyle, 10 June 1663, in Boyle, *Works*, Vol. VI, p. 147.

24. Margaret 'Espinasse, *Robert Hooke* (London: Heinemann, 1956), pp. 4–5; John Ward, *Lives of the Professors of Gresham College* (London, 1740), pp. 91, 178; and Adamson, "The Royal Society and Gresham College," p. 4. The contents of Hooke's rooms at his death in 1703 are detailed in Public Record Office (London) MS PROB 5/1324. I thank Dr. Michael Hunter for a transcript of this inventory, which he will shortly publish.

25. 'Espinasse, *Robert Hooke*, pp. 106–107, 113–127, 131–138, 141–147. The major source for Hooke's domestic life and activities is his diary for periods from the early 1670s: *The Diary of Robert Hooke, M.A., M.D., F.R.S., 1672–1680,*

ed. Henry W. Robinson and Walter Adams (London: Taylor & Francis, 1935); and *The Diary of Robert Hooke, Nov. 1688 to March 1690; Dec. 1692 to August 1693*, in Gunther, *Early Science in Oxford*, vol. X, pp. 69–265. I have surveyed the diurnal patterns of Hooke's life and tried to relate them to his place in the experimental community; Steven Shapin, "Who Was Robert Hooke?" in *Robert Hooke: New Studies,* ed. Michael Hunter and Simon Schaffer (Woodbridge, Suffolk: The Boydell Press, 1989) pp. 253–285. An unreflectively Freudian account of Hooke's sex life is found in Lawrence Stone, *The Family, Sex and Marriage in England 1500–1800* (London: Weidenfeld & Nicolson, 1977), pp. 561–563.

26. Boyle to Lady Ranelagh, 31 Aug. 1649, in Boyle, *Works,* Vol. VI, pp. 49–50, and Vol. I, p. xlv; cf. Boyle to [Benjamin Worsley?], n.d. (probably late 1640s), ibid., Vol. VI, pp. 39–40.

27. *Boyle Papers,* Royal Society (hereafter *Boyle Papers*), Vol. VIII, fol. 128, quoted in Jacob, "Boyle, Young Theodicean," p. 158 (quotation). See also Harold Fisch, "The Scientist as Priest: A Note on Robert Boyle's Natural Theology," *Isis,* 1953, 44:252–265; Shapin and Schaffer, *Leviathan and the Air-Pump,* p. 319; and, on Sunday experiments, Jacob, "Boyle, Young Theodicean," pp. 153–154. In one of Boyle's later notebooks he recorded how many experiments he had performed day by day for periods between 1684 and 1688. By then, the rule had clearly become "never on Sunday": *Boyle Papers,* Commonplace Book, 190, fols. 167–171. See also Maddison, *Life of Boyle,* p. 187; and Maddison, "Studies in the Life of Robert Boyle, F.R.S., Part IV: Robert Boyle and Some of His Foreign Visitors," *Notes Rec. Roy. Soc.,* 1954, 11:38–53, on p. 38.

28. Boyle to Benjamin Worsley, n.d., in Boyle, *Works,* Vol. VI, pp. 39–41; and Boyle to Lady Ranelagh, 13 Nov. ?, ibid., pp. 43–44. (Both letters probably date from the late 1640s.) See also Marie Boas, *Robert Boyle and Seventeenth-Century Chemistry* (Cambridge: Cambridge Univ. Press, 1958), pp. 15–16, 19, 21.

29. Note the monastic flavor of the Cowley, Evelyn, and Petty plans for philosophical colleges. Evelyn referred explicitly to a Carthusian model: Evelyn, *Diary and Correspondence,* Vol. III, p. 118.

30. Gilbert Burnet, *History of His Own Time,* 6 vols. (Oxford: Oxford Univ. Press, 1833), Vol. I, p. 351; cf. Burnet, *Select Sermons,* pp. 202, 210: Boyle "had neither designs nor passions."

31. [Robert Boyle], "An Epistological Discourse of Philaretus to Empiricus, . . . inviting All True Lovers of Vertue and Mankind, to a Free and Generous Communication of Their Secrets and Receits in Physick" (prob. written 1647), in Hartlib, comp., *Chymical, Medicinal, and Chyrurgical Addresses,* pp. 113–150, rpt. in Margaret E. Rowbottom, "The Earliest Published Writing of Robert Boyle," *Annals of Science,* 1948–1950, 6:376–389, on pp. 380–385.

32. On foreigners: Aubrey, *Brief Lives,* p. 198; Eustace Budgell, *Memoirs of the Lives and Characters of the Illustrious Family of the Boyles,* 3d ed. (London, 1737), p. 144; R. E. W. Maddison, "Studies in the Life of Robert Boyle, F.R.S., Part I: Robert Boyle and Some of His Foreign Visitors," *Notes Rec. Roy. Soc.,* 1951, 9:1–35, on p. 3; Birch, "Life of Boyle," p. cxlv. For Magalotti: W. E. Knowles Middleton, "Some Italian Visitors to the Early Royal Society," *Notes Rec. Roy. Soc.,* 1978–1979, 33:157–173, on p. 163; *Lorenzo Magalotti at the Court of Charles II: His "Relazione d'Inghilterra" of 1668,* ed. and trans. Middleton (Waterloo, Ontario: Wilfrid Laurier Univ. Press, 1980), p. 8. Similar hospitality was extended in 1669, when Magalotti escorted the Grand Duke of Tuscany to Boyle's Pall Mall laboratory: [Lorenzo Magalotti], *Travels of Cosmo the Third, Grand Duke of Tuscany* (London, 1821), pp. 291–293; and R. W. Waller, "Lorenzo Magalotti in England 1668–1669," *Italian Studies,* 1937, 1:49–66. For Evelyn's comments: John Evelyn to William Wotton, 29 Mar. 1696, quoted in Maddison, "Studies in the Life of Boyle, Part IV," p. 38.

33. Boyle Papers, Vol. XXXVII, fol. 166 (no date but probably mid to late 1640s). For background to this manuscript ("The Gentleman"), see J. R. Jacob, *Robert Boyle and the English Revolution: A Study in Social and Intellectual Change* (New York: Burt Franklin, 1977), pp. 48–49.

34. Boyle to Oldenburg, 8, c. 16 and 30 Sept. and 9 Dec. 1665; Oldenburg to Spinoza, 12 Oct. 1665; Sir Robert Moray to Oldenburg, 4 Dec. 1665, in Oldenburg, *Correspondence,* Vol. II, pp. 502, 509, 537, 568, 627, 639; and Evelyn to Wotton, 29 Mar. 1696, quoted in Maddison, "Studies in the Life of Boyle, Part IV," p. 38; and Maddison, *Life of Boyle,* pp. 186–188.

35. On the sign: Weld, *History of the Royal Society,* Vol. I, p. 136n; Maddison, *Life of Boyle,* pp. 177–178; cf. *Diary of Hooke,* in Gunther, *Early Science in Oxford,* Vol. X, p. 139 (entry for 29 July 1689); "To Mr. Boyle. Not to be spoken with." For the advertisement: Boyle Papers, Vol. XXXV, fol. 194. There are a number of other drafts of this advertisement in the Boyle Papers; one is printed in Maddison, *Life of Boyle,* p. 177.

36. Burnet, *Selected Sermons,* p. 201; Maddison, "Studies in the Life of Boyle, Part I," pp. 2–3.

37. Richard Brathwait, *The English Gentleman* (London, 1630), pp. 65–66, sign. Nnn2r; Lawrence Stone and Jeanne C. Fawtier Stone, *An Open Elite? England 1540–1880* (Oxford: Clarendon Press, 1984), pp. 307–310; and Boyle Papers, Vol. XXXVII, fol. 160v.

38. Boas, *Boyle and Seventeenth-Century Chemistry,* p. 207. On the role of the virtuoso and the expectation that his collections would be accessible to the visits of others, see Walter E. Houghton, Jr., "The English Virtuoso in the Seventeenth Century," *Journal of the History of Ideas,* 1942, 3:51–73, 190–219; and Oliver Impey and Arthur MacGregor, eds., *The Origins of Museums: The Cabinet of Curiosities in Sixteenth- and Seventeenth-Century Europe* (Oxford: Clarendon Press, 1985).

39. There was, of course, another model available in principle to identify the conditions of privacy. This was the alchemist's laboratory, but Boyle worked hard to discredit that model, even as he spent time in the relatively open laboratories of the Hartlib circle. See, e.g., Samuel Hartlib to Boyle, 28 Feb. 1654 and 14 Sept. 1658, in Boyle, *Works,* Vol. VI, pp. 78–83, 114–115.

40. Weld, *History of the Royal Society,* Vol. I, pp. 224–225.

41. Birch, *History of the Royal Society,* Vol. I, pp. 264–265. On the Society's increasing concern for secrecy and the limitation of public access in the 1670s, see Michael Hunter and Paul B. Wood, "Towards Solomon's House: Rival Strategies for Reforming the Early Royal Society," *History of Science,* 1986, 24:49–108, on pp. 74–75. The test for admittance to fellowship of a special claim to scientific knowledge was not formalized until 1730: Maurice Crosland, "Explicit Qualifications as a Criterion for Membership of the Royal Society: A Historical Review," *Notes Rec. Roy. Soc.,* 1983, 37:167–187.

42. Joseph Hill to Boyle, 20 Apr. 1685, in Boyle, *Works.* Vol. VI, p. 661. At about the same time, an eminent cleric wrote announcing his imminent visit but assured the weary Boyle that it would be sufficient to have "some servant of yours" delegated "to shew me your laboratory": Bishop of Cork to Boyle, 12 June 1683, ibid., p. 615.

43. One would like to know much more about the specific sites within the house where experimental work was done and where experimental discourses were held. In addition to rooms designated for public use, the *closet,* where many virtuosi kept their curiosities (including scientific instruments) and where intimate conversations often took place, should be of particular interest. The closet was a room variously located and variously employed in the seventeenth century, but many examples were situated off the bedroom, meaning that this was a private space, access to which acknowledged or accorded intimacy. For the closet and divisions of domestic space generally, see Mark Girouard, *Life in the English Country House: A Social and Architectural History* (Harmondsworth: Penguin, 1980), esp. pp. 129–130; and Gervase Jackson-Stops and James Pipkin, *The English Country House: A Grand Tour* (London: Weidenfeld & Nicolson, 1985), ch. 9. For an analysis of the internal layout of the house in relation to social structure, see Norbert Elias, *The Court Society,* trans. Edmund Jephcott (Oxford: Basil Blackwell, 1983), ch. 3.

44. Robert Boyle, "An Account of Philaretus [i.e., Mr. R. Boyle] during His Minority," in Boyle, *Works,* Vol. I, pp. xii–xxvi, on p. xiii.

45. Lorenzo Magalotti to Cardinal Leopold, 14 Feb. 1668, in Middleton, "Some Italian Visitors to the Royal Society," p. 160; Waller, "Magalotti in England," pp. 52–53; and *Magalotti at the Court of Charles II,* ed. and trans. Middleton, p. 8.

46. For divergences of opinion among the fellowship about whether or not mere spectators ought to be encouraged, see Hunter and Wood, "Towards Solomon's House," pp. 71, 87–92. Hooke took a particularly strong line that *participants* only were wanted; see also *Philosophical Experiments and Observations of the Late Eminent Dr. Robert Hooke,* ed. W. Derham (London, 1726), pp. 26–27.

47. Margaret 'Espinasse, "The Decline and Fall of Restoration Science," *Past and Present,* 1958, 14:71–89, on p. 86; and Quentin Skinner, "Thomas Hobbes and the Nature of the Early Royal Society," *Historical Journal,* 1969, 12:217–239, on p. 238. See also Michael Hunter, *The Royal Society and Its Fellows 1660–1700: The Morphology of an Early Scientific Institution* (Chalfont St. Giles, Bucks.: British Society for the History of Science, 1982), p. 8. On Hobbes and the Royal Society see Shapin and Schaffer, *Leviathan and the Air-Pump,* pp. 131–139.

48. Samuel Sorbière, *A Voyage to England, containing Many Things relating to the state of Learning, Religion, and Other Curiosities of That Kingdom* (London: 1709; trans. of 1664 French original), pp. 35–38; and *Journal des voyages de Monsieur de Monconys* (Lyons, 1666), separately paginated "Seconde Partie: Voyage d'Angleterre," p. 26. See also Thomas Molyneux to William Molyneux, 26 May 1683, in K. Theodore Hoppen, "The Royal Society and Ireland: William Molyneux, F.R.S. (1656–1698)," *Notes Rec. Roy. Soc.,* 1963, 18:125–135, on p. 126; and Maddison, "Studies in the Life of Boyle, Part I" (cit. n. 32), pp. 14–21. There is a brief "official" account of the society's rooms in Thomas Sprat, *History of the Royal Society* (London, 1667), p. 93.

49. *Account of the Proceedings in the Council of the Royal Society, in Order to Remove from Gresham College* (London, 1707?), partly rpt. in Weld, *History of the Royal Society,* Vol. I, pp. 82–83; and Martin, "Former Homes of the Royal Society," p. 13. A brief account of the Society's rooms in the last year of its occupancy of Gresham College is in *London in 1710: From the Travels of Zacharias Conrad von Uffenbach,* trans. and ed. W. H. Quarrell and Margaret Mare (London: Faber & Faber, 1934), pp. 97–102. Uffenbach described the "wretchedly ordered" repository and library, and the "very small and wretched" room where the society usually met. At that time it was sparsely decorated with portraits of its members (including, Uffenbach claimed, a picture of Hooke, about which he was mistaken or which was subsequently lost), two globes, a model of a contrivance for rowing, and a large pendulum clock. There is no pictorial record of an internal space occupied by the Royal Society in the seventeenth century. For an engraving (of doubtful date) recording a Crane Court meeting see T. E. Allibone, *The Royal Society and Its Dining Clubs* (Oxford: Pergamon Press, 1976), frontispiece.

50. Magalotti to Cardinal Leopold, 21 Feb. 1668, in Middleton, "Some Italian Visitors to the Royal Society," pp. 160–161; and Magalotti, *Travels of Cosmo,* pp. 185–186. Too much weight should not, perhaps, be given to Magalotti's evidence. He seems to have been confused about where exactly he was: in the 1669 account he says that he went with the Grand Duke "to Arundel House, in the interior of Gresham College." Moreover, he seems to have derived portions of his version of the society from Sorbière's earlier account.

51. *Journal des voyages de Monconys,* pp. 26–28, 47, 55–57; Sorbière, *Voyage to England,* p. 37; Maddison, "Studies in the Life of Boyle, Part I," pp. 16–19 (Monconys), 21 (Sorbière); and Magalotti to Cardinal Leopold, 21 Feb. 1668, in Middleton, "Some Italian Visitors to the Royal Society," pp. 161–162.

52. *Journal des voyages de Monconys,* p. 26 (quoted); Magalotti, *Travels of Cosmo,* pp. 186–187; and Sorbière, *Voyage to England,* pp. 36–37. For Commons practice, see Sir Thomas Smith, *De republica anglorum* (London, ca. 1600), pp. 51–52. (This practice differs from that of the House of Lords, where speakers address "My lords.")

53. On set speeches: Edward Chamberlayne, *Angliae notitia: or the Present State of England* (7th ed., London, 1673), p. 345. Cf. Sir Thomas Erskine May, *A Treatise on the Law, Privileges, Proceedings and Usage of Parliament,* ed.

T. Lonsdale Webster and William Edward Grey, 11th ed. (London: William Clowes & Sons, 1906), pp. 310, 314–315, 344–345; and Lord Campion, *An Introduction to the Procedure of the House of Commons* (London: Macmillan, 1958), pp. 190, 192. On "opposite opinions": Magalotti, *Travels of Cosmo*, pp. 187–188. Cf. J. E. Neale, *The Elizabethan House of Commons* (London: Jonathan Cape, 1949), pp. 404–407; and Smith, *De republica anglorum*, p. 52. (Needless to say, these were stipulations of ideal behavior: violations of the norms in Commons were frequent.)

54. Sorbière, *Voyage to England*, p. 38; and Magalotti, *Travels of Cosmo*, p. 187. Cf. George Henry Jennings, comp., *An Anecdotal History of the British Parliament . . .* (London: Horace, Cox, 1880), p. 433; Vernon F. Snow, *Parliament in Elizabethan England: John Hooker's Order and Usage* (New Haven, Conn.: Yale Univ. Press, 1977), p. 164; and Neale, *Elizabethan House of Commons*, p. 364.

55. *Journal des voyages de Monconys*, p. 26; Sorbière, *Voyage to England*, p. 36; Magalotti, *Travels of Cosmo*, p. 186; Thomas Sprat, *Observations on Mons de Sorbière's Voyage into England* (1665; London, 1708), pp. 164–165; Sprat, *History of the Royal Society*, p. 94. For the Commons mace: Erskine May, *Usage of Parliament*, p. 155; Campion, *Procedure of Commons*, pp. 54, 73; and for the society's mace: Margery Purver, *The Royal Society: Concept and Creation* (London: Routledge & Kegan Paul, 1967), p. 140.

56. Quoted in Hunter and Wood, "Towards Solomon's House," p. 81. The same author described the council as "the Societys Parliament" (pp. 68, 83).

57. The directed coordination of the Society's labors prompted Robert Hooke to compare it to "a Cortesian army well Disciplined and regulated though their number be but small" (quoted in Hunter and Wood, "Towards Solomon's House," p. 87). On coffeehouses see, e.g., Aytoun Ellis, *The Penny Universities: A History of the Coffee-Houses* (London: Secker & Warburg, 1956), esp. pp. 46–47 on rules of order. The Royal Society "club" of the 1670s held much of its conversation in City coffeehouses like Garraway's and Jonathan's. On occasion, experimental performances were even staged at coffeehouses. For the connections between the late-Interregnum Harringtonian Rota club, meeting at Miles's coffeehouse, and the early Royal Society, see Anna M. Strumia, "Vita istituzionale della Royal Society seicentesca in alcuni studi recenti," *Rivista Storica Italiana*, 1986, 98:500–523, on pp. 520–523. (I owe this reference to Michael Hunter.)

58. Sprat, *History of the Royal Society*, pp. 73, 100; and, on attendance, Hunter, *The Royal Society and Its Fellows*, pp. 16–19; and J. L. Heilbron, *Physics of the Royal Society during Newton's Presidency* (Los Angeles: William Andrews Clark Memorial Library, 1983), p. 4.

59. Hunter, *Science and Society in Restoration England*, p. 46.

60. The only record of a crowd scene in one of Boyle's laboratories is an account of the visit in 1677 of the German chemist Johann Daniel Kraft, when the display of phosphorus attracted "the confused curiosity of many spectators in a narrow compass." However, "no strangers were present" when the secret of the phosphorus was later revealed: Robert Hooke, *Lectures and Collections made by Robert Hooke . . .* (London, 1678), pp. 273–282; see also J. V. Golinski, "A Noble Spectacle: Research on Phosphorus and the Public Cultures of Science in the Early Royal Society," *Isis*, 1989, 80: 11–39.

61. I have prepared an extended study of the role and identity of technicians in seventeenth-century England; see also R. E. W. Maddison, "Studies in the Life of Robert Boyle, F.R.S., Part V: Boyle's Operator: Ambrose Godfrey Hanckwitz, F.R.S.," *Notes Rec. Roy. Soc.*, 1955, 11:159–188 (see p. 159 for a partial list of Boyle's technicians).

62. Robert Boyle, "A Continuation of New Experiments Physico-Mechanical, touching the Spring and Weight of the Air . . . The Second Part" (1680), in Boyle, *Works*, Vol. IV, pp. 505–593, on pp. 506–507.

63. Among very many examples, see esp. a note on the ineptitude of John Mayow (identified only by his initials): Robert Boyle, "A Continuation of New Experiments Physico-Mechanical touching the Spring and Weight of the Air" (1669), in Boyle, *Works*, Vol. III, pp. 175–276, on p. 187.

64. Burnet, *Select Sermons*, p. 200; Birch, "Life of Boyle," p. lx: "The irreligious fortified themselves against all that was said by the clergy, with this, that *it was their trade*, and that *they were paid for it.*"

65. Sprat, *History of the Royal Society*, pp. 63–67, 76, 407, 427, 431, 435; also Robert Hooke, *Micrographia* (London, 1665), "Preface," sig. glv. For visitors' accounts of social diversity in the society, see, e.g., Magalotti, *Travels of Cosmo*, pp. 186–188; Sorbière, *Voyage to England*, p. 37.

66. Joseph Glanvill, *Scepsis scientifica* (London, 1665), "Preface," sig. clr; also sig. b4v for "a Society *of persons that can command both* Wit *and* Fortune." Peter Dear rightly notes evidence that the testimony of "lowly folk" might be credible because their accounts were less likely than those of the educated to be colored by theoretical commitments. This view was, however, rarely expressed and, as Dear says, was more than counterbalanced by the consideration that "gentlemen were trustworthy just because they *were* gentlemen": Dear, *"Totius in verba"* (cit. n. 7), pp. 156–157, emphasis in original.

67. Sprat, *History of the Royal Society*, pp. 65–67. On seventeenth-century English thought about the master-servant relationship and the political significance of servitude, see C. B. Macpherson, *The Political Theory of Possessive Individualism: Hobbes to Locke* (Oxford: Oxford Univ. Press, 1970), esp. ch. 3; Christopher Hill, "Pottage for Freeborn Englishmen: Attitudes to Wage-Labour," in Hill, *Change and Continuity in Seventeenth-Century England* (Cambridge, Mass.: Harvard Univ. Press, 1975), ch. 10.

68. Sprat, *History of the Royal Society*, pp. 67–69. Cf. John Webster, *Academiarum examen* (London, 1654), p. 106, where it is recommended that youth be educated "so they may not be sayers, but doers, not idle spectators, but painful operators; . . . which can never come to pass, unless they have Laboratories as well as Libraries, and work in the fire, better than build Castles in the air."

69. Sprat, *History of the Royal Society*, p. 70. On fellows' freedom of judgment: Lotte Mulligan and Glenn Mulligan, "Reconstructing Restoration Science: Styles of Leadership and Social Composition of the Early Royal Society," *Social Studies of Science*, 1981, 11:317–364, on p. 330 (quoting William Croone); on the moral economy of the experimental community generally: Shapin and Schaffer, *Leviathan and the Air-Pump*, pp. 310–319, 332–344; and for Hobbes's suggestion that the Royal Society did indeed have "masters": ibid., pp. 112–115. On the presumed equality of all gentlemen: J. C. D. Clark, *English Society 1688–1832: Ideology, Social Structure and Political Practice during the Ancien Regime* (Cambridge: Cambridge Univ. Press, 1985), p. 103.

70. See, e.g., Peacham, *The Complete Gentleman*, p. 24; and Brathwait, *The English Gentleman*, pp. 83–84.

71. Ismael Boulliau to Christiaan Huygens, 6 Dec. 1658, in Harcourt Brown, *Scientific Organizations in Seventeenth Century France (1620–1680)* (Baltimore: Williams & Wilkins, 1934); pp. 87–89; see also pp. 108, 119, 126–127 (on civility), and p. 96 (for Oldenburg's familiarity with proceedings at Montmor's house).

72. Boyle, "Hydrostatical Discourse," p. 615. For this episode, and for Boyle-More relations generally, see Shapin and Schaffer, *Leviathan and the Air-Pump*, pp. 207–224.

73. The episode concerned reports by physicians in Danzig regarding the transfusion of animal blood into humans: see Oldenburg to Boyle, 10 Dec. 1667, in Boyle, *Works*, Vol. VI, pp. 254–255; and Oldenburg, *Correspondence* (cit. n. 9), Vol. IV, pp. 26–28.

74. Sprat, *History of the Royal Society*, pp. 97–102; Glanvill, *Scepsis scientifica*, "Preface," sig. clr.

75. There are judicial resonances here, but they should not be overemphasized. What was most often being "tried" in experiment was some hypothesis or other explanatory item. In law the trial is of matter of fact, and the jury's judgment is of what counts as fact. However, the best parallel is between the experimental show and the "show trial," where the matter of fact is known (or decided upon) in advance. Both bear the same relation to their respective genuine trials. For the judicial process of "bringing matters to a trial," see Martin, "'Knowledge is Power,'" ch. 3.

76. In this connection see David Gooding's excellent work on Faraday at the Royal Institution. Gooding studies the passage from the basement laboratory to the ground floor lecture theater as movement in the epistemological status of experimental phenomena: Gooding, "'In Nature's School': Faraday as an Experimentalist," in Gooding and Frank A. L. James, eds., *Faraday Rediscovered: Essays on the Life and Work of Michael Faraday, 1791–1867* (Basingstoke: Macmillan, 1985), pp. 106–135. See also H. M. Collins, "Public Experiments and Displays of Virtuosity: The Core-Set Revisited," *Soc. Stud. Sci.*, 1988, 18: 725–748.

77. 'Espinasse, *Robert Hooke*, pp. 106–147; and Shapin, "Who Was Robert Hooke?" The quotations, instances of which could be multiplied indefinitely, are from Hooke's 1672–1680 *Diary*, pp. 15, 37.

78. Thomas S. Kuhn, "Mathematical versus Experimental Traditions in the Development of Physical Science," in Kuhn, *The Essential Tension: Selected Studies in Scientific Tradition and Change* (Chicago: Univ. Chicago Press, 1977), pp. 31–65, on p. 43.

79. Quotations are from Hooke's 1672–1680 *Diary*, pp. 27–29, 33. For Boyle's views on what counted as an experimental failure, see Shapin and Schaffer, *Leviathan and the Air-Pump*, pp. 185–201.

80. For uses of Foucauldian notions of "discipline" and "docile bodies" in the sociology of scientific knowledge: Michael Lynch, "Discipline and the Material Form of Images: An Analysis of Scientific Visibility," *Soc. Stud. Sci.*, 1985, 15:37–66; Bruno Latour, *Science in Action: How to Follow Scientists and Engineers through Society* (Milton Keynes: Open Univ. Press, 1987), ch. 3.

81. Historians concerned with other issues have known this for some time, e.g., Hunter, *Science and Society in Restoration England*, p. 46; Hunter and Wood, "Towards Solomon's House," p. 76; and Penelope M. Gouk, "Acoustics in the Early Royal Society 1660–1680," *Notes Rec. Roy. Soc.*, 1981–1982, 36:155–175, on p. 170.

82. *Philosophical Experiments of Hooke*, ed. Derham, pp. 26–28; and Magalotti to Cardinal Leopold, 20 Feb. 1668, in Maddison, "Some Italian Visitors to the Royal Society," p. 161.

83. Birch, *History of the Royal Society*, Vol. III, p. 124 (entry for 12 Feb. 1674), and Vol. II, p. 115 (entry for 26 Sept. 1666).

84. Richard Waller, "The Life of Dr. Robert Hooke," in *The Posthumous Works of Robert Hooke . . .*, ed. Waller (London, 1705), pp. i–xxviii, on p. iii (also quoted in Weld, *History of the Royal Society*, Vol. I, p. 438). Weld was one of the first historians to note this characteristic of Royal Society experiments: "These experiments were generally repetitions of experiments already made in private and exhibited afterwards for the satisfaction and information of the Society": p. 136n.

85. Birch, *History of the Royal Society*, Vol. I, pp. 177, 194, 260 (entries for 14 Jan., 11 Feb., and 17 June 1663).

86. Ibid., pp. 139, 212, 218, 220, 238, 248, 254–255, 268, 274–275, 286–287, 295, 299–301, 305, 310, 386.

87. The story of anomalous suspension is told in Shapin and Schaffer, *Leviathan and the Air-Pump*, ch. 6. The Society ultimately came round to the view that anomalous suspension authentically existed, and, therefore, that experiments *not* revealing it were incompetent. This shift crucially involved Boyle's personal experience of the phenomenon and Huygens's visit to London to produce anomalous suspension before witnesses. For similar doubt of Hooke's experimental testimony, see "An Account of the Experiment made by Mr. *Hook*, of Preserving Animals Alive by Blowing through Their Lungs with Bellows," *Phil. Trans.*, 21 Oct. 1667, No. 28, pp. 539–540.

88. Birch, *History of the Royal Society*, Vol. II, p. 189 (entry for 25 July 1667).

# 33

# Institutional Ecology, "Translations," and Boundary Objects

## Amateurs and Professionals in Berkeley's Museum of Vertebrate Zoology, 1907–39

SUSAN LEIGH STAR

JAMES R. GRIESEMER

Most scientific work is conducted by extremely diverse groups of actors—researchers from different disciplines, amateurs and professionals, humans and animals, functionaries and visionaries. Simply put, scientific work is heterogeneous. At the same time, science requires cooperation—to create common understandings, to insure reliability across domains, to gather information which retains its integrity across time, space, and local contingencies. This creates a "central tension" in science between divergent viewpoints and the need for generalizable findings. Here we examine the development of a natural history research museum, where both heterogeneity and cooperation are central issues for participants. We develop an analytical framework which can be applied to studies similarly focused on scientific work in complex institutional settings.

The plan of the paper is as follows. First we consider ramifications of the heterogeneity of scientific work and the need for cooperation among participants for translation among social worlds. We modify the *interessement* model of Latour, Callon, and Law. We urge a more ecological approach and develop the concept of boundary objects to analyze a case study of a research museum, the Museum of Vertebrate Zoology at the University of California, Berkeley; we describe conceptions of it by participants from several distinct social worlds, including those of professional scientists, amateur naturalists, patrons, hired hands, and administrators. Our discussion is suggestive rather than conclusive, outlining an approach to case studies as well as providing a partial analysis of the case at hand. We conclude with further discussion of boundary objects and the allied issue of methods standardization.

SUSAN LEIGH STAR AND JAMES R. GRIESEMER

# INTRODUCTION: THE PROBLEM
## OF COMMON REPRESENTATION
## IN DIVERSE INTERSECTING
## SOCIAL WORLDS

Common myths characterize scientific cooperation as deriving from a consensus imposed by nature. But if we examine the actual work organization of scientific enterprises, we find no such consensus. Instead, we find that scientific work neither loses its internal diversity nor is consequently retarded by lack of consensus. Consensus is not necessary for cooperation nor for the successful conduct of work. This fundamental sociological finding holds in science no less than in any other kind of work.[1]

However, scientific actors themselves face numerous problems in trying to ensure integrity of information in the presence of such diversity. The actors trying to solve scientific problems come from different social worlds and must establish a mutual modus operandi.[2] A university administrator in charge of grants and contracts, for example, answers to a different set of audiences and pursues a different set of tasks, than does an amateur field naturalist collecting museum specimens.

When the worlds of these actors intersect a difficulty appears. The creation of new scientific knowledge depends on communication as well as on creating new findings. But because these new objects and methods mean different things in different worlds, actors are faced with the task of reconciling these meanings if they wish to cooperate. This reconciliation requires substantial labor on everyone's part. Scientists and other actors contributing to science translate, negotiate, debate, triangulate, and simplify in order to work together.

The problem of translation as described by Latour, Callon, and Law is central to the reconciliation described here.[3] In order to create scientific authority, entrepreneurs gradually enlist participants (or in Latour's words, "allies") from a range of locations, reinterpret their concerns to fit their own programmatic goals, and then establish themselves as gatekeepers (in Law's terms, as "obligatory points of passage").[4] This authority may be either substantive or methodological. Latour and Callon have called this process *interessement*, to indicate the translation of the concerns of the nonscientist into those of the scientist.

Yet, a central feature of this situation is that entrepreneurs from more than one social world are trying to conduct such translations simultaneously. It is not just a case of *interessement* from nonscientist to scientist. Unless they use coercion, each translator must maintain the integrity of the interests of the other audiences in order to retain them as allies. Yet this must be done in such a way as to increase the centrality and importance of that entrepreneur's work. The N-way nature of the *interessement* (or the challenge intersecting social worlds pose to the coherence of translations) cannot be understood from a single viewpoint. Rather, it requires an ecological analysis of the sort intended in Hughes's description of the ecology of institutions:

In some measure an institution chooses its environment. This is one of the functions of the institution as enterprise. Someone inside the institution acts as an entrepreneur . . . one of the things the enterprising element must do is choose within the possible limits the environment to which the institution will react, that is, in many cases, the sources of its funds, the sources of its clientele (whether they be clients who will buy shoes, education or medicine), and the sources of its personnel of various grades and kinds. This is an ecology of institutions in the original sense of that term.[5]

The ecological analysis does not presuppose an epistemological primacy for any one viewpoint; the viewpoint of the amateurs is not inherently better or worse than that of the professionals. The important questions concern the *flow* of objects and concepts through the *network* of participating allies and social worlds. The ecological viewpoint is antireductionist. The unit of analysis is the whole enterprise, not simply the point of view of the university administration or of the professional scientist. It does, however, entail understanding the processes of management across worlds: crafting, diplomacy, the choice of clientele and personnel. Our approach thus differs from the Callon-Latour-Law model of translations and *interessement*. First, their model is a kind of "funnelling"—reframing or mediating the concerns of several actors into a narrower passage point (see Figure 33-1). The story in this case is *necessarily* told from the point of view of one passage point, usually manager, entrepreneur, or scientist. Our analysis still contains a managerial bias, in that the stories of the museum director and sponsor are much more fully fleshed out than those of the amateur collectors or other people. But it is a many-to-many mapping, where several obligatory points of passage are negotiated with several kinds of allies, including manager-to-manager types (see Figure 33-2).

The coherence of sets of translations depends on the extent to which entrepreneurial efforts from multiple worlds can coexist, whatever processes produce them. Translation here is indeterminate, analogous to Quine's philosophical dictum about language.[6] There is an indefinite number of ways entrepreneurs from each cooperating social world may make their own work an obligatory point of passage for the whole network of participants. There is, therefore, an indeterminate number of coherent sets of translations. The problem for all the actors in a network, including scientific entrepreneurs, is to (temporarily) reduce their local uncertainty without risking a loss of cooperation from allies. Once the process has established an obligatory point of passage, the job then becomes to defend it against other translations threatening to displace it.

Our interest in coherence and cooperation in science has been shaped, in part, by trying to understand the historical development of a particular institution: natural history research

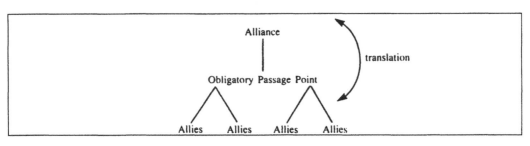

FIGURE 33-1

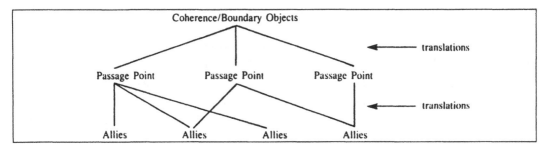

FIGURE 33-2

museums. Natural history museums originally arose when private seventeenth-century collectors opened their cabinets of curiosities to public view. Many were arranged to display, and evoke wonder at, the variety and plenitude of nature or to represent the universe in microcosm. Such museums developed as part of popular culture.[7] In the nineteenth century, many new museums were developed by amateur naturalists, rather than by members of the "general public," through their participation in amateur naturalist's societies. These societies filled an important role in the development of the museum-based science.[8] The Museum of Vertebrate Zoology (MVZ) at the University of California, Berkeley, is important as an example of a museum devoted to scientific research from its inception, aided by the alliance of an amateur naturalist/patron and a professional scientist. The MVZ did not take on scientific research as an adjunct to public instruction or popular edification as had many Eastern museums; if anything, the reverse is true. (A symbol of this is the proud advertisement on the front door: "NO PUBLIC EXHIBITS".)

As such, the development of the *research* natural history museum is important in the professionalization of natural history and an example of the changing relationship between amateurs and professionals after the professionalization of biology in America began. Unlike many cases of Eastern institutions which looked to Europe for inspiration, Western biologists struggled to gain credibility with already professionalizing Eastern United States biologists. Successful research, through which the Museum of Vertebrate Zoology's scientists hoped to gain recognition, depended on an evolving set of practices for managing the work occasioned by the intersection of professional, amateur, lay, and academic worlds.[9] There, several groups of actors—amateurs, professionals, animals, bureaucrats, and "mercenaries"—succeeded in crafting a coherent problem-solving enterprise, surviving multiple translations.

Joseph Grinnell was the first director of the Museum of Vertebrate Zoology. He worked on speciation, migration, and the role of the environment in Darwinian evolution. Grinnell's research required the labors of (among others) university administrators, professors, research scientists, curators, amateur collectors, private sponsors and patrons, field hands, government officials, and members of scientific clubs.

Some objects of interest to all these social worlds included:

- species and subspecies of mammals and birds
- the terrain of the state of California
- physical factors in California's environment (such as temperature, rainfall, and humidity)
- the habitats of collected animal species

## METHODS STANDARDIZATION AND BOUNDARY OBJECTS

It is normally the case that the objects of scientific inquiry inhabit multiple social worlds, since all science requires intersectional work. Varying degrees of coherence obtain both at different stages of the enterprise and from different points of view. Because of the heterogeneous character of scientific work and its requirement for cooperation, the management of this diversity cannot be achieved via a simple pluralism or laissez-faire. The objects *originate in,* and continue to inhabit, different worlds, reflecting the fundamental tension of science: How can findings which incorporate radically different meanings become coherent?

We see two major factors contributing to the success of the museum: *methods standardization* and the development of *boundary objects.*

Grinnell's managerial decisions about the best way to translate the interests of all these dis-

parate worlds shaped the character of the institution he built and his science.[10] His elaborate collection and curation guidelines established a museum management system in which diverse allies could participate concurrently. It was a lasting legacy. Grinnell's methods are seen as quaint and overly fastidious by current museum workers,[11] but they are still taught and practiced at the Museum of Vertebrate Zoology. (They were also adopted by several other museums around the United States during the first part of this century.[12]) For example, his course handouts for 1913[13] are similar to current field manuals for students in Zoology 107 at Berkeley.[14] There was an intimate connection between these precise standards of collection, curation and description, and the content of the scientific claims in the museum.

Museum workers managed both diversity and cooperation through *boundary objects,* those scientific objects which both inhabit several intersecting social worlds *and* satisfy the informational requirements of each.[15] Boundary objects are both plastic enough to adapt to local needs and constraints of the several parties employing them, yet robust enough to maintain a common identity across sites. They are weakly structured in common use, and become strongly structured in individual-site use. They may be abstract or concrete.[16] They have different meanings in different social worlds but their structure is common enough to more than one world to make them recognizable means of translation. The creation and management of boundary objects is key in developing and maintaining coherence across intersecting social worlds.

## GRINNELL AND THE MUSEUM OF VERTEBRATE ZOOLOGY, 1907–39

The biological sciences in America were undergoing a number of transitions during this period. The educational and cultural functions of natural history were being subsumed under scientific research goals. Biological research was increasingly conducted in universities and specialized research stations rather than in amateur societies. Professional biologists sought international credibility by distinguishing themselves from amateurs, establishing advanced degrees and specialized journals, and by eschewing the public's interests in science. For organism-based subdisciplines (e.g., ornithology, mammalogy, herpetology) the central transition was a shift from classification and morphology to process and function. Methods and practices diversified. Biological methods came to include experimental, manipulative, and quantitative techniques and natural history methods focused on increasingly specialized problems.[17]

At the same time, a number of "inventorying" efforts of the federal government were coming to fruition in reports of collecting and surveying trips to the West. The Biological Survey, for example, was a massive effort to chart the flora and fauna of the states and territories. These reports went far beyond mere catalogs. Their data was used, for example, to develop general biogeographic principles of animal and plant distribution.[18]

Ecology's participation in this meant both distinguishing itself from its descriptive natural history basis and adopting new methods. Ecologists adopted a set of problems originating in evolutionary theory (adaptation, natural selection), geography (distribution and abundance), and physiology (effects of physical factors—heat, light, soil, humidity—on life history). And they learned new methods of quantification, analysis, and use of biological indicators.[19] Ecology emerged from the last century as a distinct subdiscipline, concerned with (1) bases for adaptation, (2) extension of physiology to consider the dynamics of interacting groups of organisms,

and (3) quantification of the physical environment as it affects the life histories of organisms. New theoretical work emerged as well.[20]

Joseph Grinnell (1877–1939) extended his work in natural history to include ecological problems during this period. He studied at Stanford under Charles H. Gilbert and David Starr Jordan.[21] At Stanford, naturalists brought together problems of habitat and distribution with evolutionary theory to form an emerging geographical conception of speciation. This merger was to become of central concern to evolutionists and ecologists.[22]

## ALEXANDER AND GRINNELL

The Museum of Vertebrate Zoology was founded at Berkeley in 1908 by Annie Montague Alexander (1867–1950). Alexander was heir to a Hawaiian shipping and sugar fortune and a dedicated amateur naturalist.[23] Inspired by paleontology courses she took at Berkeley and by safari experience with her father in Africa, Alexander decided to build a museum of natural history. She chose Grinnell as first director.

Grinnell had been an enthusiastic and dedicated bird and mammal collector since his boyhood.[24] He was a founding member of the Cooper Ornithological Club, a major Western birdwatching association.

When Alexander first met Grinnell in 1907, he had already made significant theoretical contributions.[25] Jordan included him in a survey of zoologists supporting his "general law of distribution," discussed in his famous 1905 paper.[26] Grinnell became museum director in 1908; in 1913 he was appointed to the Berkeley zoology department.[27]

Beginning with Grinnell's and Alexander's own collecting efforts, the museum developed into an important repository of regional specimens of vertebrates. Alexander's contributions alone came to more than 20,000 specimens.[28] Grinnell and his staff codified a precise set of procedures for collecting and curating.[29] Many of Grinnell's monographs on the systematics, geography, and ecology of birds and mammals are still important reference works. He contributed important concepts on geographic distribution, ecology and evolution, extending Merriam's "life zone" concept to a hierarchical classification system for environments and developing a crucial concept of the niche. He argued for trinomialism in systematics and worked toward a "two-layer" theory of evolution which incorporated evolution of the environment in natural selection.[30]

## DIFFERENT SOCIAL WORLDS
## AND THEIR PERSPECTIVES

The work at the museum, like that of scientific establishments everywhere, encompassed a range of different visions stemming from the intersection of social worlds. These included amateur naturalists, professional biologists, the general public, philanthropists, conservationists, university administrators, preparators and taxidermists, and even the animals which became specimens.[31]

It is not possible to consider all these visions equally here, so we focus most fully on the entrepreneurs, Grinnell and Alexander. However, by considering their work as part of a network spanning a number of intersecting social worlds, we can begin to trace the network's paths. An adequate account of N-way translation awaits the results of tracing our way out and back again. It requires conducting such tracings from a variety of starting points (i.e., including some

starting points which would be considered "peripheral" or "subsidiary" on a one-way translation model, such as the work of commercial specimen houses or taxidermists).

These limits are, in part, conditioned by the historical record. Records of amateur collectors and articles to naturalist society newsletters are scattered. Nevertheless, it is important not to mistake the archival constraints for a theoretical model of the structure of the network itself.

## GRINNELL'S VISION

One of Grinnell's passions was the elaboration of Darwinian theory. Darwin argued that natural selection is the chief mechanism of adaptation but said little about the precise nature of environmental change. Grinnell wanted to extend the Darwinian picture by developing a theory of the evolution *of the environment* as the driving force behind natural selection.[32]

Sadly, Grinnell died before he was able to express his views in a major theoretical monograph.[33] He did outline such a volume, *Geography and Evolution*, whose chapter titles summarize his theoretical programmatic:

1. The concept of distributional limitation; chronological versus spatial conditions.
2. The nature of barriers; examples of different sorts of barriers in mammals and birds.
3. Distributional areas defined: realms, life zones, faunal areas, associations; the ecological niche.
4. Bird migration as a phase of geographic distribution.
5. Kinds of isolation; degrees of isolation as influencing results; the significance of geographic variation.
6. "Plasticity" versus "conservatism" in different groups of birds and mammals.
7. The pocket gophers and the song sparrows of California.
8. Reconcilability of geographic concept with that of genetics; species and subspecies in nature defined.
9. "Orthogenesis" from the standpoint of geographic variation.
10. The bearing of geography and evolution upon human problems.[34]

Grinnell's approaches to evolution differed radically from those of experimental genetics. His natural world was a large-scale, topographical one; units of analysis and selection included habitats and niches. This vision required vast amounts of highly detailed data about flora, fauna, and aspects of the environment. He needed a small army of assistants to collect data.

Grinnell and Alexander exchanged many letters prior to the establishment of the museum in which they expressed their hopes and visions for its future. In one of these letters, Grinnell states his scientific and political goals:

First, as regards the working up of the Alaska mammals, it seems to me it should be done as far as possible by our own men. We want to establish a *center of authority* on this coast. I take it that was one purpose you had in mind in founding the institution. I will grant that it would take our man, whoever he may be, longer to work up the paper, than the B.S. [Biological Survey] people. But in the former case we would be ever so much the stronger and better able to tackle the next problem. . . . I believe in buying desirable material where *definitely* in hand and subject to selection and inspection. I have more faith, however, in the *salaried* field man who turns in everything he finds.[35]

Grinnell was clearly concerned to insure that the materials collected by others met his scientific requirements. The odd specimen collected from here or there might serve as backup for work in taxonomy, but collection for ecological and evolutionary purposes requires thorough documentation, including documenting the presence of groups of animal species in a particular

place at the same time of day and season of the year. It also requires comparisons of samples over time—hence Grinnell's preference for the salaried "field man." Conducting this research in a museum required changes in staff, basic collecting, and curating procedures. Moreover, Grinnell also intended to build a center of authority, partly by building unique local collections of scientific value. Grinnell focused collecting efforts on the American West, a place distinguished by its great geographical diversity. His questions could only be answered by careful consideration of such geographically-based organic diversity.

Grinnell needed accurate information in the form of carefully preserved animal specimens *and* documented native habitats over tens or hundreds of years. This placed constraints on the museum's physical organization.[36] Grinnell argued that order and accuracy are the chief aims of the curator:

To secure a really practicable scheme of arrangement [of specimens, card indexes and data on specimen labels] takes the best thought and much experimentation on the part of the keenest museum curator. Once he has selected or devised his scheme, his work is not done, moreover, until this scheme is in operation through all the materials in his charge. Any fact, specimen, or record left out of order is lost. It had, perhaps, better not exist, for it is taking space somewhere; and space is the chief cost initially and currently in any museum.[37]

Grinnell continued, arguing that for accuracy:

Every item on the label of each specimen, every item of the general record in the accession catalog, must be precise as to fact. Many errors in published literature, now practically impossible to "head off," are traceable to mistakes on labels. Label-writing having to do with scientific materials is not a chore to be handed over casually.[38]

Grinnell designed the museum so that sampling from restricted locations over long periods of time would capture evolution in progress as environments changed.[39] Fulfillment of his theoretical vision required painstaking curation, thus comparisons of materials could be made by future scientists. Grinnell's concern was not unique,[40] but he was a master at articulating both the "museum conscience" and his scientific goals.[41]

Grinnell, too, had a sense of urgency about "preserving California." Alexander, Grinnell, and their associates limited themselves to California.[42] As he wrote to Alexander in the early years of the museum:

[T]here is nothing attractive about collecting in a settled-up, level country. But it *ought* to be done, and the longer we wait, the fewer "waste lots" there will be in which to trap for native mammals.[43]

Again in May of the same year, Grinnell wrote,

It would surely be a fine thing if we could acquire a collection of fresh-water ducks, geese, waders, etc. All the species, with the possible exception of killdeer and herons, are decreasing in numbers rapidly. . . . All thru [sic] San Joaquin Valley, many of the former marshy areas are now ditched or diked; and the great fields, where geese grazed, are being cut up into farms.[44]

However, the important feature of preservation was recording information, not just specimens for public education.[45] Nevertheless, it was essential to Grinnell's scientific success that he retain Alexander's patronage. He shaped research problems to work in the region which Alexander wished to document in collections. By establishing a regional center of authority, Grinnell

simultaneously shaped his research goals and leveraged Alexander's continued support—not only would she preserve a sample of California's native fauna, but also she would contribute to research.

## ALEXANDER'S VISION

Alexander, too, saw the flora and fauna of California disappearing under the advance of civilization. She felt that it should be meticulously preserved and recorded.[46] As a passionate patron, Alexander virtually controlled the museum as an autonomous organization at Berkeley. For her, the museum would demonstrate to the public the needs in conservation and zoological research.[47]

As a rich, unmarried woman, Alexander had an unusual degree of autonomy. Alexander's scrapbooks and the museum archives contain pictures of her camping out, toting rifles, and scaling mountains. She was an indefatigable collector, along with her lifelong companion, Louise Kellogg.

Alexander served the museum as its primary *patron,* funding the building, staff salaries, specimen and equipment purchases, and expeditions. She was a daily *administrator* who approved expenditures in minute detail, including operating expenses and budget reports, hiring and firing, and so forth. Grinnell reported to her and sought her advance approval of expeditions.

Alexander was not a theoretical scientist. Her primary "take" on the museum came from her commitments to conservation and educational philanthropy. The museum was a way of making a record of that which was disappearing under the advance of civilization—for her both passionate hobby and civic duty.

## THE COLLECTOR'S VISION

California was imbued with a vigorous nature-loving amateur constituency. John Muir and the Sierra Club, the Cooper Ornithological Club, the Society of Western Naturalists, and the Save the Redwoods League, among other organizations, all brought amateurs and academics together for collecting and conservation.

Amateur collectors wanted to help the scholarly pursuit of knowledge, partly as legitimacy for conservation efforts. They shared with Alexander and Grinnell a sense that the unique qualities of California and the West should be preserved and made publicly available.[48] Expeditions were at once opportunities for peaceful observation and enjoyment of nature, and a battle of wits between collectors, recalcitrant animals, and habitats.

How does one persuade a reluctant and clever animal to participate in science? For the natural historian there is a delicate balance between capturing an animal at all costs and capturing one intact, its valuable information unassailed. The animals must be captured whole; their habitats must be detailed so that the specimen has scientific meaning. ("Without a label," says one zoologist friend, "a specimen is just dead meat.") The animals must be caught quickly, before the larger ecological balances change and they adapt. Grinnell and other theorists also needed baseline data.

Animals within the museum present another kind of recalcitrance: they must be preserved against decay. The littlest allies, the dermestid beetles which clean the captured specimens so that skeletons can be used for research, are often the most difficult to discipline! They escape their bounds, eat specimens they shouldn't, and eat parts of specimens necessary for other work. Such allies are coaxed and managed through containment and a certain brute force.

A typical example appears in Louise Kellogg's field notebook from 1911:

March 20. We left the house at six and went to the Stop Thief traps first. Both had been robbed of their bait and the tracks of two animals, probably a civet and a coon were visible—in the one place the creature had reached through the trap and taken the bait without springing it and in the other had pushed aside a rock and got the bait out from above but in the scuffle the bait was caught in the trap and was found lying on one side partially eaten. I caught two *microtus* out of 21 traps . . . The bait was eaten from two set of dipodomys and the others were untouched.[49]

## THE TRAPPERS' VISION

The amateur collector was often on the front line, making contact with other social worlds: farmers on whose land they searched for specimens and trappers who could provide rare specimens. These people were invaluable sources of information and help (food, camping places)—for a price.

Most backwoods trappers being *interessed* by the museum had little interest in either conservation or science. Their coin of exchange was money, information about hunting, or possibly the exchange of a less scientifically interesting but edible specimen. Friction between viewpoints was smoothed by such exchanges. Alexander described problems with a recalcitrant trapper:

You will notice that two of the skulls are broken. It seems next to impossible to persuade a trapper to kill an animal without whacking him on the head. The bob cat is in rather a sorry plight. . . . I am holding on to Knowles [a trapper] a little longer in the hope that he may get a panther and some coyotes. . . . He set the no. 3 traps but the coyotes as he expressed it "did not throw them" although they walked all over them. . . . Knowles is about as good as the ordinary run of trappers who can't see anything in a skin except its commercial value—and the little extra care in skinning that we demand frets them.[50]

## THE UNIVERSITY ADMINISTRATION'S VISION

The University of California during this period was trying to become a legitimate, national-class university, to compete with the Eastern universities for resources and prestige. It was also still a local school, pet charity for San Francisco elite, training local doctors, lawyers, industrialists, and agriculturalists. The university accomodated the museum as long as Alexander funded it. The administration accepted Alexander's funding and control of the museum as part of this vision, measuring the museum's contribution by level of funding and prestige. In turn, Alexander enjoyed administrative power almost unheard of at major universities today, hiring and firing staff, chosing expedition sites, and liaising with the University Regents.

The different visions often clashed. Here, Grinnell responds to Alexander's chagrin about the university president's monetary vision of the museum:

I think the letter from President Wheeler is fine. You must consider his limitations (and those of the Regents) in forming any conception of the methods and aims of such an institution as the Museum. It seems nothing more than natural that these men should measure your work for the University in terms of the dollars involved. . . . It is nothing to be ashamed of, or to resent, if their appreciation seems to be prompted only by a recognition of the money cost of the Museum. They don't know any better . . .[51]

The museum was administratively separate from the Department of Zoology, and was publicly active in natural history circles. It housed meetings of natural history clubs such as the Society of Western Naturalists, thus helping to meet the university's self-image as a local cultural center.

## METHODS STANDARDIZATION
## AND BOUNDARY OBJECTS

The worlds above have both commonalities and differences. To meet the scientific goals of the museum, the trick of translation required, first, developing, teaching, and enforcing a clear set of methods to "discipline" the information from collectors, trappers, and other nonscientists; and generating boundary objects which would maximize both the autonomy and communication between worlds. Different social worlds maintained a good deal of autonomy in parallel work. Only those parts of the work essential to maintaining coherent information were pooled in the intersection of information; the others were ignored. Participants developed flexible, heterogeneous economies of information and materials where needed objects could be bartered, traded, or bought. Such economies maximized the autonomy of work considerations in intersecting worlds while ensuring "trade" across world boundaries.

From a purely logical point of view, problems posed by conflicting views can be managed in a variety of divisons of labor: "lowest common denominators"; use of versatile, plastic, reconfigurable (programmable) objects; creating a storehouse of objects from which things can be physically extracted and reconfigured; via abstraction or simplification; via parallel and limited exchanges and standardization; or via autonomous stages.

The strategies of the different participants in the museum share several of these attributes.

## METHODS AND COLLECTORS

What do you think of the system? It seems complex at first reading. But it means detailed, *exact* and easily get-at-able records. And the better the records the more valuable the specimens.[52]

Specimens are preserved in a highly standardized way, so that specific information can be recovered after storage. For example, it makes a large difference to ease of measurement, handling, and storage whether limbs are "frozen" at the sides of the body or outstretched, straight or bent. Color of pelage, scales, and so on are usually not preservable; only color photographs or accurate notes may solve this preservation problem. Whether soft parts (internal organs and fatty tissues) are preserved depends on availability of techniques, conventions for preserving external structures and the parts commonly studied. If measurements of long bones are desired the animal must usually be taken apart to expose them.[53]

For geographical distribution research, especially for inferring environmental factors limiting species' ranges from distributional data, the specimens' taxa must be linked to a geographical location and to each other. The objects of interest are *collections* of taxa from a particular geographical location. Study of the factors responsible for particular taxa in locales proceeds according to a method outlined by Grinnell et al.:

In practice, the method used in this survey to get at the causes for differential occurrence as observed was, first, to consider the observed actual instances of restriction of individuals of each kind of animal; and second, to compare all the records of occurrence with what we know in various respects of the portion of the section inhabited, this in an attempt to detect parallels between the extent of presence of the animal and of some appreciable environmental feature . . .[54]

Thus, it is necessary to translate specimens into ecological units via field notes. This creates a tension or potential incoherence between collectors and theorists. Once faunas become lists of species (and subspecies) linked to a location, their distributional limits are established in terms of the overlapping ranges of their member taxa (or a subset of indicator species). These collections must be linked to a distribution of environmental factors. Hence, in addition to the translation work of creating abstract objects (lists of species and factors) from concrete, conventionalized ones (locations, specimens, field notes), a series of increasingly abstract linked maps must be created.

Reports of field work begin with an itinerary, and often a topographic map of the region explored. Taxa represented by specimens can be plotted on these maps; if they also serve as indicators of life zones, faunas or associations, an ecological map can be constructed. In parallel, maps of environmental factor isoclines can be constructed from field notes and geographic maps. Then the environmental factors maps can be superimposed on the maps of ecological units, and the strongest concordances used to rank environmental factors as delimiters of species distributions.[55]

The specimens per se are not the primary objects of ecological study—the checklists of taxa represented in a local area are. These are then mapped into ecological units by finding subsets which are limited to a subarea. A map is constructed in terms of ranges of the ecological units set by the species ranges taken to be zonal indicators.

Grinnell and Alexander mobilized a network of collectors, cooperating scientists, and administrators to ensure the integrity of the information they collected. The standardized methods for labelling and collecting played a critical part. They were both stringent and simple, and could be learned by amateurs. They did not require an education in professional biology. At the same time, they rendered the amateurs' information amenable to professional analysis. The biologists convinced the collectors, for the most part, to adhere to these conventions—for example, to clearly specify the habitat and time of capture of a specimen in a standard format notebook.

Grinnell's insistence on and success with these standardized methods is a testament to his skillful management of the complex multiple translations involved in natural history. The protocols themselves, and the injunctions implied, are a record not only of information Grinnell needed for his theoretical developments but also of the conflicts between the participating worlds. Each protocol is a record of the process of reconciliation.

Propagating methods is difficult. Grinnell's major problem was to ensure that the amateur field data was of reliable quality; that it did not decay en route through sloppy collecting or preserving techniques; that the collectors gave enough and precise information about where they obtained the beasts. However, directions for collectors can't be so complicated that they interfere with the already-difficult job of wilderness camping, capturing sneaky little animals, or bribing reluctant farmers to preserve intact their salable specimens.

The allies enrolled by the scientist must be disciplined, but cannot be *overly* disciplined. Each world is willing—for a price—to grant autonomy to the museum and to conform to Grinnell's information-gathering standards. He only gradually comes to be an authority, partly through the standardization of methods.

Standardizing methods differs from standardizing theory. By emphasizing *how,* and not what or why, methods standardization both makes information compatible and allows for a longer "reach" across divergent worlds. Grinnell thus accomplishes several things simultaneously. Perhaps most important, methods standardization allows both collectors and professional biologists

to find a common ground in clear, precise manual tasks. Collectors do not need to learn theoretical biology in order to contribute. Potential differences in beliefs about evolution or higher-order questions are displaced by a focus on "how," not "why." Methods thus provide a useful lingua franca. They allow amateurs to contribute both to science and conservation. The standardized specimens, fieldnotes, and techniques provide consistent information for future generations or researchers elsewhere.

This approach translates the concerns of Grinnell's allies such that their pleasure is not impaired—camping, adding to personal collections, and preserving California. Grinnell creates a mesh through which collectors' products must pass but not too narrow a mesh.

One consequence is that Grinnell creates a large area of autonomy from which he can *move into* more theoretical arenas. His carefully crafted relationship with Alexander commits them both to methods and preservation techniques. As a sponsor, Alexander is concerned with preserving a representative collection of Californiana, both for posterity and as a demonstration of good scientific practice. She has little concern for scientific theory—but is quite concerned with curation and preservation.

In addition to "methods control," other means were necessary to ensure cooperation across social worlds. These were not engineered as such but emerged through work processes. As groups from different worlds work together they create various boundary objects. The intersectional nature of the museum's work creates objects which inhabit multiple worlds simultaneously, and which meet the demands of each one.

## BOUNDARY OBJECTS

Boundary objects are produced when sponsors, theorists, and amateurs collaborate to produce representations of nature. These objects include specimens, field notes, museums, and maps. Their boundary nature is reflected by the fact that they are simultaneously concrete and abstract, specific and general, conventionalized and customized. They are internally heterogeneous.

We have the following situation:

1. Many participants share a common goal: preserve California's nature. Those that do not share this goal participate in the economy via a neutral medium—direct monetary exchange. (Note: this includes the university administration!)
2. All participants agree to preserve samples of its flora and fauna, intact and well tagged.
3. For some (amateur collectors, general public, trappers, and farmers) this literal, concrete preservation of animals suffices.
4. For others (Grinnell, university administration), literal concrete preservation is only the beginning of a long process of theory making and expertise.

The different worlds share goals of conservation and of making an orderly array out of natural variety. These shared goals are lined up such that everybody is locally satisfied. How does this happen?

In building theories and an organization, Grinnell must maintain objects' conventionality for future collectors. The concerns and technologies of the amateurs, farmers, and so on must be preserved for continued full participation. But Grinnell must overcome this conventionality to make his objects scientifically interesting. It would not be enough if everyone collected objects which were not challenging science. How does Grinnell balance innovation with the conventional understandings of the amateur collectors?

Grinnell and Alexander quite brilliantly begin their enterprise by building on a goal they share with several participants (the university presidents, nature-lovers, sponsors, and local social elites): draw a line around the West (often explicitly around the state) and declare it a nature preserve. (One current museum staff member wryly stated: "When you get to the Nevada border, turn around and drive the other way!") For Grinnell, then, California became a delimitable "laboratory in the field" giving his research questions a regional focus. For the university administration, the regional focus supported its mandate to serve the people of the state. For the amateurs concerned with local flora and fauna, this boundary served their goals of preservation and conservation. This first constraint is a weak one with many advantages. It gives California itself the status of a boundary object, an object living in multiple social worlds and which has different identities in each.

Grinnell then transforms this agreement into a resource for more money. He becomes one of the primary people in charge of preserving California. He makes extensive alliances with conservation groups. This provides him with a definite but still weakly constrained and weakly structured base. His concepts build on this kernel of support. He needs a baseline for his geographical theories and comparisons, as the conservation movement needs information about the natural baseline threatened by developers. At the core of his work, then, he places a common goal and conventional understanding, bounding several coincident worlds. These coincident boundaries, around a loosely structured boundary object, provide an anchor for wider-ranging, riskier claims.[56]

From the standardized information, Grinnell builds an orderly repository. And from this library of specimens, he builds ecological theories different from those developed elewhere. His autonomy here rests on solving the problems of boundary tensions posed by the multiple intersections of the worlds which meet in the museum. Grinnell's work is highly abstract, strongly empirical, and receives strong support from participating worlds.

We found four types of boundary objects represented in these translation tasks. This is not an exhaustive list and are analytic distinctions in the sense that we are really dealing with systems of boundary objects, themselves heterogeneous.

1. *Repositories.* These are ordered "piles" of objects which are indexed in a standardized fashion. Repositories are built to deal with problems of heterogeneity caused by differences in units of analysis. An example of a repository is a library or museum. It has the advantage of modularity. People from different worlds can use or borrow from the "pile" for their own purposes without having directly to negotiate differences in purpose.

2. *Ideal type.* This is an object such as a diagram, atlas, or other description which in fact does not accurately describe the details of any one locality or thing. It is abstracted from all domains and may be fairly vague. However, it is adaptable to a local site precisely because it is vague; it serves as a means of communicating and cooperating symbolically—a "good enough" road map for all. An example of an ideal type is the species. This is a concept which in fact described no specimen, which incorporated both concrete and theoretical data, and which served as a means of communicating across both worlds. Ideal types arise with differences in degree of abstraction. They result in the deletion of local contingencies from the common object and have the advantage of adaptability.

3. *Coincident boundaries.* These are common objects which have the same boundaries but different internal contents. They arise in the presence of different means of aggregating data and when work is distributed over a large-scale geographic area. The result of such an object is that work in different sites and with different perspectives can be autonomous. However, cooperating parties can share a common referent. The advantage is the resolution of different goals. An example of coincident boundaries is the creation of the state of California itself as a boundary object for work-

ers at the museum. The maps of California created by the amateur collectors and the conservationists resembled traditional familiar roadmaps and emphasized campsites, trails, and places to collect. The maps created by the professional biologists, however, shared the same state outline (the same geopolitical boundaries) but were filled in with a highly abstract, ecologically based series of shaded areas representing "life zones."

4. *Standardized forms.* These are boundary objects devised for common communication across dispersed work groups. Because the natural history work took place at highly distributed sites by many different people, standardized methods were essential. Amateur collectors were provided with a form to fill out when they obtained an animal, standardized in the information it collected. The results of this type of boundary object are standardized indexes and what Latour would call "immutable mobiles" (objects which can be transported over long distance and convey unchanging information). The advantages of such objects are that local uncertainties (for instance, in the collecting of animal species) are deleted.

People who inhabit more than one social world—marginal people—face an analogous situation. Traditionally, the concept of marginality refers to one who has membership in more than one social world: for example, a person whose mother is white and father is black.[57] Park's classic "marginal man" discusses the tensions imposed by such multiple membership, problems of identity and loyalty.[58] Marginality has been a critical concept for understanding the ways in which the boundaries of social worlds are constructed, and the kinds of navigation and articulation performed by those with multiple memberships. The identity management strategies of marginal people—passing, trying to shift into a single world, oscillating—provide a provocative source of metaphors for understanding objects with multiple memberships. Can we find similar strategies among those creating or managing joint objects across social worlds?

A social world, such as that of amateur collectors, "stakes out" territory, literal or conceptual. If a state of war does not prevail, then institutionalized negotiations manage ordinary affairs when different social worlds share territory (for instance, the United States government and the Mafia). Such negotiations include conflict and are constantly challenged and refined. Everett Hughes described organizations which manage such spatial sovereignty collisions as "intertribal centers."[59] Gerson analyzes sovereignties based on commitments of time, money, skill and sentiment.[60] Gerson and Gerson discuss the complex management of such overlapping place perspectives.[61] The central cooperative task of social worlds which share the same space but different perspectives is translation.

We are interested in N-way translation which includes scientific objects, in particular, the kinds of translations scientists perform in order to craft objects containing elements which are different in different worlds. These are marginal objects, or boundary objects.[62] In collective work, people from different social worlds frequently have the experience of addressing an object that has different meaning for each of them. Each social world has partial jurisdiction over the object's resources, and mismatches caused by the overlap become problems for negotiation. Unlike the situation of marginal people who reflexively face identity and membership problems, however, the objects do not change themselves reflexively or voluntarily manage memberships. While they have some of the same properties as marginal people, there are crucial differences.

For people, managing multiple memberships can be volatile, elusive, or confusing; navigation is a nontrivial mapping exercise. People resolve problems of marginality in a variety of ways: by passing on one side or another, oscillating between worlds, or by forming a new social world composed of others like themselves.

However, management of these scientific objects—including construction of them—is conducted by scientists, collectors, and administrators only when their work coincides. The objects thus come to form a common boundary between worlds by inhabiting them both simultaneously. Scientists' boundary objects' management is only loosely comparable to those practiced by marginal people.

Intersections place particular demands on representations and on the integrity of information arising from more than one world. When participants in the intersecting worlds share information together, their different commitments and perceptions are resolved into representations—in the sense that a fuzzy image is resolved by a microscope. This resolution does not mean consensus. Rather, representations, or inscriptions, contain at every stage the traces of multiple viewpoints, translations, and incomplete battles. Gerson and Star[63] have discussed a similar collision in an office workplace and considered the problem of evaluating the standards which apply as reconciliation takes place—a problem which Hewitt call "due process."[64] Gokalp describes multiple fields coming together; he calls these "borderland" disciplines.[65]

The production of boundary objects is one means of satisfying these potentially conflicting sets of concerns. Other means include imperialist imposition of representations, coercion, silencing, and fragmentation.[66]

## SUMMARY

The different commitments of the participants from different social worlds reflects a fascinating phenomenon: the functioning of mixed economies of information with different values and only partially overlapping coin. Andrews has a compelling example of this from a natural history expedition of the period to Mongolia: natives there use fossils for *fang shui* (geomancy) and do so by dissolving them in liquid and drinking them.[67] Their sacred fossil beds were well protected against foraging paleontologists, who considered them equally valuable but for different reasons. The economy of the museum thus evolves as a mixture of barter, money, and complex negotiations: money in exchange for furs and animals from trappers; animals in exchange for other animals from other museums and collectors; scientific classification in exchange for specimens donated by amateurs; prestige and legitimacy for economic support; food and bait in exchange for animals' unwitting cooperation.

As the museum matures and becomes more efficient the scientists have made headway in standardizing the interfaces between different worlds. In the case of museum work, this comes from standardization of collecting and preparation methods. By reaching agreements about methods, different participating worlds establish protocols which go beyond mere trading across unjoined world boundaries. They begin to devise a common coin which makes possible new kinds of joint endeavor. But the protocols are not simply the imposition of one world's vision on the rest; if they are, they are sure to fail. Rather, boundary objects act as anchors or bridges.

The central analytical question raised by this study is: How do heterogeneity and cooperation coexist, and with what consequences for managing information? The museum is in a sense a model of information processing. In the strategies used by its participants are several sophisticated answers to problems of complexity, preservation, and coordination. Our future work will examine these answers in different domains including the history of evolutionary theory and the design of complex computer systems.

## NOTES

We would like to thank our colleague Elihu Gerson of Tremont Research Institute for many helpful conversations about the content of this paper. We would also like to thank The Bancroft Library, University of California, for access to the papers of Joseph Grinnell, Annie Alexander, and the Museum of Vertebrate Zoology. David Wake and Barbara Stein of the Museum of Vertebrate Zoology have graciously allowed us access to the museum's archives and assisted us in locating material; Howard Hutchinson of the Berkeley University Museum of Paleontology generously provided access to the Alexander-Merriam correspondence in the archives there. Annetta Carter, Frank Pitelka, Joseph Gregory and Gene Crisman have provided valuable firsthand information about Alexander, and Grinnell. We would also like to thank Michel Callon, Adele Clarke, Joan Fujimura, Carl Hewitt, Bruno Latour, John Law, and Anselm Strauss for their helpful comments and discussions of many of these ideas. Star's work on this paper was supported in part by a generous grant from the Fondation Fyssen, Paris.

1. In general social science, this finding can most clearly be seen in the studies of workplaces by Chicago school sociologists. See for example Everett C. Hughes, *The Sociological Eye* (Chicago: Aldine, 1970). For evidence of this in science, see David Hull, *Science as a Process* (Chicago and London: The University of Chicago Press, 1988); Bruno Latour and Steve Woolgar, *Laboratory Life* (Beverly Hills: Sage Publications, 1979); Bruno Latour, *Science in Action* (Cambridge: Harvard University Press, 1987); Martin Rudwick, *The Great Devonian Controversy* (Chicago and London: The University of Chicago Press, 1985); Susan Leigh Star, "Triangulating Clinical and Basic Research: British Localizationists, 1870–1906," *History of Science*, 24 (1986): 29–48.

2. Anselm Strauss, "A Social World Perspective," *Studies in Symbolic Interaction*, 1 (1978): 119–28; Elihu M. Gerson, "Scientific Work and Social Worlds," *Knowledge*, 4 (1983): 357–77; Adele Clarke, "A Social Worlds Research Adventure: The Case of Reproductive Science," in T. Gieryn and S. Cozzens (eds.), *Theories of Science in Society* (Bloomington: Indiana University Press, forthcoming).

3. Michel Callon, "Some Elements of a Sociology of Translation: Domestication of the Scallops and the Fishermen of St. Brieuc Bay," in John Law (ed.) *Power, Action and Belief, Sociological Review Monograph*, no. 32 (London: Routledge & Kegan Paul, 1985), 196–230; Bruno Latour, *Science in Action*; Latour, *The Pasteurization of France* (Cambridge: Harvard University Press, 1988).

4. John Law, "Technology, Closure and Heterogeneous Engineering: The Case of the Portugese Expansion," in Wiebe Bijker, Trevor Pinch, and Thomas P. Hughes (eds.), *The Social Construction of Technological Systems* (Cambridge, Mass.: MIT Press, 1987), 111–34; Michel Callon and John Law, "On Interests and Their Transformation: Enrollment and Counter-Enrollment," *Social Studies of Science* 12 (1982): 615–25.

5. Everett C. Hughes, "Going Concerns: The Study of American Institutions," in his *The Sociological Eye*, 52–72, at 62.

6. W. V. O. Quine, *Word and Object* (Cambridge, Mass.: MIT Press, 1960).

7. See the excellent review by L. Daston, "The Factual Sensibility," *Isis* 79 (1988): 452–67.

8. See, e.g., Sally G. Kohlstedt, "Curiosities and Cabinets: Natural History Museums and Education on the Antebellum Campus," *Isis* 79 (1988): 405–26. Although it has frequently been claimed that the rise of scientific biology coincided with the demise of natural history at the turn of the twentieth century, some have argued that natural history was "refined" rather than replaced. See, e.g., K. Benson, "Concluding Remarks: American Natural History and Biology in the Nineteenth Century," *American Zoologist* 26 (1986): 381–84. On the distinction of amateur naturalists from the public and from professional scientists, see S. Kohlstedt, "The Nineteenth-Century Amateur Tradition: The Case of the Boston Society of Natural History," in G. Holton and W. Blanpied (eds.), *Science and Its Public* (Dordrecht, Holland: D. Reidel, 1976), 173–90.

9. For an assessment of the effects on the structure of theoretical models produced, see also J. R. Griesemer, and E. M. Gerson, "Collaboration in the Museum of Vertebrate Zoology," *Journal of the History of Biology* 26(2) (1993): 185–204; J. R. Griesemer, "The Role of Instruments in the Generative Analysis of Science," in A. Clarke and J. Fujimura (eds.), *The Right Tools for the Job: At Work in Twentieth-Century Life Sciences* (Princeton: Princeton University Press), 47–76; J. R. Griesemer, "Niche: Historical Perspectives," in E. F. Keller and E. S. Lloyd (eds.), *Key Words in Evolutionary Biology* (Cambridge, Mass.: Harvard University Press, 231–40; J. R. Griesemer, "Material Models in Biology," in A. Fine, M. Forbes, and L. Wessels (eds.), *PSA 1990*, vol. 2 (East Lansing: Philosophy of Science Association, 1991), 79–93; J. R. Griesemer, "Modeling in the Museum: On the Role of Remnant Models in the Work of Joseph Grinnell," *Biology and Philosophy* 5 (1990): 3–36. Additional analysis of the role of amateur naturalists can be found in David Allen, *The Naturalist in Britain: A Social History* (London: Allen Lane, 1976).

10. Ibid.

11. Frank Pitelka, personal communication to Griesemer.

12. E. R. Hall, *Collecting and Preparing Study Specimens of Vertebrates* (Lawrence: University of Kansas, 1962).

13. Joseph Grinnell Papers, The Bancroft Library, University of California, Berkeley.

14. See manuals of instruction by Grinnell's student E. R. Hall; and S. Herman, *The Naturalist's Field Journal, A Manual of Instruction Based on a System Established by Joseph Grinnell* (Vermillion, South Dakota: Buteo Books, 1986).

15. Susan Leigh Star, "The Structure of Ill-Structured Solutions: Boundary Objects and Heterogeneous Distributed Problem Solving," in M. Huhns and L. Gasser (eds.), *Readings in Distributed Artificial Intelligence 3* (Menlo Park, Cal.: Morgan Kaufmann, 1989).

16. See Griesemer, op. cit. note 9; Nancy Cartwright and H. Mendell, "What Makes Physics' Objects Abstract?,"

in J. Cushing, C. Delaney, and G. Gutting (eds.), *Science and Reality* (Notre Dame, Ind.: University of Notre Dame Press, 1984), 134–52.

17. Garland Allen, *Life Science in the Twentieth Century* (Cambridge: Cambridge University Press, 1978); Sally G. Kohlstedt, "The Nineteenth-Century Amateur Tradition: The Case of the Boston Society of Natural History," 173–90; Benson, "Concluding Remarks"; Jane Maienschein, Ron Rainger, and Keith Benson, "Introduction: Were American Morphologists in Revolt?," *Journal of the History of Biology* 4 (1981): 83–87; Philip Pauly, *Controlling Life, Jacques Loeb & the Engineering Ideal in Biology* (New York: Oxford University Press, 1987); Ronald Rainger, "The Continuation of the Morphological Tradition: American Paleontology, 1880–1910," *Journal of the History of Biology* 14 (1981): 129–58; Garland Allen, "Morphology and Twentieth-Century Biology: A Response," *Journal of the History of Biology* 14 (1981): 159–76.

18. William Goetzmann, *Exploration & Empire* (New York: W. W. Norton, 1966); Keir B. Sterling, *Last of the Naturalists: The Career of C. Hart Merriam* (New York: Arno Press, 1977, rev. ed.); M. Smith, *Pacific Visions, California Scientists and the Environment, 1850–1915* (New Haven: Yale University Press, 1987); C. Hart Merriam, "Type Specimens in Natural History," *Science*, N.S. 5 (1897): 731–32; Merriam, "Criteria for the Recognition of Species and Genera," *Journal of Mammalogy* 1 (1919): 6–9; Merriam, "Laws of Temperature Control of the Geographic Distribution of Terrestrial Animals and Plants," *The National Geographic Magazine* 6 (1894): 229–41; Merriam, "Results of a Biological Survey of Mount Shasta, California," *Bureau of the Biological Survey, North American Fauna*, vol. 16 (1899); J. Moore, "Zoology of the Pacific Railroad Surveys," *American Zoologist* 26 (1986): 331–41; L. Spencer, "Filling in the Gaps: A Survey of Nineteenth Century Institutions Associated with the Exploration and Natural History of the American West," *American Zoologist* 26 (1986): 371–80.

19. See W. C. Allee, A. E. Emerson, O. Park, T. Park, and K. Schmidt, *Principles of Animal Ecology* (Philadelphia and London: W. B. Saunders, 1949); Sharon Kingsland, *Modeling Nature, Episodes in the History of Population Ecology* (Chicago: The University of Chicago Press, 1985); R. McIntosh, *The Background of Ecology* (Cambridge: Cambridge University Press, 1987).

20. E. Cittadino, "Ecology and the Professionalization of Botany in America, 1890–1905," *Studies in History of Biology* 4, (1980): 171–98; Joel Hagen, "Organism and Environment: Fredric Clements's Vision of a Unified Physiological Ecology," in R. Rainger, K. Benson and J. Maienschein (eds.), *The American Development of Biology* (Philadelphia: University of Pennsylvania Press, 1988): 257–80; William Kimler, "Mimicry: Views of Naturalists and Ecologists Before the Modern Synthesis," in Marjorie Grene (ed.), *Dimensions of Darwinism* (Cambridge: Cambridge University Press, 1983), 97–128. See also Kingsland, *Modeling*; MacIntosh, *Background*.

21. Hilda Grinnell, "Joseph Grinnell: 1877–1939," *The Condor* 42 (1940): 3–34.

22. Ernst Mayr, "Ecological Factors in Speciation," *Evolution* 1 (1947): 263–88; Mayr, "Speciation and Systematics," in Glenn L. Jepsen, George Gaylord Simpson, and Ernst Mayr (eds.), *Genetics, Paleontology and Evolution* (Princeton: Princeton University Press, 1949), 281–98; David Lack, "The Significance of Ecological Isolation," in Jepsen et al., *Genetics*, 299–308.

23. See Hilda W. Grinnell, *Annie Montague Alexander* (Berkeley, CA: Grinnell Naturalists Society, 1958). That she was an amateur naturalist and not merely a financial backer, is clear from Kohlstedt's discussion of the amateur tradition, "Curiosities." Amateurs were more interested in scientific investigation than the general public, which was largely interested in the exposition of ideas about nature as part of the general culture, but amateurs typically had a broad vision of the aims and nature of scientific research, ibid., 175. The dependence on amateur/patrons declined as universities and governments took over the financial stewardship of science, and eventually amateurs such as Alexander virtually disappeared from scientific academia.

24. See ibid.; Alden Miller, "Joseph Grinnell," *Systematic Zoology* 3 (1964): 195–249.

25. J. Grinnell, "The Origin and Distribution of the Chestnut-Backed Chickadee," *The Auk* 21 (1904): 364–65, 368–78.

26. D. Jordan, "The Origin of Species Through Isolation," *Science* 22 (1905): 545–62.

27. That Grinnell could become director of the museum without appointment in the Zoology department suggests that credentials for museum naturalists were not identical with those required for academic appointment. Grinnell's career marks a transitional phase in the incorporation of research natural history into academic science. For histories of the Berkeley Zoology department, including the MVZ, see Richard Eakin, "History of Zoology at the University of California, Berkeley," *Bios* 27 (1956): 66–92; and Richard Eakin, "History of Zoology at Berkeley, University of California," (1988, separate available from the department).

28. See Eakin, "History," 25.

29. These procedures included directives such as: to use a single serial set of identification numbers for all specimens collected during an expedition regardless of type, "road-kills," nests, eggs, wet preservations, and so on; to give precise data on the location of capture of a specimen including altitude and county; to "Attend minutely to proper punctuation"; to observe the proper order for reporting data on both field tags and in field notebooks; to pack "Miscellaneous material . . . with as great care as skins or skulls. Cheek pouch contents, feces, etc., should be placed in small envelopes or boxes, *with labels inserted,* and such containers packed in a stout box to prevent crushing"; and most importantly, to "Write *full* notes, even at risk of entering much information of apparently little value. One cannot anticipate the needs of the future, when notes and collection are worked up. . . . Be alert for new ideas and new facts." These quotations were taken from a handout, "Suggestions as to Collecting," used in Grinnell's natural history course, Zoology 113, Grinnell Correspondence and Papers, Bancroft Library, University of California, Berkeley. The

handout was emended and used by a number of Grinnell's successors at Berkeley and elsewhere. See also, E. R. Hall, "Collecting."

30. See Griesemer, op. cit. note 9.

31. On museums in general, see E. Alexander, *Museums in Motion: An Introduction to the History and Functions of Museums* (Nashville, Tenn.: American Association for State and Local History, 1979); Laurence V. Coleman, *The Museum in America,* 3 vols., (Washington D.C.: The American Association of Museums, 1939); George Stocking, "Essays on Museums and Material Culture," in G. Stocking, Jr. (ed.), *Objects and Others, Essays on Museums and Material Culture* (Madison: University of Wisconsin Press, 1983), 3–14. On natural history museums in particular, see C. Adams, "Some of the Advantages of an Ecological Organization of a Natural History Museum," *Proceedings of the American Association of Museums* 1 (1907): 170–78; K. Benson, "From Museum Research to Laboratory Research: The Transformation of Natural History into Academic Biology," in R. Rainger et al., *American Development,* 49–83; E. Colbert, "What is a Museum?," *Curator* 4 (1961): 138–46; Joseph Grinnell, "The Methods and Uses of a Research Museum," *Popular Science Monthly* 77 (1910): 163–69; S. Kohlstedt, "Henry A. Ward: The Merchant Naturalist and American Museum Development," *Journal of the Society for the Bibliography of Natural History* 9 (1980): 647–61; Kohlstedt "Natural History on Campus: From Informal Collecting to College Museums," (paper delivered to the West Coast History of Science Association, Friday Harbor, September, 1986); Kohlstedt, "Curiosities," 405–26; Kohlstedt, "Museums on Campus: A Tradition of Inquiry and Teaching," in R. Rainger, et al., *American Development,* 15–47; Ernst Mayr, "Alden Holmes Miller," *National Academy of Sciences of the USA, Biographical Memoirs* 33 (1973): 176–214; Ronald Rainger, "Just Before Simpson: William Diller Matthew's Understanding of Evolution," *Proceedings of the American Philosophical Society* 130 (1986): 453–74; Rainger, "Vertebrate Paleontology as Biology: Henry Fairfield Osborn and the American Museum of Natural History," in R. Rainger et al., *American Development,* 219–56; Dillon Ripley, *The Sacred Grove: Essays on Museums* (New York: Simon and Schuster, 1969); A. Ruthven, *A Naturalist in a University Museum* (Ann Arbor: University of Michigan Alumni Press, 1963).

32. Joseph Grinnell, "Significance of Faunal Analysis for General Biology," *University of California Publications in Zoology* 32 (1928): 13–18.

33. See the posthumous volume of writings, Joseph Grinnell, *Joseph Grinnell's Philosophy of Nature, Selected Writing of a Western Naturalist* (Berkeley and Los Angeles: University of California Press, 1943, reprinted by Freeport, NY: Books for Libraries Press, 1968).

34. Ibid., viii.

35. Joseph Grinnell to Annie Alexander, November 14, 1907, Joseph Grinnell Papers, The Bancroft Library, University of California, Berkeley.

36. Grinnell, "The Methods and Uses". This essay, originally a director's report to the president of the University of California, was later published in *The Popular Science Monthly* as an article outlining Grinnell's vision titled, "The Methods and Uses of a Research Museum."

37. Grinnell, "The Museum Conscience" (1922), *Philosophy of Nature,* 107–09, at 108.

38. Ibid.

39. Joseph Grinnell, "Barriers to Distribution as Regards Birds and Mammals," *The American Naturalist* 48 (1914), 248–54; Grinnell, "An Account of the Mammals and Birds of the Lower Colorado Valley with Especial Reference to the Distributional Problems Presented," *University of California Publications in Zoology* 12 (1914): 51–294.

40. See Rainger, "Just Before Simpson," for similar considerations by W. D. Matthew in the American Museum.

41. For another early example, see Adams, "Some of the Advantages."

42. See E. M. Gerson, "Audiences and Allies: The Transformation of American Zoology, 1880–1930," paper presented to the conference on the History, Philosophy and Social Studies of Biology (Blacksburg, VA, June 1987); Eakin, "History of Zoology," 25, reports the possibly apocryphal story that Jordan and Grinnell agreed that Stanford would get fishes and Berkeley would get birds and mammals.

43. Joseph Grinnell to Annie Alexander, February 13, 1911, Joseph Grinnell Papers, The Bancroft Library, University of California, Berkeley.

44. Joseph Grinnell to Annie Alexander, May 11, 1911, Joseph Grinnell Papers, The Bancroft Library, University of California, Berkeley.

45. See Grinnell, "The Methods and Uses."

46. See H. Grinnell, *Annie,* 7.

47. Annie Alexander to Joseph Grinnell, January 6, 1911, Annie M. Alexander Papers (Collection 67/121 c), The Bancroft Library, University of California, Berkeley.

48. See also Smith, *Pacific Visions.*

49. Louise Kellogg, 1911 field notebook, Fieldnote Room, Museum of Vertebrate Zoology, University of California, Berkeley. See also Annie Alexander, 1911 field notebook, for similar observations.

50. Annie Alexander to Joseph Grinnell, February 21, 1911, Annie M. Alexander Papers, The Bancroft Library, University of California, Berkeley.

51. Joseph Grinnell to Annie Alexander, March 27, 1911, Joseph Grinnell Papers, The Bancroft Library, University of California, Berkeley.

52. Joseph Grinnell to Annie Alexander, November 14, 1907, Joseph Grinnell Papers, The Bancroft Library, University of California, Berkeley.

53. See Hall, *Collecting,* for a full discussion of these preparation and preservation techniques.

54. Joseph Grinnell, J. Dixon, and Jean Linsdale, "Vertebrate Natural History of a Section of Northern California through the Lassen Peak Region," *University of California Publications in Zoology* 35 (1930): 1–594 and i–v.

55. See Griesemer, op cit. note 9.

56. William C. Wimsatt, "Robustness, Reliability and Overdetermination," in M. Brewer and B. Collins (eds.), *Scientific Inquiry and the Social Sciences* (San Francisco: Jossey-Bass, 1981), 124–63.

57. Robert E. Park, "Human Migration and the Marginal Man," in his *Race and Culture* (New York: The Free Press, 1928, reprinted 1950), 345–56; E. C. Hughes, "Social Change and Status Protest: An Essay on the Marginal Man," in his *The Sociological Eye*, 220–28.

58. See also Everett V. Stonequist, *The Marginal Man: A Study in Personality and Culture Conflict* (New York: Russell and Russell, 1937, reprinted 1961).

59. E. C. Hughes, "The Ecological Aspect of Institutions," in his *The Sociological Eye*, 5–13.

60. Elihu M. Gerson, "On 'Quality of Life,'" *American Sociological Review* 41 (1976): 793–806.

61. Elihu M. Gerson and M. Sue Gerson, "The Social Framework of Place Perspectives," in G. T. Moore and R. Golledge (eds.), *Environmental Knowing: Theories, Research and Methods* (Stroudsberg, Penn.: Dowden, Hutchinson and Ross, 1976), 196–205.

62. See Star, "Structure of Ill-Structured."

63. Elihu M. Gerson and Susan Leigh Star, "Analyzing Due Process in the Workplace," *ACM Transactions on Office Information Systems* 4 (1986): 257–70.

64. Carl Hewitt, "Offices are Open Systems," *ACM Transactions on Office Information Systems* 4 (1986): 271–87.

65. Iskander Gokalp, "Report on an Ongoing Research: Investigation on Turbulent Combustion as an Example of an Interfield Research Area" (paper presented at the Society for the Social Studies of Science, Troy, New York, 1985).

66. We are grateful to an anonymous referee for drawing our attention to the limits of the cooperation model and the importance of conflict and authority in science making.

67. Roy Chapman Andrews, *Across Mongolian Plains* (New York: D. Appleton, 1921).

# 34

# Pilgrim's Progress

## Male Tales Told during a Life in Physics

### SHARON TRAWEEK

Like many social groups that do not reproduce themselves biologically, the experimental particle physics community renews itself by training novices. Gradually, the young physicists learn the diverse criteria for a successful career. This transmission of meaning occurs not only in formal education, but also in the daily routines and in "the informal annotations of everyday experience called common sense," including stories told within this almost exclusively male community about important people and events.[1] In this chapter, I tell the tale of a pilgrim's progress in physics. It is by making progress on this journey that the pilgrim becomes a scientist. The journey itself is marked by the telling of moral tales. The five tales I shall recount are about anxiety and time, success and failure, and I shall attempt to explain how these stories could only be men's stories.

There are three stages in the education of American particle physicists: undergraduate training, graduate school, and research associate appointment, which together comprise about fifteen years in a physicist's life. Typically, only the third of these stages is played out within the precincts of a major lab like SLAC (Stanford Linear Accelerator Center); only at the completion of all three stages does one become a full-fledged member of the particle physics community. Each stage is marked by distinctive intellectual qualities which the novice must display; each stage also cultivates certain emotional states.[2]

Undergraduate physics students, to be successful, must display a high degree of intellectual skill, particularly in analogical thinking. The students learn from textbooks whose interpretation of physics is not to be challenged; in fact, it is not to be seen as interpretation. They learn to devalue past science because it is thought to provide no significant information about the current canon of physics, but they also learn, from stories in their textbooks, that there is a great gap between the heroes of science and their own limited capacities. It is not until graduate school that avuncular advisers introduce the older students to the particle physics community and cautiously allow them to see themselves as members of it; through stories of success and failure, stories about the work of the generation now in power, they teach the novices a style of "doing" physics and a "nose" for good issues. Graduate students also learn to be meticulous and very hard working.

Self-assertion and bravado must be added in the third stage, when the "students"—having earned their Ph.D.'s—become research associates. This desired ethos stands in counterpoint to, yet must include, the meticulousness and patience of the earlier phase. The "postdocs" begin to learn and communicate about physics orally, rather than through books and articles. They cultivate competitive and acerbic conversation to display independence and a contempt for mediocrity. They learn stories about those in recent generations who have "made it"; from these stories they realize how important it is to anticipate the future. Only at the completion of these first three stages can a postdoc become a full-fledged member of the particle physics community. Even so, about 75 percent leave the field after this fifteen-year training period.

Each stage has its characteristic anxiety: for the undergraduate it is a fear that one's own capacities are insignificant in comparison with those of "real scientists," or even inadequate to win admission to the community. Graduate students are afraid of using up their predoctoral years working for a team whose experiments may prove unproductive; afraid of losing their chance at success by losing time. Postdocs are looking two or three years ahead, trying to anticipate rewarding questions in physics; they become anxious about the future.

These anxieties do not disappear when the postdoc gains a permanent position; the fears of the full-fledged member of the community combine all those of the novice (fear of the accomplishments or others, fear of losing present time, fear of the future coming too fast), in somewhat revised form. The established physicists are afraid that they will not *continue* making significant contributions, that they and their work will become obsolete. These fourfold anxieties are indeed inwardly experienced, but they have been learned and cultivated in the community. It is, in part, by these anxieties that we can identify these physicists as members of their culture. In the context of a training period, the novices are learning to want passionately to do what they should by associating emotional states with certain activities.

## UNDERGRADUATE STUDENTS: INSTRUCTION IN THE MARGINS OF PHYSICS

Physics is introduced first to the undergraduate in a textbook. The instructors, who are presented as experts on physics (although not specialists in all subfields simultaneously), explain the material in the textbook. Students are given "problem sets" to solve in order to demonstrate their comprehension of the material. In "easy" problems, the students merely "plug" data into the appropriate mathematical formulae. Harder problems require the students either to recognize data in an unfamiliar form and see that it can be analyzed in ways that have already been learned, or to pick out which known formulae will serve to analyze data which are perhaps deceptively familiar. Discussion clarifies how these choices are made correctly, given the students' level of understanding.

Students also learn stereotypic experiments in highly choreographed laboratory courses. They rarely design an experiment themselves; instead they learn the classic steps in executing an experiment properly. They learn how to calculate the predicted range of error in the data, correct for it, and then analyze the data, according to certain conventional models.

Teachers show students how to recognize that a new problem is like this or that familiar

problem; in this introduction to the repertoire of soluble problems to be memorized, the student is taught not induction or deduction but analogic thinking.[3]

*Quantum Physics,* by Eyvind H. Wichmann, is a textbook that many of the postdoctoral researchers interviewed for this study once used as third-year undergraduates. It presents its topics as unfolding logically. The sequence of the presentation and the use of adverbial phrases ("around the turn of the century," "then," "today," "now," "to date") implies that the ideas that constitute the current canon of physics actually emerged chronologically in this "logical" order. The students are being introduced, subtly, to the physics community's image of its history and the place of history in its present. Practicing particle physicists look to the past only for the direct antecedents of the present; they are interested in their immediate predecessors who can be labeled the heroic discoverers of current, supposedly correct, scientific ideas. Their history of physics is a short hagiography and a list of miracles. It is this history that they teach their students: a set of oral traditions about heroes and antiheroes, detectors, and examples of "good physics judgment." The physicists' knowledge of these legends usually extends back only to their own student days; beyond this, they know only of those predecessors who can be seen as having anticipated current ideas.[4]

In the margins of Wichmann's text, the heroes of particle physics are identified.[5] These scientific giants are shown from the waist up, alone in an office, or in a portrait pose which includes only their heads and shoulders. The rhetoric of these images underlines the outward physical similarity of the men, their apparent social conformity (all but one are wearing jackets and ties), and their freedom from any particular social context (the backgrounds are blank or neutral). In another, more recent, textbook a very different photographic image—that of Richard Feynman grinning, body askew, playing bongo drums—relies heavily upon the more familiar genre for contrast.[6] In the Wichmann text Einstein, in a crumpled sweater, is the only one not wearing a suit.[7] Sommerfeld, in a hat and suit, is the only one shown outdoors (the background is out of focus). The images also reinforce the message that all major scientists are male. Ten are gazing away from the cameras, suggesting internal meditation; five are looking challengingly at the viewer.

A brief caption gives the man's birthdate and place, date of death, universities attended as a student, date of award of the Ph.D., academic positions held, references to early studies if these were not in physics, and the topics of his significant scientific work. Note is also made of any emigration from one country to another.

There is, it seems to me, a cluster of subliminal messages in these picture captions: that science is the product of individual great men; that this product is independent of all social or political contexts; that all knowledge is dependent upon or derivative from physics; that only a very few physicists will be invited into the community of particle physics; and that the boundaries of particle physics are rigidly defined.

Regarding their scientific activity as supranational and supracultural is a way for physicists to isolate their community from conflicts between their countries and maintain the stable communications network necessary for their work. The movement of Germans to Great Britain or Japanese to the United States in certain years suggests that physicists are above politics and nationalism, although political duress can threaten the proper pursuit of physics. Scientists of all nationalities—Swiss, German, Italian, Scottish, English, French, Australian, Polish, American, and Japanese—look as alike as possible in this portrait gallery, signifying that culture is not an issue among them. Listing the names and varied birthplaces again suggests that scientists emerge

in all cultures; the implication is that science and an aptitude for it are independent of variables like culture. Most physicists would argue that there are no cultural influences on their activities as scientists.

Shifts in fields of study noted in the captions suggest that physics is of more intrinsic interest for great minds than the fields they chose to leave, such as chemistry, engineering, and history. In one book for high school physics students, particle physics is represented as "the spearhead of our penetration into the unknown."[8] (Phallic imagery is found in much of the informal discourse of the male particle physicists. I know of no study of the role of sexual and sexist language in the training of any occupational groups, but such speech is abundantly present in every stage of a scientist's education.)[9] Particle physicists share the assumption that this spearhead has a shaft extending behind it; after chemistry and engineering comes biology, followed perhaps by the social sciences and humanities. They would also agree that the scale of intelligence and of reasoning capacity needed to practice these various specialties corresponds to this sequence, with particle physics the most demanding and humanities the least. Significantly, the fine arts and mathematics are not ranked in this hierarchy of knowledge. Each of them is thought to share with particle physics certain crucial characteristics: art and physics both require creative imagination; exceptional rigor in analysis is needed in both physics and mathematics. Thus, particle physics is presumed to include what is best about art and mathematics, while excluding the rest. The boundaries are finely drawn. Theoretical physicists may be chastised by their peers for being "too mathematical," or, alternatively, for lacking "physical intuition" or "cooking up schemes out of air." Experimentalists must guard against being seen as routinized "engineers" or, on the other hand, as preoccupied with bravura innovations in machine-craft.

Students also learn in Wichmann's margins what is to be excluded from their field of scientific study. One figure in the textbook shows a simple electric motor. The caption asserts that although its operation is to be explained in terms of quantum mechanics by a particle physicist, its design and construction should be in terms of classical electromagnetism and classical mechanics—the domain of engineers. The caption of another figure implies that the commercialized, popular understanding of science is merely fanciful and bears no relation to the proper study of particle physics. Women are caricatured physically and intellectually. A figure entitled "The Linear Scale of Things" graphically ranks the vast domain of physical things dependent upon elementary particles and their interactions. There is an inverse relation in the things represented between size and seriousness; the upper end of the scale is exemplified by "cute" and/or irritating creatures, from nude females to fleas. Undergraduate physics students are being asked to shift their attention from what is visible and emotionally engaging to the lower end of the scale, which the text proposes is fundamental, where nature is no longer accessible to the naked or optically aided eye.

Beyond these messages in the margin, there are instructions for the students in the body of the text, about their own status as novice physicists. They learn that information taught at each stage is often distorted or partial, a very rough approximation of the truth, which is to be disclosed at later stages. Novices are thought to be unsuited to a full disclosure of truth in these first years.[10] Stephen Brush has used textbooks from the Berkeley Physics Course Series to show that the students are urged to assume that they are not going to be an Einstein or Dirac but merely soldiers in the ranks who must learn the established rules for puzzle solving within the existing theories.[11] Recall that Francis Bacon in the *New Organon* advocated his method of investigation precisely because it enabled even the most conventional minds to make solid contributions.[12]

According to the Wichmann text, the gap between the students and the heroes identified in the margins is quite large.

These pictures and captions are consistent with what Brush describes as the "public image of scientists as rational, open-minded investigators, proceeding methodically, grounded incontrovertibly in the outcome of controlled experiments, and seeking objectively for the truth."[13] According to this idealized image of science and the scientist, rewards in the form of prizes, appointments, and publication are bestowed on those who conform to an ethos of science which values, in Robert Merton's terms, "humility, universalism, organized skepticism, disinterestedness, communism of intellectual property, originality, rationality, and individualism"—incidentally implying that these values are not incompatible.[14] A senior physicist at SLAC told me he thinks Merton's description corresponds to "an adolescent fantasy which keeps the students working" through their graduate school years and into the postdoctoral period, when they begin to get some rewards. A sociologist has reported that one of his respondents (a scientist) "indicated that the only people who took the idea of the purely objective scientist literally and seriously were the general public or the beginning science student."[15] Brush also finds that this rhetoric of disinterestedness is used explicitly to inspire young students to pursue a career in science.[16]

These textbook images of the scientist-hero, his personality and his exploits, have much in common with the fictional mode of romance. The narrative mode will change as the neophyte advances in training to become a physicist; but the image of the scientist as romantic hero has a significant place in shaping the first phase of initiation. Northrop Frye characterizes the romantic hero as a most exceptional person whose actions are marvelous; who, with great tenacity and perception, reorders our understanding of the laws of nature.[17]

## GRADUATE STUDENTS

During graduate school, the physics students are separated into subfields (solid-state physics, particle physics, plasma physics, astrophysics, and so on). Among the particle physicists, the potential theorists and experimentalists are in the same classes and mingle easily with one another. In the classroom, information is presented both through textbooks, which are essentially didactic, and through reprints of articles (papers or letters from journals). The teacher is a specialist in the subfield; the purpose of discussion continues to be clarification of the tasks to be mastered, rather than interpretation.

In the laboratory graduate students are usually given routine tasks such as dismantling, repairing, and rebuilding a piece of malfunctioning equipment. In effect, the novices are to validate their understanding of the original by making a model of it. In Balinese painting, it is a test of competence for the artist to produce a uniform background of fine detail; it is only in this context that a dynamic foreground can be seen as significant information, as deliberate and achieved rather than as error: "the function and necessity of the first level control is precisely to make the second level possible."[18] The experimentalist calls this first level of control in physics a "coherent ground state"; students must show that they can comprehend and reproduce this degree of order.

In generating a coherent ground state, the students also learn how to differentiate between errors and significant deviations in their data, and come to understand the difference between

mediocre and good experimental work. They are learning to become meticulous, patient, and persistent, and that these emotional qualities are crucial for doing good physics. They also are beginning to learn what is meant by "good taste," "good judgment," and "creative work" in physics.[19] They are receiving training in aesthetic judgments as well as in the emotional responses appropriate to those judgments (catharsis, pride, satisfaction, pleasure).[20] They are learning to live and feel physics. Most physicists said that it was in graduate school that they got their first "real feeling for physics."

During graduate school, the student either chooses or is assigned to an adviser. Typically, this person assumes an avuncular role in the novice's life.[21] No matter how outrageous or dangerous the student's errors in the laboratory, the adviser is obliged to remain tolerant. Advisers occasionally take their students "for a few beers"; the adviser tells stories and the novices joke with him.[22] During laboratory meetings, the students may briefly, teasingly "heckle" the adviser. When the student finishes graduate school, the adviser is expected to make use of his network to find the student a postdoc position. Senior experimentalists often comment on the pervasive impact their advisers had on both their personal and professional lives. Most say that they got their "sense of how to do good physics" from their adviser. In the words of Roland Barthes, "the origin of work is not in the first influence, it is in the first posture: one copies a role, then by metonomy, an art; I begin by reproducing the person I want to be."[23]

The laudatory phrases I found most frequently in a group of letters of recommendation for young physicists about to finish graduate school suggest that the ideal student is a "hard and willing worker," "careful, meticulous, and thorough," a "good colleague" who always "delivered" and had a good sense of what was possible.[24] The novice is learning by a process of trial, error, and comparison.[25]

Two of the letters of recommendation mentioned the wife of the candidate, suggesting that she "understood" that it was necessary for an experimentalist to spend many nights with the detector. Anecdotal evidence suggests that high-energy physicists typically marry as graduate students, and rarely divorce. In my discussions with about fifty wives of high-energy physicists almost all were deeply impressed with the value of their husbands' field of work. Several nodded vigorously when one well-educated wife in her late thirties told me she thought it selfish and silly for a high-energy physicist's wife to pursue her own career. She thought that one could best contribute to society and civilization by providing as much support as possible for the work of people like her husband; very little else could be as important. The older wife of a laboratory director interjected that she thought the way to avoid distracting the husband from his important work was to pursue one's own interests seriously. By their glances at each other I gathered that the younger women disagreed.

In the physics community as a whole, the proportion of wives who strongly oppose making a serious commitment to challenging work of their own is very large. In contrast, the wives of almost all of the most successful senior physicists have developed and maintained strong careers in addition to raising children (I saw men engage in parenting very rarely). This difference may be due to many factors. I suggest three possibilities: that those physicists destined to become distinguished are more likely to marry women who will sustain active careers; that the career interests of wives emerge if their husbands become especially successful, perhaps even as an emblem of that success; or that historical circumstances affect marriage values: those who married during World War II, for example, may have regarded a woman's having strong interests of her own as more acceptable than those who married in the 1950s, 1960s, and even the 1970s. Even among

this group, however, the husband's career in physics had always taken precedence in decisions about where the family should live. I found only three dual-career couples (in which both careers were apparently given equal weight) in my entire research on this community; in two of those three cases both husband and wife were high-energy physicists.

In general, the massive level of support expected by those engaged in scientific research extends not only to the laboratory staff but also to their families.[26] The families are part of the culture of high-energy physics and the stages of a career in physics mold the family, much as one might expect in other vocations such as the military, religious groups, and the arts. Those who are not married by the end of graduate school or those who are divorced can expect discussion about their personal life to be active and elaborate. I have heard male physicists in the United States, France, Germany, and the Soviet Union, but not Japan, analyze the rumors about the supposed sexual liaisons of unmarried physicists from around the world. Very rarely have I heard male physicists discuss the affairs of their married colleagues. Liaisons are discountenanced as an unworthy distraction of vital energies; from this commentary graduate students learn that a successful physicist is a married physicist. The mother of one physicist said that her son had told her he planned to marry because he did not want to bother with a social life that would "distract from his work."

Graduate students also learn stories about male scientists going to extraordinary lengths to get, record, and save data. One story concerns the bubble chamber at the now-defunct Cambridge Electron Accelerator (CEA). Bubble chambers have very sensitive and very powerful pressurization systems. As the perhaps apocryphal story goes, one night one of the propane tanks exploded, practically blowing the students out of the lab; they could have been killed. One realized he was going to lose the data for his thesis and ran back in to get it; the second explosion blew him out the door again, data in hand.

These stories follow the literary form not of romance but of high mimesis: the hero is "superior in degree to others, but not to the environment"; he is a powerful leader who is subject to the highly consistent order of nature, not a remaker of it. Whereas the romantic hero is secure in his place in the pantheon, the lesser hero of high mimesis may fall. If the story is a tragedy, his fall does not call heroism or the hero into question: he is then a "strong character in a weak situation."[27] The emotions typically generated by the high-mimetic form are pity and fear; the form emerges historically at a time when an "aristocracy is fast losing its effective power, but retaining a good deal of effective prestige."[28] The novice physicists, about to escape the power of their texts and teachers, have already begun to draw their heroes from their own kind.

## POSTDOCTORAL PHYSICISTS

The postdoctoral period, which can itself last as much as six years, concludes the long apprenticeship. Young physicists will be evaluated during this postdoctoral period to determine who will be invited to join the particle physics core community, who will become a member of one of the peripheral groups, and who will leave the field. The core community is composed of the researchers at the major laboratories and the university physics departments whose faculties include several high-energy physicists doing research at the major laboratories. Peripheral to them are the so-called facilities groups at the major labs, which maintain the research equipment, and physics faculties at lesser universities. Those who leave the field usually move into computer science, astrophysics, biophysics, or geophysics.

From the Ph.D. stage on, the successful theorists and experimentalists separate. The theorists join Theory Groups and the experimentalists join Research Groups. The experimentalist post-docs are expected to acquire and exhibit skills in detector design and construction, the design of experiments, and data analysis. Ideally, one should become equally adept at all three; at least one should not reveal a strong distaste for, or incompetence in, any of them. Versatility is important: it is not good to be identified as either a "desk" physicist or a "floor" physicist.

Postdocs are no longer students but young physicists; as such they must learn how to rely on oral rather than written information. They are expected to begin to move beyond the textbook and literature phase of their training, to scan written material primarily to find out who to talk to. Postdocs also learn about the past, conveyed to them in various oral traditions quite distinct from the history of science they were taught to avoid as undergraduates. They learn that what is current has an expected lifetime of about six months. From tales about earlier vicissitudes of their detector, and the exploits of their group leader in younger days, they learn the lore of local nostalgia.[29] Every troublesome detail is remembered; the detector itself is a mnemonic device. A detector in disuse teaches the fear of the obsolete. Postdocs learn that the living past is shallow; genesis, it is agreed, was about seventy-five years ago; genealogies of their teachers can be traced back around forty years (at least for the most notable scientists). Their broader knowledge of the past extends only to the depth of their own generation. The only ones to bother with the past are either old physicists, who no longer "have any physics left in them," or professional historians of science, who presumably "couldn't make it" as physicists.

Some of the postdocs see oral communications as a subtle tool. A European postdoc at SLAC observed to me that many American postdocs simply don't ask questions—they seem to feel that they might come across as uninformed or even stupid if they did. Another, a non-American and one of the few women in the community—she later left the field—found all this hesitation silly and asked many questions; she says that others privately thanked her for doing so. Yet another postdoc suggested that it was difficult to trust anything one heard because everyone was trying to impress the others by sounding off; he thought it best to learn on one's own.

By now the senior physicists expect the research associates to be able to do exacting work carefully, cautiously, and with persistence. Almost all postdocs tell stories of how they produced some unexpectedly essential piece of equipment or software for their research groups at the cost of an enormous amount of tedious labor in the face of serious and very complex—but ultimately uninteresting—obstacles. They usually feel that their product was hastily and greedily incorporated by the group, with little if any acknowledgment or appreciation. They no longer get the recognition they got as graduate students for doing such tasks well. Skill is taken for granted. Stories about this are told with either wry amusement or bitterness. Senior physicists will only say that postdocs must learn to live with such situations.[30]

Independent, risky work can be undertaken only if the postdoc succeeds in gaining sole responsibility for some project, a privilege not readily granted. This opportunity is won by dis-playing a convincing faith in one's own powers to do a task better than others in the allotted time and within the budget, no matter what the obstacles. This self-assertion and bravado is in part a matter of disdaining the work of others; it is necessary to show that one can and will expose mediocre work, no matter who has done it. In America postdocs learn the appropriate ways to call attention to themselves and away from their peers, and how to call upon senior group mem-bers to act as their advocates. A postdoc is expected to display drive, commitment, and charisma.

The desired presentation of self can be characterized as competitive, haughty, and superfi-

cially nonconformist. Two prominent senior physicists joked that one should "behave British and think Yiddish, but not the other way around." One group leader said that to convince others of the validity of one's work one had to have great confidence and be very "aggressive"; he added that one needed a certain "son-of-a-bitchness." An employee at SLAC who finds the habits of the physicists very interesting said that in his twenty years of watching them he had concluded that only the "blunt, bright bastards" make it, and pointed out the young physicists at the lab who in his view were clearly "too nice" to become successful. Letters of recommendation for applicants to the postdoc positions often say that even though the candidate is quiet and mild-mannered, s/he does excellent physics; in other words, those are qualities for which a candidate must compensate. Achieving the appropriate ethos can be quite stressful, and this is commented upon by many postdocs. Those unwilling or unable to develop this personal style are not likely to be recognized as serious physicists committed to their work.

In sum, senior physicists in American labs assume that good physics judgment is associated with independence, and they cultivate this trait in their postdocs by erecting barriers to it. This situation demands a "careful form of insubordination"[31] on the part of the postdoc: they respect the tacit instructions of their elders by not following their explicit instructions, and this must be done with considerable delicacy.

The postdoc situation is usually described by senior scientists, at any rate in public, rather differently. Paul Berg, in an interview at the time of his 1980 Nobel prize in chemistry, commented on how his students and research associates were building their careers by working in his lab:

My work has been built on the work of many other people, and without the people who worked with me—the post-does and students—we could never have done what we did.

In fact, many of the useful ideas came from students, while I was away.

When the head of a team like mine gets recognition, everybody in the lab knows that the credit is shared among many. I have not done any research work with my hands for five years. The work may have been initiated or guided by me, but much of the work has been done by students *who are building their careers.*

We work as a unit. Very often we cannot identify the origin of an idea. It will have been adapted and modified and changed so often, then it leads to something else, and finally there is a break-through.[32]

The discrepancy between the official description of group work as cooperative and the persistent, disguised message that only competition and transgression will prevail sets up a "double bind." Gregory Bateson, the creator of the double bind theory, says of this kind of behavior: "First, . . . severe pain and maladjustment can be induced by putting [one] in the wrong regarding [the] rules for making sense of an important relationship with another. . . . And second, . . . if this pathology can be warded off or resisted, the total experience may promote creativity."[33]

Postdocs who discover this double bind too late become angry at what they consider a deception. One group leader implied that those who complain would not have made it anyway when he said that "the unhappy RAs [postdoctoral research associates] are not the RAs we want."

Two older physicists endorse this ordeal in other terms: "Some do what they say they will do, no matter what; others give you lots of excuses about why it's not possible." "Ordinary ones keep cycling through the same mistakes; good ones become contributors."

There are many stories among postdocs about "making it big," making a major contribution to the group and assuring one's future. As one postdoc says: "There are three kinds of experimentalists: the top five percent, the next fifty percent, and the others. The top ones, no question,

they're good. The next fifty; they are very bright, but they need luck and judgment and good opportunities to make it big. And politics. The others don't make it."

A European postdoc said that the Americans are terribly competitive: "They are all trying to make a name for themselves, selling ideas and hiding ideas. They're all looking for their own private quark." An Asian postdoc who had been educated in the United States said: "People are tense and anxious; it is hard to work with them. Everyone is looking for some way to make themselves look better, to make the other guy look worse."

Another postdoc knows that he has not "made it," and he is angry. Reexamining his postdoctorate, he believes that he now understands why he failed. In the first year, he thinks, the senior experimentalists are scanning the postdocs to see who is "charismatic." They watch how the postdocs handle conversations; the preferred style is confident, aggressive, and even abrasive if one suspects that another's ideas are wrong; he feels he could have adopted this style if he had understood its importance. The next step would have been to seek out "an action sector"—an exciting, volatile, and fashionable area. At that point in his own career, "charm" became fashionable. He feels he ought to have taught himself and then taught others about "charm." He should have anticipated where the problems lay and cultivated connections accordingly. The next step would have been to gain responsibility for some large, important project—so important that others would have sought him out to talk. Ideally, he should have proposed an experiment of his own. Instead, out of loyalty and commitment, he stuck with his assigned task. Now he feels this cost him his career in high-energy physics. He believes that he would have had difficulty being granted these responsibilities, however; he sees himself as being outside the "old boys' club," because in the labs where he did graduate work his undergraduate school was not considered to be "on the map." This postdoc has come to these conclusions retroactively; he is comparing his career over the past several years with those of his peers who have made it. He has since left high-energy physics.

The graduate student's fear settles into the misery of the postdoc double bind; that misery pushes a few past their fear into a bravura performance and success. A senior experimentalist told me that someone with experience can judge new postdocs within a few days of their arrival at the laboratory. Senior physicists believe that it is not necessary to scan the hinterlands for initiates; they are sure that the exceptional candidates will eventually be brought to their attention, whether they come from Caltech and Tokyo University or from the universities of Alaska and Hokkaido. As the Americans say, "If they are good, they will get here."

The physicists see themselves as an elite whose membership is determined solely by scientific merit.[34] The assumption is that everyone has a fair start. This is underscored by the rigorously informal dress code, the similarity of their offices, and the "first naming" practiced in the community. Competitive individualism is considered both just and effective:[35] the hierarchy is seen as a meritocracy which produces fine physics.

This composite account of the postdoc's fortunes takes the literary form of low mimesis: the suffering hero strives for advancement, which is blocked by seemingly intractable obstacles; the obstacles are finally overcome by an opportunistic and vigorous response to unforeseen circumstances. While such "heroes" can inspire sympathy or scorn, we are not inclined to see them as superior beings, much less as superhuman,[36] a key difference between hero-scientists of the past and of the present.

Paradoxically, to be fully conscious of the social and psychological forces at work in this postdoctoral phase would be debilitating for the candidate, according to this community's values.

"Unconscious" in this community means arbitrary and unknowable, and hence uninteresting. Concern with these and related matters, such as how to get along with other people, is considered somewhat unscientist-like. Social eccentricity and childlike egoism are cultivated displays of commitment to rationality, objectivity, and science. Young scientists often assert their ignorance of human motives, of everything "subjective," as if that confirms their vocation.[37] Development of insight into one's own motives and actions is thought to be a diversion of time and attention better spent on science. One experimentalist has told me that he believed a successful postdoc had to be rather immature: a mature person would have too much difficulty accepting the training without question and limiting doubts to a prescribed sphere. He felt that this precondition kept most women and minorities from doing well: their social experience had taught them to doubt authority only too thoroughly.

At the end of their fifteen-year training period young particle physicists hope to become full members of the research community. However, only about a fourth of the American students will be sponsored for positions at major universities or laboratories where they will be able to continue research. Those remaining have three options, which like the less successful Ph.D.'s they take in approximately equal numbers: they can leave the field, or work at peripheral schools and cease research, or take a staff position at a major lab in which they will manage the production and maintenance of detectors (what one group leader calls "engineering management"). During their postdoctoral assignments the young physicists have learned the meaning of these four kinds of careers, as seen by the group leaders, and most have come to believe that this ranking correlates with personal ability. They know that their group leaders' evaluation of them is critical for their futures; they usually believe in its justice.

There are a very limited number of laboratories and universities "on the map" in physics. The novice physicist can learn the names of these "holy places" in physics simply by noting the places mentioned in the biographies of the great physicists located in the margins of the undergraduate textbook. As in the rest of academia and other preindustrial institutions, such as the Catholic church and the military, they are trained at the "core" and then move to the periphery.

Clear boundary markers define the community by defining specifically *both* what the group wishes to include *and* what it excludes. In the analytic language developed by Gregory Bateson, the matter in the textbook margins serves as "context markers"—signs that operate at a "higher logical type" than the (social) text—indicating to those who know the cultural clues in the context markers how to read the messages in the (social) text.[38] In other words, the immortal heroes of science in the margins of the undergraduate physics textbook define the posture one must display and the genealogy one must acquire.

To become a designer of machines one must survive all these exclusionary cuts, show oneself to be "part of the signal, not part of the background noise." In their struggle for survival novices learn about time. During the undergraduate years, students discover the insignificance of the past in high-energy physics while simultaneously learning to see the heroes of the past as inaccessibly great. Interest in the formal history of the field, full as it is of outmoded or erroneous ideas, is considered debilitating. Study of the history of physics is condensed into the generic celebration of timeless genius and "reproducing" the successful experiments under descriptions that assimilate them to current knowledge. Graduate students learn to fear losing data by accidental erasure of computer records or failure of detectors during an experiment, which results in a loss of beamtime and hence a lower production of data. Less data means a lower-quality thesis, which means less opportunity for a good postdoc position. Postdoctoral research associates,

from stories about those who have made it, realize how important it is to anticipate future new directions in theory and new solutions to the design problems of detectors. In order to be successful, they must privately figure out the future of physics. When the novices become members of an experimental research group, they begin to identify their own careers with that of a detector. After their ten years of training, they now have about ten more years to make their reputations in the field. It is as new group members that the young physicists learn the significance of the lifetimes of detectors, research groups, laboratories, careers, and ideas. Fear of obsolescence in these five areas leads to a recognition that uptime, downtime, and beamtime are scarce commodities to be acquired and used in the contest for power.

## GROUP LEADER

During his career, a group leader accumulates considerable wealth in the form of detectors, targets, and computer software, as well as his less tangible—but perhaps even more significant—reputation in the community. (In Japan this wealth is controlled by the entire *koza:* the full professor, the associate professors, and the assistant professors.) That reputation is the power that the leader wields in the community as a whole; it is symbolized by his membership on laboratory program advisory committees, which determine which experiments will be accepted, and by his control of a network cutting across laboratories and physics departments around the world. This wealth must be maintained assiduously; it is not clear that it can be inherited. Every powerful senior physicist can invoke a lineage of which he is a part, naming his teacher and his teacher's teacher. It is direct descent from one leader to another in this lineage and the attendant privileges, rights, and duties that a leader will try to bequeath to one of the postdocs who have worked with him. The generations are about fifteen years apart, which means that a group leader would be choosing among approximately twenty-five postdocs for his presumptive heir.[39] But if the group leader began to assert his influence on behalf of a successor, the other group leaders would begin to resist it. It might appear that a group leader could gain concessions and establish his heir, but in trying to do so he would have to spend some of his wealth—thereby weakening his own position, leaving him little to bequeath. Nevertheless, they try. During the old days of funding expansion they could start new groups for their heirs. Now the only group their heirs might lead is their own. Just as this generation's leaders' power reaches its zenith, their capacity for naming the next generation's leaders is lost because of declines in funding.

Among the five to ten postdocs the group leader actively supports during their careers at other departments and laboratories, one or two usually have the ambition to achieve the stature of group leader. These postdocs feel that it is better for their careers in the long range to move outside their leader's immediate circle. If he is able to establish himself, usually with the continued implicit support of the group leader, the young physicist will be extending the group leader's reputation, influence, and network, not depleting it. The leader and protégé will help each other in building and maintaining domains in their respective generations.

The senior physicists feel that they share a strong commitment to physics; they fear that the younger physicists only came into the field for the glamour and excitement. Some are pleased that biology has become fashionable, because the students who follow fashion will not be in physics. Nevertheless, some physicists are very concerned about so many physics students switching to biology.[40] I listened to one professor at a midwestern university explain for nearly

an hour to a student that while the financial opportunities were greater in biology, the "real science" always has been in physics.

The second problem, according to the senior physicists, is that funding for particle physics began to diminish around 1970. (Actually only the rate of increase has declined.) They characterize their field until that time as having "grown exponentially."[41] They mean that a sufficiently talented graduate could have expected before 1970 to spend five years in graduate school, five years as a postdoc, five years in a research group, and then to become a group leader. They realize that this is no longer possible.

The Americans believe that these two problems—the decline in quality of students and in quantity of funding—are due to forces outside the particle physics community. Nevertheless, they are compelled to cope with the consequences, obliged to spend what they consider an inordinate amount of time attending to the next generation, both in restricting entry into the field and in getting favored candidates established with research groups of their own.

Full-fledged physicists in America typically tell stories about how good their own work is and how inadequate the work of others in their generation is. For example, one physicist at SLAC said to me that "there is no one 'in-house' at Fermilab who can tie his shoes experimentally." Another physicist said that some well-known experimentalists are consistently wrong, and that their careers are founded only on their personalities. He mentioned a "personal project" of his; over the years he had followed the career of a colleague internationally known as a "brilliant ideas man" and checked out where this man's ideas actually came from. In talking with colleagues across the country, he had yet to find that even one idea had been original. He added that he had found that *one* experimentalist in the field was consistently right: a Nobel prize winner who "never has an original idea" but who specializes in "shooting down spectacular experiments." He went on to say that this man has organized a group of devoted, willing workers, whom he works very hard, and has built a standard detector very meticulously. If his experiments corroborate the "spectacular experiment," his team's work is regarded as the proof; if they contradict it, then his group gains credit for exposing error. I have been told many stories during my fieldwork by several senior physicists about this man's supposedly egocentric, authoritarian manner and his unimaginative physics.

In ironic reversal of the graduate student's stories about the fear of losing data, the anxieties of the permanent group member are about having data that no one will notice, about everyone paying attention to someone else's data. The end of an active experimental career in physics occurs at about fifty. It is considered inappropriate for someone over fifty to be making discoveries.

The senior physicists are convinced that the successes of their own generation were based on brash, youthful intelligence, independence, and competition. They wonder if there was something distinctive about their generation, the people who graduated at the end of World War II, but in general they are inclined to believe that the current young generation is not of the same quality as the physicists of the previous fifty or sixty years.

An undergraduate learns to focus on the present, a graduate student discovers that there is not enough time in the present. Postdocs should learn that the future is too short, that they have to anticipate it in order to have enough time. Full-fledged physicists worry about apportioning time between doing physics and going "on the circuit." Senior physicists know that what one needs to be concerned about is obsolescence. Whether for the laboratory, one's detector, one's career, or even one's own ideas, time is running out again, as for the graduate students, but now

it is another kind of time. What senior figures need to do before their accomplishments become seen as the last generation's, rather than the last year's, is to make a transition into being one of the statesmen of the field.

## STATESMEN IN PHYSICS

The first stage in becoming a science statesman is administering a laboratory. Each laboratory is thought by physicists to reflect the necessarily powerful personality of its director. Accelerators come into being because of the vision, creativity, and tenacity of an individual who can gather about him a team of gifted people whose work he directs and coordinates by means of his example, will, and—some would say—whim. In the United States, rule through a formal organization structure is considered bad for physics.

When I ask these statesmen if they still think about experiments, they say, "Well, I'm really too busy for that sort of thing, I don't have time. Of course, I'm interested, I keep up with things, go to conferences." Often at the very top conferences a lot of senior people sit around in their shirt sleeves, clearly enjoying the debate, but they are not the speakers, usually. That would be inappropriate.

Statesmen no longer actually do physics; they recruit students. They get money for the lab; they get money for science, they attend to the public understanding of science. It is utterly inappropriate for junior persons to be doing any of these things. Only a senior person can do this. Furthermore, only a senior person who has made a significant discovery can do it, one who has manifestly been able to avoid for an entire career the corrupting enticements of extrascientific power. On the other hand, interacting with people outside is itself a kind of corruption.

Teaching, administration, and consulting for the government are potentially contaminating because they require the cultivation of skills not thought to be based on reason—in particular, the power of persuasion. The scientists themselves usually claim that they no longer do research because they have no time; other scientists believe that these science-statesmen chose their new role because they no longer had "any science left in them." These statesmen regularly transgress the boundary between the domain of rational laws of science and the arbitrary laws of humanity, but not with impunity. As emissaries to the world of the merely human, they are disbarred from practicing science. In a final twist of irony, they take their place in the margins of the textbooks of undergraduate physics students, heroically guarding the boundaries of physics.

## GENIUSES

The textbook I reviewed at the beginning of this chapter emphasized the gap between the reading student and the very distant geniuses of science. The second story, about the exploding laboratory, suddenly situated the graduate student novice in physics as hero, gallantly rescuing data for science. The postdoc's story was about commitment, about tenacity in the face of nearly insurmountable obstacles, and about the courage to gamble, and the story of the group leader says that by the end of an exemplary career a good scientist is a negotiator, a talent broker, and a fundraiser. Finally, the scientist may become the subject of textbook stories, a genius of science held in awe by those reading their first stories in science. Those stories of timeless genius regen-

erate the romance of science. Eminent scientists also generate their own stories about their discoveries. I quote from one of those autobiographical accounts in a Nobel lecture:

That was the beginning, and the idea seemed so obvious to me and so elegant that I fell deeply in love with it. And, like falling in love with a woman, it is only possible if you do not know much about her, so you cannot see her faults. The faults will become apparent later, but after the love is strong enough to hold you to her. So, I was held to this theory, in spite of all difficulties, by my youthful enthusiasm. . . . So what happened to the old theory that I fell in love with as a youth? Well, I would say it's become an old lady, who has very little that's attractive left in her, and the young today will not have their hearts pound when they look at her anymore. But, we can say the best we can for any old woman, that she has been a very good mother and has given birth to some very good children. And I thank the Swedish Academy of Sciences for complimenting one of them. Thank you.[42]

Another Nobel laureate concluded a brief scientific autobiography by explaining his feelings for the object of his prize-winning studies: "Writing this brief biography has made me realize what a long love affair I have had with the electron. Like most love affairs, it has had its ups and downs, but for me the joys have far outweighed the frustrations."[43] Such stories express the scientists' deep desire for knowing about nature and their deep desire for acquiring data. At the same time, they also point to what these physicists feel about knowing and think about loving.[44]

In these autobiographical statements nature and ideas about nature are coalesced, anthropomorphized into a singular female love object. The image of real female human beings held by almost all these male scientists is that women are more passive, less aggressive than men. This socially constructed gender difference is used by many scientists to define the relation between themselves and their love object. The scientist is persistent, dominant, and aggressive, ultimately penetrating the corpus of secrets mysteriously concealed by a passive, albeit elusive nature. The female exists in these stories only as an object for a man to love, unveil, and know.

In their careers, physicists journey from romantic readings of others' lives, through handing on mimetic tales of heroic action and quests for survival, to becoming skilled practitioners of gossip and rhetoric. They complete the circle by telling erotic tales about physics, tales transformed into romance for the next generation of neophytes. These stories reflect how physicists come to care passionately about who they are and what they are doing. Together they form a picaresque cycle, which chronicles a journey that begins necessarily with innocence and reports its loss; it depicts the growth of strength and the pain of betrayal, hails the achievement of success, recognizes the signs of grace in eminent discoveries, looks back in erotic nostalgia, and lastly eulogizes the heroic dead.[45] In Western culture the picaresque genre is usually reserved for stories about men, not women: women are not seen as gaining strength and wisdom through the rambunctious loss of their "innocence." The very form of these exemplary tales excludes women as their proper subject.

I am not suggesting that only biological males can participate in the cycle. I am claiming that in this cycle a certain cluster of characteristics is associated with success, a cluster that is part or our culture's social construction of male gender.[46] These stories about a life in physics define virtue as independence in defining goals, deliberate and shrewd cultivation of varied experience, and fierce competition with peers in the race for discoveries. Independence, experience, competition, and individual victories are strongly associated with male socialization in our culture. By contrast, recent studies in Japan suggest that these are the qualities associated with professionally active women, not men. Women are seen as not sufficiently schooled in the masculine virtues of interdependence, in the effective organization of teamwork and camaraderie, commitment to

working in one team in order to complete a complex task successfully and consulting with group members in decision making, and the capacity to nurture the newer group members in developing these skills. It would appear that there is nothing consistent cross-culturally in the content of the virtues associated with success. We do see that the virtues of success, whatever their content, are associated with men.

By examining affect and gender in the stories physicists tell I am exploring part of a larger tale. The informal stories people tell in the laboratory can give us a special perspective on the dominant models of success and failure in a community; those models are not gender-free in form or content. Affect and gender are significant components in the division of labor in laboratory research, as well as in decision-making, dispute-making, and leadership styles that are part of the whole realm of power and tradition in scientific research. My purpose is not to make a psychological exposé, but to clarify the patterns in everyday laboratory practices.

NOTES

1. Clifford Geertz, "From the Natives' Point of View: On the Nature of Anthropological Understanding," in *Meaning in Anthropology*, ed. Keith H. Basso and Henry A. Selby (Albuquerque: University of New Mexico Press, 1976), p. 235.

2. For a study of another culture's organization of emotional states in boys and men during a very long socialization process, see Gilbert H. Herdt, *Guardian of the Flute: Idioms of Masculinity* (New York: McGraw-Hill, 1981). For an analysis of the "psychological adjustments" appropriate to different career stages in America, see Gene W. Dalton, Paul H. Thompson, and Raymond L. Price, "The Four Stages of Professional Careers: A New Look at Performance by Professionals," *Professional Dynamics*, Summer 1977, pp. 19–42. For a study of how affect is linked "to characteristic sorts of activity that change through the life cycle," see Michelle Zimbalist Rosaldo, *Knowledge and Passion: Ilongot Notions of Self and Social Life* (Cambridge: University of Cambridge Press, 1980), p. 63 and passim. For a reevaluation of the anthropological analysis of emotions, see Renato Rosaldo, "Grieving and the Anthropology of Emotions," in *Text, Play, and Story: The Construction and Reconstruction of Self and Society*, ed. by Stuart Plattner, Proceedings of the American Ethnological Society (Washington, D.C.: American Ethnological Society, 1983). The following nonanalytic, anecdotal accounts of elite male socialization in the United States provide data on the cultural construction of emotion: Scott Turow, *One L: An Inside Account of Life in the First Year at Harvard Law School* (New York: Penguin Books, 1978); Charles LeBaron, *Gentle Violence: An Account of the First Year at Harvard Medical School* (New York: Marek, 1981); and Fran Worden Henry, *Toughing It Out at Harvard* (New York: McGraw-Hill, 1984).

3. On analogic thinking in science, see Mary B. Hesse, *Models and Analogies in Science* (Notre Dame, Ind.: University of Notre Dame Press, 1979).

4. Eyvind H. Wichmann, *Quantum Physics*, Berkeley Physics Course, vol. 4 (New York: McGraw-Hill, 1971). See also Thomas S. Kuhn, "The Essential Tension: Tradition and Innovation in Scientific Research," in *Scientific Creativity: Its Recognition and Development*, ed. C. W. Taylor and Frank Barron (New York: Wiley and Sons, 1963), p. 352.

5. On the rhetoric of images and captions, see Roland Barthes, *Empire of Signs*, trans. Richard Howard (New York: Hill and Wang, 1982); *Roland Barthes*, trans. Richard Howard (New York: Hill and Wang, 1977); and *Image Music Text*, trans. Stephen Heath (New York: Hill and Wang, 1977).

6. Richard Feynman, *The Feynman Lectures in Physics* (Reading, Mass.: Addison-Wesley, 1964), p. xx.

7. Roland Barthes analyzes the popular image of Einstein as genius in "The Brain of Einstein," *Mythologies*, trans. Annette Lavers (New York: Hill and Wang, 1972), pp. 68–70. The photograph of Einstein I have most often seen in physicists' studies is the poster in which he is riding a bicycle awkwardly.

8. W. K. H. Panofsky and R. H. Dalitz, *Particle Physics* (thirteen chapters reprinted by SLAC, n.d., from *Nuclear Energy Today & Tomorrow.*)

9. For an introduction to the scholarly literature on gender, language, and power see Barrie Thorne and Nancy Henley, eds., *Language and Sex: Difference and Dominance* (Rowley, Mass.: Newbury House, 1975); Sally McConnell-Ginet, Ruth Borker, and Nelly Furman, eds., *Women and Language in Literature and Society* (New York: Praeger Publishers, 1980); and Dale Spender, *Man Made Language* (London: Routledge and Kegan Paul, 1980). For a study of the relation between linguistic competition and social action, see Alan Dundes, Terry Leach, and Bora Ozkok, "The Strategy of Turkish Boys' Dueling Rhymes," in *Directions in Sociolinguistics: The Ethnography of Communication*, ed. John J. Gumperz and Dell Hymes (New York: Holt Rinehart and Winston, 1972), pp. 130–160. I am indebted to the observations of Professor John Law, University of Keele, Professor Barrie Thorne, University of Michigan, and Frank A. Dubinskas, Boston College, for their personal communications of their experiences and observations of the rhetoric of sexual domination in scientific communities, and to Professor S. A. Edwards, University of Pittsburgh, for his observations on how "vulgar," male, sexist discourse serves to silence women in order to gain power over them. For comments on the role of male "sexual vernacular" in the American business community, see Betty Lehan Harragan, *Games Your Mother Never Taught You: Corporate Gamesmanship for Women* (New York: Warner Books,

1977), pp. 110–116, and Rosabeth Moss Kanter, *Men and Women of the Corporation* (New York: Basic Books, 1977), pp. 223–226.

10. Anthony Forge discusses this form of training as it is practiced among the Abelan in "Learning to See in New Guinea," in *Socialization: The Approach from Social Anthropology*, ed. Philip Mayer (London: Tavistock, 1970), pp. 269–291, especially 276–278. This practice of telling novices that what they once learned as truth is now to be revised is associated with long novitiates. For analysis of this practice in complex societies, see Rue Bucher and Joan G. Stelling, *Becoming Professional*, Sage Library of Social Research, vol. 46 (Beverly Hills, Calif.: Sage Publications, 1977), and Charles L. Bosk, *Forgive and Remember: Managing Medical Failure* (Chicago: University of Chicago Press, 1979), and Benson R. Snyder, *The Hidden Curriculum* (New York: Knopf, 1971).

11. Stephen Brush, "Should the History of Science Be Rated X?" *Science*, March 22, 1974, p. 1170.

12. Francis Bacon, *The New Organon and Related Writings*, ed. Warhat, pp. 352, 358. P. B. Medawar also makes this point in his *Advice to a Young Scientist* (New York: Harper and Row, 1979).

13. Stephen Brush, "Should the History of Science Be Rated X?", p. 1164.

14. Robert K. Merton, "Priorities in Scientific Discovery: A Chapter in the Sociology of Science," *American Sociological Review*, December 1957, pp. 635–659. Following the functionalist social system theory and the multivariate statistical analysis that Merton advocated, American sociologists of science have generated many studies of the "reward system" in science. See Bernard Barber, "Science: The Sociology of Science," *International Encyclopedia of the Social Sciences* (1968), vol. 14, pp. 92–100. Nevertheless, in a review article, Mulkay states that the "lack of direct data on commitment on the 'social norms of research' is astonishing, given that these norms were first formulated over 30 years ago, and given the frequency with which they have been mentioned in the literature." M. J. Mulkay, "Sociology of the Scientific Research Community," in *Science, Technology, and Society: A Cross-Disciplinary Perspective*, ed. Ina Spiegel-Rosing and Derek de Solla Price (Beverly Hills, Calif.: Sage Publications, 1977), pp. 135 and 97–99. See also M. J. Mulkay, "Some Aspects of Cultural Growth in the Natural Sciences," *Social Research*, spring 1969, pp. 22–52.

15. Mulkay, "Sociology of the Scientific Research Community," p. 108.

16. Brush, "Should the History of Science Be Rated X?"

17. Northrop Frye, *Anatomy of Criticism: Four Essays* (Princeton, N.J.: Princeton University Press, 1971), pp. 33–36.

18. Gregory Bateson, "Style, Grace and Information in Primitive Art," in *Steps to an Ecology of Mind* (New York: Ballantine Books, 1972), p. 148.

19. On the invention of the idea of creativity, see Roy Wagner, *The Invention of Culture* (Chicago: University of Chicago Press, 1981), pp. 140–145. See also Raymond Williams, *Keywords: A Vocabulary of Culture and Society* (New York: Oxford University Press, 1976), pp. 72–74.

20. See n. 2, above.

21. By referring to this relationship as avuncular, I am invoking the anthropological notion of the "avunculate": "the right and duties the maternal uncle has toward his sisters' sons and his power over them," together with the informal and ritual behavior appropriate to that relationship. Robin Fox, *Kinship and Marriage: An Anthropological Perspective* (Harmondsworth, England: Penguin Books, 1976), p. 105. See also A. R. Radcliffe Brown, "On Joking Relationships" and "A Further Note on Joking Relationships," *Structure and Function in Primitive Society* (New York: The Free Press, 1965), pp. 90–132, and Gregory Bateson, *Naven: A Survey of the Problems Suggested by a Composite Picture of the Culture of a New Guinea Tribe Drawn from Three Points of View* (Stanford, Calif.: Stanford University Press, 1958), pp. 35–53, 74–85, and passim.

22. I have no data on female advisers.

23. Roland Barthes, *Empire*, p. 99.

24. The sample included approximately thirty letters of recommendation written to one group leader, in which I noted ninety-two qualitative, evaluative remarks, five of which I saw repeated in at least ten letters, and two were repeated six times: good judgment (10); careful, meticulous, thorough (13); delivered (10); hard and willing worker (16); good colleague (11); good physicist (10); independent (6); intelligent (6). One was called original, two were said to be able to express themselves cogently, and two were identified as ready for the responsibility to organize a project.

25. For a discussion of the role of error in learning, see Gregory Bateson, *Naven*, p. 274.

26. For a study of the "crucial social support mechanisms" in science, see Ian I. Mitroff, Theodore Jacob, and Eileen Trauth Moore, "On the Shoulders of the Spouses of Scientists," *Social Studies of Science*, August 1977, pp. 303–327.

27. Northrop Frye, *Anatomy of Criticism*, pp. 33–38.

28. Ibid.

29. Nostalgia is a form of historical consciousness. According to Dean MacCannell, *The Tourist: A New Theory of the Leisure Class* (New York: Schocken Books, 1976), p. 3, nostalgia is a key component in the ethos of progress: "The progress of modernity . . . depends on its very sense of instability and inauthenticity. For moderns, reality and authenticity are thought to be elsewhere: in other historical periods and other cultures, in purer, simpler lifestyles. In other words, the concern of moderns for 'naturalness,' their nostalgia and their search for authenticity are not merely casual and somewhat decadent, though harmless, attachments to the souvenirs of destroyed cultures and dead epochs. They are also components of the conquering spirit of modernity—the grounds of its unifying consciousness." Paul Fussell, *The Great War in Modern Memory* (London: Oxford University Press, 1975), has argued that individual memories of the past are shaped by socially constructed, collective narratives which need have little relationship to the once lived experience. The narratives about detectors are success stories.

30. On the negotiation of reputation in American culture, see Erving Goffman, *The Presentation of Self in Every-day Life* (Garden City, N.Y.: Doubleday Anchor Books, 1959).

31. Professor Donald T. Campbell, Syracuse University, personal communication, April 14, 1978.

32. Stanford University, *Campus Report,* October 15, 1980, p. 4; emphasis mine.

33. Gregory Bateson, *Naven,* p. 278.

34. For a discussion of the ideology of "entitlement" among the American upper classes, see Robert Coles, *Privileged Ones* (New York: Little, Brown, 1977), pp. 361–409. Roy M. MacLeod surveys the studies of scientific elites in "Changing Perspectives in the Social History of Science," in *Science, Technology, and Society,* pp. 106–122.

35. I am indebted to Professor S. A. Edwards, University of Pittsburgh, for this point.

36. Northrop Frye, *Anatomy of Criticism,* pp. 39–45.

37. For one formulation of why science need not concern itself with motives, see Kenneth Burke, *A Grammar of Motives* (Berkeley: University of California Press, 1969), pp. 505–507.

38. Bateson, *Steps to an Ecology of Mind.*

39. Fox, *Kinship and Marriage.*

40. On the problems of recruitment and job placement in physics, see Martin L. Perl and Roland H. Good, "Graduate Education and the Future of Physics"; Eugen Merzbacher, "Physics as a Career in the Seventies"; and L. Grodzins, "Where Have All the Physicists Gone?" (papers presented at the Conference on Tradition and Change in Physics Graduate Education, Pennsylvania State University, August 1974); "Tradition and Change in Physics Graduation Education," *Physics Today,* November 1974, p. 91; "Changing Career Opportunities for Physicists," *Physics Today,* October 1977, pp. 85–86; and Thomas L. Neff, Melvyn J. Shochet, Walter D. Wales, and Jeremiah D. Sullivan, "Report on HEPAP [High Energy Physics Advisory Panel], Subpanel on High Energy Physics Manpower," February 1978.

41. On growth rates of scientific communities, see Derek de Solla Price, *Science Since Babylon* (New Haven: Yale University Press, 1961), pp. 110–116.

42. Richard P. Feynman, "The Development of the Space-Time View of Quantum Electrodynamics," *Science,* 12 August 1966, pp. 699–708.

43. "Burton Richter: A Scientific Autobiography," *SLAC Beam Line,* November 1976, pp. 7–8.

44. For a study which characterizes the historical relationship between scientist and nature as that between a dominant male and passive female, see E. F. Keller, "Baconian Science: A Hermaphroditic Birth," *Philosophical Forum,* spring 1980, pp. 299–308. See also her "Gender and Science," *Psychoanalysis and Contemporary Thought,* vol. 1, no. 3 (1978), pp. 409–433. Both are revised and included in Keller's *Reflections on Gender and Science* (New Haven: Yale University Press, 1985).

45. On the picaresque genre see Frank W. Chandler, *The Literature of Roguery* (New York: Burt Franklin, 1958), vol. 2, pp. 469–549; Stuart Miller, *The Picaresque Novel* (Cleveland: Case Western Reserve University, 1967); Harry Sieber, *The Picaresque* (London: Methuen, 1977), pp. 58–74; and Alexander Blackburn, *The Myth of the Picaro: Continuity and Transformation of the Picaresque Novel, 1554–1954* (Chapel Hill: University of North Carolina Press, 1979).

46. On gender and genre, see Susan Gubar and Sandra M. Gilbert, *The Madwoman in the Attic: The Woman Writer and the Nineteenth-Century Literary Imagination* (New Haven: Yale University Press, 1979).

# 35

# What Are We Thinking About When We Are Thinking About Computers?

C omputers offer themselves as models of mind and as "objects to think with." They do this in several ways. There is, first of all, the world of computational theories. Some artificial intelligence researchers explicitly endeavor to build machines that model the human mind. Proponents of artificial life use computational processes capable of replication and evolution to redraw the boundaries of what counts as "alive." And second, there is the world of computational objects themselves: everything from toys and games to simulation software and Internet connections. Such mundane objects of the computer culture influence thinking about self, life, and mind no less than the models of the computational philosophers. Computers in everyday life make possible a theoretical tinkering similar to what Claude Lévi-Strauss (1968) described as *bricolage*—the process by which individuals and cultures use the objects around them to reconfigure the boundaries of their cognitive categories.

Here I present examples of how engaging with a variety of computational objects (interfaces, virtual communities, and simulation games) provides material for reshowing categories of knowing, of identity, and of what is alive.

## I. THINKING ABOUT KNOWING
## THROUGH THE PRACTICE OF INTERFACES

In the 1980s most computer users who spoke of transparency were referring to a transparency analogous to that of traditional machines, an ability to "open the hood" and poke around. But when, in the mid-1980s, Macintosh computer users began to talk about transparency, they were talking about seeing their documents and programs represented by attractive and easy-to-interpret icons. They were referring to an ability to make things work without needing to go below the screen surface. This was, somewhat paradoxically, a kind of transparency enabled by complexity and opacity. As one user said, "The Mac looked perfect, finished. To install a program on my

DOS machine, I had to fiddle with things. It clearly wasn't perfect. With the Mac, the system told me to stay on the surface." This is the kind of computer interface that has come to dominate the field; no longer associated only with the Macintosh, it is nearly universal in personal computing.

Today, the word "transparency" has taken on its Macintosh meaning in both computer talk and colloquial language. In our culture of simulation, when people say that something is transparent, they mean that they can easily see how to make it work. They don't mean that they know why it is working by reference to an underlying process.

"Your orgot is being eaten up," flashes the message on the screen. It is a rainy Sunday afternoon and I am with Tim, thirteen. We are playing SimLife, Tim's favorite computer game, which sets its users to the task of creating a functioning ecosystem. "What's an orgot?" I ask Tim. He doesn't know. "I just ignore that," he says confidently. "You don't need to know that kind of stuff to play." I suppose I look unhappy, haunted by a lifetime habit of not proceeding to step two before I understand step one, because Tim tries to appease me by coming up with a working definition of orgot. "I think it is sort of like an organism. I never read that, but just from playing, I would say that's what it is."

The orgot issue will not die. A few minutes later the game informs us: "Your fig orgot moved to another species." I say nothing, but Tim reads my mind and shows compassion: "Don't let it bother you if you don't understand. I just say to myself that I probably won't be able to understand the whole game anytime soon. So I just play." I begin to look through dictionaries in which orgot is not listed and finally find a reference to it embedded in the game itself, in a file called READ ME. The text apologizes for the fact that orgot has been given several and in some ways contradictory meanings in this version of SimLife, but one of them is close to organism. Tim was right—enough.

Tim's approach to SimLife is highly functional. He says he learned his style of play from video games: "Even though SimLife's not a video game, you can play it like one." By this he means that in SimLife, as in video games, one learns from the process of play. You do not first read a rulebook or get your terms straight. At one point in the game he says, "My trilobytes went extinct. They must have run out of algae. I didn't give them algae. I forgot. I think I'll do that now." Tim can keep playing, acting on an intuitive sense of what will work even when he has no very clear idea what is driving events. When his sea urchins become extinct, I ask him why.

Tim: I don't know, it's just something that happens.
ST: Do you know how to find out why it happened?
Tim: No.
ST: Do you mind that you can't tell why?
Tim: No. I don't let things like that bother me. It's not what's important.

People use contact with technology to keep in touch with their times, to discover "what's important." The transparent early IBM PC modeled a modernist technological aesthetic, the Macintosh-style interface was consistent with a postmodern one whose theorists suggest that the search for depth and mechanism is futile, and that it is more realistic to explore the world of shifting surfaces than to embark on a search for origins and structure. From this point of view, the kind of simulation Tim is using helps people think through current challenges to traditional epistemologies where the manifest refers back to the latent, the signifier to the signified. Tim's simulation is dynamic, seductive, and elusive, a world without depth, a world of surface.

Culturally, such simulations serve as emissaries for particular meanings of what it means to "know." We are increasingly accustomed to navigating screen simulations and have grown less

likely to ask of them, "What makes you work?" We learn to stay at the surface, taking things at (inter)face value.

## 2. THINKING ABOUT IDENTITY THROUGH THE CREATION OF VIRTUAL PERSONAE

In the late 1960s and early 1970s, I was first exposed to notions that linked identity and multiplicity. My introduction to these ideas, most notably that there is no such thing as "the ego"— that each of us is a multiplicity of parts, fragments, and desiring connections—took place in the intellectual hothouse of Paris; they presented the world according to such authors as Jacques Lacan, Gilles Deleuze, and Félix Guattari. But despite such ideal conditions for absorbing theory, for me, the "French lessons" remained merely abstract exercises. These theorists of poststructuralism, and what would come to be called postmodernism, spoke words that addressed the relationship between mind and body but from my point of view had little to do with my own.

In my lack of personal connection with these ideas, I was not alone. To take one example, for many people it is hard to accept any challenge to the idea of an autonomous ego. While in recent years, psychologists, social theorists, psychoanalysts, and philosophers have argued that the self should be thought of as essentially decentered, the normal requirements of everyday life exert strong pressure on people to take responsibility for their actions and to see themselves as unitary actors. This disjuncture between theory (the unitary self is an illusion) and lived experience (the unitary self is the most basic reality) is one of the main reasons why multiple and decentered theories have been slow to catch on—or when they do, why we tend to settle back quickly into older, centralized ways of looking at things.

When twenty years later, I used my personal computer and modem to join on-line communities, I experienced my French lessons in action, their theories brought almost shockingly down to earth. In virtual communities I used language to create several characters (some of my biological gender, others not of my biological gender). My textual actions were my actions—my words made things happen. In different communities I had different routines, different friends, different names. And different on-line personae were expressing different aspects of my self. In this context, the notion of a decentered identity were concretized by experiences on a computer screen. In this environment, people think not so much about identity as about identity crises.

Through networked software known as MUDs (short for MULTI-USER DUNGEONS or MULTI-USER DOMAINS), people from all over the world log in, each at his or her individual machine, and join on-line virtual communities that exist only through and in the computer. MUDs are social virtual realities in which hundreds of thousands of people participate. The key element of "MUDding," the creation and projection of a "personae" into a virtual space, also characterizes the far more "banal" on-line communities such as those of bulletin boards, newsgroups, and "chat" rooms on commercial services.

When you join a MUD, you create a character or several characters, you specify each one's gender and other physical and psychological attributes. Other players in the MUD can see its description. It becomes your character's self-presentation. The created characters need not be human and there may be more than two genders. Players create characters who have casual and

romantic sex, hold jobs, attend rituals and celebrations, fall in love, and get married. To say the least, such goings-on are gripping: "This is more real than my real life," says a character who turns out to be a man playing a woman who is pretending to be a man. As players participate in MUDs, they become authors not only of text, but of themselves, constructing selves through social interaction.

In traditional role-playing games in which one's physical body is present, one steps in and out of a character; MUDs, in contrast, offer a parallel life. The boundaries of the game are fuzzy; the routine of playing them becomes part of their players' everyday lives. MUDs blur the boundaries between self and game, self and role, self and simulation. One player says, "You are what you pretend to be . . . you are what you play." Players sometimes talk about their real selves as a composite of their characters and sometimes talk about their MUD characters as means for working on their "real" lives. An avid participant in the on-line "talk channels" known as Internet Relay Chat describes a similar feeling: "I go from channel to channel depending on my mood. . . . I actually feel a part of several of the channels, several conversations. . . . I'm different in the different chats. They bring out different things in me."

Often, players on MUDs and the most avid participants in on-line life are people who work with computers all day at their "regular" jobs. As they play on MUDs it is common practice for them periodically to put their virtual personae to "sleep," remaining logged on to the game, but pursuing other activities. From time to time, they return to the game space. In this way, they break up their work days and experience their lives as a "cycling through" between the real world and a series of simulated ones. This same sort of "cycling through" characterizes how people play with newsgroups, Internet Relay Chat, bulletin boards, and chat rooms.

This kind of interaction with MUDs and other virtual environments is made possible by the existence of what have come to be called "windows" in modern computing environments. Windows are a way of working with a computer that makes it possible for the machine to place you in several contexts at the same time. As a user, you are attentive to only one of the windows on your screen at any given moment, but in a certain sense, you are a presence in all of them at all times. You might be writing a paper in bacteriology and using your computer in several ways to help you: you are "present" to a word-processing program in which you are taking notes and collecting thoughts; you are "present" to communication software though you are in touch with a distant computer in order to collect reference materials; and you are "present" to a simulation program which is charting the growth of bacterial colonies when a new organism enters their ecology. Each of these activities takes place in a "window," and your identity on the computer is the sum of your distributed presence.

This certainly is the case for Doug, a Dartmouth College junior who plays four characters distributed across three different MUDs. One is a seductive woman. One is a macho, cowboy type whose self-description stresses that he is a "Marlboros rolled in the tee shirt sleeve kind of guy." Then there is "Carrot," a rabbit of unspecified gender who wanders through its MUD introducing people to each other. Doug says, "Carrot is so low-key that people let it be around while they are having private conversations. So I think of Carrot as my passive, voyeuristic character." Doug's fourth character is one that he plays on a FurryMUD (MUDs on which all the characters are furry animals). "I'd rather not even talk about that character because its anonymity there is very important to me," Doug says. "Let's just say that on FurryMUDs I feel like a sexual tourist." Doug talks about playing his characters in windows that have enhanced his ability to "turn pieces of my mind on and off."

I split my mind. I'm getting better at it. I can see myself as being two or three or more. And I just turn on one part of my mind and then another when I go from window to window. I'm in some kind of argument in one window and trying to come on to a girl in a MUD in another, and another window might be running a spreadsheet program or some other technical thing for school. . . . And then I'll get a real-time message [that flashes on the screen as soon as it is sent from another system user], and I guess that's RL. It's just one more window.

The development of the windows metaphor for computer interfaces was a technical innovation motivated by the desire to get people working more efficiently by cycling through different applications, much as time-sharing computers cycled through the computing needs of different people. But in practice, windows have become a potent metaphor for thinking about the self as a multiple and distributed system. The self is no longer simply playing different roles in different settings, something that people experience when, for example, one wakes up as a lover, makes breakfast as a mother, and drives to work as a lawyer. The life practice of windows is of a distributed self that exists in many worlds and plays many roles at the same time. MUDs extend the metaphor. Now, in Doug's words, "RL" [real life] can be just "one more window."

On-line personae are objects-to-think-with for thinking about identity as multiple and decentered rather than unitary. With this comment I am of course not implying that MUDs or computer bulletin boards or chat rooms are causally implicated in the dramatic increase of people who exhibit symptoms of multiple personality disorder (MPD) (see Hacking 1995), or that people on MUDs have MPD, or that MUDding (or on-line chatting) is like having MPD. What I am saying is that the many manifestations of multiplicity in our culture, including the adoption of on-line personae, are contributing to a general reconsideration of traditional, unitary notions of identity. On-line experiences with "parallel lives" are part of the significant cultural context that supports new theorizations about multiple selves.

For example, in the psychoanalytic tradition, there are efforts to use a notion of flexibility and transparency as a way of introducing nonpathological multiplicity. Philip Bromberg's model of the healthy self is one whose resilience and capacity for joy comes from having access to its many aspects. Bromberg insists that our ways of describing "good parenting" should shift away from an emphasis on confirming a child in a "core self" and onto helping a child develop the capacity to negotiate fluid transitions between self states. The healthy individual knows how to be many but smooths out the moments of transition between states of self. Bromberg (1994) says: "Health is when you are multiple but feel a unity. Health is when different aspects of self can get to know each other and reflect upon each other. Health is being one while being many." Here is a model of multiplicity as a conscious, highly-articulated "cycling through." Its contours are illuminated by a case study of on-line identity construction. I shall call him Case, a thirty-four-year-old industrial designer.

Case reports that he likes participating in on-line virtual communities as a female because (some would think paradoxically) it makes it easier for him to be assertive and confrontational. Case's several on-line female personae—strong, dynamic, "out there" women—remind him of his mother, whom he describes as a strong, "Katherine Hepburn type." His father was a mild-mannered man, a "Jimmy Stewart type." Case says that in "real life" he has always been more like his father, but he came to feel that he paid a price for his low-key ways. When he discovered MUDs, he recognized a chance to experiment:

For virtual reality to be interesting, it has to emulate the real. But you have to be able to do something in the virtual that you couldn't in the real. For me, my female characters are interesting because I can say and

do the sorts of things that I mentally want to do, but if I did them as a man, they would be obnoxious. I see a strong woman as admirable. I see a strong man as a problem. Potentially a bully.

For Case, if you are assertive as a man, it is coded as "being a bastard." If you are assertive as a woman, it is coded as "modern and together." Case's gender-swapping gives him permission to be more assertive within his virtual community and more assertive outside of it as well:

I've never been good at bureaucratic things, but I'm much better from practicing [in the on-line world] and playing a woman in charge. I am able to do things—in the real, that is—that I couldn't have before because I have played Katherine Hepburn characters.

Case says his Katherine Hepburn personae are "externalizations of a part of myself." In one interview with him, I use the expression "aspects of the self," and he picks it up eagerly, for his on-line life reminds him of how Hindu gods could have different aspects or subpersonalities, all the while being a whole self. In response to my question, "Do you feel that you call upon your personae in real life?" Case responds:

Yes, an aspect sort of clears its throat and says, "I can do this. You are being so amazingly conflicted over this and I know exactly what to do. Why don't you just let me do it?" MUDs give me balance. In real life, I tend to be extremely diplomatic, nonconfrontational. I don't like to ram my ideas down anyone's throat. On the MUD, I can be, "Take it or leave it." All of my Hepburn characters are that way. That's probably why I play them. Because they are smart-mouthed, they will not sugarcoat their words.

In some ways, Case's description of his inner world of actors who address him and are capable of taking over negotiations is reminiscent of the language of people with MPD. But the contrast is significant: Case's inner actors are not split off from each other or his sense of "himself." He experiences himself very much as a collective self, not feeling that he must goad or repress this or that aspect of himself into conformity. He is at ease, cycling through from Katherine Hepburn to Jimmy Stewart. To use Bromberg's language, on-line life has helped Case learn how to "stand in the spaces between selves and still feel one, to see the multiplicity and still feel a unity." To use the computer scientist Marvin Minsky's (1987) phrase, Case feels at ease cycling through his "society of mind," a notion of identity as distributed and heterogeneous that undermines traditional notions of identity. Identity, after all, from the Latin *idem,* has been habitually used to refer to the sameness between two qualities. On the Internet, however, one can be many and usually is.

It is often said that we are at the end of the Freudian century. Freud after all, was a child of the nineteenth century; of course, he was carrying the baggage of a very different scientific sensibility than our own. But those who make the most of their lives on the screen are those who can most deeply reflect on the aspects of self which are revealed there. Our need for a practical philosophy of self-knowledge, one that does not shy away from issues of multiplicity, complexity, and ambivalence has never been greater. It is time to rethink our relationship to computer culture and psychoanalytic culture as a proudly held joint citizenship.

## 3. THINKING ABOUT ALIVENESS BY PLAYING WITH COMPUTER TOYS

The genius of Jean Piaget (1960) showed us the degree to which it is the business of childhood to take the objects in our world and use how they "work" to construct theories—of space, time,

number, causality, life, and mind. In the mid-twentieth century, when Piaget was formulating his theories, a child's world was full of things that could be understood in simple, mechanical ways. A bicycle could be understood in terms of its pedals and gears, a windup car in terms of its clockwork springs. Children were able to take electronic devices such as basic radios and (with some difficulty) bring them into this "mechanical" system of understanding. Since the end of the 1970s, however, with the introduction of electronic toys and games, the nature of many objects and how children understand them has changed. When children today remove the back of their computer toys to "see" how they work, they find a chip, a battery, and some wires. Sensing that trying to understand these objects "physically" will lead to a dead end, children try to use a "psychological" kind of understanding (Turkle 1984, 29–63). Children ask themselves if the games are conscious, if the games know, if they have feelings, and even if they "cheat." Earlier objects encouraged children to think in terms of a distinction between the world of psychology and the world of machines, but the computer does not. Its "opacity" encourages children to see computational objects as psychological machines.

During the last twenty years I have observed and interviewed hundreds of children as they have interacted with a wide range of computational objects, from computer programs on the screen to robots off the screen (Turkle 1984; 1995). My methods are ethnographic and clinical. In the late 1970s and early 1980s I began by observing children playing with the first generation of electronic toys and games. In the 1990s I have worked with children using new generations of computer games and software, including virtual "pets," and with children experimenting with on-line life on the Internet.

Among the first generation of computational objects was Merlin, which challenged children to games of tic-tac-toe. For children who had only played games with human opponents, reaction to this object was intense. For example, while Merlin followed an optimal strategy for winning tic-tac-toe most of the time, it was programmed to make a slip every once in a while. So when children discovered strategies that allowed them to win, when they tried these strategies a second time, they usually would not work. The machine gave the impression of not being "dumb enough" to let down its defenses twice. Robert, seven, playing with his friends on the beach, watched his friend Craig perform the "winning trick," but when he tried it, Merlin did not make its slip and the game ended in a draw. Robert, confused and frustrated, accused Merlin of being a "cheating machine." Children were used to machines being predictable. But this machine held surprises.

Robert threw Merlin into the sand in anger and frustration. "Cheater. I hope your brains break." He was overheard by Craig and Greg, aged six and eight, who salvaged the by now very sandy toy and took it upon themselves to set Robert straight. Craig offered the opinion that, "Merlin doesn't know if it cheats. It won't know if it breaks. It doesn't know if you break it, Robert. It's not alive." Greg adds, "It's smart enough to make the right kinds of noises. But it doesn't really know if it loses. That's how you can cheat it. It doesn't know you are cheating. And when it cheats it don't even know it's cheating." Jenny, six, interrupted with disdain: "Greg, to cheat you have to know you are cheating. Knowing is part of cheating."

In the early 1980s such scenes were not unusual. Confronted with objects that spoke, strategized, and "won," children were led to argue the moral and metaphysical status of machines on the basis of their psychologies: Did the machines know what they were doing? Did they have intentions, consciousness, and feelings? These first computers that entered children's lives were evocative objects: they became the occasion for new formulations about the human and the

mechanical. For despite Jenny's objections that "knowing is part of cheating," children did come to see computational objects as exhibiting a kind of knowing. She was part of the first generation of children who were willing to invest machines with qualities of consciousness as they rethought the question of what is alive in the context of "machines that think."

During the past twenty years the objects of children's lives have come to include machines of even greater intelligence, toys and games and programs that make these first cyber-toys seem primitive in their ambitions. The answers to the classical Piagetian question of how children think about life are being renegotiated as they are posed in the context of computational objects (simulation games, robots, virtual pets) that explicitly present themselves as exemplars of "artificial life."

Although the presence of the first generation of computational objects (the games like Merlin, Simon, and Speak and Spell) disrupted the classical Piagetian story for talking about aliveness, the story children were telling about such objects in the early 1980s had its own coherency. Faced with intelligent toys, children took a new world of objects and imposed a new world order in which motion had given way to emotion and cognition as the discourse children used for talking about the aliveness of computers.

In the 1990s the computational objects that evoke evolution and "artificial life" (for example computer programs such as the games of the "Sim" series which stress decentralized and "emergent" processes) have strained that order to the breaking point. Children still try to impose strategies and categories, but they do so in the manner of theoretical *bricoleurs,* or tinkerers, making do with whatever materials are at hand, making do with whatever theory can fit a prevailing circumstance. When children confront these new objects and try to construct a theory about what is alive, we see them cycling through theories of "aliveness." Tim, thirteen, says of SimLife: "The animals that grow in the computer could be alive because anything that grows has a chance to be alive." Laurence, fifteen, agrees. "The whole point of this game," he tells me,

is to show that you could get things that are alive in the computer. We get energy from the sun. The organisms in a computer get energy from the plug in the wall. I know that more people will agree with me when they make a SimLife where the creatures are smart enough to communicate. You are not going to feel comfortable if a creature that can talk to you goes extinct.

An eleven-year-old named Holly watches a group of robots with "onboard" computational intelligence navigate a maze. The robots use different strategies to reach their goal, and Holly is moved to comment on their "personalities" and their "cuteness." She finally comes to speculate on the robots' "aliveness" and blurts out an unexpected formulation: "It's like Pinocchio."

First Pinocchio was just a puppet. He was not alive at all. Then he was an alive puppet. Then he was an alive boy. A real boy. But he was alive even before he was a real boy. So I think the robots are like that. They are alive like Pinocchio [the puppet], but not "real boys."

She clears her throat and sums up her thought: "They [the robots] are sort of alive."

Robbie, a ten-year-old who has been given a modem for her birthday, puts the emphasis on mobility when she considers whether the creatures she has evolved on SimLife are alive.

I think they are a little alive in the game, but you can turn it off and you cannot "save" your game, so that all the creatures you have evolved go away. But if they could figure out how to get rid of that part of the program so that you would have to save the game and if your modem were on, then they could get out of your computer and go to America Online.

Sean, thirteen, who has never used a modem, comes up with a variant on Robbie's ideas about SimLife creatures and their Internet travel: "The [Sim] creatures could be more alive if they could get into DOS." Thus, children cycle through evolution and psychology and resurface ideas about motion in terms of the communication of bits on the Internet. In children's talk about digital "travel" via circulating disks or over modems, in their talk of viruses and networks, biology and motion are resurfacing in a new guise, now bound up in the ideas of communication and evolution. Significantly, the resurfacing of motion (Piaget's classical criterion for how a child decides whether a "traditional" object is alive) is now bound up with notions of a presumed psychology: children were most likely to assume that the creatures in Sim games have a desire to "get out" of the system and evolve in a wider computational world.

My current collection of comments about life by children who have played with the artifacts of artificial life that are available in the popular culture (small mobile robots, the games of the "Sim" series, and Tierra, a program which simulates evolutionary selection through survival of the fittest) includes the following notions: the robots are in control but not alive, would be alive if they had bodies, are alive because they have bodies, would be alive if they had feelings, are alive the way insects are alive but not the way people are alive; the Tierrans are not alive because they are just in the computer, could be alive if they got out of the computer and got onto America Online, are alive until you turn off the computer and then they're dead, are not alive because nothing in the computer is real; the Sim creatures are not alive but almost-alive, they would be alive if they spoke, they would be alive if they traveled, they're alive but not "real," they're not alive because they don't have bodies, they are alive because they can have babies, and finally, for an eleven-year-old who is relatively new to SimLife, they're not alive because these babies don't have parents. She says: "They show the creatures and the game tells you that they have mothers and fathers, but I don't believe it. It's just numbers, it's not really a mother and a father." There is a striking heterogeneity of theory here. Different children hold different theories and individual children are able to hold different theories at the same time.

In his history of artificial life, Steven Levy (1992, 6–7) suggested that one way to look at where artificial life can "fit in" to our way of thinking about life is to envisage a continuum in which Tierra, for example, would be more alive than a car but less alive than a bacterium. My observations suggest that children are not constructing hierarchies but are heading toward parallel definitions of life, which they "alternate" through rapid cycling. Multiple and alternating definitions, like thinking comfortably about one's identity in terms of multiple and alternating aspects of self, become a habit of mind.

Children speak easily about factors which encourage them to see the "stuff" of computers as the same "stuff" of which life is made. For example, the seemingly ubiquitous "transformer toys" shift from being machines to being robots to being animals (and sometimes people). Children playing with these objects are learning about the potentially fluid boundaries between mechanism and flesh.

I observe a group of seven year olds playing with a set of plastic transformer toys that can take the shape of armored tanks, robots, or people. The transformers can also be put into intermediate states so that a "robot" arm can protrude from a human form or a human leg from a mechanical tank. Two of the children are playing with the toys in intermediate states (that is, in states somewhere between being people, machines, and robots). A third child insists that this is not right. The toys, he says, should not be placed in hybrid states. "You should play them as all tank

or all people." He is getting upset because the other two children are making a point of ignoring him. An eight-year-old girl comforts the upset child. "It's okay to play them when they are in-between. It's all the same stuff," she said, "just yucky computer 'cy-dough-plasm.'" This comment is the expression of a cyborg consciousness as it expresses itself among today's children: a tendency to see computer systems as "sort of" alive, to fluidly cycle through various explanatory concepts, and to willingly transgress boundaries. Most recently, the transgressions have involved relationships with "virtual pets" (the first and most popular of these were Tamagotchi) who demand of their owners to feed them, play games with them, inquire about their health and mood, and, when they are still babies, clean up their virtual "poop." Good parenting of a Tamagotchi will produce a healthy offspring; bad parenting will lead to illness, deformity, and finally, to the pet's virtual death. The Tamagotchi are only the first in a projected series of computational objects that seem destined to teach children a new lesson about the machine world: that computational objects need to be related to as another life form.

Today's adults grew up in a psychological culture that equated the idea of a unitary self with psychological health, and in a scientific culture that taught that when a discipline achieves maturity, it has a unifying theory. When they find themselves cycling through varying perspectives on themselves (as when they cycle through a sequence such as "I am my chemicals" to "I am my history" to "I am my genes") they usually become uncomfortable (Kramer 1993). People who grew up in the world of the mechanical are more comfortable with a definition of what is alive that excludes all but the biological and resist shifting definitions of aliveness. So, when they meet ideas of artificial life which put the processes of replication and evolution rather than biology at the center of what is alive (Langton 1989) they tend to be resistant, even if intrigued. They feel as though they are being asked to make a theoretical choice against biology and for computational process. Children who have grown up with computational objects don't experience that dichotomy. They turn the dichotomy into a menu and cycle through its choices. Today's children have learned a lesson from their cyborg objects. They cycle through the cy-dough-plasm into fluid and emergent conceptions of self and life.

NOTES
This essay is drawn from Turkle (1995).

REFERENCES
Bromberg, Philip. 1994. "Speak That I May See You: Some Reflections on Dissociation, Reality, and Psychoanalytic Listening." *Psychoanalytic Dialogues* 4(4): 517–47.
Hacking, Ian. 1995. *Rewriting the Soul: Multiple Personality and the Sciences of Memory.* Princeton: Princeton University Press.
Kramer, Peter. 1993. *Listening to Prozac: A Psychiatrist Explores Antidepressant Drugs and the Remaking of the Self.* New York: Viking.
Langton, Christopher. 1989. "Artificial Life" in *Artificial Life: The Proceedings of an Interdisciplinary Workshop on the Synthesis and Simulation of Living Systems,* ed. Christopher G. Langton, Santa Fe Institute Studies in the Science of Complexity, vol. 6. Redwood City, Cal.: Addison-Wesley.
Levy, Steven. 1992. *Artificial Life: The Quest for a New Frontier.* New York: Pantheon.
Minsky, Marvin. 1987. *The Society of Mind.* New York: Simon and Schuster.
Piaget, Jean. 1960. *The Child's Conception of the World,* trans. by Joan and Andrew Tomlinson. Totowa, N.J.: Littlefield, Adams.
Turkle, Sherry. 1984. *The Second Self: Computers and the Human Spirit.* New York: Simon and Schuster.
———. 1995. *Life on the Screen: Identity in the Age of the Internet.* New York: Simon and Schuster.

# 36

# The Engendering
# of Archaeology

## Refiguring Feminist Science Studies

### ALISON WYLIE

## INTERNAL CRITIQUES:
## THE SOCIOPOLITICS OF ARCHAEOLOGY

In the last fifteen years archaeologists have been drawn into heated debates about the objectivity of their enterprise. These are frequently provoked by critical analyses that demonstrate (with hindsight) how pervasively some of the best, most empirically sophisticated archaeological practice has reproduced nationalist, racist, classist, and, according to the most recent analyses, sexist and androcentric understandings of the cultural past. Some archaeologists conclude on this basis that however influential the rhetoric of objectivity may be among practitioners, the practice and products of archaeology must inevitably reflect the situated interests of its makers. A great many others regard such claims with suspicion, if not outright hostility. They maintain the conviction—a central and defining tenet of North American archaeology since its founding as a profession early in this century—that archaeology is, first and foremost, a science and that, therefore, the social and political contexts of inquiry are properly external to the process of inquiry and to its products.[1]

The feminist critiques of archaeology on which I focus here are relative newcomers to this growing tradition of internal "sociopolitical" critique. Not surprisingly, they have drawn sharply critical reactions that throw into relief the polarized positions that dominate thinking about the status and aims of archaeology. And yet, I will argue, these feminist interventions do not readily fit any of the epistemic options defined in this debate; they exemplify a critical engagement of claims to objectivity that refuses reductive constructivism as firmly as it rejects unreflective objectivism. This is a strategic ambivalence that holds enormous promise and is typical of much feminist thinking in and about scientific practice. In this essay I first characterize what I will identify provisionally as the feminist initiatives that have emerged in archaeology since the late 1980s (qualifications of this designation come later) and then consider their larger implications.

My immediate concern is how, within the rubric of feminist science studies, we are to understand the late and rapid emergence of an archaeological interest in questions about women and gender. This leads, in turn, to a set of reflexive questions about how to do feminist science studies.

## FEMINIST CRITIQUES IN ARCHAEOLOGY

Critiques of sexism and androcentrism in archaeology fall into two broad categories that parallel analyses of other dimensions of archaeological practice (e.g., its nationalism, classism, and racism): "content" and "equity" critiques. In addition—and in this feminist critiques are distinctive—there is emerging a move toward "integrative" analyses that combine content and equity critiques.

CONTENT CRITIQUES.  Two types of content critique can usefully be distinguished. The first draws attention to erasure, to ways in which the choice of research problem or the determination of significant sites or periods or cultural complexes leaves women and gender out of account even when they are a crucial part of the story to be told. To take a prehistoric example that I will discuss in more detail later in this essay, Pat Watson and Mary Kennedy argue that dominant explanations of the emergence of horticulture in the Eastern Woodlands share a common flaw: although women are presumed to have been primarily responsible for collecting plants under earlier gatherer hunter-foraging subsistence regimes and for cultivating them when gourds and maize were domesticated, they play no role at all in accounts of how this profoundly culture-transforming shift in subsistence practice was realized.[2] Watson and Kennedy say they are "leery" of explanations that remove women from the one domain granted them as soon as an exercise of initiative is envisioned.

Often, however, straightforward erasure is not the problem and a second sort of critique is required that focuses on how women and gender are represented when they are taken into account. From the outset feminist critics have argued that, although questions about women and gender have never been on the archaeological research agenda, archaeological research problems and interpretations are routinely framed in gendered terms.[3] The functions ascribed to artifacts and sites are often gender specific, and models of such diverse cultural phenomena as subsistence practices among foragers, social organization in agrarian societies, and the dynamics of state formation often turn on the projection onto prehistory of a common body of presentist, ethnocentric, and overtly androcentric assumptions about sexual divisions of labor and the status and roles of women. Women in prehistoric foraging societies are presumed to be tied to "home bases" while their male counterparts quite literally "bring home the bacon," despite extensive ethnohistoric evidence that women in such contexts are highly mobile and that their foraging activities are often responsible for most of the dietary intake of their families and communities.

More subtle but equally problematic are interpretations of large-scale cultural transformations that treat gender roles and domestic relations as a stable (natural) substrate of social organization that is unchanged by the rise and fall of states and is, therefore, explanatorily irrelevant. In another case that I will consider, Christine Hastorf argues that the domestic units encountered in the highland Andes at the time of the Spanish conquest cannot be projected back into prehistory as if their form were a given. She offers compelling archaeological evidence that households and gender roles were substantially reshaped by the extension of Inka influence into these territories.[4] In these cases, critical (re)analysis reveals ways in which understanding has been limited

not by ignoring women and gender altogether, but by conceptualizing them in normatively middle-class, white, North American terms.

EQUITY CRITIQUES. Alongside these forms of content critique, there has grown up a sub-stantial and largely independent body of literature concerning the demography, institutional structures, funding sources, training, and employment patterns that shape archaeology. Feminist analyses of the status of women constitute some of the most fine-grained and empirically rich work of this sort.[5] These "equity critiques" document not only persistent patterns of differential support, training, and advancement for women in archaeology, but also entrenched patterns of gender segregation that circumscribe the areas in which women typically work.

While such studies provide fascinating detail on ways in which women are marginalized within archaeology, rarely are they used as a basis for understanding how the content of archaeo-logical knowledge is shaped. And although content critics provide compelling evidence that the silences and distortions they identify are systematically gendered, rarely do they make any con-nection between these and the gender imbalances in the training, employment, and reward structures of the discipline documented by equity critics. In general, sociopolitical critics in archaeology have tended to sidestep explanatory questions about how the silences and stereo-types they delineate are produced or why they persist.

INTEGRATIVE CRITIQUES. There is one study, undertaken from an explicitly feminist per-spective, that illustrates the potential fruitfulness of "integrative analyses": analyses that explore the link between workplace inequities and androcentric bias in the content of research. It is an analysis of Paleo-Indian research undertaken by Joan Gero. She begins by documenting a strong pattern of gender segregation: the predominantly male community of Paleo-Indian researchers focuses almost exclusively on stereotypically male activities—specifically, on large-scale mammoth- and bison-hunting practices, the associated kill sites and technologically sophisticated hunting tool assemblages, and the replication of these tools and of the hunting and butchering prac-tices they are thought to have facilitated. Gero finds that the women in this field have been largely displaced from these core research areas; they work on expedient blades and flake tools and focus on edge-wear analysis. Moreover, in the field of lithics analysis generally, women are cited much less frequently than their male colleagues even when they do mainstream research, except when they coauthor with men. Not surprisingly, Gero argues, their work on expedient blades and patterns of edge wear is almost completely ignored, despite the fact that these analy-ses provide evidence that Paleo-Indians exploited a wide range of plant materials, presumably foraged as a complement to the diet of Pleistocene mammals. Gero's thesis is that these social relations of Paleo-Indian research derail the Paleo-Indian research program as a whole: "women's exclusion from pleistocene lithic and faunal analysis . . . is intrinsic to, and necessary for, the bison-mammoth knowledge construct."[6] The puzzles that dominate Paleo-Indian research are quite literally created by the preoccupation with male-associated (hunting) activities. They turn on questions about what happened to the mammoth hunters when the mammoths went extinct: Did they disappear, to be replaced by small game and plant foraging groups, or did they effect a miraculous transformation as the subsistence base changed? These questions can only arise, Gero argues, if researchers ignore the evidence from female-associated tools that Paleo-Indians depended on a much more diversified set of subsistence strategies than acknowledged by stan-dard "man the (mammoth/bison) hunter" models. This is precisely the sort of evidence pro-duced mainly by women working on microblades and edge-wear patterns, and it is reported in

publications that remain largely outside the citation circles that define the dominant focus of inquiry in this area.

## ARCHAEOLOGY AS POLITICS
## BY OTHER MEANS

When critiques of androcentrism and sexism appeared in archaeology in the late 1980s, debate about the implications of sociopolitical critiques was already sharply polarized. Some of the most uncompromising critics of the explicitly positivist "New Archaeology" of the 1960s and 1970s parlayed local analyses of the play of interests in archaeology into a general rejection of all concepts or ideals of objectivity. Through the early 1980s they insisted, on the basis of arguments familiar in philosophical contexts (underdetermination of theory by evidence, theory-ladenness, and various forms of holism), that archaeologists simply "create facts," that evidential claims depend on "an edifice of auxiliary theories and assumptions" that archaeologists accept on purely conventional grounds, and that there is, therefore, no escape from the conclusion that any use of archaeological data to test reconstructive hypotheses about the past can "only result in tautology."[7] The choice between tautologies, then, must necessarily be determined by standpoint-specific interests and the sociopolitics that shape them; archaeology is quite literally politics by other means.

With these arguments, some critics within archaeology broach what Bruce Trigger has described as a nihilistic "hyperrelativism" now familiar in many of the social sciences. Given critical analyses that shatter pretensions to objectivity, demonstrating that there is no "view from nowhere," no immaculately conceived foundation of fact, no transcontextual or transhistorical standard of rationality, it is assumed that epistemic considerations play no significant role at all.[8] What counts as sound argument and evidence (as "good reasons" for accepting a knowledge claim) is entirely reducible to the sociopolitical realities that constitute the standpoint of practitioners, or communities of practitioners, and the conventions of their practice. For a great many archaeologists, these conclusions are grounds for summarily dismissing the constructivist critiques of positivism and any aligned analysis that purported to bring into view the play of politics in archaeology. A dominant counterresponse has been to call for a return to basics, to the real (empirical) business of archaeology. Not surprisingly, the feminist critiques that appeared in the late 1980s met with considerable skepticism.

What distinguishes the interventions of feminist critics in these debates is their refusal, for the most part, to embrace any of the polarized responses generated by this growing crisis of confidence in objectivist ideals. In most cases feminist critics in archaeology depend on painstakingly careful empirical analysis to establish their claims about gaps or bias in content, about inequities in the role and status of women in the field, and about the links between equity and content critiques. But however pervasive the androcentrism or sexism they delineate, and however sharply they criticize pretensions to neutrality and objectivity, they are deeply reticent to embrace any position approaching the hyperrelativism described by Trigger. They are clear about the social, political nature of the archaeological enterprise, and yet they do not consider the outcomes of inquiry or the criteria of adequacy governing practice to be reducible to the sociopolitics of practice.

Two lines of argument support this stance. For one thing, it is evident that, as a matter of contingent empirical fact, "reasons"—appeals to evidence and considerations of explanatory power, as well as of internal and cross-theory consistency—do frequently play a critical role in determining the content of archaeological interpretations and the presuppositions that frame them, including those embraced or advocated by feminists. That is to say, reasons can be causes; they shape belief and the outcomes of archaeological inquiry, although their form and authority are never transparent and never innocent of the power relations that constitute the social contexts of their production. For another, close scrutiny of archaeological practice makes it clear that, as Roy Bhaskar argued years ago, one crucial and much-neglected feature of science "is that it is *work;* and hard work at that. . . . [It] consists . . . in the transformation of given products." Most important, these "products" are built from materials that archaeologists do not construct out of whole cloth, whose properties they can be (disastrously) wrong about, and whose capacities to act or be acted upon can be exploited to powerful effect by those intent on "intervening" in the world(s) they study when these worlds are accurately understood.[9] Sociologically reductive accounts cannot make sense of these features of archaeological practice, including the practice of feminists and other critics in and of archaeology. Perhaps feminists have been more alert to these considerations because here, as in other contexts, they are painfully aware that the world is not (just) what we make it, and the cost of systematic error or self-delusion can be very high; effective activism requires an accurate understanding of the forces we oppose, conceptually, politically, and materially.

Most recently, the critics within archaeology who raised the spectre of hyperrelativism have backed away from their strongest (and most untenable) claims.[10] They seem to have recognized that, insofar as they mean to expose systematic error and explain it (e.g., by appeal to the conditions that shape knowledge production), their own practice poses a dilemma: they bring social contingencies into view by exploiting precisely the evidential constraints and other epistemic considerations they mean to destabilize. They make good use of the fact that, as enigmatic and richly constructed as archaeological evidence may be, it does routinely resist appropriation in any of the terms compatible with dominant views about the past. This capacity of the world we investigate to subvert our best expectations can force us to reassess not only specific claims about the past but also background assumptions we may not have known we held, assumptions that constitute our standpoint in the present. As critics within archaeology have moved beyond reaction against the New Archaeology and have undertaken to build their own alternative research programs, they tend to embrace epistemic positions that have much in common with those occupied by feminist critics and practitioners.

## PARALLELS WITH SCIENCE STUDIES

A similar polarizing dynamic has long structured relations between the constituent fields of science studies. After decades of rancorous debate between philosophers and sociologists it is now unavoidable, although still far from being universally accepted, that sociological challenges (themselves much modified in recent years) cannot simply be set aside by philosophers as misconceived or irrelevant; the traditional philosophical enterprise of "rational reconstruction" must be substantially broadened and not only naturalized but "psychologized" and "socialized." The hallmark of postpositivist philosophy of science is a commitment to ground philosophical analysis in a detailed understanding of scientific practice (historical or contemporary), an

exercise that has forced attention to the diversity and multidimensionality of the sciences. This, in turn, makes it increasingly difficult to sustain the faith that there is any distinctive, unifying rationality to be "reconstructed" across the historical and cultural particularity of the disciplines we identify as scientific. At the same time, many sociologists of science now emphasize that science is work made hard, in part, by engagement with the "materiel" of its technology and subject domain; practice is conditioned by the sorts of considerations that have been central to epistemological analyses of science.[11]

One implication of these developments is that none of the existing science studies disciplines has the resources to make sense of the sciences on its own, in strictly philosophical, sociological, or historical terms. As Andrew Pickering puts the point, "Scientific practice . . . is situated and evolves right on the boundary, at the point of intersection, of the material, social, conceptual (and so on) worlds"; it "cuts very deeply across disciplinary boundaries."[12] The crucial challenge, now taken up on many fronts, is to develop genuinely interdisciplinary strategies of inquiry, and for this we need problems and concepts, categories of analysis, that escape the dichotomous thinking that has structured disciplinary studies of science to date, setting "epistemic"/"internal" (constitutive) considerations in opposition to "social"/"external" (contextual) factors. This is, fundamentally, the challenge of building an integrative program of analysis capable of explaining how the thoroughly constructed materials of science—for example, whatever counts as evidence in a given context—*can*, in fact, "resist" appropriation, sometimes quite unexpectedly and decisively, and sometimes with the effect of transforming the values and interests that frame our research programs.

These questions have been central to feminist analyses of science from the outset. Given political and conceptual commitments that make corrosive hyperrelativism as uncongenial as unreflective objectivism, feminists have been exploring positions between, or "beyond," these polarized alternatives[13] throughout the period in which discipline-specific debates about the implications of hyperrelativism have run their course. Consider, for example, the efforts to articulate a viable standpoint theory made by Nancy Hartsock, Sandra Harding, and Donna Haraway; the multidimensional analyses of Evelyn Fox Keller; Helen Longino's treatment of the interplay between constitutive and contextual values in science; and innumerable critical and constructive programs of feminist analysis in the social and life sciences.[14] It is a great loss to mainstream science studies that its practitioners have considered feminist work in these areas almost not at all, even when their own debates propel them in directions already well explored by feminist philosophers, historians, and sociologists of science.

I submit that the questions constitutive of these traditions of feminist research are worth pursuing not just because they are important for science studies and for archaeology, but because we badly need more nuanced critical appraisals of the fruits and authority of science if, as feminists, we are to exploit the emancipatory capacity that it may (yet) have. Despite their sometimes apocalyptic conclusions, the practice of archaeological critics, especially the feminists among them, demonstrates just how powerful systematic empirical inquiry can be as a tool for contesting the taken-for-granteds that underwrite oppressive forms of life.

## GENDER RESEARCH IN ARCHAEOLOGY

Feminist initiatives appeared much later in archaeology than in such cognate fields as sociocultural anthropology and history. It was not until 1984 that the first paper appeared in Anglo-American archaeology that argued explicitly for the relevance of feminist insights and approaches to the study of gender. And it was another seven years before a book presented a substantial body of original work in the area. This took the form of a collection edited by Joan Gero and Margaret Conkey, *Engendering Archaeology: Women and Prehistory,*[15] which was the outcome of a small working conference convened by the editors in 1988 specifically for the purpose of mobilizing interest in the questions about women and gender posed by Conkey and Janet Spector in 1984. Most participants had never considered these questions and had no special interest in feminist initiatives.

The following year, the student organizers of an annual thematic conference at the University of Calgary chose "The Archaeology of Gender" as their topic for the fall 1989 "Chacmool" conference. To everyone's surprise, the open call for papers advertising this meeting drew over a hundred contributions on a wide range of topics, a substantially larger response than had been realized for any previous Chacmool conference.[16] The only previous meetings on gender had been annual colloquia at the meetings of the Society for Historical Archaeology (beginning in 1988) and several Norwegian and British conferences and conference sessions.[17] The 1989 Chacmool proceedings were published two years later, and in the meantime at least five other widely advertised public conferences, and a number of smaller-scale workshops and conference symposia, were organized in Australia, North America, and the United Kingdom; several of these have produced published proceedings or edited volumes. In an annotated bibliography of papers on archaeology and gender that were presented at conferences from 1964 through 1992, the editor/compiler, Cheryl Claassen, indicates that only 24 of a total of 284 entries were presented before 1988 and that only two of these appeared in print; more than half the entries are papers presented between 1988 and 1990, and fully 40 percent of those presented after 1988 have been published. So, despite the fact that little more than Conkey and Spector's 1984 paper was in print by the late 1980s, when various groups of enterprising organizers set about arranging archaeological conferences on gender, there seems to have been considerable interest in the topic that was, in a sense, just waiting for an outlet, an interest that has since taken hold across the field as a whole.[18]

The questions raised by these developments are conventional enough; they have to do with theory change, with why these initiatives should have appeared in the form they did and when they did, and with their implications for the presuppositions of entrenched traditions of research.[19] I have found these to be resolutely intractable questions, however, because the conditions shaping the emergence of gender research in archaeology are so multidimensional: a great many factors are at work, none of them separable from the others, and they operate on different scales, some highly local while others are quite general. Indeed, nothing brings home more forcefully the need for an integrative program of feminist science studies than grappling with the complexities of these recent developments in archaeology. What follows is a provisional and, most important, a syncretic account of the conditions responsible for the "engendering" of archaeology; fully integrated categories of analysis remain to be formulated. My aim is to illustrate why none of the familiar strategies for explaining science is adequate taken on its own. This will inevitably raise more questions than I can answer but will allow me to specify, in the conclusion, some of the tasks at hand in reframing science studies.

## THEORETICAL AND METHODOLOGICAL CONSIDERATIONS

When Conkey and Spector argued the case for an archaeology of gender in 1984, they suggested that the dearth of such work was to be explained by the dominance of an especially narrow, ecologically reductive conception of culture that was associated with the New Archaeology. In an effort to make archaeology scientific, attention had been diverted from all types of "internal," "ethnographic" variables; gender dynamics were just one casualty of a general preoccupation with interactions between cultural systems and their external environments, associated with the conviction that "internal" variables are both inaccessible and explanatorily irrelevant. Initially this explanation seemed persuasive; I have argued for it myself.[20] The difficulty, however, is that a great many of those who subscribed to the scientific ideals of the New Archaeology never did give up an interest in the social structures and internal dynamics of the cultural "systems" they studied; they showed great initiative in devising strategies for documenting, in archaeological terms, such inscrutables as interaction networks, kinds and degrees of social stratification, and modes of community and household organization (and changes in all of these over time). Given this, the real question is, why did these more expansive New Archaeologists not turn their attention to gendered divisions of labor and organizational structures?

This lacuna is especially puzzling given that the New Archaeology and its most stringently ecologistic models were decisively challenged at the turn of the 1980s, initiating a decade of wide-ranging exploration in which archaeologists reopened a great many questions that had been set aside by more orthodox New Archaeologists. According to the "theoretical and methodological constraint" model, research on gender and critiques of androcentrism should have appeared with these other initiatives at the beginning of the 1980s, rather than a decade later. In fact, some early critics of the New Archaeology did explicitly advocate "feminist" initiatives as an example of just the sort of politically self-conscious archaeology they endorsed. Few pursued these suggestions, however, and several have since been sharply criticized by Norwegian and British feminists who argue that their own practice was often not just androcentric but quite explicitly sexist.[21] In retrospect, it seems that the new generation of archaeologists shared with their predecessors a number of (largely implicit) presuppositions; despite other differences, they all tended to treat gender as a stable, unchanging (biological) given in the sociocultural environment. If the social roles that biological males and females occupy can be assumed to be the same across time and cultural context—to be "naturally" theirs—gender is not a variable that can be relevant in explaining cultural change. The question, why not before? then becomes, why now? Why would this particular set of taken-for-granteds come to be seen as problematic now? Here the complexity of the explanandum outstrips the explanatory resources afforded by standard categories of philosophical analysis.

## SOCIOPOLITICAL FACTORS

My thesis is that nothing in the theoretical content, intellectual history, methodological refinement, or evidential resources of contemporary archaeology can explain why an interest in questions about women and gender should have arisen (only) in the late 1980s. Sociopolitical features of the research community and its practice play a central role in determining the timing, the form, and the impact of the feminist critiques and research programs on gender that have begun to challenge the entrenched androcentrism of archaeology. In order better to understand these factors, I undertook a survey of everyone who participated in the 1989 Chacmool conference and did interviews with a number of those I identified as "catalysts": those who had been

instrumental in organizing this and related conferences and in producing the publications that drew attention to the need for and promise of feminist initiatives in archaeology. My immediate aim was to determine what factors had converged in creating the substantial constituency of archaeologists who were ready and willing to attend a conference on gender despite the lack of published work in the area.

At the outset I assumed that the emergence of feminist initiatives in archaeology had followed roughly the same course as in other closely affiliated disciplines (e.g., sociocultural anthropology, history, paleontology): they appeared when a critical mass of women entered the field who had been politicized in the women's movement and were therefore inclined to notice, and to be skeptical of, the taken-for-granteds about gender that had hitherto structured archaeological interpretation and the research agenda of the field. In archaeology a significant increase in the representation of women was not realized until after the mid-1970s. I expected, then, that participants in the 1989 Chacmool conference would prove to be predominantly women drawn from the first professional cohorts in which women were strongly represented and that they would have been attracted to the topic of the conference because of prior involvement in feminist activism and scholarship. This account would suggest that the 1989 Chacmool conference afforded participants an opportunity to integrate preexisting feminist commitments with professional interests in archaeology.

In the event, 72 percent of the 1989 Chacmool participants responded to the survey, providing me with enormously detailed answers to a lengthy list of open-ended questions about their background training and research interests, their reasons for attending the conference, their involvement with feminist scholarship and activism, and their views about why gender research should be emerging in archaeology in the late 1980s. Preliminary analysis suggests that my initial hypothesis captures the experience and motivations of most of the "catalysts" but not of conference participants. The survey results do bear out my hypothesis about the demographic profile of contributors to the Chacmool program but confound my assumptions about their backgrounds and why they attended this first public conference on "The Archaeology of Gender."

Those who attended the 1989 Chacmool conference were disproportionately women, and these women, more than the men, were drawn from cohorts that entered the field in the late 1970s and early 1980s, when the representation of women in North American archaeology doubled. Altogether 80 percent of submissions to the conference were made by women; this more than inverts the ratio of women to men in North American archaeology as a whole, where women make up roughly 36 percent of practitioners.[22] And while the average age of men and women at the time of the conference was similar (forty-three as compared to forty years), the men were more widely distributed across age grades; altogether 60 percent of the women (twice the proportion of men) were clustered in the twenty-six- to forty-year-old age range. Combined with information about their education and employment status, this suggests that, as I had expected, the majority of those who attended the conference were middle-ranked professional women who would have completed their graduate training and achieved some measure of job security by the mid- to late 1980s, just when the first stirrings of public interest in questions about women and gender began to appear in archaeology. Moreover, most of these women made it clear that the call for papers tapped an existing interest in questions about gender; only a fifth reported ever having attended a Chacmool conference in the past (over half of the men reported being regular or previous attendees), and virtually all said the main reason they attended the 1989 Chacmool conference was the topic.

The survey responses also make it clear, however, that an avowed interest in questions about gender does not necessarily reflect a feminist standpoint. Nearly half of the women and more of the men said explicitly that they do not identify themselves as feminists, and many of those who embraced the label recorded reservations about what it means. Although three-quarters of respondents (both men and women) said they had a prior interest in research on gender, altogether two-thirds described the Chacmool conference as opening up a new area of interest for them, and less than half reported any previous involvement in women's studies or familiarity with feminist research in other fields. These results are consistent with Marsha Hanen and Jane Kelley's analysis of the conference abstracts, which reveals what they describe as a "dearth" of references to feminist literature, authors, influences, or ideas.[23] Most striking, just half of the women and a quarter of the men who responded to the survey indicated any involvement in women's groups, in action on women's issues, or in "feminist activism," and most described their involvement as limited to "being on a mailing list" or "sending money," usually to women's shelters and reproductive rights groups. Very few had been involved in any direct action or frontline work with the agencies and groups they supported. No doubt this level of involvement in the women's movement (broadly construed) is substantially higher than is typical for North American archaeologists. Even so, it does not support the hypothesis that the majority of participants in the Chacmool conference on "The Archaeology of Gender" had been independently politicized as feminists and had welcomed this conference as a first public opportunity to integrate their feminist and archaeological commitments.

The results of this preliminary analysis suggest, then, that the expanded cohort of women entering the field at the turn of the 1980s brought to their work in archaeology a standpoint of sensitivity to gender issues—no doubt in some sense a gendered standpoint—but not an explicitly feminist standpoint. Hanen and Kelley describe this orientation as a largely untheorized and apolitical "grassroots" interest in questions about gender relations and categories.[24] It would seem that the 1989 Chacmool call for papers resonated with a latent awareness of the contested and contestable nature of gender roles, considered both as a feature of daily life and as a possible topic for investigation in archaeology. Indeed, for many the conference seems to have been attractive because it provided an opportunity to engage these questions at arm's length, on the relatively safe (or at least familiar) terrain of archaeological inquiry. And for some this scholarly interest proved to be politicizing: a number of respondents noted in their survey returns and in subsequent correspondence that their work on the "archaeology of gender" has put them in touch with feminist scholarship in other fields and has led to an involvement in women's groups active on issues such as workplace equity, sexual harassment, reproductive rights, and violence against women. By contrast, almost all who played a role as catalysts had already been politicized as feminists and then brought this explicitly feminist angle of vision to bear on the programs of research in which they were engaged as archaeologists.

In these two rather different senses, then, the appearance of gender research in archaeology in the last few years seems to reflect a growing awareness, among relatively young professionals in the field, of the gendered dimensions of their experience, perhaps provoked by the fact that the gender composition of their own cohort disrupts the status quo. And perhaps, as amorphous and ill-defined a standpoint as this is, it was sufficient to incline (some) members of this cohort, especially the women, to greater awareness of and skepticism about the androcentrism inherent in extant research programs. Much remains to be done to determine what constitutes this "grassroots" standpoint of gender sensitivity, how it is articulated in archaeological contexts, how it

relates to the gender politics of the larger society, and how it shapes archaeological practice; evaluation and refinement of this hypothesis will depend, in part, on further analysis of the survey responses and, in part, on comparative analysis (within archaeology and across fields). But if my argument is plausible, it was a distinctive self-consciousness about gender relations that put these new participants in a position to think differently about their discipline and their subject matter, to identify gaps in analysis, to question taken-for-granted assumptions about women and gender, and to envision a range of alternatives for inquiry and interpretation that simply had not occurred to their older, largely male colleagues—colleagues whose gender privilege (as men working in a highly masculinized disciplinary culture) includes an unquestioning fit between their gendered experience and the androcentrism that partially frames the research traditions in which they work.

## CONTENT ANALYSIS AND THE ROLE OF EVIDENCE

If it is accepted that sociopolitical factors are centrally responsible for the emergent (archaeological) interest in women and gender as a research subject, broader questions about epistemic implications immediately arise. My thesis is that although such examples make it clear that the standpoint of practitioners affects every aspect of inquiry—the formation of questions, the (re)definition of categories of analysis, the kinds of material treated as (potential) evidence, the bodies of background knowledge engaged in interpreting archaeological data as evidence, the range of explanatory and reconstructive hypotheses considered plausible, and the array of presuppositions held open to systematic examination—they also demonstrate that standpoint does not, in any strict sense, determine the outcomes of inquiry. The results produced by those working from a gender-sensitive standpoint are not explicable, in their details, in terms of the angle of vision or social location that constitutes this standpoint. Consider, briefly, two examples that illustrate this point.

In their critique of theories about the emergence of horticulture in the Eastern Woodlands, mentioned earlier, Pat Watson and Mary Kennedy begin with a conceptual analysis that draws attention to the conspicuous absence of women in accounts of how this transition was realized, even though they are accorded a central role in plant collection (before) and cultivation (after).[25] One explanatory model identifies male shamans as the catalysts for this transition; their interest in manipulating plant stocks resulted in the development of cultigens. In another, the plants effectively domesticate themselves by an "automatic" process of adaptation to conditions disrupted by human activities (in "domestilocalities"). As Watson and Kennedy point out, women passively follow plants around when they are wild and passively tend them once domesticated but play no role in the transition from one state to the other. The authors then deploy collateral evidence to show that this failure to recognize women as potential catalysts of change carries substantial costs in explanatory elegance and plausibility. The automatic domestication thesis must counter ethno- and paleobotanical evidence that the key domesticates appeared very early in environments that were by no means optimal for them, evidence that suggests that some human intervention must have been involved in the process of domestication. Likewise, the shaman hypothesis must ignore the implications of presuming that women were involved full time in the exploitation of the plants that later became domesticates, as well as ethnohistorical evidence that shamanism is by no means a male preserve and that women in foraging societies often hold the primary expertise about plant and animal resources that informs group movement and other subsistence-related decision making.

Whatever standpoint-specific factors might have put Watson and Kennedy in a position to notice the common incongruity in these explanatory models (the disappearing women), what makes their analysis compelling is their identification of internal contradictions in the logic of these models and their use of collateral evidence to call into question the assumptions that underlie these contradictions. They grant their opponents the assumptions they make about sexual divisions of labor in foraging and horticultural societies but point out that the archaeological record does not, in fact, deliver any evidence that, interpreted subject to these assumptions, would indicate that men mediated the transition to horticulture. And they make use of independent paleobotanical evidence to call into question the plausibility of "automatic domestication" accounts that deny human agency any substantial role in the transition. In neither case are the presuppositions of Watson and Kennedy's (re)interpretation of the evidence dependent on the assumptions about women's capacities that they criticize or embrace.

In a project that moves beyond critique, also mentioned earlier, Christine Hastorf relies on a similar strategy, exploiting independent background knowledge and sources of evidence to reassess the way in which women's labor and domestic units are conceptualized in state-formation theories for the highland Andes.[26] She compares the sex ratios and lifetime dietary profiles of skeletal material recovered from burials in the Montaro Valley through the period when the Inka first made their imperial presence felt in this region. She found that the dietary intake of men and women was undifferentiated until the advent of Inka influence but then diverged sharply on the isotope values associated with the consumption of maize. Comparing these results with patterns of change over time in other aspects of the sites, she found independent evidence of intensified production and increasingly segregated work areas related to the processing of maize. To interpret these findings she relied on ethnohistoric sources that establish the association of women with maize processing and beer production and suggest that Inka rule involved negotiating with local men as the heads of households and communities and extracting them from their households to serve as conscript labor on Inka construction projects. These multiple lines of evidence suggest that the gendered organization of domestic units was significantly altered by Inka rule; the hierarchical, gender-differentiated divisions of labor and consumption patterns now familiar in the region were established when local communities were incorporated into a state system. This means that gender relations and household organization cannot be treated as a stable substrate that predates and persists as a given through the rising and falling fortunes of states; state formation in the Andes depended on a fundamental restructuring of household-based social relations of production.

As in Watson and Kennedy's case, nothing in the social and political factors that may have informed Hastorf's interest in questions about gender determines that she should have found such striking divergence in the dietary profiles of men and women or such congruence in patterns of change over time in several materially and inferentially independent aspects of the archaeological record. The presuppositions that Hastorf uses to construct data as evidence are not the same as those that define the questions she asks or the range of hypotheses she entertains; they may be radically theory-laden, but they are not laden by the same theories that are tested against this evidence or frame her research program. To put the point more generally, feminist practitioners exploit the fact that androcentric assumptions about gender roles generally lack the resources to ensure that archaeological data will conform to androcentric, presentist expectations; these assumptions do not deliver, along with reconstructive hypotheses, the linking prin-

ciples necessary to establish evidential claims about the antecedent conditions that produced the contents of a specific archaeological record.

There is nothing unique to feminist or gender-sensitive research in this respect. The limited independence of facts of the record from the background assumptions that establish their import as evidence is the primary methodological resource that archaeologists use to assess the credibility of claims about the past in most contexts of inquiry.[27] It is in this that the capacity of evidence to resist our expectations resides. We can exploit this potential in any number of standpoint-specific ways; critics of racism, sexism, nationalism, and classism in archaeology use it to bring into view taken-for-granteds that we should be questioning. That they should do so is no doubt overdetermined by a range of social, theoretical, political, and empirical factors, but exactly how they proceed and what they find out—where or, indeed, whether they locate incongruities that open a space for critical engagement—is also very much a function of the evidence they engage when they assess their own interpretive hypotheses and the background assumptions, the auxiliaries, on which they rely. It is this capacity of even quite remote subjects of inquiry to act back on us that we must keep in view when negotiating polarized debates about the implications of recognizing the limitations and partiality of our sciences.

## CONCLUSIONS

I draw four forward-looking conclusions concerning the tasks that face the proponents of a genuinely interdisciplinary, integrative program of feminist science studies.

1. Critiques that bring into view the pervasive ways in which social and political factors shape inquiry, including those foregrounded by feminist critics of science, should not be the *end* of discussion about such epistemological questions as what constitutes evidence and "good reasons" in a given context of scientific practice. Rather, they should be the beginning of a new kind of discussion, which feminists are especially well situated to carry forward.

2. To set discussion on a new footing, we must break the grip of the presupposition (held by objectivists and relativists alike) that objectivity is an all-or-nothing affair, that it is something we have only if the process and products of inquiry are (implausibly) free of any social or political entanglements and something we lose irrevocably if there is any evidence that science reflects the standpoint of its makers. We must also give up the view that "neutral" investigators are best fitted to maximize the cluster of (often sharply divergent) virtues we associate with "objectivity."[28] We need accounts of knowledge production, authorization, credibility, and use that recognize that the contextual features of social location (standpoint) can make a *constructive* difference in maximizing these epistemic virtues, including quite pragmatic virtues such as reliability under specific ranges of application (a capacity to "travel") and intersubjective stability. The contributions of feminist researchers (both critical and constructive) make it clear that diverse standpoints can greatly enhance the likelihood of realizing specific sorts of empirical accuracy or explanatory breadth and may ensure that a rigorously critical perspective will be brought to bear (or, indeed, that detachment will be preserved) in the evaluation of claims or assumptions that members of a homogeneous community might never think to question.

3. These proposals have concrete implications for research practice. According to current objectivist wisdom, we can best safeguard the authority of science and of specific scientific claims by eliminating from the processes by which we evaluate knowledge claims any hint of contamination from social or political context. But from the foregoing, it follows that a commitment to objectivity may require direct consideration of the sociopolitical standpoint of inquirers in the adjudication of knowledge claims as an integral part of scientific inquiry.

4. Finally, these observations have implications for feminist science studies. They suggest a need for analyses of science that are at once empirically grounded (historically, sociologically, and in the sciences themselves) and epistemically sophisticated, that work "right at the boundary" (as Pickering has put it) between the existing science studies disciplines, and that bring together equity and content critiques. They suggest, further, that feminist science studies must incorporate a normative as well as a descriptive component and that science studies practitioners, most especially feminists, should deliberately position themselves as "insider/outsiders" with respect to the sciences they study. The work of a great many feminist theorists of science already exemplifies this hybrid stance.[29] Indeed, this active engagement with the sciences may be one reason why feminist practitioners and analysts of science have resisted the categories imposed by debates between philosophers and sociologists, constructivists and objectivists in their various fields of (metascientific) practice.

NOTES
   1. These arguments are discussed in more detail in Alison Wylie, "The Constitution of Archaeological Evidence: Gender, Politics, and Science," in *The Disunity of Science: Boundaries, Contexts, and Power,* ed. Peter Galison and David J. Stump (Stanford: Stanford Univ. Press, 1996), pp. 311–343.
   2. Patty Jo Watson and Mary C. Kennedy, "The Development of Horticulture in the Eastern Woodlands of North America: Women's Role," in *Engendering Archaeology: Women and Prehistory,* ed. Joan M. Gero and Margaret W. Conkey (Oxford: Blackwell, 1991) pp. 255–275. For other examples of critiques along these lines, see the original.
   3. See, e.g., Margaret W. Conkey and Janet D. Spector, "Archaeology and the Study of Gender," in *Advances in Archaeological Method and Theory,* vol. 7, ed. Michael B. Schiffer (New York: Academic, 1984), pp. 1–38.
   4. Christine A. Hastorf, "Gender, Space, and Food in Prehistory," in *Engendering Archaeology,* ed. Gero and Conkey, pp. 132–59.
   5. See, for example, Margaret C. Nelson, Sarah M. Nelson, and Alison Wylie, eds., *Equity Issues for Women in Archaeology* (Archaeological Papers, 5) (Washington, D.C.: American Anthropological Association, 1994).
   6. Joan M. Gero, "The Social World of Prehistoric Facts: Gender and Power in Prehistoric Research," in Hilary du Cros, and Laurajane Smith, eds., *Women in Archaeology* (Canberra: Australian National Univ. Occasional Papers, 1993), pp. 31–40, on p. 37.
   7. Ian Hodder, "Archaeology, Ideology, and Contemporary Society," *Royal Anthropological Institute News,* 1983, 56:6; Hodder, "Archaeology in 1984," *Antiquity,* 1984, 58: 26; and Michael Shanks and Christopher Tilley, *Re-Constructing Archaeology* (Cambridge: Cambridge Univ. Press, 1987), p. 111.
   8. Bruce G. Trigger, "Hyperrelativism, Responsibility, and the Social Sciences," *Canadian Review of Sociology and Anthropology,* 1989, 26: 776–797; Thomas Nagel, *The View from Nowhere* (Oxford: Oxford Univ. Press, 1986); and Richard Bernstein, *Beyond Objectivism and Relativism: Science, Hermeneutics, and Praxis* (Philadelphia: Univ. Pennsylvania Press, 1983). See also Alison Wylie, "On 'Heavily Decomposing Red Herrings,'" in *Metaarchaeology,* ed. Lester Embree (Boston: Reidel, 1992), pp. 269–288.
   9. Roy Bhaskar, *A Realist Theory of Science,* 2d ed. (Brighton, Sussex: Harvester, 1978), p. 57; and Ian Hacking, *Representing and Intervening: Introductory Topics in the Philosophy of Natural Science* (Cambridge: Cambridge Univ. Press, 1983).
   10. See, e.g., Ian Hodder, "Interpretive Archaeology and Its Role," *Amer. Antiquity,* 1991, 56: 7–18.
   11. See, e.g., Andrew Pickering, "From Science as Knowledge to Science as Practice," in *Science as Practice and Culture,* ed. Pickering (Chicago: Univ. Chicago Press, 1992), pp. 1–28.
   12. Pickering, "Knowledge, Practice, and Mere Construction," *Social Studies of Science,* 1990, 20: 682–729, p. 710.
   13. I use Bernstein's language; see Bernstein, *Beyond Objectivism and Relativism.*
   14. Nancy Hartsock, "The Feminist Standpoint: Developing the Ground for a Specifically Feminist Historical Materialism," in *Discovering Reality: Feminist Perspectives on Epistemology, Metaphysics, Methodology, and Philosophy of Science,* ed. Sandra Harding and Merrill B. Hintikka (Dordrecht/Boston: Reidel, 1983), pp. 238–310; Sandra Harding,

*Whose Science? Whose Knowledge? Thinking from Women's Lives* (Ithaca, N.Y.: Cornell Univ. Press, 1991); Donna Haraway, "Situated Knowledges: The Science Question in Feminism and the Privilege of Partial Perspective," in *Simians, Cyborgs, and Women: The Reinvention of Nature* (New York: Routledge, 1991); Evelyn Fox Keller, *Secrets of Life, Secrets of Death: Essays on Language, Gender, and Science* (New York: Routledge, 1992); Helen Longino, *Science as Social Knowledge: Values and Objectivity in Scientific Inquiry* (Princeton, N.J.: Princeton Univ. Press, 1990); Anne Fausto-Sterling, "Introduction," in *Myths of Gender: Biological Theories about Women and Men* (New York: Basic, 1985), pp. 9–12; Shulamit Reinharz, *Feminist Methods in Social Research* (Oxford: Oxford Univ. Press, 1992).

15. Conkey and Spector, "Archaeology and the Study of Gender"; and Gero and Conkey, eds., *Engendering Archaeology.*

16. See Marsha P. Hanen and Jane Kelley for background on Chacmool conferences and a discussion of topics addressed at the 1989 meeting: "Gender and Archaeological Knowledge," in *Metaarchaeology,* ed. Embree, pp. 195–227.

17. See the original for details on these meetings and the resulting publications.

18. Cheryl Claassen, "Bibliography of Archaeology and Gender: Papers Delivered at Archaeology Conferences, 1964–1992," *Annotated Bibliographies for Anthropologists,* 1992, 1(2).

19. These questions are discussed in more detail in Alison Wylie, "Feminist Critiques and Archaeological Challenges," in *Archaeology of Gender,* ed. Dale Walde and Noreen D. Willows (Calgary: Archaeological Assn., Univ. Calgary, 1991), pp. 17–23.

20. Alison Wylie, "Gender Theory and the Archaeological Record: Why Is There No Archaeology of Gender?" in *Engendering Archaeology,* ed. Gero and Conkey, pp. 31–54.

21. Examples of early interest in feminist approaches include contributions by Braithwaite and Hodder to *Ideology, Power, and Prehistory,* ed. Daniel Miller and Christopher Tilley (Cambridge: Cambridge Univ. Press, 1984). For feminist criticism of this work see Ericka Engelstad, "Images of Power and Contradiction: Feminist Theory and Postprocessual Archaeology," *Antiquity,* 1991, 65: 502–514; and Roberta Gilchrist, "Review of *Experiencing Archaeology* by Michael Shanks," *Archaeol. Rev. Cambridge,* 1992, 11:188–191.

22. Before 1973, women never made up more than 13 percent of the society's members; in 1973 their representation jumped to 18 percent and by 1976 to 30 percent. Altogether 36 percent of SAA members were women in the fall of 1988, when the Chacmool call for papers was distributed, a level of representation that has been stable in the field since. See Patterson, *Toward a Social History of Archaeology* (Orlando, Fla.: Harcourt Brace, 1995), pp. 81–82.

23. Hanen and Kelley, "Gender and Archaeological Knowledge."

24. Ibid.

25. Watson and Kennedy, "Development of Horticulture."

26. Hastorf, "Gender, Space, and Food in Prehistory."

27. This analysis is developed in more detail in Wylie, "Constitution of Archaeological Evidence."

28. See, e.g., Elisabeth Lloyd, "Objectivity and the Double Standard for Feminist Epistemologies," *Synthese,* 1996, 104: 351–381.

29. See, e.g., the works of Keller, Fausto-Sterling, and Haraway cited in note 14, above, and the collaborative work of Helen Longino and Ruth Doell: "Body, Bias, and Behavior: A Comparative Analysis of Reasoning in Two Areas of Biological Science," *Signs: Journal of Women in Culture and Society,* 1983, 9: 206–227.

# Contributors' Bibliographies

KAREN BARAD

"Reconceiving Scientific Literacy as Agential Literacy, or Learning How to Intra-act Responsibly within the World." In *Doing Cultural Studies of Science and Medicine*, ed. by Roddey Reid and Sharon Traweek. NY: Routledge, 1999.

"Getting Real: Performativity, Materiality, and Technoscientific Practices." In *Differences: A Journal of Feminist Cultural Studies*, vol. 10, no. 2 (Summer 1998).

"Meeting the Universe Halfway: Realism and Social Constructivism Without Contradiction." In *Feminism, Science and Philosophy of Science*, ed. by Lynn Hankinson Nelson and Jack Nelson, pp. 161–194. Dordrecht: Kluwer, 1996.

"A Feminist Approach to Teaching Quantum Physics." In *Teaching the Majority: Breaking the Gender Barrier in Science, Mathematics, and Engineering*, edited by Sue V. Rosser, pp. 43–75. New York: Teachers College Press, 1995.

MARIO BIAGIOLI

"Etiquette, Interdependence, and Sociability in Seventeenth-Century Science." *Critical Inquiry* 22 (1996): 193–238.

"Knowledge, Freedom, and Brotherly Love: Homosociality and the Accademia dei Lincei, 1603–1630." *Configurations* 3 (1995): 139–66.

"Confabulating Jurassic Science." In *Technoscientific Imaginaries*, edited by George Marcus, pp. 399–431. Chicago: University of Chicago Press, 1995.

*Galileo, Courtier: The Practice of Science in the Culture of Absolutism.* Chicago: University of Chicago Press, 1993.

"Science, Modernity, and the Final Solution." In *Probing the Limits of Representation*, edited by Saul Friedlander, pp. 185–205, 371–77. Cambridge, Mass.: Harvard University Press, 1992.

PIERRE BOURDIEU

*The Field of Cultural Production.* New York: Columbia University Press, 1993.

*Language and Symbolic Power.* Cambridge, Mass.: Harvard University Press, 1991.

"The Peculiar History of Scientific Reason." *Sociological Forum* 6 (1991): 3–26.

*Distinction: A Social Critique of the Judgment of Taste.* Cambridge, Mass.: Harvard University Press, 1984.

*Outline of a Theory of Practice.* Cambridge: Cambridge University Press, 1977.

## ROBERT M. BRAIN

"Standards and Semiotics." In *Inscribing Science: Scientific Texts and the Materiality of Communication,* edited by Timothy Lenoir. Stanford: Stanford University Press, 1998.

*Going to the Fair: Readings in the Culture of Nineteenth-Century Exhibitions.* Cambridge: Whipple Publications, 1993.

"The Geographical Vision and the Order of Popular Disciplines." In *Worldview and Discipline Formation: Science Studies in the German Democratic Republic,* edited by William Woodward and Robert S. Cohen. Dordrecht: Kluwer, 1990.

## MICHEL CALLON

ed. *The Laws of the Markets.* Oxford: Blackwell, 1998.

"Four Models for the Dynamics of Science." In *Handbook of Science and Technology Studies,* edited by S. Jasanoff, et al., pp. 29–63. London: Sage, 1994.

"Is Science a Public Good?" *Science, Technology, and Human Values* 19 (1994): 395–424.

"Techno-economic Networks and Irreversibility." In *A Sociology of Monsters. Essays on Power, Technology and Domination. Sociological Review Monograph,* edited by J. Law, pp.132–164. London: Routledge & Kegan Paul, 1991.

with John Law and Arie Rip, eds. *Mapping the Dynamics of Science and Technology: Sociology of Science in the Real World.* London: MacMillan, 1986.

## SANDE COHEN

*Passive Nihilism: On the Politics of Scholarly Writing.* New York: St. Martin's, 1998.

*Academia and the Luster of Capital.* Minneapolis: University of Minnesota Press, 1993.

*Historical Culture.* Berkeley: University of California Press, 1986.

## HARRY M. COLLINS

with Trevor Pinch. *The Golem: What Everyone Should Know About Science,* 2d ed. Cambridge: Cambridge University Press, 1998.

with Trevor Pinch. *The Golem at Large: What Everyone Should Know About Technology.* Cambridge: Cambridge University Press, 1998 (forthcoming).

with Martin Kusch. *The Shape of Action: What Humans and Machines Can Do.* Cambridge, Mass.: MIT Press, 1998.

*Changing Order: Replication and Induction in Scientific Practice,* 2d ed. Chicago: University of Chicago Press, 1992.

*Artificial Experts: Social Knowledge and Intelligent Machines.* Cambridge, Mass.: MIT Press, 1990.

## LORRAINE DASTON

"The Moral Economy of Science," *Osiris* 10 (1995): 3–24.

"Enlightenment Calculations," *Critical Inquiry* 21 (autumn 1994): 182–202.

with Peter Galison, "The Image of Objectivity." *Representations* 40 (fall 1992): 81–128.

"The Naturalized Female Intellect." *Science in Context* 5 (1992): 209–35; reprinted in *Historical Dimensions of Psychological Discourse,* ed. Carl F. Graumann and Kenneth J. Gergen. Cambridge: Cambridge University Press, 1996.

"Marvelous Facts and Miraculous Evidence in Early Modern Europe." *Critical Inquiry* 18 (1991): 93–124; reprinted in *Questions of Evidence, Proof, Practice,* ed. James Chandler, Arnold I. Davidson, and Harry Harootunian. Chicago: University of Chicago Press, 1994.

## ARNOLD I. DAVIDSON

"Miracle of Bodily Transformation, or, How St. Francis Received the Stigmata." In *Picturing Science, Producing Art,* edited by Peter Galison and Caroline Jones. New York: Routledge, 1998.

*The Emergence of Sexuality: Historical Epistemology and the Formation of Concepts.* Cambridge, Mass.: Harvard University Press, 1998.

ed. *Foucault and His Interlocutors.* Chicago: University of Chicago Press, 1997.

with Pierre Hadot, eds. *Philosophy as a Way of Life: Spiritual Exercises from Socrates to Foucault.* Oxford: Blackwell, 1995.

with James Chandler and Harry Harootunian, eds. *Questions of Evidence: Proof, Practice, and Persuasion Across the Disciplines.* Chicago: University of Chicago Press, 1994.

PETER GALISON

with Caroline Jones, eds. *Picturing Science, Producing Art.* New York: Routledge, 1998.
*How Experiments End.* Chicago: University of Chicago Press, 1987.
"The Americanization of Unity." *Daedalus: Science in Culture* 127 (winter 1998): 45–71.
"The Ontology of the Enemy." *Critical Inquiry* 21 (autumn 1994): 228–66.
with Lorraine Daston, "The Image of Objectivity." *Representations* 40 (fall 1992): 81–128.

JAMES R. GRIESEMER

"Tools for Talking: Human Nature, Weismannism, and the Interpretation of Genetic Information." In *Are Genes Us?* edited by Carl Cranor. New Brunswick, N.J.: Rutgers University Press, 1994.
with E. M. Gerson. "Collaboration in the Museum of Vertebrate Zoology." *Journal of the History of Biology* 26 (1993): 185–204.
"Modeling in the Museum: On the Role of Remnant Models in the Work of Joseph Grinnell." *Biology and Philosophy* 5 (1990): 3–36.
with W. C. Wimsatt. "Picturing Weismannism: A Case Study of Conceptual Evolution." In *What the Philosophy of Biology Is,* edited by Michael Ruse, pp. 75–137. Dordrecht: Kluwer, 1989.
*The Social Consequences of the New Genetics.* New Brunswick, N.J.: Rutgers University Press, 1988.

IAN HACKING

*The Social Construction of What?* Cambridge, Mass.: Harvard University Press, forthcoming.
"The Looping Effects of Human Kinds." In *Causal Cognition, an Interdisciplinary Approach,* edited by Dan Sperber, David Premack, and Ann Premack, pp. 351–83. New York: Oxford University Press, 1995.
*Rewriting the Soul: Multiple Personality and the Sciences of Memory.* Princeton: Princeton University Press, 1995.
*Representing and Intervening: Introductory Topics in the Philosophy of Science.* Cambridge: Cambridge University Press, 1983.
*The Emergence of Probability.* Cambridge: Cambridge University Press, 1975.

DONNA HARAWAY

*Modest_Witness@Second_Millennium. Female_Man©_Meets_Oncomouse™.* New York: Routledge, 1997.
"A Game of Cat's Cradle: Science Studies, Feminist Theory, Cultural Studies." *Configurations: A Journal of Literature and Science* 1 (1994): 59–71.
"The Promises of Monsters: Reproductive Politics for Inappropriate/d Others." In *Cultural Studies,* edited by Larry Grossberg, Cary Nelson, and Paula Treichler, pp. 295–337. New York: Routledge, 1992.
*Simians, Cyborgs, and Women: The Reinvention of Nature.* New York: Routledge, 1991.
*Primate Visions: Gender, Race, and Nature in the World of Modern Science.* New York: Routledge, 1989.

ROGER HART

"How to Do Things with Worlds: Incommensurability, Translation, and Problems of Existence in Seventeenth-Century China." In *Tokens of Exchange: The Problem of Translation in Global Circulations,* edited by Lydia H. Liu. Durham, N.C.: Duke University Press, forthcoming.
"Proof, Propaganda, and Patronage: The Dissemination of Western Studies in Seventeenth-Century China." Ph.D. diss., University of California, Los Angeles, 1997.
"The Flight from Reason: Higher Superstition and the Refutation of Science Studies." In *Science Wars,* edited by Andrew Ross, pp. 259–92. Durham, N.C.: Duke University Press, 1996.

THOMAS P. HUGHES

*Rescuing Prometheus.* New York: Pantheon Books, 1998.
with Thomas Agatha, eds. *Lewis Mumford: Public Intellectual.* New York: Oxford University Press, 1990.
*American Genesis: A Century of Invention and Technological Enthusiasm, 1870–1970.* New York: Viking, 1989.
*Networks of Power: Electrification in Western Society, 1880–1930.* Baltimore: Johns Hopkins University Press, 1983.
*Elmer Sperry: Inventor and Engineer.* Baltimore: Johns Hopkins University Press, 1971.

## LILY E. KAY

*Who Wrote the Book of Life? A History of the Genetic Code.* Stanford: Stanford University Press, forthcoming, 1999.

"Cybernetics, Information, Life: The Emergence of Scriptural Representations of Heredity." *Configurations* 5 (1997): 23–91.

"Rethinking Institutions: Philanthropy as an Historiographic Problem of Knowledge and Power." *Minerva* 35 (1997): 283–93.

"Who Wrote the Book of Life? Information and the Transformation of Molecular Biology, 1945–55." *Science in Context* 8 (1995): 609–34.

*The Molecular Vision of Life: Caltech, The Rockefeller Foundation, and the Rise of the New Biology.* New York: Oxford University Press, 1993.

## EVELYN FOX KELLER

"Is There an Organism in this Text?" In *Controlling Our Destinies,* edited by P. Sloan. Notre Dame, Ind.: University of Notre Dame Press, forthcoming.

"*Drosophila* Embryos as Transitional Objects: The Work of Donald Poulson and Christiane Nusslein-Volhard." *Historical Studies in the Physical and Biological Sciences* 26, no. 2 (1996): 313–46.

*Refiguring Life: Metaphors of Twentieth-Century Biology, Wellek Lectures.* New York: Columbia University Press, 1995.

## ROBERT E. KOHLER

with Henrika Kuklick. "Introduction. Science in the Field." *Osiris* 11 (1996): 1–14.

*Lords of the Fly:* Drosophila *Genetics and the Experimental Life.* Chicago: University of Chicago Press, 1994.

"*Drosophila*: the Natural History of Experimental Laboratories." *Journal of the History of Biology* 26 (1993): 281–310.

## BRUNO LATOUR

*Pandora's Hope. Essays on the Reality of Science Studies.* Cambridge, Mass.: Harvard University Press, forthcoming.

*Aramis or the Love of Technology.* Cambridge: Harvard University Press, 1996.

"On Interobjectivity—with discussion by Marc Berg, Michael Lynch, and Yrjo Engelström." *Mind, Culture, and Activity* 34 (1996): 228–45.

*We Have Never Been Modern.* Cambridge, Mass.: Harvard University Press, 1993.

## JOHN LAW

with Annemarie Mol, eds. *Complexities in Science, Technology and Medicine,* Durham, N.C.: Duke University Press, forthcoming, 1999.

with John Hassard, eds. *Actor Network and After.* Oxford, *Sociological Review* and Blackwell: 1998.

*Organizing Modernity.* Oxford and Cambridge, Mass.: Blackwell, 1994.

with Annemarie Mol, "Regions, Networks, and Fluids: Anaemia and Social Topology." *Social Studies of Science* 24, (1994): 641–671.

ed. *A Sociology of Monsters: Essays on Power, Technology and Domination.* London: Routledge, 1991.

## TIM LENOIR

*Instituting Science: The Cultural Production of Scientific Discipline.* Stanford: Stanford University Press, 1997.

with Cheryl Ross. "The Naturalized History Museum." In Peter Galison and David Stump, eds., *The Disunity of Science: Boundaries Contexts and Power.* Stanford: Stanford University Press, 1996, pp. 370–397.

"Helmholtz and the Materialities of Communication." In Thomas P. Hankins and Albert van Helden, eds., *Instruments and the Production of Scientific Knowledge,* special volume of *Osiris,* Vol. 9 (1994): 184–207.

"The Eye as Mathematician: Clinical Practice, Instrumentation, and Helmholtz's Construction of an Empiricist Theory of Vision." In David Cahan, ed., *Hermann von Helmholtz and the Foundations of Nineteenth-Century Science.* Berkeley: University of California Press, 1993: 109–153.

*Politik im Tempel der Wissenschaft: Forschung und Machtausübung im deutschen Kaiserreich.* Frankfurt/Main: Campus Verlag, 1992.

GEOFFREY LLOYD

*Aristotelian Explorations.* Cambridge: Cambridge University Press, 1996.

*Adversaries and Authorities.* Cambridge: Cambridge University Press, 1996.

*Methods and Problems in Greek Science.* Cambridge: Cambridge University Press, 1991.

*Demystifying Mentalities.* Cambridge: Cambridge University Press, 1990.

*The Revolutions of Wisdom.* Berkeley: University of California Press, 1987.

MICHAEL LYNCH

"Laboratory Space and the Technological Complex: An Investigation of Topical Contextures." *Science in Context* 41 (1991): 81–109; reprinted in *Ecologies of Knowledge: Work and Politics in Science and Technology,* edited by Susan Leigh Star, pp. 226–56. Albany, NY: SUNY Press, 1995.

*Scientific Practice and Ordinary Action.* New York: Cambridge University Press, 1993.

with Steve Woolgar, eds. *Representation in Scientific Practice.* Cambridge, Mass.: MIT Press, 1990.

"Discipline and the Material Form of Images: An Analysis of Scientific Visibility." *Social Studies of Science* 15 (1985): 37–66.

*Art and Artifact in Laboratory Science.* London: Routledge & Kegan Paul, 1985.

DONALD MACKENZIE

*Knowing Machines: Essays on Technical Change.* Cambridge, Mass.: MIT Press, 1996.

*Inventing Accuracy: A Historical Sociology of Nuclear Missile Guidance.* Cambridge, Mass.: MIT Press, 1990.

*The Social Shaping of Technology.* Milton Keynes: Open University Press, 1985; second edition co-edited with Judy Wajcman, forthcoming, 1998.

*Statistics in Britain, 1865–1930: The Social Construction of Scientific Knowledge.* Edinburgh: Edinburgh University Press, 1981.

EMILY MARTIN

*Flexible Bodies: Tracking Immunity in American Culture from the Days of Polio to the Age of AIDS.* Beacon Press, 1994.

"Body Narratives, Body Boundaries." In *Cultural Studies,* edited by Cary Nelson, Paula A. Treichler, and Lawrence Grossberg. New York: Routledge, 1992.

"The End of the Body?" *American Ethnologist* (February 1992): 120–38.

"The Egg and the Sperm: How Science Has Constructed a Romance Based on Stereotypical Male-Female Roles." *Signs: Journal of Women in Culture and Society* 16 (1991): 485–501.

*The Woman in the Body: A Cultural Analysis of Reproduction.* Boston: Beacon Press, 1987.

ANDREW PICKERING

*The Mangle of Practice: Time, Agency, and Science.* Chicago: University of Chicago Press, 1995.

"Cyborg History and the World War II Regime." *Perspectives on Science* 3 (1995): 1–48.

ed. *Science as Practice and Culture.* Chicago: University of Chicago Press, 1992.

*Constructing Quarks: A Sociological History of Particle Physics.* Chicago: University of Chicago Press, 1984.

THEODORE M. PORTER

*Trust in Numbers: The Pursuit of Objectivity in Science and Public Life.* Princeton: Princeton University Press, 1995.

"Objectivity as Standardization: The Rhetoric of Impersonality in Measurement, Statistics, and Cost-Benefit Analysis." In *Rethinking Objectivity,* edited by Allan Megill, pp. 197–237. Durham, N.C.: Duke University Press, 1995.

"The Death of the Object: Fin-de-siècle Philosophy of Physics." In *Modernist Impulses in the Human Sciences,* edited by Dorothy Ross, pp. 128–51. Baltimore: Johns Hopkins University Press, 1994.

with Gerd Gigerenzer, et al. *The Empire of Chance: How Probability Changed Science and Everyday Life.* Cambridge: Cambridge University Press, 1989

*The Rise of Statistical Thinking, 1820–1900.* Princeton: Princeton University Press, 1986.

PAUL RABINOW

*Making PCR, A Story of Biotechnology.* Chicago: University of Chicago Press, 1996.

*Essays in the Anthropology of Reason.* Princeton: Princeton University Press, 1996.

*French Modern: Norms and Forms of the Social Environment.* Chicago: University of Chicago Press, 1994 (1989).

HANS-JÖRG RHEINBERGER

*Toward a History of Epistemic Things. Synthesizing Proteins in the Test Tube.* Stanford: Stanford University Press, 1997.

"Beyond Nature and Culture: A Note on Medicine in the Age of Molecular Biology." *Science in Context* 8 (1995): 249–63.

"From Microsomes to Ribosomes: 'Strategies' of 'Representation.'" *Journal of the History of Biology* 28 (1995): 49–89.

"Experiment, Difference, and Writing. I. Tracing protein synthesis; II. The laboratory production of transfer RNA." *Studies in History and Philosophy of Science* 23 (1992): 305–31, 389–422.

with Peter McLaughlin. "Darwin's Experimental Natural History." *Journal of the History of Biology* 17 (1984): 345–68.

BRIAN ROTMAN

"The Truth About Counting." *The Sciences* (Nov/Dec 1997): 34–39.

"Counting Information: A Note on Physicalized Numbers." *Minds and Machines* 6 (1996): 229–38.

*Ad Infinitum . . . the Ghost in Turing Machine: Taking God Out of Mathematics and Putting the Body Back In.* Stanford: Stanford University Press, 1993.

*Signifying Nothing: the Semiotics of Zero.* Stanford: Stanford University Press, 1993 (1987).

"Toward a Semiotics of Mathematics." *Semiotica* 72 (1988): 1–35.

JOSEPH ROUSE

"New Philosophies of Science in North America—Twenty Years Later." *Zeitschrift für allgemeine Wissenschaftstheorie* 29 (1998): 73–124.

"Beyond Epistemic Sovereignty." In *The Disunity of Science: Boundaries, Contexts, and Power,* edited by Peter Galison and David J. Stump, pp. 398–416. Stanford: Stanford University Press, 1996.

"Feminism and the Social Construction of Scientific Knowledge." In *Feminism, Science, and the Philosophy of Science,* edited by L. H. Nelson and J. Nelson, pp. 195–216. Dordrecht: Kluwer, 1996.

*Engaging Science: How to Understand Its Practices Philosophically.* Ithaca: Cornell University Press, 1996.

*Knowledge and Power: Toward a Political Philosophy of Science.* Ithaca: Cornell University Press, 1987.

SIMON SCHAFFER

"Babbage's Intelligence: Calculating Engines and the Factory System." *Critical Inquiry* 21 (1994): 203–27.

"Self-evidence." *Critical Inquiry* 18 (1992): 327–62.

with David Gooding and Trevor Pinch, eds. *The Uses of Experiment: Studies in the Natural Sciences.* (Contributor of "Glass Works: Newton's Prisms and the Uses of Experiment," pp. 67–104.) Cambridge: Cambridge University Press, 1989.

"Astronomers Mark Time: Discipline and the Personal Equation." *Science in Context* 2 (1988): 101–31.

with Steven Shapin. *Leviathan and the Air-Pump: Hobbes, Boyle, and the Experimental Life.* Princeton: Princeton University Press, 1985.

STEVEN SHAPIN

with Christopher Lawrence, eds. *Science Incarnate: Historical Embodiments of Natural Knowledge.* Chicago: University of Chicago Press, 1998.

*The Scientific Revolution.* Chicago: University of Chicago Press, 1996.

"Here and Everywhere: Sociology of Scientific Knowledge." *Annual Review of Sociology* 21 (1995): 289–321.

*A Social History of Truth: Civility and Science in Seventeenth-Century England.* Chicago: University of Chicago Press, 1994.

with Simon Schaffer. *Leviathan and the Air-Pump: Hobbes, Boyle, and the Experimental Life.* Princeton: Princeton University Press, 1985.

SUSAN LEIGH STAR

with Geoffrey Bowker. *How Classifications Work.* Cambridge, Mass.: MIT Press, forthcoming.

with Anselm Strauss. "Layers of Silence, Arenas of Voice: The Ecology of Visible and Invisible Work." *Computer-Supported Cooperative Work: An International Journal,* in press, May, 1998.

with Geoffey Bowker and Stefan Timmermans. "Infrastructure and Organizational Transformation: Classifying Nurses' Work." In *Information Technology and Changes in Organizational Work. Proceedings IFIP WG8.2 Conference,* edited by W. Orlikowski, G. Walsham, M. Jones, and J. DeGross, pp. 344–70. London: Chapman and Hall.

with Karen Ruhleder. "Steps toward an Ecology of Infrastructure: Design and Access for Large Information Spaces." *Information Systems Research* 7 (1996): 111–34.

"Power, Technologies, and the Phenomenology of Standards: On Being Allergic to Onions." In *Sociological Review Monograph. No. 38, A Sociology of Monsters,* edited by John Law, pp. 27–57. London: Routledge, 1991.

### SHARON TRAWEEK

"Warning Signs: Acting on Images." In *Revisioning Women, Health, and Healing: Feminist, Cultural, and Technoscience Perspectives,* edited by Adele Clarke and Virginia Olesen. New York: Routledge, 1998.

"Unity, Dyads, Triads, Quads, and Complexity: Cultural Choreographies of Science." In *The Science Wars,* edited by Stanley Aronowitz and Andrew Ross. Durham, N.C.: Duke University Press, 1997.

"Bachigai [out of place] in Ibaraki: Tsukuba Science City, Japan." In *Technoscientific Imaginaries,* edited by George Marcus. Chicago: University of Chicago Press, 1996.

"Bodies of Evidence: Law and Order, Sexy Machines, and the Erotics of Fieldwork among Physicists." In *Choreographing History,* edited by Susan Foster. Bloomington: Indiana University Press, 1995.

### SHERRY TURKLE

"Cyborg Babies and Cy-Dough-Plasm: Ideas about Life in the Culture of Simulation." In *Cyborg Babies: From Technosex to Technotots,* edited by Robbie Davis-Floyd and Joseph Dumit. New York: Routledge, forthcoming.

"Seeing Through Computers: Education in a Culture of Simulation." *The American Prospect* 31, (March–April 1997).

*Life on the Screen: Identity in the Age of the Internet.* New York: Simon and Schuster, 1995.

*The Second Self: Computers and the Human Spirit.* New York: Simon and Schuster, 1984.

*Psychoanalytic Politics: Jacques Lacan and Freud's French Revolution.* New York: Basic Books, 1978.

### M. NORTON WISE

"Architectures for Steam." In *Architecture and Science,* edited by Peter Galison and Emily Thompson. Cambridge, Mass.: MIT Press, forthcoming, 1998.

"Pascual Jordan: Quantum Mechanics, Psychology, National Socialism." In *Science, Technology, and National Socialism,* edited by M. Walker and M. Renneberg, pp. 224–54. Cambridge: Cambridge University Press, 1994.

"Mediations: Enlightenment Balancing Acts, or the Technologies of Rationalism." In *World Changes: Thomas Kuhn and the Nature of Science,* edited by Paul Horwich, pp. 207–56. Cambridge, Mass.: MIT Press, 1992.

with Crosbie Smith, "Work and Waste: Political Economy and Natural Philosophy in Nineteenth Century Britain," *History of Science,* 27 (1989): Pt. I, 263–301; Pt. II, 391–449; Pt. III, 28 (1990) 221–61.

with Crosbie Smith. *Energy and Empire: A Biographical Study of Lord Kelvin.* Cambridge: Cambridge University Press, 1989.

### ALISON WYLIE

"Good Science, Bad Science, or Science as Usual?: Feminist Critiques of Science," In *Women in Human Evolution,* edited by Lori D. Hager, pp. 29–55. Routledge: New York, 1997.

"Ethical Dilemmas in Archaeological Practice: Looting, Repatriation, Stewardship, and the Transformation of Disciplinary Identity." *Perspectives on Science* 4 (1996): 154–94.

"The Constitution of Archaeological Evidence: Gender Politics and Science." In *The Disunity of Science: Boundaries, Contexts, and Power,* edited by Peter Galison and David J. Stump, pp. 311–43. Stanford: Stanford University Press, 1996.

with Valerie Pinksy, eds. *Critical Traditions in Contemporary Archaeology: Essays in the Philosophy, History and Socio-Politics of Archaeology.* Albuquerque: University of New Mexico Press, 1995.

"Doing Philosophy as a Feminist: Longino on the Search for a Feminist Epistemology." *Philosophical Topics* 23 (1995): 345–58.

# Selected Readings

Each contributor was asked to provide a list of ten books or articles (authored by other people) that s/he thought anyone interested in science studies should read. The following bibliography is a complete compilation of those lists.

Alcoff, Linda, and Elizabeth Potter, eds. *Feminist Epistemologies.* New York: Routledge, 1993.

Alder, Ken. *Engineering the Revolution: Arms and Enlightenment in France 1763–1815.* Princeton: Princeton University Press, 1997.

Alpers, Svetlana. *The Art of Describing: Dutch Art in the Seventeenth-Century.* Chicago: University of Chicago Press, 1983.

Bachelard, Gaston. *The New Scientific Spirit.* Translated by Arthur Goldhammer. Boston: Beacon Press, 1984.

Barad, Karen. "Meeting the Universe Halfway: Ambiguities, Discontinuities, Quantum Subjects, and Multiple Positionings in Feminism and Physics." In *Feminism, Science, and the Philosophy of Science: A Dialogue,* edited by Lynn H. Nelson and Jack Nelson. Dordrecht: Kluwer, 1996.

Barnes, Barry. *Scientific Knowledge and Sociological Theory.* Boston: Routledge & Kegan Paul, 1974.

———. *Interests and the Growth of Knowledge.* Boston: Routledge & Kegan Paul, 1977.

Barnes, Barry, and David Bloor. "Relativism, Rationalism and the Sociology of Knowledge." In *Rationality and Relativism,* edited by Martin Hollis and Steven Lukes, pp. 21–47. Oxford: Basil Blackwell, 1982.

Barnes, Barry, D. Bloor, and J. Henry. *Scientific Knowledge: A Sociological Analysis.* Chicago: University of Chicago Press, 1996.

Beck, Ulrich. *Ecological Politics in the Age of Risk.* Cambridge: Polity Press, 1995.

———. *Risk Society: Towards a New Modernity.* Translated by Mark Ritter. London and Newbury Park, Calif.: Sage, 1992.

Biagioli, Mario. *Galileo, Courtier: The Practice of Science in the Culture of Absolutism.* Chicago: University of Chicago Press, 1993.

Bijker, Wiebe E., Thomas P. Hughes, and Trevor J. Pinch, eds. *The Social Construction of Technological Systems: New Directions in the Sociology and History of Technology.* Cambridge, Mass.: MIT Press, 1987.

Bloor, David. *Knowledge and Social Imagery.* Chicago: University of Chicago Press, 1976.

———. "Durkheim and Mauss Revisited: Classification and the Sociology of Knowledge." *Studies in History and Philosophy of Science* 13 (1982): 267–97.

———. "A Sociological Theory of Objectivity." In *Objectivity and Cultural Divergence,* edited by S. C. Brown, pp. 229–45. Cambridge: Cambridge University Press, 1984.

———."Wittgenstein, Mannheim, and the Sociology of Mathematics." *Studies in the History and Philosophy of Science* 4 (1973): 173–91.

Blumenberg, Hans. *The Legitimacy of the Modern Age.* Translated by Robert M. Wallace. Cambridge, Mass.: MIT Press, 1983.

Bono, James J. "Science, Discourse, and Literature: The Role/Rule of Metaphor in Science." In *Literature and Science: Theory and Practice,* edited by Stuart Peterfreund, pp. 59–90. Boston: Northeastern University Press, 1990.

Bowker, Geoffrey. *Science on the Run: Information Management and Industrial Geophysics at Schlumberger, 1920–1940.* Cambridge, Mass.: MIT Press, 1994.

Bray, Francesca. *Technology and Gender: Fabrics of Power in Late Imperial China.* Berkeley: University of California Press, 1997.

Brian, Eric. *La Mesure de l'Etat: Administrateurs et Géomètres au XVIIIe Siècle.* Paris: Albin Michel, 1994.

Burkert, Walter. *Lore and Science in Ancient Pythagoreanism.* Cambridge, Mass.: Harvard University Press, 1972.

Button, Graham, ed. *Ethnomethodology and the Human Sciences.* Cambridge, Mass.: Cambridge University Press, 1991.

Cambrosio, Alberto, Daniel Jacoby, and Peter Keating. "Ehrlich's 'Beautiful Pictures' and the Controversial Beginnings of Immunological Imagery." *Isis* 84 (1993): 662–99.

Canguilhem, Georges. *The Normal and the Pathological.* Translated by Carolyn R. Fawcett in collaboration with Robert S. Cohen. New York: Zone Books, 1989.

Cartwright, Nancy. *How the Laws of Physics Lie.* Oxford: Clarendon Press, 1983.

Cartwright, Nancy, Jordi Cat, Lola Fleck, and Thomas Uebel. *Otto Neurath: Philosophy Between Science and Politics.* Cambridge: Cambridge University Press, 1996.

Certeau, Michel de. *The Writing of History.* New York: Columbia University Press, 1988.

Chemla, Karine. "Theoretical Aspects of Chinese Algorithmic Tradition 1st to 3rd Century." *Historia Scientiarum: International Journal of the History of Science of Japan* 42 (1991): 75–98.

Clarke, Adele, and Teresa Montini. "The Many Faces of RU486: Tales of Situated Knowledges and Technological Contestations." *Science, Technology, and Human Values* 18 (1993): 42–78.

Cohn, Carol. "Sex and Death in the Rational World of Defense Intellectuals." *Signs* 124: 687–718.

Collins, Harry. *Changing Order: Replication and Induction in Scientific Practice.* London: Sage, 1985.

Collins, Harry, and Trevor Pinch. *The Golem: What Everyone Should Know About Science.* Cambridge: Cambridge University Press, 1993.

Cronon, William. *Nature's Metropolis: Chicago and the Great West.* New York: W. W. Norton, 1991.

———, ed. *Uncommon Ground: Reinventing Nature.* New York: W. W. Norton, 1995.

Cullen, Christopher. *Astronomy and Mathematics in Ancient China: The Zhou Bi Suan Jing.* New York: Cambridge University Press, 1996.

Danziger, Kurt. *Constructing the Subject: Historical Origins of Psychological Research.* Cambridge: Cambridge University Press, 1990.

Dear, Peter. *Discipline and Experience: The Mathematical Way in the Scientific Revolution.* Chicago: University of Chicago Press, 1995.

De Landa, Manuel. *War in the Age of Intelligent Machines.* New York: Zone Books, 1991.

Deleuze, Gilles, and Felix Guattari. *Anti-Oedipus: Capitalism and Schizophrenia.* Translated by Robert Hurley, et al. New York: Viking Press, 1977.

Deleuze, Gilles. *Nietzsche and Philosophy.* New York: Columbia University Press, 1983.

De Man, Paul. *Resistance to Theory.* Minneapolis: University of Minnesota Press, 1986.

———. *Aesthetic Ideology.* Minneapolis: University of Minnesota Press, 1996.

Derrida, Jacques. *Of Grammatology.* Translated by Gayatri Chakravorty Spivak. Baltimore: Johns Hopkins University Press, 1976.

Descola, Philippe, and Gisli Palsson, eds. *Nature and Society: Anthropological Perspectives.* London: Routledge, 1996.

Desmond, Adrian. *The Politics of Evolution: Morphology, Medicine, and Reform in Radical London.* Chicago: University of Chicago Press, 1989.

Desrosieres, Alain. *La Politique des Grands Nombres: Histoire de la Raison Statistique.* Paris: Editions La Decouverte, 1993.

Donald, Merlin. *Origins of the Modern Mind: Three Stages in the Evolution of Culture & Cognition.* Cambridge, Mass.: Harvard University Press, 1991.

Douglas, Mary H. *Purity and Danger: An Analysis of the Concepts of Pollution and Taboo.* London: Routledge, 1966.

Downey, Gary, and Joseph Dumit, eds. *Cyborg and Citadels: Interventions in the Anthropology of Technohumanism.* Santa Fe, New Mexico: School of American Research, forthcoming.

Dreyfus, Hubert. *What Computers Can't Do.* New York: Harper & Row, 1972.

Dupré, John. *The Disorder of Things: Metaphysical Foundations of the Disunity of Science.* Cambridge, Mass.: Harvard University Press, 1993.

Edgerton, Samuel Y. *The Renaissance Rediscovery of Linear Perspective.* New York: Basic Books, 1975.

Edwards, Paul. *The Closed World: Computers and the Politics of Discourse in Cold War America.* Cambridge, Mass.: MIT Press, 1996.

Engeström, Yrjö, "When is a tool? Multiple Meanings of Artifacts in Human Activity." In *Learning, Working and Imagining: Twelve Studies in Activity Theory.* Edited by Yrjö Engeström, pp. 171–95. Helsinki: Orienta-Konsutit Og, 1990.

Ezrahi, Yaron. *The Descent of Icarus: Science and the Transformation of Contemporary Democracy.* Cambridge, Mass.: Harvard University Press, 1990.

Farquhar, Judith. *Knowing Practice: The Clinical Encounter of Chinese Medicine.* Boulder: Westview Press, 1994.

Feyerabend, Paul. *Against Method: Outline of an Anarchistic Theory of Knowledge.* London: New Left Books, 1975.
———. *Science in a Free Society.* London: New Left Books, 1978.

Findlen, Paula. *Possessing Nature: Museums, Collecting, and Scientific Culture in Early Modern Italy.* Berkeley: University of California Press, 1994.

Fleck, Ludwik. *Genesis and Development of a Scientific Fact.* Edited by Thaddeus J. Treen and Robert K. Merton. Chicago: University of Chicago Press, 1979.

Forman, Paul. "Behind Quantum Electronics: National Security as Basis for Physical Research in the United States, 1940–1960." *Historical Studies in the Physical and Biological Sciences* 18 (1987): 149–229.

Forsythe, Diana. "Blaming the User in Medical Informatics." *Knowledge and Society: The Anthropology of Science and Technology* 9 (1992): 95–111.

Foucault, Michel. *The Archaeology of Knowledge and the Discourse on Language.* Translated by A. M. Sheridan Smith. New York: Pantheon Books, 1972.
———. *The History of Sexuality.* 3 vols. London: Allen Lane, 1978–88.
———. *The Order of Things: An Archaeology of the Human Sciences.* New York: Pantheon Books, 1970.

Fu, Daiwie. "A Contextual and Taxonomic Study of the 'Divine Marvels' and 'Strange Occurrences' in the Mengxi Bitan." *Chinese Science* 11 (1993–94): 3–35.

Fujimura, Joan. *Crafting Science: A Sociohistory of the Quest for Genetics of Cancer.* Cambridge, Mass.: Harvard University Press, 1996.

Furley, David J. *The Greek Cosmologists.* Vol. I. Cambridge: Cambridge University Press, 1987.

Furth, Charlotte. "Androgynous Males and Deficient Females: Biology and Gender Boundaries in Sixteenth- and Seventeenth-Century China." *Late Imperial China* 9 (1988): 1–31.

Fyfe, Gordon, and John Law, eds. *Picturing Power: Visual Depiction and Social Relations.* London: Routledge, 1988.

Galison, Peter. *Image and Logic: A Material Culture of Microphysics.* Chicago: University of Chicago Press, 1997.
———. "The Ontology of the Enemy: Norbert Wiener and the Cybernetic Vision." *Critical Inquiry* 21 (1994): 228–65.
———, and David Stump, eds. *The Disunity of Science: Boundaries, Contexts, and Power.* Stanford: Stanford University Press, 1996.

Garfinkel, Harold. *Studies in Ethnomethodology.* Englewood Cliffs, N.J.: Prentice Hall, 1967.

Gasser, Les. "The Integration of Computing and Routine Work." *ACM Transactions on Office Information Systems* 4 (1986): 205–25.

Geison, Gerald. *The Private Science of Louis Pasteur.* Princeton: Princeton University Press, 1995.

Genette, Gerard. *Mimologics.* Translated by Thais E. Morgan. Lincoln: University of Nebraska Press, 1995.

Gieryn, Thomas F. "Boundary-work and the Demarcation of Science from Non-science: Strains and Interests in Professional Ideologies of Scientists." *American Sociological Review* 48 (1983): 781–95.

Gingras, Yves. "Following Scientists through Society? Yes, but at Arm's Length." In *Scientific Practice: Theories and Stories of Doing Physics,* edited by Jed Z. Buchwald, pp. 123–48. Chicago: University of Chicago Press, 1995.

Golinski, Jan. *Making Natural Knowledge: Constructivism and the History of Science.* Cambridge: Cambridge University Press, forthcoming.

———. "Precision Instruments and the Demonstrative Order of Proof in Lavoisier's Chemistry." *Osiris* 9 (1995): 30–47.

———. *Science as Public Culture: Chemistry and Enlightenment in Britain, 1760–1820.* Cambridge: Cambridge University Press, 1992.

Goodwin, Charles. "Professional Vision." *American Anthropologist* 96 (1994): 606–33.

———. "Seeing in Depth." *Social Studies of Science* 252 (1995): 237–84.

Gray, Chris Hables, et al., eds. *The Cyborg Handbook.* New York: Routledge, 1995.

Gusterson, Hugh. *Nuclear Rites: A Weapons Laboratory at the End of the Cold War.* Berkeley: University of California Press, 1996.

Hacking, Ian. *Representing and Intervening: Introductory Topics in the Philosophy of Natural Science.* Cambridge: Cambridge University Press, 1983.

———. *Rewriting the Soul: Multiple Personality and the Sciences of Memory.* Princeton: Princeton University Press, 1997.

———. *The Taming of Chance.* Cambridge: Cambridge University Press, 1990.

———. "Styles of Scientific Reasoning." In *Post-Analytic Philosophy,* edited by John Rajchman and Cornel West, pp. 145–163. New York: Columbia University Press, 1985.

Haraway, Donna. *Modest_Witness@Second_Millenium.FemaleMan©_Meets_OncoMouse™: Feminism and Technoscience.* New York: Routledge, 1997.

———. *Simians, Cyborgs, and Women: The Reinvention of Nature.* New York: Routledge, 1991.

———. *Primate Visions: Gender, Race, and Nature in the World of Modern Science.* New York: Routledge, 1989.

Harding, Sandra, ed. *The "Racial" Economy of Science: Towards a Democratic Future.* Bloomington: Indiana University Press, 1993.

———. *Is Science Multicultural? Postcolonialism, Feminisms, and Epistmologies.* Bloomington: Indiana University Press, 1998.

———. *Whose Science? Whose Knowledge? Thinking from Women's Lives.* Ithaca: Cornell University Press, 1991.

Hartouni, Valerie. *Cultural Conceptions: On Reproductive Technologies and the Remaking of Life.* Minneapolis: University of Minnesota Press, 1997.

Haslanger, Sally. "On Being Objective and Being Objectified." In *A Mind of One's Own: Feminist Essays on Reason and Objectivity,* edited by Louise Antony and Charlotte Witt, pp. 85–125. Boulder: Westview Press, Boulder, 1993.

Heath, Deborah and Michael Flower. "Micro-Anatomo Politics: Mapping the Human Genome Project." *Culture, Medicine, and Psychiatry* 17 (1993): 27–41.

Hess, David. *Science and Technology in a Multicultural World: The Cultural Politics of Facts and Artifacts.* New York: Columbia University Press, 1995.

Huang, Yi-long. "Court Divination and Christianity in the K'ang-Hsi Era." *Chinese Science* 10 (1991): 1–20.

Hughes, Thomas P. *Networks of Power: Electrification in Western Society, 1880–1930.* Baltimore: Johns Hopkins University Press, 1983.

Hunter, Louis C. *Steamboats on the Western Rivers, an Economic and Technological History.* Cambridge, Mass.: Harvard University Press, 1949.

Hutchins, Edwin. *Cognition in the Wild.* Cambridge, Mass.: MIT Press, 1995.

Jacob, François. *The Statue Within: An Autobiography.* Translated by Franklin Philip. New York: Basic Books, 1988.

Jasanoff, Sheila. *The Fifth Branch: Science Advisers as Policymakers.* Cambridge, Mass.: Harvard University Press, 1990.

Jordan, Kathleen, and Michael Lynch. "The Sociology of a Genetic Engineering Technique: Ritual and Rationality in the Performance of the 'Plasmid Prep.'" In *The Right Tools for the Job: At Work in the Twentieth-Century Life Sciences,* edited by Adele E. Clarke and Joan H. Fujimura, pp. 77–114. Princeton: Princeton University Press, 1992.

Keller, Evelyn Fox. *Reflections on Gender and Science.* New Haven: Yale University Press, 1985.

———. *Secrets of Life, Secrets of Death: Essays on Language, Gender, and Science.* New York: Routledge, 1992.

———, and Helen Longino, eds. *Feminism and Science.* Oxford: Oxford University Press, 1996.

Kittler, Friedrich. *Discourse Networks 1800/1900.* Stanford: Stanford University Press, 1990.

Knorr-Cetina, Karin. *The Manufacture of Knowledge: An Essay on the Constructivist and Contextual Nature of Science.* New York: Pergamon Press, 1981.

Knorr-Cetina, Karin, and Michael Mulkay, eds. *Science Observed: Perspectives on the Social Study of Science.* Beverly Hills: Sage, 1983.

Kohlstedt, Sally Gregory, and Helen E. Longino, eds. *Women, Gender, and Science: New Directions.* Chicago: University of Chicago Press, 1997.

Kubler, George. *The Shape of Time: Remarks on the History of Things.* New Haven: Yale University Press, 1962.

Kuhn, Thomas S. *The Structure of Scientific Revolutions.* Chicago: University of Chicago Press, 1962.

———. "The Function of Measurement in Modern Physical Science." *Isis* 52 (1961):161–90.

Lakatos, Imre. *Proofs and Refutations: The Logic of Mathematical Discovery.* Cambridge: Cambridge University Press, 1976.

Latour, Bruno. *Aramis, or the Love of Technology.* Cambridge, Mass.: Harvard University Press, 1996.

———. *Science in Action: How to Follow Scientists and Engineers through Society.* Philadelphia: Open University Press, 1987.

———. *The Pasteurization of France.* Cambridge, Mass.: Harvard University Press, 1988.

———. "Visualization and Cognition: Thinking with Eyes and Hands." *Knowledge and Society: Studies in the Sociology of Culture Past and Present* 6 (1986): 1–40.

———. *We Have Never Been Modern.* Translated by Catherine Porter. Cambridge: Harvard University Press, 1993.

Lave, Jean. *Cognition in Practice: Mind, Mathematics, and Culture in Everyday Life.* Cambridge, Mass.: Cambridge University Press, 1988.

Lave, Jean, and Etienne Wenger. *Situated Learning: Legitimate Peripheral Participation.* Cambridge: Cambridge University Press, 1991.

Law, John, ed. *Power, Action and Belief: A New Sociology of Knowledge?* Boston: Routledge & Kegan Paul, 1986.

Lecercle, Jean-Jacques. *The Violence of Language.* London: Routledge, 1990.

Lenoir, Timothy. *Instituting Science.* Stanford: Stanford University Press, 1997.

Lévi-Strauss, Claude. *The Savage Mind.* Chicago: University of Chicago Press, 1966.

Lindqvist, Svante. *Technology on Trial: The Introduction of Steam Power Technology into Sweden.* Stockholm: Almqvist & Wiksell, 1984.

Longino, Helen. *Science as Social Knowledge: Values and Objectivity in Scientific Inquiry.* Princeton: Princeton University Press, 1990.

Lynch, Michael, *Scientific Practice and Ordinary Action: Ethnomethodology and Social Studies of Science.* Cambridge: Cambridge University Press, 1993.

——— and Steven Woolgar, eds. *Representation in Scientific Practice.* Cambridge, Mass.: MIT Press, 1988.

MacKenzie, Donald. *Inventing Accuracy: A Historical Sociology of Nuclear Missile Guidance.* Cambridge, Mass.: MIT Press, 1990.

Marks, Harry. *The Progress of Experiment: Science and Therapeutic Reform in the United States 1900–1990.* Cambridge: Cambridge University Press, 1997.

Martin, Emily. "The End of the Body?" *American Ethnologist* 19 (1): 121–40.

———. *Flexible Bodies: Tracking Immunity in American Culture from the Days of Polio to the Age of AIDS.* Boston: Beacon Press, 1994.

Mehrtens, Herbert. *Moderne, Sprache, Mathematik: Eine Geschichte des Streits um die Grundlagen der Disziplin und des Subjekts formaler Systeme.* Frankfurt: Suhrkamp, 1990.

Miller, Perry. *The Life of the Mind in America: From the Revolution to the Civil War.* New York: Harcourt, Brace & World, 1965.

Morison, Elting. *From Know-How to Nowhere.* New York: Basic Books, 1974.

———. *Men, Machines, and Modern Times.* Cambridge, Mass.: MIT Press, 1966.

Mumford, Lewis. *Technics and Civilization.* New York: Harcourt, Brace & Company, 1934.

Myers, Greg. "From Discovery to Invention: The Writing and Rewriting of Two Patents." *Social Studies of Science* 25 (1995): 57–105.

———. "Politeness and Certainty: The Language of Collaboration in an AI Project." *Social Studies of Science* 21(1991): 37–51.

Needham, Joseph. *Science and Civilisation in China, Volumes II & III.* Cambridge: Cambridge University Press, 1956–.

Nelson, Lynn H., and Jack Nelson, eds. *Feminism, Science, and the Philosophy of Science.* Dordrecht: Kluwer, 1996.

Nietzsche, Friedrich. "Truth and Lie in a Nonmoral Sense." In *The Portable Nietzsche,* edited and translated by Walter Kaufmann, pp. 42–47. New York: Viking Press, 1968.

Noble, David. *Forces of Production: A Social History of Industrial Automation.* New York: Alfred A. Knopf, 1984.

Olesko, Kathryn. "The Meaning of Precision: The Exact Sensibility in Early Nineteenth-Century Germany." In *The Values of Precision,* edited by M. Norton Wise, pp. 103–34. Princeton: Princeton University Press, 1995.

Pestre, Dominique. "Pour une Histoire Sociale et Culturelle des Sciences: Nouvelles Définitions, Nouveaux Objets, Nouvelles Pratiques." *Annales* 50 (1995): 487–522.

Piaget, Jean. *The Child's Conception of the World.* New York: Harcourt, Brace & Company, 1929.

Pickering, Andrew. *The Mangle of Practice: Time, Agency, and Science.* Chicago: University of Chicago Press, 1995.

———, ed. *Science as Practice and Culture.* Chicago: University of Chicago Press, 1992.

Pinch, Trevor J. *Confronting Nature: The Sociology of Solar-Neutrino Detection.* Dordrecht: D. Reidel, 1986.

Porter, Theodore M. *Trust in Numbers: The Pursuit of Objectivity in Science and Public Life.* Princeton: Princeton University Press, 1995.

Rabinow, Paul. "Artificiality and Enlightenment: From Sociobiology to Biosociality." In *Incorporations, Zone 6,* edited by J. Crary and S. Kwinter. Cambridge, Mass.: MIT Press, 1992.

———. *Essays on the Anthropology of Reason.* Princeton: Princeton University Press, 1996.

Rapp, Rayna. "Chromosomes and Communication: the Discourse of Genetic Counseling." *Medical Anthropology Quarterly* 22 (1988): 143–57.

Rheinberger, Hans-Jörg. *Toward a History of Epistemic Things: Synthesizing Proteins in the Test Tube.* Stanford: Stanford University Press, 1997.

Romanyshyn, Robert D. *Technology as Symptom and Dream.* New York: Routledge, 1989.

Rotman, Brian. *Signifying Nothing: The Semiotics of Zero.* Basingstoke, N.H.: The MacMillan Press, 1989.

Rouse, Joseph. *Engaging Science: How to Understand Its Practices Philosophically.* Ithaca: Cornell University Press, 1996.

Rudwick, Martin. "The Emergence of a Visual Language for Geological Science 1760–1840." *History of Science* 14 (1976): 149–95.

Schaffer, Simon. "Enlightened Automata." In *The Sciences in Enlightened Europe,* edited by William Clark, Jan Golinski, and Simon Schaffer. Chicago: University of Chicago Press, forthcoming.

Schivelbusch, Wolfgang. *The Railway Journey: The Industrialization of Time and Space in the 19th Century.* Berkeley: University of California Press, 1986.

Secord, Anne. "Science in the Pub: Artisan Botanists in Early Nineteenth-Century Lancashire." *History of Science* 32 (1994): 269–315.

Serres, Michel, ed. *Elements d'Histoire des Sciences.* Paris: Bordas, 1989.

Shapin, Steven. "Pump and Circumstance: Robert Boyle's Literary Technology." *Social Studies of Science* 14 (1984): 481–520.

———. "Science and the Public." In *Companion to the History of Modern Science,* edited by R. C. Olby et al., pp. 990–1007. New York: Routledge, 1990.

———. *A Social History of Truth: Civility and Science in Seventeenth-Century England.* Chicago: University of Chicago Press, 1994.

———. "Trust, Honesty, and the Authority of Science." In *Society's Choices: Social and Ethical Decision Making in Biomedicine,* edited by Ruth E. Bulger, Elizabeth M. Bobby, and Harvey V. Fineberg, pp. 388–408. Washington, D.C.: National Academy Press, 1995.

———, and Simon Schaffer. *Leviathan and the Air-Pump: Hobbes, Boyle, and the Experimental Life.* Princeton: Princeton University Press, 1985.

Sibum, Otto. "Reworking the Mechanical Equivalent of Heat: Instruments of Precision and Gestures of Accuracy in Early Victorian England." *Studies in History and Philsophy of Science* 26 (1995): 73–106.

Sivin, Nathan. "Science and Medicine in Imperial China: The State of the Field." *Journal of Asian Studies* 47 (1988): 41–90.

———. "State, Cosmos, and Body in the Last Three Centuries B.C." *Harvard Journal of Asiatic Studies* 55 (1995): 5–37.

————. *Science in Ancient China: Researches and Reflections.* Vol. I. Aldershot: Variorum, 1995.

————. *Medicine, Philosophy, and Religion in Ancient China: Researches and Reflections.* Vol. II. Aldershot: Variorum, 1995.

Smith, Barbara H. *Contingencies of Value: Alternative Perspectives for Critical Theory.* Cambridge, Mass.: Harvard University Press, 1988.

Smith, Crosbie and M. Norton Wise. *Energy and Empire: A Biographical Study of Lord Kelvin.* Cambridge: Cambridge University Press, 1989.

Star, Susan Leigh. "Power, Technology and the Phenomenology of Conventions: On Being Allergic to Onions." In *A Sociology of Monsters: Power, Technology, and Domination,* edited by J. Law, pp. 26– 56. London: Routledge, 1991.

Staudenmaier, John M. *Technology's Storytellers: Reweaving the Human Fabric.* Cambridge, Mass.: MIT Press, 1985.

Suchman, Lucille. *Plans and Situated Actions: The Problem of Human-Machine Communication.* Cambridge: Cambridge University Press, 1987.

Sun-Tzu. *The Art of War.* Translated by Samuel B. Griffith. New York: Oxford University Press, 1963.

Traweek, Sharon. *Beamtimes and Lifetimes: The World of High Energy Physicists.* Cambridge, Mass.: Harvard University Press, 1988.

————. "Border Crossings: Narrative Strategies in Science Studies and Among Physicists in Tsukuba Science City, Japan." In *Science as Practice and Culture,* edited by A. Pickering, pp. 429–65. Chicago: University of Chicago Press, 1991.

Vaughan, Diane. *The Challenger Launch Decision: Risky Technology, Culture, and Deviance at NASA.* Chicago: Chicago University Press, 1996.

Vernant, Jean Pierre. *The Origins of Greek Thought.* Ithaca: Cornell University Press, 1982. Translation of *Les Origines de la Pénsee Grecque* (Paris: Presses Universitaires de France, 1962.)

Vlastos, Gregory. *Plato's Universe.* Seattle: University of Washington Press, 1975.

Wagner, Ina. "Women's Voice: The Case of Nursing Information Systems." *AI and Society,* vol. 74 (1993).

Wajcman, Judy. *Feminism Confronts Technology.* University Park: Pennsylvania State University Press, 1991.

Warwick, Andrew. "Cambridge Mathematics and Cavendish Physics: Cunningham, Campbell and Einstein's Relativity, 1905–1911. Part I: The Uses of Theory. Part II: Comparative Traditions in Cambridge Physics." *Studies in History and Philosophy of Science* 23 (1992): 625–56; 24 (1993): 1–25.

Weber, Max. "Science as a Vocation." In *From Max Weber,* translated and edited by H. H. Gerth and C. Wright Mills. New York: Oxford University Press, 1946.

Wimsatt, William C. "False Models as Means to Truer Theories." In *Neutral Models in Biology,* edited by Matthew H. Nitecki and Antoni Hoffman, pp. 23–55. New York: Oxford University Press, 1987.

Winch, Peter. *The Idea of a Social Science and its Relation to Philosophy.* London: Routledge & Kegan Paul, 1958.

Winnicott, D. W. *Playing and Reality: Transitional Objects and Transitional Phenomena.* New York: Basic Books, 1971.

Wise, M. Norton. "Mediations: Enlightment Balancing Acts, or the Technologies of Rationalism." In *World Changes: Thomas Kuhn and the Nature of Science,* edited by Paul Hozwich, pp. 207–256. Cambridge, Mass.: M.I.T. Press, 1993.

————. "Work and Waste: Political Economy and Natural Philosophy in Nineteenth-Century Britain." In *History of Science* 27(1989): 263–317; 391–449; 28(1990): 221–61.

Wittgenstein, Ludwig. *Philosophical Investigations.* Translated by G. E. M. Anscombe. Oxford: Blackwell, 1953.

White, Lynn Jr. *Medieval Technology and Social Change.* Oxford: The Clarendon Press, 1962.

Yates, JoAnne. *Control through Communication: The Rise of System in American Management.* Baltimore: Johns Hopkins University Press, 1989.

# Contributors' List

Karen Barad
Department of Women's Studies
Rutgers University
New Brunswick, NJ 08901
kbarad@rci.rutgers.edu

Mario Biagioli
Department of History of Science
Harvard University
Cambridge, MA 02138
biagioli@fas.harvard.edu

Pierre Bourdieu
College de France and E.H.E.S.S.
75006 Paris, France

Robert M. Brain
Department of History of Science
Harvard University
Cambridge, MA 02138
brain@fas.harvard.edu

Michel Callon
Centre de la Sociologie de
   l'Innovation
Ecole Superieure des Mines
75006 Paris, France
callon@paris.ensmp.fr

Sande Cohen
Department of Critical Studies
California Institute for the Arts
Valencia, CA 90291
smcohen@earthlink.com

H.M. Collins
KES
Cardiff University
Cardiff, CF1 3AT, United Kingdom
CollinsHM@cardiff.ac.uk

Lorraine Daston
Max Planck Institute for History of
   Science
D-10117 Berlin, Germany
ldaston@mpiwg-berlin.mpg.de

Arnold I. Davidson
Department of Philosophy
University of Chicago
Chicago, IL 60637

Peter Galison
Department of History of Science
Harvard University
Cambridge, MA 02138
galison@fas.harvard.edu

James R. Griesemer
Department of Philosophy
University of California
Davis, CA 95616
jrgriesemer@ucdavis.edu

Ian Hacking
Department of Philosophy
University of Toronto
Ontario, M5S 1A1, Canada
ihack@chass.utoronto.ca

Donna J. Haraway
History of Consciousness
University of California, Santa Cruz
Santa Cruz, CA 95064
haraway@cats.ucsc.edu

Roger Hart
Program in History & Philosophy of
   Science
Stanford University
Stanford, CA 94305
rhart@stanford.edu

Thomas P. Hughes
Department of History and
   Sociology of Science and
   Technology
University of Pennsylvania
Philadelphia, PA 19014
thughes@sas.upenn.edu

Lily E. Kay
Department of Evolutionary and
   Organismic Biology
Museum of Comparative Zoology
Harvard University
Cambridge, MA 02138
lkay@eob.harvard.edu

Evelyn Fox Keller
Program in Science, Technology and
   Society
Massachusetts Institute of Technology
Cambridge, MA 02139
efkeller@mit.edu

Robert E. Kohler
Department of History and Sociology
   of Science and Technology
University of Pennsylvania
Philadelphia, PA 19104
rkohler@sas.upenn.edu

Bruno Latour
Centre de la Sociologie de
   l'Innovation
Ecole Superieure des Mines
F-75006 Paris, France
latour@paris.ensmp.fr

John Law
Department of Sociology and
   Anthropology
The University of Keele
Keele, ST5 5BG, UK
soa01@cc.keele.ac.uk

Timothy Lenoir
Program in History & Philosophy of
   Science
Stanford University
Stanford, CA 94305
tlenoir@leland.stanford.edu

Geoffrey Lloyd
Faculty of Classics
Darwin College
Cambridge, CB2 3RH, UK
gel20@cam.ac.uk

Michael Lynch
Department of Human Sciences
Brunel University
West London, UB8 3PH, UK
Michael.Lynch@brunel.ac.uk

Donald MacKenzie
Department of Sociology
University of Edinburgh
Edinburgh, EH8 9LN, Scotland
D.MacKenzie@ed.ac.uk

Emily Martin
Department of Anthropology
Princeton University
Princeton, NJ 08544
emartin@phoenix.Princeton.edu

Andrew Pickering
Department of Sociology
University of Illinois at
   Urbana-Champaign
Champaign, IL 61820
pickerin@uiuc.edu

Theodore M. Porter
Department of History
UCLA
Los Angeles, CA 90024
porter@histr.sscnet.ucla.edu

Paul Rabinow
Department of Anthropology
University of California, Berkeley
Berkeley, CA 94720
rabinow@uclink.berkeley.edu

Hans-Jorg Rheinberger
Max Planck Institute for the History
   of Science
D-10117 Berlin, Germany
rheinbg@mailmac.mpiwg-berlin.
   mpg.de

Brian Rotman
ACCAD/College of the Arts
Ohio State University
Columbus, OH 43210
brianrotman.zero@MCIONE.com

Joseph Rouse
Department of Philosophy
Wesleyan University
Middletown, CT 06459
jrouse@wesleyan.edu

Simon Schaffer
Department of History and
   Philosophy of Science
University of Cambridge
Cambridge, CB2 3RH, UK
sjs16@hermes.cam.ac.uk

Steven Shapin
Department of Sociology
University of California, San Diego
La Jolla, CA 92093
sshapin@ucsd.edu

Susan Leigh Star
Graduate School of Library and
   Information Science
University of Illinois at
   Urbana-Champaign
Champaign, IL 61820
s-star1@uiuc.edu

Sharon Traweek
Department of History
UCLA
Los Angeles, CA 90024
traweek@history.ucla.edu

Sherry Turkle
Program of Science, Technology and
   Society
Massachusetts Institute of Technology
Cambridge, MA 02139
sturkle@mit.edu

M. Norton Wise
Program in History of Science
Princeton University
Princeton, NJ 08544
nortonw@princeton.edu

Alison Wylie
Department of Philosophy
Washington University
St. Louis, MO 63130
alison@twinearth.wustl.edu

# Permissions
# Acknowledgments

KAREN BARAD, "Agential Realism: Feminist Interventions in Understanding Scientific Practices." Printed by permission of the author. MARIO BIAGIOLI, "The Instability of Authorship: Credit and Responsibility in Contemporary Biomedicine." Reprinted from *The FASEB Journal* 12 (1998): 3–16. Reprinted by permission of the author. PIERRE BOURDIEU, "The Specificity of the Scientific Field and the Social Conditions of the Progress of Reason." Reprinted from *Social Science Information,* 14(1975): 19–47. Reprinted with revisions by permission of Sage Publications and the author. ROBERT M. BRAIN AND M. NORTON WISE, "Muscles and Engines: Indicator Diagrams and Helmholtz's Graphical Methods." Reprinted from *Universalgenie Helmholtz,* edited by Lorenz Kruger (Akademie Verlag, 1995), pp. 124–145. MICHEL CALLON, "Some Elements of a Sociology of Translation: Domestication of the Scallops and the Fishermen of St. Brieuc Bay." Reprinted with revisions from *Power, Action, and Belief: A New Sociology of Knowledge?,* edited by John Law (Routledge & Kegan Paul, 1986), pp. 196–229. Reprinted by permission of the author and the publisher. SANDE COHEN, "Reading Science Studies Writing." Originally printed as "Science Studies and Language Suppression." Reprinted with revisions from *Studies in History and Philosophy of Science* 29(1997): 1–23. Reprinted by permission of Elsevier Science, Ltd., Oxford, England and the author. H. M. COLLINS, "The TEA Set: Tacit Knowledge and Scientific Networks." Reprinted from *Social Studies of Science* 4(1974): 165–186. Reprinted by permission of Sage Publications Ltd. and the author. LORRAINE DASTON, "Objectivity and the Escape from Perspective." Reprinted from *Social Studies of Science* 22(1992): 597–618. Reprinted by permission of Sage Publications Ltd. and the author. ARNOLD I. DAVIDSON, "Styles of Reasoning, Conceptual History, and the Emergence of Psychiatry." Reprinted with revisions from *The Disunity of Science,* edited by Peter Galison and David J. Stump (Stanford UP, 1996), pp. 75–100 and from "Conceptual Analysis and Conceptual History," in *Stanford French Review* 8(1984): 105–122. Reprinted by permission of Stanford University Press, ANMA Libri, and the author. PETER GALISON, "Trading Zone: Coordinating Action and Belief." Reprinted with revisions from *Image and Logic,* by Peter Galison (U of Chicago P, 1997), pp. 781–844. Reprinted by permission of the University of Chicago Press and the author. IAN HACKING, "Making Up People." Reprinted from *Reconstructing Individualism: Autonomy, Individuality, and the Self in Western Thought,* edited by Thomas C. Heller, Morton Sosna, and David E. Wellbery (Stanford UP, 1986), pp. 222–236 with the permission of the publishers, Stanford University Press. © 1986 by the Board of Trustees of the Leland Stanford Junior University. DONNA J. HARAWAY, "Situated Knowledges: The Science Question in Feminism and the Privilege of Partial Perspective." Reprinted from *Feminist Studies* 14, no. 3(fall 1988): 575–600, by permission of the publisher, *Feminist Studies,* Inc., c/o Department of Women's Studies, University of Maryland, College Park, MD 20742. ROGER HART, "On the Problem of Chinese Science." Printed by permission of the author. THOMAS P. HUGHES, "The Evolution of Large Technological Systems." Reprinted from *The Social Construction of Technological Systems,* edited by Wiebe Bijker, Thomas P. Hughes, and Trevor Pinch (MIT Press, 1987), pp. 51–82. Reprinted by permission of the MIT Press. LILY E. KAY, "In the Beginning Was the Word?: The Genetic Code and the Book of Life." Portions of this essay will appear in *Who Wrote the Book of Life?:*

*A History of the Genetic Code* by Lily E. Kay, forthcoming from Stanford University Press, and are used with the permission of the publishers. EVELYN FOX KELLER, "The Gender/Science System: or, Is Sex to Gender as Nature Is to Science?" Reprinted from *Hypatia*, vol. 2(1987). Reprinted by permission of the author. ROBERT E. KOHLER, "Moral Economy, Material Culture, and Community in *Drosophila* Genetics." Printed by permission of the author. BRUNO LATOUR, "Give Me a Laboratory and I Will Raise the World." Reprinted from *Science Observed*, edited by Karen Knorr-Cetina and Michael Mulkay (Sage, 1983), pp. 141–170. Reprinted by permission of Sage Publications Ltd. and the author. BRUNO LATOUR, "One More Turn After the Social Turn . . ." Reprinted from *The Social Dimensions of Science*, edited by Ernan McMullin (U of Notre Dame P, 1992), pp. 272–294. © 1992 by University of Notre Dame Press, Notre Dame, IN. Reprinted by permission of the publisher. TIMOTHY LENOIR, "Was the Last Turn the Right Turn?: The Semiotic Turn and A. J. Greimas." Reprinted from *Configurations* 1(1994): 119–136. Copyright © 1994 by the Johns Hopkins University Press and the Society for Literature and Science. Reprinted by permission of the publishers. GEOFFREY LLOYD, "Science in Antiquity: The Greek and Chinese Cases and Their Relevance to the Problems of Culture and Cognition." Reprinted from *Modes of Thought*, edited by David R. Olson and Nancy Torrance (Cambridge UP, 1996), pp. 15–33. Reprinted by permission of Cambridge University Press and the author. MICHAEL LYNCH AND JOHN LAW, "Pictures, Texts, and Objects: The Literary Language Game of Birdwatching." Reprinted with revisions from *Human Studies* 11, nos. 2–3(1988): 271–303. Reprinted by permission of Kluwer Academic Publishers and the authors. DONALD MACKENZIE, "Nuclear Missile Testing and the Social Construction of Accuracy." Reprinted with revisions from *Inventing Accuracy: A Historical Sociology of Nuclear Missile Guidance*, by Donald MacKenzie (MIT Press, 1990), pp. 340–381. Reprinted by permission of the publisher and the author. EMILY MARTIN, "Toward an Anthropology of Immunology: The Body as Nation State." Reprinted from *Medical Anthropology Quarterly* 4, no. 4(December 1990). Reprinted by permission of the American Anthropological Association and the author. Not for further reproduction. ANDREW PICKERING, "The Mangle of Practice: Agency and Emergence in the Sociology of Science." Reprinted from *The American Journal of Sociology* 99(1993): 559–589. Reprinted by permission of the University of Chicago Press and the author. THEODORE M. PORTER, "Quantification and the Accounting Ideal in Science." Reprinted from *Social Studies of Science* 22(1992): 633–651. Reprinted by permission of Sage Publications Ltd. and the author. PAUL RABINOW, "Artificiality and Enlightenment: From Sociobiology to Biosociality." Reprinted with revisions from *Zone 6: Incorporations*, edited by Jonathan Crary and Sanford Kwinter (Zone, 1992), pp. 234–252. Reprinted by permission of the publisher and the author. HANS-JÖRG RHEINBERGER, "Experimental Systems: Historiality, Deconstructions, and the 'Epistemic Thing.'" Reprinted from *Science in Context* 7(1994): 65–81. Reprinted by permission of Cambridge University Press and the author. BRIAN ROTMAN, "Thinking Dia-Grams: Mathematics, Writing, and Virtual Reality." Reprinted with revisions from *South Atlantic Quarterly* 94, no. 2(spring 1995): 389–415. Copyright © 1995 Duke University Press. Reprinted by permission of the publisher and the author. JOSEPH ROUSE, "Understanding Scientific Practices: Cultural Studies of Science as a Philosophical Program." Printed by permission of the author. SIMON SCHAFFER, "Late Victorian Metrology and Its Instrumentation: A Manufactory of Ohms." Reprinted with revisions from an earlier version entitled "Late Victorian Metrology and Its Instrumentation: A Manufactory of Ohms," in *Invisible Connections, Instruments, Institutions, and Science*, edited by Robert Bud and Susan Cozzens (SPIE Optical Engineering Press, 1992), pp. 23–56. Reprinted by permission of the publisher and the author. STEVEN SHAPIN, "House of Experiment in Seventeenth-Century England." Reprinted from *Isis* 79(1988): 373–404. Reprinted by permission of the University of Chicago Press. SUSAN LEIGH STAR AND JAMES R. GRIESEMER, "Institutional Ecology, 'Translation,' and Boundary Objects: Amateurs and Professionals in Berkeley's Museum of Vertebrate Zoology, 1907–1939." Reprinted with revisions from *Social Studies of Science* 19(1989): 387–420. Reprinted by permission of Sage Publications Ltd. and the authors. SHARON TRAWEEK, "Pilgrim's Progress: Male Tales Told during a Life in Physics." Reprinted from *Beamtimes and Lifetimes*, by Sharon Traweek (Harvard UP, 1988), pp. 74–105. © 1988 by the President and Fellows of Harvard College. Reprinted by permission of the Harvard University Press, Cambridge, MA. SHERRY TURKLE, "What Are We Thinking about When We Are Thinking about Computers?" Reprinted from *Sociological Inquiry* 67, no. 1(1997): 72–84. ALISON WYLIE, "The Engendering of Archaeology: Refiguring Feminist Science Studies." Reprinted with revisions from *Osiris* 12(1997): 80–99. Reprinted by permission of the University of Chicago Press and the author.

# Index

# INDEX

Printed and bound by CPI Group (UK) Ltd, Croydon, CR0 4YY
01/11/2024
01782610-0015